Art in Theory 1815–1900

Art in Theory
1815–1900
An Anthology of Changing Ideas

Edited by Charles Harrison
and Paul Wood
with Jason Gaiger

BLACKWELL
Publishers

Copyright © Blackwell Publishers Ltd, 1998
Introduction, apparatus, selection and arrangement copyright © Charles Harrison, Paul
Wood and Jason Gaiger 1998

First published 1998
2 4 6 8 10 9 7 5 3 1

Blackwell Publishers Ltd
108 Cowley Road
Oxford OX4 1JF
UK

Blackwell Publishers Inc.
350 Main Street
Malden, Massachusetts 02148
USA

British Library Cataloguing in Publication Data
A CIP catalogue record for this book is available from the British Library.

Library of Congress Cataloging-in-Publication Data
Art in theory, 1815–1900: an anthology of changing ideas / edited by Charles Harrison and
Paul Wood with Jason Gaiger.
 p. cm.
 Includes bibliographical references and index.
 ISBN 0–631–20065–7 (hbk); 0–631–20066–5 (pbk).
 1. Art, Modern —19th century — Philosophy. I. Harrison, Charles, 1942 – . II. Wood,
Paul, 1949 – . III. Gaiger, Jason, 1965 – .
N6450. A779 1998 97–20 185
709'. 03'4–dc21 CIP

Typeset in 10 on 11.5pt Ehrhardt
by Pure Tech India Ltd, Pondicherry
Printed in Great Britain by T.J. International, Padstow, Cornwall

This book is printed on acid-free paper

Summary of Contents

Contents

II The Demands of the Present

5 Ralph Waldo Emerson
 from 'The American Scholar' 1837 162
6 Robert Vaughan
 'On Great Cities in their Connexion with Art' 1843 163
7 Heinrich Heine
 from Salon of 1843/1843 166
8 Ludwig Andreas Feuerbach
 from the Preface to the Second Edition of *The Essence of Christianity* 1843 167
9 Karl Marx
 on Alienation 1844 170
10 Karl Marx and Friedrich Engels
 on Historical Materialism 1845–6 173
11 Karl Marx and Friedrich Engels
 on the Bourgeoisie 1848 177
12 Théophile Thoré
 from 'Salon of 1848' 1848 179

IIB *Art and Nature Moralized*

1 Jean Auguste Dominique Ingres
 from Notebooks *c.* 1820–48 183
2 John Stuart Mill
 'What is Poetry?' 1833/59 185
3 Thomas Cole
 Letter to Luman Reed 1833 190
4 Victor Cousin
 from *Lectures on the True, the Beautiful and the Good* 1836 192
5 Friedrich Theodor Vischer
 'Overbeck's *Triumph of Religion*' 1841 196
6 John Ruskin
 from *Modern Painters* Volume 1 1843 199
7 John Ruskin
 from Preface to the Second Edition of *Modern Painters* 1844 204
8 Antonio Bianchini
 'On Purism in the Arts' 1843 211
9 Jacques Nicholas Paillot de Montabert
 'On the Necessity of Theoretical and Philosophical
 Teaching of the Arts...' 1843/55 213
10 William Wordsworth
 Letters on the Kendal and Windermere Railway 1844 216
11 Théophile Thoré
 Open Letter to Théodore Rousseau 1844 220

IIC *Systems and Techniques*

1 David Pierre Giottin Humbert de Superville
 from *Essay on Absolute Signs in Art* 1827–32 225
2 Camille Corot
 Reflections on Painting *c.* 1828 231

IID *Independence and Individuality*

III Modernity and Bourgeois Life

IIIc *Morals and Standards*

IIId *The Conditions of Art*

IV Temperaments and Techniques

xiv Contents

V Aesthetics and Historical Awareness

VI The Idea of a Modern Art

Introduction 875

Acknowledgements

Our foremost thanks go to those copyright-holders who have permitted us to reproduce texts here included, and to edit them where we have felt the need to do so. We are also indebted to the translators and editors of some specialized anthologies who have made material available to us. They have all helped to realize our intention to produce a comprehensive anthology of the ideas out of which nineteenth-century art was made.

We are grateful to the Open University for the part-time funding which allowed Jason Gaiger to begin work on *Art in Theory*, and to the Leverhume Trust for the Fellowship which enabled him to join in the project as a full participant. Our thanks are also due to Jane Robertson, formerly of Blackwell Publishers, who guided the very earliest stages of our research, and who established our contact with Jason in the first place.

In the long task of tracing and compiling material we have benefited greatly from the advice and assistance of colleagues at the Open University and elsewhere. Paul Smith and Gen Doy have been particularly helpful. So too have Kathleen Adler, David Batchelor, Jeroen Boomgaard, Anthony Coulson, Jo Dahn, Trish Evans, Tamar Garb, Andrew Hemingway, Gillian Perry, Michael Rosenthal, Eva Steinlechner, Nigel Warburton, Martha Ward and Roberta Wood. Others who helped by responding to a questionnaire circulated by Blackwell Publishers include Nanette Aldred, Richard Bionda, Deborah Cherry, Michael Corris, Colin Cruise, Terence Diffey, Carol Duncan, Amelia Jones, Adrian Lewis, John Morrison, Lynda Nead, Robert Radford, Susan Reid, Colin Rhodes, Juliet Steyn and Richard Woodfield. We are grateful to Joel Snyder for research facilities provided for Charles Harrison at the University of Chicago, and to J. A. Benigno for help in tracing material there.

Our book has benefited greatly from the commitment of those who traced and translated material, especially Andrew Brown, Peter Collier, Olivia Dawson, Carola Hicks, Sabine Jaccaud, Akane Kawakami, Christopher Miller, Jonathan Murphy, Ingeborg Owesen, Kate Tunstall, Natalie Vowles, Nicholas Walker and Hester Ysseling.

We would also like to express our considerable gratitude to Hilary Frost for her work in tracing copyright holders and securing permissions, and Andrew McNeillie, Senior Commissioning Editor for Blackwell Publishers, who responded positively to our idea of a two-volume survey of the art theory of the early modern period: *Art in Theory 1815–1900*, and *Art in Theory 1648–1815*, to which we now turn.

C. H., P. W. & J. G.

A Note on the Presentation and Editing of Texts

Where a published document was originally given a title, this has generally been used for the present publication, in single quotation marks. Titles of books are given in italics. Where a specific subtitled section of a document has been taken, this subtitle is used for the extract. The title of the whole work is then given in the introduction to that text. In the absence of original published titles we have given descriptive headings without quotation marks. The term 'from' preceding a title signifies that we have taken a specific extract or extracts from a longer text, without seeking to represent the argument of the whole. Otherwise texts are given in their entirety or are edited so as to indicate the argument of the whole.

It is the aim of this anthology that it should be wide-ranging. We have therefore preferred the course of including a greater number of texts, of which several must appear in abbreviated form, to the course of presenting a small number in their entirety. Texts have been variously edited to shorten them, to eliminate references which cannot be explained within the space available, and where necessary to preserve the flow of argument. We have provided information as to the sources for complete versions of all edited texts. We have also clearly marked where texts have been edited.

The following conventions have been used throughout. Suspended points '. . .' are used to denote the omission of words or phrases within a sentence. Suspended points within square brackets '[· · ·]' are used to denote omissions extending from a complete sentence to a paragraph or several short paragraphs. Asterisks '* * *' denote substantial omissions of more than one paragraph, and may denote exclusion of a complete subdivision of the original text. It should be noted that a paragraph may end thus [. . .], either if the last sentence of that paragraph is omitted or if the following paragraph is omitted. A paragraph may also start thus [. . .], if one or more sentences at the beginning of that paragraph have been omitted, or if a previous paragraph has been omitted.

Notes and references have only been included where we judged them necessary to the text as printed. We have generally avoided the insertion of editorial footnotes, but have supplied essential references in the introductions to individual texts.

We have corrected typographical errors and errors of transcription where we have discovered them in the anthologized texts, but otherwise we have left idiosyncrasies of punctuation, spelling and style unchanged.

Introduction

The aim of this book is to provide students of art, art history and aesthetics as well as the interested general reader with a substantial and representative collection of texts, drawn from a wide variety of nineteenth-century sources. *Art in Theory 1815–1900* was originally prompted by the welcome extended to our previous anthology, *Art in Theory 1900–1990*, and it has been designed to serve as a companion volume, with a matching extent and using similar principles of selection and organization. As with the twentieth century, the student of nineteenth-century art faces a potentially bewildering diversity of sources. Many of the relevant texts are hard to trace without the resources of a specialized library. Moreover, much of the most significant artistic theory of the period was written in languages other than English. As a consequence, a relatively fixed canon of texts tends to be repeated in different editions, among them a limited number of translations from foreign-language sources. The present anthology continues our project to improve access to the written materials associated with the development of art, both by rendering a broad selection more generally available to study and by providing indications of the nature and location of other relevant publications. While we have included those texts that are deservedly canonical, we have also aimed to provide an adequate account of the diversity of artistic theory during the nineteenth century. Approximately a third of the material in the book consists of new translations from foreign sources. We have been particularly concerned both to broaden the survey of French material beyond the standard interests of English-language art history and to correct what has for a long time been a comparative neglect of German sources. Other new translations have been made from material in Dutch, Italian, Norwegian and Russian. On the one hand we have tried to demonstrate that not all roads lead to Paris, even in the later nineteenth century; on the other that, by the end of the century, the flow of ideas *from* Paris was both widespread and rapid.

The extent of the modern

The governing interest of *Art in Theory 1900–1990* was to survey the literature of *modern* art. In the process, we intended to show that modernism itself has been and remains a complex and contested value, and we hoped that readers would be availed of an accordingly sophisticated grasp of the issues at stake. Notwithstanding the

problems in achieving consensus on the artistic character of modernism, there has been an increasing tendency in recent years to conceive of 'the modern' as contained within a finite historical period, and to locate the close of that period in the later twentieth century. The dates set at either end of that period vary according to the account on offer. But there is a growing consensus that 'the modern' should be seen as having begun in the second half of the eighteenth century and as having drawn to a close in the second half of the twentieth. A corollary of this tendency is that the modern in general, and modernism in art in particular, have come to be widely associated with now exhausted values.

Yet while it may be the case that modernism is no longer self-legitimating, we are far from convinced that its projects are complete, or that its history is closed. And while it is certainly true that great uncertainty now exists regarding key values associated with the art of the modern period – progress, individuality, self-expression, independence – this uncertainty has seemed to us the more reason to trace the origins of that art and to understand the various stages of its early development. Hence, in part, the specific justification for this volume as a form of sequel to the first.

At the time of writing it is hard not to respond to the widespread proclamation of a postmodern condition. But in our desire to distance ourselves from the presumed failures and exclusions of the recent past, we are in danger of reducing the complex history of the modern to a series of caricatures. For example, the 'Enlightenment project' is often identified with a belief in the progress to be achieved by means of rational government and expanding scientific enquiry. At the end of the twentieth century, on the other hand, optimists are thin on the ground. The political catastrophes of the twentieth century have bred deep scepticism about human perfectibility. We have become alert to the tendency of central accounts of reason either to co-opt or to marginalize the different. And we have seen the beneficial consequences of science balanced – to put it no more strongly – by its conspicuous disasters. Thus, from our present vantage point, we look into the shadows cast by Enlightenment and associate the project of modernity with a utopianism which we have ourselves outgrown.

Yet influential as this sense of the emptiness of the Enlightenment project has become, the evidence assembled in the present volume does nothing to encourage the belief that ours is the first generation to feel it. Few of the major artists, critics or aestheticians of the nineteenth century could properly be characterized as unthinking optimists, and even fewer of its major philosophers or social thinkers. As the first broad artistic movement of the century, Romanticism stands in a dialectical relationship to Enlightenment concepts of rationality, seeking on the one hand to continue the self-critical tendencies of the Enlightenment thinkers, and on the other to counter a perceived narrowness by enlarging the dimension of human experience. As for the Realist tendency that ensued, it was clearly motivated in part by the need to make substantial public culture out of the manifest evidence of social inequalities. And what of those forms of extreme scepticism supposedly characteristic of postmodern art and culture? Who better to exemplify their practical display than Edouard Manet, who first made his mark in the 1860s, and who is credited in some standard accounts as the very founder of modernist painting?

The careful reader of this anthology may be surprised to discover how many of our modern controversies and problems and insights may be traced back into the nine-

teenth century. To understand their genealogy and their antecedents is to see familiar issues in a new light – and sometimes to be alerted to their continuing relevance. It becomes all the clearer that a broad survey of the artistic theories and controversies of the nineteenth century is urgently needed, not only to further understanding of the history of modern Western culture but, in the light of that understanding, to stimulate and inform a critical re-examination of the cultural assumptions and values of the present. Paradoxically, the more firmly these latter values seem to become established, the more necessary it seems to re-examine our retrospective view of the culture of the wider modern period and to trace back the conditions of its formation. It transpires that the optimism of our predecessors was accompanied by uncertainties not unlike our own. There is a certain strength and reassurance to be derived from this lesson. We may come more readily to accept that the project of modernity – the reconciliation of the values of rationality with the goal of independence – remains both indispensable and as yet incomplete.

None of this is to imply that the present book has been compiled as a rearguard action in defence of artistic modernism. Quite the contrary. It is clear that work done by postmodernists, feminists, social historians and other revisionists will be open to criticism to the extent that it rests on caricatures of modernism, but it docs not follow that contemporary intellectual tendencies may be reduced to the status of passing fashions. Times and ideas do change. And one purpose of the present volume is to open the past to better scrutiny in order that it may be learned from – the point being that the past turns out to be as unpredictable as the future. Within the physical limits of our enterprise we have tried to represent as open a web of theories and arguments, ideas and influences, as the historical record can be made to yield. Openness is always relative however. It tends to be a matter of recognizing certain covert mechanisms of closure and of seeking self-consciously to resist them. The particular forms of closure we have tried to avoid are of two kinds: on the one hand the tendency to a kind of 'automatic' defence of modernist values against contemporary forms of revision; on the other the tendency to ignore the genuine complexities of the past in prosecution of a revisionist moral agenda in the present.

Of one thing we can be sure: whatever values modernism is taken to represent, however they may have been contested during the modern period, and whosoever may have contributed to the relevant debates, the prevalence of those values in the West is inextricably associated with the period of dominance of the educated, mercantile middle class or bourgeoisie. This is emphatically not to reduce modern art to a form of bourgeois ideology. Modernism was never a significant property in the culture of the class taken as a whole. Rather, modern forms of art developed during the nineteenth century under the interested regard of a critical and self-aware minority within the newly dominant class – a minority for whom the concept of the 'bourgeois' served ironically as the very negative of what they intended themselves to be. And if what the 'bourgeois' supposedly stood for was adherence to the profit motive and to the principle of value for money, then how better to declare an anti-bourgeois disposition than through advocacy of art as an end in itself?

An understanding of this strong but complex implication, between the growth of a mercantile bourgeoisie on the one hand and the vaunting of aesthetic principles on the other, has been one significant factor governing the principles of selection of material

for this collection, helping to establish its historical parameters. But we have also been conscious that that drive to intellectual and spiritual independence on the part of a section of the middle classes was maintained in tension with other interests. For others living and working in the urban systems of modernity, no such independence was in prospect. Indeed, in the view of many such, the aesthetic dimension *tout court* expanded out of a form of life which was already obstructing the achievement of a real and lasting social independence. The rich texture to be found in our selection derives to a large extent from this complex interplay between idealism and materialism in the world of thought, and between aesthetic autonomy and social realism in the practice of art. Indeed, we believe that this interplay conferred on that art itself much of the richness and variety we have sought to convey.

As regards our principles of selection we repeat a point asserted in the introduction to *Art in Theory 1900–1990*: 'It is art we are concerned with, and the theory it is made of; not the culture it is made of, nor the theory of the culture'. Our attention has been primarily concentrated upon the practices of painting and sculpture as fine arts, and we have considered theory as relevant *prima facie* where it can be clearly connected to the pursuit of these practices or to the business of their critical reconsideration. (Thus, for instance, the reciprocal issues that guided our selection of material on photography were the status of the photograph as a form of fine art and the implications of photography for the status of painting.) But there is a necessary rider to be added. It is this: there can be no adequate survey of fine art in the nineteenth century without due acknowledgement that the class-character of artistic culture was continually at issue in the theory that that art was made of, however circumspectly the relevant interests might sometimes be voiced. To take an example from the outset of our period, it is a notable feature of the landscape paintings Constable produced around 1815 that, for all their intended fidelity to nature, what they show us are places clearly differentiated by specific forms of ownership and of labour. To take a later example, it might seem that considerations of class had little part to play in arguments over the empirical basis of artistic representations from the 1860s to the 1880s. Yet when the French avant-garde of the time asserted its commitment to the 'truth' of empirical impressions, it tended to do so in explicit disparagement of the taste for well-rehearsed pictorial themes – and that taste was represented as characteristically *bourgeois*.

As regards the historical parameters of the present anthology, the date of the Battle of Waterloo provides a convenient point of commencement. In general and in the long term, the settlements that followed the end of the Napoleonic Wars were such as either to enable or to recognize government in the interests of the capitalist middle class, at a time when the powers of that class were sustained and increased among the countries of the West by the spread of industrialization. The period between 1815 and the turn of the century is characterized on the one hand by the sustained dominance of the middle class in the social and economic affairs of the West, and on the other by the emergence of increasingly vocal and dissident factions within it. These were the conditions of emergence of democratic nation states in the modern mould.

It should be recognized, however, that an account of the modern that starts in 1815 assumes a connection between the emergence of the bourgeoisie and the development of artistic modernism that must have its roots in the previous century, while various

other relevant issues are left unexamined, not least those which concern the identification of modernism with the currency of the Enlightenment project. A comprehensive review of the modern period in art will thus in the end have to go back beyond the date marking the outset of the present volume, and look, albeit circumspectly, to the beginnings of the Enlightenment itself and to the first emergence of characteristically bourgeois forms of artistic culture in the mid-seventeenth century. Our project will accordingly be continued and completed with the ensuing third volume in this series, *Art in Theory 1648–1815*.

The selection of texts

The process of selection of material necessarily started with a review of the work of our predecessors. There have been various previous collections of material covering the period or aspects of it. First published in 1968, Herschel B. Chipp's *Theories of Modern Art* provided an invaluable starting-point for *Art in Theory 1900–1990*, but much useful material on the late nineteenth century is also included in the earlier part of his anthology. Joshua Taylor's companion volume, *Nineteenth Century Theories of Art*, was published posthumously in 1987 and assembled a number of substantial essays in original translations. Linda Nochlin and Lorenz Eitner were responsible for pioneering volumes within the 'Sources and Documents' series published by Prentice-Hall. The former's *Realism and Tradition in Art 1848–1900* and *Impressionism and Post-Impressionism 1874–1904* were both published in 1966, the latter's two-volume *Neo-Classicism and Romanticism 1750–1850* in 1970. Among volumes restricted to the artistic theory of single countries we have been grateful for John McCoubrey's *American Art 1700–1960* (1965), Paola Barocchi's *Testimonianze e polemiche figurative in Italia* (1972), and to the three volumes of *Kunsttheorie und Kunstgeschichte des 19. Jahrhunderts in Deutschland*, edited by Werner Busch, Wolfgang Beyrodt, Harold Hammer-Schenk and Ulrich Bischoff, and published between 1982 and 1985. Finally, we should acknowledge our part of the debt to Elizabeth Holt that is owed by all concerned with the history of artistic theory and criticism. Among the many volumes she has edited there are three that are of particular relevance to the study of the nineteenth century: *From the Classicists to the Impressionists* (1966, volume three of *A Documentary History of Art*), *The Triumph of Art for the Public 1785–1848* (1970) and *The Expanding World of Art 1874–1902* (1988).

Invaluable as these previous publications have been, they are in the majority the fruits of work done during the 1960s and 1970s. Not only has more material come to light since then, but the interests of art history have tended to broaden considerably. There is a larger field now to be surveyed by any work aiming to provide adequate resources of study for the period as a whole. In fact to put the point in this fashion is to convey too strong a sense of direction in our project. It would be nearer the truth to say that, once cast adrift from those established sources which are *sine qua non*, we have not often been sure either what to look for or where *not* to look. Viewed through the legacy of modernism, the place of art in theory becomes ever harder to fix with any security. It is a consequence of the recent exorbitation of theory itself that, when one seeks to distinguish those theoretical considerations that are relevant to the

production of art from those that are not, there are relatively few decisions that the art historian can still make *a priori* on secure methodological grounds. In face of this circumstance, rather than seeking to reimpose an overview on the material surveyed, we have sought to profit from the opportunities for revision and expansion. As with *Art in Theory 1900–1990*, we have been more concerned to represent a body of ideas and concerns than to assemble an identifiable corpus of artist-authors or to do full justice to specific careers. We have intended no *a priori* distinction between authors. A text is a text whether the writer be a practising artist, a critic, a philosopher or a scientist.

One difference between this and previous collections is that we have included a higher proportion of material representative at one extreme of the philosophical underpinning of artistic debates, and at the other of the sociological background to artistic practices. We have also considered it appropriate to represent the development of art history in Germany in the later part of the century. The artistic production of the nineteenth century was informed in various ways by a recuperation and appropriation of the art of the past. The awareness of diverse phases of art and of different cultures exercised a significant influence on Western art from the period of Romanticism at least, helping not merely to loosen the grip of the classical canon but to change the larger self-images of a culture for which that canon had been a central resource. This is decidedly not an anthology of art-historical work, however, and we have otherwise tended to exclude texts that are clearly retrospective. In general we have felt justified in positively pursuing such themes as seemed both to emerge within the material and to resonate with the concerns of the present. On this principle we have done what we can to strengthen the otherwise poor representation of women's voices within the established literature of art theory. We have not gone so far, however, as retrospectively to redress those powers and mechanisms by which women were disenfranchised and silenced at the time. Rather, we have sought to ensure that those mechanisms are themselves occasionally represented and rendered visible.

How far to exercise a positive discrimination in favour of the voices of women and other marginalized producers has been one persistent dilemma accompanying our work. Another has been how to balance the respective demands of vividness and representativeness in the selection of texts. The automatic candidates for inclusion are those texts specifically addressed to artistic themes that easily meet both demands at once: Friedrich's 'Observations', Delacroix's Journals, the letters of Constable, Cézanne and Van Gogh, the critical essays of Baudelaire, Zola and Pater, the polemics of Whistler and Morris. Lengthy as some of these texts may be in their entirety, where they cannot be included as wholes they can justifiably be represented in the form of coherent and continuous samples. But these are in the minority. Crucial as the Impressionist movement is to our whole understanding of the modern in art, for example, the theoretical character of Impressionism has for the most part to be established circumstantially or through the writings of sympathetic commentators. Unlike the twentieth century, the nineteenth offers relatively few unmistakable manifestos or other self-conscious artistic statements, though far more pedagogical tracts and handbooks, many of them extensive and dull. We have offered some samples of the latter, but we have not aimed to represent their extent. It is also the

case that a higher proportion of what must count as theory is the work of those who were primarily writers, and whose literary interests and habits were often well to the fore. A further problem is that both those who wrote art criticism and those who wrote on aesthetics during the nineteenth century tended to expatiate at far greater length than their twentieth-century equivalents. The average 'Salon' was a book-length review, the typical treatise on aesthetics a work in several volumes. Where such a substantial work needed to be represented, we have normally had to choose between following the overall tenor of an argument through a succession of linked extracts and selecting a single continuous passage on the basis of its intrinsic interest. Our decisions in such cases have not been made on any single consistent principle. They have been made in response to the intrinsic qualities of the texts themselves, in the interests of the book as a whole and in order to add substance to its themes.

We make no apologies for this manner of proceeding. Our aim has been to produce a collection which is engaging as well as serviceable. There are lessons to be learned when that which is supposed to be representative of its moment turns out not to be vivid. After all, just the opposite priorities are at work in the claim that art makes for itself in the face of history. The claim, in other words, is that that which is vivid should be taken as representative. And it is the desire to represent *Art* in theory that has principally motivated our work. We have aimed to be responsive to the demands of curricula and to modern developments in theory and in art-historical work, but the agenda for this book has nevertheless been largely determined by a specific body of practical work to which nothing can now be added except through rediscovery: those actual paintings and sculptures of the nineteenth century that constituted the practical outcomes of the artists' aims and ideas, that stimulated the production of critical theories, and that served to focus or to illustrate debates on aesthetic and cultural issues. In the end, it is this absent resource that serves as organizing principle for the material in the pages that follow. Like its predecessor, this anthology will be of greatest benefit to those readers who treat it not simply as a resource for the study of art history, but as an accompaniment to the first-hand experience of works of art.

Principles of organization

The organization of material for this book has been the subject of a continuing conversation between us over the period of its production. This conversation was begun by Charles Harrison and Paul Wood in work on *Art in Theory 1900–1990* and was joined by Jason Gaiger in work on the present volume. Argument among us has continually focused on the division of the material into sections and subsections. At the heart of our project there has thus been a persistently discursive and dialectical process. Respecting the interests of a larger history, we have attempted to group the material into broad chronological divisions, but we have often had to reconsider what seemed like secure forms of periodization when the currency of theoretical debates proved these to be inappropriate. On the other hand, we have tried to recognize the tendency of the material to cluster about certain themes and issues, but have some-times had to recognize that the significance of an aesthetic issue must be allowed to have changed when the historical context of debate has shifted beyond a certain limit.

The titles of our sections and subsections represent the fruits of this process, in the form of a table of topics and concepts. We have divided the material into six broadly chronological sections. These contain the cross-currents of debate as to the role and concerns of art. Each section is introduced with an essay outlining major practical developments and theoretical concerns during the relevant period and where appropriate relating these to the wider political and economic forces at work in the history of the time. Within each of these sections texts are then grouped under thematic subheadings. Within each subheading the arrangement is generally chronological – the exceptions being where we have grouped a number of texts under a common author, or where we have meant to preserve a sequence of debate or a geographical connection. Each individual text is then provided with a brief introduction, specifying the original occasion of its publication and where relevant explaining its connection to contemporary events and controversies. A given text may thus be read for its independent content, as a moment in the development of a specific body of argument, or as a possible instance of a larger tendency or body of concerns within a broad historical period.

Inevitably our organization of this material must reflect the interests of a retrospective regard. But we hope that the categories we have devised are sufficiently open to encourage rather than to inhibit the exercise of historical imagination. It is our aim that the users of this book should be able to look back through the forms of specialization developed during the twentieth century into a world in which – to paraphrase Max Weber – the separation of value-spheres had not yet been fully accomplished.

Jason Gaiger
Charles Harrison
Paul Wood
March 1997

Part I
Feeling and Nature

I
Introduction

In 1815 the Battle of Waterloo brought an end to the long period of conflict in Europe which had been precipitated by the French Revolution. For some 25 years France had been opposed by Britain, Prussia, Austria and other European nations, acting first against the revolutionary regime and then in a series of unstable alliances against Napoleon. Now, as France's short-lived European empire was brought to an end, representatives of the principal victorious powers met at the Congress of Vienna to re-establish the boundaries of continental Europe and to propose forms of international cooperation based on a new alliance of imperial regimes. In 1818 the resulting 'Congress System' was broadened to include France herself under the restored Bourbon monarchy of Louis XVIII.

The various European countries were at very different stages of political and industrial development. Germany and Italy were both still divided into a number of small states. With a population close to that of Prussia, but only about half the respective totals of France and Austria, Britain alone of the major powers had survived the wars without occupation or serious military defeat. Despite the loss of America, she still retained control over colonies in Australia, North America, India and the West Indies, with a substantial presence in Africa. Her industrial and commercial base was well developed, and her form of government allowed for relatively rapid adaptation as accelerating mechanization and growth of opportunities for trade greatly strengthened the power of a mercantile middle class. Britain was thus well placed to take advantage of the peace at a time when systems of feudal and clerical privilege were being widely restored on the European continent.

In fact, though Europe's imperial orders may have been consolidated or re-established following the defeat of Napoleon, they persisted in the second and third decades of the century in face of considerable intellectual dissent. The retrenchment of the old systems of government across Europe was facilitated by the fear of war and instability which had been unleashed by the revolutionary regime in France. None the less, the ideas which had driven the French and American revolutions continued to exercise a vital force and, once established, the fundamental principles of liberty, equality and citizenship continued to challenge the legitimacy of government based upon aristocratic and feudal privilege. It was not only in the newly established republics that the virtues of republicanism were spoken of. The significant tendencies in the cultural and civil life of Europe and America were to a large extent those in

which revolutionary change was celebrated, or its possibility at least maintained as a subject of imaginative exploration.

In Germany, Napoleon's victory at the Battle of Jena and the establishment of the Confederation of the Rhine in 1806 had brought to an end the old order and with it the Holy Roman Empire itself. Many of the reforms carried out under the period of Napoleonic occupation subsequently remained in place. Liberal hopes for the future were effectively stifled throughout the German states, and particularly in Prussia after 1815. Nevertheless, there was no real possibility of a return to the pre-Napoleonic era. It has become a commonplace to trace the extraordinarily rich development of Romantic and Idealist thought in Germany to the restriction of possibilities for real social change. Whether this is justified or not, it is still clear that the ferment of the political upheaval in France continued to inform German critical and speculative enquiry in the domains of art, philosophy and natural science throughout the first decades of the nineteenth century.

The writings of the later Goethe (IA 12) and of his friend and admirer Carl Gustav Carus (IB 1) reflect an ongoing concern with the relationship between art and science and of both of these in turn with nature. For Goethe, though beauty in art is related to natural beauty, it is not itself a natural property but springs instead from human intelligence and understanding. Both forms of beauty are seen as putting humanity in touch with something beyond our own limited existence and comprehension. And so to enquire into such mysteries is to search for the deeper, underlying laws which inform divine as well as human creativity. Similarly, for Carus, the poetic mood represents an 'elevation of the whole human being', one which 'rouses all our spiritual powers'. Carus's *Nine Letters on Landscape Painting* has been described as 'the central Romantic document of landscape painting'. The letters were written over a period which extends from Carus's friendship with Caspar David Friedrich in Dresden to his first encounter with Goethe in Weimar. His identification of landscape as the form of art which properly belongs to the modern age relates not only to the sketches and studies from nature which he made under Friedrich's guidance, but also draws upon the broader Romantic conception of nature as the revelation of the infinite within the finite – of divine creation in the human world. Friedrich's own observations on art, written towards the end of his life, reveal an acute awareness of the role of sensibility and of the artist's individual responses to nature (IA 8). Where the Nazarenes placed emphasis on mere technique and encouraged the artificial imitation of the style of the old masters, Friedrich insisted that the artist should follow the 'inner compulsion of his heart' and should seek to combine knowledge with feeling.

At the beginning of our period, the priority accorded to art was respectively challenged and affirmed in two major contributions to aesthetic theory. The supreme status to which art had been elevated by the German Romantics was put into question in the lectures on aesthetics which Hegel gave in Berlin, in the years between his call to the chair in 1818 and his death in 1831 (IA 10). Hegel maintained that art was one of the forms in which 'divine nature' and the 'deepest interests of humanity' are revealed. None the less, he sought to show that art could no longer be conceived as the highest mode in which the mind's genuine interests are brought to consciousness. As the sensible appearance of the idea, he argued, art is only capable of representing a 'certain circle and grade of truth', and it has, historically, been superseded by religion

and by speculative philosophy. At the same time, however, also in Berlin but in relative obscurity, Schopenhauer was constructing a metaphysical system in which art was accorded a uniquely important position. Through art alone, he proposed, was it possible to achieve release from the endless cycle of desire and suffering constitutive of the human condition (IA 1). Schopenhauer characterizes aesthetic experience as a state of will-lessness in which access is gained to the eternal Ideas behind the appearances of nature. In this scheme, the artist as 'genius' is accorded a privileged position by virtue of his capacity to see beyond the limitations of striving and reasoning humanity.

In France, Britain and America, interests characteristic of Romanticism and of Naturalism asserted themselves with increasing emphasis during the second and third decades of the century. At the centre of the approximate period covered by this first section, one specific date will serve to establish some relevant relations among a series of artistic developments. In January 1824 the painter Théodore Géricault died in comparative poverty at the age of 33. Among his last works were a series of studies of the inhabitants of an insane asylum – works remarkable in conveying the disturbed and disturbing individuality of their subjects. In that same summer considerable attention was paid to three works shown at the Paris Salon by John Constable, the *Hay Wain* among them. Delacroix was one of those particularly impressed by Constable's work, and specifically by the technical means the English painter had developed to represent the effects of natural light. Delacroix's own *Scenes from the Massacre at Chios* was shown in the same Salon. Like Géricault's *Raft of the Medusa* of five years earlier, this work represented the sufferings of the otherwise uncelebrated as central to the concerns of ambitious painting. In a journal entry written at the time he was working on the *Massacre*, Delacroix adjured himself to remember certain passages by the English poet Byron, so that they might act perpetually upon his imagination. Finally, in December, Jacques-Louis David, the 'official painter' of the French Revolution, died in exile in Brussels at the age of 76. By that time the spare classical style of his earlier works had degenerated into an enervated form of virtual self-parody.

Some general tendencies can be noted in the context of these coincident examples. The first is that although classical styles were to remain prevalent in academic painting till the end of the century, they could no longer be used, as they had been earlier, to put artistic imagery at the service of progressive public ideals. Nor could they generally be used to aesthetically critical ends. In a text written in 1827 Victor Hugo explicitly identified the modern with the grotesque (IA 7). The classicizing work of Ingres was to be the exception that proved the rule (IIB 1). For all his occasional engagements with the genre of history painting, the works that have proved of abiding interest are his portraits, his nude compositions and those small pictures on literary and mythological subjects that are redolent of an idiosyncratic but covert psychological content. In the most notorious public statement in the art of the period, Delacroix's *Liberty Leading the People*, the painterly rhetoric inherited from David gives way to the more disjointed rhythms of armed insurrection (IIA 7).

A second and connected point is that in face of the evident instability of the established social order it became increasingly hard to defend the idea that consensus over canons of taste and decorum reflected some natural or God-given order of things.

Judgement on questions of value came increasingly to be expressed in terms of concepts of feeling and of subjectivity (IA 6, 8). Genius came to be associated less with the articulate formulation of shared beliefs and more with originality and individuality, as it had been by Schopenhauer (IA 9, 17). In Gautier's Preface to *Mademoiselle de Maupin* we find an early statement of the modernist principle that utilitarian values are irrelevant to the matter of artistic value and that art possesses its own intrinsic validity (IA 18). The Romantic tendency was to conceive of the poetic and the artistic as the positive other of the rational and as opening up new dimensions of feeling and experience (IA 17). Connected with this was an interest in and exploration of the 'exotic' and the uncivilized, exemplified by Delacroix's observations from his journey to North Africa (IA 15) and by the enthusiasm of Catlin for the life of the native American Indians (IB 9). In practical terms, there was a considerable increase both in the numbers and in the status of those artists who found themselves unwilling to submit to the regulations of an academy or to the dictates of a patron.

The third point to be derived from our group of examples is that in the early decades of the century it was largely in the context of nature, and of representations of the natural world, that the conflict of ideas about art was played out. On the one hand, the classical association of nature with taste was undermined in practice by those who saw nature as matter for detailed and empirical investigation, Constable foremost among them. On the other, there was an increasing tendency to claim an aesthetic validity for individual responses to nature. This tendency gathered momentum from the reciprocal effects of increasing urbanization and of widespread exploration. The upshot in the consciousness of the early nineteenth century was a profound sense of opening. On the one hand, this was intensive: the product of a new emphasis on self-consciousness and self-criticism. On the other, it was extensive: the consequence of a literal expansion in the boundaries of the world surveyed. The value of the unspoiled and the untamed was celebrated in its more domestic form in British theorizing of the picturesque (IB 3) and on a broader canvas in American contemplation of the wilderness (IB 9, 11). But that contemplation was tinged with foreboding. The form of life Catlin admired so much among the American Indians was being destroyed even as he recorded it. At the time of Waterloo the majority of the population of England worked on the land. By 1830 around half that population was living under urban conditions. As the nineteenth century progressed it became ever harder to conceive of human nature and the natural world as common features of a divine plan.

IA
Originality and Genius

1 Arthur Schopenhauer (1788–1860) from *The World as Will and Representation*

Schopenhauer published his principal work, *Die Welt als Wille und Vorstellung*, in 1818 at the age of 30. A second edition, published in 1844, was expanded into two volumes, with the second providing a number of shorter essays elaborating upon the ideas contained in the first. However, it was not until the last decade of his life that his thought became widely known, and the period of his influence properly belongs to the second half of the nineteenth century. Schopenhauer's originality resides in his account of both subjective and objective reality in terms of a blind, purposeless striving which he terms the 'will'. Within Schopenhauer's essentially pessimistic view of reality, aesthetic experience assumes a special significance. It is identified with a state of 'will-lessness' in which we are able to apprehend the pure forms or Ideas fixed in nature, independent of their manifestation in time and space. In attaining this state of 'pure objectivity of perception' we are released from the desiring and suffering attendant on the operation of the will and become pure will-less subjects of knowledge. In aesthetic experience, Schopenhauer claims, 'perceiver and perceived become one'. Art is characterized as a form of knowledge distinct from science, which remains bound to explicating the causal connections between things in the spatio-temporal world. Whilst Schopenhauer ranks the various arts according to the degree or grade of objectification of the will which they represent, he accords music a distinctive role. Music is not a copy of the Ideas, but *a copy of the will itself*, for the same force which expresses itself in the phenomenal world also expresses itself directly in music. The present extracts are taken from Volume 1, Book 3, sections 33–8 and 52, in the translation by E. F. J. Payne, London and New York: Dover, 1969, pp. 176, 178–80, 184–6, 194–8, 256–8, 262–3.

Now since as individuals we have no other knowledge than that which is subject to the principle of sufficient reason, this form, however, excluding knowledge of the Ideas, it is certain that, if it is possible for us to raise ourselves from knowledge of particular things to that of the Ideas, this can happen only by a change taking place in the subject. Such a change is analogous and corresponds to that great change of the whole nature of the object, and by virtue of it the subject, in so far as it knows an Idea, is no longer individual.

[. . .] the transition that is possible, but to be regarded only as an exception, from the common knowledge of particular things to knowledge of the Idea takes place suddenly, since knowledge tears itself free from the service of the will precisely by the subject's ceasing to be merely individual, and being now a pure will-less subject of knowledge. Such a subject of knowledge no longer follows relations in accordance with the principle of sufficient reason; on the contrary, it rests in fixed contemplation of the object presented to it out of its connexion with any other, and rises into this.

To be made clear, this needs a detailed discussion, and the reader must suspend his surprise at it for a while, until it has vanished automatically after he has grasped the whole thought to be expressed in this work.

Raised up by the power of the mind, we relinquish the ordinary way of considering things, and cease to follow under the guidance of the forms of the principle of sufficient reason merely their relations to one another, whose final goal is always the relation to our own will. Thus we no longer consider the where, the when, the why, and the whither in things, but simply and solely the *what*. Further, we do not let abstract thought, the concepts of reason, take possession of our consciousness, but, instead of all this, devote the whole power of our mind to perception, sink ourselves completely therein, and let our whole consciousness be filled by the calm contemplation of the natural object actually present, whether it be a landscape, a tree, a rock, a crag, a building, or anything else. We *lose* ourselves entirely in this object, to use a pregnant expression; in other words, we forget our individuality, our will, and continue to exist only as pure subject, as clear mirror of the object, so that it is as though the object alone existed without anyone to perceive it, and thus we are no longer able to separate the perceiver from the perception, but the two have become one, since the entire consciousness is filled and occupied by a single image of perception. If, therefore, the object has to such an extent passed out of all relation to something outside it, and the subject has passed out of all relation to the will, what is thus known is no longer the individual thing as such, but the *Idea*, the eternal form, the immediate objectivity of the will at this grade. Thus at the same time, the person who is involved in this perception is no longer an individual, for in such perception the individual has lost himself; he is *pure* will-less, painless, timeless *subject of knowledge*. [. . .]

Now in such contemplation, the particular thing at one stroke becomes the *Idea* of its species, and the perceiving individual becomes the *pure subject of knowing*. The individual, as such, knows only particular things; the pure subject of knowledge knows only Ideas. For the individual is the subject of knowledge in its relation to a definite particular phenomenon of will and in subjection thereto. This particular phenomenon of will is, as such, subordinate to the principle of sufficient reason in all its forms; therefore all knowledge which relates itself to this, also follows the principle of sufficient reason, and no other knowledge than this is fit to be of any use to the will; it always has only relations to the object. The knowing individual as such and the particular thing known by him are always in a particular place, at a particular time, and are links in the chain of causes and effects. The pure subject of knowledge and its correlative, the Idea, have passed out of all these forms of the principle of sufficient reason. Time, place, the individual that knows, and the individual that is known, have no meaning for them. First of all, a knowing individual raises himself in the manner

described to the pure subject of knowing, and at the same time raises the contemplated object to the Idea; the *world as representation* then stands out whole and pure, and the complete objectification of the will takes place, for only the Idea is the *adequate objectivity* of the will. In itself, the Idea includes object and subject in like manner, for these are its sole form. In it, however, both are of entirely equal weight; and as the object also is here nothing but the representation of the subject, so the subject, by passing entirely into the perceived object, has also become that object itself, since the entire consciousness is nothing more than its most distinct image. This consciousness really constitutes the whole *world as representation*, since we picture to ourselves the whole of the Ideas, or grades of the will's objectivity, passing through it successively. The particular things of all particular times and spaces are nothing but the Ideas multiplied through the principle of sufficient reason (the form of knowledge of the individuals as such), and thus obscured in their pure objectivity. When the Idea appears, subject and object can no longer be distinguished in it, because the Idea, the adequate objectivity of the will, the real world as representation, arises only when subject and object reciprocally fill and penetrate each other completely. [. . .]

* * *

History follows the thread of events; it is pragmatic in so far as it deduces them according to the law of motivation, a law that determines the appearing will where that will is illuminated by knowledge. At the lower grades of its objectivity, where it still acts without knowledge, natural science as aetiology considers the laws of the changes of its phenomena, and as morphology considers what is permanent in them. This almost endless theme is facilitated by the aid of concepts that comprehend the general, in order to deduce from it the particular. Finally, mathematics considers the mere forms, that is, time and space, in which the Ideas appear drawn apart into plurality for the knowledge of the subject as individual. All these, the common name of which is science, therefore follow the principle of sufficient reason in its different forms, and their theme remains the phenomenon, its laws, connexion, and the relations resulting from these. But now, what kind of knowledge is it that considers what continues to exist outside and independently of all relations, but which alone is really essential to the world, the true content of its phenomena, that which is subject to no change, and is therefore known with equal truth for all time, in a word, the *Ideas* that are the immediate and adequate objectivity of the thing-in-itself, of the will? It is *art*, the work of genius. It repeats the eternal Ideas apprehended through pure contemplation, the essential and abiding element in all the phenomena of the world. According to the material in which it repeats, it is sculpture, painting, poetry, or music. Its only source is knowledge of the Ideas; its sole aim is communication of this knowledge. Whilst science, following the restless and unstable stream of the fourfold forms of reasons or grounds and consequents, is with every end it attains again and again directed farther, and can never find an ultimate goal or complete satisfaction, any more than by running we can reach the point where the clouds touch the horizon; art, on the contrary, is everywhere at its goal. For it plucks the object of its contemplation from the stream of the world's course, and holds it isolated before it. This particular thing, which in that stream was an infinitesimal part, becomes for art a representative of the whole, an equivalent of the infinitely many in space and time. It

therefore pauses at this particular thing; it stops the wheel of time; for it the relations vanish; its object is only the essential, the Idea. We can therefore define it accurately as *the way of considering things independently of the principle of sufficient reason*, in contrast to the way of considering them which proceeds in exact accordance with this principle, and is the way of science and experience. This latter method of consideration can be compared to an endless line running horizontally, and the former to a vertical line cutting the horizontal at any point. The method of consideration that follows the principle of sufficient reason is the rational method, and it alone is valid and useful in practical life and in science. The method of consideration that looks away from the content of this principle is the method of genius, which is valid and useful in art alone. The first is Aristotle's method; the second is, on the whole, Plato's. The first is like the mighty storm, rushing along without beginning or aim, bending, agitating, and carrying everything away with it; the second is like the silent sunbeam, cutting through the path of the storm, and quite unmoved by it. The first is like the innumerable violently agitated drops of the waterfall, constantly changing and never for a moment at rest; the second is like the rainbow silently resting on this raging torrent. Only through the pure contemplation described above, which becomes absorbed entirely in the object, are the Ideas comprehended; and the nature of *genius* consists precisely in the preeminent ability for such contemplation. Now as this demands a complete forgetting of our own person and of its relations and connexions, the *gift of genius* is nothing but the most complete *objectivity*, i.e. the objective tendency of the mind, as opposed to the subjective directed to our own person, i.e., to the will. Accordingly, genius is the capacity to remain in a state of pure perception, to lose oneself in perception, to remove from the service of the will the knowledge which originally existed only for this service. In other words, genius is the ability to leave entirely out of sight our own interest, our willing, and our aims, and consequently to discard entirely our own personality for a time, in order to remain *pure knowing subject*, the clear eye of the world; and this not merely for moments, but with the necessary continuity and conscious thought to enable us to repeat by deliberate art what has been apprehended, and 'what in wavering apparition gleams fix in its place with thoughts that stand for ever!'[1] For genius to appear in an individual, it is as if a measure of the power of knowledge must have fallen to his lot far exceeding that required for the service of an individual will; and this superfluity of knowledge having become free, now becomes the subject purified of will, the clear mirror of the inner nature of the world. This explains the animation, amounting to disquietude, in men of genius, since the present can seldom satisfy them, because it does not fill their consciousness. This gives them that restless zealous nature, that constant search for new objects worthy of contemplation, and also that longing, hardly ever satisfied, for men of like nature and stature to whom they may open their hearts. The common mortal, on the other hand, entirely filled and satisfied by the common present, is absorbed in it, and, finding everywhere his like, has that special ease and comfort in daily life which are denied to the man of genius. Imagination has been rightly recognized as an essential element of genius; indeed, it has sometimes been regarded as identical with genius, but this is not correct. The objects of genius as such are the eternal Ideas, the persistent, essential forms of the world and of all its phenomena; but knowledge of the Idea is necessarily knowledge through perception, and is not

abstract. Thus the knowledge of the genius would be restricted to the Ideas of objects actually present to his own person, and would be dependent on the concatenation of circumstances that brought them to him, did not imagination extend his horizon far beyond the reality of his personal experience, and enable him to construct all the rest out of the little that has come into his own actual apperception, and thus to let almost all the possible scenes of life pass by within himself. Moreover, the actual objects are almost always only very imperfect copies of the Idea that manifests itself in them. Therefore the man of genius requires imagination, in order to see in things not what nature has actually formed, but what she endeavoured to form, yet did not bring about. [. . .]

* * *

Now according to our explanation, genius consists in the ability to know, independently of the principle of sufficient reason, not individual things which have their existence only in the relation, but the Ideas of such things, and in the ability to be, in face of these, the correlative of the Idea, and hence no longer individual, but pure subject of knowing. Yet this ability must be inherent in all men in a lesser and different degree, as otherwise they would be just as incapable of enjoying works of art as of producing them. Generally they would have no susceptibility at all to the beautiful and to the sublime; indeed, these words could have no meaning for them. We must therefore assume as existing in all men that power of recognizing in things their Ideas, of divesting themselves for a moment of their personality, unless indeed there are some who are not capable of any aesthetic pleasure at all. The man of genius excels them only in the far higher degree and more continuous duration of this kind of knowledge. These enable him to retain that thoughtful contemplation necessary for him to repeat what is thus known in a voluntary and intentional work, such repetition being the work of art. Through this he communicates to others the Idea he has grasped. Therefore this Idea remains unchanged and the same, and hence aesthetic pleasure is essentially one and the same, whether it be called forth by a work of art, or directly by the contemplation of nature and of life. The work of art is merely a means of facilitating that knowledge in which this pleasure consists. That the Idea comes to us more easily from the work of art than directly from nature and from reality, arises solely from the fact that the artist, who knew only the Idea and not reality, clearly repeated in his work only the Idea, separated it out from reality, and omitted all disturbing contingencies. The artist lets us peer into the world through his eyes. That he has these eyes, that he knows the essential in things which lies outside all relations, is the gift of genius and is inborn; but that he is able to lend us this gift, to let us see with his eyes, is acquired, and is the technical side of art. [. . .]

In the aesthetic method of consideration we found *two inseparable constituent parts:* namely, knowledge of the object not as individual thing, but as Platonic *Idea*, in other words, as persistent form of this whole species of things; and the self-consciousness of the knower, not as individual, but as *pure, will-less subject of knowledge*. The condition under which the two constituent parts appear always united was the abandonment of the method of knowledge that is bound to the principle of sufficient reason, a knowledge that, on the contrary, is the only appropriate kind for serving the will and also for science. Moreover, we shall see that the *pleasure* produced by contemplation of the beautiful arises from those two constituent parts, sometimes more from

the one than from the other, according to what the object of aesthetic contemplation may be.

All *willing* springs from lack, from deficiency, and thus from suffering. Fulfilment brings this to an end; yet for one wish that is fulfilled there remain at least ten that are denied. Further, desiring lasts a long time, demands and requests go on to infinity; fulfilment is short and meted out sparingly. But even the final satisfaction itself is only apparent; the wish fulfilled at once makes way for a new one; the former is a known delusion, the latter a delusion not as yet known. No attained object of willing can give a satisfaction that lasts and no longer declines; but it is always like the alms thrown to a beggar, which reprieves him today so that his misery may be prolonged till tomorrow. Therefore, so long as our consciousness is filled by our will, so long as we are given up to the throng of desires with its constant hopes and fears, so long as we are the subject of willing, we never obtain lasting happiness or peace. Essentially, it is all the same whether we pursue or flee, fear harm or aspire to enjoyment; care for the constantly demanding will, no matter in what form, continually fills and moves consciousness; but without peace and calm, true well-being is absolutely impossible. Thus the subject of willing is constantly lying on the revolving wheel of Ixion, is always drawing water in the sieve of the Danaids, and is the eternally thirsting Tantalus.

When, however, an external cause or inward disposition suddenly raises us out of the endless stream of willing, and snatches knowledge from the thraldom of the will, the attention is now no longer directed to the motives of willing, but comprehends things free from their relation to the will. Thus it considers things without interest, without subjectivity, purely objectively; it is entirely given up to them in so far as they are merely representations, and not motives. Then all at once the peace, always sought but always escaping us on that first path of willing, comes to us of its own accord, and all is well with us. It is the painless state, prized by Epicurus as the highest good and as the state of the gods; for that moment we are delivered from the miserable pressure of the will. We celebrate the Sabbath of the penal servitude of willing; the wheel of Ixion stands still.

But this is just the state that I described above as necessary for knowledge of the Idea, as pure contemplation, absorption in perception, being lost in the object, forgetting all individuality, abolishing the kind of knowledge which follows the principle of sufficient reason, and comprehends only relations. It is the state where, simultaneously and inseparably, the perceived individual thing is raised to the Idea of its species, and the knowing individual to the pure subject of will-less knowing, and now the two, as such, no longer stand in the stream of time and of all other relations. It is then all the same whether we see the setting sun from a prison or from a palace.

Inward disposition, predominance of knowing over willing, can bring about this state in any environment. This is shown by those admirable Dutchmen who directed such purely objective perception to the most insignificant objects, and set up a lasting monument of their objectivity and spiritual peace in paintings of *still life*. The aesthetic beholder does not contemplate this without emotion, for it graphically describes to him the calm, tranquil, will-free frame of mind of the artist which was necessary for contemplating such insignificant things so objectively, considering them

so attentively, and repeating this perception with such thought. Since the picture invites the beholder to participate in this state, his emotion is often enhanced by the contrast between it and his own restless state of mind, disturbed by vehement willing, in which he happens to be. In the same spirit landscape painters, especially Ruysdael, have often painted extremely insignificant landscape objects, and have thus produced the same effect even more delightfully.

So much is achieved simply and solely by the inner force of an artistic disposition; but that purely objective frame of mind is facilitated and favoured from without by accommodating objects, by the abundance of natural beauty that invites contemplation, and even presses itself on us. Whenever it presents itself to our gaze all at once, it almost always succeeds in snatching us, although only for a few moments, from subjectivity, from the thraldom of the will, and transferring us into the state of pure knowledge. This is why the man tormented by passions, want, or care, is so suddenly revived, cheered, and comforted by a single, free glance into nature. The storm of passions, the pressure of desire and fear, and all the miseries of willing are then at once calmed and appeased in a marvellous way. For at the moment when, torn from the will, we have given ourselves up to pure, will-less knowing, we have stepped into another world, so to speak, where everything that moves our will, and thus violently agitates us, no longer exists. This liberation of knowledge lifts us as wholly and completely above all this as do sleep and dreams. Happiness and unhappiness have vanished; we are no longer the individual; that is forgotten; we are only pure subject of knowledge. We are only that *one* eye of the world which looks out from all knowing creatures, but which in man alone can be wholly free from serving the will. [. . .]

* * *

I have devoted my mind entirely to the impression of music in its many different forms; and then I have returned again to reflection and to the train of my thought expounded in the present work, and have arrived at an explanation of the inner essence of music, and the nature of its imitative relation to the world, necessarily to be presupposed from analogy. This explanation is quite sufficient for me, and satisfactory for my investigation, and will be just as illuminating also to the man who has followed me thus far, and has agreed with my view of the world. I recognize, however, that it is essentially impossible to demonstrate this explanation, for it assumes and establishes a relation of music as a representation to that which of its essence can never be representation, and claims to regard music as the copy of an original that can itself never be directly represented. [. . .]

The (Platonic) Ideas are the adequate objectification of the will. To stimulate the knowledge of these by depicting individual things (for works of art are themselves always such) is the aim of all the other arts (and is possible with a corresponding change in the knowing subject). Hence all of them objectify the will only indirectly, in other words, by means of the Ideas. As our world is nothing but the phenomenon or appearance of the Ideas in plurality through entrance into the *principium individuationis* (the form of knowledge possible to the individual as such), music, since it passes over the Ideas, is also quite independent of the phenomenal world, positively ignores it, and, to a certain extent, could still exist even if there were no world at all, which

cannot be said of the other arts. Thus music is as *immediate* an objectification and copy of the whole *will* as the world itself is, indeed as the Ideas are, the multiplied phenomenon of which constitutes the world of individual things. Therefore music is by no means like the other arts, namely a copy of the Ideas, but a *copy of the will itself*, the objectivity of which are the Ideas. For this reason the effect of music is so very much more powerful and penetrating than is that of the other arts, for these others speak only of the shadow, but music of the essence. However, as it is the same will that objectifies itself both in the Ideas and in music, though in quite a different way in each, there must be, not indeed an absolutely direct likeness, but yet a parallel, an analogy, between music and the Ideas, the phenomenon of which in plurality and in incompleteness is the visible world. [...]

* * *

As a result of all this, we can regard the phenomenal world, or nature, and music as two different expressions of the same thing; and this thing itself is therefore the only medium of their analogy, a knowledge of which is required if we are to understand that analogy. Accordingly, music, if regarded as an expression of the world, is in the highest degree a universal language that is related to the universality of concepts much as these are related to the particular things. Yet its universality is by no means that empty universality of abstraction, but is of quite a different kind; it is united with thorough and unmistakable distinctness. In this respect it is like geometrical figures and numbers, which are the universal forms of all possible objects of experience and are *a priori* applicable to them all, and yet are not abstract, but perceptible and thoroughly definite. All possible efforts, stirrings, and manifestations of the will, all the events that occur within man himself and are included by the reasoning faculty in the wide, negative concept of feeling, can be expressed by the infinite number of possible melodies, but always in the universality of mere form without the material, always only according to the in–itself, not to the phenomenon, as it were the inner-most soul of the phenomenon without the body. This close relation that music has to the true nature of all things can also explain the fact that, when music suitable to any scene, action, event, or environment is played, it seems to disclose to us its most secret meaning, and appears to be the most accurate and distinct commentary on it. More-over, to the man who gives himself up entirely to the impression of a symphony, it is as if he saw all the possible events of life and of the world passing by within himself. Yet if he reflects, he cannot assert any likeness between that piece of music and the things that passed through his mind. For, as we have said, music differs from all the other arts by the fact that it is not a copy of the phenomenon, or, more exactly, of the will's adequate objectivity, but is directly a copy of the will itself, and therefore expresses the metaphysical to everything physical in the world, the thing-in-itself to every phenomenon. Accordingly, we could just as well call the world embodied will; this is the reason why music makes every picture, indeed every scene from real life and from the world, at once appear in enhanced significance, and this is, of course, all the greater, the more analogous its melody is to the inner spirit of the given pheno-menon. [...]

[1] Goethe's *Faust*, Bayard Taylor's translation. [Tr.]

2 Théodore Géricault (1791–1824) on Genius and Academies

Géricault was one of the foremost representatives of the Romantic tendency in French painting. His reputation was established with *The Raft of the Medusa*, exhibited in the Paris Salon in 1819. This was on the scale of the largest history painting – almost five metres high by over seven wide. Its theme, however, was the aftermath of a recent disaster at sea, and the sufferings of those involved. Among some one hundred large paintings in the Salon that year it was the only one not officially commissioned. In 1820 Géricault arranged for the work to be exhibited in England, with viewers charged an entry fee. The following text asserts his belief in the creative power of individual genius. It was probably intended as part of a longer work, which the artist was prevented from pursuing by his early death. While Géricault stresses the importance of David's role in purifying the style of French art after the *ancien régime*, he makes clear that the older painter's legacy is now exhausted. The artists of the future will not be those who adhere to the programmes of study defined by the Academy, but rather those who maintain their individuality and originality in spite of them. Strictures against formal teaching were by no means novel by the 1820s, but the concerns Géricault raises were typical of a growing conflict between academic principles and concepts of genius and individuality at a time when the authority of classical canons was waning. The Prix de Rome was awarded to the most promising graduate of the Ecole des Beaux-Arts on the basis of a historical composition, securing for its holder the opportunity for further study in Italy and thus the promise of a respectable career. It was central to a system of academic training and reward. Géricault competed for the prize in 1816, but was excluded. The text was found in a notebook after his death. It was cited by L. Batissier in his 'Biographie de Géricault', *Revue de XIX Siècle*, Paris, 1842, and was published from the original manuscript in C. Clement, *Géricault, étude biographique et critique*, Paris: Didier et Cie, 1868. The following version is taken from the latter in the 'definitive' edition of 1879, pp. 239–49, translated for this volume by Jonathan Murphy.

For an unusual reason, the superiority of the old schools of Italy, Flanders and Holland is so widely recognized that one can always refer to it without running the risk of wounding the pride of any modern school, even if we no longer praise them to the skies and recommend a long apprenticeship in their tradition to anyone wishing to pursue a career in the arts. In a rather ridiculous fashion, it was long supposed that the geographical climate was a major factor in the development of these schools; that Italy, for example, produced talented draughtsmen in the same way that the Americas produce coffee, and that the dampness of Holland was a necessary precondition for the creation of good colourists. A swift riposte, as effective as any erudite refutation of this ridiculous assertion, would be to say that today, Italy is no longer the equal of France, and her art schools are no longer centred around drawing, and that while Holland no longer produces great colourists, her dank mists remain unchanged.

So I will try here to assign a quite different cause to the greatness that these different countries have successively achieved. The arts flourished in Venice when it was a rich and powerful republic; Holland, when master of the seas, equally marked her greatness with masterpieces in all the arts. Yet the diminution of their power and wealth was inevitably followed by a disappearance of artistic talent. The most temperate climes, with the coming of liberty, have seen the talents whose birth they witnessed disappear, and for sure, the ancient laurels of Greece will not flourish anew in a land once again haunted by the spectre of slavery.

The arts then have never been a primal necessity, but are rather the fruits of abundance, ripening when more elementary needs are satisfied. When man no longer wants for his basic needs, he seeks a pleasure to stave off the boredom that contentment will inevitably bring. Luxury and the arts become a necessity, to nourish the imagination, which is truly a second life for any civilized man. The arts grow through this combination of need and fortune, and become indispensable to a great state; but they have no place assisting at the birth of a nation.

The wealth of talent to be found in France today seems a sure guarantee of the argument I am trying to develop here.

My purpose however, is to demonstrate the manner in which poor planning, and the misuse of the means at our disposal, may in fact be harmful to the national spirit, and even paralyse the happy concord of circumstances which would normally serve to assure our superiority. Here I would ask the reader to lend his full attention, and not refuse a little indulgence for the difficulties which I will find at each step, when talking of a subject which no one, as yet, has dared to address.

The Schools of Painting and Sculpture, and the Competition for the Prix de Rome

The Government has set up public schools of Drawing, open to all young students, and maintains them at great expense. Frequent competitions in these schools generate tremendous public interest, and at first glance these institutions seem to be not only of great use, but also the surest means of encouragement which could possibly be given to the arts. Never, in Athens or Rome, did the citizens find opportunities for the study of the arts or sciences the like of which are offered in France today by numerous schools. But since their creation, it is with some sorrow that I have remarked that the effect they have produced is quite different to the one expected. Indeed, rather than being to the public good, they are perhaps a major inconvenience; all they have done is create thousands of mediocre artists, and they cannot in any sense boast of having formed the most distinguished men amongst our painters, since these distinguished men were rather the founders of the schools, or were at least the first to preach the principles of taste.

David, clearly the most important artist working in France today, and the rejuvenator of the French School, owes the success which has brought him to the attention of the whole world to nothing but his own genius. He owes nothing to any school; on the contrary, the influence of a school might have been extremely detrimental to his talent if his own taste, at an early stage, had not shielded him from such influences and inclined him instead towards a complete reformation of that monstrous and absurd system which at the time was in the hands of Vanloo, Boucher, Restout and so many other profaners of great art. A prolonged study of the great masters, and a visit to Italy, combined to inspire the great character which is always to be found in his historical compositions, and he became the model and leader of a new school. The principles of his painting have caused new talents to bud and grow, and several artists, now well-renowned, did not tarry in proclaiming the glory of their master, and sharing in his triumph.

After these glorious beginnings, and that great leap towards a noble, pure style, enthusiasm could only diminish, although the excellent lessons in discernment were retained, and the Government strove to maintain the momentum to the best of its abilities. But the flames of that sacred fire, which alone can produce great things, each day glow more dimly, and exhibitions, although numerous, perhaps too numerous, each year become less interesting. One no longer encounters those noble talents which were once crowned by a generous public eager for beauty and greatness, nor those talents which once bred such widespread enthusiasm. Men like Gros, Gérard, Guérin and Girodet have looked in vain for rivals worthy of their talent, and now, when they are entrusted with the teaching of a new generation of painters filled with generous emulation, it is to be feared that at the end of their careers they might experience some justifiable regret at seeing no worthy replacements rise up to take their place. And yet to accuse them of not lavishing sufficient care and attention on their pupils would be to do them an enormous disservice. What, then, could be the origin of this tremend-ous dearth of talent, at a time when we have the Prix de Rome, the constant awarding of medals for excellence, and regular competitions at the Académie? It has long been my belief that a good education was the indispensable base for entry into any profession, and that it alone can assure veritable distinction in whichever career one chooses to follow. Education broadens the mind, expands its capacities, and illumi-nates the goal one strives to attain. No one can truly be said to be making a choice before they are in a position to weigh up its advantages and disadvantages, and with the exception of a few precocious temperaments, one rarely sees a talent of any great import declare itself before the age of sixteen years. At that age one begins to know what one wishes to do in life, and one still has all the necessary aptitude for study in a profession which one elects by choice, or into which one is compelled by an imperious force. My desire then is that the Drawing Academy should not be open to anyone who has not attained at least that age. The nation, surely, is not attempting to create an entire race of painters through this establishment, but rather to offer true genius the means to develop itself; what we have obtained instead is a whole population of painters. The lure of the Prix de Rome and the facilities of the Academy have attracted a whole crowd of competitors who would never have become painters for love alone, but who would have been worthy additions to many other professions. They pass the time of their youth in a quest for a prize that will inevitably pass them by; thereby wasting precious assets they might have employed in a manner far more profitable to themselves and their country.

The man who truly has a vocation has no fear of obstacles, as he is sure to overcome them; they often provide themselves the means to overcome them. The fever they provoke in his soul serves a purpose, apt to become the cause of the most astonishing productions.

It is towards such men that the attentions of a well-intentioned government should turn, for it is by encouraging them, appreciating them, and employing their faculties to the full that the glory of the nation will be assured; and it is through such men that the century which discovered them and put them in their rightful place will be remembered.

Even if one supposed that all the young people admitted to the schools were blessed with the same talent, would it not be dangerous to see them study together for years

on end under the same influence, copying the same models, and following in some fashion the same path? How can one hope after this that they might conserve some spark of originality? Will they not, despite themselves, have exchanged the particular qualities that they might have had, and fused together into a confused unity those unique means by which, more properly, each of us perceives the beauty of nature?

Any nuance which might survive this group experience becomes imperceptible, and it is with genuine distaste that one sees every year ten or twelve compositions, of almost identical execution, whose every stroke is painstakingly perfect, offering no germ of originality whatsoever. Having abandoned long since their own sensations, none of the competitors have managed to retain any of their individuality. The same drawing style, the same palette, minor variations in an identical system, even the same gestures and facial expressions, everything that we see in these, the sad products of our schools, seems to come from one source, inspired by one single soul – if indeed one can conceive of a soul here, lost in the midst of such anonymity, struggling to conserve its faculties and preside over these lamentable works.

I would add to this that although obstacles and difficulties frighten mediocre men, they are the necessary food of genius. They cause it to mature, and raise it up; if the way is easy it withers and dies. All that obstructs the path of genius irritates it and inspires a state of feverish agitation, upsetting and overturning those obstacles, and producing masterpieces. These are the men that a nation must strive to produce – men who allow nothing, not poverty nor persecution, to stand in their way. They simmer like volcanoes, bound to erupt, for such is their nature, burning to light up the way and astonish the world. Would we create men thus? The Academy, alas, does too much: it extinguishes the sparks of this sacred fire, it smothers it, not granting nature the time to allow it to catch. A fire must be nurtured, yet the Academy throws on too much fuel.

3 Eugène Delacroix (1798–1863) on Romanticism

The quintessential artist of French Romanticism, Delacroix grew up during the rise and fall of Napoleon. He studied at the Ecole des Beaux Arts under Guérin from 1816, and there encountered Géricault, who allowed him to see the *Raft of the Medusa* while it was still in progress. His own first success was achieved at the Salon of 1822 with *The Barque of Dante*, based on passages from *The Inferno*. This was followed two years later by *The Massacre at Chios*. These two works mark out the typical preoccupations of the French Romantics: stirring literary subject matter drawn from contemporaries such as Byron and Scott, or from earlier writers such as Dante and Shakespeare; and contemporary history, in this case the Greek war of independence. The artistic resources Delacroix brought to bear on such subjects were principally derived from Michelangelo and Rubens, influences which were leavened by his encounter with the technical radicalism of Constable's land-scape painting. During the period from September 1822 to October 1824, Delacroix kept a journal in which he discussed the search for literary subjects, and explored characteristic Romantic themes of passion, genius and imagination. It was originally published in three volumes as the *Journal de Eugène Delacroix* in Paris in 1883–5. A second edition was published there, edited by André Joubra, in 1932. The present extracts are drawn from the English translation of that edition by Walter Pach, published as *The Journal of Eugène Delacroix*, London: Jonathan Cape, 1938, pp. 41–2, 54, 64, 73–4, 82, 84–6, 94.

6 October 1822

It must not be thought that just because I rejected a thing once, I must ignore it when it shows itself today. A book in which I had never found anything worthwhile may have a moral, read with the eyes of a more mature experience.

I am borne, or, rather, my energy is borne, in another direction. I will be the trumpeter of those who do great things.

There is in me something that is often stronger than my body, which is often enlivened by it. In some people the inner spark scarcely exists. I find it dominant in me. Without it, I should die, but it will consume me (doubtless I speak of imagination, which masters and leads me).

When you have found a weakness in yourself, instead of dissembling it, cut short your acting and idle circumlocutions – correct yourself. If the spirit had merely to fight the body! But it also has malign penchants, and a portion of it – the most subtle, most divine – should battle the other unceasingly. The body's passions are all loathsome. Those of the soul which are vile are the true cancers: envy, etc. Cowardice is so loathsome it must needs be the child of body and soul together.

When I have painted a fine picture, I haven't expressed a thought. Or so they say. What fools people are! They deprive painting of all its advantages. The writer says nearly everything to be understood. In painting a mysterious bond is established between the souls of the sitters and those of the spectator. He sees the faces, external nature; but he thinks inwardly the true thought that is common to all people, to which some give body in writing, yet altering its fragile essence. Thus grosser spirits are more moved by writers than by musicians and painters. The painter's art is all the more intimate to the heart of man because it seems more material; for in it, as in external nature, justice is done frankly to that which is finite and to that which is infinite – that is, to whatever the soul finds to move it inwardly in the objects which affect the senses alone.

At midnight, 22 or 23 December 1823

[. . .] Let us do everything calmly, let us react emotionally only to fine works of art or noble deeds. Let us work tranquilly and without haste. As soon as I begin to sweat and my blood to boil, beware. Cowardly painting is the painting of a coward. [. . .]

Friday, 27 February 1824

. . . What pleases me is that I am acquiring reason without losing the emotions evoked by beauty. I certainly do not want to deceive myself, but it seems to me that I am working more calmly than ever before, and I have the same love for my work. One thing distresses me, and I do not know its cause; I need distractions, such as gatherings of friends, etc. As to the enticements that disturb most people, I have never been disquieted by them, and today less than ever. Who would believe it? What are most real to me, are the illusions that I create with my painting. The rest is shifting sand.[. . .]

Sunday, 1 April 1824

[...] Excellent ideas come to me every moment, and instead of executing them at the very moment they are clothed with the charm imagination lends to them in the form they assume at that moment, one promises oneself to do them later, but when? One forgets, or what is worse, one no longer finds any interest in what seemed inspiring. This is what happens in so wandering and impressionable a mind – one fancy drives another out more quickly than the wind changes and turns the sail the other way. Assuming that I have plenty of subjects, what shall I do with them? Keep them in storage, waiting in the cold for their turn, and never will the inspiration of the moment quicken them with the breath of Prometheus: I will have to take them from a drawer when I need to make a picture. It is the death of genius. What is happening this evening? For a whole hour I have been wavering between *Mazeppa*, *Don Juan*, *Tasso*, and a hundred others.

I think that what would be best to do when one needs a subject, is not to have recourse to the ancients and to choose of them. For what is more stupid? Among the subjects that I have kept, because they seemed lovely to me one day, what determines my choice of one over another, now that I have the same feeling for all? The mere fact that I can hesitate between two of them implies lack of inspiration. Really, if I took up my palette at this moment, and I am dying to do so, the beautiful Velasquez would be on my mind. I should want to spread out some good thick, fat paint on a brown or red canvas. What I would need, then, in finding a subject is to open a book that can inspire me and let its mood guide me. There are those that are never ineffective. Just the same with engravings. Dante, Lamartine, Byron, Michelangelo.[...]

Tuesday, 27 April 1824

At Leblond's. Interesting discussion about genius and unusual men. Dimier thought that great passions were the source of genius. I think that it is imagination alone, or better still, what amounts to the same thing, that delicacy of the organs that makes one see what others do not see, and which makes one see in a different way. I was saying that even great passions joined to imagination lead most often to disorder in the mind, etc. Dufresne said a very true thing: what made a man unusual was, fundamentally, a way utterly peculiar to himself of seeing things. He applied it to the great captains, etc., and finally to the great minds of all sorts. So, there are no rules for great souls: rules are only for people who have merely the talent that can be acquired. The proof is that they do not transmit this faculty. He was saying: 'How much reflection is needed to create a beautiful, expressive head, a hundred times more than for a problem, and yet at bottom, the matter is merely one of instinct, for it cannot explain what brings it about.' I note now that my mind is never more excited to create than when it sees a mediocre version of a subject that is suitable to me.

Friday, 7 May 1824

[...] On my way home this evening, I heard the nightingale. I hear him still, though very far away. This warbling is really unique, rather on account of the emotions it

evokes than for itself. Buffon goes into a naturalist's ecstasies over the flexibility of the throat and the varied notes of the melancholy springtime songster. As for myself, I find in him that monotony, the inexhaustible source of all that makes a lively impression. It is like a view of the vast sea. One waits always for still another wave before breaking away from the sight; one cannot leave it. How I hate all these rhymers with their rhymes, their glories, their victories, their nightingales, their meadows! How many of them really describe what a nightingale makes one feel? But if Dante speaks of it, it is as fresh as nature, and we have heard only that. Yet all is artificial and dressed up, a product of the mind. How many of them have described love? Dante is really the first of poets. One thrills with him, as if before the thing itself. Superior in this to Michelangelo, or rather, different, for in another fashion, he also is sublime, though not through his truth. *Come columbe adunate alle pasture* [Like doves gathering in the meadows], etc. *Come si sta a gracidar la rana* [As the frog sits up to croak], etc. *Come il villanello* [Like the peasant boy], etc. Therein lies what I have always dreamed, without being able to define it. Be just that in painting. It is a unique course to follow.

But when a thing bores you, do not do it. Do not pursue a fruitless perfection. There are certain faults (faults, that is, to the vulgar) which often impart life.

My picture [*Massacre at Chios*] is acquiring a twist, an energetic movement that I must absolutely complete in it. I need that good black, that blessed dirt, and those limbs that I know how to paint and few even try to get. The mulatto model will serve my purpose. I must get fullness. If my work loses in naturalness, it will be more beautiful and more fruitful. If it only holds together! O smile of the dying! The look of the mother's eye! Embraces of despair, precious domain of painting! Silent power that at first speaks only to the eyes, and which wins and makes its own all the faculties of the soul! There is the spirit, the real beauty that is proper to you, beautiful painting, so insulted, so misunderstood, delivered up to the blockheads who exploit you. But there are hearts who will still receive you devoutly; souls who will not be satisfied with phrases, any more than with fictions and ingenuities. You have only to appear with your manly and simple vigour, and you will please with a pleasure that is pure and absolute. Admit that I have worked with reason. I do not care for reasonable painting at all. I can see that my turbulent mind needs agitation, needs to free itself, to try a hundred different things before reaching the goal whose tyrannous call everywhere torments me. There is an old leaven, a black depth that demands satisfaction. If I am not quivering like a snake in the hands of Pythoness, I am cold; I must recognize it and submit to it, and to do so is happiness. Everything I have done that is worth while, was done this way. No more *Don Quixotes* and things unworthy of you! Concentrate intensely before your painting and think only of Dante. Therein lies what I have always felt in myself.

Sunday, 6 June 1824

[. . .] As soon as a man is intelligent, his first duty is to be honest and strong. It is no use to try to forget, there is something virtuous in him that demands to be obeyed and satisfied. What do you think has been the life of men who have raised themselves above the common herd? Constant strife. Struggle against the idleness that is common to them and to the average man, when it is a question of writing, if he is a writer:

because his genius clamours to be manifested; and it is not merely through some vain lust to be famed that he obeys it – it is through conscience. Let those who work lukewarmly be silent: what do they know of work dictated by inspiration? This fear, this dread of awakening the slumbering lion, whose rearings stir your very being. To sum up: be strong, simple, and true; there is your problem for all times, and it is always useful.

4 Stendhal (Marie-Henri Beyle) (1783–1842) from 'Salon of 1824'

'Stendhal' was a literary pseudonym of Marie-Henri Beyle, first used in 1817. Born in Grenoble, Beyle left for Paris at the age of sixteen and subsequently worked for the Napoleonic regime in Italy and in Paris. One of the pivotal experiences of his life was his involvement in the burning of Moscow, in 1812, and the subsequent French retreat. After Napoleon's defeat, he took up his literary career in Milan. In 1817 he published a *History of Painting in Italy* in which he questioned the prevailing assumption that classical criteria were universally applicable, contrasting 'le beau idéal antique' with 'le beau idéal moderne'. Stendhal spent the 1820s in Paris working as a writer and critic. His *Racine and Shakespeare* of 1823 was one of the first statements of literary Romanticism in France. In it Stendhal argues that Romanticism is not just a modern movement, but represents a recurring phenomenon in the art of every period, namely that kind of art which reflects on its own time rather than on unchanging, eternal factors. That is, he identifies Romanticism with 'the spirit of the age' (or *zeitgeist*, itself a German Romantic concept). Stendhal produced two Salon commentaries, in 1824 and 1827. The 1824 Salon marked the triumph of Romanticism in French art. In addition to works by Vernet, Sigalon and Delaroche, Delacroix exhibited the *Massacre at Chios* (which Stendhal found journalistic in the light of his Russian experience); and the English landscape school was represented by Constable. Stendhal's Salon was published in sixteen parts between August and December 1824. The following extracts are taken from Stendhal's *Oeuvres Complètes, Mélanges III. Peinture*, Nouvelle édition, Geneva: Edito-Service, 1972, pp. 8 (29 Aug.), 11–14 (31 Aug.), 16–17 (2 Sept.), 25–8 (12 Sept.), 35–6 (7 Oct.), 39–41 (9 Oct.), 46–7 (16 Oct.), 51–4 (27 Oct.), 66–7 (23 Nov.), 73–4 (11 Dec.), 78–81 (22 Dec.). They were translated by Jonathan Murphy for the present volume.

At the Louvre 27 August 1824

Today, my intention is only to give a brief overview of the exhibition, sparing the reader more general considerations, in order to speak briefly about a few of the more remarkable pictures which doubtless have already attracted his attention. This first visit will by no means get to the heart of the matter: it is the simple, artless expression of a first impression.

It would appear that this year, opinions are quite violently opposed, and people fall into one of two camps. The battle lines have already been drawn. The *Journal des Débats* are going to be Classical, and swear only by David, crying out that *any painted figure must be the copy of a statue*, and that the spectators should admire this, even if it bores them rigid. *Le Constitutionnel*, by contrast, has come out with some beautiful, slightly vague phrases, no doubt a sign of the times: but at least it has decided to

defend a few new ideas. It has had the audacity to proclaim that art should be allowed to take a step forward, even after David, and that there is more to painting than simply reproducing a large quantity of beautifully drawn muscles. How strange it is, after all, to believe that the French School should be immobilized for ever more, simply because it was lucky enough to produce the greatest painter of the eighteenth century in the shape of David [...]

II 31 August 1824

I have just come out of the exhibition. When I went in, I was careful to avoid buying the guidebook, which gives the subjects of the pictures and the names of the painters. My intention was that my eyes should be attracted by genuine merit alone; and that they should not be distracted by ill-deserved reputations, which are the result of bygone days for which I have little respect [...]

The public crowds around a battle scene by Horace Vernet; his magnificent *Portrait of Marshall Gouvion-Saint-Cyr* is also being widely admired, and it is indeed painted with an astonishing facility. *Joan of Arc interrogated by a Cardinal*, an *Andromache* by Prud'hon, and several *Seascapes* by Vernet have also had great success. There is also a *Massacre of Chios* by Delacroix, which is the equivalent in painting of the verses of Guiraud and de Vigny in poetry; an exaggeration of the sad and the sombre. But the public today is so bored by the Academic genre, and by these copies of statues which were so fashionable a decade ago, that it is easily impressed by the livid, half-finished cadavers to be seen in the Delacroix picture [...]

We stand on the cusp of a revolution in the arts. All those huge pictures, filled with some thirty naked figures, copied from antique statues, and those long and tedious five-act tragedies in verse are no doubt extremely respectable pieces of work, but whatever their merits, they are beginning to pall, and if David's *Sabine Women* were to be exhibited today there is no doubt that people would note that the figures are painted without passion; moreover, in any country, it is absurd to set out for battle when not wearing any clothes. 'But such is the custom in ancient bas-reliefs!' cry the classicists, these people who swear but by David, and are incapable when speaking of painting of uttering three words without using the word *style*. What do I care for ancient bas-reliefs? The time has come for good painters to try and be modern instead. The nude was pleasing to the Greeks: we on the other hand hardly ever see it, and what is more, I think we even feel some repugnance for it.

Taking no heed of the cries of my opponents, I shall tell the public, frankly and simply, what I feel about each of the pictures on view, and I shall give the reasons for my own particular point of view. My aim is that each individual spectator should learn to question his soul, and describe to himself his own sentiments, and learn thereby to pass his own judgement, and develop an individual way of seeing that reflects his own character, his tastes, and his dominant passions, if indeed passions he has, for unfortunately it is passions that we require to pass judgement in the arts [...]

III 2 September 1824

In Paris, the more a painter works, the poorer he becomes. [...] To paint a picture, one needs models, and this is an expense larger than one might believe; one also needs

canvases, and colours, and of course everyone has their own living expenses. Any young painter at the Ecole at present can only meet the basic needs of his art by accumulating debts [...]

Such is the unfortunate result of the excessive encouragements accorded to painting in the budget of the Minister for the Interior; such also is the result, in part, contrary to the intention with which they were originally introduced, of Academic competitions, and trips to Rome. Whenever I visit these competitions, I see artists advanced in years gravely occupied in assessing the extent to which various young people have successfully imitated their own method of painting. Twenty of David's pupils gather together in order to examine a painting by one young man. If, like Prud'hon, the young painter in question has any talent, and refuses to copy David, whose manner fails to meet the requirements of his soul, then David's pupils, standing on their dignity, declare unanimously, in a manner unquestioningly accepted by the public, that Prud'hon has no talent whatsoever. [...] Members of the Academy try hard to discern the extent to which any young candidate follows their own system, or imitates their manner; but genius imitates no one, and it imitates members of the Academy even less [...]

IV 12 September 1824

Imagine that we throw into prison an ordinary man, totally unfamiliar with any idea of art or literature, like one of those ignorant people with time on their hands to be found in such large numbers in any great capital, and imagine if you will that once he is over his first fear, he is told that he will only be set free when he is capable of exhibiting a nude at the Salon, perfectly drawn, according to the system of David. One would be astonished to find that this prisoner would in fact be granted his liberty after only two or three years. For good draughtsmanship, in imitation of the antique, as it is understood by the school of David, is an exact science, of the same nature as arithmetic, geometry, trigonometry, and other such sciences. So much so that, with infinite patience, and a grasp of any system of scale, one is capable after only two or three years of knowing and being able to reproduce exactly with a brush the shape and exact position of the hundred or so muscles that cover the human body. For the thirty-odd years that the tyrannical reign of David lasted, the public was obliged to believe, on pain of being accused of lacking taste and sensibility, that to have had the necessary patience to acquire the exact science of draughtsmanship was to have genius. Can anyone still remember today those exact nudes by Madame—? If one wishes to see the greatest excess executed using this system, one should pay a visit to the Girodet *Flood*, which still hangs in the Luxembourg.

But let us return to our prisoner, who we have thrown into a tower in Mont Saint Michel. If we were to tell him that he would be set free when he had developed the ability to portray in a manner recognizable to the public the despair of a lover who has just lost his mistress, or the joy of a father who sees again the son he believed dead, the poor unfortunate would find himself condemned to prison in perpetuity. This is because, unfortunately for many artists, the passions are not an exact science, which any artist can master in due course. In order to portray the passions, one must have

seen them, and one must have felt their devouring flames. Note that I do not simply say that passionate people make good painters; I say rather that all great artists are passionate men. And this is equally true in all of the arts, from Giorgione, dying at 33 because Morto di Feltre, his pupil, had stolen away his mistress, to Mozart, dying after imagining that an angel, in the aspect of a venerable old man, had called him up to Heaven.

The school of David can only paint *bodies*; it is decidedly incapable of *portraying the soul*.

Such is the quality, or rather the absence of quality, which will prevent so many of the huge canvases lauded so highly over the last twenty years from ever surviving for posterity. They are well painted, the drawing is faultless, and yet this is not enough, for they bore the viewer. And as soon as boredom makes an appearance in any of the fine arts, the end is nigh [...]

I am sure to be accused of injustice, and of lacking respect; in my defence I would ask the reader to search out in the Salon this year any picture which expresses in a manner both lively and recognizable to the public any passion of the human heart, or any movement of the soul. I myself attempted this fatal experiment last Saturday, with three friends. As soon as one considers this exhibition from this point of view, how lonely one begins to feel in the middle of more than two thousand pictures! All I ask is a soul in painting: but this plethora of figures, from so many different nations, in so many different shapes and forms, for whose invention history, fable, the poems of Ossian, the travels of de Forbin and so much more besides has been plundered, as soon as I search here for a soul I find but a vast desert of inhumanity! [...]

VI 7 October 1824

Two pictures have had great success in this exhibition, because of the *thought* they reveal: *The Dying Soldier*, by Vigneron, and the *Narcissus* by Sigalon.[1] We see a slave in atrocious pain, his body racked by convulsions, but we imagine noble Britannicus dying; before the eyes of Narcissus, we see a young emperor poison his brother. [...] It has been said that under Nero's reign the emperor's personal poisoner had no reason to live in hiding in a cave. Yet such reasoning is invalid for painting. Painting has need of a modicum of deception. [...] This young man has had his critics; thank goodness, as yet, he copies no one, but the wish has been expressed that his brushwork were smoother, and more similar to painting on porcelain. [...] This criticism is propped up by those so-called philosophical truths, which a painter, who has but the movements of the body to express those of the soul, must have the genius to ignore. It is generally accepted that a man long hardened by crime would not be overcome with such emotion at the sight of an event as simple as the killing of a slave, for to kill a slave in Rome, under the Emperors, and before the triumph of the Christian religion, was the equivalent in Paris today of having a stray dog, whose bark one finds bothersome, put down: if one accepted such reasoning, worthy indeed of the men of letters of today, who, I know not why, feel it is their duty to pass judgement on the arts, one would end up with a work as estimable as any of the hundred other pictures by cold, rational men which are so plentiful in the exhibition. These artists are of course not without merit, but one can barely find ten spectators who genuinely stop to

admire their work, whilst Sigalon might one day perhaps be a great painter, precisely because he has had the courage to reject all the half-baked philosophy which is currently the bane of the arts. His soul has imperiously dictated a picturesque truth to him, where Locusta must be a woman with extremely plain features, and she must be driven half mad by the effect of the crime. Locusta commits the crime, but she is broken by remorse; previously, we infer, she had a heart susceptible to noble and tender emotions. These are the characteristics that painting really needs, for it is this truth of feeling which is so entirely lacking in the so-called great painters of our time. [. . .]

VII 9 October 1824

No matter what I do, I find myself unable to admire Delacroix and his *Massacre of Chios*. This painting still seems to me a picture originally intended to represent a plague, which the artist, on reading reports in the newspapers, has turned into a massacre scene. In the large animated corpse which occupies the centre of the composition, I can only see an unfortunate plague victim, who has attempted to carry out an operation on himself to cut out the bubonic swelling. So much to me at least is indicated by the blood which seems to flow from the left-hand side of the figure. Another episode that all young students never fail to place in their pictures of plague scenes is that of the child who demands milk from the breast of its mother, who lies dead, and sure enough there is one to be found in the right-hand corner of Delacroix's canvas. A massacre surely demands an executioner and a victim. One needs here a fanatical Turk, as beautiful as the Turks of Girodet, massacring Greek women of angelic beauty, and threatening an old man, their father perhaps, who is also destined to be cut down by their blows.

Delacroix, like Schnetz, has a true feeling for colour: and this is saying a lot in this century of draughtsmen. I find in his work much of Tintoretto, and his figures have a genuine sense of movement.

It was claimed, in the *Journal des Débats* the day before yesterday, that *The Massacre of Chios* is Shakespearean poetry. It seems to me that this picture is mediocre through its formlessness, rather than being mediocre by insignificance, like so many Classical pictures which I could cite, and which I would be careful not to attribute to the school of Homer, whose Attic shades must be quite startled at that which is being proclaimed in their name. Delacroix has always had an immense advantage over all the other painters of large format pictures that are to be found decorating state rooms up and down the country, in that the public has always taken great note of his work. This is surely better than being praised in three or four newspapers, which hang on to old ideas, making a travesty of new ones which they are unable to refute [. . .]

David has made the present French School the most important one in Europe. There is no doubt that he was a great painter, extremely inventive, and remarkable by the force of his character, with the courage to reject the type of painting practised by Lagrenée and Vanloo. His glory shall never fade. But the artists who follow him today, in their use of drawing, are no more than copyists, and I fear that posterity may well relegate them to the rank of Vasari and Santi di Tito, who played the sort of role after Michelangelo that they play regarding the work of David [. . .]

VIII 16 October 1824

The English this year have submitted some magnificent landscapes by Constable. I am not sure there is anything we can say against them. Their truth immediately strikes the viewer and draws him into the work. The carelessness of Constable's brush is quite remarkable, the layering of his pictures sometimes leaves much to be desired, and he has no ideal; but that delicious landscape, with the dog on the left hand side, is the true mirror of nature, and it completely obliterates a large landscape by Watelet which is placed right next to it in the large central room [. . .]

X 27 October 1824

An epidemic is sweeping through the landscape painters this year at the Salon. Many of these gentlemen have attempted to do views of Italy, but they have all given their landscapes a sky from the valley of Montmorency, depicted precisely at the moment when, as the saying goes, the Heavens are going to open. When I was in Rome, the superb Pincio promenade, favoured by the French over two or three cloistered gardens, was extremely fashionable, and was the Roman equivalent of the Bois de Boulogne. One of the landscapes which I find most striking at the Salon this year is a *View of Rome from Monte Pincio*. The catalogue informs me that the painter is called Chauvin. One cannot imagine a more faithful drawing of the landscape, nor colour more strangely false. He presents us, once again, with a sky from the valley of Montmorency, stretching out over the monuments of Rome [. . .]

I was generous in my praise of the landscape of Constable; to my mind, *truth* has a charm which is immediately striking, and draws one into the picture. Aficionados of the school of David prefer by far the landscapes of Turpin de Crissé, and in particular those which show us Apollo being chased from the skies. I will refrain from passing comment on this old-fashioned idea of presenting Apollo and the Muses yet again, and say only that this is to misunderstand the nineteenth century. What disturbs me most of all is that these aficionados of old-fashioned French taste praise the landscapes of Turpin de Crissé as though they did have some sort of truth. I would say immediately that perfection in landscape, to my mind, would be to draw the sights of Italy like Chauvin, and to paint them with the naïve approach to colour of Constable [. . .]

The foliage in de Crissé's landscapes patently lacks truth and energy, for a group of trees can indeed possess energy, grace and magnificence. For example, when one enters the Tuileries by the Pont-Tournant, one can see, beyond the pool, on the left-hand side of the main alley, a group of chestnut trees which are quite obviously magnificent. Anyone who has a soul that allows him to appreciate painting will never experience this sort of sensation by looking at the landscapes of de Crissé. In the pictures of the Old School, the trees do have style, they are elegant, but they lack truth. Constable, by contrast, is as true as a mirror; but I would prefer that the mirror were placed in front of some more spectacular view, like the entry to the valley of the Grande Chartreuse near Grenoble, and not merely in front of a hay cart fording the waters of some sleepy canal [. . .]

XIII 23 November 1824

I went to the Louvre in order to gauge the reaction of the Saturday crowd to the pictures. I also wanted to see a new work, whose praises have repeatedly been sung to me: the picture that Ingres has just had installed in the Grand Hall, *The Vow of Louis XIII*. It is, in my opinion, a somewhat dry work, and moreover extremely derivative of Old Italian Masters. The Madonna is beautiful, without doubt, but she has a sort of material beauty that excludes any idea of Divinity. This failing, which is one of feeling and not of science, is all the more remarkable in the figure of the child Jesus. This child, who is extremely well drawn, is the least divine being in the whole world. The celestial physiognomy, and the *unction* indispensable in such a subject, are entirely lacking in all the characters in this picture. The catalogue informs us that Ingres now lives in Florence. How can it be that in his studies of the great painters Ingres has neglected the art of Fra Bartolommeo, the man who taught Raphael chiaroscuro? The works of this monk, which are by no means rare in Florence, are the models for this sort of unction. A story illustrates why: Fra Bartolommeo, frightened by the preaching of Savonarola, gave up the practice of his craft, fearing that he might damn himself. As he was one of the most important painters of his century, and one might say of all time, after four years the superior of his monastery ordered him to take up his brushes once again, and Fra Bartolommeo, in a spirit of obedience, began once again to produce masterpieces. Here, it seems to me, we can find the secret of the superiority of the fifteenth century over our own. Ours has just invented, two months ago, a steam cannon, capable of firing twenty cannon balls a minute the distance of a league. We triumph in all the mechanical arts, like lithography and diorama, but our hearts are cold, and passion, in any form whatsoever, is entirely lacking, in life as in painting. No single painting in the whole exhibition possesses the sort of fire we can find in an opera by Rossini [...]

XV 11 December 1824

The moment has come to say a few words about the impression that the statuary has made on the public this year. [...] Rome has just lost Canova, who invented a new type of ideal beauty, which is closer to our own way of thinking than that of the ancient Greeks. The Greeks respected above all physical force, while we seek feeling and intelligence [...]

Whatever one makes of this theory, Canova set out from an exact imitation of nature, as can be seen from the *Icarus* group, and from *Daedalus*. The one country in the world where this man is maligned the most is perhaps Rome. One should add that this illustrious figure is also an object of loathing for the current French School; he had expression, and he had grace, both of which are somewhat lacking in the school of David. David himself, perhaps the greatest painter of the eighteenth century, has I feel had more influence on the art of statuary than he has had on painting. We have seen, when talking of pictures, that a new School is beginning to emerge this year, to the great discontentment of the pupils of David. Schnetz, Delacroix, Scheffer, Delaroche and Sigalon have all been impudent enough to be admired, and in my opinion two or three of Schnetz's canvases will still be admired a hundred years

from now. No such movement yet seems to be apparent in the sculpture on view this year [. . .]

XVI 22 December 1824

There is bravura in the genius of Horace Vernet. In this timid, over-cautious century, he takes risks, and the result is a happy one; he works fast, he works well, but he works by approximations [. . .]

One critic, a great enemy of Romanticism, has used the strange epithet *Shakespearean* in order to describe Vernet's canvas, contrasting them with the *Homeric* tradition of Raphael and David. One might as well say that one will term *Romantic* anything that is not excellent. By this quite simple artifice, in the eyes of the public, slowly the word 'Romantic' would come to be synonymous with the word *bad*.

One thing that is Romantic in painting is the *Battle of Montmirail*, that masterpiece by Horace Vernet, where nothing, not even chiaroscuro, is lacking. A Classical painting, by contrast, is the battle by Salvator Rosa, of approximately the same dimensions, to be seen at the far end of the Grand Gallery on the Seine side. The Romantic, in all the arts, is the man who represents people as they are today, and not as they were in those heroic times so distant from us, and which probably never existed. If one bothers to compare the two battle scenes which I have just indicated, and above all compare the quantity of pleasure that they procure to the spectator, one will be able to form a clear idea of what Romanticism is in painting. Classicism, on the contrary, is exemplified by these completely naked men who fill David's *Intervention of the Sabine Women*. Even if their talent were identical, the Vernet battle scene would be infinitely superior. What sympathy can be felt by a Frenchman of today, who has himself carried a sword, for men who fight *stark naked*? [. . .]

[1] The scene depicted in this painting is from Racine's play *Britannicus*. Britannicus is the Emperor Nero's half brother. Nero has ordered Locusta to provide Narcissus with poison in order to kill Britannicus. Narcissus tests the efficacy of the poison on a slave.

5 Claude-Henri de Rouvroy, Comte de St Simon (1760–1825) 'The Artist, the Savant and the Industrialist'

Few ideas have pervaded the discussion of art in the modern period as thoroughly as that of the 'avant-garde'. The meaning of the term, however, is radically unstable. In some usages it has become aligned with 'Modernism' and even 'art for art's sake'. In others it is identified with the desire to change society. As a term of reference for an advanced force in culture, it first occurs in the late writings of the French utopian socialist, Henri de St Simon. Here it is the second type of meaning which is clearly intended: the artist is given the leading role in the transformation of society, working in cooperation with both the scientist and industrialist against the forces of reaction. St Simon was a product of both the French Revolution and the Enlightenment, and in his earlier writing had given priority to science and technology as the means to improve society. This tendency was fulfilled in the association he made from 1817, with Auguste Comte (cf. IIA2). However, at the end of his life he abandoned the mechanistic view of society, breaking with Comte in 1824. He moved instead to a Romantically inclined

view of society as a living organism and began to develop the doctrine known as 'New Christianity'. It was as a consequence of this turn that St Simon came to accord a larger role to art and the imagination in the process of social change. The present text represents an imaginary dialogue between an artist, a savant and an industrialist. St Simon makes it clear that he intends the term 'artist' to refer alike to poet and writer, painter and musician: all 'men of imagination'. The following extract, actually composed by St Simon's disciple, Olinde Rodriguez, is taken from the concluding chapter of *Opinions Litteraires, Philosophiques et Industrielles*, Paris: Galerie de Bossange père, 1825, pp. 332–44. It was translated by Jonathan Murphy for the present volume.

The Artist: None of us, Gentlemen, is content with his situation. But to change it is well within our powers: giving a new direction to our work, and changing the nature of the relations which until now have existed between us would be more than sufficient.

The weak have a right to complain. They have neither the hope nor the means of remedying their situation, and hence a complaint is a natural right and a source of consolation. But the strong have no such right: we, who are capable of curing the physical or moral cause of the source of our complaints, we are merely ridiculous when we start to complain.

Are we not in agreement, Gentlemen, that the strength of society resides in us, that all the energy at the Government's disposal originates in us, and that we, in a word, are the mainstay of the life of society? How could it continue to exist if our work were no more? Who could satisfy the needs of Man, or procure for him those pleasures which are also his needs, if industry, the arts and the sciences were all suddenly to disappear? What could the ruling classes do? They are neither Artists, nor Savants, nor Industrialists, and they consider it well beneath their dignity to be classed among the producers. Would it be to the ruling classes that the father with hungry mouths to feed addressed his demands for bread, clothes and shelter for his children? From them that the labourer demanded the tools for his trade or advice for the success of his harvests? From them that the rich man begged pictures and statues to charm his eye and mind, or sublime songs to please his ear and soul? In the face of such a general crisis, what could the ruling classes grant? In answer to the prayers of the public, what could they possibly give back to society? All they know how to do is to pay: and even this would be impossible if Industry, the Arts and the Sciences, over which they normally have influence, were to refuse to society the fruits of their cooperation, the results of their work and their constant vigilance.

However, let it not be understood that I regard the ruling classes as having no role to play whatsoever. Properly entrusted with the task of ordering society, they would do it an important and useful service, providing that the highest administration of public affairs be entrusted to those with positive capacities. The ruling classes would then be forced to recognize their function as secondary, and to see that there exists between themselves and the men of Industry, the Arts and the Sciences, a distance similar to the one which separates the teachers and the monitors in schools. Neither should it be understood that I am denying the purity of the intentions of the ruling classes. But they are deluded, and constantly live in a state of perpetual error, for which some blame must be attributed. They do not understand the times in which they live; they do not believe that today, consideration and respect can only be granted to men of talent and to men of value to society. They wish to be given the greatest

consideration and treated with the utmost respect, when in fact they are but mediocre men who produce no useful work, and therefore have no place amongst Savants, Industrialists and Artists.

European society is no longer composed of children who must, in their own interest, be governed by a firm and active intervention; it is made up of mature men, whose education is complete, and who need naught but instruction. Politics should now be the science of procuring for the greatest number the greatest possible sum of material goods and moral pleasures. The ruling classes, although in the sway of ancient prejudices, and living a life of delusion, do none the less pay homage, through their actions, to public opinion. They are beginning to demonstrate, if not by their actions, then at least by the form in which they present them, that they have begun to realize that they are dealing with reasonable men who do not wish to live in order that they may be governed, but who consent to be governed in order that they may live more comfortably. One may grant that, to the best of their abilities given the present state of affairs, they honour the Arts, the Sciences and Industry with their favours, but what need have these three great powers of such favour, when they are already so capable in themselves, and so indispensable to society? Those of us who oversee them might well ask the ruling classes what, in the final analysis, they have in common with us. How is it that we are at their mercy? To whom does the nation owe its well-being? Who offers the greater service to the throne? Everything which is useful to Society emerges from our minds, from our studies, from our workshops, from our factories and not from their offices or dining-rooms. If we come to conceive of a project of general utility, we are forced to beg them to lend it some consideration. Should we manage to convince them to adopt it, it is we who carry it out in accordance with their whims. But since it is they who are inferior to us in every capacity, since the sole capacity which they possess is that of surveillance (which more rightly should decrease day by day), how is it that their constant desire is to reduce us to the role of merely passive instruments, without which it would be impossible for them to carry out the most rudimentary operation? Their pride is as out of place and as ridiculous as that of the coachman who, proud of the elevation of his seat, believes himself to be above the master who pays him and feeds his horses.

I imagine that if one of us were to put these issues to a member of the ruling class, the reply would be quite simple: 'I have but one thing to say to you', he would answer, 'You are divided but we are united'.

This reply, Gentlemen, would be well-founded. Unity, which is the virtue and safeguard of the weak, is also one of the duties of the strong. Yet, rather than a happy concord reigning amongst us, there is, on the contrary, between Savants, Industrialists and Artists, a state of permanent hostility. I do not pretend that the blame is to be found on one side: we all bear some responsibility.

The Savant, influenced by the nature of his work and his natural talent, respects only rigorous reasoning and positive results, and considers the Artist a somewhat wild spirit. He believes neither in the utility or the power of the arts. But he of course forgets that reasoning merely convinces on an intellectual level, while the arts persuade by touching men's sensibilities.

Neither does the Industrialist, in general, do the Artist the justice that he deserves, but forms instead a false picture of him. He sets little store by the talents of men of

letters, poets, painters and musicians, regarding them as untrustworthy, dangerous outsiders. Normally cold and calculating in matters pertaining to material production, Industrialists look down upon any intellectual work which produces no facts amongst its results. Others seem inspired by some distant feudal associations, and forget all too often both their own plebeian origins, and the hard work which is the honourable source of their riches, and open the doors of their brilliant salons only to people whose great name or large fortune outweighs their usefulness. Doubtless they would be afraid to treat as equals men who regard as obsolete the sort of respect conferred by titles and nobility. In short, all Industrialists regard the superiority of their social position over that of Artists as being quite evident and incontestable.

We Artists – and here I speak with the same frankness – are perhaps even more exclusive and unjust. The ideal sphere which we inhabit often inclines us to cast a glance filled with pity and scorn at this earthly world. The imagination, which provides us with the sweetest pleasures and the purest consolations, seems to us the sole human faculty deserving of respect and praise, and hence we attach no great value to the work of Savants, whose importance we constantly underestimate, and we make almost nothing of their company, which seems to provide so little food for our souls. Their conversation seems too dull, and their work, to our eyes, is too purely material. We feel even more strongly about the men of industry. The low opinion that many of us have of a class of men who are both honourable and necessary is made worse by the conviction that all Industrialists are ruled exclusively by a raging passion for money. Such an eminently earthly passion is hated by poets, painters and musicians, for whom money has neither dignity nor value; since time immemorial, Artists have excelled only at spending it.

Evidently, I have spoken frankly here on behalf of all of us, and if I speak as a man who would hide nothing, it is because I desire fervently that these times were behind us. Let us change our attitude and change direction: instead of fixing our attention on the faults of one another, let us instead set about praising our qualities. Let us be filled with one great idea: the well-being of society as a whole depends entirely on the potential of the three groups which we represent. Let us always bear in mind that each of us contributes in equal measure to this good, and that if a single one of the three classes to which we belong were to disappear, society would pass into a time of great hardship and danger. Deprived of Science, Art or Industry, society would topple like a palace in an earthquake.

Let us be conscious of our mutual value, and in this way we will achieve the dignity befitting our position. Let us combine our forces, that the mediocrity of the present, which triumphs over our disarray, will be recognized for what it is, and forever banished to its proper place below. The pacific power of our triple crown will triumph over a world in transformation.

Let us unite. To achieve our one single goal, a separate task will fall to each of us.

We, the artists, will serve as the avant-garde: for amongst all the arms at our disposal, the power of the Arts is the swiftest and most expeditious. When we wish to spread new ideas amongst men, we use, in turn, the lyre, ode or song, story or novel; we inscribe those ideas on marble or canvas, and we popularize them in poetry and in song. We also make use of the stage, and it is there above all that our influence is most electric and triumphant. We aim for the heart and imagination, and hence our effect is

the most vivid and the most decisive. If today our role seems limited or of secondary importance, it is for a simple reason: the Arts at present lack those elements most essential to their success – a common impulse and a general scheme.

The peoples of antiquity, to whom feelings of universal brotherhood were entirely unknown, pushed the selfishness of individual states to its furthest point. But for them the Arts played a great political role, and exerted an important influence: they were patriotic.

Later, when a new belief spread amongst men the principles of an enlightened, humane and merciful morality, and great political associations were formed, industry began to grow and develop, and slavery, in the face of truly divine beliefs, began to decline, and the Arts still served the general movement of mankind in the most powerful fashion: they were religious.

Now that the great work of Christianity is drawing to a close, and brotherhood reigns between all men and all nations, the great fallacies are slowly being eroded, and society is becoming ever more *positive*. The Arts must now at last take the form they have evolved towards for over a century: they must be filled with *common sense*.

Such, then, is the character of the times in which we live. It has been necessary for mankind, in Europe, to pass through terrible crises, before arriving at a time of maturity and reason. Man must now ensure that all his different faculties, which have at last attained an advanced state of development, are maintained in equilibrium, and that no one in particular dominates at the expense of the rest, so that all may be directed in concert towards a goal of general and complete amelioration.

Doubtless imagination will hold man in its grip for some time to come, but the time of its exclusive reign is past; and if man is as avid as ever for the joys that the Arts bring, he none the less demands that his reason partake of these joys. If the Arts were to persist in following a course where they have nothing left to achieve, and aim still for that old-fashioned goal of merely pleasing and touching the imagination, they would risk losing for ever their importance, and far from directing the march of civilization, they would merely be classed among the base needs of our society. But if, on the other hand, they support the general movement of the human spirit, if they assist the common cause, and contribute to the growth of general well-being, producing useful sensations for mankind such as those which a developed intelligence should properly experience, if they propagate generous ideas which are in keeping with the spirit of the times together with these sensations, an immense future of glory and success will immediately open up before them. Their energies will return, and they will be raised up to the highest point they could possibly attain: for when harnessed in the direction of the public good, the force of the imagination is quite simply incalculable. [. . .]

6 Anna Jameson (1794–1826) from *Diary of an Ennuyé*

Anna Jameson was the daughter of an Irish painter. She had travelled in Europe as a governess between 1810 and 1825, and then made an uncongenial marriage. 'None seem aware how fast, how very fast the principle of life is burning away within me', she wrote, voicing a frustration widely echoed among the educated women of the nineteenth century.

Diary of an Ennuyé was her first published work. She was subsequently responsible for a number of publications on artistic and literary themes, including a *Handbook to the Public Galleries of Art in and near London*, in 1842, and she made a sustained study of the religious motifs of early Italian art. (An excerpt from her later *Sacred and Legendary Art* will be found in IIIc1.) In the passage below she tilts at the tendency to confuse expertise in the appreciation of art with a mere appetite for sensuous detail. The connoisseur whose antics she sketches has travelled from the Royal Academy at Somerset House to the Tribuna in the Uffizi – the 'Gallery' referred to – where a number of canonical works of classical and Renaissance art were shown together. She also employs the concept of seeing 'with a woman's eyes' to critical ends, imputing a form of blindness to those who claim an aesthetic pleasure in pictures of sadistic martyrdom. Despite her interest in iconography, the substantial implication of her observations is that the significant character of a work of art is revealed as much through its style as through its figurative content. *Diary of an Ennuyé* was first published in London by Henry Colburn in 1826. Our excerpt is taken from pp. 329–37 of that edition.

April 20. – During our stay at Florence, it has been one of my favourite occupations to go to the Gallery or the Pitti Palace, and placing my portable seat opposite to some favourite pictures, minutely study and compare the styles of the different masters. By the style of any particular painter, I presume we mean to express the combination of two separate essentials – first, his peculiar conception of his subject; secondly, his peculiar method of executing that conception, with regard to colouring, drawing, and what artists call handling. The former department of style, lies in the mind, and will vary according to the feelings, the temper, the personal habits and previous education of the painter: the latter is merely mechanical, and is technically termed the *manner* of a painter; it may be cold or warm, hard, dry, free, strong, tender: as we say the cold manner of Sasso Ferrato, the warm manner of Giorgione, the hard manner of Holbein, the dry manner of Perugino, the free manner of Rubens, the strong manner of Caravaggio, and so forth; I heard an amateur once observe, that one of Morland's Pigsties was painted with great *feeling:* all this refers merely to mechanical execution.

I am no connoisseur; and I should have lamented as a misfortune, the want of some fixed principles of taste and criticism to guide my judgement; some nomenclature by which to express certain effects, peculiarities, and excellencies which I felt, rather than understood; if my own ignorance had not afforded considerable amusement to myself and perhaps to others. I have derived some gratification from observing the gradual improvement of my own taste; and from comparing the decisions of my own unassisted judgement and natural feelings, with the fiat of profound critics and connoisseurs: the result has been sometimes mortifying, sometimes pleasing. Had I visited Italy in the character of a ready made connoisseur, I should have lost many pleasures; for as the eye becomes more practised, the taste becomes more discriminative and fastidious; and the more extensive our acquaintance with the works of art, the more limited is our sphere of admiration; as if the circle of enjoyment contracted round us, in proportion as our sense of beauty became more intense and exquisite. A thousand things which once had power to charm; can charm no longer; but, *en revanche*, those which *do* please, please a thousand times more: thus what we lose on one side, we gain on the other. Perhaps, on the whole, a technical knowledge of the arts is apt to divert the mind from the general effect, to fix it on petty details of execution. Here comes a connoisseur, who has found

his way, good man! from Somerset House, to the Tribune at Florence: See him with one hand passed across his brow, to shade the light, while the other extended forwards, describes certain indescribable circumvolutions in the air, and now he retires, now advances, now recedes again, till he has hit the exact distance from which every point of beauty is displayed to the best possible advantage, and there he stands – gazing, as never gazed the moon upon the waters, or love-sick maiden upon the moon! We take him perhaps for another Pygmalion? We imagine that it is those parted and half-breathing lips, those eyes that *seem* to float in light; the pictured majesty of suffering virtue, or the tears of repenting loveliness; the divinity of beauty, or '*the beauty of holiness*', which have thus transfixed him. No such thing: it is the *fleshiness* of the tints, the *vaghezza* of the colouring, the brilliance of the carnations, the fold of a robe, or the foreshortening of a little finger. O! whip me such connoisseurs! the critic's stop-watch was nothing to this.

Mere mechanical excellence, and all the tricks of art have their praise as long as they are subordinate and conduce to the general effect. In painting as in her sister arts it is necessary

Che l'arte che tutto fa nulla si scuopre [That that art which reproduces all reveals nothing].

Of course I do not speak here of the Dutch school, whose highest aim, and highest praise, is exquisite mechanical precision in the representation of common nature and still life: but of those pictures which are the productions of mind, which address themselves to the understanding, the fancy, the feelings, and convey either a moral or a practical pleasure.

In taking a retrospective view of all the best collections in Italy and of the Italian school in particular, I have been struck by the endless multiplication of the same subjects, crucifixions, martyrdoms and other scripture horrors: – virgins, saints and holy families. The prevalence of the former class of subjects is easily explained, and has been ingeniously defended; but it is not so easily reconciled to the imagination. The mind and the eye are shocked and fatigued by the succession of revolting and sanguinary images which pollute the walls of every palace, church, gallery and academy from Milan to Naples. The splendour of the execution only adds to their hideousness; we at once seek for nature, and tremble to find it. It is hateful to see the loveliest of the arts degraded to such butcher-work. I have often gone to visit a famed collection with a secret dread of being led through a sort of intellectual shambles, and returned with the feeling of one who had supped full of horrors. I do not know how *men* think, and feel, though I believe many a man, who with every other feeling absorbed in overpowering interest, could look unshrinking upon a real scene of cruelty and blood, would shrink away disgusted and sickened from the cold, obtrusive, *painted* representation of the same object; for the truth of this I appeal to men. I can only see with woman's eyes, and think and feel as I believe every woman *must*, whatever may be her love for the arts. I remember that in one of the palaces at Milan – (I think it was in the collection of the Duca Litti) we were led up to a picture defended from the air by a plate of glass, and which being considered as the gem of the collection, was reserved for the last as a kind of bonne bouche. I gave but one glance,

and turned away loathing, shuddering, sickening. The cicerone looked amazed at my bad taste, he assured me it was *un vero Correggio* [a true Correggio] (which by the way I can never believe) and that the Duke had refused for it I know not how many thousand scudi. It would be difficult to say what was most execrable in this picture, the appalling nature of the subject, the depravity of mind evinced in its conception, or the horrible truth and skill with which it was delineated. I ought to add that it hung up in the family dining-room and in full view of the dinner-table.

There is a picture among the chefs-d'œuvres in the Vatican, which if I were Pope (or Pope Joan) for a single day should be burnt by the common hangman, 'with the smoke of its ashes to poison the air', as it now poisons the sight by its unutterable horrors. There is another in the Palazzo Pitti, at which I shiver still, and unfortunately there is no avoiding it, as they have hung it close to Guido's lovely Cleopatra. In the gallery there is a Judith and Holofernes which irresistibly strikes the attention – if any thing would add to the horror inspired by the sanguinary subject, and the atrocious fidelity and talent with which it is expressed, it is that the artist was a *woman* [Artemisia Gentileschi]. I must confess that Judith is not one of my favourite heroines; but I can more easily conceive how a woman inspired by vengeance and patriotism could execute such a deed, than that she could coolly sit down, and day after day, hour after hour, touch after touch, dwell upon and almost realize to the eye such an abomination as this.

We can study anatomy, if (like a certain princess) we have a taste that way, in the surgeons' dissecting rooms, we do not look upon pictures to have our minds agonized and contaminated by the sight of human turpitude and barbarity, streaming blood, quivering flesh, wounds, tortures, death and horrors in every shape, even though it should be all very *natural*. Painting has been called the handmaid of nature; is it not the duty of a handmaid to array her mistress to the best possible advantage? At least to keep her infirmities and deformities from view and not to expose her too undressed?

But I am not so weak, so cowardly, so fastidious, as to shrink from every representation of human suffering provided that our sympathy be not strained beyond a certain point. To *please* is the genuine aim of painting as of all the fine arts; when pleasure is conveyed through deeply excited interest, by affecting the passions, the senses and the imagination, painting assumes a higher character and almost vies with tragedy; in fact it *is* tragedy to the eye, and is amenable to the same laws. The St Sebastians of Guido and Razzi; the St Jerome of Domenichino; the sternly beautiful Judith of Allori; the Pietà of Raffaelle; the San Pietro Martire of Titian; are all so many tragic *scenes*, wherein all that is revolting in circumstances or character is judiciously kept from view, where human suffering is dignified by the moral lesson it is made to convey, and its effect on the beholder at once softened and heightened by the redeeming grace which genius and poetry have shed like a glory round it.

Allowing all this I am yet obliged to confess that I am wearied with this class of pictures, and that I wish there were fewer of them.

But there is one subject which never tires, at least never tires *me* however varied, repeated, multiplied. A subject so lovely in itself that the most eminent painter cannot easily embellish it, or the meanest degrade it; a subject which comes home to our own bosoms and dearest feelings; and in which we may 'lose ourselves in all delightfulness' and indulge unreproved pleasure. I mean the *Virgin and Child*, or in other words, the

abstract personification of what is loveliest, purest, and dearest, under heaven – maternal tenderness, Virgin meekness and childish innocence, and the *beauty of holiness* over all.

It occurred to me today, that if a gallery could be formed of this subject alone, selecting one specimen from among the works of every painter, it would form not only a comparative index to their different styles, but we should find, on recurring to what is known of the lives and characters of the great masters, that each has stamped some peculiarity of his own disposition on his Virgins; and that, after a little consideration and practice, a very fair guess might be formed of the character of each artist, by observing the style in which he has treated this beautiful and favourite subject. [. . .]

7 Victor Hugo (1802–85) on the Grotesque

Hugo was a major figure in the development of a Romantic tendency in French literature. During most of his working life he also produced graphic sketches and drawings, many of them comic and grotesque, others darkly Romantic. In the mid-1850s he produced a series of works exploiting the chance configurations of inkblots, which the Surrealists were later to claim as antecedents for their own experiments with automatism. The passage that follows is taken from the lengthy preface to his play *Cromwell*. Hugo used the preface to define what he saw as the ethos of the age, building his argument upon a broad sweep of historical generalizations. The distinguishing character of modern culture, he argues, is its preoccupation with the grotesque, by which he means the comic, the eccentric, the anomalous, the monstrous, the vernacular – everything, in fact, that the classical is not. The spirit of poetry and of art, he implies, is more all-embracing than classical canons will allow. In asserting the power and vitality of local and medieval monsters against those of classical mythology he provides an echo of that strain of resistance to Mediterranean culture that had been a feature of the German Romantic movement. *Cromwell* was first published in Paris in 1827. This extract is taken from Hugo, *Oeuvres complètes* Paris: J. Hetzel and Co., 1882, pp. 16–23, translated for this volume by Jonathan Murphy. (The names of many of Hugo's local monsters are by their nature without English equivalents.)

The muse of the Ancients was a purely epic one: as a result they studied only one face of Nature, and, in their restricted form of imitation, mercilessly excluded from art anything which did not fit in with a certain category of the beautiful. The contents of this category, initially, were awe-inspiring; but as so often happens with anything which is overly systematic, in time it became restrictive, falsified and prey to convention.

Christianity brings poetry and truth. The modern muse, in a similar fashion, will bring a wider, all-embracing vision. It will acknowledge that not everything in creation is beautiful to the human eye, that the ugly co-exists side by side with the beautiful, the deformed beside the gracious, the grotesque by the sublime, Good hand in hand with Evil, and shadow with light. It will wonder whether that partial, narrow-minded judgement that artists possess has the right to lord it over the infinite and absolute wisdom of the creator; whether it is the business of man to correct God's creation; whether Nature mutilated will be more beautiful than Nature portrayed whole; whether art has the right to misrepresent man, life and creation, and whether things

will work better once their muscles or impulses have been removed; it will wonder, in short, whether harmony can ever come from incompleteness. And at that moment, its eye fixed firmly on events both laughable and magnificent, filled with the spirit of melancholic Christianity and critical philosophy, Poetry will take a great, decisive leap forward, a leap which, like a great upheaval, will change the appearance of the intellectual world. Poetry will then mirror nature, blending but not confusing in its creations shadows and light, the grotesque and the sublime. To put it in its simplest terms, it will unite the animal and the spirit, the body and the soul of man. For the point of departure for religion is ever that of poetry: such things are inevitably connected.

What we announce is a principle unknown to the Ancient world, a new category to be introduced into poetry: and as any addition to an entity modifies its whole being, we bring a new form to the world of art. Such a form is the category of the grotesque, and its form will be that of comedy.

Here I must be forgiven for pressing a point, for I have just indicated the characteristic trait, and fundamental difference, which to my mind sets our modern art apart from that of the Ancients, as the living are set apart from the dead. To use those vague but now widely accepted terms, this is the element that separates romantic from classical literature.

'At last' say those who, for some time now, have suspected that it should come to this: 'At last we have you! Caught in the act! So it is true then, you wish to make the ugly a form of imitation, and the grotesque an element of art! But what about grace, what about good taste . . . don't you know that art should rectify nature? That it should ennoble, and select its material? Did the Ancients ever portray the ugly, or the grotesque? Did they ever mix comedy and tragedy? We must follow the classics, good Sir! What of Aristotle, Boileau, La Harpe . . . I mean, really . . .!'

These arguments are solid enough, no doubt, and have the tremendous advantage of being startlingly innovative . . . but it is not my concern to answer them. For I am not building a system here – rather, God preserve me from systems. I am merely bearing witness to a fact. I am a historian, not a critic. One may take it or leave it, I am quite unconcerned: it remains as a fact of our times. Let us return instead to our subject, and see how the modern spirit is born out of this fecund union of the categories of the grotesque and the sublime: a spirit complex, and infinitely varied in its manifestations, inexhaustible in its creativity, totally opposed to the uniform simplicity of the genius of the Ancients. My aim here is to show that in order to best perceive the real and radical difference between the two literatures, one must take this as the starting point.

* * *

In modern thought, the grotesque has a huge role to play. We can see it everywhere: here, behind the deformed and the horrible, there behind the comic and the clownish. It is behind a thousand original superstitions in religion, and informs the picturesque imagination of poetry. It is the spirit of the grotesque that peopled the air, the earth, water and fire with those strange intermediary beings which were so alive in the popular traditions of the middle ages; the grotesque which dreamt up those terrifying witches' sabbaths, and it alone which lent Satan his cloven hooves, his scaly horns and his bat-like wings. It is the grotesque we must thank for those hideous pictures of Christian Hell, which the bitter genius of Milton and Dante recalled, and which

Callot, that burlesque Michelangelo, was to fill with those ridiculous images. The grotesque is closer to the world around us than it is to any ideal, yet it is filled with endless parodies of mankind. From its imagination sprang creations like Scaramouche, Crispin and the Harlequin, grimacing silhouettes of men, quite unknown to sombre antiquity, yet born in Classical Italy. And it is the grotesque too that fires the cold imagination of the North, making Sganarelle dance around Don Juan, and Mephistopheles crawl around Faust.

How free and easy it is in its bearing! How boldly it expresses those bizarre shapes that earlier ages timidly evoked! The poetry of the ancients, forced to find companions for limping Vulcan, attempted to disguise their deformity by lending it colossal proportions. The modern spirit has retained the myth of the supernatural blacksmith, but lent it an entirely different character and made it all the more striking: it changed giants into dwarves, and the Cyclops into a hobgoblin. With the same sense of originality, it took the banal myth of the Hydra of Lerna, and replaced it with all the local dragons of our legends, like the Gargoyle of Rouen, the Gra-ouilli of Metz, the Chairsallée of Troyes, the Drée of Montlhéry, and the Tarasque of Tarascon – all monsters in extraordinary shapes and forms, whose very names themselves send a tingle down the spine. All these creations demonstrate a profound, natural energy, in the face of which antiquity itself seemed to beat a retreat. One is forced to admit that the Greek Furies are far less frightening, and hence far less true, than the witches of Macbeth. Pluto is no match for the Devil.

Doubtless there is room for a whole book to be written on the use of the grotesque in the arts. One could demonstrate the countless terrifying effects that the moderns have extracted from this most powerful of categories, which a series of narrow-minded critics still feel obliged to attack. I will give some examples below of various features common to the whole concept; here I will merely note the manner in which the concept acts as an impressive counterpart to the idea of the sublime, and as such provides one of the richest sources which nature offers to art. Rubens doubtless understood it to be so, and we find many examples of it in his painting, as for instance in the portrayal of some royal feast, or coronation, or splendid ceremony, where so often we also catch sight of the face of some hideous dwarf lurking in the background. The universal beauty in which antique art solemnly decked all things was not without its own monotony: the same impression, often repeated, will inevitably pall in the longer term. One form of the sublime contrasted with another is barely the sublime at all, for one needs a certain period of respite from everything, even from beauty. The grotesque, on the other hand, by its nature, marks a sort of pause, and forms a point of comparison refreshing and sharpening our faculties, from which we can rise up towards the beautiful. The salamander increases the beauty of the ondine, as the hobgoblin renders the sylph ever more ethereal.

We can also claim that this contact with all that is shapeless or deformed changes our modern idea of the sublime, changing it into something greater, purer, more sublime even than the antique ideal of beauty, and we are within our rights to do so; for an art that contains all things will surely bring us closer to our ideal. If the Elysian fields of Homer fail to match the ethereal charm and the angelic softness of Milton's paradise, it is for a simple reason: beneath the Christian Eden lurks an Inferno more horrible by far than any antique Hades. Do we believe for one moment that Francesca

da Rimini and Beatrice would be as ravishing in the work of another poet, who failed to lock us up in the Tower of Hunger, and did not oblige us to share Ugolino's repulsive fare? Dante's grace is largely a product of his tremendous strength. Do the fleshy naiads, robust tritons, and libertine zephyrs of the ancient world have the diaphanous grace of our sylphides and ondines? Of course not, for the simple reason that our modern imagination also portrays a hideous array of creatures that roam the cemeteries – kelpies and kobolds, vampires, barghests, erlkings and ghouls – and for that reason it can give to its airy creations that incorporeal grace and that purity of essence so lacking in those pagan nymphs. The antique Venus is beautiful, admirable too, but what could be at the origin of that strange, svelte, weightless elegance in those figures of Jean Goujon, what could be the cause of the unprecedented life and strength of those figures? Could it really be anything other than their proximity to that rough, powerful sculpture from the middle ages?

If, despite this series of necessary digressions (which could in their turn be developed far more extensively), the reader has managed to follow the thread of these ideas, he will by now have understood the power of the grotesque, and seen how this tiny grain, the root of all comedy, has never ceased to grow, since its transplantation from pagan epics to the more fertile ground of the modern era. For in the new poetry, while the sublime represents the soul such as it is, purified by Christian morality, the grotesque will play the role of the beast in man. The former, cleansed of all impurity, will contain all charm, all grace, and all beauty, and one day create anew characters like Juliet, Desdemona and Ophelia, while it will fall to the latter to portray the foibles of man, his infirmities and his ugliness. In this division of all humanity and all creation, we shall look to the grotesque for all passion, vice and crime; the grotesque shall be lascivious and base, greedy, avaricious and perfidious, hypocritical and confused. We will find it made flesh in Iago, Tartuffe and Basile; Polonius, Harpagon and Bartholo; and Falstaff, Scapin and Figaro. For beauty has only one type, whilst ugliness has thousands at its disposal. Beauty, on a human scale, is but form considered in its most simple manifestation, in its most absolute symmetry, or in its most intimate harmony with our own constitution. Hence it offers us a complete whole, but one which is limited like ourselves. By contrast, the things that we term ugly are but the details of a grand design which surpasses our understanding, harmonizing not with man himself, but with the whole of creation. And for this reason ugliness constantly presents itself to us in new forms, which merely have the appearance of incompletion.

8 Caspar David Friedrich (1774–1840) 'Observations on Viewing a Collection of Paintings Largely by Living or Recently Deceased Artists'

Friedrich was the most important German landscape artist of the early nineteenth century. Born in Greifswald near the Baltic coast, he trained in Copenhagen and spent his entire working life in Dresden, one of the principal centres of German Romanticism. In these 'observations' Friedrich records his thoughts on an exhibition of paintings by contemporary artists. None of the painters he discusses have been identified, but his remarks provide a

remarkable insight into his own views on art. Whilst emphasizing the importance of feeling and the individual's response to nature over acquired skill or technique, Friedrich is also concerned with the technical demands of capturing the effects of landscape. He is strongly critical of artists such as the Nazarenes who sought to base their work on the art of an earlier period, insisting that artists must not only be true to themselves, but to the times in which they live. The original manuscript, written down by Friedrich some time around 1830, is held in the Kupferstichkabinett in Dresden. Extracts were first published by Carl Gustav Carus in *Friedrich der Landschaftsmaler*, Dresden, 1841, but the complete text was not published until 1924, in K. K. Eberlein, *C. D. Friedrich, Bekenntnisse*, Leipzig, 1924. These extracts have been translated for the present volume by Jason Gaiger from Sigrid Hinz, ed., *Caspar David Friedrich in Briefen und Bekenntnissen*, Berlin: Henschelverlag, 1968, pp. 87–134.

It makes an adverse impression on me to see large numbers of pictures displayed or stored up like merchandise in a room in such a way that it is no longer possible to look at any one picture without seeing half of four others at the same time. It is inevitable that the appreciation of valuable works of art will be impaired when they are piled up in this way. Moreover, the result of hanging contrasting pictures side by side – often done quite deliberately – is that the second picture simply cancels out or detracts from the first, thereby weakening the effect of both. In view of this initial negative state of mind, you should not be surprised if my observations on these paintings sound somewhat harsh. I look at pictures only in order to enjoy them: if I do not feel attracted to a particular work, albeit because of my own mood or negative state of mind, I prefer quietly to turn away from it. But here, no matter where I look, even the doors and windows are hung with pictures. However, since it is asked of me that I should give my opinion, let us begin!

The works of XXX remind me of playing cards: one moment shuffled one way, then another, but the cards themselves remain unchanged. In the same way, I recall having often seen these figures before and even the background is familiar to me from old paintings and engravings. One of the pictures bears all the traces of Raphael and the other of Michelangelo and their predecessors. Would it not be better if these figures bore the character of the person who painted them on their brow? Or is the artist devoid of any character? Is this what it means to study the Old Masters? What this artist has achieved could have been done at home through the study of engravings, and hardly required that he first journey to Rome. But it is current practice in religion as in art to deny healthy common sense as well as one's own feelings, thus deceiving both oneself and others. What our ancestors believed and accomplished in childish simplicity we too should believe and do with a higher more purified knowledge. What I have said here could be applied to many artists working at the present time.

The artist's feeling is his law. Pure sensibility can never be contrary to nature but is always in accord with it. However, we should never allow the feeling of another to be imposed on us as a law. Spiritual affinity results in similar work, but this affinity is far removed from crude imitation. No matter what may be said about the paintings by XXX and how similar they are to the paintings of Y, he has produced them from out of himself and they are his own.

Who wishes to know what is to be adjudged beautiful and who can teach it? And who can set limits and impose rules on what is spiritual? You mundane, dry

and leathery men are always devising rules. The majority will praise you for the crutches you offer them, but whoever is conscious of their own powers will ridicule you.

Those who sit in judgement on works of art are no longer satisfied with our German sun, moon and stars, with our rocks, trees and plants, with our plains, lakes and rivers. Everything must be Italian if it is to raise a claim to greatness and beauty.

Man stands in equal proximity and equal distance to both God and the devil. He is the highest and the lowest of creatures, the most noble and the most degenerate, the embodiment of all that is good and beautiful and of all that is despicable and accursed. He is the most sublime product of the whole of creation, but also the disfiguring stain [*Schandfleck*] in the created world.

Art occupies the role of mediator between nature and man. The original is too great and too sublime for the majority to be able to grasp it. But the copy is the product of human hands and so lies closer to our human frailty. This explains the oft-heard pronouncement that the copy is more pleasing than nature herself. There is a manner of speaking which claims that something in nature looks as beautiful as if it were painted; instead of saying of a painting that it is as beautiful as if it were nature herself.

Who is the artist who painted this animal scene? The dog is so well painted that it could be by XXX, but the figure walking him looks as if he had been painted by the dog.

The celebration of the Last Supper by XXX is a work from which young artists could learn a great deal with regard to its drawing and treatment of colours, and it could well be hung in an art school. However, it is not suitable for a church or for edifying and uplifting the souls of faithful Christians. It lacks any animating warmth; it is devoid of feeling and life.

How numerous are those who call themselves artists without realizing that this also involves something quite different from mere technical skill.

Some hold it mere folly that art must develop from within and that it is dependent on the ethical and religious worth of the individual. Yet just as only a pure, unmarked mirror can return a pure reflection, so a true work of art can only come forth from a pure soul.

What pleases us most in the pictures of the Old Masters is their pious simplicity. However, we should not seek to become simple, as many have done, and so imitate their faults, but rather to become pious and imitate their virtues.

The noble person (a painter) recognizes God in everything, the common person (also a painter) perceives only the form, but not the spirit.

Art is to be likened to a child, science to an adult.

The only true source of art is our heart, the language of a pure, childlike spirit. A picture which does not spring from this source is nothing but affectation. Every genuine work of art is conceived in consecrated hours and born in joyous ones from an inner compulsion of the heart of which the artist himself often remains unconscious.

Close your bodily eyes in order that you may first see your painting with your spiritual eye. Then bring to the light of day what you have seen in the darkness so that it can affect others, penetrating inwards from without.

Painters train themselves in invention, or as they term it, composition. Does this not mean, otherwise expressed, that they train themselves in patching and mending? A painting should not be invented [*erfunden*] but felt [*empfunden*].

If you want to know what beauty is, ask those who theorize about aesthetics. It may be useful to you at the coffee table, but not before the easel. There you need to feel what is beautiful.

Not everything can be taught and not everything can be learnt or achieved through mere dead practice at something; for that art which may genuinely be said to possess a pure spiritual nature transcends the narrow limits of manual craft. Hence it is a complete misunderstanding of what can be termed higher art when young painters form into groups in order to practise so-called composition [*Komponieren*]. The ability to express one's feelings and responses through shape and colour is something which can neither be learnt nor acquired through mere dexterity of the hand. What can and must be practised, craft, is of a more undeveloped nature, but in my opinion this, too, should be taught with more caution and with more consideration for the particular character of the student than it is, unfortunately, at present; for the treatment of a subject stands in a much closer relation to the object represented than is commonly believed – as does the object to the manner in which it is represented.

It may be a great honour to have a large public for one's works. But the honour is certainly greater to have a small but discriminating public.

This picture succeeds in articulating something by means of form and colour which cannot be expressed in words.

If only XXX were to stick to the field to which he is naturally suited and in which he has already achieved several beautiful things! Why, for example, does he suddenly paint a cross here? Would not a cud-chewing ox have been far more suitable? Do not simply mimic everything unless you feel called to do so.

At first glance this painting presents the image of a ruined cloister as a memorial of a dark and gloomy past. The present illuminates the past. In the breaking day one recognizes the retreating night. The painting leads the viewer's eye from the light into the twilight, from the twilight further into darkness, and from the darkness even further into blackness. Perhaps the artist is a Protestant and it is possible that he was contemplating ideas such as these when he was painting this theme.

This painting by XX reminds me once again of what has often been said: that if today a painter such as Raphael or some other excellent artist of an earlier age were to appear with the same great natural skills and abilities as his predecessors, he would, none the less, not paint as they did. His works would and must bear the imprint of his times and the paintings of the second Raphael would be very different from those of the first, even if they depicted the same subject. For this reason, you gentlemen from A to B who continually imitate Raphael, Michelangelo and others, your works will no

more be taken to resemble the products of these masters than the works of an ape who imitates a man – and one could easily be tempted to think you are no better than apes. Be sensible and reflect, then, and recognize yourselves and the time in which you live.

It is indeed difficult to do justice to others and not to overestimate oneself, and this is true both as regards other historical periods and particular individuals. Every age bears its own character. And every person has his own way of being. The more someone's deeds and actions are in tune with nature or humanity, the more they deserve to be respected and imitated. But the onward march of time results in permanent war, for wherever something new wishes to take shape, no matter how true and beautiful it might be, what is old and already in existence will fight against it; only through struggle and conflict can the new make room for itself, until it, in turn, is displaced by what is new. However, not every displacement of the old by the new should necessarily be seen as contributing towards an increase in our knowledge and insight. If, today, we consider this in relation to the visual arts, we may well ask whether the new school of landscape painting represents progress over what came before. I do not believe that landscape painting has ever been treated with as much honour as it properly deserves. However, I believe that it has at other times stood closer to its goal than at present, where it begins and ends with lies, and where paintings are overburdened by heaping up objects before, beside and on top of one another in the belief that this will provide content and variety. What these new landscape painters see in nature in an arc of 100 degrees, they mercilessly compress in their paintings into an angle of just 45 degrees. What in nature lies separated by a large intervening expanse, is here squeezed together in a compressed space, overfilling and glutting the eye, and creating an adverse and alarming effect upon the viewer. The element of water is always reduced in the process, and the sea shrinks to a puddle. – This unnatural and boastful striving for fullness and richness is made doubly oppressive and strident in so far as these new painters always depict a pure, limpid Italian sky under which even the most distant objects seem closer, presenting themselves with extraordinary clarity, contour and depth of shadow. They begin with a sky of pure dark blue such that the unbiased observer can see from the first glance that with the restricted means that lie at the artist's disposal the painting cannot successfully be completed in the same tone. Inevitably, all the force and vitality of the colours is employed in the middle ground, and nothing remains over for the foreground. Then anxious, wretched, clearly delineated plants and leaves, as well as figs, apricots and grapes, and even snails and other creatures are put in to compensate. Should the artist not admit that there was something of which he had failed to take account? But if we object that these gentlemen begin by painting their skies and the representation of distance too dark and pay too much attention to individual detail, they respond by declaring that 'In Italy, this is how Nature looks'. I have no intention of disputing this. But I do ask whether a sensible person should begin something without first considering whether he possesses the means to carry it through to the end. And here this means through to the foreground. Should the artist not also consider the perspective through which he is going to represent nature to us? Or is it really maintained that the artist should seek to represent nature as closely as possible in all its individual parts even when this distracts from the balance of the

whole? All of this almost suggests that the intention was to squeeze everything rather than to relate everything together. It is quite a different matter when the artist chooses to work on distance, or a view of the sky or some other subject as an exercise; here he may employ his entire palette on the chosen theme, for it exists by itself alone. Contemporary artists have deliberately avoided the task of capturing the landscape as it actually appears, but they have also failed to do justice to its various individual parts, even though at first glance they may appear to have done so: this is not the tiresome, cursory tact of the most recent age; rather it is the tact of an age long since past, meticulous, anxious, dry and desiccated, whereby far more is lost than gained . . . I have yet to see any painting of the new school which has made a favourable impression on me; instead I find these works unpleasant because of the compression of the objects and repellent because of the hardness of the colours and forms and the lack of aerial perspective – without yet quite wishing for a grey Nordic sky. Ultimately, these paintings create an adverse impression on me because they seem never to present nature in its simple nobility and grandeur – as it actually is when one has the sensibility, character and feeling to grasp it and recognize it as such. Instead I see everywhere the tiresome attempt to imitate Old Master paintings and engravings. Oh holy Nature! How oft must you yield to fashion and subject yourself to human rules? I shall remain silent concerning the great historic style with which the new landscape painters seek to dress themselves up so favourably until first the artists who practise this style, and then the critics who praise it, can say what is really meant by these words.

One cannot deny the enormous skill and accuracy with which these pictures by XX have been painted. What the hand is able to achieve has here been achieved, but one seeks in vain for something that appeals to the heart and to the feelings. These men *know* what art is and what it *ought* to be; but you do not *feel* it and have never been penetrated by it in a living way; for this reason your knowledge is dead and your sorry efforts do not speak to the heart. If you plain and sober men had once truly felt something, your paintings would not resemble corpses without sensibility or feeling, without warmth. The words of the Holy Testament could be employed here: Though I speak with the tongues of men and of angels, and have not charity, I am become as sounding brass, or a tinkling cymbal.[1] Or: if you are more skilled with the brush than any other on the globe of the earth, but lack animating feeling, all of your skill is as nothing but lifeless rubbish.

XX is reproached for demonstrating so little variety in his paintings and for always serving up the same subjects. I do not find this reproach justified, for even if there is no great variety in his choice of subjects, they are always interpreted in a typically appropriate way and never fail to produce some effect upon the viewer. It is perhaps an unreasonable demand of our age, a recognizable product of the way we are trained, to demand of someone that they be capable of representing everything. Nature does not give everything to everyone, but something to each. In each individual subject there resides an infinity of interpretations and different forms of presentation. I also recognize and respect a form of greatness when, as I have already said, someone knows the limits which nature has set them and modestly keeps to these limits by working with the strengths he has, rather than seeking by force to go beyond himself.

To learn to paint just as one can learn to stand on one leg or walk a tightrope (that is, to train the hand as the tightrope walker does the foot until finally it can do what is asked of it) is not the correct way; otherwise artists and tightrope walkers would be ranked the same. – That this is, unfortunately, generally the case I readily admit, but I claim that it ought not to be so.

The artist should not only paint what he sees before him, but also what he sees within him. If he does not see anything within him, he should give up painting what he sees before him. Otherwise his paintings will look like those Spanish screens behind which one expects only to find sick or even dead people. Herr XX has seen nothing which others do not see just as well; he cannot exactly be said to be blind, but what one demands of the artist is that he see more than others do.

This painter knows what he does, and that one feels what he does; if only it were possible to make a single artist out of the two of them!

¹ 1 Corinthians 13.

9 William Hazlitt (1778–1830) 'Originality'

Hazlitt was one of the foremost English essayists of his time, ranging across literature, theatre, popular culture, philosophy and politics, as well as art. The son of a radical Unitarian preacher, Hazlitt spent part of his early childhood in the newly formed United States, and after the family's return to London received a nonconformist education. He never lost his commitment to political liberty and to the legacy of the French Revolution. Before beginning his work in journalism, Hazlitt had contemplated a career as a painter, spending time in intensive study in the Louvre in 1802–3 during a lull in the Napoleonic wars. He subsequently wrote over fifty essays and reviews on art. These included the 1816 essay on 'Fine Art' for the *Encyclopaedia Britannica*, in which he defended the Elgin marbles against the canons of neo-classicism, on the grounds of their vitality and naturalism. His opposition to the Ideal also set him against Sir Joshua Reynolds' concept of painting as part of an improving, public, political discourse. For Hazlitt, art was fundamentally an individual matter. Originality, the key to art, lay not in individual caprice, but in the truthful imitation of hitherto undisclosed aspects of the infinity of nature. The present, late, essay, was published in *The Atlas* on 3 January 1830. The extracts are taken from *The Complete Works of William Hazlitt*, P. P. Howe ed., volume 20, *Miscellaneous Writings*, London and Toronto: J. M. Dent, 1934, pp. 296–302.

Originality is any conception of things, taken immediately from nature, and neither borrowed from, nor common to, others. To deserve this appellation, the copy must be both true and new. But herein lies the difficulty of reconciling a seeming contradiction in the terms of the explanation. For as any thing to be *natural* must be referable to a consistent principle, and as the face of things is open and familiar to all, how can any imitation be new and striking, without being liable to the charge of extravagance, distortion, and singularity? And, on the other hand, if it has no such peculiar and distinguishing characteristic to set it off, it cannot possibly rise above the level of the trite and common-place. This objection would indeed hold good and be unanswer-

able, if nature were one thing, or if the eye or mind comprehended the whole of it at a single glance; in which case, if an object had been once seen and copied in the most cursory and mechanical way, there could be no farther addition to, or variation from, this idea, without obliquity and affectation; but nature presents an endless variety of aspects, of which the mind seldom takes in more than a part or than one view at a time; and it is in seizing on this unexplored variety, and giving some one of these new but easily recognized features, in its characteristic essence, and according to the peculiar bent and force of the artist's genius, that true originality consists. Romney, when he was first introduced into Sir Joshua's gallery, said, 'there was something in his portraits which had been never seen in the art before, but which every one must be struck with as true and natural the moment he saw it.' This could not happen if the human face did not admit of being contemplated in several points of view, or if the hand were necessarily faithful to the suggestions of sense. Two things serve to perplex this question; first, the construction of language, from which, as one object is represented by one word, we imagine that it is one thing, and that we can no more conceive differently of the same object than we can pronounce the same word in different ways, without being wrong in all but one of them; secondly, the very nature of our individual impressions puts a deception upon us; for, as we know no more of any given object than we see, we very pardonably conclude that we see the whole of it, and have exhausted inquiry at the first view, since we can never suspect the existence of that which, from our ignorance and incapacity, gives us no intimation of itself. Thus, if we are shown an exact likeness of a face, we give the artist credit chiefly for dexterity of hand; we think that any one who has eyes can *see a face*; that one person sees it just like another, that there can be no mistake about it (as the object and the image are in our notion the same) – and that if there is any departure from our version of it, it must be purely fantastical and arbitrary. *Multum abludit imago* [The image differs greatly]. We do not look beyond the surface; or rather we do not see into the surface, which contains a labyrinth of difficulties and distinctions, that not all the effects of art, of time, patience, and study, can master and unfold. [. . .]

As the mind advances in the knowledge of nature, the horizon of art enlarges and the air refines. Then, in addition to an infinity of details, even in the most common object, there is the variety of form and colour, of light and shade, of character and expression, of the voluptuous, the thoughtful, the grand, the graceful, the grave, the gay, the *I know not what*; which are all to be found (separate or combined) in nature, which sufficiently account for the diversity of art, and to detect and carry off the *spolia opima* [richest spoils] of any one of which is the highest praise of human genius and skill –

> 'Whate'er Lorrain light-touch'd with softening hue,
> Or savage Rosa dash'd, or learned Poussin drew.'
> (Thomson, *The Castle of Indolence*)

All that we meet with in the master-pieces of taste and genius is to be found in the previous capacity of nature; and man, instead of adding to the store, or *creating* any thing either as to matter or manner, can only draw out a feeble and imperfect transcript, bit by bit, and one appearance after another, according to the peculiar aptitude and affinity that subsists between his mind and some one part. The mind

resembles a prism, which untwists the various rays of truth, and displays them by different modes and in several parcels. Enough has been said to vindicate both conditions of originality, which distinguish it from singularity on the one hand and from vulgarity on the other; or to show how a thing may at the same time be both true and new. This novel truth is brought out when it meets with a strong congenial mind – that is, with a mind in the highest degree susceptible of a certain class of impressions, or of a certain kind of beauty or power; and this peculiar strength, congeniality, truth of imagination, or command over a certain part of nature, is, in other words, what is meant by *genius*. This will serve to show why original inventors have in general (and except in what is mechanical), left so little for their followers to improve upon; for as the original invention implies the utmost stretch and felicity of thought, or the greatest strength and sagacity to discover and dig the ore from the mine of truth, so it is hardly to be expected that a greater degree of capacity should ever arise (than the highest), that a greater mastery should be afterwards obtained in shaping and fashioning the precious materials, than in the first heat and eagerness of discovery; or that, if the capacity were equal, the same scope and opportunity would be left for its exercise in the same field. If the genius were different, it would then seek different objects and a different vent, and open new paths to fame and excellence, instead of treading in old ones. Hence the well-known observation, that in each particular style or class of art, the greatest works of genius are the earliest. Hence, also, the first productions of men of genius are often their best. What was that *something* that Romney spoke of in Reynolds's pictures that the world had never seen before, but with which they were enchanted the moment they beheld it, and which both Hoppner and Jackson, with all their merit, have but faintly imitated since? It was a reflection of the artist's mind – an emanation from his character, transferred to the canvass. It was an ease, an amenity, an indolent but anxious satisfaction, a graceful playfulness, belonging to his disposition, and spreading its charm on all around it, attracting what harmonized with, and softening and moulding what repelled it, avoiding every thing hard, stiff, and formal, shrinking from details, reposing on effect, imparting motion to *still life*, viewing all things in their 'gayest, happiest attitudes,' and infusing his own spirit into nature as the leaven is kneaded into the dough; but, though the original bias existed in himself, and was thence stamped upon his works, yet the character could neither have been formed without the constant recurrence and pursuit of proper nourishment, nor could it have expressed itself without a reference to those objects, looks, and attitudes in nature, which soothed and assimilated with it. What made Hogarth original and inimitable, but the wonderful redundance, and, as it were, *supererogation* of his genius, which poured the oil of humanity into the wounds and bruises of human nature, redeemed, while it exposed, vice and folly, made deformity pleasing, and turned misfortune into a jest? But could he have done so if there were no enjoyment or wit in a night-cellar, or if the cripple could not dance and sing? No, the *moral* was in nature; but let no one dare to insist upon it after him, in the same language and with the same pretensions! [. . .]

In what relates to the immediate imitation of nature, people find it difficult to conceive of an opening for originality, inasmuch as they think that they themselves see the whole of nature, and that every other view of it is wrong: – in what relates to the productions of imagination or the discoveries of science, as they themselves are totally in the dark, they fancy the whole to be a fabrication, and give the inventor credit for a

sort of dealing with the Devil, or some preternatural kind of talent. Poets lay a popular and prescriptive claim to inspiration: the astronomer of old was thought able to conjure with the stars; and the skilful leech, who performed unexpected cures, was condemned for a sorcerer. This is as great an error the other way. The vulgar think there is nothing in what lies on the surface; though the learned only see beyond it by stripping off incumbrances and coming to another surface beneath the first. The difference between art and science is only the difference between the *clothed* and *naked* figure: but the veil of truth must be drawn aside before we can distinctly see the face. The physician is qualified to prescribe remedies because he is acquainted with the internal structure of the body, and has studied the symptoms of disorders: the mathematician arrives at his most surprising conclusion by slow and sure steps; and where he can add discovery to discovery by the very certainty of the hold he has of all the previous links. There is no witchcraft in either case. The invention of the poet is little more than the fertility of a teeming brain – that is, than the number and quantity of associations present to his mind, and the various shapes in which he can turn them without being distracted or losing a 'semblable coherence' of the parts; as the man of observation and reflection strikes out just and unforeseen remarks by taking off the mask of custom and appearances; or by judging for himself of men and things, without taking it for granted that they are what he has hitherto supposed them, or waiting to be told by others what they are. If there were no foundation for an unusual remark in our own consciousness or experience, it would not strike us as a discovery: it would sound like a *jeu-d'esprit*, a whim or oddity, or as flat nonsense. The mere mob, 'the great vulgar and the small', are not therefore capable of distinguishing between originality and singularity, for they have no idea beyond the *common-place* of fashion or custom. Prejudice has no ears either for or against itself; it is alike averse to objections and proofs, for both equally disturb its blind implicit notions of things. Originality is, then, 'the strong conception' of truth and nature 'that the mind groans withal', and of which it cannot stay to be delivered by authority or example. It is feeling the ground sufficiently firm under one's feet to be able to go alone. Truth is its essence; it is the strongest possible feeling of truth; for it is a secret and instinctive yearning after, and approximation towards it, before it is acknowledged by others, and almost before the mind itself knows what it is. Paradox and eccentricity, on the other hand, show a dearth of originality, as bombast and hyperbole show a dearth of imagination; they are the desperate resources of affectation and want of power. Originality is necessary to genius; for when that which, in the first instance, conferred the character, is afterwards done by rule and routine, it ceases to be genius. To conclude, the value of any work of art or science depends chiefly on the quantity of originality contained in it, and which constitutes either the charm of works of fiction or the improvement to be derived from those of progressive information. But it is not so in matters of opinion, where every individual thinks he can judge for himself, and does not wish to be set right. There is, consequently, nothing that the world like better than originality of invention, and nothing that they hate worse than originality of thought. Advances in science were formerly regarded with like jealousy, and stigmatized as dangerous by the friends of religion and the state: Galileo was imprisoned in the same town of Florence, where they now preserve his finger pointing to the skies!

10 Georg Wilhelm Friedrich Hegel (1770–1831) from *Lectures on Aesthetics*

Hegel's lectures on aesthetics belong to his mature thought and represent the most comprehensive and systematic philosophical investigation of the arts produced in modern times. Although clearly indebted to Kant's *Critique of Judgement* (1790), particularly in their emphasis on the independent value and status accorded to the aesthetic sphere, Hegel's lectures represent a decisive change of approach. Whereas Kant had primarily been concerned with characterizing the particular type of judgement which is made in calling an object beautiful, Hegel shifts the focus of attention away from the subject doing the judging towards the meaning and content of the work of art itself. Unlike Kant, Hegel saw art as having a *history* and his aesthetics combine a systematic treatment of the different types or forms of art with an historical account of the different stages of development of human artistic activity. Hegel read widely and his work reveals an extensive knowledge of the art and literature, as well as the religion and customs, of both Western and non-Western societies. He lectured on aesthetics in Berlin on four occasions, in 1820–1, 1823, 1826 and again in 1828–9. During these years he undertook extensive journeys to the Netherlands, Paris, Prague and Vienna where, as his letters and diaries reveal, he enthusiastically explored the art collections. The Berlin lectures were assembled on the basis of Hegel's own notes and from transcripts taken down by his students. They were published posthumously in 1835–8 as part of the *Freundsvereinausgabe* of Hegel's works, edited by H. G. Hotho (*Vorlesungen über die Ästhetik*, Berlin, 1835–8; second improved edition, 1842). These extracts are taken from the introduction, translated by Bernard Bosanquet in 1886 as G. W. F. Hegel, *Introductory Lectures on Aesthetics*, London: Keegan Paul, pp. 1–4, 11–20, 47–52, 54–60, 138–9, 141, 144–57, 174–5.

The present course of lectures deals with 'Aesthetic'. Their subject is the wide *realm of the beautiful*, and, more particularly, their province is *Art* – we may restrict it, indeed, to *Fine Art*.

The name 'Aesthetic' in its natural sense is not quite appropriate to this subject. 'Aesthetic' means more precisely the science of sensation or feeling. Thus understood, it arose as a new science, or rather as something that was to become a branch of philosophy for the first time, in the school of Wolff, at the epoch when works of art were being considered in Germany in the light of the feelings which they were supposed to evoke – feelings of pleasure, admiration, fear, pity, etc. The name was so inappropriate, or, strictly speaking, so superficial, that for this reason it was attempted to form other names, e.g. 'Kallistic'. But this name, again, is unsatisfactory, for the science to be designated does not treat of beauty in general, but merely of *artistic* beauty. We shall, therefore, permit the name Aesthetic to stand, because it is nothing but a name, and so is indifferent to us, and, moreover, has up to a certain point passed into common language. As a name, therefore, it may be retained. The proper expression, however, for our science is the 'Philosophy of Art', or, more definitely, the 'Philosophy of Fine Art'.

By the above expression we at once exclude the *beauty of Nature*. Such a limitation of our subject may appear to be an arbitrary demarcation, resting on the principle that every science has the prerogative of marking out its boundaries at pleasure. But this is

not the sense in which we are to understand the limitation of Aesthetic to *the beauty of art*. It is true that in common life we are in the habit of speaking of beautiful colour, a beautiful sky, a beautiful river, and, moreover, of beautiful flowers, beautiful animals, and, above all, of beautiful human beings. We will not just now enter into the controversy how far such objects can justly have the attribute of beauty ascribed to them, or how far, speaking generally, natural beauty ought to be recognized as existing besides artistic beauty. We may, however, begin at once by asserting that artistic beauty stands *higher* than nature. For the beauty of art is the beauty that is born – born again, that is – of the mind; and by as much as the mind and its products are higher than nature and its appearances, by so much the beauty of art is higher than the beauty of nature. Indeed, if we look at it *formally* – i.e. only considering in what way it exists, not what there is in it – even a silly fancy such as may pass through a man's head is *higher* than any product of nature; for such a fancy must at least be characterized by intellectual being and by freedom. In respect of its content, on the other hand, the sun, for instance, appears to us to be an absolutely necessary factor in the universe, while a blundering notion passes away as accidental and transient; but yet, in its own being, a natural existence such as the sun is indifferent, is not free or self-conscious, while if we consider it in its necessary connection with other things we are not regarding it by itself or for its own sake, and, therefore, not as beautiful.

To say, as we have said, in general terms, that mind and its artistic beauty stand *higher* than natural beauty is no doubt to determine almost nothing. For 'higher' is an utterly indefinite expression, which designates the beauty of nature and that of art as if merely standing side by side in the space of the imagination, and states the difference between them as purely quantitative, and, therefore, purely external. But the mind and its artistic beauty, in being '*higher*' as compared with nature, have a distinction which is not simply relative. Mind, and mind only, is capable of truth, and comprehends in itself all that is, so that whatever is beautiful can only be really and truly beautiful as partaking in this higher element and as created thereby. In this sense the beauty of nature reveals itself as but a reflection of the beauty which belongs to the mind, as an imperfect, incomplete mode of being, as a mode whose really substantial element is contained in the mind itself.

* * *

[. . .] In the first place, as regards the *worthiness* of art to be scientifically considered, it is no doubt the case that art can be employed as a fleeting pastime, to serve the ends of pleasure and entertainment, to decorate our surroundings, to impart pleasantness to the external conditions of our life, and to emphasize other objects by means of ornament. In this mode of employment art is indeed not independent, not free, but servile. But what *we* mean to consider, is the art which is *free* in its end as in its means.

That art is in the abstract capable of serving other aims, and of being a mere pastime, is moreover a relation which it shares with thought. For, on the one hand, science, in the shape of the subservient understanding, submits to be used for finite purposes, and as an accidental means, and in that case is not self-determined, but determined by alien objects and relations; but, on the other hand, science liberates itself from this service to rise in free independence to the attainment of truth, in which medium, free from all interference, it fulfils itself in conformity with its proper aims.

Fine art is not real art till it is in this sense free, and only achieves its highest task when it has taken its place in the same sphere with religion and philosophy, and has become simply a mode of revealing to consciousness and bringing to utterance the Divine Nature, the deepest interests of humanity, and the most comprehensive truths of the mind. It is in works of art that nations have deposited the profoundest intuitions and ideas of their hearts; and fine art is frequently the key – with many nations there is no other – to the understanding of their wisdom and of their religion.

This is an attribute which art shares with religion and philosophy, only in this peculiar mode, that it represents even the highest ideas *in sensuous forms*, thereby bringing them nearer to the character of natural phenomena, to the senses, and to feeling. The world, into whose depths *thought* penetrates, is a supra-sensuous world, which is thus, to begin with, erected as a *beyond* over against immediate consciousness and present sensation; the power which thus rescues itself from the *here*, that consists in the actuality and finiteness of sense, is the freedom of thought in cognition. But the mind is able to heal this schism which its advance creates; it generates out of itself the works of fine art as the first middle term of reconciliation between pure thought and what is external, sensuous, and transitory, between nature with its finite actuality and the infinite freedom of the reason that comprehends.

[. . .] Genuine reality is only to be found beyond the immediacy of feeling and of external objects. Nothing is genuinely real but that which is actual in its own right, that which is the substance of nature and of mind, fixing itself indeed in present and definite existence, but in this existence still retaining its essential and self-centred being, and thus and no otherwise attaining genuine reality. The dominion of these universal powers is exactly what art accentuates and reveals. The common outer and inner world also no doubt present to us this essence of reality, but in the shape of a chaos of accidental matters, encumbered by the immediateness of sensuous presentation, and by arbitrary states, events, characters, etc. Art liberates the real import of appearances from the semblance and deception of this bad and fleeting world, and imparts to phenomenal semblances a higher reality, born of mind. The appearances of art, therefore, far from being mere semblances, have the higher reality and the more genuine existence in comparison with the realities of common life.

* * *

But if, on the one side, we assign this high position to art, we must no less bear in mind, on the other hand, that art is not, either in content or in form, the supreme and absolute mode of bringing the mind's genuine interests into consciousness. The form of art is enough to limit it to a restricted content. Only a certain circle and grade of truth is capable of being represented in the medium of art. Such truth must have in its own nature the capacity to go forth into sensuous form and be adequate to itself therein, if it is to be a genuinely artistic content, as is the case with the gods of Greece. There is, however, a deeper form of truth, in which it is no longer so closely akin and so friendly to sense as to be adequately embraced and expressed by that medium. Of such a kind is the Christian conception of truth; and more especially the spirit of our modern world, or, to come closer, of our religion and our intellectual culture, reveals itself as beyond the stage at which art is the highest mode assumed by man's consciousness of the absolute. The peculiar mode to which artistic production and works of art belong no longer satisfies our supreme need. We are above the level at

which works of art can be venerated as divine, and actually worshipped; the impression which they make is of a more considerate kind, and the feelings which they stir within us require a higher test and a further confirmation. Thought and reflection have taken their flight above fine art. [...]

... It certainly is the case that art no longer affords that satisfaction of spiritual wants which earlier epochs and peoples have sought therein, and have found therein only; a satisfaction which, at all events on the religious side, was most intimately and profoundly connected with art. The beautiful days of Greek art, and the golden time of the later middle ages are gone by. The reflective culture of our life of today, makes it a necessity for us, in respect of our will no less than of our judgement, to adhere to general points of view, and to regulate particular matters according to them, so that general forms, laws, duties, rights, maxims are what have validity as grounds of determination and are the chief regulative force. But what is required for artistic interest as for artistic production is, speaking generally, a living creation, in which the universal is not present as law and maxim, but acts as if one with the mood and the feelings, just as, in the imagination, the universal and rational is contained only as brought into unity with a concrete sensuous phenomenon. Therefore, our present in its universal condition is not favourable to art. As regards the artist himself, it is not merely that the reflection which finds utterance all round him, and the universal habit of having an opinion and passing judgement about art infect him, and mislead him into putting more abstract thought into his works themselves; but also the whole spiritual culture of the age is of such a kind that he himself stands within this reflective world and its conditions, and it is impossible for him to abstract from it by will and resolve, or to contrive for himself and bring to pass, by means of peculiar education or removal from the relations of life, a peculiar solitude that would replace all that is lost.

In all these respects art is, and remains for us, on the side of its highest destiny, a thing of the past. Herein it has further lost for us its genuine truth and life, and rather is transferred into our *ideas* than asserts its former necessity, or assumes its former place, in reality. What is now aroused in us by works of art is over and above our immediate enjoyment, and together with it, our judgement; inasmuch as we subject the content and the means of representation of the work of art and the suitability or unsuitability of the two to our intellectual consideration. Therefore, the *science* of art is a much more pressing need in our day than in times in which art, simply as art, was enough to furnish a full satisfaction. Art invites us to consideration of it by means of thought, not to the end of stimulating art production, but in order to ascertain scientifically what art is.

* * *

[...] For us, the idea of beauty and of art is a presupposition given in the system of philosophy. But as we cannot in this place discuss this system, and the connection of art with it, we have not yet the idea of the beautiful before us *in a scientific form*; what we have at command are merely the elements and aspects of it, as they are or have at former periods been presented, in the diverse ideas of the beautiful and of art in the mere common consciousness. [...] Having started from this point, we shall subsequently pass to the more profound consideration of the views in question, in order thereby to gain the advantage of, in the first place, obtaining a general idea of our object, and further, by a brief criticism effecting a preliminary acquaintance with its

higher principles, with which we shall have to do in the sequel. By this mode of treatment our final introduction will act, so to speak, as the overture to the account of the subject itself, and will serve the purpose of a general collection and direction of our thoughts towards the proper object-matter of our discussion.

What we know, to begin with, as a current idea of the work of art, comes under the three following general predicates:

(1) We suppose the work of art to be no natural product, but brought to pass by means of human activity.
(2) To be essentially made *for* man, and, indeed, to be more or less borrowed from the sensuous and addressed to man's sense.
(3) To contain an *end*.

As regards the first point, that a work of art is taken to be a product of human activity, this view has given rise (a) to the view that this activity, being the *conscious* production of an external object, can also be *known*, and *expounded*, and learnt, and prosecuted by others. For, what one can do, it might seem, another can do, or imitate, as soon as he is acquainted with the mode of procedure; so that, supposing universal familiarity with the rules of artistic production, it would only be a matter of anyone's will and pleasure to carry out the process in a uniform way, and so to produce works of art. It is thus that the above-mentioned rule-providing theories and their precepts, calculated for practical observance, have arisen. But that which can be executed according to such instruction can only be something formally regular and mechanical. For only what is mechanical is of such an external kind that no more than a purely empty exercise of will and dexterity is required to receive it among our ideas and put it in act; such an exercise not needing to be supplemented by anything concrete, or anything that goes beyond the precepts conveyed in general rules. This is most vividly displayed when precepts of the kind in question do not limit themselves to what is purely external and mechanical, but extend to the meaning-laden spiritual activity of true art. In this region the rules contain nothing but indefinite generalities; e.g. 'The theme ought to be interesting, and each individual ought to be made to speak according to his rank, age, sex, and position.' But if rules are meant to be adequate on this subject, their precepts ought to have been drawn up with such determinate-ness that they could be carried out just as they are expressed, without further and original activity of mind. Being abstract, however, in their content, such rules reveal themselves, in respect of their pretension of being adequate to fill the consciousness of the artist, as wholly inadequate, inasmuch as artistic production is not formal activity in accordance with given determinations. For it is bound as spiritual activity to work by drawing on its own resources, and to bring before the mind's eye a quite other and richer content and ampler individual creations than any abstract formulae can dictate. Such rules may furnish guidance in case of need, if they contain anything really definite, and therefore of practical utility; but their directions can only apply to purely external circumstances.

(b) The tendency which we have just indicated has therefore been abandoned, and, in place of it, the opposite principle has been pursued to no less lengths. For the work of art came to be regarded no longer as the product of an *activity general* in

mankind, but as the work of a mind endowed with wholly peculiar gifts. This mind, it is thought, has then nothing to do but *simply* to give free play to its particular gift, as though it were a specific force of nature, and is to be entirely released from attention to laws of universal validity, as also from the interference of reflection in its instinctively creative operation. And, indeed, it is to be guarded therefrom, inasmuch as its productions could only be infected and tainted by such a consciousness. In this aspect the work of art was pronounced to be the product of *talent* and *genius*, and stress was laid on the natural element which talent and genius contain. The view was partly right. Talent is specific, and genius universal capability, with which a man has not the power to endow himself simply by his own self-conscious activity. [. . .]

In this place we have only to mention the aspect of falsity in the view before us, in that all consciousness respecting the man's own activity was held, in the case of artistic production, not merely superfluous, but even injurious. Production on the part of talent and genius then appears, in general terms, as a *state*, and, in particular, as a state of *inspiration*. To such a state, it is said, genius is in part excited by a given object, and in part it has the power of its own free will to place itself therein. [. . .]

I will not enter more closely into the confusions which have prevailed respecting the conception of inspiration and genius, and which prevail even at the present day respecting the omnipotence of inspiration as such. We need only lay down as essential the view that, though the artist's talent and genius contains a natural element, yet it is essentially in need of cultivation by thought, and of reflection on the mode in which it produces, as well as of practice and skill in producing. A main feature of such production is unquestionably external workmanship, inasmuch as the work of art has a purely technical side, which extends into the region of handicraft; most especially in architecture and sculpture, less so in painting and music, least of all in poetry. Skill in this comes not by inspiration, but solely by reflection, industry, and practice; and such skill is indispensable to the artist, in order that he may master his external material, and not be thwarted by its stubbornness.

Moreover, the higher an artist ranks, the more profoundly ought he to represent the depths of heart and mind; and these are not known without learning them, but are only to be fathomed by the direction of a man's own mind to the inner and outer world. So here, too, *study* is the means whereby the artist brings this content into his consciousness, and wins the matter and burden of his conceptions. [. . .]

(c) A third view, which concerns the idea of the work of art as a product of human activity, refers to the position of such a work towards the external appearances of nature. It was an obvious opinion for the common consciousness to adopt on this head, that the work of art made by man ranked *below* the product of nature. The work of art has no feeling in itself, and is not through and through a living thing, but, regarded as an external object, is dead. But we are wont to prize the living more than the dead. We must admit, of course, that the work of art has not in itself movement and life. An animated being in nature is within and without an organization appropriately elaborated down to all its minutest parts, while the work of art attains the semblance of animation on its surface only, but within is common stone, or wood and canvas, or, as in the case of poetry, is idea, uttering itself in speech and letters. But this aspect, viz. its external existence, is not what makes a work into a production of fine

art; it is a work of art only in as far as, being the offspring of mind, it continues to belong to the realm of mind, has received the baptism of the spiritual, and only represents that which has been moulded in harmony with mind. A human interest, the spiritual value which attaches to an incident, to an individual character, to an action in its plot and in its dénouement, is apprehended in the work of art, and exhibited more purely and transparently than is possible on the soil of common unartistic reality. This gives the work of art a higher rank than anything produced by nature, which has not sustained this passage through the mind. So, for instance, by reason of the feeling and insight of which a landscape as depicted by an artist is a manifestation, such a work of mind assumes a higher rank than the mere natural landscape. For everything spiritual is better than anything natural. At any rate, no existence in nature is able, like art, to represent divine ideals.

Upon that which, in works of art, the mind borrows from its own inner life it is able, even on the side of external existence, to confer *permanence*; whereas the individual living thing of nature is transient, vanishing, and mutable in its aspect, while the work of art persists. Though, indeed, it is not mere permanence, but the accentuation of the character which animation by mind confers, that constitutes its genuine pre-eminence as compared with natural reality. [. . .]

(d) Granting, then, that the work of art is made by man as a creation of mind, we come to the last question, which will enable us to draw a deeper result from what has been said. What is man's need to produce works of art? On the one hand the production may be regarded as a mere toy of chance and of man's fancies, that might just as well be let alone as pursued. For, it may be said, there are other and better means for effecting that which is the aim of art, and man bears in him interests that are yet higher and of more import than art has power to satisfy. But, on the other hand, art appears to arise from the higher impulse and to satisfy the higher needs, at times, indeed, even the highest, the absolute need of man, being wedded to the religious interests of whole epochs and peoples, and to their most universal intuitions respecting the world. This inquiry concerning the not contingent but absolute need of art we cannot as yet answer completely, seeing that it is more concrete than any shape which could here be given to the answer. We must, therefore, content ourselves for the present with merely establishing the following points.

The universal and absolute need out of which art, on its formal side, arises has its source in the fact that man is a *thinking* consciousness, i.e. that he draws out of himself, and makes explicit *for himself*, that which he is, and, generally, whatever is. The things of nature are only *immediate and single*, but man as mind *reduplicates* himself, inasmuch as prima facie he *is* like the things of nature, but in the second place just as really is *for* himself, perceives himself, has ideas of himself, thinks himself, and only thus is active self-realizedness. This consciousness of himself man obtains in a twofold way: *in the first place theoretically*, in as far as he has inwardly to bring himself into his own consciousness, with all that moves in the human breast, all that stirs and works therein, and, generally, to observe and form an idea of himself, to fix before himself what thought ascertains to be his real being, and, in what is summoned out of his inner self as in what is received from without, to recognize only himself. Secondly, man is realized for himself by *practical* activity, inasmuch as he has the impulse, in the medium which is directly given to him, and externally presented before him, to

produce himself, and therein at the same time to recognize himself. This purpose he achieves by the modification of external things upon which he impresses the seal of his inner being, and then finds repeated in them his own characteristics. Man does this in order as a free subject to strip the outer world of its stubborn foreignness, and to enjoy in the shape and fashion of things a mere external reality of himself. Even the child's first impulse involves this practical modification of external things. A boy throws stones into the river, and then stands admiring the circles that trace themselves on the water, as an effect in which he attains the sight of something that is his own doing. This need traverses the most manifold phenomena, up to the mode of self-production in the medium of external things as it is known to us in the work of art. And it is not only external things that man treats in this way, but himself no less, i.e. his own natural form, which he does not leave as he finds it, but alters of set purpose. This is the cause of all ornament and decoration, though it may be as barbarous, as tasteless, as utterly disfiguring or even destructive as crushing Chinese ladies' feet, or as slitting the ears and lips. It is only among cultivated men that change of the figure, of behaviour, and of every kind and mode of self-utterance emanates from spiritual education.

The universal need for expression in art lies, therefore, in man's rational impulse to exalt the inner and outer world into a spiritual consciousness for himself, as an object in which he recognizes his own self. He satisfies the need of this spiritual freedom when he makes all that exists explicit for himself *within*, and in a corresponding way realizes this his explicit self *without*, evoking thereby, in this reduplication of himself, what is in him into vision and into knowledge for his own mind and for that of others. This is the free rationality of man, in which, as all action and knowledge, so also art has its ground and necessary origin. [...]

* * *

But inasmuch as the task of art is to represent the idea to direct perception in sensuous shape, and not in the form of thought or of pure spirituality as such, and seeing that this work of representation has its value and dignity in the correspondence and the unity of the two sides, i.e. of the Idea and its plastic embodiment, it follows that the level and excellency of art in attaining a realization adequate to its idea must depend upon the grade of inwardness and unity with which Idea and Shape display themselves as fused into one.

Thus the higher truth is spiritual being that has attained a shape adequate to the conception of spirit. This is what furnishes the principle of division for the science of art. For before the mind can attain the true notion of its absolute essence, it has to traverse a course of stages whose ground is in this idea itself; and to this evolution of the content with which it supplies itself, there corresponds an evolution, immediately connected therewith, of the plastic forms of art, under the shape of which the mind as artist presents to itself the consciousness of itself.

* * *

... We must begin by recalling to mind ... that the Idea *qua* the beautiful in art is not the Idea as such, in the mode in which a metaphysical logic apprehends it as the absolute, but the Idea as developed into concrete form fit for reality, and as having entered into immediate and adequate unity with this reality. For the *Idea as such*, although it is the essentially and actually true, is yet the truth only in its generality which has not yet taken objective shape; but the *Idea* as the *beautiful in art* is at once

the Idea when specially determined as in its essence individual reality, and also an individual shape of reality essentially destined to embody and reveal the Idea. [. . .]

Now because the Idea is in this fashion concrete unity, it follows that this unity can enter into the art-consciousness only by the expansion and reconciliation of the particularities of the Idea, and it is through this evolution that artistic beauty comes to possess a *totality of particular stages and forms*. Therefore, after we have studied the beauty of art in itself and on its own merits, we must see how beauty as a whole breaks up into its particular determinations. This gives . . . *the doctrine of the types of art*. These forms find their genesis in the different modes of grasping the Idea as artistic content, whereby is conditioned a difference of the form in which it manifests itself. Hence the types of art are nothing but the different relations of content and shape, relations which emanate from the Idea itself, and furnish thereby the true basis of division for this sphere. For the principle of division must always be contained in *that* conception whose particularization and division is in question.

We have here to consider *three* relations of the Idea to its outward shaping.

(α) First, the Idea gives rise to the beginning of Art when, being itself still in its indistinctness and obscurity, or in vicious untrue determinateness, it is made the import of artistic creations. As indeterminate it does not yet possess in itself that individuality which the Ideal demands; its abstractness and one-sidedness leave its shape to be outwardly bizarre and defective. The first form of art is therefore rather a mere search after plastic portrayal than a capacity of genuine representation. The Idea has not yet found the true form even within itself, and therefore continues to be merely the struggle and aspiration thereafter. In general terms we may call this form the *Symbolic* form of art. In it the abstract Idea has its outward shape external to itself in natural sensuous matter, with which the process of shaping begins, and from which, *qua* outward expression, it is inseparable.

Natural objects are thus primarily left unaltered, and yet at the same time invested with the substantial Idea as their significance, so that they receive the vocation of expressing it, and claim to be interpreted as though the Idea itself were present in them. At the root of this is the fact that natural objects have in them an aspect in which they are capable of representing a universal meaning. But as an adequate correspondence is not yet possible, this reference can only concern *an abstract attribute*, as when a lion is used to mean strength.

On the other hand, this abstractness of the relation brings to consciousness no less strongly the foreignness of the Idea to natural phenomena; and the Idea, having no other reality to express it, expatiates in all these shapes, seeks itself in them in all their unrest and disproportion, but nevertheless does not find them adequate to itself. Then it proceeds to exaggerate the natural shapes and the phenomena of reality into indefiniteness and disproportion, to intoxicate itself in them, to seethe and ferment in them, to do violence to them, to distort and explode them into unnatural shapes, and strives by the variety, hugeness, and splendour of the forms employed to exalt the phenomenon to the level of the Idea. For the Idea is here still more or less indeterminate and non-plastic, but the natural objects are in their shape thoroughly determinate. [. . .]

These aspects may be pronounced in general terms to constitute the character of the primitive artistic pantheism of the East, which either charges even the meanest objects

with the absolute import, or again coerces nature with violence into the expression of its view. By this means it becomes bizarre, grotesque, and tasteless, or turns the infinite but abstract freedom of the substantive Idea disdainfully against all phenomenal being as null and evanescent. By such means the import cannot be completely embodied in the expression, and in spite of all aspiration and endeavour the reciprocal inadequacy of shape and Idea remains insuperable. This may be taken as the first form of art – Symbolic art with its aspiration, its disquiet, its mystery and its sublimity.

(β) In the second form of art, which we propose to call *Classical*, the double defect of symbolic art is cancelled. The plastic shape of symbolic art is imperfect, because, in the first place, the Idea in it only enters into consciousness in *abstract* determinateness or indeterminateness, and, in the second place, this must always make the conformity of shape to import defective, and in its turn merely abstract. The classical form of art is the solution of this double difficulty; it is the free and adequate embodiment of the Idea in the shape that, according to its conception, is peculiarly appropriate to the Idea itself. With it, therefore, the Idea is capable of entering into free and complete accord. Hence, the classical type of art is the first to afford the production and intuition of the completed Ideal, and to establish it as a realized fact.

The conformity, however, of notion and reality in classical art must not be taken in the purely *formal* sense of the agreement of a content with the external shape given to it, any more than this could be the case with the Ideal itself. Otherwise every copy from nature, and every type of countenance, every landscape, flower, or scene, etc., which forms the purport of any representation, would be at once made classical by the agreement which it displays between form and content. On the contrary, in classical art the peculiarity of the content consists in being itself concrete idea, and, as such, the concrete spiritual; for only the spiritual is the truly inner self. To suit such a content, then, we must search out that in Nature which on its own merits belongs to the essence and actuality of the mind. It must be the absolute notion that *invented* the shape appropriate to concrete mind, so that the *subjective* notion – in this case the spirit of art – has merely *found* it, and brought it, as an existence possessing natural shape, into accord with free individual spirituality. This shape, with which the Idea as spiritual – as individually determinate spirituality – invests itself when manifested as a temporal phenomenon, is *the human form*. Personification and anthropomorphism have often been decried as a degradation of the spiritual; but art, in as far as its end is to bring before perception the spiritual in sensuous form, must advance to such anthropomorphism, as it is only in its proper body that mind is adequately revealed to sense. The migration of souls is in this respect a false abstraction, and physiology ought to have made it one of its axioms that life had necessarily in its evolution to attain to the human shape, as the sole sensuous phenomenon that is appropriate to mind. The human form is employed in the classical type of art not as mere sensuous existence, but exclusively as the existence and physical form corresponding to mind, and is therefore exempt from all the deficiencies of what is merely sensuous, and from the contingent finiteness of phenomenal existence. The outer shape must be thus purified in order to express in itself a content adequate to itself; and again, if the conformity of import and content is to be complete, the spiritual meaning which is the content must be of a particular kind. It must, that is to say, be qualified to express itself completely in the physical form of man, without projecting into another world beyond the scope

of such an expression in sensuous and bodily terms. This condition has the effect that Mind is by it at once specified as a particular case of mind, as human mind, and not as simply absolute and eternal, inasmuch as mind in this latter sense is incapable of proclaiming and expressing itself otherwise than as intellectual being.

Out of this latter point arises, in its turn, the defect which brings about the dissolution of classical art, and demands a transition into a third and higher form, viz. into the *Romantic* form of art.

(γ) The romantic form of art destroys the completed union of the Idea and its reality, and recurs, though in a higher phase, to that difference and antagonism of two aspects which was left unvanquished by symbolic art. The classical type attained the highest excellence, of which the sensuous embodiment of art is capable; and if it is in any way defective, the defect is in art as a whole, i.e. in the limitation of its sphere. This limitation consists in the fact that art as such takes for its object Mind – the conception of which is *infinite* concrete universality – in the shape of *sensuous* concreteness, and in the classical phase sets up the perfect amalgamation of spiritual and sensuous existence as a Conformity of the two. Now, as a matter of fact, in such an amalgamation Mind cannot be represented according to its true notion. For mind is the infinite subjectivity of the Idea, which, as absolute inwardness, is not capable of finding free expansion in its true nature on condition of remaining transposed into a bodily medium as the existence appropriate to it.

As *an escape from such a condition* the romantic form of art in its turn dissolves the inseparable unity of the classical phase, because it has won a significance which goes beyond the classical form of art and its mode of expression. This significance – if we may recall familiar ideas – coincides with what Christianity declares to be true of God as Spirit, in contradistinction to the Greek faith in gods which forms the essential and appropriate content for classical art. In Greek art the concrete import is potentially, but not explicitly, the unity of the human and divine nature; a unity which, just because it is purely *immediate* and *not explicit*, is capable of adequate manifestation in an immediate and sensuous mode. The Greek god is the object of naïve intuition and sensuous imagination. His shape is, therefore, the bodily shape of man. The circle of his power and of his being is individual and individually limited. In relation with the subject, he is, therefore, an essence and a power with which the subject's inner being is merely in latent unity, not itself possessing this unity as inward subjective knowledge. Now the higher stage is the *knowledge* of this *latent* unity, which as latent is the import of the classical form of art, and capable of perfect representation in bodily shape. The elevation of the latent or potential into self-conscious knowledge produces an enormous difference. It is the infinite difference which, e.g., separates man as such from the animals. Man is animal, but even in his animal functions he is not confined within the latent and potential as the animal is, but becomes conscious of them, learns to know them, and raises them – as, for instance, the process of digestion – into self-conscious science. By this means Man breaks the boundary of merely potential and immediate consciousness, so that just for the reason that he knows himself to be animal, he ceases to be animal, and, as *mind*, attains to self-knowledge. [. . .]

. . . In this third stage the object (of art) is *free*, concrete intellectual being, which has the function of revealing itself as spiritual existence for the inward world of spirit. In conformity with such an object-matter, art cannot work for sensuous perception. It

must address itself to the inward mind, which coalesces with its object simply and as though this were itself, to the subjective inwardness, to the heart, the feeling, which, being spiritual, aspires to freedom within itself, and seeks and finds its reconciliation only in the spirit within. It is this *inner* world that forms the content of the romantic, and must therefore find its representation as such inward feeling, and in the show or presentation of such feeling. The world of inwardness celebrates its triumph over the outer world, and actually in the sphere of the outer and in its medium manifests this its victory, owing to which the sensuous appearance sinks into worthlessness.

But, on the other hand, this type of Art, like every other, needs an external vehicle of expression. Now the spiritual has withdrawn into itself out of the external and its immediate oneness therewith. For this reason, the sensuous externality of concrete form is accepted and represented, as in symbolic art, as something transient and fugitive. And the same measure is dealt to the subjective finite mind and will, even including the peculiarity or caprice of the individual, of character, action, etc., or of incident and plot. The aspect of external existence is committed to contingency, and left at the mercy of freaks of imagination, whose caprice is no more likely to mirror what is given *as* it is given, than to throw the shapes of the outer world into chance medley, or distort them into grotesqueness. For this external element no longer has its notion and significance, as in classical art, in its own sphere, and in its own medium. It has come to find them in the feelings, the display of which is *in themselves* instead of being in the external and *its* form of reality, and which have the power to preserve or to regain their state of reconciliation with themselves, in every accident, in every unessential circumstance that takes independent shape, in all misfortunes and grief, and even in crime.

Owing to this, the characteristics of symbolic art, in difference, discrepancy, and severance of Idea and plastic shape, are here reproduced, but with an essential difference. In the sphere of the romantic, the Idea, whose defectiveness in the case of the symbol produced the defect of external shape, has to reveal itself in the medium of spirit and feelings as perfected in itself. And it is because of this higher perfection that it withdraws itself from any adequate union with the external element, inasmuch as it can seek and achieve its true reality and revelation nowhere but in itself.

This we may take as in the abstract the character of the symbolic, classical, and romantic forms of art, which represent the three relations of the Idea to its embodiment in the sphere of art. They consist in the aspiration after, and the attainment and transcendence of, the Ideal as the true Idea of beauty.

* * *

[. . .] For *symbolic* art attains its most adequate reality and most complete application in *architecture*, in which it holds sway in the full import of its notion, and is not yet degraded to be, as it were, the inorganic nature dealt with by another art. The *classical* type of art, on the other hand, finds adequate realization in sculpture, while it treats architecture only as furnishing an enclosure in which it is to operate, and has not acquired the power of developing painting and music as absolute forms for its content. The *romantic* type of art, finally, takes possession of painting and music, and in like manner of poetic representation, as substantive and unconditionally adequate modes of utterance. Poetry, however, is conformable to all types of the beautiful, and extends over them all, because the artistic imagination is its proper medium, and imagination is essential to every product that belongs to the beautiful, whatever its type may be.

11 Friedrich Schleiermacher (1768–1834) from 'On the Concept of Art'

Schleiermacher is known principally for his writings in theology and the philosophy of religion. Benedetto Croce was the first to draw attention to the significance and originality of Schleiermacher's contribution to the theory of art, which was neglected for much of the nineteenth century. Schleiermacher first lectured on the subject of aesthetics in Berlin in 1819 and again in 1825 and 1831/2. The lectures were published posthumously in 1842. Like those of Hegel, they were put together from Schleiermacher's own notes and the transcripts of his students. Wilhelm Dilthey later identified Schleiermacher as *the* aesthetic theorist of Romanticism. He formed part of the close circle of the early German Romantics and in Berlin he was in regular contact with such leading figures as Ludwig Tieck and Friedrich Schlegel. For Schleiermacher, the human mind is productive even in the reception of external impressions and the core of his aesthetics resides in an account of artistic productivity. In the following extract, taken from a lecture delivered to the Prussian Royal Academy of Sciences in 1831/2, he maintains that art begins with the immediate expression of feeling, in gesture and the utterance of noise, but that art proper only comes into being once the immediacy of feeling is given harmony and measure through the intervention of a process of reflection. Art is grasped as a refined and heightened articulation of the inner life rather than as the imitation or transformation of the external world. The lecture was delivered in two parts, on 11 August 1831 and 2 August 1832. It was published, together with the remaining fragment of a projected third lecture, under the title 'Über den Umfang des Begriffs der Kunst in Bezug auf die Theorie dersselben' in volume III/3 of Schleiermacher's *Werke*, edited by L. Jonas, Berlin, 1835. These extracts have been translated for the present volume by Nicholas Walker from Thomas Lehnerer (ed.), Friedrich Schleiermacher, *Ästhetik/Über den Begriff der Kunst* (Aesthetics/on the concept of art), Hamburg: Felix Meiner Verlag, 1984, pp. 161–4, 171–3, 177–8.

Let us begin therefore by recalling an old saying, and one also repeatedly to be heard in the mouths of more recent artists, that all art arises from a kind of spiritual enthusiasm [*Begeistung*], from the dynamic life which belongs to the innermost powers of the mind and soul. And let us also take up another such saying, and one which is just as deeply rooted in our mode of thinking, namely that all art must prove its worth in and as an actual work. The next step would naturally then be to observe whether and the extent to which such a work arises from this dynamic life in the same way in the various different arts. But given the intrinsic difficulty of the matter, it would perhaps be advisable to begin with those arts where the path between these two poles must inevitably be a short one, thereby revealing the process itself in its simplest form. We would be most fortunate, and could count on having made an auspicious start, if on the one hand we could identify something closely related to yet quite different from art itself precisely in order to show how the one differs from the other, and if on the other hand we could also successfully extend what we have thereby discovered to those other arts where the path between the poles is not so direct and the process in question is not so simple.

Now we can surely identify the feelings of joy and pain, without particularly concerning ourselves with their specific content or their occasioning factors, as two forms of stimulation which do intimately belong to the innermost source of life. Both

of them find their appropriate expression in the medium of sound and in the spontaneous movements of the body. Uninhibited joy simply wells up within us before it gradually subsides in ever decreasing circles, immediately embracing and transporting us, manifesting itself in a profusion of various half-articulated sounds from the highest register to the lowest. And similarly too, pain expresses itself in sighs and shrieks completely lacking in measure or moderation, flailing about in terrible convulsions and traversing the entire scale of possible sound, frequently repeating the most arbitrary and extravagant of bodily movements. In neither case can we possibly describe these forms of expression directly in terms of a work of art. And yet these forms of expression undeniably represent the first beginnings of two arts, initiate a process in which something originally art-less develops into something explicitly artistic, namely into the arts of dance and song. And the even broader domains of dramatic representation and music itself are but a natural extension of these two original arts. But what constitutes the specific difference then between the art-less and the artistic dimension? Undoubtedly this, that the raw and undisciplined movements of the former are subjected to measure and regulation. The more powerful the original level of excitement is the less the latter are to be found. It is the very essence of that art-less condition that the excitement and the expression are immediately identical, are simultaneously and completely combined with one another in an unconscious union, that they come into being together and subside together. To put it more precisely, they are truly one and the same and can only artificially be separated from one another from the perspective of an external observer. In every case of genuine artistic achievement, on the other hand, this identity is done away with. The original excitement as such knows nothing of measure or regulation but the typical expressions of the former are transformed and brought under some form of order once they enter the element of art, so that what appears externally has already been envisaged inwardly. Another higher power has intervened here and separated out what was previously immediately indistinguishable; a moment of reflection breaks in, as it were, to accomplish this separation, breaks the original raw power of the excitement by a tarrying postponement on the one hand and simultaneously asserts itself as an ordering principle by inhibiting the movement already initiated. This is therefore the essential aspect which distinguishes art from the pure process of nature, the moment of conception when that which subsequently emerges externally is first inwardly envisaged. An initial inner excitement must always be presupposed, one which wakes and arouses some externally directed function from slumbering latency; action must first be stimulated by such an impulse but these are merely the conditions of art. Artistic activity as such only arises where a powerful measure of reflection [*Besinnung*] is also present in this process, one that is capable of elevating this natural process beyond itself and transfiguring it into a revelation of the spirit which is conscious of itself and has mastered the original excitement. This is indeed the profound and original sense of the saying that the passions, or rather the states we merely passively suffer, are soothed and moderated through the arts. Where the impulse which transforms the excited movement into a pure form of external expression is strong enough, it also exercises in turn an effect upon our feelings and sensations, for the desires which hasten to secure some particular end are not themselves subject to this law. If in this area, then, the artistic is distinguished from

the art-less essentially through the intervention of anticipatory reflection, envisaging the end before the act, and if we discover such reflection at work in all the arts, then we are entitled to make the bold, albeit provisional, claim that this is the essence of art itself. But if the immediate coincidence of excitement and expression is broken by such anticipatory reflection, then the whole relationship between these two moments naturally finds itself transformed as well. For if, in the art-less condition, the moment of excitation only exercises a purely immediate effect, then it will also generally find itself exhausted within a relatively small sphere of movement, and if it is too weak it will exercise little or no effect whatsoever. In this way, therefore, every particular kind of excitation will tend to produce certain other analogous and related forms of expression, although they will all be rather slight and sporadic in character. But if the process is delayed by anticipatory reflection, a second state of excitement may arise through and during such inhibition, a state which might well have produced nothing on its own account but which now serves to bring something to expression far beyond its original measure. In the realm of art, therefore, it is possible to find forms of representational expression which are related to a range of different states of excitement. And this has an effect upon the entire organization of human life, for the more sense for art a people possesses the more the latter will develop a festive sense for celebrations. Whatever moves men in the affairs of life remains inwardly preserved, anticipatory reflection stirs itself into action, restrains itself in order not to dissipate all its energies on petty and insignificant pursuits, and the festive celebration of life is nothing but a collective act of expression for that urge to representation stored up within the people. But it is also quite possible to imagine that there are certain moments of excitement that touch our essential being so profoundly that they come as it were almost to represent an infinite task for original and paradigmatic reflection [*urbildliche Besinnung*]. In this connection one individual act, however far-reaching it may be, cannot suffice, the original excitement remains unstilled, continues to press for external expression, and this single element, penetrating as it does our entire being with a superabundant force of excitement, also sustains the energy of paradigmatic reflection and constitutes the theme and substance of life as a whole. And if we now consider the relationships which may obtain between these three enumerated elements, namely excitation, anticipatory envisagement and external realization, then we can almost infer from these all the various forms of expression which the history of art presents us with. Not one of these elements can ever be completely absent if anything resembling art can come into being or continue to survive anywhere at all; but it is quite possible that one of them can recede almost to vanishing point in comparison with the others, or can alternatively exceed those others in force and emphasis. [. . .]

[. . .] Is it therefore movement in this extended sense of the word through which alone the inner life announces itself? Two starting points seem to offer themselves to me in this connection if I consider the phenomena of musical and mimetic movement. In the first place I would ask: where precisely does the latter have its source and origin? And in the second instance I would ask: does music, this singular response to the challenge of life, this unique and harmonious combination of individual feelings, announce itself in any other way than through a complete series of physical actions? I know of only one possible answer to both of these questions. Those movements

through which life as such announces itself in all its particular aspects and changing states have their foundation in bodily form itself. And life proper, in its innermost self-identity, also announces itself immediately, apart from that mediated access to it which we construct from observing the entire series of its various activities, in bodily form as such. One and the same spirit in its particular manifestation immediately initiates those movements in order to express this or that aspect of its life, one and the same spirit calmly mirrors itself and its essential character in the bodily form it shapes for itself. For who would care to deny that the spirit develops its bodily form, that the inner relationship of articulated parts changes in a way quite differently from the case of other animal life, just as the spiritual capacities also make themselves that much more obvious here. Indeed this transpires before our very eyes: it has already begun with the initially obscure development of life itself; the human form is predestined in its original and fundamental features to receive the particular character of spirit. Just as intelligence expresses itself in characteristic form, so too it manifests itself out-wardly as such in terms of bodily form. [. . .] In the first place we can only conceive the significant movements of the body as so many reactions to some impression received from without, but they also accompany every aspect of pure self-activity whenever the latter expresses itself externally. Thus we have now considered creative formative activity [*gestaltbildende Tätigkeit*] of spirit as the original revelation of itself in its own authentic identity; but we also find this activity, just like movement itself, at work in the midst of all life as an attempt to externalize the inner content of some state or condition. I shall not enter here into discussion of the most mysterious manifesta-tions of this creative formative activity in the spontaneous form of dreams, or of the way in which the soul in a state of extreme tension can even project its own images into the external world with such power that it believes it physically perceives these images with its own eyes. But how often we see things differently from the way they really are, see more than things actually bring before our eyes, see things entwined with what we ourselves, each in our own fashion, inwardly cast over them, either to moderate their impact or to immerse ourselves more deeply within them as the case may be. And if, according to the variety of our moods, we seek out some particular natural environment, whether to take us out of ourselves or to submerge ourselves entirely within it, now the dense protective shade, now the sunny open landscape, here the overhanging rocks, there the clear and leafy grove: the more we immerse ourselves in whatever speaks most harmoniously to us, the more we simply engage with this dimension and desire to behold nothing else, then what is this but an abbreviated form of our own most formative activity? We are overjoyed to see and discover what we ourselves would fain have imagined. How often do we not shape living forms for ourselves, or rather how often do not the living forms take shape in us, whether through recollection or not, whenever we try and hold or recapture some especially significant spiritual moment of experience? In these cases we can see how significant movement and imaginative configuration work together and serve to supplement one another. Both aspects are equally original and equally spontaneous ways in which we externalize some momentary state or mood of our own. [. . . .]

Let us now attempt to summarize the course of our previous discussion and return to those initial propositions from which we began: we claimed that sound and move-ment originally arise out of some external influence upon our state of sensibility, but

that art itself only properly begins where the immediate connection between the inwardly moved state of mind and its external manifestation is broken; one can also no longer say that the activity of art emerges from this inwardly moved state of mind; it is much rather the case that one is already inwardly moved and that the subsequent expression of this state acquires a certain measure and determinacy, whether as sound or as movement, something which does not merely transpire simply by virtue of the original movement but rather because the artistic activity has already been introduced into it; it must be all the same to the artist whether he intervenes to inhibit or moderate his own inwardly moved state or that of another person, as long as he has properly recognized it for what it is. [. . .]

. . . I would like to strongly contest the claim that not all individuals but only a select number are really artists. For we can look upon people collectively as a group in which art, in however imperfect a form, is always already to be found. For there wherever life really stirs, even it be a quite rudimentary form of spiritual development, where the urgent needs of life still leave some room for the free play of expression, where the rigours and deprivations of the immediate environment are not so severe as to prevent any intimation of aesthetic grace, there also we shall find art. Music and the mimetic arts in the widest sense – for dance also clearly belongs to the latter category – can expect to find the greatest number of active participants; the art of poetry – even if the practitioning artists themselves are rather rarer – is enjoyed by the greatest numbers of people, and it is only the various branches of sculpture and painting which must content themselves with a much more limited sphere of recognition. But all of those who actively share in the experience of art works for themselves in some way or other are also to be regarded as artists. The sense for art and the production of art are simply two different stages of development, for it is one and the same art that is present in the lover of art and in the artist as such, and this not merely in the individual who judges with a certain facility but also in the individual who simply enjoys art and finds some satisfaction in the latter. The impulse in question, therefore, is a wholly universal one. It is a universal need for the inner to express itself, and equally universal is the need for temporal and spatial measure, for rhythm and proportion, both of which are already given to man in the very form of his body and his essential vital movements. But in order to discover precisely what inspires people to pursue one art form rather than another we must take care not to lose ourselves too much in the differences between the various kinds of art, and even more not to confuse the enthusiasm for one particular art with the general interest which itself determines the nature of the artist's work for him, namely his interest in those for whom he produces the work of art and who expect to find themselves and their conditions expressed and represented in that work. [. . .]

12 Johann Wolfgang von Goethe (1749–1832) from 'Maxims and Reflections'

Nietzsche famously claimed that Goethe was not so much a great individual as a culture, and in Germany it has now become a commonplace to speak of the *Goethezeit*, or 'age of Goethe'. The 'Maxims and Reflections' belong to the later period of Goethe's career and

represent the highly refined and condensed result of a lifetime's thought and reflection. Goethe's ideas are informed not only by his own creative work as a dramatist and writer but by his sustained engagement with the most progressive ideas of his time. These aphorisms touch upon some of the enduring themes of his work: the relationship between nature and art, the role of genius and creativity, and the distinctions between symbol and allegory, and between Classicism and Romanticism. The 'Maxims and Reflections' were first published, in part, as *Sprüche in Prosa* in 1840, then as *Maximen und Reflexionen*, under the editorship of Max Heckers, by the Goethe Gesellschaft in Weimar in 1907. These extracts have been translated for the present volume by Nicholas Walker from the Hamburger Ausgabe of *Goethes Werke*, volume XII, Hamburg: Christian Wegner Verlag, 1953, pp. 467–93.

The beautiful is a manifestation of mysterious laws of nature which would have remained eternally concealed from us without the appearance of the former.

He to whom nature has once begun to reveal her open mystery comes to experience an irresistible yearning for her most worthy interpreter, namely for art.

Beauty: a gentle and elevated harmony pervading everything which immediately pleases without requiring cogitation or reflection.

Art: another nature, also mysterious like her but more intelligible; for the former springs from the understanding.

Nature works her effects in accordance with laws she gave herself in harmonious agreement with the creator, art works her effects in accordance with rules she has agreed upon in understanding with the genius.

We know no other world than that which stands in relationship to mankind; we desire no other art than that which is an image of this relationship.

Art is a mediator of the inexpressible; and that is why it seems a vain thing to try and mediate art in turn through words. Yet it profits our understanding when we strive to do so, and this in turn assists our practical capacities as well.

Organic Nature: something living down to the tiniest detail; Art: something felt down to the tiniest detail.

Every good and every bad work of art, once it has arisen, belongs to nature. The antique belongs to nature and indeed, when it addresses us, to the most natural nature of all, and yet it is not this noble nature but rather the commonplace one which we are supposed to study!

For the commonplace is precisely what such gentlemen call nature! To draw upon oneself may well mean nothing but to make oneself at home with what's most comfortable!

The highest aspiration of art is to present human forms in the most sensuously significant and most beautiful fashion that is possible.

There is no surer way of evading the world than through art, and there is no surer way of connecting with the world than through art.

Even in the moment of our greatest delight, even in the moment of our greatest distress, we stand in need of the artist.

The manifestation of the idea of the beautiful is as ephemeral as the manifestation of the sublime, of the joyous, of the comical. And that is the reason why it is so difficult to speak of the same.

The law which manifests itself in appearance, in the greatest freedom, according to its own innermost conditions, is what brings forth objective beauty, one indeed which needs must find the subjects worthy to appreciate the same.

The symbol transforms appearance into an idea, and the idea into an image, and does so in such a way that the idea in the image continues to remain infinitely fecund, and infinitely beyond our reach, will always continue to remain, even when expressed in every language that there is, inexpressible.

Allegory transforms appearance into a concept, the concept into an image, and does so in such a way that the concept in the image is to be held and had in its limited and finished form, and is to be expressed in that image.

My relationship to Schiller is based upon our shared and decisive orientation towards a single purpose, upon our common activity directed as it was upon the various means through which we strove to attain that purpose.

On occasion of a gentle difference of opinion once expressed between us, something of which I am once again reminded by a certain passage in his correspondence, I made the following observations.

There is a great difference between the case in which the poet seeks the particular for the sake of the universal and that in which the poet beholds the universal in the particular. The former way of proceeding gives rise to allegory, where the particular counts merely as a representative or example of the universal; but it is the latter which properly corresponds to the nature of poetry, for it expresses a particular without reflecting upon or adverting to the universal. Now if we only grasp this particular in a living fashion, then we also obtain the universal at the same time, although we are not aware of the fact, or become aware of it only much later.

The true symbolism is one in which the particular represents the universal, not as a dream or shade, but as the living and momentary revelation of the inexhaustible.

The what of a work of art interests men more than the how; they can grasp the former through the details, but they cannot seize the latter through the whole. Hence the tendency to extract the parts, for with the proper attentiveness the effect of the totality also makes itself felt, albeit unconsciously, in everyone.

The question: 'But where did the poet find such a thing?' only touches on the what; about the how no one learns anything at all.

No one is ever really master of their own productivity, and we must all be willing to receive it as it comes.

The first and last thing demanded of genius is: the love of truth.

The genius exhibits a certain ubiquity, in general matters prior to experience, in particular matters after experience.

The happy fortune of a genius: to be born in times of seriousness.

The genius with an elevated mind seeks to advance beyond his century; the wilful talent with a mind of his own often seeks to hold his own century back.

The magnificent ecclesiastical hymn: *Veni creator spiritus* is actually an appeal to genius; that is why it speaks so forcibly to human beings richly endowed with strength and spirit.

One should think of all things in terms of praxis, and thereby strive to ensure that all related manifestations of a great idea, insofar as they are to be brought to appearance through human agency, should have an appropriate effect upon one another. Painting, sculpture and acting all stand in an indissoluble relationship with each other; yet an artist who feels called to one of these must take care lest he be damaged by one of the others: the sculptor can be seduced by the painter, the painter by the actor, and all three can so confound one another that none manages to survive on their own two feet.

Every great artist tears us away, and contaminates us. Everything of any capacity within us is thereby excited, and since we have an inkling of greatness and some faculty for it, we can very easily come to believe that the source of it all lies in us.

If a man is not inclined to learn from much more highly developed artists of earlier and contemporary times just what it is he is lacking in to become a genuine artist, then he will fall short of his own talent all for the sake of a false notion of proper originality; for it is not only what we are born with, but also what we can acquire that belongs to us and constitutes our being.

What is not original has no significance anyway, and what is original always bears the marks of individual failure within it.

The so-called art of creatively drawing upon oneself usually produces eccentric originals and mannerists.

In every artist there lies a core of rashness without which talent is inconceivable, and this is something which is particularly encouraged when we attempt to confine the capable individual, to utilize him for and restrict him to one-sided purposes.

There is no patriotic art and no patriotic science. Like everything genuinely great they both belong to the entire world and can only be promoted by free and unrestricted intercommunication between every living contemporary with constant consideration for everything we have learnt and received from the past.

The classical is the healthy, the romantic the sick.

When artists speak of nature they always intelligently divine the idea without their being conscious of the fact.

And so it befalls all those who spend their praise upon experience alone; they do not reflect that experience is simply the half of experience itself.

People like to say: 'Artist, you should study Nature!' But it is no small matter to develop the noble out of the commonplace, the beautiful from the formless.

First of all we hear about nature and about imitation; then there is supposed to be natural beauty. And one is supposed to choose. The best of course! And how is this to be recognized? According to which norm are we to make our choice? And where precisely is this norm? Is this not then to be found in nature too?

Nature cannot be separated from the idea without destroying both life and art alike.

13 Thomas Carlyle (1795–1881) 'Symbols' from *Sartor Resartus*

Scottish by birth, Carlyle became one of the Victorian literary 'patriarchs' whose published opinions on history, morality and society defined the ethos of the period. Prior to that, however, he had been an important, if not entirely reliable, conduit for German philosophical ideas into English-speaking culture. In 1830–1 he was also briefly influenced by St Simon's New Christianity (cf. IA5). *Sartor Resartus* (the Tailor Re-tailored) tells through the words of a first-person Editor, the story of a German 'Professor of Things-in-general' at the 'University of Know-not-where', and his Philosophy of Clothes. The point is that material things (clothes) serve to conceal the profounder spiritual reality beneath. The book achieved influence over more than one generation of artists seeking to articulate a place for art, and a belief in spiritual values, in the face of nineteenth-century capitalism. It thus represents a form of opposition to capitalism distinct from that philosophical materialism represented by Marx, Proudhon and others. In the present extract, Carlyle discusses the power of symbols in the conduct of human life, and asserts the dominance of the symbolic and imaginative faculties over those of rationality and calculation: in essence, the artistic over the scientific. *Sartor Resartus* was begun in 1830 and finished in July 1831. It was published in serial form in *Fraser's Magazine* between November 1833 and August 1834. It did not appear in book form until printed by Emerson (cf. IIA5; IID6), in Boston, in 1836; the first English edition came in 1838. The present extracts are taken from the original text as it appeared in *Fraser's Magazine*, in the edition edited by Kerry McSweeney and Peter Sabor, Oxford: Oxford University Press, 1987, chapter 3, pp. 165–70.

[. . .] 'The benignant efficacies of Concealment,' cries our Professor, 'who shall speak or sing? SILENCE and SECRECY! Altars might still be raised to them (were this an altar-building time) for universal worship. Silence is the element in which great things fashion themselves together; that at length they may emerge, full–formed and majestic, into the daylight of Life, which they are thenceforth to rule.

[. . .]Speech is too often not, as the Frenchman defined it, the art of concealing Thought; but of quite stifling and suspending Thought, so that there is none to conceal. Speech too is great, but not the greatest. As the Swiss Inscription says: *Sprechen ist silbern, Schweigen ist golden* (Speech is silvern, Silence is golden); or as I might rather express it: Speech is of Time, Silence is of Eternity.

[. . .] 'Of kin to the so incalculable influences of Concealment, and connected with still greater things, is the wondrous agency of *Symbols*. In a Symbol there is conceal-

ment and yet revelation: here, therefore, by Silence and by Speech acting together, comes a doubled significance. And if both the Speech be itself high, and the Silence fit and noble, how expressive will their union be! Thus in many a painted Device, or simple Seal-emblem, the commonest Truth stands out to us proclaimed with quite new emphasis.

'For it is here that Fantasy with her mystic wonderland plays into the small prose domain of Sense, and becomes incorporated therewith. In the Symbol proper, what we can call a Symbol, there is ever, more or less distinctly and directly, some embodyment and revelation of the Infinite; the Infinite is made to blend itself with the Finite, to stand visible, and as it were attainable, there. By Symbols, accordingly, is man guided and commanded, made happy, made wretched. He every where finds himself encompassed with Symbols, recognized as such or not recognized: the Universe is but one vast Symbol of God; nay, if thou wilt have it, what is man himself but a Symbol of God, is not all that he does symbolical; a revelation to Sense of the mystic god-given Force that is in him; a "Gospel of Freedom", which he, the "Messias of Nature", preaches, as he can, by act and word? Not a Hut he builds but is the visible embodyment of a Thought; but bears visible record of invisible things; but is, in the transcendental sense, symbolical as well as real.'

[. . .] 'Yes, Friends,' elsewhere observes the Professor, 'not our Logical, Mensurative faculty, but our Imaginative one is King over us; I might say, Priest and Prophet to lead us heavenward; or Magician and Wizard to lead us hellward. Nay, even for the basest Sensualist, what is Sense but the implement of Fantasy; the vessel it drinks out of? Ever in the dullest existence, there is a sheen either of Inspiration or of Madness (thou partly hast it in thy choice, which of the two) that gleams in from the circumambient Eternity, and colours with its own hues our little islet of Time. The Understanding is indeed thy window, too clear thou canst not make it; but Fantasy is thy eye, with its colour-giving retina, healthy or diseased. Have not I myself known five hundred living soldiers sabred into crows' meat, for a piece of glazed cotton, which they called their Flag; which, had you sold it at any market-cross, would not have brought above three groschen? Did not the whole Hungarian Nation rise, like some tumultuous moon-stirred Atlantic, when Kaiser Joseph pocketed their Iron Crown; an implement, as was sagaciously observed, in size and commercial value, little differing from a horse-shoe? It is in and through *Symbols* that man, consciously or unconsciously, lives, works, and has his being: those ages, moreover, are accounted the noblest which can the best recognize symbolical worth, and prize it the highest. For is not a Symbol ever, to him who has eyes for it, some dimmer or clearer revelation of the Godlike?

'Of Symbols, however, I remark farther, that they have both an extrinsic and intrinsic value; oftenest the former only. What, for instance, was in that clouted Shoe which the Peasants bore aloft with them as ensign in their *Bauernkrieg* (Peasants' War)? Or in the Wallet-and-staff round which the Netherland *Gueux*, glorying in that nickname of Beggars, heroically rallied and prevailed, though against King Philip himself? Intrinsic significance these had none: only extrinsic; as the accidental Standards of multitudes more or less sacredly uniting together; in which union itself, as above noted, there is ever something mystical and borrowing of the Godlike. Under a like category too, stand, or stood, the stupidest heraldic coats-of-arms; military

Banners every where; and generally all national or other sectarian Costumes and Customs; they have no intrinsic, necessary divineness, or even worth; but have acquired an extrinsic one. Nevertheless through all these there glimmers something of a Divine Idea; as through military Banners themselves, the Divine Idea of Duty, of heroic Daring; in some instances of Freedom, of Right. Nay, the highest ensign that men ever met and embraced under, the Cross itself, had no meaning save an accidental extrinsic one.

'Another matter it is, however, when your Symbol has intrinsic meaning, and is of itself *fit* that men should unite round it. Let but the Godlike manifest itself to Sense; let but Eternity look, more or less visibly, through the Time-Figure (*Zeitbild*)! Then is it fit that men unite there; and worship together before such Symbol; and so from day to day, and from age to age, superadd to it new divineness.

'Of this latter sort are all true Works of Art: in them (if thou know a Work of Art from a Daub of Artifice) wilt thou discern Eternity looking through Time; the Godlike rendered visible. Here too may an extrinsic value gradually superadd itself: thus certain *Iliads*, and the like, have, in three thousand years, attained quite new significance. But nobler than all in this kind are the Lives of heroic, god-inspired Men; for what other Work of Art is so divine? In Death too, in the Death of the Just, as the last perfection of a Work of Art, may we not discern symbolic meaning? In that divinely transfigured Sleep, as of Victory, resting over the beloved face which now knows thee no more, read (if thou canst for tears) the confluence of Time with Eternity, and some gleam of the latter peering through.

'Highest of all Symbols are those wherein the Artist or Poet has risen into Prophet, and all men can recognize a present God, and worship the same: I mean religious Symbols. Various enough have been such religious Symbols, what we call *Religions*; as men stood in this stage of culture or the other, and could worse or better body forth the Godlike: some Symbols with a transient intrinsic worth; many with only an extrinsic. If thou ask to what height man has carried it in this matter, look on our divinest Symbol: on Jesus of Nazareth, and his Life, and his Biography, and what followed therefrom. Higher has the human Thought not yet reached: this is Christianity and Christendom; a Symbol of quite perennial, infinite character; whose significance will ever demand to be anew inquired into, and anew made manifest. But on the whole, as Time adds much to the sacredness of Symbols, so likewise in his progress he at length defaces, or even desecrates them; and Symbols, like all terrestrial Garments, wax old. Homer's Epos has not ceased to be true; yet it is no longer *our* Epos, but shines in the distance, if clearer and clearer yet also smaller and smaller, like a receding star.

'Of this thing however be certain: wouldst thou plant for Eternity, then plant into the deep infinite faculties of man, his Fantasy and Heart; wouldst thou plant for Year and Day, then plant into his shallow superficial faculties, his Self-love and Arithmetical Understanding, what will grow there. A Hierarch, therefore, and Pontiff of the World will we call him, the Poet and inspired Maker; who, Prometheus-like, can shape new Symbols, and bring new Fire from Heaven to fix it there. Such too will not always be wanting; neither perhaps now are. Meanwhile, as the average of matters goes, we account him Legislator and wise who can so much as tell when a Symbol has grown old, and gently remove it.' [. . .]

14 Heinrich Heine (1797–1856) from *Salon of 1831*

Born and educated in Germany, Heine lived from 1831 until his death in Paris. His reputation as a poet and writer was secured in the late 1820s, principally with his *Book of Songs* of 1827, but also by a series of introspective prose writings based on journeys in the Harz mountains and elsewhere. Unable to secure a literary or academic career in Germany, Heine went to Paris not as a direct result of the revolution of 1830, but because of a mixture of personal and religious, as well as political, motives. He wrote that he was travelling to Paris 'to breathe fresh air'. Briefly influenced around 1830 by St Simon's 'New Christianity', Heine's writing took on a more socially critical edge after his move to France. His work was subsequently banned in Germany, where it has remained controversial as a consequence of his association in the 1840s with the young Karl Marx. In Paris, Heine was largely dependent on journalism for an income, and his writing covered a wide variety of cultural and political subjects. Amongst his Salon reviews, the best known remains the first, of 1831, in which he attempts to assess the impact of revolution on the arts. It was originally published in German in the periodical *Morgenblatt*, in Augsburg, in September and October 1831, and was then published in book form in both French and German in 1833–4. The present extracts are taken from the translation by Charles Godfrey Leland in *The Salon, or Letters on Art, Music, Popular Life and Politics* (volume 4 of *The Works of Heinrich Heine*), London: Heinemann, 1893, pp. 1–3, 24–8, 30–1, 34–8, 88–9.

The Exhibition (*Salon*) is at length closed, its pictures having been shown since the beginning of May. They were generally looked at with only fleeting glances, for people's minds were busy with other things, and anxiously occupied with perplexing politics. As for me, who had but recently come for the first time to the capital of France, and who was bewildered with innumerable new impressions, I was much less able than others to wander through the halls of the Louvre in a befitting tranquil state of mind. There they stood, close one by the other, three thousand beautiful pictures, the poor children of Art, to whom the multitude threw only the alms of an indifferent look. How they begged in silent sorrow for a little bit of sympathy, or to be sheltered in some tiny corner of the heart! It was all in vain, for all hearts were full of families of their own feelings, and had neither board nor lodging to bestow on such strangers. Aye, there it was; the Exhibition was like an orphan asylum – a crowd of infants gathered here and there, left to themselves, and none of them related one to the other in any way. They moved our souls, as they are wont to be moved on seeing child-like helplessness and youthful despair.

With what a different feeling are we seized on entering a gallery of those Italian paintings which are not exposed like foundlings to the cold world, but which, on the contrary, have drawn their nourishment from the breast of one great common mother, and who, like members of one large family, live together in peace and unity, speaking the same language, though they may not utter the same words!

The Catholic Church, which was once such a mother for this and all other arts, is now herself poor and helpless. Every painter now works according to his own taste and on his own account. The caprices of the day, the whims of the wealthy, or of his own idle heart, suggest subjects; the palette offers the most glowing colours, and the

canvas is patient to endure. Add to this, that now a badly understood Romanticism flourishes among French painters, and according to its chief rule, every artist strives to paint as differently as possible from all others, or, as the current phrase has it, to develop his own individuality. What pictures are thereby full oft produced may be imagined easily enough.

As the French have in any case much sound common-sense, they have always decided accurately as to failures, readily recognized what was truly characteristic and easily fished out the true pearls from this pictured ocean of many colours. The artists whose works were most discussed and most highly praised were Ary Scheffer, Horace Vernet, Delacroix, Decamps, Lessore, Schnetz, Delaroche, and Robert. I will therefore limit myself to repeating public opinion, which differs little on the whole from mine, and also avoid as much as possible criticism of technical merits or defects.

* * *

Delacroix has contributed a picture before which there was always a crowd, and which I therefore class among those which attracted the most attention. The sacredness of the subject forbids a severe criticism of the colouring, with which fault might otherwise be found. But despite a few artistic defects, there prevails in the picture a great thought, which strangely attracts us. It represents a group of the people during the Revolution of July, from the centre of which – almost like an allegorical figure – there rises boldly a young woman with a red Phrygian cap on her head, a gun in one hand, and in the other a tricolour flag. She strides over corpses calling men to fight – naked to the hips, a beautiful impetuous body, the face a bold profile, an air of insolent suffering in the features – altogether a strange blending of Phryne, *poissarde*,[1] and goddess of liberty. It is not distinctly shown that the artist meant to set forth the latter; it rather represents the savage power of the people which casts off an intolerable burden. I must admit that this figure reminds me of those peripatetic female philosophers, those quickly-running couriers of love or quickly-loving ones, who swarm of evenings on the Boulevards. And also that the little chimneysweep Cupid, who stands with a pistol in either hand by this alley-Venus, is perhaps soiled by something else as well as soot; that the candidate for the Pantheon who lies dead on the ground was perhaps selling *contre-marques* yestreen at the door of a theatre, and that the hero who storms onward with his gun, the galleys in his features, has certainly the smell of the criminal court in his abominable garments. And there we have it! a great thought has ennobled and sainted these poor common people, this *crapule*, and again awakened the slumbering dignity in their souls.

Holy July days of Paris! ye will eternally testify in favour of the original dignity of man – a dignity which ne'er can be destroyed. He who beheld you grieves no more o'er ancient graves, but, full of joy, believes in the resurrection of races. Holy days of July! how beautiful was the sun and how great the people of Paris! The gods in heaven, who gazed on the great battle, shouted for joy; gladly would they have left their golden chairs and gone to earth to become citizens of Paris. [. . .]

There is no picture in the Salon in which colour is so sunk in as in the July Revolution of Delacroix. But just this absence of varnish and sheen, with the powder-smoke and dust which covers the figures as with a grey cobweb, and the sun-dried hue which seems to be thirsting for a drop of water, all gives to the picture a truth, a reality, an originality in which we find the real physiognomy of the days of July. [. . .]

Sometimes in the month of July the sun has most powerfully inflamed with its rays Parisian hearts when freedom was threatened, and, drunk with sunlight, the people of Paris rose against the crumbling bastilles and ordinances of serfdom. The sun and the city sympathize wondrously, and love one another. Before the sun of the evening sinks into the sea, her last fond lingering gaze rests with delight on Paris as the bravest of all towns, and she kisses with fleeting rays the tricoloured flag on its towers. Barthelemy, one of the best of French poets, has wisely proposed to celebrate the festival of July by a symbolic wedding, and as the Doge of Venice annually ascended the golden Bucentaur to ally all-conquering Venice to the Adriatic Sea, so should Paris every year be married on the Place de la Bastille to the sun, to the great flaming lucky star of her freedom.

* * *

France has . . . its standing and never moving army of art critics, who carp at and condemn, according to old conventional rules, every new work, its subtle and refined connoisseurs who sniff round in the ateliers, smiling approbation when any one tickles their hobby [. . .]

The poor, wretched rascal with his miserable intelligence or 'understanding', he knows not how accurately he condemns himself. Poor understanding or sense should never have the first word when works of art are discussed, any more than it was called to take any leading part in their creation. The idea of a work of art is born of the emotions or feeling, and this demands of free, wild fancy the aid of realization. Fancy then throws him all her flowers – indeed, almost smothers the idea, and would more probably kill it than give it life, if understanding did not come limping up to put aside or clip away the superabundant blossoms. Understanding or judgment only keeps order, and is, so to speak, the police in the realm of art. In life it is generally a cold calculator who adds up our follies; unfortunately, it is often only the bookkeeper of the bankruptcy of a broken heart.

The great error always exists in or consists of this: that the critic asks, 'What should the artist do?' It would be much more correct to say, 'What does the artist desire?' or even, 'What must the artist execute?' The question, What should the artist do? originated with those art philosophers who, without any poetry of their own, abstracted characteristics from different works of art, and from what existed deduced a standard or rule for all future art, and so established species, definitions, and rules. They did not know that all such abstractions can only be of use to judge of imitations, but that every original artist, and even every new genius in art, should be judged according to his own law of art, which he brings with him. Rules and all such antiquated doctrines are, for such souls, much less applicable. 'There are no laws or rules of fencing for young giants,' says Menzel, because they break through every parade. Every genius should be studied, and only judged according to what he himself wills or means. Here we have only to answer the question, 'Has he the ability to carry out his idea?' 'Has he applied the right means?' Here we stand on firm ground. We measure or decide no longer, as to the work submitted, according to our own subjective wishes, but we come to mutual intelligence as to the God-given means at the command of the artist for realizing his idea. In the recitative arts, these means consist of intonation or sound and words. In the representative arts, they are supplied by colour and form. Sounds and words, colours and forms, that above all which appears to sense,

are, however, only symbols of the idea – symbols which rise in the soul of the artist when it is moved by the Holy Ghost of the world [*Weltgeist*]; for his art-works are but symbols, by which he conveys his ideas to others. He who expresses the most, and the most significant, with the fewest and simplest symbols, he is the greatest artist.

* * *

Returning to my subject, I should here have praised many a brave painter but, despite the best will, it is all the same impossible to calmly analyse their merits, for there, out of doors, the storm rages too terribly, and no one can concentrate his thoughts when such tempests re-echo in the soul. It is even on so-called peaceful days very hard in Paris to turn one's mind away from what is in the streets, and indulge in wistful private dreams [*privatträumend nachzuhängen*]. And though Art blooms more luxuriantly in Paris than elsewhere, we are still disturbed in its enjoyment at every moment by the rude rush and roar of life; the sweetest tones of Pasta and of Malibran are jarred by the suffering cries of bitter poverty, and the intoxicated heart, which has just drank eagerly from the inspiring cup of Robert's colour, will be immediately after sobered by the sight of public misery. It requires almost a Goethean egoism to attain here to undisturbed art enjoyment, and how very difficult art criticism thereby becomes I feel at this moment. I succeeded yesterday evening in writing something more of this paper, after I had, however, seen a deathly pale man fall to the ground on the Boulevards from hunger and wretchedness. But, when all at once a whole race falls on the Boulevard of Europe, then it is impossible to write further in peace. When the eyes of the critic are wet with tears his opinion is not worth much.

[1] *Poissarde*, a fish-woman; metaphorically, any very insolent and vulgar woman of the street type.

15 Eugène Delacroix (1798–1863) Letters and Notes on his Journey to North Africa

In 1832 Delacroix was able to use his social connections in order to accompany the Count de Mornay on a French diplomatic mission to Morocco. The political point of the mission was to ensure friendly relations with Morocco while the French extended their recent conquest of Algeria. Artistically, Delacroix's experiences in North Africa helped sustain him for the rest of his career. The vividness of his verbal descriptions and visual images also energized a wider strain of exoticism which continued to run through French art until well into the twentieth century. By the same token, Delacroix's observations seemed to confirm that the classical tradition had weakened, at least in the form transmitted by the Academy, and that measures of authenticity in experience and response would have to be sought elsewhere. The following extracts are drawn from two sources: the Journal entries from Pach's translation (cf. IA3 for publication details), pp. 101, 103–4, 106–8, 122; the letters from *Eugène Delacroix: Selected Letters 1813–1863*, translated by Jean Stewart with an introduction by John Russell, London: Eyre and Spottiswoode, 1971, pp. 181, 186, 187–8, 193–4.

Letter to J.-B. Pierret, Tangier, 25 January 1832

I've just arrived in Tangier. I have rushed through the town. I am quite bewildered by all that I've seen. I can't let the mail boat go – it's leaving shortly for Gibraltar –

without telling you something of my amazement at all the things I've seen. We landed in the midst of the strangest crowd of people. The Pasha of the city received us, surrounded by his soldiers. One would need to have twenty arms and forty-eight hours a day to give any tolerable impression of it all. The Jewesses are quite lovely. I'm afraid it will be difficult to do more than paint them: they are real pearls of Eden. We were given a superb reception, by local standards. They treated us to the most peculiar military music. At the moment I'm like a man in a dream, seeing things he's afraid will vanish from him. [...]

Journal entry, Tangier, 26 January 1832

WITH the *pasha*. The entrance to the castle: The guardsmen in the court, the façade, the lane between two walls. At the end, under a sort of vault, men seated, making a brown silhouette against a bit of sky.

The handsome man with the green sleeves.

The mulatto slave who poured the tea, yellow caftan and burnous attached in back, turban. The old man who gave the rose with *haik* and dark blue caftan.

The pasha with his two haiks or hoods, and the burnous beside. All three of them on a white mattress with a long square cushion covered with printed calico. A long narrow cushion of checkered cloth, another in horsehair, of various patterns; tips of the feet visible, the inkwell made of horn, various small objects lying about.

The head of the customs house leaning on his elbow, his arm bare, if I remember rightly: very wide haik on his head, white turban on top, amaranth-coloured cloth hanging over his breast, his cowl not in use, his legs crossed. We had met him mounted on a grey mule as we came up. A great deal of his leg was to be seen; a little of his coloured breeches; his saddle covered in front and behind by a scarlet cloth. A red band went around the hind quarters of the horse and hung down. The red halter or rather the breastpiece of the harness also hanging down. A Moor led the horse by the halter.

The handsome man with the green sleeves, his outer shirt in dimity, bare-footed in the presence of the pasha.

The garden divided by alleys covered with trellises. Large orange trees covered with fruits; on the ground fruit had fallen; high walls enclosed the garden. [...]

Journal entry, 29 January 1832

[...] The scene of the fighting horses. From the start, they stood up and fought with a fierceness which made me tremble for those gentlemen, but it was really admirable for a painting. I witnessed, I am certain, the most fantastic and graceful movements that Gros and Rubens could have imagined. Then the grey got his neck around the other one. For a time that seemed endless, it was impossible to make him let go. Mornay managed to dismount. While he was holding him by the bridle, the black reared furiously. The other kept on fiercely biting him behind. In all this struggle the consul fell down. We then let the two horses go; they kept on fighting with each other as they got to the river, both falling into it as they continued fighting and at the same time trying to get out of the water; their feet slipped in the mud at the edge; they were

all dirty and shiny, wet to the mane. After repeated beatings, the grey let go his hold and went toward the middle of the water; the black came out of it, etc.. . . . At the other side the soldier trying to tuck up his clothes so as to get the other horse out.

The dispute of the soldier with the groom. Sublime, with his mass of draperies, looking like an old woman and yet with something martial about him.

On our return, superb landscapes to the right, the mountains of Spain in the tenderest tones, the sea a dark greenish blue like a fig, the hedges yellow at the top because of the bamboo, green at the base on account of the aloes.

The hobbled white horse that wanted to jump onto one of ours.

On the beach, when about to come back, met the sons of the *caid*, all on mules. The oldest one, his dark blue burnous; haik about like that of our soldier, but very clean; caftan of a canary yellow. One of the young children all in white with a kind of braided cord from which a weapon was probably hanging.

Journal entry, Tuesday 21 February 1832

The Jewish wedding. The Moors and the Jews at the entrance. The two musicians. The violinist, his thumb in the air, the under side of the other hand very much in the shadow, light behind, the haik on his head transparent in places; white sleeves, shadowy background. The violinist; seated on his heels and on his gelabia. Blackness between the two musicians below. The body of the guitar on the knee of the player; very dark toward the belt, red vest, brown ornaments, blue behind his neck. Shadow from his left arm (which is directly in front of one) cast on the haik over his knee. Shirtsleeves rolled up showing his arms up to the biceps; green woodwork at his side; a wart on his neck, short nose.

At the side of the violinist, pretty Jewish woman; vest, sleeves, gold and amaranth. She is silhouetted halfway against the door, halfway against the wall; nearer the foreground, an older woman with a great deal of white, which conceals her almost entirely. The shadows full of reflections; white in the shadows.

A pillar cutting out, dark in the foreground. The women to the left in lines one above the other like flower pots. White and gold dominate, their handkerchiefs are yellow. Children on the ground in front.

At the side of the guitarist, the Jew who plays the tambourine. His face is a dark silhouette, concealing part of the hand of the guitarist. The lower part of his head cuts out against the wall. The tip of a gelabia under the guitarist. In front of him, with legs crossed, the young Jew who holds the plate. Grey garment. Leaning against his shoulder, a young Jewish child about ten years old.

Against the door of the stairway, Prisciada; purplish handkerchief on her head and under her throat. Jews seated on the steps; half seen against the door, strong light on their noses, one of them standing straight up on the staircase; a cast shadow with reflections clearly marked on the wall, the reflection a light yellow.

Above, Jewesses leaning over the balcony rail. One at the left, bare-headed, very dark, clear-cut against the wall, lit by the sun. In the corner, the old Moor with his beard on one side; shaggy haik, his turban placed low on the forehead, grey beard against the white haik. The other Moor, with a shorter nose, very masculine, turban sticking out. One foot out of the slipper, sailor's vest and sleeves the same.

On the ground, in the foreground, the old Jew playing the tambourine; an old handkerchief on his head, his black skullcap visible. Torn gelabia; his black coat visible near the neck.

The women in the shadow near the door, with many reflections on them.

Letter to Frédéric Villot, Tangier, 29 February 1832

[...] This place is made for painters. Economists and Saint-Simonians might find much to criticize as regards human rights and equality before the law, but beauty abounds here; not the over-praised beauty of fashionable paintings. The heroes of David and Co. with their rose-pink limbs would cut a sorry figure beside these children of the sun, who moreover wear the dress of classical antiquity with a nobler air, I dare assert. If you ever have a few months to spare, come to Barbary and there you will see those natural qualities that are always disguised in our countries, and you'll feel moreover the rare and precious influence of the sun, which gives intense life to everything. I shall doubtless bring back some sketches, but they will convey very little of the impression that all this makes on one. [...]

Letter To J.-B. Pierret, Tangier, 29 February 1832

[...] I gladly spend part of my time working, and another quite considerable part just letting myself live; but the thought of my reputation, of that Salon which I was supposed to be missing, never occurs to me. I'm even sure that the considerable sum of curious information that I shall bring back from here will be of little use to me. Away from the land where I discovered them, such particulars will be like trees torn from their native soil; my mind will have forgotten its impressions, and I shall disdain to give a cold and imperfect rendering of the living and striking sublimity that lies all about one here, and staggers on with its reality. Imagine, my friends, what it is to see lying in the sun, walking about the streets, cobbling shoes, figures like Roman consuls, like Cato or Brutus, not even lacking that disdainful look which those rulers of the world must have worn; these people possess only a single blanket, in which they walk about, sleep or are buried, and they look as satisfied as Cicero must have been in his curule chair. I tell you, you'll never be able to believe what I shall bring back, because it will be far removed from the natural truth and nobility of these men. There's nothing finer in classical art. Yesterday a peasant came by, got up like this [a sketch]. And this was what a wretched Moor looked like, begging for a handful of coppers a couple of days ago. All of them in white, like Roman senators or Greeks at the Panathenaean festival. [...]

Journal Entry, Tangier, 28 April 1832

[...] This people is wholly antique. This exterior life and these carefully closed houses: the women withdrawn, etc. The other day, quarrel with sailors who wanted to enter a Moorish house. A Negro threw his wooden shoe in their faces, etc.

Abou, the general who conducted us, was seated the other day on the doorstep; our kitchen boy was seated on the bench. He bent over to the side only the least bit so as to let us pass. There is something democratic in such offhand manners. The big men of the country will squat down in the sun on a street corner and chat together, or stretch out in the shop of some merchant.

These people have a small number of legal cases, anticipated or possible: for certain cases, a given punishment in a given circumstance; but the whole business is arranged without those endless and tiresome details with which our modern authorities overwhelm us. Custom and ancient usage govern everything. [...]

Certain quite common and antique customs possess a majesty which is lacking among us in even the gravest circumstances. The custom of having the women go on Friday to the graves with the branches that are sold in the market. The weddings with music, the presents borne behind them by the relatives, the *couscous*, the bags of wheat on mules and asses, an ox, clothes on cushions, etc.

It must be difficult for them to conceive of the turbulent mind of the Christians and that restlessness of ours which urges us on to novelties. We notice a thousand things which are lacking with these people. Their ignorance produces their calm and their happiness; but we ourselves, are we at the summit of what a more advanced civilization can produce?

They are closer to nature in a thousand ways: their dress, the form of their shoes. And so beauty has a share in everything that they make. As for us, in our corsets, our tight shoes, our ridiculous pinching clothes, we are pitiful. The graces exact vengeance for our science.

Letter to Auguste Jal, Tangier, 4 June 1832

[...] We are at last about to sail for poor France, and I was anxious not to leave Africa without sending you a word of thanks.

Your newspapers, your cholera, your politics, all these things unfortunately detract from the pleasure of going home. If you knew how peacefully men live here under the scimitar of tyrants; above all, how little they are concerned about all the vanities that fret our minds! Fame, here, is a meaningless word; everything inclines one to delightful indolence; nothing suggests that this is not the most desirable state in the world. Beauty lies everywhere about one. It drives one to despair, and painting, or rather the frantic desire to paint, seems the greatest of follies. You have seen Algiers, and you can imagine what the natives of these regions are like. Here there is something even simpler and more primitive; there is less of the Turkish alloy; I have Romans and Greeks on my doorstep: it makes me laugh heartily at David's Greeks, apart, of course, from his sublime skill as a painter. I know now what they were really like; their marbles tell the exact truth, but one has to know how to interpret them, and they are mere hieroglyphs to our wretched modern artists. If painting schools persist in setting Priam's family and the Atrides as subjects to the nurslings of the Muses, I am convinced, and you will agree with me, that they would gain far more from being shipped off as cabin boys on the first boat bound for the Barbary coast than from spending any more time wearing out the classic soil of Rome. Rome is no longer to be found in Rome. [...]

16 Honoré de Balzac (1799–1850) from *The Unknown Masterpiece*

Balzac's long short story is dated February 1832 and was first published in an eponymous compilation in Paris in 1845. It is set in the seventeenth century and its principal characters are the senior painter Porbus, the young Nicholas Poussin and a legendary master called Frenhofer. In the first of our three excerpts Frenhofer is made the mouthpiece for a critique of simple equations of realism with lifelikeness; in the second he sketches the conditions for an ideal form of pictorial mimesis; in the third the 'unknown masterpiece' is finally disclosed, in terms suggestive of the conflict between an extreme realist assiduousness and an extreme modernist aestheticism, and prophetic as to the outcome. The narrative concludes with Frenhofer discovered dead amidst the destruction of his life's work. The story provided a compelling point of literary reference for accounts of the modern painter's psychology, and exercised a powerful hold over the imaginations of various artists. Notable among these was Cézanne, who at times represented his own endeavour in terms that Balzac's story had helped to furnish, and who adopted Frenhofer's 'there are no lines in nature' as his own personal dictum. Our text is taken from the English Caxton Edition, London: Caxton Press, 1899, pp. 12–15, 21–3 and 40–4.

'The mission of art is not to copy nature, but to give expression to it! You are not a base copyist, but a poet!' cried the old man, earnestly, interrupting Porbus with an imperious gesture. 'Otherwise, a sculptor would end all his labours in merely mould-ing women. But try to mould your mistress's hand and place it before you; you will find a horrible dead thing without any resemblance, and you will be compelled to have recourse to the chisel of the man who, without copying it for you exactly, will instil movement and life into it. We have to grasp the spirit, the soul, the features, of things and beings. Effects! effects! why, they are the accidents of life, and not life itself. A hand – as I have taken that example – a hand is not simply a part of the body, it expresses and continues a thought which we must grasp and render. Neither the poet nor the painter nor the sculptor should separate cause and effect, which are inextric-ably bound up in each other! There is the real struggle! Many painters triumph instinctively, knowing nothing of this canon of art. You draw a woman, but you do not see her! Not thus do we succeed in forcing nature to yield up her secrets. Your hand reproduces, unconsciously on your part, the model you have copied in your master's studio. You do not go down far enough into the intimate knowledge of form, you do not pursue it with sufficient love and perseverance in its windings and its flights. Beauty is a stern, uncompromising thing, which does not allow itself to be attained in that way; you must bide its time, keep watch upon it, press it close, and hold it fast to force it to surrender. Form is a Proteus much more difficult to seize, and much more prolific in changes of aspect than the fabled Proteus; only after a long contest can one force it to show itself in its real shape. You are content with the first view that it presents to you, or with the second or the third, at all events: but that is not the way that victorious fighters act! The unvanquished painters never allow them-selves to be deceived by all these will-o'-the-wisps, they persevere until nature is driven to show itself to them all naked and in its true guise. Such was the course pursued by Raphael,' said the old man, removing his black velvet cap to express the

respect inspired in him by the king of art: 'his great superiority is due to the instinctive sense which, in him, seems to desire to shatter form. Form is, in his figures, what it is in ourselves, an interpreter for the communication of ideas and sensations, an exhaustless source of poetic inspiration. Every figure is a world in itself, a portrait of which the original appeared in a sublime vision, in a flood of light, pointed to by an inward voice, laid bare by a divine finger which showed what the sources of expression had been in the whole past life of the subject. You give your women fine dresses of flesh, lovely draperies of hair, but where is the blood that engenders tranquillity or passion, and causes its peculiar effects? [...]

'Because you have produced something which resembles a woman more than a house, you think that you have gained your end, and, proud beyond measure because you are no longer obliged to write beneath your figures: *currus venustus* [graceful chariot] or *pulcher homo* [handsome man], as did the early painters, you fancy that you are wonderful artists! Aha! not yet, my excellent friends! you must wear out many brushes, cover many canvases, before you reach that stage! Assuredly a woman carries her head in that way, she holds her skirt so, her eyes have that languishing, melting expression of gentle resignation, the fluttering shadow of the eyelashes wavers so upon her cheeks! It is true and it is not true. What does it lack? a mere nothing, but that nothing is everything. You produce the appearance of life, but you do not express its overflowing vitality, that indefinable something which is the soul, perhaps, and which floats mistily upon the surface, – in a word, that flower of life that Titian and Raphael grasped.'

* * *

'Show my work!' exclaimed the old man, excitedly. 'No, no! I have still to put some finishing touches to it. Yesterday, toward evening, I thought that it was done. The eyes seemed moist to me, the flesh rose and fell. The locks of hair moved. It breathed! Although I have found a way to represent upon a flat canvas the relief and rounded forms of nature, this morning, by daylight, I realized my error. Ah! to attain that glorious result, I studied with the utmost care the great masters of colouring, I analysed and dissected, layer by layer, the pictures of Titian, that king of light; like that monarch of painters, I sketched my figure in a light tone with soft, thick colour, – for shadow is only an incident, remember that, my boy! – Then I returned to my work, and, by means of half-tones and varnish, making the latter less and less transparent, I made the shadow more and more pronounced, even to the deepest black; for the shadows of ordinary painters are of a different nature from their light tones; they are wood, brass, whatever you choose, except flesh in shadow. You feel that, if their figures should change their positions, the shaded places would not brighten and become light. I have avoided that fault, into which many of the most illustrious painters have fallen, and in my work the light can be felt under the opacity of the deepest shade! I have not, like a multitude of ignorant fools who imagine that they draw correctly because they make a sharp, smooth stroke, marked the outlines of my figure with absolute exactness, and brought out in relief every trifling anatomical detail, for the human body is not bounded by lines. In that respect, sculptors can approach reality more nearly than we painters. Nature provides a succession of rounded outlines which run into one another. Strictly speaking, drawing does not exist [...]

'The line is the method by which man expresses the effect of light upon objects; but there are no lines in nature, where everything is rounded; it is in modelling that one draws, that is to say, one takes things away from their surroundings; the distribution of light alone gives a lifelike appearance to the body! Wherefore, I have not sharply defined the features, I have enveloped the outlines in a cloud of warm, half-light tones which make it impossible to place your finger on the precise spot where the outline ends and the background begins. Near at hand, the work looks downy and seems to lack precision; but at a distance of two yards it all becomes distinct and stands boldly forth; the body turns, the shape becomes prominent, you can feel the air circulating all about. But I am not content as yet, I have my doubts. It may be that we ought not to draw a single line, perhaps it would be better to attack a figure in the middle, giving one's attention first to the parts that stand out most prominently in the light, and to pass thence to the darker portions. Is not such the method of the sun, the divine painter of the universe? O Nature, Nature! who has ever followed thee in thy flight? Observe that too much knowledge, like ignorance, leads to a negation. I doubt my own work!'

* * *

'Come in, come in,' said the old man, beaming with happiness. 'My work is perfect, and now I can exhibit it with pride. Never will painter, brushes, colours, canvas, and light produce a rival to *Catherine Lescault*, the beautiful courtesan!'

Impelled by intense curiosity, Porbus and Poussin ran into the centre of a vast studio covered with dust, where everything was in confusion, with pictures hanging on the walls here and there. They paused at first before a life-size picture of a woman, half-nude, at which they gazed in admiration.

'Oh! do not waste time over that,' said Frenhofer; 'that is a canvas that I daubed to study a pose; that picture is worth nothing at all. Those are my mistakes,' he continued, pointing to a number of fascinating compositions on the walls about them.

Thereupon, Porbus and Poussin, dumbfounded by that contemptuous reference to such works, looked about for the portrait he had described to them, but could not succeed in finding it.

'Well, there it is!' said the old man, whose hair was in disorder, whose face was inflamed by supernatural excitement, whose eyes snapped, and whose breath came in gasps, like that of a young man drunk with love. – 'Ah!' he cried, 'you did not anticipate such perfection! You are in presence of a woman and you are looking for a picture. There is such depth of colour upon that canvas, the air is so true, that you cannot distinguish it from the air about us. Where is art? lost, vanished! Those are the outlines of a real young woman. Have I not grasped the colouring, caught the living turn of the line that seems to mark the limits of the body? Is it not the self-same phenomenon presented by objects that swim in the atmosphere like fish in the water? Mark how the outlines stand out from the background! Does it not seem to you as if you could pass your hand over that back? For seven years I have studied the effects of the joining of light and figures. See that hair, does not the light fall in a flood upon it? Why, she breathed, I verily believe! – Look at that bosom! Ah! who would not kneel and adore it? The flesh quivers. Wait, she is about to rise!'

'Can you see anything?' Poussin asked Porbus.

'No. – And you?'

'Nothing.'

The two painters left the old man to his raving, and looked about to see whether the light, falling too full upon the canvas that he pointed out to them, did not neutralize all its fine effects. They examined the painting from the right side and the left and in front, stooping and standing erect in turn.

'Yes, oh! yes, that is a canvas,' said Frenhofer, misunderstanding the object of that careful scrutiny. 'See, there are the frame and the easel, and here are my paints, my brushes.'

And he seized a brush which he handed them with an artless gesture.

'The old lansquenet is making sport of us,' said Poussin, returning to his position in front of the alleged picture. 'I can see nothing there but colours piled upon one another in confusion, and held in restraint by a multitude of curious lines which form a wall of painting.'

'We are mistaken,' said Porbus, 'look!'

On drawing nearer, they spied in one corner of the canvas the end of a bare foot standing forth from that chaos of colours, of tones, of uncertain shades, that sort of shapeless mist; but a lovely foot, a living foot! They stood fairly petrified with admiration before that fragment, which had escaped that most incredible, gradual, progressive destruction. That foot appeared there as the trunk of a Parian marble Venus would appear among the ruins of a burned city.

'There is a woman underneath!' cried Porbus, calling Poussin's attention to the layers of paints which the old painter had laid on, one after another, believing that he was perfecting his picture.

The two artists turned instinctively toward Frenhofer, beginning to understand, but only vaguely as yet, the trance in which he lived.

'He speaks in perfect good faith,' said Porbus.

'Yes, my friend,' interposed the old man, rousing himself, 'one must have faith, faith in art, and live a long, long while with his work, to produce such a creation. Some of those shadows have cost me many hours of toil. See on that cheek, just below the eye, there is a slight penumbra which, if you observe it in nature, will seem to you almost impossible to reproduce. Well, do you fancy that that effect did not cost me incredible labour? And so, dear Porbus, scrutinize my work with care, and you will understand better what I said to you about the manner of treating the model and the contours. Look at the light on the bosom, and see how I have succeeded, by a succession of heavy strokes and relief-work, in catching the genuine light and combining it with the gleaming whiteness of the light tints; and how, by the contrary process, by smoothing down the lumps and roughness of the paint, I have been able, by dint of touching caressingly the contour of my figure, swimming in the half-light, to take away every suggestion of drawing and of artificial methods, and to give it the aspect, the very roundness of nature. Go nearer and you will see that work better. At a distance, it is invisible. Look! at that point, it is very remarkable, in my opinion.'

With the end of his brush he pointed out to the two painters a thick layer of light paint.

Porbus put his hand on the old man's shoulder and turned toward Poussin.

'Do you know that in this man we have a very great artist?' he said.

'He is even more poet than artist,' said Poussin, with perfect gravity.

'That,' added Porbus, pointing to the canvas, 'marks the end of our art on earth.'

'And, from that, it will pass out of sight in the skies,' said Poussin.

'How much enjoyment over that piece of canvas!' exclaimed Porbus.

The old man, absorbed in reverie, did not listen to them; he was smiling at that imaginary woman.

'But sooner or later he will discover that there is nothing on his canvas!' cried Poussin. [. . .]

17 Washington Allston (1779–1843) from 'Art'

Allston was the pioneer of a painting of Romantic mood in America. He left Washington in 1801 to study at the Royal Academy in England, and subsequently spent four years in Italy, where he began a lifelong friendship with the Romantic poet Coleridge. He was also acquainted with Wordsworth and Southey, with Reynolds and Fuseli, and with Constable's friend Sir George Beaumont. He was in Boston between 1808 and 1811 and returned there for good in 1818, embarking on an ambitious work, *Belshazzar's Feast*, which he was never to finish. In 1830 he moved to Cambridge, Mass., and began work on a course of lectures on art, with the aim of delivering them to a select audience in Boston. Four were completed, one of them under the simple title 'Art'. Allston distinguishes between natural creation and artistic creation, arguing for the equation of individuality and originality with a form of 'human' or 'poetic' truth. This truth is a form of unarguable truth to nature, which is recognized in the unity of the artist's production. A collection of Allston's *Lectures on Art and Poems* was edited after his death by Richard Henry Dana, Jr, and was published in New York by Baker and Scribner in 1850. The following excerpts are taken from the facsimile reprint of that edition, Gainesville, Florida: Scholars' Facsimiles and Reprints, 1967, pp. 76–9, 80–1, 83 and 85–7.

[. . .] If it be true . . . that no two minds were ever found to be identical, there must then in every individual mind be *something* which is not in any other. And, if this unknown something is also found to give its peculiar hue, so to speak, to every impression from outward objects, it seems but a natural inference, that, whatever it be, it *must* possess a pervading force over the entire mind, – at least, in relation to what is external. But, though this may truly be affirmed of man generally, from its evidence in any one person, we shall be far from the fact, should we therefore affirm, that, otherwise than potentially, the power of outwardly manifesting it is also universal. We know that it is not, – and our daily experience proves that the power of reproducing or giving out the individualized impressions is widely different in different men. With some it is so feeble as apparently never to act; and, so far as our subject is concerned, it may practically be said not to exist; of which we have abundant examples in other mental phenomena, where an imperfect activity often renders the existence of some essential faculty a virtual nullity. When it acts in the higher degrees, so as to make another see or feel *as* the Individual saw or felt, – this, in relation to Art, is what we mean, in its strictest sense, by Originality. He, therefore, who possesses the power of presenting to another the *precise* images or emotions as they existed in himself, presents that which can be found nowhere else, and was first found by and within

himself; and, however light or trifling, where these are true as to his own mind, their author is so far an originator.

But let us take an example, and suppose two *portraits*; simple heads, without accessories, that is, with blank backgrounds, such as we often see, where no attempt is made at composition; and both by artists of equal talent, employing the same materials, and conducting their work according to the same technical process. We will also suppose ourselves acquainted with the person represented, with whom to compare them. Who, that has ever made a similar comparison, will expect to find them identical? On the contrary, though in all respects equal, in execution, likeness, &c., we shall still perceive a certain *exclusive something* that will instantly distinguish the one from the other, and both from the original. And yet they shall both seem to us true. But they will be true to us also in a double sense; namely, as to the living original and as to the individuality of the different painters. Where such is the result, both artists must originate, inasmuch as they both outwardly realize the individual image of their distinctive minds.

Nor can the truth they present be ascribed to the technic process, which we have supposed the same with each; as, on such a supposition, with their equal skill, the result must have been identical. No; by whatever it is that one man's mental impression, or his mode of thought, is made to differ from another's, it is that something, which our imaginary artists have here transferred to their pencil, that makes them different, yet both original.

Now, whether the medium through which the impressions, conceptions, or emotions of the mind are thus externally realized be that of colours, words, or any thing else, this mysterious though certain principle is, as we believe, the true and only source of all originality.

In the power of assimilating what is foreign, or external, to our own particular nature consists the individualizing law, and in the power of reproducing what is thus modified consists the originating cause.

* * *

That an absolute identity between any natural object and its represented image is a thing impossible, will hardly be questioned by any one who thinks, and will give the subject a moment's reflection; and the difficulty lies in the nature of things, the one being the work of the Creator, and the other of the creature. We shall therefore assume as a fact, the eternal and insuperable difference between Art and Nature. That our pleasure from Art is nevertheless similar, not to say equal, to that which we derive from Nature, is also a fact established by experience; to account for which we are necessarily led to the admission of another fact, namely, that there exists in Art a *peculiar something* which we receive as equivalent to the admitted difference. Now, whether we call this equivalent, individualized truth, or human or poetic truth, it matters not; we know by its *effects*, that some such principle does exist, and that it acts upon us, and in a way corresponding to the operation of that which we call Truth and Life in the natural world. [...]

The fact, that truth may subsist with a very considerable admixture of falsehood, is too well known to require an argument. However reprehensible such an admixture may be in morals, it becomes in Art, from the limited nature of our powers, a matter of necessity.

For the same reason, even the realizing of a thought, or that which is properly and exclusively human, must ever be imperfect. If Truth, then, form but the greater proportion, it is quite as much as we may reasonably look for in a work of Art. But why, it may be asked, where the false predominates, do we still derive pleasure? Simply because of the Truth that remains. If it be further demanded, What is the minimum of truth in order to [cause] a pleasurable effect? we reply, So much only as will cause us to feel that the truth *exists*. It is this feeling alone that determines, not only the true, but the degrees of truth, and consequently the degrees of pleasure [. . .]

But it must not be inferred that originality consists in any contradiction to Nature; for, were this allowed and carried out, it would bring us to the conclusion, that, the greater the contradiction, the higher the Art. We insist only on the modification of the natural by the personal; for Nature is, and ever must be, at least the sensuous ground of all Art: and where the outward and inward are so united that we cannot separate them, there shall we find the perfection of Art. So complete a union has, perhaps, never been accomplished, and *may* be impossible; it is certain, however, that no approach to excellence can ever be made, if the *idea* of such a union be not constantly looked to by the artist as his ultimate aim. Nor can the idea be admitted without supposing a *third* as the product of the two, – which we call Art; between which and Nature, in its strictest sense, there must ever be a difference; indeed, a *difference with resemblance* is that which constitutes its essential condition.

* * *

The question now arises, What, then, is that which seems to us so like an *alter et idem*, – which appears to know act upon, and is recognized by us, through an animal, a bird, a tree, and a thousand different, nay, opposing objects, in the same way, and to the same end? The inference follows of necessity, that the mysterious cause must be in some general law, which is absolute and *imperative* in relation to every such object under certain conditions. And we receive the solution as true, – because we cannot help it. The reality, then, of such a law becomes a fixture in the mind.

But we do not stop here: we would know something concerning the conditions supposed. And in order to know this, we go back to the effect. And the answer is returned in the form of a question, – May it not be something *from ourselves*, which is reflected back by the object, – something with which, as it were, we imbue the object, making it correspond to a *reality* within us? Now we recognize the reality within; we recognize it also in the object, – and the affirming light flashes upon us, not in the form of *deduction*, but of inherent Truth, which we cannot get rid of; and we *call* it Truth, – for it will take no other name.

It is a common saying, that there is more in a name than we are apt to imagine. And the saying is not without reason; for when the name happens to be the true one, being proved in its application, it becomes no unimportant indicator as to the particular offices for which the thing named was designed. So we find it with respect to the Truth of which we speak; its distinctive epithet marking out to us, as its sphere of action, the mysterious intercourse between man and man; whether the medium consist in words or colours, in thought or form, or in any thing else on which the human agent may impress, be it in a sign only, his own marvellous life. As to the

process or *modus operandi*, it were a vain endeavour to seek it out: that divine secret must ever to man be an humbling darkness. It is enough for him to know that there is that within him which is ever answering to that without, as life to life, – which must be life, and which must be true.

18 Théophile Gautier (1811–1872) from Preface to *Mademoiselle de Maupin*

Gautier was born in the Pyrenees close to the Spanish border (a fact which helped sustain a lifelong exotic self-image), and spent his working life in Paris. In addition to his work as a poet and novelist, he was a prolific journalist, writing reviews of books, plays, music, ballet and opera, as well as of the annual Salon and other art exhibitions. In later years he also travelled widely, from Spain and North Africa, to Greece, Turkey and Russia. An early adherent of Romanticism, he became Victor Hugo's leading supporter in the scandal surrounding the latter's play *Hernani* in 1830. The red waistcoat which Gautier adopted at the time was taken to symbolize a committed Romanticism. However, Gautier and other members of the younger generation responded to the political upheaval of 1830 with a new emphasis on art as an end in itself, to be set against the turmoil of actual social life. In May 1834 he was attacked for 'depravity' in taste and morals by the establishment journal *Le Constitutionnel*. He responded by means of a preface to his then forthcoming novel *Mademoiselle de Maupin*. Gautier's text is generally seen as a manifesto of 'art for art's sake'. He dated the preface 'May 1834' to commemorate the incident which gave rise to it, though the book was in fact published in 1835. The present extract is translated for this volume by Jonathan Murphy from *Mademoiselle de Maupin*, Paris: Libraire Garnier Frères, 1930, pp. 1–47.

It is no less absurd to call a man drunkard because he describes a drunken orgy, or debauched because he describes debauchery, than to claim virtue for a man because he has written a work of morality; our daily experience teaches us the contrary. – It is the character who speaks, not the author; his hero is an atheist, this does not make the author one; his brigands speak and act like brigands, he is not on that account a brigand. At this rate, we should have to guillotine Shakespeare, Corneille and all the tragedians; they have more murders on their consciences than Mandrin and Cartouche; yet we have not, nor do I see the day when we shall, however moral and virtuous the critics wax. To substitute the author for the work and descend to personalities is the vice of these little narrow-brained scribblers; it gives an air of petty scandal to their pitiful lucubrations, which, as they well know, no one would read if there were no more to them than their own personal opinion.

I am hard put to discover the purpose of all this vociferation. Why so much hollering and dudgeon? – What makes these puny, second-rate Geoffroys set themselves up as the Don Quixotes of morality and act like literary constables, whipping out their truncheon to belabour in virtue's name any idea found wandering through a book with its mob-cap on at too rakish an angle or its skirt tucked-up too high at the back. – It is most peculiar.

Whatever they say, this epoch is immoral (if the word means anything, which I doubt); the quantity of immoral books that it produces and the enthusiasm with which

they are received are proof enough of that. – Books take their tone from the times, not vice versa. – The Regency created Crébillon, not he it. If Boucher's little shepherdesses wore paint and little else, it was because little marchionesses did the same. – Paintings are made from models, not taken as models. Someone or other somewhere said that literature and the arts influence morality. Whoever it was, he was a first-class ninny. – It is as if one said: peas make Spring grow; they don't; Spring makes peas grow, as Summer makes cherries. Trees bear fruit, fruit do not, I submit, bear trees; this is the eternal law, invariable in its variety; the centuries go by, and each century bears its own fruit, which is not that of the preceding century; books are not the fruits of morality.

Alongside the moral journalists, fertilized by this shower of homilies – as if by a summer shower in a park – there has grown up (between the boards of the Saint-Simonian stage) a little straggle of mushrooms of a new and rather curious kind; let us examine them scientifically.

These are the utilitarian critics, poor fellows whose noses are too short for glasses, but who still cannot see beyond the ends of their noses.

When an author landed some volume or other – novel or poems – on their desks, these gentlemen would nonchalantly tilt their chairs back, balance on the back legs, then, rocking judiciously to and fro, they would look important and ask:

– What use is this book? How does it serve the moralization and well-being of the most populous and penurious class? What! Not a word of the needs of society, nothing civilizing, nothing progressive? You could be making a grand synthesis of human affairs, following the progress of providential and regenerating ideas through the phases of history, how is it then possible to make novels and poems that lead nowhere, that do not encourage the present generation to set out upon the road to the future? How can one be interested in form, style, and rhyme when such grave matters are at issue? – What do we care about style, rhyme and form? As if that were the question! (*sc*: as if they were capable of asking it!) – Society is afflicted, it is torn apart from within (*sc*: no one is subscribing to the utilitarian magazines). It is for the poet to seek the cause of this malaise and cure it. How must he do this? He must care for humanity heart and soul (philanthropic poets! what a charming and unusual spectacle *that* would afford!). This is the poet that we are waiting for, upon whose name we call! When he arises, the masses shall acclaim him, palms shall bedeck him, he shall hold forth from the tribune of the people. . . .

All in good time; but since we wish the reader to remain awake till the end of this blessed preface, we here cease our very faithful imitation of the utilitarian style, since it is more than somewhat soporific and could, with advantage, replace laudanum and academic speeches.

No, you imbeciles, no, cretins and goitres, a book does not make gelatine soup; – a novel is not a pair of seamless boots, nor a sonnet a continuous-jet syringe; a play is not a railway, though all these things are civilizing and encourage humanity upon the road to progress.

By the bowels of all popes past, present and future, no, two hundred thousand times no.

One does not make a cotton bonnet from a metonymy, nor put on a comparison instead of a slipper; an antithesis cannot do duty for an umbrella; one cannot, alas,

upholster the belly with a few gaudy rhymes instead of a waistcoat. I remain convinced that an ode is too light for winter wear, and that one would be no better dressed in a strophe, antistrophe and epode than the wife of the cynic, who, content with no other garment than truth, went about stark naked, as the story tells.

And yet the famous Monsieur de La Calprenède once had a suit, and, being asked what cloth it was made of, replied: 'Of Silvandre.' – *Silvandre* was a play of his that had just been successfully staged.

Arguments of this kind make one shrug one's shoulders above the ears; higher than the Duke of Gloucester.

These are people who claim to be economists, who wish to rebuild society from the foundations up, and they put forward such crack-brained rubbish in all seriousness.

A novel has two uses: – one material, the other spiritual, if the term be permitted about a novel. – The material use is first and foremost the few thousand francs that enter the author's pocket, and ballast it such that neither wind nor devil carry him off; for the bookseller, it is a handsome pedigree horse which prances and curvets between the shafts of a steel and ebony cabriolet, as Figaro says; for the paper merchant, it is one more factory on the banks of some stream or other, and often the ruin of a landscape; for printers, a few tons of logwood that allow them to wet their whistles once a week; for the reading-room, it is quantities of coins slimed with plebeian verdigris, and a quantity of grease so great that, were a way found to collect and put it to use, it would supersede whale-fishing. – The spiritual use is that while one is reading novels, one sleeps, and reads neither useful, progressive, virtuous journals nor any other indigestible and stultifying drug.

Well, who do I *now* hear say that novels contribute nothing to civilization? – I leave aside the tobacco-sellers, grocers and chip-fryers, who have a great interest in this branch of literature, since the paper used is, for the most part, better than that of newspapers.

Truly, when one hears the republican or Saint-Simonian utilitarians speechify, it has one rolling in the aisles. – I should like to know the exact meaning of that loutish substantive with which they daily plump the vacuity of their columns, and which is a shibboleth and sacramental term in their eyes. – Utility: what is this word, and to what does it apply?

There are two kinds of utility, and the word is invariably relative in sense. What is of service to one person is useless for another. You are a cobbler, I am a poet. – It is of service to me that my second line rhyme with my first. – A rhyming dictionary is great service to me; you have not the slightest need for it in cobbling a pair of old boots, and it may reasonably be thought that a paring knife is not much help in making an ode. – Upon which, you object that a cobbler is much superior to a poet, and that one manages better without the one than the other. Without wishing to slight the honourable profession of cobbler, which I honour no whit less than that of constitutional monarch, I humbly confess that I had rather my shoe flapped than that my lines rhymed ill, and that I should get along more easily without footwear than without poems. I almost never go out; being more agile of mind than foot, I wear out my soles less often than a virtuous republican who scurries from minister to minister in hopes that one of them will idly toss him a ministerial post.

There are those, I know, who prefer mills to churches, the bread of the body to that of the soul. To these, I have nothing to say. They deserve to be economists in this world *and* the next.

Is anything absolutely useful in this world, this life? In the first place, our being alive and on earth is of very little service. I defy the most erudite to tell me what use we are, if it is not to subscribe to the *Constitutionnel*, nor any kind of journal at all.

But the utility of our existence being once admitted *a priori*, what is of *real* use in sustaining it? A little soup and a piece of meat twice a day is all that is required to fill the belly, *stricto sensu*. Man, whom a coffin two foot by six quite suffices after death, needs scarcely more space during his lifetime. A hollow cube measuring seven or eight feet in each direction, equipped with a breathing hole – one cell in the hive – is sufficient accommodation to prevent the rain running down his neck. A blanket properly rolled around him will keep off the cold as well as, and better than, the most elegant, the best-cut tailcoat from Straub's.

With these things, he can, quite literally, subsist. You can live on 25 centimes a day, we are told; but keeping oneself alive is not living, and I cannot see that life in a town organized on utilitarian principles would be more agreeable than residence at Père-la-Chaise.

Nothing beautiful is indispensable to life. – If flowers were eliminated, the world would suffer no material loss; yet who wishes there were no more flowers? I would rather give up potatoes than roses, and I cannot believe that there is a single utilitarian in the world who would grub up a tulip-bed for the sake of planting cabbages.

What use is the beauty of women? What use is painting? Who would be mad enough to prefer Mozart to Monsieur Carrel,[1] and Michelangelo to the inventor of white mustard?

The useless alone is truly beautiful; everything useful is ugly, since it is the expression of a need, and man's needs are, like his pitiful, infirm nature, ignoble and disgusting. – The most useful place in the house is the latrines.

I am myself, *pace* these gentlemen, one of those for whom the superfluous is necessary. To a particular pot of which I make nightly use, I prefer a Chinese vase, covered with mandarins and dragons, which is of no use whatsoever, and among my talents I most esteem that of not guessing rebuses and charades. I would happily give up my rights as a Frenchman and a citizen for the sight of an authentic Raphael or a beautiful woman naked: – the Princess Borghese, for example, when she posed for Canova, or Julia Grisi as she got into the bath. I should happily consent to the return of the anthropophagous King Charles X if he brought me a basket of Tokay or Johannisberg from his Bohemian Castle, and I should find the electoral laws sufficiently liberal, if certain streets were wider and certain other things narrower. Although I am not a dilettante, I prefer the street-fiddler and the tambourine to the sound of the judge's bell. I would sell my shirt for a jewel, and my bread for preserves. – The occupation best suited to a policeman is, in my view, to do nothing, or meditatively to smoke his pipe or cigar. I also have great esteem for those who play skittles, and those who make excellent verses. You see that utilitarian principles are rather remote from my nature, and that I shall never be a contributor to virtuous journals – short of conversion, which would be a droll thing.

Instead of creating a Monthyon Prize to recompense the virtuous, I should prefer to bestow, like that great and misunderstood philosopher Sardanapalus, a large sum on anyone who could invent a new pleasure; for pleasure seems to me the goal of life, and the only useful thing in the world. God willed it so, He who made women, perfumes, light, beautiful flowers, fine wines, mettlesome horses, greyhounds and Persian cats; He who told his angels not 'Be virtuous' but 'Be full of love'. He gave us a mouth more sensitive than the rest of our skin for kissing women, eyes raised to the skies with which to see the light, a subtle sense of smell with which to breathe in the essence of flowers; muscular thighs with which to grip the flank of the stallion, and fly fast as thought without railway or steam boiler; delicate hands with which to caress the graceful heads of greyhounds, the downy backs of cats and the sleek shoulders of creatures of easy virtue; He accorded to ourselves alone the glorious privilege of drinking without thirst, striking a light, and making love all year round, things which distinguish us from the brute beasts much better than the use of newspapers and the production of legal documents.

My God! what a foolish thing is this supposititious perfectibility of the species with which they are forever dinning our ears! They talk as if man were a machine admitting of improvement, and that a better adjusted cog or better placed counterweight might make him function more easily and conveniently. When science has contrived to offer man a double stomach, so that he can ruminate like a cow; eyes on the far side of his head so that, like Janus, he can see people sticking their tongue out behind his back, and contemplate his indignity in a less embarrassing position than that of the callipygous Venus in Athens; wings implanted in his shoulders so that he need no longer pay six sous to ride in the omnibus; when it has created a new organ; then, then indeed, the word *perfectibility* will begin to mean something. Has anything been done since all this perfecting started, that was not done as well, or better, before the Flood?

[1] Presumably Armand Carrel (1800–36), who was killed in a duel the year after the publication of *Mademoiselle Maupin*; he co-founded the daily *Le National* in 1830.

IB
Responses to Nature

1 Carl Gustav Carus (1789–1869) from *Nine Letters on Landscape Painting*

Born in the year of the French Revolution, Carl Gustav Carus belongs to the later generation of German Romantics. His *Nine Letters on Landscape Painting* succeeds in bringing together the diverse strands of Romantic thought rather than breaking new ground, and provides an eloquent testament to the force and coherence of Romantic conceptions of nature. Carus trained and practised as a doctor and in 1814 was appointed Director of the new Academy for Surgery and Medicine in Dresden. He published extensively throughout his long career, producing two important textbooks on animal anatomy and gynaecology, illustrated with his own engravings. He also wrote on art, psychology and the philosophy of nature. His work as a painter was strongly influenced by his friendship with Caspar David Friedrich, whom he met in 1817, and with whom he went on sketching trips in Saxony and Bohemia. Written in epistolary form, with the letters following the changes of the season, Carus's *Nine Letters on Landscape Painting* set out to show that reflection upon art is not necessarily inimical to artistic creativity and that thought and feeling complement each other. Carus maintains that landscape painting should not be understood as a mere imitation or mirroring of nature as we find it, but is itself the product of the human mind or spirit. The task of the artist is to intensify the observed particular, whereby the divine creativity bodied forth in nature is reflected once again in the creative work of the artist. Originally published as *Neun Briefe über Landschaftsmalerei, geschrieben in den Jahren 1815 bis 1824*, Dresden, 1831, these extracts have been translated for the present volume by Nicholas Walker from the reprinted edition, K. Gerstenberg, ed, Dresden: Wolfgang Jess, 1955, letters I, II, III and V, pp. 17–23, 31–6, 41–4, 46–9, 89–91, 96–7.

Outside the snow flurries ice-cold at my window pane, a profound stillness surrounds me, the room provides a comforting warmth, and the lamp which has been timely lit against the long bleak evenings of early winter sheds its gentle light about me. At such a time as this, indeed, there can be nothing more welcome than to give free play to one's thoughts in the quiet contemplation of artistic objects, little by little to make oneself utterly at home in the realm of the beautiful, thus consigning our dreary days to oblivion and relinquishing all memory of an earlier, more troubled mood. Perhaps then, dear Ernest, you will graciously receive, as ever, the echo of those thoughts my

mind pursued in hours like these, and perhaps you will also find in these commun-
ications the fulfilment of that resolution with which I promised once I should unfold
to you my thoughts upon the meaning and the proper end of art in general, and of
landscape painting in particular. – You may seek in vain here for ordered presentation
and sufficient comprehension in these reflections, and you may regard much of what I
say as grounded in a personal view of things which lacks all confirmation in the minds
of others. Then take these thoughts, to speak with Hamlet, as airy phantoms of the
brain, and show me if you can a straighter and more fruitful path to follow.

I would certainly not wish that you believe, along with many others, that all
investigation into art and beauty, in spoken or in written form, be counted but a
degradation, a desecration even, of the subject, as if it were the case that feeling
merely, and sensation, should here hold sway and thus decide that depth and clarity
can never be conjoined. – For surely man, when he feels at home with himself, always
represents a Unity, and it is only insofar as he manifests himself as a whole that he is
capable of attaining all that is elevated and beautiful; why then should it disturb or
even cool the spirit if it once can clearly grasp what warms our feelings, and how then
could we recognize and inwardly receive in all its depth the beautiful, which in itself is
nothing but a perfected whole (*kosmos*), if not with our whole soul? – Indeed, it is my
sure conviction that all art remains dead and buried for us as long as our sentiments
are inwardly untouched, that the cold calculation of contrasts and concepts of the
understanding can merely give birth to crippled poetry. [. . .] And I also sense that a
truly poetic mood simply represents an elevation of the whole human being and one
which rouses all our spiritual powers; I have likewise grasped the error of those who,
precisely through a very excess of reflection, themselves repudiate reflection in all
matters of art. Hence it is that I no longer shrink from embracing beauty with every
fibre of my soul, that I now experience a real and undiminished poetic delight only
when the work of art conjoins a living summons to our feelings with a clear perception
of inner perfection and a recognition of the artist's purer will. This is a delight which,
grounded as it is in beauty, truth and right, will never weaken with repeated
contemplation of the object, and serves to set the seal of classic standing on the
work of art. Yielding wholly to this inner pleasure, let us therefore freely spread our
thoughts upon the wide and distant fields of beauty; and just as from a mountain peak
we can look down with undiminished pleasure having once traversed the tortuous
valleys down below, and just as, indeed, the impression of the whole is heightened if
we as it were repeat, incorporate the earlier delight we felt at various stages of the way,
just so the train of thought which plays around these objects can also never harm the
living, joyful pleasure that we take in all the wondrous and mysterious effects of art;
and, indeed, just as all genuine study of nature only leads us on towards the thresh-
hold of even greater mysteries, and cannot fail to inspire us all the more greatly with a
sacred awe, so too we may await the very same from an open examination of art. None
the less, it remains true that artists can hardly be blamed for suspiciously resisting the
deal of aesthetic sound and fury so widely to be encountered in books and lectures.

And, my dear Ernest, has that moment of re-creation, that repetition of an eternally
active world-creation, that free production and reproduction of artistic genius, ever
ceased to strike you too as something especially mighty and wonderful? – How
otherwise has man proved capable of creating even the slightest of living products,

and how otherwise has any science ever been led directly to life itself, if not in the first instance through a process of mortification, that is, through analysis? – We analyse and break down the leaf of the plant into its various cells, its respiratory orifices, its vessels and fibres, and the tiniest of creatures teaches us how to separate out the features of comparative anatomy into even smaller shapes and structures, – and yet! Will all this science ever help us to animate the tiniest of mites, or to reconstitute by its means the tiniest leaf of a plant? – And now simply consider the creations of art which although not themselves alive can none the less appear to us like living things, and which, being produced by human beings, testify to the inner affinity between man and the world spirit.

* * *

Thus the creative power of art continues to exercise its effect, and the world, already lying formed as it does before our senses, arises for us anew beneath our own hands. From all her forms and products something always speaks to us, in a wonderful and distinctive language, offers itself to the purpose of the artist. Sun and moon, air and clouds, mountain and valley, trees and flowers, the most varied of creatures, and the even more varied and elevated individuality of mankind appears as if reborn with all their own authentic power over us, awakening now brighter or now gloomier moods within us, but always raising us up far beyond the commonplace through perception of the divine, namely that creative power within man himself. For this is precisely the reason why art appears to us as a mediator of religion, inasmuch as art teaches us to recognize and brings us into closer proximity with the original power and soul of the world, which the weakness of human insight is incapable of grasping in its totality, and does so by presenting us with it in a miniature form, that is within the human spirit itself; and that is also why, on the one hand, the artist must look upon himself as a sacred vessel that must remain unsullied by everything vulgar, impure and commonplace; and, on the other hand, that is also why the work of art must never approach too closely to nature, but must rather elevate itself above her if the creation of the work through the spirit is not to be forgotten and the relationship of art to man himself is not to be lost from sight.

Let us therefore, dear friend, turn now to a closer examination of the purpose and significance of landscape painting in particular. This is an art which indeed properly belongs to the modern age alone, an art which is much less complete as yet and perhaps only now beginning to approach its fullest flowering, whereas most of the other arts rather resemble a Janus-head that is already half-turned towards the past or an intellectual monument to fairer days now presiding over the graves of the past. But every kind of mimetic art necessarily exerts an essentially two-fold effect upon us: in the first instance by virtue of the imitated object, whose distinctive character affects us even as an image in much the same way as it does in nature, and in the second instance by virtue of the fact that the work of art is itself a creation of the human spirit which in truly expressing its own thoughts helps to elevate every other companion spirit beyond the commonplace (much as the world itself can be regarded in a higher sense as an expression of divine thoughts).

Let us initially consider these two effects of landscape painting separately in order to prepare for a final, shared and fruitful result to our enquiry. What then is the actual effect of landscape and its objects in living nature itself? This is the first question to be

asked, before we proceed to enquire further into the effect of the same in visual art: the solid earth, with all of its varied shapes and features like rocks and mountains, valleys and plains, its placid and its rushing waters, the clouds and airy breezes, these are more or less the forms through which the life of the earth reveals itself to us; a life of such immeasurable dimensions in comparison with our own smallness that we human beings are hardly willing or able to regard it as life at all. But then the life of plants seems to stand on a higher level and in much closer proximity to ourselves, and it is this life in its relationship to the aforementioned phenomena which constitutes the distinctive object of the art of landscape. – Now in nature we certainly do not feel ourselves addressed by such phenomena in a passionate or violent manner; they are too remote from us for this, as far as their aesthetic effect is concerned; for it is quite clear that the shipwrecked cannot be expected to appreciate the beauty of the crashing waves, or those fleeing a conflagration to dwell upon the beauty of the resulting illumination. Only what touches us directly, only what is most closely associated with us can immediately excite us so profoundly by all its changing configurations, is capable of filling us with desire or loathing. In that free living nature which appears to us in all its calm objectivity all we perceive is a still and constant life, uniformly turned in upon itself: the changing seasons and hours of the day, the passing train of clouds and all the many-coloured splendours of the sky, the ebb and flow of the sea, the gradual but inexorably sustained transformation of the earth's surface, the weathering of naked rocky peaks, whose grains are washed down and eventually come to form fertile land, the creation of springs and sources which follow the path of mountain chains to become streams and finally rivers, all of this obeys its still and everlasting laws, to whose dominion we ourselves are also subject, laws which carry us away with them however much we strive to resist, which with secret power force us to behold the mighty and even monstrous domain of natural events, and thereby take us out of ourselves, allowing us to experience our own weakness and insignificance; yet the contemplation of these things also serves to calm and quieten our inner storms and inevitably exerts a general pacifying effect upon us. Go up then to the summit of the mountain, look out across all the distant hilly peaks, contemplate the steady progress of the rivers and every splendour that reveals itself to your gaze, and what feeling is it that then seizes hold of you? – There is a quiet sense of devotion within you, you lose yourself in boundless space, your whole being experiences a gentle elevation and purification, your very self vanishes away, you are nothing and God is everything.

* * *

[. . .] Behind and beneath everything which we perceive and conceive, behind and beneath everything that exists and everything that we ourselves are, there lies an everlasting, ultimate and infinite unity. There is a profound and most interior consciousness which, precisely because it provides the original possibility of all knowing, demonstrating and explaining, can itself never be explained or demonstrated (just as the proposition a = a is insusceptible to further demonstration but merely represents something which must be recognized as valid in and for itself); and it is this consciousness which provides the firm conviction of such unity in a more or less clear or obscure manner according to the level of development we have attained. Language endeavours to express this immeasurably great dimension with the word: 'God'. – This ultimate dimension is revealed to us inwardly as Reason and outwardly

as Nature, but we also feel ourselves to be a part of this revelation, as creatures of reason and nature ourselves, and thus also as totalities which bear reason and nature within us, and to that degree we also partake of the divine. Thus the possibility of pursuing a two-fold path is opened up within the higher regions of our spiritual life: either we can strive to lead the infinite variety of reason and nature back to the original and divine unity, or we can allow the self to become productive in its own right and thus present this inner unity through external variety itself. In the latter case we require a skilful act of doing [*können*], in the former we require an act of knowing [*erkennen*]. Knowing gives rise to science as an organized body of knowledge, doing or making gives rise to art. In science man feels himself to be in God, in art he feels God to be in himself. – Thus art certainly cannot be elevated above science, since the latter clearly remains the sublime path which leads mankind into the region of highest unity; but it is also clear that science, as a path directly opposed to that of art, transcends all individual existence, mortifies the body that the spirit may live, and is fully justified in its efforts to do so, as I have already remarked above. Doubtless you will counter me here with evidence of the actual creation of a scientific body of doctrine in order to demonstrate that science too must produce and form itself externally; but this fact does not need to be adduced here precisely because such creative activity belongs no longer to science but to art. For it is only in this way that man can reveal himself as a totality, and although art and science can be separated from one another in analysis, they can never be wholly separated from one another in actuality. The presentation of science can therefore never succeed without art (without the skilful organization of thoughts and words), and the production of the work of art will equally remain impossible without science (as skill without knowledge).

It will be even easier, as I believe, for us to reach agreement on the second issue raised by your remarks. I have indeed claimed that man, in beholding the entire magnitude of nature in all her splendour, becomes aware of his own littleness and insignificance, and further that man, in sensing everything immediately within God, thereby enters into this infinite totality himself, entirely relinquishing, as it were, his individual existence, but I do not believe I have thereby said anything other than what you yourself intended; for there is no loss in such absorption, there is only increase, and what was formerly contemplated in a purely spiritual manner, namely our conviction of unity in the infinite All, is here almost brought directly before the natural eye; thus it is that our distinctive standpoint, our own relation to nature, will have to be grasped in an ever purer fashion.

* * *

That mere truth alone does not yet constitute the really highest achievement of painting, does not yet constitute that which alone draws us to this art, can most easily be seen simply by comparing painting with a mirror image of nature. Attempt this experiment but once, and behold the natural landscape in a mirror! You will see her reflected there with all her many charms, all her various colours and forms, but if you concentrate carefully upon this mirror image, and compare it with that impression which the landscape depicted in an accomplished work of art has already vouchsafed to you, what then do you notice? – Obviously that the latter is infinitely more remote from the former as regards the truth; the appeal of beautiful natural phenomena, the brilliance of natural colours, all of this is barely even half-captured in the painted

image; and yet at the same time you really do perceive the genuine work of art as a totality, as a world in little (as a microcosm) in and for itself; the mirror image, on the other hand, will always appear as nothing but a kind of individual sample, a single aspect of nature in her infinite wealth, rudely torn from its original organic connections and artificially compressed within unnatural limits; unlike the work of art, it will not appear as the intrinsically self-contained creation of a spiritual power which is essentially related to ourselves, which calls out for us to embrace it, but rather simply as one individual note out of an infinite harmony, as something isolated which, insofar as it always increasingly demands to be supplemented by other things, can never procure for us that total inner contentment which arises partly from our free and uninhibited exposure to nature herself, and partly from the contemplation of a genuine work of art.

Insofar as our preceding discussion has manifestly revealed that truth in landscape painting does not of itself procure the full satisfaction we have been seeking, it has become clear that in addition we still require what I already demanded of every work of art in my opening letter, namely that we are actually able to feel that the work of art owes its existence to the creative power of the human spirit, and consequently that the work of art, having itself emerged from a unified totality, represents an intrinsically developed and self-contained, and as it were organic, whole. If this is conceded, then it must also further be the case, given that the soul creating the work can only be conceived of in a certain state, in a certain attitude, that the work of art itself should also necessarily express a certain state. This in turn can only transpire in the art of landscape insofar as the landscape in question is perceived and represented from a certain aspect which is congruent with that inner mood. This leads us further still. For since this sense for things can only be expressed through the representation of objects, and since the expression of this sense also intrinsically involves the appropriate choice of depicted objects in the first place ... we can now formulate the principal task of landscape painting more precisely as follows:

It is the representation of a certain mood of our affective life (a certain sense) through the reproduction of a corresponding mood in the life of nature (truth).

Above all I cannot conceal how wondrously surprised I was when I finally realized that whereas earlier and ancient times were so highly gifted in many arts and sciences, they nevertheless produced nothing at all in the field of landscape painting proper, and would merely mention here that, on the contrary, this art only emerged at the beginning of the seventeenth century, and did so at a stroke, like Minerva from the brows of Jove, quite without older models and in total independence. – How could it be, I asked myself, that the Greeks, who felt and brought forth such free, pure and magnificent examples of architecture, sculpture and poetry, should have had no sense or inclination for the imitation of natural landscape? And is it perhaps possible to discover any reasons which would clearly reveal to us why they were actually incapable of entertaining such an inclination? – The answer to this question long remained shrouded in mystery until at last understanding seemed to dawn upon me in the following manner. – For when we look back upon earlier states and conditions of the human race, we find ourselves compelled, for the most part, to apply a criterion drawn

from the development of a single individual human life, which is all we can properly have direct experience of. Now if we do so with regard to the problem in question, we cannot fail to remark that in our early youth we are always oriented in the first instance to the perception of human things; the sky and the earth, the plants and animals, initially concern us only in relation to our own human states and conditions. Man feels an active power within himself, the whole of nature lies before him as a potential element for him to form and shape, and he cannot help but regard her in the first instance solely as material for his purposes. Thus in the very beginning he can hardly recognize any other object of aspiration and imagination than man himself and his manifold states and conditions, and indeed he feels compelled by the vivid force of phantasy to ascribe a human individuality even to lifeless things, and further to divine things as well. [...]

As far as the proper art of landscape is concerned this clearly presupposes a higher level of culture and experience. It requires a certain power of abstraction and self-renunciation in order freely to recognize the external world, formerly regarded simply as an element for our own activity, now as something which is also beautiful and sublime in its own right; it requires a certain level of philosophical development to perceive, or at least to intimate, that the entire manifestation of nature represents the revelation of a single infinitely sublime divinity, one which cannot simply be reduced to the human and is indeed inaccessible to the senses; specifically to recognize therefore this elevated beauty in its own right within the totality of the world in general and in those parts of it perceptible to ourselves, and to make it the very end and object of artistic imitation. In short, what is here required is that man must utterly relinquish the egoistic tendency to relate the entirety of nature to himself alone, and must rather open himself to the pure intuition of the beauty of the world as a whole. It is therefore only from such an attitude as this (whether it exists as a clear consciousness or merely as an obscure presentiment within the artist) that the art of landscape proper could arise. Man had first to recognize the divinity of nature as the authentic bodily revelation of God, or expressed in human terms, as the language of God, man had first to learn this language, had first to learn how to experience according to the proper sense of nature (for there can be no question of dead reproduction here, as our example of the mirror-image revealed), before he was able, at last, to proclaim the worldly gospel of art to mankind in this very language (and to do so, as is properly said of poets in this regard, with the tongues of angels).

2 Joseph Mallord William Turner (1775–1851) on Colour

Born into an artisanal milieu in London (his father was a hairdresser, and his childhood works were displayed in the shop window), Turner achieved early success as an artist at the Royal Academy schools. He was elected a full member in 1802 and Professor of Perspective in 1807. Described by Constable as possessing 'a wonderful breadth of mind', Turner was widely read in the theory of art. What he did not have however, was the facility for expressing his ideas in words. His lectures were difficult to understand, and scholars have found his notes nearly unintelligible. Turner gave his lectures twelve times between 1811 and 1828, and the course usually consisted of six lectures. Only one, from 1811,

has been published in full. The present notes are from additions made by Turner in 1818 to the fifth lecture, on colour in painting. In the Academic tradition, colour had been subordinate to drawing. Only with scientific developments at the end of the eighteenth century did colour come to be seen as a serious and sytematic issue in the teaching of art, and a proper subject of aesthetic reflection. In his lecture notes Turner argues, through a discussion of Titian and other Old Masters, that colour *is* a matter for systematic study, but on the other hand that the final effect *cannot* be calculated in advance. Quality of effect, in the last instance, is down to the imaginative genius of the artist. The present text was clarified from Turner's manuscript by John Gage and first published by him as Part C of Appendix II to his *Colour in Turner*, London: Studio Vista, 1969, pp. 202–9. Internal editorial marks are Gage's. Turner's idiosyncracies of syntax and spelling have been retained.

Of combinations, or what may be considered as such, uniformity holds the highest class to the guidance of rules, as the lowest to those of lines; and by their joint informing only, can the hope of speculating upon colour be tolerated, as has been emphatically said of the material colour. If we mix two, we reduce the purity of the first; a third impairs that purity still more; and all beyond is monotony, discord and mud; or, as Sir Joshua [Reynolds] says, practice must in some cases precede theory. If not, too much time would be lost to obtain that theory, which would arrive too late for practice. If Titian chose rightly in his third style of colouring, the uniform breadth or commixture takes the higher rank, supported by his matured judgement thro all the glowing brilliance of combinations full, deep, rich, pure, colouring which only [he] himself had the hardihood to condemn; tho the worldly admiration of the former style still feels disposed to hold in the balance his opinion with his practice. *Can* breadth of tone constitute *all* the requisites to produce style? Undoubtedly it is a great portion of the characteristics of each master as well as *school* of art, but it cannot be *all* without excluding *all* whose works do not posess this excellency. And tho it marks a considerable enlargement of practical powers, in evincing the very nice distinction between uniformity and monotony, breadth of tone, corruption of colour, baldness and insipidity, [yet] *chiaroscuro* [and] *colour must* exist in *all*; and the divisions of each master would be as numerous as [the] primitives in class, [just] as our former [?] one and three [?] combinations would, of course, as they proceeded towards this breadth, take precedence, by quantities in one class, quality in another.

Rembrandt and Van Goyen both possess uniformity and breadth of tone; but no person conversant with technicalities would call them similar. Breadth, therefore, becomes like all other elementary principles: relative and comparative; and tho using it constantly as [the] explicative or principle characteristic of style, tone cannot be wholly removed from its quality of elementary induction of rules. As to quantity, simple light and shade has its first reflexes, [which] break upon it; refraction returns, changing shadows positive into shadows negative, shade on to shade, to the very verge of its existence. This is the arrangement of the *St Peter Martyr* possessing only continued, diagonally placed *waved lines*, which Lomazzo calls serpent-like, reared into form by their continued and obliquely undeterminable lines, passing through to the top of the picture as trees, undeterminable of attitude, but by the extreme lines carrying the eye towards infinitude *opposite distinct proportion* [struck by T.] by the definite proportions of architectural columns, which carry always the

associated notion of their diameter and [the] proportionate height of the entablature, and brings down or checks by the known right angle of the entablature (continuity of line). And no line is allowed to interrupt that sentiment of continuity. The companion picture, mistaking the P. of painting, is of architect. lines dividing the picture vertically and placed angularly. [In the *S. Peter Martyr*] the sublimity of the other arrangements of lines, by its unshackled obliquity and waved lines, obtains the associated feelings of force [and] continuity, that rushes like *the ignited spark* from earth towards heaven, struggling as the ascending rocket with the elements, and when no more propelled by the force, it scatters round its falling embers, seeking again its earthly bourne, while diffusing around its living radiance, as the descending cherub with the palm of beatitude sheds the mellow glow of gold through the dark embrowned foliage, to the dying martyr. Thus we are presented with the two great divisions of breadth [and] light and darkness, pictorial imp...to be qualified by Chiaroscuro; and if they must be weighed in the balance, who will dare hold the beam, farther than comparative[ly], and by [thinking that] what has been done may be done again, by quantity? But where shall we find the rules, the proportion of weight or measure, of the other requisite: *quality*: the $\frac{1}{8}$ of light in Rembrandt, the decimal of Rubens, or the magnitudes of Correggio? And who will say their respective qualities, tho attached, dwelt [?and] rely'd upon the lines in the space and forms, as to quantity, [which] *exist*, were *created*, are *evinced*, are their respective [?] styles, [and] constitute solely the whole of their works, by portioning out this quantity? Or that the followers [or] imitators, the prop... only the quantity of Correggio's *Notte*, the quantity of Guido's *Aurora*, or even the lines of the *Three Trees* of Rembrandt, would give their qualities? If so, Domenichino's repetition of Titian's *St Peter Martyr* would not have lingered at Florence [*sc.* Bologna?] with the immoveable fresco of Andrea del Sarto, or, to come nearer home, without the qualities of art which the lost pictures of Sir Joshua at the fire at Belvoir Castle possessed of their own, wrought from his own mine, his own comprehensive power, the quantities, or approach towards the quantity of light and shade of Correggio's *Notte* would have availed but little. The recipe of Carracci cannot [?] tell us [] as in that style [it] may be concurred [with], but to execute it is quite another thing. Opie has said that the picture of the 3 Maries...[has a] union of powers so gigantic in conception, [that] if they had been fully substantiated, the great powers of the Roman school would have sunk into comparative obscurity with the powerful Carracci; [and] that the *Transfiguration* of Raphael would partake more of M.A. [] chiaroscuro, to imitate M.A. in design, Titian in colour, Coreggio in force, that the Raffael in expression.

Thus for style, and if breadth is to be considered as style, or its part, and $\frac{1}{8}$ of light a decimal or a magnitude, work them by the lesser means, use them by the greater, [and] their products are *two*. Force them down to rules, [and] they rise by combination, each a product of combination relatively to its union, comparative[ly] to its amalgamation. Might not the lesser truth, *rules* pervade, so rigidly enforced upon *style*?

Thus having, I trust, detailed the value short of colouring or sentiment – tho used by Akenside – allowable to lines, or at least geometric qualities, if not the generic power of lines distinguishable from those used as the means of obtaining the stereography of planes, their positions and situations as mere vehicles of light, shade and

colours; I shall therefore consider them as to their respective values in their common acceptation, to produce combinations constitutive of chiaroscuro, and, lastly, of colours. The greater truth to define breadth of style brings down the terribilita [?] of Michel Angelo, the plafonds, [the] deities of art, the prophets and sybils of the Sistina, to magnitudes. Would they become the magnitudes of Correggio's breadth; would the Aurora and the Horses of the Sun by Julio assimilate [breadth], as they do in subjects? Might they possibly be united; might [they] possibly, if so, improved as to style, [which] might render one more aerial [?], [or] might possibly decimate each other by decimals of breadth. Increase the $\frac{1}{8}$ of Rembrandt and we have de Koning [?Koninck]; reduce the $\frac{1}{8}$ to $\frac{1}{16}$, [and] the candle-light of Schalken gleams. Where then are the boundaries? *None.* Why then can rules, enclosing [?] round these constellations of art, receive light from them to show their value by reflexes, as in polished bodies? The principal receives the secondary, and gives it again in concentrated light; why then can rules not be content to be received and acknowledged by their respective styles? Such are ungrateful [who] try to pierce

> *That solemn majesty, that soft repose*
> *Dear to the curious eye, and only found*
> *Where some few objects fill an ample ground.*
> [Du Fresnoy, *De Arte Graphica*]

or will essays its power, its limitations of breadths of shade as [of] extinction of light. It risks *extinction* of its light, expelled by style, and her breadths weakened by extension [?] It has no resting place; it must fly towards *Uriel* [?] in the *sun*, or, plunged into shade, half flying, half on foot

> *it plunges into the abyss of darkness*
> *plumb down it drops, till some opposing and refracting*

Plane sends it has [*sic*] many lines aloft.

This leads me to the uniform tone or breadths of colour considered in practice amenable only to common light and shade, and aerial qualities which are so but by convenience, tho alas too often by caprice. These are backgrounds, too often sacrificed [?] to fill a space, which might as well be occupied by any thing else – or, in better terms, a space to be filled. There are many opinions of the subject, but one I will mention: space would be easily attained if emptiness could give it, or the anecdote of Rubens.

Thus from great opinions, as well as works, the use and effect of this most difficult appendage called background, one uniform breadth of coloured shade, and misapplication of *incongruity* [struck by T.] means calculated for other purposes become so obviously at variance with common nature as to require some distinction for the other arrangements of elementary principles, and for action. But it is to these subductions of the causes and principles and laws of light *and aerial* [perspective] [struck by T.] that we must place the neglect or evasion of at least arial combinations and thin gradations of colouring, tone and feeling, bartered for shadows but to relieve, and colours to excite,

fair
As full with front in all the blaze of light,
The hero of the piece should meet the sight.

This rule as enforced by Fresnoy belongs, says Sir Joshua, to the art in its infant state; for the more advanced know that such an apparent artificial arrangement would be for that reason [in-] artificial; and we still should lose

That solemn majesty, that soft repose,
Dear to the curious eye, and only found
Where few fair objects fill an ample ground.

But rules of light and shadow, however enforced by practice, should have some general principle educed from, or countenanced [by] nature, the lap of truth and natural phenomena. Artificial phenomena can always be constrained [?countenanced] by some arrangement, works or theory, as midnight shadow or meridian glow; or breadth of shade pass[ing] in [-to] breadth of light; or [as] Correggio amply *lights*, and round them brings gentle shades mingling. And tho the mechanical exactitude [of] the $\frac{1}{8}$ of light to shadow as in Rembrandt, or the more extended amplitude as in Rubens, [or] the concentrated light, as in the Notte of Correggio may be portioned out; without *this* combination and endless modification of tones and affinities, arriving [*sc.* deriving] from chiaroscuro, *through colours and coloured lights and shades* [struck by T.], one produces breadth, [and] the use of the other, contrast. When would the labours of building up a theory for either *end*, but at the confines of shade and the approach of colour?

Colour, the use of which aids, exalts, and in the union with lights and shadows, makes a whole *when harmonious* [struck by T.]; or debases, distracts breadth and produces glaring inconsistencies.

Colours are as primitives deductable [? from white light] in succession by the prism and the incidental ray of light; and tho qualities of sentiment have been attempted, they must be left with those who framed them; and it must be admitted that [although] such have regulated some theorists, and formed their characteristic systems of pure colour and arrangements, still, upon further inquiry, it would be found that form contributed mostly to the character of each master, and colour to that of the different schools. And of the practice of these sentiments of colour, particularly in those who follow colour as sentiment, such as glory: yellow; blue: duty; red: power, as primitives; authority: purple; green: servitude, as compounds; they must be left with those who framed them as emblematical concepts [?] and typical allusions.

But as to tone or strength, comparatively *red* possesses the utmost power of attracting vision, it being the first ray of light and the first which acknowledges [?] the diminishing of light, tho it is a shade to yellow, as blue is to red. Thus far as [to] primitive strengths; and in arial [perspective] yellow would be medium, red material, blue distance. White in [the] prismatic order, [as] in the rainbow, is the union or compound [of] light, as daylight; while the commixture of our material *colours* becomes the opposite, darkness.

Light is therefore colour, and shadow the privation of it by the removal of these rays of colour, or subduction of power; and these are to be found throughout nature in the ruling principles of diurnal variations. The *crimsoned morn* [struck by T. and 'grey dawn' substituted], the *golden* sun rise and red departing ray, in ever changing combination, are constantly found to be by subduction or inversion [?] of [the] rays or their tangents. These are the pure combinations [of] aerial colours; the dense material of white [the] *adventitious* or pictorial means, *the means* of the gradation of colours. Hence arises the quality of its force, and each becomes a light and [a] shadow of its own power, comparative to the means; and thence opens an immense field of combinations of the primitive and comparative. Thence it proceeds to the combinations of the dense material colour and the [pictorial] means [of expressing colour]. White [is] the substitute of light, as it is the compound in aerial light; the very inverse of colourable materials mixed produces strength or weakness, lightness or, [when] equal each to each, the destruction of colour: to one the tone of colour, [to the other], corruption of colour. The science of art and her combinations [is] colouring, not colour. And here we are left by theory, and where we ought to be left, for the working of genius or the exercise of talent.

Here begins the ornamental style and the severe [?] *the tone of Lombardy* [struck by T.]. The embrowned, the gloom, is [the] medium of the Dutch school; the glow, of the Venetian as to tone; the depth, of the Bolognese school [*margin*: character of each school]; and these tones are upon the same principles of nature, white being the light of the cold, yellow of the *embrowned* [struck by T.] warm scale. Thus the light of the St Pt Martyr is white to the breadth or key note, blue, [and is] widely diffused over the picture as clouds upon a clear sky, contrasted with dark umber trees. [The picture] has its deepest shadows with a deep blue, which serves as the breadth of shade, and low sunk horizon.

[In] the *Marriage of Cana* by Veronese, *white*, greys and a faint medium of the yellow, with a blue sky, for the breadths of the half-tints and the lights. The colours of the figures are its shadows by contrast, [and] collectively its breadth [is] pure; tho gay, [it is] full of power. And thus the St Mark, *so called* [struck by T.] by Tintoretto is buoyant by [the] apposition of forcible combinations, [just] as comparatively it is the lightest as to degrees of *force* and execution.

Thus likewise from the [?] the golden light and embrowned medium, tho they are both nearer and [have a] stronger quality of approach to vision in this class of degrees of strength, [in] this, blue and white, or in the former, of aerial lights, yet they are constrained to become mediums or gradations, by blue in its comparative degree of parity of light and shadow. And shadow becomes black by possessing least [*sic*] reflexes than the other colours; yet these, following as to their comparative force with blue, would create gradation of force by the more forcible [colours]. They are the near tones of dark yellow, and dark are [*sic*] expelled. This, if I may be allowed, is the scale of its powers. This is the whirlwind that sweeps the foreground, with the bright flash of polished steel and iron armour, the compelling power of colours used as shade to light, that wrought the whole to harmony.

This power is in contrary distinction to the chiaroscuro of the Bolognese School, whose colours are primitives of light by contrast of shade, not only of their own, but by the medium of half tone. [It] is shadow by the medium of reflexes, thus producing

concentration of colours and of lights by shade, while [?] in the former school, light by breadth appears *spread over the whole* (light by opposition of colours of bleak purity); [and] by colour; that which in power becomes purities and degrees of their own, [in] force [is] considered as shadow effected.

Thus in the concentration of lights of Correggio, the white is this means. Thus the yellow is [?has] the scale of its tones from red to brown and blue; and hence those midnight shadows become toned or tinged with other primitives, or admitted pure as means of *contrasts*.

In the ornamental or the more widely diffused style of Rubens, we still find it as an auxiliary of light and power in contrast, [or] shade and force of colours as to shadows; and its broken or grey mediums keeping up the balance against the warm colours, and enabling him to use white as a colour in scale, and [the] scale of the other combinations, [the] combination of lights never [or] seldom appearing as his object.

To these primitives, or arrangements to produce combinations of them, whether used separately by some and counteracted by others, or made to unite and harmonize by the united efforts of light and shade, and of shadows as to their powers, and by reflexes used respectively as colours as well as the light and shade of colours, there is another combination of colouring [to be added], viz. the union of the many to produce the general tone, perhaps better called the combination of colour, [and] sometimes called historic tone. The corruption of colours, in as much as the one is [the] means used, [or] sought for, [is] positively indefinable.

This tone denies to theory the least indulgence. It is here referred to inferences only of what may yet be done. Theory can only refer instruction to informers by what has been done; by some having been more fortunate in combinations of colouring than others. Thus the sepulchral darkness in the *Raising of Lazarus* by Domenichino [*sc.* Guercino]; the glowing [?] brown sepulchral darkness in the *Crucifixion* of Tintoretto; [and] the lurid gloom of [?] the pale gleaming light of Rembrandt, upon the cross and dying Saviour, enwrapped with coloured shade as indescribable in tone as evanescent twilight.

[In] the *Mount of Olives* by Correggio, that immeasurable tone which pervades over 2 thirds of the picture; or the tone of the *Deluge* by Poussin, carrying along earth, perishable materials, under one lurid, watery, subjugated interval of light, that sets aside all comparative theory, however obtained; tho drawn from nature and her effects, these are the materials and instruments of [our] representations and our perceptions. 'Tis here that aerial perspective has her limits; and if theory dared to stipulate for aerial hues, peculiar colours or tones of colour, she would here step to self-destruction. It is here the utmost range of art that should tell. [The] imagination of the artist dwells *enthroned* in his own recess [and] must be incomprehensible as from darkness; and even words fall short of illustration, or become illusory of pictorial appreciations. Akenside terms it the high born soul [which] should not descend to any humble quarry. For amid

> The various forms which this full world presents
> Like rivals to his choice, what human breast
> E'er doubts, before the transient and minute,
> To prize the vast, the stable, the sublime.

Nature and her effects are the materials offered to our pattern of imitation with the combinations of the science of art which we received [?]; which tho asserted in the commencement by theory, here fall far short of perception, and invention and practice, and the uppermost range of art. And in the science of colour, if she were to stipulate for hues and tones of colour beyond mechanical principles, she would step to self destruction; for recipes of colour would but extend mediocrity, and such practice could but generate manner instead of style. Nature and her effects are every day offered to our choice of imitation, to be collated with the science of art, and united by theory to practical inference. [As to] rules, here, in the uppermost range of art, perception ventures not beyond mechanical principles. These are the double affinities by which every one works in his own way; but Scylla and Charybdis lie [?] in the path; the little more, or less; the ridiculous, or sublime. Recipes for colouring or [the] quantum of light and shade could but extend into mediocrity, and general practice into manner instead of purity of style.

3 William Hazlitt (1778–1830) 'On the Picturesque and the Ideal, a Fragment'

Hazlitt was caught up in the legacy of the French Revolution. Questions of democracy, authority and the popular will informed his political writings, as he strove to counter 'the old, obscene, drivelling prejudices of superstition and tyranny'. In the field of art these sentiments associated him with the move away from the authority of the classical canon, as it was enshrined in the Academies. However, in common with others such as Wordsworth and Constable, Hazlitt was also becoming sceptical of the eighteenth-century fashion for the Sublime. In the present essay, which he himself subtitled 'A Fragment', Hazlitt tackles a distinction which had exercised many since the Enlightenment, and was to remain a preoccupation of the Romantic movement: the distinction between that which is striking for its exaggeration, its peculiarity, its excess; and that which impresses itself by its wholeness, its proportion and its harmony. Both have their place in art. But Hazlitt finally, and despite his antipathy to the canonical, values the Ideal the higher. Originally published in Hazlitt's *Table Talk* in 1821–2, the present extracts are taken from the Everyman edition, London: J. M. Dent, 1908, pp. 317–21.

The natural in visible objects is whatever is ordinarily presented to the senses: the picturesque is that which stands out, and catches the attention by some striking peculiarity: the *ideal* is that which answers to the preconceived imagination and appetite in the mind for love and beauty. The picturesque depends chiefly on the principle of discrimination or contrast; the *ideal* on harmony and continuity of effect: the one surprises, the other satisfies the mind; the one starts off from a given point, the other reposes on itself; the one is determined by an excess of form, the other by a concentration of feeling.

The picturesque may be considered as something like an excrescence on the face of nature. It runs imperceptibly into the fantastical and grotesque. Fairies and satyrs are picturesque; but they are scarcely *ideal*. They are an extreme and unique conception of a certain thing, but not of what the mind delights in, or broods fondly over. The image created by the artist's hand is not moulded and fashioned by the love of good

and yearning after grace and beauty, but rather the contrary: that is, they are ideal deformity, not ideal beauty. Rubens was perhaps the most picturesque of painters; but he was almost the least *ideal*. So Rembrandt was (out of sight) the most picturesque of colourists; as Correggio was the most *ideal*. In other words, his composition of light and shade is more a whole, more in unison, more blended into the same harmonious feeling than Rembrandt's, who staggers by contrast, but does not soothe by gradation. Correggio's forms, indeed, had a picturesque air; for they often incline (even when most beautiful) to the quaintness of caricature. Vandyke, I think, was at once the least picturesque and least *ideal* of all the great painters. He was purely natural, and neither selected from outward forms nor added any thing from his own mind. He owes every thing to perfect truth, clearness, and transparency; and though his productions certainly arrest the eye, and strike in a room full of pictures, it is from the contrast they present to other pictures, and from being stripped quite naked of all artificial advantages. They strike almost as a piece of white paper would, hung up in the same situation. – I began with saying that whatever stands out from a given line, and as it were projects upon the eye, is picturesque; and this holds true (comparatively) in form and colour. A rough terrier-dog, with the hair bristled and matted together, is picturesque. As we say, there is a decided character in it, a marked determination to an extreme point. A shock-dog is odd and disagreeable, but there is nothing pictur-esque in its appearance: it is a mere mass of flimsy confusion. A goat with projecting horns and pendent beard is a picturesque animal: a sheep is not. A horse is only picturesque from opposition of colour; as in Mr. Northcote's study of Gadshill, where the white horse's head coming against the dark scowling face of the man makes as fine a contrast as can be imagined. An old stump of a tree with rugged bark, and one or two straggling branches, a little stunted hedge-row line, marking the boundary of the horizon, a stubble-field, a winding path, a rock seen against the sky, are picturesque, because they have all of them prominence and a distinctive character of their own. They are not objects (to borrow Shakespeare's phrase) 'of no mark or likelihood.' A country may be beautiful, romantic, or sublime, without being picturesque. The Lakes in the North of England are not picturesque, though certainly the most interesting sight in this country. To be a subject for painting, a prospect must present sharp striking points of view or singular forms, or one object must relieve and set off another. There must be distinct stages and salient points for the eye to rest upon or start from, in its progress over the expanse before it. The distance of a landscape will oftentimes look flat or heavy, that the trunk of a tree or a ruin in the foreground would immediately throw into perspective and turn to air. Rembrandt's landscapes are the least picturesque in the world, except from the strait lines and sharp angles, the deep incision and dragging of his pencil, like a harrow over the ground, and the broad contrast of earth and sky. Earth, in his copies, is rough and hairy; and Pan has struck his hoof against it! – A camel is a picturesque ornament in a landscape or history-piece. This is not merely from its romantic and oriental character; for an elephant has not the same effect, and if introduced as a necessary appendage, is also an unwieldy incumbrance. A negro's head in a group is picturesque from contrast: so are the spots on a panther's hide. This was the principle that Paul Veronese went upon, who said the rule for composition was *black upon white, and white upon black*. He was a pretty good judge. His celebrated picture of the Marriage of Cana is in all likelihood the

completest piece of workmanship extant in the art. When I saw it, it nearly covered one side of a large room in the Louvre (being itself forty feet by twenty) – and it seemed as if that side of the apartment was thrown open, and you looked out at the open sky, at buildings, marble pillars, galleries with people in them, emperors, female slaves, Turks, negroes, musicians, all the famous painters of the time, the tables loaded with viands, goblets, and dogs under them – a sparkling, overwhelming confusion, a bright, unexpected reality – the only fault you could find was that no miracle was going on in the faces of the spectators: the only miracle there was the picture itself! [. . .]

I imagine that Rubens's landscapes are picturesque: Claude's are *ideal*. Rubens is always in extremes: Claude in the middle. Rubens carries some one peculiar quality or feature of nature to the utmost verge of probability: Claude balances and harmonizes different forms and masses with laboured delicacy, so that nothing falls short, no one thing overpowers another. Rainbows, showers, partial gleams of sunshine, moon-light, are the means with which Rubens produces his most gorgeous and enchanting effects: there are neither rainbows, nor showers, nor sudden bursts of sunshine, nor glittering moon-beams in Claude. He is all softness and proportion; the other is all spirit and brilliant excess. The two sides (for example) of one of Claude's landscapes balance one another, as in a scale of beauty: in Rubens the several objects are grouped and thrown together with capricious wantonness. Claude has more repose: Rubens more gaiety and extravagance. And here it might be asked, Is a rainbow a picturesque or an *ideal* object? It seems to me to be both. It is an accident in nature; but it is an inmate of the fancy. It startles and surprises the sense, but it soothes and tranquillizes the spirit. It makes the eye glisten to behold it, but the mind turns to it long after it has faded from its place in the sky. It has both properties then of giving an extraordinary impulse to the mind by the singularity of its appearance, and of riveting the imagination by its intense beauty. [. . .]

A number of sheep coming to a pool of water to drink, with shady trees in the back-ground, the rest of the flock following them, and the shepherd and his dog left carelessly behind, is surely the *ideal* in landscape-composition, if the *ideal* has its source in the interest excited by a subject, in its power of drawing the affections after it linked in a golden chain, and in the desire of the mind to dwell on it for ever. The *ideal*, in a word, is the height of the pleasing, that which satisfies and accords with the inmost longing of the soul: the picturesque is merely a sharper and bolder impression of reality. [. . .]

The individual, the characteristic in painting, is that *which is* in a marked manner – the *ideal* is that which we wish any thing to be, and to contemplate without measure and without end. The first is truth, the last is good. The one appeals to the sense and understanding, the other to the will and the affections. The truly beautiful and grand attracts the mind to it by instinctive harmony, is absorbed in it, and nothing can ever part them afterwards. Look at a Madonna of Raphael's: what gives the *ideal* character to the expression, – the insatiable purpose of the soul, or its measureless content in the object of its contemplation? A portrait of Vandyke's is mere indifference and still-life in the comparison: it has not in it the principle of growing and still unsatisfied desire. In the *ideal* there is no fixed stint or limit but the limit of possibility: it is the infinite with respect to human capacities and wishes. Love is for this reason an *ideal* passion.

We give to it our all of hope, of fear, of present enjoyment, and stake our last chance of happiness wilfully and desperately upon it.

4 John Constable (1776–1837) Four Letters to John Fisher

These letters were written during a period when the painter was working on a sequence of substantial landscapes of English scenery – the six-foot canvases referred to in the second letter. They were transcribed and published by C.R. Leslie in his *Memoirs of the Life of John Constable*, London, first edition 1843, second and expanded edition 1845. John Fisher was Archdeacon of Salisbury Cathedral and a constant friend and confidant to Constable on the subject of his art. The letters testify to the painter's governing interests: in the legacy of the French and Dutch landscape painting of the seventeenth century; in the close empirical observation of familiar scenes; and in the possibility of reconciliation of the two in an ambitious form of naturalistic art. In the final letter he refers to the recent exhibition of three of his pictures at the Salon in Paris, among them *The Hay Wain* ('The Waggon'), completed earlier that year. An acquaintance recently returned from Paris wrote to say that Constable's pictures had 'created a division in the school of landscape painters of France. You are accused of carelessness by those who acknowledge the truth of your effect; and the freshness of your pictures has taught them that though your means may not be essential, your end must be to produce an imitation of nature, and the next exhibition in Paris will teem with your imitators...' (cited in the *Memoirs*, p. 144). Delacroix was among those who acknowledged the originality of the English painter's technique. The effect of his work was to be particularly pronounced among members of the Barbizon school. Constable's dealer declined to sell *The Hay Wain* in Paris and it finally entered the collection of the National Gallery in London in 1886. The following excerpts are taken from the second edition of the *Memoirs*, 1845, pp. 90–3, 142–3 and 145–6.

Hampstead, September 20th, 1821

My dear Fisher, How much I should like to come to you! and I cannot say I will not, but I fear I must go into Suffolk soon, on account of a job. I have made some studies, carried farther than any I have done before; particularly a highly elegant group of trees (ashes, elms, and oaks), which will be of as much service to me as if I had bought the field and hedge row which contain them; I have likewise made many skies and effects; we have had noble clouds and effects of light and dark and colour, as is always the case in such seasons as the present. The great Claude does not come to the Academy this year (a young lady is copying it), but they expect it next year, and it would have been madness for me to have meddled with it this season, as I am now behindhand with the bridge. The beautiful Ruysdael, 'The Windmill' which we admired, is at the Gallery. I trust I shall be able to procure a memorandum of it; and there is a noble N. Poussin at the Academy, a solemn, deep, still summer's noon, with large umbrageous trees, and a man washing his feet at a fountain near them. Through the breaks in the trees are mountains, and the clouds collecting about them with the most enchanting effects possible. It cannot be too much to say that this

landscape is full of religious and moral feeling. It is not large, about three and a half feet, and I should like to, and will, if possible, possess a fac-simile of it. I must make time. If I cannot come to you, I will send you the results of this summer's study. My wife and children are well, we have not had an hour's illness all the summer.

Fisher wrote on September 26th 1821 to say that he had defended the extensive sky in one of Constable's paintings against 'a grand critical party', and that he had silenced them by referring to prints of works by the Dutch painters Wouvermans and Van der Neer. In the same letter he reported on a recent day's fishing in the New Forest when he had been as happy as when he was 'a careless boy'. Constable responded.

Hampstead, October 23rd, 1821

...My dear Fisher, I am most anxious to get into my London painting-room, for I do not consider myself at work unless I am before a six-foot canvass. I have done a good deal of skying, for I am determined to conquer all difficulties, and that among the rest. And now talking of skies, it is amusing to us to see how admirably you fight my battles; you certainly take the best possible ground for getting your friend out of a scrape (the example of the old masters). That landscape painter who does not make his skies a very material part of his composition, neglects to avail himself of one of his greatest aids. Sir Joshua Reynolds, speaking of the landscapes of Titian, of Salvator, and of Claude, says: 'Even their *skies* seem to sympathize with their subjects'. I have often been advised to consider my sky as '*a white sheet thrown behind the objects*'. Certainly, if the sky is obtrusive, as mine are, it is bad; but if it is evaded, as mine are not, it is worse; it must and always shall with me make an effectual part of the composition. It will be difficult to name a class of landscape in which the sky is not the key note, the standard of scale, and the chief organ of sentiment. You may conceive, then, what a 'white sheet' would do for me, impressed as I am with these notions, and they cannot be erroneous. The sky is the force of light in nature, and governs every thing; even our common observations on the weather of every day are altogether suggested by it. The difficulty of skies in painting is very great, both as to composition and execution; because, with all their brilliancy, they ought not to come forward, or, indeed, be hardly thought of any more than extreme distances are; but this does not apply to phenomena or accidental effects of sky, because they always attract particularly. I may say all this to you, though *you* do not want to be told that I know very well what I am about, and that my skies have not been neglected, though they have often failed in execution, no doubt, from an over-anxiety about them, which will alone destroy that easy appearance which nature always has in all her movements.

How much I wish I had been with you on your fishing excursion in the New Forest! What river can it be? But the sound of water escaping from mill-dams, &c. willows, old rotten planks, slimy posts, and brickwork, I love such things. Shakespeare could make every thing poetical; he tells us of poor Tom's haunts among 'sheep cotes and mills'. As long as I do paint, I shall never cease to paint such places. They have always been my delight, and I should indeed have been delighted in seeing what you describe, and in your company, 'in the company of a man to whom nature does not spread her volume in vain'. Still I should paint my own places best; painting is with me but another word for feeling, and I associate 'my

careless boyhood' with all that lies on the banks of the Stour; those scenes made me a painter, and I am grateful; that is, I had often thought of pictures of them before I ever touched a pencil, and your picture is the strongest instance of it I can recollect; but I will say no more, for I am a great egotist in whatever relates to painting. Does not the Cathedral look beautiful among the golden foliage? its solitary grey must sparkle in it.

Charlotte Street [London], November 17th [1824]

My dear Fisher, Thank you for your letter of yesterday [1824]...John Dunthorne is here; he cheers and helps me so much, that I could wish to have him always with me; he forwards me a good deal in subordinate parts, such as tracing, squaring, &c. This morning a gentleman called on me who has nine telescopes; you may judge how thick they soon got; it is John's forte, he is to see them to morrow. I am planning a large picture, and I regard all you say; but I do not enter into that notion of varying one's plans to keep the public in good humour. Change of weather and effect will always afford variety. What if Vander Velde had quitted his sea pieces, or Ruysdael his waterfalls, or Hobbema his native woods. The world would have lost so many features in art. I know that you wish for no material alteration; but I have to combat from high quarters, even from Lawrence, the plausible argument that *subject* makes the picture. Perhaps you think an evening effect might do; perhaps it might start me some new admirers, but I should lose many old ones. I imagine myself driving a nail; I have driven it some way, and by persevering I may drive it home; by quitting it to attack others, though I may amuse myself, I do not advance beyond the first, while that particular nail stands still. No man who can do any one thing well, will be able to do any other different thing equally well; and this is true even of Shakespeare, the greatest master of variety. Send me the picture of the shady lane when you like. Do you wish to have any other? The sketch-book I am busy with for a few days; it is full of boats and coast scenes. Subjects of this sort seem to me more fit for execution than for sentiment. I hold the genuine pastoral feeling of landscape to be very rare, and difficult of attainment. It is by far the most lovely department of painting as well as of poetry. I looked into Angerstein's the other day; how paramount is Claude!...

Charlotte Street, December 17th [1824]

My dear Fisher, ... How much I should like to pass a day or two with you at Bath; but after such an interrupted summer, and so much indisposition in the autumn, I find it quite impossible to leave London, my work is so much behind hand. We hear of sad illnesses all round us, caused, no doubt, by the excessive wet. I have just received a letter from Sir George Beaumont; he has been seriously ill, and quite unable until lately to touch a pencil. Every thing which belongs to me belongs to you, and I should not have hesitated a moment about sending you the Brighton sketch-book, but when you wrote, my Frenchman was in London, we were settling about work, and he has engaged me to make twelve drawings, to be engraved here, and published in Paris, all from this book. I work at these in the evening. This book is larger than my others, and does not contain odds and ends, but all regular compositions of boats or beach scenes;

there may be about thirty of them. If you wish to see them for a few days, tell me how I am to send them to you. My Paris affairs go on very well. Though the Director, the Count Forbin, gave my pictures very respectable situations in the Louvre in the first instance, yet on being exhibited a few weeks, they advanced in reputation, and were removed from their original situations to a post of honour, two prime places in the principal room. I am much indebted to the artists for their alarum in my favour; but I must do justice to the Count, who is no artist I believe, and thought that as the colours are rough, they should be seen at a distance. They found the mistake, and now acknowledge the richness of texture, and attention to the surface of things. They are struck with their vivacity and freshness, things unknown to their own pictures. The truth is, they study (and they are very laborious students) pictures only; and as Northcote says, 'They know as little of nature as a hackney-coach horse does of a pasture'. In fact, it is worse, they make painful studies of individual articles, leaves, rocks, stones, &c. singly; so that they look cut out, without belonging to the whole, and they neglect the look of nature altogether, under its various changes. I learnt yesterday that the proprietor asks twelve thousand francs for them. They would have bought one, 'The Waggon,' for the nation, but he would not part them. He tells me the artists much desire to purchase and deposit them in a place where they can have access to them. Reynolds is going over in June to engrave them, and has sent two assistants to Paris to prepare the plates. He is now about 'The Lock,' and he is to engrave the twelve drawings. In all this I am at no expense, and it cannot fail to advance my reputation. My wife is translating for me some of the criticisms. They are amusing and acute, but shallow. After saying 'It is but justice to admire the truth, the colour, and the general vivacity and richness of surface, yet they are like preludes in music, and the full harmonious warblings of the Æolian lyre, which *mean nothing*'; and they call them 'orations and harangues, and high flowery conversations affecting a careless ease', &c. However, it is certain they have made a stir, and set the students in landscape to thinking. Now you must believe me, there is no other person living but yourself to whom I could write in this manner, and all about myself; but take away a painter's vanity, and he will never touch a pencil again.

5 Antoine Quatremère de Quincy (1755–1849) from *Imitation in the Fine Arts*

Quatremère de Quincy was a man whose ideas were formed in the eighteenth century but who exercised influence well into the nineteenth century through his powerful administrative position as Permanent Secretary of the Institut des Beaux-Arts, a position he held from 1816 to 1839. He initially studied sculpture in the French school at Rome in the 1770s, where he was a contemporary of the painter Jacques-Louis David. Here he was influenced by Winckelmann's ideas on the pre-eminence of classical Greece. Subsequently he defended the Ideal, and the view of art as a significant form of intellectual accomplishment, against the encroaching naturalism and Romanticism of the early nineteenth century. For Quatremère, a supporter of Ingres, the value of art had relatively little to do with truth to external nature, just as the pleasures to be derived from art were not to any significant extent pleasures of the senses. His *Essai sur la nature, le but et les moyens de l'imitation*

dans les beaux-arts, published in 1823, was an extensive work of 47 chapters, running to over 450 pages. Quatremère had an impact in England, and several of his works were contemporaneously translated. The present extracts are taken from the translation by J. C. Kent, *An Essay on the Nature, the End and the Means of Imitation in the Fine Arts*, London: Smith, Elder & Co., Cornhill, 1837, pp. 121–7 and 192–9.

PART I: OF THE NATURE OF IMITATION

Chapter XII

It is the fictious and the incomplete in every art, and these alone, which constitute art, and become moreover the sources of the pleasure of imitation.

Since, by the laws of nature, an art can be nothing else than a manner of seizing and presenting a single aspect of the universal model, nothing can be more futile than any effort on the part of the artist to give to his image an additional truth, or an increase of resemblance elicited from a source beyond the sphere of its imitation. In whatever way he borrows, from whencesoever he may draw his resources, whether by an admixture of forms of composition, by a complication of means, by inclining to identical fidelity, or by all and every transfer of physical or moral qualities from the field of reality to that of imitation, the error is the same, and the result will be alike in all. The efficacy of imitation is destroyed precisely by what it were thus supposed would add to it, and in that case also the mixture of elements neutralizes them.

Of a truth, it is the *fictious* and *incomplete* in every art that constitute it art. It is thence that it derives its principal force, and the effect of its action. And thence, too, proceeds its power of giving pleasure.

It is indeed on this two-fold *defect* that the condition of the pleasure we receive from imitation is dependent. That condition consists in the mind being apprised, and clearly perceiving that, though the scheme of seducing it may be entertained, the means of deceiving it are wanting . . . , and that what is presented to it, is truly a thing which is the image of some other. Then, nowise doubting but that the imitable object or subject is shown only in a single one of its aspects, it enjoys so much the more in proportion as, captivated by the art that concentres it in that one point of view, it neither desires, nor thinks of suspecting there is any other.

Let the real be substituted more or less in place of the fictious, by a near approach in the work of imitation to that physical or moral identity of which we have so often spoken; let the resemblance in every art be rendered absolutely complete by a super-addition of individual and vulgar truth, or by the combination of means appertaining to another imitative mode; let, for instance, all that art has clothed with poetical metaphor, be restored to precise language, and what will be the consequence? The disenchantment of reality substituted for the charm of imitation. But it is argued that there will be the pleasure to be derived from nature. Even so; but art has nothing to do with such pleasure. It is not concerned about the pleasure experienced on viewing nature herself and in herself, but contrariwise, nature in her image. To enjoy nature, requires neither forms nor means of art. To disannul art, or, which is the same thing, the representative effect of its image, would be doing like the child, who, when

breaking the mirror, in order to lay hold on his own reflected appearance, annihilated the one by destroying the other.

Such, then, is the result of that complement which foolish and ignorant persons would fain add to every imitative mode [. . .]

And what other result do they attain, than that of diminishing and frequently disannulling the efficacy of their own imitation, who associate with it either an alien imitation, or a charm-dispelling reality, and who consider themselves warranted (as we have before seen) in introducing vulgar language into an heroic action, by an alliance of elements altogether incompatible; who mingle, with the sublime sentiments of the most affecting incidents, burlesque circumstances derived from the social condition of the lowest grades; who are desirous that every thing should be done and said, in poetry, and on the stage, as it actually takes place on the world's stage; who think that theatrical delivery should not differ from common conversation, nor theatrical action from familiar bearing; who, not knowing how to distinguish imitative truth from servile transcript, would wish that the fidelity of the pantographe, or the camera-obscura should be the measure of pictorial verisimilitude in the arts of design; who acknowledge no other resemblance than that of portraiture, no other imitation of man, than that of a man; who, mistaken in their notions of imitative variety, . . . set the pleasure it occasions to the account of the promiscuous commingling of different forms of composition; and finally, who believe they are rendering a service to art by removing the difficulty that attends the attainment of positive truth in images which are but fictious, and the production of a complete resemblance by means fitted only to make it less perfect?

What result can possibly follow from all such endeavours; but that, while believing they are adding to the efficacy of art by augmenting the identity between the image and its model, they are more or less enfeebling the distinctness of that line of demarcation which ought to separate nature from imitation; and the consequence must be that both the truth of art and of nature will alike be absent.

To deliver art from the trammels which occasion the difficulty of its operations would be to dispense with the efforts it must make in order to appear not to need such exemption. To take away its subserviency would be to cut off from it the source of that resistance which is the cause of its strength. It would be just as though one were to free the dancer from the clog of keeping time, while the merit as well as the pleasure of the dance arises from the very circumstance that its action is subjected to that clog.

How strange is the ignorance, how singular the delusion evinced by that inability to discern what constitutes, throughout every form of composition, the merit and the pleasure of imitation! which merit and pleasure consist in producing resemblance, notwithstanding the dissimilarity, in giving the effect of the reality and of the object despite what is wanting in order to its being the real object; in appearing the thing itself, by means different and far distant from it; in the banishing even a suspicion of constraint while under the very yoke of rules, attaining the charm of ease in the midst of difficulties, producing an impression of the true with the elements of the false, giving life to what is but a shadow, and from the nonentity of fiction calling forth the wonder of existence.

PART II: OF THE END OF IMITATION

Chapter III

Of the superiority, in imitation, of the pleasure of the mind, over that addressed to the senses alone.

In order to form a just estimate of what ought to be the end of imitation, that is, of the pleasure towards which it should incline, it will be necessary to render a further account of this pleasure, not in itself, but in its effects, I mean its useful effects.

It is already known what utility I speak of, and that neither political utility, nor that related to morality, can have any thing to do with this theory.

The useful effects of the pleasure of imitation consist in the knowledge, the sensations, the ideas, and the images we acquire through it; in other words, in that which increases the scope of our understanding, enriches our minds with new conceptions, and opens to our imaginations vistas without number, revealing prospects without a limit.

Now, I ask what the imitation that is limited to the senses, in the choice of its subjects and in its mode of representing them, I ask what are its useful effects, what its images can teach me, restricted as they are to the gratification of the eye. I ask what they show me that I do not already know; what they put me in a condition to perceive over and above their model, what impressions depending on art they communicate to me; in short, what acquisition such kind of imitation can promise me or give me reason to hope for.

I shall be told that it gives me what nature, whose portraiture it is, gives me. I answer, no. It does not give it, precisely because it is only a portrait, and because a portrait is only a part of the resemblance of the natural object, and presents only a single aspect; because such an image, thus limited, and which cannot carry my imagination beyond the confines of reality, gives only the finite, instead of the infinite, to which the soul aspires.

There can be no doubt that what we should require of imitation in the fine arts, is that it satisfy the cravings of our minds after unlimited impressions, and ever renewed sensations, that is, inexhaustible in their effects as is nature in her combinations. Such is the enjoyment that we demand of art; and such cannot be that of an imitation whose sole property is to exhibit objects, precisely as they are everywhere and at all times presented to us. [. . .]

We have had occasion to remark in what estimation every system of imitation must be held, in which is alone repeated vulgar manners, trivial phrases, the commonplaces of every day language, scenes drawn from the lowest grades of society, or images presenting only the individuality of persons and bodies, as well as all representations which can be accounted no other than so many copies, the types and proofs of which are matters of daily experience, instead of being true originals, either in the common or figurative sense of the word; for that is no true original the model of which can anywhere be instanced.

Wherefore should I wish for a copy? What need have I of the appearances of things whose reality I am wholly indifferent to? What worth can I attach to the

image, when I hold its model in contempt, more especially since there is nothing beyond to compensate for the absence of all those properties which nature denies it?

Whatever amount of sensual pleasure may arise from such like productions, allowing that pleasure to be the end of imitation, is there any thing, I ask, to warrant me setting so high a value upon its works? Can the end attained be worth the pains bestowed? [...]

It is requisite to make some distinction, on this point of criticism, respecting the greater or less estimation due to the works, in which art is limited to that local, partial, or individual truth, which I cannot allow to be the definitive aim of imitation. And first of all it is necessary to distinguish between the *kind* of imitation, and what is termed *style*, *taste*, *manner*, as applied to the work of imitation. Thus the Flemish pictures are of a *kind*, which, presenting to us the mechanism of art in its greatest perfection, have no pretension beyond that of speaking to the eye, without addressing aught to the mind. The pleasure these works afford is not the only one to be expected from imitation. But we can require nothing more from works which neither give promise of, nor are fitted to produce any thing more.

There are others which, though destined to a higher purpose, are, from the *taste* and *manner* in which they are conceived and executed, far from responding to it. I could cite instances in every period. But, that I may be the better understood, I will confine myself to those of the earliest ages of art, when it was not yet brought to perfection. In those works, despite the charm their want of affectation, and their simplicity invest them with, we nevertheless discover additional proof of the positions here maintained: namely, that what is too frequently taken for the end of imitation, is not so; since the pleasure arising from individual truth, only exists in the productions of that period, from the absence of what art had not then acquired the means of producing.

It needs but to complete the parallel, in order to prove to demonstration what we have just advanced. If those works, conceived and executed in the spirit of portraiture, (I speak of those of the fifteenth century), be compared with the works of the sixteenth (such as those of Michael Angelo, Rafaello, and their schools), it will not be difficult to obtain a clear and distinct idea of the description of pleasure which I maintain ought to constitute the true end of imitation.

What are those paintings of the early stages of the renovation of art? Portraits, doubtless faithful ones, of the men of that period. Physiognomy, attitudes, attire, character, form, and expression, in all, the exact image of the personages then existing, after the manner that they really were, the fashion of the habiliments, costumes, and accessories of the times. Well! those paintings had not, for contemporaries, and still have not, for us (setting aside the interest imparted to them by antiquity), any other value than that appertaining to the repetition of what one sees; they make no other impression than that of a portrait. Nothing more can be expected, and the most lively imagination would in vain seek for any other pleasure, from them. Even subjects of history, either ancient or drawn from a foreign country, personages to whatever age or nation they may be supposed to belong, when subjected to the same local costume, the same reality of portraiture, are insufficient to carry the spectator beyond this limited point of view, and, whatever useful lessons the artist may derive from them, such works leave us devoid of ideas, impressions, images, feelings and desires.

Pass we to the next century and the works of art when fully developed. What a different world do Rafaello and the grand masters of his time open up to us! How many ideas and images that would have been unknown to us, had not imitation attained its aim! What another kind of truth, and in what a different sphere is it revealed to the artist! By how new a manner of viewing nature is her realm enlarged! How much additional food for the imagination, how many new objects for the mind to observe and become acquainted with, and fruitful subjects for taste to criticize! What an unfailing source of pleasures for the understanding and the sentiment! In short, what creations, for the existence of which we are indebted to imitation, not that which is limited to showing us what is real, but that which, by the aid of what is, shows us what has no real existence! [...]

6 Samuel Palmer (1805–1881) Letter to John Linnell

Palmer represents the visionary strain in Romantic landscape art, which had stronger roots in Germany (see IA8 and IB1) than it did in England. His principal English mentor was William Blake, not himself noted as a landscapist, but whose illustrations to Virgil's *Pastorals* were particularly influential on the younger artist. Palmer had been introduced to Blake in 1824 by the painter John Linnell, the recipient of the present letter. In the early 1820s they also became acquainted with the work of Dürer and the Northern 'Primitives', as well as with their German contemporaries the Nazarenes (cf. IIB5). These interests encouraged the formation in the mid-1820s of a group calling itself 'The Ancients' based in the village of Shoreham, Kent. It was in Shoreham that Palmer's most intense work was done, between c. 1826 and 1830. He viewed nature as the disclosure of God, and believed that landscape art represented nature refracted through 'the soul's alchemy'. The present letter is taken from *The Letters of Samuel Palmer* (two volumes), ed. Raymond Lister, Oxford: Clarendon Press, 1974, volume 1, pp. 47–52.

Shoreham Kent, December 21st 1828

My dear Sir

[...] I have begun to take off a pretty view of part of the village, and have no doubt but the drawing of choice positions and aspects of external objects is one of the varieties of study requisite to build up an artist, who should be a magnet to all kinds of knowledge: though, at the same time I can't help seeing that the general character- istics of Nature's beauty not only differ from, but are, in some respects, opposed to those of Imaginative Art; and *that*, even in those scenes and appearances where she is loveliest, and most universally pleasing. Nature, with mild, reposing breadths of lawn and hill, shadowy glades and meadows, is sprinkled and showered with a thousand pretty eyes and buds and spires and blossoms, gemm'd with dew, and is clad in living green. Nor must be forgot the mottley clouding, the fine meshes, the aerial tissues that dapple the skies of spring; nor the rolling volumes and piled mountains of light; nor the purple sunset blazon'd with gold; nor the translucent amber. Universal nature wears a lovely gentleness of mild attraction; but the leafy lightness, the thousand repetitions of little forms, which are part of its own generic perfection; and who would wish them but what they are? – seem hard to be reconciled with the unwinning

severity, the awfulness, the ponderous globosity of Art. Milton, by one epithet, draws an oak of the largest girth I ever saw; – 'Pine and *Monumental* Oak' [*Il Penseroso*]: I have just been trying to draw a large one in Lullingstone; but the Poet's tree is huger than any in the park: there, the moss, and rifts, and barky furrows, and the mouldering grey, tho' that adds majesty to the lord of forrests; mostly catch the eye before the grasp and grapple of the roots; the muscular belly and shoulders; the twisted sinews. Many of the fine pictures of the 13th, 14th, and two following centuries, which our modern addlepates grin at for Gothick and barbarous, do seem to me, I confess, much deteriorated, by the faces, though exquisitely drawn, looking like portraits, which many of them are; and from the naked form, thwarted with fringes, and belts, and trappings, being generally neglected, or ill expressed, through a habit of disproportioned attention to secondary things, as the stuff and texture of draperies etc. which ended at last in the Dutch school; with this damning difference; that in the fine old works the Heads are always most elaborated; – on the Flemish canvas, the least finished of any part; and yielding to the perfected polish of stew-pans and chamber pots: a preference most religiously observ'd by the cleverest disciples of that style at present. An instance of this appear'd in the last exhibition; where was a painting, in which, against the sky and distance, beautiful, intense, and above the Dutch perception, there came a woman's head; hard to tell, whether quite neglected or laboriously muzzed: the least perfect object in the piece; with a careful avoidance of all shape, roundness, and outline. But nature is not like this: I saw a lovely little rustic child this evening, which took my fancy so much, that I long, with tomorrow's light, God sparing me, to make a humble attempt to catch some of its graces: if I can atal succeed, it will be nothing Dutch, or boorish. Temporal Creation, whose beauties are, in their kind, perfect; and made, and adapted by the benevolent Authour to please all eyes, and gladden all hearts – seems to differ from images of the mind. [...]

The perfection of nature is not the perfection of severest art: they are two things: the former we may liken to an easy charming colloquy of intellectual friends; the latter is 'Imperial Tragedy'. *That*, is graceful humanity; *This*, is Plato's Vision. [...]

General nature is wisely and beneficently adapted to refresh the senses and sooth the spirits of general *observers*. We find hundreds in rapture when they get into the fields, who have not the least relish for grand art. General Nature is simple and lovely; but compared with the loftier vision, it is the shrill music of the 'Little herd grooms, Keeping their beasts in the budded-brooms; And crowing in pipes made of green corn', to the sound of the chant and great organ, pealing through dusky aisles, and reverberating in the dome; or the trombone and drums and cymbals of the banner'd march. Every where curious, articulate, perfect, and inimitable of structure, like her own entomology, Nature does yet leave a space for the soul to climb above her steepest summits: as, in her own dominion she swells from the herring to leviathan; from the hodmandod to the elephant, so divine Art piles mountains on her hills, and continents upon those mountains.

However, creation sometimes pours into the spiritual eye the radiance of Heaven: the green mountains that glimmer in a summer gloaming from the dusky yet bloomy East; the moon, opening her golden eye, or walking in brightness among innumerable islands of light, not only thrill the optic nerve, but shed a mild, a grateful an unearthly lustre into the inmost spirits, and seem the interchanging twilight of that peaceful

country, where there is no sorrow and no night. After all, I doubt not but there must be the study of this creation, as well as art and vision; tho' I cannot think it other than the veil of heaven, through which her divine features are dimly smiling; the setting of the table before the feast, the symphony before the tune, the prologue of the drama; a dream of antepast and proscenium of eternity. I doubt not, if I had the wisdom to use it rightly (and who can so well instruct me as yourself?) it would prove a helpful handmaid and comate of art, tho' dissimilar; as mercury sympathizes with gold, learning with genius, and poetry, with reverence to speak it, with religion. [...]

I remain Dear Sir
Your obliged affectionate Servant
Samuel Palmer.

7 John Constable (1776–1837) Introduction to *English Landscape*

In 1829 Constable undertook the publication of a series of plates from his own paintings, to be engraved in mezzotint by David Lucas under his supervision. The finished collection of 22 images was issued in 1833. In its full form the title announced *Various Subjects of Landscape, Characteristic of English Scenery, principally intended to display the Phenomena of the Chiar'oscuro of Nature*. Constable's introduction went through a number of drafts, reaching the definitive form represented here in May 1833. Composed self-consciously to fulfil a public function, the painter's prose lacks the spontaneity and directness of his letters. The principal argument is clear, however: an art nourished at the 'Primitive Source' of nature is more likely to result in an original style than one based upon 'departed excellence', and though it may be harder to assimilate will prove in the end of more lasting value. In fact it was not to be until the late 1880s that Constable's importance was first widely acknowledged in England. In its original form the introduction was prefaced by quotations of poetry by Virgil, Thomson, Wordsworth and Ovid. It is reprinted in R. B. Beckett (ed.), *John Constable's Discourses*, Ipswich: Suffolk Records Society, volume XIV, 1970, pp. 9–10, from which source this text is taken.

The Author rests in the belief that the present collection of Prints of Rural Landscape may not be found wholly unworthy of attention. It originated in no mercenary views, but merely as a pleasing professional occupation, and was continued with a hope of imparting pleasure and instruction to others. He had imagined to himself certain objects in art, and has always pursued them.

Much of the Landscape, forming the subject of these Plates, going far to embody his ideas (owing perhaps to the rich and feeling manner in which they are engraved) he has been tempted to publish them, and offers them as the result of his own experience, founded as he conceives it to be in a just observation of natural scenery in its various aspects. From the almost universal esteem in which the Arts are now held, the Author is encouraged to hope that this work may not be found unacceptable, since perhaps no branch of the Art offers a more inviting study than Landscape.

> Soul-soothing Art! whom morning, noon-tide, even
> Do serve with all their fitful pageantry.

The immediate aim of the Author in this publication is to increase the interest for, and promote the study of, the Rural Scenery of England, with all its endearing associations, its amenities, and even in its most simple localities; abounding as it does in grandeur, and every description of Pastoral Beauty: England, with her climate of more than vernal freshness, and in whose summer skies, and rich autumnal clouds, 'with thousand liveries dight', the Student of Nature may daily watch her endless varieties of effect, for by him it is, that these changes are particularly observed: '*Multa vident Pictores in imminentia et in umbris quae nos non videmus*' [Painters perceive much which we do not see in things impending and in the shadows].– CICERO.

It is therefore perhaps in its professional character that this work may be most considered, so far as it respects the ART; its aim being to direct attention to the source of one of its most efficient principles, the 'CHIAR'-OSCURO OF NATURE', to mark the influence of light and shadow upon Landscape, not only in its general effect on the whole, and as a means of rendering a proper emphasis on the 'parts', in Painting, but also to show its use and power as a medium of expression, so as to note 'the day, the hour, the sunshine, and the shade'. In some of these subjects of Landscape an attempt has been made to arrest the more abrupt and transient appearances of the CHIAR'-OSCURO IN NATURE; to shew its effect in the most striking manner, to give 'to one brief moment caught from fleeting time', a lasting and sober existence, and to render permanent many of those splendid but evanescent Exhibitions, which are ever occurring in the changes of external Nature.

In the selection of these subjects, a partiality has perhaps been given to those of a particular neighbourhood: some of them, however, may be more generally interesting, as the scenes of many of the marked historical events of our middle ages. The most of these subjects, chiefly consisting of home scenery, are from Pictures exhibited by the Author at the Royal Academy during the past few years; they are taken from real places, and are meant particularly to characterize the scenery of England; the effects of light and shadow being transcripts only of such as occurred at the time of being taken.

In Art as in Literature, however, there are two modes by which men endeavour to attain the same end, and seek distinction. In the one, the Artist, intent only on the study of departed excellence, or on what others have accomplished, becomes an imitator of their works, or he selects and combines their various beauties; in the other he seeks perfection at its PRIMITIVE SOURCE, NATURE. The one, forms a style upon the study of pictures, or the art alone; and produces, either 'imitative', 'scholastic', or that which has been termed 'Eclectic Art'. The other, by study equally legitimately founded in art, but further pursued in such a far more expansive field, soon finds for himself innumerable sources of study, hitherto unexplored, fertile in beauty, and by attempting to display them for the first time, forms a style which is original; thus adding to the Art, qualities of Nature unknown to it before.

The results of the one mode, as they merely repeat what has been done by others, and by having the appearance of that with which the eye is familiar, can be easily comprehended, soon estimated, and are at once received. Thus the rise of an artist in a sphere of his own must almost certainly be delayed; it is to time generally that the justness of his claims to a lasting reputation will be left; so few appreciate any deviation from a beaten track, can trace the indications of Talent in immaturity, or

are qualified to judge of productions bearing an original cast of mind, of genuine study, and of consequent novelty of style in their mode of execution.

J. C. 35, CHARLOTTE STREET, FITZROY SQUARE,
May, 1833.

8 John Constable (1776–1837) from 'Discourses'

Immediately following the publication of his *English Landscape*, Constable was invited to lecture to the Literary and Scientific Society of Hampstead, where he was then living, and chose as his theme 'An Outline of the History of Landscape Painting'. He followed this with a second lecture two years later, in June 1835, using prints, drawings and painted copies to illustrate the works he discussed. That autumn he lectured on the same theme at the Worcester Institution for promoting Literature, Science and the Fine Arts, now extending the series to three. It was then arranged for him to give a series of four lectures to the prestigious Royal Institution in London, before an audience drawn from the world of science as well as the arts. These took place at weekly intervals between 26 May and 16 June 1836, with Constable drawing so far as possible on works that could be seen in the National Gallery in London. On 25 July he gave a final lecture to the Literary and Scientific Society in Hampstead. His biographer C. R. Leslie attended all five of the latter lectures in London, taking careful notes. He later used these to represent the lectures in his *Memoirs of the Life of John Constable*. R. B. Beckett (see IB7) provides a more complete account of the Discourses, supplementing Leslie's text from Constable's own record of the first lecture in Hampstead, from press reports of the lectures in Worcester and from further surviving notes in the artist's hand. The effect, however, is to prove Leslie a reliable witness and a discriminating editor. We have therefore taken our extracts from his texts of the second, fourth and last lectures, as given in the *Memoirs*, second edition, London, 1845, pp. 342–4, 354–5 and 356–61. In the first lecture Constable provided a survey of the origins and early development of landscape in art, paying particular tribute to the work of Dürer and of Titian. In an opening section of the second lecture he gave enthusiastic accounts of the work of Poussin and Claude. In the third he dwelt on four exceptional examples of the genre, by Titian, Poussin, Rubens and Rembrandt. His conclusion to the series at the Royal Institution – that landscape painting deserved to be considered an experimental science – was no doubt made with the mixed composition of his audience in mind.

From Lecture II, Royal Institution, 26 May 1836

[. . .] 'The deterioration of art has every where proceeded from similar causes, the imitation of preceding styles, with little reference to nature. In Italy, the taste was for the beautiful, but the beautiful in the hands of the mannerists became the insipid, and from that descended to the unmeaning. In Germany a clumsy imitation of Italian art, and particularly of M. Angelo, produced inflation and bombast, as in the works of Goltzius and Sprangher; while in Flanders and Holland, the taste for the picturesque, when colour, chiaroscuro, and execution were gone, left only the coarse and the mean.

'The decline of history was parallel with that of landscape. What is termed the 'French taste', (as opposed to good taste) and which may be characterized as *romantic hyperbole*, began with Lucatelli, a pupil of Pietro da Cortona, who died about 1717. He

was an Italian, and practised his art chiefly in Rome; but his style soon spread itself in France, where it destroyed whatever may have remained of the influence of Poussin, Le Sueur, or Sebastian Bourdon. He painted chiefly historical subjects for churches, and was like his master, a compendious painter – a mannerist – a self-worshipper; he preferred forms of his own imagination to those of nature. In his works may be seen the beginning of that prettiness which soon afterwards in Marco Ricci, Paulo Panini, and Zuccherelli, and Vernet in landscape, displayed itself so offensively. In history, Mengs, Cipriani, Angelica Kauffman, &c. followed this emasculated taste, to the exclusion of all that is found in art.

'But the climax of absurdity to which the art may be carried, when led away from nature by fashion, may be best seen in the works of Boucher. Good temper, suavity, and dissipation, characterized the personal habits of this perfect specimen of the French School of the time of Louis the Fifteenth, or the early part of the last century. His landscape, of which he was evidently fond, is pastoral; and such pastorality! the pastoral of the Opera house. But at this time, it must be remembered, the court were in the habit of dispersing into the country, and duchesses were to be seen performing the parts of shepherdesses, milk maids, and dairy maids, in cottages; and also brewing, baking, and gardening, and sending the produce to market. These strange anomalies were played off on the canvasses of Boucher. His scenery is a bewildered dream of the picturesque. From cottages adorned with festoons of ivy, sparrow pots, &c. are seen issuing opera dancers with mops, brooms, milk pails, and guitars; children with cocked hats, queues, bag wigs, and swords, – and cats, poultry, and pigs. The scenery is diversified with winding streams, broken bridges, and water wheels; hedge stakes dancing minuets – and groves bowing and curtsying to each other; the whole leaving the mind in a state of bewilderment and confusion, from which laughter alone can relieve it – Boucher told Sir Joshua Reynolds, "that he never painted from the life, for that nature put him out".

'It is remarkable how nearly, in all things, opposite extremes are allied, and how they succeed each other. The style I have been describing was followed by that which sprung out of the Revolution, when David and his contemporaries exhibited their stern and heartless petrifactions of men and women, – with trees, rocks, tables, and chairs, all equally bound to the ground by a relentless outline, and destitute of chiaroscuro, the soul and medium of art.'

Constable spoke of the want of sense in David's large picture, in which the Romans and the Sabines are about to join battle, stark naked, but with helmets on their heads, and shields and spears in their hands. 'What,' he said, 'would be the impression of a spectator of such a scene, but that he saw before him a number of savages who had accidentally found and snatched up these weapons and accoutrements?'

From Lecture IV, Royal Institution, 16 June 1836

[. . .] 'The landscape of Gainsborough is soothing, tender, and affecting. The stillness of noon, the depths of twilight, and the dews and pearls of the morning, are all to be found on the canvasses of this most benevolent and kind-hearted man. On looking at them, we find tears in our eyes, and know not what brings them. The lonely haunts of

the solitary shepherd, – the return of the rustic with his bill and bundle of wood, – the darksome lane or dell, – the sweet little cottage girl at the spring with her pitcher, – were the things he delighted to paint, and which he painted with exquisite refinement, yet not a refinement beyond nature. Gainsborough has been compared to Murillo by those who cannot distinguish between the *subject* and the *art*. Like Murillo he painted the peasantry of his country, but here the resemblance ceases. His taste was in all respects greatly superior to that of the Spanish painter.'

'Constable spoke of Cozens and Girtin as possessing genius of the very highest order, though their works being comparatively few and in water colours chiefly, they are less known than they deserve to be. [. . .]

'As your kind attention,' he said, 'has so long been given to my description of pictures, it may now be well to consider in what estimation we are to hold them, and in what class we are to place the men who have produced them. – It appears to me that pictures have been over-valued; held up by a blind admiration as ideal things, and almost as standards by which nature is to be judged rather than the reverse; and this false estimate has been sanctioned by the extravagant epithets that have been applied to painters, as "the divine", "the inspired", and so forth. Yet, in reality, what are the most sublime productions of the pencil but reflections of some of the forms of nature, and copies of a few of her evanescent effects; and this is the result, not of inspiration, but of long and patient study, under the direction of much good sense. – It was said by Sir Thomas Lawrence, that "we can never hope to compete with nature in the beauty and delicacy of her separate forms or colours, – our only chance lies in selection and combination." Nothing can be more true, – and it may be added, that selection and combination are learned from nature herself, who constantly presents us with compositions of her own, far more beautiful than the happiest arranged by human skill. I have endeavoured to draw a line between genuine art and mannerism, but even the greatest painters have never been wholly untainted by manner. – Painting is a science, and should be pursued as an inquiry into the laws of nature. Why, then may not landscape painting be considered as a branch of natural philosophy, of which pictures are but the experiments?'

From Last Lecture, Hampstead, 25 July 1836

'The difference between the judgments pronounced by men who have given their lives to a particular study, and by those who have attended to that study as the amusement only of a few leisure hours, may be thus illustrated. I will imagine two dishes, the one of gold, the other of wood. The golden dish is filled with diamonds, rubies, and emeralds, – and chains, rings, and brooches of gold; while the other contains shell-fish, stones, and earths. These dishes are offered to the world, who choose the first; but it is afterwards discovered that the dish itself is but copper gilt, the diamonds are paste, the rubies and emeralds painted glass, and the chains, rings, &c. counterfeit. In the mean time, the naturalist has taken the wooden dish, for he knows that the shell-fish are pearl oysters, and he sees that among the stones are gems, and mixed with the earths are the ores of the precious metals.

'The decline of painting, in every age and country, after arriving at excellence, has been attributed by writers who have not been artists to every cause but the true one.

The first impression and a natural one is, that the fine arts have risen or declined in proportion as patronage has been given to them or withdrawn, but it will be found that there has often been more money lavished on them in their worst periods than in their best, and that the highest honours have frequently been bestowed on artists whose names are scarcely now known. Whenever the arts have not been upheld by the good sense of their professors, patronage and honours so far from checking their downward course, must inevitably accelerate it.

'The attempt to revive styles that have existed in former ages, may for a time appear to be successful, but experience may now surely teach us its impossibility. I might put on a suit of Claude Lorraine's clothes and walk into the street, and the many who know Claude but slightly would pull off their hats to me, but I should at last meet with some one, more intimately acquainted with him, who would expose me to the contempt I merited.

'It is thus in all the fine arts. A new Gothic building, or a new missal, is in reality little less absurd than a *new ruin*. The Gothic architecture, sculpture, and painting, belong to peculiar ages. The feelings that guided their inventors are unknown to us, we contemplate them with associations, many of which, however vague and dim, have a strong hold on our imaginations, and we feel indignant at the attempt to cheat us by any modern mimicry of their peculiarities.

'It is to be lamented that the tendency of taste is at present too much towards this kind of imitation, which, as long as it lasts, can only act as a blight on art, by engaging talents that might have stamped the Age with a character of its own, in the vain endeavour to reanimate deceased Art, in which the utmost that can be accomplished will be to reproduce a body without a soul.

'Attempts at the union of uncongenial qualities in different styles of Art have also contributed to its decline.'

In illustration of this, Constable showed a print from Vernet, the trees of which were in a mannered imitation of Salvator Rosa, without his nature and wildness, while the rocks were in the artificial style of Berghem.

'In the foreground,' he said, 'you will perceive an emaciated French dancing master, in a dress something like one of Salvator's banditti, but intended by Vernet for a fisherman. It is thus the art is deteriorated by the mannerists who employ themselves in sweeping up the painting rooms of preceding ages. Imitators always render the defects of their model more conspicuous. Sir George Beaumont, on seeing a large picture by a modern artist, intended to be in the style of Claude, said, "I never could have believed that Claude Lorraine had so many faults, if I had not seen them all collected together on this canvass." It is useful, therefore, to a painter to have imitators, as they will teach him to avoid every thing they do.

'The young painter, who regardless of present popularity, would leave a name behind him, must become the patient pupil of nature. If we refer to the lives of all who have distinguished themselves in art or science, we shall find they have always been laborious. The landscape painter must walk in the fields with an humble mind. No arrogant man was ever permitted to see nature in all her beauty. If I may be allowed to use a very solemn quotation, I would say most emphatically to the student, "Remember now thy Creator in the days of thy youth." The friends of a young artist should

not look or hope for precocity. It is often disease only. Quintilian makes use of a beautiful simile in speaking of precocious talent. He compares it to the forward ear of corn that turns yellow and dies before the harvest. Precocity often leads to criticism, – sharp, and severe as the feelings are morbid from ill health. Lord Bacon says, "when a young man becomes a critic, he will find much for his amusement, little for his instruction." The young artist must receive with deference the advice of his elders, not hastily questioning what he does not yet understand, otherwise his maturity will bear no fruit. The art of seeing nature is a thing almost as much to be acquired as the art of reading the Egyptian hieroglyphics. The Chinese have painted for two thousand years, and have not discovered that there is such a thing as chiaroscuro.'

Constable then gave some practical rules for drawing from nature, and showed some beautiful studies of trees. One, a tall and elegant ash, of which he said 'many of my Hampstead friends may remember this *young lady* at the entrance to the village. Her fate was distressing, for it is scarcely too much to say that she died of a broken heart. I made this drawing when she was in full health and beauty; on passing some time afterwards, I saw, to my grief, that a wretched board had been nailed to her side, on which was written in large letters "*All vagrants and beggars will be dealt with according to law.*" The tree seemed to have felt the disgrace, for even then some of the top branches had withered. Two long spike nails had been driven far into her side. In another year one half became paralyzed, and not long after the other shared the same fate, and this beautiful creature was cut down to a stump, just high enough to hold the board.'

 Constable exhibited an outline of the principal figure in Fuseli's 'Lazar house', and showed that the swellings and depressions in the outline of a figure in fine action never occur exactly on the opposite sides, and the same he said would be found true of trees when healthy.

 He quoted from Thomson's 'Seasons' the sixteen introductory lines to the 'Winter' as a beautiful instance of the poet identifying his own feelings with external nature. He noticed also Milton's love of landscape, and how often in his poems the most simple imagery is mingled with the most sublime. 'Thus he has compared the army of the Cherubim attendant on the Archangel, while conducting our first parents from Paradise, to an evening mist.

> The Archangel stood, and from the other hill
> To their fix'd station, all in bright array
> The Cherubim descended; on the ground,
> Gliding meteorous, as evening mist
> Ris'n from a river o'er the marish glides,
> And gathers ground fast at the lab'rer's heel,
> Homeward returning.

Introducing the homely incident of the labourer's return, and calling up all the rustic fireside associations connected with it in the midst of a description of the host of Heaven.

 'There has,' said Constable, 'never been an age, however rude or uncultivated, in which the love of landscape has not in some way been manifested. And how could it be

otherwise? for man is the sole intellectual inhabitant of one vast natural landscape. His nature is congenial with the elements of the planet itself, and he cannot but sympathize with its features, its various aspects, and its phenomena in all situations' [. . .]

9 George Catlin (1796–1872) 'Letter from the Mouth of the Yellowstone River'

Catlin discharged his vocation as an artist in a remarkable manner. He devoted his entire life and working career to the provision of a graphic record of the native American Indians, travelling widely throughout North America between 1829 and 1837 and staying with numerous different tribes. By 1838 he had produced over 600 pictures detailing their appearance and their customs. The letter quoted here was written after an unprecedented journey by steamer, covering a distance of some 2000 miles and lasting almost three months. The conditions Catlin describes were distinctive of the experience of several American painters of the time: on the one hand conscious of their remoteness from European standards and models of sophistication, on the other convinced that the wilderness was a 'true source' and a 'true school'. It is typical of this circumstance that Catlin should think of his native models as at one and the same time close to nature and the equals in 'grace and beauty' of the figures represented by classical Greek sculptors. The value to the artist of this exposure to 'human beings in the simplicity of nature' is underlined by his awareness of the fragility of their state, and of the inevitability of its corruption and loss at the approach of civilization. Catlin's collection was shown in a touring exhibition in America in 1838–9, in London in 1840–5 and subsequently in Paris (see IIc9). His literary accounts and illustrations were widely published in America, England and France. The original version of the present letter was addressed to the editor of the *New York Commercial Advertiser*, who published it on 24 July 1832. Catlin revised it for reprinting in his *Letters and Notes on the Manners, Customs and Conditions of the North American Indians*, two volumes with 400 illustrations, London and New York: Wiley and Putnam, 1841, pp. 14–16, from which this text has been taken.

Mouth of Yellow Stone, Upper Missouri, 1832

[. . .] You will, no doubt, be somewhat surprised on the receipt of a Letter from me, so far strayed into the Western World; and still more startled, when I tell you that I am here in the full enthusiasm and practice of my art. That enthusiasm alone has brought me into this remote region, 3,500 miles from my native soil; the last 2,000 of which have furnished me with almost unlimited models, both in landscape and the human figure, exactly suited to my feelings. I am now in the full possession and enjoyment of those conditions, on which alone I was induced to pursue the art as a profession; and in anticipation of which alone, my admiration for the art could ever have been kindled into a pure flame. I mean the free use of nature's undisguised models, with the privilege of selecting for myself. If I am here losing the benefit of the fleeting fashions of the day, and neglecting that elegant polish, which the world says an artist should draw from a continual intercourse with the polite world; yet have I this consolation, that in this country, I am entirely divested of those dangerous steps and allurements which beset an artist in fashionable life; and have little to steal my

thoughts away from the contemplation of the beautiful models that are about me. If, also, I have not here the benefit of that feeling of emulation, which is the life and spur to the arts, where artists are associates together; yet am I surrounded by living models of such elegance and beauty, that I feel an unceasing excitement of a much higher order – the certainty that I am drawing knowledge from the true source. My enthusiastic admiration of man in the honest and elegant simplicity of nature, has always fed the warmest feelings of my bosom, and shut half the avenues to my heart against the specious refinements of the accomplished world. This feeling, together with the desire to study my art, independently of the embarrassments which the ridiculous fashions of civilized society have thrown in its way, has led me to the wilderness for a while, as the true school of the arts.

I have for a long time been of the opinion, that the wilderness of our country afforded models equal to those from which the Grecian sculptors transferred to the marble such inimitable grace and beauty; and I am now more confirmed in this opinion, since I have immersed myself in the midst of thousands and tens of thousands of these knights of the forest; whose whole lives are lives of chivalry, and whose daily feats, with their naked limbs, might vie with those of the Grecian youths in the beautiful rivalry of the Olympian games.

No man's imagination, with all the aids of description that can be given to it, can ever picture the beauty and wildness of scenes that may be daily witnessed in this romantic country; of hundreds of these graceful youths, without a care to wrinkle, or a fear to disturb the full expression of pleasure and enjoyment that beams upon their faces – their long black hair mingling with their horses' tails, floating in the wind, while they are flying over the carpeted prairie, and dealing death with their spears and arrows, to a band of infuriated buffaloes; or their splendid procession in a war-parade, arrayed in all their gorgeous colours and trappings, moving with most exquisite grace and manly beauty, added to that bold defiance which man carries on his front, who acknowledges no superior on earth, and who is amenable to no laws except the laws of God and honour.

In addition to the knowledge of human nature and my art, which I hope to acquire by this toilsome and expensive undertaking, I have another in view, which, if it should not be of equal service to me, will be of no less interest and value to posterity. I have, for many years past, contemplated the noble races of red men who are now spread over these trackless forests and boundless prairies, melting away at the approach of civilization. Their rights invaded, their morals corrupted, their lands wrested from them, their customs changed, and therefore lost to the world; and they at last sunk into the earth, and the ploughshare turning the sod over their graves, and I have flown to their rescue – not of their lives or of their race (for they are 'doomed' and must perish), but to the rescue of their looks and their modes, at which the acquisitive world may hurl their poison and every besom of destruction, and trample them down and crush them to death; yet, phœnix-like, they may rise from the 'stain on a painter's palette', and live again upon canvas, and stand forth for centuries yet to come, the living monuments of a noble race. For this purpose, I have designed to visit every tribe of Indians on the Continent, if my life should be spared; for the purpose of procuring portraits of distinguished Indians, of both sexes in each tribe, painted in their native costume; accompanied with pictures of their villages, domestic habits,

games, mysteries, religious ceremonies, and so forth with anecdotes, traditions, and history of their respective nations. [...]

10 Thomas Cole (1801–1848) from 'Essay on American Scenery'

Cole was the principal figure in the establishment of the Hudson River School of painting. By virtue of his contribution to art, to literature and to the development of aesthetic ideas, he was also a dominant figure in the development of a specifically American form of Romanticism and of an American tradition in painting during the early nineteenth century. The 'Essay on American Scenery' was first published in the *American Monthly Magazine*, no. 1, January 1836, pp. 1–12. Cole opens his argument with an exposition of the civilizing potential of 'rural nature' and of the need for resources of resistance to a 'meagre utilitarianism'. The more interesting aspect of his text, however, is the ground it shares with the passages from Catlin (IB9) and Morse (IID3), and in the connection drawn between the wildness of the American landscape and the vigour of the young republic. Cole acknowledges the absence of those literary and classical associations – 'vestiges of antiquity' – through which meaning and value are traditionally established in old-world landscape. But he is able to claim that American scenery is significant on the one hand of 'the great struggle for freedom' and on the other of the prospect of a secure and democratic future. Like Catlin, however, he cannot remain unaware of the inevitable consequences of the progress of civilization. It is this more pessimistic view of 'the road society has to travel' that sustains the programme of paintings outlined in the letter to his patron cited in IIB3. The essay is reprinted in Thomas Cole, *The Collected Essays and Prose Sketches*, ed. Marshall Tymn, St Paul, Minnesota: John Colet Press, 1980. The present extracts are taken from pp. 6–8 and 16–17 of that edition.

* * *

There are those who through ignorance or prejudice strive to maintain that American scenery possesses little that is interesting or truly beautiful – that it is rude without picturesqueness, and monotonous without sublimity – that being destitute of those vestiges of antiquity, whose associations so strongly affect the mind, it may not be compared with European scenery. But from whom do these opinions come? From those who have read of European scenery, of Grecian mountains, and Italian skies, and never troubled themselves to look at their own; and from those travelled ones whose eyes were never opened to the beauties of nature until they beheld foreign lands, and when those lands faded from the sight were again closed and for ever; disdaining to destroy their trans-atlantic impressions by the observation of the less fashionable and unfamed American scenery. Let such persons shut themselves up in their narrow shell of prejudice – I hope they are few, – and the community increasing in intelligence, will know better how to appreciate the treasures of their own country.

I am by no means desirous of lessening in your estimation the glorious scenes of the old world – that ground which has been the great theatre of human events – those mountains, woods, and streams, made sacred in our minds by heroic deeds and immortal song – over which time and genius have suspended an imperishable halo. No! But I would have it remembered that nature has shed over *this* land beauty and magnificence, and although the character of its scenery may differ from the old world's, yet inferiority must not therefore be inferred; for though American scenery

is destitute of many of those circumstances that give value to the European, still it has features, and glorious ones, unknown to Europe. [...] The most distinctive, and perhaps the most impressive, characteristic of American scenery is its wildness.

It is the most distinctive, because in civilized Europe the primitive features of scenery have long since been destroyed or modified – the extensive forests that once overshadowed a great part of it have been felled – rugged mountains have been smoothed, and impetuous rivers turned from their courses to accommodate the tastes and necessities of a dense population – the once tangled wood is now a grassy lawn; the turbulent brook a navigable stream – crags that could not be removed have been crowned with towers, and the rudest valleys tamed by the plough.

And to this cultivated state our western world is fast approaching: but nature is still predominant, and there are those who regret that with the improvements of cultivation the sublimity of the wilderness should pass away; for those scenes of solitude from which the hand of nature has never been lifted, affect the mind with a more deep toned emotion than aught which the hand of man has touched. Amid them the consequent associations are of God the creator – they are his undefiled works, and the mind is cast into the contemplation of eternal things.

* * *

I will now venture a few remarks on what has been considered a grand defect in American scenery – the want of associations, such as arise amid the scenes of the old world.

We have many a spot as umbrageous as Vallombrosa, and as picturesque as the solitudes of Vaucluse; but Milton and Petrarch have not hallowed them by their footsteps and immortal verse. He who stands on Mont Albano and looks down on ancient Rome, has his mind peopled with the gigantic associations of the storied past; but he who stands on the mounds of the West, the most venerable remains of American antiquity, *may* experience the emotion of the sublime, but it is the sublimity of a shoreless ocean un-islanded by the recorded deeds of man.

Yet American scenes are not destitute of historical and legendary associations – the great struggle for freedom has sanctified many a spot, and many a mountain, stream, and rock, has its legend, worthy of poet's pen or the painter's pencil. But American associations are not so much of the past as of the present and the future. Seated on a pleasant knoll, look down into the bosom of that secluded valley, begirt with wooded hills – through those enamelled meadows and wide waving fields of grain, a silver stream winds lingeringly along – here, seeking the green shade of trees – there, glancing in the sunshine: on its banks are rural dwellings shaded by elms and garlanded by flowers – from yonder dark mass of foliage the village spire beams like a star. You see no ruined tower to tell of outrage – no gorgeous temple to speak of ostentation; but freedom's offspring – peace, security, and happiness, dwell there, the spirits of the scene. On the margin of that gentle river the village girls may ramble unmolested – and the glad school-boy, with hook and line, pass his bright holiday – those neat dwellings, unpretending to magnificence, are the abodes of plenty, virtue, and refinement. And in looking over the yet uncultivated scene, the mind's eye may see far into futurity. Where the wolf roams, the plough shall glisten; on the gray crag shall rise temple and tower – mighty deeds shall be done in the now pathless wilderness; and poets yet unborn shall sanctify the soil.

... Yet I cannot but express my sorrow that the beauty of such landscapes is quickly passing away – the ravages of the axe are daily increasing – the most noble scenes are made destitute, and oftentimes with a wantonness and barbarism scarcely credible in a civilized nation. The wayside is becoming shadeless, and another generation will behold spots, now rife with beauty, desecrated by what is called improvement; which, as yet, generally destroys Nature's beauty without substituting that of Art. This is a regret rather than a complaint; such is the road society has to travel; it may lead to refinement in the end, but the traveller who sees the place of rest close at hand, dislikes the road that has so many unnecessary windings.

I will now conclude, in the hope that, though feebly urged, the importance of cultivating a taste for scenery will not be forgotten. Nature has spread for us a rich and delightful banquet. Shall we turn from it? We are still in Eden; the wall that shuts us out of the garden is our own ignorance and folly. [...]

11 Pietro Selvatico (1803–1880) on Landscape

Born in Padua in 1803, Selvatico was strongly influenced by German Romanticism. His most important work, *Sull'educazione del pittore storico odierno italiano* (On the education of the history painter in contemporary Italy) contrasts the formal training provided by the academies with the type of study undertaken in medieval workshops. Selvatico accepts the conventional elevation of history painting above landscape painting but, as the following extract shows, he attributes an independent value and importance to the depiction of landscape. Landscape possesses its own specific demands and the art of landscape is to be learnt not from the imitation of the Old Masters but through the direct study of nature itself. Indeed, Selvatico recommends the use of non-oil based paints to facilitate the rapid recording of natural effects, and rejects current theories based on the various 'types' of landscape in favour of the notion that artistic 'truth' is to be derived directly from nature as it is found. *Sull'educazione del pittore storico odierno italiano* was published in Padova in 1842. The text of the present extract has been translated for this volume by Olivia Dawson and Jason Gaiger from the version reprinted in Paola Barocchi, *Testimonianze e polemiche figurative in Italia*, Messina and Florence: Casa Editrice G. D' Anna, 1972, pp. 136–8.

'Whoever cannot be an artist, should paint landscapes, fruit or flowers: it is always better, to do something rather than nothing,' concluded Milizia in his article, *Landscape*.[1] With these words he no doubt intended to signify that he did not hold in very high esteem the ability to excel in the art of painting landscapes. It seems to me that teachers of landscape painting do indeed overly exaggerate the difficulty of their art, placing landscape painting almost on the same rank as the highest genre of painting. If you listen to them, you will hear how much importance they attach to their clear skies, to the freshness and naturalness of the foliage on their trees, and to the depiction of water through confident strokes of the paintbrush. They say that to reach perfection in such things it is necessary to possess an exquisite understanding of the real world, a fecund imagination and the ability to enjoy the music of colour with one's eyes. I accept that there are difficulties, and that these are indeed numerous, because it is always difficult to do something well. However, even if exceptional skill is required to become a good landscape painter, much less is required than to become a history

painter. Thus it is that when a history painter wishes to paint a landscape the way lies open in front of him, for he has but to look at the countryside to ensure that he will render it successfully. This is perfectly natural, since someone who can represent man and his passions accurately possesses many more skills than are needed to represent trees, houses and streams in a pleasing manner. However, it is not true, as many believe, that the possession of these skills enables the history painter to dispense with the study from real life of those objects in the countryside which he might wish to put in the background of his paintings. Woe to the many painters who live in this state of arrogant credulity; for they will only be able to offer us landscapes which are completely indeterminate or utterly false. For the history painter to be a good land-scapist he must frequently study from nature and, when necessary, return to consult it again. In fact, I would advise him, almost as a respite from other long and arduous tasks, during our joyous festive Italian autumns to go wandering over the knolls and the hills of the countryside and through the gorges of the Alps where the torrents run down the valleys in majestic disorder and where the mountains are reflected in clear lakes. In addition, I suggest that whenever he finds a picturesque view of the countryside he put it into the keep of his sketch book the moment he sees it, without taking the thousands of liberties that painters of landscapes and panoramas are in the habit of introducing into their studies. Within a few years he will have accumulated a precious repertoire which will be of great advantage when he comes to paint a landscape.

Furthermore, in order for these pictorial reminders to record the colour as well as the form of the represented object, I would advise the painter of such sketches to use those boxes of paints mixed with honey and gum which they know how to prepare so well in Paris and London. These paints have certain advantages which oil-based paints or those made of pure gum arabic do not. Painting a landscape with oils involves the considerable labour of having to prepare the palette afresh each time and having to wait for the first application of paint to partially set before being able to continue or finish the painting. It means always having to carry innumerable small containers, as well as oils and paintbrushes. These are tedious and time-consuming, both to take out and set up at the beginning and to clean and put away at the end. Nor is it any easier with the pure gum-based paints. For first, the right amount of each colour has to be laid out in order to make up the desired tint, and secondly, since this type of paint lacks body, a great many layers are needed to attain any intensity in the dark colours. None of these inconveniences are encountered with paints which are ground with honey and gum, for here it is enough simply to pass a wetted paintbrush over one of the tablets and this will pick up a sufficient amount of paint to colour a good stretch of paper. Moreover, these paints have the further advantage of drying quickly and that the tint never appears grainy.

To advise landscape painters and history painters alike to copy their landscapes from nature must seem like telling someone who is hungry: eat if you want to satisfy your hunger, for this is clearly the only way to represent reality successfully. And yet not everyone agrees. It is not a rare thing to see even experienced artists who, wishing to master the correct methods of painting the countryside think they can learn by copying from the lithographs of famous French landscape painters, such as Hubert, Cogniet and many others, seeing in them a wonderful liveliness and spontaneity. In

fact, they do sometimes possess these qualities, but this is not always accompanied by an adherence to truth.

Whilst starting with such lithographs is indispensable for those who have no idea how to draw, for history painters it is completely futile: their eyes and hands are constantly being exercised by the copying of objects far more difficult than hills and trees, and for this reason they have at their disposal more than enough appropriate techniques for representing the countryside.

This would be the place to repeat all the rules on landscape which were laid down by G. de Lairesse, de Piles, the Encyclopedists, etc.; at this point I should consider the various distinctions bequeathed to us by these theorists concerning landscapes of mixed, natural and ideal types; this would be the place to show where one kind of landscape is appropriate and where another. But my pitiful ignorance does not allow me to master so much doctrine, and, in my ignorance, I have always maintained that only one kind of landscape can legitimately be introduced into painting, that is to say, that which evokes perfectly the idea of the truth which surrounds us.

[1] *Dizionario delle belle arti del disegno*, Bassano, 1797.

Part II
The Demands of the Present

II
Introduction

1848 was the 'year of revolutions'. By the light of hindsight the two preceding decades show signs of unrest and flux, as though marked by the struggle of the modern to achieve its definitive form in Western Europe. That struggle reveals itself most clearly in two particular areas: in the development of novel forms of social organization, and in a growing emphasis upon the subjective experience of the individual. It might briefly have seemed that the conservative powers had reimposed the old order in 1815, but a mere fifteen years after the defeat of Napoleon's army, revolution came again to France. The Bourbons were finally deposed, and following the revolution of July 1830 a constitutional monarchy was established under Louis-Philippe. This was the insurrection immortalized in Delacroix's *Liberty Leading the People*, shown in the Salon the following year.

A comparable social and political turmoil marked the opening of the 1830s in England, then the other main European power. The Great Reform Bill of 1832 did not so much effect as recognize a transfer of power from the aristocracy to the middle classes. In conceding the principle of adult male suffrage it both headed off the threat of revolution in the French manner and changed the practical terms of reference for notions of democracy. In the long term, however, it also had the effect of dividing working-class from middle-class radicals, and this at a time when there were powerful material pressures for change, both in the social and economic organization of the country and in the lives of its working population. In each decade between 1820 and 1850 industrial production in Britain increased by between a third and a half. The historian Eric Hobsbawm has argued that in the early nineteenth century Britain passed through 'a crisis which reached its stage of greatest acuteness' in the 1830s and 1840s.

At the same time in the United States the foundations were being laid for an industrial development that before long would challenge Europe. In 1825 the opening of the Erie canal linked the Hudson with the Great Lakes. The benefit to New York was immediate, and within fifteen years it had outstripped the power centres of Boston, Philadelphia and Baltimore to become the principal city of the Union. It is significant that by as early as the mid 1820s there was already a sufficient concentration of artists in New York to produce two rival Academies, divided in part on the question of how great a degree of independence and self-government the profession could or should sustain (IID 2 and 3). Whatever forces for change may have been at

work under the surfaces of European societies, and whatever specific friendships and alliances may have been forged across the Atlantic, to the proud republicans of the new world, the 'old world' generally meant monarchy, aristocracy, classical culture and, above all, patronage.

In one form or another the bourgeois order was consolidated during the 1830s and 1840s, and certain basic patterns of social, economic and cultural development were established for the remainder of the century. Aristocratic, artisanal and agrarian forms of social organization persisted, where they did, under conditions of increasing conservatism and isolation – isolation, that is to say, within the current of the modern. There was an increasing tendency for the middle class itself to divide, as those who believed they occupied the middle-ground by virtue of their heredity and education sought to maintain their elevation above those who had gained it through the fruits of business and industry. The possession of taste and discrimination was the advantage the 'haute' or the 'upper' claimed over the 'petit' or the 'lower', and culture was their favoured proving ground. Théophile Thoré (IIA 12 and IIB 11) and Charles Baudelaire (IID 13) were among the writers who elaborated on the philistinism of the bourgeoisie for the benefit of an audience that presumably saw itself as neither bourgeois nor philistine. It was not by such contests as these, however, that the social constitution of the modern state was determined. The significant struggle in this respect was the one in which the newly dominant capitalist middle class was engaged by another emergent social force: the urban working class. To put this point another way, we might say that the emergence of struggle between these two latter factions was a defining condition of what came to be seen as modern social life (IIA 9).

As we suggested earlier, if these were the patterns that were being established during the twenty-odd years before 1848, they are unlikely to have been identifiable as such in the experience of the typical individual. What clearly was noticed was the increasing redundancy of certain protocols, the irrevocable disappearance of certain forms of handicraft (IIA 4), and, of course, the rapid growth in the major cities and in their populations (IIA 6, IID 7 and 11). England was not to become predominantly urban until the mid century, and France not for a long time after that, while the northern, southern and eastern sections of Europe remained relatively backward in their political and economic development. At the cutting edge in England and France, however, the present was evidently experienced as a time of significant transition in social conditions and modes of existence, with certain past forms and values now clearly irrelevant or unattainable, and with the future uncertain and unmapped. The evidence suggests that social change was experienced during the 1830s and 1840s in unusually immediate and quotidian terms (IIA 5, IID 13), and less as the random effect of infrastructural processes that were themselves buried and untraceable. As a higher proportion of the populations was engaged in forms of commerce and manufacture, clearer distinctions were made between work-time and leisure-time, and these distinctions in turn linked to an awareness of crowded streets, enticing shop-windows and accelerating forms of transport and communication. It is during this period that a distinct and self-conscious sense of modernity can be seen to emerge in France and England, composed of three characteristic preoccupations of the urban life of the time: the mass, the spectacle and the commodity. This transformation in social experience had a driving force – an engine in an almost literal sense. The railway,

itself a product of the industrial revolution, hastened and helped to shape the social and cultural revolution of the period – to the dismay of some who saw a previously perpetual Nature thus put at risk (IIB 10).

There were as many different responses to this widespread sense of change as there were different commentators. But these responses may be grouped according to certain broad categories or tendencies, and they in turn will serve to distinguish the concerns of contemporary thought about art and culture. The first tendency may be connected to the rational and scientific aspect of the age. This was a period when the discourse of progress was still in its infancy and when the desire to know went hand-in-hand with the desire to classify, to organize and to control. Utilitarianism and positivism were the standard-bearers of this tendency, each responding to the sense of change with a new system of ideas. For Jeremy Bentham in England, art was required to prove its usefulness if it was to be allowed to survive in a utilitarian state (IIA 1). In France, Auguste Comte, while not discussing art as such, implicitly consigns it to the metaphysical past along with religion, rendered redundant by the positive science of society (IIA 2). However, his erstwhile mentor St Simon had already indicated a socially useful role for the artist as a form of propagandist for the rational future (IA 5). In concert with other intellectuals, artists were charged with the task of leading humanity forwards, as part of a kind of secular priesthood. St. Simon referred to this secular priesthood as an avant-garde, and the term has stuck to the modern practice of art ever since, for all the subsequent mutations and controversies to which it has been prone and for all the distance it has travelled from its original context of use. Towards the end of the period here under review Karl Marx was to apply the same concept to the matter of social transformation by a conscious political avant-garde (IIA 11).

The second broad tendency is characterized less by any purposive desire to define developments and to control them than by its articulation of a sense of profound disturbance. The representative concern here was that the 'progress' entailed by processes of industrialization and secularization, far from being beneficial to society, might actually hasten its barbarization. There was a consequent attempt to articulate the modern as a value necessarily continuous both with the appreciation of unchanging nature and with certain values in the culture of the past (IIB 6 and 7). While this tendency was certainly not conservative in all its aspects, it embraced some who spoke from determinedly conservative positions (IIB 1 and 10), including those who felt that a Christian morality and way of life were under threat (IIB 5 and 9). The sense of nature threatened was thus typically associated with the idea that one's proper human nature was put at risk by processes of modernization. Yet the elevation of nature as a standard could serve very different perceptions of the problems of the present. Where that standard was conceived by reference to classical canons, the Fall was the image typically evoked (IIB 3). But sometimes nature was made to stand for a world to be grasped empirically, to be wondered at and studied in its plain details. In such cases something more complex and potentially radical was afoot. What the modern was made to stand for was the ability fully to open one's eyes to the world (IIB 11).

This sense of nature as deserving of unconditional study carried echoes of the scientific ethos already noted. But whereas the idea of a *social* science seemed almost inevitably to entrain the urge to prescribe, the practice of *natural* science seemed more

readily restricted to the task of description and analysis. In the practice of art, a stress on the continuing value of nature as a study in itself tended to dovetail with a growing interest in the means by which natural effects are perceived and recorded. Both in England and in France the 1830s saw the publication of important and influential studies of colour, of its effects and interactions and of the means of its depiction (IIc4 and 5). The advocates of a modern naturalism in painting were thus provided with an apparently objective basis upon which to counter the traditional assumption that the study of nature confirms the rightness of classical canons. In the more advanced criticism of the time the ability to evoke strong sensations of colour was now recognized as a distinguishing sign of modernity in painting (IIc9). The true defining moment of the interface between art and science, however, came with the invention of photography, and with the transcription not of colours but of the effects of light (II c6 and 7). Publication of the first successful results in fixing an image on a light-sensitive surface sent a shock wave through the practice of art. On hearing of the invention, the academic painter Paul Delaroche is reported to have said, 'From today, painting is dead'. His announcement may have been premature, but it was soon to become clear that the role of art must change in an age of photographic reproduction. Over the course of the next hundred years and more, the extent and nature of that change was to remain the subject of a continuing debate.

We have singled out one final category of response to the sense of change. What gave the responses in question their urgency was the sense that there were precious rights and forms of experience to be safeguarded from the reach of the state and from the extension of its institutions. Thus, while the disposition in question was distinct from the more conservative forms of resistance to modern developments, it had little in common with the systematizing tendencies of utilitarianism or positivism. It was largely fixated upon the character of urban life, yet was not prescriptive about the direction that life should take. And while it is not generally associated with enthusiasm for nature per se, something of the naturalist's inclination to observe and to transcribe is transferred to the flora and fauna of the city streets (IID7 and 13). The period saw the emergence of the form of activity that Walter Benjamin was retrospectively to describe as 'botanizing on the asphalt'. The individual is the key ideological figure here, and it is one which was to remain entirely central to the cause of avant-garde art during the nineteenth century. The assertion of individuality may not have chimed with calls for collective action made on the revolutionary left, but it did not follow that it was conservative in spirit or in form. The recent memory of France's republican episode and the establishment of an independent American republic ensured that the artist's struggle for freedom of expression and for professional independence could be articulated against a background of larger political concerns, the light of personal autonomy set against the darkness of aristocratic privilege and patronage (IID2, 3 and 9). Towards the end of the twentieth century Michel Foucault referred to the human individual as like a name written in sand, effaced when the tide comes in. During the period under consideration, however, as the modern rose like a new continent out of the seas of the past, one writer after another turned to the first person singular as a fixed point of reference. The writers in question – Kierkegaard (IID4 and 14), Poe (IID7 and 8), Stirner (IID12), Baudelaire (IID13) – are among the most compelling witnesses to the transformations of their

time. We have included one anonymous text in this section to serve as reminder that whatever values may have been accorded to independence and individuality in the 1830s and 1840s, they were not generally looked for – or even allowed – in the productions of women (IID 5).

In reviewing the practice of art during the years between 1830 and 1848, it should be borne in mind that fundamental challenges to the Academies in France and England were still in the future, albeit the theoretical materials of those challenges were in process of accumulation. For the most part conflicts of priority still took place within a forum which the Academies defined and they were still subject to the authority with which the Academies were invested. In practical terms, the exercise of this authority entailed the provision of training and the maintenance of standards in accordance with an established canon of values and examples. Though this canon remained predominantly classical, the Academies could not show themselves entirely unresponsive to change while claiming to fulfil a public function, particularly given the effective disappearance of the aristocracy as a guarantor of patronage and prestige. In France the *juste milieu* stood for a centre-ground of bourgeois eclecticism and for a vision of history rendered congenial to the preoccupations of the times. Its typical manifestations were history paintings with neither the moral strenuousness of David's early work nor the accusatory pathos of Delacroix's. Faces and figures of the present appear in these paintings got up in togas, in doublets or in rags in staged attempts to be simultaneously profound and relevant. It was against the background of such efforts that Baudelaire called ironic attention to the heroism of modern life (IID 13). It is significant, however, that it was in a review of the Salon that that call was made. For all that Ingres and Delacroix each in their separate ways also despised this centre-ground, it was to the Salon too that their major work was addressed (IIA 7). There are parallels with the situation in England. Though Turner was a square peg in a round hole, he served the Royal Academy throughout his long professional life.

With Turner's work counted as something of an exception to prove the rule, it may be said that the pace of stylistic change in the 1830s and 1840s was gradual in comparison both with the early years of the Romantic movement, and with the years after 1848, when the Realist tendency gained momentum in France and when the Pre-Raphaelites came to public attention in England. In France in this interim period, innovation tended to occur within the relatively restricted space between the classical and the natural. In this context Corot is the paradigm figure (IIc 2). In his apparently modest art the natural world provided ground for experiment that was not a forum of substantial public dispute, where the possibility of technical change could be pursued without invoking vexed discussion of subject-matter and its significance. Delacroix remarked in the 1840s that nature was his dictionary, to be transformed by the exercise of artistic imagination. In his obituary on Delacroix, Baudelaire wrote that his painting worked as a 'mnemonic device' to recall the sum of poetic feelings and thoughts of the past which would otherwise have been 'engulfed forever in the night of time'. By the time that obituary was written, in 1865, it was probably stretching a point to suggest that the canonical art of the past was still fully accessible even through the medium of Delacroix's genius. But during the 1830s and the 1840s, the artists deserving of particular note do seem to have been those who maintained a Janus-like aspect: keeping alive the vision of a culture that was rapidly sinking below

the horizon while responding to new configurations which had yet to become distinct. In Marx's memorable perception, the circumstance was one in which 'all that is solid melts into air' (IIA 11). In 1848 the storm was finally to burst in social uprisings across Europe. Somehow, the impact would resolve the artistic tensions too (IIA 12).

IIA
Utility and Revolution

1 Jeremy Bentham (1748–1832) 'Reward Applied to Art and Science'

Bentham was the founder of utilitarianism, a school of philosophy which sought to discover rational principles for maximizing human happiness and social benefit. Though much of his vast body of writings remained fragmentary and unpublished during his lifetime, his influence was enormous. He travelled widely and in 1792 was made an honorary citizen of the French Republic. In the present extract he addresses the question as to how a wise legislator may, through reward, realize the goal of achieving 'the greatest happiness of the greatest number', turning his attention to the domain of art. Bentham maintains that the utility or value of the arts 'is exactly in proportion to the pleasure they yield' and, consistent with his premises, reaches the conclusion that 'prejudice apart, the game of push-pin is of equal value with the arts and sciences of music and poetry'. The extract is taken from *The Rationale of Reward*, first published in London by John and H. L. Hunt in 1825. It is important to note, however, that the papers which form the basis of this work were composed significantly earlier. They were originally incorporated into a larger, two-volume work edited by M. Dumont in 1811 and published in Paris under the title *Théorie des Peines et des Recompenses*. The editor of the English edition does not provide a literal translation of M. Dumont's work but has 'availed himself wherever he could of the original manuscripts'. The opening remarks are taken from Bentham's own 'Preliminary Observations'. The rest of the text is from Book III, 'Reward Applied to Art and Science', pp. 205–8.

The greatest happiness of the greatest number ought to be the object of every legislator; for accomplishing his purposes respecting this object, he possesses two instruments – Punishment and Reward. The theories of these two forces divide between them, although in unequal shares, the whole field of legislation.

The subject of the present work is Reward; and not Reward alone, but every other use which can be made of that matter of which rewards may be formed.

In the following work, the different sources from which rewards may be derived are examined; the choice which ought to be made between the different modifications of which it is susceptible, is pointed out; and rules are laid down for the production of the greatest effect with the least portion of this precious matter.

* * *

Taken collectively, and considered in their connection with the happiness of society, the arts and sciences may be arranged in two divisions, viz. 1. Those of amusement and curiosity; 2. Those of utility, immediate and remote. These two branches of human knowledge require different methods of treatment on the part of governments.

By arts and sciences of amusement, I mean those which are ordinarily called the *fine arts*; such as music, poetry, painting, sculpture, architecture, ornamental gardening, &c. &c. Their complete enumeration must be excused; it would lead us too far from our present subject, were we to plunge into the metaphysical discussions necessary for its accomplishment. Amusements of all sorts would be comprised under this head.

Custom has, in a manner, compelled us to make the distinction between the arts and sciences of amusement, and those of curiosity. It is not however proper to regard the former as destitute of utility: on the contrary, there is nothing, the utility of which is more incontestable. To what shall the character of utility be ascribed, if not to that which is a source of pleasure? All that can be alleged in diminution of their utility is, that it is limited to the excitement of pleasure: they cannot disperse clouds of grief or misfortune. They are useless to those who are not pleased with them: they are useful only to those who take pleasure in them, and only in proportion as they are pleased.

By arts and sciences of curiosity, I mean those which in truth are pleasing, but not in the same degree as the fine arts, and to which at the first glance we might be tempted to refuse this quality. It is not that these arts and sciences of curiosity do not yield as much pleasure to those who cultivate them as the fine arts; but the number of those who study them is more limited. Of this nature are the sciences of heraldry, of medals, of pure chronology, the knowledge of ancient and barbarous languages, which present only collections of strange words, and the study of antiquities, inasmuch as they furnish no instruction applicable to morality, or any other branch of useful or agreeable knowledge.

The utility of all these arts and sciences, – I speak both of those of amusement and of curiosity, – the value which they possess, is exactly in proportion to the pleasure they yield. Every other species of preeminence which may be attempted to be established among them is altogether fanciful. Prejudice apart, the game of push-pin is of equal value with the arts and sciences of music and poetry. If the game of push-pin furnish more pleasure, it is more valuable than either. Everybody can play at push-pin: poetry and music are only relished by a few. The game of push-pin is always innocent: it were well could the same be always asserted of poetry. Indeed, between poetry and truth there is a natural opposition: false morals, fictitious nature: the poet always stands in need of something false. When he pretends to lay his foundations in truth, the ornaments of his superstructure are fictions; his business consists in stimulating our passions, and exciting our prejudices. Truth, exactitude of every kind, is fatal to poetry. The poet must see everything through coloured media, and strive to make everyone else do the same. It is true, here have been noble spirits, to whom poetry and philosophy have been equally indebted, but these exceptions do not remove the mischiefs which have resulted from this magic art. If poetry and music deserve to be preferred before a game of push-pin, it must be because they are calculated to gratify those individuals who are most difficult to please.

All the arts and sciences, without exception, inasmuch as they constitute innocent employments, at least of time, possess a species of moral utility, neither the less real nor important, because it is frequently observed. They compete with, and occupy the place of those mischievous and dangerous passions and employments, to which want of occupation and ennui give birth. They are excellent substitutes for drunkenness, slander, and the love of gaming.

The effects of idleness upon the ancient Germans may be seen in Tacitus: his observations are applicable to all uncivilized nations: for want of other occupations they waged war upon each other: it was more animated amusement than that of the chase. The chieftain who proposed a martial expedition, at the first sound of his trumpet ranged under his banners a crowd of idlers, to whom peace was a condition of restraint, of languor, and of ennui. Glory could be reaped only in one field: opulence knew but one luxury. This field was that of battle; this luxury that of conquering or recounting past conquests. Their women themselves, ignorant of those agreeable arts which multiply the means of pleasing, and prolong the empire of beauty, became the rivals of the men in courage, and, mingling with them in the barbarous tumult of a military life, became unfeeling as they.

It is to the cultivation of the arts and sciences that we must, in great measure, ascribe the existence of that party which is now opposed to war: it has received its birth amid the occupations and pleasures furnished by the fine arts. These arts, so to speak, have enrolled under their peaceful banners that army of idlers which would have otherwise possessed no amusement but in the hazardous and bloody game of war.

Such is the species of the utility which belongs indiscriminately to all the arts and sciences. Were it the only reason, it would be a sufficient reason for desiring to see them flourish and receive the most extended diffusion.

* * *

2 Auguste Comte (1798–1857) 'The Nature and Importance of the Positive Philosophy'

Comte is generally regarded as the founder of the modern discipline of sociology. His 'positive philosophy' exercised an enormous influence on nineteenth-century thought, both for its emphasis on the proper aims and methods of scientific enquiry and for its more ambitious claims concerning the realization of a new age of science. From 1817 he came under the influence of the social reformer Claude-Henri de Saint-Simon, working as his secretary until their violent quarrel in 1824 (cf. IA5, above). Comte's principal work, the *Cours de philosophie positive* (Course in positive philosophy), was published in six volumes, from 1830 to 1842. The present extract is taken from the opening section of the first volume, in which Comte sketches the broad outlines of his new 'social physics'. Comte contends that human knowledge passes through three great stages, the theological, the metaphysical and the scientific or positive. Though the latter has irrefutably established itself in the domain of the natural sciences, enquiry into the existence of 'invariable natural laws' has yet to be extended to the study of social phenomena. The ambition of Comte's positive philosophy goes beyond the merely descriptive in so far as he maintains that insight into such general laws will offer a basis for social re-organization and for

overcoming the 'great political and moral crisis that societies are now undergoing'. In 1853 Comte's *Cours de philosophie positive* was translated and condensed into a two-volume English edition by Harriet Martineau, herself an important interpreter of economic, social and political theory and a forceful advocate of women's rights. These extracts are taken from the first volume, published under the title *The Positive Philosophy of Auguste Comte*, London: John Chapman, 1853, pp. 1–2, 5–8, 14–16.

In order to understand the true value and character of the Positive Philosophy, we must take a brief general view of the progressive course of the human mind, regarded as a whole; for no conception can be understood otherwise than through its history.

From the study of the development of human intelligence, in all directions, and through all times, the discovery arises of a great fundamental law, to which it is necessarily subject, and which has a solid foundation of proof, both in the facts of our organization and in our historical experience. The law is this: – that each of our leading conceptions, – each branch of our knowledge, – passes successively through three different theoretical conditions: the Theological, or fictitious; the Metaphysical, or abstract; and the Scientific, or positive. In other words, the human mind, by its nature, employs in its progress three methods of philosophizing, the character of which is essentially different, and even radically opposed: viz., the theological method, the metaphysical, and the positive. Hence arise three philosophies, or general systems of conceptions on the aggregate of phenomena, each of which excludes the others. The first is the necessary point of departure of the human understanding; and the third is its fixed and definitive state. The second is merely a state of transition.

In the theological state, the human mind, seeking the essential nature of beings, the first and final causes (the origin and purpose) of all effects, – in short, Absolute knowledge, – supposes all phenomena to be produced by the immediate action of supernatural beings.

In the metaphysical state, which is only a modification of the first, the mind supposes, instead of supernatural beings, abstract forces, veritable entities (that is, personified abstractions) inherent in all beings, and capable of producing all phenomena. What is called the explanation of phenomena is, in this stage, a mere reference of each to its proper entity.

In the final, the positive state, the mind has given over the vain search after Absolute notions, the origin and destination of the universe, and the causes of phenomena, and applies itself to the study of their laws, – that is, their invariable relations of succession and resemblance. Reasoning and observation, duly combined, are the means of this knowledge. What is now understood when we speak of an explanation of facts is simply the establishment of a connection between single phenomena and some general facts, the number of which continually diminishes with the progress of science.

* * *

The Law of human development being thus established, let us consider what is the proper nature of the Positive Philosophy.

As we have seen, the first characteristic of the Positive Philosophy is that it regards all phenomena as subjected to invariable natural *Laws*. Our business is, – seeing how

vain is any research into what are called *Causes*, whether first or final, – to pursue an accurate discovery of these Laws, with a view to reducing them to the smallest possible number. By speculating upon causes, we could solve no difficulty about origin and purpose. Our real business is to analyse accurately the circumstances of phenomena, and to connect them by the natural relations of succession and resemblance. The best illustration of this is in the case of the doctrine of Gravitation. We say that the general phenomena of the universe are *explained* by it, because it connects under one head the whole immense variety of astronomical facts; exhibiting the constant tendency of atoms towards each other in direct proportion to their masses, and in inverse proportion to the squares of their distances; whilst the general fact itself is a mere extension of one which is perfectly familiar to us, and which we therefore say that we know; – the weight of bodies on the surface of the earth. As to what weight and attraction are, we have nothing to do with that, for it is not a matter of knowledge at all. Theologians and metaphysicians may imagine and refine about such questions; but positive philosophy rejects them. When any attempt has been made to explain them, it has ended only in saying that attraction is universal weight, and that weight is terrestrial attraction: that is, that the two orders of phenomena are identical; which is the point from which the question set out. Again, M. Fourier, in his fine series of researches on Heat, has given us all the most important and precise laws of the phenomena of heat, and many large and new truths, without once inquiring into its nature, as his predecessors had done when they disputed about calorific matter and the action of an universal ether. In treating his subject in the Positive method, he finds inexhaustible material for all his activity of research, without betaking himself to insoluble questions.

Before ascertaining the stage which the Positive Philosophy has reached, we must bear in mind that the different kinds of our knowledge have passed through the three stages of progress at different rates, and have not therefore arrived at the same time. The rate of advance depends on the nature of the knowledge in question, so distinctly that, as we shall see hereafter, this consideration constitutes an accessory to the fundamental law of progress. Any kind of knowledge reaches the positive stage early in proportion to its generality, simplicity, and independence of other departments. Astronomical science, which is above all made up of facts that are general, simple, and independent of other sciences, arrived first; then terrestrial Physics; then Chemistry; and, at length, Physiology.

It is difficult to assign any precise date to this revolution in science. It may be said, like everything else, to have been always going on; and especially since the labours of Aristotle and the school of Alexandria; and then from the introduction of natural science into the West of Europe by the Arabs. But, if we must fix upon some marked period, to serve as a rallying point, it must be that, – about two centuries ago, – when the human mind was astir under the precepts of Bacon, the conceptions of Descartes, and the discoveries of Galileo. Then it was that the spirit of the Positive Philosophy rose up in opposition to that of the superstitious and scholastic systems which had hitherto obscured the true character of all science. Since that date, the progress of the Positive Philosophy, and the decline of the other two, have been so marked that no rational mind now doubts that the revolution is destined to go on to its completion, – every branch of knowledge being, sooner or later, brought within the operation of

Positive Philosophy. This is not yet the case. Some are still lying outside: and not till they are brought in will the Positive Philosophy possess that character of universality which is necessary to its definitive constitution.

In mentioning just now the four principal categories of phenomena, – astronomical, physical, chemical, and physiological, – there was an omission which will have been noticed. Nothing was said of Social phenomena. Though involved with the physiological, Social phenomena demand a distinct classification, both on account of their importance and of their difficulty. They are the most individual, the most complicated, the most dependent on all others; and therefore they must be the latest, – even if they had no special obstacle to encounter. This branch of science has not hitherto entered into the domain of Positive Philosophy. Theological and metaphysical methods, exploded in other departments, are as yet exclusively applied, both in the way of inquiry and discussion, in all treatment of Social subjects, though the best minds are heartily weary of eternal disputes about divine right and the sovereignty of the people. This is the great, while it is evidently the only gap which has to be filled, to constitute, solid and entire, the Positive Philosophy. Now that the human mind has grasped celestial and terrestrial physics, – mechanical and chemical; organic physics, both vegetable and animal, – there remains one science, to fill up the series of sciences of observation, – Social physics. This is what men have now most need of: and this it is the principal aim of the present work to establish.

It would be absurd to pretend to offer this new science at once in a complete state. Others, less new, are in very unequal conditions of forwardness. But the same character of positivity which is impressed on all the others will be shown to belong to this. This once done, the philosophical system of the moderns will be in fact complete, as there will then be no phenomenon which does not naturally enter into some one of the five great categories. All our fundamental conceptions having become homogeneous, the Positive state will be fully established. It can never again change its character, though it will be for ever in course of development by additions of new knowledge.

* * *

The Positive Philosophy offers the only solid basis for that Social Reorganization which must succeed the critical condition in which the most civilized nations are now living.

It cannot be necessary to prove to anybody who reads this work that Ideas govern the world, or throw it into chaos; in other words, that all social mechanism rests upon Opinions. The great political and moral crisis that societies are now undergoing is shown by a rigid analysis to arise out of intellectual anarchy. While stability in fundamental maxims is the first condition of genuine social order, we are suffering under an utter disagreement which may be called universal. Till a certain number of general ideas can be acknowledged as a rallying-point of social doctrine, the nations will remain in a revolutionary state, whatever palliatives may be devised; and their institutions can be only provisional. But whenever the necessary agreement on first principles can be obtained, appropriate institutions will issue from them, without shock or resistance; for the causes of disorder will have been arrested by the mere fact of the agreement. It is in this direction that those must look who desire a natural and regular, a normal state of society.

Now, the existing disorder is abundantly accounted for by the existence, all at once, of three incompatible philosophies, – the theological, the metaphysical, and the positive. Any one of these might alone secure some sort of social order; but while the three co-exist, it is impossible for us to understand one another upon any essential point whatever. If this is true, we have only to ascertain which of the philosophies must, in the nature of things, prevail; and, this ascertained, every man, whatever may have been his former views, cannot but concur in its triumph. The problem once recognized cannot remain long unsolved; for all considerations whatever point to the Positive Philosophy as the one destined to prevail. It alone has been advancing during a course of centuries, throughout which the others have been declining. The fact is incontestable. Some may deplore it, but none can destroy it, nor therefore neglect it but under penalty of being betrayed by illusory speculations. This general revolution of the human mind is nearly accomplished. We have only to complete the Positive Philosophy by bringing Social phenomena within its comprehension, and afterwards consolidating the whole into one body of homogeneous doctrine. The marked preference which almost all minds, from the highest to the commonest, accord to positive knowledge over vague and mystical conceptions, is a pledge of what the reception of this philosophy will be when it has acquired the only quality that it now wants – a character of due generality. When it has become complete, its supremacy will take place spontaneously, and will re-establish order throughout society. There is, at present, no conflict but between the theological and the metaphysical philosophies. They are contending for the task of reorganizing society; but it is a work too mighty for either of them. The positive philosophy has hitherto intervened only to examine both, and both are abundantly discredited by the process. It is time now to be doing something more effective, without wasting our forces in needless controversy. It is time to complete the vast intellectual operation begun by Bacon, Descartes, and Galileo, by constructing the system of general ideas which must henceforth prevail among the human race. This is the way to put an end to the revolutionary crisis which is tormenting the civilized nations of the world.

3 Marie-Camille de G. (dates unknown) 'Fine Arts. Salon of 1834'

It is usually assumed that few if any women wrote art criticism in early nineteenth-century France. In fact the number increased as the periodical press expanded during the 1830s, and issues concerning women and the visual arts were discussed with some frequency, normally in the context of the annual Salon exhibitions. There had been a tendency for women critics to use male pseudonyms or to retain anonymity. This tendency declined as the market increased, however, since the establishment of a recognizable persona was a necessary condition of earning money by writing. Marie-Camille de G. was a member of a small group of utopian socialists who wrote and produced the short-lived *Tribune des femmes* (originally entitled *La Femme libre*), distributing it through street sales. Surnames were withheld not in the interests of anonymity but in order to avoid use of the patriarchal names of husbands and fathers. The journal was shut down in 1834 when uprisings in several French towns were answered by repressive measures from the government. This text was originally published as 'Beaux-Arts. Salon de 1834' in *Tribune des femmes*, volume II, April 1834, pp. 158–64, from which these extracts are taken. Translation

from the original source has been made for this volume by Jonathan Murphy. Delaroche's painting of *The Execution of Lady Jane Gray* is now in the collection of the National Gallery in London. Ingres's *Martyrdom of St Symphorian* is in the cathedral of Autun.

The artist must move the spectator. But such a power can only be possessed by an artist who is inspired by some all-encompassing, religious idea, for such an idea itself is a muse. Like Orpheus animating the stones, or the painters of the Vatican instilling conviction in the men who saw their pictures, an idea fills souls with enthusiasm and turns poets into prophets. The history of art can be divided into periods of *thought* and periods of *form*. Under the sway of religious thought, form is like the outpourings of an ardent soul, naïve and sublime, lacking order in its naturalness, simple and biblical, like the patriarchal language of Homer, or the free and easy charm of medieval poetry. But when this source of inspiration dries up, and incredulity takes its place at the altar, freezing the words on the lips of the priest, the predominance of thought is succeeded by a predominance of form. Art becomes severe, regular and classical. When Aristophanes has the Gods descend from Olympus down onto the stage, clothes them in rags, and makes them the butt of the jokes of the people, meretricious rhetoric takes centre stage. Similarly, in the Sixteenth century, that century of endless disputes between monks and kings and Popes, when the mystic silence of church and cloister was troubled for the first time, and the Divine dove, startled from its gothic nest, took wing and ascended to its father in Heaven, the arts came out of the temple as cold as a body bereft of life. The Renaissance was proclaimed: and this truly was the triumph of empty form over thought. Humanity and the arts form an indissoluble whole; when humanity is religious the arts flourish, fired by enthusiasm, but when it is incredulous, they wither and die, from lack of inspiration.

In the same way that humanity tires of walking an arid path where no feeling of happiness blossoms, and of having no thoughts with which its broken soul might repose, the arts, when classical periods draw to a close, and centuries like that of Augustus or Louis XIV draw their last breath, having uttered their final words in Virgil or Racine, and merit is no longer to be found but in imitation or pastiche, the arts strive to return to life, and seek out a new form of originality. The rules of rhetoric are broken, and liberty, art and *romanticism* spring forth. Soon too come the intermediaries, eclectic men in the fields of art, philosophy and politics; men with vision, marching towards a visionary future. Such an era is our own: in literature, Casimir Delavigne is side by side with Victor Hugo, and in painting, Delaroche is side by side with Ingres. It is to be hoped that in sculpture too, similar luminaries will soon emerge.

No new *thought*, as yet, animates these innovators, who work only with form, but the ground is being prepared, so that the voice of God may be heard, when his chosen representative appears.

These principles should help us to understand this year's Salon and the attitudes that people are taking towards it. Why is it that a crowd of artists and amateurs throngs around two pictures by Delaroche and Ingres in particular? For one good reason: the eclectic talent of Delaroche and the original genius of Ingres bear witness to all the problems that are currently besetting art.

The subject of Delaroche's painting is Lady Jane Gray, at the moment when the executioner is about to follow the orders of Queen Mary and bring down his axe upon her neck. She fills us with pity: she is about to die for a dream, for wanting to be dressed in royal robes, and for wanting to see her own eyes sparkle beneath a diamond crown. Mary has forced her from the throne to the Tower, and for her crown, has given her a blindfold to hide her eyes, and for a cushion to rest her head, an executioner's block. How she has suffered! What tears she has cried over her glorious past! And how gladly she now gives up a life that has contained so much suffering! Her thoughts race...does she know that the executioner's blade will grant her immortality? He stands before her, with great dignity, hiding his own pain beneath the furrows of his brow. We can almost believe that he is asking himself how it came about that a mere seventeen years could bring such grace to a girl as young and beautiful as this, and how it came to pass that she must now abandon her life of sweet comfort, and lay down her head beneath his axe. Beside her stands the Keeper of the Tower, expressionless, while to her rear her two servants swoon away. The colour of the painting is striking in its truthfulness, the drawing unexceptional, the poses natural, but it is with some disappointment that one notes that the artist was too concerned with individual detail, and that the carpet is carefully laid out, the folds of Lady Jane's dress fall too regularly, and that nothing, not the tiniest stroke, is missing. Delaroche takes up a particular idea, meticulously researches all the necessary details, and repeats them with great care, but he lacks originality. He is merely a man of great talent.

Anyone who cannot conceive of unity in variety should examine Ingres's contribution to the Salon this year. The subject is Saint-Symphorien, in prison, where he has suffered thirst, hunger and all the tortures known to man. His flesh may have bled and been lacerated into strips by the blows of the lictor, his body may be broken, but his soul stands fast. Ingres is a man of genius.

According to the distinction that we have made between eclectic artists and original artists, with Delaroche we would place Delacroix and Vernet; with Ingres we place Granet, Decamps and the elder Scheffer.

Delacroix has sent several pictures, the most worthy of note being *The Battle of Nancy*, where Charles the Bold, Duke of Burgundy was killed, and *The Women of Algiers*.

On coming out of the museum one is struck by a sad thought. We see battles, shipwrecks, scaffolds, landscapes, portraits, thousands of pictures, but so few pictures with any vision. We see extraordinary attempts at drawing and colour, a prodigious expenditure of talent, but the resulting paintings are nothing more than hackneyed, sterile scenes.

Painters represent women in a multitude of styles. They turn them into flowers with which they furnish exquisite boudoirs; they intoxicate them with perfumes and honeyed words; they show them at elegant society balls where you could mistake them for priestesses in their rich robes; and in interior scenes they stretch them out voluptuously, dreaming on sumptuous divans. Now they are painted like blooms in the sun, blossoming beneath the sweet breath of their lover, now, with scant regard for their modesty, their beautiful bodies are desecrated as they are dragged before the executioner. Surely, Gentlemen, we have had our fill of perfumes and beautiful

clothes, passionate embraces and scaffolds: the time has come to grant women a place worthy of them, the due place they deserve! We have seen again this year yet another Eve picking the forbidden fruit. The painter in question would be well advised to go and look closely at a picture by Jules Laure, an artist of our acquaintance, who we can thank for faithfully portraying the thoughts of a great woman. He will see Lélia kneeling beside the body of Sténio; a world of suffering weighs down on the shoulders of the young woman, and cruel disappointments have caused her beautiful face to pale. Perhaps it will occur to him that for long enough now the daughters of Eve have torn at their flesh and sacrificed their hearts for the sons of Adam, for long enough they have watered the paths of the earth with their tears: it is time a new Eden appeared. Artists! If you love *women*, if some time their beauty has filled your soul with poetry, and lent delicacy and inspiration to your brush to fix your dreams and joys on canvas, show her growing in liberty. Imagine the progression. First, crushed beneath shields, walking like a worker, suffering under the weight of her chains; her body, her thoughts, her desires, all her existence broken by the hand of her tyrant; then, beginning to look more resolutely at her master and transforming her slavery into a tutelage, which in turn she hopes to surpass. For women wish to be free, as God has breathed a love of liberty into their souls. But free to pour balm on the wounds of humanity, like a holy dove descending from the skies; free to quell the bellicose urges of man, and lead him back to God, back to the path of peace and happiness; free to embrace the universe with the intelligence of a savant, and to embrace it with love; free to serve as the bond not simply between individuals but between entire peoples. Women yearn for a pedestal in the temple, to preach to the world the sacred words that inspire hearts and show men the path into the future.

The working classes only entered the pictures of the salon with weapons in their hands, stained with mud and blood, with hate in their hearts and cruelty in their eyes. Artists! If you really feel solidarity with the people, if you have felt the strength and grandeur beneath that surface of rude ignorance, show too their weeping wounds, that those who have the power to tend to such suffering are moved to action! If you love drama, paint those awful scenes which are played out every day before your eyes, paint an unhappy father dying in a pauper's bed, filled with agony and misery. Paint his numerous children who beg for bread with their cries and their tears, paint his daughter whose income cannot possibly meet the needs of her father and her brothers, and further off, in the background, paint the rich man offering her the gold she needs to minister to her father and save his life . . . but at a terrible price! Let your canvas cry out in despair so that the world can see the anguish, the torture and the terrible sacrifices which civilization veils with a deceptive smile: let the terrible cries of hunger and the awful spectre of prostitution be seen! Let your pictures be a mirror which reflects the pain of the poor, let them seize that poverty and distill it so strong that the rich catch their breath and are brought to their senses. In Anvers, they say, a Rubens picture of Christ is veiled, as the very sight of it sends electric shocks through spectators; let your works be so, that the privileged are ashamed of their happiness, while thousands of others agonize in misery.

If you are filled with enthusiasm, enlarge your canvas so that all humanity can play out its giant drama there. Let your canvas be an elemental maelstrom, water and earth, and air and fire; – fill it with the hopes of the world. Let it transport us a

thousand leagues over the seas; fill it with mountains and forests and pyramids and temples; let it take the world in its hands, and forge it anew, let it listen to that gathering storm of progress, as the mighty voice of God calls out and urges us on to new worlds of ideas, achievements and inventions. For we march on inexorably, to a temple of joys which we dimly perceive on the horizon, whose marble columns and eternal towers we will one day see standing tall before us.

A great mission awaits the artists of today!

4 Augustus Welby Pugin (1812–52) 'On the Wretched State of Architecture at the Present Day'

This text is taken from the Conclusion to Pugin's *Contrasts*. The full description of this book is 'A Parallel between the Noble Edifices of the Fourteenth and Fifteenth Centuries, and Similar Buildings of the Present Day; shewing the Present Decay of Taste'. The author was an architect, and the substance of his polemical publication was provided by a series of paired illustrations, each showing a supposedly representative area of a modern town juxtaposed with its imagined medieval equivalent, to the disadvantage of the former. Pugin's construction of the middle ages was utopian and his anti-modernism largely conservative. But there were two powerful and complementary critical implications to his thesis. The first was that the underlying social and ethical condition of a given society might be diagnosed both through the forms of its design and through the forms of human labour required to implement them. The second was that deleterious architectural and social consequences could be seen to follow when the forces of industrialization and mass production were harnessed to the profit motive. His work was thus formative not only of the nineteenth-century Gothic revival in England, but of a distinct critical current within the theory of the European modern movement in design and architecture. John Ruskin (IIIA9, IIIc6) and William Morris (VB4 and 5) were among those who continued this current, while the Omega Workshops in London and the Bauhaus in Germany were among the various twentieth-century enterprises in which attempts were made to put the resulting theories into practice. Pugin's views were echoed in official circles at the time and were to receive considerable support. In 1836 a select committee of the British government recommended the establishment of schools of design and public museums, principally as means to improve the standard of design in manufacture. In 1852 a Museum of Manufactures was established with the aim of satisfying the need voiced in *Contrasts* for 'a museum where the finest specimens of each style might be found'. This was later to become the Victoria and Albert Museum. And Pugin's assault on the decayed classicism of public buildings could have had no more conspicuous outcome than the rebuilding of the Houses of Parliament to designs which he helped to develop. (Compare Semper's criticism of the Parliament buildings in IIIA5.) *Contrasts* was privately published by the author in London in 1836. Our text is taken from the original edition, pp. 30–3 and 35.

Perhaps there is no theme which is more largely dilated on, in the present day, than the immense superiority of this Century over every other that has preceded it. This great age of improvement and increased intellect, as it is called, is asserted to have produced results which have never been equalled; and, puffed up by their supposed excellence, the generation of this day look back with pity and contempt on all that passed away before them.

In some respects, I am willing to grant, great and important inventions have been brought to perfection: but, it must be remembered, that these are purely of a mechanical nature; and I do not hesitate to say, that as works of this description progressed, works of art and productions of mental vigour have declined in a far greater ratio.

Were I to dilate on this subject, I feel confident I could extend this principle throughout all the branches of what are termed the fine arts; but as my professed object is to treat on Architecture, I will confine my observations to that point, leaving to some more able hand the task of exposing false colour and superficial style, which has usurped nature of effect and severity of drawing, and of asserting the immense superiority of the etchings of the old schools over the dry and mechanical productions of the steel engravers of our time, whose miserable productions, devoid of soul, sentiment, or feeling, are annually printed by the thousand, and widely circulated, to remain an everlasting disgrace on the era in which they were manufactured.

Let us now, therefore, examine the pretensions of the present Century to a superiority in architectural skill; let us examine the results – that is, the edifices that have been produced: and, I feel confident, we shall not be long in deciding that, so far from excelling past ages, the architectural works of our time are even below par in the scale of real excellence.

Let us look around, and see whether the Architecture of this country is not entirely ruled by whim and caprice. Does locality, destination, or character of a building, form the basis of a design? no; surely not. We have Swiss cottages in a flat country; Italian villas in the coldest situations; a Turkish kremlin for a royal residence; Greek temples in crowded lanes; Egyptian auction rooms; and all kinds of absurdities and incongruities: and not only are separate edifices erected in these inappropriate and unsuitable styles, but we have only to look into those nests of monstrosities, the Regent's Park and Regent Street, where all kind of styles are jumbled together to make up a mass.

It is hardly possible to conceive that persons, who had made the art of Architecture the least part of their study, could have committed such enormities as are existing in every portion of these buildings. Yet this is termed a great metropolitan improvement: why, it is a national disgrace, a stigma on the taste of the country; and so it will remain till the plaster and cement, of which it is composed, decay.

Of an equally abominable description are the masses of brick and composition which have been erected in what are termed watering-places, particularly at Brighton, the favoured residence of royalty, and the sojourn of all the titled triflers who wait upon the motions of the court. In this place the vile taste of each villa and terrace is only surpassed by the royal palace itself, on which enormous sums have been lavished, amply sufficient to have produced a fabric worthy of a kingly residence. It would be an endless task to point out and describe all the miserable edifices that have been erected, within the last Century, in every class of Architecture; suffice it to observe, that it would be extremely difficult, if not impossible, to find one amongst the immense mass which could be handed down to succeeding ages as an honourable specimen of the architectural talent of the time.

This is a serious consideration, for it is true. Where, I ask, are the really fine monuments of the country to be found, but in those edifices erected centuries ago,

during the often railed at and despised period of the Middle Ages? What would be the interest of the cities, or even towns and villages, of this country, were they deprived of their ancient gigantic structures, and the remains of their venerable buildings? Why, even in the metropolis itself, the abbey church and hall of Westminster still stand pre-eminent over every other ecclesiastical or regal structure that has since been raised.

No one can look on Buckingham Palace, the National Gallery, Board of Trade, the new buildings at the British Museum, or any of the principal buildings lately erected, but must feel the very existence of such public monuments as a national disgrace.

And if we regard the new castle at Windsor, although the gilding and the show may dazzle the vulgar and the ignorant, the man of refined taste and knowledge must be disgusted with the paucity of ideas and meagre taste which are shewn in the decoration; and he will presently discover, that the elongated or extended quatrefoil and never-ending set of six pateras, in the rooms called Gothic, and the vile scroll-work intended for the flowing style of Louis Quatorze, announce it as being the work of the plasterer and the putty presser, instead of the sculptor and the artist.

Nor is there to be found among the residences of the nobility, either in their town mansions or country seats, lately erected, any of those imposing and characteristic features, or rich and sumptuous ornaments, with which the residences of the Tudor period abounded.

Nor can any thing be more contemptible than the frittered appearance of the saloons and galleries, crowded with all sorts of paltry objects, arranged, as if for sale, in every corner, which have replaced the massive silver ornaments, splendid hangings, and furniture of the olden time.

Indeed, I fear that the present general feeling for ancient styles is but the result of the fashion of the day, instead of being based on the solid foundation of real love and feeling for art itself; for, I feel confident, if this were not the case, purchasers could never be found for the host of rubbish annually imported and sold: nor could persons, really acquainted with the beauty of what they profess to admire, mutilate fine things when they possess them, by altering their greatest beauties to suit their own caprice and purposes – a barbarity continually practised in what is called fitting-up old carvings.

Yes, believe me, this goût for antiquities is of too sudden a nature to have proceeded from any real conviction of the beauty of those two styles, or to have been produced from other motives but those of whim and fashion; and I do believe that, were some leading member of the *haut ton* to set the fashion for some new style, the herd of collectors would run as madly after their new plaything, as they do after the one they have got at present.

The continual purchase of these things, at extravagant prices, may benefit the broker and the salesman, but does not advance a restoration of such art or style one iota.

Were these people of power and wealth really impressed with a feeling of admiration for the glorious works of ancient days, and anxious for the restoration of the skill and art which produced them, instead of filling their apartments with the stock of a broker's shop, they would establish a museum, where the finest specimens of each style might be found, and from which the sculptor and the artist might school themselves in their principles. They would send forth men to preserve faithful

representations of the most interesting monuments of foreign lands, and extend a fostering care for the preservation and repair of those fine remains rapidly falling into decay; and, by encouraging talent where it is to be found, raise up by such means a race of artists, who, I hesitate not to say, could be found able to conceive and execute things equally fine and masterly as in more ancient days, but who, for want of such support, are compelled to leave the study of what they most admire, and in which they would excel, for some grovelling occupation by which to gain a bare subsistence.

I state this to wrest from these mere buyers of curiosities the title of patrons of art, which has so undeservedly been bestowed upon them. It was under the fostering care of the Catholic church, and its noble encouragement, the greatest efforts of art have been achieved; deprived of that, the arts in vain look for an equivalent: for its professors must either starve neglected, or sacrifice the noblest principles and beauties of their art to the caprice and ignorance of their employers.

I could not refrain from making this digression, as I feel that what I have just stated is one of the great causes of the present wretched state of art.

I trust I have now shewn satisfactorily that this country, however it may excel in mechanical contrivances, has so little to boast on the score of improvement in art, that, were it not for the remains of the edifices produced during the Middle Ages, the architectural monuments of this country would be contemptible in the extreme.

The truth of this assertion, coupled with the fact that there never was a period when there were so many lectures, academies, drawing schools, and publications on the subject, proves how little the noble arts of Architecture, Painting, and Sculpture, are suited to the trammels of a system; and nothing has tended more to produce the vile results we see, than the absurd idea that persons can be brought up as easily to practise in those exalted professions, as to fill the humble station of a trafficker in merchandise or a mechanical trade; when, in truth, few are there who ever have, or ever can, attain to great excellence in the arts, and the station they arrive at must depend entirely on their own souls and exertions – for small indeed is the instruction that can be imparted on the subject, beyond the mere mechanical use of the tools, and the general principles of drawing.

* * *

I feel acutely the fallen condition of the arts, when each new invention, each new proceeding, seems only to plunge them deeper in degradation. I wish to pluck from the age the mask of superior attainments so falsely assumed, and I am anxious to direct the attention of all back to the real merit of past and better days. It is among their remains that excellence is only to be found; and it is by studying the zeal, talents, and feelings, of these wonderful but despised times, that art can be restored, or excellence regained. (Laus Deo.)

5 Ralph Waldo Emerson (1803–1882) from 'The American Scholar'

Emerson was the leading figure of the New England Transcendentalists. These represented the American development of the ideas of European Romanticism. Opposed to the mechanistic philosophies dominant in the eighteenth century, they were committed to a

belief in the unity of nature and humanity, and claimed the priority of insight over rationality. Emerson had visited Europe in 1832–3, and in England had met Coleridge, Wordsworth and Carlyle (whose *Sartor Resartus* (see IA13) he first printed in book form). His address, 'The American Scholar', has been viewed as the manifesto for a new type of American intellectual. In its affirmation of the humble and proximate over the academic and remote, it was influential upon figures such as Whitman (see IIID9), Melville and others identified with the American cultural 'Renaissance' of the mid-1830s to 1860s. It was first delivered at Harvard on 31 August 1837 and published in the *Works of Ralph Waldo Emerson*, London: Routledge, 1889, pp. 514–72. The present extract is from p. 571.

If there is any period one would desire to be born in, – is it not the age of Revolution; when the old and the new stand side by side, and admit of being compared; when the energies of all men are searched by fear and by hope; when the historic glories of the old can be compensated by the rich possibilities of the new era? This time, like all times, is a very good one, if we but know what to do with it.

I read with joy some of the auspicious signs of the coming days, as they glimmer already through poetry and art, through philosophy and science, through church and state.

One of these signs is the fact, that the same movement which effected the elevation of what was called the lowest class in the state assumed in literature a very marked and as benign an aspect. Instead of the sublime and beautiful; the near, the low, the common, was explored and poetized. That, which had been negligently trodden under foot by those who were harnessing and provisioning themselves for long journeys into far countries, is suddenly found to be richer than all foreign parts. The literature of the poor, the feelings of the child, the philosophy of the street, the meaning of household life, are the topics of the time. It is a great stride. It is a sign – is it not? – of new vigour, when the extremities are made active, when currents of warm life run into the hands and the feet. I ask not for the great, the remote, the romantic; what is doing in Italy or Arabia; what is Greek art, or Provençal minstrelsy; I embrace the common. I explore and sit at the feet of the familiar, the low. Give me insight into to-day, and you may have the antique and future worlds. What would we really know the meaning of? The meal in the firkin; the milk in the pan; the ballad in the street; the news of the boat; the glance of the eye; the form and the gait of the body; – show me the ultimate reason of these matters; show me the sublime presence of the highest spiritual cause lurking, as always it does lurk, in these suburbs and extremities of nature; let me see every trifle bristling with the polarity that ranges it instantly on an eternal law; and the shop, the plough, and the ledger, referred to the like cause by which light undulates and poets sing; and the world lies no longer a dull miscellany and lumber-room, but has form and order; there is no trifle; there is no puzzle; but one design unites and animates the farthest pinnacle and the lowest trench.

6 Robert Vaughan (1795–1868) 'On Great Cities in their Connexion with Art'

This text is taken from Vaughan's book *The Age of Great Cities*. Vaughan was an English Doctor of Divinity with a tendency to non-conformism and with a sceptical cast of mind. The

subtitle of his work was 'Modern Society Viewed in its Relation to Intelligence, Morals and Religion'. His principal concern was to identify the characteristics and tendencies of modern societies, and in particular to explain what he saw as the conflict between Feudalism – by which he meant the concentration of power and wealth in the hands of a minority – and Civilization. 'If the baron be not so military as formerly', he wrote on his opening page, 'he is more opulent.' The present excerpt is notable for Vaughan's attribution of the civilizing powers of art not, as was virtually automatic at the time, to the responsible guardianship of the gentleman and the scholar, but rather to the agency of 'the trader and the citizen'. The tenor of his analyses is one of moderate and ironic republicanism. (On the subject of patronage, his views may be compared with those of the Americans Dunlap and Morse, IID2 and 3.) *The Age of Great Cities* was first published in London: Jackson and Walford, 1843. Our excerpt is taken from the original edition, chapter IV, section iv, pp. 130–6.

[. . .] It is not disputed, that in any land where there are flourishing cities, the territorial aristocracy will be distinguished as patrons of the beautiful in art. But whence has this aristocracy derived the wealth by means of which it indulges so largely in the gratification of those tastes? Whence has it derived these tastes themselves? And whence came the men of genius possessing the power to minister to those tastes? On these questions, it is not too much to say, that as the town has made the country, giving to its lands a beauty and value they would not otherwise have possessed; so the citizen has made the noble, by cultivating in him a taste for art, which would not otherwise have formed a part of his character. For it must be obvious that the country which should be purely agricultural, producing no more than may be consumed by its own agricultural population, must unavoidably be the home of a scattered, a rude, and a necessitous people, and its chiefs be little elevated above the coarse untaught mass of their dependants. Burgesses produce both the useful and the ornamental, and minister in this manner both to the need and the pleasure of nobles and kings. What they sell not at home they send abroad. In either case, wealth is realized; lands become more valuable; public burdens can be borne; and along with the skill which produces embellishment, come the means by which it may be purchased.

In this manner, the baron has been elevated by the burgess, and courts have been refined by cities. [. . .] It will be admitted, that, notwithstanding some occasional and strong exceptions, there is generally in an aristocracy a spirit and dignity, an almost innate sense of the proper, which could hardly fail to bring improvement . . . along with it. It is nevertheless true, that the revival of the fine arts in Europe was much more the work of its merchants than of its nobles, or of its princes. Had the noble families of Europe all perished, an aristocracy of wealth and genius would have risen in place of an aristocracy of privilege, and would, no doubt, have conferred on such refinements much of that kind of patronage which has been dispensed in their favour during the last three or four centuries by other hands. Even now, were cities to cease, the fine arts would cease. It is probable they would linger last, where they made their appearance last, in the mansion of the great landholder; but ceasing to have any connexion with the trader and the citizen, they would soon die out everywhere.

It would seem to be the notion of some men that where there is no high hereditary class, possessing large hereditary wealth, there can be no successful cultivation of art, or of intelligence of any kind, in their higher forms. But the slightest acquaintance

with the history of ancient Greece should have sufficed to prevent such an error – an error which is a disgrace to the intelligence of any man not born and bred in the lowest pauperism. It may well be doubted, if the world would hitherto have seen such an age as that of Augustus, or that of Louis XIV, if it had not previously seen the age of Pericles. It is a remarkable fact, and one which the class of persons adverted to would do well to consider, that the states of Greece, which knew nothing of hereditary distinctions, which were not possessed of large wealth, which consisted of so many city communities, and were pervaded generally by the spirit of republicanism, colonization, and commerce – that it was given to those states to supply to all subsequent time the models of the wonderful in science and art, models which the proudest empires have done well to imitate, which they have rarely equalled, and never surpassed.

In saying thus much, we do not say that a large class of wealthy patrician families may not exercise a most beneficial influence on the progress of art. We only maintain that the successful patronage of the fine arts depends less on the existence of noble families, than upon the existence of prosperous cities. Without the former kind of patronage, art may be wanting in some of its higher attributes; without the latter, it would cease to have existence. Such, however, is not the common idea on this subject, even with persons who flatter themselves that they understand it very much better than their neighbours. Such is nevertheless the true idea. The republican traders of Holland could boast of a fine school of art in the seventeenth century, while a hundred years were to pass before England, with all the supposed advantages of her aristocratic institutions, could be said to possess one. We have become great in art, as we have become great in commerce, and only in that proportion. Since the seventeenth century, we have surpassed the Hollanders almost immeasurably in our naval power, in our colonial empire, and in our commercial greatness, and our school of art is just such an improvement on the Dutch school, as the wide and powerful influence which has thus come upon our affairs might have led the sagacious to expect.

Nor should it be overlooked, that the qualities of aristocratic patronage which are favourable to art in some respects, are very unfavourable to it in others. It is a patronage which is naturally restricted to works of the highest class. Its smile is hard to win, and is rarely obtained until the artist has gained a position which makes him in a good degree independent of it. Struggling genius has often had reason to be thankful that there is a lower patronage as well as a higher. It is only the aristocracy in art that are allowed to rise to some affinity with the aristocracy in rank.

It is true, democracy is not without its pride and jealousies in relation to such things. It has often dispensed its frowns so as to preclude the private citizen, however opulent, from any ostentatious indulgence of his taste in this form. The feeling of repugnance to any marked display of this kind in the case of the leading men of the state, was very strong in the Greek republics; and we find that the same causes have served to produce and perpetuate a feeling of this kind in the United States. It is a feeling which leads to two evils – it invades liberty, and it discourages art.

But while it is in the nature of a democracy to be thus jealous even of the appearance of an inroad upon the great line of equality, it generally compensates for the good which it prevents with the one hand, by the good which it confers with the

other. It discountenances the private patronage of art, but it can lavish its wealth, almost without limit, upon edifices and monuments designed to do honour to the state – and thus the waters which are shut out from many lesser channels, flow naturally in greater confluence along their permitted course.

In a republic, man learns to look on all about him as, in a sense, his equals. It is to the state only that he can bow as to a superior. He sees a majesty in art, and he knows of no connexion appropriate to it, in its more conspicuous and imposing forms, save the majesty of the state. His jealousy of assumption where all should be equal, his proud estimate of himself, the homage with which he regards that mystic image the state, and the reverence with which he looks on art, all concur to put him upon this course. Our own exemption from this feeling is one of the advantages arising from our mixed state of society.

It appears, then, that the ornamental arts owe their existence to the same causes which give existence to cities; and that society becomes possessed of the beautiful in art, only as cities become prosperous and great. It has appeared, moreover, that while there are advantages and disadvantages pertaining to the different forms of civil society, as regards their influence on art, it is a fact, that the popular states of antiquity have supplied the models in relation to this high department of civilization, which the more aristocratic, and the monarchical states of later times, have been content to imitate or mutilate, but which they have never been known to improve.

7 Heinrich Heine (1797–1856) from Salon of 1843

Heine's Salon debut had been in 1831 (see IA14). There he discussed the impact of revolution on art and art criticism, giving prominence to Delacroix's *Liberty Leading the People*. By the early 1840s the situation had changed. Heine remained a radical poet and social critic but the Salon seemed moribund. However, for Heine this very mediocrity was the hallmark of the period. It represented the triumph of bourgeois values throughout society, up to and including the highest genres of art. The present extract is taken from the translation by Charles Godfrey Leland in *The Salon, or Letters on Art, Music, Popular Life and Politics* (volume 4 of *The Works of Heinrich Heine*), London: Heinemann, 1893, pp. 118–21.

The Exhibition of pictures for this year excites unusual interest, yet it is impossible for me to pass even a half-way seasonable opinion as to the vaunted pre-eminence of this Salon. So far, I have only felt discontent beyond comparison when I wandered through the halls of the Louvre. These delicious colours which all burst loose screaming at me at once, this variegated lunacy which grins at me from every side, this anarchy in gold frames makes a painful, evil impression on me. I torture myself in vain in trying to set in order this chaos in my mind, and to find therein the thoughts of the time, or even the allied mark of common character, by which these pictures show themselves as the results of our time. For all works of one and the same period have a trace or trait of such character, the painter's mark, which we call the spirit of the age. Thus, for example, the canvases of Watteau, Boucher, Vanloo, reflect the graceful, powdered playfulness of *pastourelles* and fêtes, the rouged and frivolous emptiness *des fadaises galantes*, the sweetish hooped-petticoat happiness of the prevalent Pompadour rule, in which we see everywhere gaily-ribboned shepherds' crooks, and never a

sword. On the other hand, the pictures of David and his school are only the coloured echo of the Republican virtuous period which laps over into the Imperial glory of war-time; and here we find a forced inspiration for the marble model, an abstract frosty intoxication of reason, the design being correct, severe, and hard, the colour turbid, harsh, and indigestible – a Spartan broth. But what will manifest itself as the real character of the age to our descendants when they study the pictures of our present painters? By what common peculiarities will these pictures show themselves at a glance as the products of our present period? Has, perhaps, the spirit of *bourgeoisie*, of industrialism, which penetrates all French life, shown itself so powerful in the arts of design that every picture of our time bears the stamp of its coat of arms? It is especially the pictures of saints which abound in the Exhibition of this year which awaken in me such conjecture. There hangs in the long hall a Flagellation (of Christ), the principal figure in which, with his suffering air, resembles the chairman or president of some company which has come to grief, and now appears before the stockholders and creditors to give an account of himself and his transactions. Yes, the latter also appear on the scene in the form of hangmen and Pharisees who are terribly angry at the *Ecce Homo*, and seem to have lost a great deal of money by their investments. [...] The faces in the properly so-called historical pictures, representing heathen or mediæval subjects, also recall retail shops, stock gambling, mercantilism, and petty *bourgeois* life. There may be seen a William the Conqueror, who only needs a bear-skin cap to be changed into an honest National Guard, who with model zeal mounts guard, pays his bills punctually, honours his wife, and who certainly deserves the Legion of Honour. But – the portraits! The greater part of them have such a *pecuniary* expression, one so egoistic and morose, that I can only explain it by thinking that the living original during the time when he was sitting for his portrait thought of the money which it would cost, while the painter was regretting on his side the time which he must devote to the pitiable money-job. [...]

8 Ludwig Andreas Feuerbach (1804–72) from Preface to the Second Edition of *The Essence of Christianity*

In the same year in which he added this preface to *The Essence of Christianity*, Feuerbach summarized the path of his intellectual development in one short sentence: 'God was my first, Reason my second, and Man my third and last thought'. Feuerbach originally intended to enter the ministry, studying theology at Heidelberg. In 1824 he transferred to Berlin to study under Hegel, whose speculative comprehension of religion from the standpoint of reason he at first enthusiastically endorsed, but later came to criticize from the perspective of his own 'materialist' philosophy. Feuerbach sought to go beyond Hegel by revealing conventional Christianity to be no more than a 'dream of the human mind', the projection of our own human essence onto a transcendent beyond. Feuerbach places man at the centre of his thought, maintaining that the illusions of religion and speculative philosophy need to be replaced with an account of 'the real, complete nature of man'. Although Feuerbach's unconventional ideas prevented him from attaining a secure academic position, his critique of religion and his 'sensualist' philosophy, with its emphasis on man's physical and embodied existence, were strongly influential on Marx and Engels and on a generation of later thinkers. *Über das Wesen des Christenthums* was originally published in Leipzig in

1841, appearing in a second, expanded edition in 1843, when this preface was added. It was translated into English by the novelist and free thinker George Eliot in 1854. This extract is from the reprint of that translation published by Harper & Brothers in New York in 1957, pp. xxxiii–xxxvi, xxxix, xliv.

[. . .] The ideas of my work are only conclusions, *consequences*, drawn from premisses which are not themselves mere ideas, but objective facts either actual or historical – facts which had not their place in my head simply in virtue of their ponderous existence in folio. I unconditionally repudiate *absolute*, immaterial, self-sufficing speculation, – that speculation which draws its material from within. I differ *toto cœlo* from those philosophers who pluck out their eyes that they may see better; for *my* thought I require the senses, especially sight; I found my ideas on materials which can be appropriated only through the activity of the senses. I do not generate the object from the thought, but the thought from the object; and I hold *that* alone to be an object which has an existence beyond one's own brain. I am an idealist only in the region of *practical* philosophy, that is, I do not regard the limits of the past and present as the limits of humanity, of the future; on the contrary, I firmly believe that many things – yes, many things – which with the short-sighted, pusillanimous practical men of to-day, pass for flights of imagination, for ideas never to be realized, for mere chimeras, will to-morrow, *i.e.*, in the next century, – centuries in individual life are days in the life of humanity, – exist in full reality. Briefly, the 'Idea' is to me only faith in the historical future, in the triumph of truth and virtue; it has for me only a political and moral significance; for in the sphere of strictly theoretical philosophy, I attach myself, in direct opposition to the Hegelian philosophy, only to *realism*, to materialism in the sense above indicated. The maxim hitherto adopted by speculative philosophy: All that is mine I carry with me, the old *omnia mea mecum porto*, I cannot, alas! appropriate. I have many things outside myself, which I cannot convey either in my pocket or my head, but which nevertheless I look upon as belonging to me, not indeed as a mere man – a view not now in question – but as a philosopher. I am nothing but a *natural philosopher in the domain of mind*; and the natural philosopher can do nothing without instruments, without material means. In this character I have written the present work, which consequently contains nothing else than the principle of a new philosophy verified practically, i.e., *in concreto*, in application to a special object, but an object which has a universal significance: namely, to religion, in which this principle is exhibited, developed, and thoroughly carried out. This philosophy is essentially distinguished from the systems hitherto prevalent, in that it corresponds to the real, complete nature of man; but for that very reason it is antagonistic to minds perverted and crippled by a superhuman, i.e., anti-human, anti-natural religion and speculation. It does not, as I have already said elsewhere, regard the *pen* as the only fit organ for the revelation of truth, but the eye and ear, the hand and foot; it does not identify the *idea* of the fact with the fact itself, so as to reduce real existence to an existence on paper, but it separates the two, and precisely by this separation attains to the *fact itself*; it recognizes as the true thing, not the thing as it is an object of the abstract reason, but as it is an object of the real, complete man, and hence as it is itself a real, complete thing. This philosophy does not rest on an Understanding *per se*, on an absolute, nameless understanding, belonging one knows not to whom, but on the

understanding of man; – though not, I grant, on that of man enervated by speculation and dogma; – and it speaks the language of men, not an empty, unknown tongue. Yes, both in substance and in speech, it places philosophy in *the negation of philosophy*, i.e., it declares *that* alone to be the true philosophy which is converted *in succum et sanguinem* [in sap and blood], which is incarnate in Man; and hence it finds its highest triumph in the fact that to all dull and pedantic minds, which place the *essence* of philosophy in the *show* of philosophy, it appears to be no philosophy at all.

This philosophy has for its principle, not the Substance of Spinoza, not the *ego* of Kant and Fichte, not the Absolute Identity of Schelling, not the Absolute Mind of Hegel, in short, no abstract, merely conceptional being, but a *real* being, the true *Ens realissimum* [the most perfect, most actual being] – man; its principle, therefore, is in the highest degree positive and real. It generates thought from the *opposite* of thought, from Matter, from existence, from the senses; it has relation to its object first through the senses, i.e., passively, before defining it in thought. Hence my work, as a specimen of this philosophy, so far from being a production to be placed in the category of Speculation, – although in another point of view it is the true, the incarnate result of prior philosophical systems, – is the direct opposite of speculation, nay, puts an end to it by explaining it. Speculation makes religion say only what it has *itself* thought, and expressed far better than religion; it assigns a meaning to religion without any reference to the *actual* meaning of religion; it does not look beyond itself. I, on the contrary, let religion itself speak; I constitute myself only its listener and interpreter, not its prompter. Not to invent, but to discover, 'to unveil existence,' has been my sole object; to *see* correctly, my sole endeavour. It is not I, but religion that worships man, although religion, or rather theology, denies this; it is not I, an insignificant individual, but religion itself that says: God is man, man is God; it is not I, but religion that denies the God who is *not* man, but only an *ens rationis*, – since it makes God become man, and then constitutes this God, not distinguished from man, having a human form, human feelings, and human thoughts, the object of its worship and veneration. I have only found the key to the cipher of the Christian religion, only extricated its true meaning from the web of contradictions and delusions called theology; – but in doing so I have certainly committed a sacrilege. If therefore my work is negative, irreligious, atheistic, let it be remembered that atheism – at least in the sense of this work – is the secret of religion itself; that religion itself, not indeed on the surface, but fundamentally, not in intention or according to its own supposition, but in its heart, in its essence, believes in nothing else than the truth and divinity of human nature. Or let it be *proved* that the *historical* as well as the rational arguments of my work are false; let them be refuted – not, however, I entreat, by judicial denunciations, or theological jeremiads, by the trite phrases of speculation, or other pitiful expedients for which I have no name, but by *reasons*, and such reasons as I have not already thoroughly answered.

Certainly, my work is negative, destructive; but, be it observed, only in relation to the *un*human, not to the human elements of religion.

* * *

Religion is the dream of the human mind. But even in dreams we do not find ourselves in emptiness or in heaven, but on earth, in the realm of reality; we only see real things in the entrancing splendour of imagination and caprice, instead of in the simple daylight of reality and necessity. Hence I do nothing more to religion – and to

speculative philosophy and theology also – than to open its eyes, or rather to turn its gaze from the internal towards the external, i.e., I change the object as it is in the imagination into the object as it is in reality.

But certainly for the present age, which prefers the sign to the thing signified, the copy to the original, fancy to reality, the appearance to the essence, this change, inasmuch as it does away with illusion, is an absolute annihilation, or at least a reckless profanation; for in these days *illusion* only is *sacred, truth profane*. Nay, sacredness is held to be enhanced in proportion as truth decreases and illusion increases, so that the highest degree of illusion comes to be the highest degree of sacredness. Religion has disappeared, and for it has been substituted, even among Protestants, the *appearance* of religion – the Church – in order at least that 'the faith' may be imparted to the ignorant and indiscriminating multitude; *that* faith being still the Christian, because the Christian churches stand now as they did a thousand years ago, and now, as formerly, the *external signs* of the faith are in vogue. That which has no longer any existence in faith (the faith of the modern world is only an ostensible faith, a faith which does not believe what it fancies that it believes, and is only an undecided, pusillanimous unbelief) is still to pass current as *opinion*: that which is no longer sacred in itself and in truth is still at least to *seem* sacred. Hence the simulated religious indignation of the present age . . .

* * *

I have sketched, with a few sharp touches, the historical solution of Christianity, and have shown that Christianity has in fact long vanished, not only from the reason but from the life of mankind, that it is nothing more than a *fixed idea*, in flagrant contradiction with our fire and life assurance companies, our railroads and steam-carriages, our picture and sculpture galleries, our military and industrial schools, our theatres and scientific museums.

9 Karl Marx (1818–1883) on Alienation

The concept of 'alienation' has been widely applied to the arts in the modern period, where it is usually taken to indicate a disaffected psychological disposition on the part of the artist. In the present text, however, Marx views alienation in social terms. He sees it as a characteristic of men's estrangement from their work and their products in the period of modern capitalist production. That which makes humans human, referred to by Marx as their 'species being', is their free, creative capacity. Capitalist commodity production robs them of this. To an extent, for Marx, the opposite of the alienated labour demanded by commodity production is to be found in the work of art; though the comparison is not explicitly made in the present text. Marx wrote these early notes in Paris in 1844. After graduating in philosophy from university in Germany, he had taken up a career in journalism. Following the censorship of his newspaper, he moved to Paris, the centre of radical politics and culture for the whole of Europe, in late 1843. The manuscript remained unpublished in his lifetime. The ideas contained in it however became influential in the twentieth century, following its first publication in the *Marx-Engels Gesamtausgabe*, Moscow, 1927–35. The present extracts are from the translation of the 'Economic and Philosophical Manuscripts' of 1844 by Gregor Benton, in *Karl Marx: Early Writings*, Harmondsworth: Penguin, 1975, pp. 323–30, 359–61.

[...] The *devaluation* of the human world grows in direct proportion to the *increase in value* of the world of things. Labour not only produces commodities; it also produces itself and the workers as a *commodity* and it does so in the same proportion in which it produces commodities in general.

This fact simply means that the object that labour produces, its product, stands opposed to it as *something alien*, as a *power independent* of the producer. The product of labour is labour embodied and made material in an object, it is the *objectification* of labour. The realization of labour is its objectification. In the sphere of political economy this realization of labour appears as a *loss of reality* for the worker, object-ification as *loss of and bondage to the object*, and appropriation as *estrangement*, as *alienation*. [...]

Up to now we have considered the estrangement, the alienation of the worker only from one aspect, i.e. his *relationship to the products of his labour*. But estrangement manifests itself not only in the result, but also in the *act of production*, within the *activity of production* itself. How could the product of the worker's activity confront him as something alien if it were not for the fact that in the act of production he was estranging himself from himself? After all, the product is simply the résumé of the activity, of the production. So if the product of labour is alienation, production itself must be active alienation, the alienation of activity, the activity of alienation. The estrangement of the object of labour merely summarizes the estrangement, the alienation in the activity of labour itself. [...]

We now have to derive a third feature of *estranged labour* from the two we have already looked at.

Man is a species-being, not only because he practically and theoretically makes the species – both his own and those of other things – his object, but also – and this is simply another way of saying the same thing – because he looks upon himself as the present, living species, because he looks upon himself as a *universal* and therefore free being.

Species-life, both for man and for animals, consists physically in the fact that man, like animals, lives from inorganic nature; and because man is more universal than animals, so too is the area of inorganic nature from which he lives more universal. Just as plants, animals, stones, air, light, etc., theoretically form a part of human con-sciousness, partly as objects of science and partly as objects of art – his spiritual inorganic nature, his spiritual means of life, which he must first prepare before he can enjoy and digest them – so too in practice they form a part of human life and human activity. [...]

The animal is immediately one with its life activity. It is not distinct from that activity; it *is* that activity. Man makes his life activity itself an object of his will and consciousness. He has conscious life activity. It is not a determination with which he directly merges. Conscious life activity directly distinguishes man from animal life activity. Only because of that is he a species-being. Or rather, he is a conscious being, i.e. his own life is an object for him, only because he is a species-being. Only because of that is his activity free activity. Estranged labour reverses the relationship so that man, just because he is a conscious being, makes his life activity, his *being*, a mere means for his *existence*.

The practical creation of an *objective world*, the *fashioning* of inorganic nature, is proof that man is a conscious species-being, i.e. a being which treats the species as its own essential being or itself as a species-being. It is true that animals also produce. They build nests and dwellings, like the bee, the beaver, the ant, etc. But they produce only their own immediate needs or those of their young; they produce one-sidedly, while man produces universally; they produce only when immediate physical need compels them to do so, while man produces even when he is free from physical need and truly produces only in freedom from such need; they produce only themselves, while man reproduces the whole of nature; their products belong immediately to their physical bodies, while man freely confronts his own product. Animals produce only according to the standards and needs of the species to which they belong, while man is capable of producing according to the standards of every species and of applying to each object its inherent standard; hence man also produces in accordance with the laws of beauty.

It is therefore in his fashioning of the objective that man really proves himself to be a *species-being*. Such production is his active species-life. Through it nature appears as *his* work and his reality. The object of labour is therefore the *objectification of the species-life of man*: for man reproduces himself not only intellectually, in his consciousness, but actively and actually, and he can therefore contemplate himself in a world he himself has created. In tearing away the object of his production from man, estranged labour therefore tears away from him his *species-life*, his true species-objectivity, and transforms his advantage over animals into the disadvantage that his inorganic body, nature, is taken from him. [. . .]

An immediate consequence of man's estrangement from the product of his labour, his life activity, his species-being, is the *estrangement of man from man.* When man confronts himself, he also confronts *other* men. What is true of man's relationship to his labour, to the product of his labour and to himself, is also true of his relationship to other men, and to the labour and the object of the labour of other men.

In general, the proposition that man is estranged from his species-being means that each man is estranged from the others and that all are estranged from man's essence.

* * *

This estrangement partly manifests itself in the fact that the refinement of needs and of the means of fulfilling them gives rise to a bestial degeneration and a complete, crude and abstract simplicity of need; or rather, that it merely reproduces itself in its opposite sense. Even the need for fresh air ceases to be a need for the worker. Man reverts once more to living in a cave, but the cave is now polluted by the mephitic and pestilential breath of civilization. Moreover, the worker has no more than a precarious right to live in it, for it is for him an alien power that can be daily withdrawn and from which, should he fail to pay, he can be evicted at any time. He actually has to *pay* for this mortuary. A dwelling in the *light*, which Prometheus describes in Aeschylus as one of the great gifts through which he transformed savages into men, ceases to exist for the worker. [. . .]

The simplification of machinery and of labour is used to make workers out of human beings who are still growing, who are completely immature, out of *children*, while the worker himself becomes a neglected child. The machine accommodates itself to man's *weakness*, in order to turn *weak* man into a machine. [. . .]

[...] Any *luxury* that the worker might enjoy is reprehensible, and anything that goes beyond the most abstract need – either in the form of passive enjoyment or active expression – appears to him as a luxury. Political economy, this science of *wealth*, is therefore at the same time the science of denial, of starvation, of *saving*, and it actually goes so far as to *save* man the *need* for fresh *air* or physical *exercise*. This science of the marvels of industry is at the same time the science of *asceticism*, and its true ideal is the *ascetic* but *rapacious* skinflint and the *ascetic* but *productive* slave. Its moral ideal is the *worker* who puts a part of his wages into savings, and it has even discovered a servile *art* which can dignify this charming little notion and present a sentimental version of it on the stage. It is therefore – for all its worldly and debauched appearance – a truly moral science, the most moral science of all. Self-denial, the denial of life and of all human needs, is its principal doctrine. The less you eat, drink, buy books, go to the theatre, go dancing, go drinking, think, love, theorize, sing, paint, fence, etc., the more you *save* and the greater will become that treasure which neither moths nor maggots can consume – your *capital*. The less you *are*, the less you give expression to your life, the more you *have*, the greater is your *alienated* life and the more you store up of your estranged life. [...]

10 Karl Marx (1818–1883) and Friedrich Engels (1820–1895) on Historical Materialism

Marx and Engels met in Paris in 1844 in response to Engels' publication of two articles in the radical journal edited by Marx, the *Deutsch-Französische Jahrbücher*. After Marx's expulsion from Paris at the instigation of the Prussian authorities, their collaboration continued in Brussels during 1845–7. *The German Ideology*, a 700-page manuscript written in 1845–6, contained the first exposition of their materialist philosophy of history. It was written against the dominant Hegelian philosophical idealism, in which both had been trained. In place of the emphasis on spirit as the motivating factor of human life, Marx and Engels stressed actual social relations, and in particular economic power. They did not however separate questions of 'spirit' from those of society, much less deny their existence altogether. What they did, in effect, was reverse the traditional polarity: they read the world of ideas as dependent on the form of material reality. 'The ideas of the ruling class are in every epoch the ruling ideas.' The implications for the world of the mind, art practice included, are fundamental. Overtaken by the revolutions of 1848, and unpublished in their lifetime, *The German Ideology* first appeared in the *Marx-Engels Gesamtausgabe*, Moscow 1932. The present extracts are taken from the translation by W. Lough, C. Dutt and C. P. Magill, edited and introduced by C. J. Arthur, London: Lawrence and Wishart, 1970/74, pp. 37, 42, 46–8, 58–9, 64.

Preface

Hitherto men have constantly made up for themselves false conceptions about themselves, about what they are and what they ought to be. They have arranged their relationships according to their ideas of God, of normal man, etc. The phantoms of their brains have got out of their hands. They, the creators, have bowed down before their creations. Let us liberate them from the chimeras, the ideas, dogmas,

imaginary beings under the yoke of which they are pining away. Let us revolt against the rule of thoughts. Let us teach men, says one, to exchange these imaginations for thoughts which correspond to the essence of man; says the second, to take up a critical attitude to them; says the third, to knock them out of their heads; and – existing reality will collapse.

These innocent and childlike fancies are the kernel of the modern Young-Hegelian philosophy, which not only is received by the German public with horror and awe, but is announced by our philosophic heroes with the solemn consciousness of its cataclysmic dangerousness and criminal ruthlessness. The first volume of the present publication has the aim of uncloaking these sheep, who take themselves and are taken for wolves; of showing how their bleating merely imitates in a philosophic form the conceptions of the German middle class; how the boasting of these philosophic commentators only mirrors the wretchedness of the real conditions in Germany. It is its aim to debunk and discredit the philosophic struggle with the shadows of reality, which appeals to the dreamy and muddled German nation. [...]

A. IDEALISM AND MATERIALISM

First Premises of Materialist Method

The premises from which we begin are not arbitrary ones, not dogmas, but real premises from which abstraction can only be made in the imagination. They are the real individuals, their activity and the material conditions under which they live, both those which they find already existing and those produced by their activity. These premises can thus be verified in a purely empirical way.

The first premise of all human history is, of course, the existence of living human individuals. Thus the first fact to be established is the physical organization of these individuals and their consequent relation to the rest of nature. Of course, we cannot here go either into the actual physical nature of man, or into the natural conditions in which man finds himself – geological, orohydrographical, climatic and so on. The writing of history must always set out from these natural bases and their modification in the course of history through the action of men.

Men can be distinguished from animals by consciousness, by religion or anything else you like. They themselves begin to distinguish themselves from animals as soon as they begin to *produce* their means of subsistence, a step which is conditioned by their physical organization. By producing their means of subsistence men are indirectly producing their actual material life.

The way in which men produce their means of subsistence depends first of all on the nature of the actual means of subsistence they find in existence and have to reproduce. This mode of production must not be considered simply as being the production of the physical existence of the individuals. Rather it is a definite form of activity of these individuals, a definite form of expressing their life, a definite *mode of life* on their part. As individuals express their life, so they are. What they are, therefore, coincides with their production, both with *what* they produce and with *how* they produce. The nature of individuals thus depends on the material conditions determining their production. [...]

The fact is, therefore, that definite individuals who are productively active in a definite way enter into these definite social and political relations. Empirical observation must in each separate instance bring out empirically, and without any mystification and speculation, the connection of the social and political structure with production. The social structure and the State are continually evolving out of the life-process of definite individuals, but of individuals, not as they may appear in their own or other people's imagination, but as they *really* are; i.e. as they operate, produce materially, and hence as they work under definite material limits, presuppositions and conditions independent of their will.

The production of ideas, of conceptions, of consciousness, is at first directly interwoven with the material activity and the material intercourse of men, the language of real life. Conceiving, thinking, the mental intercourse of men, appear at this stage as the direct efflux of their material behaviour. The same applies to mental production as expressed in the language of politics, laws, morality, religion, metaphysics, etc. of a people. Men are the producers of their conceptions, ideas, etc. – real, active men, as they are conditioned by a definite development of their productive forces and of the intercourse corresponding to these, up to its furthest forms. Consciousness can never be anything else than conscious existence, and the existence of men is their actual life-process. If in all ideology men and their circumstances appear upside-down as in a *camera obscura*, this phenomenon arises just as much from their historical life-process as the inversion of objects on the retina does from their physical life-process.

In direct contrast to German philosophy which descends from heaven to earth, here we ascend from earth to heaven. That is to say, we do not set out from what men say, imagine, conceive, nor from men as narrated, thought of, imagined, conceived, in order to arrive at men in the flesh. We set out from real, active men, and on the basis of their real life-process we demonstrate the development of the ideological reflexes and echoes of this life-process. The phantoms formed in the human brain are also, necessarily, sublimates of their material life-process, which is empirically verifiable and bound to material premises. Morality, religion, metaphysics, all the rest of ideology and their corresponding forms of consciousness, thus no longer retain the semblance of independence. They have no history, no development; but men, developing their material production and their material intercourse, alter, along with this their real existence, their thinking and the products of their thinking. Life is not determined by consciousness, but consciousness by life. In the first method of approach the starting-point is consciousness taken as the living individual; in the second method, which conforms to real life, it is the real living individuals themselves, and consciousness is considered solely as *their* consciousness.

This method of approach is not devoid of premises. It starts out from the real premises and does not abandon them for a moment. Its premises are men, not in any fantastic isolation and rigidity, but in their actual, empirically perceptible process of development under definite conditions. As soon as this active life-process is described, history ceases to be a collection of dead facts as it is with the empiricists (themselves still abstract), or an imagined activity of imagined subjects, as with the idealists.

Where speculation ends – in real life – there real, positive science begins: the representation of the practical activity, of the practical process of development of

men. Empty talk about consciousness ceases, and real knowledge has to take its place. When reality is depicted, philosophy as an independent branch of knowledge loses its medium of existence.

* * *

B. THE ILLUSION OF THE EPOCH

Civil Society and the Conception of History

[. . .] From this it follows that this transformation of history into world history is not indeed a mere abstract act on the part of the 'self-consciousness', the world spirit, or of any other metaphysical spectre, but a quite material, empirically verifiable act, an act the proof of which every individual furnishes as he comes and goes, eats, drinks and clothes himself.

This conception of history depends on our ability to expound the real process of production, starting out from the material production of life itself, and to comprehend the form of intercourse connected with this and created by this mode of production (i.e. civil society in its various stages), as the basis of all history; and to show it in its action as State, to explain all the different theoretical products and forms of consciousness, religion, philosophy, ethics, etc. etc. and trace their origins and growth from that basis; by which means, of course, the whole thing can be depicted in its totality (and therefore, too, the reciprocal action of these various sides on one another). It has not, like the idealistic view of history, in every period to look for a category, but remains constantly on the real *ground* of history; it does not explain practice from the idea but explains the formation of ideas from material practice; and accordingly it comes to the conclusion that all forms and products of consciousness cannot be dissolved by mental criticism, by resolution into 'self-consciousness' or transformation into 'apparitions', 'spectres', 'fancies', etc. but only by the practical overthrow of the actual social relations which gave rise to this idealistic humbug; that not criticism but revolution is the driving force of history, also of religion, of philosophy and all other types of theory.

* * *

Ruling Class and Ruling Ideas

The ideas of the ruling class are in every epoch the ruling ideas, i.e. the class which is the ruling *material* force of society, is at the same time its ruling *intellectual* force. The class which has the means of material production at its disposal, has control at the same time over the means of mental production, so that thereby, generally speaking, the ideas of those who lack the means of mental production are subject to it. The ruling ideas are nothing more than the ideal expression of the dominant material relationships, the dominant material relationships grasped as ideas; hence of the relationships which make the one class the ruling one, therefore, the ideas of its dominance. The individuals composing the ruling class possess among other things consciousness, and therefore think. Insofar, therefore, as they rule as a class and

determine the extent and compass of an epoch, it is self-evident that they do this in its whole range, hence among other things rule also as thinkers, as producers of ideas, and regulate the production and distribution of the ideas of their age [. . .]

11 Karl Marx (1818–1883) and Friedrich Engels (1820–1895) on the Bourgeoisie

In the mid-1840s Marx and Engels had become active in radical politics and journalism. Marx, then exiled in Brussels, was invited by a leftist group in London, the League of the Just, to write their programme. This he and Engels did during December 1847 to January 1848. The group, meanwhile, had changed their name to the Communist League, and they adopted the 12,000-word programme as their Manifesto. The observation of its opening lines, that 'a spectre is haunting Europe – the spectre of Communism', appeared prophetic in the light of subsequent events, as revolution broke out in several countries during 1848. In addition to its well-known rallying cry for the workers of all nations to unite, the Manifesto also contained vivid analyses of the dynamic of modern bourgeois society. Retrospectively, and unexpectedly, it seems that Baudelaire and Marx were writing about the same thing, albeit from different perspectives: the one mapping society's transient, shifting phenomena in the modern city (cf. IID13), the other analysing its underlying causes in the mode of production. In particular, Marx emphasized the dynamic, revolutionary nature of modern capitalism: 'all that is solid melts into air'. Originally published in London, in German, in February 1848, *The Communist Manifesto* has subsequently been translated and reprinted the world over. The present extracts are taken from the English translation of 1888 by Samuel Moore, in the Penguin edition, London, 1967, pp. 80–6.

The modern bourgeois society that has sprouted from the ruins of feudal society has not done away with class antagonisms. It has but established new classes, new conditions of oppression, new forms of struggle in place of the old ones. [. . .]

Modern industry has established the world market, for which the discovery of America paved the way. This market has given an immense development to commerce, to navigation, to communication by land. This development has, in its turn, reacted on the extension of industry; and in proportion as industry, commerce, navigation, railways extended, in the same proportion the bourgeoisie developed, increased its capital, and pushed into the background every class handed down from the Middle Ages.

We see, therefore, how the modern bourgeoisie is itself the product of a long course of development, of a series of revolutions in the modes of production and of exchange.

Each step in the development of the bourgeoisie was accompanied by a corresponding political advance of that class. An oppressed class under the sway of the feudal nobility, an armed and self-governing association in the medieval commune; here independent urban republic (as in Italy and Germany), there taxable 'third estate' of the monarchy (as in France), afterwards, in the period of manufacture proper, serving either the semi-feudal or the absolute monarchy as a counterpoise against the nobility, and, in fact, corner-stone of the great monarchies in general, the bourgeoisie has at last, since the establishment of Modern Industry and of the world market, conquered for itself, in the modern representative State, exclusive political sway. The executive

of the modern State is but a committee for managing the common affairs of the whole bourgeoisie.

The bourgeoisie, historically, has played a most revolutionary part.

The bourgeoisie, wherever it has got the upper hand, has put an end to all feudal, patriarchal, idyllic relations. It has pitilessly torn asunder the motley feudal ties that bound man to his 'natural superiors', and has left remaining no other nexus between man and man than naked self-interest, than callous 'cash payment'. It has drowned the most heavenly ecstasies of religious fervour, of chivalrous enthusiasm, of philistine sentimentalism, in the icy water of egotistical calculation. It has resolved personal worth into exchange value, and in place of the numberless indefeasible chartered freedoms, has set up that single, unconscionable freedom – Free Trade. In one word, for exploitation, veiled by religious and political illusions, it has substituted naked, shameless, direct, brutal exploitation.

The bourgeoisie has stripped of its halo every occupation hitherto honoured and looked up to with reverent awe. It has converted the physician, the lawyer, the priest, the poet, the man of science, into its paid wage-labourers.

The bourgeoisie has torn away from the family its sentimental veil, and has reduced the family relation to a mere money relation.

The bourgeoisie has disclosed how it came to pass that the brutal display of vigour in the Middle Ages, which Reactionists so much admire, found its fitting complement in the most slothful indolence. It has been the first to show what man's activity can bring about. It has accomplished wonders far surpassing Egyptian pyramids, Roman aqueducts, and Gothic cathedrals; it has conducted expeditions that put in the shade all former Exoduses of nations and crusades.

The bourgeoisie cannot exist without constantly revolutionizing the instruments of production, and thereby the relations of production, and with them the whole relations of society. Conservation of the old modes of production in unaltered form, was, on the contrary, the first condition of existence for all earlier industrial classes. Constant revolutionizing of production, uninterrupted disturbance of all social conditions, everlasting uncertainty and agitation distinguish the bourgeois epoch from all earlier ones. All fixed, fast-frozen relations, with their train of ancient and venerable prejudices and opinions are swept away, all new-formed ones become antiquated before they can ossify. All that is solid melts into air, all that is holy is profaned, and man is at last compelled to face with sober senses, his real conditions of life, and his relations with his kind. [...]

The bourgeoisie, by the rapid improvement of all instruments of production, by the immensely facilitated means of communication, draws all, even the most barbarian, nations into civilization. The cheap prices of its commodities are the heavy artillery with which it batters down all Chinese walls, with which it forces the barbarians' intensely obstinate hatred of foreigners to capitulate. It compels all nations, on pain of extinction, to adopt the bourgeois mode of production; it compels them to introduce what it calls civilization into their midst, i.e., to become bourgeois themselves. In one word, it creates a world after its own image.

The bourgeoisie has subjected the country to the rule of the towns. It has created enormous cities, has greatly increased the urban population as compared with the rural, and has thus rescued a considerable part of the population from the idiocy of

rural life. Just as it has made the country dependent on the towns, so it has made barbarian and semi-barbarian countries dependent on the civilized ones, nations of peasants on nations of bourgeois, the East on the West. [. . .]

The bourgeoisie, during its rule of scarce one hundred years, has created more massive and more colossal productive forces than have all preceding generations together. Subjection of Nature's forces to man, machinery, application of chemistry to industry and agriculture, steam-navigation, railways, electric telegraphs, clearing of whole continents for cultivation, canalization of rivers, whole populations conjured out of the ground – what earlier century had even a presentiment that such productive forces slumbered in the lap of social labour? [. . .]

Modern bourgeois society with its relations of production, of exchange and of property, a society that has conjured up such gigantic means of production and of exchange, is like the sorcerer, who is no longer able to control the powers of the nether world whom he has called up by his spells.

12 Théophile Thoré (1807–1869) from 'Salon of 1848'

Thoré reviewed each of the annual Salons between 1835 and 1849 (see also IIIB8). He had responded at an early stage in his career to the ideas of St Simon (IA5) and retained a strong engagement in political thought and activity. The Salon of 1848 took place in the wake of revolution. The events of February not only interrupted the operations of the Salon jury but led to the temporary dismantling of the system of privilege on which those operations were based. As a convinced republican, Thoré took the opportunity of his review to celebrate the resulting anarchy (though not to approve incompetence in the works on display), to bid an ironic farewell to a regime committed to 'material interests and the baser passions', and to welcome in a 'new, poetic and civilizing art'. Under these conditions only the works of Delacroix held his attention long enough to produce a reasoned critical judgement. By December, Louis Napoleon Bonaparte had been adopted as president. The following year Thoré was exiled under threat of death for his part in an unsuccessful revolt. He was not to return to France until after the amnesty of 1859, though he continued writing in exile, adopting the pseudonym William Bürger in 1854 (see IIIB8 and IIIC9). The 'Salon de 1848' was first published in *Le Constitutionnel*, Paris, 1848. It was reprinted in *Salons de T. Thoré*, Paris: Libraire International, 1868, pp. 557–65, from which this translation has been made by Jonathan Murphy. On the occasion of the reprint, Thoré appended a brief note in his persona as William Bürger, to the effect that the 'Salon of 1848' was of interest as a souvenir of the hope and enthusiasm inspired by the revolution – at the time.

The revolution of February surprised the jury of the academy in the midst of its functions. The weighing of souls had begun: the light, free sketches of Lessore had already been rejected, and that famous woman's torso, the delight of the crowd, had been hung in the right place. But at the first hint of the insurrection, the worthies of the Civil List snatched up their glasses and wigs and took to their heels.

The jury itself, the management of the Beaux-Arts, and the old administrative staff of the museums have all gone with the abolishing of the List. Nothing yet has been set up in their place; only Jeanron has been appointed Keeper of the Pictures at the Louvre. Since the beginning of the upheavals, the arts have all been left to fend for themselves. [. . .]

The first step to protect the arts that should have been taken after the revolution was to gather all the artists together and invite them to elect a permanent committee to represent them to the Republic, which would have been able to help them formulate and express their wishes. Instead, all that has happened is the setting up of a commission to hang the work in the Salon. The meeting took place at the Ecole des Beaux-Arts, where the teachers called in all the students. And guess who got the most votes . . . M. Léon Cogniet. For the rest, with the exception of two members of the old jury, Messieurs Brascassat and Abel de Pujol, the make-up of this temporary committee – a fair expression of all the tendencies and all the different styles – serves to prove that a system of universal suffrage gets nearer to the truth than any other. One of the more bizarre twists of the election was the name Couture coming out of the urn after that of Abel de Pujol, and the name Théodore Rousseau coming out after that of Brascassat. Among the sculptors, the assembly also passed two jurors from the old régime, while also proclaiming the names of Barye, Rudé, David [d'Angers] and other independent artists.

May the peace remain, now that the artistic community has placed those formerly banished by the academy at its head, and that we now have at the very top of the state a poet, a labourer and the historian of the ex-king Louis-Philippe. February 24th seems almost a century ago.

M. Jeanron and his staff have worked miracles in hanging so many pictures on the walls of the museum, and in getting so many blocks of stone, plaster and marble up onto the first floor. But it was extremely important that this national exhibition should not be put off, and there was no question of resolving in time the questions that the choice of a new jury and a new location would have raised. But we are assured that in years to come, the galleries of the museum itself will not be used for such temporary exhibitions. The king's departure will free up a considerable amount of space in the Louvre, the Tuileries and in all the national monuments.

So the 5,180 works presented for selection before the revolution have all been passed without examination, and the only task of the artists' commission has been to oversee the classification, to ensure that no work worthy of serious consideration be hung in some dark corner. But it must be said that this over-hasty classification leaves much to be desired: this author notes in particular a Meissonier portrait, a forest scene by Diaz, and several other distinguished landscapes lost in the midst of some rather more outlandish creations.

This 1848 Salon is indeed an extremely curious spectacle. There are paintings here the like of which one never sees, even in the most far-flung provincial antique shops. Yet the Salons have always contained some such works, their presence sanctioned by the Civil List jury, as that jury was always more concerned with keeping out its enemies than it was with examining the merits of individual works. What has changed today is the prodigious number of these eccentric images. But public response is an adept teacher. One may legitimately hold out the hope that the reception accorded by the public to several hundred such daubings might convince the daubers in question to embrace another career. Only yesterday (perhaps I should say: a hundred years ago) – under the reign of the last Bourbon, these poor journeymen who had strayed into the arts could still cry out that they were being neglected or persecuted, and lacked nothing but exposure to a wider public. But exposure to ridicule is now what they

face. One hopes that these estimable citizens will no longer persist in attempting to force entry into the world of art; the new Republic will offer them an honest trowel instead of a brush.

For my part, despite the slightly comic nature of the present Salon, I am not entirely convinced of the necessity of there being a jury at all, except for the question of the layout of the Salon. I would even go so far as to back, at the next national exhibition, the trying-out of a policy of unlimited freedom, provided that some intelligent committee be appointed to separate the genuine works of art from the indescribable rubbish. Any lunatic has the right to speak in a public place, but at the risk of being booed by the crowd or silenced by a more eloquent orator. Freedom will always be the best means of achieving justice and social order.

What is unusual, and slightly saddening, is that from this jumble of bizarre creations no genuinely new talent has emerged. But perhaps one should expect this: how indeed could artists be expected to flourish under a régime dedicated to the glorification of material interests and the baser passions? Amongst those that God had predestined for poetry the weakest have passed away, like Hector Martin; only the strongest and the most patient have taken their rightful place, in spite of those times of oppression. The present generation has almost run its course. The hopes of the Republic are carried by those young and vigorous generations yet untried, whose vocation will be nurtured by a national teaching programme, instilling noble thoughts and ideas, and promoting the creation of a brilliant, human, universal ideal of art. I am confident that before a year has elapsed, we will see in the next Salon (and even more so in the new public monuments) some daring attempts at achieving this new, fecund and durable art.

This then will be the last inventory of such bric-à-brac; pictures like lost children, destined to die without ever having lived – or illegitimate offspring, with no right to a name. The Republic, besides encouraging the growth of this new, poetic and civil-izing art, will deliver us from these parasites which have sucked its blood and sapped its strength. One of the principal benefits of the new Republic and of the freedoms to come will be to ensure that the people have work that befits their individual talents; working for the glory and the success of France, they will find happiness in their own lives. Charity, to be successful, must be aimed at others. The charity that begins at home, despite what the proverbs tell us, leads only to egotism and anarchy.

Eugène Delacroix has always been a master of that supreme art that stirs the hearts and minds of a people, turning history into memorable images. His painting deserves the radiant place it has on the cupolas and ceilings of our monuments. His *Liberty leading the People* has just been transferred to the Luxembourg, where it now hangs beside *The Massacre of Chios*; both being episodes of great import and beauty in contemporary settings. It is said that he has just begun an *Equality leading the People*; for our recent revolution is the true sister of that national one to which he paid homage eighteen years ago. This time, the entire population made a contribution, and the spoils of victory will be shared out equally amongst them. One can only hope that Delacroix makes haste, and that both paintings will soon be on display, hanging side by side above the head of the President in the National Assembly. Delacroix is like a great epic poet, who, when working on a massive scale, occasionally decorates the

margin of the manuscript with precious verses. The epic painter, resting between large projects, fills his canvases with imagination, feeling and colour.

* * *

The painting *Arab Actors and Clowns* contains about a dozen figures, executed with the sort of proportions one usually finds in Poussin. In the midst of Moors or Jews, resplendent in richly coloured costumes, and women seated or reclining in a variety of postures, two arab players are acting out a sort of pantomime in the open air. There are majestic figures, draped in strange tissues, like sixteenth-century Venetians in a Titian painting; voluptuous, coquettish women, whose tawny faces glow in the sunlight; an extraordinary variety of pure tones, in red, orange, blue and silver, broken tones of leaf-brown, pearl, coffee, lilac and roses, set against a green landscape, all under the deep skies of the Orient. It is a masterpiece of light, reminiscent of the *Jewish Wedding in Morocco* in the Luxembourg.

* * *

Worthy of note after the Delacroix are Diaz and Meissonier, together with a few other landscapes and portraits, a few bigger canvases, two marbles by Clésinger and Pradier, and several large statues. Then comes the great number of unexceptional works, and those mildly pleasing in their eccentric naivety. But I will detain the reader no longer with talk of this year's Salon. There are more interesting spectacles which await us in the world of politics. Today, we can do better than making art or poetry: we can make living history.

IIB
Art and Nature Moralized

1 Jean Auguste Dominique Ingres (1780–1867) from Notebooks

Almost alone among the painters of his generation, Ingres secured some continuing critical currency both for the specific legacy of David and for the broader classical tradition, though the frozen sensuality of his style rendered it less suitable for the expression of traditional ideals than of psychological idiosyncracies. He took up a Prix de Rome in 1806 and remained in Italy until 1824, returning to France at the time when his Raphaelesque *Vow of Louis XIII* was shown in the Salon. For ten years he maintained an influential studio in Paris, but returned to Rome in 1835 as Director of the French Academy, a post he held for six years. In the final two decades of his life he was a leading figure in the artistic establishment of Paris, though one widely respected by younger artists. Among these latter was Degas, who formed a large collection of his drawings. Though Ingres made few formal statements on his art he left a number of written observations in notebooks and other manuscripts, many of them in epigrammatic form. After his death these were transcribed by H. Delaborde and were published, together with surviving correspondence and with statements recorded by pupils, in his *Ingres. Sa vie, ses travaux, sa doctrine, d'après notes, manuscript et les lettres du maître*, Paris: Henri Plon, 1870. Delaborde organized the material under thematic headings, and since few of the documents are dated it is now impossible to ascribe precise dates to more than a few of the resulting passages. In making our selection of material we have given preference to passages which are most likely to be the first-hand writings of the artist and which are dated or can be assigned an approximate date on circumstantial grounds. The period covered by these excerpts is from *c.*1820 to 1848. Delaborde's organization of the material was largely followed by Walter Pach in his *Ingres*, New York and London, 1939. Our translations are taken from this source, pp. 160, 173–4 and 189–91, though we have restored the continuity of individual passages by reference to Delaborde. (For later material by Ingres see IIID1.)

There are not two arts, there is only one: it is the one which has as its foundation the beautiful, which is eternal and natural. Those who seek elsewhere deceive themselves, and in the most fatal manner. What do those so-called artists mean, when they preach the discovery of the 'new'? Is there anything new? Everything has been done, everything has been discovered. Our task is not to invent but to continue, and we have enough to do if, following the examples of the masters, we utilize those innumerable types which nature constantly offers to us, if we interpret them with wholehearted sincerity, and ennoble them through that pure and firm style without which no work has beauty. What an

absurdity it is to believe that the natural dispositions and faculties can be compromised by the study – by the imitation, even, of the classic works! The original type, man, still remains: we have only to consult it in order to know whether the classics have been right or wrong and whether, when we use the same means as they, we lie or tell the truth.

There is no longer any question of discovering the conditions, the principles of the beautiful. The thing is to apply them without letting the desire to invent cause us to lose sight of them. Beauty, pure and natural, has no need to surprise through novelty: it is enough that it be beauty. But man is in love with change, and change, in art, is very often the cause of decadence.

Expression in painting demands a very great science of drawing; for expression cannot be good if it has not been formulated with absolute exactitude. To seize it only approximately is to miss it, and to represent only those false people whose study it is to counterfeit sentiments which they do not experience. The extreme precision we need is to be arrived at only through the surest talent for drawing. Thus the painters of expression, among the moderns, turn out to be the greatest draftsmen. Look at Raphael!

Expression, an essential element of art, is therefore intimately bound up with form. Perfection of colouring is so little required that excellent painters of expression have not had, as colourists, the same superiority. To blame them for that is to lack adequate knowledge of the arts. One may not ask the same man for contradictory qualities. Moreover the promptness of execution which colour needs in order to preserve all its prestige does not harmonize with the deep study demanded by the great unity of the forms. [. . .]

Let me hear no more of that absurd maxim: 'We need the new, we need to follow our century, everything changes, everything is changed.' Sophistry – all of that! Does nature change, do the light and air change, have the passions of the human heart changed since the time of Homer? 'We must follow our century': but suppose my century is wrong? Because my neighbour does evil, am I therefore obliged to do it also? Because virtue, as also beauty, can be misunderstood by you, have I in turn got to misunderstand it? Shall I be compelled to imitate *you!*

Upon this globe there was a little corner of earth which was called Greece, where, under the fairest sky, among inhabitants endowed with an intellectual organization that was unique, letters and the arts shed what was practically a second light upon the things of nature, for all the peoples and all the generations to come. Homer was the first to reveal through poetry the beauties of nature, as God organized life by bringing it forth from chaos. He has forever instructed the human race, he has established the beautiful through precepts and through immortal examples. All the great men of Greece, poets, tragedians, historians, artists of every kind, painters, sculptors, and architects, are all born of him: and, as long as Greek civilization lasted, as long after that as Rome reigned over the world, men have continued to put into practice the same principles that once were found. Later on, in the great modern periods, men of genius did over what had been done before them. Homer and Phidias, Raphael and Poussin, Gluck and Mozart have, in reality, said the same things.

It is error then; error to believe that health for art resides in absolute independence; to believe that our natural disposition runs the risk of being stifled by the discipline of the ancients; that the classic doctrines impede or arrest the flight of the intelligence.

Quite the contrary: they favour its development, they render its strength more certain and fructify its aspirations; they are a help and not a hindrance. Moreover, there are not two arts, there is but one: it is that which is founded upon the imitation of nature, of beauty – immutable, infallible, and eternal. What do you mean, what is it you come to preach to me with your pleadings in favour of the 'new'? Outside of nature there is no such thing as the new, there is nothing but what is called the baroque; outside of art, as it was understood and practised by the ancients, there is nothing, there can be nothing but caprice and aimless wandering. Let us believe what they believed, which is to say the truth, the truth which is of all times. Let us translate it differently from them, if we can, as far as expression is concerned, but let us be like them in knowing how to recognize it, to honour it, to adore it in spirit and in principle, and let us leave to their howling those who try to insult us with a word like 'old-fashioned'.

They want novelty! They want, as they say, progress in variety, and to refute us who recommend the strict imitation of the antique and of the masters, they cast up to us the movement of the sciences in our century! But the nature of the latter is quite different from the nature of art. The domain of the sciences enlarges through the effect of time; the discoveries in them are due to the most patient observation of certain phenomena, to the perfecting of certain instruments, sometimes even to chance. What can chance reveal to us in the domain created by the imitation of forms? Does any part of drawing remain to be discovered? Shall we, by means of patience or of better eyeglasses, perceive in nature any new outlines, any new colour, a new kind of modelling? There is nothing essential to discover in art after Phidias and after Raphael, but there is always enough to do, even after them, to maintain the cult of the true and to perpetuate the tradition of the beautiful.

2 John Stuart Mill (1806–1873) 'What is Poetry?'

Mill's early education was remarkable both for its severity and its rigour. It was strictly supervised by his father, the philosopher James Mill, a friend and disciple of Jeremy Bentham, who sought to make of his son a leader and prophet of Benthamite ideas (cf.IIᴀ1, above). Although Mill devoted his first publications to utilitarianism, and helped to form the Utilitarian Society in 1823, he suffered a breakdown in 1826, shortly after editing Bentham's *Rationale of Juridical Evidence*. Henceforth, his sympathies and intellectual interest widened and he responded powerfully to the poetry and ideas of Coleridge and Wordsworth. Mill's subsequent work has been described as an attempt to 'humanize' utilitarianism, recognizing differences in the quality as well as the quantity of pleasure, and restoring the importance of cultural values. In his short essay 'What is Poetry?' Mill firmly rejects the doctrine that the essence of art consists in the imitation of nature, defining poetry as 'the expression or uttering forth of feeling'. In distinction to eloquence, which remains audience-directed, poetry is feeling 'confessing itself to itself in moments of solitude' in symbols which provide the nearest possible representation of what takes place in the poet's mind. Mill carries these insights over to embrace the visual arts, distinguishing between painting which depends upon mere imitation and that which expresses human feeling and thus genuine creation. 'What is Poetry?' was first published in the *Monthly Magazine*, in January 1833. Mill reprinted it in a revised and expanded form under the title 'Thoughts on Poetry and its Varieties' in his *Dissertations and Discussions* of 1859. The present extract is

taken from this later version of the text, reprinted in the *Collected Edition of the Works of John Stuart Mill: Autobiography and Literary Essays*, John M. Robson and Jack Stillinger (eds.), Toronto and Buffalo: University of Toronto Press, 1981, pp. 343–5, 347–50, 351–3.

It has often been asked, What is Poetry? And many and various are the answers which have been returned. The vulgarest of all – one with which no person possessed of the faculties to which poetry addresses itself can ever have been satisfied – is that which confounds poetry with metrical composition: yet to this wretched mockery of a definition, many had been led back, by the failure of all their attempts to find any other that would distinguish what they have been accustomed to call poetry, from much which they have known only under other names.

That, however, the word poetry imports something quite peculiar in its nature, something which may exist in what is called prose as well as in verse, something which does not even require the instrument of words, but can speak through the other audible symbols called musical sounds, and even through the visible ones which are the language of sculpture, painting, and architecture; all this, we believe, is and must be felt, though perhaps indistinctly, by all upon whom poetry in any of its shapes produces any impression beyond that of tickling the ear. The distinction between poetry and what is not poetry, whether explained or not, is felt to be fundamental: and where every one feels a difference, a difference there must be. [...]

The object of poetry is confessedly to act upon the emotions; and therein is poetry sufficiently distinguished from what Wordsworth affirms to be its logical opposite, namely, not prose, but matter of fact or science. The one addresses itself to the belief, the other to the feelings. The one does its work by convincing or persuading, the other by moving. The one acts by presenting a proposition to the understanding, the other by offering interesting objects of contemplation to the sensibilities.

This, however, leaves us very far from a definition of poetry. This distinguishes it from one thing, but we are bound to distinguish it from everything. To bring thoughts or images before the mind for the purpose of acting upon the emotions, does not belong to poetry alone. It is equally the province (for example) of the novelist: and yet the faculty of the poet and that of the novelist are as distinct as any other two faculties; as the faculties of the novelist and of the orator, or of the poet and the metaphysician. The two characters may be united, as characters the most disparate may; but they have no natural connexion.

Many of the greatest poems are in the form of fictitious narratives, and in almost all good serious fictions there is true poetry. But there is a radical distinction between the interest felt in a story as such, and the interest excited by poetry; for the one is derived from incident, the other from the representation of feeling. In one, the source of the emotion excited is the exhibition of a state or states of human sensibility; in the other, of a series of states of mere outward circumstances. Now, all minds are capable of being affected more or less by representations of the latter kind, and all, or almost all, by those of the former; yet the two sources of interest correspond to two distinct, and (as respects their greatest development) mutually exclusive, characters of mind.

* * *

In limiting poetry to the delineation of states of feeling, and denying the name where nothing is delineated but outward objects, we may be thought to have done

what we promised to avoid – to have not found, but made a definition, in opposition to the usage of language, since it is established by common consent that there is a poetry called descriptive. We deny the charge. Description is not poetry because there is descriptive poetry, no more than science is poetry because there is such a thing as a didactic poem. But an object which admits of being described, or a truth which may fill a place in a scientific treatise, may also furnish an occasion for the generation of poetry, which we thereupon choose to call descriptive or didactic. The poetry is not in the object itself, nor in the scientific truth itself, but in the state of mind in which the one and the other may be contemplated. The mere delineation of the dimensions and colours of external objects is not poetry, no more than a geometrical ground-plan of St Peter's or Westminster Abbey is painting. Descriptive poetry consists, no doubt, in description, but in description of things as they appear, not as they are; and it paints them not in their bare and natural lineaments, but seen through the medium and arrayed in the colours of the imagination set in action by the feelings. If a poet describes a lion, he does not describe him as a naturalist would, nor even as a traveller would, who was intent upon stating the truth, the whole truth, and nothing but the truth. He describes him by imagery, that is, by suggesting the most striking likenesses and contrasts which might occur to a mind contemplating the lion, in the state of awe, wonder, or terror, which the spectacle naturally excites, or is, on the occasion, supposed to excite. Now this is describing the lion professedly, but the state of excitement of the spectator really. The lion may be described falsely or with exaggeration, and the poetry be all the better; but if the human emotion be not painted with scrupulous truth, the poetry is bad poetry, i.e. is not poetry at all, but a failure.

Thus far our progress towards a clear view of the essentials of poetry has brought us very close to the last two attempts at a definition of poetry which we happen to have seen in print, both of them by poets and men of genius. The one is by Ebenezer Elliott, the author of *Corn-Law Rhymes*, and other poems of still greater merit. 'Poetry,' says he, 'is impassioned truth.' The other is by a writer in *Blackwood's Magazine*, and comes, we think, still nearer the mark. He defines poetry, 'man's thoughts tinged by his feelings.' There is in either definition a near approximation to what we are in search of. Every truth which a human being can enunciate, every thought, even every outward impression, which can enter into his consciousness, may become poetry when shown through any impassioned medium, when invested with the colouring of joy, or grief, or pity, or affection, or admiration, or reverence, or awe, or even hatred or terror: and, unless so coloured, nothing, be it as interesting as it may, is poetry. But both these definitions fail to discriminate between poetry and eloquence. Eloquence, as well as poetry, is impassioned truth; eloquence, as well as poetry, is thoughts coloured by the feelings. Yet common apprehension and philo-sophic criticism alike recognize a distinction between the two: there is much that every one would call eloquence, which no one would think of classing as poetry. A question will sometimes arise, whether some particular author is a poet; and those who maintain the negative commonly allow, that though not a poet, he is a highly eloquent writer. The distinction between poetry and eloquence appears to us to be equally fundamental with the distinction between poetry and narrative, or between poetry and description, while it is still farther from having been satisfactorily cleared up than either of the others.

Poetry and eloquence are both alike the expression or utterance of feeling. But if we may be excused the antithesis, we should say that eloquence is *heard*, poetry is *overheard*. Eloquence supposes an audience; the peculiarity of poetry appears to us to lie in the poet's utter unconsciousness of a listener. Poetry is feeling, confessing itself to itself in moments of solitude, and embodying itself in symbols, which are the nearest possible representations of the feeling in the exact shape in which it exists in the poet's mind. Eloquence is feeling pouring itself out to other minds, courting their sympathy, or endeavouring to influence their belief, or move them to passion or to action.

All poetry is of the nature of soliloquy. It may be said that poetry which is printed on hot-pressed paper and sold at a bookseller's shop, is a soliloquy in full dress, and on the stage. It is so; but there is nothing absurd in the idea of such a mode of soliloquizing. What we have said to ourselves, we may tell to others afterwards; what we have said or done in solitude, we may voluntarily reproduce when we know that other eyes are upon us. But no trace of consciousness that any eyes are upon us must be visible in the work itself. The actor knows that there is an audience present; but if he act as though he knew it, he acts ill. A poet may write poetry not only with the intention of printing it, but for the express purpose of being paid for it; that it should *be* poetry, being written under such influences, is less probable; not, however, impossible; but no otherwise possible than if he can succeed in excluding from his work every vestige of such lookings-forth into the outward and every-day world, and can express his emotions exactly as he has felt them in solitude, or as he is conscious that he should feel them though they were to remain for ever unuttered, or (at the lowest) as he knows that others feel them in similar circumstances of solitude. But when he turns round and addresses himself to another person; when the act of utterance is not itself the end, but a means to an end – viz. by the feelings he himself expresses, to work upon the feelings, or upon the belief, or the will, of another, – when the expression of his emotions, or of his thoughts tinged by his emotions, is tinged also by that purpose, by that desire of making an impression upon another mind, then it ceases to be poetry, and becomes eloquence.

Poetry, accordingly, is the natural fruit of solitude and meditation; eloquence, of intercourse with the world. The persons who have most feeling of their own, if intellectual culture has given them a language in which to express it, have the highest faculty of poetry; those who best understand the feelings of others, are the most eloquent. The persons, and the nations, who commonly excel in poetry, are those whose character and tastes render them least dependent upon the applause, or sympathy, or concurrence of the world in general. Those to whom that applause, that sympathy, that concurrence are most necessary, generally excel most in eloquence. And hence, perhaps, the French, who are the least poetical of all great and intellectual nations, are among the most eloquent: the French, also, being the most sociable, the vainest, and the least self-dependent.

If the above be, as we believe, the true theory of the distinction commonly admitted between eloquence and poetry; or even though it be not so, yet if, as we cannot doubt, the distinction above stated be a real *bona fide* distinction, it will be found to hold, not merely in the language of words, but in all other language, and to intersect the whole domain of art.

* * *

In the arts which speak to the eye, the same distinctions will be found to hold, not only between poetry and oratory, but between poetry, oratory, narrative, and simple imitation or description.

Pure description is exemplified in a mere portrait or a mere landscape – productions of art, it is true, but of the mechanical rather than of the fine arts, being works of simple imitation, not creation. We say, a mere portrait, or a mere landscape, because it is possible for a portrait or a landscape, without ceasing to be such, to be also a picture; like Turner's landscapes, and the great portraits by Titian or Vandyke.

Whatever in painting or sculpture expresses human feeling – or character, which is only a certain state of feeling grown habitual – may be called, according to circumstances, the poetry, or the eloquence, of the painter's or the sculptor's art: the poetry, if the feeling declares itself by such signs as escape from us when we are unconscious of being seen; the oratory, if the signs are those we use for the purpose of voluntary communication.

The narrative style answers to what is called historical painting, which it is the fashion among connoisseurs to treat as the climax of the pictorial art. That it is the most difficult branch of the art we do not doubt, because, in its perfection, it includes the perfection of all the other branches: as in like manner an epic poem, though in so far as it is epic (i.e. narrative) it is not poetry at all, is yet esteemed the greatest effort of poetic genius, because there is no kind whatever of poetry which may not appropriately find a place in it. But an historical picture as such, that is, as the representation of an incident, must necessarily, as it seems to us, be poor and ineffective. The narrative powers of painting are extremely limited. Scarcely any picture, scarcely even any series of pictures, tells its own story without the aid of an interpreter. But it is the single figures which, to us, are the great charm even of an historical picture. It is in these that the power of the art is really seen. In the attempt to narrate, visible and permanent signs are too far behind the fugitive audible ones, which follow so fast one after another, while the faces and figures in a narrative picture, even though they be Titian's, stand still. Who would not prefer one Virgin and Child of Raphael, to all the pictures which Rubens, with his fat, frouzy Dutch Venuses, ever painted? Though Rubens, besides excelling almost every one in his mastery over the mechanical parts of his art, often shows real genius in grouping his figures, the peculiar problem of historical painting. But then, who, except a mere student of drawing and colouring, ever cared to look twice at any of the figures themselves? The power of painting lies in poetry, of which Rubens had not the slightest tincture – not in narrative, wherein he might have excelled.

The single figures, however, in an historical picture, are rather the eloquence of painting than the poetry: they mostly (unless they are quite out of place in the picture) express the feelings of one person as modified by the presence of others. Accordingly the minds whose bent leads them rather to eloquence than to poetry, rush to historical painting. The French painters, for instance, seldom attempt, because they could make nothing of, single heads, like those glorious ones of the Italian masters, with which they might feed themselves day after day in their own Louvre. They must all be historical; and they are, almost to a man, attitudinizers. If we wished to give any young artist the most impressive warning our imagination could devise against that kind of vice in the pictorial, which corresponds to rant in the histrionic art, we would advise

him to walk once up and once down the gallery of the Luxembourg. Every figure in French painting or statuary seems to be showing itself off before spectators: they are not poetical, but in the worst style of corrupted eloquence.

3 Thomas Cole (1801–1848) Letter to Luman Reed

Reed was Cole's most important patron. He had recently commissioned an Italian landscape, and had discussed the possibility of a series of pictures to decorate a private gallery, thus offering Cole the prospect of realizing a project he already had in mind. The letter was written on 8 September 1833 in the light of this discussion. Cole's plan for *The Course of Empire* was consonant both with his view of the natural grandeur and innocence of American scenery and with his pessimistic conviction of the consequences of civilization (see IB10). While at work on the series he confided to his journal his fear that the union of states would not hold and that 'pure republican government' would come to an end. It should be borne in mind, however, that an apocalyptic and pessimistic account of the course of empire in the old world was likely to have had its attractions to the self-made merchants and free-traders of the new, such as Reed. Cole completed work on the commission in 1836, when the series was exhibited in New York to considerable acclaim. James Fennimore Cooper described *The Course of Empire* as 'the work of the highest genius this country has ever produced'. The series of paintings is now in the collection of the New York Historical Society. The letter was first published in Louis L. Noble (ed.), *The Course of Empire, Voyage of Life, and other Pictures of Thomas Cole, N. A., with Selections from his Letters and Miscellaneous Writings*, New York: Lamport, Blakeman and Law, 1853, pp. 176–9, from which this text is taken.

Catskill, September 18th, 1833

My dear Sir, – The desire you expressed, that I should paint pictures to fill one of your rooms, has given me much pleasure; and I have made some rough drawings (which I send you) of the arrangement that appears to me most suitable, and in accordance with the subjects I should wish to paint. I mentioned to you a favourite subject that I had been cherishing for several years with the *faint* hope that, some day or other, I might be able to embody it. Your liberality has presented an opportunity; and I trust that nothing will now prevent me from completing what I have so long desired. In the drawings you will perceive that I have taken one side of the room for this subject; and, as my description to you of my plan was very imperfect, I will now take the liberty of making an extract from my memorandum book of what I have conceived about it.

A series of pictures might be painted that should illustrate the history of a natural scene, as well as be an epitome of Man, – showing the natural changes of landscape, and those effected by man in his progress from barbarism to civilization – to luxury – to the vicious state, or state of destruction – and to the state of ruin and desolation.

The philosophy of my subject is drawn from the history of the past, wherein we see how nations have risen from the savage state to that of power and glory, and then fallen, and become extinct. Natural scenery has also its changes, – the hours of the day

and the seasons of the year – sunshine and storm: these justly applied will give expression to each picture of the series I would paint. It will be well to have the same location in each picture: this location may be identified by the introduction of some striking object in each scene – a mountain of peculiar form, for instance. This will not in the least preclude variety. The scene must be composed so as to be picturesque in its wild state, appropriate for cultivation, and the site of a sea-port. There must be the sea, a bay, rocks, waterfalls and woods.

The First Picture, representing the savage state, must be a view of a wilderness, – the sun rising from the sea, and the clouds of night retiring over the mountains. The figures must be savage, clothed in skins, and occupied in the chase. There must be a flashing chiaroscuro, and the spirit of motion pervading the scene, as though nature were just springing from chaos.

The Second Picture must be the pastoral state, – the day further advanced – light clouds playing about the mountains – the scene partly cultivated – a rude village near the bay – small vessels in the harbour – groups of peasants either pursuing their labours in the field, watching their flocks, or engaged in some simple amusement. The chiaroscuro must be of a milder character than in the previous scene, but yet have a fresh and breezy effect.

The Third must be a noonday, – a great city girding the bay, gorgeous piles of architecture, bridges, aqueducts, temples – the port crowded with vessels – splendid processions, &c. – all that can be combined to show the fullness of prosperity: the chiaroscuro broad.

The Fourth should be a tempest, – a battle, and the burning of the city – towers falling, arches broken, vessels wrecking in the harbour. In this scene there should be a fierce chiaroscuro, masses and groups swaying about like stormy waves. This is the scene of destruction or vicious state.

The Fifth must be a sunset, – the mountains riven – the city a desolate ruin – columns standing isolated amid the encroaching waters – ruined temples, broken bridges, fountains, sarcophagi, &c. – no human figure – a solitary bird perhaps: a calm and silent effect. This picture must be as the funeral knell of departed greatness, and may be called the state of desolation.

You will perceive what an arduous task I have set myself; but your approbation will stimulate me to conquer difficulties. These five pictures, with three smaller ones above, and two others by the fire-place, will occupy all that side of the room. The three high pictures will be something in character with those over which they hang.

To fill the other side of the room and the ends will require eighteen or twenty pictures, five of which will be larger than the Italian Scene. For the completion of all these pictures I cannot reckon upon less than two years' labour; and they may require more time: at all events, nothing should prevent me from using every means and exertion to make the work satisfactory to you, and creditable to myself.

You will wish me to say something about the price: it is the subject I am least willing to encounter. My desire to undertake a work on which I may hope to establish a lasting reputation, and the fear that such an opportunity may never offer again, may make me forget, in a measure, my pecuniary interests: on the other hand, the profit-able commissions I already have, the consideration that a painter's wants are like those of other men, and the necessity, in undertaking a work like yours, of neglecting for a

time my general reputation, may cause me to make a demand greater than you have calculated upon. I trust I shall not be unreasonable nor extravagant. For the ten pictures occupying the side with the fire-place I must ask $2,500. Five of the pictures will be much larger than your Italian Scene, and will require greater study, as the figures, though small, will in some of them be numerous, and I should desire to paint them carefully. For the other side and the ends – five of which will be large pictures – I cannot ask less than the same, making $5,000 for the completion of the whole room. This may appear a large sum; but I assure you that if I calculated according to the prices I have received for my pictures lately, the amount of the last mentioned side alone would be double the sum I ask: but I shall be happy to do them, so that I may have an opportunity of executing the others.

I am, yours truly,
Thomas Cole.

4 Victor Cousin (1792–1867) from *Lectures on the True, the Beautiful and the Good*

Cousin was a lecturer in philosophy at the Sorbonne in Paris during the early nineteenth century. His course of lectures *Du vrai, du beau et du bien* commenced in December 1817, but was not published until 1836. His main influence was felt during the period of the July Monarchy, when he was identified as the key philosopher of the *juste milieu* – the eclectic school which dominated French art between Romanticism and the rise of Realism. In his introduction Cousin stated, 'Under these three heads, the True, the Beautiful, the Good, we embrace psychology, placed by us at the head of all philosophy'. His work is identified with the origins of the doctrine of 'l'art pour l'art' (art for art's sake), and it can be seen from the following extract that he does indeed argue the necessity of art's independence from any utilitarian, religious or political purpose. His basic philosophical position was one of religious spiritualism, however. In 1854 his lectures were reprinted in their definitive form, with simultaneous French and English editions, published in Paris, Edinburgh and New York. By then, what might originally have appeared as a challenging anti-utilitarianism had become a vehicle of conservative opposition to Realism in art and literature alike. In 1888, when Ernest Renan warned against a 'magistracy . . . appealing to superstition and imposture in order to maintain its power', it was with an unmistakable reference to Cousin's title (see the introduction to IIIA2). M. V. Cousin, *Lectures on the True, the Beautiful and the Good*, was first published in Edinburgh and New York in 1854; our text is taken from the edition of 1873, New York: D. Appleton and Co., Lecture VIII, 'On Art', pp. 163–4, and Lecture IX, 'The Different Arts', pp. 165–7 and 169–72.

Lecture VIII

[. . .] In vindicating the independence, the proper dignity, and the particular end of art, we do not intend to separate it from religion, from morals, from country. Art draws its inspirations from these profound sources, as well as from the ever open source of nature. But it is not less true that art, the state, religion, are powers which have each their world apart and their own effects; they mutually help each other; they should not serve each other. As soon as one of them wanders from its end, it errs, and

is degraded. Does art blindly give itself up to the orders of religion and the state? In losing its liberty, it loses its charm and its empire.

Ancient Greece and modern Italy are continually cited as triumphant examples of what the alliance of art, religion, and the state can do. Nothing is more true, if the question is concerning their union; nothing is more false, if the question is concerning the servitude of art. Art in Greece was so little the slave of religion, that it little by little modified the symbols, and, to a certain extent, the spirit itself, by its free representations. There is a long distance between the divinities that Greece received from Egypt and those of which it has left immortal exemplars. Are those primitive artists and poets, as Homer and Dedalus are called, strangers to this change? And in the most beautiful epoch of art, did not Aeschylus and Phidias carry a great liberty into the religious scenes which they exposed to the gaze of the people, in the theatre, or in front of the temples? In Italy as in Greece, as everywhere, art is at first in the hands of priesthoods and governments; but, as it increases its importance and is developed, it more and more conquers its liberty. Men speak of the faith that animated the artists and vivified their works; that is true of the time of Giotto and Cimabue; but after Angelico de Fiesole, at the end of the fifteenth century, in Italy, I perceive especially the faith of art in itself and the worship of beauty. Raphael was about to become a cardinal; yes, but always painting Galatea, and without quitting Fornarine. Once more, let us exaggerate nothing; let us distinguish, not separate; let us unite art, religion, and country, but let not their union injure the liberty of each. Let us be thoroughly penetrated with the thought, that art is also to itself a kind of religion. God manifests himself to us by the idea of the true, by the idea of the good, by the idea of the beautiful. Each one of them leads to God, because it comes from him. True beauty is ideal beauty, and ideal beauty is a reflection of the infinite. So, independently of all official alliance with religion and morals, art is by itself essentially religious and moral; for, far from wanting its own law, its own genius, it everywhere expresses in its works eternal beauty. Bound on all sides to matter by inflexible laws, working upon inanimate stone, upon uncertain and fugitive sounds, upon words of limited and finite signification, art communicates to them, with the precise form that is addressed to such or such a sense, a mysterious character that is addressed to the imagination and the soul, takes them away from reality, and bears them sweetly or violently into unknown regions. Every work of art, whatever may be its form, small or great, figured, sung, or uttered, – every work of art, truly beautiful or sublime, throws the soul into a gentle or severe reverie that elevates it towards the infinite. The infinite is the common limit after which the soul aspires upon the wings of imagination as well as reason, by the route of the sublime and the beautiful, as well as by that of the true and the good. The emotion that the beautiful produces turns the soul from this world; it is the beneficent emotion that art produces for humanity.

Lecture IX

A resumé of the last lecture would be a definition of art, of its end and law. Art is the free reproduction of the beautiful, not of a single natural beauty, but of ideal beauty, as the human imagination conceives it by the aid of data which nature furnishes it.

The ideal beauty envelops the infinite: – the end of art is, then, to produce works that, like those of nature, or even in a still higher degree, may have the charm of the infinite. But how and by what illusion can we draw the infinite from the finite? This is the difficulty of art, and its glory also. What bears us towards the infinite in natural beauty? The ideal side of this beauty. The ideal is the mysterious ladder that enables the soul to ascend from the finite to the infinite. The artist, then, must devote himself to the representation of the ideal. Every thing has its ideal. The first care of the artist will be, then, whatever he does, to penetrate at first to the concealed ideal of his subject, for his subject has an ideal, – in order to render it, in the next place, more or less striking to the senses and the soul, according to the conditions which the very materials that he employs – the stone, the colour, the sound, the language – impose on him.

So, to express the ideal of the infinite in one way or another, is the law of art; and all the arts are such only by their relation to the sentiment of the beautiful and the infinite which they awaken in the soul, by the aid of that high quality of every work of art that is called expression.

Expression is essentially ideal: what expression tries to make felt, is not what the eye can see and the hand touch, evidently it is something invisible and impalpable.

The problem of art is to reach the soul through the body. Art offers to the senses forms, colours, sounds, words, so arranged that they excite in the soul, concealed behind the senses, the inexpressible emotion of beauty.

Expression is addressed to the soul as form is addressed to the senses. Form is the obstacle of expression, and, at the same time, is its imperative, necessary, only means. By working upon form, by bending it to its service, by dint of care, patience, and genius, art succeeds in converting an obstacle into a means.

By their object, all arts are equal; all are arts only because they express the invisible. It cannot be too often repeated, that expression is the supreme law of art. The thing to express is always the same, – it is the idea, the spirit, the soul, the invisible, the infinite. But, as the question is concerning the expression of this one and the same thing, by addressing ourselves to the senses which are diverse, the difference of the senses divides art into different arts.

. . . Of the five senses which have been given to man, three – taste, smell, and touch – are incapable of producing in us the sentiment of beauty. Joined to the other two, they may contribute to the understanding of this sentiment; but alone and by themselves they cannot produce it. Taste judges of the agreeable, not of the beautiful. No sense is less allied to the soul and more in the service of the body; it flatters, it serves the grossest of all masters, the stomach. If smell sometimes seems to participate in the sentiment of the beautiful, it is because the odour is exhaled from an object that is already beautiful, that is beautiful for some other reason. Thus the rose is beautiful for its graceful form, for the varied splendour of its colours; its odour is agreeable, it is not beautiful. Finally, it is not touch alone that judges of the regularity of forms, but touch enlightened by sight.

There remain two senses to which all the world concedes the privilege of exciting in us the idea and the sentiment of the beautiful. They seem to be more particularly in the service of the soul. The sensations which they give have something purer, more intellectual. They are less indispensable for the material preservation of the indi-

vidual. They contribute to the embellishment rather than to the sustaining of life. They procure us pleasures in which our personality seems less interested and more self-forgetful. To these two senses, then, art should be addressed, is addressed, in fact, in order to reach the soul. Hence the division of arts into two great classes, – arts addressed to hearing, arts addressed to sight; on the one hand, music and poetry; on the other, painting, with engraving, sculpture, architecture, gardening. [. . .]

The arts are called the fine arts, because their sole object is to produce the disinterested emotion of beauty, without regard to the utility either of the spectator or the artist. They are also called the liberal arts, because they are the arts of free men and not of slaves, which affranchise the soul, charm and ennoble existence; hence the sense and origin of those expressions of antiquity, *artes liberales*, *artes ingenuæ* [liberal and honourable arts]. There are arts without nobility, whose end is practical and material utility; they are called trades, such as that of the stove-maker and the mason. True art may be joined to them, may even shine in them, but only in the accessories and the details. [. . .]

The sole object of art is the beautiful. Art abandons itself as soon as it shuns this. It is often constrained to make concessions to circumstances, to external conditions that are imposed upon it; but it must always retain a just liberty. Architecture and the art of gardening are the least free of arts; they are subjected to unavoidable obstacles; it belongs to the genius of the artist to govern these obstacles, and even to draw from them happy effects, as the poet turns the slavery of metre and rhyme into a source of unexpected beauties. Extreme liberty may carry art to a caprice which degrades it, as chains too heavy crush it. It is the death of architecture to subject it to convenience, to *comfort*. Is the architect obliged to subordinate general effect and the proportions of the edifice to such or such a particular end that is prescribed to him? He takes refuge in details, in pediments, in friezes, in all the parts that have not utility for a special object, and in them he becomes a true artist. Sculpture and painting, especially music and poetry, are freer than architecture and the art of gardening. One can also shackle them, but they disengage themselves more easily.

Similar by their common end, all the arts differ by the particular effects which they produce, and by the processes which they employ. They gain nothing by exchanging their means and confounding the limits that separate them. I bow before the authority of antiquity; but, perhaps, through habit and a remnant of prejudice, I have some difficulty in representing to myself with pleasure statues composed of several metals, especially painted statues. [. . .] Sculpture is an austere muse; it has its graces, but they are those of no other art. Flesh–colour must remain a stranger to it: there would nothing more remain to communicate to it but the movement of poetry and the indefiniteness of music! And what will music gain by aiming at the picturesque, when its proper domain is the pathetic? [. . .]

Since the *Laocoon* of Lessing, it is no longer permitted to repeat, without great reserve, the famous axiom, – *Ut pictura poesis*; or, at least, it is very certain that painting cannot do every thing that poetry can do. Everybody admires the picture of Rumour, drawn by Virgil; but let a painter try to realize this symbolic figure; let him represent to us a huge monster with a hundred eyes, a hundred mouths, and a hundred ears, whose feet touch the earth, whose head is lost in the clouds, and such a figure will become very ridiculous.

So the arts have a common end, and entirely different means. Hence the general rules common to all, and particular rules for each. . . . I limit myself to repeating, that the great law which governs all others, is expression. Every work of art that does not express an idea signifies nothing; in addressing itself to such or such a sense, it must penetrate to the mind, to the soul, and bear thither a thought, a sentiment capable of touching or elevating it. From this fundamental rule all the others are derived; for example, that which is continually and justly recommended, – composition. To this is particularly applied the precept of unity and variety. But, in saying this, we have said nothing so long as we have not determined the nature of the unity of which we would speak. True unity, is unity of expression, and variety is made only to spread over the entire work the idea or the single sentiment that it should express. It is useless to remark, that between composition thus defined, and what is often called composition, as the symmetry and arrangement of parts according to artificial rules, there is an abyss. True composition is nothing else than the most powerful means of expression.

5 Friedrich Theodor Vischer (1807–1887) 'Overbeck's *Triumph of Religion*'

Friedrich Overbeck (1789–1869) was one of the founders of the brotherhood of St Luke and a leading member of the Nazarenes, a group of German artists active in Rome in the early nineteenth century. They sought to bring about the regeneration of religious painting by turning back to the art of the late medieval and Renaissance periods, before the onset of the Academic tradition. In 1840 Overbeck completed his monumental *Triumph of Religion in the Arts*, an ambitious allegory depicting the history of religious art. Friedrich Theodor Vischer's biting critique, articulated from the standpoint of Hegel's aesthetics, views the work as symptomatic of the failings of the Nazarene movement as a whole. Vischer contrasts the psuedo-naivity of the painting with the self-conscious and reflective process required to conceive such a subject in the first place. Although modelled on the work of Raphael and Perugino, Overbeck's painting seeks to do something 'thoroughly modern'; it represents an 'act of reflection' which already stands outside of what it depicts. Here, 'art turns back on itself and makes itself into its own object'. Vischer rejects the possibility of a return to the direct and simple faith of an earlier period, insisting that we cannot go back behind the achievements of the last several hundred years. A genuinely religious art can no longer depict holy figures floating on clouds, but must depict reality 'as it truly is'. The shift from the medieval world view to our own is irreversible, and the artist is referred back to the domain of human history. Vischer observes that all the vitality is drained from Overbeck's figures; even the great artists and poets depicted in the lower half of the canvas are 'desiccated and devoid of substance'. 'Overbeck's *Triumph der Religion*' was first published in *Deutsche Jahrbücher für Wissenschaft und Kunst*, no. 28, in 1841. These extracts have been translated for the present volume by Jason Gaiger from *Kritische Gänge*, volume V, second expanded edition, Robert Vischer (ed.), Munich: Meyerand Jessen Verlag, 1922, pp. 3–4, 7–8, 24–6, 29, 33.

I stood before the much discussed painting in the Städel Institute in Frankfurt. One's eyes must first adjust to the panel with its upper half cut in the shape of a semi-circle and its effusion of colours and groups of figures. Let us begin at once with its division into parts, for the painting is arranged in two large halves. These are intimately bound

together in the mind of the artist and of the Middle Ages in which he lives. For the eye, however, there is no unity, no middle point, no interconnection between the two parts which could bring them together as the totality of a *single* action. But let us not judge too hastily, for the master has no lesser example before him than that of Raphael's 'Theology' in the *Stanza della Segnatura*. [. . .]

The arched upper section holds a gathering of heavenly figures from the Christian firmament; they sit or stand upon clouds, just as in paintings of the Middle Ages and its less vigorous blossoming in the succeeding centuries. Mary with child occupies the centre. She holds a quill in her hand and contemplates a song of praise whose first word, *Magnificat*, she has already written upon a scroll of paper which she holds in her left. At the same time, 'as leader of the choir, she demands of everyone that they give honour to God the Lord'. Holy figures from both the Old and the New Testament surround her, foremost of all those who can be considered representatives of religious art, Luke as painter and David with his harp, whilst the Holy Virgin herself represents the highest of the arts, poetry. Of the other figures who occupy this Olympus we shall say a few words later on.

In the lower half of the painting the earth extends in bright planes and hills, and in the foreground one can see a large gathering of artists. The entire upper part of the panel is intended to represent a vision which hovers before them; none of the figures looks upwards, and there is no suggestion in them, except perhaps for two or three of the figures, that they are remotely aware of what is taking place above.

* * *

What this painting offers us is a recapitulation of the history of art, a lecture on its past, which, at the same time, contains a moral lesson for art's future. Here, art turns back upon itself and makes itself into its own object. It is an act of reflection, and it is from this act that the picture as a whole has arisen. This alone suffices to show that it is a thoroughly modern product, by which I mean modern in a negative sense. But how can this be said of a work which is so thoroughly immersed in the faith of the good old times, which flows from the spring of purest piety, and for which Perugino and Raphael guided the artist's pencil? Later we will discuss the execution of the painting and the way in which its mood is articulated through aesthetic forms. Here the task is solely to grasp the idea which it represents. Never would it have occurred to the Old Masters to paint the visual arts as such. They depicted individual artists, but that is something different. Occasionally, through allegory, they represented the various arts, but that too is something different. On no occasion did they use their brushes to present a lecture on the history of art so as to draw from it a *fabula docet* [instructive story] and to establish a particular perspective on this history as the only correct one. Nor is it a matter of chance they neglected to do so, for they were firmly rooted in the native soil of art, and did not stand outside in an external position from where they could paint observations about it.

* * *

I shall now grasp the matter at its root and declare that the principle of the Reformation – which was only partly established by the church but subsequently brought to completion by science, organized knowledge – has once and for all completely emptied the medieval Olympus. Our God is an immanent God. His habitat is everywhere and nowhere. His body is the entire world and He is present only in the minds

of men. To honour *this* God is the highest task of new art. The domain of the modern artist is history, the world as the stage on which God is revealed. The artist must depict reality as it truly is, not in hazy romantic images but in clear, solid outlines, as a movement in which the ethical power of God's presence is revealed and 'divine powers ascend and descend, passing between them the golden pail'.[1] We no longer know of any miracle which is not a miracle of the human spirit, and it is this inner romanticism which the artist must realize in appropriate and plastically purified forms. Clerical-religious painting, which was previously regarded as the highest branch of history painting, has been driven from its place, indeed, it has been completely extinguished. It is now three hundred years since such religious art died out and it is only with galvanic shocks that artists have sought to bring it back to a new artificial life. It may well be that Madonnas and other holy figures will still be painted: prescriptions should not be placed upon the artist. An artist may occasionally be seized by the spirit of the Middle Ages and seek to paint a small holy picture, just as, on another occasion, he may choose to bring the old Gods back amongst us for a few hours. But the artist cannot establish these tasks as principles. To attempt to do so would be to turn himself into a living cadaver. Our art has lost everything, and thereby gained everything: it has lost the entire *fata morgana* of a transcendent world, but gained the entire real world. In the painting of the Middle Ages, just as in the religious beliefs of that age, the entire world is transferred to a heaven above; ours, by contrast, reveals heaven on earth. The atmosphere of this planet is no longer the domain of spirits. The horizon has been cleansed and fairies and gnomes no longer shimmer through the mist. There are no more Madonnas or other divinities enthroned upon clouds reddened by the setting sun. There is mist, and there are clouds, but the world itself is now placed in the full light of day. Whereas previously a second realm was placed between the world and the sun and drew the light away from it, the world now lies openly revealed before us, illuminated by the rays of art, and surrounded by air and light.

* * *

...It is easy to understand why in this narrowly closed circle [of the Nazarenes] it is the ideal of the Madonna which the artist most often seeks to depict. It is not, indeed, the Madonna as the proud queen of heaven, but as the chaste handmaid of the Lord, the bride who modestly reflects upon the mystery of her calling, which presents the appropriate subject for Overbeck's childlike grace. Yes! The Madonna depicted here is beautiful, a pure dove free of gall. And yet, there is also something here, I know not what, something of the almanac, of violets and forget-me-nots, a characteristic which is unmistakable in all modern Madonnas. We gaze upon them everywhere in this age of personal albums, with its abundance of mirrors, fashion magazines and copper engravings in small pocket books. How could it be otherwise! How can it be possible to deny one's times! The 'Madonna at Prayer' in the Allerheilige Church in Munich is a delightful, charming, pious picture, and yet she too possesses this same characteristic. For we know that there are no human virgins who are at the same time divine, and that there is no conceiving of children except in accordance with the common laws of nature. Whether particular individuals believe this to be the case or not is unimportant. It is in the atmosphere, and we imbibe the cultural transformation which has taken place with every breath. And yet, under these conditions, a virgin

IIB Art and Nature Moralized 199

mother is to be depicted! Not in the pure ethical sense in which true love ennobles the sensuous, so that we can say that the woman who is true always remains a chaste bride. Rather, what the artist seeks to depict is a miracle in the religious sense, something ungraspable for us. And this deliberate repudiation of the consciousness of the age is something which we are not supposed to detect in the painting itself? No, our Madonnas are not the Madonnas of the church of old ... Although the picture is, indeed, beautiful, I am none the less right to claim that for us a Madonna is an impossibility.

* * *

There is another thing which we have not yet discussed – the characters who occupy the lower half of the picture. These are, as one might expect, desiccated and devoid of substance. These are not human beings. They are not bold enough to be human. The swollen heaven above presses down upon them like a burden. A real human being looks different, he has vitality in his muscles and a sense of his own power. He stands and moves differently upon the earth, aware of his sovereignty and possessed of divinity. Is the speaking figure there supposed to be Dante? He appears excited and eager and the features of his face are recognizable, but he must have fallen ill since last I saw him. He is no longer the coarse and furious man who compassed with his poetry the horrors of Hell and who once beat a smith on the streets of Florence because he recited his poetry badly. And there sits Michelangelo, deep in reflection as was his wont, but he has been tamed, his flesh has fallen away and his fiery gaze is extinguished. Is this indeed his last testament?

[1] A reference to Goethe's *Faust*, lines 449–51.

6 John Ruskin (1819–1900) from *Modern Painters*, Volume 1

By 1869, when he was appointed Slade Professor of Fine Art at the University of Oxford, Ruskin had become *the* Victorian authority on art, with a reputation built on his voluminous writings on painting, drawing, architecture and political economy. The first volume of *Modern Painters* was published in 1843, when Ruskin was only 24. He wrote it after graduating from Oxford the previous year. By this time he had already travelled to Italy – seeing Rome, Naples and Venice in 1840. On the return journey he encountered, and was overawed by, the Alps, which confirmed in him a poetic feeling for nature. As early as 1835 Ruskin had also discovered Turner, whom he met in 1840, describing him in his diary as 'the man who beyond all doubt is the greatest of the age'. *Modern Painters* itself had its origins in Ruskin's determination to answer criticism of Turner and to accord his work the pre-eminent status he felt it deserved. Subsequent volumes were published in 1846 (Vol. II), 1856 (Vols. III and IV) and 1860 (Vol. V). In the present extracts Ruskin distinguishes truth in art from imitation. The latter is determined by the senses, and value in art is more than merely sensory. It is this higher truth that Ruskin equates with beauty. Interestingly, Ruskin's formulation of *why* certain forms give pleasure and others do not anticipates the later Modernist critic Clement Greenberg's assertion that one can no more *choose* to like what is good in art than one can 'choose to have sugar taste sweet or lemons sour'. For Ruskin, God made us that way (though the 'man of taste' may be needed to help us realize it). Taste, the ability to discern beauty, is however no

caprice. For Ruskin it represents the acme of human intelligence, or rather the point at which intelligence intersects with morality. Our extracts from *Modern Painters* volume 1, subtitled 'Of General Principles, and of Truth', are taken from chapter V, 'Of Ideas of Truth'; VI, 'Of Ideas of Beauty'; and VII, 'Of Ideas of Relation', in the 1900 edition London: George Allen, pp. 24–34.

Of Ideas of Truth

The word Truth, as applied to art, signifies the faithful statement, either to the mind or senses, of any fact of nature.

We receive an idea of truth, then, when we perceive the faithfulness of such a statement.

The difference between ideas of truth and of imitation lies chiefly in the following points:

First, – Imitation can only be of something material, but truth has reference to statements both of the qualities of material things, and of emotions, impressions, and thoughts. There is a moral as well as material truth, – a truth of impression as well as of form, – of thought as well as of matter; and the truth of impression and thought is a thousand times the more important of the two. Hence, truth is a term of universal application, but imitation is limited to that narrow field of art which takes cognizance only of material things.

Secondly, – Truth may be stated by any signs or symbols which have a definite signification in the minds of those to whom they are addressed, although such signs be themselves no image nor likeness of anything. Whatever can excite in the mind the conception of certain facts, can give ideas of truth, though it be in no degree the imitation or resemblance of those facts. If there be – we do not say there is, – but if there be in painting anything which operates, as words do, not by resembling anything, but by being taken as a symbol and substitute for it, and thus inducing the effect of it, then this channel of communication can convey uncorrupted truth, though it do not in any degree resemble the facts whose conception it induces. But ideas of imitation, of course, require the likeness of the object. They speak to the perceptive faculties only: truth to the conceptive.

Thirdly, and in consequence of what is above stated, an idea of truth exists in the statement of *one* attribute of anything, but an idea of imitation requires the resemblance of as many attributes as we are usually cognizant of in its real presence. A pencil outline of the bough of a tree on white paper is a statement of a certain number of facts of form. It does not yet amount to the imitation of anything. The idea of that form is not given in nature by lines at all, still less by black lines with a white space between them. But those lines convey to the mind a distinct impression of a certain number of facts, which it recognizes as agreeable with its previous impressions of the bough of a tree; and it receives, therefore, an idea of truth. If, instead of two lines, we give a dark form with the brush, we convey information of a certain relation of shade between the bough and sky, recognizable for another idea of truth: but we have still no imitation, for the white paper is not the least like air, nor the black shadow like wood. It is not until after a certain number of ideas of truth have been collected together, that we arrive at an idea of imitation.

Hence it might at first sight appear, that an idea of imitation, inasmuch as several ideas of truth are united in it, is nobler than a simple idea of truth. And if it were necessary that the ideas of truth should be perfect, or should be subjects of contemplation *as such*, it would be so. But, observe, we require to produce the effect of imitation only so many and such ideas of truth as the *senses* are usually cognizant of. Now the senses are not usually, nor unless they be especially devoted to the service, cognizant, with accuracy, of any truths but those of space and projection. It requires long study and attention before they give certain evidence of even the simplest truths of form. For instance, the quay on which the figure is sitting, with his hand at his eyes, in Claude's 'Seaport,' No. 14 in the National Gallery, is egregiously out of perspective. The eye of this artist, with all his study, had thus not acquired the power of taking cognizance of the apparent form even of a simple parallelopiped: how much less of the complicated forms of boughs, leaves, or limbs? Although, therefore, something resembling the real form is necessary to deception, this something is not to be called a *truth* of form; for, strictly speaking, there are no degrees of truth, there are only degrees of approach to it; and an approach to it, whose feebleness and imperfection would instantly offend and give pain to a mind really capable of distinguishing truth, is yet quite sufficient for all the purposes of deceptive imitation. It is the same with regard to colour. If we were to paint a tree sky-blue, or a dog rose-pink, the discernment of the public would be keen enough to discover the falsehood; but, so that there be just so much approach to truth of colour as may come up to the common idea of it in men's minds, that is to say, if the trees be all bright green, and flesh unbroken buff, and ground unbroken brown, though all the real and refined truths of colour be wholly omitted, or rather defied and contradicted, there is yet quite enough for all purposes of imitation. The only facts, then, which we are usually and certainly cognizant of, are those of distance and projection; and if these be tolerably given, with something like truth of form and colour to assist them, the idea of imitation is complete. [. . .]

We shall see, in the course of our investigation of ideas of truth, that ideas of imitation not only do not imply their presence, but even are inconsistent with it; and that pictures which imitate so as to deceive, are never true. But this is not the place for the proof of this; at present we have only to insist on the last and greatest distinction between ideas of truth and of imitation – that the mind, in receiving one of the former, dwells upon its own conception of the fact, or form, or feeling stated, and is occupied only with the qualities and character of that fact or form, considering it as real and existing, being all the while totally regardless of the signs or symbols by which the notion of it has been conveyed. These signs have no pretence, nor hypocrisy, nor legerdemain about them; – there is nothing to be found out, or sifted, or surprised in them; – they bear their message simply and clearly, and it is that message which the mind takes from them and dwells upon, regardless of the language in which it is delivered. But the mind, in receiving an idea of imitation, is wholly occupied in finding out that what has been suggested to it is not what it appears to be: it does not dwell on the suggestion, but on the perception that it is a false suggestion: it derives its pleasure, not from the contemplation of a truth, but from the discovery of a falsehood. So that the moment ideas of truth are grouped together, so as to give rise to an idea of imitation, they change their very nature – lose their essence as ideas of truth – and are corrupted

and degraded, so as to share in the treachery of what they have produced. Hence, finally, ideas of truth are the foundation, and ideas of imitation, the destruction, of all art. We shall be better able to appreciate their relative dignity after the investigation which we propose of the functions of the former; but we may as well now express the conclusion to which we shall then be led – that no picture can be good which deceives by its imitation, for the very reason that nothing can be beautiful which is not true.

Of Ideas of Beauty

Any material object which can give us pleasure in the simple contemplation of its outward qualities without any direct and definite exertion of the intellect, I call in some way, or in some degree, beautiful. Why we receive pleasure from some forms and colours, and not from others, is no more to be asked or answered than why we like sugar and dislike wormwood. The utmost subtlety of investigation will only lead us to ultimate instincts and principles of human nature, for which no farther reason can be given than the simple will of the Deity that we should be so created. We may indeed perceive, as far as we are acquainted with His nature, that we have been so constructed as, when in a healthy and cultivated state of mind, to derive pleasure from whatever things are illustrative of that nature; but we do not receive pleasure from them *because* they are illustrative of it, nor from any perception that they are illustrative of it, but instinctively and necessarily, as we derive sensual pleasure from the scent of a rose. On these primary principles of our nature, education and accident operate to an unlimited extent; they may be cultivated or checked, directed or diverted, gifted by right guidance with the most acute and faultless sense, or subjected by neglect to every phase of error and disease. He who has followed up these natural laws of aversion and desire, rendering them more and more authoritative by constant obedience, so as to derive pleasure always from that which God originally intended should give him pleasure, and who derives the greatest possible sum of pleasure from any given object, is a man of taste.

This, then, is the real meaning of this disputed word. Perfect taste is the faculty of receiving the greatest possible pleasure from those material sources which are attractive to our moral nature in its purity and perfection. He who receives little pleasure from these sources wants taste; he who receives pleasure from any other sources, has false or bad taste.

And it is thus that the term 'taste' is to be distinguished from that of 'judgement', with which it is constantly confounded. Judegement is a general term, expressing definite action of the intellect, and applicable to every kind of subject which can be submitted to it. There may be judgement of congruity, judgement of truth, judgement of justice, and judgement of difficulty and excellence. But all these exertions of the intellect are totally distinct from taste, properly so called, which is the instinctive and instant preferring of one material object to another without any obvious reason, except that it is proper to human nature in its perfection so to do.

Observe, however, I do not mean by excluding direct exertion of the intellect from ideas of beauty, to assert that beauty has no effect upon, nor connection with the intellect. All our moral feelings are so interwoven with our intellectual powers, that we cannot affect the one without in some degree addressing the other; and in all high

ideas of beauty, it is more than probable that much of the pleasure depends on delicate and untraceable perceptions of fitness, propriety, and relation, which are purely intellectual, and through which we arrive at our noblest ideas of what is commonly and rightly called 'intellectual beauty.' But there is yet no immediate *exertion* of the intellect; that is to say, if a person receiving even the noblest ideas of simple beauty be asked *why* he likes the object exciting them, he will not be able to give any distinct reason, nor to trace in his mind any formed thought, to which he can appeal as a source of pleasure. He will say that the thing gratifies, fills, hallows, exalts his mind, but he will not be able to say why, or how. If he can, and if he can show that he perceives in the object any expression of distinct thought, he has received more than an idea of beauty – it is an idea of relation.

Ideas of beauty are among the noblest which can be presented to the human mind, invariably exalting and purifying it according to their degree; and it would appear that we are intended by the Deity to be constantly under their influence, because there is not one single object in nature which is not capable of conveying them, and which, to the rightly perceiving mind, does not present an incalculably greater number of beautiful than of deformed parts; there being in fact scarcely anything, in pure undiseased nature, like positive deformity, but only degrees of beauty, or such slight and rare points of permitted contrast as may render all around them more valuable by their opposition – spots of blackness in creation, to make its colours felt.

But although everything in nature is more or less beautiful, every species of object has its own kind and degree of beauty; some being in their own nature more beautiful than others, and few, if any, individuals possessing the utmost degree of beauty of which the species is capable. This utmost degree of specific beauty, necessarily coexistent with the utmost perfection of the object in other respects, is the ideal of the object.

Ideas of beauty, then, be it remembered, are the subjects of moral, but not of intellectual perception. By the investigation of them we shall be led to the knowledge of the ideal subjects of art.

Of Ideas of Relation

I use this term rather as one of convenience than as adequately expressive of the vast class of ideas which I wish to be comprehended under it, namely, all those conveyable by art, which are the subjects of distinct intellectual perception and action, and which are therefore worthy of the name of thoughts. But as every thought, or definite exertion of intellect, implies two subjects, and some connection or relation inferred between them, the term 'ideas of relation' is not incorrect, though it is inexpressive.

Under this head must be arranged everything productive of expression, sentiment, and character, whether in figures or landscapes, (for there may be as much definite expression and marked carrying out of particular thoughts in the treatment of inanimate as of animate nature,) everything relating to the conception of the subject and to the congruity and relation of its parts; not as they enhance each other's beauty by known and constant laws of composition, but as they give each other expression and meaning, by particular application, requiring distinct thought to discover or to enjoy; the choice, for instance, of a particular lurid or appalling light to illustrate an

incident in itself terrible, or of a particular tone of pure colour to prepare the mind for the expression of refined and delicate feeling; and, in a still higher sense, the invention of such incidents and thoughts as can be expressed in words as well as on canvas, and are totally independent of any means of art but such as may serve for the bare suggestion of them. The principal object in the foreground of Turner's 'Building of Carthage' is a group of children sailing toy boats. The exquisite choice of this incident, as expressive of the ruling passion which was to be the source of future greatness, in preference to the tumult of busy stonemasons or arming soldiers, is quite as appreciable when it is told as when it is seen, – it has nothing to do with the technicalities of painting; a scratch of the pen would have conveyed the idea and spoken to the intellect as much as the elaborate realizations of colour. Such a thought as this is something far above all art; it is epic poetry of the highest order. Claude, in subjects of the same kind, commonly introduces people carrying red trunks with iron locks about, and dwells, with infantine delight, on the lustre of the leather and the ornaments of the iron. The intellect can have no occupation here; we must look to the imitation or to nothing. Consequently, Turner arises above Claude in the very first instant of the conception of his picture, and acquires an intellectual superiority which no powers of the draughtsman or the artist (supposing that such existed in his antagonist) could ever wrest from him.

Such are the function and force of ideas of relation. They are what I have asserted . . . to be the noblest subjects of art. Dependent upon it only for expression, they cause all the rest of its complicated sources of pleasure to take, in comparison with them, the place of mere language or decoration; nay, even the noblest ideas of beauty sink at once beside these into subordination and subjection. . . . The utmost glory of the human body is a mean subject of contemplation, compared to the emotion, exertion, and character of that which animates it; the lustre of the limbs of the Aphrodite is faint beside that of the brow of the Madonna; and the divine form of the Greek god, except as it is the incarnation and expression of divine mind, is degraded beside the passion and the prophecy of the vaults of the Sistine.

Ideas of relation are of course, with respect to art generally, the most extensive as the most important source of pleasure. [. . .]

By the term 'ideas of relation,' then, I mean in future to express all those sources of pleasure, which involve and require, at the instant of their perception, active exertion of the intellectual powers.

7 John Ruskin (1819–1900) from Preface to the Second Edition of *Modern Painters*

Modern Painters was immediately successful on its first publication in 1843. For the second edition of 1844 Ruskin contributed an extensive new preface. In this he first took up the argument against critics who had claimed that, in attending to 'modern painters', he was denigrating the standards of the canonical past. Although Ruskin is not usually identified with the avant-garde, these passages articulate key principles of subsequent avant-gardism: that the moderns can equal the level of achievement of the ancients; but that if they do, it will have to be on their own terms; and furthermore, that if they are

successful, they cannot expect to be widely liked for it. The rest of the new preface is taken up by a discussion of landscape painting, as an exemplification of the previous point. For Ruskin the shortcoming of classical landscape (such as that of Claude Lorrain) can be traced to its tendency to idealize. The modern landscape must be specific. Yet for all that, Ruskin's is not a defence of materialism or naturalism. For him, mere fidelity to detail falls short. It is as if, for Ruskin, the typical *must* be achieved, but it has to be reached not by idealization, let alone abstraction, but through an intensification of the particular. This the artist will find in concentration upon Nature as given to him by God, and not through the exercise of his own limited imagination. It goes without saying that the artist whom Ruskin had foremost in mind here was Turner. The present extracts from the preface are taken from the 1900 edition of *Modern Painters*, London: George Allen, pp. xi–l.

Three points I would ... especially insist upon as necessary to be kept in mind in all criticism of modern art. First, that there are few, very few, of even the best productions of antiquity, which are not visibly and palpably imperfect in some kind or way, and conceivably improvable by farther study; that every nation, perhaps every generation, has in all probability some peculiar gift, some particular character of mind, enabling it to do something different from, or something in some sort better than, what has been before done; and that therefore, unless art be a trick or a manufacture of which the secrets are lost, the greatest minds of existing nations, if exerted with the same industry, passion, and honest aim as those of past time, have a chance in their particular walk of doing something as great, or, taking the advantage of former example into account, even greater and better. [...]

The second point on which I would insist is, that if a mind *were* to arise of such power as to be capable of equalling or excelling some of the greater works of past ages, the productions of such a mind would, in all probability, be totally different in manner and matter from all former productions; for the more powerful the intellect, the less will its works resemble those of other men, whether predecessors or contemporaries. Instead of reasoning, therefore, as we commonly do, in matters of art, that because such and such a work does not resemble that which has hitherto been a canon, therefore it *must* be inferior and wrong in principle; let us rather admit that there is in its very dissimilarity an increased chance of its being itself a new, and perhaps a higher, canon. If any production of modern art can be shown to have the authority of nature on its side, and to be based on eternal truths, it is all so much more in its favour, so much farther proof of its power, that it is totally different from all that have been before seen.

The third point on which I would insist is, that, if such a mind were to arise, it would at once divide the world of criticism into two factions: the one, necessarily the larger and louder, composed of men incapable of judging except by precedent, ignorant of general truth, and acquainted only with such particular truths as may have been illustrated or pointed out to them by former works, which class would of course be violent in vituperation, and increase in animosity as the master departed farther from their particular and preconceived canons of right, thus wounding their vanity by impugning their judgment; the other, necessarily narrow of number, composed of men of general knowledge and unbiassed habits of thought, who would recognize in the work of the daring innovator a record and illustration of facts before unseized; who would justly and candidly estimate the value of the truths so rendered, and would increase in fervour of admiration as the master strode farther

and deeper, and more daringly into dominions before unsearched or unknown; yet diminishing in multitude as they increased in enthusiasm. For by how much their leader became more impatient in his step, more impetuous in his success, more exalted in his research, by so much must the number capable of following him become narrower; until at last, supposing him never to pause in his advance, he might be left in the very culminating moment of his consummate achievement, with but a faithful few by his side, his former disciples fallen away, his former enemies doubled in numbers and virulence, and the evidence of his supremacy only to be wrought out by the devotion of men's lives to the earnest study of the new truths he had discovered and recorded.

* * *

It is a question which, in spite of the claims of Painting to be called the sister of Poetry, appears to me to admit of considerable doubt, whether art has ever, except in its earliest and rudest stages, possessed anything like efficient moral influence on mankind.[. . .] It appears to me that a rude symbol is oftener more efficient than a refined one in touching the heart; and that as pictures rise in rank as works of art, they are regarded with less devotion and more curiosity.

But, however this may be, and whatever influence we may be disposed to admit in the great works of sacred art, no doubt can, I think, be reasonably entertained as to the utter inutility of all that has been hitherto accomplished by the painters of landscape. No moral end has been answered, no permanent good effected, by any of their works. They may have amused the intellect, or exercised the ingenuity, but they never have spoken to the heart. Landscape art has never taught us one deep or holy lesson; it has not recorded that which is fleeting, nor penetrated that which was hidden, nor interpreted that which was obscure, it has never made us feel the wonder, nor the power, nor the glory of the universe; it has not prompted to devotion, nor touched with awe; its power to move and exalt the heart has been fatally abused, and perished in the abusing. That which ought to have been a witness to the omnipotence of God, has become an exhibition of the dexterity of man; and that which should have lifted our thoughts to the throne of the Deity, has encumbered them with the inventions of His creatures.

* * *

The cause of the evil lies, I believe, deep-seated in the system of ancient landscape art; it consists, in a word, in the painter's taking upon him to modify God's works at his pleasure, casting the shadow of himself on all he sees, constituting himself arbiter where it is honour to be a disciple, and exhibiting his ingenuity by the attainment of combinations whose highest praise is that they are impossible.

* * *

[. . .] The true ideal of landscape is precisely the same as that of the human form; it is the expression of the specific – not the individual, but the specific – characters of every object, in their perfection. There is an ideal form of every herb, flower, and tree, it is that form to which every individual of the species has a tendency to arrive, freed from the influence of accident or disease. Every landscape painter should know the specific characters of every object he has to represent, rock, flower, or cloud; and in his highest ideal works all their distinctions will be perfectly expressed, broadly or delicately, slightly or completely, according to the nature of the subject, and the

degree of attention which is to be drawn to the particular object by the part it plays in the composition. Where the sublime is aimed at, such distinctions will be indicated with severe simplicity, as the muscular markings in a colossal statue; where beauty is the object, they must be expressed with the utmost refinement of which the hand is capable.

This may sound like a contradiction of principles advanced by the highest authorities; but it is only a contradiction of a particular and most mistaken application of them. Much evil has been done to art by the remarks of historical painters on landscape. Accustomed themselves to treat their backgrounds slightly and boldly, and feeling (though, as I shall presently show, only in consequence of their own deficient powers) that any approach to completeness of detail therein injures their picture by interfering with its principal subject, they naturally lose sight of the peculiar and intrinsic beauties of things which to them are injurious, unless subordinate. Hence the frequent advice given by Reynolds and others, to neglect *specific* form in landscape, and treat its materials in large masses, aiming only at general truths. [. . .]

* * *

It is not . . . detail sought for its own sake, not the calculable bricks of the Dutch house-painters, nor the numbered hairs and mapped wrinkles of Denner, which constitute great art, they are the lowest and most contemptible art; but it is detail referred to a great end, sought for the sake of the inestimable beauty which exists in the slightest and least of God's works, and treated in a manly, broad, and impressive manner. There may be as much greatness of mind, as much nobility of manner, in a master's treatment of the smallest features, as in his management of the most vast; and this greatness of manner chiefly consists in seizing the specific character of the object, together with all the great qualities of beauty which it has in common with higher orders of existence, while he utterly rejects the meaner beauties which are accidentally peculiar to the object, and yet not specifically characteristic of it. I cannot give a better instance than the painting of the flowers in Titian's picture above mentioned [*Bacchus and Ariadne*]. While every stamen of the rose is given, because this was necessary to mark the flower, and while the curves and large characters of the leaves are rendered with exquisite fidelity, there is no vestige of particular texture, of moss, bloom, moisture, or any other accident, no dewdrops, nor flies, nor trickeries of any kind; nothing beyond the simple forms and hues of the flowers, even those hues themselves being simplified and broadly rendered. The varieties of Aquilegia have, in reality, a greyish and uncertain tone of colour; and, I believe, never attain the intense purity of blue with which Titian has gifted his flower. But the master does not aim at the particular colour of individual blossoms; he seizes the type of all, and gives it with the utmost purity and simplicity of which colour is capable.

These laws being observed, it will not only be in the power, it will be the duty, – the imperative duty, – of the landscape painter, to descend to the lowest details with undiminished attention. Every herb and flower of the field has its specific, distinct, and perfect beauty; it has its peculiar habitation, expression, and function. The highest art is that which seizes this specific character, which develops and illustrates it, which assigns to it its proper position in the landscape, and which, by means of it, enhances and enforces the great impression which the picture is intended to convey. Nor is it of

herbs and flowers alone that such scientific representation is required. Every class of rock, every kind of earth, every form of cloud, must be studied with equal industry, and rendered with equal precision. And thus we find ourselves unavoidably led to a conclusion directly opposed to that constantly enunciated dogma of the parrot-critic, that the features of nature must be 'generalized'; a dogma whose inherent and broad absurdity would long ago have been detected, if it had not contained in its convenient falsehood an apology for indolence, and a disguise for incapacity. Generalized! As if it were possible to generalize things generically different. [. . .]

[. . .] There is no grandeur, no beauty of any sort or kind, nothing but destruction, disorganization, and ruin, to be obtained by the violation of natural distinctions. The elements of brutes can only mix in corruption, the elements of inorganic nature only in annihilation. We may, if we choose, put together centaur monsters; but they must still be half man, half horse; they cannot be both man and horse, nor either man or horse. And so, if landscape painters choose, they may give us rocks which shall be half granite and half slate; but they cannot give us rocks which shall be either granite or slate, nor which shall be both granite and slate. Every attempt to produce that which shall be *any* rock, ends in the production of that which is *no* rock.

It is true that the distinctions of rocks and plants and clouds are less conspicuous, and less constantly subjects of observation, than those of the animal creation; but the difficulty of observing them proves not the merit of overlooking them. It only accounts for the singular fact, that the world has never yet seen anything like a perfect school of landscape. For just as the highest historical painting is based on perfect knowledge of the workings of the human form and human mind, so must the highest landscape painting be based on perfect cognizance of the form, functions, and system of every organic or definitely structured existence which it has to represent.

* * *

Let me, at the risk of tediously repeating what is universally known, refer to the common principles of historical composition, in order that I may show their application to that of landscape. The merest tyro in art knows that every figure which is unnecessary to his picture is an encumbrance to it, and that every figure which does not sympathize with the action interrupts it. He that gathereth not with me scattereth, is, or ought to be, the ruling principle of his plan; and the power and grandeur of his result will be exactly proportioned to the unity of feeling manifested in its several parts, and to the propriety and simplicity of the relations in which they stand to each other.

All this is equally applicable to the materials of inanimate nature. Impressiveness is destroyed by a multitude of contradictory facts, and the accumulation which is not harmonious is discordant. He who endeavours to unite simplicity with magnificence, to guide from solitude to festivity, and to contrast melancholy with mirth, must end by the production of confused inanity. There is a peculiar spirit possessed by every kind of scene; and although a point of contrast may sometimes enhance and exhibit this particular feeling more intensely, it must be only a point, not an equalized opposition. Every introduction of new and different feeling weakens the force of what has already been impressed, and the mingling of all emotions must conclude in apathy, as the mingling of all colours in white.

Let us test by these simple rules one of the 'ideal' landscape compositions of Claude, that known to the Italians as Il Mulino. [...] This is, I believe, a fair example of what is commonly called an 'ideal' landscape; i.e., a group of the artist's studies from Nature, individually spoiled, selected with such opposition of character as may insure their neutralizing each other's effect, and united with sufficient unnaturalness and violence of association to insure their producing a general sensation of the impossible. Let us analyse the separate subjects a little in this ideal work of Claude's.

Perhaps there is no more impressive scene on earth than the solitary extent of the Campagna of Rome under evening light. Let the reader imagine himself for a moment withdrawn from the sounds and motion of the living world, and sent forth alone into this wild and wasted plain. The earth yields and crumbles beneath his foot, tread he never so lightly, for its substance is white, hollow, and carious, like the dusty wreck of the bones of men. The long knotted grass waves and tosses feebly in the evening wind, and the shadows of its motion shake feverishly along the banks of ruin that lift themselves to the sunlight. Hillocks of mouldering earth heave around him, as if the dead beneath were struggling in their sleep; scattered blocks of black stone, four-square, remnants of mighty edifices, not one left upon another, lie upon them to keep them down. A dull purple poisonous haze stretches level along the desert, veiling its spectral wrecks of massy ruins, on whose rents the red light rests, like a dying fire on defiled altars. The blue ridge of the Alban Mount lifts itself against a solemn space of green, clear, quiet sky. Watch-towers of dark clouds stand steadfastly along the promontories of the Apennines. From the plain to the mountains, the shattered aqueducts, pier beyond pier, melt into the darkness, like shadowy and countless troops of funeral mourners, passing from a nation's grave.

Let us, with Claude, make a few 'ideal' alterations in this landscape. First, we will reduce the multitudinous precipices of the Apennines to four sugar-loaves. Secondly, we will remove the Alban Mount, and put a large dust-heap in its stead. Next we will knock down the greater part of the aqueducts, and leave only an arch or two, that their infinity of length may no longer be painful from its monotony. For the purple mist and declining sun, we will substitute a bright blue sky, with round white clouds. Finally, we will get rid of the unpleasant ruins in the foreground; we will plant some handsome trees therein, we will send for some fiddlers, and get up a dance, and a picnic party.

It will be found, throughout the picture, that the same species of improvement is made on the materials which Claude had ready to his hand. The descending slopes of the city of Rome, towards the pyramid of Caius Cestius, supply not only lines of the most exquisite variety and beauty, but matter for contemplation and reflection in every fragment of their buildings. This passage has been idealized by Claude into a set of similar round towers, respecting which no idea can be formed but that they are uninhabitable, and to which no interest can be attached, beyond the difficulty of conjecturing what they could have been built for. The ruins of the temple are rendered unimpressive by the juxtaposition of the water-mill, and inexplicable by the introduction of the Roman soldiers. The glide of the muddy streams of the melancholy Tiber and Anio through the Campagna is impressive in itself, but altogether ceases to be so, when we disturb their stillness of motion by a weir,

adorn their neglected flow with a handsome bridge, and cover their solitary surface with punts, nets, and fishermen.

It cannot, I think, be expected, that landscapes like this should have any effect on the human heart, except to harden or to degrade it; to lead it from the love of what is simple, earnest, and pure, to what is as sophisticated and corrupt in arrangement, as erring and imperfect in detail. So long as such works are held up for imitation, landscape painting must be a manufacture, its productions must be toys, and its patrons must be children.

My purpose then, in the present work, is to demonstrate the utter falseness both of the facts and principles; the imperfection of material, and error of arrangement, on which works such as these are based; and to insist on the necessity, as well as the dignity, of an earnest, faithful, loving study of nature as she is, rejecting with abhorrence all that man has done to alter and modify her. [. . .]

If, however, I shall have frequent occasion to insist on the necessity of this heartfelt love of, and unqualified submission to, the teaching of nature, it will be no less incumbent upon me to reprobate the careless rendering of casual impression, and mechanical copyism of unimportant subject, which are too frequently visible in our modern school. Their lightness and desultoriness of intention, their meaningless multiplication of unstudied composition, and their want of definiteness and loftiness of aim, bring discredit on their whole system of study, and encourage in the critic the unhappy prejudice that the field and hill-side are less fit places of study than the gallery and the garret. Not every casual idea caught from the flight of a shower or the fall of a sunbeam, not every glowing fragment of harvest light, nor every flickering dream of copse-wood coolness is to be given to the world as it came, unconsidered, incomplete, and forgotten by the artist as soon as it has left his easel. That only should be considered a picture, in which the spirit, not the materials, observe, but the animating emotion of many such studies is concentrated, and exhibited by the aid of long-studied, painfully-chosen forms; idealized in the right sense of the word, not by audacious liberty of that faculty of degrading God's works which man calls his 'imagination,' but by perfect assertion of entire knowledge of every part and character and function of the object, and in which the details are completed to the last line compatible with the dignity and simplicity of the whole, wrought out with that noblest industry which concentrates profusion into point, and transforms accumulation into structure. Neither must this labour be bestowed on every subject which appears to afford a capability of good, but on chosen subjects in which nature has prepared to the artist's hand the purest sources of the impression he would convey. These may be humble in their order, but they must be perfect of their kind. There is a perfection of the hedgerow and cottage, as well as of the forest and the palace; and more ideality in a great artist's selection and treatment of roadside weeds and brook-worn pebbles, than in all the struggling caricature of the meaner mind, which heaps its foreground with colossal columns, and heaves impossible mountains into the encumbered sky. Finally, these chosen subjects must not be in any way repetitions of one another, but each founded on a new idea, and developing a totally distinct train of thought: so that the work of the artist's life should form a consistent series of essays, rising through the scale of creation from the humblest scenery to the most exalted; each picture being a necessary link in the chain, based on what

preceded, introducing to what is to follow, and all, in their lovely system, exhibiting and drawing closer the bonds of nature to the human heart.

8 Antonio Bianchini (1803–1884) 'On Purism in the Arts'

As Bianchini himself observes in this short 'manifesto', the term 'Purism' was originally a literary term, used to designate those writers who modelled their style on the writing of the *trecento*. By the 1830s, however, it was also used to describe those artists working in Rome who had adopted the ideals of the German Nazarenes (see IIB5, above). In both fields dispute rapidly arose about the proper relation of modern art to the arts of the past. Bianchini's manifesto is essentially a defence of purism against various criticisms and perceived misunderstandings. Its status as an expression of the views of the group as a whole is confirmed by the signatures of Friedrich Overbeck, Tommaso Minardi and Pietro Tenerani, leading representatives of the movement in Rome. Bianchini was a noted Greek and Latin scholar and a student of Overbeck and Minardi. His works decorate the 'Capella del Sacramento' in the cathedral at Orvieto. The manifesto was originally published in Bianchini's *Del purismo nelle arti* in Rome in 1843. It has been translated for this volume by Olivia Dawson and Jason Gaiger from the text as reprinted in Paola Barocchi, *Testimonianze e polemiche figurative in Italia*, Messina and Florence: Casa Editrice G. D'Anna, 1972, pp. 185–7.

It often happens that writers waste their time on frivolous questions that are destined to be forgotten almost as soon as they flare up. In our time this took place concerning the question of language and the term *romanticism*, and it seems that the same thing will take place today in the discussion amongst artists concerning *purism* and *impurism*. Such debates arise out of pride and never from an orderly love of truth. This is made clear by the way in which one person's opinion is simply confronted by the dictum of another, repeated without any analysis or definition, and – which is to say much the same thing – without knowing what the matter in question actually is. Those who genuinely love truth would not allow themselves to condemn something new before knowing what it is; to become acquainted with something one must turn to those who practise it. It is for this reason that many came to slander purism in public, making numerous false accusations against this humble sect and causing them to be held in disfavour by others who were equally imprudent and who were prepared to use all their authority against something so small.

The *purists* are popularly accused of the following sins: (1) of persistently copying nature in its most miserable form and with every possible defect; (2) of wanting to return modern painting to its infancy with Cimabue, and of wanting the arts of drawing and painting to be learned from him or someone similar; (3) of despising the artifice of shading, and all that is understood by the nouns *mass* and *chiaroscuro*; (4) of condemning not only Correggio or Michelangelo, but all of Raphael's paintings from the *Disputa* onwards; (5) of refusing to make distinctions of time and place by marking the differences in dress and architecture that others frankly term *costumes*. If there was anything else I intended to include, it has escaped my powers of recollection.

And now I shall discuss the origins and the beliefs of *purism*. I do not think that this group came exclusively from Germany. It must have been about twenty years ago that

a number of art students, scattered here and there and not yet acquainted with each other, began to think and talk about a reform, which, perhaps through their declarations and their example, or perhaps through a spontaneous movement, has now reached various parts of Italy and has spread widely in Germany and in France. I first found myself talking about them in 1833. Since there had only recently been much discussion about language, and since at that time I was less familiar with artistic than literary studies, in which the adherents of the *trecento* were called *purists*, I applied the same name to their works. This term passed on from mouth to mouth and soon became the name by which they were universally known. These artists maintained that the art of drawing had fallen from the heights of that virile excellence from which man's life and work inevitably declines, and that drawing too had deteriorated with age. Just as nature, in its every part, testifies to the wisdom of its author by demonstrating that everything has a purpose and answers to that purpose, we human beings, with our human will and understanding, have been granted a purpose in accordance with which each person, according to whether he fulfils that purpose or not, is to be praised or reprimanded. The goal of painting is to give something to the soul by means of the eyes, just as words reach the soul by means of the ears.

These artists reminded us that drawing and colour are the materials and the instruments of art, and that their object is to teach and move us. Like a farmer who, when a tree is crooked, cannot be satisfied with straightening it only half way, but bends it back all the way in the opposite direction, so they too not only took their young followers back to the time of Raphael, but pushed them still further by recommending they study Giotto and his contemporaries. What I wish to stress here is that the purists have not lost their powers of sight or intelligence to such an extent as to believe that they could learn from the Old Masters how to draw the nude, or to spread tints, or to depict different planes or any such similar effect. It is true, however, that they seek to discover in these artists the strict, simple and clear way in which they represent the things they depict and which form the subject of their paintings. Their opinion is that since man, through lack or through excess, can never achieve perfection, the least deficient approach should be chosen, which is to aspire to fulfil the end of painting by means which, though not particularly pleasing in themselves, are effective, rather than abandoning or neglecting that end for the love of techniques which are useless but pleasing to the artist who employs them. It is pointless to discuss whether or not artists such as Giotto, the Gaddi, Buonamico and Simone demonstrate their ideas clearly without caring about details, as I have said, when those who deny this are scornful of ancient painting and despise it as openly as that individual who swore against the *Promessi Sposi*[1] by saying and putting in print that he had never read it. It must now be clear to the reader that it was neither the custom of the Old Masters nor is it the intention of the purists to portray nature in every minute detail, as some who are ignorant of both the Old Masters and the purists claim. For they know that the exact imitation of figures as they are present in the flesh – and so supremely human – tempts the painter into depicting many qualities which are not suited to the subject-matter, and by encouraging viewers to linger in their admiration of the outer surface, they are hindered from penetrating with their soul the spirit of the representation. Furthermore, since the depiction of human forms does not serve the artist for base gratification of the sense of sight but as

ideal characters through which to represent the sentiments, desires, suffering and actions of each of us, the figure could not be a receptacle for the mutable fibre of man if it was shown with anger, or joy stamped on its face, for those emotions could not have the same appearance in a beggar or a servant as they do in a prince. Now, someone who wishes to be a vigorous and direct speaker must remember the true meaning and sound of words and little by little accustom his mind and attune his language so that each idea is represented in his thoughts by the appropriate sign, and by this means he will gently acquire the power of speech. Similarly, in order for young painters to faithfully portray the features of the body it is necessary for them to have them all in mind so as to distinguish the old from the young, the healthy from the infirm, the refined from the rustic, and the weak from the robust. These are things which are sometimes apparent from very small signs and require diligence to be perceived. [...]

After establishing the end of art and implying that no work of art should lack this but should always speak to the soul, and after extolling the example of the Old Masters both as good in themselves and as the opposite of the reprehensible excesses of the moderns, the purists have not placed restrictions on themselves by imitating anyone in particular or by holding one style in greater sympathy than another. They insist that what is seen should be cultivated in the imagination under the aspect preferred by each individual and should be reproduced in a manner according to each person's inclination and strengths. Someone who understands light must speak through shading, someone who is aware of colour should speak through tints, some- one who thinks most clearly in terms of form should speak through drawing, but everyone must speak and make themselves heard. For this reason some have been called purists who are not, this being something which they either do not seek or are not able to be; and yet others are regarded as purists without intentionally wanting to be. [...]

Antonio Bianchini
acceded
F. Overbeck
Tom. Minardi
Pietro Tenerani

[1] A reference to *The Betrothed*, a novel by Alessandro Manzoni (1785–1873), published in 1827.

9 Jacques Nicholas Paillot de Montabert (1771–1849) 'On the Necessity of Theoretical and Philosophical Teaching of the Arts in our Education'

Paillot de Montabert was a painter and theorist who was in America at the time of the French Revolution and joined David's studio in Paris on his return at the beginning of the nineteenth century. He is best known as the author of a *Complete Treatise on Painting*, which offers an extensive exposition of neo-classical thought on the subject. The following passage is taken from his later work *L'Artistaire*, the aim of which was to support the conviction announced on its title page that the Fine Arts – defined as Painting, Sculpture,

Architecture, Poetry, Music, Mime and Gymnastics – were 'the sacred repositories and eloquent means of revelation of the eternal principle of beauty and of all perfection'. The first two-thirds of the book is devoted to the exposition of this thesis, the remainder to a review of the educational and institutional measures required to give practical effect to the civilizing power of the arts as thus conceived. Though Paillot de Montabert was conservative in his faith in the authority of classical and religious models, he was perceptive in his understanding of the damage done to artistic education by submission to fashion and to the priorities of management. The work was completed in 1843, though publication was delayed as a result of the author's illness and death. It was first published, posthumously, as *L'Artistaire. Livre des principales initiations aux beaux-arts*, ed. P. Carpentier, Paris: Alexandre Johanneau Libraire, 1855. The following excerpt has been taken from this edition, section XXX, pp. 251–6, translated for this volume by Jonathan Murphy.

The arts will never be understood, appreciated, or awarded their proper place until they are taught publicly in our schools. Only when a theoretical and philosophical study of these arts forms an integral part of our education will progress be made.

It is a widely held belief that the arts have the ability to touch and move the soul, and can impress all types of beauty upon it. In the light of this, it is quite clear that nobody should be allowed to misuse them, or divert them from their true purpose; nor should any education be considered complete if it has not consisted partly of teaching in this area.

The magic and force of attraction exerted by the arts is well recognized; yet it seems to pass unnoticed that no one takes it upon themselves to demonstrate their true utility. Many teachers teach as though their sole purpose were one of agreeable amusement; else the arts are treated as an entirely vain pursuit, or a means of acquiring money.

If, in education, the cultivation of the pleasing arts does not tend towards the principles and elements of true beauty, these arts can only serve to teach vanity. Young students who follow the common crowd will come to believe that success in these pleasing arts is highly meritorious, and will neglect talents of a far more useful nature, which they will disdain as mere adjuncts of necessity. Praise and prizes should be the sole preserve of the student who excels most in understanding and reproducing the truly beautiful. No traps should be laid for young minds.

Imagine, if you will, a young person who receives congratulations from all sides for his excellence in the execution of any of the arts, for the brilliance of his touch on the piano, or for pictures exhibited in the Salon at the Louvre, or because her dance has been noticed at all of the most important balls in our capitals. If one asks such a person what central obligation is imposed when one produces art in public, this hapless young person will reply that their only intention is to receive the approval of people of taste; our young person, alas, is unaware that anyone who has the talent of identifying what is merely popular today is now considered to be a person of taste.

What is required is that the unitary moral and social character of the arts should be demonstrated in education. If this were the case, no one would dare to profane the arts. Those who spoke of them would respect them and those who practised them honour them.

In classical Greece, a feeling and respect for the arts instilled in the public by a thousand masterpieces was a sure guarantee against the ignorance or caprice of the administrators of the arts; but where, one might ask, are we to find such masterpieces in the France of today? For every ten or twenty years, a new generation of artists or critics sets about ridiculing their predecessors with impunity. The new generation of artists and critics are blindly accepted by the leaders of our artistic institutions, who are either totally fascinated by, or perhaps merely complicitous with, these harmful innovators. Despite the respect which must be accorded to public opinion, trust alone in the opinion of that public is far from sufficient. Public opinion, perhaps by design, until now, has had no access to a true knowledge of the arts. Such knowledge, then, is evidently of importance in our education.

Given that the arts are an eminently moral concern, their principles must be taught to all, and should constitute a fundamental aspect of the education of every man. Allowing for the fact that many of the present legislators and directors of teaching in the arts might not have had the opportunity to learn to recognize the truly moral and social character which the arts possess, can one honestly expect them to guide the arts in the direction of the general social good? And what if, on the other hand, the arts were in the hands of more cynical men, who wished merely to harness them to an idea of corrupt profit? They would be unable to do so if the nation had been taught to recognize the utility and sanctity of these arts. With an artistic component in a liberal education, men would soon become accustomed to venerating the arts.

One should not make light of the difficulties to be faced by an administrator of the arts in France today, for his mind is bound to be filled with an enormous variety of conflicting demands. Imagine the disorder to be found there: dance, at balls, solemn feasts and in theatres; the overly pretty little pictures of the annual Salon; the atrocious little statues to be found in our chapels; the barbarous music of choristers on days of high ceremony; the ornate livery for state banquets and costume dramas; prizes to be handed out in art schools; the sycophancy of high-ranking officials and the dubious flattery of newspapers: and the veritable explosion of ambition among the pupils in the art schools. In addition to this, a director's memory will be filled with the names of all the most fashionable artists. The fashions change, but his task is none the less to work within them. Each step taken in the process of judgement which he must undertake is taken with hesitation. Directors too are doubtless also handicapped by that national affliction – a pretention to infallibility in matters of taste. We can conclude from all this that even the most scrupulous director, worried and harried from all sides, will finally be led astray from the true path, and is bound to lose the crucial sense of serving society through the arts.

It is plain to see how little can be expected from these directors, protectors and so-called connoisseurs, who cannot possibly have a true understanding of the arts as no such understanding ever formed a part of their education.

What must be established at all costs is that a cultivation of the arts is not merely an agreeable occupation, but an important exercise in the productive combinations of harmony and beauty. To make manifest the principles of beauty is to understand the principles of goodness and propriety; it is also by consequence a training which makes familiar the sacred nature of virtue itself.

At a time when the men who cultivate the arts have no true understanding of them, and lack the capacity to demonstrate how the instructive marvels contained therein can pass beyond their natural boundaries, it is scarcely surprising that the men whose task it is to demonstrate and teach the arts are themselves no less sterile.

Art must, of necessity, undergo a certain process of vulgarization as it is a teaching handed down from generation to generation, but the traditions handed down should be treated with the sanctity more usually reserved for holy scripture. Can we, today, really consider our academies and private schools to be any form of sanctuary? Do their leaders teach by the eternal timeless rules, or by those which are merely to be discerned in their own work? Are our schools protected by sworn guardians, who stand firm against the tedium of routine and fashion? Unfortunately not. To give but one example from the art of painting, there exists in our studios today, to describe the practice of painting, a veritable base cant, which is treated by its few initiates as a sacred language. Such an argot will inevitably change in the course of a decade, and its very existence has the unfortunate effect of excluding the vast majority from any measure of artistic understanding.

It might be objected to all this that a truly artistic imagination confers its own special rights on any free artist. To claim, however, that any teacher or demonstrator of the arts should be allowed their complete liberty would be completely untenable, for the duty of the teacher is no less sacred than that of the artist himself, and the evil which would result from the false demonstrations of a teacher would be infinitely more pernicious than any damage done by one aberrant work produced by an artist. No law should impose restrictions on a free artist. But many laws should bind those entrusted with the teaching of the arts.

To the ancients, Art, being divinely inspired, was sacred. For we moderns, Art seems nothing more than caprice, or a mere reflection of our changing times. But let us not lose sight of what is at stake: when we lose the sense of the sacred nature of Art, we also lose all sense of its importance.

10 William Wordsworth (1770–1850) Letters on the Kendal and Windermere Railway

These letters were occasioned by a proposal to extend an existing railway into a pictur-esque part of the English Lake District, where Wordsworth lived. He had already published a sonnet on the subject, and had received considerable criticism concerning the character of the views expressed. The letters offer interesting testimony on the development of an aesthetic regard towards picturesque landscape, on the tendency to extreme forms of paternalism among the educated middle class in mid-nineteenth century England, and on the relationship between the two. (For a contemporary and contrasting attitude towards the aesthetic experience of the urban masses, see IIA6.) The letters were originally published in *The Morning Post* on 11 and 20 December 1844. Despite the further criticism their publication attracted, Wordsworth revised them for reissue in the form of a pamphlet, privately printed in January 1845. The letters were subsequently included in *The Prose Works of William Wordsworth*, ed. Grosart, London, 1876, volume II. Our extracts are taken from *The Prose Works of William Wordsworth*, ed. W. J. B. Owen and Jan Worthing-ton-Smyser, Oxford: Clarendon Press, 1974, volume 3, pp. 340–4 and 352–3.

To the Editor of *The Morning Post*

Sir – Some little time ago you did me the favour of inserting a sonnet expressive of the regret and indignation which, in common with others all over these Islands, I felt at the proposal of a railway to extend from Kendal to Low Wood, near the head of Windermere. The project was so offensive to a large majority of the proprietors through whose lands the line, after it came in view of the Lake, was to pass, that, for this reason, and the avowed one of the heavy expense without which the difficulties in the way could not be overcome, it has been partially abandoned, and the terminus is now announced to be at a spot within a mile of Bowness. But as no guarantee can be given that the project will not hereafter be revived, and an attempt made to carry the line forward through the vales of Ambleside and Grasmere, and as in one main particular the case remains essentially the same, allow me to address you upon certain points which merit more consideration than the favourers of the scheme have yet given them. The matter, though seemingly local, is really one in which all persons of taste must be interested, and, therefore, I hope to be excused if I venture to treat it at some length. [...]

The projectors have induced many to favour their schemes by declaring that one of their main objects is to place the beauties of the Lake district within easier reach of those who cannot afford to pay for ordinary conveyances. Look at the facts. Railways are completed, which, joined with others in rapid progress, will bring travellers who prefer approaching by Ullswater to within four miles of that lake. The Lancaster and Carlisle Railway will approach the town of Kendal, about eight or nine miles from eminences that command the whole vale of Windermere. The Lakes are therefore at present of very easy access for *all* persons; but if they be not made still more so, the poor it is said, will be wronged. Before this be admitted let the question be fairly looked into, and its different bearings examined. No one can assert that, if this intended mode of approach be not effected, anything will be taken away that is actually possessed. The wrong, if any, must lie in the unwarrantable obstruction of an attainable benefit. First, then, let us consider the probable amount of that benefit.

Elaborate gardens, with topiary works, were in high request, even among our remote ancestors, but the relish for choice and picturesque natural *scenery* (a poor and mean word which requires an apology, but will be generally understood), is quite of recent origin. Our earlier travellers – Ray, the naturalist, one of the first men of his age – Bishop Burnet, and others who had crossed the Alps, or lived some time in Switzerland, are silent upon the sublimity and beauty of those regions; and Burnet even uses these words, speaking of the Grisons – 'When they have made up estates elsewhere they are glad to leave Italy and the best parts of Germany, and to come and live among those mountains of which the very sight is enough to fill a man with horror.' The accomplished Evelyn, giving an account of his journey from Italy through the Alps, dilates upon the terrible, the melancholy, and the uncomfortable; but, till he comes to the fruitful country in the neighbourhood of Geneva, not a syllable of delight or praise. In the Sacra Telluris Theoria of the other Burnet there is a passage – omitted, however, in his own English translation of the work – in which he gives utterance to his sensations, when, from a particular spot he beheld a tract of the Alps rising before him on the one hand, and on the other the Mediterranean Sea

spread beneath him. Nothing can be worthier of the magnificent appearances he describes than his language. In a noble strain also does the Poet Gray address, in a Latin Ode, the *Religio loci* at the Grande Chartruise. But before his time, with the exception of the passage from Thomas Burnet just alluded to, there is not, I believe, a single English traveller whose published writings would disprove the assertion, that, where precipitous rocks and mountains are mentioned at all, they are spoken of as objects of dislike and fear, and not of admiration. Even Gray himself, describing, in his Journal, the steeps at the entrance of Borrowdale, expresses his terror in the language of Dante: – 'Let us not speak of them, but look and pass on.' In my youth, I lived some time in the vale of Keswick, under the roof of a shrewd and sensible woman, who more than once exclaimed in my hearing, 'Bless me! folk are always talking about prospects: when I was young there was never sic a thing neamed.'

[...] But what has all this to do with the subject? – Why, to show that a vivid perception of romantic scenery is neither inherent in mankind, nor a necessary consequence of even a comprehensive education. It is benignly ordained that green fields, clear blue skies, running streams of pure water, rich groves and woods, orchards, and all the ordinary varieties of rural nature, should find an easy way to the affections of all men, and more or less so from early childhood till the senses are impaired by old age and the sources of mere earthly enjoyment have in a great measure failed. But a taste beyond this, however desirable it may be that every one should possess it, is not to be implanted at once; it must be gradually developed both in nations and individuals. Rocks and mountains, torrents and wide-spread waters, and all those features of nature which go to the composition of such scenes as this part of England is distinguished for, cannot, in their finer relations to the human mind, be comprehended, or even very imperfectly conceived, without processes of culture or opportunities of observation in some degree habitual. In the eye of thousands and tens of thousands, a rich meadow, with fat cattle grazing upon it, or the sight of what they would call a heavy crop of corn, is worth all that the Alps and Pyrenees in their utmost grandeur and beauty could show to them; and, notwithstanding the grateful influence, as we have observed, of ordinary nature and the productions of the fields, it is noticeable what trifling conventional prepossessions will, in common minds, not only preclude pleasure from the sight of natural beauty, but will even turn it into an object of disgust. 'If I had to do with this garden,' said a respectable person, one of my neighbours, 'I would sweep away all the black and dirty stuff from that wall.' The wall was backed by a bank of earth, and was exquisitely decorated with ivy, flowers, moss, and ferns, such as grow of themselves in like places; but the mere notion of fitness associated with a trim garden-wall prevented, in this instance, all sense of the spontaneous bounty and delicate care of nature. In the midst of a small pleasure-ground, immediately below my house, rises a detached rock, equally remarkable for the beauty of its form, the ancient oaks that grow out of it, and the flowers and shrubs which adorn it. 'What a nice place would this be,' said a Manchester tradesman, pointing to the rock, 'if that ugly lump were but out of the way.' Men as little advanced in the pleasure which such objects give to others are so far from being rare, that they may be said fairly to represent a large majority of mankind. This is a fact, and none but the deceiver and the willingly deceived can be offended by its being stated. But as a more susceptible taste is undoubtedly a great acquisition, and has been

spreading among us for some years, the question is, what means are most likely to be beneficial in extending its operation? Surely that good is not to be obtained by transferring at once uneducated persons in large bodies to particular spots, where the combinations of natural objects are such as would afford the greatest pleasure to those who have been in the habit of observing and studying the peculiar character of such scenes, and how they differ one from another. Instead of tempting artisans and labourers, and the humbler classes of shopkeepers, to ramble to a distance, let us rather look with lively sympathy upon persons in that condition, when, upon a holiday, or on the Sunday, after having attended divine worship, they make little excursions with their wives and children among neighbouring fields, whither the whole of each family might stroll, or be conveyed at much less cost than would be required to take a single individual of the number to the shores of Windermere by the cheapest conveyance. It is in some such way as this only, that persons who must labour daily with their hands for bread in large towns, or are subject to confinement through the week, can be trained to a profitable intercourse with nature where she is the most distinguished by the majesty and sublimity of her forms.

* * *

To the Editor of *The Morning Post*

Wm. Wordsworth
Rydal Mount, Dec. 9, 1844

Sir – As you obligingly found space in your journal for observations of mine upon the intended Kendal and Windermere Railway, I venture to send you some further remarks upon the same subject. The scope of the main argument, it will be recollected, was to prove that the perception of what has acquired the name of picturesque and romantic scenery is so far from being intuitive, that it can be produced only by a slow and gradual process of culture; and to show, as a consequence, that the humbler ranks of society are not, and cannot be, in a state to gain material benefit from a more speedy access than they now have to this beautiful region. Some of our opponents dissent from this latter proposition, though the most judicious of them readily admit the former; but then, overlooking not only positive assertions, but reasons carefully given, they say, 'As you allow that a more comprehensive taste is desirable, you ought to side with us;' and they illustrate their position, by reference to the British Museum and National Picture Gallery. 'There,' they add, 'thanks to the easy entrance now granted, numbers are seen, indicating by their dress and appearance their humble condition, who, when admitted for the first time, stare vacantly around them, so that one is inclined to ask what brought them hither? But an impression is made, something gained which may induce them to repeat the visit until light breaks in upon them, and they take an intelligent interest in what they behold.' Persons who talk thus forget that, to produce such an improvement, frequent access at small cost of time and labour is indispensable. Manchester lies, perhaps, within eight hours' railway distance of London; but surely no one would advise that Manchester operatives should contract a habit of running to and fro between that town and London, for the sake of forming an intimacy with the British Museum and National Gallery? No, no; little

would all but a very few gain from the opportunities which, consistently with common sense, could be afforded them for such expeditions. Nor would it fare better with them in respect of trips to the lake district; an assertion, the truth of which no one can doubt, who has learned by experience how many men of the same or higher rank, living from their birth in this very region, are indifferent to those objects around them in which a cultivated taste takes so much pleasure. I should not have detained the reader so long upon this point, had I not heard (glad tidings for the directors and traffickers in shares!) that among the affluent and benevolent manufacturers of Yorkshire and Lancashire are some who already entertain the thought of sending, at their own expense, large bodies of their workmen, by railway, to the banks of Windermere. Surely those gentlemen will think a little more before they put such a scheme into practice. The rich man cannot benefit the poor, nor the superior the inferior, by anything that degrades him. Packing off men after this fashion, for holiday entertainment, is, in fact, treating them like children. They go at the will of their master, and must return at the same, or they will be dealt with as transgressors.

* * *

It will be felt by those who think with me upon this occasion that I have been writing on behalf of a social condition which no one who is competent to judge of it would be willing to subvert, and that I have been endeavouring to support moral sentiments and intellectual pleasures of a high order against an enmity which seems growing more and more formidable every day; I mean 'Utilitarianism,' serving as a mask for cupidity and gambling speculations. My business with this evil lies in its reckless mode of action by Railways, now its favourite instruments. Upon good authority I have been told that there was lately an intention of driving one of these pests, as they are likely too often to prove, through a part of the magnificent ruins of Furness Abbey – an outrage which was prevented by some one pointing out how easily a deviation might be made; and the hint produced its due effect upon the engineer.

Sacred as that relic of the devotion of our ancestors deserves to be kept, there are temples of Nature, temples built by the Almighty, which have a still higher claim to be left unviolated. Almost every reach of the winding vales in this district might once have presented itself to a man of imagination and feeling under that aspect, or, as the Vale of Grasmere appeared to the Poet Gray more than seventy years ago. 'No flaring gentleman's-house' says he, 'nor garden-walls break in upon the repose of this little unsuspected *paradise*, but all is peace,' &c., &c. Were the Poet now living, how would he have lamented the probable intrusion of a railway with its scarifications, its intersections, its noisy machinery, its smoke, and swarms of pleasure-hunters, most of them thinking that they do not fly fast enough through the country which they have come to see. [. . .]

Wm. Wordsworth
Rydal Mount, Dec. 17, 1844

11 Théophile Thoré (1807–1869) Open Letter to Théodore Rousseau

Thoré prefaced his review of the 1844 Salon with this open letter to an artist friend. Rousseau was one of a group of painters working in France during the mid-nineteenth

century, who were associated with the village of Barbizon in the Fontainebleau forest. Their typical works were scenes of landscape and peasant agriculture, with marked naturalistic lighting effects and robust forms of facture. Thoré used the pretext of the open letter to develop a persistent and influential theme of his criticism: that pursuit of the material concerns of bourgeois society is incompatible with the appreciation of nature or of art, and that the typical bourgeois, in consequence, does not properly *see*. This is the other side of the coin of that association of republicanism with the innocence of unspoiled nature that is found in such American writers as Catlin and Cole (IB9 and 10). The reference to the prison of St Pélagie is a reminder that Thoré was incarcerated in 1840 for the purportedly anarchist views expressed in a political pamphlet. His concluding mild admonishment to Rousseau calls to mind those of the painter's small and atmospheric landscapes that presuppose a state of solitude and stillness in their imagined spectator. The open letter was originally published as a preface to Thoré's Salon review in *L'Artiste*, Paris, 1844; it was reprinted in Thoré, *Le Salon de 1844 précédé d'une lettre à Théodore Rousseau*, Paris: Alliance des Arts, 1844, pp. vii–xxxvi, and subsequently in *Salons de T. Thoré*, Paris: Librairie International, 1868, pp. 1–12, from which source the translation for this volume has been made by Jonathan Murphy. (For further information on Thoré see the introduction to IIA12, and for his later writing see IIIB8 and IIIC9.)

While we sit here in Paris, straining to catch a glimpse of some poor corner of the sky through an angular window, you are out in the fresh air contemplating the wide open horizons of the Midi. Where are you now, you and Dupré? In the Landes? Or in the Pyrenees? And what are the pair of you doing? You are looking, of course, with that steady unblinking gaze of yours, staring with those eyes as wide as the Arc de Triomphe. All passes through them, the mountains, the torrents, even the great oaks of Fontainebleau without bending their tips. Doubtless even as I speak the Pyrenees are passing before your eyes, and fixing themselves in your great imagination. One day you will come across them again in that great storehouse which is your memory, and you will see them more clearly from afar than you do close up. Lamennais said to me once in Sainte-Pélagie: 'It is quite curious – I never really saw Italy till I was thrown into prison. I was in Rome once, years ago, trying to track down some now forgotten Pope, and I noticed nothing, as I was entirely caught up in my own thoughts: but today, images awake in me and I see pictures that must have slipped surreptitiously into my mind.'

You, dear poet, have spent your life looking at the great outdoors, at the fair weather and the rain, and at a thousand things imperceptible to the common eye. Nature for you has mystic beauties which escape us, and secret favours that you lovingly reproduce. When one has a feeling and a love for the spectacle of nature one is fortunate to be a painter like yourself. Otherwise the joys of contemplation are also a cause of tremendous suffering, as one is incapable of expressing one's enthusiasm. We, the profane, have but a sterile love, painful like some great romantic passion, impossible to satisfy, but the love you feel is of a different order. Painting, after all, is a true dialogue with the outside world, a productive, material communication. You truly master nature, and from this loving exchange a new being is born – the child of nature and art.

Most men simply do not know how to see. Their eyes are stopped up with material concerns. When, on occasion, an opportunity to make use of their sight arises, they

reflect in a totally unenlightened manner. What do they imagine? Having no image to reflect upon, their imagination remains as dull as a stagnant pond in the mist. Rather than engaging in an edifying process of contemplation, they become waylaid by some idea that has no bearing on the scene before their eyes.

I took a trip once with a bourgeois, who was determined to show me his home country. As the evening began to draw in, after a tiring journey through twisting country roads, we finally came across a little river, in a small hollow between two sharp rock faces. The sun began to go down before us and bathed the tips of the rocks in a fiery glow. One whole bank of the little torrent was in shadow, but had the most extraordinary tonal values which were reflected in the rushing water below, forming two images joined at the foot, the one shimmering, head down, drowning in the gulf of the brook, like Shakespeare's pale Ophelia, the other dark and immobile like an immense statue in bronze. It was like a phantasmagoria from Hoffman's darkest dreams. The other bank, meanwhile, illuminated brightly by the shafts of sunlight, was clear, pink and sparkling, as though studded with a thousand jewels. What a sight! And what a contrast... What an admirable subject!

My companion, meanwhile, was staring with curiosity into the river, and cried out several times, 'How clear the water is, how clear!' Without averting my gaze I pushed him roughly. 'Open your eyes,' I said, 'look at the landscape and the light. The light won't last. You can stare at the water some other time.'

Have I ever told you about my first visit to the sea? A whole group of us had set out on foot from a village that was no more than a league from the coast. We had deliberately chosen our route so as to arrive at the sea behind the highest dunes, so that I might be struck all at once by the great spectacle of the sea. I had run on ahead, and when I arrived at the highest point an extraordinary view awaited me. The sea and the sky were joined in a unique, shimmering, silvery plane, in an effect that I have never seen since, and they glowed with an almost supernatural brilliance. I genuinely wondered where the sea began; I seemed to have been transported beyond land and sea to an altogether more luminous sphere, and I was seized with an enthusiasm so expansive that I was forced to catch my breath. Unable to take flight, in an attempt to lose all merely physical sensation I fell my length upon the ground, where I would have liked to glorify nature with the force of some grand tempest. Instead I was overcome, and began to sob softly, silently, so that I could still hear the great harmonious voice of the immensity.

There I lay on the side of the dune, my eyes bathed in light, when my companions reappeared. The first, seeing me slumped and immobile, rushed up and asked me whether I had fallen prey to some sudden illness.

The feeling of art, the vision of beauty, the love of nature, and the enthusiasm for life itself are today quite rare qualities. In the sixteenth century, by contrast, such feelings were almost universal. But today bourgeois society concerns itself with the exploitation of dead things in the name of industry, forgetting that industry itself is never more than one face of a coin, whose meaning and significance are inevitably written on the other side. It is like a Roman medal: one side portrays a living head, but the other lends it significance with some material emblem, such as an architectural facade, or an allegorical figure in need of interpretation.

Industry, of course, can be as human as art. It is linked to the arts by still unexplained affinities, but until now the two worlds have been kept apart. Our civilization has broken up the unity of man and turned him against himself. Politics has always been a divisive affair: it would be better served by championing the ideals of men such as Pierre Leroux instead, where 'the perfect man takes his place in the perfect society'.

The material race which we are in the process of creating, for whom access to the world of the spirit is foreclosed, and who are all strangers to the true sense of life, is of course not without its uses, but can such things be justified in any wider scheme? Beauty and a certain utility need not be enemies. One can angle for the commonest fish in the river while still admiring the light on the limpid water and the glistening rocks by the shore. In a world where the slavery of the lower classes had been abolished, the rich could still wear new clothes and eat at sumptuous tables. For the most part, Man could well do without this preposterous headlong rush after all that is useful. Like bread and steel, poetry too has its uses. I myself would rather live in some quiet corner of the country, half thinker, half peasant, in a working man's coarse shirt, wearing stout clogs, eating home-made bread with potatoes from my own garden, and drinking some simple local wine, than live in the turbulent rush of the metropolis, surrounded by luxury and any amount of material pleasures. I remember well a confidence of Lamennais', during one dark hour in prison: 'I was born to be a gardener,' he said, 'a thirst for beauty, truth and the common good is worth more than a thirst for gold, as the only true riches are to be found in moderation, in human brotherhood, in well-executed work and in the joys of the heart and the spirit.'

I have never been of the opinion that social problems are impossible to resolve. If one looks at the natural condition of man as Jean-Jacques Rousseau did, one sees a measure of truth in the melancholy opening of *Emile*: 'All is well when it leaves the hands of the Creator; discord comes from the hand of Man alone'. But the City of God is to be found at the heart of nature: in equality we will find the Republic of the Future.

* * *

One thing, however, must be guarded against. A love of nature, of poetry and of art should not lead to an isolation of man from man and from society. On the contrary, such sentiments should form the link between all men and all things, as these sentiments are the same as those of universal religion. Here, my dear Rousseau, I will allow myself one slight criticism. You have always practised an ingenuous detachment from all things not directly connected to your art. You have lived as a stranger to all the passions that move us, and are a stranger to the legitimate interests of community life. You have lived as a hermit of the Thebaid, with an almost impious intensity. The Thebaid, of course, was a cerebral paradise, vibrant with life and colour, but would it not be true to say that your secret worries and travails, your habitual suffering, perhaps even that occasional impotence to be found in the expressive side of your art, would it not be fair to say that all these things are a consequence of your voluntary sequestration, of your wilful denial of a certain number of your faculties? In mixing a little more with men and women, your talent would doubtless have gained in acuity and appeal, while losing none of its originality. And moreover, if men like yourself were to live in community, how much would they bring to their

fellows! It may be that you have understood and practised only half of your duty – the perfection and the elevation of man's common nature. For we all have another duty too: the duty to contribute directly to the perfecting of our fellow creatures by a holy communion of sentiments and thoughts. I half imagine your reply: you tell me that I speak of politics and not of art.

But politics is the sister of the poetry which you love so well, and when politics are insincere, poetry itself suffers and cannot fulfil its natural role.

IIc
Systems and Techniques

1 David Pierre Giottin Humbert de Superville (1770–1849) from *Essay on Absolute Signs in Art*

Humbert de Superville was born in the Low Countries before the wars which separated Belgium from Holland, but was one of that generation of intellectuals whose positive response to the French Revolution gave them for a while the identity of citizens of Europe. His *Essai sur les signes inconditionnels dans l'art* was written while he was Director of the Cabinet of Casts and Prints at the University of Leiden. It was published in three books in Leiden by C.C. van der Hoek between 1827 and 1832, though it remained incomplete. It was copiously illustrated with the author's diagrams and drawings. Among those subject to its fascination were the colour-theorists Field and Chevreul (IIc4 and 5), the pedagogue Charles Blanc (IVB5) and the painter Georges Seurat (VIB9). This remarkable work has so far remained untranslated into English, no doubt on account of the idiosyncracy and allusiveness of its style, and it is difficult to represent faithfully in excerpt. De Superville's aim was to uncover the original principles of all forms of human visual expression – or signs – and by this means to account for the responses they evoked. The encyclopedic nature of his interests was typical of the intellectual legacy of the Enlightenment, while the opportunity for practical exploration of other cultures came as a consequence of Napoleonic expansionism. His interest in the aetiology of expression appears distinctly modern, however. The basic assumption of his enterprise was that there are common aspects to the responses evoked by signs, and that the emotional effects of formal properties and characteristics – the pleasing nature of a symmetrical face in repose, of an early Italian altarpiece or of an Egyptian temple – must be traceable to primal causes in biology and in human evolution. Thus, when he argues for the necessity of separating the arts of painting, sculpture and architecture, as he does in the second passage given below, this is not to preserve their modern specialization, but rather because he believes that their origins are distinct and that in consequence *their meanings and functions must be*. The following excerpts are taken from the original edition, Book I, pp. 8–10, 'Solution', which is concerned with the expressive character of colour, and Book III, pp. 73–6, 'Appel', which is concerned with the Arts of Design. They have been translated for this volume by Jonathan Murphy. The 'problem' referred to in the first passage is: how do colours signify as such, which is to say – in de Superville's terms – how is their 'absolute' nature to be established?

ON COLOUR, AND ON THE ARTS OF DESIGN

Resolution of the problem

The whole question would be reduced to its most basic elements, if it were possible to consider colours in an *abstract* fashion, in the fashion that until now, we have been considering simple lines, while excluding ideas of chance variation or concrete quality. We concluded there that, providing these lines or contours were visible, and discernible to the naked eye against any background, the imagination and the faculty of comprehension would do the rest. But the question remains as to whether it will be possible to treat colour in the same fashion. Will we be able to separate and isolate colours from the area they cover? Indeed, will we be able to separate them from each other? Will a red circle or a blue triangle, if only for one instant, cease to be a circle or a triangle and offer us, in a purely abstract fashion, the *coloured signs* of a moral, intellectual or aesthetic language? When we say *colour*, it would seem apparent that we imply either *area*, *surface* or *figure* too, and this would seem to suggest, if indeed it is the case, a near impossibility as regards the task of discerning within one object two distinct properties; the impossibility, in short, of dividing the indivisible. That which we judge to be *complex* on account of an apparently double impression on our sight organs may in fact be one single unit. Without pausing to tease out the different strands of this argument which I direct against myself, which may be either plausible or specious, I will simply note here, for the purposes of this study, that given the infinite number of objects which continually present themselves to our sight (and which, despite appearances, we do not immediately perceive as both form and colour), it might well be that colours divided in a chaotic fashion into so many diverse substances appear to us, after all, to appertain exclusively to none of those substances in particular, and in this fashion, detached as they would be from their object, and transformed, so to speak, into *concepts* or *abstract perceptions*, they might sometime serve as *signs* now *absolute* (outside of any particular limits), now *supplementary* or *identical*, where no other sign could possibly be as eloquent, and the colours themselves could not be indifferently replaced by any other. This much we might conclude from an examination of our sentiments, and our occasional desire for a *more analogous relation* between form and colour in a certain object, or more simply from our acknowledgement that such an association is already present; and we might assume that this feeling is dictated to us by the *absolute nature of colour*.

Since time immemorial, white scarves and banners have blown in the breeze and have been given as gifts, and even today they are exchanged as signs of peace and goodwill among Hindus and among the majority of the inhabitants of the South Seas. The literature of other peoples, both ancient and modern, also records such practices. When Plato writes that 'Temples dedicated to the Gods, and the vestments of enlightened and pacific men should be of this colour', and when we see that even a religion such as Sabaism makes use of the same colour to symbolize innocence and sanctity, can we not conclude, in the face of such remarkably analogous ideas and illusions, that they have one single source in our minds? Are these impressions not the same as those caused by daylight itself, by the silvery, peaceful light of the moon, and by the purity of the snow? In the same fashion darkness and the sombre depths of the

earth must necessarily have instilled in man the idea that all dark or black colours necessarily imply silence and solitude, sadness, death and oblivion. And if black and white, the one light itself, the other its absence, naturally provoke these differing interpretations, it will surely follow that a third no-less striking colour can be added to them. As the instinctive hieroglyph of life and movement, of heat and flashes of light, the colour red must be the excess of luminous rays, just as the colour black is its absorption and annihilation. If we move on to the next step in the argument, it becomes apparent that neither light nor darkness, nor flames, nor blood are ever conceived of in any distinct predetermined form, and it is in fact by colour alone that these phenomena are distinguished and cause such a powerful impression on us. Does it not follow from this then that in accordance with the impression that they make on us, our faculty of sentiment should assimilate these *coloured signs* to the *revealing linear signs* of that impression *on the human face?* In fact we regard both colour and line as the identical signs of one invariable language, and the associations of the one automatically imply the associations of the other. Examine the following diagram:

red white black

The colour white, an invariable, pure sign, like the horizontal line, occupies the middle place between two extremes. By fine gradations, these two extremes approach the centre in the form of intermediary colours, equivalent in turn to the degrees of obliqueness of the line to the vertical plane. The essence of the colour yellow is to be found in its equidistance between white and the red; a greater or lesser degree of proximity to either one of these two colours will necessarily produce either pale yellow or orange, while azure blue, the intermediary between white and black, will naturally be found between two further nuances, pearl and indigo.

So much then for colours; we shall return to the theme below. But before abandoning them completely, I would beg the reader's indulgence in allowing me to appeal to the one indisputable authority in order to gauge the validity of the solution so far. I turn of course to women, as their greater sensitivity will tell us all. Let us

consider women, if we may, at whatever stage of life, at those moments when decisions are to be made regarding a choice of clothes or even the furnishing of a house. Her dress, or even the decoration of her apartments, will reveal to us the *secrets of colour*, often betraying without her knowledge the secrets of her opinions, her heart and her love. Whether out in society, or cloistered in a retreat, a woman such as Saint Teresa or Madame de Lavallière has more to teach us about the *moral value of colours* – by a simple violet picked by her own hand, or by a tear shed on a lily ripped from its stalk – than our reasoning ever will. Only the instinctive, sensitive voice of a woman can make correct decisions in this area: she alone should be the oracle that we consult.

BOOK THREE

An appeal!

... the *signs* of Architecture, Statuary and Painting are never anything other than *a progressive modification through thought and feeling of basic signs, resulting in the creation of these three arts*. The following definition then necessarily follows, and is, moreover, the only rigorously exact definition following the sense of our principles. As such, it will be seen to be the best introduction to this third and last part of the book: *a theoretical and practical summary and application of all preceding observations*. The three arts are then as follows:

Architecture, in its origins, is filled with the desire to rival nature. It constantly echoes her solemn imposing effects. This pretension is well founded, as it has indeed the power to succeed providing that desire is sufficiently powerful. Its two models are organic and inorganic nature; that is to say, the rocks and the forests. Its materials are those of nature herself.

Statuary, at its origins, was nothing other than a representation of the dead. Its purpose was not merely imitation, or representation as an idle object of art, but to eternalize or propagate the memory of the departed. Statuary then is exclusively commemorative and monumental. Its types are that of animate forms, like man or the lion: its materials the hard stone of one single block.

Painting, in its origins, was nothing more than a symbolic or ideographic form of writing. In both cases, it takes its signs from nature, not as objects to be imitated, but as figurative and visible signs of intellectual endeavour. Painting then should exclusively aim to be the visible expression of thought: which is tantamount to saying that for we Christians it should be the expression of religious thought. Its types and means are shape and colour, interpreted through the spirit.

In order to conserve the original purity of all three arts, they must be prevented, at all costs, from intruding upon each other in any fashion, as any form of mutual contamination inevitably leads to their decay. If Architecture becomes overloaded with sculptures to a degree exceeding that acceptable in what is known as *building sculpture*, it begins to intrude on the domain of Statuary, in whose hands alone the chisel should rightly remain. When Statuary, in turn, strives to animate and soften marble, to imitate flesh, or the texture and lightness of hair and drapery, it in turn

begins to intrude on the means by which Painting, by far more advantageous means, offers us these things: qualities which it in turn must guard jealously. When Painting *simulates* stones, metal, buildings, statues and low relief statuary, it intrudes on both Architecture and Statuary, which present us with these objects in their real form. It is for this reason that Painting must use shape and colour to represent *schematic thought* by visible means, and it borrows these from the phenomena of the natural world alone. . . . one cannot insist too much on the importance of this demarcation, in particular on that distinction between Statuary and Painting, which in appearance, when their expressive potential is at its fullest, have their roots in the *same two types*. These *types* however do not have the same force of law for both arts. While Statuary is only absolutely Statuary when it transforms a shapeless block of marble or granite into some animal form (whether man or lion), the same cannot be said to be exactly true of Painting, when we talk of Painting in its most exclusive sense, which is that of *schematic form*. *Schematic form* will remain as such regardless of the *object* or *sign* it chooses to represent. It may be most fitting for the human face, where what is required is a less material, more eloquent representation of an idea. It follows from this, that as the essence of Statuary is to be found in the *materiality of forms*, and the essence of Painting in the *schematization of signs*, that the first of these arts is necessarily completely removed from all religious ideas, and the second is merely *coloured mud* without them. The last corollary that follows from this is that the monuments of Statuary should be impregnated with a sense of time, and should last as long as it is possible for anything to last down here on this earth, defying the flight of the centuries, while the productions of Painting, by contrast, should be nothing more than the *actual and instantaneous expression of the fleeting nature of the object or sign* which it takes as its base, in order to stimulate the production of an intellectual image which is then absent. Time consecrates the Colossus, but any picture which betrays the slightest intention to portray an *existence*, or a *material reality* existing before or after the impression that it makes on us, is nothing other than, and indeed can be nothing other than, merely *coloured mud!*

If we impartially review all that remains from previous ages, and all that we inherit in the form of the art and monuments of different peoples and different times, several conclusions can be drawn. Greece, for example, never had Statuary in its pure form, nor veritable Painting neither; despite the beautiful ideal of *Ordre Poestum* (if such an idea is indeed fitting for Greek art) neither can its Architecture be said to bear any comparison with that of Egypt, which alone exulted the arts of Architecture and Statuary to a supreme degree. Egypt itself, in turn, as a result of the astonishing materiality of its system, was even further than Greece from an ideal of Painting. Painting itself, in order to free itself from matter, and shine with its own natural beauty, was forced to wait long for any inspiration analogous to its essence. Painting was only born in its true form in Italy, under the auspices of the Christian religion, in the thirteenth and fourteenth centuries. All the sadder then, that its apostasy and despoliation was taking place at exactly the moment when religious Architecture, its beautiful partner, its elder sister and companion, was reaching its fullest stage of development . . . But let us not anticipate here on one last consequence to be deducted from our principle. All our observations have tended towards one implication, one

undeniable conclusion. We shall try to develop this idea, draw out its implications in a series of *tableaux* or pictures, demanding, so to speak, that Architecture, Statuary and Painting should together give birth to some work that concords completely both with their essence and with the genuinely important interests of man and society. With this end in mind, the fact that we shall force them to adopt or reject the pre-existing types is an inevitable consequence of the strict and rigorous observation of our theory: by this I mean it is the irrevocable edict of our emotional faculty. We do well to remember here the words of the great Pascal: '*The advances made by those who precede us should be the means, and not the end, of our studies.*' One last essential observation remains to be made.

Although we cannot insist too much on the fact that any production in one or other of the arts should present itself to us as an absolute production, existing through and for itself, it should not be concluded from this that there is never any possibility of association between the three arts. *Association* and *assimilation* are not synonymous. It is one thing to confound in the same production the signs and means of two arts, but it is another thing altogether to have them concord with each other with one single purpose, and one single emotional goal, ensuring that each maintains its individual value all the while in its particular domain. Such (if I may use a comparison here) is the union of the two sexes: the result of this conjunction is by no means a monstrous being, uniting the two sexes in one single *teras*. But such monstrous unions do exist by contrast in the arts: observe for example a building overloaded with sculpture, or worse still a building groaning beneath the weight of sculptures painted in colours not found in the materials when they are in their natural state. Such are the metopes and tympani of the Parthenon, and such are those vast paintings where the artists of ancient Egypt created nothing of consequence, but presented the viewer with the brilliant but no less reprehensible fascination of hermaphrodite productions. These are all examples of assimilation and confusion, not of association. Let us make no mistake. It is only ever the case that two of the three arts which concern us here can be associated together, and it will always be the case that one of these two arts should be Architecture. Architecture alone can associate with Statuary or Painting, for according to the type of construction in question, other elements can be admitted into its general scheme: either one or several statues, or one or several frescoes or pictures (but never the one and the other conjointly), and even then the one or the other on the exterior of the building. Let us not, in the manner of ancient Egypt, place statues at the entrance to a building, unless we espouse wholeheartedly its associative system. Even then, we may still believe that the portico of Hermopolis, in the absence of its Colossus, and that the Colossus of Thebes, distant from any construction, are more eloquent than the marvel of Ibsamboul itself, which, while bringing together two means of expression, necessarily enfeebles both the one and the other. Once seen as a giant's palace, the edifice ceases to be immense. When seen as the inhabitant or guardian of a pyramid, the Colossus himself becomes a statue of normal proportions. The more we see that two arts have worked together, the less these gateways, labyrinths and sphinxes will seem to address man alone, and have man alone for their sole rule and measure. More vigorously still do we condemn and reject any painting on the exterior of a building. Such a practice is a flagrant violation of the rules of good taste, and can still be found on some of the more ancient churches of Tuscany.

Nothing in the rules of Architecture can excuse such a fault; and often enough has it been said that a picture never produces the slightest effect when displayed in the open air! We are forced to conclude that only the interior of a building can admit such an *association of signs*. Before we penetrate its interior, an edifice should have told us all that it has to say, and all that it ought to tell us. The *absolute task* of Architecture is thereby completed, and completed by Architecture alone. When such a condition has been fulfilled, whatever the exterior of the building has communicated to us may be repeated by the interior, and more information may be added by the associated art, which is called upon to complete and to illuminate more fully the eloquence of the first . . .

2 Camille Corot (1796–1875) Reflections on Painting

There are considerable records of Corot's various opinions on art. Many of these are derived from the second-hand accounts of friends and acquaintances, however, and are thus both difficult to date and of occasionally doubtful authenticity. The following practical reflections were transcribed from Corot's notebooks by E. Moreau-Nélaton and were published in his *Histoire de Corot et de ses oeuvres*, Paris: H. Floury, 1905, pp. 206 and 209. They date from soon after the painter's first visit to Italy in 1825, and from the period when his characteristic style was established. Corot had absorbed the principles of classical land-scape painting, but combined these with a discipline of empirical observation that was particularly attentive to the effects of natural light. The typical results are formally elegant but apparently modest paintings that combine evocations of a golden age with highly specific and technically modern atmospheric effects. The painter's own account of his working process testifies to the care with which he established the tonal structure and relations of his compositions, though the finished works of this period retain a sense of considerable spontaneity and lightness of touch. The text from Moreau-Nélaton has been translated for this volume by Jonathan Murphy. (For a later entry from Corot's notebooks see IVA1.)

The most important things to study are shape and tonal values. These two things for me are the only serious starting points for any study of art. Colour and execution add charm to the work.

When one starts to prepare a study or a picture it has always seemed vital to me to begin by indicating the darkest values (assuming that the canvas is white) and to proceed in order towards the lightest value. I myself use a system noting twenty tones between the darkest and lightest values. In this way your study or picture will be set out in a logical order. Such an order should hinder neither the draughtsman nor the colourist. Always look for blocks, for the ensemble, and never lose sight of the first impression. Drawing is the first thing to work on, then the tonal values. Look for the relation between shape and value. These are the essential starting points. Then colour, and execution last of all. If you want to do a study or a picture, first try out the shape in your head. When you have tried it out in all sorts of ways, then move on to the values. Look for them in blocks. Be conscientious. A good method to follow, if your canvas is white, is to start with the darkest tone. Proceed from there to the lightest. It is most illogical to start with the sky.

3 Benjamin Robert Haydon (1786–1846) on Anatomy as the Basis of Drawing

Haydon trained as an artist at the Royal Academy schools and had ambitions to be a history painter in the grand manner. However, his history paintings have generally been thought dull and much of his best work was achieved in contemporary genre scenes and portraiture. In later years he became estranged from the Academy and fell into debt. The conviction that his career had been a failure led Haydon to suicide at the age of sixty. Earlier, however, he had been a prominent figure. His was a leading voice in the defence of the Elgin marbles, valuing their naturalism over the then dominant conventions of neo-classicism. In 1816 he contributed the essay 'Painting' to the *Encyclopaedia Britannica*. The present text is drawn from a lecture first delivered in 1835, and subsequently published as the first of his *Lectures on Painting and Design*. In the lecture Haydon seeks to base drawing in observation and the study of anatomy. This will provide 'unalterable and eternal principles' on which to base the practice of art; principles which Haydon continued to believe were best exemplified in the Parthenon sculptures. The present extract is from B. R. Haydon, *Lectures on Painting and Design*, London: Longman, 1844, pp. 13–18.

[. . .] The first great step in the reform of design, as applied to art and manufacture, is to be assured that the human figure is the basis of all drawing, and then to settle on such principles as cannot be shaken, a lasting and imperishable standard of the form of the most gifted being on earth, viz. man, and to ascertain what are his physical superiorities as a species, and what are his mental, as expressed by his physical figure; so that the principle may be comprehended and adopted as a leading basis for the use of all those who devote themselves to sculpture and painting, either as tutors or students. Secrets should be banished from art, as they have long been from science; be assured, if all men were always to tell all they know, if rule and principle were daily increased, still there would be something unknown and untouched, to be discovered by genius, while nature continued to shine with her accustomed splendour; and, as Reynolds says, I venture to intrude the following principles of my own practice with diffidence, and when better are suggested, shall withdraw them without regret.

Many years ago, whilst dissecting a lion, in my early youth, I was amazingly impressed with its similarity as well as its difference in muscular and bone construction to the human figure.

It was evident the lion was but a modification of the human being, varied in organic construction and muscular arrangement, only where it was necessary he should be, that his bodily powers might suit his instincts, his propensities, his appetites, and his lower degree of reasoning power.

On comparing the two, I found the human being stood erectly on two feet, the lion horizontally on four. On placing the lion on his two hind feet, resting on the heel and toes like the human being, I found he could not remain so; I found he had no power of grasping with his fore-paws (answering to the human hand, and but a modification); I found he could not move his fore-paw arms right from the shoulder, nor his hind-feet limbs right from the hip; I found his feet flat, his body long, his brain diminished, his

eyes *above* the centre of his head, his jaw immense, and vast muscle occupying that portion of the scull, to assist the action of the jaw, which is filled by brain in a human creature; I found his spine long, his pan-bone narrow, his inner ancle lower than the outer, his chest contracted, and his fore-arm as long as his upper-arm.

I put down these distinctions as points characteristic in head and figure of a brutal and unintellectual being.

I then examined the man: I found his power of grasping with his hand, by the action of his thumb, perfect; I found the motion of his arm free from the shoulder-joint, and his thighs free from the hip; I found his feet arched, his inner ancle the highest, his pan-bone large, which, by resistance to the action of the great extensor of the legs, increases their power, his eyes at the centre of his skull, his upper-arm longer than the fore-arm, his spine short, and his brain enormous.

I put down these distinctions as characteristic in face and figure of a superior and intellectual being.

These differences are facts – they were intentional, or accidental! – they were formed by the Creator, or they were not! – if they were as they were, there was reason in the differences, and that reason issued from the Creator's mind. Surely, then, it was justifiable to lay down a principle of form from ascertaining these distinctions. Full of delight, reference was at once made to the Metopes of the Temple of Theseus (which, being executed fifty years before the Parthenon, were more likely to develop system than the latter works from the Parthenon itself, where art is so exquisitely concealed); and all the points put down as characteristic of a perfect human figure, were so evident, as not to be mistaken; and both in the works of the Parthenon, executed by Phidias and his school, and in those of the Temple of Theseus, the principles of a standard figure were so distinct, that I will defy any artist to have developed them so systematically and so decidedly without intention and without knowledge.

Encouraged by such delightful confirmation, I came to the following conclusions: they have been my own guide for nearly thirty years, and I can recommend them as a sound and practical code for building a standard human being, which can be varied to suit the different characters and infinite differences of nature, according to the artist's particular want.

All objects, animate and inanimate, but principally men and brute animals, are the instruments of a painter and sculptor, as influenced by passion or intention, acting on feature or form, excited by some interesting object or some powerful event.

Man, being the principal vehicle of conveying ideas by his features and form; the *first* thing to ascertain is the immediate causes of his motion as a being directed by his will; the next, the great characteristic distinction of him as man, and as a species and an intellectual being, distinguished from animals; and the last, which of these causes of motion are excited by any particular passion or intention.

We cannot ascertain, and never shall be able to do so, how an intention acts by the will on the muscular arrangement of the frame, any more than we can ascertain what vitality is, – we only know it by its consequences; and the duty of the great artist is to represent the consequences of an idea acting on the form and feature, on the parts which it does influence, and on the parts it does not, so truly, as to excite associations in the mind of the spectator of the very idea which has agitated the being represented.

The bones are the foundation of the form, and the muscles and the tendons the means by which he moves them, as his passions or intentions excite him.

Each particular passion will excite a given number of these means, and none more or less than are requisite; the rest will remain unexcited.

The bones, the things moved, and the muscles, the things moving, are all covered by skin; and the mechanism of the art is to express the passion or intention, and its consequences, by the muscles that are and those that are not influenced, and to shew the true effect of *both* acting *beneath* and shewing *above* the skin which covers them.

When the mind is thoroughly informed of the means *beneath* the skin, the eye instantly comprehends the *hint* above it; and when any passion is wanted to be expressed, the means and their consequences (if the artist be deeply qualified) will be as complete in form, and as true in effect, as nature, and the idea represented will be doubly effectual by the perfection of the means of representation.

If the character be a god, his feature and form must be built on these unalterable and eternal principles, for how can we represent a god but by elevating our own qualifications?

These are the principles then of a great Greek standard of figure, ascertained most carefully by comparing a brutal form with an intellectual form, and confirmed by a careful reference to the greatest Greek works existing – of the finest and the only perfect period of art in the world – by the greatest and only perfect artist the world ever saw – Phidias!

First – Select what is peculiarly human, in form, feature, and proportion.

Secondly – Ascertain the great causes of motion.

Thirdly – Remember the opposite contours of a limb can never be the same from inherent formation, nor of a body if the least inclined from the perpendicular.

And Fourthly – That the form of a part varies with its action or its repose, and that all action depends on the predominance of some of the causes of motion over the others.

The peculiar characteristics of a form which belongs exclusively to an intellectual being, and the causes of its motion, being ascertained, and none more or less being selected, for a given action; as external shape depends on internal organization, acting on external covering, the forms must be essential.

This is the standard of man's figure as a species, and the principle by which to estimate the period of all the works of antiquity; for, as the great works vary from neglect of this principle, they were executed either before it was ascertained, or have degenerated to some other system, less founded in nature, afterwards.

It is this union of nature with ideal beauty, the probabilities and accidents of bone, flesh, and tendon, from extension, flexion, gravitation, compression, action, or repose, that rank the Elgin marbles above all other works of art in the world.[...]

4 George Field (1777?–1854) 'On the Relations and Harmony of Colours' and 'On the Physical Causes of Colours'

George Field's work, like de Superville's, occupies a territory between empirical science, speculative aesthetics and artistic instruction. Like de Superville he believed there were

fundamental harmonic principles which governed natural forms and processes and also determined the success of forms of art. His first substantial publication, *Chromatics* of 1817, was 'an Essay on the Harmony and Analogy of Colours' with reference to both music and art. His most influential publications, however, were those specifically directed to the field of colour and optics. His *Chromatography: or a treatise on Colours and Pigments and of their Powers in Painting* was first published in London in 1835, thus predating the better-known work of Chevreul (IIc5). The book remained in use as a practical and theoretical manual for painters until the end of the nineteenth century, further editions following in 1841, 1869, 1873 and 1885. Its appeal may have been due in part to the fact that his analyses of the principles of contrast and harmony were not simply the fruits of scientific observation, but were also, like those of Chevreul, informed by study of the effects achieved by skilled painters in their use of pigments. Field himself refers to the problem of ambiguity in classification and nomenclature where colours and their effects are concerned. It may be noted in this connection that the combination of what he refers to as 'tints' and 'shades' constitutes the full range of what Corot conceived of as 'values'. Our excerpts are taken from the 'new, improved edition' of *Chromatography*, London: Tilt and Bogue, 1841, chapter III, pp. 49–52 and 54–5 and chapter IV, pp. 80–3.

On the Relations and Harmony of Colours

[...] [The] principle of contrast applies even to *individual colours*, and conduces greatly to good colouring, when it is carried into the variety of hue and tint in the same colour, not only as respects their light and shade, but also in regard to warmth and coolness, and likewise to colour and neutrality. Hence the judicious landscape-painter knows how to avail himself of warmth and coolness in the juxtaposition of his greens, as well as of their lightness and darkness, or their brilliancy or brokenness, in producing the most beautiful and varied effects; which spring in other cases from a like management of blue, white, and other colours. These powers of a colour upon itself are highly important to the painter, and conduce to that gratification from fine colouring, by which a good eye is so mysteriously affected.

In landscape we find Nature employing broken colours in enharmonic consonance and variety, and, equally true to picturesque relations, she employs also broken forms and figures in conjoint harmony with colours; occasionally throwing into the composition a regular form, or a primary colour, for the sake of animation and contrast. It is otherwise however, yet no less true to the wider laws of harmony, in another class of her beauties, as in flowers and animate nature, to which she deals not unsparingly the primary colours, alone, and in combination with regular and beautiful forms and figures; which in like manner she associates still more simply in crystals, gems, and conchal productions – true and unconfounded in all things to the laws of general harmony and order, in which man fails only when he neglects the imitation of nature. The smoothness and making out, the delicate finish and tracery, that are so essential in the latter objects, are totally out of place in landscape, and yield to broader, and, in a comprehensive sense, more refined practice and principles of harmony and accordance in forms and colours.

If we inspect the works of Nature closely, we shall find that they have no uniform tints, whether it be in the animal, vegetal, or mineral creation; – be it flesh or foliage, the earth or the sky, a flower or a stone, – however uniform its colour may appear at a

distance, it will, when examined nearly, or even microscopically, be found constituted of a variety of hues and shades, compounded with harmony and intelligence.

Upon the more intimate union, or the blending and gradience of contrasts from one to another mutually, depend some of the most fascinating effects of colouring; and the practical principle upon which these are effected is too important to be passed over. This principle consists in the blending and gradating by *mixture*, while we avoid the *compounding* of contrasting colours; i.e. the colours must be kept distinct in the act of blending them, or otherwise they will run into dusky neutrality and defile each other, as is the case in blending and gradating from green to red, or from hue to hue – from blue to orange, or to and from coldness and warmth – from yellow to purple, or to and from advancing and retiring colours: it is the same in light and shade, or white and black, which *mix* with clearness, and *compound* with hue. Now, there are only two ways in which this distinctness in union of contrasts can be effected in practice: the one of which is by hatching, or breaking them together, in mixture, without compounding them uniformly; and the other is by glazing, in which the colours unite and penetrate mutually, without monotonous composition.

Transparency and *opacity* constitute another contrast of colouring, the first of which belongs to shade and blackness, the latter to light and whiteness; – even contrast has its contrast, for *gradations, or intermedia*, are antagonists to *contrasts, or extremes;* and, upon the right management of contrasts and gradation depends the harmony and melody, the breaks and cadences, the tone, effect, and general expression of a picture; so that painting is an affair of judicious contrasting so far as it regards colour, if even it be not such altogether.

These contrasts may also be variously or totally conjoined; thus, in contrasting any colour, if we wish it to have light or *brilliancy*, we degrade, or cast its opposite into shade; – if we would have it *warm*, we cool its antagonist; and if *transparent*, we oppose it by an opaque contrary, and *vice versa*, &c.: indeed, in practice, all these must be in some measure combined.

Such are some of the powers of contrast in colouring alone, and such the diversity of art upon which skill in colouring depends. It must not be forgotten, however, that contrasts or extremes, whether of light and shade, or of colours, become violent and offensive when they are not reconciled by the interposition of their media, or a mean which partakes of both extremes of a contrast: thus blue and orange in contrast become reconciled, softened in effect, and harmonized when a broken colour composed of the two is interposed; the same of other colours, shades, and contrasts.

* * *

By mixing his *colours with white*, the artist obtains what he has appropriately called his *tints*; by mixing *colours with colours*, he obtains compound colours, or *hues*; finally, by mixing *colours or tints with black*, he gets what are properly called *shades*; yet these distinctions are very commonly confounded.

The foregoing classification of colours is an arrangement which exhibits a correct genealogy of their hues and shades in a general view, and enables us to comprehend the simplicity of relation which subsists among an infinity of hues, shades, and tints of colour, while it is calculated to give precision to language respecting colours, the nomenclature of which has ever been exceedingly arbitrary, mutable, and irrelative. The names of colours, consisting of terms imposed without general reference or

analogy, according to views and fashions ever varying, are for the most part idiomatical and ambiguous in all languages; yet, boundless as is the variety of hues and compounds, the cultivated eye will readily distinguish the degrees of relation in every possible instance to the preceding denominations of classes. [. . .]

On the Physical Causes of Colours, &c.

[. . .] Colour, and what in painting is called transparency, belong principally we perceive to shade; and the judgment of great authorities, by which they have been attached to light as its properties merely, has led to error in an art to which colour is pre-eminently appropriate; – hence the painter has considered colour in his practice as belonging to light only, and hence many have employed a uniform shade tint, regarding shadows only as darkness, blackness, or the mere absence of light, when in truth shadows are infinitely varied by colour, and always so by the colours of the lights which produce them. We must, however, avoid conducting to a vicious extreme, while we incline attention toward the relation of colour to shade, both light and shade being in strictness coessential to colour; but, as transparent, colour inclines to shade, and as opaque it partakes of light, yet the general tendency of colour is to transparency and shade, all colour being a departure from light. It hence becomes a maxim, which he who aspires to good colouring must never lose sight of, *that the colour of shadow is always transparent, and that of extreme light objects only opaque*. It follows that *white* is to be kept as much as possible out of shadow, and *black*, for the same reason, out of colour, employing opaque tints in each case, instead of black or white, whenever it is necessary to cover, and glazing them with transparent colours. Such practice would also be more favourable to durability of the tones of pictures than the shades and tints produced with black and white. The hues and shadows of Nature are in no ordinary case either black or white, which are always poor, frigid, and fearful in colouring, except as local colours. [. . .]

It is to be noted also, that the colour of shadow is always complementary to that of its light, modified by the local colours upon which it falls; and this accords equally with correct observation and the foregoing principles, although these are at variance with the ordinary practice of artists.

Of the mechanical, dynamical, and optical relations of light and shade, so far as regards painting and colours, we need only briefly remark, that the motion or action of light is either *direct, reflected,* or *inflected;* – that the DIRECT LIGHTS of the sun and moon are always in straight lines nearly parallel to each other; – that artificial lights diverge from themselves as centres in radii, and all light partakes of the colour of the medium through which it passes; – that of REFLECTED LIGHT, the angles of reflection are always equal to the angles of incidence, and partake of the colours of the reflected surfaces; – and, respecting REFRACTED LIGHTS, that in passing through transparent media, or by opaque objects, light, whether direct or reflected, is always inflected with a development also of much or little colour; and that the shadows of light in each case is always the chromatic equivalent of such light. [. . .]

In passing an opaque object, light is always bent or inflected toward, or into, its shadow, and the shadow bends into the light; consequently, there is a penumbra

surrounding every shade, forming a softening medium between it and the light, and aiding reflection in enlightening every shade; every light has hence its shade, and every shadow its light. It is in the management of these properties of light that the skill of the artist is no less requisite and conspicuous than in the management of colours, with which they are intimately connected. [. . .]

5 Eugène Chevreul (1786–1889) 'On Colouring in Painting' and 'Of the Complex Associations of Colours, viewed critically'

Chevreul's book *De la loi des contrastes simultane des couleurs* was first published in Paris in 1839 and rapidly achieved a widespread influence. The author was director of the dye works of the Gobelins tapestry factory and based his theoretical observations on considerable practical experience in a variety of media. Besides the problems of matching coloured threads, the topics covered in his study included considerations of colour in painting, paper-hanging, architecture, clothing and horticulture. He paid particular attention to the study of chromatic effects in art. His exposition of the ways in which colours react upon each other through laws of 'simultaneous contrast' was to confirm the efficacy of procedures developed in practice by Delacroix and others, and was to provide theoretical justification for the principle of 'optical mixture' adopted by the Impressionist painters. The text of the following extracts is taken from the translation by John Spanton, *The Laws of Contrast of Colour: and their Application to the Arts*, London and New York: Routledge, Warnes and Routledge, 1859, part II, section III, chapters I and II, pp. 82–102 (paras 301–42) and part II sixth division, pp. 214–17 (paras 618–21). The original publication was illustrated with colour plates, and we have eliminated those few passages which depend on reference to these.

ON COLOURING IN PAINTING

CHAPTER I

On Colouring

301. *True or absolute colouring* is the faithful reproduction in painting of the modifications that light enables us to perceive in the objects taken for models.

302. In the ordinary use of the word *colouring*, we allude to the more or less perfect manner in which the painter has complied with the rules,

1 Of aerial perspective.
2 Of the harmony of local colours, and of the colours of the different objects composing the picture.

ARTICLE I

Of Aerial Perspective

303. We must not believe that the employment of many colours in a composition is indispensable to give the epithet of *colourist* to the artist, for in painting in *camaïeu*

[pictures painted in one colour only] the simplest of all, in which we only distinguish two colours including white, the artist may be honoured with the title of *colourist*, if his work presents lights and shades distributed as they are upon the model. To convince ourselves of the justice of the expression, it will suffice to remark that the model might very well appear to the painter coloured with a single colour, modified by light and shade. In the same sense this epithet may be applied to the engraver, who, by means of his burin, reproduces a picture as faithfully as possible, in respect both to the aerial perspective of its different planes, and to the relief of each particular object.

304. A painter who has faithfully reproduced the aerial perspective, with all its modifications of white and coloured light and of shades, has effected a *true or absolute colouring*, which, however, may not be universally deemed as perfect as that in which this quality of absolute colouring is not found, at least in the same degree of perfection.

Imperfectly faithful imitation

305. *A painter may have perfectly seized upon all the modifications of white and coloured light, but in his imitation modifications or a part of them are more strongly marked than in nature.*

It almost always happens that *true but exaggerated colouring* is more agreeable than absolute colouring; and that many persons who experience pleasure in sceing the modifications of exaggerated coloured light which a picture may exhibit, do not feel the same pleasure from the sight of a model, because the modifications corresponding to those which are imitated in excess are not sufficiently prominent to be evident to them. Besides, the relish of the eye for an excess of an exciting cause, is essentially analogous to the inclination we have for food and drink of a flavour and odour more or less pungent.

306. A painter may have perfectly seized all the modifications of light which bring forward the planes and the relief of objects; the modifications of the coloured light of his picture may be true, but the colours may not be those of his model. As in pictures in which there is a dominant colour, not found in the model, which is often called *the tone of such a picture, and the tone of such a painter*, if he uses it habitually.

307. We may form a very just idea of these pictures, by supposing the artist to have painted them while looking at his model through a glass of precisely the colour, to enable him to see the tint which predominates in his imitation. We may mention, as an example of this kind of imitation, a landscape painted from its reflection in a black mirror, the effect of which is very soft and harmonious. Thus we speak of brilliant or warm, cold or dull colouring.

Of Colouring in respect to the Harmony of the Colours of the various objects composing the Picture

308. The colouring of the picture may be *true or absolute*, and yet the effect may not be agreeable, because the colours of the objects are not harmonious. On the contrary, a

picture may please by the harmony of local colours of each object, and by that of the colours of objects contiguous to each other, and yet may offend in its gradation of lights and shades, and by the *fidelity* of its colours. In a word, it offends by *true or absolute* colouring, while a picture in flat tints, the colours of which are perfectly assorted for the eye, although not those which belong to the objects imitated, produces, with regard to general harmony of colours, an extremely agreeable effect.

309. The general conclusion resulting from the analysis just made of the word colouring, is, that the epithet *colourist* may be applied to painters endowed, in very different degrees, with the faculty of imitating coloured objects by means of painting.

310. They who know the difficulties of *chiaro-'scuro* and drawing, may give the name of colourists to painters remarkable for the skill with which they bring out objects placed upon the different planes of their pictures, by means of correct drawing and a skilful gradation of light and shade, even when their pictures do not exactly produce every modification of coloured light, and have not this harmony of different colours properly distributed, to complete the effects of perfect colouring.

311. They who are not accustomed to judge of painting, or who are ignorant of the art of *chiaro-'scuro*, are generally inclined to refuse the title of colourist to such painters, while they unhesitatingly accord it to others who reproduce the modifications of coloured light, and who tastefully distribute the different colours of their pictures. Besides, colour so powerfully influences the eyes, that frequently those who are strangers to painting can only conceive a colourist to be skilful whose tints are vivid, although his works may evince a want of observation.

312. We see by this how the judgment of many persons will differ according to the importance which they respectively attach to one quality of colouring rather than to another.

313. For a painter to be a perfect colourist, he must not only imitate the model by reproducing the image faithfully, with respect to the variously coloured light, but also with regard to harmony of tints in the local colours, and in the colours of the different objects imitated. And although there are colours inherent to the model, which the painter cannot change without being unfaithful to nature, yet, in every composition, there are also colours at his disposal which must be chosen so as to harmonize with the first. We shall return to this subject in the next chapter.

314. It is thus evident, that when a change in the colours of a picture has been effected by time, it is impossible to decide whether the artist who painted it should be called a *perfect* colourist (310). But if we refer to what I have said of the painter who has correctly seized all the modifications of light adapted to bring out the distances and relief of objects, who has truly represented the modifications of coloured light, but which are not those of the model (312), we may very easily conceive how, at the present day, after the lapse of one, two, or three centuries, we may apply the name of *colourist* to Albano, Titian, Rubens, and others. In fact, the pictures of these great masters now present to us gradations, more or less perfect, of light and shade, and such harmonies of colours, that it is impossible to mistake or not to admire them; and the idea that so many pictures, not more than twenty or five-and-twenty years old, painted by artists of undoubted ability, have failed in colour more than the preceding, also increases our admiration of the latter.

CHAPTER II

Utility of the Law of Simultaneous Contrast of Colours in the Art of Colouring

315. As to the advantages the painter will find in it when it is required, –

1 To perceive and to imitate promptly and surely the modifications of the light on the model.
2 To harmonize those colours of a composition which are essentially inherent to the nature of the objects to be produced.

316. We learn by the law of *simultaneous contrast of colours*, that when we regard attentively two coloured objects at the same time, neither of them appears of the colour peculiar to it; that is to say, such as it would appear if viewed separately, but of a tint resulting from the peculiar colour and the complementary of the colour of the other object. On the other hand, if the colours of the objects be not of the same tone, the lightest tone will be lowered, and the darkest tone will be heightened.

317. The first conclusion from this is, that the painter will rapidly appreciate in his model the colour peculiar to each part, and the modifications of tone and of colour which they receive from contiguous colours. He will also perceive and be prepared to imitate modifications in them, which, if they had not always escaped him because of their feeble intensity, might have been disregarded, because the eye is peculiarly susceptible of fatigue when it seeks to disentangle modifications, the cause of which is unknown, and which are not very prominent.

318. Let us now return to *mixed contrast*, in order to make it evident that the painter is liable to see the colours of his model inaccurately. As the eye, after observing one colour for a certain time, has acquired a tendency to see its complementary, and as this tendency is of some duration, it follows, that not only the eyes of the painter thus affected cannot see correctly the colour which he had for some time looked at, but also whatever colour he sees while this modification lasts. So that, conformably to what we know of mixed contrast, he will see, – not the colour which is before him, – but the result of this colour, and of the complementary of that seen previously. It must be remarked, that besides the want of clearness of view which will arise, in most cases, from the want of exact coincidence of the second image with the first – for example, when the eye has seen a sheet of green paper A, in the first place, and, in the second place, a sheet of blue paper, B, of the same dimensions, but placed differently, this second image, not being coincident in all its surface with the first, A, as represented in the figure, the eye will see the sheet B violet only in the part where the two images coincide. Consequently, this defect of perfect coincidence of images will affect the outline of the second image, as well as the colour which it really possesses.

319. We can establish three conditions in the appearance of the same object relatively to the state of the eye; in the first, the organ simply perceives the image of the object without taking into account the distribution of colours, light, and shade; in the second, the spectator, seeking to understand this distribution, observes it attentively, when the object presents to him all the phenomena of simultaneous contrast of tone and colour that it is capable of exciting in him. In the third case,

the organ, from the prolonged impression of the colours, possesses in the highest degree a tendency to see the complementary of these colours; these different states of the organ being continuous.

I have no doubt that the dull colouring with which many artists of merit have been reproached is partly due to this cause, as I shall show more minutely hereafter.

Utility of this Law in order to imitate promptly and surely the Modification of Light on the Model

320. The painter, knowing that the impression of one colour beside another is the result of the mixture of the first with the complementary of the second, has only to estimate mentally the intensity of the influence of this complementary, to reproduce faithfully in his imitation the complex effect which he has before his eyes.

321. 1. A painter wishing to imitate a white stuff with two contiguous borders, one red, the other blue, perceives each of them changed by the influence of their reciprocal contrast; thus the red becomes more and more orange, in proportion as it approaches the blue, while the latter becomes more and more green as it approaches the red. The painter, therefore, making the borders of a single red and a single blue, reduced in some parts by white or by shade, will reproduce the effects he wishes to imitate. Whenever it is found that the painting is not sufficiently marked, he is sure of what he must add without departing from the truth, farther than exaggerating a little.

2. A grey pattern drawn upon a yellow ground – the ground may be of paper, silk, cotton, or wool; according to its contrast, the design will appear of a lilac or a violet colour.

The painter who would imitate this object, can reproduce it faithfully with grey. But if a painter, ignorant of the reciprocal influence of blue and red, convinced that he must represent what he sees, adds green to his blue, and orange to his red; as in the second example, he will trace a pattern more or less violet upon the yellow ground. Now – supposing that the painter had perfectly seized the modifications of the model, and, subsequently, had retouched his copy sufficiently to produce a perfectly faithful effect, it is evident it would have been perfect only after a number of trials, since he must have effaced what was first done.

3. I cite a third example of the influence of contrast not relating to colours, like the two preceding, but to the different tones of the same colour, contiguous to each other.

Suppose several bands in juxtaposition, 1, 2, 3, 4, of different tones in flat tints of the same scale, to form part of an object: to imitate it perfectly, it is evident that it must be painted in flat tints; but this object will appear to the eye a channelled surface, the lines where the two bands touch will appear like a relief by the effect of contrast of tone; therefore, if the painter is ignorant of this, he will reproduce, not an absolute copy of the model, but an exaggerated one. [. . .] *To imitate the model faithfully, we must copy it differently from what we see it.*

322. From the above we educe the six following principles: –

1. Put a colour upon a canvas, it not only colours that part of the canvas to which the pencil has been applied, but it also colours the surrounding space with the complementary of that colour.

Thus, a red circle is surrounded with a green areola, becoming weaker as it extends from the circle: –

A green circle is surrounded with a red areola.
An orange „ „ blue „
A blue „ „ orange „
A yellow „ „ violet „
A violet „ „ yellow „

2. White placed beside a colour heightens its tone; it is as if we took away from the colour the white light which enfeebled its intensity.

3. Black placed beside a colour weakens, and in some cases impoverishes, its tone, as upon certain yellows. It is, in fact, adding to black the complementary of the contiguous colour.

4. Put grey beside a colour, the latter is rendered more brilliant, and at the same time it tints this grey with its complementary.

323. From this principle it results that in many cases where grey is near to a pure colour in the model, the painter, if he wishes to imitate this grey which appears to him tinted with the complementary of the pure colour, need not use a coloured grey, as the effect will be produced in the imitation by the juxtaposition of the colour with the grey contiguous to it.

Besides, the importance of this principle cannot be doubted, when we consider that all the modifications which a monochronous object presents (excepting those which result from the reflections of coloured lights emanating from neighbouring objects), arise from the different relations of position between the parts of the object and the eye of the spectator; so that it is strictly true to say that, to reproduce by painting all these modifications, it suffices to have a colour exactly identical to that of the model, with black and white. In fact, with white we can reproduce all the modifications due to the weakening of the colour by light, and with black, those which are due to the height of its tone. If the colour of the model in certain parts gives rise to the manifestation of its complementary, because these parts do not return to the eye enough colour and white light to neutralize this manifestation, the modification may be imitated by the employment of a normal-grey tone, properly surrounded with the colour of the object.

It is necessary, in many cases, to employ with the colour of the object the colours which are near it; that is to say, the hues of the colour. For example; in imitating a rose, we can employ red shaded with a little yellow, and a little blue, or, in other terms, shaded with orange and violet; but the green shadows which we perceive in certain parts arise from the juxtaposition of red and normal grey.

5. To put a dark colour near a different, but lighter colour, is to heighten the tone of the first, and to lower that of the second, independently of the modification resulting from the mixture of the complementaries. An important consequence of this principle is, that the first effect may neutralize the second, or even oppose it. For example; a light blue placed beside a yellow tinges it orange, and consequently heightens its tone; while there are some blues, so dark relatively to the yellow, that they weaken it so much as not only to hide the orange tint, but even to cause sensitive eyes to feel that

the yellow is rather green than orange. A very natural result, if we consider that the paler the yellow, the greener it appears.

6. Put beside each other two flat tints of different tones of the same colour, chiaro-'scuro is produced, because, in setting out from the line of juxtaposition, the tint of the band of the highest tone is insensibly enfeebled, while, setting out from the same line, the tint of the band of the lowest tone becomes heightened; thus there is a true gradation of light.

The same gradation takes place in all the juxtapositions of colours distinctly separated.

I believe that attention to these principles, and especially a perfect knowledge of the consequences of the last three, exercises a very happy influence upon the art of painting, giving to the artist such a knowledge of colours as he cannot possess before the law of their simultaneous contrast and its consequences have been developed.

Among the details which the painter endeavours to render, there are many which, due to contrast, either of colour or of tone, must be produced spontaneously. I presume that the Greek painters, whose palette was composed only of black, white, red, yellow, and blue, and who executed so many pictures which their contemporaries have spoken of with intense admiration, painted conformably to the simple method of which I speak; *devoting themselves to great effects, many small ones resulted from them.*

Utility of the Law in order to Harmonize those Colours of a Composition which are Inherent to the Nature of the Object represented.

324. In all, or nearly all, the compositions of painting, we must distinguish the colours which the painter is under the necessity of using, and those which he may choose, because, unlike the former, they are not inherent in the model. For example, in painting a human figure, the colour of the flesh, the eyes, and the hair, are fixed by the model; but the painter has a choice of draperies, ornaments, background, &c. In an historical picture, the flesh colours are, in the majority of the figures, at the choice of the painter, as are also the draperies and all the accessories, which can be placed and imagined according to his judgment.

In a landscape, the colours are determined by the subject, yet not so arbitrarily but that we can substitute for the true colour that of a neighbouring scale; the artist may choose the colour of the sky, imagine numerous accidental effects, introduce into his composition animals, draped-figures, carriages, &c., of which the form and colour may be so selected as to produce the best possible effect with the actual objects of the scene.

325. A painter may also choose a dominant colour which produces, on every object in his composition, the same effect as if they were illuminated by a light of the same colour, or as if they were seen through a coloured glass.

326. Although the law of contrast affords different methods of imparting value to a colour, genius alone can indicate the mode in which this idea should be realized in a painting.

327. Whenever the artist would attract the eye by colours, doubtless the principle of *harmony of contrast* must be his guide. The law of *simultaneous contrast* indicates the means of giving value to the pure colours by each other; means which, although spoken of, are but little known, as may be commonly seen in portraits of vivid colours,

badly assorted; and in those numerous small compositions in tints broken with grey, where we look in vain for a pure tone; which, however, from the objects represented in them, are eminently adapted to receive all vivid colours.

328. The contrast of the most opposite colours is as agreeable as possible, when they are of the same tone. But if crudity or too great intensity of colours is feared, we must have recourse to the light tones of their respective scales.

329. When the painter breaks tones with grey, and wishes to avoid monotony, or when on the planes which are more remote, yet not so remote as to render their differences of colour inappreciable, he wishes every part to be as distinct as possible, he must have recourse to the principle of *harmony of contrast*, and mix his colours with grey.

330. This method of bringing out a colour by contrast, in using either light tones complementary or more or less opposed, or broken tones more or less grey, and of tints complementary to each other; or, in employing a broken tone, of a tint complementary to a more or less pure contiguous colour, ought especially to fix the attention of portrait painters. A portrait will have a very poor effect when neither the colour of the dress nor of the background have been well chosen.

331. The portrait-painter must endeavour to find the predominating colour in the complexion he has to paint; and this found and faithfully reproduced, he has to seek whatever accessories at his disposal will give value to it. It is a very common error to suppose that the complexion in women, to be beautiful, must consist only of red and white: if this opinion be true for most of the women of our temperate climate, it is certain that in warmer regions there are brown, bronzed, or even copper complexions endued with a brilliancy, I may say beauty, appreciated only by those who, in pronouncing upon a new object, lay aside habitual expressions, which (albeit unconsciously to most men), exercise so powerful an influence upon their judgment of objects seen for the first time.

332. In order to make the best use of colours without being under the necessity of multiplying them, as, for example, in draperies of a single colour, recourse may be had to the coloured rays emanating from neighbouring bodies, whether visible to the spectator or out of sight. For example, a green or yellow light falling upon part of a blue drapery renders it green, and by contrast heightens the blue-violet tone of the rest; a golden yellow light falling on part of a purple drapery imparts to it a golden tint, which makes the purple of the rest come out, &c.

333. The principle of harmony of contrast then procures for the painter in chiaro-'scuro the means of realizing, with respect to brilliancy of colours and distinction of parts, such effects as are produced in paintings of flat tints.

334. Having treated of the utility of the law of simultaneous contrast in the intelligent use of pure opposite colours, and of colours broken by grey similarly opposed when it is required to multiply pure and varied colours, it now remains for me to treat of those cases in which the painter, desiring less diversity in the object, less variety in the colours, employs sparingly the *harmony of contrast*, preferring the *harmony of scale* and the *harmony of hues*.

335. The greater the variety of colours and accessories in a composition, the more the eyes of the spectator are distracted, and the more difficulty is experienced in fixing attention. If then, this condition of diversity of colours and accessories is obligatory on

the artist, the more obstacles there are to surmount in drawing and fixing the attention of the spectator upon the physiognomy of the figures, whether they represent the actors in a single scene, or whether they are simply portraits. In the latter case, if the model has such an ordinary physiognomy, as recommends itself neither by its expression nor its beauty, and still more, if he must conceal or dissemble a natural defect, all that is accessory to this physiognomy, all the resources of contrasted colours, well assorted, should come to his aid.

336. But if, fervently inspired, he appreciates the purity of expression, the nobility and loftiness of character pertaining to his model; or even if a physiognomy, to most eyes common-place, strikes him by such an expression as he judges to belong only to men animated by noble ideas, it is to such a model that he will address himself and fix his chief attention; so that in giving it life upon his canvas, no one can mistake either the resemblance, or the sentiment which directed his pencil. Everything being accessory to the physiognomy, the draperies will be of black or of sombre colours; and if ornaments relieve them, they will be simple, and always in keeping with the subject.

337. When, in this point of view, we examine the masterpieces of Vandyke, and trace the beauty of their effect to the simplicity of the means which produce it, – when we consider the elegance of their attitudes, which always appear natural, the taste which presided over the selection of all the accessories, we are struck with admiration of the genius of the artist, who has not had recourse to those means, so much abused at the present day, of attracting attention, either by giving to the most vulgar person an heroic attitude, to the most common-place physiognomy pretension to profound thought, or by seeking extraordinary effects of light, such as filling the figure with a strong light, while the rest of the composition is in shade.

338. These reflections indicate the course which an historical painter must take, when he would particularly fix the attention upon the physiognomy of the persons in a remarkable scene. The more he employs allied scales, the more care he must take to select such as do not lose too much by their mutual juxtaposition.

339. There is another important direction to give, which is to avoid as much as possible the same kind of images on different objects; thus figures clothed in draperies with large flower patterns, in a room where the carpet and porcelain vases repeat the same images, are never free from objection, for it is troublesome to the eye to distinguish those parts of the picture which the similarity of ornaments tends to confound together. Upon the same principle, the painter must generally avoid placing beside the faithful copy of a model the copy of an imitation which repeats this model. For example, when he paints a vase of flowers, the artist produces most effect, other things being equal, in painting a vase of grey or white porcelain, instead of a vase upon which a profusion of similar objects are its ornaments.

340. When it is required that a certain colour shall predominate in a composition, or to speak more correctly, when the scene is illuminated by a coloured light, shed over every object, we must not only take simultaneous contrast into consideration, but also the modification which results from the mixture of colours comprising the recomposition of white light by means of a proper proportion of the differently coloured elementary rays.

341. We must here attentively study the article which treats of the principal cases of the modifications of light resulting from coloured rays falling upon bodies of various

colours, when, although the coloured light chosen imparts value to certain colours of the objects upon which it falls, it also impoverishes and even neutralizes others. Consequently, in employing any predominant colour, we must renounce the advantages of others, or the effect produced will be false. For example: if orange colour predominates, for the colouring to be true it must necessarily follow –

1 That the purples must be more or less red.
2 That the reds must be more or less scarlet.
3 That the scarlets must be more or less yellow.
4 That the orange must be more intense, more vivid.
5 That the yellows must be more or less intense, and orange.
6 That the greens lose their blue, and consequently become yellower.
7 That the light blues become more or less light grey.
8 That the deep indigo becomes more or less maroon.
9 That the violets lose some of their blue.

Thus we see that orange light heightens all the colours which contain red and yellow, while, neutralizing a portion of blue in proportion to its intensity, it destroys wholly or partially this colour in the body which it illuminates, and consequently disturbs the greens and the violets.

342. With reference to the true imitation of colouring, it appears to me that painters of interiors have, other things being equal, more skill than historical painters in faithfully reproducing the modifications of light. Historical painters, attaching more importance to the attitudes and physiognomy of their figures than to the other parts of their composition, attend less to small details, the faithful imitation of which is the essential merit of the painter of interiors. Besides, the historical painter is never in a position to see the whole of the scene he would represent, while the painter of interiors, having constantly his model before him, sees it completely, as he imitates it upon the canvas. Hence, therefore, in every small composition the colours, as well as the objects represented, must be distributed with a kind of symmetry, so as to avoid being what I can best express by the term *spotty*. In fact, for want of a good distribution of objects, the canvas will not be filled in some parts, or, if it is, there will be, in many places, evident confusion; so also if the colours be not properly distributed, the picture will be spotty, because they are too far isolated from the others.

343. I believe that those painters who will study the mixed and simultaneous contrasts of colours, in order to employ rationally the coloured elements of their palette, will perfect themselves in *absolute colouring* as by studying the principles of geometry they perfect themselves in linear perspective. I have no doubt but that the difficulty encountered by painters ignorant of the law of contrast, of faithfully imitating their model, has been with many the cause of a colouring dull and inferior to that of artists, who, less careful than they in the fidelity of imitation, or not so well organized for seizing all the modifications of light, have worked more by their first impressions, or, in other words, seeing the model more rapidly, their eyes have not had time to become fatigued; and thus, content with the imitation which they have made, they have not returned to their work too often to modify, to efface, and afterwards to reproduce it upon a canvas soiled by the colours first put on. There

are, indeed, many painters, to whom the axiom, 'Let well alone,' is peculiarly applicable.

* * *

Of the complex associations of colours, reviewed critically

618. It is evident that the rules prescribed for judging of a colour, and the associations of two colours, in an absolute manner, must serve for judging under the colours of an association, however complex it may be. We shall consider the masses of colours which are upon the same plane, the extent which each occupies, and the harmony which unites them together. On submitting to a similar examination the colours on the other planes, we can then look at the colours of the latter. The critic who is well satisfied with seeing clearly at the same time, only a very small number of the objects that a picture presents to him and who is also accustomed to examine a coloured composition in this manner, is in the position of a person who reads in succession writing on the same side of a sheet of paper; one series of lines crossing the first at right angles, and the third composed of lines running diagonally across the paper. The critic must review the *ensemble* of the picture as to its colours, and then, being attentive to their particular and general associations, he will be in a condition to enter into the thought of the painter, and to see whether he has employed the most suitable harmonies to express it; . . . although it is easier to form with opposed colours than with neighbouring colours binary assortments favourable to the associated colours, yet, when a great number of pure and brilliant colours are employed, it is more difficult to harmonize them than if we produced the effect with a small number of colours, which would involve only the harmony of analogy, or that of scale, or of hue.

619. Although harmony of contrast most favourably causes two colours to impart value to each other, yet, when we desire to derive the greatest advantage from a union of numerous brilliant colours in any work – a picture, for instance, – this diversity presents some difficulties in the general harmony, which a smaller number of colours, and especially of brilliant colours, would not present. It is, therefore, evident that, if we compare two effective pictures, well adapted to be judged under the relation of colour (other things being equal), the one which presents more harmony of contrast of colour will have the greater merit, on account of the difficulty overcome in the employment of the colours; but it must not be inferred that the painter of the other picture is not a colourist; for the art of colouring is composed of several elements, and the talent of opposing pure colours to each other, is only one of these elements.

620. Let us now consider the relations existing between the subjects of painting and the harmonies they admit of. We know that the more pictures address the eye by numerous contrasts, the more difficulty the spectator experiences in fixing his attention; especially if the colours are pure, varied, and skilfully distributed upon canvas. It results, therefore, from this, that these colours, being much more vivid than the flesh tints, the painter who wishes that his idea should be found in the expression of his figures, and who, deeming this part of his art superior to the rest, is convinced that the

eyes of most people ignorant of the art of seeing, being carried away by their first impressions, are incapable of returning from these to receive others; – the painter, I say, who knows all this, and is conscious of his power, will be restrained in the use of harmonies of contrast, and prodigal of the harmonies of analogy. But he will not derive advantage from these harmonies, especially in a subject covering a vast space filled with human figures, as the 'Last Judgment' of M. Angelo, unless he avoids confusion by correct drawing, by a distribution of the figures in groups, skilfully distributed over the canvas, so that they may cover it almost equally, yet without cold symmetry. The eye of the spectator must embrace all these groups easily, and seize the respective positions; while in looking into one of them he must discover a variety which will invite his attention to other groups.

621. The painter who fails to gain the effects of the physiognomies, &c., in having recourse to the harmonies of analogy, will not have the same advantage in fixing general attention, as the painter who employs the harmonies of contrast.

The harmonies of contrast of colour are especially applicable to scenes (illumined by a too-vivid light), representing fetes, ceremonies, &c., which may be sober without being mournful; they are also applicable to large subjects, comprising groups of men animated with various passions.

The result of this view is, that the critic must never compare the colouring of two large compositions without taking into account the difference which may exist in the suitableness of each subject with one kind of harmony more than with the other.

6 William Henry Fox Talbot (1800–1877) 'Photogenic Drawing'

Artists had made use of the camera obscura since the Renaissance, and the principle of projecting an image through a small hole onto a screen had been known to the Greeks. It was not until the 1830s in France and England, however, that scientific developments of the previous century quite suddenly bore fruit in two different methods of mechanically reproducing, and then fixing, images. The precise question of priority between Fox Talbot and Daguerre (see IIc7) is unclear, but the implications for art were profound, and rapidly felt. Henry Fox Talbot, a Cambridge-trained scientist, developed a method of making negative images on paper in 1835, spurred by a wish to record landscapes he had seen in Italy a few years before. By 1839 he was able to fix these images. On hearing of Daguerre's breakthrough in France, Fox Talbot hastily wrote the present paper which was delivered to the Royal Society in London on 31 January 1839. In addition to the technicalities of his process, Fox Talbot speculated about possible applications. These he saw mainly as the recording of landscapes and plants, buildings and sculptures, by scientists, architects, archaeologists and so on. But he was also drawn briefly to note the aesthetic properties peculiar to 'photogenic drawing' itself, particularly regarding detail and qualities of light and shade. To that extent photography, at the very moment of its birth, was perceived as containing the seeds of those independent effects which ultimately led it to overtake, and not merely to serve, drawing and painting as the primary representational mode of modern society. The full title of Fox Talbot's paper was 'Some Account of the Art of Photogenic Drawing, or, The Process by Which Natural Objects May Be Made to Delineate Themselves without the Aid of the Artist's Pencil'. He had it privately printed as a pamphlet in London, and its first publication proper followed in *The London and Edinburgh Philosophical Magazine and Journal of Science*, volume XIV, March

1839. Our extracts are taken from the text as reprinted in Beaumont Newhall (ed.), *Photography: Essays and Images*, New York and London: Secker and Warburg, 1980/81, pp. 23–31.

In the spring of 1834 I began to put in practice a method which I had devised some time previously, for employing to purposes of utility the very curious property which has long been known to chemists to be possessed by the nitrate of silver; namely, its discolouration when exposed to the violet rays of light. This property appeared to me to be perhaps capable of useful application in the following manner.

I proposed to spread on a sheet of paper a sufficient quantity of the nitrate of silver, and then to set the paper in the sunshine, having first placed before it some object casting a well-defined shadow. The light, acting on the rest of the paper, would naturally blacken it, while the parts in shadow would retain their whiteness. Thus I expected that a kind of image or picture would be produced, resembling to a certain degree the object from which it was derived. I expected, however, also, that it would be necessary to preserve such images in a portfolio, and to view them only by candlelight; because if by daylight, the same natural process which formed the images would destroy them, by blackening the rest of the paper.

Such was my leading idea before it was enlarged and corrected by experience. It was not until some time after, and when I was in possession of several novel and curious results, that I thought of inquiring whether this process had been ever proposed or attempted before? I found that in fact it had; but apparently not followed up to any extent, or with much perseverance. The few notices that I have been able to meet with are vague and unsatisfactory; merely stating that such a method exists of obtaining the outline of an object, but going into no details respecting the best and most advantageous manner of proceeding.

The only definite account of the matter which I have been able to meet with, is contained in the first volume of the *Journal of the Royal Institution*, page 170, from which it appears that the idea was originally started by Mr Wedgwood, and a numerous series of experiments made both by him and Sir Humphry Davy, which however ended in failure. I will take the liberty of quoting a few passages from his memoir.

'The copy of a painting, immediately after being taken, must be kept in an obscure place. It may indeed be examined in the shade, but in this case the exposure should be only for a few minutes. No attempts that have been made to prevent the uncoloured parts from being acted upon by light, have as yet been successful. They have been covered with a thin coating of fine varnish; but this has not destroyed their susceptibility of becoming coloured. When the solar rays are passed through a print and thrown upon prepared paper, the unshaded parts are slowly copied; but the lights transmitted by the shaded parts are seldom so definite as to form a distinct resemblance of them by producing different intensities of colour.

'The images formed by means of a *camera obscura* have been found to be too faint to produce, in any moderate time, an effect upon the nitrate of silver. To copy these images was the first object of Mr Wedgwood, but all his numerous experiments proved unsuccessful.'

These are the observations of Sir Humphry Davy. I have been informed by a scientific friend that this unfavourable result of Mr Wedgwood's and Sir Humphry Davy's experiments, was the chief cause which discouraged him from following up with perseverance the idea which he had also entertained of fixing the beautiful images of the *camera obscura*. And no doubt, when so distinguished an experimenter as Sir Humphry Davy announced 'that all experiments had proved unsuccessful,' such a statement was calculated materially to discourage further inquiry. The circumstance also, announced by Davy, that the paper on which these images were depicted was liable to become entirely dark, and that nothing hitherto tried would prevent it, would perhaps have induced me to consider the attempt as hopeless, if I had not (fortunately) before I read it, already discovered a method of overcoming this difficulty, and of *fixing* the image in such a manner that it is no more liable to injury or destruction. [. . .]

First Applications of this Process

The first kind of objects which I attempted to copy by this process were flowers and leaves, either fresh or selected from my herbarium. These it renders with the utmost truth and fidelity, exhibiting even the venation of the leaves, the minute hairs that clothe the plant, &c. &c.

It is so natural to associate the idea of *labour* with great complexity and elaborate detail of execution, that one is more struck at seeing the thousand florets of an *Agrostis* depicted with all its capillary branchlets (and so accurately, that none of all this multitude shall want its little bivalve calyx, requiring to be examined through a lens), than one is by the picture of the large and simple leaf of an oak or a chestnut. But in truth the difficulty is in both cases the same. The one of these takes no more time to execute than the other; for the object which would take the most skilful artist days or weeks of labour to trace or to copy, is effected by the boundless powers of natural chemistry in the space of a few seconds.

To give an idea of the degree of accuracy with which some objects can be imitated by this process, I need only mention one instance. Upon one occasion, having made an image of a piece of lace of an elaborate pattern, I showed it to some persons at the distance of a few feet, with the inquiry, whether it was a good representation? when the reply was, 'That they were not to be so easily deceived, for that it was evidently no picture, but the piece of lace itself.'

At the very commencement of my experiments upon this subject, when I saw how beautiful were the images which were thus produced by the action of light, I regretted the more that they were destined to have such a brief existence, and I resolved to attempt to find out, if possible, some method of preventing this, or retarding it as much as possible. [. . .]

My first trials were unsuccessful, as indeed I expected; but after some time I discovered a method which answers perfectly, and shortly afterwards another. On one of these more especially I have made numerous experiments; the other I have comparatively little used, because it appears to require more nicety in the management. It is, however, equal, if not superior, to the first in brilliancy of effect.

This chemical change, which I call the *preserving process*, is far more effectual than could have been anticipated. The paper, which had previously been so sensitive to light, becomes completely insensible to it, insomuch that I am able to show the Society specimens which have been exposed for an hour to the full summer sun, and from which exposure the image has suffered nothing, but retains its perfect whiteness.

On the Art of Fixing a Shadow

The phenomenon which I have now briefly mentioned appears to me to partake of the character of the *marvellous*, almost as much as any fact which physical investigation has yet brought to our knowledge. The most transitory of things, a shadow, the proverbial emblem of all that is fleeting and momentary, may be fettered by the spells of our '*natural magic*', and may be fixed for ever in the position which it seemed only destined for a single instant to occupy.

This remarkable phenomenon, of whatever value it may turn out in its application to the arts, will at least be accepted as a new proof of the value of the inductive methods of modern science, which by noticing the occurrence of unusual circumstances (which accident perhaps first manifests in some small degree), and by following them up with experiments, and varying the conditions of these until the true law of nature which they express is apprehended, conducts us at length to consequences altogether unexpected, remote from usual experience, and contrary to almost universal belief. Such is the fact, that we may receive on paper the fleeting shadow, arrest it there and in the space of a single minute fix it there so firmly as to be no more capable of change, even if thrown back into the sunbeam from which it derived its origin. [. . .]

Portraits

Another purpose for which I think my method will be found very convenient, is the making of outline portraits, or *silhouettes*. These are now often traced by the hand from shadows projected by a candle. But the hand is liable to err from the true outline, and a very small deviation causes a notable diminution in the resemblance. I believe this manual process cannot be compared with the truth and fidelity with which the portrait is given by means of solar light.

Paintings on Glass

The shadow-pictures which are formed by exposing paintings on glass to solar light are very pleasing. The glass itself, around the painting, should be blackened; such, for instance, as are often employed for the magic lantern. The paintings on the glass should have no bright yellows or reds, for these stop the violet rays of light, which are the only effective ones. The pictures thus formed resemble the productions of the artist's pencil more, perhaps, than any of the others. Persons to whom I have shown them have generally mistaken them for such, at the same time observing, that the *style* was new to them, and must be one rather difficult to acquire. It is in these pictures

only that, as yet, I have observed indications of *colour*. I have not had time to pursue this branch of the inquiry further. It would be a great thing if by any means we could accomplish the delineation of objects in their natural colours. I am not very sanguine respecting the possibility of this; yet, as I have just now remarked, it appears possible to obtain at least *some indication* of variety of tint. [. . .]

Architecture, Landscape, and External Nature

. . . Perhaps the most curious application of this art is the one I am now about to relate. At least it is that which has appeared the most surprising to those who have examined my collection of pictures formed by solar light.

Every one is acquainted with the beautiful effects which are produced by a *camera obscura* and has admired the vivid picture of external nature which it displays. It had often occurred to me, that if it were possible to retain upon the paper the lovely scene which thus illuminates it for a moment, or if we could but fix the outline of it, the lights and shadows, divested of all *colour*, such a result could not fail to be most interesting. And however much I might be disposed at first to treat this notion as a scientific dream, yet when I had succeeded in fixing the images of the solar micro-scope by means of a peculiarly sensitive paper, there appeared no longer any doubt that an analogous process would succeed in copying the objects of external nature, although indeed they are much less illuminated.

Not having with me in the country a *camera obscura* of any considerable size, I constructed one out of a large box, the image being thrown upon one end of it by a good object glass fixed in the opposite end. This apparatus being armed with a sensitive paper, was taken out in a summer afternoon and placed about one hundred yards from a building favourably illuminated by the sun. An hour or two afterwards I opened the box, and I found depicted upon the paper a very distinct representation of the building, with the exception of those parts of it which lay in the shade. A little experience in this branch of the art showed me that with smaller *camerae obscurae* the effect would be produced in a smaller time. Accordingly I had several small boxes made, in which I fixed lenses of shorter focus, and with these I obtained very perfect but extremely small pictures; such as without great stretch of imagination might be supposed to be the work of some Lilliputian artist. They require indeed examination with a lens to discover all their minutiae.

In the summer of 1835 I made in this way a great number of representations of my house in the country, which is well suited to the purpose, from its ancient and remarkable architecture. And this building I believe to be the first that was ever yet known *to have drawn its own picture*.

The method of proceeding was this: having first adjusted the paper to the proper focus in each of these little *camerae*, I then took a number of them with me out of doors and placed them in different situations around the building. After the lapse of half an hour I gathered them all up, and brought them within doors to open them. When opened, there was found in each a miniature picture of the objects before which it had been placed.

To the traveller in distant lands, who is ignorant, as too many unfortunately are, of the art of drawing, this little invention may prove of real service; and even to the artist

himself, however skilful he may be. For although this natural process does not produce an effect much resembling the productions of his pencil, and therefore cannot be considered as capable of replacing them, yet it is to be recollected that he may often be so situated as to be able to devote only a single hour to the delineation of some very interesting locality. Now, since nothing prevents him from simultaneously disposing, in different positions, any number of these little *camerae*, it is evident that their collective results, when examined afterwards, may furnish him with a large body of interesting memorials, and with numerous details which he had not had himself time either to note down or to delineate.

Delineations of Sculpture

Another use which I propose to make of my invention is for the copying of statues and bas-reliefs. I place these in strong sunshine, and put before them at a proper distance, and in the requisite position, a small *camera obscura* containing the prepared paper. In this way I have obtained images of various statues, &c. I have not pursued this branch of the subject to any extent; but I expect interesting results from it, and that it may be usefully employed under many circumstances.

Copying of Engravings

The invention may be employed with great facility for obtaining copies of drawings or engravings, or facsimiles of MSS. For this purpose the engraving is pressed upon the prepared paper, with its engraved side in contact with the latter. The pressure must be as uniform as possible, that the contact may be perfect; for the least interval sensibly injures the result, by producing a kind of cloudiness in lieu of the sharp strokes of the original.

When placed in the sun, the solar light gradually traverses the paper, except in those places where it is prevented from doing so by the opake lines of the engraving. It therefore of course makes an exact image or print of the design. This is one of the experiments which Davy and Wedgwood state that they tried, but failed, from want of sufficient sensibility in their paper.

The length of time requisite for effecting the copy depends on the thickness of the paper on which the engraving has been printed. At first I thought that it would not be possible to succeed with thick papers; but I found on trial that the success of the method was by no means so limited. It is enough for the purpose, if the paper allows any of the solar light to pass. When the paper is thick, I allow half an hour for the formation of a good copy. In this way I have copied very minute, complicated, and delicate engravings, crowded with figures of small size, which were rendered with great distinctness.

The effect of the copy, though of course unlike the original (substituting as it does lights for shadows, and vice versa,) yet is often very pleasing, and would, I think, suggest to artists useful ideas respecting light and shade. [. . .]

I have thus endeavoured to give a brief outline of some of the peculiarities attending this new process, which I offer to the lovers of science and nature. That

it is susceptible of great improvements, I have no manner of doubt; but even in its present state I believe it will be found capable of many useful and important applications besides those of which I have given a short account in the preceding pages.

7 Joseph-Louis Gay-Lussac (1778–1850) Report on the Daguerreotype

The Daguerreotype photographic process was developed in France in the 1830s on the basis of technical developments made by a lithographer, Nicephore Niepce in the late 1820s. Louis-Jacques-Mande Daguerre was a scene painter and owner of the Diorama in Paris. This was a device for displaying large paintings, some 14 x 20 metres in size, of famous scenes and events. Daguerre used a camera obscura to trace scenes projected onto the canvases, and it was a desire to fix these images that stimulated his experiments in photography. By 1837 he was able to fix images on a copper plate. The momentous nature of the discovery was quickly understood, and in 1839 the French government purchased the rights to the process. Daguerre and Niepce's son received annual pensions for life. On 30 July 1839 the Report of a Special Commission was read to the French parliament recommending approval of the Bill for the purchase and the pensions which had been drawn up the previous month. The Report was delivered by Joseph-Louis Gay-Lussac, himself an eminent scientist and member of the Institut de France. While recognizing the present limitations of the process, the Report stresses the potential of Daguerre's discovery, in particular for the natural sciences, but also for travellers, architects and painters. The present extracts from Gay-Lussac's Report are taken from the translation by J. P. Simon of Daguerre's book *A Practical Description of that Process called the Daguerreotype*, London: John Churchill, 1839, pp. 9–16. The Report was followed by a technical description of the Daguerreotype process.

Gentlemen,

Whatever contributes to the progress of civilization, and tends to ameliorate the physical or moral welfare of man, ought to be the constant object of the solicitude of an enlightened government, which, even at the height of its grandeur, does not forget to bestow honourable rewards on those who aid in this noble task, and whose happy efforts are crowned with success.

It is thus that already do the law and guardians of property in literature and the useful arts, secure to the inventors advantages proportionate to the services they have rendered to society; a mode of remuneration so much the more just, so much the more honourable, that it resolves itself into a contribution absolutely voluntary, in exchange for the services they have rendered, and that, independent of the caprices, or whims of favours.

However, if such a mode of encouragement is the best in the most part of circumstances, there are cases in which it is impracticable, or at least inadequate, whilst other great discoveries demand the most marked and solemn testimonies.

Gentlemen (or my Lords), Such appears to us the discovery of M. Daguerre, [...] which is the art of fixing the images produced by the Camera Obscura on a metallic surface, and there to be permanently fixed.

However, we must hasten to state, that (though we wish not to reflect on the merit of that beautiful discovery), the design of the artist (*light*) is not replete in colours, '*black* and *white*' being the composition of the whole. The natural image, varied in colours, may remain long, and perhaps for ever, a hidden mystery to human sagacity. Yet let us not rashly say that it is impossible; for the success of M. Daguerre unfolds to the world a new order of possibility. Requested to give our opinion on the importance and consequences of M. Daguerre's invention, we have formed it on the perfection of the results. [. . .] Our conviction on the importance of that new invention is complete, and we should be glad to find the House participating in the same feelings. It is certain that, from the discovery of M. Daguerre, physical science is now put in possession of a chemical re-agent, sensible, in a very extraordinary degree, to luminous rays or influences, of a new instrument, which will become, for the intensity of light, and all the phenomena of the luminous bodies, that which the microscope is for minute objects, and that it will give rise to new researches and new discoveries.

Already this re-actif has received the most delicate impressions by the feeble light of the moon; and M. Arago has conceived the hope, that a lunar chart may be traced by that satellite herself.

This House has had an opportunity of convincing itself by the proofs that were submitted to its inspection, that bas-reliefs, statues, monuments, in a word, inanimate nature, can be rendered, with a perfection unattainable otherwise, since the impressions taken by M. Daguerre's process are the faithful images of Nature herself.

The perspective of a landscape, and of every object, is traced with a precision and mathematical exactness; nothing, no not even the smallest object can escape the eye and pencil of the new painter '*light*', and as only a few minutes are required for the perfection of its work, a field of battle in all its phases will be represented with a perfection inaccessible by any other means.

Artificial arts for the representation of forms – the designs for perfect models of perspective, as well as the distribution of light and of shadows – the natural sciences for the study of species and their organization will surely make of M. Daguerre's process numerous applications. In short, the problem of its application to the taking of likenesses is nearly resolved, and the difficulties which remain yet unconquered are weighed and can leave little doubt of their being overcome. Nevertheless it must not be forgotten that coloured objects are not reproduced with their proper colours, and that the various luminous rays not acting alike on M. Daguerre's re-actif, the harmony of shades and of lights, or luminous rays, in coloured objects is inevitably altered. This is a point of demarcation traced by nature herself to the new process. [. . .]

The chief advantage of M. Daguerre's process consists in obtaining quickly, and in a most correct manner, the image of objects, whether it be to preserve it, or to reproduce (or copy) it afterwards by engravings, or by lithographic means; from this it will appear, that if only concentrated in the hands of a single individual, an invention like this would not have had sufficient scope to unfold its merits; whilst on the contrary, if freely given to the public this invention will receive in the hands of the painter, of the architect, of the traveller, and in the hands of the naturalist, numberless applications. In short, in the possession of a single individual, it would have remained a long time stationary (that is, unpropagated) and would have faded away (or been

forgotten) perhaps. On the contrary in the hands of the public, it will grow (or improve), and will ameliorate itself by the aid of all; thus under such circumstances it became important that it was made a public property. On the other hand, the invention of M. Daguerre ought to have attracted the attention of the government, and induced it to confer on him a marked and solemn reward.

To those who are proud of national glory (*as the liberals of this country say*), and who know, that a people do not shine over other nations, but in proportion to the greater progress that they are enabled to make in the advancement of civilization; towards such, it will be observed, the process of M. Daguerre must be a great discovery. He is the origin of a new art, in the midst of an old civilization, which will be a marked data or event, that will be considered and preserved as a title of national glory.

8 Joseph Mallord William Turner (1775–1851) on Printmaking

Printmaking formed a major part of Turner's output. The reasons for this were partly technical. Despite the monochrome nature of most printing and Turner's reputation as a colourist, there were relationships between techniques employed in print media and water-colour painting, as well as the potentially dramatic contrasts of light and dark, that encouraged a cross-fertilization of experiment. There were also economic reasons, how-ever. A considerable part of Turner's income derived from his marketing of engravings. Indeed, his first series, the *Liber Studiorum* of 1807 (based on Claude's *Liber Veritatis*) was designed to publicize Turner's expertise across a range of artistic genres. Subsequent series were worked up from landscape sketches made on his extensive travels (e.g. *Rivers of England*). In addition, prints were made from finished oil paintings. In 1838 Turner exhibited at the Royal Academy a pair of paintings: *Ancient Italy* and *Modern Italy*. The latter was turned over for engraving the following year. Turner's correspondence with the engraver William Miller gives an insight into both his working methods and his enduring financial concerns. The present letters are taken from the *Collected Correspondence of J. M. W. Turner* (nos 246, 250, 251), edited by John Gage, Oxford, 1980: Clarendon Press, pp. 184–5, 187–8. Internal editorial marks are Gage's.

22 Oct. 1841

My Dear Sir,
So much time – for I only return'd from Switzerland last night – since your letter and the arrival of the proof, for Mr Moon has sent only *one*, that I hope you have proceeded with the plate, in which case it is evident you must take off *three* and mark the two for me – if you adopt the same medium of transfer – but I would say send them direct – my remarks would be wholly yours – and some inconvenience to both avoided – if you have not done anything take off one for me ... so now to business.

It appears to me that you have advanced so far that I do think I could now recollect sufficiently – without the Picture before me but will now point out *turn over* and answer your questions viz. if the sky you feel [is] right you could advance more confidently therefore do not touch the sky at present but work the rest up to it. The distance may be too dark, tho it wants more fine work, more character of woods down to the very campagna of Rome a bare sterile flat ... much lighter in tone.

The question of a perpendicular line to the water ... pray do not think of it until after the very last touched proof, for it has a beautiful quality of silvery softness, what is only checked by the rock which is the most unfortunate in the whole plate – how to advise you here I know not, but think fine work would blend the same with the reflections of it with the water – this is the worst part and I fear will give us some trouble to conquer and if you can make it like the water in the middle of the plate, I should like it better. The Houses above and particularly [?] from the Figures, and the parts from and with the Boys looking down are what I most fear about, which range all along the rock and the broken entrance and the shrine want more vigours to detach from the Town all the corner – figures &c. The foreground will be required to be more spirited and bold; open work, dashing *Wollett like toutches* and bright lights; so do all you can in the middle part and lower [?] part of the Town and leave *it* all for the present in front. The *Figure* in front would be better with the white cloth over the face done by one line only [*diagram*] and perhaps a child wrapped up in swaddling clothes before him would increase the sentiment [?] of the whole. The ground on which she kneels *and* [seal] *to the front wall* [*deleted*] break with small pebbles on broken pavement – Now for the good parts – the greatest part of the sky, all the *left side*, the upper castle and Palace and partly round to the Sybil Temple – *Town* and procession on the right side, and the water in the middle particularly good and I hope to keep it untouched if possible.

I am glad to hear you say I can have the picture after the first touched proof and *that* [*deleted*] this long letter of directions will be equal to *one* and you will be able to proceed with confidence – write if you feel any difficulty and believe me truly yours J. M. W. Turner

June 24 1842

Dear Sir
I have now nearly done all I have to do before I quit for *My Trip*, so make all *haste* possible to get your plate finished *first* and foremost.

Let me know as soon as possible and ask your *Printer* what he will Print. 500 Grand Eagle – Eagle – or Columbia – India and Plain *for* (paper included). Not every proof to be N^o *and marked* by him when taken off and all failures in so doing – to be rendered unsaleable – by marking & *given up* – *but not charged* – what time the 500 will take printing and all sent to me or in London – and if the number is increased, what reduction per *100* and if ready money – what discount?

Your answer as soon as possible – viz. at your earliest convenience will oblige Yours truly
J. M. W. Turner

Saturday, July 9, 1842

My Dear Sir
I beg to thank you for the terms of the Printer, and will thank you for your kindness in offering to look after the Printing during progress – but your plate is Mr Moon's, and I was asked for a plate of my own *only*. May I now trouble you further by asking him, the Printer, if he allows *discount* for ready Money and how many printing presses he

has ... and if *two* or more plates were worked at the same time – what deductions he could make in proportions.

Yours most truly

J. M. W. Turner

9 Charles Baudelaire (1821–1867) 'On Colour'

Baudelaire's self-contained essay on colour forms section III of his *Salon of 1846*, where it is preceded by a discussion of the nature of Romanticism and followed by a tribute to the work of Delacroix. On the one hand it furnishes a vivid counter to naturalistic bases for the analysis of colour in painting; on the other it provides confirmation of the acute powers of observation and description that informed Baudelaire's own work as a critic of painting. The *Salon de 1846* was originally published as a separate pamphlet under the name Baudelaire Dufays (a reference to the author's mother's maiden name), Paris, 1846. Our text is taken from the translation by Jonathan Mayne in his edition of Baudelaire, *Art in Paris: 1845–1862. Salons and other Exhibitions*, London: Phaidon, 1964, pp. 48–52. For further excerpts from the *Salon of 1846*, see IID13. (The Catlin referred to is the George Catlin of IB9, two of whose paintings of native American Indians were included in the Salon, drawing the comment from Baudelaire that these works were 'curiosities of a certain importance'. The meaning of 'terrible' here is not 'bad', but 'conveying a sense of terror'.)

Let us suppose a beautiful expanse of nature, where there is full licence for everything to be as green, red, dusty or iridescent as it wishes; where all things, variously coloured in accordance with their molecular structure, suffer continual alteration through the transposition of shadow and light; where the workings of latent heat allow no rest, but everything is in a state of perpetual vibration which causes lines to tremble and fulfils the law of eternal and universal movement. An immensity which is some-times blue, and often green, extends to the confines of the sky; it is the sea. The trees are green, the grass and the moss are green; the tree-trunks are snaked with green, and the unripe stalks are green; green is nature's ground-bass, because green marries easily with all the other colours.[1] What strikes me first of all is that everywhere – whether it be poppies in the grass, pimpernels, parrots, etc. – red sings the glory of green; black (where it exists – a solitary and insignificant cipher) intercedes on behalf of blue or red. The blue – that is, the sky – is cut across with airy flecks of white or with grey masses, which pleasantly temper its bleak crudeness; and as the vaporous atmosphere of the season – winter or summer – bathes, softens or engulfs the contours, nature seems like a spinning-top which revolves so rapidly that it appears grey, although it embraces within itself the whole gamut of colours.

The sap rises, and as the principles mix, there is a flowering of *mixed tones*; trees, rocks and granite boulders gaze at themselves in the water and cast their *reflections* upon them; each transparent object picks up light and colour as it passes from nearby or afar. According as the daystar alters its position, tones change their values, but, always respecting their natural sympathies and antipathies, they continue to live in harmony by making reciprocal concessions. Shadows slowly shift, and colours are put to flight before them, or extinguished altogether, according as the light, itself shifting,

may wish to bring fresh ones to life. Some colours cast back their reflections upon one another, and by modifying their own qualities with a *glaze* of transparent, borrowed qualities, they combine and recombine in an infinite series of melodious marriages which are thus made more easy for them. When the great brazier of the sun dips beneath the waters, fanfares of red surge forth on all sides; a harmony of blood flares up at the horizon, and green turns richly crimson. Soon vast blue shadows are rhythmically sweeping before them the host of orange and rose-pink tones which are like a faint and distant echo of the light. This great symphony of today, which is an eternal variation of the symphony of yesterday, this succession of melodies whose variety ever issues from the infinite, this complex hymn is called *colour*.

In colour are to be found harmony, melody and counterpoint.

If you will examine the detail within the detail in an object of medium dimensions – for example, a woman's hand, rosy, slender, with skin of the finest – you will see that there is perfect harmony between the green of the strong veins with which it is ridged and the ruby tints which mark the knuckles; pink nails stand out against the topmost joints, which are characterized by several grey and brown tones. As for the palm of the hand, the lifelines, which are pinker and more wine-coloured, are separated one from another by the system of green or blue veins which run across them. A study of the same object, carried out with a lens, will afford, within however small an area, a perfect harmony of grey, blue, brown, green, orange and white tones, warmed by a touch of yellow – a harmony which, when combined with shadows, produces the colourist's type of modelling, which is essentially different from that of the draughts-man, whose difficulties more or less boil down to the copying of a plaster cast.

Colour is thus the accord of two tones. Warmth and coldness of tone, in whose opposition all theory resides, cannot be defined in an absolute manner; they only exist in a relative sense.

The lens is the colourist's eye.

I do not wish to conclude from all this that a colourist should proceed by a minute study of the tones commingled in a very limited space. For if you admit that every molecule is endowed with its own particular tone, it would follow that matter should be infinitely divisible; and besides, as art is nothing but an abstraction and a sacrifice of detail to the whole, it is important to concern oneself above all with *masses*. I merely wished to prove that if the case were possible, any number of tones, so long as they were logically juxtaposed, would fuse naturally in accordance with the law which governs them.

Chemical affinities are the grounds whereby Nature cannot make mistakes in the arrangement of her tones; for with Nature, form and colour are one.

No more can the true colourist make mistakes; everything is allowed him, because from birth he knows the whole scale of tones, the force of tone, the results of mixtures and the whole science of counterpoint, and thus he can produce a harmony of twenty different reds.

This is so true that if an anti-colourist landowner took it into his head to repaint his property in some ridiculous manner and in a system of cacophonous colours, the thick and transparent varnish of the atmosphere and the learned eye of a Veronese between them would put the whole thing right and would produce a satisfying ensemble on canvas – conventional, no doubt, but logical.

This explains how a colourist can be paradoxical in his way of expressing colour, and how the study of nature often leads to a result quite different from nature.

The air plays such an important part in the theory of colour that if a landscape-painter were to paint the leaves of a tree just as he sees them, he would secure a false tone, considering that there is a much smaller expanse of air between the spectator and the picture than between the spectator and nature.

Falsifications are continually necessary, even in order to achieve a *trompe-l'oeil*.

Harmony is the basis of the theory of colour.

Melody is unity within colour, or overall colour.

Melody calls for a cadence; it is a whole, in which every effect contributes to the general effect.

Thus melody leaves a deep and lasting impression on the mind.

Most of our young colourists lack melody.

The right way to know if a picture is melodious is to look at it from far enough away to make it impossible to understand its subject or to distinguish its lines. If it is melodious, it already has a meaning and has already taken its place in your store of memories.

Style and feeling in colour come from choice, and choice comes from temperament.

Colours can be gay and playful, playful and sad, rich and playful, gay, rich and sad, commonplace and original.

Thus Veronese's colour is tranquil and gay. Delacroix's colour is often plaintive, and that of M. Catlin is often terrible.

For a long time I lived opposite a drinking-shop which was crudely striped in red and green; it afforded my eyes a delicious pain.

I do not know if any *analogist* has ever established a complete scale of colours and feelings, but I remember a passage in Hoffmann which expresses my idea perfectly and which will appeal to all those who sincerely love nature: 'It is not only in dreams, or in that mild delirium which precedes sleep, but it is even awakened when I hear music – that perception of an analogy and an intimate connexion between colours, sounds and perfumes. It seems to me that all these things were created by one and the same ray of light, and that their combination must result in a wonderful concert of harmony. The smell of red and brown marigolds above all produces a magical effect on my being. It makes me fall into a deep reverie, in which I seem to hear the solemn, deep tones of the oboe in the distance.'[2]

It is often asked if the same man can be at once a great colourist and a great draughtsman.

Yes and no; for there are different kinds of drawing.

The quality of pure draughtsmanship consists above all in precision, and this precision excludes *touch*; but there are such things as happy touches, and the colourist who undertakes to express nature through colour would often lose more by suppressing his happy touches than by studying a greater austerity of drawing.

Certainly colour does not exclude great draughtsmanship – that of Veronese, for example, which proceeds above all by ensemble and by mass; but it does exclude the meticulous drawing of detail, the contour of the tiny fragment, where touch will always eat away line.

The love of air and the choice of subjects in movement call for the employment of flowing and fused lines.

Exclusive draughtsmen act in accordance with an inverse procedure which is yet analogous. With their eyes fixed upon tracking and surprising their line in its most secret convolutions, they have no time to see air and light – that is to say, the effects of these things – and they even compel themselves *not* to see them, in order to avoid offending the dogma of their school.

It is thus possible to be at once a colourist and a draughtsman, but only in a certain sense. Just as a draughtsman can be a colourist in his broad masses, so a colourist can be a draughtsman by means of a total logic in his linear ensemble; but one of these qualities always engulfs the detail of the other.

The draughtsmanship of colourists is like that of nature; their figures are naturally bounded by a harmonious collision of coloured masses.

Pure draughtsmen are philosophers and dialecticians.

Colourists are epic poets.

[1] Except for yellow and blue, its progenitors: but I am only speaking here of pure colours. For this rule cannot be applied to transcendent colourists who are thoroughly acquainted with the science of counterpoint.

[2] Kreisleriana. It is the third of the detached observations entitled *Höchst zerstreute Gedanken*.

IID
Independence and Individuality

1 Thomas Carlyle (1795–1881) from 'Signs of the Times'

Apart from a brief visit to London in 1824 (when he met Coleridge), Carlyle had hardly been out of Scotland before 1830. When he wrote 'Signs of the Times', he was living at Craigenputtock, a remote farming community in Dumfriesshire. The essay therefore represents a remarkable confirmation of the power and reach of the modern technology which it so critically reviews. Carlyle, steeped in religious thought and German Romanticism, remained deeply suspicious of the way in which all aspects of modern life seemed to be becoming infused with the ethos of mechanization. Using a contrast derived from physics, Carlyle argued that a full sense of human life comprised not only a 'mechanics' but also a 'dynamics'. This latter, the *in*calculable, creative dimension, remains for Carlyle the seat of genuine human accomplishment. The essay was originally published in the *Edinburgh Review* volume XLIX, June 1829, pp. 441–4. Our extract is taken from the text as printed in Alasdair Clayre (ed.), *Nature and Industrialisation*, Oxford: Oxford University Press, 1977, pp. 229–34.

Were we required to characterize this age of ours by any single epithet, we should be tempted to call it, not an Heroical, Devotional, Philosophical, or Moral Age, but, above all others, the Mechanical Age. It is the Age of Machinery, in every outward and inward sense of that word; the age which, with its whole undivided might, forwards, teaches and practises the great art of adapting means to ends. Nothing is now done directly, or by hand; all is by rule and calculated contrivance. For the simplest operation, some helps and accompaniments, some cunning abbreviating process is in readiness. Our old modes of exertion are all discredited, and thrown aside. On every hand, the living artisan is driven from his workshop, to make room for a speedier, inanimate one. The shuttle drops from the fingers of the weaver, and falls into iron fingers that ply it faster. The sailor furls his sail, and lays down his oar; and bids a strong, unwearied servant, on vaporous wings, bear him through the waters. Men have crossed oceans by steam; the Birmingham Fire-king has visited the fabulous East; and the genius of the Cape, were there any Camoens now to sing it, has again been alarmed, and with far stranger thunders than Gamas. There is no end to machinery. Even the horse is stripped of his harness, and finds a fleet fire-horse yoked in his stead. Nay, we have an artist that hatches chickens by steam; the very

brood-hen is to be superseded! For all earthly, and for some unearthly purposes, we have machines and mechanic furtherances; for mincing our cabbages; for casting us into magnetic sleep. We remove mountains, and make seas our smooth highway; nothing can resist us. We war with rude Nature; and, by our resistless engines, come off always victorious, and loaded with spoils.

What wonderful accessions have thus been made, and are still making, to the physical power of mankind; how much better fed, clothed, lodged and, in all outward respects, accommodated men now are, or might be, by a given quantity of labour, is a grateful reflection which forces itself on every one. What changes, too, this addition of power is introducing into the Social System; how wealth has more and more increased, and at the same time gathered itself more and more into masses, strangely altering the old relations, and increasing the distance between the rich and the poor, will be a question for Political Economists, and a much more complex and important one than any they have yet engaged with.

But leaving these matters for the present, let us observe how the mechanical genius of our time has diffused itself into quite other provinces. Not the external and physical alone is now managed by machinery, but the internal and spiritual also. Here too nothing follows its spontaneous course, nothing is left to be accomplished by old natural methods. Everything has its cunningly devised implements, its pre-established apparatus; it is not done by hand, but by machinery. Thus we have machines for Education: Lancastrian machines; Hamiltonian machines; monitors, maps and emblems. Instruction, that mysterious communing of Wisdom with Ignorance, is no longer an indefinable tentative process, requiring a study of individual aptitudes, and a perpetual variation of means and methods, to attain the same end; but a secure, universal, straightforward business, to be conducted in the gross, by proper mechanism, with such intellect as comes to hand. Then, we have Religious machines, of all imaginable varieties; the Bible-Society, professing a far higher and heavenly structure, is found, on inquiry, to be altogether an earthly contrivance: supported by collection of moneys, by fomenting of vanities, by puffing, intrigue and chicane; a machine for converting the Heathen. It is the same in all other departments. Has any man, or any society of men, a truth to speak, a piece of spiritual work to do; they can nowise proceed at once and with the mere natural organs, but must first call a public meeting, appoint committees, issue prospectuses, eat a public dinner; in a word, construct or borrow machinery, wherewith to speak it and do it. Without machinery they were hopeless, helpless; a colony of Hindoo weavers squatting in the heart of Lancashire. Mark, too, how every machine must have its moving power, in some of the great currents of society; every little sect among us, Unitarians, Utilitarians, Anabaptists, Phrenologists, must have its Periodical, its monthly or quarterly Magazine; – hanging out, like its windmill, into the *popularis aura* [the breath of popular favour], to grind meal for the society.

With individuals, in like manner, natural strength avails little. No individual now hopes to accomplish the poorest enterprise single-handed and without mechanical aids; he must make interest with some existing corporation, and till his field with their oxen. In these days, more emphatically than ever, 'to live, signifies to unite with a party, or to make one.' Philosophy, Science, Art, Literature, all depend on machinery. No Newton, by silent meditation, now discovers the system of the world from the

falling of an apple; but some quite other than Newton stands in his Museum, his Scientific Institution, and behind whole batteries of retorts, digesters, and galvanic piles imperatively 'interrogates Nature,' – who, however, shows no haste to answer. In defect of Raphaels, and Angelos, and Mozarts, we have Royal Academies of Painting, Sculpture, Music; whereby the languishing spirit of Art may be strengthened, as by the more generous diet of a Public Kitchen. Literature, too, has its Paternoster-row mechanism, its Trade-dinners, its Editorial conclaves, and huge subterranean, puffing bellows; so that books are not only printed, but, in a great measure, written and sold, by machinery.

National culture, spiritual benefit of all sorts, is under the same management. No Queen Christina, in these times, needs to send for her Descartes; no King Frederick for his Voltaire, and painfully nourish him with pensions and flattery: any sovereign of taste, who wishes to enlighten his people, has only to impose a new tax, and with the proceeds establish Philosophic Institutes. Hence the Royal and Imperial Societies, the Bibliothèques, Glyptothèques, Technothèques, which front us in all capital cities; like so many well-finished hives, to which it is expected the stray agencies of Wisdom will swarm of their own accord, and hive and make honey. In like manner, among ourselves, when it is thought that religion is declining, we have only to vote half-a-million's worth of bricks and mortar, and build new churches. In Ireland it seems they have gone still farther, having actually established a 'Penny-a-week Purgatory-Society'! Thus does the Genius of Mechanism stand by to help us in all difficulties and emergencies, and with his iron back bears all our burdens.

These things, which we state lightly enough here, are yet of deep import, and indicate a mighty change in our whole manner of existence. For the same habit regulates not our modes of action alone, but our modes of thought and feeling. Men are grown mechanical in head and in heart, as well as in hand. They have lost faith in individual endeavour, and in natural force, of any kind. Not for internal perfection, but for external combinations and arrangements, for institutions, constitutions, – for Mechanism of one sort or other, do they hope and struggle. Their whole efforts, attachments, opinions, turn on mechanism, and are of a mechanical character.

We may trace this tendency in all the great manifestations of our time; in its intellectual aspect, the studies it most favours and its manner of conducting them; in its practical aspects, its politics, arts, religion, morals; in the whole sources, and throughout the whole currents, of its spiritual, no less than its material activity. [. . .]

To us who live in the midst of all this, and see continually the faith, hope and practice of every one founded on Mechanism of one kind or other, it is apt to seem quite natural, and as if it could never have been otherwise. Nevertheless, if we recollect or reflect a little, we shall find both that it has been, and might again be otherwise. The domain of Mechanism, – meaning thereby political, ecclesiastical or other outward establishments, – was once considered as embracing, and we are persuaded can at any time embrace, but a limited portion of man's interests, and by no means the highest portion.

To speak a little pedantically, there is a science of *Dynamics* in man's fortunes and nature, as well as of *Mechanics*. There is a science which treats of, and practically addresses, the primary, unmodified forces and energies of man, the mysterious springs of Love, and Fear, and Wonder, of Enthusiasm, Poetry, Religion, all which

have a truly vital and *infinite* character; as well as a science which practically addresses the finite, modified developments of these, when they take the shape of immediate 'motives,' as hope of reward, or as fear of punishment.

Now it is certain, that in former times the wise men, the enlightened lovers of their kind, who appeared generally as Moralists, Poets or Priests, did, without neglecting the Mechanical province, deal chiefly with the Dynamical; applying themselves chiefly to regulate, increase and purify the inward primary powers of man; and fancying that herein lay the main difficulty, and the best service they could undertake. But a wide difference is manifest in our age. For the wise men, who now appear as Political Philosophers, deal exclusively with the Mechanical province; and occupying themselves in counting-up and estimating men's motives, strive by curious checking and balancing, and other adjustments of Profit and Loss, to guide them to their true advantage: while, unfortunately, those same 'motives' are so innumerable, and so variable in every individual, that no really useful conclusion can ever be drawn from their enumeration. But though Mechanism, wisely contrived, has done much for man in a social and moral point of view, we cannot be persuaded that it has ever been the chief source of his worth or happiness. Consider the great elements of human enjoyment, the attainments and possessions that exalt man's life to its present height, and see what part of these he owes to institutions, to Mechanism of any kind; and what to the instinctive, unbounded force, which Nature herself lent him, and still continues to him. Shall we say, for example, that Science and Art are indebted principally to the founders of Schools and Universities? Did not Science originate rather, and gain advancement, in the obscure closets of the Roger Bacons, Keplers, Newtons; in the workshops of the Fausts and the Watts; wherever, and in what guise soever Nature, from the first times downwards, had sent a gifted spirit upon the earth? Again, were Homer and Shakspeare members of any beneficed guild, or made Poets by means of it? Were Painting and Sculpture created by forethought, brought into the world by institutions for that end? No; Science and Art have, from first to last, been the free gift of Nature; an unsolicited, unexpected gift; often even a fatal one. These things rose up, as it were, by spontaneous growth, in the free soil and sunshine of Nature. They were not planted or grafted, nor even greatly multiplied or improved by the culture or manuring of institutions. Generally speaking, they have derived only partial help from these; often enough have suffered damage. They made constitutions for themselves. They originated in the Dynamical nature of man, not in his Mechanical nature.

2 William Dunlap (1766–1839) 'Address to the Students of the National Academy of Design'

In 1825, a group of thirty independent artists based in New York, in the words of the painter Samuel Morse, 'having the interests of their own profession to consult, combined together...for mutual benefit, in a society called the *Drawing Association*'. A year later this resolved itself into the National Academy of Design. Dunlap was a founder and Vice-President of the National Academy and a strong defender of its standing against the much longer established American Academy of Fine Arts. He was also a prolific literary figure and author-to-be of the monumental *History of the Rise and Progress of the Arts of Design in*

the United States. He delivered the present address as 'Professor of Historical Painting' at the Academy on 18 April 1831, on the occasion of the annual award of prizes for drawing. He was emphatic in associating the spirit of republicanism with protection of the artist's individual independence and with freedom from patronage – a theme taken up by Morse in the text that follows. It was above all through its support for such principles that the National Academy sought to distinguish itself from its rival. It is also of note that the designation 'Design' tended to be preferred to 'Fine Art' throughout the nineteenth century by those concerned with the social functions of artistic practices (see, for instance, VB4). The address was printed as a pamphlet by the National Academy of Design, New York, 1831. The following version is taken from pp. 3, 5–11 and 15–16 of the original publication.

Young Gentlemen,

You are preparing to enter the lists of fame, as members of an honourable profession. Let me take this opportunity of addressing a few words to you on what I consider the conduct proper for an artist in his intercourse with his fellow men. And first, – let him never for a moment forget that the professor of any one of the Fine Arts administers only to the mental pleasures, and is in duty bound to purify and elevate the minds of mankind. He does not supply the wants of the body, or pamper the baser appetites; but offers food and health to the better portion of our mixed and imperfect nature. Though his labours are intended to please, he will only aim, if true to himself and his profession, to give that pleasure which refines, that gratification which virtue approves. [. . .]

The fine arts can be relished by none who have not previously attained knowledge, taste, and refinement; and in proportion to these attainments is the pleasure the arts impart. As man becomes refined, his wants and his enjoyments increase. The savage feels no want of Homer or Milton, of Shakespeare or Dante; – their immortal poems present no images to his eye or ear; even if the words could be conveyed in his own language, the ideas would be still unintelligible. The sculpture of Phidias, or the painting of Raphael, would give him no more pleasure than the tawdry figures we see borne about our streets for sale on the heads of their manufacturers, or the glaring coloured prints which we may remember to have been delighted with in childhood. The uninstructed labourer in civilized society is nearly as dead to those objects which fill us with delight, as the savage. But the man who reads – who delights in books – the educated man – *feels* the want of the works of the poet, the painter, the sculptor, the engraver, and the architect. As this want, this desire, is gratified, he almost acquires new senses, so greatly is the power of enjoyment increased. It is the 'appetite that grows by what it feeds on.' He knows no satiety. He desires something more and more elevated. He thirsts for the pure pleasures derived from the fountain of the arts, which pours its fertilizing streams, its brilliant and healthful waters, to enrich the human mind and increase human happiness. The more he drinks, the more he relishes, and the clearer is his apprehension of the value of the purifying and healing spring from which his enjoyments flow. It is to such men that the professor of the fine arts must address his labours – not as one looking to them for protection, but as a friend, benevolently imparting and receiving good.

The artist is uniformly in higher estimation where society is of the highest grade. I have shown that it is only the well-informed who can truly estimate the works of art, or the merit of their authors. In the brightest period of the existence of Greece,

immediately preceding and during the reign of Alexander, the estimation in which artists were held corresponded with the high attainments of the people; – a people instructed by those sages whose maxims are now revered as leading to the purest morality. The same may be said of all countries, and all ages. Ancient Rome and modern Italy support my assertion; and the most enlightened countries of Europe, at the present day, do the same. Where men know most, the arts are most esteemed. In enlightened Greece they revered, they almost adored their artists, – they did not talk of patronizing them. They looked to them for instruction and sublime pleasure, and not as objects wanting protection. Patronage! degrading word! Only used by presumptuous ignorance, – only submitted to by the basest sycophancy. Every artist who has the feelings of a man, or more especially of a republican man, will spurn from him the offer of patronage, as debasing to himself, to his art, and to his country.

Every artist who is worthy of the name, possesses the power of communicating pleasure or instruction, or both, to those who are enlightened enough to seek the pleasure and instruction to be derived from his works. It is only in a country of barbarians that he can want patronage. If he truly loves his art, his pecuniary wants will be few, and the wise and the virtuous will be happy to administer to those wants, in fair exchange of their products for his, as equals, giving benefit for benefit. 'Poor and content is rich, and rich enough.' Wealth is only to be valued as power; – that which increases the sphere of utility – enables us to bestow happiness on others, and increase the still more precious source of power – wisdom.

If the rich man, rich in taste and knowledge, as well as in the gifts of fortune, desires, as he must desire, to possess the work of the artist, he seeks for it – exchanges a part of his possessions for it – and is as much obliged as obliging. Nay *more* – for what is the trash, 'which was his, is mine, and has been slave to thousands,' compared to the work of art, breathing promethean fire, soul, life, and immortality? It is only the ignorant who thinks, in such a case, that he is a patron; and it is only the unworthy who considers himself as patronized.

In that country where artists *must be patronized*, the arts are unknown, mind is uncultivated, and (unless the benevolent desire of ameliorating society should detain them) from that country artists ought to fly. If we could suppose a country, and surely it is hard to imagine such among civilized nations, in which a legislator should use the title of artist as a term of reproach wherewith to brand a fellow citizen, – should use it, surrounded by the elected representatives of the people of that country, and find none in that assemblage of the best and wisest, to reprove his folly and expose his ignorance – ought not artists to shun that country? Unless they resided in it, as missionaries do among savages, sacrificing their comforts, health, and even life, returning good for evil, and renouncing the present for the sake of the future. But there is no such country. We might as well suppose an artist so base, as to consider the title appertaining to his profession as a stigma. [. . .]

Our beloved country is politically a democracy. When all our fellow citizens shall have a true notion of the character of a democrat, no man will feel pride from the mere possession of wealth, or degradation from the absence of it. – No man will be so absurd as to think that he patronizes the author whose book he buys, or the painter or sculptor whose works decorate his walls and give lessons of wisdom to his children, any more than he will think that he protects the advocate who defended him in the

court of justice, or the physician who rescued him from pain and death. The time has not long passed away, since authors, in Europe, called for patronage, and wrote fulsome dedications to titled blockheads; – when those books which taught wisdom and independence, were ushered in by servile flattery. But genius burst the bonds which a barbarous age and barbarous governments had imposed upon her; and men are taught to look with reverence and love to those who delight and instruct them. Johnson indignantly rejected patronage, and we should think it ridiculous to look for a patron to a Byron or a Scott – a Cooper or an Irving.

The artist will address his works to the enlightened men who can appreciate their value. They are equals, bestowing and receiving good. The friend will assist his friend – the man of taste will applaud and aid the artist – the artist will receive and reciprocate; – but in this there is neither patronage nor dependence.

* * *

It is for painters and other artists, to teach mankind the true estimation in which the professors of the fine arts must be held. And first, need I say, they must esteem themselves, so far as to avoid all that is low, all that is servile, all that is false. Can there be any thing so contemptible, as a sycophant who debases the Heaven-imparted talent intrusted to him? Sycophancy is incompatible with true genius. We often see it united to mediocrity in the arts. If you see a man bowing to the rich or influential, for patronage and good dinners, flattering power for recommendation and protection, becoming a thing of bows, and smiles, and honeyed words, be assured that he lacks mind as much as he lacks self respect. The bowing, smiling sycophant, is as opposite to the polite man as possible, for politeness, the desire to exchange both civilities and services, belongs to the independent man of genius. Genius is modest, but never suffers itself to be trampled upon. It feels that it belongs to nature's aristocracy, and despises the aristocracy of mere wealth. The aristocracy of nature is composed of the nobles who are stamped such by their Maker, and are in principle and practice true democrats – lovers of their fellow men, and supporters of the equal rights of all. I trust that such aristocrats will be formed in this Academy: artists who love their art; who fear to do wrong, lest they should injure that they love, as the good husband, son, or father, dreads to bring pain or dishonour on his wife, his father or his child; feeling the value of the talent lent them by their Maker, and wishing happiness to all their fellow creatures, as children of the same beneficent Father. As members of the same profession – as children of the same Father – be charitable to the defects of each other, and deprive the enemies of the arts of the power to say, with truth, that their professors are disposed to disunion.

This Academy, of which you have been worthy students, and, as I hope, will be honourable members, being composed solely of artists, will strive to maintain that dignified station which belongs to the arts of design and their professors. [. . .]

3 Samuel F. B. Morse (1791–1872) 'Examination of Colonel Trumbull's Address'

The American painter Samuel Morse had studied in London with Benjamin West and was a friend of Washington Allston. Though now better remembered as the inventor of the

telegraph, he was a founder and first President of the National Academy of Design. The occasion for the present text was a published address by the painter John Trumbull, President of the American Academy of Fine Arts, in which the founders of the National Academy were described as secessionists from the more established body and were accused of creating a schism. (See the previous text.) In his riposte, issued in 1833, Morse clearly equates the independent values of art with the republican vitality of America itself. By contrast he associates the American Academy with submission to the humiliating forms of old-world systems of patronage. Morse's 'examination' was printed by William Dunlap in a section on Academies in his *History of the Rise and Progress of the Arts of Design in the United States*, New York, published by the author in 1834, volume III, pp. 130–1, from which this text is taken. Dunlap added the following rider: 'Let the general reader pass over the chapters on academies, but let the lover of the arts peruse them carefully, and he will never again ask the question, "Why do not the two institutions unite?" or listen to assertions, that the artists who form and govern the National Academy of Design are "*disorganizers*," or "*seceders*," from an academy of which they were members, or dissatisfied persons who desired to possess property belonging to others.' Dunlap also took the opportunity to note that the artists of Philadelphia had recently organized an Academy of Design, 'to be directed by artists, and composed of artists only'. (See IVв11.)

[. . .] On the first page of the address appears the following paragraph: 'It has been proved by all experience, and, indeed, it is a truism, that the *arts* cannot flourish, without patronage in some form; it is manifest, that *artists* cannot interchangeably purchase the works of each other and prosper; they are necessarily dependent upon the protection of the rich and the great. In this country there is no sovereign who can establish and endow academies, etc.'

Let us see how this paragraph will read by substituting *literature* for the *arts*; for it is as applicable to the one as the other. It is a truism, that *literature* cannot flourish without patronage in some form; it is manifest, that *authors* cannot interchangeably purchase the works of each other and prosper; they are necessarily dependent on the protection of the rich and the great, etc. All this is as true of *authors* as of *artists*: now let me ask of any author, what kind of *patronage* he seeks from the *rich* and the *great*? What sort of *dependence* he has on them for *protection* in this country, since there is no *sovereign* to whom he can look for *protection*, no aristocracy on which he can depend for *patronage*? Is there a man of independent feelings, of whatever profession he may be, who does not feel disgust at language like this? And is it to be supposed that the artists of the country are so behind the sentiments of their countrymen, as not to spurn any *patronage* or *protection* that takes such a shape as this? – The artist, poor, helpless thing, must learn to *boo* and *boo* in the halls and antechambers of my lord, implore his lordship's protection, advertise himself painter to his majesty or his royal highness, boast over his fellows, because he has his grace for a patron, and think himself well off if he may be permitted[1] to come in at the back door of his patron's gallery.

If there are any who desire to have such a patronizing institution as this – if there are artists who desire to be thus *protected* and thus *dependent*, it is a free country, and there is room for all; every man to his taste; – but the artists of the National Academy have some sense of character to be deadened, some pride of profession to be humbled, some aspirings after excellence in art to be brought down, some of the independent

spirit of their country to lose, before they can be bent to the purposes of such an anti-republican institution. In making these remarks on the language and sentiments of the address, I disclaim identifying them with those of the stockholders of the American Academy. I know not that there are any who have imbibed such degrading notions of the arts, or such contemptuous opinions of artists; if there are, we wish them to rally round just such a tree as the sentiments of the address would nurture. We believe that our climate is uncongenial to the growth of such an aristocratic plant; and that the public will not be long in deciding whether such an institution, or the National Academy, is most in harmony with the independent character of the country.

I come now to speak of the *fundamental cause* of the collisions between the two academies; collisions which, it is to be feared, will often recur, until this *cause* shall be removed. It lies in the *name* of *Academy of Arts*, given at its formation to the American Academy of Fine Arts. It was not an Academy of Arts, and could not be, for it wanted the *essential quality* of an Academy of Arts, viz., *a body of artists to control its concerns*; and no provision is made in its constitution, to give it into the hands of artists at a future period. Every Academy of Arts in the world is exclusively under the control of artists, who elect into their own body, choose their own officers, and manage the entire concerns of the Academy; subject only, in aristocratic and despotic countries, to the approval or disapproval of the king or emperor, and even in England the monarch, the *patron*, has yielded to the will of the artist.[2]

[1] 'All artists *shall be permitted* to exhibit their works. Amateurs *shall be invited* to expose their performances.' [*Laws of the American Academy of Fine Arts.*]

[2] An anecdote of an occurrence, not long ago, in the Royal Academy of London will well illustrate the kind of control in that monarchical country, which the king exercises over the artists. Sir Thomas Lawrence's death occasioned the vacancy of the presidential chair of the Royal Academy. – The king (George IV), desirous of seeing the celebrated Wilkie elevated to the vacant seat, hinted his wishes, in a tone a little too dictatorial to the academicians. The academicians, feeling that their independence was attacked, and although Wilkie was a deserved favourite with them all, and but for the officiousness of the king would have been their choice, immediately elected Sir M. A. Shee their president, who still fills the chair with honour to himself and to the Academy. So strong was public opinion in favour of this act of independence, that the king ratified their choice.

4 Søren Kierkegaard (1813–1855) Journal Entry, 1 August 1835

The Danish philosopher and religious thinker Søren Kierkegaard is widely regarded as a precursor of modern existentialism, because of the way he placed the category of the individual and the paradoxical demands of human freedom at the centre of his thought. Born in Copenhagen, he read theology at the university but constantly deferred entering the ministry. He produced a large number of highly unorthodox critical and philosophical works, many written under an elaborate sequence of *noms de plume* (see IID10, below). However, from 1834 until shortly before his death at the age of 42, Kierkegaard also kept an extensive private journal. This contains many of his most important insights and reflections and represents a significant part of his life's work. In the entry reprinted here, written in Gilleleie in Denmark on 1 August 1835, Kierkegaard identifies the problem of realizing one's own authentic possibilities as a human being as something prior to and more fundamental than the pursuit of 'objective truth' and the 'life of the understanding'. He takes up the Socratic motto 'Know thyself', but provides it with a deeper and more

subjective interpretation, recognizing individuality as a task to be realized on the basis of discovering what is true for oneself. The present extract is taken from *The Journals of Kierkegaard 1834–1854*, translated and edited by Alexander Dru, London New York and Toronto: Oxford University Press, 1938, pp. 15–20.

What I really lack is to be clear in my mind *what I am to do*,[1] not what I am to know, except in so far as a certain understanding must precede every action. The thing is to understand myself, to see what God really wishes *me* to do; the thing is to find a truth which is true *for me*, to find *the idea for which I can live and die*. What would be the use of discovering so-called objective truth, of working through all the systems of philosophy and of being able, if required, to review them all and show up the inconsistencies within each system; – what good would it do me to be able to develop a theory of the state and combine all the details into a single whole, and so construct a world in which I did not live, but only held up to the view of others; – what good would it do me to be able to explain the meaning of Christianity if it had *no* deeper significance *for me and for my life*; – what good would it do me if truth stood before me, cold and naked, not caring whether I recognized her or not, and producing in me a shudder of fear rather than a trusting devotion? I certainly do not deny that I still recognize an *imperative of understanding* and that through it one can work upon men, *but it must be taken up into my life*, and *that is* what I now recognize as the most important thing. That is what my soul longs after, as the African desert thirsts for water. That is what I lack, and that is why I am left standing like a man who has rented a house and gathered all the furniture and household things together, but has not yet found the beloved with whom to share the joys and sorrows of his life. But in order to find that idea, or better still, in order to find myself, it is no use throwing myself still further into life. And that is just what I have done hitherto. That is why I thought it would be a good thing to throw myself into the study of the law so as to develop my sharpness of mind in the complications of life. Here was a great mass of detail in which I could lose myself; here perhaps I might be able to work out a complete whole from given facts, an organum of theft, following up its darker side (and here a certain spirit of association is also extremely remarkable). I therefore wanted to be a barrister so that by putting myself in another man's role I could, as it were, find a substitute for my own life, and find distraction in outward change. That was what I lacked in order to be able *to lead a complete human life* and not merely one of the understanding,[2] so that I should not, in consequence, base the development of my thought upon – well, upon something that is called objective – something that is in any case not my own, but upon something which grows together with the deepest roots of my life, through which I am so to speak, grafted upon the divine, hold fast to it, even though the whole world fell apart. *That is what I lack and that is what I am striving after*. It is with joy, and inwardly strengthened, that I contemplate those great men who have thus found the precious stone, for the sake of which they sell all, even their lives, whether I see them intervene forcefully in life, and without faltering go forward on the path marked out for them, or discover them remote from the highway, absorbed in themselves and in working for their noble aim. And I look with reverence even upon the errors which lie so near by. It is this divine side of man, his inward action which means everything, not a mass of information; for that will certainly follow and then all that knowledge

will not be a chance assemblage, or a succession of details, without system and without a focusing point. I too have certainly looked for such a centre. I have looked in vain for an anchorage in the boundless sea of pleasure and in the depth of understanding; I have felt the almost irresistible power with which one pleasure reaches out its hand to the next; I have felt the kind of meretricious ecstasy that it is capable of producing, but also the *ennui* and the distracted state of mind that succeeds it. I have tasted the fruit of the tree of knowledge, and often delighted in its taste. But the pleasure did not outlast the moment of understanding and left no profound mark upon me. It seems as though I had not drunk from the cup of wisdom, but had fallen into it. I have searched with resignation for the principle of my life, by trying to believe that since all things proceeded according to unalterable laws things could not be otherwise, by dulling my ambition and the antennae of my vanity. And because I could not adapt everything to my own mind I withdrew, conscious of my own ability, rather like a worn out parson resigning with a pension. What did I find? Not my Self, which was what I was looking for (thinking of my soul, if I may so express it, as shut in a box with a spring-lock which external circumstances, by pressing upon the lock, were to open). – And so the first thing to be decided, was the seeking and finding of the Kingdom of Heaven. But just as a heavenly body, if we imagine it in the process of constituting itself, would not first of all determine how great its surface was to be and about which other body it was to move, but would first of all allow the centripetal and centrifugal forces to harmonize its existence, and then let the rest take its course – similarly, it is useless for a man to determine first of all the outside and afterwards fundamentals. One must know oneself before knowing anything else (γνῶθι σέαυτον). It is only after a man has thus understood himself inwardly, and has thus seen his way, that life acquires peace and significance; only then is he rid of that tiresome, ill-omened fellow-traveller, the irony of life,[3] which shows itself in the sphere of understanding, bidding true understanding begin with ignorance (Socrates) like God creating the world out of nothing. But it really belongs in the waters of morality, with those who are still not in the trade winds of virtue. There man is hurled about in the most terrifying fashion; at one moment it makes him happy and contented to go forward with set purpose along the right path, at the next it hurls him into the abyss of despair. Often it lulls him to sleep with the thought 'things cannot, after all, be otherwise', only to wake him suddenly to the severest of tests. Often it draws a veil of forgetfulness over the past only to make every trifle stand out once more in a vivid light. While he fights his way along that road and rejoices at having overcome temptation, there follows, perhaps at the very same moment and hot upon the most complete victory, some seemingly insignificant outward circumstance that thrusts him straight down from the summit of the rock like Sisyphus. Often when a man has concentrated all his strength upon something he comes across some little outward circumstance that annihilates everything. (For example: a man who is tired of life and wants to throw himself into the Thames and is stopped at the decisive moment by the sting of a gnat.) Like consumption it often suffers a man to feel at his very best when he is at his worst. In vain he turns against it; he has not the strength, and the fact that he has so often been through the same experience is no help to him; it is not the kind of experience he acquires in that way which matters. Just as no one, however much experience of swimming he may have, could keep afloat in a storm, but only a man who was absolutely convinced from

experience that he was lighter than water, in the same way the man who has no inward hold on life cannot keep afloat in life's storm. Only when a man has understood himself in that way is he in a position to carve out an independent existence and thus escape abandoning his self. How often we see – (at a time when we praise the Greek historian to the skies who knew how to copy a foreign style with the most baffling likeness to the original, instead of censuring him because an author's most prized quality is always to have a personal style, i.e. a mode of expression and presentation shaped by his own individuality) – how often we see people who either from indolence of mind live on the crumbs that fall from the tables of others, or for more selfish reasons familiarize themselves with the lives of others, and finally, like the liar by the frequent repetition of his stories, believe them. Although I am still far from having reached so complete an understanding of myself, I have, with profound respect for its significance, tried to preserve my individuality – worshipped the unknown God. Warned by a premature apprehension I have tried to avoid coming in too close contact with those phenomena whose power of attraction would perhaps exercise too great an influence upon me. I have tried to master them, studied them individually and examined their importance in men's lives, but at the same time guarded against going, like the moth, too near the flame. I have had but little to win or lose from the ordinary run of men. Partly because everything which occupies them – so-called practical life – only interests me slightly; partly because the coldness and lack of interest with which they treat the more profound and spiritual emotions in man have estranged me still further. With few exceptions my associates have not exerted any particular influence upon me. A life which is not clear about itself inevitably displays an uneven surface; they have stopped short at particular facts and their apparent disharmony; they were not sufficiently interested in me to try to resolve them in a higher agreement or to perceive the inner necessity of it. Their opinion of me was therefore always one-sided, and I have, as a result, alternately laid too much, or too little weight upon their pronouncements. I have now withdrawn from their influence and their possibly misleading effect upon the compass of my life. And so I stand once again at the point where I must begin my life in a different way. I shall now try to fix a calm gaze upon myself and begin to act in earnest; for only thus shall I be able, like the child calling itself 'I' with its first conscious action, to call myself 'I' in any deeper sense.

But for that patience is necessary, and one cannot reap immediately where one has sown. I shall bear in mind the method of the philosopher who bade his disciples keep silence for three years after which time all would come right. One does not begin feasting at dawn but at sunset. And so too in the spiritual world it is first of all necessary to work for some time before the light bursts through and the sun shines forth in all its glory. For although it is said that God allows the sun to shine upon the good and the wicked, and sends down rain upon the just and the unjust, it is not so in the spiritual world. And so the die is cast – I cross the Rubicon! This road certainly leads me *to strife*; but I shall not give up. I will not grieve over the past – for why grieve? I will work on with energy and not waste time grieving, like the man caught in the quicksands who began by calculating how far down he had already sunk, forgetting that all the while he was sinking still deeper. I will hurry along the path I have discovered, greeting those whom I meet on my way, not looking back as did Lot's wife, but remembering that it is a hill up which we have to struggle.

1 How often, when one believes one has understood oneself best of all, one finds that one has caught the cloud
 instead of Juno.
2 For otherwise how near man is to madness, in spite of all his knowledge. What is truth but to live for an idea?
 Ultimately everything must rest upon a postulate; but the moment it is no longer outside him, and he lives in it,
 then and only then does it cease to be a postulate for him.
3 In a sense it remains with him even then, but he is able to bear the squalls of life; for the more completely a man
 lives for an idea the more easily does he end by basking in the admiration of the world. Often, too, a curious
 apprehensiveness obtrudes itself that just as one really hopes to have understood oneself best one has only
 learnt someone else's life by heart.

5 Anonymous, 'Women Artists'

L'Artiste was the principal art journal in France during the period of the Romantic move-
ment. The author of this text appears to have been male, the views it propounds being
entirely standard. While on the one hand offering patronizing encouragement to the
engagement of women artists in the lower genres and in craft-like activities, it effectively
warns them away from such strenuous masculine activities as history painting. The
implication is that those who pursue an exceptional independence in their careers are
liable to be greeted with more than mere disapproval. They risk categorization as sexual
libertines or monstrosities and consequent ostracism from polite society. This text was
originally published as 'Les Dames Artistes' in *L'Artiste*, volume 10, Paris, 1836, pp. 15–16,
from which source it has been translated for this volume by Jonathan Murphy.

While still waiting for that great day of general emancipation which they have so long
been promised, women are increasingly beginning to make public their capacities in
the arts. Their intellectual horizons, which were previously limited to light poetry or
novels, have grown to include the vast fields of painting and music. Music, which
today is the most popular art form, and also undoubtedly the most powerful one,
offers an almost unlimited freedom to women who manage to excel here. Music can
give a reputation which may not spread at the speed of light, but which could be said
to grow at the speed of sound, and such a reputation can soon echo around the
kingdoms and capitals of Europe. And this is not all: it can also lead to material wealth
to be envied by the lords of high finance, and profits greater than those to be made at
the stock exchange: profits greater even than those to be had by illegal means. In
short, to move with the spirit of the times, it is through music that the greatest
fortunes in the arts are to be made. But such advantage may bring disadvantage. The
musician herself must appear in theatres or at the very least in concert halls, and she
must expose her face and her bearing to the inquisitive glances of the people. She
must acknowledge the crowd, and bow for each round of applause which she receives.
She must, in short, shed some of that reticence which women have so much advantage
in retaining. It is not given to everyone to desire to, to be able to, or even to dare to run
the gauntlet of such judgement. Painting, by contrast, offers women fame and fortune
in a lesser measure, more slowly acquired, but it better suits those with family duties,
and those who are of a modest and retiring disposition. I refer not here to those who,
mistaking the vocation of their sex, are filled with the desire to be painters in the same
manner as men. Even if the noisy, over-familiar atmosphere of the studio itself were
not essentially antipathetic to the codes of decency imposed on women, their physical

weakness, and their shy and tender imagination would be confused in the presence of the large canvases, and of subjects either too free or too restricting, such as those which normally form the basis of great painting. The same limitations exist for women in all the arts. As musicians they perform best when singing, or playing the piano, or the harp, or when expressing their heartfelt emotions through the composing of romances. But their talents are not best served by an attempting to take on the rigours of composition. The genius of Mozart and Beethoven will find no more rival in the future than it has in the past. Similarly, in painting, artists who have most to fear from comparison with the fairer sex will more likely be in the line of Petitot than in that of Rubens.

The same is demonstrated if one examines the history of literature by women. In the other arts they should follow the route parallel to that taken by Madame de Lafayette, Madame de Sévigné and Madame de Cottin in French literature. In gaining the right to be noted as an exception to their sex, they have too much to lose of the graces with which nature has endowed them. One cannot of course go so far as to forbid this, but a woman wishing to mark her work with that masculine stamp which Madame de Staël put upon her own work exposes herself to the dubious compliment of having managed to suppress the female side of her character. In painting women only have an indisputable talent for landscape, interior scenes, pastel, watercolour, portrait painting and, above all, for miniature, which perhaps should be reserved for they alone. The possibilities, then, are often considerable, and there is much scope for original contributions.

Neither should one forget painting on porcelain. This of course is not a separate genre in its own right, but it is one which has the precious advantage of affording an occasion to exercise skill in many different styles. The large-scale painting which we would forbid women can be brought within their grasp by copying on porcelain. This is a type of work requiring intelligence, delicacy and attention, most befitting to their nature. The example of Madame Jacotot, who has made such beautiful copies of paintings by Raphael, demonstrates that here women are capable of what we may consider to be genuine art. But this is a career that the poor taste of our century has almost abolished, and with the exception of a few rare copies done at the factories of Sèvres, or of a few vases to be decorated with fruits and flowers for private industry, painting on porcelain today has nothing to offer. The rest is mere illustration, inferior in its taste and execution to that of fabric and wallpaper

* * *

One female artist, whose reputation is well founded, Mlle Gérard, exhibits portraits in pastel each year in the Louvre demonstrating how this type of painting, rediscovered by Henriquel-Dupont and Giraud, befits the talent of women. Since one is speaking here of an exhibition, it would be most fitting to mention if not all the women who are exhibiting this season, at the very least those who are worthy of note, but unfortunately time and space dictate otherwise. Such a critique will take place when the salon itself is opened to the public. Suffice it to say that each year the number of women exhibiting grows. One feels that one can now genuinely believe that from now on women will share with men the genres which are most fitting to their abilities, such as still-life, landscape and portraiture. As regards miniature, one could perhaps say, when faced with the ardour and success with which women are applying

themselves in this domain, that it will soon be theirs alone. Any success is worthy of recognition, and women must surely be encouraged in any excursion that they make outside of the limits imposed upon them. One should never demand that a woman surpass her limitations; but any great achievement should receive its just reward.

6 Ralph Waldo Emerson (1803–1882) 'Beauty' from *Nature*

Emerson's *Nature* is one of a trio of works – the others being 'The American Scholar' (IIA5), and his Address to the Divinity School at Harvard of 1838 – which articulate his philosophy of individualism and self-sufficiency, rooted in humankind's unity with nature. This philosophy represented the resolution of a crisis of faith brought on by Emerson's break with orthodox Christianity in the early 1830s. As such it formed the cornerstone of his influence on subsequent American thought. Chapter III, 'Beauty', follows, and is drawn in contrast to Chapter II, 'Commodity'. Nature is seen as the source of both. Commodities, however, are in Emerson's words 'temporary and mediate'. Nature provides the basic resources for human life, and what Emerson calls 'the useful arts' – trade, inventions, technology and so forth – are amplifications of nature's basic, life-sustaining power. The useful arts serve humanity's material needs; commodities are the means to an end. But for Emerson humanity also has other needs. These are 'ultimate' rather than 'mediate', and concern the soul rather than the body. As he puts it, introducing Chapter III, 'A nobler want of man is served by nature, namely the love of Beauty'. Beauty, in contrast to Commodity, is an end in itself. The present text is that of the original 1836 edition as reprinted in Emerson's *Nature: Origin, Growth, Meaning*, edited by Merton M. Sealts, Jr, and Alfred R. Ferguson, Carbondale and Edwardsville: South Illinois University Press, 1969, pp. 11–14.

[. . .] The ancient Greeks called the world $\kappa o\sigma\mu o\varsigma$, beauty. Such is the constitution of all things, or such the plastic power of the human eye, that the primary forms, as the sky, the mountain, the tree, the animal, give us a delight *in and for themselves*; a pleasure arising from outline, colour, motion, and grouping. This seems partly owing to the eye itself. The eye is the best of artists. By the mutual action of its structure and of the laws of light, perspective is produced, which integrates every mass of objects, of what character soever, into a well coloured and shaded globe, so that where the particular objects are mean and unaffecting, the landscape which they compose, is round and symmetrical. And as the eye is the best composer, so light is the first of painters. There is no object so foul that intense light will not make beautiful. And the stimulus it affords to the sense, and a sort of infinitude which it hath, like space and time, make all matter gay. Even the corpse hath its own beauty. But beside this general grace diffused over nature, almost all the individual forms are agreeable to the eye, as is proved by our endless imitations of some of them, as the acorn, the grape, the pine-cone, the wheat-ear, the egg, the wings and forms of most birds, the lion's claw, the serpent, the butterfly, sea-shells, flames, clouds, buds, leaves, and the forms of many trees, as the palm.

For better consideration, we may distribute the aspects of Beauty in a threefold manner.

1. First, the simple perception of natural forms is a delight. The influence of the forms and actions in nature, is so needful to man, that, in its lowest functions, it seems to lie on the confines of commodity and beauty. To the body and mind which have

been cramped by noxious work or company, nature is medicinal and restores their tone. The tradesman, the attorney comes out of the din and craft of the street, and sees the sky and the woods, and is a man again. In their eternal calm, he finds himself. The health of the eye seems to demand a horizon. We are never tired, so long as we can see far enough.

But in other hours, Nature satisfies the soul purely by its loveliness, and without any mixture of corporeal benefit. I have seen the spectacle of morning from the hilltop over against my house, from day-break to sun-rise, with emotions which an angel might share. The long slender bars of cloud float like fishes in the sea of crimson light. From the earth, as a shore, I look out into that silent sea. I seem to partake its rapid transformations: the active enchantment reaches my dust, and I dilate and conspire with the morning wind. How does Nature deify us with a few and cheap elements! Give me health and a day, and I will make the pomp of emperors ridiculous. The dawn is my Assyria; the sun-set and moon-rise my Paphos, and unimaginable realms of faerie; broad noon shall be my England of the senses and the understanding; the night shall be my Germany of mystic philosophy and dreams. [. . .]

The inhabitants of cities suppose that the country landscape is pleasant only half the year. I please myself with observing the graces of the winter scenery, and believe that we are as much touched by it as by the genial influences of summer. To the attentive eye, each moment of the year has its own beauty, and in the same field, it beholds, every hour, a picture which was never seen before, and which shall never be seen again. The heavens change every moment, and reflect their glory or gloom on the plains beneath. The state of the crop in the surrounding farms alters the expression of the earth from week to week. The succession of native plants in the pastures and roadsides, which make the silent clock by which time tells the summer hours, will make even the divisions of the day sensible to a keen observer. The tribes of birds and insects, like the plants punctual to their time, follow each other, and the year has room for all. By water-courses, the variety is greater. In July, the blue pontederia or pickerel-weed blooms in large beds in the shallow parts of our pleasant river, and swarms with yellow butterflies in continual motion. Art cannot rival this pomp of purple and gold. Indeed the river is a perpetual gala, and boasts each month a new ornament.

But this beauty of Nature which is seen and felt as beauty, is the least part. The shows of day, the dewy morning, the rainbow, mountains, orchards in blossom, stars, moonlight, shadows in still water, and the like, if too eagerly hunted, become shows merely, and mock us with their unreality. Go out of the house to see the moon, and 't is mere tinsel; it will not please as when its light shines upon your necessary journey. The beauty that shimmers in the yellow afternoon of October, who ever could clutch it? Go forth to find it, and it is gone: 't is only a mirage as you look from windows of diligence.

2. The presence of a higher, namely, of the spiritual element is essential to its perfection. The high and divine beauty which can be loved without effeminacy, is that which is found in combination with the human will, and never separate. Beauty is the mark God sets upon virtue. Every natural action is graceful. Every heroic act is also decent, and causes the place and the bystanders to shine. We are taught by great actions that the universe is the property of every individual in it. Every rational

creature has all nature for his dowry and estate. It is his, if he will. He may divest himself of it; he may creep into a corner, and abdicate his kingdom, as most men do, but he is entitled to the world by his constitution. In proportion to the energy of his thought and will, he takes up the world into himself. 'All those things for which men plough, build, or sail, obey virtue;' said an ancient historian. 'The winds and waves,' said Gibbon, 'are always on the side of the ablest navigators.' So are the sun and moon and all the stars of heaven. When a noble act is done, – perchance in a scene of great natural beauty; when Leonidas and his three hundred martyrs consume one day in dying, and the sun and moon come each and look at them once in the steep defile of Thermopylae; when Arnold Winkelried, in the high Alps, under the shadow of the avalanche, gathers in his side a sheaf of Austrian spears to break the line for his comrades; are not these heroes entitled to add the beauty of the scene to the beauty of the deed? When the bark of Columbus nears the shore of America; – before it, the beach lined with savages, fleeing out of all their huts of cane; the sea behind; and the purple mountains of the Indian Archipelago around, can we separate the man from the living picture? Does not the New World clothe his form with her palm-groves and savannahs as fit drapery? Ever does natural beauty steal in like air, and envelope great actions. When Sir Harry Vane was dragged up the Tower-hill, sitting on a sled, to suffer death, as the champion of the English laws, one of the multitude cried out to him, 'You never sate on so glorious a seat.' Charles II., to intimidate the citizens of London, caused the patriot Lord Russel to be drawn in an open coach, through the principal streets of the city, on his way to the scaffold. 'But,' to use the simple narrative of his biographer, 'the multitude imagined they saw liberty and virtue sitting by his side.' In private places, among sordid objects, an act of truth or heroism seems at once to draw to itself the sky as its temple, the sun as its candle. Nature stretcheth out her arms to embrace man, only let his thoughts be of equal greatness. Willingly does she follow his steps with the rose and the violet, and bend her lines of grandeur and grace to the decoration of her darling child. Only let his thoughts be of equal scope, and the frame will suit the picture. A virtuous man is in unison with her works, and makes the central figure of the visible sphere. Homer, Pindar, Socrates, Phocion, associate themselves fitly in our memory with the whole geography and climate of Greece. The visible heavens and earth sympathize with Jesus. And in common life, whosoever has seen a person of powerful character and happy genius, will have remarked how easily he took all things along with him, – the persons, the opinions, and the day, and nature became ancillary to a man.

3. There is still another aspect under which the beauty of the world may be viewed, namely, as it becomes an object of the intellect. Beside the relation of things to virtue, they have a relation to thought. The intellect searches out the absolute order of things as they stand in the mind of God, and without the colours of affection. The intellectual and the active powers seem to succeed each other in man, and the exclusive activity of the one, generates the exclusive activity of the other. There is something unfriendly in each to the other, but they are like the alternate periods of feeding and working in animals; each prepares and certainly will be followed by the other. Therefore does beauty, which, in relation to actions, as we have seen, comes unsought, and comes because it is unsought, remain for the apprehension and pursuit of the intellect; and then again, in its turn, of the active power. Nothing divine dies.

All good is eternally reproductive. The beauty of nature reforms itself in the mind, and not for barren contemplation, but for new creation.

All men are in some degree impressed by the face of the world. Some men even to delight. This love of beauty is Taste. Others have the same love in such excess, that, not content with admiring, they seek to embody it in new forms. The creation of beauty is Art.

The production of a work of art throws a light upon the mystery of humanity. A work of art is an abstract or epitome of the world. It is the result or expression of nature, in miniature. For although the works of nature are innumerable and all different, the result or the expression of them all is similar and single. Nature is a sea of forms radically alike and even unique. A leaf, a sun-beam, a landscape, the ocean, make an analogous impression on the mind. What is common to them all, – that perfectness and harmony, is beauty. Therefore the standard of beauty is the entire circuit of natural forms, – the totality of nature; which the Italians expressed by defining beauty 'il piu nell' uno' [the most in one]. Nothing is quite beautiful alone: nothing but is beautiful in the whole. A single object is only so far beautiful as it suggests this universal grace. The poet, the painter, the sculptor, the musician, the architect, seek each to concentrate this radiance of the world on one point, and each in his several work to satisfy the love of beauty which stimulates him to produce. Thus in Art, is nature passed through the alembic of man. Thus in art, does nature work through the will of a man filled with the beauty of her first works.

The world thus exists to the soul to satisfy the desire of beauty. Extend this element to the uttermost, and I call it an ultimate end. No reason can be asked or given why the soul seeks beauty. Beauty, in its largest and profoundest sense, is one expression for the universe. God is the all-fair. Truth, and goodness, and beauty, are but different faces of the same All. But beauty in nature is not ultimate. It is the herald of inward and eternal beauty, and is not alone a solid and satisfactory good. It must therefore stand as a part and not as yet the last or highest expression of the final cause of Nature.

7 Edgar Allan Poe (1809–1849) from *The Man of the Crowd*

After youthful failures at university and in the army, Edgar Poe made a literary reputation as a poet, story writer and editor during the 1830s in the major eastern cities of the United States. Poe's literary production is renowned for its evocation of the fantastic and supernatural. But he also evoked the uncanny as it revealed itself in ordinary life. This appealed to Baudelaire, who translated some of his work into French, and produced two critical studies of his work and character. Poe was one of the first to sense the alienation at the heart of modernity. Whereas critics like Engels (cf. IID11) described the crowd in sociological terms, Poe seemed to accord his crowd a psychology. In the present extract from *The Man of the Crowd*, Poe describes and classifies the urban mass in a way which suggests Walter Benjamin's later description of the flaneur as 'botanizing on the asphalt'. The story was originally published in *Graham's Magazine*, New York, 1840. The present text is taken from Poe's *Tales of Mystery and Imagination*, Everyman edition (1908), reprinted and edited with an introduction by Graham Clarke, London: Dent, 1993, pp. 107–12.

Ce grand malheur, de ne pouvoir être seul. – La Bruyère

[...] Not long ago, about the closing in of an evening in autumn, I sat at the large bow window of the D—— Coffee House in London. [...] With a cigar in my mouth and a newspaper in my lap, I had been amusing myself for the greater part of the afternoon, now in poring over advertisements, now in observing the promiscuous company in the room, and now in peering through the smoky panes into the street.

This latter is one of the principal thoroughfares of the city, and had been very much crowded during the whole day. But, as the darkness came on, the throng momently increased; and, by the time the lamps were well lighted, two dense and continuous tides of population were rushing past the door. At this particular period of the evening I had never before been in a similar situation, and the tumultuous sea of human heads filled me, therefore, with a delicious novelty of emotion. I gave up, at length, all care of things within the hotel, and became absorbed in contemplation of the scene without.

At first my observations took an abstract and generalizing turn. I looked at the passengers in masses, and thought of them in their aggregate relations. Soon, however, I descended to details, and regarded with minute interest the innumerable varieties of detail, dress, air, gait, visage, and expression of countenance.

By far the greater number of those who went by had a satisfied business-like demeanour, and seemed to be thinking only of making their way through the press. Their brows were knit, and their eyes rolled quickly; when pushed against by fellow-wayfarers they evinced no symptom of impatience, but adjusted their clothes and hurried on. Others, still a numerous class, were restless in their movements, had flushed faces, and talked and gesticulated to themselves, as if feeling in solitude on account of the very denseness of the company around. When impeded in their progress, these people suddenly ceased muttering, but redoubled their gesticulations, and awaited, with an absent and overdone smile upon the lips, the course of the persons impeding them. If jostled, they bowed profusely to the jostlers, and appeared overwhelmed with confusion. – There was nothing very distinctive about these two large classes beyond what I have noted. Their habiliments belonged to that order which is pointedly termed the decent. They were undoubtedly noblemen, merchants, attorneys, tradesmen, stock-jobbers – the Eupatrids and the commonplaces of society – men of leisure and men actively engaged in affairs of their own – conducting business upon their own responsibility. They did not greatly excite my attention.

The tribe of clerks was an obvious one; and here I discerned two remarkable divisions. There were the junior clerks of flash houses – young gentlemen with tight coats, bright boots, well-oiled hair, and supercilious lips. Setting aside a certain dapperness of carriage, which may be termed *deskism* for want of a better word, the manner of these persons seemed to me an exact fac-simile of what had been the perfection of *bon ton* about twelve or eighteen months before. They wore the cast-off graces of the gentry; – and this, I believe, involves the best definition of the class.

The division of the upper clerks of staunch firms, or of the 'steady old fellows', it was not possible to mistake. These were known by their coats and pantaloons of black or brown, made to sit comfortably, with white cravats and waistcoats, broad

solid-looking shoes, and thick hose or gaiters. – They had all slightly bald heads, from which the right ears, long used to pen-holding, had an odd habit of standing off on end. I observed that they always removed or settled their hats with both hands, and wore watches, with short gold chains of a substantial and ancient pattern. Theirs was the affectation of respectability; – if indeed there be an affectation so honourable.

There were many individuals of dashing appearance, whom I easily understood as belonging to the race of swell pick-pockets, with which all great cities are infested. I watched these gentry with much inquisitiveness, and found it difficult to imagine how they should ever be mistaken for gentlemen by gentlemen themselves. Their voluminousness of wristband, with an air of excessive frankness, should betray them at once.

The gamblers, of whom I described not a few, were still more easily recognizable. They wore every variety of dress, from that of the desperate thimble-rig bully, with velvet waistcoat, fancy neckerchief, gilt chains, and filigreed buttons, to that of the scrupulously inornate clergyman than which nothing could be less liable to suspicion. Still all were distinguished by a certain sodden swarthiness of complexion, a filmy dimness of eye, and pallor and compression of lip. There were two other traits, moreover, by which I could always detect them; – a guarded lowness of tone in conversation, and a more than ordinary extension of the thumb in a direction at right angles with the fingers. – Very often, in company with these sharpers, I observed an order of men somewhat different in habits, but still birds of a kindred feather. They may be defined as the gentlemen who live by their wits. They seem to prey upon the public in two battalions – that of the dandies and that of the military men. Of the first grade the leading features are long locks and smiles; of the second frogged coats and frowns.

Descending in the scale of what is termed gentility, I found darker and deeper themes for speculation. I saw Jew pedlars, with hawk eyes flashing from countenances whose every other feature wore only an expression of abject humility; sturdy professional street beggars scowling upon mendicants of a better stamp, whom despair alone had driven forth into the night for charity; feeble and ghastly invalids, upon whom death had placed a sure hand, and who sidled and tottered through the mob, looking every one beseechingly in the face, as if in search of some chance consolation, some lost hope; modest young girls returning from long and late labour to a cheerless home, and shrinking more tearfully than indignantly from the glances of ruffians, whose direct contact, even, could not be avoided; women of the town of all kinds and of all ages – the unequivocal beauty in the prime of her womanhood, putting one in mind of the statue in Lucian, with the surface of Parian marble, and the interior filled with filth – the loathsome and utterly lost leper in rags – the wrinkled, bejewelled, and paint-begrimed beldame, making a last effort at youth – the mere child of immature form, yet, from long association, an adept in the dreadful coquetries of her trade, and burning with a rabid ambition to be ranked the equal of her elders in vice; drunkards innumerable and indescribable – some in shreds and patches, reeling, inarticulate, with bruised visage and lack-lustre eyes – some in whole although filthy garments, with a slightly-unsteady swagger, thick sensual lips, and hearty-looking rubicund faces – others clothed in materials which had once been good, and which even now were scrupulously well brushed – men who walked with a more than naturally firm

and springy step, but whose countenances were fearfully pale, whose eyes hideously wild and red, and who clutched with quivering fingers, as they strode through the crowd, at every object which came within their reach; beside these, pie-men, porters, coal-heavers, sweeps; organ-grinders, monkey-exhibitors, and ballad-mongers, those who vended with those who sang; ragged artisans and exhausted labourers of every description, and all full of a noisy and inordinate vivacity which jarred discordantly upon the ear, and gave an aching sensation to the eye.

As the night deepened, so deepened to me the interest of the scene; for not only did the general character of the crowd materially alter (its gentler features retiring in the gradual withdrawal of the more orderly portion of the people, and its harsher ones coming out into bolder relief, as the late hour brought forth every species of infamy from its den), but the rays of the gas-lamps, feeble at first in their struggle with the dying day, had now at length gained ascendancy, and threw over everything a fitful and garish lustre. All was dark yet splendid – as that ebony to which has been likened the style of Tertullian.

The wild effects of the light enchained me to an examination of individual faces; and although the rapidity with which the world of light flitted before the window, prevented me from casting more than a glance upon each visage, still it seemed that, in my then peculiar mental state, I could frequently read, even in that brief interval of a glance, the history of long years. [. . .]

8 Edgar Allan Poe (1809–1849) from *The Colloquy of Monos and Una*

Written at a time when naturalism and the response to modernity were gaining ground in avant-garde ideology, Poe's spiritualist fantasy stands as a kind of missing link between an earlier Romantic sensibility and the Symbolism of the later century. Along with certain works by Delacroix and Baudelaire (see IIIA4; IIID5 and 6), Poe's writing sounds a note of resistance to the rhetoric of utility and 'progress'. In the present extract Monos and Una have just been reborn into Eternal Life, and Monos recalls the time of their death, the age of modernity. The text originally appeared in *Graham's Magazine*, no. 19, New York, 1841, pp. 52–5, and was subsequently published in Poe's *Tales*, New York, 1845, pp. 100–9. Our selection is taken from *The Complete Poetry and Selected Criticism of Edgar Allan Poe*, edited with an introduction by Allen Tate, New York: Meridian, 1968, pp. 276–85 (our extract from pp. 277–80).

[. . .] *Monos.* One word first, my Una, in regard to man's general condition at this epoch. You will remember that one or two of the wise among our forefathers – wise in fact, although not in the world's esteem – had ventured to doubt the propriety of the term 'improvement', as applied to the progress of our civilization. There were periods in each of the five or six centuries immediately preceding our dissolution, when arose some vigorous intellect, boldly contending for those principles whose truth appears now, to our disenfranchised reason, so utterly obvious – principles which should have taught our race to submit to the guidance of the natural laws, rather than attempt their control. At long intervals some master-minds appeared, looking upon each advance in practical science as a retro-gradation in the true utility. Occasionally the poetic

intellect – that intellect which we now feel to have been the most exalted of all – since those truths which to us were of the vague idea of the philosophic, and find in the mystic parable that tells of the tree of knowledge, and of its forbidden fruit, death-producing, a distinct intimation that knowledge was not meet for man in the infant condition of his soul. And these men – the poets – living and perishing amid the scorn of the 'utilitarians' – of rough pedants, who arrogated to themselves a title which could have been properly applied only to the scorned – these men, the poets, pondered piningly, yet not unwisely, upon the ancient days when our wants were not more simple than our enjoyments were keen – days when mirth was a word unknown, so solemnly deep-toned was happiness – holy, august and blissful days, when blue rivers ran undammed, between hills unhewn, into far forest solitudes, primaeval, odorous, and unexplored.

Yet these noble exceptions from the general misrule served but to strengthen it by opposition. Alas! we had fallen upon the most evil of all our evil days. The great 'Movement' – that was the cant term – went on: a diseased commotion, moral and physical. Art – the Arts – arose supreme, and, once enthroned, cast chains upon the intellect which had elevated them to power. Man, because he could not but acknowledge the majesty of Nature, fell into childish exultation at his acquired and still-increasing dominion over her elements. Even while he stalked a God in his own fancy, an infantine imbecility came over him. As might be supposed from the origin of his disorder, he grew infected with system, and with abstraction. He enwrapped himself in generalities. Among other odd ideas, that of universal equality gained ground; and in the face of analogy and of God – in despite of the loud warning voice of the laws of gradation so visibly pervading all things in Earth and Heaven – wild attempts at an omni-prevalent Democracy were made. Yet this evil sprang necessarily from the leading evil, Knowledge. Man could not both know and succumb. Meantime huge smoking cities arose, innumerable. Green leaves shrank before the hot breath of furnaces. The fair face of Nature was deformed as with the ravages of some loathsome disease. And methinks, sweet Una, even our slumbering sense of the forced and of the far-fetched might have arrested us here. But now it appears that we had worked out our own destruction in the perversion of our taste, or rather in the blind neglect of its culture in the schools. For, in truth, it was at this crisis that taste alone – that faculty which, holding a middle position between the pure intellect and the moral sense, could never safely have been disregarded – it was now that taste alone could have led us gently back to Beauty, to Nature, and to Life. But alas for the pure contemplative spirit and majestic intuition of Plato! Alas for the μουσική [mousikē: the arts of the Muses] which he justly regarded as an all-sufficient education for the soul! Alas for him and for it! – since both were so desperately needed when both were most entirely forgotten or despised.

Pascal, a philosopher whom we both love, has said, how truly! – 'que tout notre raisonnement se reduit à ceder au sentiment' [ultimately all our reasoning amounts to a yielding to sentiment]; and it was not impossible that the sentiment of the natural, had time permitted it, would have regained its old ascendancy over the harsh mathematical reason of the schools. But this thing was not to be. Prematurely induced by intemperance of knowledge, the old age of the world drew on. This the mass of mankind saw not, or, living lustily although unhappily, affected not to see. But, for

myself, the Earth's records had taught me to look for widest ruin as the price of highest civilization. I had imbibed a prescience of our Fate from comparison of China the simple and enduring, with Assyria the architect, with Egypt the astrologer, with Nubia, more crafty than either, the turbulent mother of all Arts. In history of these regions I met with a ray from the Future. The individual artificialities of the three latter were local diseases of the Earth, and in their individual overthrows we had seen local remedies applied; but for the infected world at large I could anticipate no regeneration save in death. That man, as a race, should not become extinct, I saw that he must be 'born again.'

And now it was, fairest and dearest, that we wrapped our spirits, daily, in dreams. Now it was that, in twilight, we discoursed of the days to come, when the Art-scarred surface of the Earth, having undergone that purification which alone could efface its rectangular obscenities, should clothe itself anew in the verdure and the mountain-slopes and the smiling waters of Paradise, and be rendered at length a fit dwelling-place for man: – for man the Death-purged – for man to whose now exalted intellect there should be poison in knowledge no more – for the redeemed, regenerated, blissful, and now immortal, but still for the material, man. [. . .]

9 Horatio Greenough (1805–1852) 'Remarks on American Art'

Greenough graduated from Harvard in 1825 and left immediately for Rome and thence Florence, where he pursued a career as a sculptor of statuary in the classical mould. He retained contact with American artists, remained determinedly patriotic, and received his most important commissions from the US government, but he did not finally return to Boston until two years before his death. The following essay was first published in *The United States Magazine and Democrat's Review*, July 1843. Though Greenough was conservative in his work and in certain of his views, like Dunlap, Morse and Cole, he was emphatic in his belief that the American artist stood to gain by freedom from academic prescription and from patronage. The essay was reprinted in Greenough's collection *Travels, Observations and Experiences of a Yankee Stonecutter*, published under the pseudonym Horace Bender, New York: G. P. Putnam, 1852, pp. 116–26. The present text is taken from the facsimile of that edition, Gainesville, Florida: Scholars Facsimiles and Reprints, 1958.

The susceptibility, the tastes, and the genius which enable a people to enjoy the Fine Arts, and to excel in them, have been denied to the Anglo-Americans, not only by European talkers, but by European thinkers. The assertion of our obtuseness and inefficiency in this respect, has been ignorantly and presumptuously set forth by some persons, merely to fill up the measure of our condemnation. Others have arrived at the same conclusion, after examining our political and social character, after investigating our exploits and testing our capacities. They admit that we trade with enterprise and skill, that we build ships cunningly and sail them well, that we have a quick and far-sighted apprehension of the value of a territory, that we make wholesome home-spun laws for its government, and that we fight hard when molested in any of these homely exercises of our ability; but they assert that there is a stubborn, antipoetical tendency in all that we do, or say, or think; they attribute our very excellence in the ordinary business of life, to causes which must prevent our development as artists.

Enjoying the accumulated result of the thought and labour of centuries, Europe has witnessed our struggles with the hardships of an untamed continent, and the disadvantages of colonial relations, with but a partial appreciation of what we aim at, with but an imperfect knowledge of what we have done. Seeing us intently occupied during several generations in felling forests, in building towns, and constructing roads, she thence formed a theory that we are good for nothing except these pioneer efforts. She taunted us, because there were no statues or frescoes in our log-cabins; she pronounced us unmusical, because we did not sit down in the swamp with an Indian on one side, and a rattlesnake on the other, to play the violin. That she should triumph over the deficiencies of a people who had set the example of revolt and republicanism, was natural; but the reason which she assigned for those deficiencies was not the true reason. She argued with the depth and the sagacity of a philosopher who should conclude, from seeing an infant imbibe with eagerness its first aliment, that its whole life would be occupied in similar absorption. [. . .]

It is true, that before the Declaration of Independence, Copley had in Boston formed a style of portrait which filled Sir Joshua Reynolds with astonishment; and that West, breaking through the bar of Quaker prohibition, and conquering the prejudice against a provincial aspirant, had taken a high rank in the highest walk of art in London. Stuart, Trumbull, Allston, Morse, Leslie, Newton followed in quick succession, while Vanderlyn won golden opinions at Rome, and bore away high honours at Paris. So far were the citizens of the Republic from showing a want of capacity for art, that we may safely affirm, that the bent of their genius was rather peculiarly in that direction, since the first burins of Europe were employed in the service of the American pencil, before Irving had written, and while Cooper was yet a child. That England, with these facts before her, should have accused us of obtuseness in regard to art, and that we should have pleaded guilty to the charge, furnishes the strongest proof of her disposition to underrate our intellectual powers, and of our own ultra docility and want of self-reliance. [. . .]

Since that period art has received a new impulse among us. Artists have arisen in numbers; the public gives its attention to their productions; their labours are liberally rewarded. It seems now admitted that wealth and cultivation are destined to yield in America the same fruits that they have given in Italy, in Spain, in France, Germany and England. It seems now admitted that there is no anomalous defect in our mental endowments; that the same powers displayed in clearing the forest and tilling the farm, will trim the garden. It seems clear that we are destined to have a school of art. It becomes a matter of importance to decide how the youth who devote themselves to these studies are to acquire the rudiments of imitation, and what influences are to be made to act upon them. This question seemed at one time to have been decided. The friends of art in America looked to Europe for an example, and with the natural assumption that experience had made the old world wise in what relates to the fine arts, determined upon forming Academies as the more refined nations of the continent have ended by doing. We might as well have proposed a national church establishment. That the youth must be taught is clear – but in framing an institution for that object, if we look to countries grown old in European systems, it must be for warning rather than example. We speak from long experience and much observation of European Academies. We entertain the highest respect for the professional ability and for the personal character of the gentle-

men who preside over those institutions. Nay, it is our conviction of their capacity and of their individual willingness to impart knowledge, which forces upon us the opinion of the rottenness of the systems of which they are the instruments.

De Tocqueville remarks upon the British aristocracy, that, notwithstanding their sagacity as a body, and their integrity and high-toned character as individuals, they have gradually absorbed everything and left the people nothing; while he declares the American *employés*, though they are sometimes defaulters and dishonest, yet, after all, get little beyond their dues, and are obliged to sacrifice both reputation and self-respect in order to obtain that little. Those who direct the Academies of Fine Arts in Europe, are prone to take an advantage of their position analogous to that enjoyed by the aforesaid aristocracy. As the latter come to regard the mass as a flock to be fed, and defended, and cherished, for the sake of their wool and mutton, so the former are not slow to make a band of educandi the basis of a hierarchy. Systems and manner soon usurp the place of sound precept. Faith is insisted on rather than works. The pupils are required to be not only docile but submissive. They are not free.

To minds once opened to the light of knowledge, an adept may speak in masses, and the seed will fall on good ground; but to awaken a dormant soul, to impart first principles, to watch the budding of the germ of rare talent, requires a contact and relations such as no professor can have with a class, such as few men can have with any boy. If Europe must furnish a model of artistical tuition, let us go at once to the records of the great age of art in Italy, and we shall there learn that Michael Angelo and Raphael, and their teachers also, were formed without any of the cumbrous machinery and mill-horse discipline of a modern Academy. They were instructed, it is true; they were apprenticed to painters. Instead of passively listening to an experienced proficient merely, they discussed with their fellow students the merits of different works, the advantages of rival methods, the choice between contradictory authorities. They formed one another. Sympathy warmed them, opposition strengthened, and emulation spurred them on. [. . .]

The president and the professors of an Academy are regarded by the public as, of course, at the head of their respective professions. Their works are models, their opinions give the law. The youth are awed and dazzled by their titles and their fame; the man of genius finds them arrayed in solid phalanx to combat his claim. In those countries where a court bestows all encouragement, it is found easy to keep from those in power all knowledge of a dangerous upstart talent. How far this mischievous influence can be carried may be gathered from the position in which Sir Joshua Reynolds and *his court* managed to keep men like Wilson and Gainsborough. He who sees the productions of these men in company with those of their contemporaries, and who remembers the impression which Sir Joshua's writings had conveyed of their standing as artists, will perceive with surprise that they were not the victims of any overt act of misrepresentation, but that they were quietly and gently praised out of the rank due to them into an inferior one, by a union of real talent, constituted influence, and a sly, cool, consistent management.

Many of the ablest painters and sculptors of Europe have expressed to us directly and frankly the opinion that Academies, furnished though they be with all the means to form the eye, the hand, and the mind of the pupil, are positively hindrances instead of helps to art.

The great element of execution, whether in painting or in sculpture, is imitation. This is the language of art. Almost all clever boys can learn this to a degree far beyond what is supposed. That objects be placed before them calculated to attract their attention and teach them the rules of proportion, while they educate the eye to form and colour, no one will dispute; but the insisting upon a routine, the depriving them of all choice or volition, the giving a false preference to readiness of hand over power of thought, all these are great evils, and we fully believe that they fall with a withering force on those minds especially whose nourishment and guidance they were intended to secure [. . .]

Leonardo da Vinci coiled a rope in his studio, and drew from it, with the subtlest outline and the most elaborate study of light and shade. 'Behold!' said he, 'my academy!' He meant to show that the elements of art can be learned without the pompous array of the antique school or the lectures of the professor. Few will be tempted to follow his example; but even that were far better than a routine of instruction which, after years of drudgery and labour, sends forth the genius and the block-head so nearly on a level with each other, the one manacled with precepts, the other armed with them at all points.

The above reflections have been drawn from us by the oft-repeated expressions of regret which we have listened to, 'that from the constitution of our society, and the nature of our institutions, no influences can be brought to bear upon art with the vivifying power of court patronage.' We fully and firmly believe that these institutions are more favourable to a natural, healthful growth of art than any hot-bed culture whatever. We cannot – (as did Napoleon) – make, by a few imperial edicts, an army of battle painters, a hierarchy of drum-and-fife glorifiers. Nor can we, in the life-time of an individual, so stimulate this branch of culture, so unduly and disproportionately endow it, as to make a Walhalla start from a republican soil. The monuments, the pictures, the statues of the republic will represent what the people love and wish for, – not what they can be made to accept, not how much taxation they will bear. We hope by such slow growth to avoid the reaction resulting from a morbid development; a reaction like that which attended the building of St Peter's; a reaction like that consequent upon the outlay which gave birth to the royal mushroom at Versailles; a reaction like that which we anticipate in Bavaria, unless the people of that country are constituted differently from the rest of mankind.

If there be any youth toiling through the rudiments of art, at the forms of the simple and efficient school at New York (whose title is the only pompous thing about it), with a chilling belief that elsewhere the difficulties he struggles with are removed or modified, we call upon him to be of good cheer, and to believe – what from our hearts we are convinced of – that there is at present no country where the development and growth of an artist is more free, healthful, and happy than it is in these United States. [. . .]

10 Søren Kierkegaard (1813–1855) on the Classic Work, and on Art and Poetry

Kierkegaard published his second major work, *Either-Or*, in two volumes in 1843. Kierke-gaard disguises his own opinions by speaking through two different authorial voices, one 'hedonistic' and the other 'ethical', and by publishing the book under the name of a

pseudonymous editor, Victor Eremtia, who claims in the preface to have come across the two sets of papers quite by chance. Both of the extracts reprinted here are written from the standpoint of the hedonist. The first, on the classic work, is taken from the section entitled 'The Immediate Erotic Stages or the Musical-Erotic'. Here the author seeks to show that although it is historical good fortune which bestows on the artist the material or subject-matter for his creative work, the 'classic work' arises only as the correlation of the appropriate subject-matter with the artist's formative activity. The second extract, on art and poetry, is taken from the section entitled 'Silhouettes'. Its starting point is Lessing's celebrated discussion of the distinction between poetry and visual art in his *Laocöon* (1766), where it is maintained that the medium of sculpture cannot allow the expression of pain without contravening the requirements of beauty. Kierkegaard's fictitious author seeks to show that only poetry and psychology, but not the visual arts, can depict what he terms 'reflective sorrow'. Originally published under the title *Enten-Eller: Et Livs-Fragment* in Copenhagen in 1843, the present extracts are taken from the translation by Howard V. Hong and Edna H. Hong, *Either/Or: A Fragment of Life*, Princeton: Princeton University Press, 1987. The first extract is from pp. 48, 49–50, 51–3, 54–5; the second extract is from pp. 169–72.

on the Classic Work

From the moment my soul was first astounded by Mozart's music and humbly bowed in admiration, it has often been a favourite and refreshing occupation for me to deliberate on the way that happy Greek view of the world that calls the world a χόσμος [cosmos] because it manifests itself as a well–organized whole, as an elegant, transparent adornment for the spirit that acts upon and operates throughout it, the way that happy view lets itself be repeated in a higher order of things, in the world of ideals, the way there is here again a ruling wisdom especially wonderful at uniting what belongs together, Axel with Valborg, Homer with the Trojan War, Raphael with Catholicism, Mozart with Don Juan. There is a paltry disbelief that seems to contain considerable healing power. It thinks that such a connection is accidental and sees nothing more in it than a very fortunate conjunction of the various forces in the game of life. It thinks that it is accidental that the lovers find each other, accidental that they love each other. There might have been a hundred other girls with whom he could have been just as happy, whom he could have loved just as much. It considers that many a poet has lived who would have been just as immortal as Homer if that glorious subject matter had not been taken over by him, many a composer who would have been just as immortal as Mozart if the opportunity had offered itself. This wisdom contains considerable consolation and balm for all mediocrities, who thereby see themselves in a position to delude themselves and like-minded people into thinking that they did not become as exceptional as the exceptional ones because of a mistaken identification on the part of fate, a mistake on the part of the world. This produces a very convenient optimism. But it is abhorrent, of course, to every high-minded soul, every optimate, to whom it is not as important to rescue himself in such a paltry manner as it is to lose himself by contemplating greatness; whereas it is a delight to his soul, a sacred joy, to see united that which belongs together. This is good fortune, not in the sense of the accidental, and thus presupposes two factors, whereas the accidental consists in the unarticulated interjections of fate. This is good fortune in history, the divine interplay of the historic forces, the festival period of the historic epoch. [. . .]

In a classic work, good fortune – that which makes it classic and immortal – is the absolute correlation of the two forces. This correlation is so absolute that a subsequent reflective age will scarcely be able, even in thought, to separate that which is so intrinsically conjoined without running the danger of causing or fostering a misunderstanding. For example, if it is said that it was Homer's good fortune that he acquired that most exceptional epic subject matter, this can lead one to forget that we always have this epic subject matter through Homer's conception, and the fact that it appears to be the most perfect epic subject matter is clear to us only in and through the transubstantiation due to Homer. If, however, Homer's poetic work in permeating the subject matter is emphasized, then one runs the risk of forgetting that the poem would never have become what it is if the idea with which Homer permeated it was not its own idea, if the form was not the subject matter's own form. The poet wishes for his subject matter, but, as they say, wishing is no art; this is quite correct and truthfully applies to a host of powerless poetic wishes. To wish properly, however, is a great art, or, more correctly, it is a gift. It is the inexplicability and mysteriousness of genius, just as with a divining rod which never has the notion to wish except in the presence of that for which it wishes. Hence, wishing has a far deeper significance than it ordinarily does; indeed, to abstract reason it appears ludicrous, since it rather thinks of wishing in connection with what is not present, not in connection with what is present.

* * *

All classic productions rank equally high, as previously noted, because each one ranks infinitely high. Consequently, if one nevertheless wants to introduce a certain order into this series, it stands to reason that it cannot be based on anything essential, for that would mean that there was an essential difference, and that in turn would mean that the word 'classic' was wrongly predicated of all of them. If a classification were based on the dissimilar nature of the subject matter, one would immediately be involved in a misunderstanding, which in its wider extension would end with the annulment of the whole concept of the classic. The subject matter is an essential element, inasmuch as it is one factor, but it is not the absolute, since it is only one element. It could be pointed out that in a sense certain kinds of classic works have no subject matter, whereas in others, however, the subject matter plays a very important role. The former is the case with works we admire as classic in architecture, sculpture, music, painting – especially the first three, and even in painting, insofar as there is any question of subject matter it has importance almost solely as an occasion. The second is true of poetry, this word understood in its widest meaning to denote all artistic production that is based on language and the historical consciousness. This comment is in itself altogether correct, but it is a mistake to base a classification on it by regarding the absence or presence of subject matter as an advantage or a detriment to the creative individual. If it is strictly understood, the result will be to argue the very opposite of what was really intended, as is always the case when one moves abstractly in dialectical qualifications, where it is the case that one not only says one thing and means something else but says something else; what one thinks one is saying one does not say but says the opposite. So it is when the subject matter is made the principle of division. In speaking of it, one speaks of something entirely different: namely, the formative activity.

But the same thing happens if one starts with the formative activity and emphasizes it alone. In maintaining the distinction here and emphasizing that in some respects the

formative activity is creative to the degree that it creates the subject matter in the process, whereas in other respects it receives the subject matter, then here again, although one thinks one is speaking of the formative activity, one is actually speaking of the subject matter and is basing the classification on the division of the subject matter.

The same holds for the formative activity as the point of departure in such a classification as for the subject matter. Consequently, a single aspect cannot be used as the basis for an order of rank, because it is still too essential to be sufficiently accidental, too accidental to be a basis for an essential ranking. But this thoroughgoing mutual permeation – which justifies saying, if one wishes to speak clearly, that the subject matter permeates the form and also that the form permeates the subject matter – this mutual permeation, this like-for-like in the immortal friendship of the classic, may serve to illuminate the classic from a new side and to limit it in such a way that it does not become too copious. [. . .]

[. . .] Only where the idea is brought to rest and transparency in a definite form can there be any question of a classic work, but then it will also be capable of withstanding the times. This unity, this mutual intimacy in each other, every classic work has, and thus it is readily perceived that every attempt at a classification of the various classic works that has as its point of departure a separation of subject matter and form or of idea and form is *eo ipso* a failure.

Another way might be proposed. The medium through which the idea becomes visible could be made the object of consideration. Having noted that one medium is richer and another less rich, one could base the division on this difference by finding a facilitation or an impediment in the varying richness or poverty of the medium. But the medium stands in an all too necessary relation to the whole production to keep a division based on it from becoming entangled in the above-mentioned difficulties after a few turns of thought.

I believe, however, that the following observations will open the prospect for a division that will have validity precisely because it is completely accidental. The more abstract and thus the more impoverished the idea is, the more abstract and thus the more impoverished the medium is; hence the greater is the probability that no repetition can be imagined, and the greater is the probability that when the idea has acquired its expression it has acquired it once and for all. On the other hand, the more concrete and thus the richer the idea and likewise the medium, the greater is the probability of a repetition. As I now place the various classic works side by side and, without wishing to rank them, am amazed that all stand equally high, it nevertheless will be readily apparent that one section has more works than another or, if it does not, that there is the possibility that it can have, whereas any possibility for the other is not so readily apparent.

I would like to develop this point in somewhat more detail. The more abstract the idea is, the less the probability. But how does the idea become concrete? By being permeated by the historical. The more concrete the idea, the greater the probability. The more abstract the medium is, the less the probability; the more concrete, the more. But what does it mean that the medium is concrete except that it either is, or is seen in its approximation to, language, for language is the most concrete of all media. Hence, the idea that is disclosed in sculpture is totally abstract and has no relation to

the historical; the medium through which it becomes manifest is likewise abstract. Consequently, it is very probable that the section of classic works that comprises sculpture will include only a few. The witness of time and the agreement of experience bear me out on this. But if I take a concrete idea and a concrete medium, the situation is different. Homer certainly is a classic epic poet, but precisely because the idea that becomes manifest in the epic is a concrete idea and because the medium is language, it is conceivable that the section of classic works that includes the epic has many works, which are all equally classic because history continually provides new epic subject matter. Here, too, the witness of history and the agreement of experience bear me out.

* * *

on Art and Poetry

Since the time when Lessing defined the boundaries between poetry and art in his celebrated treatise *Laokoon*, it no doubt may be regarded as a conclusion unanimously recognized by all aestheticians that the distinction between them is that art is in the category of space, poetry in the category of time, that art depicts repose, poetry motion. For this reason, the subject for artistic portrayal must have a quiet transparency so that the interior rests in the corresponding exterior. The less this is the case, the more difficult becomes the task for the artist, until the distinction asserts itself and teaches him that this is no task for him at all.

If we apply to the relation between sorrow and joy that which has been casually stated but not developed here, it is easy to perceive that joy is far easier to depict artistically than sorrow. By no means does this deny that grief can be depicted artistically, but it certainly does say that there comes a point where it is essential to posit a contrast between the interior and the exterior, which makes a depiction of it impossible for art. This in turn is due to the singular nature of sorrow. By nature, joy wishes to disclose itself; sorrow wishes to conceal itself, indeed, at times even to deceive. Joy is communicative, sociable, open, wishes to express itself. Sorrow is inclosingly reserved, silent, solitary, and seeks to return into itself. Surely no one who has made life the object of any observation at all will deny the correctness of this. There are people whose make-up is so constituted that when their emotions are stirred the blood rushes to the surface of the skin, and in this way the interior motion becomes visible in the exterior; others are so constituted that the blood recedes, withdraws into the heart chamber and the inner parts of the organism. It is somewhat like this with respect to the mode of expressing joy and sorrow. The first make-up described is much easier to observe than the second. In the first, one sees the manifestation; the interior motion is visible in the exterior. In the second, one has an intimation of the interior motion. The exterior pallor is, as it were, the interior's good-bye, and thought and imagination hurry after the fugitive, which hides in the secret recesses. This applies particularly to the kind of sorrow I shall consider more explicitly here, what could be called reflective sorrow. Here the exterior has at most only a suggestion that puts one on the track, sometimes not even that much. This sorrow cannot be depicted artistically, for the interior and the exterior are out of balance, and thus it does not lie within spatial categories. In yet another respect it

cannot be depicted artistically, for it does not have inner stillness but is constantly in motion; even if this motion does not enrich it with new effects, the motion itself is nevertheless the essential. Like a squirrel in its cage, it turns around in itself, yet not as uniformly as does that animal, but with a continual alternation in the combination of the interior elements of sorrow. What excludes reflective sorrow as the subject for artistic depiction is that it lacks repose, is not at one with itself, does not come to rest in any one definite expression. Just as the patient in his pain tosses from one side to the other, so reflective sorrow is tossed about in order to find its object and its expression. If the sorrow is in repose, the interior of sorrow will gradually work its way outward, become visible in the exterior, and in this way become a subject for artistic depiction. If sorrow has inner repose and rest, the motion begins outward from the inside; reflective sorrow moves inward, like blood rushing from the outer surface, and lets one have an intimation of it only because of the fleeting pallor. Reflective sorrow does not involve any essential change in the exterior; even in the first moment of sorrow it hurries inward, and only the more careful observer has an intimation of its disappearance; later it carefully sees to it that the exterior is as inconspicuous as possible.

By withdrawing inward in this way, it finally finds an inclosure, an innermost retreat, where it thinks it can remain, and now it begins its uniform movement. Like the pendulum in a clock, it swings back and forth and cannot find rest. It continually begins from the beginning and deliberates anew, interrogates the witnesses, checks and examines the various statements, something it has already done hundreds of times, but it is never finished. In the course of time, the uniformity has something anaesthetizing about it. Just as the uniform dripping of rain from the roof, the uniform whirring of a spinning wheel, and the monotonous sound of a man pacing back and forth with measured steps on the floor above have an anaesthetizing effect, so reflective grief eventually finds solace in this motion, which as an illusory motion becomes a necessity for it. At last there is a kind of balance; the need to give vent to the grief, insofar as it may ever have asserted itself at all, ceases; the exterior is calm and quiet; and deep within, in its little nook, grief lives like a well–guarded prisoner in an underground prison, who lives on year after year in his uniform movement, walking to and fro in his cubbyhole, never weary of travelling the long or short road of sorrow.

Reflective sorrow can be occasioned in part by the individual's subjective quality, in part by the objective sorrow or the occasion of the sorrow. A morbidly reflective individual will transform every sorrow into a reflective sorrow; his individual make-up and structure render it impossible for him to assimilate the sorrow right away. But this is a morbidity that cannot be of particular interest to us, because in that way every accidentality can undergo a metamorphosis by which it becomes a reflective sorrow. It is another matter when the objective sorrow or the occasion of the sorrow in the individual himself fosters the reflection that makes the sorrow into a reflective sorrow. This is everywhere the case when the objective sorrow in itself is not finished, when it leaves a doubt, whatever its nature is. Here at once a great multiplicity appears for thought, greater according to the richness of one's life and experience or one's inclination to engage one's keenness in such imaginary constructions.

But it is by no means my intention to go through the whole multiplicity; I want to single out only one aspect as it has appeared for my observation. If the occasion for sorrow is a deception, then the objective sorrow itself is of such a quality that it engenders reflective sorrow in the individual. That a deception is actually a deception is often very difficult to determine clearly, and yet everything depends upon that. As long as this is debatable, the sorrow will find no repose but must continue to ramble back and forth in reflection. Furthermore, if this deception does not involve anything external but a person's whole inner life, his life's innermost core, the probability of the continuance of the objective sorrow becomes greater and greater. But what can more truthfully be called a woman's life than her love? Consequently, if the sorrow of an unhappy love is due to a deception, we have unconditionally a reflective sorrow, whether it continues for a lifetime or the individual conquers it. Unhappy love is in itself undoubtedly the deepest sorrow for a woman, but it does not follow from this that every unhappy love engenders a reflective sorrow. If, for example, the beloved dies, or she perhaps does not find her love returned at all, or her life situation makes the fulfilment of her wish impossible, this certainly is an occasion for sorrow, but not a reflective sorrow, except to the extent that the person concerned was morbid before, and then she thereby lies outside our interest. But if she is not morbid, then her sorrow becomes an immediate sorrow and as such can also become the subject of artistic portrayal, whereas on the other hand it is impossible for art to express and portray the reflective sorrow or the point of it. In other words, immediate sorrow is the immediate imprint and expression of the sorrow's impression, which, just like the picture Veronica preserved on her linen cloth, is perfectly congruous, and sorrow's sacred lettering is stamped on the exterior, beautiful and clear and legible to all.

Reflective sorrow, then, cannot become a subject for artistic portrayal. For one thing, it is never really present but is continually in the process of becoming; for another, the exterior, the visible, is a matter of unimportance and indifference. So if art will not limit itself to the naïveté (examples are found in old books) in which a figure is portrayed that can represent almost anything, but one discovers on its breast a plaque, a heart or something similar, on which one may read everything, especially when the figure's posture draws a person's attention to it, even points to it, an effect that could just as well be achieved by writing above it 'Please note!' – if art will not do this, it will be obliged to reject pictures of that kind and leave reflective grief to poetic or psychological treatment.

11 Friedrich Engels (1820–1895) on the Crowd in the City

Engels' family were relatively liberal capitalists, owning a textile factory in Germany and holding a partnership in another in Manchester. In his youth, Engels learned the business of business, as well as of radical politics and journalism. In the milieu of Young Hegelianism, and under the influence of the German-Jewish communist Moses Hess, Engels came to recognize the importance of developments in England, where industrial capitalism was far more advanced than in Germany or in France. He worked in the family firm in Manchester between 1842–4, businessman by day, and socialist researcher in his spare time. His book, *The Condition of the Working Class in England in 1844* was published in Germany in 1845, and subsequently in English translation in the United States in 1887 and in England

in 1892. It contains vivid descriptions of the plight of the working class in the modern city, as well as an analysis of the causes of their exploitation. The present extract can be found at pp. 23–5 of chapter three, 'The Great Towns', in the George Allen and Unwin edition of 1952. We have used the translation made by Florence Kelley Wischnewetzky for the edition of 1887.

A town, such as London, where a man may wander for hours together without reaching the beginning of the end, without meeting the slightest hint which could lead to the inference that there is open country within reach, is a strange thing. This colossal centralization, this heaping together of two and a half millions of human beings at one point, has multiplied the power of this two and a half millions a hundredfold; has raised London to the commercial capital of the world, created the giant docks and assembled the thousand vessels that continually cover the Thames. I know nothing more imposing than the view which the Thames offers during the ascent from the sea to London Bridge. The masses of buildings, the wharves on both sides, especially from Woolwich upwards, the countless ships along both shores, crowding ever closer and closer together, until, at last, only a narrow passage remains in the middle of the river, a passage through which hundreds of steamers shoot by one another; all this is so vast, so impressive, that a man cannot collect himself, but is lost in the marvel of England's greatness before he sets foot upon English soil.

But the sacrifices which all this has cost become apparent later. After roaming the streets of the capital a day or two, making headway with difficulty through the human turmoil and the endless lines of vehicles, after visiting the slums of the metropolis, one realizes for the first time that these Londoners have been forced to sacrifice the best qualities of their human nature, to bring to pass all the marvels of civilization which crowd their city; that a hundred powers which slumbered within them have remained inactive, have been suppressed in order that a few might be developed more fully and multiply through union with those of others. The very turmoil of the streets has something repulsive, something against which human nature rebels. The hundreds of thousands of all classes and ranks crowding past each other, are they not all human beings with the same qualities and powers, and with the same interest in being happy? And have they not, in the end, to seek happiness in the same way, by the same means? And still they crowd by one another as though they had nothing in common, nothing to do with one another, and their only agreement is the tacit one, that each keep to his own side of the pavement, so as not to delay the opposing streams of the crowd, while it occurs to no man to honour another with so much as a glance. The brutal indifference, the unfeeling isolation of each in his private interest becomes the more repellant and offensive, the more these individuals are crowded together, within a limited space. And, however much one may be aware that this isolation of the individual, this narrow self-seeking is the fundamental principle of our society everywhere, it is nowhere so shamelessly barefaced, so self-conscious as just here in the crowding of the great city. The dissolution of mankind into monads, of which each one has a separate principle, the world of atoms, is here carried out to its utmost extreme. [. . .]

What is true of London, is true of Manchester, Birmingham, Leeds, is true of all great towns. Everywhere barbarous indifference, hard egotism on one hand, and nameless misery on the other, everywhere social warfare, every man's house in a

state of siege, everywhere reciprocal plundering under the protection of the law, and all so shameless, so openly avowed that one shrinks before the consequences of our social state as they manifest themselves here undisguised, and can only wonder that the whole crazy fabric still hangs together. [...]

12 Max Stirner (1805–1856) from *The Ego and Its Own*

Max Stirner was the pseudonym of Johann Kaspar Schmidt, a member of the *Freien*, a group of young radicals in Berlin whose members included Bruno Bauer and Friedrich Engels. *The Ego and Its Own* exercised a powerful and immediate impact when it was published in 1844, and the seriousness with which Stirner's critique was received is testified by Marx and Engels' lengthy response in *The German Ideology* (see IIA10, above). The book has two principal divisions. The first historical part, entitled 'Man', argues that men have consistently sacrificed their individuality to some extra-personal entity or 'spook', whether this be God, Hegel's notion of 'spirit', or 'society'. In the second part, simply entitled 'I', Stirner argues that the self or ego must for the first time realize that its power resides in itself and thereby regain sovereignty over its own domain. In the extract reprinted here, Stirner contrasts the notion of 'freedom' (*Freiheit*) with that of 'ownness' (*Eigenheit*), playing on the notion of property which the latter term carries with it. Whereas freedom is always particular and rapidly devolves into a new form of dominion, ownness involves 'possession, power and control over things'. In making ourselves free from everything that is not ourselves, the 'I' is to become the 'beginning, middle and end' of all things. Though Stirner's work was largely forgotten in the second half of the nineteenth century, it underwent a renaissance amongst artists and thinkers in the early twentieth century and has been widely published ever since. It was originally published as *Der Einzige und sein Eigentum* in Berlin in 1844 and was translated into English by Steven Byington in 1907. The present extracts are taken from the reprint of that translation published by the Rebel Press, London, 1982, pp. 3, 4–5, 155–6, 157, 159, 160, 161, 163–4, 165, 357–8, 360–1.

What is not supposed to be my concern! First and foremost, the Good Cause, then God's cause, the cause of mankind, of truth, of freedom, of humanity, of justice; further, the cause of my people, my prince, my fatherland; finally, even the cause of Mind, and a thousand other causes. Only *my* cause is never to be my concern. [...]

* * *

God and mankind have concerned themselves for nothing, for nothing but themselves. Let me then likewise concern myself for *myself*, who am equally with God the nothing of all others, who am my all, who am the only one.

If God, if mankind, as you affirm, have substance enough in themselves to be all in all to themselves, then I feel that *I* shall still less lack that, and that I shall have no complaint to make of my 'emptiness.' I am not nothing in the sense of emptiness, but I am the creative nothing, the nothing out of which I myself as creator create everything.

Away, then, with every concern that is not altogether my concern! You think at least the 'good cause' must be my concern? What's good, what's bad? Why, I myself am my concern, and I am neither good nor bad. Neither has meaning for me.

The divine is God's concern; the human, man's. My concern is neither the divine nor the human, not the true, good, just, free, etc., but solely what is *mine*, and it is not a general one, but is – unique, as I am unique.

Nothing is more to me than myself!

* * *

'Does not the spirit thirst for freedom?' – Alas, not my spirit alone, my body too thirsts for it hourly! When before the odorous castle-kitchen my nose tells my palate of the savoury dishes that are being prepared therein, it feels a fearful pining at its dry bread; when my eyes tell the hardened back about soft down on which one may lie more delightfully than on its compressed straw, a suppressed rage seizes it; when – but let us not follow the pains further. – And you call that a longing for freedom? What do you want to become free from, then? From your hardtack and your straw bed? Then throw them away! – But that seems not to serve you: you want rather to have the freedom to enjoy delicious foods and downy beds. Are men to give you this 'freedom' – are they to permit it to you? You do not hope that from their philanthropy, because you know they all think like – you: each is the nearest to himself! How, therefore, do you mean to come to the enjoyment of those foods and beds? Evidently not otherwise than in making them your property!

If you think it over rightly, you do not want the freedom to have all these fine things, for with this freedom you still do not have them; you want really to have them, to call them *yours* and possess them as *your property*. Of what use is a freedom to you, indeed, if it brings in nothing? And, if you became free from everything, you would no longer have anything; for freedom is empty of substance. Whoso knows not how to make use of it, for him it has no value, this useless permission; but how I make use of it depends on my personality.

I have no objection to freedom, but I wish more than freedom for you: you should not merely *be rid* of what you do not want; you should not only be a 'freeman,' you should be an 'owner' too.

* * *

What a difference between freedom and ownness! One can get *rid* of a great many things, one yet does not get rid of all; one becomes free from much, not from everything. Inwardly one may be free in spite of the condition of slavery, although, too, it is again only from all sorts of things, not from everything; but from the whip, the domineering temper, of the master, one does not as slave become *free*. 'Freedom lives only in the realm of dreams!' Ownness, on the contrary, is my whole being and existence, it is I myself. I am free from what I am *rid* of, owner of what I have in my *power* or what I *control*. *My own* I am at all times and under all circumstances, if I know how to have myself and do not throw myself away on others. To be free is something that I cannot truly *will*, because I cannot make it, cannot create it: I can only wish it and – aspire toward it, for it remains an ideal, a spook. The fetters of reality cut the sharpest welts in my flesh every moment. But *my own* I remain. [. . .]

* * *

What the craving for freedom has always come to has been the desire for a *particular* freedom, such as freedom of faith; the believing man wanted to be free and independent; of what? of faith perhaps? no! but of the inquisitors of faith. So now 'political or

civil' freedom. The citizen wants to become free not from citizenhood, but from bureaucracy, the arbitrariness of princes, and the like. [. . .]

The craving for a *particular* freedom always includes the purpose of a new *dominion*, as it was with the Revolution, which indeed 'could give its defenders the uplifting feeling that they were fighting for freedom,' but in truth only because they were after a particular freedom, therefore a new *dominion*, the 'dominion of the law.'

Freedom you all want, you want *freedom*. Why then do you higgle over a more or less? *Freedom* can only be the whole of freedom; a piece of freedom is not *freedom*. You despair of the possibility of obtaining the whole of freedom, freedom from everything – yes, you consider it insanity even to wish this? – Well, then leave off chasing after the phantom, and spend your pains on something better than the – *unattainable*.

'Ah, but there is nothing better than freedom!'

What have you then when you have freedom – for I will not speak here of your piecemeal bits of freedom – complete freedom? [. . .]

Why will you not take courage now to really make *yourselves* the central point and the main thing altogether? Why grasp in the air at freedom, your dream? Are you your dream? Do not begin by inquiring of your dreams, your notions, your thoughts, for that is all 'hollow theory.' Ask yourselves and ask after yourselves – that is *practical*, and you know you want very much to be 'practical.' But there the one hearkens what his God (of course what he thinks of at the name God is his God) may be going to say to it, and another what his moral feelings, his conscience, his feeling of duty, may determine about it, and a third calculates what folks will think of it – and, when each has thus asked his Lord God (folks are a Lord God just as good as, nay, even more compact than, the other-worldly and imaginary one: *vox populi, vox dei* [the voice of the people is the voice of God]), then he accommodates himself to his Lord's will and listens no more at all for what *he himself* would like to say and decide.

Therefore turn to yourselves rather than to your gods or idols. Bring out from yourselves what is in you, bring it to the light, bring yourselves to revelation.

* * *

If your efforts are ever to make 'freedom' the issue, then exhaust freedom's demands. Who is it that is to become free? You, I, we. Free from what? From everything that is not you, not I, not we. I, therefore, am the kernel that is to be delivered from all wrappings and – freed from all cramping shells. What is left when I have been freed from everything that is not I? Only I; nothing but I. But freedom has nothing to offer to this I himself. As to what is now to happen further after I have become free, freedom is silent – as our governments, when the prisoner's time is up, merely let him go, thrusting him out into abandonment.

Now why, if freedom is striven after for love of the I after all – why not choose the I himself as beginning, middle, and end? Am I not worth more than freedom? Is it not I that make myself free, am not I the first? Even unfree, even laid in a thousand fetters, I yet am; and I am not, like freedom, extant only in the future and in hopes, but even as the most abject of slaves I am – present.

Think that over well, and decide whether you will place on your banner the dream of 'freedom' or the resolution of 'egoism,' of 'ownness.' 'Freedom' awakens your *rage* against everything that is not you; 'egoism' calls you to *joy* over yourselves, to self-enjoyment; 'freedom' is and remains a *longing*, a romantic plaint, a Christian hope for

unearthliness and futurity; 'ownness' is a reality, which *of itself* removes just so much unfreedom as by barring your own way hinders you. What does not disturb you, you will not want to renounce; and, if it begins to disturb you, why, you know that 'you must obey *yourselves* rather than men!'

Freedom teaches only: Get yourselves rid, relieve yourselves, of everything burdensome; it does not teach you who you yourselves are. Rid, rid! so call, get rid even of yourselves, 'deny yourselves.' But ownness calls you back to yourselves, it says 'Come to yourself!' Under the aegis of freedom you get rid of many kinds of things, but something new pinches you again: 'you are rid of the Evil One; evil is left.' As *own* you are *really rid of everything*, and what clings to you *you have accepted*; it is your choice and your pleasure. The *own* man is the *free-born*, the man free to begin with; the free man, on the contrary, is only the *eleutheromaniac*, the dreamer and enthusiast.

The former is *originally free*, because he recognizes nothing but himself; he does not need to free himself first, because at the start he rejects everything outside himself, because he prizes nothing more than himself, rates nothing higher, because, in short, he starts from himself and 'comes to himself.' Constrained by childish respect, he is nevertheless already working at 'freeing' himself from this constraint. Ownness works in the little egoist, and procures him the desired – freedom.

Thousands of years of civilization have obscured to you what you are, have made you believe you are not egoists but are *called* to be idealists ('good men'). Shake that off! Do not seek for freedom, which does precisely deprive you of yourselves, in 'self-denial'; but seek for *yourselves*, become egoists, become each of you an *almighty ego*. [. . .]

I secure my freedom with regard to the world in the degree that I make the world my own, 'gain it and take possession of it' for myself, by whatever might, by that of persuasion, of petition, of categorical demand, yes, even by hypocrisy, cheating, etc.; for the means that I use for it are determined by what I am. [. . .]

* * *

As the world as property has become a *material* with which I undertake what I will, so the spirit too as property must sink down into a *material* before which I no longer entertain any sacred dread. Then, firstly, I shall shudder no more before a thought, let it appear as presumptuous and 'devilish' as it will, because, if it threatens to become too inconvenient and unsatisfactory for *me*, its end lies in my power; but neither shall I recoil from any deed because there dwells in it a spirit of godlessness, immorality, wrongfulness, as little as St Boniface pleased to desist, through religious scrupulousness, from cutting down the sacred oak of the heathens. If the *things* of the world have once become vain, the thoughts of the spirit must also become vain.

No thought is sacred, for let no thought rank as 'devotions'; no feeling is sacred (no sacred feeling of friendship, mother's feelings, etc.), no belief is sacred. They are all *alienable*, my alienable property, and are annihilated, as they are created, by *me*.

* * *

Self-enjoyment is embittered to me by my thinking I must serve another, by my fancying myself under obligation to him, by my holding myself called to 'self-sacrifice,' 'resignation,' 'enthusiasm.' All right: if I no longer serve any idea, any 'higher essence,' then it is clear of itself that I no longer serve any man either, but –

under all circumstances – *myself*. But thus I am not merely in fact or in being, but also for my consciousness, the – unique.

There pertains to *you* more than the divine, the human, etc.; *yours* pertains to you.

Look upon yourself as more powerful than they give you out for, and you have more power; look upon yourself as more, and you have more.

You are then not merely *called* to everything divine, *entitled* to everything human, but *owner* of what is yours, that is, of all that you possess the force to make your own, you are *appropriate* and capacitated for everything that is yours.

People have always supposed that they must give me a destiny lying outside myself, so that at last they demanded that I should lay claim to the human because I am – man. This is the Christian magic circle. Fichte's ego too is the same essence outside me, for every one is ego; and, if only this ego has rights, then it is 'the ego,' it is not I. But I am not an ego along with other egos, but the sole ego: I am unique. Hence my wants too are unique, and my deeds; in short, everything about me is unique. And it is only as this unique I that I take everything for my own, as I set myself to work, and develop myself, only as this. I do not develop men, nor as man, but, as I, I develop – myself.

This is the meaning of the – *unique one*.

13 Charles Baudelaire (1821–1867) 'To the Bourgeoisie' and 'On the Heroism of Modern Life'

These are respectively the opening dedication and the closing section of Baudelaire's extensive *Salon of 1846*. (For full bibliographical reference see IIc9.) The cover of his previous Salon review had announced a forthcoming work 'On Modern Painting' which never actually appeared. It seems likely that the *Salon of 1846* incorporated material from the intended more general study. For all the ironical tone of his address 'To the Bourgeoisie', and for all the familiarity of his equation of the bourgeoisie with philistinism (see IIB11), the writer's sharpest criticism is directed at the more established arbiters of sense and taste: 'the monopolists of the things of the mind'. Baudelaire had a remarkable ability to think his way through any critical position that was in danger of hardening into a dogma. In his acknowledgement of the ways in which modern societies and their cultural institutions were being positively transformed under bourgeois administration and entrepreneurship, he showed himself already a more subtle realist than the majority of those who were just beginning to call themselves Realists. The specific terms of Baudelaire's homily are echoed by Boudin in a letter of 1868 (see IIID14); and they were clearly in Henri Matisse's mind in 1908, when he proposed 'an art which could be for every mental worker, for the business-man as well as the man of letters … something like a good armchair which provides relaxation from physical fatigue' (see *Art in Theory 1900–1990*, IB5). 'On the Heroism of Modern Life' is a similarly double-edged text. At one level it functions as a critique of the conservatism and sentimentality of a culture that could only conceive of history painting in terms of an idealized past. At another level it offers a veiled admonition to the would-be Realist that there could be no truly modern form of painting without a strong capacity for irony and an admission of bathos. Baudelaire's challenge was to be met by Edouard Manet – though not for another decade and a half. The translation of these passages has been taken from Jonathan Mayne, (ed.), *Art in Paris*, London, 1964, pp. 41–3 and 116–19.

To the Bourgeoisie

You are the majority – in number and intelligence; therefore you are the force – which is justice.

Some are scholars, others are owners; a glorious day will come when the scholars shall be owners and the owners scholars. Then your power will be complete, and no man will protest against it.

Until that supreme harmony is achieved, it is just that those who are but owners should aspire to become scholars; for knowledge is no less of an enjoyment than ownership.

The government of the city is in your hands, and that is just, for you are the force. But you must also be capable of feeling beauty; for as not one of you today can do without power, so not one of you has the right to do without poetry.

You can live three days without bread – without poetry, never; and those of you who can say the contrary are mistaken; they are out of their minds.

The aristocrats of thought, the distributors of praise and blame, the monopolists of the things of the mind, have told you that you have no right to feel and to enjoy – they are Pharisees.

For you have in your hands the government of a city whose public is the public of the universe, and it is necessary that you should be worthy of that task.

Enjoyment is a science, and the exercise of the five senses calls for a particular initiation which only comes about through goodwill and need.

Very well, you need art.

Art is an infinitely precious good, a draught both refreshing and cheering which restores the stomach and the mind to the natural equilibrium of the ideal.

You understand its function, you gentlemen of the bourgeoisie – whether law-givers or businessmen – when the seventh or the eighth hour strikes and you bend your tired head towards the embers of your hearth or the cushions of your arm-chair.

That is the time when a keener desire and a more active reverie would refresh you after your daily labours.

But the monopolists have decided to keep the forbidden fruit of knowledge from you, because knowledge is their counter and their shop, and they are infinitely jealous of it. If they had merely denied you the power to create works of art or to understand the processes by which they are created, they would have asserted a truth at which you could not take offence, because public business and trade take up three quarters of your day. And as for your leisure hours, they should be used for enjoyment and pleasure.

But the monopolists have forbidden you even to enjoy, because you do not understand the technique of the arts, as you do those of the law and of business.

And yet it is just that if two-thirds of your time are devoted to knowledge, then the remaining third should be occupied by feeling – and it is by feeling alone that art is to be understood; and it is in this way that the equilibrium of your soul's forces will be established.

Truth, for all its multiplicity, is not two-faced; and just as in your politics you have increased both rights and benefits, so in the arts you have set up a greater and more abundant communion.

You, the bourgeois – be you king, law-giver, or business-man – have founded collections, museums and galleries. Some of those, which sixteen years ago were only open to the monopolists, have thrown wide their doors to the multitude.

You have combined together, you have formed companies and raised loans in order to realize the idea of the future in all its varied forms – political, industrial and artistic. In no noble enterprise have you ever left the initiative to the protesting and suffering minority [i.e. the Republican faction], which anyway is the natural enemy of art.

For to allow oneself to be outstripped in art and in politics is to commit suicide; and for a majority to commit suicide is impossible.

And what you have done for France, you have done for other countries too. The Spanish Museum is there to increase the volume of general ideas that you ought to possess about art; for you know perfectly well that just as a national museum is a kind of communion by whose gentle influence men's hearts are softened and their wills unbent, so a foreign museum is an international communion where two peoples, observing and studying one another more at their ease, can penetrate one another's mind and fraternize without discussion.

You are the natural friends of the arts, because you are some of you rich men and the others scholars.

When you have given to society your knowledge, your industry, your labour and your money, you claim back your payment in enjoyments of the body, the reason and the imagination. If you recover the amount of enjoyments which is needed to establish the equilibrium of all parts of your being, then you are happy, satisfied and well-disposed, as society will be satisfied, happy and well-disposed when it has found its own general and absolute equilibrium.

And so it is to you, the bourgeois, that this book is naturally dedicated; for any book which is not addressed to the majority – in number and intelligence – is a stupid book. 1st May 1846

On the Heroism of Modern Life

Many people will attribute the present decadence in painting to our decadence in behaviour.[1] This dogma of the studios, which has gained currency among the public, is a poor excuse of the artists. For they had a vested interest in ceaselessly depicting the past; it is an easier task, and one that could be turned to good account by the lazy.

It is true that the great tradition has been lost, and that the new one is not yet established.

But what *was* this great tradition, if not a habitual, everyday idealization of ancient life – a robust and martial form of life, a state of readiness on the part of each individual, which gave him a habit of gravity in his movements, and of majesty, or violence, in his attitudes? To this should be added a public splendour which found its reflection in private life. Ancient life was a great *parade*. It ministered above all to the pleasure of the eye, and this day-to-day paganism has marvellously served the arts.

Before trying to distinguish the epic side of modern life, and before bringing examples to prove that our age is no less fertile in sublime themes than past ages, we may assert that since all centuries and all peoples have had their own form of beauty, so inevitably we have ours. That is in the order of things.

All forms of beauty, like all possible phenomena, contain an element of the eternal and an element of the transitory – of the absolute and of the particular. Absolute and eternal beauty does not exist, or rather it is only an abstraction skimmed from the general surface of different beauties. The particular element in each manifestation comes from the emotions: and just as we have our own particular emotions, so we have our own beauty.

Except for Hercules on Mount Oeta, Cato of Utica and Cleopatra (whose suicides are not *modern* suicides), what suicides do you find represented in the old masters? . . .

As for the garb, the outer husk, of the modern hero, although the time is past when every little artist dressed up as a grand panjandrum and smoked pipes as long as duck-rifles, nevertheless the studios and the world at large are still full of people who would like to poeticize *Antony* with a Greek cloak and a parti-coloured vesture.

But all the same, has not this much-abused garb its own beauty and its native charm? Is it not the necessary garb of our suffering age, which wears the symbol of a perpetual mourning even upon its thin black shoulders? Note, too, that the dress-coat and the frock-coat not only possess their political beauty, which is an expression of universal equality, but also their poetic beauty, which is an expression of the public soul – an immense cortège of undertaker's mutes (mutes in love, political mutes, bourgeois mutes . . .). We are each of us celebrating some funeral.

A uniform livery of affliction bears witness to equality; and as for the eccentrics, whose violent and contrasting colours used easily to betray them to the eye, today they are satisfied with slight nuances in design in cut, much more than in colour. Look at those grinning creases which play like serpents around mortified flesh – have they not their own mysterious grace? [. . .]

Let not the tribe of colourists be too indignant. For if it is more difficult, their task is thereby only the more glorious. Great colourists know how to create colour with a black coat, a white cravat and a grey background.

But to return to our principal and essential problem, which is to discover whether we possess a specific beauty, intrinsic to our new emotions, I observe that the majority of artists who have attacked modern life have contented themselves with public and official subjects – with our victories and our political heroism. Even so, they do it with an ill grace, and only because they are commissioned by the government which pays them. However there are private subjects which are very much more heroic than these.

The pageant of fashionable life and the thousands of floating existences – criminals and kept women – which drift about in the underworld of a great city; the *Gazette des Tribunaux* and the *Moniteur* all prove to us that we have only to open our eyes to recognize our heroism.

Suppose that a minister, baited by the opposition's impertinent questioning, has given expression once and for all – with that proud and sovereign eloquence which is proper to him – to his scorn and disgust for all ignorant and mischief-making oppositions. The same evening you will hear the following words buzzing round you on the Boulevard des Italiens: 'Were you in the Chamber today? and did you see the minister? Good Heavens, how handsome he was! I have never seen such scorn!'

So there *are* such things as modern beauty and modern heroism!

And a little later; – 'I hear that K. – or F. – has been commissioned to do a medal on the subject; but he won't know how to do it – he has no understanding for these things.'

So artists can be more, or less, fitted to understand modern beauty! [. . .]

The life of our city is rich in poetic and marvellous subjects. We are enveloped and steeped as though in an atmosphere of the marvellous; but we do not notice it.

The *nude* – that darling of the artists, that necessary element of success – is just as frequent and necessary today as it was in the life of the ancients; in bed, for example, or in the bath, or in the anatomy theatre. The themes and resources of painting are equally abundant and varied; but there is a new element – modern beauty. [. . .]

[1] These two types of decadence must not be confused; one has regard to the public and its feelings, the other concerns the studios alone.

14 Søren Kierkegaard (1813–1855) 'The Individual'

Carrying the subtitle 'A Hint', this journal entry of 1847 was subsequently used as an appendix to *The point of view for my work as an author*, published by Kierkegaard in 1848. Kierkegaard contrasts his own emphasis on the individual, confronted with the demand of making deliberate and significant choices concerning his or her own existence, with both the all-encompassing philosophical rationalism of Hegelian thought (here identified as 'the system') and the complacent acceptance of received truth and religious dogma in organized Christianity. The achievement of individuality is something which 'cannot be taught'. It represents, rather, a 'moral task' and this, potentially at least, exposes the artist to life-threatening danger. The entry, reprinted here in its entirety, is taken from *The Journals of Kierkegaard 1834–1854*, translated and edited by Alexander Dru, London, New York and Toronto, 1938, pp. 227–8.

'The individual' is the category through which, from a religious point of view, our age, our race and its history must pass. And the man who stood and fell at Thermopylae was not as convinced as I am, who stand at the narrow pass 'the individual'. It was his duty to prevent the hordes from forcing their way through that narrow pass; if they got through he was lost. My duty is, at any rate at first sight, much easier and seems to place me in far less danger of being trodden down; as though I were an unimportant servant who, if possible, was to help the masses trying to go through the narrow pass, 'the individual', through which, be it noted, no one can ever go without first becoming 'the individual'. Yet had I to crave an inscription on my grave I would ask for none other than 'the individual' – and even if it is not understood now, then in truth it will be. It was with that category that I worked at a time when everything in Denmark was directed towards the system; now it is no longer so much as mentioned. My possible importance is undoubtedly linked to that category. My writings may soon be forgotten, like those of many another writer. But if that was the right category, and everything in order with that category, if in this I saw aright, if I understood aright that such was my task, neither pleasurable nor thankful, whether vouchsafed to me in inward suffering such as has certainly rarely been experienced, or whether in outward sacrifices such as not every man is willing to make – in that case I shall endure and my writings with me.

'The individual'; now that the world has gone so far along the road of reflection Christianity stands and falls with that category. But for that category Pantheism would have triumphed. There will therefore certainly arise men who will know how to distort its meaning in a very different sense (they will not have had to work to bring it to light); but 'the individual' is and remains the anchor in the confusion of Pantheism, the hellebore which can sober people and the weight upon which stress can be laid, only that as the confusion grows greater and greater those who are to work with it (at the capstan – or where the weights are put on) must have an increasingly dialectical relation to it. I bind myself to make every man whom I can include in the category 'the individual' into a Christian or rather, since no man can do that for another, I vouch for his becoming one. As 'that individual' he is alone, alone in the whole world, alone – before God: then it will be easy to obey. Ultimately all doubt has its stronghold in the illusions of temporal existence, such as that one is several people or all mankind, who can in the end thus overawe God (just as the 'people' overawe the King or the 'public' overawe the alderman) and oneself become Christ. Pantheism is an optical illusion, one of the vaporous notions formed at random by temporal existence, or one of those atmospheric phenomena which it produces and which are supposed to be eternity. The point is however, that this category cannot be taught; the use of it is an art, a moral task, and an art the exercise of which is always dangerous and at times might even require the life of the artist. For that which divinely understood is the highest of all things will be looked-upon by a self-opinionated race and the confused crowd as *lèse majesté* against the 'race', the 'masses', the 'public' etc.

'The individual'; that category has only been used once before and then by Socrates, in a dialectical and decisive way, to disintegrate paganism. In Christianity it will be used once again – in order to make men (the Christians) into Christians. It is not the category which missionaries can use in dealing with heathens when they preach the Gospel, but the category of a missionary in Christendom itself, so as to make the change, which lies in being and becoming a Christian, a more inward change. When he comes the missionary will use that category. For if the age is waiting for a hero it waits in vain. It is far more probable that a man will come who will teach them obedience in divine weakness – by making them rebel against God by putting to death the one who was obedient to God.

Part III
Modernity and Bourgeois Life

III
Introduction

By later standards the revolutions of 1848 were little more than skirmishes. Even in Paris, which underwent two revolutions in the year, the fighting lasted a mere three days in February and four in June. In Germany there were 'uprisings'. In England there was no revolution at all. Chartist demonstrations were as close as the country came to insurrection. Yet 1848 marks a significant moment in European history. On the one hand it was seen by many at the time as marking that final break with the past for which they had been waiting with such impatience (IIIA 1). On the other, it can be seen with the benefit of hindsight as the last time that the bourgeoisie, as a class, acted as a revolutionary force. Though conditions varied from one country to another, in the West from mid-century on, modern society meant bourgeois society (IIIA 2, IIIB 4). It does not follow, however, that the texts included in this section can be categorized according to the specific class positions represented by their authors. It is noticeable that during the periods of their maturity a high proportion of these authors suffered imprisonment or exile, imposed or self-imposed (IIIA 3; IIIB 3, 8, 9 and 13). If there was a common element in the views for which each was temporarily silenced, however, it is to be found neither in support for nor in opposition to the rise of the bourgeoisie, but rather in a common sense that conservative control and censorship must be resisted, from whatever direction it happened to be imposed.

In France the crisis following the revolutions was resolved after a fashion in 1851, when a coup d'état delivered the short-lived Second Republic into the arms of Napoleon's nephew, Louis Napoleon. With the army behind him, he was duly crowned Emperor in the following year. His state, the Second Empire, lasted until his military adventurism caused its downfall in the disastrous Franco-Prussian war of 1870. It was during the two decades of his rule that Paris was transformed into what Benjamin was to call the 'capital of the nineteenth century'. At one level this transformation may be associated with the spectacular albeit reactionary remodelling effected by Baron Haussmann, Louis Napoleon's Prefect of the Seine. The boulevards Haussmann drove through the heart of the city gave visible form to the new social order, in the process displacing those urban communities that had been established on an older pattern. The physical renewal of the city thus did much to decide the imagery of the modern in France. If we seek to account for the extraordinary vitality of Parisian culture during these years, however, the processes of physical renewal will not in themselves stand as sufficient explanation. Indeed, that

vitality was achieved at least as much despite Haussmann's enterprise as because of it. There are two particular factors by which the avant-garde culture of the time may be recognized. The first is the distance it maintained from the proffered image of civil society. The second is its emphasis upon the continuing visibility of those whom that image tended to exclude, for all that the society relied in unacknowledged ways upon their services: the stonebreakers, ragpickers, laundresses, entertainers and prostitutes, forced to eke out an existence in the margins of public life (IIIB 3, IIID 7 and 8). The form of culture that we now think of as modernism was thus far from being the straightforward accompaniment to an imposed modernization. The monkey danced, but it was not to the tune the organ-grinder played. In this specific case, energy flowed from the bottom up, or rather from the outside in, finding the vacant spaces that Haussmann's scheme had left, and filling them with descriptions and with pictures.

England also modernized. The Great Exhibition of 1851 served as an international showcase for British industry and manufacture, as a magnet for foreign trade, and as a general stimulus to thought about the relations of art, design and manufacture (IIIA 5 and 9). As a second marker for the mid-century this occasion does nothing to diminish the relative significance of 1848. Rather, it tends to underline it. Considered as a nodal point, that's to say, the Great Exhibition avails a matching perspective both upon the social and economic transformations of the previous decades, and upon the determining conditions of the ensuing years. Looking back from the exhibition, we can observe that its antecedents were to be found in the France of the post-revolutionary years. A first 'Exposition du Produits de l'Industrie Français' was staged in Paris in 1798, and a further ten such exhibitions were held in the ensuing half century. These were generally organized under the three categories of raw materials, machinery and manufacture. The same categories were adopted for the Great Exhibition, with the addition of the Fine Arts as a fourth (painting nevertheless being explicitly excluded by the commissioners, on the grounds that 'being but little affected by material conditions, it seemed to rank as an independent art'). And looking forward from 1851, we can note that the Great Exhibition served to initiate a series of similar enterprises, staged at intervals of between one and seven years in Europe, North America and Australia during the remainder of the century and into the next. There were international fairs in Dublin and New York in 1853, but it was the Paris World's Fair of 1855 that constituted the first substantial response to the English initiative. This exhibition included a substantial section on Fine Art, with painting as the major medium represented, in a pattern that was to be generally followed for the remainder of the century. Paris was the site of further international exhibitions in 1867, 1878, 1889 and 1900. Whatever other functions these exhibitions may have fulfilled, each was intended to advertise the development of trade and industry within the context of a specific national culture and each sought to establish that culture as modern in the light of an international regard. Modernism spread from these exhibitions like a virus. To note their occasions and their locations around the globe is to follow the routes of its transmission (to Vienna in 1873, to Philadelphia in 1876, to Sydney and Melbourne in 1879–81, to Chicago in 1893 . . .).

By the time of the Great Exhibition the British railway network was virtually complete. The next two decades saw what was effectively a second industrial revolu-

tion, based not in textiles as the first had been, but in the staples of iron, steel and coal. This enlargement of the industrial base both stimulated and was in turn stimulated by a worldwide expansion of railways and shipping. Among the consequences were an increase in employment and in social stability in England, the emergence of a rentier class of no small significance for the patronage of the arts, and the generation of surplus capital which was used on a massive scale to underwrite development in other countries, among them the USA. Alike in England and in France the 25 year period after 1848 was marked by a major economic leap forward and, at the political level, by the establishment of a stable bourgeois order as the new norm for developed societies. During this period these two countries thus remained pre-eminent as world powers, to an extent now hard to conceive. At the mid-century southern and eastern Europe remained undeveloped, while both Italy and Germany remained collections of disjoined principalities rather than nations in the modern sense. The United States was certainly developing fast as an industrial power but it was not in a position fully to exploit its enormous potential until after 1865, when the Civil War ended in victory for the North, with its industrial base and its more modern capitalist economy.

The question inevitably arises why the most developed modernist culture should have flourished in France, when the industrial basis of modernization was laid down earlier and more pervasively in England. Certainly, if modernism were to be measured solely in terms of industrialization and of its social and economic effects, then nowhere was more modern than London or Manchester. But the fact is that the cultural forms we identify with modernism tended to develop in conjunction with a *discourse* on the subject of modernity. In France, argument over the respective priorities of classical traditions and modern themes could be traced back to the formation of the Academy in the mid-seventeenth century, while the annual Salons had provided a continuing public focus for discussion of the issues at stake. These issues had acquired added impetus and urgency during the period of the Revolution, and the resulting discourse was one within which it now seemed relevant to express intuitions of what it was like to be transformed by urbanization and by capitalism. If these intuitions originated within intellectual and artistic avant-gardes, they could nevertheless be registered publicly in the context of exhibitions that were sponsored by the state. A form of oppositional sub-culture was thus able to identify itself with debate about art in France – or at least in Paris – and to connect that debate to forms of political opposition. We should also bear in mind that the regular provision of a public forum provided support for relevant publications, and these in turn provided writers with opportunities for paid employment. Among those who wrote reviews of the Paris Salon in the mid-nineteenth century were some of the major figures in French literature. Forms of literary and artistic radicalism were thus availed of mutual support and stimulation, and were able to resonate with one another to the point of affecting the character of the wider culture.

In England, on the other hand, the Royal Academy was a far more recent institution, founded in the later eighteenth century, while even in the mid-nineteenth it was still ringed round by a protective wall of aristocratic patronage. For all the wider art-historical importance of work shown there by Constable and by Turner, its exhibitions were never to occupy a central position in the nation's intellectual culture. Controversy did come to the Academy, in 1848, with the work of the Pre-Raphaelite

Brotherhood (IIIc 2–5), but the work of the artists concerned could hardly have been associated with the expression of a dissident modernism. Though much work has been done in recent years to rescue that work from its disparagement by the triumph-ant modernism of the twentieth century, no amount of sympathetic pleading can make of it a technically or ideologically robust response to the contradictions of the modern, let alone a source of generative or transformatory intuitions. To that extent, it remains symptomatic. It is significant of the differences between cultural conditions in England and in France that the one piece of criticism we have to offer by a major figure in the field of English literature is neither supportive of the Pre-Raphaelite work it addresses, nor in itself representative of an oppositional point of view (IIIc 3).

We should also take into account the different forms of establishment of bourgeois society in the respective countries. In England, industrial and commercial develop-ment was achieved at great social cost, but thanks in part to the resources of Empire and in part to traditions of reform, it was achieved without an overt rending of the social fabric. In France it was as though all had been shaken loose, for better or worse (IIIa 1, 2 and 4). The art historian T. J. Clark has observed that we shall fail to understand Delacroix, Daumier or Baudelaire (and he might have added Courbet and even Manet) unless we situate them in relation to the revolutions of 1848, and to a moment when 'everything was at risk'. In England, and indeed to an extent in Germany, change in art largely took the form of an extension of subject-matter – often by recourse to imagery derived from history, from literature and from religious and other mythology – within an established technical manner and without serious divergence from normal forms of institutional practice. In France, on the other hand, it was as if the avant-garde had itself been shaken loose from the institutional structure. After 1848 it became increasingly self-sustaining. It engaged with new social forms self-consciously and occasionally with an apparent interventionist intent (IIIb 3–5 and 8). It distinguished the terms of its address from those of the Academy and the *juste milieu* by means of an accelerating technical radicalism (IIIb 14), and it began unevenly and unsystematically to explore alternative forms and venues of exhibition (IIIb 6, IIId 13), thus preparing the ground for those quite different patterns of professional practice that were to be developed in concert with a nascent capitalist art market in the last quarter of the century.

The conditions of the practice of art were subject to diverse forms of description and theorization during the period in question. We have grouped these under four general headings. The first assembles a number of efforts either simply to register the nature of the new circumstances or, in the more ambitious cases, to explain them. Common to many of the authors represented is a sense of the novelty of the conditions surveyed, of a consequent opening of intellectual perspectives, and of there being claims to be made on a new kind of future (IIIa 1 and 3). Thoughts of a different temper are articulated by Delacroix, who remains unenthused by the discourse of progress and by any materially grounded promise of beneficial change, sensing the present rather as a volcano beneath his feet (IIIa 4). It is notable that such figures of dynamism and change recur even in more objective attempts to think through the nature of the processes at work. We have already noted the apocalyptic suggestion of the early Marx that 'all that is solid melts into air'. Even in his mature work of the 1850s and 1860s, however, Marx's thought is conditioned by a sense of the social

structure as impermanent. He registers the possibilities for a more just and equable society that are opened up by capitalism's own revolutionary aspect (IIIA 8), even as he analyses the strange magic of false wants that its commodity form generates, turning relations between people into simulacra of relations between things (IIIA10). The intended dedicatee of Marx's *Capital* was Charles Darwin, who for his part applied the pervasive sense of dynamism and conflict to an analysis of the shaping forces at work in nature itself. His *Evolution of Species* was first published in 1859. When he came to apply his findings to the human species, his outlook remained in certain respects that of an English Victorian. In its assertion of the relativism of cultural values, however, his work furnished a revolutionary contrast to two important systems of belief. It goes almost without saying that his theories flew in the face of prevailing religious doctrine. But his findings also ran counter to the less-than-scientific prejudices of those who sought to justify the Western domination of the world with theories of inherent cultural and spiritual superiority (IIIA11).

Under our second heading are grouped a range of texts variously addressed to the nature of Realism in the practice of art. There are various factors that may help to explain why the demands of Realism should have been felt so widely and so deeply from the late 1840s to the 1860s, not simply among French writers and artists, but in Russia (IIIB 1, 9 and 10), and in due course in America (IIIB 18). Perhaps the most important is that as the practices and institutions of art came to be prised apart from aristocratic investments and from classical forms of culture, it became increasingly possible, even necessary, to conceive of those practices and institutions as representing a different and broader constituency (IIIB 8, 13 and 15). The sense of representation here should be understood as including both what it was that was pictured in art and who it was that the resulting pictures were supposed to be for. The changes in question were in turn informed by the various scientific or at least secular attempts that had been made to conceptualize the nature and structure of modern social life (IIIB 3). They also came to be informed by those positivist psychological theories that attributed an objective validity to the spontaneous perception of nature, by implication condemning canonical forms of composition and representation for their mediation of the truth (IIIB 11 and 15). There was a strong sense that the old gods served mystification, even the god of Romanticism with its attendant values of feeling and sensibility. What was required now was something plainer and more firmly grounded in the apprehension of material reality. Courbet is the major figure among the painters and the *locus classicus* is his 'savoir pour pouvoir' (IIIB 6): to know in order to be able to do; to be a man as well as a painter, and faithfully to record the manners and ideas of the age. It is to be remarked, however, that Realism itself remains a form of construction. Courbet does not put himself forward as a mere recording device, nor does he reduce art to documentation. The purpose of his Realism – 'my aim', as he says – is both to achieve a sense of his own 'independence and originality' *and* to 'create a living art'.

There remained those who were concerned with the articulation and maintenance of standards derived from the art of the past. The majority of writers in this category tended also to believe that there were moral precepts by which the practice of art ought to be governed, and that these percepts were undermined by the conditions of modernity. For them, the stronger the evidence that the world was changing, the

more important that art should serve as the repository of values that were tried and tested, even sanctified, and that it should remain true to reliable standards of technical excellence. In England during the mid-century discussion of art was largely dominated by voices of this persuasion. It followed that the field of debate was established between an outright conservatism on the one hand (IIIc3) and the nuanced attempt to meet modernity half way on the other (IIIc10). The terms of this debate are sharply posed in Ruskin's confrontation with the critic of the London *Times* over the work of the Pre-Raphaelites (IIIc5). Ruskin was by now a figure of overarching importance in England, but he was not a critic to whom a technically modern practice could confidently look for support. In France, the academic was open to attack from a more vigorous quarter (IIIc9).

The commitment to Realism and Naturalism had been central to the avant-garde impulse, in France above all, but it had never been entirely unopposed, even within the avant-garde itself. Or rather, we might say that it was only through admission of its necessarily partial and constituted aspect that Realism could be reconciled with other avant-garde interests (IIID6 and 8). At first it was the commitment to new forms of subject-matter that impelled exploration of the means of art and of the characteristics of representation itself. Increasingly, however, that exploration was driven by the idea that modernity might be associated not simply with the themes but with the *effects* of art. At this point Realism and Naturalism began to mutate into something else, even in the hands of those who conceived of themselves from the outset as Realists or Naturalists. From the early 1860s onward, the ground of the modern was to be defined in France in terms of an inescapable dialectic between two extreme positions: on the one hand an absolute fidelity to nature; on the other an art of entirely autonomous effects. Testimony to the significance of this moment and to the issues at stake is to be found in conservative accounts of the Salon des Refusés in 1863 (IIID11) and in responses to the exhibition of Manet's *Olympia* in the Salon of 1865 (IIID12). This testimony carries the more weight for the fact that 1865 was effectively the last year in which the official Salon – rather than its exclusions – provided a focus for substantial controversy. Further testimony is also to be found in very different form in texts by Baudelaire and by Boudin. Their suggestion is that in the overlooked, the apparently peripheral and even the sordid aspects of bourgeois life there may be found the moments of a strange and new form of the modern – a form of truth to be captured in all its *artificiality* (IIID8 and 14). Lastly and perhaps most poignantly of all, testimony to the condition of modernism in the 1860s is to be found in Manet's own glancing evocation of 'sincerity' as the final court of appeal – the justification for the course which his perplexing and unpopular art had had to take (IIID13).

IIIA
Modern Conditions

1 Théophile Gautier (1811–1872) 'Art in 1848'

For information on Gautier see IA18. Like Thoré (IIA12), but in more openly effusive tones, Gautier welcomed the revolution of 1848 as marking the dawning of a new age, and as opening up the possibility of a new and revitalized artistic culture. In the republican rhetoric of 1789, the models of a corrective vigour in expression and of vitality in artistic culture had been the works of the Greeks and the Romans. For the republicans of 1848, however, it was the now bankrupt authority of the classical that needed to be replaced. One alternative was to look to the exotic cultures of the East and of the so-called primitives. Another was to effect a shift in the priorities of the genres: to divert attention away from the large officially sponsored history painting, for so long the primary vehicle of classical style in art, and to concentrate rather upon painting's more portable forms, the landscape and the portrait. In fact the picture that with hindsight most clearly marks the break that Gautier describes was painted on the scale of a large history painting, though it was aggressively unclassical in style and though it possessed many of the features of work in the lower genres. This was Courbet's *Burial at Ornans*, shown at the Salon in 1850 (see IIIB3 and 4). Gautier's actual taste in art was not as radical as his rhetoric suggests, however, and he was not to be among the supporters of Realism in painting. 'L'Art en 1848' was originally published in *L'Artiste*, series V, volume 1, Paris, 15 May 1848, pp. 9–11. That source was used for the following translation, made for this volume by Jonathan Murphy.

A dynasty has been overturned and the Republic proclaimed: but art pays no heed to such events. Art is eternal because it is human; systems of government may change but it endures. How many revolutions, how many empires, how many peoples have shone, been eclipsed and forgotten while the cavalcades of Phidias still stand proud in the marble friezes of the Parthenon! How many riots have taken place at the foot of the Acropolis, riots of which no trace can be uncovered, even by the keenest of our historians!

Smoke from the fray fills the public squares and hides the plunging perspectives; but soon enough a wind comes up and blows away the whiff of powder, sweeps away the opaque clouds, and the temple of art appears again in its white serenity, cast against the unalterable azure of the sky.

Art is above this tumult and these events. Art reigns through the strength of its ideas, it contains whole civilizations, and of that great upheaval which seems to change the face of the world, there often remains nothing but the verse of the poet, or the statue of the sculptor who refers to it or sets it in stone. How unimportant is the bustle of the street, and the fear of the bourgeoisie! Art looks on, impassive, dreamy, interrupting its reverie from time to time to pick up the pen, the brush, or the chisel, for it knows that it has centuries at its disposal, and that Plato's Republic, which banished poetry after crowning it with laurels, would not have survived one minute.

Artists, never was the moment more beautiful. Nothing now hinders your development: take flight into the blue and endless sky, soak yourself in the rays of the sun, get drunk on the pure air, rise up like the lark, like the falcon, like the eagle, higher, ever higher! Set yourselves down on the virgin snows of those distant, inaccessible peaks! Girdle the earth with your flight, like a lover draping the hips of his beloved! The universe belongs to you, the visible world, the world of the mind, religion, poetry and history, the civilizations of the past, present and future, all that the soul can dream or conceive of belongs to you.

You happy few who are young, be not afraid of your youth, but let loose the reigns and gallop away audaciously, enthusiastic, and filled with love! Let horses of flame drag your bright chariot through the road of the Empyrean! Heed not the timid, with their lamentable tales of Phaeton and Icarus, be not afraid of a fall from the heavens, as to fly so high is already enough, and to fall one must first have achieved greatness. Let life course unchecked through your fecund veins in torrents of purple, fear not the beating of your heart or the tumult of your soul as it fiercely struggles in its prison of clay – for this, from now on, will be the only prison we know: by force and perseverance in your studies, by boldness and freedom in your work, you must strive to be the artists worthy of this colossal, climactic century, this great nineteenth century, the most beautiful epoch ever seen by humankind since the Earth first started its endless whirl around the Sun. Be worthy of this age, where the genius of man has stopped time, space and suffering, and imprisoned the forces of nature – steam, iron, light and electricity – in bands of steel. For if your will is strong, how pitiful will seem those much vaunted centuries of Pericles, Leo X and Louis XIV beside our own! How insignificant will seem the achievements in art of a small town in Attica, or a pope and a king beside the greatness of a People at liberty!

What a prodigious instant in the life of humanity we live! Will we not be like gods, as it says in the Bible? Yet this time, there will be no blue venomous serpent to whisper a tempting word into our ear. At last we are finally taking possession of our planet. The forces of nature belong to us, and soon will hold no secrets for Man. A race greater than that of the fabled Titans or the biblical giants will soon cover the globe, and we shall build not Babels of confusion but towers of harmony, matchless pinnacles which will pierce the skies, provoking this time no anger in a jealous God, as we rise above the Flood and the ages of barbarism.

What an endless field of possibility is today open to the artist! Past is the age of three or four tired Greek and Roman ideals, degraded by servile reproduction, and artists today have at their disposal all the types of the huge family of man. The mysterious Orient is finally becoming accessible, lifting a corner of its veil; those

beautiful, pure faces, so calm and dreamy, pale and fresh from the cool shadow of the harem, or bronzed to coppery gold by the fiery sun, faces which previously blossomed in a forgotten, secret solitude, leaving no silhouette in our memory, will soon present their perfect lines and noble profiles for artistic study, to the admiration of the people. This unknown world, prevented by iconoclastic Islam from translating its thought into shape and colour, thanks to the travels of our artists, is beginning to become familiar to us. The sight of primitive nature offers to the brush a thousand subjects for Edenic eclogues. In Tahiti, that Oceanic Cockaigne, every day one sees Venus emerging from the Seas, decked with pearls, printing her beautiful naked feet on the pink shells by the shore. The mountains of India are sculpted with pagodas, and dotted with monstrous idols and pale elephants carrying towers of gold. The eye is greeted by complexions of yellow bronze and maidens whose glances have the charm of delicate blossoms, while swathes of gauze and clouds of perfume fill the air. The ear thrills to the tinkling of bracelets which clink around the ankles of temple dancers, while stairs of marble descend to sacred rivers, and majestic tigers prowl through its jungles. Even the tips of the Earth have their own cold beauty and their own snowy grace. America, although discovered nearly four centuries ago, is still the New World: its towering Cordillera, its virgin forests, its pampas and savannahs, its giant rivers and birds of paradise, and its brightly coloured races, all offer subjects of an inexhaustible magnificence.

The power of steam has changed the world, turning previously long voyages into short trips. But it is not merely in the physical world that artists will find their inspiration, for all the classical ancient myths must be rewritten. The old and ancient emblems are now empty of meaning. A whole new vast system of symbols must be invented, answering the new needs of our times, in the fields of theology, politics and allegory. Christianity itself is receiving new interpretations, and reviving itself at primitive springs, so that it can no longer be conveyed by models established in the Middle Ages. The formulas of the *ancien régime* are totally unsuitable for our new Republic, and to make use of them would be to misunderstand or falsify our modern tendencies. By the same token, the decoration of our great national buildings, the frequency of popular festivals, and the whole movement of a way of life yet unknown will have to represent in a palpable form ideas and abstract concepts unknown to Richardson, Gravelot, César Ripa and all the other ancient model authors.

Many people believe that Art has breathed its last gasp. I feel that, on the contrary, it is still in its infancy. The Earth is not old; it is barely six thousand years old, a mere instant in the life of a planet. Our Earth is but a child, scarce out of its swaddling bands. To my mind, the masterpieces that are generally believed to be unsurpassable are merely the early efforts of a child who shows promise. Now, at last, comes the time when man must work, and we will soon see what the power of thought, freed from its yoke, is capable of producing. From nature and freedom, combined with imagination, new unexpected marvels will spring forth, and soon a wave of universal belief will buoy up even the heaviest of spirits, like a huge tidal wave righting capsized vessels, propelling us towards new, unknown horizons.

We will be surprised to find that, despite our many museums, galleries, libraries, so much research and study, we have yet to discover so many striking and adorable details in the portrait of that universal mother, ever young and smiling, that is Nature.

To work then, happy generations, salute the promised land, that happy island, that El Dorado, which emerges sparkling and radiant through the morning mist!

A Renaissance brighter than that illustrated by Michelangelo and Raphael, and all those immense geniuses, forefathers of our modern thought, will be studded with the sparkle of your fame and echo with your names!

Some time, no doubt, will be required, for great results to be achieved, but they will come about through that secret force that hides beneath the surface. Doubtless, painters and poets though we be, the tumult and smoke of the events across Europe will muffle our voices and obscure our painting. There will be disasters and struggles, misery and suffering. Many of us will perish in solitude, abandoned and forgotten. But no matter! No religion can be held responsible for its priests, nor a theory for its execution, nor politics for its ministers: and no freedom is responsible for the people that it delivers.

* * *

What used to be called history painting (if I may be excused the paradox) no longer exists. Or rather, it no longer exists in the form practised by David, Guérin, Girodet, Gros, Meynier and other luminaries of the Empire and the Restoration, where a noble, solemn subject was treated in epic fashion, in a highly stylized manner, on a canvas of huge dimensions. The painters who were practised in this art were profoundly disdainful of genre painting and landscape, and we were lucky to get a portrait out of them, or a painting of a sovereign or dignitary treated in some pseudo-historical fashion. Other artists and the general public regarded these masters with a humble sort of terror, as the history painters inspired the same sort of sleepy veneration as the tragedians. The French, that shallow people, have only ever admired the things that bore them.

Now we seem to have recovered somewhat from our infatuation with history painting, and we believe that Andromache has mourned Hector long enough, that Dido must now have finished telling us her adventures, that Orestes has fought long enough against the Furies, and that he has now had plenty of time to sit on the Cappaudas to rid himself of his obsessions. These heroes and heroines took up too much space with their ill-textured torsos, their empty contours and their over-complicated drapery. No one today has room to give up twenty feet of wall to mythology, for these so-called history painters took all their subjects from fables; history, henceforth, is perhaps the place to which they should be consigned.

Paintings of this dimension are now an anachronism and a nonsense for our age, unless designed for a particular place, and even then perhaps we would be better served by painting directly upon the wall of a building, either as fresco, or in oils, or even in wax. It seems logical to divide painting into two categories, with monumental painting on the one hand, and easel painting on the other. The former should serve to decorate national and public buildings, temples of prayer and temples of pleasure; the latter should fill our galleries and satisfy our individual taste. The former, intimately linked to architecture, must give pride of place to composition, to style and sober colour, and be executed on a large, simple scale, in proportions that accord with those of the monument in question; the latter, whose function is to be transported from place to place, has no call to be executed on an enormous scale. Medium or even small dimensions are most fitting. Here we look for imagination, caprice, a highly polished

execution, a concern for detail, a precious or piquant touch, where originality can spread its wings: easel work is painting for the sake of painting, and art for the sake of art.

It is through the practice of wall painting that the illustrious masters of Italy forged that unique, robust male temperament, that proud and haughty disposition, and that sustained style. The greatest of our artists have never attained such a facility on a large scale. Some of our artists are perhaps more ingenious, more innovative even, and some are veritable savants in matters of aesthetics, but even they at the best of times remain easel painters.

For several years now in France almost no painting has taken place *in situ*. Churches were decorated, in a reasonable manner, with paintings executed without regard for their destination, unadapted in any fashion to the compartmental nature of the architecture in question. But for some time now, thanks to a more intelligent understanding of the needs of art, the bareness of the public buildings of Paris has begun to be clothed in paintings once again.

The chapels of Saint-Merry, Saint-Séverin, Saint-Germain-des-Prés, Saint-Germain-l'Auxerrois, the Jeunes-Aveugles, the staircase of the Orsay palace, the library of the Upper Chamber and various rooms in the Chamber of Deputies have all furnished Delacroix, Chasseriau, Flandrin, Amaury Duval, Lehmann, Gigoux, Mottez, Riesener, Roqueplan, Guichard and many others with opportunities to develop a new aspect of their talent and to bring out qualities which would certainly have remained hidden had they been forced to continue painting on canvas, whatever inspiration had come to their brush. We should set ourselves a goal; in five or six years from now all the monuments of Paris, which is now a veritable metropolis of liberty, should be clothed in a magnificent array of masterpieces. To that end we should put to work those legions of talent which are now scattered haphazardly all over Paris, that multitude of able hands which have no outlet for their skills at present, and who presently cover the long galleries of the Louvre with canvases that no one will buy, irrespective of their merit. For the rapid and perfect execution of the huge task of adorning our public buildings, in order that they may be fitting for that gigantic Republic to come, we should aim to recruit whole armies and camps of painters, next to which the great schools of Italy, with their numerous pupils, would be no more than provincial drawing circles.

There is no doubt that individualism might suffer, and that some might lose their originality in attention to tiny details, but great works are nearly always collective affairs. No one knows the names of those who built and sculpted our cathedrals. Raphael himself, despite his personal value, summarizes a whole civilization, and sums up a whole group of painters whose identity is wrapped up in his own. With the exception of the rare critics who have examined his work in detail, few people are aware how many different geniuses are grouped under his one name. Are we to conclude from this that Raphael took advantage of his collaborators? Of course not. He merely supplemented their possibilities, and gave them what they lacked. Working alone he might have been as great, but his talents would have been more thinly spread. The loss would have been ours. Thought is fast, but the hand is slow and life presents many obstacles. Many an artist ascends to heaven without having had the time to reveal the half of his secret. Why not make use of those

fingers in search of inspiration, patiently awaiting an idea from the heart or from the brain?

Never has the knowledge of artistic practice been more widespread; never has the manipulation of the brush and of colours, and the material side of art like the techniques of layering, scumbling and glazing, been better understood. Venice itself has been forced to give up its secrets one by one to our patient researchers. The dark night of Rembrandt has been illuminated and we now know as much about Rubens as Anvers ever did. Florence and Rome have also been forced to yield up their secrets to the ear of good Father Ingres, and despite that hostile air that its saints possess, the bleeding wounds of its Christs, the livid vestments of its cadaverous monks, even Catholic Spain has handed over its sombre, rich palette for our examination. The purple lips of the Virgins of Murillo have been analysed, and the bluish wounds of Zurbaran's martyrs too. We know how to do everything: we know not what to do. So many expert hands, so many subtle, knowing brushes have nothing to paint; one sees poor abandoned artists wandering through galleries and giving themselves up to fantasies more wilful than inspired, and these thousand variations are a sure sign that art lacks an obvious theme to embroider. The Republic, no doubt, will provide one: our fathers had their Christian symbolism, which the artists of the Renaissance wedded in happy marriage to pagan ideas which once again had come to light after an eclipse of several centuries. We ourselves have the idea of nature, invented scarce eighty years ago by Jean-Jacques Rousseau, a citizen of Geneva; for sure, matter, the world, is vast, and one can find there many a subject; but nature is merely facts and not faith. The ranks of capable landscape painters have swelled considerably in recent times, whilst the number of idealist painters shrinks from day to day, and this can be put down to neither a lack of talent nor a lack of genius, for never was the French school more brilliant or able than it is today. Paris is the capital of the arts; how mistaken we are in sending our prizewinners to Rome.

2 Ernest Renan (1823–1892) on Culture and Plutocracy

Renan was a major figure in the intellectual history of France in the nineteenth century and published widely on the history and nature of religions, on philology and on epistemology and the philosophy of science. Though not published until 1888, *L'Avenir de la science, pensées de 1848*, was actually his first major work, originally written in 1848–9 and bearing the imprint of its revolutionary moment – as its subtitle implies. The book was an ambitious attempt to consider prospects for the advancement of science – or reason in general – in the light of an analysis of history. Soon after completing the work, however, Renan spent eight months in Italy, where 'the artistic side of life . . . revealed itself resplendent and comforting'. He came to regard his book as 'harsh, dogmatic, sectarian and hard', and he set it aside till near the end of his life. When he finally decided to issue it, he left it untransformed as a memorial to its period and to his own youth, merely providing a preface to explain the conditions of its composition and withdrawal. In the process, however, he offered a conclusion that was both an admonishment to his younger self and an acknowledgement of the spirit in which the book had been composed. 'Enlightenment, morality, art will always be represented among mankind by a magistracy, by a minority, preserving the traditions of the true, the good and the beautiful. But we must be

on our guard against this magistracy disposing of the public forces and appealing to superstition and imposture in order to maintain its power' (p. xi). There is a clear reference here to the position that Victor Cousin had come to represent (see IIB4). Our extract is taken from the English version, *The Future of Science, Ideas of 1848*, London: Chapman and Hall, 1891, chapter XX, pp. 382–92.

The great misfortune of contemporary society is that intellectual culture is not recognized in it as a religious concern; that poetry, science, and literature are regarded as an artistic luxury appealing only to the classes privileged by fortune. Greek art produced for the sake of the country, for the national thought; the art of the seventeenth century produced for the king, which was, in one way, to produce for the nation. Art, in our day, produces only at the express or understood command of individuals. The artist corresponds to the amateur, as the cook does to the gastronomist. This is a deplorable situation at an epoch when, with rare exceptions, the subdivision of property makes it impossible for private individuals to achieve great things. Greece owed her poems, her temples, and her statues to her inward spontaneousness, they were due to her own fecundity and to her craving to satisfy one of the needs of human nature. With us, art is granted a few sparing subsidies, which are made not from a desire to see the national thought finding expression in great works, not by the inward impulsion which inclines man to realize beauty, but from a calm and critical consideration that art should have its place and from a reluctance to be behind the past. But if people merely obeyed the pure and spontaneous love of what is beautiful, little would be done. One of the reasons recently advanced in favour of the scheme for the completion of the Louvre was that it would be a means of giving employment to artists. I should be curious to know whether Pericles advanced this argument to the Athenians when the question of building the Parthenon was discussed.

Reflect for a moment on the consequences of this deplorable regime which subjects art, and more or less literature and poetry, to the fancy of individuals. In the productions of the mind, as in all other kinds, the question of supply and demand prevails, and it must necessarily happen that it is wealth which makes the demand. So that the man who contemplates living by intellectual production must first of all anticipate the demand of the rich man in order to comply with it. Now what does the rich man demand in the way of intellectual productions? Is it serious literature? Is it high philosophy, or, in the way of art, pure and severe productions, high moral creations? Assuredly not. It is amusing literature; serial stories, romances, clever plays in which his opinions are flattered, and so on. Thus, with the rich man regulating the literary and artistic production by his tastes, which are pretty well known, and these tastes being as a rule (there are a few noble exceptions) for frivolous literature and for art unworthy of the name, it was bound to happen that such a state of things would lower literature, art, and science. For with the rich man's taste setting the value of things, a jockey or a danseuse who correspond to this taste are persons of more value than the savant or the philosopher, whose works he does not want. That is why a composer of novels for serials may make a brilliant fortune and attain what is called a position in the world, while a real savant . . . could not make a living out of his works.

I mean by plutocracy a state of society in which wealth is the principal thing, in which one can do nothing unless one is rich, in which the chief object of ambition is to

become rich, in which capacity and morality are generally valued (and more or less accurately) by a money standard, so that the best criterion of the *élite* of a nation is the cess-rate. It will not, I imagine, be questioned that the society of the present day combines these different characteristics. That being granted, I maintain that all the faults of our intellectual development come from plutocracy, and that it is in this respect above all that our modern societies are inferior to Greek society. In fact, when wealth becomes the principal aim of human life, or at all events the necessary condition of all other ambitions, let us consider what will be the direction given to the mind. What is needed to become rich? Is it to be a savant, a wise man, or a philosopher? Not at all; these are, upon the contrary, more obstacles than anything else. He who devotes his life to science may rest assured that he will die in want, unless he has a patrimony, or unless he finds a means of utilizing his science, that is to say, unless he can make a livelihood out of pure science. For it will be observed that when a man makes a living by intellectual labour, it is not as a rule his true science that he brings into play, but his inferior qualities. M. Lebronne has made more by compiling second-rate elementary books than by the admirable researches which have rendered his name famous. Vico earned his living by composing prose and poetic pieces of the most contemptible rhetoric for princes and nobles, and could not find a publisher for his *Science Nouvelle*. So true is it that it is not the intrinsic value of things which constitutes their value, but the relation which they bear to those who hold the purse-strings. I may without vanity consider myself to possess as much capacity as any clerk or shopman. Yet the latter are able, in serving purely material interests, to gain an honest living, while I, who appeal to the soul, I, the priest of true religion, do not, in sober truth, know where I am to look for my daily bread next year.

The profound truth of the Greek intelligence is derived, as it seems to me, from the fact that riches constituted, in their highly organized civilization, merely a motive of itself, but not a necessary condition to any other ambition. Hence arose the perfection of spontaneousness in the development of individual characters. A man was a poet or a philosopher because it was part of his human nature, and because he was specially endowed in that way. With us, upon the contrary, there is a tendency imposed upon whomsoever seeks to make a situation for himself in external life. The faculties which he must cultivate are those which serve to make rich: the industrial spirit and practical intelligence. Now these faculties are of very small value: they do not make a man better, or more elevated, or more clear-sighted in divine things; quite the contrary. A man devoid of worth or morality, selfish and lazy, will be more likely to make his fortune upon the Stock Exchange than one who concerns himself with serious matters. That is not just, and therefore it will disappear. Plutocracy, then, is not very favourable to the legitimate development of intelligence. England, the country of wealth, is of all civilized countries the one in which you find the minimum of the philosophical development of the intelligence. The nobles in former times regarded it as beneath their dignity to concern themselves with literature. The rich generally have coarse tastes and attach the idea of good form (*bon ton*) to matters which are ridiculous or purely of convention. A gentleman rider, however insignificant he is, may pass for a model of fashion. But I call him in so many words a fool.

Plutocracy, in another order of ideas, is the source of all our wars, because of the evil feelings it inspires among those whom fate has made poor. The latter, in truth,

seeing that they are nothing because they possess nothing, direct all their activity towards this one aim; and as, in many cases, this is slow, difficult, and even impossible, evil thoughts germ; jealousy and hatred of the rich, the idea of stripping him of what he possesses. The remedy for this is not to contrive so that the poor may become rich, nor to excite this desire in him, but so to act that riches may become a secondary and insignificant thing; that without it one may be very happy, very great, very noble, and very handsome; that without it one may become influential and highly esteemed in the State. The remedy, in other words, is not to excite among men appetites which all cannot satisfy, but to destroy this appetite or to change the object of it, seeing that this object does not belong to the essence of human nature; but that, on the contrary, it impedes the proper development of it.

3 Richard Wagner (1813–1883) 'The Revolution'

After a failed attempt to establish himself in Paris between 1839 and 1842, Wagner returned to Germany at the age of 28 and found employment as conductor of the court opera at Dresden. He was there until 1849. The revolutions of 1848 in Paris stimulated reform movements elsewhere, including the German states, and Wagner, although later an arch-conservative, was at this time caught up in the wave of radicalism. His assistant, August Rockel, lost his post due to his political activities, and started a newspaper, the *Volksblätter* in August 1848. Wagner contributed several anonymous articles, including 'The Revolution' on 8 April 1849. The following month, May 1849, the Dresden Uprising broke out. After its suppression, Wagner fled into exile in Switzerland, where he was to remain for the next ten years. Wagner's invocation of Revolution contains images of cataclysm, of the existing world being shaken and destroyed, comparable to those in the contemporaneous writings of such diverse figures as Marx (IIA11) and Delacroix (IIIA4). And also like the early Marx (IIA9), he identifies the freedom to be brought by Revolution with a freedom from alienated labour and enjoyment of creative power. The present extracts are from the translation of Wagner's text by P. R. J. Ford and Mary Whittal in *Wagner: A Documentary Study*, compiled and edited by Herbert Barth, Dietrich Mack and Egon Voss, Vienna and London: Thames and Hudson, 1975, pp. 170–3.

If we look out over the nations and peoples of Europe we see everywhere the ferment of a mighty movement, whose first ripples have already reached us and whose full weight threatens to engulf us soon. Europe appears to us like some immense volcano, from within which a constantly growing, alarming roar can be heard; from its crater dark, stormy pillars of smoke are already rising into the sky and forming heavy blankets of cloud, plunging the surrounding earth into darkness, while individual rivers of lava have already broken through the crust and go pouring down into the valleys, destroying everything in their path, fiery harbingers of the coming eruption.

A supernatural force seems to be about to seize our continent, to lift it from its well-tried course and hurl it off on to another track. Yes, the old world, we can see, is about to collapse; from it a *new* world will arise, for the sublime Goddess of *Revolution* comes thundering in on the wings of the storm, lightning flashing round her august head, a sword in her right hand, torch in her left, her eye so dark, so vengeful, so cold; and yet what a glow of the purest love, what abundant happiness it radiates *upon him*

who dares to look straight and unswerving into this sombre eye! She thunders down upon us, the ever-rejuvenating mother of mankind, destroying and blessing she sweeps across the earth; and before her the howl of the storm, shaking so violently all that man has fashioned that vast clouds of dust darken the air; wherever her mighty foot treads what vain presumption built to last a thousand years crashes in ruins, and the hem of her robe sweeps away its last remains! But behind her there is revealed to us, bathed in glowing sunshine, an unsuspected paradise of happiness, and where her foot has passed in destruction, sweet-scented flowers spring from the ground and the joyful hallelujahs of liberated mankind fill the air, which is yet re-echoing with the din of conflict.

And now look around you. There you see some mighty prince, his heart beating anxiously, his breath hesitant, struggling to put on a calm and collected air as he tries to deny to himself and to others what he nevertheless clearly sees is inescapable. And there you see another, his leathery old face furrowed with every vice, fishing out and bringing into play all those crafty little tricks which have already earned him many a little title and many a little medal; now a diplomatic smile spreads across his inscrutable countenance as he tries to calm down the snivelling Junkers and their swooning dames by the semi-official intimation that the highest authorities are already devoting their attention to this strange apparition, that couriers with Cabinet decrees have already been despatched in all directions, that the considered opinion of the wise statesman, Prince Metternich himself, is already on its way from London, that the competent security forces all around have been alerted, so that elegant society may look forward to the surprise of being able to inspect for themselves this notorious vagabond, Revolution – in chains, of course, in an iron cage – at the next Court ball. And there is yet a third, calculating the approach of the phenomenon, then running to the stock exchange to study and assess the rise and fall of the stocks, haggling and bargaining, trying to squeeze out the last ounce of speculative profit, until with one stroke his whole shabby business is blown to smithereens. And now again, see behind the dusty desk one of those rusted and furred-up cogs of our present-day bureaucracy, scratching his blunt old pens across the page with no thought in his mind but to add more and more to the ancient heap of the paper world-order. Between the piles of documents and contracts lie the hearts of living men, like dried plants, crumbling to dust in these modern torture-chambers. There there is immense activity, for the country-wide net is torn in several places and the surprised spiders are busily spinning new threads to repair the weak spots. No ray of light enters there, all is eternal night and darkness, and it is in night and darkness that the whole apparatus will disappear without trace. But from this side can be heard bright martial music, the swords and bayonets are gleaming, heavy cannons rattle past and the long columns of troops wind along shoulder-to-shoulder. The brave band of heroes have set forth to match arms with the Revolution. The general marches them right and left and places here the infantry, there the hussars and draws up his long ranks of soldiers and the shattering artillery; and the Revolution, head high in the clouds, approaches – and they cannot see it and wait for the foe; and it is already in their midst; and its tempestuous force seizes them and scatters their ranks and pulverizes their borrowed strength, and the general sits there still, studying the map and working out from which side the enemy might attack, and how strong he is and when he will come! And now the vision again

changes: we see an anxious worried face, that of an honest and industrious citizen. He has worked and struggled his whole life long and faithfully served the common weal, as far as his strength allowed him; no tears, no injustice taints the little sheaf which he has fathered through his fruitful efforts, to support *him* in his weak old age and *his* children as they enter a hostile world. Certainly he felt the approach of the storm, certainly he realizes no power can resist it, but his heart bleeds as he looks back on his arduous existence, the sole fruit of which is now destined to be destroyed. We must not condemn him if he clutches anxiously at his little nest-egg and in his blind fervour vainly resists the impending change with all his strength. Harken, unfortunate! Lift your eyes and look up to where thousands upon thousands are gathering on the hillsides to await the new sun, full of joyful expectation! Look at them, they are your brothers, your sisters, they are the host of all the poor, those wretches who have never yet known *anything* from life but *suffering*, who were strangers on this earth of joy; they are all longing for just *this* Revolution, which *you* are afraid of, to set them free from this world of despair, to create a new world of happiness for *everyone*! Look, there come thousands pouring from the factories; they have laboured and produced the finest cloths, but they themselves and their children are naked, they freeze and hunger for it is not to *them* that the fruits of their labour belong, they belong to the rich and mighty, who call the earth and its inhabitants their *own*. See how they come from the farms and villages; they have tilled the soil and made of it a garden of plenty, and their efforts have produced crops in abundance, enough to feed every man alive – and yet they are poor and hungry and naked, for it is not to them and the others who are in need that the earth's gifts belong, they belong to the rich and mighty, who call earth and its inhabitants their *own*. By the hundred thousand, by the million, they are all assembled on the heights and look out to the far horizon, where the gathering clouds announce the approach of the liberating Revolution, and all of them, who have nothing left to regret, whose very sons are stolen from them to be turned into devoted warders of their imprisoned father, whose daughters must walk the streets of our cities laden with shame, victims of the low desires of the rich and mighty, all of them with their pallid, care-worn faces, their weak and shivering limbs, all of them, who have *never* known happiness, they are gathered there on the heights and, trembling with excited expectation, they look out with fervent gaze upon the approaching phenomenon, and listen in silent rapture to the roar of the rising storm as it brings to their ears the greeting of the Revolution; 'I am the ever-rejuvenating, ever-creating life! Where I am not is death! I am the dream, the comfort, the hope of the oppressed! I destroy what is, and wherever I go new life springs from the dead rocks. I come to you to smash all the chains which crush you, to redeem you from the embrace of death and breathe young life into your veins. All that exists must pass away, that is the eternal law of nature, the rule of life, and I, the eternal destroyer, have come to fulfil the law and create the eternally youthful life. I will utterly annihilate the established order in which you live, for it springs from sin, its flower is misery and its fruit is crime; but the seed has ripened and I am the reaper. I will destroy every wrong which has power over men. I will destroy the domination of one over the other, of the dead over the living, of the material over the spiritual, I will shatter the power of the mighty, of the law and of property. Man's master shall be his *own* will, his *own* desire his only law, his *own* strength his only property, *for only the free man is holy and there is*

nought higher than he. Let there be an end to the wrong that gives one man power over millions, which subjects millions to the will of one individual, to the evil which teaches that one has the power to give happiness to all others. Equals may not rule equals, equals have no higher power than equals, *and since all are equal I shall destroy all dominion of one over the other.* [. . .]

'Let there be an end to the injustice that makes man subject to his own works, to property. Man's highest possession is his creative power, that is the spring from which all happiness for ever arises and your greatest real pleasure lies not in *what is produced* but in the *act of production*, in the use of *your own power.* [. . .]

'I will destroy the existing order of things which divides mankind into hostile nations, into strong and weak, into those with rights and those without, into rich and poor, for this order simply makes *wretches* of all. I will destroy the order of things which makes millions into slaves of the few, and these few into slaves of their own paper and their own wealth. I will destroy this order of things which divides work from enjoyment, which makes work a burden and enjoyment a vice, and renders *one* man miserable through want and *the other* miserable through excess. I will destroy this order of things which consumes men's strength in the service of the dominion of the dead, of lifeless matter which keeps half of mankind inactive or engaged in useless activity, which compels hundreds of thousands to devote the flower of their youth in busy indolence to the preservation of this damnable state of affairs as soldiers, officials, speculators and financiers, while the other half has to sustain the whole shameful edifice at the cost of the exhaustion of their powers and the sacrifice of any enjoyment of life. I will wipe from the face of the earth every trace of this crazy order of things, this compact of violence, lies, worry, hypocrisy, poverty, misery, suffering, tears, deceit and crime which fathers an occasional burst of impure lust, but almost never a ray of pure joy.' [. . .]

And see, the hosts on the hillsides fall silent on their knees, they hark with dumb rapture, and as the sunparched earth sucks up the cooling raindrops, so their hearts, scorched by misery, gulp down the draught of the thundering storm and new life courses through their veins. The storm rolls nearer and nearer, on its wings the Revolution; the re-awakened hearts open wide and the Revolution, victorious, enters into their minds, their bones, their flesh and fills them utterly. They jump up from the earth in divine rapture; no longer are they the poor, the starving, bowed down by misery, their proud figures arise, with the glow of enthusiasm transfiguring their faces, their eyes are alight with excitement and, with the heaven-shaking cry *'I am a man!'*, the millions, the living Revolution, the man-become-god, burst forth into the valleys and the plains and proclaim to the whole world the new gospel of happiness!

4 Eugène Delacroix (1798–1863) on Modernity

Delacroix resumed the *Journal* he had kept in 1822–4 (cf. IA3) after a gap of 23 years, in January 1847. He kept it on a regular basis thereafter until his death in August 1863. A variety of comments on modernity and the ideology of progress are scattered throughout the *Journal.* Like Wagner (IIIA3), but to opposite effect, Delacroix employs the image of a volcano to capture the sense of social upheaval. From his 1849 comments on Baudelaire, temporarily enthused by revolution, to his reaction to the 1856 agricultural exhibition,

Delacroix maintains a mordant hostility to promises of improvement. Against the grand abstractions, he sets what he himself may hope to achieve: 'a good employment of the passing day'. Our extracts are taken from *The Journal of Eugène Delacroix*, translated by Walter Pach, London: Jonathan Cape, 1938, pp. 182–3, 196–8, 310–12, 511–14, 598–9. All the extracts were written in Paris; the final one is a copy of a letter to his cousin in Strasbourg, written after returning to Paris from a visit there.

February 5, 1849

M. Baudelaire came in as I was starting to work anew on a little figure of a woman in Oriental costume lying on a sofa, undertaken for Thomas, of the Rue du Bac. He told me of the difficulties that Daumier experiences in finishing.

He ran on to Proudhon, whom he admires and whom he calls the idol of the people. His views seem to be of the most modern, and altogether in the line of progress. Continued with the little figure after his departure.

Am in a very poor state of mind. Today it is public affairs which are the cause. Another day, it will be for some other reason. Must one not always be fighting against some bitter idea?

Monday, April 23, 1849

From knowledge which has been growing inescapable for a year, I believe one can affirm that all progress must necessarily carry with it not a still greater progress, but finally the negation of progress, a return to the point from which we set out. The history of the human race is there to prove it. Yet consider the blind confidence of this generation – and of the one which preceded it – in modern ideas, in the coming of some sort of new era of humanity. We are supposed to see a complete change in our destiny; but for that to occur, there ought first to be a sign of it, I think, in the nature of man himself. Nothing in the centuries which preceded us is offered as justification of the bizarre confidence I mention, and it is in itself the only thing that hints at those future successes, those revolutions in human destiny which are so greatly desired. Is it not evident that progress, toward good or toward evil, has today brought society to the edge of an abyss into which it may very well fall, to make way for a state of complete barbarism; and the reason, the sole reason for this – does it not reside in that law which dominates all others here below, i.e. the need for change, whatever it may be? We must change. *Nil in eodem statu permanet* [Nothing ever remains in the same state]. That which ancient wisdom had discovered, before having made so many experiments, must necessarily be accepted by us, and we must submit to it. What is at present dying out among us will doubtless recreate itself, or will maintain itself at some other place, for a time of more or less duration.

The frightful *Prophète* [an opera by Meyerbeer], which its author doubtless looks upon as progress, is the annihilation of art. His submission to an imperious need to do something better or something different from what had been done, in a word the need to change, has caused him to lose sight of the eternal laws of taste and logic which govern the arts. Men like Berlioz and Hugo, and the rest of those so-called reformers, have not yet managed to abolish the laws which I just mentioned; but they have brought about a belief in the possibility of working along lines other than those of truth and reason. The same thing in politics. You can't get out of the beaten path save

by returning to the infancy of society; and, after one reform has followed another, savagery is necessarily the state brought about by these changes.

Mozart said: 'Violent passions should never be expressed to the point where they arouse disgust; even in situations of horror, music should never offend the ear and cease to be music.'

May 16, 1853

Girardin still believes firmly in the attainment of universal well-being, and one of the means of producing it, one that he returns to with predilection, is the ploughing, by machinery and on a large scale, of all the lands of France. He thinks he is contributing greatly to the happiness of mankind by dispensing with work; he pretends to think that all those unfortunate beings who wrest their food from the earth, painfully – as I admit, but with the feeling of their energy and of their well-employed perseverance, will be very moral and well satisfied with themselves when this land, which was their fatherland at all events, where their children were born and in which they buried their parents, should no longer be anything more than a place for the manufacture of products, exploited by the great arms of a machine, and yielding up the greater part of its production to the impure and godless hands of speculators. Will steam stop before churches and cemeteries? And will the Frenchman, returning to his fatherland after some years, be reduced to asking where it was that his village stood, and where the grave of his fathers was? For villages will be as useless as the rest; villagers are those who cultivate the soil, for they have to stay in the place where their care is required at every moment. It will be necessary to build cities on the basis of this workless and disinherited mass of people, who will no longer find anything to do in the fields, it will be necessary to construct for them immense barracks where they will lodge pell-mell. And when they are there, the Fleming beside the man of Marseilles, of Normandy and of Alsace, what will they have to do but read the quotations in the newspaper, not to see whether the harvest has been good in their beloved fields, not to see if they can advantageously sell their wheat, their hay, or their grapes, but to see whether their stocks in the unanimous universal property are going up or down? They will have paper instead of land! They will go to the billiard-rooms to gamble with this paper against that of their unknown neighbours, different in customs and in speech, and when they are ruined, will they at least have the chance they once had, when hail had destroyed their fruits or harvest, of repairing their misfortune by dint of work and constancy, or at least of drawing some consolation from the hope of a better year, from the sight of that field which they had watered so often with their sweat?

O unworthy philanthropists! O philosophers without heart and without imagination! You think that man is a machine, like your other machines; you degrade him from his most sacred rights, under pretext of saving him from labour which you affect to look on as vile and which are the law of his being, not only the one which commands that he himself create resources against need, but the one which at the same time raises him in his own eyes and employs the short span of time given him in a way that is almost sacred. O wretched journalists, scribblers and cracked-brained schemers! Instead of transforming the human race into a vile herd, let it have its true heritage – its attachment, its devotion to the soil! [. . .] Alas, poor peasants, poor villagers! The

hypocritical preaching you have offered them has already borne its fruits all too well! If your machine does not do its work on the earth, it is already working in their abused imagination. Their ideas of a general dividing-up, of leisure and of continual pleasure, are realized in these unworthy projects. They are already abandoning the work of the field in haphazard fashion and with the most ill-founded hopes; they are rushing headlong to the cities, where nothing but disappointment awaits them; there they complete the perversion of those feelings of dignity offered by the love of labour, and the more your machines feed them the more they will become degraded! What a noble spectacle in this best of centuries – human cattle fattened by the philosophers!

June 6, 1856

On leaving the Hôtel de Ville yesterday I went to see the famous agricultural exposition. All eyes are fastened upon it; people stand in admiration before these beautiful works of the imagination: machines for exploiting the earth, animals from all countries brought for a fraternal competition of all peoples: there is not one little bourgeois who, on leaving the place, is not infinitely grateful to himself for having been born in such a precious century. For my own part, I felt the greatest sadness amidst that bizarre mixture of things: those poor animals can't make out what that stupid crowd wants of them; they do not recognize the chance keepers who have been furnished to them. As to the peasants who have accompanied their beloved beasts, they lie there near their charges, casting anxious glances at the idle passers-by, and keeping watch to forestall the insults or the impudent teasing which they are by no means spared.

On entering that exposition of machines designed to plough, to sow and to reap, I thought myself in an arsenal amidst the machines of war: this is how I picture those ballistas and catapults, those coarse instruments bristling with iron points, and those chariots armed with scythes and steel blades: these are engines of Mars and not of blonde Ceres.

The complication of those frightful instruments is in singular contrast with the innocent nature of their employment; What! that frightful machine armed with tusks and points, bristling with sharp blades, is destined to give to man his daily bread! The plough, which I am astonished not to see placed among the constellations, like the lyre and the chariot, will now be no more than an instrument fallen to contempt! The horse has had his day, as well: new means are demanded by our insatiable desires.

Those little steam engines with their pistons, their balance wheel and their flaming throat are the horses of the future. The fearful and lugubrious jingling of their wheels and . . . Don Quixote would have laid lance in rest, etc.

Poor abused peoples, you will not find happiness in the disappearance of labour! Look at those idlers condemned to drag the burden of their days and not knowing what to do with their time, which the machines cut into still further. In other times, travel was a recreation for them: getting out of their daily torpor, seeing other regions and other customs beguiled the ennui which weighs upon them and pursues them. Nowadays, they are swept along at such speed that they can see nothing; they count the stages of their journey by the railroad stations – which all look alike. When they have crossed the whole of Europe, it seems as if they had not left those insipid stations which appear to follow them throughout their idleness and their incapacity for

enjoyment. The costumes and the varied usages that they have sought at the ends of the earth will not be long in looking the same everywhere.

Already the Ottoman who used to walk about in robes and slippers under his always-laughing sky has imprisoned himself in the ignoble clothing of our so-called civilization: he wears tight garments, as in countries where fresh air is an enemy against which one must protect oneself: he has adopted those monotonous colours which belonged to the peoples of the North, living as they do amid mud and hoar-frost. Instead of gazing upon the Bosporus as it smiles beneath its sun – and it was with tranquillity that they used to contemplate it – they shut themselves in to see French comedies in little theatres; you find the same comedies, the same newspapers and the same profitless noise in every part of the world, as you find the eternal railroad station, with its cyclops and its savage whistles.

One won't be able to go three leagues without that barbarous accompaniment: the fields and the mountains will be furrowed with it: we shall meet as the birds meet, in the plains of the air. Seeing no longer counts for anything: the object of arriving is to start out again. People will go from the Paris stock exchange to the St Petersburg stock exchange: business will demand the services of everybody, when there are no longer any harvests to be reaped by willing hands, no more fields to look after and improve by intelligent care. The thirst for acquiring riches, which give so little enjoyment, will have made of this world a world of brokers. They say that this is a fever as necessary to the life of societies as, according to physicians, an actual fever is to the human body in certain maladies. What, then, is this new malady unknown to so many societies of the past, which nevertheless astonished the world by their great and genuinely useful enterprises, by conquests in the domain of great ideas, by true riches employed to increase the splendour of governments, and to raise in their own esteem the subjects of these governments? Why is that pitiless activity not employed in digging vast canals to carry off the waters of those fatal floods of which we hear with consternation, why is it not used in the raising of dykes capable of stemming them? That is what Egypt did, disciplining the waters of the Nile and setting up the Pyramids against the invasion of the sands of the desert; that is what the Romans did when they covered the world of antiquity with their roads, with their bridges and also with their arches of triumph.

Who will raise a dike against evil impulses? What hand will make the overflow of wild passions return to their bed? Where is the people that will raise a dike against cupidity, against low envy, against the calumny that flouts honest men in silence, or the impotence of laws? When will that other machine, the pitiless press, be disciplined? when will the honour and the reputation of the upright man or the eminent man – and consequently the envied man – no longer be the target of poisoned calumnies from the merest non-entity?

(Tag all this on to the observations of the month of May, 1853, occasioned by those that Girardin set down on the subject of a mechanically ploughed France.)

Paris, September 3, 1857

I am writing to my good cousin:

'Despite the solitary life that I lead here, as much as that is possible in Paris, I shall often regret our real tranquillity in Strasbourg and the good it did me in particular,

with my badly impaired health and my restless, fatigued mind. In your peaceful city, everything seemed to me to breathe calm: here all I find on every face is burning fever: every place seems given up to perpetual change. This new world, good or bad, which is trying to reach the light across our ruins, is like a volcano under our feet, and lets no one catch his breath again save those who, like myself, begin to look upon themselves as strangers amid the things that are happening, and for whom hope is limited to a good employment of the passing day. So far I have gone out but once into the streets of Paris: I was frightened by all those faces of intriguers and of prostitutes.'

5 Gottfried Semper (1803–1879) from *Science, Industry and Art*

Semper designed some of the most magnificent public buildings of the nineteenth century, including the Dresden Opera House, the Polytechnikum in Zurich and the Burgtheatre in Vienna. He was also the author of a number of important writings in which he sought to assess the role of material, purpose and technique in the development of form in the applied arts. Forced to flee Dresden after the Prussian suppression of the Saxon uprising in 1849, Semper spent two years in Paris before being invited to London in 1851, where he contributed to the building of the Great Exhibition. This exhibition brought together 7,000 exhibits from thirty different nations and was seen by some six million visitors. It also set a precedent for a series of world fairs which were to have a widespread impact on culture and the arts in the second half of the nineteenth century. Semper's response to this first 'World-Fare', written in German and published the next year, carried the full title, 'Science, Industry and Art: Some Suggestions towards Encouraging the National Feeling for Art'. Semper sought to show not only that scientific progress and the development of new technical means release new architectural and expressive possibilities, but that the very concepts of style and design, traditionally dependent upon a completely different relation between human labour and the materials worked upon, undergo a fundamental revaluation in the industrial age. Semper's ideas received more sustained treatment in his major theoretical work *Der Stil in der technischen und tektonischen Künsten oder praktische Ästhetik* (Style in the technical and structural arts, or practical aesthetics), published in two volumes in 1860 and 1863. The present essay was first published as *Wissenschaft, Industrie und Kunst; Vorschläge zur Anregung nationalen Kunstgefühles*, Braunschweig, 1852. These extracts have been translated for the present volume by Nicholas Walker from Gottfried Semper, *Wissenschaft, Industrie und Kunst und andere Schriften über Architektur, Kunsthandwerk und Kunstunterricht*, Hans M. Wingler (ed.), Frankfurt: Florian Kupterberg Verlag, 1966, pp. 27–8, 31–2, 33, 34–8, 40, 41–2.

Barely four weeks have passed since the close of the exhibition, and some of the items still lie unpacked in the now derelict halls of the Hyde Park building, yet public interest in this 'world-phenomenon' has already passed, rushing forward to other more exciting, and perhaps more immediately topical, events. None of the enthusiastic newspaper correspondents who originally hailed the opening day of this 'World-Fare' as the beginning of a new age now raise their voices any more. – And yet, the great impression which the exhibition made upon thousands of wondering minds and striving spirits still continues to ferment within them. The full import of this feeling cannot properly be measured.

* * *

We can already perceive that these inventions no longer represent, as they once did, merely means for obviating need and procuring enjoyment; rather, it is need and enjoyment which have now become means for the inventions. The very order of things has been reversed.

But what is the necessary consequence of all this? The present age does not find time to make itself familiar with the benefits which are half thrust upon it and to make itself master of them. It is like a Chinese who is expected to eat with knife and fork. Speculation now casts itself upon the means and presents us with new benefits; where none exists, speculation there creates a thousand useful things, great and small; ancient and obsolescent conveniences of one kind or another are called back to life if nothing really new can be thought up. We can accomplish the most intractable and laborious things with playful ease by the application of technical means borrowed from science; the hardest porphyry and granite can be cut like chalk and polished like wax, ivory can be softened and pressed into shapes, India rubber and gutta-percha can be vulcanized and used to produce deceptive imitations of carvings in wood, metal and stone, in ways which far transcend the natural domain of fabricated materials. Metal is no longer smelted or beaten, but is now deposited with galvano-plastic techniques based upon natural forces quite unknown until recent times. Talbotype rapidly follows upon daguerreotype, immediately consigning the latter to total oblivion. Machines now sow, knit, engrave, cut and paint, thereby deeply intervening in the realm of human art and exposing every human skill to scorn.

Are not all of these great and splendid achievements? – I do not wish to bemoan the universal situation of which these merely represent some of the minor symptoms, for I am quite certain that this situation will successfully prove, sooner or later, to be the salvation and worthy accomplishment of society in every respect. Nor do I wish here to touch upon all those difficult and important questions which our situation provokes. Rather I shall merely attempt in what follows to point out some of the confusions which this development has now produced in that field of human capacities concerned with the understanding and creation of fine art.

* * *

The 'superfluity of means' is the first great danger with which art has to wrestle. This expression is indeed somewhat illogical (for there is no real superfluity of means, but only a lack in our own capacity to master them properly), but it is justified in so far as it does correctly designate what is wrong in the current situation.

The realm of praxis is striving in vain to master the material at its disposal, and especially from the spiritual and cultural point of view. – Praxis beholds its materials given over to constant reassessment and re-evaluation at the whim of science, without the possibility of developing a proper style through long historical exposure to popular use. The earlier founders of great and flourishing art came upon their materials as something almost already kneaded, as it were, by the instinctual practice of the people; and by plastically developing and elaborating this quasi-natural element into a more refined significance they simultaneously bestowed upon their creations the impress of strict necessity and spiritual freedom, thereby turning them into a universally intelligible expression of a true idea, one which continued to live on

historically in these creations as long as some trace or awareness of them still remained.

* * *

Amongst those concepts which the doctrine of taste has always striven to define, the concept of 'style' continues to play a central role. Of course, this expression also belongs amongst those which have been subject to such variable interpretation that certain doubters would therefore dearly deny it any sound conceptual basis whatsoever. Yet every artist, and every true connoisseur, possesses a genuine feeling of what the term implies, however difficult it might be to express this in words.

If nature, for all her manifold variety, is none the less extremely sparing and simple in her motifs, if she displays a constant renewal of these same forms, subtly and innumerably modified as they are in accordance with the specific levels of development and the different living conditions of her creatures, in some cases appearing developed one way, in others appearing either in a simplified or a more elaborate manner, then something similar is true for the technical arts as well: they too are based upon certain fundamental forms which, conditioned as they are by an original idea, still permit for all their constant repetition an infinite variety which is itself conditioned by other more precisely defining circumstances of one kind or another.

Thus it transpires that certain aspects which appear to be essential in one formal combination, may yet appear in another related one merely as a hint or suggestion; while aspects the original germ or trace of which was hardly perceptible in the first combination may now perhaps emerge more eloquently and more emphatically in the new combination.

This fundamental form, as the simplest expression of the original idea, is particularly subject to specific modification according to the respective materials which are applied in the further development of the form in question, and according to the various instruments used in the process. Finally, there are also a large number of influential circumstances external to the work itself, which represent important contributory factors in its actual production, like, for example, the location, the climate, the particular historical juncture, certain customs and cultural peculiarities, the social status and position of the person for whom the product is destined, and many more such things. In accordance with our preceding discussion, and without too much arbitrariness, one can conveniently divide the doctrine of style into three separate parts.

The doctrine of the fundamental motifs and all the more basic forms derived from them can constitute the first part of the doctrine of style, essentially concerned with the history of art.

There is no doubt that it produces a certain emotional satisfaction in us to encounter a work, however remote the time of its original production may be, in which the fundamental motif suffuses the entire composition like a basic tonality. And in genuine artistic activity it is certainly desirable to experience clarity and freshness in apprehending the product, for this is something which helps to guard against caprice and meaninglessness and even positively encourages inventiveness. The new is thereby related to the old without simply becoming a copy of the latter, and is liberated from dependence upon the more vacuous influences of fashion.

For the sake of clarity I should like to offer an example of the all-pervading influence which such an original form can exert upon the development of the arts.

The mat, and the more elaborately worked, and later printed, carpet which evolved out of it originally constituted various ways of dividing up domestic space, and therefore also represented the fundamental motif of all later forms of wall decoration and many other related branches of industrial design and architecture. Although the techniques involved in these different fields of application may assume the most varied directions, the latter will always display open signs of their common origin in the area of style. Now amongst the ancients – from the Assyrians right up to the Romans – and later amongst the medievals we can actually see that the manner in which the wall-space is divided into fields, along with the nature of the ornamentation, the principle of colouration, even the historical character of the sculpture and painting involved, the glass painting and the floor decoration, in short everything which is connected with it, all of this still remained dependent upon the fundamental motif, either through unconscious traditionalism or through conscious intent.

Fortunately, this historical part of the doctrine of style can still perspicuously be pursued even in our current confusing circumstances. For a complete historical picture, for cultural cross-comparison, and for general reflection alike, one only has to consider the immense wealth of material on show in the London Exhibition, all those works already mentioned which have been produced by peoples at a most basic level of human culture!

However, the second part of the doctrine of style, which ought to teach us how to give a new and different shape to these original motifs by means of our own technical methods and how to treat the raw material itself with our advanced technologies in accordance with principles of style, this remains all the more difficult and obscure. Here I could also offer another example which will reveal the problems attendant upon realizing the basic principles involved in the technical doctrine of style.

The great granite and porphyry monuments of Egypt still exert an enormous emotional power over each and every one of us. What does this magic really consist in? In part it is surely because they represent as it were the neutral ground upon which the harsh, resistant material itself and the softness of the human hand with all its simple tools (like the hammer and chisel) encounter one another and come to a kind of mutual pact. 'Thus far, and no further; this way, and this way alone!' This is what their mute and immemorial language tells us. – The sublime repose and the massiveness displayed by these monuments, the rather angular and levelled sophistication of their characteristic forms, the modesty and reticence with which this awkward material is fashioned, the atmosphere which surrounds them, all these are beautiful expressions of style, ones which now, when we can cut through the hardest stone like bread and cheese, no longer possess the entire necessity that formerly attached to them. How should we treat granite today? It is very difficult to provide a satisfactory answer to this question! The most obvious response is probably to say that we should only employ this material there where its characteristic permanence is really required, and attempt to develop appropriate rules for its stylistic treatment from that condition alone. The scant regard actually paid to such considerations in our own time is amply demonstrated by certain extravagances prominently produced by the great manufacturers of granite and porphyry in Sweden and Russia.

The example I have given leads on to a more general question which would itself alone provide more than adequate matter for an entire chapter, if I were permitted to extend the present essay into a book. – Where then will it lead to, this 'devaluation' of the material brought about by mechanical treatment, by the production of surrogate materials, and by so many other new inventions? And the devaluation of labour, the devaluation of the shaping, artistic and creative finish which is caused by the same developments, where will this lead to? I do not refer, of course, to the devaluation of price, but the devaluation of intrinsic significance, of the idea. Has not the arrival of the machine made it quite impossible for us to enjoy the new Houses of Parliament in London? How will the advance of time or science bring order and principle into these still continuing and confusing conditions? How will we be able to prevent this universal devaluation from spreading to the genuinely hand-crafted and traditionally produced works? And how then will we avoid regarding such things as nothing but an expression of affectation, of antiquarian curiosity, of esoteric interest and eccentricity?

Since the technical doctrine of style throws up such difficulties as far as the identification and application of its principles are concerned, we can hardly indeed speak in our own time of the third and important part of the same discipline. By this I mean that part which would discuss the local, historical and personal influences that lie beyond the art work itself but affect the way it is produced, and which would also include the coherence of the art work with other things like aesthetic character and general expression. This is what the rest of this essay will attempt to show.

We have already pointed out the dangers which threaten our own industrial art and art in general on account of the superfluity of means, to retain this expression for the moment. But now we must pose the question: what is the nature of the influence exerted upon industrial art by the speculation which is sustained by the power of capital and largely directed by science? And what will be the ultimate consequences of this new and ever-increasing protectorate?

'If it really recognizes its true advantage, such speculation will seek out and acquire the best forces it can, and will thereby reveal more zeal as the protectress and cultivator of the arts and artists than any Maecenas or any Medici has ever done.'

Yes indeed! But there is a difference between working at the behest of speculation and producing one's own work as a free individual. In the former case one is doubly dependent: a slave to one's employer and to the fashion of the moment which ultimately procures the demand for one's wares. One sacrifices one's individuality, one's very 'birthright' for a dish of lentils. Artists certainly also knew the meaning of self-denial in earlier times, but then they sacrificed their ego only for the greater glory of God.

* * *

The path which all our industry, and all art along with it, is inexorably following is very clear: everything is calculated with an eye to the market and adapted to the latter. Now any commodity designed for the market must permit the greatest possible range of universal application, must not express any other features than those which are permitted by the purpose and the material of the object in question. The ultimate location for which the object is destined remains unknown, and likewise the personal qualities of the individual whose property it will become. The object is therefore not permitted to enjoy any characteristic features or any local colour (in the broadest sense

of the expression), but must rather possess the capacity to accommodate itself harmoniously into any and every environment.

* * *

We now have at our disposal an enormous wealth of knowledge, an unparalleled virtuosity in technological matters, an abundance of artistic traditions and universally intelligible images, and an authentic vision of nature, and we certainly must not abandon all of this to more or less semi-barbarian ways in the future. What we have to learn from the peoples of non-European culture is the art of attaining those simple and intelligible melodies of forms and tonal hues instinctively bestowed upon human products in their simplest expressions, something which becomes ever more difficult to accomplish with our advanced technological means. We must therefore observe the simplest products of human handicraft and the history of their subsequent development with the same attentiveness which we pay to nature herself in all her varied manifestations. Some of the examples from the Great Exhibition only revealed the miscalculations which can be produced by otherwise laudable attempts at the immediate imitation of nature in the domain of industrial art, if they are guided neither by quasi-natural instinct nor by a careful study of style. This could clearly be seen from many a childish, rather than genuinely childlike, attempt of this sort.

But while our industrial art continues to advance and economize in such an aimless fashion, it also unconsciously serves to accomplish the noble task of destroying traditional types of design through its own way of treating ornament.

6 Joseph-Arthur, Comte de Gobineau (1816–1882) from *Essay on the Inequality of the Human Races*

A French aristocrat by birth, Gobineau was a career diplomat as well as an author. He wrote stories, and a 'History of the Persians', which was part of a wider interest in Oriental culture. He is remembered however for his four-volume *Essay on the Inequality of the Human Races*, published between 1853 and 1855. Gobineau's thesis has powerful cultural implications. It is an argument about human societies measured by their customs, their artefacts and their aesthetics. His racism is, paradoxically, principled. And its principle is that of the absolute superiority of the Western tradition. That is to say, Gobineau's argument represents one of those cases where a thesis is pushed to so extreme a point that its meanings turn inside out. The language of rationality and civilization gives rise to barbarism and the irrational. This is not to say that racism is endemic to the Western mind. It is however to recognize that the Holocaust in general, and in the particular case of the arts, theories of 'degeneracy' (cf. also VB17), have a genealogy back into the centre of the tradition. Aberrant they may be, incomprehensible they are not. The present extracts have been translated for the present volume by Christopher Miller from the French edition of 1884, Paris: Libraire de Firmin-Didot: volume 1, pp. 1–2, 3, 23–4, 149–50, 155–6, 220, 222–3, and volume 4, pp. 491–2, 560, 563–4.

The fall of civilizations is at once the most striking and obscure of all historical phenomena. Inspiring the mind with terror, it is a calamity so majestic and inscrutable that the thinker never tires of meditating and studying it or returning to the mystery

that it represents. Scrutiny of the birth and formation of peoples undoubtedly affords highly remarkable observations: the consecutive development of societies, their accomplishments, conquests and triumphs have all that is required to make a deep impression upon the captivated imagination. But all these facts, great though they may be supposed, appear susceptible of easy explanation; we accept them as the simple consequence of the intellectual gifts of mankind. When once these gifts are acknowledged, we are not astonished by their consequences; by their very existence, they explain the great things which derive from them. But when we perceive that, after a period of strength and glory, all human societies come to decline and fall, all of them, I say, without exception; when we become aware with what fearful silence the earth displays upon its surface the debris of the civilizations that preceded our own, and not merely those of known civilizations, but of others known to us only by name; of others again whose stones, like skeletons scattered beneath the contemporary forests of the world, have handed down to us not even that semblance of memory; when the mind, reverting to our modern States, takes the measure of their extreme youth, and recognizes that some, having arisen but yesterday, are already in a state of decrepitude; then we acknowledge, not without a shudder of philosophical terror, how rigorously the word of the prophets on the instability of all things applies to peoples – to peoples no less than to States, to States no less than to individuals; and we are forced to admit that any human agglomeration, were it protected by the most ingenious interweaving of social ties, contracts, upon the day of its birth, concealed amid the elements of life, the germ of its inevitable death. [...]

It is we modern men who know best of all how every agglomeration of men and every mode of intellectual culture resulting therefrom must perish.

* * *

Peoples perish because they are degenerate, and for no other reason; this is the calamity that renders them vulnerable to the shock of disasters that close upon them. Then, no longer able either to withstand the blows inflicted by adverse fortune or to pick themselves up again after suffering them, they place before us the spectacle of their death throes. If they die, it is because they no longer possess the vigour that their ancestors displayed in passing through the dangers of life; it is, in short, because they are *degenerate*. The expression is, I repeat, excellent; but it requires better explanation; it requires that we assign it a sense. How and why is that vigour lost? This is what we need to know. How does a people degenerate? That is what we must explain. Till now, we have been content with the word, while the thing itself has remained obscure. It is this further step that I now propose to take.

I believe, then, that the word *degenerate*, when applied to a people, must and does signify that this people no longer has the intrinsic value that it once had, because it no longer has the same blood in its veins; successive admixtures to that blood have modified its value. In other words, though the name is preserved, it is no longer the race of its founders; in short, that the man of decadence, he who one calls the *degenerate* man is, from the ethnic point of view, a product different from the heroes of the great epochs. I am willing to acknowledge that he possesses something of their essence; but the more he degenerates, the more tenuous this becomes. The heterogeneous elements which now predominate in him compose a wholly new nationality, of an unfortunate originality; he belongs to that race that he still describes as his

fathers' only by a very collateral line. He will die once and for all, and his civilization with him, on the day that the original ethnic component has been so subdivided and overwhelmed by contributions from foreign races that the essential quality of this component no longer exercises sufficient influence.

* * *

As to the Adamite, the first created man, it is impossible to discover anything of his specific characteristics, nor how much of his likeness any of the new families has lost or retained; let us therefore leave him entirely out of the argument. In this way, our examination cannot go further back than the races of secondary formation.

These well-characterized races I find to be no more than three: the white, the black and the yellow. Though I make use of denominations borrowed from skin-colour, I do not find the expression either felicitous or exact. The three categories of which I speak are not precisely distinguished by skin colouration, which is always very various in its nuances, and we have seen above that it was accompanied by still more important elements of conformation. But, short of myself inventing new names [...] I wish to assert, once and for all, that I understand by *whites*, men who are also designated by the names Caucasian, Semitic or Japhetic race. I call the Hamites *black*; and the Altaic, Mongol, Finnish and Tartar branch *yellow*. These are the three pure and primitive elements of humanity.

* * *

Having thus established the physical difference of the races, it remains to be decided whether this fact is accompanied by inequality, either in beauty of form or measurement of muscular strength. This question cannot long remain in doubt.

I have already noted that, of the human groups, those which belong to the European nations and their descent are the most beautiful. To be convinced of this, it is sufficient to compare the various types distributed through the globe [...]

Those who come closest [to the European standard of beauty] are our closest relations. Such are the degenerate Aryan family of India and Persia, and the Semitic populations least abased by contact with the blacks. As all these races further depart from the white type, their features and limbs undergo distortion of form: defects of proportion, which, as they are magnified, eventually produce that extraordinary ugliness which is the ancient fate and unavoidable character of the majority of the human branches. We are no longer the dupes of the doctrine reproduced by Helvétius in his book *De l'Esprit*, which contrives to make the notion of Beauty a wholly artificial and variable idea. Let all those who have yet some scruples on this point consult the admirable *Essai sur le Beau* of Monsieur Gioberti, and their doubts will be laid to rest. Never has it been more clearly demonstrated that the beautiful is an absolute and necessary idea, which cannot be applied optionally. It is on the basis of the principles solidly established by the Piedmontese philosopher that I do not hesitate to acknowledge the white race as superior in beauty to all others, who, among themselves, differ again in the extent to which they approach or depart from the model offered to them. There is, then, inequality of beauty among the human groups, an inequality logical, explainable, permanent and indelible.

* * *

From among the multitudes of nations which have lived or which live today on earth, only ten have raised themselves to the state of complete societies. The remain-

der, more or less independent, gravitate around them like planets around their suns. If in these ten civilizations there should be found, either an element of life alien to the white impulse, or an element of death which does not come from races annexed by the civilizers, or from the disorder introduced by admixture, it is clear that the theory set out in these pages is false. [. . .]

I have said that the great human civilizations are only ten in number and that all the others were born of the initiative of the white race. At the head of this list, we must place:

I. The Indian civilization. It advanced along the shores of the Indian Ocean, in the north and the west of the continent of Asia, beyond the Brahmaputra. Its centre was a branch of the white nation of the Aryans.

II. Next come the Egyptians. To them are drawn the Ethiopians, the Nubians and some small peoples who live west of the Ammon oasis. A colony of Aryans from India established itself in the upper Nile valley and created this society.

III. The Assyrians – to whom are connected the Jews, Phoenicians, Lydians, Carthaginians and Hymiarites – derive their social intelligence from the great white invasions to which the names of Ham and Shem can still be assigned. As to the Zoroastrian–Iranians who dominated an early epoch of Asia under the names of Medes, Persians and Bactrians, this was a branch of the Aryan family.

IV. The Greeks were born of the same Aryan rootstock, and it was Semitic elements which modified them.

V. The counterpart of what occurred in Egypt is found in China. An Aryan colony from India brought social enlightenment. But instead of mixing with the black population, as occurred on the banks of the Nile, it melted into the mass of yellow Malays. It also received from the North-west, considerable numbers of white elements; these too were Aryan, though no longer Hindu.

VI. The ancient civilization of the Italian peninsula, whence came Roman culture, was a complex imbrication of Celts, Iberians, Aryans and Semites.

VII. In the fifth century, the Germanic races transformed the genius of the West. They were Aryan.

VIII, Under these figures, I classify the three civilizations of America, those
IX, X. of the Alleghanians, Mexicans and Peruvians.

Of the first seven civilizations, which are those of the ancient world, six belong, at least in part, to the Aryan race, and the seventh, that of Assyria, is beholden for the Iranian renaissance – still its most illustrious historical monument – to the Aryans. Almost the entire continent of Europe is currently occupied by groups in which the white principle exists, but in which non-Aryan elements are more numerous. When Aryan branches have not dominated, there has been no civilization in Europe.

In the ten civilizations, not one Melanian race appears among the initiators. Only half-breeds have even risen to the rank of initiates.

Similarly: no spontaneous civilizations among the yellow nations; and stagnation when the Aryan blood was exhausted.

* * *

The greatest abundance of life – the most considerable agglomeration of forces – is today to be found concentrated in the series of lands embraced by an imaginary line drawn from Tornio [Finland] and enclosing Denmark and Hanover, following the course of the Rhine at some small distance from its right bank as far as Basel, taking in Alsace and upper Lorraine, then following the course of the Seine till it flows into the sea, continuing into Great Britain and reaching Iceland in the West.

In this area there remains the last remnant of the Aryan element, thoroughly disfigured, denuded, and sullied, it is true, but not yet completely overwhelmed. There too beats the heart of our society and consequently of modern civilization. This situation has never previously been analysed, explained, nor understood; it is nevertheless keenly sensed by most people. So true is this that many make it the starting point for their speculations about the future. They foresee the day when the ice-floes of death have invaded those regions which today seem the most flourishing and richly endowed.

* * *

The white race, considered in the abstract, has now vanished from the face of the earth. It passed through the age of the gods, when it was absolutely pure; the age of heroes, when the admixtures were moderate as to strength and number; the age of nobility, when faculties that remained great were no longer renewed from the exhausted springheads; it then proceeded more or less rapidly in different places towards the definitive intermingling of all its principles as a result of heterogeneous marriages. Consequently it is now represented only by hybrids; those who occupied the territories of the first mixed societies had, of course, the time and opportunity to decline the furthest. As to the masses which, in Western Europe and North America, today represent the last possible form of culture, they still offer a fair semblance of strength, and are indeed less degraded than the inhabitants of Campania, Susiana and the Yemen. But this superiority moves constantly towards disappearance; the proportion of Aryan blood, having already suffered multiple sub-division, though it still exists today in our countries and alone upholds the edifice of our society, moves every day towards the ultimate degree of absorption.

When this result has been attained, the era of unity will begin. The white principle, held in check in each individual, will stand in relation to the two others in the ratio of one to two, and this unhappy ratio will be sufficient to paralyse its action almost completely. It is all the more deplorable when one reflects that the state of fusion, far from being the result of direct marriage between the three major types in their pure state, will merely be the *caput mortuum* [worthless residue] of an infinite series of admixtures, or, we should say, contaminations; the furthest point of mediocrity in every department; mediocrity of physical strength, of beauty, of intellectual ability; we might almost say, nothingness.

* * *

Even if we halt in those periods which must some little way precede the death rattle of our species, and avert our eyes from these ages invaded by death, in which the world, now silent, will continue in our absence to describe its impassive orbit in space, I wonder if we have not the right to call this less distant epoch, which will witness the final abasement of our species, the end of the world. Nor can I pretend that it is an easy matter to sustain some vestige of love for the destinies of these scattered beings

now stripped of their strength, beauty and intelligence, did one not remember that there is left to them one thing at least: religious faith, that last link, sole memory and precious heritage of better days.

But religion itself never promised us eternity; and science, in demonstrating that we had a beginning, seemed always to assure us that we must have an end. There is therefore no reason for astonishment or despair at discovering a further confirmation of what could never have been in doubt. What is sad in this prediction is not death, but the certainty that we shall come to it degraded; and perhaps this shame, to which our descendants are condemned, might leave us unmoved, did a secret horror not impress upon us the fact that the rapacious hands of destiny already lie heavy upon us.

7 Karl Marx (1818–1883) on Individual Production and Art

Marx's manuscript known as the *Grundrisse* was written in 1857–8, but only became widely known in the 1970s. Then it formed a central part of the 'rediscovery' of aspects of Marx's thought which had been occluded by the conventional attribution of a strict economic determinism to 'Marxism'. In particular, interest centred on the attention he devoted to cultural and ideological aspects of the social whole. In the first extract reprinted here, Marx critically discusses the category of the 'individual' (cf. IID *passim*). He indicates that the notion is a historical construct, the product of bourgeois social relations, which bourgeois thought then maps back onto the past (eg. in 'Robinson Crusoe' stories). The effect is to render what is actually historical and contingent, natural and necessary. The second extract represents one of Marx's very few explicit statements about art. To an extent it reveals Marx's own status as an educated bourgeois with a predilection for the classics. But it also shows him struggling to integrate his aesthetic preference with the relativistic lessons of his own philosophy: historical materialism (cf. IIA10). Another complication centres on the fact that in his thought of the 1840s, before the development of fully fledged historical materialism (cf. IIA9), Marx seems to see the work of art as the 'other' of commodity production: a glimpse of non-alienated labour (as it also was for Proudhon; cf. IIIB13). Yet by the late 1850s he had come to see art as part of the ideological 'super-structure' of society and therefore as ultimately dependent on the wider social relations of a given epoch. The relation between these two views – of art as the paradigm of free creation, and art as symptom of class society – constitutes the tensioned legacy of Marxism for the arts. (It should be said that Marx's own attempt at integration, through the child/adult metaphor, has carried little weight.) The *Grundrisse der Kritik der politischen Ökonomie* was first published in Moscow in 1939. The present extracts are from the translation by Martin Nicolaus, published as *Grundrisse. Foundations of the Critique of Political Economy (Rough Draft)*, Harmondsworth: Penguin, 1973, pp. 83–4 and 109–11.

The object before us, to begin with, *material production*.

Individuals producing in society – hence socially determined individual production – is, of course, the point of departure. The individual and isolated hunter and fisherman, with whom Smith and Ricardo begin, belongs among the unimaginative conceits of the eighteenth-century Robinsonades, which in no way express merely a reaction against over-sophistication and a return to a misunderstood natural life, as cultural historians imagine. As little as Rousseau's *contrat social*, which brings

naturally independent, autonomous subjects into relation and connection by contract, rests on such naturalism. This is the semblance, the merely aesthetic semblance, of the Robinsonades, great and small. It is, rather, the anticipation of 'civil society', in preparation since the sixteenth century and making giant strides towards maturity in the eighteenth. In this society of free competition, the individual appears detached from the natural bonds etc. which in earlier historical periods make him the accessory of a definite and limited human conglomerate. Smith and Ricardo still stand with both feet on the shoulders of the eighteenth-century prophets, in whose imaginations this eighteenth-century individual – the product on one side of the dissolution of the feudal forms of society, on the other side of the new forces of production developed since the sixteenth century – appears as an ideal, whose existence they project into the past. Not as a historic result but as history's point of departure. As the Natural Individual appropriate to their notion of human nature, not arising histori-cally, but posited by nature. This illusion has been common to each new epoch to this day. [...]

The more deeply we go back into history, the more does the individual, and hence also the producing individual, appear as dependent, as belonging to a greater whole: in a still quite natural way in the family and in the family expanded into the clan [*Stamm*]; then later in the various forms of communal society arising out of the antitheses and fusions of the clans. Only in the eighteenth century, in 'civil society', do the various forms of social connectedness confront the individual as a mere means towards his private purposes, as external necessity. But the epoch which produces this standpoint, that of the isolated individual, is also precisely that of the hitherto most developed social (from this standpoint, general) relations. The human being is in the most literal sense a ζῶον πολιτικόν [political animal] not merely a gregarious animal, but an animal which can individuate itself only in the midst of society. Production by an isolated individual outside society – a rare exception which may well occur when a civilized person in whom the social forces are already dynamically present is cast by accident into the wilderness – is as much of an absurdity as is the development of language without individuals living *together* and talking to each other.

* * *

Notabene in regard to points to be mentioned here and not to be forgotten:

[...] *The uneven development of material production relative to e.g. artistic development.* In general, the concept of progress not to be conceived in the usual abstractness. Modern art etc. This disproportion not as important or so difficult to grasp as within practical-social relations themselves. [...]

In the case of the arts, it is well known that certain periods of their flowering are out of all proportion to the general development of society, hence also to the material foundation, the skeletal structure as it were, of its organization. For example, the Greeks compared to the moderns or also Shakespeare. It is even recognized that certain forms of art, e.g. the epic, can no longer be produced in their world epoch-making, classical stature as soon as the production of art, as such, begins; that is, that certain significant forms within the realm of the arts are possible only at an undevel-oped stage of artistic development. If this is the case with the relation between different kinds of art within the realm of the arts, it is already less puzzling that it is the case in the relation of the entire realm to the general development of society.

The difficulty consists only in the general formulation of these contradictions. As soon as they have been specified, they are already clarified.

Let us take e.g. the relation of Greek art and then of Shakespeare to the present time. It is well known that Greek mythology is not only the arsenal of Greek art but also its foundation. Is the view of nature and of social relations on which the Greek imagination and hence Greek [mythology] is based possible with self-acting mule spindles and railways and locomotives and electrical telegraphs? What chance has Vulcan against Roberts & Co., Jupiter against the lightning-rod and Hermes against the Crédit Mobilier? All mythology overcomes and dominates and shapes the forces of nature in the imagination and by the imagination; it therefore vanishes with the advent of real mastery over them. What becomes of Fama alongside Printing House Square? Greek art presupposes Greek mythology, i.e. nature and the social forms already reworked in an unconsciously artistic way by the popular imagination. This is its material. Not any mythology whatever, i.e. not an arbitrarily chosen unconsciously artistic reworking of nature (here meaning everything objective, hence including society). Egyptian mythology could never have been the foundation or the womb of Greek art. But, in any case, a *mythology*. Hence, in no way a social development which excludes all mythological, all mythologizing relations to nature; which therefore demands of the artist an imagination not dependent on mythology.

From another side: is Achilles possible with powder and lead? Or the *Iliad* with the printing press, not to mention the printing machine? Do not the song and the saga and the muse necessarily come to an end with the printer's bar, hence do not the necessary conditions of epic poetry vanish?

But the difficulty lies not in understanding that the Greek arts and epic are bound up with certain forms of social development. The difficulty is that they still afford us artistic pleasure and that in a certain respect they count as a norm and as an unattainable model.

A man cannot become a child again, or he becomes childish. But does he not find joy in the child's naïveté, and must he himself not strive to reproduce its truth at a higher stage? Does not the true character of each epoch come alive in the nature of its children? Why should not the historic childhood of humanity, its most beautiful unfolding, as a stage never to return, exercise an eternal charm? There are unruly children and precocious children. Many of the old peoples belong in this category. The Greeks were normal children. The charm of their art for us is not in contradiction to the undeveloped stage of society on which it grew. [It] is its result, rather, and is inextricably bound up, rather, with the fact that the unripe social conditions under which it arose, and could alone arise, can never return.

8 Karl Marx (1818–1883) on Base and Superstructure

Marx's 1859 preface to his planned *Contribution to the Critique of Political Economy* is one of the cornerstones of his thought. As a developed statement of historical materialism it has significant consequences for the arts. The metaphor of the 'base' and the 'superstructure' asserts that in the last instance the ideological forms of a society – its

philosophy, its politics, its religion, its art – are dependent on that society's mode of production. What the preface does not do (but what Marx's mature thought has often been said to do, by supporters and detractors alike), is claim that this is all one-way traffic: that the 'base' *completely* determines the 'superstructure', for example, that the art of the modern period is and is only a vehicle for middle-class values. Marx's preface is a rebuttal of philosophical idealism. His 'superstructure' is not however a passive reflection of economics but an area of struggle, the place where a society sorts out its self-consciousness, becomes aware of its conditions of existence, and therefore – for Marx – avails itself of the tools for bettering them. The present extract is drawn from the translation by Rodney Livingstone and Gregor Benton in *Karl Marx: Early Writings*, Harmondsworth: Penguin, 1975, pp. 425–6.

[. . .] In the social production of their existence, men inevitably enter into definite relations, which are independent of their will, namely relations of production appropriate to a given stage in the development of their material forces of production. The totality of these relations of production constitutes the economic structure of society, the real foundation, on which arises a legal and political superstructure and to which correspond definite forms of social consciousness. The mode of production of material life conditions the general process of social, political and intellectual life. It is not the consciousness of men that determines their existence, but their social existence that determines their consciousness. At a certain stage of development, the material productive forces of society come into conflict with the existing relations of production or – this merely expresses the same thing in legal terms – with the property relations within the framework of which they have operated hitherto. From forms of development of the productive forces these relations turn into their fetters. Then begins an era of social revolution. The changes in the economic foundation lead sooner or later to the transformation of the whole immense superstructure. In studying such transformations it is always necessary to distinguish between the material transformation of the economic conditions of production, which can be determined with the precision of natural science, and the legal, political, religious, artistic or philosophic – in short, ideological forms in which men become conscious of this conflict and fight it out. Just as one does not judge an individual by what he thinks about himself, so one cannot judge such a period of transformation by its consciousness, but, on the contrary, this consciousness must be explained from the contradictions of material life, from the conflict existing between the social forces of production and the relations of production. No social order is ever destroyed before all the productive forces for which it is sufficient have been developed, and new superior relations of production never replace older ones before the material conditions for their existence have matured within the framework of the old society. Mankind thus inevitably sets itself only such tasks as it is able to solve, since closer examination will always show that the problem itself arises only when the material conditions for its solution are already present or at least in the course of formation. In broad outline, the Asiatic, ancient, feudal and modern bourgeois modes of production may be designated as epochs marking progress in the economic development of society. The bourgeois mode of production is the last antagonistic form of the social process of production – antagonistic not in the sense of individual antagonism but of

an antagonism that emanates from the individuals' social conditions of existence – but the productive forces developing within bourgeois society create also the material conditions for a solution of this antagonism. The prehistory of human society accordingly closes with this social formation.[. . .]

9 John Ruskin (1819–1900) from 'Modern Manufacture and Design'

In 1858 Ruskin had revisited Italy and had again been deeply impressed by the achievements of the Renaissance. The contrast with the dystopia of Victorian capitalism could not have been more violent. Ruskin was at this time becoming interested in the social context of art, rather than in the theory of art per se (cf. IIB6 and 7), and was led to questions of political economy. In 1860 he wrote a series of lectures opposed to the prevailing ethos of *laissez-faire* capitalism, based in part on the ideas of the utopian socialist Robert Owen. The present lecture was first delivered to the Mechanics Institute in Bradford on 1 March 1859. In it Ruskin argued that social conditions influence art and design, and that in the conditions then prevailing in the major manufacturing towns, good design was impossible. What was required was not, however, a return to the Middle Ages. The art and design of that time, for all its qualities, had been the product of a society of gross *in*equality. For Ruskin, the imperative was to produce favourable *modern* circumstances, the better to influence good modern design. The present selection is taken from the text of Ruskin's lecture as published in *The Two Paths: Being Lectures on Art and its Application to Decoration and Manufacture* (1859), in the 1912 edition, London: Everett & Co., pp. 52–77 (our extract from pp. 66–74).

* * *

Last week, I drove from Rochdale to Bolton Abbey; quietly, in order to see the country, and certainly it was well worth while. I never went over a more interesting twenty miles than those between Rochdale and Burnley. Naturally, the valley has been one of the most beautiful in the Lancashire hills; one of the far away solitudes, full of old shepherd ways of life. At this time there are not – I speak deliberately, and I believe quite literally – there are not, I think, more than a thousand yards of road to be traversed anywhere, without passing a furnace or mill.

Now, is that the kind of thing you want to come to everywhere? Because, if it be, and you tell me so distinctly, I think I can make several suggestions tonight, and could make more if you give me time, which would materially advance your object. The extent of our operations at present is more or less limited by the extent of coal and ironstone, but we have not yet learned to make proper use of our clay. Over the greater part of England, south of the manufacturing districts, there are magnificent beds of various kinds of useful clay; and I believe that it would not be difficult to point out modes of employing it which might enable us to turn nearly the whole of the south of England into a brick-field, as we have already turned nearly the whole of the north into a coal-pit. I say 'nearly' the whole, because, as you are doubtless aware, there are considerable districts in the south composed of chalk, renowned up to the present time for their downs and mutton. But, I think, by examining carefully into the conceivable uses of chalk, we might discover a quite feasible probability of turning

all the chalk districts into a limekiln, as we turn the clay districts into a brick-field. There would then remain nothing but the mountain districts to be dealt with; but, as we have not yet ascertained all the uses of clay and chalk, still less have we ascertained those of stone; and I think, by draining the useless inlets of the Cumberland, Welsh, and Scotch lakes, and turning them, with their rivers, into navigable reservoirs and canals, there would be no difficulty in working the whole of our mountain districts as a gigantic quarry of slate and granite, from which all the rest of the world might be supplied with roofing and building stone.

Is this, then, what you want? You are going straight at it at present; and I have only to ask under what limitations I am to conceive or describe your final success? Or shall there be no limitations? There are none to your powers; every day puts new machinery at your disposal, and increases, with your capital, the vastness of your undertakings. The changes in the state of this country are now so rapid, that it would be wholly absurd to endeavour to lay down laws of art education for it under its present aspect and circumstances; and therefore I must necessarily ask, how much of it do you seriously intend within the next fifty years to be coal-pit, brick-field, or quarry? For the sake of distinctness of conclusion, I will suppose your success absolute: that from shore to shore the whole of the island is to be set as thick with chimneys as the masts stand in the docks of Liverpool; that there shall be no meadows in it; no trees; no gardens; only a little corn grown upon the housetops, reaped and threshed by steam: that you do not leave even room for roads, but travel either over the roofs of your mills, on viaducts; or under their floors, in tunnels, that, the smoke having rendered the light of the sun unserviceable, you work always by the light of your own gas: that no acre of English ground shall be without its shaft and its engine; and therefore, no spot of English ground left, on which it shall be possible to stand, without a definite and calculable chance of being blown off it, at any moment, into small pieces.

Under these circumstances (if this is to be the future of England), no designing or any other development of beautiful art will be possible. Do not vex your minds, nor waste your money with any thought or effort in the matter. Beautiful art can only be produced by people who have beautiful things about them, and leisure to look at them; and unless you provide some elements of beauty for your workmen to be surrounded by, you will find that no elements of beauty can be invented by them.

I was struck forcibly by the bearing of this great fact upon our modern efforts at ornamentation in an afternoon walk, last week, in the suburbs of one of our large manufacturing towns. I was thinking of the difference in the effect upon the designer's mind, between the scene which I then came upon, and the scene which would have presented itself to the eyes of any designer of the middle ages, when he left his workshop. Just outside the town I came upon an old English cottage, or mansion, I hardly know which to call it, set close under the hill, and beside the river, perhaps built somewhere in the Charles's times, with mullioned windows and a low arched porch; round which, in the little triangular garden, one can imagine the family as they used to sit in old summer times, the ripple of the river heard faintly through the sweet-briar hedge, and the sheep on the far-off wolds shining in the evening sunlight. There, uninhabited for many and many a year, it had been left in unregarded havoc of

ruin; the garden gate still swung loose to its latch; the garden, blighted utterly into a field of ashes, not even a weed taking root there; the roof torn into shapeless rents; the shutters hanging about the windows in rags of rotten wood; before its gate, the stream which had gladdened it now soaking slowly by, black as ebony, and thick with curdling scum; the bank above it trodden into unctuous, sooty slime: far in front of it, between it and the old hills, the furnaces of the city foaming forth perpetual plague of sulphurous darkness; the volumes of their storm clouds coiling low over a waste of grassless fields, fenced from each other, not by hedges, but by slabs of square stone, like gravestones, riveted together with iron.

That was your scene for the designer's contemplation in his afternoon walk at Rochdale. Now fancy what was the scene which presented itself, in his afternoon walk, to a designer of the Gothic school of Pisa – Nino Pisano, or any of his men.

On each side of a bright river he saw rise a line of brighter palaces, arched and pillared, and inlaid with deep red porphyry, and with serpentine; along the quays before their gates were riding troops of knights, noble in face and form, dazzling in crest and shield; horse and man one labyrinth of quaint colour and gleaming light – the purple, and silver, and scarlet fringes flowing over the strong limbs and clashing mail, like sea-waves over rocks at sunset. Opening on each side from the river were gardens, courts, and cloisters; long successions of white pillars among wreaths of vine; leaping of fountains through buds of pomegranate and orange; and still along the garden paths, and under and through the crimson of the pomegranate shadows, moving slowly, groups of the fairest women that Italy ever saw – fairest, because purest and thoughtfullest; trained in all high knowledge, as in all courteous art – in dance, in song, in sweet wit, in lofty learning, in loftier courage, in loftiest love – able alike to cheer, to enchant, or save, the souls of men. Above all this scenery of perfect human life, rose dome and bell-tower, burning with white alabaster and gold: beyond dome and bell-tower the slopes of mighty hills, hoary with olive; far in the north, above a purple sea of peaks of solemn Apennine, the clear, sharp-cloven Carrara mountains sent up their steadfast flames of marble summit into amber sky; the great sea itself, scorching with expanse of light, stretching from their feet to the Gorgonian isles; and over all these, ever present, near or far – seen through the leaves of vine, or imaged with all its march of clouds in the Arno's stream, or set with its depth of blue close against the golden hair and burning cheek of lady and knight, that untroubled and sacred sky, which was to all men, in those days of innocent faith, indeed the unquestioned abode of spirits, as the earth was of men; and which opened straight through its gates of cloud and veils of dew into the awfulness of the eternal world: a heaven in which every cloud that passed was literally the chariot of an angel, and every ray of its Evening and Morning streamed from the throne of God.

What think you of that for a school of design?

I do not bring this contrast before you as a ground of hopelessness in our task; neither do I look for any possible renovation of the Republic of Pisa, at Bradford, in the nineteenth century; but I put it before you in order that you may be aware precisely of the kind of difficulty you have to meet, and may then consider with yourselves how far you can meet it. To men surrounded by the depressing and

monotonous circumstances of English manufacturing life, depend upon it, design is simply impossible. This is the most distinct of all the experiences I have had in dealing with the modern workman. He is intelligent and ingenious in the highest degree – subtle in touch and keen in sight; but he is, generally speaking, wholly destitute of designing power. And if you want to give him the power, you must give him the materials, and put him in the circumstances for it. Design is not the offspring of idle fancy; it is the studied result of accumulative observation and delightful habit. Without observation and experience, no design – without peace and pleasurableness in occupation, no design – and all the lecturings and teachings and prizes, and principles of art, in the world, are of no use so long as you don't surround your men with happy influences and beautiful things. It is impossible for them to have right ideas about colour, unless they see the lovely colours of nature unspoiled; impossible for them to supply beautiful incident and action in their ornament, unless they see beautiful incident and action in the world about them. Inform their minds, refine their habits, and you form and refine their designs; but keep them illiterate, uncomfortable, and in the midst of unbeautiful things, and whatever they do will still be spurious, vulgar, and valueless.

I repeat, that I do not ask you nor wish you to build a new Pisa for them. We don't want either the life or the decorations of the thirteenth century back again; and the circumstances with which you must surround your workmen are those simply of happy modern English life, because the designs you have now to ask for from your workmen are such as will make modern English life beautiful. All that gorgeousness of the middle ages, beautiful as it sounds in description, noble as in many respects it was in reality, had, nevertheless, for foundation and for end, nothing but the pride of life – the pride of the so-called superior classes; a pride which supported itself by violence and robbery, and led in the end to the destruction both of the arts themselves and the States in which they flourished.

The great lesson of history is, that all the fine arts hitherto – having been supported by the selfish power of the noblesse, and never having extended their range to the comfort or the relief of the mass of the people – the arts, I say, thus practised, and thus matured, have only accelerated the ruin of the State they adorned; and at the moment when, in any kingdom, you point to the triumphs of its greatest artists, you point also to the determined hour of the kingdom's decline. The names of great painters are like passing bells: in the name of Velasquez, you hear sounded the fall of Spain; in the name of Titian, that of Venice; in the name of Leonardo, that of Milan; in the name of Raphael, that of Rome. And there is profound justice in this; for in proportion to the nobleness of the power is the guilt of its use for purposes vain or vile; and hitherto the greater the art, the more surely has it been used, and used solely, for the decoration of pride, or the provoking of sensuality. Another course lies open to us. We may abandon the hope – or if you like the words better – we may disdain the temptation, of the pomp and grace of Italy in her youth. For us there can be no more the throne of marble – for us no more the vault of gold – but for us there is the loftier and lovelier privilege of bringing the power and charm of art within the reach of the humble and the poor; and as the magnificence of past ages failed by its narrowness and its pride, ours may prevail and continue, by its universality and its lowliness. [...]

10 Karl Marx (1818–1883) 'The Fetishism of Commodities'

The commodity is the central fact of modern production. It is not however a simple matter of goods being produced for social use. Products are not consumed for their use-value alone. For Marx, modern production itself has an ideological dimension at its heart. This he refers to as the 'fetishism' of commodities. The question of art's relationship to ideology (cf. IIID7 and 8) is crucial to our sense of what art is and can be. So too, therefore, is the question of the relation of art as a form of production to commodity production in general. Marx's principal analysis of the commodity is given in *Capital*. He argues that commodity fetishism results when the social character of labour is concealed, when relationships between people become confused with relations between things. *Das Kapital* volume 1 was first published in 1867. The present extracts are taken from the translation by Samuel Moore and Edward Aveling of 1887 in the Progress Publishers/Lawrence & Wishart edition, London, 1974, chapter I, section iv, 'The Fetishism of Commodities and the Secret thereof', pp. 76–8 and 80–1.

The Fetishism of Commodities and the Secret thereof

A commodity appears, at first sight, a very trivial thing, and easily understood. Its analysis shows that it is, in reality, a very queer thing, abounding in metaphysical subtleties and theological niceties. So far as it is a value in use, there is nothing mysterious about it, whether we consider it from the point of view that by its properties it is capable of satisfying human wants, or from the point that those properties are the product of human labour. It is as clear as noon-day, that man, by his industry, changes the forms of the materials furnished by Nature, in such a way as to make them useful to him. The form of wood, for instance, is altered, by making a table out of it. Yet, for all that, the table continues to be that common, every-day thing, wood. But, so soon as it steps forth as a commodity, it is changed into something transcendent. It not only stands with its feet on the ground, but, in relation to all other commodities, it stands on its head, and evolves out of its wooden brain grotesque ideas, far more wonderful than 'table-turning' ever was.

The mystical character of commodities does not originate, therefore, in their use-value. Just as little does it proceed from the nature of the determining factors of value. For, in the first place, however varied the useful kinds of labour, or productive activities, may be, it is a physiological fact, that they are functions of the human organism, and that each such function, whatever may be its nature or form, is essentially the expenditure of human brain, nerves, muscles, &c. Secondly, with regard to that which forms the ground-work for the quantitative determination of value, namely, the duration of that expenditure, or the quantity of labour, it is quite clear that there is a palpable difference between its quantity and quality. In all states of society, the labour-time that it costs to produce the means of subsistence, must necessarily be an object of interest to mankind, though not of equal interest in different stages of development. And lastly, from the moment that men in any way work for one another, their labour assumes a social form.

Whence, then, arises the enigmatical character of the product of labour, so soon as it assumes the form of commodities? Clearly from this form itself. The equality of all

sorts of human labour is expressed objectively by their products all being equally values; the measure of the expenditure of labour-power by the duration of that expenditure, takes the form of the quantity of value of the products of labour; and finally, the mutual relations of the producers, within which the social character of their labour affirms itself, take the form of a social relation between the products.

A commodity is therefore a mysterious thing, simply because in it the social character of men's labour appears to them as an objective character stamped upon the product of that labour; because the relation of the producers to the sum total of their own labour is presented to them as a social relation, existing not between themselves, but between the products of their labour. This is the reason why the products of labour become commodities, social things whose qualities are at the same time perceptible and imperceptible by the senses. In the same way the light from an object is perceived by us not as the subjective excitation of our optic nerve, but as the objective form of something outside the eye itself. But, in the act of seeing, there is at all events, an actual passage of light from one thing to another, from the external object to the eye. There is a physical relation between physical things. But it is different with commodities. There, the existence of the things *qua* commodities, and the value-relation between the products of labour which stamps them as commodities, have absolutely no connexion with their physical properties and with the material relations arising therefrom. There it is a definite social relation between men, that assumes, in their eyes, the fantastic form of a relation between things. In order, therefore, to find an analogy, we must have recourse to the mist-enveloped regions of the religious world. In that world the productions of the human brain appear as independent beings endowed with life, and entering into relation both with one another and the human race. So it is in the world of commodities with the products of men's hands. This I call the Fetishism which attaches itself to the products of labour, so soon as they are produced as commodities, and which is therefore inseparable from the production of commodities.

This Fetishism of commodities has its origin, as the foregoing analysis has already shown, in the peculiar social character of the labour that produces them.

As a general rule, articles of utility become commodities, only because they are products of the labour of private individuals or groups of individuals who carry on their work independently of each other. The sum total of the labour of all these private individuals forms the aggregate labour of society. Since the producers do not come into social contact with each other until they exchange their products, the specific social character of each producer's labour does not show itself except in the act of exchange. In other words, the labour of the individual asserts itself as a part of the labour of society, only by means of the relations which the act of exchange establishes directly between the products, and indirectly, through them, between the producers. To the latter, therefore, the relations connecting the labour of one individual with that of the rest appear, not as direct social relations between individuals at work, but as what they really are, material relations between persons and social relations between things. [. . .]

Man's reflections on the forms of social life, and consequently, also, his scientific analysis of those forms, take a course directly opposite to that of their actual historical development. He begins, post festum, with the results of the process of development

ready to hand before him. The characters that stamp products as commodities, and whose establishment is a necessary preliminary to the circulation of commodities, have already acquired the stability of natural, self-understood forms of social life, before man seeks to decipher, not their historical character, for in his eyes they are immutable, but their meaning. Consequently it was the analysis of the prices of commodities that alone led to the determination of the magnitude of value, and it was the common expression of all commodities in money that alone led to the establishment of their characters as values. It is, however, just this ultimate money-form of the world of commodities that actually conceals, instead of disclosing, the social character of private labour, and the social relations between the individual producers. When I state that coats or boots stand in a relation to linen, because it is the universal incarnation of abstract human labour, the absurdity of the statement is self-evident. Nevertheless, when the producers of coats and boots compare those articles with linen, or, what is the same thing, with gold or silver, as the universal equivalent, they express the relation between their own private labour and the collective labour of society in the same absurd form.

The categories of bourgeois economy consist of such like forms. They are forms of thought expressing with social validity the conditions and relations of a definite, historically determined mode of production, viz., the production of commodities. The whole mystery of commodities, all the magic and necromancy that surrounds the products of labour as long as they take the form of commodities, vanishes therefore, so soon as we come to other forms of production. [. . .]

11 Charles Darwin (1809–1882) from *The Descent of Man and Selection in Relation to Sex*

Darwin's *Origin of Species* was published in 1859, though he had been developing the ideas on which it was based over the previous twenty years. It took a further decade before he felt confident enough to apply his theory to human beings. This work has never escaped controversy. In the nineteenth century, Christians disputed his account of human descent from the apes; more recently Darwin has been accused of sexism and racism. The present selections undoubtedly combine a striving for balanced judgement on the basis of evidence with the cultural prejudices of his time. From the point of view of the present anthology, it is interesting that when Darwin tries to assess the relative distribution of mental capacity between the sexes it is particularly to the evidence of the arts, among other forms of intellectual enquiry, that he turns. What he does however, is to pay scant attention to social factors, and instead link the exercise of faculties such as the imagination directly to the biological process of selection. He goes on to discuss the role of aesthetic factors in sexual selection. The upshot is twofold. On the one hand Darwin is led to accord aesthetic judgements, and the artefacts which we call works of art and design, a very prominent place in human evolution. On the other, his study leads him to reject the idea of 'any universal standard of beauty', specifically that of classical antiquity, and to confirm a marked difference in canons of aesthetic quality. The present extracts are drawn from *The Descent of Man and Selection in Relation to Sex* (1871), reprint of the second, 1874, edition, New York: Rand, McNally & Co., 1974, part III, chapters XIX-XXI, pp. 561–60, 568–71, 576–9, 612–13.

With mankind the differences between the sexes are greater than in most of the Quadrumana, but not so great as in some, for instance, the mandrill. Man on an average is considerably taller, heavier, and stronger than woman, with squarer shoulders and more plainly-pronounced muscles. Owing to the relation which exists between muscular development and the projection of the brows, the superciliary ridge is generally more marked in man than in woman. His body, and especially his face, is more hairy, and his voice has a different and more powerful tone. [...]

Man is more courageous, pugnacious and energetic than woman, and has a more inventive genius. His brain is absolutely larger, but whether or not proportionately to his larger body, has not, I believe, been fully ascertained.

* * *

There can be little doubt that the greater size and strength of man, in comparison with woman, together with his broader shoulders, more developed muscles, rugged outline of body, his greater courage and pugnacity, are all due in chief part to inheritance from his half-human male ancestors. These characters would, however, have been preserved or even augmented during the long ages of man's savagery, by the success of the strongest and boldest men, both in the general struggle for life and in their contests for wives; a success which would have ensured their leaving a more numerous progeny than their less favoured brethren. [...]

Difference in the Mental Powers of the two Sexes. – With respect to differences of this nature between man and woman, it is probable that sexual selection has played a highly important part. I am aware that some writers doubt whether there is any such inherent difference; but this is at least probable from the analogy of the lower animals which present other secondary sexual characters. No one disputes that the bull differs in disposition from the cow, the wild-boar from the sow, the stallion from the mare, and, as is well known to the keepers of menageries, the males of the larger apes from the females. Woman seems to differ from man in mental disposition, chiefly in her greater tenderness and less selfishness; and this holds good even with savages, as shown by a well-known passage in Mungo Park's Travels, and by statements made by many other travellers. Woman, owing to her maternal instincts, displays these qualities towards her infants in an eminent degree; therefore it is likely that she would often extend them towards her fellow-creatures. Man is the rival of other men; he delights in competition, and this leads to ambition which passes too easily into selfishness. These latter qualities seem to be his natural and unfortunate birthright. It is generally admitted that with woman the powers of intuition, of rapid perception, and perhaps of imitation, are more strongly marked than in man; but some, at least, of these faculties are characteristic of the lower races, and therefore of a past and lower state of civilization.

The chief distinction in the intellectual powers of the two sexes is shown by man's attaining to a higher eminence, in whatever he takes up, than can woman – whether requiring deep thought, reason, or imagination, or merely the use of the senses and hands. If two lists were made of the most eminent men and women in poetry, painting, sculpture, music (inclusive both of composition and performance), history, science, and philosophy, with half-a-dozen names under each subject, the two lists would not bear comparison. We may also infer, from the law of the deviation from averages, so well illustrated by Mr Galton, in his work on 'Hereditary genius,' that if

men are capable of a decided pre-eminence over women in many subjects, the average of mental power in man must be above that of woman. [. . .]

Now, when two men are put into competition, or a man with a woman, both possessed of every mental quality in equal perfection, save that one has higher energy, perseverance, and courage, the latter will generally become more eminent in every pursuit, and will gain the ascendancy. He may be said to possess genius – for genius has been declared by a great authority to be patience; and patience, in this sense, means unflinching, undaunted perseverance. But this view of genius is perhaps deficient; for without the higher powers of the imagination and reason, no eminent success can be gained in many subjects. These latter faculties, as well as the former, will have been developed in man, partly through sexual selection, – that is, through the contest of rival males, and partly through natural selection, – that is, from success in the general struggle for life; and as in both cases the struggle will have been during maturity, the characters gained will have been transmitted more fully to the male than to the female offspring. It accords in a striking manner with this view of the modification and re-inforcement of many of our mental faculties by sexual selection, that, firstly, they notoriously undergo a considerable change at puberty, and, secondly, that eunuchs remain throughout life inferior in these same qualities. Thus man has ultimately become superior to woman.

* * *

The Influence of Beauty in determining the Marriages of Mankind. – In civilized life man is largely, but by no means exclusively, influenced in the choice of his wife by external appearance; but we are chiefly concerned with primeval times, and our only means of forming a judgment on this subject is to study the habits of existing semi-civilized and savage nations. If it can be shown that the men of different races prefer women having various characteristics, or conversely with the women, we have then to inquire whether such choice, continued during many generations, would produce any sensible effect on the race, either on one scx or both according to the form of inheritance which has prevailed.

It will be well first to show in some detail that savages pay the greatest attention to their personal appearance. That they have a passion for ornament is notorious; and an English philosopher goes so far as to maintain, that clothes were first made for ornament and not for warmth. As Professor Waitz remarks, 'however poor and miserable man is, he finds a pleasure in adorning himself.' The extravagance of the naked Indians of South America in decorating themselves is shown 'by a man of large stature gaining with difficulty enough by the labour of a fortnight to procure in exchange the chica necessary to paint himself red.' The ancient barbarians of Europe during the Reindeer period brought to their caves any brilliant or singular objects which they happened to find. Savages at the present day everywhere deck themselves with plumes, necklaces, armlets, ear-rings, &c. They paint themselves in the most diversified manner. [. . .]

In one part of Africa the eyelids are coloured black; in another the nails are coloured yellow or purple. In many places the hair is dyed of various tints. In different countries the teeth are stained black, red, blue, &c., and in the Malay Archipelago it is thought shameful to have white teeth 'like those of a dog.' Not one great country can be named, from the Polar regions in the north to New Zealand in the south, in

which the aborigines do not tattoo themselves. This practice was followed by the Jews of old, and by the ancient Britons. [. . .]

The hair is treated with especial care in various countries; it is allowed to grow to full length, so as to reach to the ground, or is combed into 'a compact frizzled mop, which is the Papuan's pride and glory.' In Northern Africa 'a man requires a period of from eight to ten years to perfect his coiffure.' With other nations the head is shaved, and in parts of South America and Africa even the eyebrows and eyelashes are eradicated. [. . .]

As the face with us is chiefly admired for its beauty, so with savages it is the chief seat of mutilation. In all quarters of the world the septum and more rarely the wings of the nose are pierced; rings, sticks, feathers, and other ornaments being inserted into the holes. The ears are everywhere pierced and similarly ornamented [. . .]

Hardly any part of the body, which can be unnaturally modified, has escaped. The amount of suffering thus caused must have been extreme, for many of the operations require several years for their completion, so that the idea of their necessity must be imperative. The motives are various; the men paint their bodies to make themselves appear terrible in battle; certain mutilations are connected with religious rites, or they mark the age of puberty, or the rank of the man, or they serve to distinguish the tribes. Amongst savages the same fashions prevail for long periods, and thus mutilations, from whatever cause first made, soon come to be valued as distinctive marks. But self-adornment, vanity, and the admiration of others, seem to be the commonest motives. [. . .]

We thus see how widely the different races of man differ in their taste for the beautiful. In every nation sufficiently advanced to have made effigies of their gods or of their deified rulers, the sculptors no doubt have endeavoured to express their highest ideal of beauty and grandeur. Under this point of view it is well to compare in our mind the Jupiter or Apollo of the Greeks with the Egyptian or Assyrian statues; and these with the hideous bas-reliefs on the ruined buildings of Central America.

The senses of man and of the lower animals seem to be so constituted that brilliant colours and certain forms, as well as harmonious and rhythmical sounds, give pleasure and are called beautiful; but why this should be so, we know not. It is certainly not true that there is in the mind of man any universal standard of beauty with respect to the human body. It is, however, possible that certain tastes may in the course of time become inherited, though there is no evidence in favour of this belief; and if so, each race would possess its own innate ideal standard of beauty. It has been argued that ugliness consists in an approach to the structure of the lower animals, and no doubt this is partly true with the more civilized nations, in which intellect is highly appreciated; but this explanation will hardly apply to all forms of ugliness. The men of each race prefer what they are accustomed to; they cannot endure any great change; but they like variety, and admire each characteristic carried to a moderate extreme. Men accustomed to a nearly oval face, to straight and regular features, and to bright colours, admire, as we Europeans know, these points when strongly developed. On the other hand, men accustomed to a broad face, with high cheek-bones, a depressed nose, and a black skin, admire these peculiarities when strongly marked. No doubt characters of all kinds may be too much developed for beauty. Hence a perfect beauty, which implies many characters modified in a particular manner, will

be in every race a prodigy. As the great anatomist Bichat long ago said, if every one were cast in the same mould, there would be no such thing as beauty. If all our women were to become as beautiful as the Venus de Medici, we should for a time be charmed; but we should soon wish for variety; and as soon as we had obtained variety, we should wish to see certain characters a little exaggerated beyond the then existing common standard.

* * *

Man may be excused for feeling some pride at having risen, though not through his own exertions, to the very summit of the organic scale; and the fact of his having thus risen, instead of having been aboriginally placed there, may give him hope for a still higher destiny in the distant future. But we are not here concerned with hopes or fears, only with the truth as far as our reason permits us to discover it; and I have given the evidence to the best of my ability. We must, however, acknowledge, as it seems to me, that man with all his noble qualities, with sympathy which feels for the most debased, with benevolence which extends not only to other men but to the humblest living creature, with his god-like intellect which has penetrated into the movements and constitution of the solar system – with all these exalted powers – Man still bears in his bodily frame the indelible stamp of his lowly origin.

IIIB
Realism and Naturalism

1 Vissarion Grigorievich Belinsky (1811–1848) 'A View of Russian Literature in 1847'

Belinsky was one of the founding figures of the nineteenth-century radical intelligentsia in Russia. Expelled from university, and thus prevented from pursuing an academic career, he earned his living as a journalist and literary critic. He was initially committed to German Idealist philosophy, being influenced in his early writing by Schelling and Hegel. In the 1840s however, in reaction to the deepening backwardness imposed by the Tsarist autocracy, Belinsky turned to Naturalism and developed the idea that the purpose of art and literature was to express the problems of contemporary society. His *View of Russian Literature in 1847* represents an early statement of what were to become repeated refrains in the Realist theory of art. These included the propositions that art must address the lives of ordinary people; that Realism is opposed to 'pure art' and aestheticism; that it is none the less more than mere copying or reportage; and that, to this end, its goal should be to represent the *type*. Belinsky's essay was first published in the journal *Sovremennik* (The Contemporary) in 1848. The present extracts are taken from *V. G. Belinsky: Selected Philosophical Works*, Moscow: Foreign Language Publishing House, 1948, pp. 404–5, 412–13, 422–31.

[. . .] The natural school now stands in the forefront of Russian literature. On the one hand, we can say, without falling into exaggeration as a consequence of bias or prejudice, that the public, that is to say, the majority of readers, stand for it; this is not conjecture, but a fact. Today all literary activity is concentrated in the magazines, and which magazines enjoy the greatest popularity, have the largest number of readers, and exercise the greatest influence on public opinion, if not those which publish the works of the natural school? Which novels and stories are read by the public with particular interest, if not those that belong to the natural school – rather should we say: does the public read novels and stories that do not belong to the natural school? What critics wield a greater influence on public opinion, or rather, what critics are more in touch with the opinion and tastes of the public, than those who stand for the natural, against the rhetorical school? On the other hand, who is the constant topic, who is the target of constant and vehement attacks, if not the natural school? Factions that have nothing in common with each other act in full accord and unanimity when they fall upon the natural school, attribute to it views which are

alien to it and intentions which it never had; put a false interpretation on its every word and every act, now, forgetful of the proprieties, heaping the most violent abuse on it, now complaining of it almost plaintively. What is there in common between Gogol's inveterate enemies, the representatives of the vanquished rhetorical school, and the so-called Slavophiles? Nothing at all! Yet the latter, accepting Gogol as the founder of the natural school, attack that school in full accord with the former, using the very same words and the same arguments; they have found it necessary to differ from their new allies only in logical inconsistency, as a result of which they have placed to Gogol's credit the very qualities for which his school is persecuted, on the grounds that he wrote out of a sort of 'urge of self-purification.' To this it should be added that the anti-natural schools have not been able to produce a single work of any merit that would prove by deeds the possibility of doing good writing on precepts opposed to those professed by the natural school. All their strivings in this direction have contributed to the triumph of naturalism and the defeat of rhetoricism.

* * *

Our literature was the fruit of conscious thought, it appeared as an innovation, began as imitation. However, it did not stop at this, but strove constantly to originality and nationality; from a rhetorical literature it strove to become a *natural* literature. It is this striving, attended as it is by noticeable and constant successes, that constitutes the sense and soul of the history of our literature. We shall assert without prevarication that in no other Russian writer was this striving so successful as it was in Gogol. This could be achieved only by making art base itself exclusively on real life, eschewing all ideals. To do this it was necessary to make an exclusive study of the crowd, the mass, to depict ordinary people, and not only pleasant exceptions to the general rule which always lead poets to idealization and bear an alien stamp. Herein lies the great service rendered by Gogol, and this is what men of the old school impute to him as a great crime against the laws of art. In this way he completely changed the prevailing view on art itself. The old and threadbare definition of poetry as 'nature beautified' may be applied at a stretch to the works of any of the Russian poets; but this cannot be done in regard to the works of Gogol. Another definition of art fits them – art as the representation of reality in all its fidelity. Here the crux of the matter is *types*, the *ideal* being understood not as an adornment (consequently a falsehood) but as the relations in which the author places the types he creates in conformity with the idea which his work is intended to develop.

Art in our days has outstripped theory. The old theories have lost all their prestige; even people reared on these theories follow not them, but an odd mixture of old and new ideas.

* * *

There remains to be mentioned the attacks launched against present-day literature and naturalism in general from the aesthetic point of view, in the name of pure art, which is an aim in itself and recognizes no aims outside itself. There is some foundation for this idea, but its overstatement is seen at a first glance. This idea is of a purely German origin; it could be born only among a contemplative, cogitative and dreamful people, and could not possibly have appeared among a practical people, whose public life offers to all and sundry a wide field for lively activity. Even its votaries do not fully understand what pure art is, hence it is a sort of ideal with them

and does not exist in reality. It is in effect the bad extreme of another bad extreme, that is to say, of an art that is didactic, instructive, cold, dry, and dead, of an art whose works are merely rhetoric exercises on a given theme. Art undoubtedly must first be art as such, and only afterwards can it be an expression of the spirit and drift of society in a given epoch. With whatever beautiful ideas a poem is filled and however much it deals with contemporary problems, if it has no poetry in it it can neither contain beautiful ideas or any problems, and all that can be traced in it is merely a good intention badly executed. When a novel or a story, however faithfully and meticulously copied from nature its narrative may be, contains no images and persons, no characters, nothing *typical*, the reader will not find naturalness in it, will not perceive the effects of either keen observation or happy description. The characters will all seem to merge into one, and the narrative will strike him as a tangled skein of baffling events. The laws of art cannot be infringed with impunity. To copy faithfully from nature it is not sufficient to be merely able to write, that is, to command the art of the copyist or scribe; one must be able to pass the facts of reality through one's imagination and endow them with new life. A well-written and veracious report on a judicial case of romantic interest is not a novel and can serve merely as material for a novel, that is to say, provide the poet with an occasion for writing a novel. But for this he must probe to the core of the matter, unravel the secret spiritual motives which have prompted the actions of the characters, grasp the angle of the case which forms the centre of these events and gives them the sense of something whole, complete, united and self-contained. And this only a poet can do. Nothing would seem easier than making a faithful portrait of a man. Some men have practised this genre all their lives and are still incapable of painting a familiar face in such a manner that others should recognize whose portrait it is. The ability to paint a faithful portrait is a talent of its kind, but that is not all. An ordinary painter has made a fairly lifelike portrait of your friend; the resemblance is indubitable in the sense that you cannot but instantly recognize whose portrait it is, but you are nevertheless not quite satisfied; it seems to you that the portrait does and yet does not resemble the original. But were the portrait to be painted by Tyranov or Bryullov, it will seem to you that no mirror so faithfully reflects the image of your friend as does this portrait, because it will be not merely a portrait, but a work of art which has caught not only the outward resemblance but the soul of the original. And so, only talent can render a faithful copy of actual life; and however negligible the work may be in other respects, the more it strikes us as being true to nature the more indubious is the talent of the author. That fidelity to nature is not the be all and end all of art, especially in poetry, is another matter. In painting, by virtue of this art's essential character, the ability alone to copy faithfully from nature may often be a sign of unusual talent. In poetry this is not quite so. A man cannot be a poet unless he is able to copy nature faithfully, but this ability alone is insufficient to make a poet, at least an admirable poet. It is usually said that the faithful copying from nature of the ghastly (for instance, murders, executions and the like), without ideas and artistic treatment, evokes repugnance but not enjoyment. This is more than unjust; it is false. The spectacle of a murder or an execution is not a subject that can afford pleasure, and in the work of a great poet the reader enjoys not the murder or the execution but the skill with which the poet handles them; consequently, this enjoyment is aesthetic and not psychological, it is combined with involuntary horror

and repugnance, whereas the picture of a noble feat or the joy of love affords a pleasure that is more complex, hence complete, being as aesthetic as it is psychological. A man with no talent will never be able to give a faithful picture of a murder or a scene of execution though he might have a thousand opportunities of studying this subject in actual life; the best that he can do is to give a more or less faithful description, but he will never be able to present a faithful picture. His description may evoke strong curiosity but not enjoyment. If, without having talent, this person has undertaken to paint the picture of such an event, this picture will always arouse only disgust, not because it has been faithfully copied from nature, but for an opposite reason – because melodrama is not a dramatic picture, and theatrical effects are not emotional expression.

But while fully admitting that art must first of all be art, we nevertheless are of the opinion that the idea of a pure abstract art, living in its own sphere and having nothing in common with other aspects of life, is a dreamy abstraction. Such art has never existed anywhere. [. . .]

Art and literature in our day have more than ever before become the expression of social problems, because in our day these problems have become more general, more accessible, and clearer, have become for all an interest of the first degree, have taken precedence over all other problems. [. . .]

Greek art is nearest the ideal of so-called pure art, but did not fully achieve it; as for modern art, it was always remote from this ideal and has today become still more remote; but that precisely is its strength. Artistic interest as such could not but yield to other more important human interests, and art nobly undertook to serve these interests as their mouthpiece. Art has not thereby ceased to be art, but has merely acquired a new character. To deny art the right of serving public interests means debasing it, not raising it, for that would mean depriving it of its most vital force, i.e., idea, making it an object of sybaritic pleasure, the plaything of lazy idlers. This would even mean killing it, as is evidenced today by the wretched plight of the art of painting. This art, seemingly oblivious of the seething life around it, with eyes closed to everything that is alive, modern and valid, seeks inspiration in the outlived past and derives therefrom ready-made ideals to which people have long ago grown cold, which are no longer of interest to anybody and give no warmth to or evoke lively sympathy in anyone. [. . .]

2 Eugène Delacroix (1798–1863) on Realism and Naturalism

Delacroix continued to be identified with Romanticism throughout his long career. He was particularly consistent in his emphasis on the imagination (cf.IIIᴅ6). In the *Journal* which he kept from 1847 to his death in 1863, he frequently criticized those newer movements and artists whose work seemed to disparage the imagination in the name of a more faithful or objective transcription of reality. These included Courbet, in particular, though Delacroix did grudgingly respect the power of Courbet's work. More generally he was opposed to the entire ethos of Realism or Naturalism; although he did allow that, at certain times, a dose of Realism could provide an antidote to the mannerism of the academy. His response to photography was likewise nuanced. He disliked its apparent exclusion of the work of

imagination, yet seems to have recognized that certain photographs, often the 'imperfect' ones, had a quality which could attract his eye. In the obituary article which he published in 1863, Baudelaire wrote that for Delacroix, nature was 'but a dictionary'; that is, it contained all the words, but was not itself a work of literature. The axiom of Delacroix's career was that nature required transformation by the imagination to be made over into a successful work of art. Realism ultimately failed to do this. The extracts are from *The Journal of Eugène Delacroix*, translated by Walter Pach, London: Jonathan Cape, 1938, pp. 187, 292–4, 479–80, 644–7, 665–8.

Monday, March 5, 1849

I went with Meissonier to his studio to see his drawing of the *Barricade*. His faithfulness in representation is horrible, and though one cannot say that the thing is not exact, perhaps there is lacking that indefinable thing which makes of an *odious object an object of art*. I say the same about his studies from nature; they are colder than his composition, and yet drawn with the same pencil with which Watteau would have drawn his coquettes and his delightful figures of shepherds. Immense merit, despite that. More and more I see, for my instruction and for my consolation, the confirmation of the thing that Cogniet told me last year with reference to the *Man Devoured by a Lion* when he saw that picture alongside that of the cows by Mlle Bonheur, which is to say that there is something else in painting beside exactitude and precise rendering from the model. [. . .]

Friday, April 15, 1853

I went to see the paintings by Courbet. I was astonished at the vigour and the relief in his principal picture [*The Bathers*]; but what a picture! What a subject! The commonness of the forms would do no harm; it is the commonness and the uselessness of the thought which are abominable; and if only his idea, common and useless as it is, were clear! What are those two figures doing? A fat bourgeoise is seen from the back, completely nude save for a carelessly painted bit of cloth, covering the lower part of her buttocks; she comes out of a little strip of water which does not seem deep enough for even a foot-bath. She makes a gesture which expresses nothing, and another woman, whom one may suppose to be her maid, is seated on the ground, taking off her shoes and stockings. One sees stockings that have just been taken off, one of them only halfway, I think. Between these two figures there is an exchange of thoughts which one cannot understand. The landscape is of an extraordinary vigour, but Courbet has done no more than enlarge a study exhibited there, near his large canvas; the conclusion is that the figures were put in afterward and without connection with their surroundings. This brings up the question of harmony between the accessories and the principal object, a thing lacking in the majority of great painters. It is not the biggest defect in Courbet. There is also a *Spinner Asleep*, which presents the same qualities, both of vigour and of imitation. The wheel, the distaff – admirable; the dress, the armchair – heavy and without grace. The *Two Wrestlers* show lack of action, and confirm the artist's impotence in the matter of invention. The background kills the figures; it would be necessary to cut off more than three feet all around.

Oh, Rossini! Oh, Mozart! Oh, geniuses inspired in all the arts, who draw from things only such elements of them as are to be shown to the mind! What would you say before these pictures? Oh, *Semiramis!* Oh, entry of the priests to crown Ninias!

Saturday, April 16, 1853

In the morning, someone brings Millet in for a visit. He talks about Michelangelo and about the Bible which is, he says, the only book that he reads, or practically that. This explains the somewhat ambitious look of his peasants. Moreover he is a peasant himself, and boasts of it. He is certainly of the constellation or squadron of artists with beards who made the Revolution of 1848, or who applauded it, apparently believing that there would be equality of talents as of fortune. As a man, however, Millet seems to me to be above that level; in the small number of his works that I have been able to see, works differing but little one from another, a deep but pretentious feeling evidently struggles against dry or else confused execution in an effort to reveal itself.

August 3, 1855

I went to the Exposition; I noticed that fountain which spouts gigantic artificial flowers.

The sight of all those machines makes me feel very bad. I don't like that stuff which, all alone and left to itself, seems to be producing things worthy of admiration.

After leaving, I went to see Courbet's exhibition; he has reduced the admission to ten cents. I stay there alone for nearly an hour and discover that the picture of his which they refused [*The Artist's Studio*] is a masterpiece; I simply could not tear myself away from the sight of it. He has made enormous progress, and yet that made me admire his *Burial*. In the latter work the figures are one on top of the other, the composition is not well understood. But there are superb details: the priests, the choir boys, the vase of holy water, the weeping women, etc. In the later work (the *Studio*) the planes are well understood, there is atmosphere and there are some parts that are important in their execution: the haunches, and the thigh of the nude model and her bosom; the woman in the front plane, with a shawl. The only fault is that the picture he is painting offers an ambiguity: it looks as if it had a *real sky* in the midst of the picture. They have refused one of the most singular works of this period; but a strapping lad like Courbet is not going to be discouraged for so small a thing as that.

September 1 [1859] Strasbourg

The most obstinate realist is still compelled, in his rendering of nature, to make use of certain conventions of compositions or of execution. If the question is one of composition, he cannot take an isolated piece of painting or even a collection of them and make a picture from them. He must certainly circumscribe the idea in order that the mind of the spectator shall not float about in an ensemble that has, perforce, been cut to bits; otherwise art would not exist. When a photographer takes a view, all

you ever see is a part cut off from a whole: the edge of the picture is as interesting as the centre; all you can do is to suppose an ensemble, of which you see only a portion, apparently chosen by chance. The accessory is capital, as much as the principal; most often, it presents itself first and offends the sight. One must make more concessions to the infirmity of the reproduction in a photographic work than in a work of the imagination. The photographs which strike you most are those in which the very imperfection of the process as a matter of absolute rendering leaves certain gaps, a certain repose for the eye which permit it to concentrate on only a small number of objects. If the eye had the perfection of a magnifying glass, photography would be unbearable: one would see every leaf on a tree, every tile on a roof, and on these tiles, mosses, insects, etc. And what shall we say of those disturbing pictures produced by actual perspective, defects less disturbing perhaps in a landscape, where parts in the foreground may be magnified in even an exaggerated way without the spectator's being offended, save when human figures come into question? The obstinate realist will therefore, in his picture, correct that inflexible perspective which falsifies our seeing of objects by reason of its very correctness.

In the presence of nature herself, it is our imagination that makes the picture: we see neither the blades of grass in a landscape nor the accidents of the skin in a pretty face. Our eye, in its fortunate inability to perceive these infinitesimal details, reports to our mind only the things which it ought to perceive; the latter, again, unknown to ourselves, performs a special task; it does not take into account all that the eye presents to it; it connects the impressions it experiences with others which it received earlier, and its enjoyment is dependent on its disposition at the time. That is so true that the same view does not produce the same effect when taken in two different aspects.

What causes the inferiority of modern literature is the attempt to render everything; the ensemble disappears, drowned in the details, and ennui is the consequence. [...] Painting is fortunate in demanding no more than a glance in order to attract and to fix.

October 12, 1859

Real beauty in the arts is eternal and would be accepted at all periods; but it wears the dress of its century: something of that dress clings to it, and woe to the works which appear in periods when the general taste is corrupted!

Truth is described to us as naked: I can conceive that only for abstract truth; but every truth in the arts comes about through means in which the hand of man is felt, and consequently with the form agreed on and adopted in the time when the artist lives.

The speech of his time gives a particular colour to the work of the poet. That is so true that it is impossible, in a translation made at a much later time, to give an exact idea of a poem. That of Dante, despite all the more or less successful attempts, will never be rendered in its native beauty by the language of Racine and Voltaire. The same is true of Homer. Vergil, coming at a more refined period, resembling our own, even Horace, despite the conciseness of his language, will be rendered more happily in French; Abbé Delille has translated Vergil. Boileau might have translated Horace.

And so it would be to a lesser extent the difficulty resulting from the diversity of languages than the different spirit of the period which presents an obstacle to genuine translation. The Italian of Dante is not the Italian of our day; the ideas of antiquity are suited to a language of antiquity. We speak of the ancient authors as elemental in their naturalness; it is their period which was so, and only by comparison with our own.

The usages of a period differ completely; the way to be expressive, to be humorous – to express oneself, in a word – is in harmony with the turn of the mind peculiar to the men of the time. [. . .]

February 22, 1860

Realism should be defined as the antipode of art. It is perhaps more odious in painting and in sculpture than in history and the novel; I do not mention poetry: for, by reason of the mere fact that the instrument of the poet is a pure convention, a measured language, in a word, which immediately places the reader above the earthy quality of everyday life, one sees how grotesque would be the contradiction in terms if anyone spoke of realistic poetry, admitting that such a monster could be conceived. What, in sculpture for example, would a realistic art be? Mere casts from nature would always be superior to the most perfect imitation which the hand of man can produce: for can one conceive a case in which the mind would not guide the hand of the artist and will anyone believe it possible, likewise, that, despite all attempts to imitate, he will not tinge his singular work with the colour of his mind, unless one go to the point of supposing that the eye alone and the hand be sufficient to produce – I will not merely say an exact imitation – but even any work whatsoever?

If *realism* is not to be a word devoid of sense, all men would have to have the same mind, the same fashion of conceiving things. [. . .]

For what is the supreme purpose of every type of art, if it is not the effect? Does the mission of the artist include merely a disposing of the materials, leaving it to the spectator to draw from them, as best he can, a nondescript pleasure, each man after his own fashion? Is there not, independent of the interest that the mind discovers in the simple and clear carrying on of a composition, in the charm of situations ably controlled, a kind of moral sense attaching even to a fable? Who will bring it into clear view with more of success than the man who has disposed in advance all the parts of the composition, and in such a way that the spectator or the reader is led to perceive this, and to be seized and charmed thereby?

What do I find in a great number of modern works? An enumeration of everything that is to be presented to the reader, especially that of material objects, minute descriptions of characters, who do not describe themselves by their actions. It is as if I were seeing those building-sheds where each of the stones carved separately is before my eyes, but without relationship to its place in the ensemble of the monument. I detail them, one after the other, instead of seeing a vault, a gallery, or, even more, a whole palace, in which cornices, columns, capitals, even statues, combine only to form an ensemble either grandiose or merely agreeable but where all the parts are fused and coordinated by an intelligent art.

In the majority of modern compositions, I see the author intent on describing an accessory character with the same care as the characters which should occupy the

centre of the stage. He exhausts himself in showing me under every aspect the super who is to appear only for a moment, and the mind is as much bound up with that character as with the hero of the story.

The first of principles is that of the need for sacrifices.

Isolated portraits, whatever their perfection, cannot form a picture. The special sentiment of the work is the one thing that can give unity, and the one way to obtain that is to show only those things which deserve to be seen.

Art, like poetry, lives through fictions. Propose to the professional realist the painting of supernatural objects: a god, a nymph, a monster, a fury, all those things of the imagination which transport the mind! [...]

Realism is the great resource of the innovators at those periods when the schools are becoming languid and turning to mannerism; through it they awaken once more the blasé taste of the public, while the schools turn in the circle of the same inventions. [...]

3 Max Buchon (c. 1819–1869) on Courbet's *Stonebreakers* and *Burial at Ornans*

Courbet grew up in the Franche-Comté in South-western France, and came to Paris in 1839. Ten years later the reception of his *After Dinner at Ornans* at the Salon encouraged him to see himself as the potential leader of an emerging tendency. In the following year, at the combined Salon of 1850–1, he showed the *Stonebreakers* and the huge *Burial at Ornans* together with the *Peasants of Flagey*, three uningratiating paintings based on scenes of rural life, all executed in a style which was clearly intended to appear 'post-Romantic'. These new works did indeed serve to establish the character of Realism as an artistic movement, both for those hostile to all it implied and for the few sympathetic writers grouped around Champfleury. The *Burial* in particular served as a focus for controversy. Buchon was a friend of Courbet's from his youth and is depicted among the mourners in the *Burial*. Like other members of the Realists' circle he was interested in the vernacular culture of the French countryside, and he shared with Champfleury a specific concern with the survival of folk-songs and stories. He was briefly imprisoned after the 1848 revolution and went into exile to escape arrest after the coup d'état of 1851. A first draft of the present essay was written to publicize an exhibition of the *Stonebreakers* and the *Burial* in Besançon, and was published in *Le Démocrate Franc-Comtois* on 25 April 1850. The present revised version was used for a similar exhibition in Dijon in the following July, and was originally published as 'Annonce', in *Le Peuple, Journal de la Révolution Sociale*, no. 18, 7 June 1850. Our text is taken from the translation in P. Ten-Doesschate Chu (ed.), *Courbet in Perspective*, Englewood Cliffs, New Jersey: Prentice-Hall, 1977, pp. 60–3. The *Burial at Ornans* is now in the collection of the Musée d'Orsay in Paris. The *Stonebreakers* was destroyed during the Second World War, though a smaller and reversed version survives in the Oscar Reinhardt Collection in Winterthur.

The painting of the *Stonebreakers* represents two life-size figures, a child and an old man, the alpha and the omega, the sunrise and the sunset of that life of drudgery. A poor young lad, between twelve and fifteen years old, his head shaven, scurvy, and stupid in the way misery too often shapes the heads of the children of the poor; a lad of fifteen years old lifts with great effort an enormous basket of stones, ready to be

measured or to be interspersed in the road. A ragged shirt; pants held in place by a breech made of a rope, patched on the knees, torn at the bottom, and tattered all over; lamentable, down-at-heel shoes, turned red by too much wear, like the shoes of that poor worker you know: That sums up the child.

To the right is the poor stonebreaker in old sabots fixed up with leather, with an old straw hat, worn by the weather, the rain, the sun, and the dirt. His shaking knees are resting on a straw mat, and he is lifting a stonebreaker's hammer with all the automatic precision that comes with long practice, but at the same time with all the weakened force that comes with old age. In spite of so much misery, his face has remained calm, sympathetic, and resigned. Does not he, the poor old man, have, in his waistcoat pocket, his old tobacco box of horn bound with copper, out of which he offers, at will, a friendship pinch to those who come and go and whose paths cross on his domain, the road?

The soup pot is nearby, with the spoon, the basket, and the crust of black bread.

And that man is always there, lifting his obedient hammer, always, from New Year's Day to St Sylvester's; always he is paving the road for mankind passing by, so as to earn enough to stay alive. Yet this man, who in no way is the product of the artist's imagination, this man of flesh and bones who is really living in Ornans, just as you see him there, this man, with his years, with his hard labour, with his misery, with his softened features of old age, this man is not yet the last word in human distress. Just think what would happen if he would take it into his head to side with the Reds: He could be resented, accused, exiled, and dismissed. Ask the prefect.

From this scene, which, in spite of its fascination, is merely imperturbably sincere and faithful [to reality], from this scene, in front of which one feels so far removed from whimpering tendencies and from all melodramatic tricks, let us turn to Mr Courbet's principal work of this year, *A Burial at Ornans*.

Twenty-odd feet wide and twelve feet high, with fifty-two life-size figures ... such a crowd, so much material, so much work!

For those who, like us, have the honour of knowing those good people of Ornans to some extent, it is at first an encounter with a rather naïve effect to see that painting in which are grouped, in several rows, all those persons whom you have just greeted on the road and who are assembled there by the master's brush in such a natural, intelligent, and simple manner. The priest, the mayor, the deputy – nobody is missing. They are there, as I said, fifty altogether – all with their individual characters, their traditional outfits, and their own personal worries.

And yet, when, after a glance at that large composition in its entirety, the eye is drawn to the gravedigger who sits there on his knees on the edge of the grave into which he is to let down the corpse, some indefinable austere thought is suddenly aroused by that yawning hole. It is a thought that seems to suddenly illuminate these faces as by lightning, and that makes the painting into a veritable synthesis of human life, especially because of the wide landscape background, that sombre and grey sky, and the atmosphere of contemplation that envelops everything.

Formerly, in the old dances of death, Death in person forced kings, popes, emperors – all the great of the world and all the oppressors of the poor – to dance around, whether they liked it or not.

It seems to us that Mr Courbet, with his gravedigger, has obtained an equally powerful and significant effect, and has done so without departing from that absolute realism which, from now on, is indispensable in painting as well as in politics; a realism appreciated in advance by the good women of Ornans, in the same way as the *Presse* and the *National* will be able to appreciate it at the forthcoming exhibition.

In fact, that man, that gravedigger, shows no meanness in his robust posture. He is even the only one in that immense reunion who kneels, and yet, look! he alone carries his head high, he alone commands.

Tomorrow that man, who is in his prime, will return quietly to his vinegrower's cottage which he left yesterday; today only he feels as if he is the last link with earthly matters, the gatekeeper of the hereafter.

And yet, must it be said? through the vague oppression caused by his contemplation, one returns unconsciously – no doubt through the idea of compensation – to our poor stonebreaker. In the mind of the painter he might well be nothing but the psychological antithesis, the counterpoise – I would almost say the revenger.

In fine, before going to Paris, two paintings will be exhibited in the coming days in Dijon, as they have been in Besançon. I hope that the artists, the loafers, and, above all, the ordinary folks will go to judge the paintings for themselves. Their colossal dimensions are unusual, no doubt, for these so-called genre paintings that are the specialty of Mr Courbet. Yet who would dare to complain of the big size of the bottle, if the wine inside is of good quality?

Mr Courbet paints as he feels, and does not imitate this master or that school, nor is he out for applause. The painting that he wants is neither Italian nor Flemish: It is the painting of Ornans, the painting à la Courbet.

From his free and frank demeanour, which he will justify more and more every year, it is easy to recognize the true son of the Franche-Comté, the veritable child of that rugged country, where those three impetuous rebels of the philosophical and literary world were born: Fourier, Proudhon, and Victor Hugo. That method, though, appears to us the only true, the only rational, and the only acceptable one; therefore, we don't hesitate to wish him all sorts of appreciation.

4 Champfleury (Jules Fleury-Husson) (1821–1889) '*The Burial at Ornans*'

Champfleury was a novelist, art historian and journalist, with an interest in popular imagery and music. In the Salon of 1848 he had singled out Courbet's contributions among the 5,500 works on display, and he wrote enthusiastically about his *After Dinner at Ornans* the following year. His study *Le Réalisme* was published in 1857, effectively defining a broad cultural tendency with which Courbet's work was by then firmly identified. He was a consistent supporter of the painter's work, and later of Manet's. His essay on the *Burial at Ornans* combines a defence of the painting with an attempt to correct the prevailing misconception of Realism: that it was either a brand of terroristic socialism or a form of rustic primitivism, or a combination of the two. In his reference to the 'black and serious costume' of the bourgeoisie, Champfleury echoes the observations of Baudelaire (see his 'On the Heroism of Modern Life', IID13). Longchamp is a Parisian racetrack, Panurge a character from Rabelais' *Pantagruel*, Nicholas de la Largillière (1656–1746) an earlier

painter known for portraits of royalty and dignitaries. The essay was originally published as 'L'Enterrement d'Ornans' in the *Messager de l'Assemblée*, 25–26 February, 1851; reprinted with slight changes in *Grand figures d'hier et d'aujourd hui*, Paris 1861, pp. 231–44. This version is taken from the translation of the latter text in P. Ten-Doesschate Chu (ed.), *Courbet in Perspective*, Englewood Cliffs: Prentice-Hall, 1977, pp. 64–8 and 71–3.

I heard the comments of the crowd in front of the painting of the *Funeral at Ornans*; I had the courage to read the nonsense that has been printed regarding this picture, and I wrote this article. Just as in politics, one sees strange alliances of opposed parties reunite to combat a common enemy, the most audacious among the well-known critics have entered the ranks of fools and have fired against reality.

Mr Courbet has wanted to represent a small-town funeral as it occurs in the region of the Franche-Comté and he has painted fifty people, life-size, going to the cemetery. That is the painting.

Some find it too big and they refer the painter to the scribblers' school of Mr Meissonnier.

Others complain that the bourgeois of Ornans lack elegance and resemble the caricatures of Daumier.

Some chilled Romantics protest against the ugly as simple ignoramuses.

The lovers of faded ribbons and rancid make-up, who sing about the exploits of eighteenth-century girls, tremble when they see black suits, and exclaim: 'The world is lost, there are no more pompons, no beauty spots, no pink silk ribbons.'

One likes to think of Courbet as a savage who studied painting while watching the cows.

Some are certain that the painter is a leader of a socialist ring.

Finally, the opinion of the good-for-nothings can be epitomized in this well-known sentence which flourished during the Empire:

All one sees in these paintings is of such bad taste that one recognizes nature only in its degradation. The men are ugly and badly done, their suits are gross, their houses shabby. One finds in them nothing but a base truth.

The academician who talked this way in 1810 meant to designate Teniers, Ostade, and Brawer [Brouwer]. The crities of 1850 have not changed the arguments of the academician in any way.

Good grief!

A painting does not cause so much noise if it does not have serious qualities. As it happens, more often the critic who denies is more valuable than the critic who affirms. The *contra* is more useful than the *pro*. It is through similar unintentional means that one makes a work a success. 'I love my enemies more than my friends,' are the words of a great man who knew how detractors are dying to talk, and he was right. *The country is in danger!* exclaims the *Constitutionnel*, with reference to the painting of Mr Courbet. Immediately all the curious people of Paris run to the danger, which consists of the *Funeral at Ornans*; they come back from the Salon and tell about the scandal to all who want to hear about it. 'The Barbarians have entered the exhibition.' They cry out that Mr Courbet is the son of the democratic Republic of 1848; they want to hang

a crepe over the Apollo Belvedere; they propose to close the room of the classical antiquities. If one listened to them, the members of the Institute would have to sit down on their chairs, as the senators did once on their curule chairs, and die proudly, beaten by the muddy sabots of the savage realists.

* * *

These days it is customary to find out whether the pen of a novelist is dipped in communism, whether the melody is Saint-Simonian, or whether the brush is egalitarian. There is not a shade of socialism in the *Funeral at Ornans*; and for me it is not enough to paint the *Stonebreakers* in order to show a strong desire to improve the condition of the working classes.

These dangerous fantasies could lead to a classification of artists in parties, whereby they could be claimed now by one, then by the other. One will never persuade me that 'Rembrandt was the pupil of Luther.' Impure mixtures of hazy pantheism, of symbolic antitheses, and of realities, when will you stop browning in the same casserole in order to poison youth?

Nevertheless, I want to draw again from that well, out of which no truth will come, to show that Mr Courbet is not as socialist as one would have it. Not that I want to attach him to another party, because that would be as fatal for the painter as for his future works.

Woe to those artists who want to teach through their works, or who want to associate themselves with the acts of some governments. They can stir up the passions of the masses for five minutes, but they only present *passing events*.

If socialism were fundamentally but a new form of liberalism, or a sort of *opposition* in different garb, what chances would a socialist painter have? His work would become outdated as quickly as the very name of the doctrine, which is already much less resounding than in the two first years of the Revolution.

Painting no more has as its mission the exposure of social systems than does music; when painting is turned into teaching it is not painting anymore. It becomes a pulpit that is sad and painful to look at, because there is no preacher on it.

Fortunately, Mr Courbet has not wanted to prove anything by his *Funeral*. It is the death of a bourgeois, who is followed to his last resting place by other bourgeois. One knows that the painting is not a family portrait; where is the vinegrower who is rich enough to order such an important canvas? It is simply, as I have seen it printed on posters when Mr Courbet exhibited his paintings in Besançon and Dijon, the HISTORY PAINTING of a funeral at Ornans. It has pleased the painter to show us the small-town domestic life. He has said to himself that printed cotton dresses and black suits are as good as Spanish costumes, the laces and feathers of the time of Louis XIII, medieval armours, and the paillettes of the Regency; and, with the courage of an ox, he plunged into that immense canvas, unprecedented so far.

* * *

As for the alleged ugliness of the bourgeois of Ornans, he has not exaggerated anything; it is the ugliness of the province as opposed to the ugliness of Paris. Everybody exclaims that the vergers are disgraceful. Because there is a little wine in their bloated heads... Is that all? The wine gives a diploma to those who love her and she colours the noses of drinkers with a powerful red; it is the emblem of the drunkards [...]

It is funny that while so many bad things have been said about those happy-looking vergers, nobody has thought of broaching the subject of the ugliness of the business-man, so well represented by a deathly-pale-looking person, with thin lips, who has a dry and cold neatness that points to the pettiness of life. There is an ugly man, parsimonious and prudent, steady and virtuous. That is ugliness.

* * *

Mr Courbet can boldly state that three women's heads, the children, the grave-digger, and several other figures, are characteristic of modern beauty; and that the vergers make up the balance and will cause everyone to proclaim the *Funeral at Ornans* the masterpiece of the *ugly*. Is it the painter's fault that material interests, small-town life, sordid egoism, and provincial pettiness have marked the faces with their claws, have made the eyes dim, have wrinkled the foreheads and stupefied the mouths? Many bourgeois are like that; Mr Courbet has painted bourgeois. [. . .]

There are in France still many feeble-minded people. The courtesans of the Regency, rouge, beauty spots, and lambs have greatly troubled the minds of those poor people, who find neither glory nor happiness in their own time and who can see in their imagination only little poems, suppers, and small dogs, marchionesses [and] actresses. . . . They ignore the fact that the modern costume is in harmony with modern physiognomy, and that the fancy frills of the costumes of Watteau would make us look more ridiculous than Cassandre. Our black and serious costume has its grounds and it requires the tender dreams of a *précieux* to exclaim how happy he was that the next Longchamp would bring leaves to the trees and feathers to men's hats.

Fortunately, the time has come for these pantheists, who made nature play such silly comedies. A new art appears, serious and full of conviction, ironic and brute, sincere and full of poetry. Those who expose all that conceited bric-à-brac will soon appear; feelings are running high everywhere. The intelligent young wait for the first audacious one who will blow up all those hunters for words, that school of pleasant-ness, those beautiful spirits, those sheep of Panurge who jump over the same ditch, those makers of proverbs, those cliché writers, those pastrycooks, with their poems all made in the same mould.

And there will be no temple large enough to contain all the yellow-jacketed books that one will be obliged to tear up before discarding them; because one will have to demonstrate how badly they were stitched, with what bad material they were filled, and what a sad lining was underneath. A difficult job that requires more than one day. [. . .]

From a distance, when one enters the room, the *Funeral* looks as if it is framed by a doorway; everybody is surprised by that simple painting, as one is surprised at seeing those naive woodcuts, carved by a clumsy hand, that head the broadsides describing murder cases, printed in the Rue Gît-le-Coeur. The effect is the same because the execution is equally simple. Cultured art finds the same accent as primitive art. The result is as captivating as the painting of a great master. The simplicity of the black costumes is akin to the grandeur of parliaments in red robes by Largillière. It is the modern bourgeoisie, full-length, in all its ridiculousness, its ugliness and its beauty.

The scandal aroused by the *Funeral* of Mr Courbet is due in part to a strong, robust, and powerful individuality that crushes the neighbouring paintings. The critics are excited about a painting of the head of a smoker, a self-portrait of the

artist. There is genius in the *Funeral at Ornans*; the portrait of the *Man with the Pipe*, which is so much admired, is painted ten times better in ten heads of the *Funeral*. I am not going to give any advice to the painter; let him go where his brush takes him. He has produced a masterpiece in this time of mediocrity; let us hope that by working, he will forget the misery inflicted on him by mediocrities.

5 Gustave Courbet (1819–1877) Letter to Champfleury

Courbet's large canvas *The Painter's Studio* was subtitled 'a real allegory summing up seven years of my artistic and moral life'. He addressed this letter to Champfleury in 1854 while the work was unfinished, though well advanced. His clear intention was to leave on record a series of clues to the allegory it contained, though without offering a complete solution. It has been suggested that the aim was to disclose its meaning to friends while concealing the political character of its references from the strict censorship of Napoleon III's regime. This suggestion gains support from Champfleury's testimony in the 1880s that the painting embodied topical references which had been largely forgotten. Champfleury himself is portrayed in the picture, together with Buchon, Proudhon and Baudelaire, among those figures at the right who represent Courbet's 'shareholders . . . friends, fellow-workers and art-lovers'. *The Painter's Studio* is now in the collection of the Musée d'Orsay in Paris. The full text of the letter was first published, from an undated but autograph version in the Louvre, in *Gustave Courbet: 1819–1877*, catalogue of an exhibition at the Grand Palais, Paris: Réunion des Musées nationaux, 1978. This translation is taken from the English version of the catalogue, London, 1978, pp. 254–5. A detailed exposition of the references contained in the letter may be found in both the French and English versions of the same catalogue.

Dear friend,

In spite of being assailed by hypochondria I have launched into an enormous painting, twenty feet by twelve, perhaps even bigger than the *Burial*, which will show that I am still alive, and so is Realism, since we're talking of that [*puisque réalisme il y a*]. It's the moral and physical history of my studio, part 1: all the people who serve my cause, sustain me in my ideal and support my activity; people who live on life, those who live on death; society at its best, its worst and its average – in short, it's my way of seeing society with all its interests and passions; it's the whole world coming to me to be painted. You see, the picture has no title. I will try and give you a clearer idea by a matter-of-fact description. The scene is set in my Paris studio. It is divided into two parts, with myself in the middle, painting a picture. On the right are all the share-holders, that is to say friends, fellow-workers [*travailleurs*] and art lovers. On the left is the other world of commonplace life: the masses, wretchedness, poverty, wealth, the exploited and the exploiters, people who live on death. On the wall at the back are my *Return from the fair* and *Bathers*, and the picture I am working on is one of a donkey-driver meeting a girl and pinching her bottom; there's a landscape with a mill and donkeys laden with sacks. I'll tell you who all the characters are, starting at the extreme left. The first is a Jew whom I saw once in England, making his way through the hurly-burly of a London street; he was holding a casket reverently on his right arm, covering it with his left hand, and seemed to be saying: 'I've got the best of it'.

His complexion was like ivory, he had a long beard and was wearing a turban and a long black gown that trailed on the ground. Next to him is a curé with a coarse red face [*une trogne rouge*] and a triumphant expression. In front of them is a weather-beaten old man, a diehard republican (that Minister of the Interior, for instance, who was in the Assembly when Louis XVI was condemned to death, the one who was still following courses at the Sorbonne last year) – a man 90 years old with a begging-bag in his hand, dressed in old patched white linen and wearing a broad- brimmed hat; he is looking at a heap of romantic paraphernalia at his feet, and the Jew feels sorry for him. Then there's a huntsman [*Chasseur*], a scytheman, a strong man and a clown, a rag-and-bone merchant, a labourer's wife, a labourer and an undertaker's mute; a skull lying on a newspaper; an Irishwoman suckling a child, and a lay figure. The Irishwoman comes from England too – I saw her in a London street wearing nothing but a black straw hat, a torn green veil and a ragged black shawl, and carrying a naked baby under her arm. The old-clothes man [*marchand d'habits-galons*] presides over all this, displaying his frippery to all these people, each of whom expresses great interest in his own way. Behind his back, in the foreground, is a guitar and a plumed hat.

Part 2. Then comes the canvas on my easel, and myself painting in Assyrian profile. Behind my chair is a nude female model, leaning on the chair-back for a moment as she watches me paint. Her clothes are lying on the ground in front of the picture, then there is a white cat beside my chair. Next to the model is Promayet with a violin under his arm, as in the portrait he sent me. Then Bruyas, Cuenot, Buchon and Proudhon (I would very much like to have the philosopher Proudhon, who shares our way of thinking, and I would be very happy if he would pose. If you see him, ask if I may expect his help). Then comes your turn, in the foreground, sitting on a stool with your legs crossed and a hat on your lap. Beside you, still further forward, is a society woman, dressed to the nines, with her husband. Then on the extreme right, perched with one leg on a table, is Baudelaire, reading a great book; beside him, a negress looking coquettishly at her reflection in a mirror. Right at the back, in a window recess, two lovers are whispering to each other; one of them is seated on a hammock. Above the window are voluminous draperies of green serge. Against the wall are also some plasters, a shelf with a bottle [*fillette*] on it, a lamp, some pots, canvases turned back to front, then a screen, then nothing but a great bare wall.

I have explained all this very badly, the wrong way round – I ought to have begun with Baudelaire, but it would take too long to start again. Make it out as best you can. People will have their work cut out to judge the picture – they must just do their best. For, of course, there are people who wake up at night shouting and screaming: I want to judge, I must judge! Can you imagine, my dear chap, that when I had already conceived this picture I was suddenly overtaken by a frightful jaundice which lasted more than a month. Knowing how impatient I am once I have made up my mind to paint something, you can imagine what a state I was in – wasting a month, when I couldn't afford to lose a single day! All the same I think I shall manage – I have still got two days for each character, except for the accessories, but somehow or other I must get it done. I shall be sending 14 pictures to the exhibition, practically all new ones except for the *Burial*, the *Stone-breakers* and myself with a pipe; Bruyas has just bought this from me for 2,000 francs, and he also bought the *Spinner* for 2,500. I'm in luck, I'll be able to pay my debts and cope with the exhibition as well. I don't know how I could

have done it otherwise – one must never lose heart. I have a country scene of *The grain sifters* which belongs to the same series as *Young ladies of the village*, a strange picture too. I feel very depressed – my soul is quite empty, my liver and heart full of gall. At Ornans I drink at a sportsmen's café with 'Gai Savoir' people and go to bed with a servant girl. None of this cheers me up. You know my 'wife' got married. I no longer have her or the child – apparently she was forced to it by poverty. That's how society devours people. We had been together 14 years. I gather Promayet is very unhappy too. Try to help him find something. Pride and probity will be the death of us all. At this moment I can't do a thing, but I absolutely must be ready for the exhibition. Tell Promayet that I haven't received the canvases. I embrace you with all my heart.
Gustave Courbet

6 Gustave Courbet (1819–1877) Statement on Realism

Courbet had intended *The Painter's Studio* for inclusion in the official exhibition at the 1855 World's Fair, which replaced the Salons of that and the previous year. It was rejected, however, together with the *Burial at Ornans*. The painter responded by reviving a plan for an independent display of his work, which he staged under the title 'Realism – Gustave Courbet' on a site near the entry to the fair. It was unprecedented for a retrospective survey of this nature to be mounted without state backing. The exceptional nature of the enterprise must have been made all the clearer by the inclusion in the official exhibition of a separate salon containing a large number of Ingres's most important works. Delacroix visited Courbet's pavilion and noted in his journal apropos the *Studio*, 'they have rejected one of the most singular works of our time' (IIIB2). Champfleury published an article in support of the 'Pavilion of Realism', and it has been been suggested that he was the effective author of the following statement, which was printed above Courbet's initials as a preface to the catalogue. It is not unlikely that the wording was the product of some form of collaboration, but the style and sentiments are close enough to those of other known statements by the artist to justify leaving the attribution as it stands. The translation of the text is taken from *Gustave Courbet: 1819–1877*, London, 1978, p. 77.

The title 'realist' has been imposed on me in the same way as the title 'romantic' was imposed on the men of 1830. Titles have never given the right idea of things; if they did, works would be unnecessary.

Without going into the question as to the rightness or wrongness of a label which, let us hope, no one is expected to understand fully, I would only offer a few words of explanation which may avert misconception.

I have studied the art of the ancients and moderns without any dogmatic or preconceived ideas. I have not tried to imitate the former or to copy the latter, nor have I addressed myself to the pointless objective of 'art for art's sake'. No – all I have tried to do is to derive, from a complete knowledge of tradition, a reasoned sense of my own independence and individuality.

To achieve skill through knowledge – that has been my purpose. To record the manners, ideas and aspect of the age as I myself saw them – to be a man as well as a painter, in short to create living art – that is my aim.
G. C.

7 Jean-François Millet (1814–1875) on Truth in Painting

Millet was born of peasant stock in Normandy. His evident artistic talent gained him recognition and he was awarded financial support to go and study in Paris in 1837. The teaching of Paul Delaroche, the Romantic Salon painter, was not however congenial to him. None the less, apart from periods back in Normandy, Millet pursued an artistic career in Paris for twelve years. After only modest Salon success, and severe criticism in 1848, he finally left Paris in 1849 for the artistic colony in the village of Barbizon, in the forest of Fontainebleau. Millet was committed to representing the truth of peasant life, yet he did so under a predominantly religious aspect and did not personally wish to be identified with the socialist tendency with which he was frequently associated in the wake of 1848. He strove for a sense of truth which transcended the contingencies of time and place, while yet being rooted in the realities of a life of the soil and the seasons. There follow extracts from several of his letters, and from a notebook. The first letter (to Sensier, of 1850) and the last four (to Sensier and Pelloquet, of 1863, 1865 and 1867) are taken from the translations made by Julia Cartwright in her *Jean-François Millet: His Life and Letters*, London and New York: Swan Sonnenschein & Co, 1896, pp. 105–6, 239–40, 241–2, 283, 300. The notebook entry (on Sutter, of 1858) and the second letter (to Thoré, of 1862) are translated for the present volume by Jonathan Murphy, from the French text as printed in Etienne Moreau-Nélaton, *Millet raconté par lui-même*, three volumes, Paris: Henri Laurens, 1921, volume 2, pp. 60–1 and 106–7.

(i) Letter to Sensier, February 1850

My dear Sensier,

Yesterday, Friday, I received the colours, the oil, canvas, etc., which you sent me, and the accompanying sketch of the picture. These are the titles of the three pictures destined for the sale in question:

(1) *A Woman Crushing Flax*;
(2) *A Peasant and his Wife going to Work in the Fields*;
(3) *Gatherers of Wood in the Forest.*

I do not know if the word *Ramasseurs* can appear in print. If not, you can call the picture, *Peasants Gathering Wood*, or anything else you choose. The picture consists of a man binding sticks in a faggot, and of two women, one cutting off a branch, the other carrying a load of wood. That is all.

As you will see by the titles of the pictures, there are neither nude women nor mythological subjects among them. I mean to devote myself to other subjects; not that I hold that sort of thing to be forbidden, but that I do not wish to feel myself compelled to paint them.

But, to tell the truth, peasant-subjects suit my nature best, for I must confess, at the risk of your taking me to be a Socialist, that the human side is what touches me most in art, and that if I could only do what I like, or at least attempt to do it, I would paint nothing that was not the result of an impression directly received from Nature, whether in landscape or in figures. The joyous side never shows itself to me; I know not if it exists, but I have never seen it. The gayest thing I know is the calm,

the silence, which are so delicious, both in the forest and in the cultivated fields, whether the soil is good for culture or not. You will confess that it always gives you a very dreamy sensation, and that the dream is a sad one, although often very delicious.

You are sitting under a tree, enjoying all the comfort and quiet which it is possible to find in this life, when suddenly you see a poor creature loaded with a heavy faggot coming up the narrow path opposite. The unexpected and always striking way in which this figure appears before your eyes reminds you instantly of the sad fate of humanity – weariness. The impression is similar to that which La Fontaine expresses in his fable of the Wood-cutter:

> 'Quel plaisir a-t-il eu depuis qu'il est au monde?
> En est-il un plus pauvre en la machine ronde?'

In cultivated land sometimes – as in places where the ground is barren – you see figures digging and hoeing. From time to time, one raises himself and straightens his back, as they call it, wiping his forehead with the back of his hand – 'Thou shalt eat bread in the sweat of thy brow.'

Is this the gay and playful kind of work that some people would have us believe? Nevertheless, for me it is true humanity and great poetry.

I must stop, or I shall end by tiring you. You must forgive me. I am all alone, and have no one with whom I can share my impressions. I have let myself go, without thinking what I was saying. I will not start this subject again. [. . .]

(ii) Comments on David Sutter's Philosophie des Beaux Arts appliquée à la peinture, 1858

The art of painting consists in expressing the appearance of bodies. This is not the end of art, but the means, the language which one uses in order to express one's thoughts. What we call *composition* is the art of transmitting these thoughts to other people. For that reason one can prescribe a rule to no one. Nothing else can be considered a composition that does not contain the essential element of *order*. Order puts each thing in the place that is right and fitting, and as a result creates an impression of clarity, simplicity and strength. These are the things that Poussin termed *The proprieties* [*Les convenances*].

It is a mistake to believe that there are *rules of art*, already discovered and established for the use of people wishing to make art. Anyone who can see nature for himself, and who can receive the impressions from it, will not learn from anyone else the means of communicating them to other people: that which he feels for himself alone determines expression. You can't give a dog a nose: you can merely train it to use the one it has. This is all that education can do. The example of *strong individuals*, whatever they have done, and however different they may appear from each other, proves that nobody can fail to obey this law of *order*; and naturally, for without order expression cannot emerge, as things only have value in accordance with the place they occupy. Strong individuals differ only in the final character of their work: they would all teach the same principles. To be frankly Peter or Paul, that is *originality*. One can teach someone the material side of art, but only up to a certain point: he will be able to

repeat, to a greater or lesser degree, what others have said before him, but he will never walk out on his own until he learns to see with his own eyes. I recently came across a saying in the *Cuisinier Français* which is more instructive than it appears to be on first reading: 'To make jugged hare, first take one hare...' – one cannot become that which one is not called to be, and the best teaching can do no more than develop a faculty that is already latent. The hen must sit on her eggs, but if the eggs are unfertilized, what is the use of trying to hatch them?

Beauty is the result of *harmony*. I do not know whether in art one thing is more beautiful than another. Which is the most beautiful, a straight tree or a crooked tree? – the one that fits the situation the best. In the right place, a hunchback will be more beautiful than Apollo himself. However one looks at it, however one turns it around, and whatever one chooses to call it, *order* will always carry the day. *Order* and *harmony* are the same thing.

(iii) Letter to Thoré, 1862

Barbizon, 18 February

My dear Thoré,

Since you wish to concern yourself with the pictures I am presently exhibiting at Martinet's, I should like to tell you a little about the idea behind them. You can judge for yourself if there is anything of value in the following few notes. First of all I should tell you that what I seek to express in everything I do is a sense of the rustic: from now on, my motto will be: *rus!*

In *Woman Returning from the Well* I have tried to make it clear that the woman is neither a water-carrier by trade, nor a servant girl: that she has drawn the water for her own use in the house, water to make soup for her husband and her children; that she should seem to be carrying neither more nor less than the weight of the full buckets; that through the sort of grimace she is making because of the weight pulling her arms, and through the eyes which are blinking from the light, one may read from her face a quality of rustic goodness. As always, I have striven with a kind of horror to avoid anything that might be considered to verge on sentimentality. I wanted to show her, on the contrary, carrying out an ordinary activity with simplicity and cheerfulness, looking upon it not as a chore, but with all the other household tasks as simply another part of her everyday life. I really want people to feel the coolness of the well, and to imagine, from that ageless air it has, the countless others who might have drawn water from it before.

In the *Sheep which have just been Shorn* I have sought to express that kind of bewilderment and confusion that sheep seem to feel when they have just been shorn, and the curiosity and amazement that the ones that haven't yet been shorn express when they see the others so naked. I have tried to give a peaceful, rustic air to the house, so that one might imagine that there are still crops in the enclosure behind, in the shade of the poplar trees; finally, to make it look as if it were old enough for generations to have lived there.

A *Woman Feeding her Children*. I wanted this to seem like a bird's nest, and show the mother feeding the hungry beaks. The man works to earn the bread for all that.

Finally, in case you feel it necessary to point it out, in everything I do, I try to avoid a sense of things having the air of being thrown together by chance, but that there exists between them an indispensable, strong connection. I want the beings I paint to look as if they are devoted to what they do so that it is impossible to imagine them being other than they are: to show, in short, that people or things are always there for a purpose. I try to show plainly and forcefully that which is necessary, but I have a horror of things which are useless or there merely to fill up space. Such things can do nothing other than enfeeble the work.

I do not know if there is anything you can use in what I have just said, but here it is anyway.

My dear Thoré, I shake your hand warmly and wish you perfect health.
J. F. Millet

(iv) Letter to Sensier, 1863

Barbizon, 30 May

My Dear Sensier,

[...] All this gossip about my *Homme à la Houe* seems to me very strange, and I am grateful to you for reporting it to me. Certainly, I am surprised at the ideas which people are so good as to impute to me! I wonder in what Club my critics have ever seen me! They call me a Socialist, but really I might reply with the poor *commissionnaire* from Auvergne, 'They call me a Saint Simonist. That is not true, I do not even know what it means.' Is it then impossible simply to accept the ideas that come into one's mind, at the sight of the man who 'eats bread by the sweat of his brow'? There are people who say that I see no charms in the country. I see much more than charms there – infinite splendours. I see, as well as they do, the little flowers of which Christ said: 'I say unto you, that even Solomon in all his glory was not arrayed like one of these.'

I see very well the *auréoles* of the dandelions and the sun spreading his glory in the clouds, over the distant worlds. But none the less I see down there in the plain the steaming horses leading the plough, and in a rocky corner a man quite worn-out, whose *han* has been heard since morning, and who tries to straighten himself and take breath for a moment. The drama is surrounded with splendour.

It is not my invention, and this expression – 'the cry of the ground' – was heard long ago. My critics are men of taste and instruction, I suppose, but I cannot put myself in their skin, and since I have never, in all my life, known anything but the fields, I try and say, as best I can, what I saw and felt when I worked there. Those who can do this better than I can are fortunate people. [...]

(v) Letter to Pelloquet, 1863

Barbizon, 2 June

Monsieur,

I am very much gratified by the manner in which you speak of my pictures in the Exhibition. This has given me the more pleasure, because of the way in which you

discourse upon Art in general. You belong to the exceedingly small number of writers who believe (all the worse for those who do not!) that Art is a language, and that all language is intended for the expression of ideas. Say it, and say it over again! Perhaps it will make some one think a little! If more people shared your belief, there would not be so much empty painting and writing. That is called cleverness, and those who practise it are loudly praised. But, in good faith, and if it were true cleverness, should it not be employed to accomplish good work, and then hide its head modestly behind the work? Is cleverness to open a shop on its own account? I have read, I cannot remember where, 'Woe to the artist who shows his talent more than his work.' [. . .]

[. . .] I will, at the risk of wearying you, try and tell you as best I can, certain things which are matters of faith with me, and which I should like to express clearly in my work. The objects introduced in a picture should not appear to be brought together by chance, and for the occasion, but should have a necessary and indispensable connection. I want the people that I represent to look as if they belonged to their place, and as if it would be impossible for them to think of being anything else but what they are. A work must be all of a piece, and persons and objects must always be there for a purpose. I wish to say fully and forcibly what is necessary, so much so that I think things feebly said had better not be said at all, since they are, as it were, spoilt and robbed of their charm. But I have the greatest horror of useless accessories, however brilliant they may be. These things only serve to distract and weaken the general effect. It is not so much the nature of the subjects represented, as the longing of the artist to represent them which produces the beautiful, and this longing in itself creates the degree of power with which his task is accomplished. One may say that everything is beautiful in its own time and place, and on the other hand that nothing can be beautiful out of its right place and season. There must be no weakening of character. Let Apollo be Apollo and Socrates remain Socrates. Do not let us try to combine the two; they would both lose in the process. Which is the handsomest – a straight tree, or a crooked one? The one that we find in its place. I conclude therefore that the beautiful is the suitable.

This principle is capable of infinite development, and might be proved by endless examples. It must, of course, be understood that I am not speaking of absolute beauty, for I do not know what that is, and it has always seemed to me the vainest of delusions. I think that people who devote themselves to that idea only do so because they have no eyes for the beauty of natural objects. They are buried in the contemplation of the art of the past, and do not see that Nature is rich enough to supply all needs. [. . .]

(vi) Letter to Sensier, 1865

Barbizon, 29 March

My dear Sensier,

I am very glad that you are going to do the articles on the Salon. You may be sure that I will tell you everything I can think of, either about Art in general, or any particular

works. It seems to me that you might show, by going back a little, that Art began to decline from the moment when the artist no longer leant directly and simply upon impressions taken from nature. Then clever execution rapidly took the place of nature, and the decadence began. Force departs directly you turn aside from nature, as we learn from the fable of Antaeus, whose powers failed when his feet no longer rested on the ground, and who recovered his strength every time he touched the earth. Say that briefly but fully, and repeat it as often as possible. Show your readers that for the same reason Art has steadily declined in modern times, and give as many examples as possible. [. . .]

In the end, it always comes back to this – a man must be touched himself before he can touch others; and work that is done as a speculation, however clever it may be, can never effect this, because it has not got the breath of life. Quote St Paul's expression: *aes sonans et cymbalum tinniens* [sounding brass, or a tinkling cymbal].

(vii) Letter to Sensier, 1867

Barbizon, 23 April

My dear Sensier,

What you tell me is, as you say, new and encouraging. But do not tire yourself too much, for interviews such as you have had with M. Silvestre do not always produce a calming effect. I place full confidence in your wisdom, and since you ask my advice, am very glad that you laid stress on the *rustic* side of my art, for to say the truth, if this side is not brought out in my work, I have failed. I reject with my whole might the democratic idea, as it is understood in the language of the clubs, which some persons have tried to impute to me. I have only tried to make people think of the man whose life is spent in toil, and who eats bread in the sweat of his brow. You can honestly say that I have never tried to defend any cause. But I am a peasant of peasants. As for any explanation of my method of painting, that would take a long time, for I have never paid much attention to this; and if I have a style of my own, it has only been the result of entering more or less fully into my subject, and knowing the difficulties of life by my own experience. [. . .]

8 Théophile Thoré, writing as William Bürger (1807–1869) 'New Tendencies in Art'

This essay belongs to a persistent exhortatory tendency in French criticism of the mid century, and provides one of its most forceful expressions. The characteristic features of this tendency are a sense of the potential universality and cosmopolitanism of modern culture, combined with a conviction of the central position of France in the definition of the modern; an impatience with outmoded and exhausted symbols and references; and an assumption that the central vitalizing image of a new art must be a modern human figure derived from the study of nature. Similar motifs may be found individually or in combination in the writing of Marie-Camille de G. (IIA3), Baudelaire (IID13), Gautier (IIIA1) and Castagnary (IIIB14), and in a changed form in Hugo's late writing on Paris (see VIA1). Each writes as if the

task of criticism were actually to effect an overdue and impending change in the character of the culture as a whole. It is significant that Thoré seems unaware of any difficulty there might be in developing the modern figure through the study of nature. Of all the features of the 'new tendency' the final assumption listed above was the first to prove vulnerable (see Castagnary, IIIв15). Within a decade it had become clear that concepts of modernity could not so easily be reconciled with concepts of nature, and the human figure had become a focus for the resulting anxieties. Though Thoré opens his essay with a reference to the Universal Exhibition of 1855 it should be borne in mind that he saw neither the official exhibition nor Courbet's 'Pavilion of Realism'. The essay was written while he was still in exile. It was first published in Brussels in 1857, and was included in *Salons de T. Thoré, 1844–48*, Paris: Librairie International, 1868. This translation has been made by Christopher Miller from the latter edition, sections I–III, V, VII–IX, pp. xiii–xxii, xxvi–xxx, xxxv–xliv.

I

The Universal Exhibition of 1855 bestowed definitive recognition on the artists of the Romantic school. Till then contested, the earliest talents of that school were unreservedly acknowledged by France and Europe. Pictorial Romanticism, like literary Romanticism, triumphed in the court of public opinion. It is therefore finished. Who conquers, dies. Such is the implacable law: *Vicit, ergo vixit.*

Freedom of invention and style was no small conquest. But what will poetry, form, sentiment and image make of their new-found liberty?

Literary and pictorial Romanticism were mere instruments in the preparation of a new and truly human art – an art expressive of that new society of which the nineteenth century presents every symptom. This fact was intuited by one of the pioneers of Romanticism, in a beautiful maxim of eternal truth: New society, new art.

Well, in France as elsewhere, there is today a singular anxiety, an irresistible aspiration towards a life essentially different from the life of the past. In science and the religions that summarize it, in politics and the social economics through which it is applied, in the components of social economics – agriculture, industry and trade – the conditions prevailing in the old society have all been overturned. Peerless discoveries give every idea and fact unexpected and indefinite extension. It is as if an invisible telegraph instantly and everywhere circulated the impressions of the peoples, the thoughts of mankind: events and novelties of every kind. The least moral or physical *frisson* is communicated through adjacency and transmitted throughout the globe. Humanity is in process of formation, and its furthest extremities will soon share in its consciousness.

The principal characteristic of modern society – of future society – will be universality.

Where in former times – indeed, yesterday – a people was circumscribed by the petty confines of territory, tradition, idolatrous worship, egotistical laws, obscure prejudices, customs, and language, today it tends to spread beyond narrow boundaries, open its frontiers, generalize its traditions and mythology, humanize its laws, enlighten its notions, expand its customs, enlarge its interests, and everywhere lavish its energy, language and genius.

This is the current propensity within Europe and even elsewhere; it is the sign that defines the times. The rest is accidental, an epiphenomenon scarcely to be weighed in

the great accounts of civilization. And all this is fairly widely admitted, or at least intuited. Less familiar, it seems, even among perceptive thinkers, is the transformation that these influences imply for poetry, literature and the arts.

How will the arts be modified by the social metempsychosis now in process?

This aesthetic question is a very curious one, and of the utmost importance for the future of poetry and the fine arts.

II

The last literary and artistic school often explored the past; one of its merits was to revive and restore many aspects of history – its own history – that lay forgotten or disfigured.

And often it ventured instinctively into space, and there attempted its voyage around the world . . . of the imagination. For it was, as a rule, at a corner of the national fireside that it invented its paintings of 'foreign' life; from a mirror of which artists have the gift it borrowed those fantastical reflections of 'alien' landscapes resplendent beneath distant horizons.

True, this poet, it was said, had been to Palestine, this to the banks of the Rhine, another to the Alps or Pyrenees. But from these odysseys, authentic or invented, no poet or man of letters ever returned with such 'local colour' as Romanticism sought to deploy in its pictures.

The Frenchman travels little and travels ill. French is spoken everywhere, so he dispenses with 'foreign' languages; failing to communicate with the native populations of the countries through which he passes, he learns little and disdains much.

Our ingenious fabulists thus owed their success, not to say renown, to merely intellectual excursions, devoid of profound and direct relations with the spirit of 'abroad'. And this was true not just of letters, but of philosophy, politics and history too.

Among the painters, similarly, very few had the privilege of admiring 'foreign' skies. But it was these infrequent escapades that had fostered the originality and strength of their talents. I do not here refer to the little monastic colony that had buried itself in the catacombs of Rome. But one fine day, some unhinged artist thought to go to the Orient and see patrols, caravans, schools and cafés; another to Algeria and Morocco for veiled women, Moorish dancers, Arab horsemen, lions and panthers; a third to Switzerland for a glimpse of flocks descending through a ravine; another again . . . Intrepid adventurers!

However, under the reign of the last school, painters and men of letters alike almost invariably retained not merely their French cast of mind – no vice, on the contrary – but also their national and thus restricted point of view; their French, that is, exclusive, prejudices; their individual ideas.

But now that easy communications have placed all peoples in contact with each other, there is already a generation of young men who know languages, who, far from their homes, have studied the old world of Asia or the new world of America. One can no longer remain mewed up in philosophical, religious, literary or artistic systems, in little symbols and little mythologies, at a time when all religions and institutions,

all thoughts and all forms first confront then pervade each other in a chain of reciprocal influence, changing what is too native, reviving what is cosmopolitan and general; when cults that formerly met in anger meet to converse; when political revolutions penetrate every zone and have brought together the missionaries of every sentiment and language; when emigration – entire tribes dashing headlong before them – has become a permanent phenomenon; when China is open to Europeans, and the Chinese up sticks and invade Western America; when Indians and all the inhabitants of old Asia come to visit European exhibitions, those meeting-places of the entire world. Ancient stigmata of race, old local superstitions, ancient forms embalmed by each people within the shadows of its frontiers: these things have had their day. There is but one race and one people, one religion and one symbol: – Humanity!

III

Therefore the revolution to be made – the revolution now taking place in poetry (that is, in literature and art) – directly concerns thought, and not merely form, style, manner and expression. The spirit of plastic art is now at liberty. Originality and individuality have been attained. The technique displayed by writers and artists is extraordinary. Never have arts and letters been practised, never have language, drawing, and form in general been handled with such dexterity; never has execution been so deft. It is not in these departments that progress can be made today.

And if the revolution is to be made in thought, it must be made in the very subject-matter of the arts. Astounding this may seem, but it is so. Those who boldly claimed that, in the arts, subject-matter was indifferent, did so to protest at the importance claimed for heroic and conventional subjects. Well, perhaps the subject does *not* matter – on condition the artist's creation touches the soul and man himself is its 'hero'.

Here, none the less, is why changes in thought must be reflected in the subject:

The feature that defined the 'Renaissance' was its daring to represent the human figure not according to an orthodox and invariable typology, but by imitating individuals.

In that respect, Romanticism followed the liberating promptings of the sixteenth century; in another respect, it reacted against the Renaissance, which had revived the Olympian pantheon. Thus the sixteenth century itself became a resurrector of the dead, since its principal achievement was restoring the old medieval style.

The Renaissance and all the European schools that came after it stripped religious allegory of its surface, but they preserved its foundation. Christian no less than pagan art had been and continued to be a mythology, a veritable hieroglyph, enveloping thought in symbolic form.

Thus, where the pagans made not a woman but a Venus, the Christians made a Virgin. In either allegory, Venus/the Virgin stood for the perfect woman. And the remainder of the sex had as its emblems, in pagan times the chorus of goddesses and nymphs, the graceful suite of the mother of Love, and in Christian times the chorus of women saints and martyrs, the pious suite of the mother of the Redeemer.

All ideas were expressed in this way. A metaphorical personification translated them. Wishing to mythologize the torture of genius, the ancients chained Prometheus to the Caucasus and the Christians nailed Christ to his cross. As sovereign and founding power, the ancients had Jupiter the Thunderer, 'master of gods and men'; the Christians had the eternal Father, prime mover and judge supreme; for youth and poetic beauty, the former paid homage to the harmonious Apollo, the latter to the gentle Saint John, the well-loved disciple. And so too for the rest.

The two mythologies also borrowed other living forms less noble than the allegories borrowed from human form: the spotless lamb and immaculate dove, the conquering eagle and voluptuous swan.

Vegetable and mineral too contributed their notes to this conventional and some-what esoteric language.

Everything was pervaded by imaginary beings. Paganism had a predilection for the world of man, and peopled the forests with fauns and satyrs, the fountains with naiads and the sea with tritons and sirens. Christianity, its gaze transported to the soul's future dwelling, studded its sky with angels and archangels, cherubim and seraphim: the intermediaries between man and Divinity.

Much could be conveyed by these strange creations; for those initiated in the ancient cult and for the adherents of the cult that replaced it, they signified an entire doctrine. But for the uninitiated, this was a dead letter, an enigma.

* * *

IV

Literature and art have alternated between these two languages – these two arts – for the last three centuries. In the West, there are only two forms, the Catholic and the pagan allegory, each expressive of a partial notion, both equally impenetrable to the 'foreigner' and equally irrelevant to the modern spirit of the peoples who still use them.

The art of the nineteenth century requires something else.

V

In the art of former times – of yesterday – man did not exist. He has not yet been invented.

Almost never has man, *qua* man, been the immediate subject of painting and the other plastic arts – nor even of literature, for the two poetic schools follow one another and are in essence one.

Yes, there have been exceptions – the greatest of the great. Their genius portrayed human nature without the artifice of religious or poetic fiction. This is their title to immortality.

It is the eternal glory of Rabelais, Molière, Shakespeare and Cervantes, and certain other rare spirits, that they created men, and with them names, as worthy of admira-tion as any hero 'beloved of the Muses'. Panurge is the equal of Thersites; Othello of the raging Orestes; Don Quixote of the invincible Achilles; and Arnolphe in pursuit of

his Agnès is no less moving than the husband of the perfidious Helen under the walls of Ilion.[1]

At around this time, there was a cunning genius, who was forbidden by poetic orthodoxy from placing man centre-stage; he preferred not to compromise with heroes and chose animals instead, giving them words as witty as those of princes: he was La Fontaine.

The novel too, almost from the first, adopted an audacious conduct. Rousseau's *La Nouvelle Héloïse* offered to the compassion of the public a 'heroine' who, though noble, was not descended from either Jupiter, Caesar or Louis XIV; what a stir it caused.

And in the theatre, the intrepid eighteenth century – avid for experiment – reacted against the heroic tragedy and ventured, with Diderot, into popular drama.

In our own day too, after a sufficiently long diversion, some theatre and novel writers, Balzac and George Sand among others, owe to this innovative trend their main claims upon posterity.

In painting, exceptions to the heroic *furia* have been scarcely more common than in literature.

By nature, the old Latin race flinches from the sacrifice of traditional mummeries. What a scandal in Italy when Caravaggio and his colleagues, including the Frenchman Valentin, began to make life-size paintings of rough adventurers like themselves, flamboyant, well armed and delighted to be alive! They were accompanied by the Spaniard José Ribera and his student, Salvator Rosa, who were also enamoured of such subjects, and sometimes showed 'the ordinary man' with all the vigour of eloquence and *terribilitas* of truth. Yet even these violent 'naturalists' rendered the brow's furrows or the trumpery of costume better than depth of sentiment or character.

Spain is a country of extreme contrasts, and Philip the Fourth's painter, the resplendent Velazquez, alongside perhaps the most mystical art that has ever existed, royally portrayed drunkards and gypsies. And in his wake came the painter of ecstasies and vaporous apparitions, the sweet-toothed Murillo, who also brought beggars to life and irradiated with his warm colours the life of mere mortals laughing over a glass or biting into the cluster of grapes.

In France, the LeNain brothers, like Spaniards adrift in French waters, for a while painted peasants and workers with a grave naivety that attains to style. But these were small paintings, which, under the reign of the bombastic Lebrun, was a recipe for passing unnoticed; we therefore know almost nothing of the lives of these strange masters.

In the eighteenth century, Watteau, Chardin, Greuze, Boucher and even Fragonard painted familiar subjects: pastorals, peasant scenes, boudoirs, conversation pieces, family and household scenes. But these were still on a small scale, life-size depictions being the prerogative of Venus and Pompadour.

For all that the admirers of the 'great genre' can say, this 'little school' is perhaps the most French – the only French – school in our entire tradition. In the sixteenth century, were not our artists – with the exception of the Clouets, who were of Flemish origin – all Florentines? In the seventeenth century, all Romans? Is not the illustrious Poussin, for all his philosophical value, a man rather of Rome than of Les Andelys?[2]

In consequence this lively school of eighteenth century 'minor' masters quickly came to inspire a deep-rooted horror. Mythology and heroology quickly returned to

fashion, and Louis David, though *sans-culottes* abounded, returned to ancient times for his nude figures. But Watteau's nudes are finer. The masterpiece of the painter of the *Oath of the Horatii*, *Brutus* and *Leonidas* is precisely a subject of his own time, which he painted as he saw it: his *Marat* assassinated in his bathtub.

These schools of grave-diggers and resurrectionists seem finally to have been overthrown in their turn by Romanticism.

* * *

VII

No, man *qua* man has almost never been treated according to his proportion and deserts, except by this son of a Dutch miller [Rembrandt], by the few realists whom we have cited above, and by some eccentrics of our own time.

It was the merit of Géricault and Léopold Robert to have touched on contemporary life, the former in his *Medusa* and *Horsemen*, the latter in his *Reapers* and *Fishermen*. Others again, even among the living, some of them bold, some less so, have set off down this forsaken but luminous path; it does not lead to Parnassus.

Yet it should not be thought that the Romantic insurrection completely banished the false gods from the nineteenth century, swept away Olympus and the empyrean, gave the ancient heroes their marching orders, and restored to man what is man's.

Art is metamorphosed only by the strongest convictions – convictions strong enough also to transform societies.

When the first Christians sculpted their faith in stone, marble or metal, they were ready to die for it. The idea itself impassioned them; they sought to imprint it upon their images. And the art of primitive Christianity was therefore completely new and distinct from previous art.

Fundamentally, Romanticism mattered so little in terms of form that Romantics could identify with the various party dockets: Catholic, Protestant, philosophical, absolutists, liberal, republican.

Thus contemporary painters have merely done what those of the Renaissance did; much less, no doubt; they changed the mould, but teemed into it the same ideas and subject-matter. This is easily shown by analysis of the catalogue of the Universal Exhibition or those of more recent exhibitions. Leaf through the works of the most famous artists: half Catholic symbols, half pagan symbols; the rest is allegories, apotheoses, memories or portraits of princes; here a Virgin, there a Magdalene; a Sphinx or a Sibyl; an Odalisque or a Venus. Sometimes we see a queen over whose head the axe is suspended, or little princes condemned to death – royal blood being the primary condition of our interest and compassion; or again, images borrowed from the highest vein of poetry, and which require a high degree of education in the spectator.

It is, inexorably, the same two-fold hieroglyphic language; the language that we have identified in Old Masters since the Renaissance.

How many contemporary painters can we count as exceptions to this rule? Perhaps the painter of the *Massacre at Chios* and of the *Women of Algiers*? Perhaps the painter of poachers intent on their prey, of Turks who sit smoking in the shade or children who play in the sun? If, in their capricious productions, they adhere still to pure

Romanticism, to 'art for art's sake' rather than 'art for man's sake', they yet impart to them a fire, verve and life that raises their indifferent subjects to meaning, emotion and character. Let us then say that Eugène Delacroix and Decamps to some extent – by certain irresistible tendencies – belong to that new art of which Romanticism was the precursor. Of today's artists, Courbet, almost alone, expresses it as best he can.

But can we not count upon the rising generation, whose struggling forms even now loom up on the horizon? It is the property of youth to find without effort. Instinct leads to more discoveries than does reason. It is the young who discover everything, who, in every age and country direct the world, whatever their elders say. How old were the founders of the present school when they specified the freedoms that they sought – freedoms now admitted? Several were already famous thirty years ago! How old was Raphael when he painted his first masterpieces?

Immortal youth, yours is boldness and conviction. You venture resolutely into the unknown. You swim across rivers and ford the mountain torrent to pick from the far bank strangely scented flowers of a colour unnamed. You climb mountain and glacier to view from the summit the splendour spread around. You pursue chimeras, tame them and put them to domestic work in the home. From you alone can we expect initiative, penetration, that salutary impulsion toward destiny.

Dear artists unknown to me, you who aspire to Beauty and Truth, turn towards what is young in you, to what is eternally young and cannot die: towards Nature. It is through the love and study of Nature that all art and poetry has renewed and incessantly renews itself. Make the thought that embraces 'the human race' your own. Art is like honeysuckle: it must bind itself to a strong and evergreen stem independent of the seasons, winding itself around this sturdy idea; when the honeysuckle has found in bush and copse this obliging guardian, does it not climb freely, even into the branches of the oak? Does it not then leaf, bud and blossom?

O my young friends, you whom I have never seen, does not intuition rather than experience, impatience rather than self-discipline, cry out to you, saying 'simply *because* it is, what is must cease to be'? That which is the present is not the future; tomorrow it will be the past. What *must* be – prediction and necessity both – *you* must bring about. As the poet is said to have the cure of souls, so each generation has the cure of ideas.

Think, speak and act. With age comes self-reproach: I might have done more. Therefore now do! Nothing is indifferent. Your every gesture has infinite repercussion. Every man is a god whose frown sets the universe atremble.

When a pebble is thrown into a lake, everything, down to the furthermost depths, moves with it. The water's every molecule shifts into new series. The surface of the lake puckers from bank to bank. And if, afterwards, everything seems as it was, the level of the lake has none the less been raised by imperceptible, incalculable degree. The old order has been overthrown – by a pebble.

VIII

* * *

For now, we need, first and foremost, to raze the prison of the two-fold symbol, escape from the Babel of confused languages and create, through common thought, a

common language; a luminous form free of all the shadows cast upon human nature by the high walls of absolute systems and local prejudices, by the errors of every kind that divide the family of nations.

And the alphabet of this truly universal typography can have but a single common character: mankind.

Then fine arts and letters would cease to be the distraction of the erudite and refined – the aristocratic curiosity that they have been since the Renaissance, and still are – to become a common currency for the transmission and exchange of feelings, an everyday language within reach of everyone.

For you cannot believe that the plebeians in France, that is, the French people, have ever been much interested in Marot and Ronsard, Boileau and Racine, Monsieur Lamartine and Monsieur Hugo? In Poussin and Lesueur, Watteau and Boucher, Delacroix and Ingres? These are entertainments for the refined – amongst whom, alas, we number!

It is rightly said that the arts and letters have always been the true French nobility. Nobility indeed, which has rarely derogated to the point of mixing with the uneducated commoner. But precisely this demarcation of intellectual classes is unjust and must be done away with.

And when, as Monsieur Edgar Quinet puts it, 'fictitious formulae have given way to the accent of spontaneity', when everyone is initiated into the language of the arts, expressing human and therefore general conceptions, then, no doubt, new allegories will close upon common thought. For allegory, we willingly confess, is no less immortal than its mother poetry. All art rests on group relations, as do all languages, however universal; word and image necessarily move from special and concrete significance to a harmony of analogy that is more or less collective and abstract; if this were not so, we should require as many words and images as there are ideas in the human mind and objects in nature, that is, infinity.

But everyone would be capable of lifting the veil upon these unforeseen metaphors, these fables born of the reciprocal agreement of all intelligence.

There can be no danger of an idea being locked into its hieroglyph when everyone has the keys and can set it free.

Voltaire, who somewhere wrote that 'Fables are merely the history of primitive times', elsewhere wrote: 'Is not a fiction announcing *new* and interesting truths a fine thing?'

It is indeed. The literary and pictorial metaphor is a fine rhetorical mask; but one must know what lies beneath.

IX

If art were a matter of form alone, then, when a certain degree of plastic perfection for a certain idea had been attained by a particular people – and this has been seen more than once: in Greece at the time of Phidias and Apelles, in the Italy of Michelangelo and Raphael – there would be nothing for posterity to do, nothing but to imitate and admire.

And therefore superficial minds – unable to cast their imagination into the future – when they see the perfection of these images behind them, are unaware that similar or

greater perfection can be attained by inventing a new philosophy, and locate the type of art and beauty, some in classical Greece, others in the Italian Renaissance, and some in the Middle Ages.

But in truth there is no type in art, any more than there is in nature.

What is the type of the beautiful landscape? The torrid countryside of the tropics, or the frozen extents of the North? Italy or Scotland? Do you prefer mountains or sea? Spring or autumn? Calm or storm?

What is the most beautiful type in the human race? The Greek? The Roman? Or the Arab? The English? Or perhaps the Parisian?

Phrenologists too are often asked: what *is* the perfect type of cerebral organization? Show me the head where all is as it should be!

But Raphael as painter, Richelieu as politician, Molière as poet, Newton as scientist, Beethoven as musician, Watt as mechanical engineer, are they not as they should be – for the task required? For they are painter, poet, scientist and politician only as they differ. If they all resembled each other, and the others resembled them in a common type, a single man might replace all others; and then there would be neither humanity nor science; there would be no art, science, thought or action; there would be nothing. A solitary god. Vacuity.

It is therefore absurd to seek a type in art. How should we believe that the future is – behind us?

Art is incessantly and indefinitely mutable and perfectible, as are all mankind's manifestations, as is everything in the universe that has life.

Why did Michelangelo and Raphael not despair, coming as they did after Phidias and Apelles? And how did they raise themselves as high in poetry as the inimitable Greeks?

By not imitating.

They sought another form of thought, one distinct from the thought of the ancient world, and they expressed it with the aid of faculties which are not, as we see, the privilege of a single people or a single civilization, but constitute the indefectible genius of the human race.

And why should the centuries to come not produce artists as great as Raphael and Michelangelo? No reason. But a condition applies, which allowed the Italians to equal the Greeks. It is: do not imitate the Renaissance, but express another idea and another civilization.

Without this, things are at an end.

Thought alone makes veritable revolutions. The change of form is pure fantasy, and everyone can contribute with pen or paintbrush. But you cannot change the foundation at a whim. It is no more possible for one man, or several, to change an art lock, stock and barrel, than to change the intimate constitution of a society.

The transmutation of art cannot therefore take place unless the universal mind changes too. Is it changing? Will it change!

[1] Panurge is one of Pantagruel's companions in Rabelais's oeuvre; Don Quixote is the hero of Cervantes' eponymous novel; Thersites, Achilles and Menelaus (Helen's husband) are all characters from the *Iliad*; Orestes is from Aeschylus' *Oresteia*; and Arnolphe and Agnès are from Molière's *L'École des femmes*.

[2] Poussin was born in Les Andelys in 1594.

9 Nikolai Gavrilovich Chernyshevsky (1828–1889) 'The Aesthetic Relation of Art to Reality', Reviewed by the Author

In May 1855 Chernyshevsky completed and published his dissertation, 'The Aesthetic Relation of Art to Reality', in which he sought to refute the basic principles of Idealism and to lay the foundation for a new, materialist aesthetics. These ambitions were, however, severely constrained by the conditions in Imperial Russia under which the thesis was written, and the necessity of meeting restrictions imposed by the government censors. In an attempt to overcome these difficulties, Chernyshevsky published a review of his own dissertation in the radical-democrat journal *Sovremennik* (Contemporary) under the pseudonym N. P., thereby allowing himself greater freedom to develop his ideas. The criticisms which he levels at the 'incomplete' and 'one-sided' exposition of the thesis are, in fact, carefully placed protests at the results of official censorship. Against all attempts to ground the theory of art in the ideal, Chernyshevsky maintains that true beauty is to be found in reality. The compensatory function fulfilled by the dreams of the imagination must be replaced by the recognition that 'works of art cannot possibly stand comparison with living reality' and that 'beauty is life'. Chernyshevsky was strongly influenced by the work of Herzen and Belinsky (see IIIB1, above), and by Feuerbach's materialist criticism of Hegel (see IIA8, above). In 1862 he was arrested for 'revolutionary activities' and confined in the Fortress of St Peter and Paul in St Petersburg, where he wrote his celebrated novel *What is to be Done?* After enduring a mock execution, he was sent to prison in Siberia where he remained until the last years of his life. His 'review' of his dissertation was published in *Sovremennik*, volume 51, no. 6, St Petersburg, 1855; these extracts are taken from the translation in *N. G. Chernyshevsky: Selected Philosophical Essays*, Moscow: Foreign Languages Publishing House, 1953, pp. 382–3, 385–8, 390–2, 397, 403, 406–9.

The systems of conceptions, out of which the prevailing aesthetic ideas developed, have now given way to other conceptions of the world and of human life, which, less seductive to the imagination, perhaps, are more in conformity with the deductions drawn from the strict, unprejudiced investigations of facts in the present state of development of the natural, historical and moral sciences. The author of the book under review is of the opinion that, in view of the close dependence of aesthetics upon our general conceptions of nature and of man, a change in these conceptions should cause a change in the theory of art. We do not undertake to decide to what degree his own theory, which he offers in place of the old, is correct; time will decide that, and Mr Chernyshevsky himself admits that 'his exposition may be incomplete, inadequate and onesided'. It must be conceded, however, that the prevailing views on aesthetics, deprived by modern analysis of the metaphysical foundation on which they had so self-confidently towered at the end of the last and beginning of the present century, must either find new support or yield to other conceptions if they are not reconfirmed by a strict analysis. The author is firmly convinced that the theory of art must acquire a new form – we are ready to assume that it will, because it is difficult for a separate part of a general philosophical edifice to remain standing when the whole edifice is being rebuilt. In what way must the theory of art change? 'Respect for real life, distrust of *a priori* hypotheses, even though they tickle one's fancy, such is the character of the trend that now predominates in science,' he says, and he thinks that 'our aesthetic convictions should also be brought into line with this.' To achieve

this aim, he first analyses the former conceptions of the essence of beauty, the sublime and the tragic, the relation of imagination to reality, the superiority of art to reality, the content and essential purpose of art, or the need from which arises man's striving to create works of art. Discovering, as he thinks, that these conceptions do not stand criticism, he tries to deduce from an analysis of facts a new conception, which, in his opinion, is more in conformity with the general character of the ideas that are accepted by science in our times. [...]

* * *

Lately, a distinction is being rather often drawn between a man's 'real, earnest and true' wishes, strivings and needs and his 'fictitious, imaginary, idle ones, to which the man who expresses, or imagines he possesses, attaches no real significance.' [...]

In general, a man who lives in a false environment has many false desires. Formerly, no attention was paid to this important circumstance, and as soon as it was observed that a man was inclined to dream, no matter what of, the whim of a morbid or idle fancy was at once proclaimed a fundamental and inalienable require- ment of human nature, necessarily demanding satisfaction. And what inalienable requirements were not found in man! All man's desires and strivings were proclaimed boundless and insatiable. Today this is done with greater circumspection. Today, an examination is made of the circumstances under which certain desires develop and the circumstances under which they abate. As a result, a very modest but very consoling fact has been revealed, viz., in essence, the requirements of human nature are very moderate. They reach fantastically enormous dimensions only as a consequence of extremes, only when a man is morbidly excited by unfavourable circumstances, when anything like moderate satisfaction is completely lacking. Even man's passions 'seethe like a turbulent flood' only when they encounter too many obstacles: but when a man is in favourable circumstances his passions cease to seethe and, while retaining their force, they lose their disorderliness, their all-devouring greed and destructiveness. A healthy man is not lustful. Mr Chernyshevsky quotes, in passing, and in different places, several examples illustrating this. The opinion that 'man's desires are limit- less,' he says, is false in the sense in which it is usually understood, viz., that 'no reality can satisfy them'. On the contrary, a man is satisfied not only 'with the best that can exist in reality', but also with a rather modest reality. A distinction must be drawn between what is actually felt and what is only said. Dreaming whips up desire to fever heat only when wholesome, even though fairly simple, food is lacking. This is a fact, proved by the whole course of human history and experienced by every man who has seen life and has watched himself. It is a particular case of the general law of human life that passions assume abnormal development only as a consequence of the abnor- mal conditions of the one who gives way to them, and only when the natural and, in essence, fairly moderate needs from which a given passion arises have been too long denied calm and by no means titanic satisfaction. [...]

The imagination builds castles in the air when the dreamer lacks not only a good house, but even a tolerable hut. It takes free rein when the feelings are not engaged; the absence of satisfactory conditions in real life is the source of life in imagination. But as soon as reality becomes at all tolerable, all the dreams of the imagination become pale and dull. The indisputable fact that we forget and abandon the seemingly most luxurious and gorgeous dreams as unsatisfactory as soon as the phenomena of

real life surround us, serves as indubitable proof that the dreams of the imagination are far less beautiful and attractive than what we find in reality. This concept constitutes one of the fundamental differences between the obsolete world outlook, under whose influence the transcendental systems of science arose, and science's present-day conception of nature and of life. Science today recognizes that reality is far superior to dreams, for it has learned how pale and unsatisfactory is life that is engrossed in the dreams of the imagination. Formerly, it was accepted without strict investigation that the dreams of the imagination are superior to and more attractive than the phenomena of real life. In the sphere of literature, this former preference for the dreamy life gave rise to romanticism.

* * *

How wretched is the beauty of living people, our kinfolk and friends, compared with the beauty of the wonderful beings that inhabit the ethereal world, those inexpressibly, inconceivably beautiful sylphs, houris, peris, and the like! How can one refrain from saying that reality is insignificant compared with the dreams of the imagination? But one thing is lost sight of here: we simply cannot picture these houris, peris and sylphs to ourselves otherwise than as possessing the ordinary features of real people. However much we may command our imagination: 'show me something more beautiful than man', it shows us man and nothing but man, although it boasts that it is not showing man, but a more beautiful being; or, if it labours to create something independent, something that has nothing corresponding to it in reality, it drops from complete exhaustion after showing us a nebulous, pale and indefinite phantom in which absolutely nothing can be discerned. This has been noted by science lately, and it is recognized as a fundamental fact in science and in all the other spheres of human activity, that a man cannot imagine anything higher or better than what he meets with in reality. And what you don't know of, what you have not the slightest idea of, you cannot wish for.

Until this important fact was recognized, people believed in what fantastic dreams 'told' in the literal sense of the word, without investigating whether there was any meaning in what they told, whether they presented anything resembling a definite image, or were just empty words. Their high-flown language was taken as a guarantee of the superiority of these empty phrases to reality, and all human requirements and strivings were attributed to the striving for nebulous and totally meaningless phantoms. That was the period of idealism in the broadest sense of the term.

Among the phantoms that were introduced into science in this way was the phantom of fantastic perfection: 'man is satisfied only with the absolute, he demands the absolutely perfect.' [. . .]

Man seeks only that which is 'good', he does not seek 'perfection'. Only abstract mathematics demands perfection; even applied mathematics is satisfied with approximate calculations. The quest for perfection in any sphere of life whatsoever is prompted by abstract, morbid, or idle fantasy. We want to breathe pure air; but do we notice that absolutely pure air never exists anywhere? It always contains poisonous carbon dioxide and other noxious gases, but in such small quantities that they do not affect our organism and therefore do not in the least inconvenience us. We want to drink pure water, but the water in rivers, brooks and springs always contains mineral admixtures – if they are there in small quantities (as is always the case in good water)

they do not mar our pleasure when we quench our thirst with water. As for absolutely pure (distilled) water, it is even unpleasant to the taste. These examples are too materialistic? Let us quote others: would anybody think of saying that a man who does not know *everything* is ignorant? No, we do not even look for a man who knows *everything*; we expect a learned man to know all that is *essential*, and that he should know *many* (although by no means *all*) details. Are we dissatisfied with a history, for example, in which not absolutely all problems are explained, not absolutely all details are given, in which not absolutely all the author's views and statements are correct? No, we are satisfied, extremely satisfied, with a book in which the *chief* problems are solved, in which the most essential details are given, in which the author's *principal* opinions are correct, and in which there are *very few* wrong or inadequate explanations. In short, the requirements of human nature are satisfied by the 'tolerable'; fantastic perfection is sought only by idle fantasy. Our senses, our mind and heart know nothing about it; and even fantasy only utters empty phrases about it; it, too, has no living, definite conception of it.

Thus, science has lately recognized the necessity of drawing a strict distinction between the true requirements of human nature, which seek, and have a right to find, satisfaction in real life, and fictitious, imaginary requirements, which remain, and must remain, idle dreams. In Mr Chernyshevsky's work we several times find fleeting references to this necessity, and in one place he even develops this idea somewhat. 'An artificially developed man' (i.e., one who has been corrupted by his unnatural position among other men) 'has many artificial requirements, so perverted as to be false and fantastic, which cannot be fully satisfied because in essence they are not the requirements of his nature, but the desires prompted by a distorted imagination, which it is almost impossible to please without earning the ridicule and contempt of the very man whom we strive to please, for he himself feels instinctively that his requirements are not worth pleasing.'

* * *

Proclaiming the absolute as the aim of man's desires, and placing the human desires that cannot find satisfaction in reality higher than the modest desires that can be satisfied by the objects and phenomena of the real world, the prevailing theory applies this general view, by which it explains the origin of all man's intellectual and moral activities, also to the origin of art, the content of which, according to this theory, is 'beauty'. The beauty that man meets with in reality, it says, suffers from serious flaws which mar it. But our aesthetic sense seeks perfection; therefore, to satisfy the demand of the aesthetic sense which cannot find satisfaction in reality, our imagination is roused to create a new beauty that will be free from the flaws that mar beauty in nature and in life. These works of creative imagination find realization in works of art that are free from the flaws that mar beauty in reality and, therefore, properly speaking, only works of art are truly beautiful, whereas the phenomena of nature and real life possess only illusory beauty. Thus, beauty created by art stands much higher than what seems (only seems) to be beauty in reality.

The sharp criticism to which beauty represented by reality is subjected, with the object of exposing the numerous flaws that mar it, confirms this thesis.

Mr Chernyshevsky places reality above the dreams of the imagination and, therefore, cannot share the opinion that beauty created by the imagination stands higher

than the beauty of the phenomena of reality. In this, applying his fundamental convictions to this particular question, he will be supported by all those who share these convictions, and he will be opposed by all those who adhere to the old opinion that imagination can rise above reality. Agreeing with Mr Chernyshevsky's general scientific convictions, the reviewer must also admit the correctness of his particular deduction that the beauty of reality stands higher than the creations of the imagination realized by art.

* * *

Connecting all that has been said, says Mr Chernyshevsky in conclusion, we get the following view on art: the essential purpose of art is to reproduce everything in life that is of interest to man. Very often, especially in poetical works, the explanation of life, judgment of its phenomena, also comes to the forefront. The relation of art to life is the same as that of history; the only difference in content is that history speaks of social life, whereas art speaks of individual life; history speaks of the life of mankind, whereas art speaks of the life of a man (pictures of nature serve only as the setting for phenomena of human life, or as an allusion, a presentiment of these phenomena. As regards difference in form, the author defines it as follows: history, like every science, is concerned only with the clarity, intelligibility, of its scenes; art is concerned with the living fullness of detail). The first function of history is to portray the past. The second, which is not performed by all historians, is to explain it, to pronounce judgment on it. By failing to perform the second function, the historian remains a mere chronicler, and his work serves merely as material for the genuine historian, or as reading matter to satisfy curiosity. When performing this second function, the historian becomes a thinker, and his work acquires scientific merit. Exactly the same must be said about art. When confining himself to the reproduction of the phenomena of life, the artist satisfies our curiosity or stimulates our recollections of life. But if at the same time he explains and pronounces judgment on the phenomena reproduced, he becomes a thinker and, in addition to its artistic merit, his work acquires a still higher significance, viz., scientific significance.

* * *

The difference between the author's conception of beauty and that which he rejects is very important. If beauty is 'the perfect manifestation of the idea in an individual being', then there is no beauty in real objects, for the idea fully manifests itself only in the whole universe and cannot find complete realization in an individual object. From this it follows that beauty is introduced into reality only by our imagination, that, therefore, the true sphere of beauty is the sphere of imagination, and therefore, art, which realizes the ideals of the imagination, stands higher than reality and springs from man's striving to create beauty which he does not find in reality. On the other hand, from the conception proposed by the author, viz., 'beauty is life', it follows that true beauty is the beauty of reality, that art (as the author believes) cannot create anything equal in beauty to the phenomena of the real world, and therefore, the origin of art is easily explained by the author's theory as we have set it forth above.

Criticizing the terms in which the concept of the sublime is defined in the prevailing system of aesthetics, viz., 'the sublime is preponderance of the idea over the form' and 'the sublime is that which rouses in us the idea of the infinite', the author arrives at the conclusion that these definitions are wrong. He is of the opinion

that an object may create the impression of the sublime without in the least rousing the idea of the infinite. Therefore, the author is again obliged to seek another definition, and he thinks that all phenomena in the sphere of the sublime are embraced and explained by the following formula: 'The sublime is that which is much bigger than anything with which we compare it.' For example, he says, Kazbek is a magnificent mountain (although it does not seem to us to be boundless and infinite) because it is much bigger than the hills that we are accustomed to see. The Volga is a magnificent river because it is much wider than small rivers. Love is a sublime passion because it is much more intense than daily, petty calculations and intrigues. Julius Caesar, Othello and Desdemona are sublime personages because Julius Caesar is a greater genius than ordinary people, Othello loves and is jealous, and Desdemona loves much more intensely than ordinary people do.

From the prevailing definitions, which Mr Chernyshevsky rejects, it follows that beauty and the sublime in the strict sense of the terms are not met with in reality, but are introduced into it only by our imagination. From Mr Chernyshevsky's definitions it follows, on the contrary, that the beautiful and the sublime do actually exist in nature and in human life. But it also follows from it that the enjoyment of objects that possess these qualities depends directly upon the conceptions of the person concerned. Beautiful is that in which we see life that corresponds to *our* conceptions of life; the sublime is that which is much bigger than the objects with which *we* compare it. Thus, the objective existence of the beautiful and the sublime in reality is reconciled with man's subjective views.

* * *

... The task the author set himself, viz., to bring the fundamental concepts of aesthetics into line with the present development of science, has been carried out to the best of the author's ability, and he concludes his investigation with the following words:

> Defence of reality as against fantasy, the endeavour to prove that works of art cannot possibly stand comparison with living reality – such is the essence of this essay. But does not what the author says degrade art? Yes, if showing that art stands *lower* than real life in the artistic perfection of its works means degrading art. But protesting against panegyrics does not mean disparagement. Science does not claim to stand higher than reality, but it has nothing to be ashamed of in that. Art, too, must not claim to stand higher than reality; that would not be degrading for it. Science is not ashamed to say that its aim is to understand and explain reality and then to use its explanation for the benefit of man. Let not art be ashamed to admit that its aim is to compensate man in case of absence of opportunity to enjoy the full aesthetic pleasure afforded by reality by, as far as possible, reproducing this precious reality, and by explaining it for the benefit of man.

This conclusion, in our opinion, is insufficiently developed. It still leaves for many people grounds for assuming that the significance of art is actually belittled by the rejection of fulsome praise of the absolute merit of its works, and by the substitution of the needs of man as its origin and aims for immeasurably lofty transcendental origin

and aims. On the contrary, this is precisely what enhances the real significance of art, for this explanation gives it an unchallengeable and honourable place among the activities that benefit man; and to be of benefit to man means having the right to the highest respect of man. Man venerates that which serves to benefit him. He calls bread 'father bread' because it is his food; he calls the earth 'mother earth' because it feeds him. Father and mother! All the panegyrics in the world are nothing compared with these sacred names; all high-flown praise is hollow and empty compared with the sentiment of filial love and gratitude. Science too is deserving of this sentiment because it serves to benefit man. Art is deserving of it when it serves to benefit man. And it brings him many, many benefits, for the work of the artist, particularly of the poet worthy of the name, is a 'text-book of life', as the author rightly calls it, and a textbook that is studied with pleasure by everybody, even by those who do not know of, or dislike, other textbooks. And art should be proud of this lofty, beautiful and beneficial significance it has for man.

10 Nikolai Alexandrovich Dobrolyubov (1836–1861) from 'When Will the Day Come?'

Despite his early death, Dobrolyubov was one of the most significant Russian social and literary critics of the generation after Belinsky (cf. IIIв1). Like Belinsky he wrote against both reaction in social life (which he referred to as a 'kingdom of darkness') and artificiality in art. The present extract is from the opening of his review of a novel by Turgenev, *On The Eve*. Dobrolyubov parodies aestheticist criticism. As a social reformer he is disposed to take from Turgenev not a sense of the skill of the novel's literary composition, but what it enables the reader to learn of 'the facts of our own lives'. In a society systematically prevented from knowing itself, art, for Dobrolyubov, is one of the few ways one may come to the truth. The review was originally published in 1860 in the journal *Sovremennik* (Contemporary). Our extract is taken from *N. A. Dobrolyubov: Selected Philosophical Essays*, translated by J. Fineberg, Moscow: Foreign Languages Publishing House, 1956, pp. 389–91.

Aesthetical criticism has now become the hobby of sentimental young ladies. In conversation with them the devotees of pure art may hear many subtle and true observations, and then they can sit down and write a review in the following style. 'Here is the content of Mr Turgenev's new novel' (follows a summary of the story). 'This pale sketch is enough to show how much life and poetry, of the freshest and most fragrant kind, is to be found in this novel. But only by reading the novel itself can one obtain a true idea of that feeling for the most subtle poetical shades of life, of that keen psychological analysis, of that profound understanding of the hidden streams and currents of public thought, and of that friendly and yet bold attitude towards reality which constitute the distinguishing features of Mr Turgenev's talent. See, for example, how subtly he has noted these psychological features' (then comes a repetition of a part of the summary, followed by an excerpt from the novel); 'read this wonderful scene which is depicted with such grace and charm' (excerpt); 'recall this poetical living picture' (excerpt), 'or this lofty and bold delineation' (excerpt). 'Does not this penetrate to the depths of your soul, compel your heart to beat faster, animate and embellish your life, exalt before you human dignity and the great, eternal

significance of the sacred ideas of truth, goodness and beauty! *Comme c'est joli, comme c'est delicieux!'*

We are unable to write pleasant and harmless reviews of this sort because we are little acquainted with sentimental young ladies. Openly confessing this, and disclaiming the role of 'cultivator of the aesthetic tastes of the public,' we have chosen for ourselves a different task, one more modest and more commensurate with our abilities. We simply wish to sum up the data that are scattered throughout the author's work, which we accept as accomplished facts, as phenomena of life that confront us. This is not a complicated task, but it is one that must be undertaken because, what with the multiplicity of their occupations and the need for relaxation, people are rarely willing to go into all the details of a literary production, to analyse, verify and put in their proper places all the figures that combine to make this intricate report on one of the aspects of our social life and then to ponder over the result, over what it promises, and what obligations it imposes upon us. But such verification and reflection will be very useful in the case of Mr Turgenev's new novel.

We know that the devotees of pure aesthetics will at once accuse us of wanting to thrust our own views upon the author and to set tasks for his talent. We shall therefore make the following reservation, tedious though it may be to do so. No, we have no wish to thrust anything upon the author; we say at the very outset that we do not know what object the author had in view, or what views prompted him to write the story that constitutes the contents of the novel *On the Eve*. The important thing for us is not so much what the author *wanted* to say, as what he *said*, even unintentionally, simply in the process of truthfully reproducing the facts of life. We prize every talented production precisely because it enables us to study the facts of our own lives which, without these facts, are so little exposed to the gaze of the ordinary observer.

To this day there is no publicity in our lives except official publicity; everywhere we encounter not living but official persons, persons who are serving in one sphere or another; in government offices we meet clerks, at balls we meet dancers, in clubs – card players, in theatres – hairdressers' clients, and so forth. Everybody hides his spiritual life as far away from the public gaze as possible; everybody looks at us as much as to say: 'I have come here to dance, or to show my coiffure. That being the case, be satisfied with the fact that I am going about my business, and please don't take it into your head to question me about my feelings and my ideas.' And indeed, nobody makes any attempt to make anybody confess, nobody is interested in anyone; everybody in society goes his own way, regretting that he must come together with others on official occasions as, for example, a first night at the opera, an official banquet, or a meeting of some committee or other. Under these circumstances, how is a man, who does not devote himself exclusively to the observation of social habits, to study and learn what life is? On top of all this there is the variety, even opposites, in the different circles and classes of our society! Ideas that have become banal and out of date in one circle are still hotly debated in another; what some regard as inadequate and weak others regard as excessively sharp and bold, and so forth.

We have no other way of knowing what is defeated, what is victorious, or what is beginning to permeate and predominate in the moral life of society, but literature, and

mainly through its artistic productions. The author-artist, although not troubling to draw any general conclusions about the state of public thought and morality, is always able to grasp their most essential features, throw a vivid light upon them, and place them before the eyes of thinking people. That is why we think that as soon as it is recognized that an author-artist possesses talent, that is, the ability to feel and depict the phenomena with lifelike truth, this very recognition creates legitimate ground for taking his productions as a basis for the discussion of the milieu, the epoch, which prompted the author to write this or that production. And here the criterion of the author's talent will be the breadth of his conception of life, the degree to which the images he has created are permanent and comprehensive. [. . .]

11 Émile Littré (1801–1881) from 'On Some Issues in Psycho-physiology'

Littré had two major spheres of influence in later-nineteenth century France, as the compiler of an authoritative dictionary of the French language, and as a writer on the science of knowledge and perception from a positivist standpoint. In the latter role he helped to establish the view that optical sensations are involuntary and thus 'objective' responses to phenomena (see IIIB15.) It was a short step from here to the idea that the strength of an artist's sensation – and not, for instance, skill in depiction – was what assured the truth of the resulting representation. This idea was to be mobilized by some supporters of the Impressionists in order to defend the supposedly 'exaggerated' colour of their paintings. In 1877 a satirical reviewer attributed to Cézanne the claim that the strange appearance of his paintings was the result of his 'strong sensations'. Littré cannot be held to account for such sallies. It is clear, however, that his theorization of the 'impression' was of considerable relevance to claims for the validity of so-called 'Impressionist' painting. In the following text he associates the impression with 'all that we can know', with 'the fundamental fact of all consciousness' and with 'a primary certainty'. The present article was originally published as 'De quelques points de physiology psychique' in *La Philosophie positive*, Paris, March–April, 1860. This version is taken from the text reprinted in Littré, *La Science au point de vue philosophique*, Paris, fourth edition, 1876, pp. 307–8, 312–15 and 315–25, translated for this volume by Jonathan Murphy. In order to measure the influence of Littré's ideas on his French audience, it is necessary to appreciate the original sense of the terms he used. We therefore append the following translator's note.

The difficulty of translating this complex text is due in part to Littré's use of the word 'expérience', which can mean both 'experience' in the sense of a series of events in the mind, and 'experiment' in the scientific sense. As France's most famous lexicographer, Littré was fanatically precise. The ambiguity is therefore no accident. The point he is making as a positivist is that a scientific experiment can only ever have the force of experience. If our scientific evidence is only one more form of sense data he is justified in using 'expérience' in both senses at once. But in English the same term will not cover both senses simultaneously, and we are thus required to decide. The alternative to facing this decision is to make more use of the qualifying term 'empirical', but the consequence would be to bring Littré's text too close to English forms of thought.

Among other unusual words, Littré's use of 'psychisme' to mean mind has been rendered as 'psychism' to retain the newness of the idea, while 'phénoménalité', used as an abstract noun describing the property of being a phenomenon, has simply been translated as 'phenomenon'. Where Littré writes of the 'monde extérieur' he means nothing more nor less than 'the world exterior to what we experience as our mind'; this has been translated as 'the exterior world', since 'outside world' has too many other associations. Lastly, 'relativité' has simply been translated as 'relativity', with the intention of retaining the sense that we can only have a relation to the world, and never know the world itself. In English this is also the older sense of the word, before it was given its present meaning by Einstein and contemporary science.

1 Preamble

It seemed indispensable to me that the word 'physiology' should appear in the title of this work. I could alternatively have made use of the phrase 'cerebral physiology', but 'cerebral physiology' concerns much wider issues which I do not intend to address. The brain has all sorts of functions and capabilities which will not occupy us here; we shall concentrate instead on the manner in which an impression and its results are conveyed, and on the notion of the exterior world, and of that of the ego.

For this reason I decided to make use of the phrase *psychic physiology*, which I have shortened to *psycho-physiology*. By *psycho* I refer to all things relating to feeling, and ideas; by *physiology* I refer to the formation and combination of these feelings and ideas in relation to the structure and function of the brain. [...] I am unable to conceive of any sort of physiology where theories of feeling and ideas, in their most advanced state, would not be a major preoccupation.

2 On the notion of the exterior world, or object, or non-ego

It is certain that, when the notion of a world exterior to us is produced in us, this notion has no form other than that of an impression. That alone is all that we can know; and, when we attempt to go beyond this, we are creating hypotheses that we shall never be able to verify. Phenomenality, which is all we have access to, presents itself to us in a form which we call matter; and it is convenient, to help us live our lives, to consider these ensembles of phenomena as other beings, or as substance; but in the final analysis we do not know so much. To give names to that mass of data which we believe to be impressions of the outside world is no more than an artifice of our mind.

Chemists customarily conceive of matter as being composed of atoms. Their justification for this action is that it provides a logical explanation for a multitude of facts which would otherwise escape explanation, and that to this day no experiment or observation has so far disproved the theory. But it none the less remains undeniable that the atomic composition of bodies is an idea of the mind, or hypothesis. And further to this, we are forced to admit that we will never have any means of verifying the theory. Even if it came to pass, at some future juncture, that an objection were to be raised to the theory, our investigations and experiments could never take us any closer to atoms themselves, and they would remain a pure concept.

In the same way that chemists regard themselves as being forced to deduce the existence of atoms, man in general, or indeed any animal of a higher order, is forced to deduce that the exterior world does in fact have existence, without ever really knowing the nature of the exterior world. Both parties here are drawing a conclusion which is born from mental phenomena. The conclusion about the exterior world is shared by all men, and by all animals which possess a brain of a type similar to our own. This impression is formed spontaneously, and without extended study; it dates back to a stage in our individual development of which we have no recollection.

Whenever we talk of inference, we talk of secondary things. Here I am merely repeating in another form an idea put forward by Destutt de Tracy. But if we consider the nature of this inference, it becomes apparent that it is purely experiential. After we have felt the impression of resistance a sufficient number of times, in a constantly identical fashion, we translate it into the idea of the exterior world. Our experience (and here experience is truly the result of empirical findings) results in a spontaneous induction, which is the first of all the inductions we make, and in fact the foundation of all following inductions.

Readers may perhaps be surprised that I have not yet begun to consider any organic conditions, but we are not yet in a position to do so. For the moment, all that we know are impressions; and it is only after we have established both the psychic value that these impressions have for us, and the notion of the exterior world and the experience which produces it, that we will be able to make use of this new element of knowledge, and to treat the study of the mind as being part of the exterior world, or object. It will be clear by now that the object of this discussion is not to put into doubt the existence of the exterior world. Our aim here is to classify the types of certainty to which we can have access, and to draw a distinction between those which are primary and those which are secondary. The truth of the matter, and here we have a truth which apparently flies in the face of common sense, is that the notion of the exterior world is not a primary one, but in fact depends on something which precedes it, thereby imbuing it with an inevitably relative character.

3 The notion of the interior world, or subject, or ego

The faculty of thought, in the psychic operations that it carries out, advances no further than the notion of the exterior world. It is reduced to being inseparable from impressions, and is also born only secondarily, with no other guarantee than the consistency of those same impressions. It has no extension in the interior world, or subject, or ego. To present things thus, in my opinion, is to tell only half the story; and it seems to me that the interior world, or subject, or ego, must necessarily operate within the same constraints as those which operate on the object. It too is also born secondarily, in accordance with the law of the consistency of impressions. Once one admits the parallel that operates here, it becomes impossible not to extend to the subject the doctrine of the object.

The notion of the object comes from the impression which we call resistance. The notion of the subject comes from the impressions which we term pleasure or pain, or in general, internal sensibility.

The formation of notions concerning the object is born from the repetition of impressions which we term exterior; the formation of the notion of the subject is born from the repetition of impressions which we term interior.

In the same manner that analysis demonstrates to us the birth of a world exterior to us, it also serves to demonstrate the birth of the interior world.

In the same manner that we have no memory of the moment or the series of progressions which awoke in us the notion of the object, equally we have no memory of the moment or progression which led us to the notion of the subject.

* * *

The fundamental fact of all consciousness, the one that supposes no other, and is irreducible, is the idea of impression and its elaboration. After this, as a result of a certain series of developments, the psychic embryo becomes segmented into two correlative portions, forming on the one side the notion of the external world, and on the other the notion of the internal world. At this point, the psyche in question has received the elements essential for its constitution.

Whilst the faculty of will is not directly part of my subject here, I do not intend to pass it by entirely, but will note in passing how it too behaves as part of consciousness. In the same manner that the notion of the exterior world is produced through a determined order of special impressions, and that an equally determined number of special impressions produces the notion of the internal world, it is still to one particular type of impression that the faculty of will must be attached. It is dependent, for its origin, on the impression that consciousness receives from its relation to the muscular system. Will commences in the desire to move particular muscles.

The idea of relativity is imposed on us by the conditions of our nature. If we consider a brain, which either directly or indirectly is linked to nerves, some going to the periphery, others to the interior, and others to the muscular system, we can see from this simple disposition that from one side we receive a notion of the exterior world, from another the notion of the inside world, and from a third the faculty of will. The homogeneity is complete, and consciousness elaborates the material that it receives, but, no more than the object, or the subject, or the faculty of will itself, does it possess any spontaneity which might pre-exist any of the above, presenting it with independent elements.

4 The psychic notion of experience

If we follow the preceding arguments, it becomes possible to give a definition of experience in its psychic form. Experience is a series of impressions which repeat themselves in an identical fashion in a certain order, and which lead to a notion of permanence which becomes accepted as a form of certainty, precisely because it is the product of undeniably identical data. The first effect that experience has is to create within us that notion of a subject and of an object. It is through this that we pass beyond simple irreducible impressions.

When put thus, not only does the legitimacy of scientific experimentation become apparent, but we are also forced to admit that it is the only possible means by which we can arrive at any true form of knowledge. We were already aware of this empirically, thanks to positivist science, which has demonstrated motion to metaphysics by

pointing to actual movement. But it is worthwhile investigating, in the psychic processes themselves, the conditions on which this mode of progression relies.

The manner in which experience is psychically constituted bears witness to the fact that experience is nothing other than a contact with phenomenality. If the impression which is at the origin of all consciousness can be called a primary certainty, it follows that experience can be designated as a form of secondary certainty.

There is a tendency, in philosophical language, to mistake reality or substantiality with certainty. Reality or substantiality escape us, for the undeniable reason that we can never know anything other than our impressions. But certainty does not in fact escape us; it is secondary, derived, induced, and has no bearing on anything other than phenomenality. Here we are on more solid ground and in experience in this domain we can be sure of a measure of success. The fact that we remain here undeceived is at once the guarantee and limit of human certainty.

In the past, it seemed possible that phenomena were neither regular, nor constant, and for a long time this opinion was widely accepted by mankind. But contrary to this old-fashioned and superficial opinion, it has now been established that phenomena are indeed regular and constant. When measured with the most sensitive instruments available today, the phenomenon studied naturally concords its appearance and development with a pre-established appropriate scheme. The same regularity and constancy are also to be found in experience, such as it imprints itself on our consciousness.

The mind, or if I may be permitted a neologism which better fits my idea here, the psychism, is not solely to be found in adult man, but can be traced back to the most tender years of a child's development. Nor is it limited to mankind: it is to be found in all beings which possess some form of nervous tissue. The further one descends down the scale, the more the distinction between the ego and the non-ego narrows, until a point is reached where it ceases to exist.

* * *

We must, however, go one step further, and leave the realm of the psychic, and pass into that of scientific experimentation itself. We learn, by a process of experimentation, that mind never appears but when it is linked to some material substance; we have no evidence for a mind that is not linked to a body, or, more exactly, to some sort of nervous tissue. Whenever we encounter a body capable of carrying out one or several activities, we say that these activities are the properties, or force, of this organized substance. We can of course, by a process of abstraction, separate the mind from the organism, in the same fashion that we separate the concept of weight from bodies that have that property; and we can thus say that weight, like the mind, has no extension. But this abstraction does not correspond to any reality to be found in nature.

5 Limits of the human mind

All that has been said above has the force of doctrine, and can be accepted without reference to any form of deduction. But one is forced to accept that deductions are extremely important, demonstrating that the human mind is enclosed within the narrowest limits of relativity, and that in experience the first steps taken by the mind to pass beyond pure and simple impressions are to be found.

The concept of relativity implies concrete limits. The human mind has difficulty in conceiving of this relative and limited position which its own constitution imposes upon it, and man's thought today tends in several directions in an attempt to take account of this. Opinions can generally be divided into three schools of thought here. Man believes either that everywhere matter possesses the same sort of phenomenality, or that some form of universal life similar to his own life circulates in all things, and blossoms in a form of supreme thought which is his own, or, finally, that the things we call causality are easily traceable to a certain origin, and thus furnish an explanation both of mankind and of the universe. These three strands of thought can be characterized under the terms materialism, pantheism and theism. The essential axiom of materialism is the eternity of matter, the idea that matter has neither an origin nor an end. This of course has not always been the opinion of the majority of men, and in days gone by men believed both in the possibility of creation and of destruction of substances. How did we arrive at this axiom, which today has achieved such ascendancy over our ways of thinking? One must reply, by experience, *a posteriori*. Our most delicate and precise scientific experiments show us only the transformation of matter. Nothing is ever created; all is born from some preceding substance. Nothing is destroyed; all matter, after some apparent dissolution, merely returns to other states. So long as we remain in the realm of the contingent and the empirical our certainty is complete, and no doubt arises that might cause us to question that certainty. But if we attempt to pass beyond our experience, and to transform a relative axiom into an absolute axiom, we surpass the limits of the human mind, and we find that we are attributing to it a form of substance, and an eternal quality which it cannot in fact possess.

It will be objected to this that I am forcing myself into a position where I must admit creation, and the production of things out of a void. This is not in fact the case. It is not in fact possible to treat these two hypotheses, the idea of the eternity of matter and of its creation, in the same fashion. Before scientific experimentation, both ideas had an equal force over our intelligence; but experimentation has put a considerable distance between the two. No experiment has ever demonstrated that any substance can be produced out of nothingness, and experimentation has constantly demonstrated that all matter persists in some form or other, merely going through a process of transformation. We have then no valid proof of any form of creation; on the contrary we have every reason to imagine that matter is in fact permanent. This even has the force of certainty for us; but as I have said, this is a secondary certainty, a contingent certainty, and an experiential certainty. We know matter only as phenomenality, not as substance itself. How can we possibly imagine that we have the right to speak of the past or future eternity of a thing, when that thing only ever presents itself to us in the form of phenomenonality?

A further objection may of course be raised. It is logically necessary either that matter be eternal, or that it was created at some past juncture; there is no other alternative. I am aware, of course, that for the modern mind, in its present state, there is no alternative to this; but I refuse to be caught between the horns of this particular dilemma myself. We may recall that in the course of our education, our intelligence is repeatedly forced to admit the truth of things which previously appeared inconceivable, and to reject things which we previously imagined to have the force of

irrevocable truth. One must add to this the limited nature of psychic understanding. To merely add blocks of finite time, end to end, will never give man any understanding of eternity; the limited nature of our thought is a poor guarantee that these blocks of time may not one day come to an end.

One cannot repeat too often that the things which are conceivable or inconceivable are only ever so within our own limits; for this is one of the most important results of psycho–physiology. Within our own experience, the terms conceivable and inconceivable have truth and certainty; but when we attempt to extend these things beyond our own limits, we can no longer be assured that they have any meaning whatsoever, and they may fall back upon us with the force of an arrow shot straight up into the sky. It is clear that the human mind does not infer the world, but discovers it by experience; and it is equally clear that experience has no bearing on questions of essence or origin.

The doctrine of the eternity of matter represents one integral part of the human spirit, a tendency to be concerned with the predominance of the object. Pantheism, on the other hand, demonstrates another central preoccupation of the human spirit; the concentration on the notions of life and sensibility. My purpose here is not to recall all the various forms which pantheism can take, but merely to demonstrate the latest incarnation of this particular belief. In this hypothesis, another form of eternity appears, and it takes the form of that of the spirit. Initially, this spirit is diffused in a confused fashion through the mass that it animates, but it begins to separate itself from that matter in sentient beings, through their wishes and their thoughts, and finally it achieves a form of self-possession and self-consciousness in human intelligence, which thereby becomes part of some supreme existence, and forms the realm of supreme thought. We may concede that it is logical for a philosopher who finds thought in both men and beasts to imagine that the source of such thought is infused in all beings, and that this spirit emerges through outlets which we term living, sentient beings, just as heat from the earth's core erupts through the inflamed fissures of volcanoes. But to imagine is not to conclude; and the only permissible conclusion is that nothing authorizes the extension of the theory of the psyche which we and our fellow animals possess to all substances, all time and all space.

12 Gustave Courbet (1819–1877) Letter to Young Artists

Courbet met the writer Jules Castagnary in 1860, and it was at the latter's urging and with his assistance that he established a studio open to young artists in Paris the following year. He was also prompted by overtures from disaffected students of the Ecole des Beaux-Arts, who looked to him as an independent figure with a substantial reputation in the now much debated field of Realism (see IVB4). For the benefit of those who might be attracted to his teaching, therefore, he set out his beliefs about the practice of art in the form of an open letter. The letter has been seen as a definitive statement of Realism, but it is significant that Courbet avoids any mention of the term. The views expressed are certainly consonant with the theories of Naturalism that Castagnary was developing at the time, and it is possible that the critic had some hand in the composition of the letter, which he was to include under the title 'Courbet: His Studio; his Theories' in his own volume *Les Libres propos* in 1864. As in the earlier statement on Realism however (IIIB6), the wording and sentiments are quite consistent with other writings definitely attributable to the artist. The letter was originally

published in *Courrier du dimanche*, Paris, 25 December 1861. It was reprinted in Pierre Courthion (ed), *Courbet raconté par lui-même et par ses amis*, Geneva: Pierre Cailler, 1950, volume 2, pp. 204–7, from which source it has been translated for this volume by Jonathan Murphy.

Paris, 25 December 1861

My dear Friends and Brothers

You have opened a new studio where you will be able to continue your education as artists in complete freedom, and you have been kind enough to ask me to be its director.

Before I answer you, I must explain what the word 'director' means to me. I would be most unhappy with any relation between us which installed me as Professor while leaving you as students.

I must explain to you what I recently told a conference in Anvers: I do not have, and indeed cannot have students.

To my mind, every artist must be his own master: hence I could not begin to think of setting myself up as a teacher to be imitated.

I am incapable of teaching my own art, or the art of any school whatsoever, as I hold that art cannot be taught, and believe that art is completely individual. For each particular artist it is nothing more or less than a talent of his own inspiration, and his own studies of the artistic tradition.

I should add that art, or talent, to my mind, can be nothing other than the application of each individual artist's own personal faculties to the ideas and themes of the times in which he lives.

For painting especially, art can be nothing other than the representation of objects visible and tangible to each artist.

No era or time can be reproduced but by its own artists, by the artists living at that particular time. The artists of any given century are thus totally incapable of reproducing people or things from a past or future century: they can paint neither the past nor the future.

In that sense, I deny that historical painting can reproduce the past. All history painting must, in its essence, be contemporary. Each particular epoch must have its own artists, who express and reproduce it for future ages. An epoch that has not portrayed itself through its own artists has no right to be portrayed by future generations, for this would be a falsification of history.

The history of a given era finishes with that era itself, and with those amongst its inhabitants who have chosen to portray it. It should not be given to a future time to add anything to the expression of a former time, to embellish the past, or cause it to seem greater than it is. What has been, has been. The human spirit must work in the present, with its surroundings, building on what has already been achieved. One should never start afresh, but always move from synthesis to synthesis, and from conclusion to conclusion.

A man who picks up an era at exactly the point at which past times left it is the only true artist. To look to the past is to do nothing but waste time and effort, to have understood nothing, and made no use of the teaching of the past. Hence it comes as no

surprise that our own archaic schools produce nothing but the most worthless compilations.

I also hold that painting is a quite concrete art, and can consist of nothing but the representation of real, tangible things. It is a physical language, whose words are visible objects. No abstract, invisible, intangible object can ever be material for a painting.

Imagination, in art, is a matter of finding the most complete expression of a tangible thing: it is never a matter of imagining or creating that thing itself.

Beauty is in nature, and is there to be found in reality in the most diverse shapes and forms. As soon as it is found, it enters into the realm of art, or rather it belongs to the artist who knows how to find it. As soon as beauty becomes perceptible and visible, it possesses the proper form of artistic expression. We have no right to amplify that expression by any form of artifice. Any contact with artifice can only alter its natural form, and hence falsify and weaken it, for the beauty to be found in nature is superior to any artistic convention.

Beauty, like truth, is a thing relative to the time in which one lives, and to the individual who is capable of perceiving it. The capacity to express beauty is directly related to the individual artist's capacity to perceive it.

These are the bases for all my ideas concerning art. And with such ideas, to conceive of joining a project whose object is to teach the principles of artistic conventions would be to fall back into the banal, incomplete ideas which until now have been the basis of modern art.

There can be no schools: there can only be painters. Schools only serve the purpose of searching out the analytical procedures of art. No individual school can lead to a meaningful synthesis. Painting risks falling into abstraction if it allows any particular aspect of art to dominate, whether it be drawing, or colour, or composition, or any other of those multiple means which, only when taken together, constitute this particular art.

I cannot then have the pretension to open any school, take any pupils, or teach any particular artistic tradition. I can only explain to other artists, who would be my collaborators and not my students, the method by which, in my opinion, one becomes a painter: all I can do is pass on the method which I myself have tried to follow since my beginnings, where one is entirely free to pursue one's own individuality, and to search for the form of expression most fitting to one's own particular temperament. To that end, the setting up of a common studio, which would hark back to the most fertile collaborations of the Renaissance, would most certainly be of great use, and might contribute to the opening of a new phase of modern painting, and I would willingly do whatever necessary to assist in its foundation.

With kindest regards,
Gustave Courbet.

13 Pierre-Joseph Proudhon (1809–1865) 'Definition of the New School'

Proudhon was a critic, philosopher and social theorist whose ideas were descended from Jean-Jacques Rousseau. He also responded to the ideas of Saint-Simon and subsequently

of Feuerbach, though his arguments for social reform were based upon observation of actual economic inequalities. His *Système des contradictions économiques* was published in 1846. His most famous dictum, 'Property is theft', was uttered in answer to the title of his own book *What is Property?* in 1840, though the idea derived from the time of the French Revolution. He was imprisoned on political grounds during the years 1849–52. Proudhon wrote copiously, but his unsystematic utopianism brought him into conflict with Marx. It also led him to accord art a prominent place in his thought. For him it was the one human means by which the restrictions of material reality might be transcended. It was accordingly for him both the highest form of labour and the primary expression of virtue in social life. He strongly opposed the principle of 'l'art pour l'art' ('art for art's sake') and the separation of intuition from reason that he associated with the Romantics. Though he grew up, like Courbet, in the Franche-Comté, the two met for the first time in Paris in 1847, when a close friendship developed, resulting in a frequent exchange of ideas over the next two decades. Castagnary and Pissarro (see VIc11) were among other figures who responded positively to Proudhon's work. In the book from which this passage is taken, Courbet is accorded a central role in establishing the nature and direction of artistic culture as a whole. Our text is taken from *Du principe de l'art et sa destination sociale* (The Principle of Art), Paris: Garnier Frères, 1865, chapter XIV: 'Nature of art in the period now beginning; definition of the new school', pp. 218–34, translated for this volume by Christopher Miller. The book was published posthumously. A portrait by Courbet showing Proudhon with his two young daughters was also completed after the writer's death.

[. . .] We have said that art has its origin and *raison d'être* in a faculty peculiar to man, the aesthetic faculty. And we went on to say that it consisted in a more or less idealized representation of ourselves and of things, with a view to our moral and physical improvement.

It follows that art cannot subsist apart from truth and justice; that science and morality are its leading lights; that it is, indeed, ancillary to these; and that its first law is therefore to respect morals and rationality. By contrast, the old school, Romantic and classical alike, held – and was supported in this view by distinguished philosophers – that art was independent of any moral and philosophical condition; that it subsisted by itself, as did the faculty that gave rise to it. This is the opinion that we now wish to examine in depth, for it is this which creates all the difficulty between the schools.

Does art, then, think or know? Does it reason? Does it conclude? To this categorical question, the Romantic school, still bolder than its rival, has replied no less categorically, NO. What it calls fantasy, genius, inspiration and spontaneity – and these are nothing but systematic ignorance – thus become the essential condition of art. To know nothing, to forswear reasoning, to abstain from reflection, since it would chasten verve and discourage inspiration; to have a holy terror of philosophy; such were the maxims of the proponents of art for art's sake. We do not condemn science in itself, they say; we do full justice to its utility and respectability, and we are not slow to honour its representatives. We merely claim that it is of no assistance to art; that it is, indeed, fatal to art. Art is all spontaneity; it is unaware of itself; it knows itself not; it is pure intuition; it does not know what guides it, what it is doing, nor where it is going. Let others express themselves in coherent, logical fashion; let them seek reasons and show connections; that is the business of philosophy, which one may find entirely

plausible, but which does not concern the artist. The Muse – universal faculty, divine inspiration – is incoercible, refractory to analysis as to discipline; she visits now one, now another; to each she says: 'You shall be an artist!' Happy the man she covers with her wings! The admiration of mankind is his; he shall attain immortality. But in vain would he seek to detain the celestial spirit with chains of meditation or hope to command her in the name of a theory; dialectic would make her flee his side forever. The most ignorant of men may be fortunately inspired; the rash individual who thinks to lay hold of her through philosophy, criticism or pure reason will never succeed.

This exclusion of science from the field of art extends to morality too. Art exists in and for itself, they say; it is independent of notions of justice and virtue; it is the absolutism of liberty. No doubt what is moral is beyond praise, and what is criminal is worthy of reproof; this we do not deny. We have never claimed that art can change the nature and quality of things, make crime virtuous, make moral good of moral bad. We say that art, as such, is free of moral consideration as it is of philosophical lucubration; it can occur and develop under conditions of superstitution and debauchery, as it can under knowledge and saintliness; it can produce masterpieces on immoral and absurd subjects neither more or less than in the celebration of ideas and civic and domestic virtues.

Thus, because Giulio Romano and others have painted obscene pictures with wonderful talent, because Parny wrote *La Guerre des dieux* and Voltaire *La Pucelle*, people imagined that art was sufficient unto itself, and that, when all else was dead, art would have the power to resuscitate the corpse and ennoble humanity. And this was the crudest of sophistries. They did not understand that works such as those that I have cited are monsters, in which the hideous subject is arbitrarily married to a beautiful form of a kind *long since created and revealed*. For the question is not whether Voltaire and Giulio Romano, who came when the development of language, literature and art was complete, can do what they will with style and brush; the question is whether language and art would ever have attained, under the influence of works like *La Pucelle* and engravings like those of *Aretino*, the point of perfection at which these great artists found them. The creators of the French language, let us remind ourselves, were Malherbe, Corneille, Boileau, Pascal, Bossuet and others like them, the most severe, exact and chaste of geniuses. We should judge of the rest by this analogy.

The question of the independence of art leads to another: that of its end or destination. On this point, as on the preceding one, the old school is no less explicit and decisive. According to the classics and Romantics – it would be quibbling to distinguish them – art is its own end. It is a manifestation of beauty and the ideal; what purpose could one ascribe to it other than that of pleasure and entertainment? It is hostile to any utilitarian end. If it favours morality, if it aids health or contributes to wealth, so much the better for them; the politician can exploit this to justify the imposition on art of public order restrictions; but this does not mean that art recognizes a sovereignty outside itself. The legislator's decrees are not groundless; they must be respected; as a citizen, the artist complies with them; as interpreter of the ideal, he gives them not the slightest heed. In imparting to you his personal impressions, whatever they are, he seeks only to excite in you that intimate delectation which doubles one's enjoyment of reality, and which is often, indeed, a substitute for

possession of that reality. What matter here the morality or logic of the fact? What matter its value, economic or moral? You are beguiled, enthused, transported: the artist asks no more. The rest is outside his competence and responsibility.

I shall not waste time on a refutation of this theory, which is based on a misunderstanding, and which everyone can today judge by its fruits; it is this theory, which, for the last sixty years (one could go further back), has brought art to decadence and ruin.

The human soul is made up of a sort of polarity: CONSCIENCE and *Science*, in other words, JUSTICE and *Truth*. Around this basic axis the other faculties gravitate: memory, imagination, judgement, language, love, politics, industry, commerce and art. Ignorance of this constitution led the artists astray, or more exactly, yielded this false aesthetic. They saw the human soul as a triad, in which feeling, *aesthesia*, made its appearance as a third term equal, in their view, to the other two; whereas there is in fact only a dyad, or, as I put it just now, a polarity, in which art can clearly be considered only an auxiliary function. Proof of this subordination of art *vis-à-vis* conscience and science is the fact that [. . .] in everything pertaining to pure science and law, the idea and the ideal are identical and sufficient; that in this respect, the role of art is annihilated, and comes into play again only relative to individual objects, to individuals and their actions. The proper idea of these, that is the form, figure or image – which necessarily differs from type or law – is different from the ideal. Thus science and conscience are, for us, the two sources of the ideal, that is, of our faculty to see things according to their law and to seek to reduce things to that law. And art which declared itself independent of science and morality would therefore run counter to its own origins: it would be a contradiction. [. . .]

It is against this degrading theory of art for art's sake that Courbet, and with him, the whole of the school currently termed realist, ardently and energetically protest. 'No', he says – I voice Courbet's thoughts as they appear in his works rather than in his writings – 'No, it is not true that the sole end of art is pleasure, for pleasure is not an end; it is not true that art has no other end than itself, for everything is connected, everything is bound together, everything is part of everything else, everything in humanity and nature has an end; the idea of a faculty without goal, of a principle without consequence, of a cause without an effect, is as absurd as that of an effect without a cause. The goal of art is to lead us to a better knowledge of ourselves, by the revelation of all our thoughts, even the most secret, of all our tendencies, our virtues, our vices, our affectations, and thus to contribute to the development of our dignity, to the perfection of our being. It is not in our power to be nourished by chimeras, to intoxicate ourselves with illusion, to lead ourselves astray with mirages, as do the classics, the Romantics and all those who pursue a vain ideal; but to deliver ourselves from pernicious illusions by denouncing them.'

* * *

The works of Courbet are far from being either caricatures or burlesques; his supporters and his adversaries alike recognize that he stays close to the truth; the former praise the realism which the latter reproach. It is not satire, though he is not lacking in satirical notions; but satire does not exhaust his thought; it is merely one variety within his work, as it is a variety, a separate genre, within the works of Boileau and Horace. There is no satirical allusion in the *Return from the Fair*. Courbet does not proceed by hyperbole, derision or invective; his irony never degenerates into

calumny; he is free of hatred as he is of flattery. If, as an artist, he manifests a brutal anger, it is not against the subjects that he paints or the vices or affectations that he attacks; it is against his colleagues, who obstinately proceed down a cul-de-sac. In this respect, people were right to say that the blows he struck by sending the *Burial*, the *Bathing Woman*, etc., to the Salons of 1851 and 1853, were worthy of a fairground strongman.

It would be no truer to call him a *genre* painter, like the Dutch and Flemish, whose paintings, though pleasant or comic, are insubstantial; they rarely go to the heart of things, reflect no philosophical concerns, and reveal more imagination than observation. Is there a Teniers similar in cast to Courbet? I could not say: I would in any event reply that Teniers was in advance of his day; this is not unprecedented in art. Courbet's pictures are mirrors of truth; qualities and defects of execution apart, their merit, till now unequalled, lies in the profundity of the idea; the fidelity of the types, the purity of the mirror and the power of the reflection. This painting aims higher than art itself; its motto is the inscription on the temple at Delphi, *Men, know yourselves* and, with John the Baptist, implicitly continues *and amend yourselves* if you value life and honour.

Should one then say, as the writers of the new school do, that these pictures are pure realism? Take care, I should reply; your realism would compromise the truth that you claim to serve. The real is not the same thing as the true; the former refers mainly to matter, the second to the laws that govern it; the latter alone is intelligible, and can on that account serve as object and goal of art; the former has, of itself, no sense. The old schools departed from truth through the door of the ideal; do not yourself depart through the door of the real.

[. . .] Physical reality, remember, has no value unless through the spirit, through the ideal that breathes within it, and which does not consist merely of a certain symmetry or elegance of form. Will you then, by dint of seeking reality, sacrifice the spirit to matter, just as the idolaters of form, by dint of seeking the ideal, sacrificed virtue to an illusion?

I therefore conclude . . . that in the execution of a portrait, and *a fortiori* of a scene from social life, the intervention of the ideal is essential; again, not in the sense that the artist should redo, correct or embellish the work of nature and society – the work, perhaps, of crime; but precisely in order to retain his characters' truth and life, the spirit of their physiognomy. This is what Courbet meant (and though Courbet often expresses himself badly, he knows exactly what he means) when he threw out this challenge to his adversaries: 'You who take it upon you to paint Caesars and Charlemagnes, could you paint your father's portrait?'.

Since, according to the new school no less than previous ones, the ideal is essential to art; and since the real is represented in all schools merely as brute matter, substance or support for form, idea or ideal, it is *not* by its realism that we should define this school; it is the way in which it (in its turn) makes the ideal work. The ideal of Egyptian art made it typical, symbolic and metaphysical; for the same reason, Greek art was idolatrous and devoted to the cult of form; Christian art was, in its turn, under the influence of the gospel, spiritual and ascetic; that of the Renaissance is ambiguous, part-pagan, part-Christian; Dutch art, finally, was a product of democracy and free thought, and free of all mythology, allegory, idolatry and spirituality – indeed, of all

hierarchical respect; it accepted the people as subject, type, sovereign and ideal, and has deservedly been defined by us as *human art*. But this term is more revolutionary than philosophical, and though it admirably marks the sudden transition between the Catholic, feudal world and the world of science and liberty, it is no longer adequate; it is not sufficiently distinctive; it lacks all perspective for us, seeming to suggest that, today, art need only continue what the Dutch began, whereas art has already left the Dutch behind. As to the idealists of the fantastic, who, as 'classics' and 'Romantics', occupy the entire period between the Revolution and the Second Empire, they have no place here; they have no more ideal than the purest realist would have, if any such existed.

The question of defining the new school and determining the new character of its art is therefore reducible to one concerning the general nature of the idealism to which it must hereafter refer. First and foremost, I note that the artistic ideal of the Egyptians, the Greeks, the Christians and even that of the Renaissance, corresponds to a religious dogma, of which the ideal is merely the translation; it turns on this dogma; all its inventions can effectively be traced thereto. One can therefore broadly call it *dogmatic idealism*. Since the Lutheran-Dutch reform, dogma has *a priori* given way to free thinking; art has perceived its ideal everywhere, in the infinity of nature and humanity, and in the contemplation of their splendour and laws; and it has gravitated, not, as before, towards a supreme ideal, the source of all inspiration and centre of all ideals, but towards a goal superior to this, a goal which exceeds the sphere proper to art: the gradual education of humankind. We can therefore say that decentralized, universal, natural and human idealism, which governs the new art, is *anti-dogmatic*. If we transform this purely negative epithet into an affirmative equivalent, we might say: *critical idealism, critical school*. I fear, however, that the somewhat arbitrary sensitivities of our language will not allow the usage *critical art*. I therefore suggest that those who are difficult to please should place, alongside the word *art*, the adjective *rational* – a usage sufficiently warranted by the *irrationality* of art during the first half of this century – which means more or less the same as *critical*.

In the same way, then, that there has existed, since Descartes and Kant, an anti-dogmatic or critical philosophy; in the same way that, following the example of this philosophy, literature in its turn has for the most part become critical; so art too, developing parallel to philosophy, science, industry, politics and letters, was duty bound to be renewed through the critical.

Critical, from the Greek, *krino*, I judge. Critical art, meaning art that renders justice, an art which begins by doing justice to itself, in declaring itself the servant not of the absolute but of pure reason and law; art no longer content to express or impart impressions or symbolize ideas or acts of faith; but which, in its turn uniting conscience and science to feeling, discerns, discusses, blames and approves in its own way; an art which brings to the definitions of philosophy and morality its own sanction, that of the beautiful and the sublime; an art which, consequently, throwing in its lot with the movement of civilization and adopting its principles, is incapable of perverting itself through abuse of the ideal, and thus itself becoming an instrument and cause of corruption.

In the person of its interpreter, the new school, art tells us: this thought, this action, habit or institution is declared by law and by philosophy, true or false, just

or unjust, virtuous or blameworthy, useful or harmful; I, in my turn, shall demonstrate, using the means that I possess, that this same action is, furthermore, beautiful or ugly, generous or ignoble, gracious or brutal, spiritual or stupid, joyful or sad, harmonious or chaotic; so that, when you have gathered, relative to a single thing, the witness of science, the judgement of justice and the sanction of art, you will have the greatest certainty as to its nature, and you will love or detest it forever.

Of course, till the birth of this new school, art had not understood its mission with such clarity and elevation; it was quite unaware that it was the auxiliary and complement of reason; it did not attempt the role of educator; far from it; it made every effort to embellish and glorify immorality itself, putting itself forward as arbiter of morality and belief and affecting to exercise the prerogatives of the absolute. And thus the aesthetic faculty, becoming depraved through idolatry, had become for mankind a source of sin, and for society a factor of dissolution.

Now this spontaneous corruption of art, and, through art, of public and private morality, is no longer possible. Art has become rational; it reasons; it has become critical and renders justice. It goes hand in hand with *positive philosophy*, *positive politics* and *positive metaphysics*, and no longer professes indifference in matters of faith, government or morality. Subordinating idealism to reason, it can no longer be a cause of tyranny, prostitution or pauperism. Were it merely an art of observation, lacking in all inspiration, it would be dishonest with itself and would destroy itself of its own volition, which is impossible. The artist can sell himself; for many years to come, painting and sculpture, like the novel and the play, will have their infamous exponents; but art is henceforth incorruptible.

14 Jules-Antoine Castagnary (1830–1888) 'The Three Contemporary Schools'

Castagnary began his career as an art critic in 1857. Like Champfleury, he saw late Romanticism as the established and dominant tendency in French painting of the mid-century, and was looking for an art with the potential to supplant it. And like both Champfleury and Thoré, he looked outside the established classical canons of art history for precedents, to artists of the Dutch and Spanish schools in particular. He became a faithful supporter of Courbet after first visiting his studio in 1860. His concept of contemporary Naturalism owed much to the rural themes of the Barbizon painters, Millet and Rousseau among them, though like Baudelaire he was also convinced that 'the life of the cities' must furnish the principal themes for a properly modern art. But where Baudelaire had seen art as balanced between the values of the 'transitory and contingent' and those of the 'eternal and immutable', Castagnary conceived of Naturalist art as unreservedly 'a part of social consciousness'. The text that follows was included under the title 'Les Trois écoles contemporaines' as the opening section of Castagnary's review of the 1863 Salon, originally published as 'Salon de 1863' in *Nord*, Brussels, 14 May–12 September 1863. (Castagnary published a second review of the 1863 Salon in the *Courrier du dimanche* in Paris.) The present text was reprinted in Castagnary, *Salons: 1857–1870*, Paris: Bibliothèque Charpentier, 1892. This extract is taken from pp. 102–6 of that edition, translated for this volume by Christopher Miller.

What is the purpose of painting?

'To express the Ideal', a chorus of enthusiasts cries out, 'To represent the Beautiful'. Empty words!

The Ideal is not a revelation from on high, set up before humanity, which must ever approach but can never attain it; the Ideal is the free product of the conscience of each and every person placed in contact with external realities, and thus an individual concept varying from artist to artist.

The Beautiful is not a reality which exists outside man, which imposes itself on the mind along with the very form or aspect of objects: the Beautiful is an abstract word, an abbreviation, under the label of which we group a mass of different phenomena which act in a certain way on our organs and our intelligence; consequently, it is an individual or collective concept which varies, in a given society, from age to age, and, within a particular age, from man to man.

Let us place our feet a little more firmly on the ground, for it is there that the truth is to be found.

The purpose of painting is to express, according to the means at its disposal, the society that produces it. In this way, then, a mind free of the prejudices of education must conceive of it; in this way the great masters of all ages have understood and practised it. Society is a moral being which does not directly apprehend itself, and which, if it is to become aware of its reality, needs to exteriorize itself, as the philosophers say, to put its faculties to work and to see itself in their combined product. An age knows itself only through the exploits that it performs: political, literary, scientific, industrial and artistic achievements, all of which are marked with the stamp of its genius, carry the imprint of its particular character and distinguish it from the preceding epoch and the epoch to come. Consequently, painting is not an abstract concept, raised above history, alien to human vicissitudes, to the revolutions in morals and notions; it is a part of social consciousness, a fragment of the mirror in which each generation in its turn contemplates itself, and as such, it must follow society step by step and describe its incessant transformations. Who would be so bold as to deny that, if each civilization, and, within each civilization, each epoch, had thus set down its own image on canvas and revealed, in passing, the secret of its genius, we should possess, for the whole duration of its history, the successive aspects that humanity presents to art? Who would deny that the destiny of painting would then have been fulfilled?

This first point about the destination of painting once established, where do we in France stand today as regards the realization of this destiny?

Here, I cannot conceal the fact, I am in almost complete disagreement with my best friends and colleagues in criticism. Where they cry decadence, I, for the very same reasons, announce progress. It is, then, vital that my pen should not stumble, and that I set out my idea with the utmost clarity.

However radical and profound the differences that separate our artists, however complete the antagonism of their theories and manners, however vigorous, lastly, that precious individuality to which everyone now lays claim, and which is so dear to their hearts, one can, without doing excessive violence to temperaments and tendencies, place all painters in three main groups: the classics, the Romantics and the Naturalists.

The classics, through Louis David, their Saint John the Baptist, and Ingres, their Messiah, supported on the left by the Ecole des Beaux-Arts, and on the right by the Ecole de Rome, having on their side, moreover, the protection of the establishment, the awards and the commissions, seem, despite repeated warnings from the public, unwilling to give ground or give the game up.

The Romantics, decimated by mortality, abandoned by the literature that once raised them so high but has since turned to other glorifications, discouraged by the general defection of minds, shaken in their own esteem, have fallen silent, and already dream of a capitulation whose terms would allow them to emerge, arms and belongings intact, from a citadel that they can no longer defend.

The Naturalists, young, ardent, full of conviction, careless of the blows to be given or taken, are mounting the assault on all sides; and already their enterprising heads are to be found at all the summits of art.

Two schools, then, under threat; one on the attack. This is the position in the citadel that we have just inspected. At this year's Salon, the three flags are still present. Let us salute in them the past and the future, and before proceeding to enumerate their strengths, let us ponder a while the distinctive characteristics of each army.

Classic school, Romantic school, Naturalist school, all three are in agreement about the point of departure: nature is the foundation of art.

But:

The classic school states that nature must be corrected under the guidance of antiquity or the masterpieces of the Renaissance. Reality alarms and frightens it. Claiming to purify and idealize, it weakens or deforms; when it is not merely conventional, it invariably diminishes.

The Romantic school states that art is free; that nature must be interpreted freely by the liberated artist. It is not afraid of reality, but escapes reality by travestying it as the whims of imagination dictate; when it is not mere sleepwalking, it is invariably rather hit and miss.

The Naturalist school states that art is the expression of life in all its forms and all its degrees, and that its only goal is to reproduce nature by bringing nature to its maximum power and intensity; it is truth counterpoised by science.

And the results are what you might expect from these tendencies.

The classical school, with its elevated ideal, its delicate choice of models and constant quest for noble outline, has maintained the dignity of art in France. But because it imposed on the groups and combinations of groups presented by the external world certain preconceived attitudes and traditional forms, because it neglected colour which is, of all painting's resources, that which gives the most immediate sense of life, it extinguished the artist's spontaneity, ossified the imagination, sullied naivety and grace, those two wings of genius, and finally constituted the negation of its own origins and aim.

The Romantic school, with its thoughtless individualism, its exclusive preoccupation with colour, its ophthalmic derangements, its incessant incursions into the domain of literature, threw art off course and led it into anarchy and disarray. By its adoration of the accessory, of furniture, arms, costumes, antiquarianism and bric-à-brac, by its subordination of character to the picturesque, it created a class of

superficial and turbulent collectors whose noxious influence persists today, and opened the door to the most shameless commercialism; in short, it is to this school that must be ascribed the main causes of the degradation of painting that we have observed over the last twenty years.

The Naturalist school re-establishes the broken relations between man and nature. By its dual focus, upon the life of the fields, which it already interprets with such agrestic power, and the life of the cities, whence its greatest triumphs will come, it tends to embrace all forms of the visible world. Already it has ended the separation of line and colour, and restored them to their true role. By returning the artist to the centre of his epoch and obliging him to think, it determines the true utility, and thus the morality, of art. These few words are sufficient to give us confidence in its destination. What the artistic curiosity of the Valois, the refined taste of the Medici, the aspirations and pomp of Louis XIV, and the onerous protection of the academic establishment could not accomplish, the simple development of liberty, the awakening of decentralizing instincts, will be produced in France.

For the first time in three centuries, French society is giving birth to a school of French painting that is in its own image, and no longer in the image of peoples now extinct; a painting which describes its own appearance and way of life, and no longer those of civilizations long vanished; which in its every facet bears the imprint of that society's luminous grace and clear, lucid, penetrating mind.

May it weigh equal in the balance of posterity, some centuries hence, with the fiercely energetic painting of Spain, the familiar and intimate scenes of the Dutch, and Italian painting, the most pure, harmonious and radiant that ever flourished beneath a blue sky!

15 Jules-Antoine Castagnary (1830–1888) 'Naturalism'

In 1867 the Champ de Mars in Paris was the site of an ambitious Universal Exhibition, drawing visitors from across the world. There was a major showing of recent art, which led to public attention being diverted from the annual Salon. At the same time a huge retrospective exhibition of Ingres' work was held at the Ecole des Beaux-Arts, attracting some 40,000 viewers. Castagnary nevertheless represented the Salon as a victory for the naturalist tendency he supported. In the account of Naturalism that he offers on this occasion there are two developments worthy of note. The first is that 'nature' and 'man' are now clearly distinguished, like 'the countryside' and 'the city'. Though the terms are not yet presented as antitheses, it will not be long before the countryside becomes associated with reconnection to a 'human nature' with which the 'man' of the city can no longer be identified. (This association was not a new one in the nineteenth century, but it gained a new urgency from the increasing effects of urbanization.) The second development lies in the claim that Naturalism involves a 'scientific' objectivity of vision – a claim that now serves to dissociate Naturalism from the explicitly populist concerns of Realism. If the artists' eyes are wide open to the phenomena of the present, Castagnary implies, and if their resulting sensations are transcribed spontaneously, without recourse to notions of the poetic, then the resulting images will be possessed of an irrefutable truth. This positivistic belief in the objectivity of sensation was to be an important component in justifications of Impressionist painting during the 1870s (see IIIʙ11). As 'Le Naturalisme', this text originally formed the

opening to an unfinished review of the Salon of 1867. The review was published in the form of three short fragments under the title 'Le Monde artistique' in *Liberté*, Paris, 25 and 28 May and 7 June 1867; these were subsequently reprinted together as 'Salon de 1867' in Castagnary, *Salons: 1857–1870*, Paris: Bibliothèque Charpentier, 1892. This extract is taken from pp. 241–4 of the latter edition, translated for this volume by Christopher Miller.

Nature and man, the countryside and the city; – the countryside with the depth of its sky, the green of its trees, its transparent water and horizons dimly perceived through the mist, all the attractions of vegetative life under the changing light of the seasons and days; – the city: man, woman and family, forms conditioned by function and character, the diversity of social spectacle freely displayed under the sun in the public square or discretely encompassed within the confines of the house, all the recurring surprises of individual or collective life in the stark light of passion and morals: such, in its immensity, is the domain set out before the eye of the painter, the precise point of that universality from which he is enjoined to draw the substance of his art.

What need is there to retrace history, take refuge in legend, or scan the archives of the imagination? Beauty lies before our eyes, not in the brain; in the present, not the past; in truth and not in dream; in life and not in death. The universe before our eyes is that which the painter must represent and translate. The poetry accessible to our souls is made of all the sensations that it transmits to us. Make haste, do not delay even the length of an hour: forms and aspects will be changed tomorrow. To paint what exists, at the moment at which you perceive it, is not merely to satisfy the aesthetic requirements of your contemporaries, it is to write history for posterity; under this double title, it exactly fulfils the goal of art.

Naturalism, of which I have already spoken so often, and to which I shall return over the course of this brief outline, Naturalism, I say, has no other object and accepts no other definition.

After so much blind resistance and instinctive hostility, it is triumphant in today's painting; but if its triumph is ensured for ever, this is because it is consistent with the scientific method of observation and in harmony with the general tendencies of the human mind. There lies the secret of its ascension and the measure of its infallibility.

This year's Salon has been neglected by collectors and ignored by the public. The trickle of visitors is imperceptible. The attendants, who had only ever seen deserts in painting, are astonished to find themselves in the midst of one. Paintings and statues lament a solitude to which France has not accustomed them. From time to time, one meets a wanderer, uncertain of his course, vainly seeking the groups who, in previous years, would safely have marked out for him the paintings most in vogue. The ingenuity of Monsieur Gérôme, the poverty of Monsieur Meissonier and the elegance of Monsieur Cabanel lack all effect; there is no one in front of their paintings because there is no one at the exhibition.

This result was predictable. Those who decreed that the exhibition would take place this year as it has in the past, despite the coexistence of the Universal Exhibition, should have thought of this. Decreeing the simultaneity of the two exhibitions evidently meant sacrificing one to the other, the small to the great, the habitual to the extraordinary. The public which, on the Champs de Mars, pays a mere twenty *sous* for the most unexpected sights and most various entertainments, for the industry

of all the nations, for fifteen years of European art, not to mention the comings and goings of a cosmopolitan crowd as curious as its products and who come, like them, from the four corners of the earth, this public, I say, could summon little enthusiasm for one year of French sculpture and painting collected in the Champs-Elysées; and from the very first days, it was clear where it would take its money, time, and admiration. [...]

Well, let me say at once that neither indifference nor neglect are justified. Though it contains no major works, the Salon of this year is none the less worthy of our attention; the new tendencies in art are seen ever more clearly, more clearly than in any previous Salon; it testifies to the definitive reorientation of the minds of France. Despite the prejudices of the administration, despite the hostility of the Ecole, despite the opposition of the juries, Naturalism carries the day. Religion is dead, history is dead, mythology is dead. The old sources of inspiration, so dear to indolence and mediocrity, are all dried up.

That is what the 1867 Salon so loudly declares. Painting, which had, for so many years, dragged itself along in a rut, now takes its bearings for a new destiny. It understands that the visible world is its sole domain; that the sole forms and aspects to the reproduction of which we can react are those conveyed to our senses by the spectacle of things; that art cannot contradict the first and essential data of observation; that if the painter wishes to charm us today, he must bend the knee to the rationalism of our time, accept the agenda of a society transformed by truth and no longer sensitive to anything but the beauties of truth. And this is why it has gone over lock, stock and barrel to Naturalism.

Prodigious reversal! How many undecided yet remain! The poetry that the painter had been accustomed to seek in books, pictures and bas-reliefs, wherever, in short, it was ready made and in some sense obligatory, he must henceforth find in nature and in life. That profound, mysterious chemistry by which the work of art lives, known to him only through ancient literature and art, he must now extract directly from the eternal recipient, composing it himself with his imagination and sensibility alone.

True, the task is an arduous and perilous one; but who can deny that the resulting art is more human, and thus greater and more fertile?

16 Edmond and Jules de Goncourt (1822–1896 and 1830–1870, respectively) from *Journal*

In addition to an early attempt at becoming landscape artists, the Goncourt brothers contributed to a variety of literary genres. They wrote plays, social history, art criticism and several novels. They remain best known for their *Journal*, begun in 1851, and continued by Edmond alone after Jules' death in 1870. In the present extracts, the brothers address Realism, and the linked questions of truth and contemporaneity. For them, the classical heritage has degenerated and become merely academic. Thus they are dismissive of art which they regard as perpetuating those values, such as that of Ingres. Conversely, they value the work of the illustrator Constantin Guys, who was also the subject of Baudelaire's essay 'The Painter of Modern Life' (cf. IIID8). For the Goncourts, art must be contemporary. And yet art is not photography: its 'truth' has to be partly constituted out of fiction. One of the potential pictorial resources for such an art seemed to

be the Oriental prints which the Goncourts had begun to collect. In a glancing prefiguration of much subsequent modernist theory, they set the Gothic and the Oriental together, contrasting their curious, observation-based distortions with the 'false' ideal of the classical mainstream. Our extracts are taken from the translations in George G. Becker and Edith Philips (eds), *Paris and the Arts, 1851–1896: From the Goncourt Journal*, Cornell University Press, Ithaca and London, 1971, pp. 36–91.

30 October 1857

Realism is born and breaks out when the daguerreotype and photograph show how much art differs from reality.

23 April 1858

At Gavarni's we meet Guys, the artist for the *Illustrated London News*, who, with high style and strong brush strokes, presents brothel scenes conveying the moral physiognomy of prostitution in this century.

He is a strange man who has experienced all the ups and downs of life, who has ranged widely through the world and its hazards, who has impaired his health in all sorts of climates and loves; a man who has known the furnished lodgings of London, fashionable great houses, German gambling dens, Greek massacres, Paris boarding houses, newspaper offices, the trenches at Sevastopol, mercury cures, the plague, Oriental dogs, duels, prostitutes, thieves, roués, usury, poverty, cut-throats, and the lower depths where all fallen creatures swarm as in the sea – all those nameless and shoeless men, all those submerged and terrible beings who never come up to the surface in novels.

A small man, he has survived all that with energy, a terrific energy concealed behind his grey moustaches; he is strange, chameleon-like, diverse, changing his voice and his appearance, seeming multiple and various, making you forget for a moment the grumbler you have next to you, and with his lively speech and mobile face continually changing his mask, becoming all the characters he depicts for you; limping along the road and bumping into you as he is blown along by the wind; with a quick and nervous gesture of the palm of his hand constantly pushing up his sleeves over his bony arms; diffuse, verbose, overflowing with parentheses, zigzagging from idea to idea, losing the thread, finding it again, never letting go your attention for a moment, holding you constantly under the spell of his brilliant, colourful speech, which is loud and almost visible to the eye, like a painting. An eloquence which is loquacious, felicitous, and very personal. And all of a sudden when your attention is about to wander, he catches it again with a vulgar image or a slangy metaphor, and out of the disorder and bedazzlement there suddenly issues a phrase worthy of one of the great German thinkers, or an object is defined by a word from the technical vocabulary of art with the sharpness of relief of the Elgin Marbles.

He evokes a thousand things in his promenade through memory, tossing out from time to time handfuls of irony, sketches, memories, landscapes, pictures, profiles, vignettes of streets, crossroads, or sidewalks where you hear the clattering of women's sandals; views of cities riddled with bullets, gutted and bleeding, hospitals teeming

with rats. Then in contrast with all that – as in an album you find a thought by Balzac on the back of a drawing by Decamps – he comes out with social sketches, comments on the English species and the French species that are new and have not been mouldering in books, a comparative philosophy of the national character of peoples, two-minute satires, pamphlets in one word.

10 December 1860

The true is the basis of all art; it is its foundation and its conscience. But why are the mind and the soul not completely satisfied with it? Shouldn't there be an alloy of the false in order for a work to be regarded as a masterpiece by posterity?

January 1862

Art is not one, or rather there is no single art. Japanese art is as great an art as Greek art. Greek art, frankly, what is it? The realism of the beautiful. No fantasy, no dream. The absolute of line. Not a grain of opium, so soft, so caressing to the soul, in representations of nature or of man.

11 March 1862

I have been to see the famous *La Source* by M. Ingres. It is a recreation of the body of a young girl of antiquity, a rendering that is worked over, polished, naively stupid. The female body is not immutable. It changes according to civilizations, periods, customs. The body of the time of Phidias is no longer that of our time. Other customs, another age, another line. The elongation, the free-flowing grace of Goujon or Parmigiano are only the woman of their time, caught in the elegance of the type. In the same way Boucher merely paints the frivolous woman of the eighteenth century, full of dimples. The painter who does not paint the woman of his time will not endure.

October 1863

The other day I bought some albums of Japanese obscenities. They delight me, amuse me, and charm my eyes. I look on them as being beyond obscenity, which is there, yet seems not to be there, and which I do not see, so completely does it disappear into fantasy. The violence of the lines, the unexpected in the conjunctions, the arrangement of the accessories, the caprice in the poses and the objects, the picturesqueness, and, so to speak, the landscape of the genital parts. Looking at them, I think of Greek art, boredom in perfection, an art that will never free itself from the crime of being *academic!*

19 July 1864

This evening the sun looks like a wafer of cherry-coloured sealing wax, glued onto the sky over a pearl-coloured sea. Only the Japanese have dared, in their colour albums, to give these strange effects of nature.

30 September 1864

Chinese art, and particularly Japanese art, those arts which appear so incredibly fantastic to bourgeois eyes, are drawn direct from nature. Everything that they do is taken from observation. They represent what they see: the incredible effects of the sky, the stripes on a mushroom, the transparency of the jellyfish. Their art copies nature as does Gothic art.

Basically there is no paradox in saying that a Japanese album and a painting by Watteau are drawn from an intimate study of nature. Nothing like this in the Greeks: their art, except for sculpture, is false and invented. Their last word is the arabesque, a contorted monstrosity and an elegant geometry.

17 Edmond and Jules de Goncourt (1822–1896 and 1830–1870, respectively) from Preface to *Germinie Lacerteux*

As well as the *Journal* for which they are best remembered, the Goncourt brothers were prolific novelists. Their commitment to the representation of modern life led them to undertake extensive research and documentation into a variety of social milieux to provide convincing naturalistic backgrounds for the human dramas enacted in their novels. This led to critical controversy, and accusations of outraging public morality. The most lasting of their novels was *Germinie Lacerteux*, first published in Paris in 1864. In their preface the Goncourts outline their sense of literary Realism, of the novel as a 'living form of literary study and social enquiry'. The present text is taken from the English translation, published as *Germinie Lacerteux: A Realistic Novel*, London: Vizetelly & Co., 1887, pp. v–vii.

We must ask pardon of the public for presenting them with this book, and warn them of what they will find in it.

The public like false novels: this novel is a true one.

They like books which have the appearance of being in society: this book comes from the street.

They like equivocal little works, girls' memoirs, alcove confessions, erotic unclean-ness, the scandals exposed in the windows of the book-shops: what they are about to read is severe and pure. Let them not expect the low-necked photography of Pleasure: the following study is the clinic of Love.

The public further like to read what is soothing and comforting, adventures that end well, imaginings that disturb neither their digestion nor their serenity: this book, with its sad and violent diversion, is adapted to vex their habits and injure their hygiene.

Why, then, have we written it? Is it simply in order to shock the public and scandalize their tastes?

No.

Living in the nineteenth century, at a time of universal suffrage, and democracy, and liberalism, we asked ourselves whether what are called 'the lower orders' had no claim upon the Novel; whether the people – this world beneath a world – were to

remain under the literary ban and disdain of authors who have hitherto maintained silence regarding any soul and heart that they might possess. We asked ourselves whether, in these days of equality, there were still for writer and reader unworthy classes, misfortunes that were too low, dramas too foul-mouthed, catastrophes too base in their terror. We became curious to know whether Tragedy, that conventional form of a forgotten literature and a vanished society, was finally dead; whether, in a country devoid of caste and legal aristocracy, the miseries of the lowly and the poor would speak to interest, to emotion, to pity, as loudly as the miseries of the great and rich; whether, in a word, the tears that are wept below could provoke weeping like those that are wept above.

These thoughts prompted us to venture upon the humble novel of 'Sister Philomena' in 1861; they at present prompt us to publish 'Germinie Lacerteux.'

Now, though the book be slandered, this will be of little consequence to it. At the present time, when the Novel is widening and increasing; when it is beginning to be the great, serious, impassioned, living form of literary study and social inquiry; when, through analysis and psychological investigation, it is becoming moral, contemporary History – when the Novel has undertaken the studies and duties of science, it is able to claim the liberties and immunities of the latter. And if it seeks for Art and Truth; if, to the fortunate ones of Paris, it shows miseries that it is good not to forget; if it causes worldly people to see what ladies of charity have the courage to see, what queens used formerly to bring beneath their children's eyes in the hospitals – that present, living, human suffering, which counsels charity; if the Novel has that religion which the last century called by the wide, vast name of *Humanity*, the consciousness of this is sufficient for it, and implies its right.

18 Thomas Eakins (1844–1916) Letter to Benjamin Eakins

Eakins was born in Philadelphia and was in Paris between 1866 and 1870, studying at the Ecole des Beaux-Arts under Jean-Léon Gérôme and subsequently also under Léon Bonnat. While there he wrote home regularly to his father, reporting on his progress. The following letter was written in March 1868 and expresses a forceful commitment to the study of nature and to the principle of originality on the part of a still immature and self-consciously American student. Five years after his return to Philadelphia, Eakins was to paint *The Gross Clinic*, a work remarkable both for the intense naturalism of its figuration and for its underlying psychological power. He was to be a forceful advocate of the need for first-hand study of the human figure (see IVʙ11), and to the end of his working life he was to develop his compositions through assiduous preparatory drawings and sketches both of their figurative components and of their spatial structures. Despite the impatience with the classical tradition expressed in his letter, he never lost his respect for Gérôme's example, remaining in correspondence with the French academician for several years after his return to America. The full text of this letter was first published in Kathleen A. Foster and Cheryl Leibold, *Writing About Eakins: The Manuscripts in Charles Bregler's Thomas Eakins Collection*, Philadelphia: University of Pennsylvania Press, 1989, pp. 206–8, from which source the present version is taken. We have eliminated words and phrases crossed through in Eakins's manuscript but reproduced by Foster and Leibold.

Friday, March 6, 1868

Dear Father,

I will again be running out of money about April 15th when my rent day comes again. I will try make out my account next week, I have too much to talk about this time. When earnest people argue together it will generally be found upon reflection that they are all arguing on the same side of the main question with some misunderstanding in a trifle, and so I look on the argument between you on the one side and the crowd on the other against you, for I cannot conceive that they should believe that an artist is a creator. I think Herbert Spencer will set them right on painting. The big artist does not sit down monkey like & copy a coal scuttle or an ugly old woman like some Dutch painters have done nor a dungpile, but he keeps a sharp eye on Nature & steals her tools. He learns what she does with light the big tool & then colour then form and appropriates them to his own use. Then he's got a canoe of his own smaller than Nature's but big enough for every purpose except to paint the midday sun which is not beautiful at all. It is plenty strong enough though to make midday sunlight or the setting sun if you know how to handle it. With this canoe he can sail parallel to Nature's sailing. He will soon be sailing only where he wants to selecting nice little coves & shady shores or storms to his own liking, but if ever he thinks he can sail another fashion from Nature or make a better shaped boat he'll capsize or stick in the mud & nobody will buy his pictures or sail with him in his old tub. If a big painter wants to draw a coal scuttle he can do it better than the man that has been doing nothing but coal scuttles all his life. That's sailing up Pig's run among mud & slops and back houses. The big painter sees the marks that Nature's big boat made in the mud & he understands them & profits by them. The lummix that never wondered why they were there rows his tub about instead of sailing it & where he chances to see one of Nature's marks why he'll slap his tub into the mud to make his mark too but he'll miss most of them not knowing where to look for them. But if more light comes on to the concern that is the tide comes up the marks are all hidden & the big artist knows that nature would have sailed her boat a different way entirely & he sails his as near as he can to how nature would have sailed hers according to his experience & memory & sense. The stick in the mud shows some invention he has for still hunting these old marks a plomb line to scrape the shore and he flatters himself with his ability to tell a boat mark from a muskrat hole in the deepest water, and then he thinks he knows nature a great deal better than any one else. I have seen big log books kept of the distances made in different tacks by great artists without saying a word about tide or wind or anything else the length of a certain bone in the leg of a certain statue compared to the bone of the nose of a certain other one & a connection with some mystic number the whole which would more mystify the artists that made them than anyone else. Then the professors as they are called read Greek poetry for inspiration & talk classic & give out classic subjects & make a fellow draw antique not see how beautiful those simple hearted big men sailed but to observe their mud marks which are easier to see & measure than to understand. I love sunlight & children & beautiful women & men their heads & hands & most everything I see & some day I expect to paint them as I see them and even paint some that I remember or imagine make up

from old memories of love & light & warmth &c &c. but if I went to Greece to live there twenty years I could not paint a Greek subject for my head would be full of classics the nasty besmeared wooden hard gloomy tragic figures of the great French school of the last few centuries & Ingres & the Greek letters I learned at the High School with old Haverstick & my mud marks of the antique statues.

Heavens what will a fellow ever do that runs his boat a mean old tub in the marks not of nature but of another man that run after nature centuries ago and who the fools & historians & critics will have run his boat in the marks of an Egyptian boat that was after a Chinese $+(a + b + \&c)$ x ... Nature at last or maybe God like intelligence or atmospheric effect or sentiment of colour lush or juice or juicy effect etc (see newspapers or Atlantic monthly magazine) No the big artists were the most timid of themselves & had the greatest confidence in Nature & when they made an unnatural thing they made it as Nature would made it had she made it & thus they are really closer to Nature than the coal scuttle men painters ever suspect. In a big picture you can see what o'clock it is afternoon or morning if its hot or cold winter or summer & what kind of people are there & what they are doing & why they are doing it. The sentiments run beyond words. If a man makes a hot day he makes it like a hot day he once saw or is seeing if a sweet face a face he once saw or which he imagines from old memories or parts of memories & his knowledge & he combines & combines never creates but at the very first combination no man & less of all himself could ever disentangle the feelings that animated him just then & refer each one to its right place.

I must go to school now. I got admitted yesterday to the studio of Dumont the sculptor in our school. I am going to model in clay every once in a while. I think I will thus learn faster. When I am tired of painting I will go to the class & be fresh & I will see more models & choose. The sculptors are not so noisy as painters. They are heavier duller looking boys proverbially. I was well received & spent 15 francs on them to give them the welcome. They tried to make the things pleasant. I can now talk good enough to understand all they say & make them understand me it is not like when I went into Gerome's first when I did not understand a word of slang which we always talk and very little French too. Love to all my friends.

[Unsigned]

IIIc
Morals and Standards

1 Anna Jameson (1794–1860) 'Of the Origin and General Significance of the Legends Represented in Art'

For information on the earlier work of Anna Jameson see IA6. After 1840 Jameson devoted herself principally to the study of art, profiting from an acquaintance with German work in art history and doing much to render the subject accessible to the English general reader. During the early 1840s she also published two volumes providing information on the contents of public and private collections in the area of London. Her particular field of study was the Christian iconography of Italian art, which she treated not simply as a form of illustrated dogma, but rather as a repository of mythical themes that were open to historical enquiry. The argument of the present passage appears to share some ground with contemporary pleas for the religious appreciation of religious art. Its more substantial implication, however, is that the critical understanding of art requires the exercise of historical imagination and enquiry. The following passage is taken from the opening to Jameson's book *The Poetry of Sacred and Legendary Art*, London, 1848. This formed the first of a four-volume study devoted to Christian iconography, the last being published in 1864, after her death. Our text is taken from the ninth edition, London: Green and Co., 1883, pp. 1–7 and 10.

We cannot look round a picture gallery – we cannot turn over a portfolio of prints after the old masters, nor even the modern engravings which pour upon us daily, from Paris, Munich, or Berlin – without perceiving how many of the most celebrated productions of Art, more particularly those which have descended to us from the early Italian and German schools, represent incidents and characters taken from the once popular legends of the Catholic Church. This form of '*Hero-Worship*' has become, since the Reformation, strange to us – as far removed from our sympathies and associations as if it were antecedent to the fall of Babylon and related to the religion of Zoroaster, instead of being left but two or three centuries behind us, and closely connected with the faith of our forefathers and the history of civilization and Christianity. Of late years, with a growing passion for the works of Art of the Middle Ages, there has arisen among us a desire to comprehend the state of feeling which produced them, and the legends and traditions on which they are founded; – a desire to understand, and to bring to some surer critical test, representations which have become familiar without being intelligible. To enable us to do this, we must pause for

a moment at the outset; and, before we plunge into the midst of things, ascend to higher ground, and command a far wider range of illustration than has yet been attempted, in order to take cognizance of principles and results which, if not new, must be contemplated in a new relation to each other.

The Legendary Art of the Middle Ages sprang out of the legendary literature of the preceding ages. For three centuries at least, this literature, the only literature which existed at the time, formed the sole mental and moral nourishment of the *people* of Europe. The romances of Chivalry, which long afterwards succeeded, were confined to particular classes, and left no impress on Art, beyond the miniature illuminations of a few manuscripts. This legendary literature, on the contrary, which had worked itself into the life of the people, became, like the antique mythology, as a living soul diffused through the loveliest forms of Art, still vivid and vivifying, even when the old faith in its mystical significance was lost or forgotten. And it is a mistake to suppose that these legends had their sole origin in the brains of dreaming monks. The wildest of them had some basis of truth to rest on, and the forms which they gradually assumed were but the necessary result of the age which produced them. They became the intense expression of that inner life, which revolted against the desolation and emptiness of the outward existence; of those crushed and outraged sympathies which cried aloud for rest, and refuge, and solace, and could nowhere find them. It will be said, 'In the purer doctrine of the GOSPEL.' But where was that to be found? The Gospel was not then the heritage of the poor: Christ, as a comforter, walked not among men. His own blessed teaching was inaccessible except to the learned: it was shut up in rare manuscripts; it was perverted and sophisticated by the passions and the blindness of those few to whom it *was* accessible. The bitter disputes in the early Church relative to the nature of the Godhead, the subtle distinctions and incomprehensible arguments of the theologians, the dread entertained by the predominant Church of any heterodox opinions concerning the divinity of the Redeemer, had all conspired to remove *Him*, in His personal character of Teacher and Saviour, far away from the hearts of the benighted and miserable people – far, far away into regions speculative, mysterious, spiritual, whither they could not, dared not follow Him. In this state of things, as it has been remarked by a distinguished writer, 'Christ became the object of a remoter, a more awful adoration. The mind began, therefore, to seek out, or eagerly to seize, some other more material beings in closer alliance with human sympathies.' [Milman] [. . .]

Out of these vital aspirations – not indeed always 'well or wisely placed,' but never, as in the heathen mythology, degraded to vicious and contemptible objects – arose and spread the universal passion for the traditional histories of the saints and martyrs, – personages endeared and sanctified in all hearts, partly as examples of the loftiest virtue, partly as benign intercessors between suffering humanity and that Deity who, in every other light than as a God of Vengeance, had been veiled from their eyes by the perversities of schoolmen and fanatics, till He had receded beyond their reach, almost beyond their comprehension. Of the prevalence and of the incalculable influence of this legendary literature from the seventh to the tenth century, that is, just about the period when Modern Art was struggling into existence, we have a most striking picture in Guizot's 'Histoire de la Civilisation.' 'As after the siege of Troy (says this philosophical and eloquent writer) there were found, in every city of

Greece, men who collected the traditions and adventures of heroes, and sung them for the recreation of the people, till these recitals became a national passion, a national poetry; so, at the time of which we speak, the traditions of what may be called the heroic ages of Christianity had the same interest for the nations of Europe. There were men who made it their business to collect them, to transcribe them, to read or recite them aloud, for the edification and delight of the people. And this was the only literature, properly so called, of that time.'

Now, if we go back to the *authentic* histories of the sufferings and heroism of the early martyrs, we shall find enough there, both of the wonderful and the affecting, to justify the credulity and enthusiasm of the unlettered people, who saw no reason why they should not believe in one miracle as well as in another. In these universally diffused legends, we may recognize the means, at least one of the means, by which a merciful Providence, working through its own immutable laws, had provided against the utter depravation, almost extinction, of society. Of the 'Dark Ages,' emphatically so called, the period to which I allude was perhaps the darkest; it was 'of Night's black arch the key-stone.' At a time when men were given over to the direst evils that can afflict humanity, – ignorance, idleness, wickedness, misery; at a time when the everyday incidents of life were a violation of all the moral instincts of mankind; at a time when all things seemed abandoned to a blind chance, or the brutal law of force; when there were no repose, no refuge, no safety anywhere; when the powerful inflicted, and the weak endured, whatever we can conceive of most revolting and intolerable; when slavery was recognized by law throughout Europe; when men fled to cloisters, to shut themselves from oppression, and women to shield themselves from outrage; when the manners were harsh, the language gross; when all the softer social sentiments, as pity, reverence, tenderness, found no resting-place in the actual relations of life; when for the higher ranks there was only the fierce excitement of war, and on the humbler classes lay the weary, dreary monotony of a stagnant existence, poor in pleasures of every kind, without aim, without hope; *then* – wondrous reaction of the ineffaceable instincts of good implanted within us! – arose a literature which reversed the outward order of things, which asserted and kept alive in the hearts of men those pure principles of Christianity which were outraged in their daily actions; a literature in which peace was represented as better than war, and sufferance more dignified than resistance; which exhibited poverty and toil as honourable, and charity as the first of virtues; which held up to imitation and emulation self-sacrifice in the cause of good, and contempt of death for conscience' sake; a literature in which the tenderness, the chastity, the heroism of woman, played a conspicuous part; which distinctly protested against slavery, against violence, against impurity in word and deed; which refreshed the fevered and darkened spirit with images of moral beauty and truth; revealed bright glimpses of a better land, where 'the wicked cease from troubling,' and brought down the angels of God with shining wings and bearing crowns of glory, to do battle with the demons of darkness, to catch the fleeting soul of the triumphant martyr, and carry it at once into a paradise of eternal blessedness and peace!

Now the Legendary Art of the three centuries which comprise the revival of learning, was, as I have said, the reflection of this literature, of this teaching. Considered in this point of view, can we easily overrate its interest and importance?

When, after the long period of darkness which followed upon the decline of the Roman Empire, the Fine Arts began to revive, the first, and for several ages the only, impress they received was that of the religious spirit of the time. Painting, Sculpture, Music, and Architecture, as they emerged one after another from the 'formless void,' were pressed into the service of the Church. But it is a mistake to suppose, that in adroitly adapting the reviving Arts to her purposes, in that magnificent spirit of calculation which at all times characterized her, the Church from the beginning selected the subjects, or dictated the use that was to be made of them. We find, on the contrary, edicts and councils *repressing* the popular extravagances in this respect, and denouncing those apocryphal versions of sacred events and traditions which had become the delight of the people. But vain were councils and edicts; the tide was too strong to be so checked. The Church found herself obliged to accept and mould to her own objects the exotic elements she could not eradicate. She *absorbed*, so to speak, the evils and errors she could not expel. There seems to have been at this time a sort of compromise between the popular legends, with all their wild mixture of northern and classical superstitions, and the Church legends properly so called. The first great object to which reviving Art was destined, was to render the Christian places of worship a theatre of instruction and improvement for the people, to attract and to interest them by representations of scenes, events, and personages, already so familiar as to require no explanation, appealing at once to their intelligence and their sympathies; embodying in beautiful shapes (beautiful at least in their eyes) associations and feelings and memories deep-rooted in their very hearts, and which had influenced, in no slight degree, the progress of civilization, the development of mind. Upon these creations of ancient Art we cannot look as *those* did for whom they were created; we cannot annihilate the centuries which lie between us and them; we cannot, in simplicity of heart, forget the artist in the image he has placed before us, nor supply what may be deficient in his work, through a reverentially excited fancy. We are critical, not credulous. We no longer accept this polytheistic form of Christianity; and there is little danger, I suppose, of our falling again into the strange excesses of superstition to which it led. But if we have not much sympathy with modern imitations of Mediaeval Art, still less should we sympathize with that narrow puritanical jealousy which holds the monuments of a real and earnest faith in contempt. All that God has permitted once to exist in the past should be considered as the possession of the present; sacred for example or warning, and held as the foundation on which to build up what is better and purer. It should seem an established fact, that all revolutions in religion, in government, and in art, which begin in the spirit of scorn, and in a sweeping destruction of the antecedent condition, only tend to a reaction. Our puritanical ancestors chopped off the heads of Madonnas and Saints, and paid vagabonds to smash the storied windows of our cathedrals; – *now*, are these rejected and outraged shapes of beauty coming back to us, or are we not rather going back to them? As a Protestant, I might fear lest in doing so we confound the eternal spirit of Christianity with the mutable forms in which it has deigned to speak to the hearts of men, forms which must of necessity vary with the degree of social civilization, and bear the impress of the feelings and fashions of the age which produce them; but I must also feel that we ought to comprehend, and to hold in due reverence, that which has once been consecrated to holiest aims, which has shown us what a

magnificent use has been made of Art, and how it may still be adapted to good and glorious purposes, if, while we respect these time-consecrated images and types, we do not allow them to fetter us, but trust in the progressive spirit of Christianity to furnish us with new impersonations of the good – new combinations of the beautiful. I hate the destructive as I revere the progressive spirit. We must laugh if any one were to try and persuade us that the sun was guided along his blazing path by 'a fair-haired god who touched a golden lyre;' but shall we therefore cease to adore in the Apollo Belvedere the majestic symbol of light, the most divine impersonation of intellectual power and beauty? So of the corresponding Christian symbols: – may that time never come, when we shall look up to the effigy of the winged and radiant angel trampling down the brute-fiend, without a glow of faith in the perpetual supremacy and final triumph of good over evil!

* * *

In the old times the painters of these legendary scenes and subjects could always reckon securely on certain associations and certain sympathies in the minds of the spectators. We have outgrown these associations, we repudiate these sympathies. We have taken these works from their consecrated localities, in which they once held each their dedicated place, and we have hung them in our drawing-rooms and our dressing-rooms, over our pianos and our side-boards – and now what do they say to us? That Magdalene, weeping amid her hair, who once spoke comfort to the soul of the fallen sinner, – that Sebastian, arrow-pierced, whose upward ardent glance spoke of courage and hope to the tyrant-ridden serf, – that poor tortured slave, to whose aid St Mark comes sweeping down from above, – can they speak to *us* of nothing save flowing lines and correct drawing and gorgeous colour? Must we be told that one is a Titian, the other a Guido, the third a Tintoret, before we dare to melt in compassion or admiration? – or the moment we refer to their ancient religious signification and influence, must it be with disdain or with pity? This, as it appears to me, is to take not a rational, but rather a most irrational as well as a most irreverent, view of the question; it is to confine the pleasure and improvement to be derived from works of Art within very narrow bounds; it is to seal up a fountain of the richest poetry, and to shut out a thousand ennobling and inspiring thoughts. Happily there is a growing appreciation of these larger principles of criticism as applied to the study of Art. People look at the pictures which hang round their walls, and have an awakening suspicion that there is more in them than meets the eye – more than mere connoisseurship can interpret; and that they have another, a deeper significance than has been dreamed of by picture dealers and picture collectors, or even picture critics.

2 Dante Gabriel Rossetti (1828–1882) 'Hand and Soul'

Rossetti was one of the founders of the Pre-Raphaelite Brotherhood, based among students at the Royal Academy schools in London, in 1848. Along with William Holman Hunt and John Everett Millais, the other leading artists of the group, Rossetti advocated a detailed form of Naturalism. He also brought to the group a pronounced medievalism and an interest in linking painting and poetry. He was the driving force behind the short-lived Pre-Raphaelite journal *The Germ*, which appeared for four issues in 1850. The present

essay was written specifically for the first issue. It takes the form of a fable of the life of an Italian painter of the thirteenth century. For Rossetti and his colleagues the Academy represented a debased form of art. Its roots lay in the High Renaissance, in particular in the achievement of Raphael. In order to recapture the vigour of art before the onset of academicization, it was necessary therefore to return to the earlier period: the period of Cimabue, Giotto and, in poetry, Dante. Writing in 1899, the artist's brother William Michael Rossetti commented that 'Though the form of this tale is that of a romantic metaphor, its substance is a very serious manifesto of art-dogma. It amounts to saying, The only satisfactory works of art are those which exhibit the very soul of the artist. To work for fame or self-display is a failure, and to work for direct moral proselytizing is a failure; but to paint that which your own perceptions and emotions urge you to paint promises to be a success for yourself, and hence a benefit to the mass of beholders'. The present extract is taken from *The Germ*, no. 1, January 1850, pp. 23–32.

Before any knowledge of painting was brought to Florence, there were already painters in Lucca, and Pisa, and Arezzo, who feared God and loved the art. The keen, grave workmen from Greece, whose trade it was to sell their own works in Italy and teach Italians to imitate them, had already found rivals of the soil with skill that could forestall their lessons and cheapen their crucifixes and *addolorate*, more years than is supposed before the art came at all into Florence. The pre-eminence to which Cimabue was raised at once by his contemporaries, and which he still retains to a wide extent even in the modern mind, is to be accounted for, partly by the circumstances under which he arose, and partly by that extraordinary *purpose of fortune* born with the lives of some few, and through which it is not a little thing for any who went before, if they are even remembered as the shadows of the coming of such an one, and the voices which prepared his way in the wilderness. It is thus, almost exclusively, that the painters of whom I speak are now known. They have left little, and but little heed is taken of that which men hold to have been surpassed; it is gone like time gone – a track of dust and dead leaves that merely led to the fountain.

Nevertheless, of very late years, and in very rare instances, some signs of a better understanding have become manifest. A case in point is that of the tryptic and two cruciform pictures at Dresden, by Chiaro di Messer Bello dell' Erma, to which the eloquent pamphlet of Dr Aemmster has at length succeeded in attracting the students. There is another still more solemn and beautiful work, now proved to be by the same hand, in the gallery at Florence. It is the one to which my narrative will relate.

This Chiaro dell' Erma was a young man of very honourable family in Arezzo; where, conceiving art almost, as it were, for himself, and loving it deeply, he endeavoured from early boyhood towards the imitation of any objects offered in nature. The extreme longing after a visible embodiment of his thoughts strengthened as his years increased, more even than his sinews or the blood of his life; until he would feel faint in sunsets and at the sight of stately persons. When he had lived nineteen years, he heard of the famous Giunta Pisano; and, feeling much of admiration, with, perhaps, a little of that envy which youth always feels until it has learned to measure success by time and opportunity, he determined that he would seek out Giunta, and, if possible, become his pupil.

Having arrived in Pisa, he clothed himself in humble apparel, being unwilling that any other thing than the desire he had for knowledge should be his plea with the great painter; and then, leaving his baggage at a house of entertainment, he took his way along the street, asking whom he met for the lodging of Giunta. It soon chanced that one of that city, conceiving him to be a stranger and poor, took him into his house, and refreshed him; afterwards directing him on his way.

When he was brought to speech of Giunta, he said merely that he was a student, and that nothing in the world was so much at his heart as to become that which he had heard told of him with whom he was speaking. He was received with courtesy and consideration, and shewn into the study of the famous artist. But the forms he saw there were lifeless and incomplete; and a sudden exultation possessed him as he said within himself, 'I am the master of this man.' The blood came at first into his face, but the next moment he was quite pale and fell to trembling. He was able, however, to conceal his emotion; speaking very little to Giunta, but, when he took his leave, thanking him respectfully.

After this, Chiaro's first resolve was, that he would work out thoroughly some one of his thoughts, and let the world know him. But the lesson which he had now learned, of how small a greatness might win fame, and how little there was to strive against, served to make him torpid, and rendered his exertions less continual. Also Pisa was a larger and more luxurious city than Arezzo; and, when in his walks, he saw the great gardens laid out for pleasure, and the beautiful women who passed to and fro, and heard the music that was in the groves of the city at evening, he was taken with wonder that he had never claimed his share of the inheritance of those years in which his youth was cast. And women loved Chiaro; for, in despite of the burthen of study, he was well-favoured and very manly in his walking; and, seeing his face in front, there was a glory upon it, as upon the face of one who feels a light round his hair.

So he put thought from him, and partook of his life. But, one night, being in a certain company of ladies, a gentleman that was there with him began to speak of the paintings of a youth named Bonaventura, which he had seen in Lucca; adding that Giunta Pisano might now look for a rival. When Chiaro heard this, the lamps shook before him, and the music beat in his ears and made him giddy. He rose up, alleging a sudden sickness, and went out of that house with his teeth set.

He now took to work diligently; not returning to Arezzo, but remaining in Pisa, that no day more might be lost; only living entirely to himself. Sometimes, after nightfall, he would walk abroad in the most solitary places he could find; hardly feeling the ground under him, because of the thoughts of the day which held him in fever.

The lodging he had chosen was in a house that looked upon gardens fast by the Church of San Rocco. During the offices, as he sat at work, he could hear the music of the organ and the long murmur that the chanting left; and if his window were open, sometimes, at those parts of the mass where there is silence throughout the church, his ear caught faintly the single voice of the priest. Beside the matters of his art and a very few books, almost the only object to be noticed in Chiaro's room was a small consecrated image of St Mary Virgin wrought out of silver, before which stood always, in summer-time, a glass containing a lily and a rose.

It was here, and at this time, that Chiaro painted the Dresden pictures; as also, in all likelihood, the one – inferior in merit, but certainly his – which is now at Munich. For

the most part, he was calm and regular in his manner of study; though often he would remain at work through the whole of a day, not resting once so long as the light lasted; flushed, and with the hair from his face. Or, at times, when he could not paint, he would sit for hours in thought of all the greatness the world had known from of old; until he was weak with yearning, like one who gazes upon a path of stars.

He continued in this patient endeavour for about three years, at the end of which his name was spoken throughout all Tuscany. As his fame waxed, he began to be employed, besides easel-pictures, upon paintings in fresco: but I believe that no traces remain to us of any of these latter. He is said to have painted in the Duomo: and D'Agincourt mentions having seen some portions of a fresco by him which originally had its place above the high altar in the Church of the Certosa; but which, at the time he saw it, being very dilapidated, had been hewn out of the wall, and was preserved in the stores of the convent. Before the period of Dr Aemmster's researches, however, it had been entirely destroyed.

Chiaro was now famous. It was for the race of fame that he had girded up his loins; and he had not paused until fame was reached: yet now, in taking breath, he found that the weight was still at his heart. The years of his labour had fallen from him, and his life was still in its first painful desire.

With all that Chiaro had done during these three years, and even before, with the studies of his early youth, there had always been a feeling of worship and service. It was the peace-offering that he made to God and to his own soul for the eager selfishness of his aim. There was earth, indeed, upon the hem of his raiment; but *this* was of the heaven, heavenly. He had seasons when he could endure to think of no other feature of his hope than this: and sometimes, in the ecstacy of prayer, it had even seemed to him to behold that day when his mistress – his mystical lady (now hardly in her ninth year, but whose solemn smile at meeting had already lighted on his soul like the dove of the Trinity) – even she, his own gracious and holy Italian art – with her virginal bosom, and her unfathomable eyes, and the thread of sunlight round her brows – should pass, through the sun that never sets, into the circle of the shadow of the tree of life, and be seen of God, and found good: and then it had sccmed to him, that he, with many who, since his coming, had joined the band of whom he was one (for, in his dream, the body he had worn on earth had been dead an hundred years), were permitted to gather round the blessed maiden, and to worship with her through all ages and ages of ages, saying, Holy, holy, holy. This thing he had seen with the eyes of his spirit; and in this thing had trusted, believing that it would surely come to pass.

But now, (being at length led to enquire closely into himself,) even as, in the pursuit of fame, the unrest abiding after attainment had proved to him that he had mis-interpreted the craving of his own spirit – so also, now that he would willingly have fallen back on devotion, he became aware that much of that reverence which he had mistaken for faith had been no more than the worship of beauty. Therefore, after certain days passed in perplexity, Chiaro said within himself, 'My life and my will are yet before me: I will take another aim to my life.'

From that moment Chiaro set a watch on his soul, and put his hand to no other works but only to such as had for their end the presentment of some moral greatness that should impress the beholder: and, in doing this, he did not choose for his medium the action and passion of human life, but cold symbolism and abstract impersonation.

So the people ceased to throng about his pictures as heretofore; and, when they were carried through town and town to their destination, they were no longer delayed by the crowds eager to gaze and admire: and no prayers or offerings were brought to them on their path, as to his Madonnas, and his Saints, and his Holy Children. Only the critical audience remained to him; and these, in default of more worthy matter, would have turned their scrutiny on a puppet or a mantle. Meanwhile, he had no more of fever upon him; but was calm and pale each day in all that he did and in his goings in and out. The works he produced at this time have perished – in all likelihood, not unjustly. It is said (and we may easily believe it), that, though more laboured than his former pictures, they were cold and unemphatic; bearing marked out upon them, as they must certainly have done, the measure of that boundary to which they were made to conform.

And the weight was still close at Chiaro's heart: but he held in his breath, never resting (for he was afraid), and would not know it.

Now it happened, within these days, that there fell a great feast in Pisa, for holy matters: and each man left his occupation; and all the guilds and companies of the city were got together for games and rejoicings. And there were scarcely any that stayed in the houses, except ladies who lay or sat along their balconies between open windows which let the breeze beat through the rooms and over the spread tables from end to end. And the golden cloths that their arms lay upon drew all eyes upward to see their beauty; and the day was long; and every hour of the day was bright with the sun.

So Chiaro's model, when he awoke that morning on the hot pavement of the Piazza Nunziata, and saw the hurry of people that passed him, got up and went along with them; and Chiaro waited for him in vain.

For the whole of that morning, the music was in Chiaro's room from the Church close at hand: and he could hear the sounds that the crowd made in the streets; hushed only at long intervals while the processions for the feast-day chanted in going under his windows. Also, more than once, there was a high clamour from the meeting of factious persons: for the ladies of both leagues were looking down; and he who encountered his enemy could not choose but draw upon him. Chiaro waited a long time idle; and then knew that his model was gone elsewhere. When at his work, he was blind and deaf to all else; but he feared sloth: for then his stealthy thoughts would begin, as it were, to beat round and round him, seeking a point for attack. He now rose, therefore, and went to the window. It was within a short space of noon; and underneath him a throng of people was coming out through the porch of San Rocco.

The two greatest houses of the feud in Pisa had filled the church for that mass. The first to leave had been the Gherghiotti; who, stopping on the threshold, had fallen back in ranks along each side of the archway: so that now, in passing outward, the Marotoli had to walk between two files of men whom they hated, and whose fathers had hated theirs. All the chiefs were there and their whole adherence; and each knew the name of each. Every man of the Marotoli, as he came forth and saw his foes, laid back his hood and gazed about him; to show the badge upon the close cap that held his hair. And of the Gherghiotti there were some who tightened their girdles; and some shrilled and threw up their wrists scornfully, as who flies a falcon; for that was the crest of their house.

On the walls within the entry were a number of tall, narrow frescoes, presenting a moral allegory of Peace, which Chiaro had painted that year for the Church. The Gherghiotti stood with their backs to these frescoes: and among them Golzo Ninuccio, the youngest noble of the faction, called by the people Golaghiotta, for his debased life. This youth had remained for some while talking listlessly to his fellows, though with his sleepy sunken eyes fixed on them who passed: but now, seeing that no man jostled another, he drew the long silver shoe off his foot, and struck the dust out of it on the cloak of him who was going by, asking him how far the tides rose at Viderza. And he said so because it was three months since, at that place, the Gherghiotti had beaten the Marotoli to the sands, and held them there while the sea came in; whereby many had been drowned. And, when he had spoken, at once the whole archway was dazzling with the light of confused swords; and they who had left turned back; and they who were still behind made haste to come forth: and there was so much blood cast up the walls on a sudden, that it ran in long streams down Chiaro's paintings.

Chiaro turned himself from the window; for the light felt dry between his lids, and he could not look. He sat down, and heard the noise of contention driven out of the church-porch and a great way through the streets; and soon there was a deep murmur that heaved and waxed from the other side of the city, where those of both parties were gathering to join in the tumult.

Chiaro sat with his face in his open hands. Once again he had wished to set his foot on a place that looked green and fertile; and once again it seemed to him that the thin rank mask was about to spread away, and that this time the chill of the water must leave leprosy in his flesh. The light still swam in his head, and bewildered him at first; but when he knew his thoughts, they were these: –

'Fame failed me: failed me: and now this also, – the hope that I nourished in this my generation of men, – shall pass from me, and leave my feet and my hands groping. Yet, because of this, are my feet become slow and my hands thin. I am as one who, through the whole night, holding his way diligently, hath smitten the steel unto the flint, to lead some whom he knew darkling; who hath kept his eyes always on the sparks that himself made, lest they should fail; and who, towards dawn, turning to bid them that he had guided God speed, sees the wet grass untrodden except of his own feet. I am as the last hour of the day, whose chimes are a perfect number; whom the next followeth not, nor light ensueth from him; but in the same darkness is the old order begun afresh. Men say, "This is not God nor man; he is not as we are, neither above us: let him sit beneath us, for we are many." Where I write Peace, in that spot is the drawing of swords, and there men's footprints are red. When I would sow, another harvest is ripe. Nay, it is much worse with me than thus much. Am I not as a cloth drawn before the light, that the looker may not be blinded; but which sheweth thereby the grain of its own coarseness; so that the light seems defiled, and men say, "We will not walk by it." Wherefore through me they shall be doubly accursed, seeing that through me they reject the light. May one be a devil and not know it?'

As Chiaro was in these thoughts, the fever encroached slowly on his veins, till he could sit no longer, and would have risen; but suddenly he found awe within him, and held his head bowed, without stirring. The warmth of the air was not shaken; but there seemed a pulse in the light, and a living freshness, like rain. The silence was a

painful music, that made the blood ache in his temples; and he lifted his face and his deep eyes.

A woman was present in his room, clad to the hands and feet with a green and grey raiment, fashioned to that time. It seemed that the first thoughts he had ever known were given him as at first from her eyes, and he knew her hair to be the golden veil through which he beheld his dreams. Though her hands were joined, her face was not lifted, but set forward; and though the gaze was austere, yet her mouth was supreme in gentleness. And as he looked, Chiaro's spirit appeared abashed of its own intimate presence, and his lips shook with the thrill of tears; it seemed such a bitter while till the spirit might be indeed alone.

She did not move closer towards him, but he felt her to be as much with him as his breath. He was like one who, scaling a great steepness, hears his own voice echoed in some place much higher than he can see, and the name of which is not known to him. As the woman stood, her speech was with Chiaro: not, as it were, from her mouth or in his ears; but distinctly between them.

'I am an image, Chiaro, of thine own soul within thee. See me, and know me as I am. Thou sayest that fame has failed thee, and faith failed thee; but because at least thou hast not laid thy life unto riches, therefore, though thus late, I am suffered to come into thy knowledge. Fame sufficed not, for that thou didst seek fame: seek thine own conscience (not thy mind's conscience, but thine heart's), and all shall approve and suffice. For Fame, in noble soils, is a fruit of the Spring: but not therefore should it be said: "Lo! my garden that I planted is barren: the crocus is here, but the lily is dead in the dry ground, and shall not lift the earth that covers it: therefore I will fling my garden together, and give it unto the builders." Take heed rather that thou trouble not the wise secret earth; for in the mould that thou throwest up shall the first tender growth lie to waste; which else had been made strong in its season. Yea, and even if the year fall past in all its months, and the soil be indeed, to thee, peevish and incapable, and though thou indeed gather all thy harvest, and it suffice for others, and thou remain vext with emptiness; and others drink of thy streams, and the drouth rasp thy throat; – let it be enough that these have found the feast good, and thanked the giver: remembering that, when the winter is striven through, there is another year, whose wind is meek, and whose sun fulfilleth all.'

While he heard, Chiaro went slowly on his knees. It was not to her that spoke, for the speech seemed within him and his own. The air brooded in sunshine, and though the turmoil was great outside, the air within was at peace. But when he looked in her eyes, he wept. And she came to him, and cast her hair over him, and, took her hands about his forehead, and spoke again:

'Thou hast said,' she continued, gently, 'that faith failed thee. This cannot be so. Either thou hadst it not, or thou hast it. But who bade thee strike the point betwixt love and faith? Wouldst thou sift the warm breeze from the sun that quickens it? Who bade thee turn upon God and say: "Behold, my offering is of earth, and not worthy: thy fire comes not upon it: therefore, though I slay not my brother whom thou acceptest, I will depart before thou smite me." Why shouldst thou rise up and tell God He is not content? Had He, of His warrant, certified so to thee? Be not nice to seek out division; but possess thy love in sufficiency: assuredly this is faith, for the heart must believe first. What He hath set in thine heart to do, that do thou; and even

though thou do it without thought of Him, it shall be well done: it is this sacrifice that He asketh of thee, and His flame is upon it for a sign. Think not of Him; but of His love and thy love. For God is no morbid exactor: He hath no hand to bow beneath, nor a foot, that thou shouldst kiss it.'

And Chiaro held silence, and wept into her hair which covered his face; and the salt tears that he shed ran through her hair upon his lips; and he tasted the bitterness of shame.

Then the fair woman, that was his soul, spoke again to him, saying:

'And for this thy last purpose, and for those unprofitable truths of thy teaching, – thine heart hath already put them away, and it needs not that I lay my bidding upon thee. How is it that thou, a man, wouldst say coldly to the mind what God hath said to the heart warmly? Thy will was honest and wholesome; but look well lest this also be folly, – to say, "I, in doing this, do strengthen God among men." When at any time hath he cried unto thee, saying, "My son, lend me thy shoulder, for I fall?" Deemest thou that the men who enter God's temple in malice, to the provoking of blood, and neither for his love nor for his wrath will abate their purpose, – shall afterwards stand with thee in the porch, midway between Him and themselves, to give ear unto thy thin voice, which merely the fall of their visors can drown, and to see thy hands, stretched feebly, tremble among their swords? Give thou to God no more than he asketh of thee; but to man also, that which is man's. In all that thou doest, work from thine own heart, simply; for his heart is as thine, when thine is wise and humble; and he shall have understanding of thee. One drop of rain is as another, and the sun's prism in all: and shalt not thou be as he, whose lives are the breath of One? Only by making thyself his equal can he learn to hold communion with thee, and at last own thee above him. Not till thou lean over the water shalt thou see thine image therein: stand erect, and it shall slope from thy feet and be lost. Know that there is but this means whereby thou may'st serve God with man: – Set thine hand and thy soul to serve man with God.'

And when she that spoke had said these words within Chiaro's spirit, she left his side quietly, and stood up as he had first seen her; with her fingers laid together, and her eyes steadfast, and with the breadth of her long dress covering her feet on the floor. And, speaking again, she said:

'Chiaro, servant of God, take now thine Art unto thee, and paint me thus, as I am, to know me: weak, as I am, and in the weeds of this time; only with eyes which seek out labour, and with a faith, not learned, yet jealous of prayer. Do this; so shall thy soul.'

And Chiaro did as she bade him. While he worked, his face grew solemn with knowledge: and before the shadows had turned, his work was done. Having finished, he lay back where he sat, and was asleep immediately: for the growth of that strong sunset was heavy about him, and he felt weak and haggard; like one just come out of a dusk, hollow country, bewildered with echoes, where he had lost himself, and who has not slept for many days and nights. And when she saw him lie back, the beautiful woman came to him, and sat at his head, gazing, and quieted his sleep with her voice.

The tumult of the factions had endured all that day through all Pisa, though Chiaro had not heard it: and the last service of that Feast was a mass sung at midnight from

the windows of all the churches for the many dead who lay about the city, and who had to be buried before morning, because of the extreme heats.

In the Spring of 1847 I was at Florence. Such as were there at the same time with myself – those, at least, to whom Art is something, – will certainly recollect how many rooms of the Pitti Gallery were closed through that season, in order that some of the pictures they contained might be examined, and repaired without the necessity of removal. The hall, the staircases, and the vast central suite of apartments, were the only accessible portions; and in these such paintings as they could admit from the sealed *penetralia* were profanely huddled together, without respect of dates, schools, or persons.

I fear that, through this interdict, I may have missed seeing many of the best pictures. I do not mean *only* the most talked of: for these, as they were restored, generally found their way somehow into the open rooms, owing to the clamours raised by the students; and I remember how old Ercoli's, the curator's, spectacles used to be mirrored in the reclaimed surface, as he leaned mysteriously over these works with some of the visitors, to scrutinize and elucidate.

One picture, that I saw that Spring, I shall not easily forget. It was among those, I believe, brought from the other rooms, and had been hung, obviously out of all chronology, immediately beneath that head by Raphael so long known as the 'Berrettino,' and now said to be the portrait of Cecco Ciulli.

The picture I speak of is a small one, and represents merely the figure of a woman, clad to the hands and feet with a green and grey raiment, chaste and early in its fashion, but exceedingly simple. She is standing: her hands are held together lightly, and her eyes set earnestly open.

The face and hands in this picture, though wrought with great delicacy, have the appearance of being painted at once, in a single sitting: the drapery is unfinished. As soon as I saw the figure, it drew an awe upon me, like water in shadow. I shall not attempt to describe it more than I have already done; for the most absorbing wonder of it was its literality. You knew that figure, when painted, had been seen; yet it was not a thing to be seen of men. This language will appear ridiculous to such as have never looked on the work; and it may be even to some among those who have. On examining it closely, I perceived in one corner of the canvass the words *Manus Animam pinxit* [the hand has painted the soul], and the date 1239. [. . .]

3 Charles Dickens (1812–1870) 'Old Lamps for New Ones'

The principles upon which the Pre-Raphaelite Brotherhood was formed owed much to the example of the Nazarenes in Germany. It was their shared belief that the art of the period before Raphael was distinguished by a purity of faith and expression not to be discovered in subsequent art. In this belief they were on common ground with Pugin and with others who looked for a renewal of design and craftsmanship as an index of the spiritual health of society (see IIA4; Dickens makes passing reference to Pugin's role in the revival of 'gothic' forms of typography). Though their paintings were the results of painstaking and detailed observation, the misconception to which they rendered themselves vulnerable was that

they were proposing to reverse the technical and intellectual development of art and to restore the 'primitive' styles of the early Renaissance. As a consequence they were subject to a tactic familiar in French responses to Realist painting: writers tended to interpret the deliberate avoidance of classical idealization as the sign of wilful incompetence and of a misguided pursuit of ugliness, particularly where the treatment of the human figure was concerned (compare also Galeotti's critique of the Italian Purists, IIIc7). Dickens's apparent misunderstanding of the Brotherhood's aims was no doubt strategic and deliberate, though his dislike of their work was evidently sincere enough. The painting to which he pays particular attention is *Christ in the House of His Parents* by Millais, now in the collection of the City of Birmingham Museum and Art Gallery. Among other references: 'Young England' was a contemporary revivalist movement; the mention of 'desecration' in connection with the Post Office concerns a defeated proposal for deliveries of mail on a Sunday; Hogarth had published a pictorial *Satire on False Perspective* in 1754. The article was originally published in *Household Words, a Weekly Journal conducted by Charles Dickens*, volume 1, no. 12, London, 15 June 1850, pp. 265–7, from which source this text is taken.

The Magician in 'Aladdin' may possibly have neglected the study of men, for the study of alchemical books; but it is certain that in spite of his profession he was no conjuror. He knew nothing of human nature, or the everlasting set of the current of human affairs. If, when he fraudulently sought to obtain possession of the wonderful Lamp, and went up and down, disguised, before the flying-palace, crying New Lamps for Old ones, he had reversed his cry, and made it Old Lamps for New ones, he would have been so far before his time as to have projected himself into the nineteenth century of our Christian Era.

This era is so perverse, and is so very short of faith – in consequence, as some suppose, of there having been a run on that bank for a few generations – that a parallel and beautiful idea, generally known among the ignorant as the Young England hallucination, unhappily expired before it could run alone, to the great grief of a small but a very select circle of mourners. There is something so fascinating, to a mind capable of any serious reflection, in the notion of ignoring all that has been done for the happiness and elevation of mankind during three or four centuries of slow and dearly-bought amelioration, that we have always thought it would tend soundly to the improvement of the general public, if any tangible symbol, any outward and visible sign, expressive of that admirable conception, could be held up before them. We are happy to have found such a sign at last; and although it would make a very indifferent sign, indeed, in the Licensed Victualling sense of the word, and would probably be rejected with contempt and horror by any Christian publican, it has our warmest philosophical appreciation.

In the fifteenth century, a certain feeble lamp of art arose in the Italian town of Urbino. This poor light, Raphael Sanzio by name, better known to a few miserably mistaken wretches in these later days, as Raphael (another burned at the same time, called Titian), was fed with a preposterous idea of Beauty – with a ridiculous power of etherealizing, and exalting to the very Heaven of Heavens, what was most sublime and lovely in the expression of the human face divine on Earth – with the truly contemptible conceit of finding in poor humanity the fallen likeness of the angels of God, and raising it up again to their pure spiritual condition. This very fantastic whim

effected a low revolution in Art, in this wise, that Beauty came to be regarded as one of its indispensable elements. In this very poor delusion, Artists have continued until this present nineteenth century, when it was reserved for some bold aspirants to 'put it down.'

The Pre-Raphael Brotherhood, Ladies and Gentlemen, is the dread Tribunal which is to set this matter right. Walk up, walk up; and here, conspicuous on the wall of the Royal Academy of Art in England, in the eighty-second year of their annual exhibition, you shall see what this new Holy Brotherhood, this terrible Police that is to disperse all Post-Raphael offenders, has 'been and done!'

You come – in this Royal Academy Exhibition, which is familiar with the works of Wilkie, Collins, Etty, Eastlake, Mulready, Leslie, Maclise, Turner, Stanfield, Landseer, Roberts, Danby, Creswick, Lee, Webster, Herbert, Dyce, Cope, and others who would have been renowned as great masters in any age or country and you come, in this place, to the contemplation of a Holy Family. You will have the goodness to discharge from your minds all Post-Raphael ideas, all religious aspirations, all elevating thoughts; all tender, awful, sorrowful, ennobling, sacred, graceful, or beautiful associations; and to prepare yourselves, as befits such a subject – Pre-Raphaelly considered – for the lowest depths of what is mean, odious, repulsive, and revolting.

You behold the interior of a carpenter's shop. In the foreground of that carpenter's shop is a hideous, wry-necked, blubbering, red-headed boy, in a bed-gown; who appears to have received a poke in the hand, from the stick of another boy with whom he has been playing in an adjacent gutter, and to be holding it up for the contempla- tion of a kneeling woman, so horrible in her ugliness, that (supposing it were possible for any human creature to exist for a moment with that dislocated throat) she would stand out from the rest of the company as a Monster, in the vilest cabaret in France, or the lowest ginshop in England. Two almost naked carpenters, master and journey- man, worthy companions of this agreeable female, are working at their trade; a boy, with some small flavour of humanity in him, is entering with a vessel of water; and nobody is paying any attention to a snuffy old woman who seems to have mistaken that shop for the tobacconist's next door, and to be hopelessly waiting at the counter to be served with half an ounce of her favourite mixture. Wherever it is possible to express ugliness of feature, limb, or attitude, you have it expressed. Such men as the carpenters might be undressed in any hospital where dirty drunkards, in a high state of varicose veins, are received. Their very toes have walked out of Saint Giles's.

This, in the nineteenth century, and in the eighty-second year of the annual exhibition of the National Academy of Art, is the Pre-Raphael representation to us, Ladies and Gentlemen, of the most solemn passage which our minds can ever approach. This, in the nineteenth century, and in the eighty-second year of the annual exhibition of the National Academy of Art, is what Pre-Raphael Art can do to render reverence and homage to the faith in which we live and die! Consider this picture well. Consider the pleasure we should have in a similar Pre-Raphael rendering of a favourite horse, or dog, or cat; and, coming fresh from a pretty considerable turmoil about 'desecration' in connexion with the National Post Office, let us extol this great achievement, and commend the National Academy!

In further considering this symbol of the great retrogressive principle, it is parti-
cularly gratifying to observe that such objects as the shavings which are strewn on the
carpenter's floor are admirably painted; and that the Pre-Raphael Brother is indis-
putably accomplished in the manipulation of his art. It is gratifying to observe this,
because the fact involves no low effort at notoriety; everybody knowing that it is by no
means easier to call attention to a very indifferent pig with five legs, than to a
symmetrical pig with four. Also, because it is good to know that the National
Academy thoroughly feels and comprehends the high range and exalted purposes of
Art; distinctly perceives that Art includes something more than the faithful portrait-
ure of shavings, or the skilful colouring of drapery – imperatively requires, in short,
that it shall be informed with mind and sentiment; will on no account reduce it to a
narrow question of trade-juggling with a palette, palette-knife, and paint-box. It is
likewise pleasing to reflect that the great educational establishment foresees the
difficulty into which it would be led, by attaching greater weight to mere handicraft,
than to any other consideration – even to considerations of common reverence or
decency; which absurd principle, in the event of a skilful painter of the figure
becoming a very little more perverted in his taste, than certain skilful painters are
just now, might place Her Gracious Majesty in a very painful position, one of these
fine Private View Days.

Would it were in our power to congratulate our readers on the hopeful prospects of
the great retrogressive principle, of which this thoughtful picture is the sign and
emblem! Would that we could give our readers encouraging assurance of a healthy
demand for Old Lamps in exchange for New ones, and a steady improvement in the
Old Lamp Market! The perversity of mankind is such, and the untoward arrange-
ments of Providence are such, that we cannot lay that flattering unction to their souls.
We can only report what Brotherhoods, stimulated by this sign, are forming; and what
opportunities will be presented to the people, if the people will but accept them.

In the first place, the Pre-Perspective Brotherhood will be presently incorporated,
for the subversion of all known rules and principles of perspective. It is intended to
swear every P. P. B. to a solemn renunciation of the art of perspective on a soup-plate
of the willow pattern; and we may expect, on the occasion of the eighty-third
Annual Exhibition of the Royal Academy of Art in England, to see some pictures
by this pious Brotherhood, realizing Hogarth's idea of a man on a mountain
several miles off, lighting his pipe at the upper window of a house in the foreground.
But we are informed that every brick in the house will be a portrait; that the
man's boots will be copied with the utmost fidelity from a pair of Bluchers, sent
up out of Northamptonshire for the purpose; and that the texture of his hands
(including four chilblains, a whitlow, and ten dirty nails) will be a triumph of the
Painter's art.

A Society, to be called the Pre-Newtonian Brotherhood, was lately projected by a
young gentleman, under articles to a Civil Engineer, who objected to being considered
bound to conduct himself according to the laws of gravitation. But this young
gentleman, being reproached by some aspiring companions with the timidity of his
conception, has abrogated that idea in favour of a Pre-Galileo Brotherhood now
flourishing, who distinctly refuse to perform any annual revolution round the Sun,
and have arranged that the world shall not do so any more. The course to be taken by

the Royal Academy of Art in reference to this Brotherhood is not yet decided upon; but it is whispered that some other large Educational Institutions in the neighbourhood of Oxford are nearly ready to pronounce in favour of it.

Several promising Students connected with the Royal College of Surgeons have held a meeting, to protest against the circulation of the blood, and to pledge themselves to treat all the patients they can get, on principles condemnatory of that innovation. A Pre-Harvey-Brotherhood is the result, from which a great deal may be expected – by the undertakers.

In literature, a very spirited effort has been made, which is no less than the formation of a P. G. A. P. C. B., or Pre-Gower and Pre-Chaucer Brotherhood, for the restoration of the ancient English style of spelling, and the weeding out from all libraries, public and private, of those and all later pretenders, particularly a person of loose character named Shakespeare. It having been suggested, however, that this happy idea could scarcely be considered complete while the art of printing was permitted to remain unmolested, another society, under the name of the Pre-Laurentius Brotherhood, has been established in connexion with it, for the abolition of all but manuscript books. These Mr Pugin has engaged to supply, in characters that nobody on earth shall be able to read. And it is confidently expected by those who have seen the House of Lords, that he will faithfully redeem his pledge.

* * *

All these Brotherhoods, and any other society of the like kind, now in being or yet to be, have at once a guiding star, and a reduction of their great ideas to something palpable and obvious to the senses, in the sign to which we take the liberty of directing their attention. We understand that it is in the contemplation of each Society to become possessed, with all convenient speed, of a collection of such pictures; and that once, every year, to wit upon the first of April, the whole intend to amalgamate in a high festival, to be called the Convocation of Eternal Boobies.

4 John Everett Millais (1829–1896) Letter to Mrs Combe on *Before the Flood*

Millais was one of the founders of the Pre-Raphaelite Brotherhood in 1848, along with William Holman Hunt and Dante Gabriel Rossetti, his fellow students at the Royal Academy schools in London. When paintings in the detailed Pre-Raphaelite style were exhibited at the Academy in 1850, criticism was widespread. In the present letter, Millais articulates the ideas behind his work as if to counter charges such as those Dickens had levelled at his *Christ in the House of his Parents* (IIIc3). Principal among these is the belief that art reaches beyond sensory pleasure, and should aim at 'unworldly usefulness'. For Millais, the artist is a spiritual mentor of humankind, the artwork a kind of visual sermon. That said, art has its material side: the reason for the letter in the first place is to thank Mrs Combe for buying a friend's painting, and Millais closes by reminding her that his own work is for sale. The letter was written in 1851 and is reprinted from John Guille Millais, *The Life and Letters of Sir John Everett Millais*, volume 1, London: Methuen & Co., 1899, pp. 103–5.

83, Gower Street,

[May] 28th 1851

My Dear Mrs Combe, – I feel it a duty to render you my most heartfelt thanks for the noble appreciation of my dear friend Collins' work and character. I include character, for I cannot help believing, from the evident good feeling evinced in your letter, that you have thought more of the beneficial results the purchase may occasion him than of your personal gratification at possessing the picture.

You are not mistaken in thus believing him worthy of your kindest interests, for there are few so devotedly directed to the one thought of some day (through the medium of his art) turning the minds of men to good reflections and so heightening the profession as one of unworldly usefulness to mankind.

This is our great object in painting, for the thought of simply pleasing the senses would drive us to other pursuits requiring less of that unceasing attention so necessary to the completion of a perfect work.

I shall endeavour in the picture I have in contemplation – 'For as in the Days that were Before the Flood,' etc., etc. – to affect those who may look on it with the awful uncertainty of life and the necessity of always being prepared for death. My intention is to lay the scene at the marriage feast. The bride, elated by her happiness, will be playfully showing her wedding-ring to a young girl, who will be in the act of plighting her troth to a man wholly engrossed in his love, the parents of each uniting in congratulation at the consummation of their own and their children's happiness. A drunkard will be railing boisterously at another, less intoxicated, for his cowardice in being somewhat appalled at the view the open window presents – flats of glistening water, revealing but the summits of mountains and crests of poplars. The rain will be beating in the face of the terrified attendant who is holding out the shutter, wall-stained and running down with the wet, but slightly as yet inundating the floor. There will also be the glutton quietly indulging in his weakness, unheeding the sagacity of his grateful dog, who, thrusting his head under his hands to attract attention, instinctively feels the coming ruin. Then a woman (typical of worldly vanity) apparelled in sumptuous attire, withholding her robes from the contamination of his dripping hide. In short, all deaf to the prophecy of the Deluge which is swelling before their eyes – all but one figure in their midst, who, upright with closed eyes, prays for mercy for those around her, a patient example of belief standing with, but far from, them placidly awaiting God's will.

I hope, by this great contrast, to excite a reflection on the probable way in which sinners would meet the coming death – all on shore hurrying from height to height as the sea increases; the wretched self-congratulations of the bachelor who, having but himself to save, believes in the prospect of escape; the awful feelings of the husband who sees his wife and children looking in his face for support, and presently disappearing one by one in the pitiless flood as he miserably thinks of his folly in not having taught them to look to God for help in times of trouble; the rich man who, with his boat laden with wealth and provisions, sinks in sight of his fellow-creatures with their last curse on his head for his selfishness; the strong man's strength failing

gradually as he clings to some fragment floating away on the waste of water; and other great sufferers miserably perishing in their sins.

I have enlarged on this subject and the feelings that I hope will arise from the picture, as I know you will be interested in it. One great encouragement to me is the certainty of its having this one advantage over a sermon, that it will be all at once put before the spectator without that trouble of realization often lost in the effort of reading or listening.

My pleasure in having indirectly assisted two friends in the disposal of their pictures is enhanced by the assurance that you estimate their merits. It is with extreme pleasure that I received that letter from Mr Combe in which he approves of his picture of 'The Return of the Dove to the Ark,' universally acknowledged to be my best work, parts of which I feel incapable of surpassing. When you come to town I will show you many letters from strangers desirous of purchasing it, which is the best proof of its value in their eyes. The price I have fixed on my picture is a hundred and fifty guineas; and I hope some day you will let me paint you, as a companion, 'The Dove's First Flight,' which would make a beautiful pendant.

Ever yours affectionately,
John Everett Millais.

5 *The Times* Critic and John Ruskin (1819–1900) Exchange on the Pre-Raphaelites

On 3 and 7 May, 1851, *The Times* published a review of the annual Exhibition at the Royal Academy which contained forceful criticism of the paintings of the Pre-Raphaelites. The anonymous critic chastised the works of these artists as 'monkish follies', ridiculing them for adopting the style and mannerisms of an earlier age and for their neglect of the laws of perspective and of light and shade. Whilst insisting upon his non-affiliation to the group, John Ruskin wrote two letters to *The Times* defending their work from what he saw as unduly harsh and misplaced criticism. In the first, published on 13 May, he defends the 'truth' or accuracy both of the Pre-Raphaelites' treatment of perspective and of their depiction of detail, maintaining that 'there has been nothing in art so earnest and so complete as these pictures since the days of Dürer'. Although clearly uncomfortable with the term 'Pre-Raphaelite', Ruskin none the less rejects the accusation that these artists slavishly imitate the art of the past, maintaining that they seek only to free themselves of the accumulated artifices and conventions of academic picture-making. In the second letter of 26 May he raises a number of specific criticisms of the works in the exhibition, but this now on the basis of that 'more serious enquiry into their merits and faults' which he had urged in the first. After this letter there is found a response to Ruskin, defending the position taken up in the original review. The anonymous author goes on to criticize Ruskin for reducing the notion of artistic truth to mere imitation, raising arguments which Ruskin himself had developed in relation to the work of Turner in *Modern Painters* (see IIB6 and 7). The anonymous reviews of the exhibition at the Royal Academy were published in *The Times*, 3 May 1851, p. 8 and 7 May 1851, p. 8. The Pre-Raphaelite painters referred to are John Everett Millais, William Holman Hunt, Charles Allston Collins and Ford Madox Brown. The author also mentions John Henry Fuseli (1741–1825). Ruskin's letters in defence of the PRB were published in *The Times*, 13 May, 1851, p. 8. and 26 May 1851, p. 8. Ruskin

discusses Millais' *Mariana, The Return of the Dove to the Ark* and *The Woodman's Daughter*, Hunt's *Valentine Rescuing Sylvia from Proteus*, and Collins' *Convent Thoughts*. The 'response' of the anonymous reviewer was published in *The Times*, 26 May 1851, p. 8.

Anonymous reviews of the works of the Pre-Raphaelites

3 May 1851

* * *

[...] We cannot censure at present as amply or as strongly as we desire to do, that strange disorder of the mind or the eyes which continues to rage with unabated absurdity among a class of juvenile artists who style themselves P.R.B., which, being interpreted, means *Pre-Raphael-brethren*. Their faith seems to consist in an absolute contempt for perspective and the known laws of light and shade, an aversion to beauty in every shape, and a singular devotion to the minute accidents of their subjects, including, or rather seeking out, every excess of sharpness and deformity. Mr Millais, Mr Hunt, Mr Collins – and in some degree – Mr Brown, the author of a huge picture of Chaucer, have undertaken to reform the art on these principles. The Council of the Academy, acting in a spirit of toleration and indulgence to young artists, have now allowed these extravagances to disgrace their walls for the last three years, and though we cannot prevent men who are capable of better things from wasting their talents on ugliness and conceit, the public may fairly require that such offensive jests should not continue to be exposed as specimens of the waywardness of these artists who have relapsed into the infancy of their profession.

* * *

7 May 1851

In the North Room will be found, too, Mr Millais' picture of 'The Woodman's Daughter,' from some verses by Mr Coventry Patmore, and as the same remarks will apply to the other pictures of the same artist, 'The Return of the Dove to the Ark' and Tennyson's 'Mariana' as well as to similar works by Mr Collins, as 'Convent Thoughts', and to Mr Hunt's 'Valentine receiving Proteus' we shall venture to express our opinion on them all in this place. These young artists have unfortunately become notorious by addicting themselves to an antiquated style and an affected simplicity in Painting, which is to genuine art what the mediaeval ballads and designs in *Punch* are to Chaucer and Giotto. With the utmost readiness to humour even the caprices of Art when they bear the stamp of originality and genius, we can extend no toleration to a mere servile imitation of the cramped style, false perspective, and crude colour of remote antiquity. We do not want to see what Fuseli termed drapery 'snapped instead of folded,' faces bloated into apoplexy or extenuated to skeletons, colour borrowed from the jars in a druggist's shop, and expression forced into caricature. It is said that the gentlemen have the power to do better things, and we are referred in proof of their handicraft to the mistaken skill with which they have transferred to canvas the hay which lined the lofts in Noah's Ark, the brown leaves of the coppice where Sylvia strayed, and the prim vegetables of a monastic garden. But

we must doubt a capacity of which we have seen so little proof, and if any such capacity did ever exist in them, we fear that it has already been overlaid by mannerism and conceit. To become great in art, it has been said that a painter must become as a little child, though not childish, but the authors of these offensive and absurd productions have continued to combine the puerility or infancy of their art with the uppishness and self-sufficiency of a different period of life. That morbid infatuation which sacrifices truth, beauty, and genuine feeling to mere eccentricity deserves no quarter at the hands of the public, and though the patronage of art is sometimes lavished on oddity as profusely as on higher qualities, these monkish follies have no more real claim to figure in any decent collection of English paintings than the aberrations of intellect which are exhibited under the name of Mr Ward.

* * *

John Ruskin, letter in defence of the PRB, 13 May 1851

Sir:– Your usual liberty will, I trust, give a place in your columns to this expression of my regret that the tone of the critique which appeared in *The Times* of Wednesday last on the works of Mr Millais and Mr Hunt, now in the Royal Academy, should have been scornful as well as severe.

I regret it, first, because the mere labour bestowed on these works, and their fidelity to a certain order of truth (labour and fidelity which are altogether indisputable) ought at once to have placed them above the level of mere contempt; and, secondly, because I believe these young artists to be at a most critical period of their career – at a turning point, from which they may either sink into nothingness or rise to a very real greatness; and I believe also, that whether they choose the upward or downward path may in no small degree depend upon the character of the criticism which their works have to sustain. I do not wish in any way to dispute or invalidate the general truth of your critique on the Royal Academy; nor am I surprised at the estimate which the writer formed of the pictures in question when, rapidly compared with works of a totally different style and aim; nay, when first I saw the chief pictures by Millais in the Exhibition of last year I had nearly come to the same conclusions myself. But I ask for your permission, in justice to artists who have at least given much time and toil to their pictures, to institute some more serious enquiry into their merits and faults than your general notice of the Academy could possibly have admitted.

Let me state, in the first place, that I have no acquaintance with any of these artists and very imperfect sympathy with them. No one who has met with any of my writings will suspect me of desiring to encourage them in their Romanist and Tractarian tendencies. I am glad to see that Mr Millais' lady in blue is heartily tired of her painted window and idolatrous toilet-table; and I have no particular respect for Mr Collins' lady in white, because her sympathies are limited by a dead wall, or divided between some gold fish and a tadpole – (the latter Mr Collins may, perhaps, permit me to suggest *en passant*, as he is already half a frog, is rather too small for his age). But I happen to have a special acquaintance with the water plant *Alisma Plantago*, among which the said gold fish are swimming; and as I never saw it so thoroughly or so well

drawn, I must take leave to remonstrate with you, when you say sweepingly that these men 'sacrifice *truth* as well as feeling to eccentricity.' For as a mere botanical study of the water-lily and *Alisma*, as well as of the common lily and several other garden flowers, this picture would be invaluable to me, and I heartily wish it were mine.

But, before entering into such particulars, let me correct an impression which your article is likely to induce in most minds, and which is altogether false. These Pre-Raphaelites (I cannot compliment them on common-sense in choice of a *nom de guerre*) do *not* desire nor pretend in any way to imitate antique painting as such. They know very little of ancient paintings who suppose the works of these young artists to resemble them. As far as I can judge of their aim – for, as I said, I do not know the men themselves – the Pre-Raphaelites intend to surrender no advantage which the knowledge or inventions of the present time can afford to their art. They intend to return to early days in this one point only – that, as far as in them lies, they will draw either what they see, or what they suppose might have been the actual facts of the scene they desire to represent, irrespective of any conventional rules of picture-making; and they have chosen their unfortunate though not inaccurate name because all artists did this before Raphael's time, and after Raphael's time did *not* this, but sought to paint fair pictures, rather than represent stern facts; of which the consequence has been that, from Raphael's time to this day, historical art has been in acknowledged decadence.

Now, sir, presupposing that the intention of these men was to return to archaic *art* instead of to archaic *honesty*, your critic borrows Fuseli's expression respecting ancient draperies 'snapped instead of folded,' and asserts that in these pictures there is a '*servile* imitation of *false* perspective.' To which I have just this to answer:

That there is not one single error in perspective in four out of the five pictures in question; and that in Millais' 'Mariana' there is but this one – that the top of the green curtain in the distant window has too low a vanishing-point; and that I will undertake, if need be, to point out and prove a dozen worse errors in perspective in any twelve pictures, containing architecture, taken at random from among the works of the popular painters of the day.

Secondly: that, putting aside the small Mulready, and the works of Thorburn and Sir W. Ross, and perhaps some others of those in the miniature room which I have not examined, there is not a single study of drapery in the whole Academy, be it in large works or small, which for perfect truth, power and finish could be compared for an instant with the black sleeve of the Julia, or with the velvet on the breast and the chain mail of the Valentine, of Mr Hunt's picture; or with the white draperies on the table of Mr Millais' 'Mariana,' and of the right-hand figure in the same painter's 'Dove returning to the Ark.'

And further: that as studies both of drapery and of every minor detail, there has been nothing in art so earnest or so complete as these pictures since the days of Albert Durer. This I assert generally and fearlessly. On the other hand, I am perfectly ready to admit that Mr Hunt's 'Sylvia' is not a person whom Proteus or any one else would have been likely to fall in love with at first sight; and that one cannot feel very sincere delight that Mr Millais' 'Wives of the Sons of Noah' should have escaped the Deluge;

and many other faults besides, on which I will not enlarge at present, because I have already occupied too much of your valuable space, and I hope to enter into more special criticism in a future letter.

I have the honour to be, Sir,

Your obedient servant,

The author of 'Modern Painters'

John Ruskin, letter in defence of the PRB, 26 May 1851

Sir:

Your obliging insertion of my former letter encourages me to trouble you with one or two further notes respecting the Pre-Raphaelite pictures. I had intended, in continuation of my first letter, to institute as close an inquiry as I could into the character of the morbid tendencies which prevent these works from favourably arresting the attention of the public; but I believe there are so few pictures in the Academy whose reputation would not be grievously diminished by a deliberate inventory of their errors, that I am disinclined to undertake so ungracious a task with respect to this or that particular work. These points, however, may be noted, partly for the consideration of the painters themselves, partly that forgiveness of them may be asked from the public in consideration of high merits in other respects.

The most painful of these defects is unhappily also the most prominent – the commonness of feature in many of the principal figures. In Mr Hunt's 'Valentine defending Sylvia,' this is, indeed, almost the only fault. Further examination of this picture has even raised the estimate I had previously formed of its marvellous truth in detail and splendour in colour; nor is its general conception less deserving of praise; the action of Valentine, his arm thrown round Sylvia, and his hand clasping hers at the same instant as she falls at his feet, is most faithful and beautiful, nor less so the contending of doubt and distress with awakening hope in the half-shadowed, half-sunlit countenance of Julia. Nay, even the momentary struggle of Proteus with Sylvia just past, is indicated by the trodden grass and broken fungi of the foreground. But all this thoughtful conception, and absolutely inimitable execution, fail in making immediate appeal to the feelings, owing to the unfortunate type chosen for the face of Sylvia. Certainly this cannot be she whose lover was

> 'As rich in having such a jewel,
> As twenty seas, if all their sands were pearl.'

Nor is it, perhaps, less to be regretted that, while in Shakspeare's play there are nominally 'Two Gentlemen,' in Mr Hunt's picture there should only be one – at least, the kneeling figure on the right has by no means the look of a gentleman. But this may be on purpose, for any one who remembers the conduct of Proteus throughout the previous scenes will, I think, be disposed to consider that the error lies more in Shakspeare's nomenclature than in Mr Hunt's ideal.

No defence can, however, be offered for the choice of features in the left-hand figure of Mr Millais' 'Dove returning to the Ark.' I cannot understand how a painter so sensible of the utmost refinement of beauty in other objects should deliberately

choose for his model a type far inferior to that of average humanity, and unredeemed by any expression save that of dull self-complacency. Yet, let the spectator who desires to be just turn away from this head, and contemplate rather the tender and beautiful expression of the stooping figure, and the intense harmony of colour in the exquisitely finished draperies; let him note also the ruffling of the plumage of the wearied dove, one of its feathers falling on the arm of the figure which holds it, and another to the ground, where, by the bye, the hay is painted not only elaborately, but with the most perfect ease of touch and mastery of effect, especially to be observed because this freedom of execution is a modern excellence, which it has been inaccurately stated that these painters despise, but which, in reality, is one of the remarkable distinctions between their painting and that of Van Eyck or Memling, which caused me to say in my first letter that 'those knew little of ancient painting who supposed the works of these men to resemble it.'

Next to this false choice of feature, and in connection with it, is to be noted the defect in the colouring of the flesh. The hands, at least in the pictures in Millais, are almost always ill painted, and the flesh tint in general is wrought out of crude purples and dusky yellows. It appears just possible that much of this evil may arise from the attempt to obtain too much transparency – an attempt which has injured also not a few of the best works of Mulready. I believe it will be generally found that close study of minor details is unfavourable to flesh painting; it was noticed of the drawing by John Lewis, in the old water-colour exhibition of 1850, (a work which, as regards its treatment of detail, may be ranged in the same class with the Pre-Raphaelite pictures), that the faces were the worst painted portions of the whole.

The apparent want of shade is, however, perhaps the fault which most hurts the general eye. The fact is, nevertheless, that the fault is far more in the other pictures of the Academy than in the Pre-Raphaelite ones. It is the former that are false, not the latter, except so far as every picture must be false which endeavours to represent living sunlight with dead pigments. I think Mr Hunt has a slight tendency to exaggerate reflected lights; and if Mr Millais has ever been near a piece of good painted glass, he ought to have known that its tone is more dusky and sober than that of his Mariana's window. But for the most part these pictures are rashly condemned because the only light which we are accustomed to see represented is that which falls on the artist's model in his dim painting room, not that of sunshine in the fields.

I do not think I can go much further in fault-finding. I had, indeed, something to urge respecting what I supposed to be the Romanizing tendencies of the painters; but I have received a letter assuring me that I was wrong in attributing to them anything of the kind; whereupon, all that I can say is that, instead of the 'pilgrimage' of Mr Collins' maiden over a plank and round a fish-pond, that old pilgrimage of Christiana and her children towards the place where they should 'look the Fountain of Mercy in the face,' would have been more to the purpose in these times. And so I wish them all heartily good-speed, believing in sincerity that if they temper the courage and energy which they have shown in the adoption of their systems with patience and discretion in framing it, and if they do not suffer themselves to be driven by harsh or careless criticism into rejections of the ordinary means of obtaining influence over

the minds of others, they may, as they gain experience, lay in our England the foundations of a school or art nobler than the world has seen for three hundred years. I have the honour to be, Sir,
Your obedient servant,
The author of 'Modern Painters'

Anonymous response to Ruskin, 26 May 1851

We should find it no difficult task to destroy the web which the paradoxical ingenuity of our correspondent, the 'Author of *Modern Painters*' has spun, but we must confine our reply within narrower limits than the letters with which he has favoured us. If we spoke with severity of the productions of the young artists to which this correspondence relates, it was with a sincere desire to induce them, if possible, to relinquish what is absurd, morbid, and offensive in their works, and to cultivate whatever higher and better qualities they possess; but at present these qualities are wholly overlaid by the vices of a style which has probably answered its purpose by obtaining for these young gentlemen a notoriety less hard to bear, even in the shape of ridicule, than public indifference. This perversion of talent – if talent they have – we take to be fairly obnoxious to criticism; and we trust the authority of the 'Author of *Modern Painters*' will not have the opposite effect of perpetuating or increasing the defects of a style which, in spite of his assertions, we hold to be a flagrant violation of nature and truth. In fact, Mr Ruskin's own works might prove the best antidote to any such false theory; for (if we remember rightly) he has laid it down in his defence of Mr Turner's landscapes, that truth in painting is not the mere imitative reproduction of this or that object, as they *are*, but the reproduction or image of the general effect given by an assemblage of objects as they *appear* to the sight. Mr Millais and his friends have taken refuge in the opposite extreme of exaggeration from Mr Turner; but, as extremes meet, they both find an apologist in the same critic. Aerial perspective, powerful contrasts of light and shade, with form and colour fused in the radiance of the atmosphere, are characteristics of Mr Turner. The P.R.B.s, to whom the 'Author of *Modern Painters*' has transferred his affections, combine a repulsive precision of ugly shape with monotony of tone in such works as 'Sylvia' or 'Convent Thoughts', or distorted expression, as in 'Mariana' or the 'Dove in the Ark'. Mere truth of imitation in the details of a flower or a lock of hair cease to be truth in combination with the laws of effect. Nobody compares the pimples on a face by Denner with the broad flesh of Titian. Many of our correspondent's assertions may be more summarily disposed of by reference to the pictures in question than by discussion in this place; but though he has carried the rights of defence to their utmost limits, we submit that enough remains, even on his own admissions, to condemn these unfortunate attempts, and that the mere expression of a difference of taste does not suffice to shake any of those established rules of art and criticism upon which such works have been tried and found wanting. It will give us great pleasure if we find next year that these young painters are able to throw off the monkish disguise in which they have been fooling, and stand forth as the founders of the illustrious school which our correspondent announces to the world.

6 John Ruskin (1819–1900) 'The Nature of Gothic'

By 1846 the first two volumes of *Modern Painters* (see IIb6 and 7) had appeared. In the second half of the 1840s, Ruskin's interest came to centre on architecture, and particularly Gothic architecture. In 1848 he visited the cathedrals of Northern France, and by the next year had published *The Seven Lamps of Architecture*. Later the same year he went to Venice for an extended stay, which gave rise to *The Stones of Venice*. The first volume appeared in 1851, and was followed by a second in 1853. 'The Nature of Gothic' forms chapter six of that work. The early pages of this – extensive – chapter attempt to imaginatively encompass not merely the essence of the Gothic style, but the Gothic character. Using the conceit of a migrating bird, flying over the European continent, Ruskin suggests a fundamental difference between the Mediterranean, classically dominated cultures, and those others, north of the Alps, which he identifies as 'Gothic' in spirit. The present extracts are drawn from the 1853 edition, London: Smith and Elder, sections I, IV, VI, VII and VIII of chapter six, pp. 151–8.

[. . .] I shall endeavour . . . to give the reader in this chapter an idea, at once broad and definite, of the true nature of *Gothic* architecture, properly so called; not of that of Venice only, but of universal Gothic [. . .]

[. . .] We shall find that Gothic architecture has external forms, and internal elements. Its elements are certain mental tendencies of the builders, legibly expressed in it; as fancifulness, love of variety, love of richness, and such others. Its external forms are pointed arches, vaulted roofs, &c. And unless both the elements and the forms are there, we have no right to call the style Gothic. It is not enough that it has the Form, if it have not also the power and life. It is not enough that it has the Power, if it have not the form. [. . .]

I believe, that the characteristic or moral elements of Gothic are the following, placed in the order of their importance:

1. Savageness.
2. Changefulness.
3. Naturalism.
4. Grotesqueness.
5. Rigidity.
6. Redundance.

These characters are here expressed as belonging to the building; as belonging to the builder, they would be expressed thus: – 1. Savageness, or Rudeness. 2. Love of Change. 3. Love of Nature. 4. Disturbed Imagination. 5. Obstinacy. 6. Generosity. And I repeat, that the withdrawal of any one, or any two, will not at once destroy the Gothic character of a building, but the removal of a majority of them will. [. . .]

I am not sure when the word 'Gothic' was first generically applied to the architecture of the North; but I presume that, whatever the date of its original usage, it was intended to imply reproach, and express the barbaric character of the nations among whom that architecture arose. It never implied that they were literally of Gothic lineage, far less that their architecture had been originally invented by the Goths themselves; but it did imply that they and their buildings together exhibited a degree

of sternness and rudeness, which, in contradistinction to the character of Southern and Eastern nations, appeared like a perpetual reflection of the contrast between the Goth and the Roman in their first encounter. And when that fallen Roman, in the utmost impotence of his luxury, and insolence of his guilt, became the model for the imitation of civilized Europe, at the close of the so-called Dark ages, the word Gothic became a term of unmitigated contempt, not unmixed with aversion. From that contempt, by the exertion of the antiquaries and architects of this century, Gothic architecture has been sufficiently vindicated; and perhaps some among us, in our admiration of the magnificent science of its structure, and sacredness of its expression, might desire that the term of ancient reproach should be withdrawn, and some other, of more apparent honourableness, adopted in its place. There is no chance, as there is no need, of such a substitution. As far as the epithet was used scornfully, it was used falsely; but there is no reproach in the word, rightly understood; on the contrary, there is a profound truth, which the instinct of mankind almost unconsciously recognizes. It is true, greatly and deeply true, that the architecture of the North is rude and wild; but it is not true, that, for this reason, we are to condemn it, or despise. Far otherwise: I believe it is in this very character that it deserves our profoundest reverence.

. . . The charts of the world which have been drawn up by modern science have thrown into a narrow space the expression of a vast amount of knowledge, but I have never yet seen any one pictorial enough to enable the spectator to imagine the kind of contrast in physical character which exists between Northern and Southern countries. We know the differences in detail, but we have not that broad glance and grasp which would enable us to feel them in their fulness. We know that gentians grow on the Alps, and olives on the Apennines; but we do not enough conceive for ourselves that variegated mosaic of the world's surface which a bird sees in its migration, that difference between the district of the gentian and of the olive which the stork and the swallow see far off, as they lean upon the sirocco wind. Let us, for a moment, try to raise ourselves even above the level of their flight, and imagine the Mediterranean lying beneath us like an irregular lake, and all its ancient promontories sleeping in the sun: here and there an angry spot of thunder, a grey stain of storm, moving upon the burning field; and here and there a fixed wreath of white volcano smoke, surrounded by its circle of ashes; but for the most part a great peacefulness of light, Syria and Greece, Italy and Spain, laid like pieces of a golden pavement into the sea-blue, chased, as we stoop nearer to them, with bossy beaten work of mountain chains, and glowing softly with terraced gardens, and flowers heavy with frankincense, mixed among masses of laurel, and orange, and plumy palm, that abate with their grey-green shadows the burning of the marble rocks, and of the ledges of porphyry sloping under lucent sand. Then let us pass farther towards the north, until we see the orient colours change gradually into a vast belt of rainy green, where the pastures of Switzerland, and poplar valleys of France, and dark forests of the Danube and Carpathians stretch from the mouths of the Loire to those of the Volga, seen through clefts in grey swirls of rain-cloud and flaky veils of the mist of the brooks, spreading low along the pasture lands: and then, farther north still, to see the earth heave into mighty masses of leaden rock and heathy moor, bordering with a broad waste of gloomy purple that belt of field and wood, and splintering into irregular and grisly islands amidst the northern

seas, beaten by storm, and chilled by ice-drift, and tormented by furious pulses of contending tide, until the roots of the last forests fail from among the hill ravines, and the hunger of the north wind bites their peaks into barrenness; and, at last, the wall of ice, durable like iron, sets, deathlike, its white teeth against us out of the polar twilight. And, having once traversed in thought this gradation of the zoned iris of the earth in all its material vastness, let us go down nearer to it, and watch the parallel change in the belt of animal life: the multitudes of swift and brilliant creatures that glance in the air and sea, or tread the sands of the southern zone; striped zebras and spotted leopards, glistening serpents, and birds arrayed in purple and scarlet. Let us contrast their delicacy and brilliancy of colour, and swiftness of motion, with the frost-cramped strength, and shaggy covering, and dusky plumage of the northern tribes; contrast the Arabian horse with the Shetland, the tiger and leopard with the wolf and bear, the antelope with the elk, the bird of paradise with the osprey: and then, submissively acknowledging the great laws by which the earth and all that it bears are ruled throughout their being, let us not condemn, but rejoice in the expression by man of his own rest in the statutes of the lands that gave him birth. Let us watch him with reverence as he sets side by side the burning gems, and smooths with soft sculpture the jasper pillars, that are to reflect a ceaseless sunshine, and rise into a cloudless sky: but not with less reverence let us stand by him, when, with rough strength and hurried stroke, he smites an uncouth animation out of the rocks which he has torn from among the moss of the moorland, and heaves into the darkened air the pile of iron buttress and rugged wall, instinct with work of an imagination as wild and wayward as the northern sea; creations of ungainly shape and rigid limb, but full of wolfish life; fierce as the winds that beat, and changeful as the clouds that shade them.

There is, I repeat, no degradation, no reproach in this, but all dignity and honour-ableness: and we should err grievously in refusing either to recognize as an essential character of the existing architecture of the North, or to admit as a desirable character in that which it yet may be, this wildness of thought, and roughness of work; this look of mountain brotherhood between the cathedral and the Alp; this magnificence of sturdy power, put forth only the more energetically because the fine finger-touch was chilled away by the frosty wind, and the eye dimmed by the moor-mist, or blinded by the hail; this outspeaking of the strong spirit of men who may not gather redundant fruitage from the earth, nor bask in dreamy benignity of sunshine, but must break the rock for bread, and cleave the forest for fire, and show, even in what they did for their delight, some of the hard habits of the arm and heart that grew on them as they swung the axe or pressed the plough. [. . .]

7 Melchior Galeotti (1824–1870) Critique of the Purists

Melchior Galeotti is principally known for his later studies of Sicilian painting and sculpture. At the age of 28 he published a pamphlet entitled *Sull'arte pittorica e sulle attuali dottrine della medessima* (On the pictorial arts and the topical doctrines of the present day). In it he identifies Purism and Naturalism as competing offshoots of the same root, connecting their rise to prominence with the decline of Idealism, or neo-classicism, whose principal

representative in Italy had been the German painter Anton Raphael Mengs (1728–79). Like Bianchini (see IIB8, above), Galeotti recognizes that the debate surrounding Purism in the visual arts was an extension of a dispute which had already broken out in the field of literature. Unlike Bianchini, however, he criticizes the Purists for adopting the same 'super-stitions' as their literary counterparts, maintaining that they have 'abandoned nature' and given themselves up to an 'extravagant and deformed style of painting'. His second point of reference is the correct evaluation of the work of the Carracci brothers, Agostino (1557–1602) and Annibale (1560–1609). Galeotti insists on the greatness and vitality of the school of the Carracci, contrasting it with the enervated and lifeless products of the Purists themselves. *Sull'arte pittorica e sulle attuali dottrine della medessima* was published in Palermo in 1852. These extracts have been translated for the present volume by Olivia Dawson and Jason Gaiger from the text as reprinted in Paola Barocchi, *Testimonianze e polemiche figurative in Italia*, Messina and Florence: Casa Editrice G. D'Anna, 1972, pp. 202–4.

Now, to return to the subject of contemporary painting, I hold Mengs's precepts to have been far more damaging than his actual practice. For whilst in his paintings he showed that strict adherence to the example of Greek art, especially with regard to form, is of the highest value in painting, the majority of his generation of artists, overlapping with our own childhood, is deserving only of our laughter and scorn. His writings, however, contain all the sophistic principles to which a theory based on the ideal can give rise and are harmful to art. As soon as this first erroneous and aberrant maxim fell, two others took its place, both made of the same stuff, the one unnatural and the other anti-pictorial. Although offshoots of the same root, they tend in opposite directions and are in conflict with one another, contesting for sovereignty. Contemporary painting is trapped within the circle of these two warring factions. It must be clear to everyone that I am speaking about Purism and Naturalism. These elegant names, having created great commotion and undignified and fruitless conflicts in the world of literature, have now entered into the studio of the artist, causing an even greater tumult. However, they have not caught the world's attention as they did before, either because their goods are out of date and the demand today is for continuous *nouveautés*, or because little importance is given to the art of painting and little is cared for the opinions of artists and their quarrels. The purity of the written language has always been, and always must be, held in the highest regard, for it is only through safeguarding its purity that the individual character of a language can be preserved: foreign words and constructions should be excluded which, if they take root, must inevitably contaminate the customs and ideas of a culture. But in Italy, as a result of an extreme and justly scrupulous zeal in dealing with equally extreme circumstances, those who could see no further than the writers of the fourteenth century made the purity of language into an issue and set it up in opposition to the living idiom of language which is constantly growing and changing. These thinkers wanted to return us to a highly restricted, if distinguished, circle of fourteenth-century authors, even though these writers have been superseded by five centuries of innovation, diversity, change and discovery. Yet they rejected many words as antiquated, and in so doing they themselves put forward the principal argument which militates against their proposals, that is, that certain expressions become obsolete. The demand for purism resulted in a superstitious admiration for the first

writers in the Italian vernacular. Both the positive and the negative results of their studies are known to us all, as are the inane results of their contrived attempts at imitation. It is not my intention to dwell on this here. But I do ask: is it reasonable to adopt these same superstitions in the art of painting? Should we follow the proposals or the example of the Germans who want to reduce painting to what it was in its childhood and adolescence, from Cimabue to Fra Angelico and Perugino? On the one hand, they present a strong argument for the impossibility of an ideal without precedents. On the other hand, what they have produced, their constant changes of direction and their failure to find a satisfactory intellectual and aesthetic model, show how misguided it is to seek to find this ideal in the work of human hands rather than directly in reality itself. It is ridiculous to expect to realize this ideal by imitating the first steps which were made in the pictorial representation of nature. [...]

* * *

All manner of unusual, extravagant, and deformed styles of painting have resulted from the presumptuous desire to abandon or transform nature as we find her. These are applauded for reasons of fashion rather than true feeling, and after a short time are universally scorned. And now this bizarre and turbid purism has arrived which healthy common sense must reject, considering that it was born in a country in which metaphysical systems and aesthetic theories tend to precede artistic and literary creations, and where originality is expected to be achieved by the force of reflection alone. Allusive creations are supposed to signify the most difficult concepts of the human spirit and one sees, or wishes to make oneself see, something strange, transcendent, mystical and sublime in their figures, which seem to aspire to the taste of the mosaicists of the thirteenth century. What is most peculiar, however, is that they expect to revive the art of painting in this manner. They attack the Carracci, saying that far from reforming painting and returning it to its proper path, they diverted it from its true purpose, leading it away from its earlier value and perfection. I do not hold it necessary to respond to these accusations, for they incorporate principles which are permanently at war with the truth and have never led, nor will ever lead, to reconciliation with beauty. But you who stumble along behind the shadows of your imagination, which you then display before you in accordance with some measure of beauty, you who believe that you must depose from their throne those great artists who were true masters, those artists who, notwithstanding confusions and differences between the schools, shared a common goal and reached such greatness as to triumph through the centuries and over every strange and contrived fashion – what have you achieved that can be measured against the school of the Carracci? From this school, which saved painting when your principles, which in substance are old, had adulterated and spoiled it, arose Domenichino, Guido and Albani. There is no need to list all the numerous masterpieces; it suffices to mention the *Communion of St Jerome*. This famous painting, placed opposite the *Transfiguration*, fills the observer with astonishment and enchantment in equal measure, and one never tires of long admiration. You, however, amidst so many tedious and futile declarations, have never achieved, nor will ever achieve, a single figure that could withstand comparison with this paragon. Since you abhor the studies which are essential to art, without which no amount of brush work will succeed in achieving that clarity which is the soul of painting and which, I would claim, is the

highest expression of beauty, you will always remain below that pinnacle of perfection, no matter how high you flatter yourselves to have ascended. You float to and fro, lost among vaporous concepts which, through an excessive and misconceived spirituality, waste away the flesh, bones, muscles, energy and life of your figures. You must realize that to reach these heights a brief and impetuous flight, like that of a partridge, will not suffice, but only one that is long and steady like the flight of an eagle.

8 Pietro Selvatico (1803–1880) on the Merits of the Purists

For further information on Selvatico see IB11, above. Selvatico's hostility to academicism and his admiration for the art of the medieval and early Renaissance periods was informed by his knowledge of the writings of Wilhelm Wackenroder and Ludwig Tieck, as well as the Idealism of G. W. F. Hegel (see IA10, above). He responded positively to the ideas of the Purists, and whilst not insensitive to the excesses of some of them, he sought to defend Purism against the accusations which had been raised against it. In the following extracts from his essay *Del purismo nella pittura* (On Purism in painting), Selvatico responds point for point to the criticisms which Bianchini had summarized in his earlier discussion (see IIB8, above). The passages in inverted commas refer back to this text. Selvatico's essay was included in his *Scritti d'arte*, published in Florence in 1859. This translation has been made for the present volume by Olivia Dawson and Jason Gaiger from the text as reprinted in Paola Barocchi, *Testimonianze e polemiche figurative in Italia*, Messina and Florence: Casa Editrice G. D' Anna, 1972, pp. 207–8, 209–12.

The Nazarenes

To those who look to the stirrings of man's affections more than to his great deeds, it must have been a very moving sight to observe, at the beginning of the present century, a band of young Germans – poor almost to the point of indigence – wandering amongst the august structures that the gospel had built upon the ruins of Imperial Rome. There amongst the primitive basilicas where, in the age of faith, Christians had shed their tears and joy, their earthly thoughts and hopes, these errant supplicants went about retracing the traditions of archaic art, hoping to give new life to art, which had been corrupted by the influence of the Carracci which was at that time spreading about the world like the devastations wrought by Napoleon. The guardians of the status quo laughed at the sight of these poor foreign pilgrims wandering through Rome who, after having religiously gathered the remnants of forgotten Christian art, retreated to an abandoned convent where they ate almost like anchorites and posed for each other because they did not have the means to pay for a model. Because of their long wavy hair, which they wore to the shoulders in the German fashion, they were derisively called *Nazarenes*. But after only a few years a number of other youths, this time Italians, joined the derided group. These young people ignored the protests of their fellows, who gave them up as hopelessly lost, and rejected the style of Canova which at that time had ignited the enthusiasm of everyone. Instead, they joined together with these poor Nazarenes to meditate on the chaste

and expressive works of the fourteenth and fifteenth centuries and to rediscover those essential rules which had produced the masters of the sixteenth century, of which Raphael [*l'Urbinate*] was the greatest. – Who could ever have told these venerable representatives of the status quo that the future of art rested with these scorned young men and that after a few years the world would hail them amongst its best artists? These men were Vogel, Cornelius, Schadow, Enrico Hess, Veit, Steinle, and that profound thinker and learned master of composition, Friedrich Overbeck, the Fra Angelico of our day. There, too, was Tommaso Minardi and the indefatigable genius Pietro Tenerani, the greatest sculptor not only in Italy, but perhaps in the world today.

* * *

Accusations Directed at the Purists

One of the strangest, if not the most ill-founded, of these accusations, was that the Purists sought to 'imitate nature in the most wretched manner possible and to reveal its every defect'. But whoever repeated this claim could not have seen any Purist work of art, nor could they have engaged in debate with any follower of this school. For if there is one thing that the Purists despise, it is precisely the minute imitation of nature which has become so fashionable of late. This leads religious and historical painters into reproducing the minuscule details of what is depicted together with the imperfections which are so often encountered in reality, such that one feels as much disgust at the work of the brush or the chisel as would be caused by seeing these things in nature. The opposite accusation would have been closer to the truth: that the Purists were too infatuated with the *ideal* and for that reason had abandoned the path of truth. Because of their constant yearning to reach the heights of the *idea* they neglected the elements in reality which would have stopped them from attaining that peak. As a consequence, they ignored the defects of nature, maintaining that these were merely accidental and did not belong to the representation of man as our Creator intended when he left His hands. In painting these defects are no more than irritating distractions for the observer, whom the Purists would like to be intent solely on reading the feelings and thoughts of the work of art and not the miserable skills of the hand which are supposed to copy a man as if he were a cauliflower or an onion.

But, ultimately, there were only a few who raised these accusations. Many more identified Purism with the desire to 'return painting to its infancy with Cimabue and Giotto, and of wanting to learn the art of drawing and painting from the artists of the fourteenth century and from them alone'. This, too, was more a maliciously exaggerated idea than a candid opinion expressed in good faith. For if the Purists considered the study of these archaic painters very useful for the chaste simplicity that could be learned from them, they did not dream of saying that one should turn to these painters to improve one's brushwork or that their drawing and use of colour were worthy of imitation. What they did say was that the naturalness of the figures in the fourteenth century, the pure symmetry of the folds and the economy of line, provided a surer and readier model through which to understand the motion and simplicity of natural things. The facts themselves confirm what I have said, for not one of the good Purists ever conceived of painting on wood, canvas or the wall in the

dry and unfinished style of Giotto or of copying the extremities of his figures, which though fitting within the context of the whole, are not well drawn. They all diligently sought to depict real life, not in its most minute accidental features, which lie furthest removed from the *idea*, but in a form which corresponds perfectly in its parts to the type and to the concept which is to be represented. That the Purists believed that only archaic works of art were able to express ideas and that painting should continue in this archaic style is shown to be untrue by the high praise they bestowed on Guido's *Pietà* in the Bologna Pinacoteca, a painting of sublime expressiveness, and the *Christ of the Coin* by the immortal Cadorino at Dresden, the highest realization of the loftiest idea in art, an image of incomparable truthfulness.

There were some, it is true, who misconstrued Purism and, under the mantle of presenting themselves as pure, adopted the mistakes and the sterility of Cimabue. But these people were neither 'Purists', nor 'Macchinists', nor 'Naturalists', nor were they real painters, but rather mere daubsters incapable of producing anything of worth, whatever style or system they followed. They should no more be taken as examples on which to base accusations against the Purists than one should speak ill of the historical novel as a genre simply because hundreds of mediocre writers, in the wake of Walter Scott and Manzoni,[1] infected the literary public with two-a-penny novels good only for the entertainment of the servant quarters.

Other enemies of Purism came into the fray, accusing them of 'despising the art of shading and all that is meant by the terms mass and chiaroscuro'. And this was true, if by 'mass' was meant those large areas of light and shade with which Benvenuti and Camuccini and many other minor artists prepared the bright and dark areas of their paintings, not caring to observe these effects in reality, but rather taking pleasure in distorting them in ways which would appeal to the observer. But it is no longer true if what is meant is that the Purists did not value the correct gradation of light and the varying scale of light and dark in painting. For the true and good Purists aimed at nothing but the correct representation of truth, both in respect of the idea and the form, and they would not have succeeded in achieving this without possessing a well-founded science of chiaroscuro.

Even fiercer opponents than those we have already discussed were those who accused the Purists of 'condemning not only Correggio and Michelangelo but all the paintings of Raphael from the *Disputà* onwards'. This accusation, even if it is somewhat exaggerated, is at least partially founded in truth. For although the Purists were never so foolish as to disparage the supreme merits of Allegri and Michelangelo, and the last works of Sanzio, but on the contrary greatly revered them, they did not hold them in the same blind admiration that was lavished on them by their numerous acolytes. And they were right, for if we take for example Correggio, who was a master of chiaroscuro without equal, we can see that he chose forms which were always somewhat affected, unnatural and far from possessing the noble simplicity of truth. His faces possess a mawkish grimace. In the grouping of his figures he rarely sought beautiful proportions or restraint in his use of line. Contour is often lost beneath the strokes of his industrious brush and his use of drapery is often a pretext for using sumptuous tones and harmonious colours in the light areas and transparent masses in the dark. These same faults, offset in part by the inimitable appeal of his colours and his use of chiaroscuro, engendered in his fellow citizens of Parma and his neighbours

from Lombardy, the Modenese and the Bolognese, the fervent desire to imitate him. And thus, little by little, these three schools, unable to emulate the master's strengths, passed on his defects (as is the rule with those who imitate), and so gradually led art into the degraded practice of painters such as Fontana, Tinarini and the decorative artist Procaccini.

If the Purists were right to prevent their young students from studying Correggio, these same grounds were even stronger in respect of Michelangelo. For, as Minardi observed in his admirable speech, Michelangelo 'was able to manipulate matter and put it at the service of his ideas like a divine being'.[2] With his strength of spirit and his thirst for independence in art he wanted to arouse the admiration of his contemporaries, who were already too corrupted, through the extraordinary rather than the real and through exaggeration rather than moderation. He was therefore the first to break with the austere art of the fifteenth century and to enthrone convention, implanting it in other artists so that the repulsive miasma, no longer contained by his immense genius, like Dante's wild beast, was able to infect the entire world.

* * *

[1] Alessandro Manzoni (1785–1873), Italian novelist and playwright, author of *I promessi Sposi* (The Betrothed), published in 1827.
[2] Tommaso Minardi, 'Lezione sulle qualità essenziali delle pitture di Michelangelo Buonarroti nella gran volta della Cappella Sistina', in *Scritti*, Rome, 1864.

9 Théophile Thoré, writing as William Bürger (1807–1869) 'Salon of 1861'

At the outset of the 1860s both Ingres and Delacroix were near the end of their working lives, while Courbet was far from being an officially approved artist. Within the Salon and the Ecole des Beaux-Arts those indifferent or hostile to the developments of Realism and Naturalism in painting now looked to a continuation of classical themes in the work of such figures as Gérôme, Cabanel and Bouguereau, artists all in their late thirties, each of whom had responded decisively to the example of Ingres' work. The standing of these three artists in particular was based on the claim that they were the rightful heirs and appropriate guardians of art's traditional standards and ideals. Restored by amnesty to the fray of Salon criticism, and with considerable experience of the Dutch painting of the seventeenth century, Thoré here seeks to undermine that claim, on the one hand by restoring a sense of art-historical proportion to the assessment of contemporary achievements, on the other by ridiculing the pretended idealism of the typical classical nude, which tended to occupy a central place in these painters' work. Like Castagnary, he equates modernity in art with an unmediated response to nature. The painters he criticizes here were to remain well supported by official patronage and by collectors (many of them from America). All three were to become Professors at the Ecole des Beaux-Arts, and they were to retain considerable influence in the Salon through the 1880s and beyond. But during the 1860s and 1870s the development of a distinctly modern tradition attracted increasing attention both from writers and from private collectors. (Though, for a very different and more positive response to Gérôme's example, see IIIв18.) Hennequin and Lethière were pupils of David. Gérôme's *Phryne* is now in the Kunsthalle, Hamburg, and Cabanel's *Satyr Carrying off a*

Nymph in the Musée des Beaux-Arts, Lille. This extract is taken from section IV of a review originally published as 'Salon de 1861' in *Le Temps*, Paris, 1861; reprinted in *Salons de W. Bürger, 1861 à 1868*, Paris: Librairie de Ve. Jules Renouard, 1870. The translation for this volume has been made by Christopher Miller, using the latter edition, pp. 122–8. (For previous information on Thoré and for other texts by the same author, see IIA12, IIB11 and IIIB8.)

Conversancy with older paintings makes the appreciation of modern painting very difficult – perhaps too difficult.

The reasons for this are very simple: firstly, what remains of the old schools is a selection of masterpieces, or at least works recommended by higher qualities, by the interest of historical or poetical subject, by composition or execution. In vulgar terms, it is the pick of the crop. They have already been sorted by series of artistic generations, by collectors' sympathies and critics' disputes, and everything unworthy of preservation has disappeared.

Posterity is a patient and obstinate fisherman, which casts its nets in the depths of history, removes the best and throws the small fry back into the deep.

Then again, one may reasonably claim that in certain periods, under the influence of certain conditions which gave rise to the great schools, inspiration was more powerful, and technical procedures, the practice of painting itself, were more efficacious. There are moments when all the productions of a school are excellent, almost without distinction; for example, the Venetian school, from the Bellinis to Paolo Veronese.

When one is passionately interested in the treasures of art bequeathed to us by the Old Masters, modern art leaves one somewhat cold. One does not often find collectors of old paintings including modern paintings in their collections. How many of today's artists would stand even the remotest comparison with the artists of the sixteenth or seventeenth century? Yet there are some, perhaps a dozen in the entire century, who will be caught in the great nets of history and saved from oblivion.

Criticism is a kind of rod-and-line fishing; one must choose among one's catch. In stormy, overcast times like ours, the fish are biting all right, but one finds little on the hook but pallid sticklebacks. Yet we have already fished some curious big 'uns from muddy waters, and some lively tiddlers. Courbet can be counted a shark. What do we find today at the sharp end of the hook?

At the Salon there is a species of painter in considerable demand; they are sent to us from the South in bulk on a seasonal basis. They come from the depths of Italy or Greece. Early in the century they were called *classics*, and at that stage they still possessed a certain virile strength. Today this race has degenerated and its productions are merely grotesque.

What a decline, from the Greeks of David to the Greeks of Monsieur Gérôme! Give us back David, Hennequin and Lethière! David represented *Leonidas at Thermopylae* with austere conviction; Monsieur Gérôme offers the young ladies of Paris a doll stripped bare before drunken and lubricious old satyrs, who are grimacing as if they were seeing a real naked woman for the very first time.

We are no more moralizing than was Diderot, who finally lost patience with the indecency of the Pompadour school and wrote a sentence as exact as original: 'A naked

woman is not indecent, a woman whose skirts have been lifted *is*'. That exhibitor of puppets, the Greek advocate who lifts the skirts right off his courtesan-client, is too risqué. Monsieur Gérôme is proclaimed a scholarly archaeologist of antiquity; there is nothing antique, still less of the Attic, in the feeble composition of his *Phryne*. If the scene, such as the painter has depicted it, had occurred during the decadence of Rome, a time in some ways similar to our own, it might perhaps be acceptable. But in Greece, in the fourth century BC, it is complete nonsense.

The Greeks were passionate about plastic beauty, and were accustomed to seeing, in public games and indeed everywhere, models of the Venuses, goddesses and nymphs, whom their sculptors and painters immortalized in marble or on the inner walls of monuments and private houses. Thus everything in Monsieur Gérôme's painting is false: the melodramatic movement of the advocate, the prudish attitude of Phryne, the disordered and ridiculous physiognomies of the members of the Areopagus. True, the courtesan has little to be proud of as she shows her meagre torso and swollen legs. As to the Areopagites, one might take them for an assembly of ancient members of the brotherhood of those who today occupy the criminal courts. As regards execution, the drawing is of scant interest, the colour crude, and there is no *chiaroscuro*. [. . .]

The imitators of Monsieur Gérôme – if it is he who invented this caricatural 'resurrectionism' of antiquity – are present in abundance at the Salon, and we have not noted all the names of those who paint Greek, Etruscan or Roman interiors, pagan scenes or mythological subjects.

Fauns and satyrs are of course a great success amidst this pagan renaissance. Monsieur Cabanel has painted a *Satyr Carrying Off a Nymph*, a big and much admired picture, and which is, by the way, quite as good as a painting of a church or a battle; Monsieur Bouguereau a *Faun Embracing a Fauness*: a large naked woman, soft and plump, with two fat children, one of whom is frowning; two other naked children, entitled *Retour des champs*; plus a pastoral scene and a portrait.

All these painters are greeted with sympathy by the critics, who are somewhat sceptical today, as they lack any fixed points of reference. Luminous ideas are few and far between in the arts, as they are in the social world. Art goes where it can, knowing neither where it is going nor, indeed, where it would like to go.

But there is one word that the critics hold scintillating up to the light whatever the topic, though it loses its shine entirely when the attempt is made to illuminate works of art with it: the Ideal.

What is the ideal? Is it in the subject or in the way the subject is interpreted? If the ideal is present in the *School of Athens* by Raphael, is it also present in Rembrandt's *Anatomy Lesson*? Why is a Poussin landscape more ideal than a Ruysdael landscape? We do not take it upon ourselves to be the sphinx of these aesthetic mysteries.

If a symbolic intention constitutes the ideal, it is sufficient for the merest naturalist to entitle the figure of a sleeping woman: *Slumber*. Thereupon the critics can give themselves up to the most ingenious speculations: 'Death is sleep . . . it is perhaps an awakening! etc.'. Just as the fine group of shepherds by an ancient tomb in Poussin's *Arcadia* incites one to grave thoughts about 'the instability of happiness and brevity of life'.

One can practise these philosophical entertainments just as well before a Brouwer *Smoker* as a Carracci *Muse*. A Smoker! What a profound allegory! Alas! Everything is evanescent as smoke! Life is short, happiness is fleeting, only virtue is enviable. We are back with Poussin's *Arcadia* – thanks to some denizen of a low dive!

To be honest, art is not as ingenious as the critic. The true artist is somewhat simpler; he is content to represent what he sees and express what he feels – two inseparable terms of any truly artistic creation. They are the self and not-self of philosophy, naively, irresistibly put into practice: a real form borrowed from the outside world and animated by the feeling it inspires in the inner man. Nature and humanity are indissolubly both the object and subject of all arts, just as they are of science and industry. Art shows the phenomena of universal life, science explains them, industry accommodates to the needs of man. Art propounds, science expounds, industry compounds.

If we put aside the ideal, it is a puzzle to know why artists like Monsieur Cabanel paint hybrids with cloven-hooves rather than painting mankind. I know that Correggio painted his *Antiope* with a satyr contemplating her, and that it is a masterpiece. But we are no longer in the sixteenth century, which sought to rid itself of Catholic devils by evoking the monsters of another mythology. Let us return to nature; she is less deceptive than mythologies, religions and systems in general.

10 Ford Madox Brown (1821–1893) on *Work*

Born in Calais, Brown received his artistic training in Bruges and Antwerp. Some years older than Millais, Hunt and Rossetti, he was never a member of the Pre-Raphaelite Brotherhood, though the detailed, accurate technique he had developed resulted in his being closely identified with them. In 1845, in Italy, he had become acquainted with, and technically influenced by, the group of German artists known as the 'Nazarenes' (cf. IIB5). Brown helped pass on their admixture of studied technique, religious feeling and anti-academicism to the emergent Pre-Raphaelites. His major painting *Work* was begun in 1852, completed in 1863 and exhibited in 1865 (a large version is presently in Manchester, a smaller one in Birmingham). It is a kind of visual representation of that strain of Victorian moral and social radicalism exemplified by Ruskin and Carlyle (cf. IID1 and IIIA9). Brown read and annotated Carlyle's *Past and Present* while working on the painting, and depicted him in it. Brown's description of his painting, and of the ideas which informed it, was written for the catalogue of a one-man show in 1865. The present text is taken from Ford Madox Hueffer, *Ford Madox Brown: A Record of his Life and Work*, London: Longmans, Green & Co., 1896, pp. 189–95.

This picture was begun in 1852 at Hampstead. The background, which represents the main street of that suburb not far from the Heath, was painted on the spot.

At that time extensive excavations were going on in the neighbourhood, and, seeing and studying daily as I did the British excavator, or *navvy*, as he designates himself, in the full swing of his activity (with his manly and picturesque costume, and with the rich glow of colour which exercise under a hot sun will impart), it appeared to me that he was at least as worthy of the powers of an English painter as the fisherman of the Adriatic, the peasant of the Campagna, or the Neapolitan lazzarone. Gradually this

idea developed itself into that of *Work* as it now exists, with the British excavator for a central group, as the outward and visible type of *Work*. Here are presented the young navvy in the pride of manly health and beauty; the strong fully-developed navvy who does his work and loves his beer; the selfish old bachelor navvy, stout of limb, and perhaps a trifle tough in those regions where compassion is said to reside; the navvy of strong animal nature, who, but that he was when young *taught* to work at useful work, might even now be working at the *useless crank*. Then Paddy with his larry and his pipe in his mouth. The young navvy who occupies the place of hero in this group, and in the picture, stands on what is termed a landing-stage, a platform placed half-way down the trench; two men from beneath shovel the earth up to him as he shovels it on to the pile outside. Next in value of significance to these is the ragged wretch who has never been *taught* to *work*; with his restless, gleaming eyes he doubts and despairs of every one. But for a certain effeminate gentleness of disposition and a love of nature he might have been a burglar! He lives in Flower and Dean Street, where the policemen walk two and two, and the worst cut-throats surround him, but he is harmless; and before the dawn you may see him miles out in the country, collecting his wild weeds and singular plants to awaken interest, and perhaps find a purchaser in some sprouting botanist. When exhausted he will return to his den, his creel of flowers then rests in an open court-yard, the thoroughfare for the crowded inmates of this haunt of vice, and played in by mischievous boys, yet the basket rarely gets interfered with, unless through the unconscious lurch of some drunkard. The bread-winning implements are sacred with the very poor. In the very opposite scale from the man who can't work, at the further corner of the picture, are two men who appear as having nothing to do. These are the brain-workers, who, seeming to be idle, work, and are the cause of well-ordained work and happiness in others – sages, such as in ancient Greece published their opinions in the market square. Perhaps one of these may already, before he or others know it, have moulded a nation to his pattern, converted a hitherto combative race to obstinate passivity; with a word may have centupled the tide of emigration, with another, have quenched the political passions of both factions – may have reversed men's notions upon criminals, upon slavery, upon many things, and still be walking about little known to some. The other, in friendly communion with the philosopher, smiling perhaps at some of his wild sallies and cynical thrusts (for Socrates at times strangely disturbs the seriousness of his auditory by the mercilessness of his jokes – against vice and foolishness), is intended for a kindred and yet very dissimilar spirit. A clergyman, such as the Church of England offers examples of – a priest without guile – a gentleman without pride, much in communion with the working classes, 'honouring all men,' 'never weary in well-doing.' Scholar, author, philosopher, and teacher, too, in his way, but not above practical efforts, if even for a small resulting good. Deeply penetrated as he is with the axiom that each unit of humanity feels as much as all the rest combined, and impulsive and hopeful in nature, so that the remedy suggests itself to him concurrently with the evil.

Next to these, on the shaded bank, are different characters out of work: haymakers in quest of employment; a Stoic from the Emerald Island, with hay stuffed in his hat to keep the draught out, and need for Stoicism just at present, being short of baccy; a young shoeless Irishman, with his wife, feeding their first-born with cold pap; an old sailor turned haymaker; and two young peasants in search of harvest work, reduced in

strength, perhaps by fever – possibly by famine. Behind the Pariah, who never has learned to work, appears a group of a very different class, who, from an opposite cause, have not been sufficiently used to work either. These are the *rich*, who 'have no need to work' – not at least for bread – *the 'bread of life'* is neither here nor there. The pastrycook's tray, the symbol of superfluity, accompanies these. It is peculiarly English; I never saw it abroad that I remember, though something of the kind must be used. For some years after returning to England I could never quite get over a certain socialistic twinge on seeing it pass, unreasonable as the feeling may have been. Past the pastrycook's tray come two married ladies. The elder and more serious of the two devotes her energies to tract distributing, and has just flung one entitled, 'The Hodman's Haven; or, Drink for Thirsty Souls,' to the somewhat uncompromising specimen of navvy humanity descending the ladder: he scorns it, but with good-nature. This well-intentioned lady has, perhaps, never reflected that excavators may have notions to the effect that ladies might be benefited by receiving tracts containing navvies' ideas! nor yet that excavators are skilled workmen, shrewd thinkers chiefly, and, in general, men of great experience in life, as life presents itself to them.

 In front of her is the lady whose only business in life as yet is to dress and look beautiful for our benefit. She probably possesses everything that can give enjoyment to life; how then can she but enjoy the passing moment, and, like a flower, feed on the light of the sun? Would anyone wish it otherwise? Certainly not I, dear lady. Only in your own interest, seeing that certain blessings cannot be insured for ever – as, for instance, health may fail, beauty fade, pleasures through repetition pall – I will not hint at the greater calamities to which flesh is heir – seeing all this, were you less engaged watching that exceedingly beautiful tiny greyhound in a red jacket that *will* run through that lime, I would beg to call your attention to my group of small, exceedingly ragged, dirty children in the foreground of my picture, where you are about to pass. I would, if permitted, observe that, though at first they may appear just such a group of ragged dirty brats as anywhere get in the way and make a noise, yet, being considered attentively, they, like insects, molluscs, miniature plants, &c., develop qualities to form a most interesting study, and occupy the mind at times when all else might fail to attract. That they are motherless, the baby's black ribbons and their extreme dilapidation indicate, making them all the more worthy of con-sideration; a mother, however destitute, would scarcely leave the eldest one in such a plight. As to the father, I have no doubt he drinks, and will be sentenced in the police-court for neglecting them. The eldest girl, not more than ten, poor child! is very worn-looking and thin; her frock, evidently the compassionate gift of some grown-up person, she has neither the art nor the means to adapt to her own diminutive proportions – she is fearfully untidy, therefore, and her way of wrenching her brother's hair looks vixenish and against her. But then a germ or rudiment of good housewifery seems to pierce through her disordered envelope, for the younger ones are taken care of, and nestle to her as to a mother; the sunburnt baby, which looks wonderfully solemn and intellectual, as all babies do, as I have no doubt your own little cherub looks at this moment asleep in its charming bassinet, is fat and well-to-do, it has even been put into poor mourning for its mother. The other little one, though it sucks a piece of carrot in lieu of a sugarplum, and is shoeless, seems healthy and happy, watching the workmen. The care of the two little ones is an anxious charge

for the elder girl, and she has become a premature scold all through having to manage that *boy* – that boy, though a merry, good-natured-looking young Bohemian, is evidently the plague of her life, as boys always are. Even now he *will* not leave that workman's barrow alone, and gets his hair well pulled, as is natural. The dog which accompanies them is evidently of the same outcast sort as themselves. The having to do battle for his existence in a hard world has soured his temper, and he frequently fights, as by his torn ear you may know; but the poor children may do as they like with him; rugged democrat as he is, he is gentle to them, only he hates minions of aristocracy in red jackets. The old bachelor navvy's small valuable bull-pup also instinctively distrusts outlandish-looking dogs in jackets.

The couple on horseback in the middle distance consists of a gentleman, still young, and his daughter. (The rich and the poor both marry early, only those of moderate incomes procrastinate.) This gentleman is evidently very rich, probably a colonel in the army, with a seat in Parliament, and fifteen thousand a year and a pack of hounds. He is not an over-dressed man of the tailor's dummy sort – he does not put his fortune on his back, he is too rich for that; moreover, he looks to me an honest, true hearted gentleman (he was painted from one I know), and could he only be got to hear what the two sages in the corner have to say, I have no doubt he would be easily won over. But the road is blocked, and the daughter says we must go back, papa, round the other way.

The man with the beer-tray, calling 'Beer ho!' so lustily, is a specimen of town pluck and energy contrasted with country thews and sinews. He is hump-backed, stunted in his growth, and in all matters of taste vulgar as Birmingham can make him look in the 19th century. As a child he was probably starved, stunted with gin, and suffered to get run over. But energy has brought him through to be a prosperous beer-man, and 'very much respected,' and in his way he also is a sort of hero; that black eye was got probably doing the police of his master's establishment, and in an encounter with some huge ruffian whom he has conquered in fight, and hurled out through the swing-doors of the palace of gin prone on to the pavement. On the wall are posters and bills, one of the 'Boys' Home, 41 Euston Road,' which the lady who is giving tracts will no doubt subscribe to presently and place the urchin playing with the barrow in; one of 'The Working Men's College, Great Ormond Street,' or if you object to these, then a police bill offering 50*l*. reward in a matter of highway robbery. Back in the distance we see the Assembly-room of the 'Flamstead Institute of Arts,' where Professor Snoöx is about to repeat his interesting lecture on the habits of the domestic cat. Indignant pussies up on the roof are denying his theory *in toto*.

The less important characters in the background require little comment. Bobus, our old friend, 'the sausage-maker of Houndsditch,' from 'Past and Present,' having secured a colossal fortune (he boasts of it *now*) by anticipating the French Hippophage Society in the introduction of horseflesh as a *cheap* article of human food, is at present going in for the county of Middlesex, and, true to his old tactics, has hired all the idlers in the neighbourhood to carry his boards. These being one too many for the bearers, an old woman has volunteered to carry the one in excess.

The episode of the policeman who has caught an orange-girl in the heinous offence of resting her basket on a post, and who himself administers justice in the shape of a

push that sends her fruit all over the road, is one of common occurrence, or used to be – perhaps the police now 'never do such things.'

I am sorry to say that most of my friends, on examining this part of my picture, have laughed over it as a good joke. Only two men saw the circumstance in a different light; one of them was the young Irishman who feeds his infant with pap. Pointing to it with his thumb, his mouth quivering at the reminiscence, he said, 'That, Sir, *I* know to be true.' The other was a clergyman; his testimony would perhaps have more weight. I dedicate this portion of the work to the Commissioners of Police.

Through this picture I have gained some experience of the navvy class, and I have usually found, that if you can break through the upper crust of *mauvaise honte* which surrounds them in common with most Englishmen, and which, in the case of the navvies, I believe to be the cause of much of their bad language, you will find them serious, intelligent men, and with much to interest in their conversation, which, moreover, contains about the same amount of morality and sentiment that is commonly found among men in the active and hazardous walks of life, for that their career is one of hazard and danger none should doubt. Many stories might be told of navvies' daring and endurance, were this the place for them. One incident peculiarly connected with this picture is the melancholy fact that one of the very men who sat for it lost his life by a scaffold accident before I had yet quite done with him. I remember the poor fellow telling me, among other things, how he never but once felt nervous with his work, and this was having to trundle barrows of earth over a plank-line crossing a rapid river at a height of *eighty feet* above the water. But it was not the height he complained of, it was the *gliding motion of the water underneath.*

I have only to observe, in conclusion, that the effect of hot July sunlight, attempted in this picture, has been introduced because it seems peculiarly fitted to display *work* in all its severity, and not from any predilection for this kind of light over any other.

N.B. – In several cases I have had the advantage of sittings from personages of note, who, at a loss of time to themselves, have kindly contributed towards the greater truthfulness of some of the characters. As my object, however, in all cases, is to delineate types and not individuals, and as, moreover, I never contemplated employing their renown to benefit my own reputation, I refrain from publishing their names.

11 Matthew Arnold (1822–1888) 'Sweetness and Light'

The following excerpts are taken from the opening and closing sections of Arnold's book *Culture and Anarchy*. Like Renan's *The Future of Science* (IIIA2), this work is a study of the relations between knowledge, culture and social civilization. And like the French writer, Arnold places a concept of 'right reason' at the centre of his argument. There are marked differences between the assumptions and conclusions of the two works, however. Renan was driven by a youthful sense of frustration at those social conditions that impeded the progress of rational enquiry. He held, as he later expressed it, that the 'noblest craving of our nature' is curiosity, and its gratification science. (In his 'Painter of Modern Life', Baudelaire was to write of curiosity as a mainspring of genius; see IIID8, part III.) Yet in his retrospective view, Renan was obliged to admit that 'No one knows where the good lies in the social order'. Arnold, on the other hand, writes with the confidence of one convinced

that culture as he understands it is the sure condition of social good. He effectively associates curiosity with social climbing, and while allowing the concept to be free from such associations in French usage, he makes clear that for him the crucial motivating force is not 'scientific passion' but 'the love of perfection'. It is also noteworthy that unlike the republicans of the 1830s, who regarded individuality as a spur to enterprise and as a right to be defended, Arnold's tendency is to identify individualism with a form of selfish materialism, and thus to treat it as disharmonious. His concept of a culture of 'sweetness and light' vividly expresses that paternalistic belief in the possibility of a universally *congenial* society that was to be so strong a component in the social and educational attitudes of Victorian England. *Culture and Anarchy: An Essay in Political and Social Criticism*, was first published in London: Smith, Elder & Co., January 1869. Our excerpts are taken from the edition of 1949, London: John Murray, chapter I, 'Sweetness and Light', pp. 4–10, 30–1, and 'Conclusion', pp. 157–9.

The disparagers of culture make its motive curiosity; sometimes, indeed, they make its motive mere exclusiveness and vanity. The culture which is supposed to plume itself on a smattering of Greek and Latin is a culture which is begotten by nothing so intellectual as curiosity; it is valued either out of sheer vanity and ignorance, or else as an engine of social and class distinction, separating its holder, like a badge or title, from other people who have not got it. No serious man would call this *culture*, or attach any value to it, as culture, at all. To find the real ground for the very differing estimate which serious people will set upon culture, we must find some motive for culture in the terms of which may lie a real ambiguity; and such a motive the word *curiosity* gives us.

I have before now pointed out that we English do not, like the foreigners, use this word in a good sense as well as in a bad sense. With us the word is always used in a somewhat disapproving sense. A liberal and intelligent eagerness about the things of the mind may be meant by a foreigner when he speaks of curiosity, but with us the word always conveys a certain notion of frivolous and unedifying activity. In the *Quarterly Review*, some little time ago, was an estimate of the celebrated French critic, M. Sainte-Beuve, and a very inadequate estimate it in my judgment was. And its inadequacy consisted chiefly in this: that in our English way it left out of sight the double sense really involved in the word *curiosity*, thinking enough was said to stamp M. Sainte-Beuve with blame if it was said that he was impelled in his operations as a critic by curiosity, and omitting either to perceive that M. Sainte-Beuve himself, and many other people with him, would consider that this was praiseworthy and not blameworthy, or to point out why it ought really to be accounted worthy of blame and not of praise. For as there is a curiosity about intellectual matters which is futile, and merely a disease, so there is certainly a curiosity, – a desire after the things of the mind simply for their own sakes and for the pleasure of seeing them as they are, – which is, in an intelligent being, natural and laudable. Nay, and the very desire to see things as they are, implies a balance and regulation of mind which is not often attained without fruitful effort, and which is the very opposite of the blind and diseased impulse of mind which is what we mean to blame when we blame curiosity. Montesquieu says: – 'The first motive which ought to impel us to study is the desire to augment the excellence of our nature, and to render an intelligent being yet more intelligent.' This is the true ground to assign for the genuine scientific passion, however manifested,

and for culture, viewed simply as a fruit of this passion; and it is a worthy ground, even though we let the term *curiosity* stand to describe it.

But there is of culture another view, in which not solely the scientific passion, the sheer desire to see things as they are, natural and proper in an intelligent being, appears as the ground of it. There is a view in which all the love of our neighbour, the impulses towards action, help, and beneficence, the desire for removing human error, clearing human confusion, and diminishing human misery, the noble aspiration to leave the world better and happier than we found it, – motives eminently such as are called social, – come in as part of the grounds of culture, and the main and pre-eminent part. Culture is then properly described not as having its origin in curiosity, but as having its origin in the love of perfection; it is *a study of perfection*. It moves by the force, not merely or primarily of the scientific passion for pure knowledge, but also of the moral and social passion for doing good.

* * *

[. . .] Religion, the greatest and most important of the efforts by which the human race has manifested its impulse to perfect itself, – religion, that voice of the deepest human experience, – does not only enjoin and sanction the aim which is the great aim of culture, the aim of setting ourselves to ascertain what perfection is and to make it prevail; but also, in determining generally in what human perfection consists, religion comes to a conclusion identical with that which culture, – culture seeking the determination of this question through *all* the voices of human experience which have been heard upon it, of art, science, poetry, philosophy, history, as well as of religion, in order to give a greater fulness and certainty to its solution, – likewise reaches. Religion says: *The kingdom of God is within you*; and culture, in like manner, places human perfection in an *internal* condition, in the growth and predominance of our humanity proper, as distinguished from our animality. It places it in the ever-increasing efficacy and in the general harmonious expansion of those gifts of thought and feeling, which make the peculiar dignity, wealth, and happiness of human nature. As I have said on a former occasion: 'It is in making endless additions to itself, in the endless expansion of its powers, in endless growth in wisdom and beauty, that the spirit of the human race finds its ideal. To reach this ideal, culture is an indispensable aid, and that is the true value of culture.' Not a having and a resting, but a growing and a becoming, is the character of perfection as culture conceives it; and here, too, it coincides with religion.

And because men are all members of one great whole, and the sympathy which is in human nature will not allow one member to be indifferent to the rest or to have a perfect welfare independent of the rest, the expansion of our humanity, to suit the idea of perfection which culture forms, must be a *general* expansion. Perfection, as culture conceives it, is not possible while the individual remains isolated. The individual is required, under pain of being stunted and enfeebled in his own development if he disobeys, to carry others along with him in his march towards perfection, to be continually doing all he can to enlarge and increase the volume of the human stream sweeping thitherward. And here, once more, culture lays on us the same obligation as religion, which says, as Bishop Wilson has admirably put it, that 'to promote the kingdom of God is to increase and hasten one's own happiness.'

But, finally, perfection, – as culture from a thorough disinterested study of human nature and human experience learns to conceive it, – is a harmonious expansion of *all* the powers which make the beauty and worth of human nature, and is not consistent with the over-development of any one power at the expense of the rest. Here culture goes beyond religion, as religion is generally conceived by us.

If culture, then, is a study of perfection, and of harmonious perfection, general perfection, and perfection which consists in becoming something rather than in having something, in an inward condition of the mind and spirit, not in an outward set of circumstances, – it is clear that culture ... has a very important function to fulfil for mankind. And this function is particularly important in our modern world, of which the whole civilization is, to a much greater degree than the civilization of Greece and Rome, mechanical and external, and tends constantly to become more so. But above all in our own country has culture a weighty part to perform, because here that mechanical character, which civilization tends to take everywhere, is shown in the most eminent degree. Indeed nearly all the characters of perfection, as culture teaches us to fix them, meet in this country with some powerful tendency which thwarts them and sets them at defiance. The idea of perfection as an *inward* condition of the mind and spirit is at variance with the mechanical and material civilization in esteem with us, and nowhere, as I have said, so much in esteem as with us. The idea of perfection as a *general* expansion of the human family is at variance with our strong individualism, our hatred of all limits to the unrestrained swing of the individual's personality, our maxim of 'every man for himself.'

* * *

The pursuit of perfection, then, is the pursuit of sweetness and light. He who works for sweetness and light, works to make reason and the will of God prevail. He who works for machinery, he who works for hatred, works only for confusion. Culture looks beyond machinery, culture hates hatred; culture has one great passion, the passion for sweetness and light. It has one even yet greater! – the passion for making them *prevail*. It is not satisfied till we *all* come to a perfect man; it knows that the sweetness and light of the few must be imperfect until the raw and unkindled masses of humanity are touched with sweetness and light. If I have not shrunk from saying that we must work for sweetness and light, so neither have I shrunk from saying that we must have a broad basis, must have sweetness and light for as many as possible. Again and again I have insisted how those are the happy moments of humanity, how those are the marking epochs of a people's life, how those are the flowering times for literature and art and all the creative power of genius, when there is a *national* glow of life and thought, when the whole of society is in the fullest measure permeated by thought, sensible to beauty, intelligent and alive. Only it must be *real* thought and *real* beauty; *real* sweetness and *real* light. Plenty of people will try to give the masses, as they call them, an intellectual food prepared and adapted in the way they think proper for the actual condition of the masses. The ordinary popular literature is an example of this way of working on the masses. Plenty of people will try to indoctrinate the masses with the set of ideas and judgments constituting the creed of their own profession or party. Our religious and political organizations give an example of this way of working on the masses. I condemn neither way; but culture works differently. It does not try to teach down to the level of inferior classes; it does not try to win them

for this or that sect of its own, with ready-made judgments and watchwords. It seeks to do away with classes; to make the best that has been thought and known in the world current everywhere; to make all men live in an atmosphere of sweetness and light, where they may use ideas, as it uses them itself, freely, – nourished, and not bound by them.

This is the *social idea*; and the men of culture are the true apostles of equality. The great men of culture are those who have had a passion for diffusing, for making prevail, for carrying from one end of society to the other, the best knowledge, the best ideas of their time; who have laboured to divest knowledge of all that was harsh, uncouth, difficult, abstract, professional, exclusive; to humanize it, to make it efficient outside the clique of the cultivated and learned, yet still remaining the *best* knowledge and thought of the time, and a true source, therefore, of sweetness and light. [. . .]

* * *

[. . .] Through culture seems to lie our way, not only to perfection, but even to safety. Resolutely refusing to lend a hand to the imperfect operations of our Liberal friends, disregarding their impatience, taunts, and reproaches, firmly bent on trying to find in the intelligible law of things a firmer and sounder basis for future practice than any which we have at present, and believing this search and discovery to be, for our generation and circumstances, of yet more vital and pressing importance than practice itself, we nevertheless may do more, perhaps, we poor disparaged followers of culture, to make the actual present, and the frame of society in which we live, solid and seaworthy, than all which our bustling politicians can do.

For we have seen how much of our disorders and perplexities is due to the disbelief, among the classes and combinations of men, Barbarian or Philistine, which have hitherto governed our society, in right reason, in a paramount best self; to the inevitable decay and break-up of the organizations by which, asserting and expressing in these organizations their ordinary self only, they have so long ruled us; and to their irresolution, when the society, which their conscience tells them they have made and still manage not with right reason but with their ordinary self, is rudely shaken, in offering resistance to its subverters. But for us, – who believe in right reason, in the duty and possibility of extricating and elevating our best self, in the progress of humanity towards perfection, – for us the framework of society, that theatre on which this august drama has to unroll itself, is sacred; and whoever administers it, and however we may seek to remove them from their tenure of administration, yet, while they administer, we steadily and with undivided heart support them in repressing anarchy and disorder; because without order there can be no society, and without society there can be no human perfection. [. . .]

Thus, in our eyes, the very framework and exterior order of the State, whoever may administer the State, is sacred; and culture is the most resolute enemy of anarchy, because of the great hopes and designs for the State which culture teaches us to nourish. But as, believing in right reason, and having faith in the progress of humanity towards perfection, and ever labouring for this end, we grow to have clearer sight of the ideas of right reason, and of the elements and helps of perfection, and come gradually to fill the framework of the State with them, to fashion its internal composition and all its laws and institutions conformably to them, and to make the State more and more the expression, as we say, of our best self, which is not manifold,

and vulgar, and unstable, and contentious, and ever-varying, but one, and noble, and secure and peaceful, and the same for all mankind, – with what aversion shall we not *then* regard anarchy, with what firmness shall we not check it, when there is so much that is so precious which it will endanger!

IIID
The Conditions of Art

1 Jean Auguste Dominique Ingres (1780–1867) Opinions on the Salon and the Patronage of Art

In 1848, Ingres accepted a position on a Standing Commission on the Fine Arts established by the government of the French Republic in that year. The first of the texts reproduced below is from an official minute of oral depositions on the subject of the annual Salon exhibition, made to the commission between November 1848 and December 1849 (hence the mixture of direct and reported speech, which we have not attempted to correct). The ensuing passages headed 'The Salon' and 'Encouragement' were included in a dossier of fragmentary undated notes published by Delaborde after the artist's death. The 'last exhibition' referred to at the outset was the juryless Salon of 1848 (see IIA12). Ingres's apparently contradictory views on the future of the Salon reflect a long-standing conflict between his sense of his own high vocation on the one hand and on the other the humiliating reception he believed his work had occasionally received in Paris – notably in the Salons of 1819 and 1834, when he had shown respectively his *Grande Odalisque* and *Martyrdom of St Symphorian* (see IIA3). After the latter event he had returned to Rome determined not to engage in any further public commissions. It was only the considerable success of his *Antiochus and Stratonice* in a showing organized by its private buyer, the Duc d'Orléans, that had lured him back to Paris in 1841. On the subject of exhibitions and patronage his conclusion was in fact rational, if unlikely to be adopted: there should be a concentration of public support and prestige upon work in the highest genres; no compromise with this policy being desirable, and the judgements of juries being untrustworthy, the only alternative was a free-for-all in which, by implication, the interests of the market would rule – as was only appropriate for work in the lower genres. By conferring prestige arbitrarily, the Salon simply served to confuse matters. The minute of the standing commission was first transcribed and published by J. L. Fouché under the title 'L'Opinion d'Ingres sur le Salon', in *La Chronique des arts*, Paris, March 1908, p. 99. 'The Salon' and 'Encouragement' were first published in H. Delaborde, *Ingres. Sa vie, ses travaux, sa doctrine, d'après notes, manuscrit et les lettres du maître*, Paris: Henri Plon, 1870, pp. 370–4. The existence of the transcript serves both to confirm Ingres's personal authorship of the notes recorded by Delaborde and to associate them with the period of the artist's involvement with the commission, in 1848–9. All three passages have been translated for this volume by Christopher Miller. (For earlier writings by Ingres, see IIB1.)

The last exhibition did not scandalize him so much as has been reported. He thinks there should be complete freedom of entry. His ideas may be foolhardy, eccentric; this is not, he feels, the time to develop them. Freedom must be complete because rejection of a mediocre work often reduces to despair a man who can provide for himself and his family only by his art.

Given the diseased state of the art, a heroic remedy is no doubt required: the gates of the Salon should be completely shut. It will be said: Monsieur Ingres is barbarous, Monsieur Ingres is destructive. No, he is not a barbarian. He destroys in order to rebuild.

To remedy this tide of mediocrity – which has destroyed all notion of a School – this banality, which is a public scourge, which afflicts taste and burdens the administration, fruitlessly absorbing resources, it would be best to abandon exhibitions; to declare boldly that only monumental painting will be encouraged. A decree would go out for the decoration of the great national buildings, of churches whose walls crave the painter's touch. The decoration would be entrusted to superior artists, who would employ the mediocre as assistants; the latter would thus cease to oppress art, becoming useful. The young artists would be proud to aid their masters. Use could be made of anyone who could hold a brush.

Why do the Italians have such subtle notions of painting? Because they see it all around them. What is to stop France becoming a second Italy? Has she not everything required to become the first nation of art?

In this way the resources of art would be employed for glory, profit and humanity. The superior men would be honoured by setting them tasks worthy of them and the nascent talents would be encouraged.

To return to the exhibitions, they must either be ended or be completely free.
And later:
You wish to make a choice? How? I say it is impossible. There would be innumerable complaints. Reasonable people run mad when their self-esteem is at stake.

Collections and exhibitions date from decadent times. In the great epochs of art, pictures served a purpose.

Why exhibit portraits, genre paintings and so on? The former are for family use, for the alcove; the latter should be confined to collectors' galleries.

True, exhibitions have become the custom and therefore cannot be abandoned; but they should not be encouraged. They ruin art; they turn it into a trade that the artist no longer respects. Exhibitions have become cheap stores in which mediocrity is shamelessly flaunted. These exhibitions are useless and dangerous. Apart from the need to be humane, they should be abolished.

A permanent exhibition was proposed, in which works would be admitted by rotation. Delacroix opposed this idea; Ingres was in favour.

The Salon

I know well enough that I touch upon a delicate nerve. I know everything that can be objected in favour of the Salon exhibitions, all the arguments about the influence that these solemn festivities, long adopted and protected by the government, exert upon

artists' lives and reputations; but for myself, I declare the Salon an *impossible* thing, useless, today, from every point of view. Moreover, I see in them a dangerous custom, a means of corrupting and destroying art as I understand it; for the Salon, such as we have made it, kills art; it is only the trade of painting that it invigorates.

And, in the first place, morally offensive items apart, should everything be accepted, for the simple reason that one has no right to refuse the work of a French citizen, who is often the father of a family, living by his profession, and whom a refusal would damage in the eyes of his clientele? When I consider the point that things have reached, and supposing the Salon should continue at all, I am almost tempted to adopt this view. Should one, on the contrary, accept only certain works selected by a jury? But now find me a jury with sufficient community of ideas and principles to know exactly what choices to make, one which will not be tugged this way and that by the difficulty of agreement, by fear of disputes or by the example of extreme indulgence!

Then, what disappointments lie in wait for the artist who is badly placed or unlucky in his neighbours! How many artists, having painted a good picture, scarcely recognize it, lost as it is in the huge space or disfigured by the contrast of strident paintings usurping attention on all sides! Then, why is the admission procedure not used for awards too? As a result, they are always unwisely bestowed. God forbid I should suspect the good faith and fairness of the judges, but in fact their decisions are mostly perverse. Truly, in the interest of the artists themselves, I would ask that the Salon be abolished.

And as to the interests of art, abolition would be necessary *a fortiori*. The Salon stifles and corrupts all feeling for greatness and beauty; artists are impelled to exhibit by the lure of profit, by the desire to be noticed at any price, by the presumed good fortune of an eccentric subject designed for effect and with a high price in mind. The Salon is, literally, the merest shopful of pictures, a cheap store offering an overwhelming number of items. In the Salon, industry reigns in the place of art.

Such are my thoughts. They will not be accepted, I fear, but they shall at least be known. Were I alone in my protest about the Salons, I should persist.

Encouragement

The government has no obligation to encourage any genre other than history painting. Genre strictly speaking – scenes of family life, modern scenes, fruits and flowers, still life, etc. – should be left to private individuals, to collectors. This is how things were done last century. Then there were much-visited collections in Paris; there were some in the provinces, too, notably in Toulouse, which was rightly dubbed 'the city of connoisseurs'; there one found not only minor Dutch and Flemish masters, but agreeable works by contemporary painters. These collections were quite enough to make artists' reputations and quite the equal of our confused 'Salon'. The government should leave genre painters and their works to the collectors; its commissions and encouragement should be confined to the few history painters worthy of the name; the rest it should dispose of. Its own tranquillity and the progress of the art would both be served by dismissing this throng of petitioners!

As to artists who, though not of the first rank, deserve attention, it could employ them either to multiply copies of masterpieces (of which there cannot be too many) or to assist masters in the execution of great works.

Thus the state's task is simply to encourage history painting in the present and the reproduction of the most beautiful monuments of the past; the rest is none of its business.

2 Richard Wagner (1818–1883) from 'The Art-Work of the Future'

Though he claimed it was conceived in Paris, this essay was written in Zürich, where Wagner had gone to avoid arrest following his involvement in the Dresden Uprising of May 1849 (see IIIA3). It was dedicated to the radical atheist philosopher Ludwig Feuerbach (see IIA8). In his proposal for the Art-Work of the Future, Wagner envisages an artistic form of the very highest order that yet has its origins in communal need – a dream that has returned at intervals ever since to trouble thought about the social function of art. He conceived of the arts in two broad categories: dance, tone (or music) and poetry were those derived directly from 'artistic man', while architecture, sculpture and painting were those that depended upon the shaping of 'nature's stuffs'. In the first of the following passages he outlines his concept of the *Gesamtkunstwerk* – a single artistic enterprise to which the different arts were each to contribute, though without surrendering their independent standards or their autonomy. In his own operas – and particularly in the cycle of the *Ring of the Nibelungs* (1852–74) – he came closer to achieving a practical realization of this ambitious project than must have seemed conceivable to the vast majority of his readers at the time. Yet one reason why his ideas exercised such power over the artists of the later nineteenth century was that the imaginative scale of his 'Art-Work of the Future' was virtually absolute. Therein lay its true radicalism and its strange hold over the imaginations of others – even the painters, who were supposed to find fulfilment producing landscapes to enrich his back-drops or history paintings to be animated by his actors (see, for instance, VIc8). Autocratic as Wagner's vision appears in certain respects, it was founded in optimistic social and artistic beliefs, which were in part the products of a revolutionary moment. In the second passage he asserts the necessarily collaborative and popular nature of the Art-Work of the Future. From his perspective, the conditions required for such a work were socially entirely desirable and yet nevertheless unimaginable within the prevailing culture. It was this belief that fuelled his virulent attack upon the cultural conditions of the present. 'The Art-Work of the Future' was originally published as *Das Kunstwerk der Zukunft*, in Leipzig: Otto Wigand, 1849 (dated 1850). The following extracts are taken from the translation by William Ashton Ellis in *Richard Wagner's Prose Works*, volume, I, 'The Art-Work of the Future, &c.', London: Kegan Paul, Trench, Trübner & Co., 1892, chapter IV, pp. 182–91 and chapter V, pp. 195–6, 201–2, 204–5 and 207–10.

Outlines of the Art-Work of the Future

If we consider the relation of modern art – so far as it is truly *Art* – to public life, we shall recognize at once its complete inability to affect this public life in the sense of its own noblest endeavour. The reason hereof is, that our modern art is a mere product of Culture and has not sprung from Life itself; therefore, being nothing but a hot-house

plant, it cannot strike root in the natural soil, or flourish in the natural climate of the present. Art has become the private property of an artist-caste; its taste it offers to those alone who *understand* it; and for its understanding it demands a special study, aloof from actual life, the study of *art-learning*. This study, and the understanding to be attained thereby, each individual who has acquired the gold wherewith to pay the proffered delicacies of art conceives to-day that he has made his own: if, however, we were to ask the Artist whether the great majority of art's amateurs are able to understand him in his best endeavours, he could only answer with a deep-drawn sigh. But if he ponder on the infinitely greater mass of those who are perforce shut out on every side by the evils of our present social system from both the understanding and the tasting of the sweets of modern art, then must the artist of to-day grow conscious that his whole art-doings are, at bottom, but an egoistic, self-concerning business; that his art, in the light of public life, is nothing else than luxury and superfluity, a self-amusing pastime. The daily emphasized, and bitterly deplored abyss between so-called culture and un-culture is so enormous; a bridge between the two so inconceivable; a reconcilement so impossible; that, had it any candour, our modern art, which grounds itself on this unnatural culture, would be forced to admit, to its deepest shame, that it owes its existence to a life-element which in turn can only base *its own* existence on the utter death of culture among the real masses of mankind.

The only thing which, in the position thus assigned to her, our Modern Art should be able to effect – and among honest folk, indeed, endeavours – namely, the *spreading abroad of culture*, she cannot do; and simply for the reason that, for Art to operate on Life, she must be herself the blossom of a *natural* culture, i.e., such an one as has grown up from below, for she can never hope to rain down culture from *above*. Therefore, taken at its best, our 'cultured' art resembles an orator who should seek to address himself in a foreign tongue to a people which does not understand it: his highest flights of rhetoric can only lead to the most absurd misunderstandings and confusion. –

Let us first attempt to trace the *theoretic* path upon which Modern Art must march forward to redemption from her present lonely, misprised station, and toward the widest understanding of general public Life. That this redemption can only become possible by the *practical* intermediation of public Life, will then appear self-evident.

[. . .] *Plastic Art* can only attain creative strength by going to her work in unison with *artistic* Man, and not with men who purpose mere *utility*.

Artistic Man can only fully content himself by uniting every branch of Art into the *common* Artwork: in every *segregation* of his artistic faculties he is *unfree*, not fully that which he has power to be; whereas in the *common* Artwork he is *free*, and fully that which he has power to be.

The *true* endeavour of Art is therefore all-embracing: each unit who is inspired with a true *art-instinct* develops to the highest his own particular faculties, not for the glory of these special faculties, but for the glory of *general Manhood in Art*.

The highest conjoint work of art is the *Drama*: it can only be at hand in all its *possible* fulness, when in it each *separate branch of art* is at hand in *its own utmost fulness*.

The true Drama is only conceivable as proceeding from a *common urgence of every art* towards the most direct appeal to a *common public*. In this Drama, each separate art can only bare its utmost secret to their common public through a mutual parleying with the other arts; for the purpose of each separate branch of art can only be fully

attained by the reciprocal agreement and co-operation of all the branches in their common message.

Architecture can set before herself no higher task than to frame for a fellowship of artists, who in their own persons portray the life of Man, the special surroundings necessary for the display of the Human Artwork. Only that edifice is built according to Necessity, which answers most befittingly an aim of man: the highest aim of man is the artistic aim; the highest artistic aim – the Drama. In buildings reared for daily use, the builder has only to answer to the lowest aim of men: beauty is therein a luxury. In buildings reared for luxury, he has to satisfy an unnecessary and unnatural need: his fashioning therefore is capricious, unproductive, and unlovely. On the other hand, in the construction of that edifice whose every part shall answer to a common and artistic aim alone, – thus in the building of the *Theatre*, the master-builder needs only to comport himself as *artist*, to keep a single eye upon the *art-work*. In a perfect theatrical edifice, Art's need alone gives law and measure, down even to the smallest detail. This need is twofold, that of *giving* and that of *receiving*, which reciprocally pervade and condition one another. The *Scene* has firstly to comply with all the conditions of 'space' imposed by the joint [*gemeinsam*] dramatic action to be displayed thereon: but secondly, it has to fulfil those conditions in the sense of bringing this dramatic action to the eye and ear of the spectator in intelligible fashion. In the arrangement of the *space for the spectators*, the need for optic and acoustic understanding of the artwork will give the necessary law, which can only be observed by a union of beauty and fitness in the proportions; for the demand of the collective [*gemeinsam*] audience is the demand for the *artwork*, to whose comprehension it must be distinctly led by everything that meets the eye. Thus the spectator transplants himself upon the stage, by means of all his visual and aural faculties; while the performer becomes an artist only by complete absorption into the public. Everything, that breathes and moves upon the stage, thus breathes and moves alone from eloquent desire to impart, to be seen and heard within those walls which, however circumscribed their space, seem to the actor from his scenic standpoint to embrace the whole of humankind; whereas the public, that representative of daily life, forgets the confines of the auditorium, and lives and breathes now only in the artwork which seems to it as Life itself, and on the stage which seems the wide expanse of the whole World. [. . .]

But not the fairest form, the richest masonry, can alone suffice the Dramatic Artwork for the perfectly befitting spatial terms of its appearance. The Scene which is to mount the picture of Human Life must, for a thorough understanding of this life, have power to also show the lively counterfeit of Nature, in which alone artistic Man can render up a speaking likeness of himself. The casings of this Scene, which look down chill and vacantly upon the artist and the public, must deck themselves with the fresh tints of Nature, with the warm light of heaven's aether, to be worthy to take their share in the human artwork. Plastic *Architecture* here feels her bounds, her own unfreedom, and casts herself, athirst for love, into the arms of Painting, who shall work out her redemption into fairest Nature.

Here *Landscape-painting* enters, summoned by a common need which she alone can satisfy. What the painter's expert eye has seen in Nature, what he now, as artist, would fain display for the artistic pleasure of the full community, he dovetails into the

united work of all the arts, as his own abundant share. Through him the scene takes on complete artistic truth: his drawing, his colour, his glowing breadths of light, compel Dame Nature to serve the highest claims of Art. That which the landscape-painter, in his struggle to impart what he had seen and fathomed, had erstwhile forced into the narrow frames of panel-pictures, – what he had hung up on the egoist's secluded chamber-walls, or had made away to the inconsequent, distracting medley of a picture-barn, – *therewith* will he henceforth fill the ample framework of the Tragic stage, calling the whole expanse of scene as witness to his power of recreating Nature. The illusion which his brush and finest blend of colours could only hint at, could only distantly approach, he will here bring to its consummation by artistic practice of every known device of optics, by use of all the art of 'lighting.' The apparent roughness of his tools, the seeming grotesqueness of the method of so-called 'scene-painting,' will not offend him; for he will reflect that even the finest camel's-hair brush is but a humiliating instrument, when compared with the perfect Artwork; and the artist has no right to *pride* until he is *free*, i.e., until his artwork is completed and alive, and *he*, with all his helping tools, has been absorbed into it. But the finished artwork that greets him from the *stage* will, set within this frame and held before the common gaze of full publicity, immeasurably more content him than did his earlier work, accomplished with more delicate tools. He will not, forsooth, repent the right to use this scenic space to the benefit of such an artwork, for sake of his earlier disposition of a flat-laid scrap of canvas! For as, at the very worst, his work remains the same no matter what the frame from which it looks, provided only it bring its subject to intelligible show: so will his artwork, in *this* framing, at any rate effect a livelier impression, a greater and more universal understanding, than the whilom landscape picture.

The organ for all understanding of Nature, is Man: the landscape-painter had not only to impart to men this understanding, but to make it for the first time plain to them by depicting Man in the midst of Nature. Now by setting his artwork in the frame of the Tragic stage, he will expand the individual man, to whom he would address himself, to the associate manhood of full publicity, and reap the satisfaction of having spread his understanding out to that, and made it partner in his joy. But he cannot fully bring about this public understanding until he allies his work to a joint and all-intelligible aim of loftiest Art; while this aim itself will be disclosed to the common understanding, past all mistaking, by the actual bodily man with all his warmth of life. Of all artistic things, the most directly understandable is the Dramatic-Action [*Handlung*], for reason that its art is not complete until every helping artifice be cast behind it, as it were, and genuine life attain the faithfullest and most intelligible show. And thus each branch of art can only address itself to the *understanding* in proportion as its core – whose relation to Man, or derivation from him, alone can animate and justify the artwork – is ripening toward the *Drama*. In proportion as it passes over into Drama, as it pulses with the Drama's light, will each domain of Art grow all-intelligible, completely understood and justified.[1]

On to the stage, prepared by architect and painter, now steps *Artistic Man*, as Natural Man steps on the stage of Nature. What the statuary and the historical painter endeavoured to limn on *stone* or *canvas*, they now limn upon *themselves*, their form, their body's limbs, the features of their visage, and raise it to the consciousness of full

artistic life. The same sense that led the sculptor in his grasp and rendering of the human figure, now leads the *Mime* in the handling and demeanour of his actual body. The same eye which taught the historical painter, in drawing and in colour, in arrangement of his drapery and composition of his groups, to find the beautiful, the graceful and the characteristic, now orders the whole breadth of *actual human show*. Sculptor and painter once freed the Greek Tragedian from his cothurnus and his mask, upon and under which the real man could only move according to a certain religious convention. With justice, did this pair of plastic artists annihilate the last disfigurement of pure artistic man, and thus prefigure in their stone and canvas the tragic Actor of the Future. As they once descried him in his undistorted truth, they now shall let him pass into reality and bring his form, in a measure sketched by them, to bodily portrayal with all its wealth of movement.

Thus the illusion of plastic art will turn to truth in Drama: the plastic artist will reach out hands to the *dancer*, to the *mime*, will lose himself in them, and thus become himself both mime and dancer. – So far as lies within his power, he will have to impart the inner man, his feeling and his will–ing, to the eye. The breadth and depth of scenic space belong to him for the plastic message of his stature and his motion, as a single unit or in union with his fellows. But where his power ends, where the fulness of his will and feeling impels him to the *utter*ing of the inner man by means of *Speech*, there will the Word proclaim his plain and conscious purpose: he becomes a *Poet* and, to be poet, a *tone-artist* [*Tonkünstler*]. But as dancer, tone-artist, and poet, he still is one and the same thing: nothing other than *executant, artistic Man, who, in the fullest measure of his faculties, imparts himself to the highest expression of receptive power.* [...]

Not one rich faculty of the separate arts will remain unused in the United Artwork of the Future; in *it* will each attain its first complete appraisement. Thus, especially, will the manifold developments of Tone, so peculiar to our instrumental music, unfold their utmost wealth within this Artwork; nay, Tone will incite the mimetic art of Dance to entirely new discoveries, and no less swell the breath of Poetry to unimagined fill. For Music, in her solitude, has fashioned for herself an organ which is capable of the highest reaches of expression. This organ is the *Orchestra*. The tone-speech of Beethoven, introduced into Drama by the orchestra, marks an entirely fresh departure for the dramatic artwork. While Architecture and, more especially, scenic Landscape-painting have power to set the executant dramatic Artist in the surroundings of physical Nature, and to dower him from the exhaustless stores of natural phenomena with an ample and significant background, – so in the Orchestra, that pulsing body of many-coloured harmony, the personating individual Man is given, for his support, a stanchless elemental spring, at once artistic, natural, and human.

The Orchestra is, so to speak, the loam of endless, universal Feeling, from which the individual feeling of the separate actor draws power to shoot aloft to fullest height of growth: it, in a sense, dissolves the hard immobile ground of the actual scene into a fluent, elastic, impressionable aether, whose unmeasured bottom is the great sea of Feeling itself. Thus the Orchestra is like the *Earth* from which Antaeus, so soon as ever his foot had grazed it, drew new immortal life-force. By its essence diametrically opposed to the scenic landscape which surrounds the actor, and therefore, as to

locality, most rightly placed in the deepened foreground outside the scenic frame, it at like time forms the perfect complement of these surroundings; inasmuch as it broadens out the exhaustless *physical* element of Nature to the equally exhaustless *emotional* element of artistic Man. These elements, thus knit together, enclose the performer as with an atmospheric ring of Art and Nature, in which, like to the heavenly bodies, he moves secure in fullest orbit, and whence, withal, he is free to radiate on every side his feelings and his views of life, – broadened to infinity, and showered, as it were, on distances as measureless as those on which the stars of heaven cast their rays of light.

[1] It can scarcely be indifferent to the modern landscape-painter to observe by how few his work is really understood to-day, and with what blear-eyed stupidity his nature-paintings are devoured by the Philistine world that pays for them; how the so-called 'charming prospect' is purchased to assuage the idle, unintelligent, visual gluttony of those same *need*-less men whose sense of hearing is tickled by our modern, empty music-manufacture to that idiotic joy which is as repugnant a reward of his performance to the *artist* as it fully answers the intention of the *artisan*. Between the 'charming prospect' and the 'pretty tune' of our modern times there subsists a doleful affinity, whose bond of union is certainly not the musing calm of Thought, but that vulgar slipshod *sentimentality* which draws back in selfish horror from the sight of human suffering in its surroundings, to hire for itself a private heavenlet in the blue mists of Nature's generality. These sentimentals are willing enough to see and hear everything: only *not* the *actual, undistorted Man*, who lifts his warning finger on the threshold of their dreams. *But this is the very man whom we must set up in the forefront of our show!*

The Artist of the Future

Having sketched in general outline the nature of the Art-work into which the whole art-family must be absorbed, to be there redeemed by universal understanding, it remains to ask: What are the life-conditions which shall summon forth the Necessity of this Art-work and this redemption? Will this be brought about by Modern Art, in impatient need of understanding, from out her own premeditated plan, by arbitrary choice of means, and with fixed prescription of the 'modus' of the union that she has recognized as necessary? Will she be able to draw up a constitutional chart, a tariff of agreement with the so-called un-culture of the Folk? And if she brought herself to stoop to this, would such an agreement be actually effected by that 'constitution'? Can Cultured Art press forward from her abstract standpoint *into Life*; or rather, must not *Life press forward into Art*, – Life *bear* from out itself its only fitting Art, and mount up into that, – instead of art (well understood: the *Cultured Art*, which sprang from regions outside Life) *engendering Life* from out herself and mounting thereinto?

Let us therefore first agree as to *whom* we must consider the creator of the Art-work of the Future; so that we may argue back from him to the life-conditions which alone can permit his art-work and himself to take their rise.

Who, then, will be the *Artist of the Future*?

Without a doubt, the Poet.[2]

But *who* will be the Poet?

Indisputably the *Performer* [*Darsteller*].

Yet *who*, again, will be the Performer?

Necessarily the *Fellowship of all the Artists*. –

In order to see the Performer and the Poet take natural rise, we must first imagine to ourselves the artistic Fellowship of the future; and that according to no arbitrary canon, but following the logical course which we are bound to take in drawing from the Art-work itself our conclusions as to those artistic organs which alone can call it into natural life. –

The Art-work of the Future is an associate work, and only an associate demand can call it forth.

* * *

The *free Artistic Fellowship* is therefore the foundation, and the first condition, of the Art-work itself. From it proceeds the *Performer*, who, in his enthusiasm for this one particular hero whose nature harmonizes with his own, now raises himself to the rank of *Poet*, of artistic *Lawgiver* to the fellowship; from this height, again, to descend to complete absorption in the fellowship. The function of this lawgiver is therefore never more than *periodic*, and is confined to the one particular occasion which has been prompted by his individuality and thereby raised to a common 'objective' for the art of all; wherefore his rule can by no means be extended to *all* occasions. The dictatorship of the poet-actor comes to its natural close together with the attainment of his specific purpose: that purpose which he had raised into a common one, and in which his personality was dissolved so soon as ever his message had been shared with the community. Each separate member may lift himself to the exercise of this dictatorship, when he bears a definite message which so far answers to his individuality that in its proclamation he has power to raise it to a common purpose. For in that artistic fellowship which combines for no other aim than the satisfaction of a joint artistic impulse, it is impossible that any other thing should come to definite prescription and resolve, than that which compasses the mutual satisfaction of this impulse: namely, Art herself, and the laws which summon forth her perfect manifestment by the union of the individual with the universal.

* * *

Who, then, will be the *Artist of the Future?* The poet? The performer? The musician? The plastician? – Let us say it in one word: the *Folk. That selfsame Folk to whom we owe the only genuine Art-work, still living even in our modern memory, however much distorted by our restorations; to whom alone we owe all Art itself.*

* * *

If we have finally proved that *the Folk* must of necessity be the Artist of the future, we must be prepared to see the intellectual egoism of the artists of the Present break forth in contemptuous amazement at the discovery. They forget completely that in the days of national blood-brotherhood, which preceded the epoch when the absolute Egoism of the individual was elevated to a religion, – the days which our historians betoken as those of prehistoric myth and fable, – the Folk, in truth, was already the only poet, the only artist; that all their matter, and all their form – if it is to have any sound vitality – they can derive alone from the fancy of these art-inventive Peoples. On the contrary, they regard the Folk exclusively under the aspect lent it nowadays by their culture-spectacled eyes. From their lofty pedestal, they deem that only their direct antithesis, the raw uncultured masses, can mean for them 'the Folk.' As they look down upon the people, there rise but fumes of beer and spirits to their nostrils;

they fumble for their perfumed handkerchiefs, and ask with civilized exasperation: 'What! The *rabble* is in future to replace us in Art-making? The rabble, which does not so much as understand us, when *we* provide its art? Out of the reeking gin-shop, out of the smoking dung-heap, are we to see arise the mould of Beauty and of Art?' –

Quite so! Not from the filthy dregs of your Culture of to-day, not from the loathsome subsoil of your modern 'polite education,' not from the conditions which give your modern civilization the sole conceivable base of its existence, shall arise the Art-work of the Future. Yet reflect! that this rabble is in no wise a normal product of real human nature, but rather the artificial outcome of your denaturalized culture; that all the crimes and abominations with which ye now upbraid this rabble, are only the despairing gestures of the battle which the true nature of Man wages against its hideous oppressor, modern Civilization; and that these revolting features are no wise the real face of Nature, but rather the reflection of the hypocritical mask of your State, and Criminal-Culture. Further reflect: that, where one portion of the social system busies itself alone with *superfluous* art and literature, another portion must necessarily redress the balance by scavenging the dirt of your useless lives; that, where fashion and dilettantism fill up one whole unneedful life, there coarseness and grossness must make out the substance of another life, – a life ye cannot do without; that, where need-less luxury seeks violently to still its all-devouring appetite, the natural Need can only balance its side of the account with Luxury by drudgery and want, amidst the most deforming cares. [. . .]

. . . Neither you nor this rabble do we understand by the term, *the Folk*: only when neither Ye nor It shall exist any longer, can we conceive the presence of the Folk. Yet even now the Folk is living, wherever ye and the rabble are not; or rather, it is living in your twin midst, but ye wist not of it. Did ye *know* it, then were ye yourselves the Folk; for no man can know the fullness of the Folk, without possessing a share therein. The highest educated alike with the most uneducated, the learned with the most unlearned, the high-placed with the lowly, the nestling of the amplest lap of luxury with the starveling of the filthiest den of Hunger, the ward of heartless Science with the wastrel of the rawest vice, – so soon as e'er he feels and nurtures in himself a stress which thrusts him out from cowardly indifference to the criminal assemblage of our social and political affairs, or heavy-witted submission thereunder, – which inspires him with loathing for the shallow joys of our inhuman Culture, or hatred for a Utilitarianism that brings its uses only to the need-less and never to the needy, – which fills him with contempt for those self-sufficient thralls, the despicable Egoists! or wrath against the arrogant outragers of human nature, – he, therefore, who *not* from this conglomerate of pride and baseness, of shamelessness and cringing, thus not from the *statutory rights* which hold this composite together, but from the fulness and the depth of naked *human nature* and the irrefutable right of its absolute Need, draws force for resistance, for revolt, for assault upon the oppressor of this nature, – he then who *must* withstand, revolt, and deal assault, and openly avows this plain necessity in that he gladly suffers every other sorrow for its sake, and, if need should be, will even offer up his life, – *he, and he alone belongs to the Folk*; for he and all his fellows feel a common *Want*.

[2] We must beg to be allowed to regard the *Tone*-poet as included in the *Word*-poet,–whether personally or by fellowship, is here a matter of indifference.

3 Eduard Hanslick (1825–1904) from *On the Beautiful in Music*

The ideas of the Austrian theorist and music critique Eduard Hanslick can usefully be contrasted to those of Wagner. Hanslick trenchantly opposed Wagner's theory of the total art work and his attempt to unify the symphonic with the operatic. Wagner, in turn, parodied his critic in the character of Sixtus Beckmesser in his opera *Die Meistersinger*. Hanslick's *On the Beautiful in Music*, first published in 1854 and quickly running through several editions, is not only one of the earliest but also one of the most influential defences of formalism in music. He starts out by rejecting two widely held assumptions: that the task of music is to arouse the emotions and that the emotions form the subject-matter which music illustrates or represents. Hanslick maintains that the beautiful in music is 'specifically musical', dependent upon nothing external and consisting entirely of 'sounds aesthetically combined'. The essence of music is to be found in what he terms '*tönend bewegte Formen*' (literally, 'sounding forms in motion'). As the century progressed, music was increasingly seen as a model for that independence from merely descriptive concerns which became such a central preoccupation within the visual arts. Hanslick's emphasis on the autonomous status of music, and his likening of music to 'a language which we speak and understand, but are unable to translate' can also be seen as prefiguring later twentieth-century discussions of abstract art. *Vom Musikalisch-Schönen* was first published in Leipzig in 1854. These extracts are taken from the translation of the seventh German edition made by Gustav Cohen in 1891 and reprinted, Indianapolis and New York: The Liberal Arts Press, 1957, pp. 7, 9–10, 20–1, 47–9, 50–3.

The course hitherto pursued in musical aesthetics has nearly always been hampered by the false assumption that the object was not so much to inquire into what is beautiful in music as to describe the feelings which music awakens. This view entirely coincides with that of the older systems of aesthetics, which considered the beautiful solely in reference to the sensations aroused and the philosophy of beauty as the offspring of sensation ($\alpha\iota\sigma\theta\eta\sigma\iota\varsigma$).

Such systems of aesthetics are not only unphilosophical, but they assume an almost sentimental character when applied to the most ethereal of all arts; and though no doubt pleasing to a certain class of enthusiasts, they afford but little enlightenment to a thoughtful student who, in order to learn something about the real nature of music, will, above all, remain deaf to the fitful promptings of passion and not, as most manuals on music direct, turn to the emotions as a source of knowledge.

* * *

[. . .] The task of clearly realizing music as a self-subsistent form of the beautiful has hitherto presented insurmountable difficulties to musical aesthetics, and the dictates of 'emotion' still haunt their domain in broad daylight. Beauty in music is still as much as ever viewed only in connection with its subjective impressions, and books, critiques, and conversations continually remind us that the emotions are the only aesthetic foundations of music, and that they alone are warranted in defining its scope.

Music, we are told, cannot, like poetry, entertain the mind with definite conceptions; nor yet the eye, like sculpture and painting, with visible forms. Hence, it is argued, its object must be to work on the feelings. 'Music has to do with feelings.' This expression, 'has to do,' is highly characteristic of all works on musical aesthetics.

But what the nature of the link is that connects music with the emotions, or certain pieces of music with certain emotions; by what laws of nature it is governed; what the canons of art are that determine its form – all these questions are left in complete darkness by the very people who have 'to do' with them. Only when one's eyes have become somewhat accustomed to this obscurity does it become manifest that the emotions play a double part in music, as currently understood.

On the one hand it is said that the aim and object of music is to excite emotions, i.e., pleasurable emotions; on the other hand, the emotions are said to be the subject matter which musical works are intended to illustrate.

Both propositions are alike in this, that one is as false as the other.

The refutation of the first of these propositions, which forms the introduction to most manuals of music, must not detain us long. The beautiful, strictly speaking, aims at nothing, since it is nothing but a form which, though available for many purposes according to its nature, has, as such, no aim beyond itself. If the contemplation of something beautiful arouses pleasurable feelings, this effect is distinct from the beautiful as such. I may, indeed, place a beautiful object before an observer with the avowed purpose of giving him pleasure, but this purpose in no way affects the beauty of the object. The beautiful is and remains beautiful though it arouse no emotion whatever, and though there be no one to look at it. In other words, although the beautiful exists for the gratification of an observer, it is independent of him.

In this sense music, too, has no aim (object), and the mere fact that this particular art is so closely bound up with our feelings by no means justifies the assumption that its aesthetic principles depend on this union.

* * *

The proposition that the feelings are the subject which music has to represent is due partly to the theory according to which the ultimate aim of music is to excite feelings and partly to an amended form of this theory.

A philosophical disquisition into an art demands a clear definition of its subject matter. The diversity of the subject matter of the various arts and the fundamental difference in the mode of treatment are a natural sequence of the dissimilarity of the senses to which they severally appeal. Every art comprises a range of ideas which it expresses after its own fashion in sound, language, colour, stone, etc. A work of art, therefore, endows a definite conception with a material form of beauty. This definite conception, its embodiment, and the union of both are the conditions of an aesthetic ideal with which a critical examination into every art is indissolubly connected.

The subject of a poem, a painting, or a statue may be expressed in words and reduced to ideas. We say, for instance, this picture represents a flower girl, this statue a gladiator, this poem one of Roland's exploits. Upon the more or less perfect embodiment of the particular subject in the artist's production depends our verdict respecting the beauty of the work of art.

The whole gamut of human feelings has with almost complete unanimity been proclaimed to be the subject of music, since the emotions were thought to be in antithesis to the definiteness of intellectual conceptions. This was supposed to be the feature by which the musical ideal is distinguished from the ideal of the other fine arts and poetry. According to this theory, therefore, sound and its ingenious combinations are but the material and the medium of expression by which the composer represents

love, courage, piety, and delight. The innumerable varieties of emotion constitute the idea which, on being translated into sound, assumes the form of a musical composition. The beautiful melody and the skilful harmony as such do not charm us, but only what they imply: the whispering of love, or the clamour of ardent combatants.

In order to escape from such vague notions we must, first of all, sever from their habitual associations metaphors of the above description: The *whispering* may be expressed, true, but not the whispering of love; the *clamour* may be reproduced, undoubtedly, but not the clamour of ardent combatants. Music may reproduce phenomena such as whispering, storming, roaring, but the feelings of love or anger have only a subjective existence.

Definite feelings and emotions are unsusceptible of being embodied in music.

Our emotions have no isolated existence in the mind and cannot, therefore, be evoked by an art which is incapable of representing the remaining series of mental states. They are, on the contrary, dependent on physiological and pathological conditions, on notions and judgments – in fact, on all the processes of human reasoning which so many conceive as antithetical to the emotions.

* * *

So far we have considered only the negative aspect of the question, and have sought to expose the fallacy that the beautiful in music depends upon the accurate expression of feelings.

We must now, by way of completing the exposition, bring to light also its positive aspect, and endeavour to determine the nature of the beautiful in music.

Its nature is specifically musical. By this we mean that the beautiful is not contingent upon nor in need of any subject introduced from without, but that it consists wholly of sounds artistically combined. The ingenious co-ordination of intrinsically pleasing sounds, their consonance and contrast, their flight and reapproach, their increasing and diminishing strength – this it is which, in free and unimpeded forms, presents itself to our mental vision.

The primordial element of music is euphony, and rhythm is its soul: rhythm in general, or the harmony of a symmetrical structure, and rhythm in particular, or the systematically reciprocal motion of its several parts within a given measure. The crude material which the composer has to fashion, the vast profusion of which it is impossible to estimate fully, is the entire scale of musical notes and their inherent adaptability to an endless variety of melodies, harmonies, and rhythms. Melody, unexhausted, nay, inexhaustible, is pre-eminently the source of musical beauty. Harmony, with its countless modes of transforming, inverting, and intensifying, offers the material for constantly new developments; while rhythm, the main artery of the musical organism, is the regulator of both, and enhances the charms of the timbre in its rich variety.

To the question: What is to be expressed with all this material? the answer will be: Musical ideas. Now, a musical idea reproduced in its entirety is not only an object of intrinsic beauty but also an end in itself, and not a means for representing feelings and thoughts.

The essence of music is sound and motion.

The arabesque, a branch of the art of ornamentation, dimly betokens in what manner music may exhibit forms of beauty though no definite emotion be involved.

We see a plexus of flourishes, now bending into graceful curves, now rising in bold sweeps; moving now toward, and now away from each other; correspondingly matched in small and large arcs; apparently incommensurable, yet duly proportioned throughout; with a duplicate or counterpart to every segment; in fine, a compound of oddments, and yet a perfect whole. Imagine now an arabesque, not still and motionless, but rising before our eyes in constantly changing forms. Behold the broad and delicate lines, how they pursue one another; how from a gentle curve they rise up into lofty heights, presently to descend again; how they widen and contract, surprising the eye with a marvellous alternation of quiescence and mobility. The image thus becomes nobler and more exalted. If, moreover, we conceive this living arabesque as the active emanation of inventive genius, the artistic fullness of whose imagination is incessantly flowing into the heart of these moving forms, the effect, we think, will be not unlike that of music.

When young, we have probably all been delighted with the ever-changing tints and forms of a kaleidoscope. Now, music is a kind of kaleidoscope, though its forms can be appreciated only by an infinitely higher ideation. It brings forth a profusion of beautiful tints and forms, now sharply contrasted and now almost imperceptibly graduated; all logically connected with each other, yet all novel in their effect; forming, as it were, a complete and self-subsistent whole, free from any alien admixture. The main difference consists in the fact that the musical kaleidoscope is the direct product of a creative mind, whereas the optic one is but a cleverly constructed mechanical toy. [...]

* * *

The 'specifically musical' must not, however, be understood only in the sense of acoustic beauty or symmetry of parts – both of which elements it embraces as of secondary importance – and still less can we speak of 'a display of sounds to tickle the ear,' or use similar phraseology which is generally intended to emphasize the absence of an intellectual principle. But, by laying stress on musical beauty, we do not exclude the intellectual principle; on the contrary, we imply it as essential, for we would not apply the term 'beautiful' to anything wanting in intellectual beauty; and in tracing the essential nature of beauty to a morphological source, we wish it to be understood that the intellectual element is most intimately connected with these sonorific forms. The term 'form' in musical language is peculiarly significant. The forms created by sound are not empty; not the envelope enclosing a vacuum, but a well, replete with the living creation of inventive genius. Music, then, as compared with the arabesque, is a picture, yet a picture the subject of which we cannot define in words, or include in any one category of thought. In music there is both meaning and logical sequence, but in a musical sense; it is a language we speak and understand, but which we are unable to translate. It is a highly suggestive fact that, in speaking of musical compositions, we likewise employ the term 'thought,' and a critical mind easily distinguishes real thoughts from hollow phrases, precisely as in speech. The Germans significantly use the term *Satz* ('sentence') for the logical consummation of a part of a composition, for we know exactly when it is finished, just as in the case of a written or spoken sentence, though each has a logic of its own.

The logic in music, which produces in us a feeling of satisfaction, rests on certain elementary laws of nature which govern both the human organism and the phenom-

ena of sound. It is, above all, the primordial law of 'harmonic progression' which, like the curve lines in painting and sculpture, contains the germ of development in its main forms, and the (unfortunately almost unexplained) cause of the link which connects the various musical phenomena.

All musical elements are in some occult manner connected with each other by certain natural affinities, and since rhythm, melody, and harmony are under their invisible sway, the music created by man must conform to them – any combinations conflicting with them bearing the impress of caprice and ugliness. Though not demonstrable with scientific precision, these affinities are instinctively felt by every experienced ear, and the organic completeness and logic, or the absurdity and unnaturalness of a group of sounds, are intuitively known without the intervention of a definite conception as the standard of measure, the *tertium comparationis* [third term of comparison].

From this negative rationalness, inherent in music and founded on laws of nature, springs the possibility of its becoming invested also with positive forms of beauty.

The act of composing is a mental working on material capable of receiving the forms which the mind intends to give. The musical material in the hands of creative genius is as plastic and pliable as it is profuse. Unlike the architect, who has to mould the coarse and unwieldy rock, the composer reckons with the ulterior effect of past sounds. More ethereal and subtle than the material of any other art, sound adapts itself with great facility to any idea the composer may have in his mind. Now, as the union of sounds (from the interdependence of which the beautiful in music flows) is not effected by mechanically stringing them together but by acts of a free imagination, the intellectual force and idiosyncrasy of the particular mind will give to every composition its individual character. A musical composition, as the creation of a thinking and feeling mind, may, therefore, itself possess intellectuality and pathos in a high degree. Every musical work ought to bear this stamp of intellectuality, but the music itself must furnish evidence of its existence. Our opinion regarding the seat of the intellectual and emotional elements of a musical composition stands in the same relation to the popular way of thinking as the idea of immanence does to that of transcendence. The object of every art is to clothe in some material form an idea which has originated in the artist's imagination. In music this idea is an acoustic one; it cannot be expressed in words and subsequently translated into sounds. The initial force of a composition is the invention of some definite theme, and not the desire to describe a given emotion by musical means. Thanks to that primitive and mysterious power whose mode of action will forever be hidden from us, a theme, a melody, flashes on the composer's mind. The origin of this first germ cannot be explained, but must simply be accepted as a fact. When once it has taken root in the composer's imagination, it forthwith begins to grow and develop, the principal theme being the centre round which the branches group themselves in all conceivable ways, though always unmistakeably related to it. The beauty of an independent and simple theme appeals to our aesthetic feeling with that directness which tolerates no explanation except, perhaps, that of its inherent fitness and the harmony of parts, to the exclusion of any alien factor. It pleases for its own sake, like an arabesque, a column, or some spontaneous product of nature – a leaf or a flower.

4 Charles Baudelaire (1821–1867) *Correspondences*

Of all Baudelaire's poems this is the one that seems most clearly to have spoken to the interests of the advanced artists of his time and of subsequent decades, combining as it did a series of motifs that were to have clear relevance to the preoccupations of painting, and particularly to those which helped direct the Symbolist movement in the 1880s and 1890s (see Section VIc). These were, firstly, the idea that nature is both concealed and revealed by an intervening forest of symbols, and that art is at best a form of matching artifice; secondly, the idea of a synaesthetic correspondence between scents, colours, sounds, tastes and tactile sensations; and thirdly, a fascination with intense sensual effects pursued, at least in imagination, to the point of corruption. The poem was originally published in Baudelaire, *Les Fleurs du Mal*, Paris, 1857, in the section 'Spleen et Idéal' (Spleen and Ideal). This text is from *Les Fleurs du Mal: The Complete Text of The Flowers of Evil*, in a new translation by Richard Howard, London: Pan Books, 1892, p. 15.

Correspondances

La Nature est un temple où de vivants piliers
Laissent parfois sortir de confuses paroles;
L'homme y passe à travers des forêts de symboles
Qui l'observent avec des regards familiers.

Comme de longs échos qui de loin se confondent
Dans une ténébreuse et profonde unité,
Vaste comme la nuit et comme la clarté,
Les parfums, les couleurs et les sons se répondent.

Il est des parfums frais comme des chairs d'enfants,
Doux comme les hautbois, verts comme les prairies,
– Et d'autres, corrompus, riches et triomphants,

Ayant l'expansion des choses infinies,
Comme l'ambre, le musc, le benjoin et l'encens,
Qui chantent les transports de l'esprit et des sens.

Correspondences

The pillars of Nature's temple are alive
and sometimes yield perplexing messages;
forests of symbols between us and the shrine
remark our passage with accustomed eyes.

Like long-held echoes, blending somewhere else
into one deep and shadowy unison
as limitless as darkness and as day,
the sounds, the scents, the colours correspond.

There are odours succulent as young flesh,
sweet as flutes, and green as any grass,
while others – rich, corrupt and masterful –

possess the power of such infinite things
as incense, amber, benjamin and musk,
to praise the senses' raptures and the mind's.

5 Charles Baudelaire (1821–1867) 'Critical Method – on the Modern Idea of Progress as Applied to the Fine Arts'

In 1855, Baudelaire wrote three parts of a review of the art included in the Exposition Universelle in Paris, of which this was the first. In the case of a substantial review, it was a common convention in nineteenth-century France for the opening section to address some general issue raised by the work on view, before the writer proceeded to address the individual artists and their works. It was thus often in such opening sections that critics tended to expound their theories or to nail their colours to the mast. In this case the opportunity to compare the artistic offerings of different nations led Baudelaire to an admission of his lack of any system and to a declaration of his reliance upon feeling or intuition. His ensuing critique of the idea of progress serves as a warning to his compatriots against any complacency over the recent achievements of French art. Baudelaire was originally commissioned to write on the Exposition Universelle for the Parisian journal *Le Pays*. The present section was published in that journal on 26 May and a second, on Delacroix, on 3 June. Thereafter another writer was assigned to the exhibition, though Baudelaire published a further article on the substantial showing of Ingres's work in *Le Portefeuille*, Paris, 12 August. He subsequently reassembled the three sections with some additional material and they appeared in this form in the posthumously published collection *Curiosités esthétiques*, C. Asselineau and T. de Banville (eds), Paris: Poulet-Malassis, 1868. Our excerpt is taken from the translation of the latter version in Jonathan Mayne (ed), *Art in Paris 1845–1862: Salons and other Exhibitions Reviewed by Charles Baudelaire*, London: Phaidon, 1964: 'Exposition Universelle I. Critical Method – on the Modern Idea of Progress as Applied to the Fine Arts – on the Shift of Vitality', pp. 121–8, but without the later additions.

There can be few occupations so interesting, so attractive, so full of surprises and revelations for a critic, a dreamer whose mind is given to generalization as well as to the study of details – or, to put it even better, to the idea of an universal order and hierarchy – as a comparison of the nations and their respective products. When I say 'hierarchy', I have no wish to assert the supremacy of any one nation over another. Although Nature contains certain plants which are more or less holy, certain forms more or less spiritual, certain animals more or less sacred; and although, following the promptings of the immense universal analogy, it is legitimate for us to conclude that certain nations (vast animals, whose organisms are adequate to their surroundings) have been prepared and educated by Providence for a determined goal – a goal more or less lofty, more or less near to Heaven; – nevertheless all I wish to do here is to assert their *equal* utility in the eyes of Him who is indefinable, and the miraculous way in which they come to one another's aid in the harmony of the universe.

Any reader who has been at all accustomed by solitude (far better than by books) to these vast contemplations will already have guessed the point that I am wanting to make; and, to cut across the periphrastics and hesitations of Style with a question which is almost equivalent to a formula, I will put it thus to any honest man, always provided that he has thought and travelled a little. Let him imagine a modern Winckelmann (we are full of them; the nation overflows with them; they are the idols of the lazy). What would *he* say, if faced with a product of China – something weird, strange, distorted in form, intense in colour and sometimes delicate to the point of evanescence? And yet such a thing is a specimen of universal beauty; but in order for it to be understood, it is necessary for the critic, for the spectator, to work a transformation in himself which partakes of the nature of a mystery – it is necessary for him, by means of a phenomenon of the will acting upon the imagination, to learn of himself to participate in the surroundings which have given birth to this singular flowering. Few men have the divine grace of cosmopolitanism in its entirety; but all can acquire it in different degrees. The best endowed in this respect are those solitary wanderers who have lived for years in the heart of forests, in the midst of illimitable prairies, with no other companion but their gun – contemplating, dissecting, writing. No scholastic veil, no university paradox, no academic utopia has intervened between them and the complex truth. They know the admirable, eternal and inevitable relationship between form and function. Such people do not criticize; they contemplate, they study.

If, instead of a pedagogue, I were to take a man of the world, an intelligent being, and transport him to a faraway country, I feel sure that, while the shocks and surprises of disembarkation might be great, and the business of habituation more or less long and laborious, nevertheless sooner or later his sympathy would be so keen, so penetrating, that it would create in him a whole new world of ideas, which would form an integral part of himself and would accompany him, in the form of memories, to the day of his death. Those curiously-shaped buildings, which at first provoke his academic eye (all peoples are academic when they judge others, and barbaric when they are themselves judged); those plants and trees, which are disquieting for a mind filled with memories of its native land; those men and women, whose muscles do not pulse to the classic rhythms of his country, whose gait is not measured according to the accustomed beat, and whose gaze is not directed with the same magnetic power; those perfumes, which are no longer the perfumes of his mother's boudoir; those mysterious flowers, whose deep colour forces an entrance into his eye, while his glance is teased by their shape; those fruits, whose taste deludes and deranges the senses, and reveals to the palate ideas which belong to the sense of smell; – all that world of new harmonies will enter slowly into him, will patiently penetrate him, like the vapours of a perfumed Turkish bath; all that undreamt-of vitality will be added to his own vitality; several thousands of ideas and sensations will enrich his earthly dictionary, and it is even possible that, going a step too far and transforming justice into revolt, he will do like the converted Sicambrian [Clovis] and burn what he had formerly adored – and adore what he had formerly burnt.

Or take one of those modern 'aesthetic pundits', as Heinrich Heine calls them [Salon of 1831] – Heine, that delightful creature, who would be a genius if he turned more often towards the divine. What would *he* say? what, I repeat, would *he* write if

faced with such unfamiliar phenomena? The crazy doctrinaire of Beauty would rave, no doubt; locked up within the blinding fortress of his system, he would blaspheme both life and nature; and under the influence of his fanaticism, be it Greek, Italian or Parisian, he would prohibit that insolent race from enjoying, from dreaming or from thinking in any other ways but his very own. O ink-smudged science, bastard taste, more barbarous than the barbarians themselves! you that have forgotten the colour of the sky, the movement and the smell of animality! you whose wizened fingers, paralysed by the pen, can no longer run with agility up and down the immense keyboard of the universal *correspondences*!

Like all my friends I have tried more than once to lock myself up within a system in order to preach there at my ease. But a system is a kind of damnation which forces one to a perpetual recantation; it is always necessary to be inventing a new one, and the drudgery involved is a cruel punishment. Now my system was always beautiful, spacious, vast, convenient, neat and, above all, water-tight; at least so it seemed to me. But always some spontaneous, unexpected product of universal vitality would come to give the lie to my childish and superannuated wisdom – that lamentable child of Utopia! It was no good shifting or stretching my criterion – it always lagged behind universal man, and never stopped chasing after multiform and multi-coloured Beauty as it moved in the infinite spirals of life. Condemned unremittingly to the humiliation of a new conversion, I took a great decision. To escape from the horror of these philosophical apostasies, I haughtily resigned myself to modesty; I became content to *feel*; I returned to seek refuge in impeccable *naïveté*. I humbly beg pardon of the academics of all kinds who occupy the various workrooms of our artistic factory. But it is *there* that my philosophic conscience has found its rest; and at least I can declare – in so far as any man can answer for his virtues – that my mind now rejoices in a more abundant impartiality.

Anyone can easily understand that if those whose business it is to express beauty were to conform to the rules of the pundits, beauty itself would disappear from the earth, since all types, all ideas and all sensations would be fused in a vast, impersonal and monotonous unity, as immense as boredom or total negation. Variety, the *sine qua non* of life, would be effaced from life. So true is it that in the multiple productions of art there is an element of the ever-new which will eternally elude the rules and analyses of the school! That shock of surprise, which is one of the great joys produced by art and literature, is due to this very variety of types and sensations. The *aesthetic pundit* – a kind of mandarin-tyrant – always puts me in mind of a godless man who substitutes himself for God.

With all due respect to the over-proud sophists who have taken their wisdom from books, I shall go even further, and however delicate and difficult of expression my idea may be, I do not despair of succeeding. *The Beautiful is always strange*. I do not mean that it is coldly, deliberately strange, for in that case it would be a monstrosity that had jumped the rails of life. I mean that it always contains a touch of strangeness, of simple, unpremeditated and unconscious strangeness, and that it is this touch of strangeness that gives it its particular quality as Beauty. It is its endorsement, so to speak – its mathematical characteristic. Reverse the proposition, and try to imagine a *commonplace Beauty*! Now how could this necessary, irreducible and infinitely varied strangeness, depending upon the environment, the climate, the manners, the race, the

religion and the temperament of the artist – how could it ever be controlled, amended and corrected by Utopian rules conceived in some little scientific temple or other on this planet, without mortal danger to art itself? This dash of strangeness, which constitutes and defines individuality (without which there can be no Beauty), plays in art the role of taste and of seasoning in cooking (may the exactness of this comparison excuse its triviality!), since, setting aside their utility or the quantity of nutritive substance which they contain, the only way in which dishes differ from one another is in the *idea* which they reveal to the palate.

Therefore, in the glorious task of analysing this fine exhibition, so varied in its elements, so disturbing in its variety, and so baffling for the pedagogues, I shall endeavour to steer clear of all kind of pedantry. Others enough will speak the jargon of the studio and will exhibit *themselves* to the detriment of the *pictures*. In many cases erudition seems to me to be a childish thing and but little revealing of its true nature. I would find it only too easy to discourse subtly upon symmetrical or balanced composition, upon tonal equipoise, upon warmth and coldness of tone, etc. O Vanity! I choose instead to speak in the name of feeling, of morality and of pleasure. And I hope that a few people who are learned without pedantry will find my *ignorance* to their liking.

The story is told of Balzac (and who would not listen with respect to any anecdote, no matter how trivial, concerning that great genius?) that one day he found himself in front of a beautiful picture – a melancholy winter-scene, heavy with hoar-frost and thinly sprinkled with cottages and mean-looking peasants; and that after gazing at a little house from which a thin wisp of smoke was rising, 'How beautiful it is!', he cried. 'But what are they doing in that cottage? What are their thoughts? What are their sorrows? has it been a good harvest? *No doubt they have bills to pay?*'

Laugh if you will at M. de Balzac. I do not know the name of the painter whose honour it was to set the great novelist's soul a-quiver with anxiety and conjecture; but I think that in his way, with his delectable *naïveté*, he has given us an excellent lesson in criticism. You will often find me appraising a picture exclusively for the sum of ideas or of dreams that it suggests to my mind.

Painting is an evocation, a magical operation (if only we could consult the hearts of children on the subject!), and when the evoked character, when the reanimated idea has stood forth and looked us in the face, we have no right – at least it would be the acme of imbecility! – to discuss the magician's formulae of evocation. I know of no problem more mortifying for pedants and philosophizers than to attempt to discover in virtue of what law it is that artists who are the most opposed in their method can evoke the same ideas and stir up analogous feelings within us.

There is yet another, and very fashionable, error which I am anxious to avoid like the very devil. I refer to the idea of 'progress'. Transported into the sphere of the imagination – and there have been hotheads, fanatics of logic who have attempted to do so – the idea of progress takes the stage with a gigantic absurdity, a grotesqueness which reaches nightmare heights. The theory can no longer be upheld. The facts are too palpable, too well known. They mock at sophistry and confront it without flinching. In the poetic and artistic order, the true prophets are seldom preceded by forerunners. Every efflorescence is spontaneous, individual. Was Signorelli really the begetter of Michelangelo? Did Perugino contain Raphael? The artist stems only from

himself. His own works are the only promises that he makes to the coming centuries. He stands security only for himself. He dies childless. He has been his own king, his own priest, his own God.

It is just the same with the nations that joyfully and successfully cultivate the arts of the imagination. Present prosperity is no more than a temporary and alas! a very short-termed guarantee. There was a time when the dawn broke in the east; then the light moved towards the south, and now it streams forth from the west. It is true that France, by reason of her central position in the civilized world, seems to be summoned to gather to herself all the ideas, all the poetic products of her neighbours and to return them to other peoples, marvellously worked upon and embroidered. But it must never be forgotten that nations, those vast collective beings, are subject to the same laws as individuals. They have their childhood, in which they utter their first stammering cries and gradually grow in strength and size. They have their youth and maturity, the period of sound and courageous works. Finally they have their old age, when they fall asleep upon their piled-up riches. It often happens that it is the root principle itself that has constituted their strength, and the process of development that has brought with it their decadence – above all when that root principle, which was formerly quickened by an all-conquering enthusiasm, has become for the majority a kind of routine. Then, as I half suggested a moment ago, the vital spirit shifts and goes to visit other races and other lands. But it must not be thought that the newcomers inherit lock, stock and barrel from their predecessors or that they receive from them a ready-made body of doctrine. It often happens (as happened in the Middle Ages) that all being lost, all has to be re-fashioned.

Anyone who visited the *Exposition Universelle* with the preconceived idea of finding the children of Leonardo, Raphael and Michelangelo among the Italians, the spirit of Dürer among the Germans, or the soul of Zurbaran and Velasquez among the Spaniards, would be preparing himself for a needless shock. I have neither the time, nor perhaps sufficient knowledge, to investigate what are the laws which shift artistic vitality, or to discover why it is that God dispossesses the nations sometimes for a while only, and sometimes for ever; I content myself with noting a very frequent occurrence in history. We are living in an age in which it is necessary to go on repeating certain platitudes – in an arrogant age which believes itself to be above the misadventures of Greece and Rome. [...]

6 Charles Baudelaire (1821–1867) 'The Queen of the Faculties'

The following passage is taken from Baudelaire's 'Salon of 1859'. Section I of this review, 'The Modern Artist', is taken up by a critical account of those who degrade the artist's calling through 'discredit of the imagination, disdain of the great' and 'exclusive *practice* of technique'. The succeeding section, on 'The Modern Public and Photography', is included below as text IVc5. In the present text, which forms the third section of the Salon, Baudelaire develops the positive counterpart to his opening negative account, in the process distancing himself from the more doctrinaire forms of Realism prevalent at the time. By 'The Queen of the Faculties' he means imagination, which he is careful to distinguish from Idealism. As is often the case in Baudelaire's writing on art, this passage

contains strong echoes of the views of Delacroix. The 'Salon de 1859' was originally published in four instalments in the *Revue Française*, Paris, 10 June – 20 July 1859. The following text is taken from the translation by Jonathan Mayne in *Art in Paris: 1845–1862*, London: Phaidon, 1964, pp. 155–8.

In recent years we have heard it said in a thousand different ways, 'Copy nature; just copy nature. There is no greater delight, no finer triumph than an excellent copy of nature.' And this doctrine (the enemy of art) was alleged to apply not only to painting but to all the arts, even to the novel and to poetry. To these doctrinaires, who were so completely satisfied by Nature, a man of imagination would certainly have had the right to reply: 'I consider it useless and tedious to represent what *exists*, because nothing that *exists* satisfies me. Nature is ugly, and I prefer the monsters of my fancy to what is positively trivial.' And yet it would have been more philosophical to ask the doctrinaires in question first of all whether they were quite certain of the existence of external nature, or (if this question might seem too well calculated to pander to their sarcasm) whether they were quite certain of knowing *all nature*, that is, all that is contained in nature. A 'yes' would have been the most boastful and extravagant of answers. So far as I have been able to understand its singular and humiliating incoherences, the doctrine meant – at least I do it the honour of believing that it meant: The artist, the true artist, the true poet, should only paint in accordance with what he sees and with what he feels. He must be *really* faithful to his own nature. He must avoid like the plague borrowing the eyes and the feelings of another man, however great that man may be; for then his productions would be lies in relation to himself, and not *realities*. But if these pedants of whom I am speaking (for there is a pedantry even among the mean-spirited) and who have representatives everywhere (for their theory flatters impotence no less than laziness) – if these pedants, I say, did not wish the matter to be understood in this way, let us simply believe that they meant to say, 'We have no imagination, and we decree that no one else is to have any.'

How mysterious is Imagination, that Queen of the Faculties! It touches all the others; it rouses them and sends them into combat. At times it resembles them to the point of confusion, and yet it is always itself, and those men who are not quickened thereby are easily recognizable by some strange curse which withers their productions like the figtree in the Gospel.

It is both analysis and synthesis; and yet men who are clever at analysis and sufficiently quick at summing up, can be devoid of imagination. It is that, and it is not entirely that. It is sensitivity, and yet there are people who are very sensitive, too sensitive perhaps, who have none of it. It is Imagination that first taught man the moral meaning of colour, of contour, of sound and of scent. In the beginning of the world it created analogy and metaphor. It decomposes all creation, and with the raw materials accumulated and disposed in accordance with rules whose origins one cannot find save in the furthest depths of the soul, it creates a new world, it produces the sensation of newness. As it has created the world (so much can be said, I think, even in a religious sense), it is proper that it should govern it. What would be said of a warrior without imagination? that he might make an excellent soldier, but that if he is put in command of an army, he will make no conquests. The case could be compared to that of a poet or a novelist who took away the command of his faculties from the

imagination to give it, for example, to his knowledge of language or to his observation of facts. What would be said of a diplomat without imagination? that he may have an excellent knowledge of the history of treaties and alliances in the past, but that he will never guess the treaties and alliances held in store by the future. Of a scholar without imagination? that he has learnt everything that, having been taught, could be learnt, but that he will never discover any laws that have not yet been guessed at. Imagination is the queen of truth, and the *possible* is one of the provinces of truth. It has a positive relationship with the infinite.

Without imagination, all the faculties, however sound or sharpened they may be, are as though they did not exist, whereas a weakness in some of the secondary faculties, so long as they are excited by a vigorous imagination, is a secondary misfortune. None of them can do without it, but the lack of some of them can be made up by it. Often when our other faculties only find what they are seeking after successive trials of several different methods which are ill-adapted to the nature of things, imagination steps in, and proudly and simply guesses the answer. Finally, it plays a powerful role even in ethical matters; for – allow me to go so far and to ask, What is virtue without imagination? You might as well speak of virtue without pity, virtue without Heaven – it is a hard, cruel, sterilizing thing, which in some countries has become bigotry and in others protestantism.

In spite of all the magnificent privileges that I attribute to the imagination, I will not pay your readers the insult of explaining to them that the more it is helped in its work, the more powerful it is, and that there is nothing more formidable in our battles with the ideal than a fine imagination disposing of an immense armoury of observed fact. [. . .]

Imagination, one must conclude, thanks to its *supplementing* nature, embraces also the critical spirit.

7 Victor Fournel (1829–1894) 'The Art of *Flânerie*'

The *flâneur* in Walter Benjamin's memorable phrase, is one who 'botanizes upon the asphalt'. Where, for Champfleury, the artist is an impassioned naturalist whose pictures are assured of objectivity by the force of his sensations, for Fournel he is an 'idler' who registers the passing impressions of the city with the sensitivity of a photographic plate. The 'stonebreakers' whose performance Fournel's *flâneur* admires are actual men at work on the streets of Paris. A viewer who had observed Courbet's work in the Salon of 1850–1 might conceivably have registered the irony. Fournel was not writing as an engaged critic of art, however. He is representative of a number of writers in the Paris of the 1850s and 1860s who devoted themselves to advertising the delights of the capital, its theatrical entertainments, its exhibitions and its streets (for later forms of the same type of publication, see VB11 and VIA2). The title of the book from which this excerpt is taken can be translated as *Things to be Seen on the Streets of Paris*. It is noteworthy that the urban paintings of the Impressionists were to conjure up a similar repertoire of sights. As the author makes clear, the concepts of the *flâneur* (or stroller) and the *badaud* (or idler) gained a specific meaning in the context of the time and place, and through the particular forms of self-image open to the prosperous Parisian male (see also the following text). This was the type of spectator whose interests and point of view were to be both represented

by Manet's painting and critically reflected back from its surfaces. Fournel's book was originally published as *Ce qu'on voit dans les rues de Paris*, Paris: Adolphe Delahays, 1858. The following extract is taken from chapter II, pp. 261–4, translated for this volume by Christopher Miller.

What a fine and enjoyable thing is *flânerie*, and how full of charms and enticements is the work of the *badaud*! Those who have once tasted it can never afterwards be sated; they return to it incessantly, as – it is said – one returns to one's first loves. 'A sluggard's life!' cry the serious. Sluggard! Now really; I should not wish to overstep the bounds of civility with anyone; but it is clear that you have never *flâné*, gentlemen, and are incapable of doing so; it is not given to everyone to *flâner* naively yet knowingly... This life is, on the contrary, for those able to understand and practice it, the most active of lives, the most fertile and productive; an intelligent and conscientious idler, who scrupulously performs his duties – that is, observes and remembers everything – can play a leading role in the republic of art. Such a man is an impassioned, peripatetic daguerreotype upon whom the least trace registers; in him are reproduced, with every reflection that they cast, the progress of things, the movement of the city, the multifarious physiognomy of the public mind, the beliefs, antipathies and adorations of the mass.

It was while strolling through Paris that Balzac made so many priceless discoveries, heard so many quips, unearthed so many representative types. It was a sort of *flânerie* upon the ocean wave that led Christopher Columbus to discover America. And many new Americas remain to be discovered by one strolling his own course through certain as yet uncharted domains of the Parisian Ocean.

Have you ever considered all that this charming word *flânerie*, so beloved of poets and humorists, holds in store? To make interminable expeditions through streets and promenades; to wander, attentive to what may chance, with one's hands in one's pockets and an umbrella under one's arm, like any upright soul; to follow one's nose, with no notion of haste or destination, like Jean de la Fontaine as he set off for the Académie; to stop at every store to examine the images, at the corner of every street to study the posters, at every book-stall to run a hand over the bindings; to see a crowd gathered round a performing rabbit, and to join it, careless of one's dignity, fascinated, delighted, giving oneself up to the spectacle heart, soul and senses; to listen, here to the homily of a soap-seller, there to the poetical pitch of a hawker of watches at twenty-five sous, and further on to the reiterated complaints of misunderstood charlatans; if need be, to follow the music of a passing regiment for mile upon mile along the *quais*, or listen in all earnestness to the cooings of the café Morel's prima donna; to savour the variety of the hurdy-gurdies' tones; to watch the exploits of open-air magician, acrobat and hypnotist; to admire the stone-breakers' performance; to run when one sees others running, stop when one wants, sit down whenever one desires, Lord, what pleasure! And this is the life of the *badaud*!

Tell me, you sad, censorious moralists, are there many lives to compare with this?

Here I would willingly begin by setting out the theory of *flânerie*; but what distinguishes this theory from all others is that it does not and cannot exist. The amiable science of *flânerie* is instinctively known to its initiates; engraved upon its banner we read the magic inscription of the *Abbaye de Thélème*: 'Do as you wish'.[1]

¹ [Translator's note:] The *Abbaye de Thélème* is a utopian institution founded by Gargantua in Rabelais's book of that name; see chapters LII–LVII. Rabelais's inscription reads FAY CE QUE VOULDRAS [Do as you would].

8 Charles Baudelaire (1821–1867) from 'The Painter of Modern Life'

Of all Baudelaire's writings, this lengthy essay did more than any other to define and to direct the character of modernity as represented in art during the later nineteenth century. In fact its themes and concepts were to retain their power over the minds of artists and other writers well into the twentieth. Among the most enduring of these are the notion of beauty as a kind of dialectical product, composed both of the eternal and of the transitory, and thus necessarily associated with modernity; the idea of the artist as a type in whom the worldly and the childlike are combined; the appeals to dandyism and to artifice in the face of a tedious Naturalism; and the characterization of the prostitute as an inescapable figure in the imagery of modern society. The Monsieur G. upon whom so much is made to hang was Constantin Guys (1805–92), an illustrator and watercolourist in whose works the observation of social mannerisms was combined with the fruits of a roving pictorial journalism. (Much of his work was published in the *Illustrated London News*.) Further mention of Guys is to be found in the *Journal* of the Goncourts (see IIIB16). It is Manet, however, whom subsequent history has tended to identify as the paradigmatic 'painter of modern life', though his work was not known to Baudelaire when the essay was composed. The essay was originally published as 'Le peinture de la vie moderne' in *Le Figaro*, Paris, 26 and 28 November and 3 December 1863, from a text of 1859. The following excerpts are taken from the translation in Jonathan Mayne (ed), *The Painter of Modern Life and other Essays*, London: Phaidon, 1964, pp. 1–3, 5–10, 12–14, 26–38 and 40.

I. Beauty, Fashion and Happiness

The world – and even the world of artists – is full of people who can go to the Louvre, walk rapidly, without so much as a glance, past rows of very interesting, though secondary, pictures, to come to a rapturous halt in front of a Titian or a Raphael – one of those that have been most popularized by the engraver's art; then they will go home happy, not a few saying to themselves, 'I know my Museum'. Just as there are people who, having once read Bossuet and Racine, fancy that they have mastered the history of literature.

Fortunately from time to time there come forward righters of wrong, critics, amateurs, curious enquirers, to declare that Raphael, or Racine, does not contain the whole secret, and that the minor poets too have something good, solid and delightful to offer; and finally that however much we may love *general* beauty, as it is expressed by classical poets and artists, we are no less wrong to neglect *particular* beauty, the beauty of circumstance and the sketch of manners.

It must be admitted that for some years now the world has been mending its ways a little. The value which collectors today attach to the delightful coloured engravings of the last century proves that a reaction has set in in the direction where it was required; Debucourt, the Saint-Aubins and many others have found their places in the dictionary of artists who are worthy of study. But these represent the past: my concern today is with the painting of manners of the present. The past is interesting not only

by reason of the beauty which could be distilled from it by those artists for whom it was the present, but also precisely because it is the past, for its historical value. It is the same with the present. The pleasure which we derive from the representation of the present is due not only to the beauty with which it can be invested, but also to its essential quality of being present.

I have before me a series of fashion-plates dating from the Revolution and finishing more or less with the Consulate. These costumes, which seem laughable to many thoughtless people – people who are grave without true gravity – have a double-natured charm, one both artistic and historical. They are often very beautiful and drawn with wit; but what to me is every bit as important, and what I am happy to find in all, or almost all of them, is the moral and aesthetic feeling of their time. The idea of beauty which man creates for himself imprints itself on his whole attire, crumples or stiffens his dress, rounds off or squares his gesture, and in the long run even ends by subtly penetrating the very features of his face. Man ends by looking like his ideal self. These engravings can be translated either into beauty or ugliness; in one direction, they become caricatures, in the other, antique statues.

* * *

This is in fact an excellent opportunity to establish a rational and historical theory of beauty, in contrast to the academic theory of an unique and absolute beauty; to show that beauty is always and inevitably of a double composition, although the impression that it produces is single – for the fact that it is difficult to discern the variable elements of beauty within the unity of the impression invalidates in no way the necessity of variety in its composition. Beauty is made up of an eternal, invariable element, whose quantity it is excessively difficult to determine, and of a relative, circumstantial element, which will be, if you like, whether severally or all at once, the age, its fashions, its morals, its emotions. Without this second element, which might be described as the amusing, enticing, appetizing icing on the divine cake, the first element would be beyond our powers of digestion or appreciation, neither adapted nor suitable to human nature. I defy anyone to point to a single scrap of beauty which does not contain these two elements. [...]

The duality of art is a fatal consequence of the duality of man. Consider, if you will, the eternally subsisting portion as the soul of art, and the variable element as its body [...]

III. The Artist, Man of the World, Man of the Crowd, and Child

Today I want to discourse to the public about a strange man, a man of so powerful and so decided an originality that it is sufficient unto itself and does not even seek approval. Not a single one of his drawings is signed, if by signature you mean that string of easily forgeable characters which spell a name and which so many other artists affix ostentatiously at the foot of their least important trifles. Yet all his works are signed – with his dazzling *soul*; and art-lovers who have seen and appreciated them will readily recognize them from the description that I am about to give.

A passionate lover of crowds and incognitos, Monsieur C. G. carries originality to the point of shyness. [...]

When at last I ran him to earth, I saw at once that it was not precisely an *artist*, but rather a *man of the world* with whom I had to do. I ask you to understand the word *artist* in a very restricted sense, and *man of the world* in a very broad one. By the second I mean a man of the whole world, a man who understands the world and the mysterious and lawful reasons for all its uses; by the first, a specialist, a man wedded to his palette like the serf to the soil. Monsieur G. does not like to be called an artist. Is he not perhaps a little right? His interest is the whole world; he wants to know, understand and appreciate everything that happens on the surface of our globe. The artist lives very little, if at all, in the world of morals and politics. If he lives in the Bréda district, he will be unaware of what is going on in the Faubourg Saint-Germain. Apart from one or two exceptions whom I need not name, it must be admitted that the majority of artists are no more than highly skilled animals, pure artisans, village intellects, cottage brains. Their conversation, which is necessarily limited to the narrowest of circles, becomes very quickly unbearable to the *man of the world*, to the spiritual citizen of the universe.

And so, as a first step towards an understanding of Monsieur G., I would ask you to note at once that the mainspring of his genius is *curiosity*.

Do you remember a picture (it really is a picture!), painted – or rather written – by the most powerful pen of our age, and entitled *The Man of the Crowd*? [see IID7]. In the window of a coffee-house there sits a convalescent, pleasurably absorbed in gazing at the crowd, and mingling, through the medium of thought, in the turmoil of thought that surrounds him. But lately returned from the valley of the shadow of death, he is rapturously breathing in all the odours and essences of life; as he has been on the brink of total oblivion, he remembers, and fervently desires to remember, everything. Finally he hurls himself headlong into the midst of the throng, in pursuit of an unknown, half-glimpsed countenance that has, on an instant, bewitched him. Curiosity has become a fatal, irresistible passion!

Imagine an artist who was always, spiritually, in the condition of that convalescent, and you will have the key to the nature of Monsieur G.

Now convalescence is like a return towards childhood. The convalescent, like the child, is possessed in the highest degree of the faculty of keenly interesting himself in things, be they apparently of the most trivial. Let us go back, if we can, by a retrospective effort of the imagination, towards our most youthful, our earliest, impressions, and we will recognize that they had a strange kinship with those brightly coloured impressions which we were later to receive in the aftermath of a physical illness, always provided that that illness had left our spiritual capacities pure and unharmed. The child sees everything in a state of newness; he is always *drunk*. Nothing more resembles what we call inspiration than the delight with which a child absorbs form and colour. I am prepared to go even further and assert that inspiration has something in common with a convulsion, and that every sublime thought is accompanied by a more or less violent nervous shock which has its repercussion in the very core of the brain. The man of genius has sound nerves, while those of the child are weak. With the one, Reason has taken up a considerable position; with the other, Sensibility is almost the whole being. But genius is nothing more nor less than *childhood recovered* at will – a childhood now equipped for self-expression with manhood's capacities and a power of analysis which enables it to order

the mass of raw material which it has involuntarily accumulated. It is by this deep and joyful curiosity that we may explain the fixed and animally ecstatic gaze of a child confronted with something new, whatever it be, whether a face or a landscape, gilding, colours, shimmering stuffs, or the magic of physical beauty assisted by the cosmetic art. A friend of mine once told me that when he was quite a small child, he used to be present when his father dressed in the mornings, and that it was with a mixture of amazement and delight that he used to study the muscles of his arms, the gradual transitions of pink and yellow in his skin, and the bluish network of his veins. The picture of external life was already filling him with awe and taking hold of his brain. He was already being obsessed and possessed by form. Predestination was already showing the tip of its nose. His sentence was sealed. Need I add that today that child is a well-known painter?

I asked you a moment ago to think of Monsieur G. as an eternal convalescent. To complete your idea, consider him also as a man-child, as a man who is never for a moment without the genius of childhood – a genius for which no aspect of life has become *stale*.

I have told you that I was reluctant to describe him as an artist pure and simple, and indeed that he declined this title with a modesty touched with aristocratic reserve. I might perhaps call him a dandy, and I should have several good reasons for that; for the word 'dandy' implies a quintessence of character and a subtle understanding of the entire moral mechanism of this world; with another part of his nature, however, the dandy aspires to insensitivity, and it is in this that Monsieur G., dominated as he is by an insatiable passion – for seeing and feeling – parts company decisively with dandyism. '*Amabam amare*,' said St Augustine. 'I am passionately in love with passion,' Monsieur G. might well echo. The dandy is blasé, or pretends to be so, for reasons of policy and caste. Monsieur G. has a horror of blasé people. He is a master of that only too difficult art – sensitive spirits will understand me – of being sincere without being absurd. I would bestow upon him the title of philosopher, to which he has more than one right, if his excessive love of visible, tangible things, condensed to their plastic state, did not arouse in him a certain repugnance for the things that form the impalpable kingdom of the metaphysician. Let us be content therefore to consider him as a pure pictorial moralist, like La Bruyère.

The crowd is his element, as the air is that of birds and water of fishes. His passion and his profession are to become one flesh with the crowd. For the perfect *flâneur*, for the passionate spectator, it is an immense joy to set up house in the heart of the multitude, amid the ebb and flow of movement, in the midst of the fugitive and the infinite. To be away from home and yet to feel oneself everywhere at home; to see the world, to be at the centre of the world, and yet to remain hidden from the world – such are a few of the slightest pleasures of those independent, passionate, impartial natures which the tongue can but clumsily define. The spectator is a *prince* who everywhere rejoices in his incognito. The lover of life makes the whole world his family, just like the lover of the fair sex who builds up his family from all the beautiful women that he has ever found, or that are – or are not – to be found; or the lover of pictures who lives in a magical society of dreams painted on canvas. Thus the lover of universal life enters into the crowd as though it were an immense reservoir of electrical energy. Or we might liken him to a mirror as vast as the crowd itself; or to a

kaleidoscope gifted with consciousness, responding to each one of its movements and reproducing the multiplicity of life and the flickering grace of all the elements of life. He is an 'I' with an insatiable appetite for the 'non-I', at every instant rendering and explaining it in pictures more living than life itself, which is always unstable and fugitive.

* * *

IV. Modernity

. . . Be very sure that this man, such as I have depicted him – this solitary, gifted with an active imagination, ceaselessly journeying across the great human desert – has an aim loftier than that of a mere *flâneur*, an aim more general, something other than the fugitive pleasure of circumstance. He is looking for that quality which you must allow me to call 'modernity'; for I know of no better word to express the idea I have in mind. He makes it his business to extract from fashion whatever element it may contain of poetry within history, to distil the eternal from the transitory. Casting an eye over our exhibitions of modern pictures, we are struck by a general tendency among artists to dress all their subjects in the garments of the past. Almost all of them make use of the costumes and furnishings of the Renaissance, just as David employed the costumes and furnishings of Rome. There is however this difference, that David, by choosing subjects which were specifically Greek or Roman, had no alternative but to dress them in antique garb, whereas the painters of today, though choosing subjects of a general nature and applicable to all ages, nevertheless persist in rigging them out in the costumes of the Middle Ages, the Renaissance or the Orient. This is clearly symptom-atic of a great degree of laziness; for it is much easier to decide outright that everything about the garb of an age is absolutely ugly than to devote oneself to the task of distilling from it the mysterious element of beauty that it may contain, however slight or minimal that element may be. By 'modernity' I mean the ephemeral, the fugitive, the contingent, the half of art whose other half is the eternal and the immutable. Every old master has had his own modernity; the great majority of fine portraits that have come down to us from former generations are clothed in the costume of their own period. They are perfectly harmonious, because everything – from costume and coiffure down to gesture, glance and smile (for each age has a deportment, a glance and a smile of its own) – everything, I say, combines to form a completely viable whole. This transitory, fugitive element, whose metamorphoses are so rapid, must on no account be despised or dispensed with. By neglecting it, you cannot fail to tumble into the abyss of an abstract and indeterminate beauty, like that of the first woman before the fall of man. If for the necessary and inevitable costume of the age you substitute another, you will be guilty of a mistranslation only to be excused in the case of a masquerade prescribed by fashion. (Thus, the goddesses, nymphs and sultanas of the eighteenth century are still convincing portraits, *morally* speaking.)

It is doubtless an excellent thing to study the old masters in order to learn how to paint; but it can be no more than a waste of labour if your aim is to understand the special nature of present-day beauty. The draperies of Rubens or Veronese will in no

way teach you how to depict *moire antique, satin à la reine* or any other fabric of modern manufacture, which we see supported and hung over crinoline or starched muslin petticoat. In texture and weave these are quite different from the fabrics of ancient Venice or those worn at the court of Catherine. Furthermore the cut of skirt and bodice is by no means similar; the pleats are arranged according to a new system. Finally the gesture and the bearing of the woman of today give to her dress a life and a special character which are not those of the woman of the past. In short, for any 'modernity' to be worthy of one day taking its place as 'antiquity', it is necessary for the mysterious beauty which human life accidentally puts into it to be distilled from it. And it is to this task that Monsieur G. particularly addresses himself.

I have remarked that every age had its own gait, glance and gesture. The easiest way to verify this proposition would be to betake oneself to some vast portrait-gallery, such as the one at Versailles. But it has an even wider application. Within that unity which we call a Nation, the various professions and classes and the passing centuries all introduce variety, not only in manners and gesture, but even in the actual form of the face. Certain types of nose, mouth and brow will be found to dominate the scene for a period whose extent I have no intention of attempting to determine here, but which could certainly be subjected to a form of calculation. Considerations of this kind are not sufficiently familiar to our portrait-painters; the great failing of M. Ingres, in particular, is that he seeks to impose upon every type of sitter a more or less complete, by which I mean a more or less despotic, form of perfection, borrowed from the repertory of classical ideas.

In a matter of this kind it would be easy, and indeed legitimate, to argue *a priori*. The perpetual correlation between what is called the 'soul' and what is called the 'body' explains quite clearly how everything that is 'material', or in other words an emanation of the 'spiritual', mirrors, and will always mirror, the spiritual reality from which it derives. If a painstaking, scrupulous, but feebly imaginative artist has to paint a courtesan of today and takes his 'inspiration' (that is the accepted word) from a courtesan by Titian or Raphael, it is only too likely that he will produce a work which is false, ambiguous and obscure. From the study of a masterpiece of that time and type he will learn nothing of the bearing, the glance, the smile or the living 'style' of one of those creatures whom the dictionary of fashion has successively classified under the coarse or playful titles of 'doxies', 'kept women', *lorettes*, or *biches*.

The same criticism may be strictly applied to the study of the military man and the dandy, and even to that of animals, whether horses or dogs; in short, of everything that goes to make up the external life of this age. Woe to him who studies the antique for anything else but pure art, logic and general method! By steeping himself too thoroughly in it, he will lose all memory of the present; he will renounce the rights and privileges offered by circumstance – for almost all our originality comes from the seal which Time imprints on our sensations.

* * *

IX. The Dandy

The man who is rich and idle, and who, even if blasé, has no other occupation than the perpetual pursuit of happiness; the man who has been brought up amid luxury and

has been accustomed from his earliest days to the obedience of others – he, in short, whose solitary profession is elegance, will always and at all times possess a distinct type of physiognomy, one entirely *sui generis*. Dandyism is a mysterious institution, no less peculiar than the duel: it is of great antiquity, Caesar, Catiline and Alcibiades providing us with dazzling examples; and very widespread, Chateaubriand having found it in the forests and by the lakes of the New World. Dandyism, an institution beyond the laws, itself has rigorous laws which all its subjects must strictly obey, whatever their natural impetuosity and independence of character. The English more than others have cultivated the society-novel, and French writers, who, like M. de Custine, have made a speciality of love-stories, have taken immediate and very proper care to endow their characters with fortunes ample enough to pay without thinking for all their extravagances; and they have gone on to dispense them of any profession. These beings have no other calling but to cultivate the idea of beauty in their persons, to satisfy their passions, to feel and to think. They thus possess a vast abundance both of time and money, without which fantasy, reduced to a state of passing reverie, can hardly be translated into action. It is sad but only too true that without the money and the leisure, love is incapable of rising above a grocer's orgy or the accomplishment of a conjugal duty. Instead of being a passionate or poetical caprice, it becomes a repulsive utility.

If I speak of love in connection with dandyism, this is because love is the natural occupation of the idle. The dandy does not, however, regard love as a special target to be aimed at. If I have spoken of money, this is because money is indispensable to those who make a cult of their emotions; but the dandy does not aspire to money as to something essential; this crude passion he leaves to vulgar mortals; he would be perfectly content with a limitless credit at the bank. Dandyism does not even consist, as many thoughtless people seem to believe, in an immoderate taste for the toilet and material elegance. For the perfect dandy these things are no more than symbols of his aristocratic superiority of mind. Furthermore to his eyes, which are in love with *distinction* above all things, the perfection of his toilet will consist in absolute simplicity, which is the best way, in fact, of achieving the desired quality. What then is this passion, which, becoming doctrine, has produced such a school of tyrants? what this unofficial institution which has formed so haughty and exclusive a sect? It is first and foremost the burning need to create for oneself a personal originality, bounded only by the limits of the proprieties. It is a kind of cult of the self which can nevertheless survive the pursuit of a happiness to be found in someone else – in woman, for example; which can even survive all that goes by in the name of illusions. It is the joy of astonishing others, and the proud satisfaction of never oneself being astonished. A dandy may be blasé, he may even suffer; but in this case, he will smile like the Spartan boy under the fox's tooth.

It can be seen how, at certain points, dandyism borders upon the spiritual and social. But a dandy can never be a vulgarian. If he committed a crime, it would perhaps not ruin him; but if his crime resulted from some trivial cause, his disgrace would be irreparable. Let not the reader be scandalized by this gravity amid the frivolous; let him rather recall that there is a grandeur in all follies, an energy in all excess. A weird kind of spiritualist, it must be admitted! For those who are at once its priests and its victims, all the complicated material conditions to which they submit,

from an impeccable toilet at every hour of the day and the night to the most perilous feats of the sporting field, are no more than a system of gymnastics designed to fortify the will and discipline the soul. In truth I was not altogether wrong to consider dandyism as a kind of religion. The strictest monastic rule, the inexorable order of the Assassins according to which the penalty for drunkenness was enforced suicide, were no more despotic, and no more obeyed, than this doctrine of elegance and originality, which also imposes upon its humble and ambitious disciples – men often full of fire, passion, courage and restrained energy – the terrible formula: *Perinde ac cadaver* [just like a corpse]!

Whether these men are nicknamed exquisites, *incroyables*, beaux, lions or dandies, they all spring from the same womb; they all partake of the same characteristic quality of opposition and revolt; they are all representatives of what is finest in human pride, of that compelling need, alas only too rare today, of combating and destroying triviality. It is from this that the dandies obtain that haughty exclusiveness, provocative in its very coldness. Dandyism appears above all in periods of transition, when democracy is not yet all-powerful, and aristocracy is only just beginning to totter and fall. In the disorder of these times, certain men who are socially, politically and financially ill at ease, but are all rich in native energy, may conceive the idea of establishing a new kind of aristocracy, all the more difficult to shatter as it will be based on the most precious, the most enduring faculties, and on the divine gifts which work and money are unable to bestow. Dandyism is the last spark of heroism amid decadence; and the type of dandy discovered by our traveller in North America does nothing to invalidate this idea; for how can we be sure that those tribes which we call 'savage' may not in fact be the *disjecta membra* [severed limbs] of great extinct civilizations? Dandyism is a sunset; like the declining daystar, it is glorious, without heat and full of melancholy. But alas, the rising tide of democracy, which invades and levels everything, is daily overwhelming these last representatives of human pride and pouring floods of oblivion upon the footprints of these stupendous warriors. Dandies are becoming rarer and rarer in our country, whereas amongst our neighbours in England the social system and the constitution (the true constitution, I mean: the constitution which expresses itself through behaviour) will for a long time yet allow a place for the descendants of Sheridan, Brummel and Byron, granted at least that men are born who are worthy of such a heritage.

What to the reader may have seemed a digression is not so in truth. The moral reflections and considerations provoked by an artist's drawings are in many cases the best translation of them that criticism can make; such suggestions form part of an underlying idea which begins to emerge as they are set out one after the other. It is hardly necessary to say that when Monsieur G. sketches one of his dandies on the paper, he never fails to give him his historical personality – his legendary personality, I would venture to say, if we were not speaking of the present time and of things generally considered as frivolous. Nothing is missed: his lightness of step, his social aplomb, the simplicity in his air of authority, his way of wearing a coat or riding a horse, his bodily attitudes which are always relaxed but betray an inner energy, so that when your eye lights upon one of those privileged beings in whom the graceful and the formidable are so mysteriously blended, you think: 'A rich man perhaps, but more likely an out-of-work Hercules!'

The distinguishing characteristic of the dandy's beauty consists above all in an air of coldness which comes from an unshakeable determination not to be moved; you might call it a latent fire which hints at itself, and which could, but chooses not to burst into flame. It is this quality which these pictures express so perfectly.

X. Woman

The being who, for the majority of men, is the source of the liveliest and even – be it said to the shame of philosophic pleasures – of the most lasting delights; the being towards whom, or on behalf of whom, all their efforts are directed; that being as terrible and incommunicable as the Deity (with this difference, that the Infinite does not communicate because it would thereby blind and overwhelm the finite, whereas the creature of whom we are speaking is perhaps only incomprehensible because it has nothing to communicate); that being in whom Joseph de Maistre saw a graceful animal whose beauty enlivened and made easier the serious game of politics; for whom, and through whom, fortunes are made and unmade; for whom, but above all *through whom*, artists and poets create their most exquisite jewels; the source of the most exhausting pleasures and the most productive pains – Woman, in a word, for the artist in general, and Monsieur G. in particular, is far more than just the female of Man. Rather she is a divinity, a star, which presides at all the conceptions of the brain of man; a glittering conglomeration of all the graces of Nature, condensed into a single being; the object of the keenest admiration and curiosity that the picture of life can offer its contemplator. She is a kind of idol, stupid perhaps, but dazzling and bewitching, who holds wills and destinies suspended on her glance. She is not, I must admit, an animal whose component parts, correctly assembled, provide a perfect example of harmony; she is not even that type of pure beauty which the sculptor can mentally evoke in the course of his sternest meditations; no, this would still not be sufficient to explain her mysterious and complex spell. We are not concerned here with Winckelmann and Raphael; and I hope that I shall not appear to wrong him when I say that despite the wide range of his intelligence, I feel sure that Monsieur G. would willingly pass over a fragment of antique statuary if otherwise he might let slip an opportunity of enjoying a portrait by Reynolds or Lawrence. Everything that adorns woman, everything that serves to show off her beauty, is part of herself; and those artists who have made a particular study of this enigmatic being dote no less on all the details of the *mundus muliebris* [feminine world] than on Woman herself. No doubt Woman is sometimes a light, a glance, an invitation to happiness, sometimes just a word; but above all she is a general harmony, not only in her bearing and the way in which she moves and walks, but also in the muslins, the gauzes, the vast, iridescent clouds of stuff in which she envelops herself, and which are as it were the attributes and the pedestal of her divinity; in the metal and the mineral which twist and turn around her arms and her neck, adding their sparks to the fire of her glance, or gently whispering at her ears. What poet, in sitting down to paint the pleasure caused by the sight of a beautiful woman, would venture to separate her from her costume? Where is the man who, in the street, at the theatre, or in the

park, has not in the most disinterested of ways enjoyed a skilfully composed toilette, and has not taken away with him a picture of it which is inseparable from the beauty of her to whom it belonged, making thus of the two things – the woman and her dress – an indivisible unity? This is the moment, it seems to me, to return to certain questions concerning fashion and finery which I did no more than touch upon at the beginning of this study, and to vindicate the art of the dressing-table from the fatuous slanders with which certain very dubious lovers of Nature have attacked it.

XI In Praise of Cosmetics

[. . .] The majority of errors in the field of aesthetics spring from the eighteenth century's false premise in the field of ethics. At that time Nature was taken as ground, source and type of all possible Good and Beauty. The negation of original sin played no small part in the general blindness of that period. But if we are prepared to refer simply to the facts, which are manifest to the experience of all ages no less than to the readers of the Law Reports, we shall see that Nature teaches us nothing, or practically nothing. I admit that she *compels* man to sleep, to eat, to drink, and to arm himself as well as he may against the inclemencies of the weather: but it is she too who incites man to murder his brother, to eat him, to lock him up and to torture him; for no sooner do we take leave of the domain of needs and necessities to enter that of pleasures and luxury than we see that Nature can counsel nothing but crime. It is this infallible Mother Nature who has created patricide and cannibalism, and a thousand other abominations that both shame and modesty prevent us from naming. On the other hand it is philosophy (I speak of good philosophy) and religion which command us to look after our parents when they are poor and infirm. Nature, being none other than the voice of our own self-interest, would have us slaughter them. I ask you to review and scrutinize whatever is natural – all the actions and desires of the purely natural man: you will find nothing but frightfulness. Everything beautiful and noble is the result of reason and calculation. Crime, of which the human animal has learned the taste in his mother's womb, is natural by origin. Virtue, on the other hand, is artificial, supernatural, since at all times and in all places gods and prophets have been needed to teach it to animalized humanity, man being powerless to discover it by himself. Evil happens without effort, naturally, fatally; Good is always the product of some art. All that I am saying about Nature as a bad counsellor in moral matters, and about Reason as true redeemer and reformer, can be applied to the realm of Beauty. I am thus led to regard external finery as one of the signs of the primitive nobility of the human soul. Those races which our confused and perverted civilization is pleased to treat as savage, with an altogether ludicrous pride and complacency, understand, just as the child understands, the lofty spiritual significance of the toilet. In their naif adoration of what is brilliant – many-coloured feathers, iridescent fabrics, the incomparable majesty of artificial forms – the baby and the savage bear witness to their disgust of the real, and thus give proof, without knowing it, of the immateriality of their soul. Woe to him who, like Louis XV (the product not of a true civilization but of a recrudescence of barbarism), carries his degeneracy to the point of no longer having a taste for anything but nature unadorned.

Fashion should thus be considered as a symptom of the taste for the ideal which floats on the surface of all the crude, terrestrial and loathsome bric-à-brac that the natural life accumulates in the human brain: as a sublime deformation of Nature, or rather a permanent and repeated attempt at her *reformation*. [. . .]

* * *

XII. Women and Prostitutes

Having taken upon himself the task of seeking out and expounding the beauty in *modernity*, Monsieur G. is thus particularly given to portraying women who are elaborately dressed and embellished by all the rites of artifice, to whatever social station they may belong. Moreover in the complete assemblage of his works, no less than in the swarming ant-hill of human life itself, differences of class and breed are made immediately obvious to the spectator's eye, in whatever luxurious trappings the subjects may be decked.

At one moment, bathed in the diffused brightness of an auditorium, it is young women of the most fashionable society, receiving and reflecting the light with their eyes, their jewellery and their snowy, white shoulders, as glorious as portraits framed in their boxes. Some are grave and serious, others blonde and brainless. Some flaunt precocious bosoms with an aristocratic unconcern, others frankly display the chests of young boys. They tap their teeth with their fans, while their gaze is vacant or set; they are as solemn and stagey as the play or opera that they are pretending to follow.

Next we watch elegant families strolling at leisure in the walks of a public garden, the wives leaning calmly on the arms of their husbands, whose solid and complacent air tells of a fortune made and their resulting self-esteem. Proud distinction has given way to a comfortable affluence. Meanwhile skinny little girls with billowing petti-coats, who by their figures and gestures put one in mind of little women, are skipping, playing with hoops or gravely paying social calls in the open air, thus rehearsing the comedy performed at home by their parents.

Now for a moment we move to a lowlier theatrical world where the little dancers, frail, slender, hardly more than children, but proud of appearing at last in the blaze of the limelight, are shaking upon their virginal, puny shoulders absurd fancy-dresses which belong to no period, and are their joy and their delight.

Or at a café door, as he lounges against the windows lit from within and without, we watch the display of one of those half-wit peacocks whose elegance is the creation of his tailor and whose head of his barber. Beside him, her feet supported on the inevitable footstool, sits his mistress, a great baggage who lacks practically nothing to make her into a great lady – that 'practically nothing' being in fact 'practically everything', for it is *distinction*. Like her dainty companion, she has an enormous cigar entirely filling the aperture of her tiny mouth. These two beings have not a single thought in their heads. Is it even certain that they can see? Unless, like Narcissuses of imbecility, they are gazing at the crowd as at a river which reflects their own image. In truth, they exist very much more for the pleasure of the observer than for their own.

And now the doors are being thrown open at Valentino's, at the Prado, or the Casino (where formerly it would have been the Tivoli, the Idalie, the Folies and the Paphos) – those Bedlams where the exuberance of idle youth is given free rein.

Women who have exaggerated the fashion to the extent of perverting its charm and totally destroying its aims, are ostentatiously sweeping the floor with their trains and the fringes of their shawls; they come and go, pass and repass, opening an astonished eye like animals, giving an impression of total blindness, but missing nothing.

Against a background of hellish light, or if you prefer, an *aurora borealis* – red, orange, sulphur-yellow, pink (to express an idea of ecstasy amid frivolity), and sometimes purple (the favourite colour of canonesses, like dying embers seen through a blue curtain) – against magical backgrounds such as these, which remind one of variegated Bengal Lights, there arises the Protean image of wanton beauty. Now she is majestic, now playful; now slender, even to the point of skinniness, now cyclopean; now tiny and sparkling, now heavy and monumental. She has discovered for herself a provocative and barbaric sort of elegance, or else she aspires, with more or less success, towards the simplicity which is customary in a better world. She advances towards us, glides, dances, or moves about with her burden of embroidered petticoats, which play the part at once of pedestal and balancing-rod; her eye flashes out from under her hat, like a portrait in its frame. She is a perfect image of the savagery that lurks in the midst of civilization. She has her own sort of beauty, which comes to her from Evil always devoid of spirituality, but sometimes tinged with a weariness which imitates true melancholy. She directs her gaze at the horizon, like a beast of prey; the same wildness, the same lazy absent-mindedness, and also, at times, the same fixity of attention. She is a sort of gipsy wandering on the fringes of a regular society, and the triviality of her life, which is one of warfare and cunning, fatally grins through its envelope of show. The following words of that inimitable master, La Bruyère, may be justly applied to her: 'Some women possess an artificial nobility which is associated with a movement of the eye, a tilt of the head, a manner of deportment, and which goes no further.'

These reflections concerning the courtesan are applicable within certain limits to the actress also; for she too is a creature of show, an object of public pleasure. Here however the conquest and the prize are of a nobler and more spiritual kind. With her it is a question of winning the heart of the public not only by means of sheer physical beauty, but also through talents of the rarest order. If in one aspect the actress is akin to the courtesan, in another she comes close to the poet. We must never forget that quite apart from natural, and even artificial, beauty, each human being bears the distinctive stamp of his trade, a characteristic which can be translated into physical ugliness, but also into a sort of 'professional' beauty.

In that vast picture-gallery which is life in London or Paris, we shall meet with all the various types of fallen womanhood – of woman in revolt against society – at all levels. First we see the courtesan in her prime, striving after patrician airs, proud at once of her youth and the luxury into which she puts all her soul and all her genius, as she delicately uses two fingers to tuck in a wide panel of silk, satin or velvet which billows around her, or points a toe whose over-ornate shoe would be enough to betray her for what she is, if the somewhat unnecessary extravagance of her whole toilette had not done so already. Descending the scale, we come down to the poor slaves of those filthy stews which are often, however, decorated like cafés; hapless wretches, subject to the most extortionate restraint, possessing nothing of their own, not even the eccentric finery which serves as spice and setting to their beauty.

Some of these, examples of an innocent and monstrous self-conceit, express in their faces and their bold, uplifted glances an obvious joy at being alive (and indeed, one wonders why). Sometimes, quite by chance, they achieve poses of a daring and nobility to enchant the most sensitive of sculptors, if the sculptors of today were sufficiently bold and imaginative to seize upon nobility wherever it was to be found, even in the mire; at other times they display themselves in hopeless attitudes of boredom, in bouts of tap-room apathy, almost masculine in their brazenness, killing time with cigarettes, orientally resigned – stretched out, sprawling on settees, their skirts hooped up in front and behind like a double fan, or else precariously balanced on stools and chairs; sluggish, glum, stupid, extravagant, their eyes glazed with brandy and their foreheads swelling with obstinate pride. We have climbed down to the last lap of the spiral, down to the *femina simplex* of the Roman satirist [Juvenal]. And now, sketched against an atmospheric background in which both tobacco and alcohol have mingled their fumes, we see the emaciated flush of consumption or the rounded contours of obesity, that hideous health of the slothful. In a foggy, gilded chaos, whose very existence is unsuspected by the chaste and the poor, we assist at the Dervish dances of macabre nymphs and living dolls whose childish eyes betray a sinister glitter, while behind a bottle-laden counter there lolls in state an enormous Xanthippe whose head, wrapped in a dirty kerchief, casts upon the wall a satanically pointed shadow, thus reminding us that everything that is consecrated to Evil is condemned to wear horns.

Please do not think that it was in order to gratify the reader, any more than to scandalize him, that I have spread before his eyes pictures such as these; in either case this would have been to treat him with less than due respect. What in fact gives these works their value and, as it were, sanctifies them is the wealth of thoughts to which they give rise – thoughts however which are generally solemn and dark. If by chance anyone should be so ill-advised as to seek here an opportunity of satisfying his unhealthy curiosity, I must in all charity warn him that he will find nothing whatever to stimulate the sickness of his imagination. He will find nothing but the inevitable image of vice, the demon's eye ambushed in the shadows or Messalina's shoulder gleaming under the gas; nothing but pure art, by which I mean the special beauty of evil, the beautiful amid the horrible. In fact, if I may repeat myself in passing, the general feeling which emanates from all this chaos partakes more of gloom than of gaiety. It is their moral fecundity which gives these drawings their special beauty. They are heavy with suggestion, but cruel, harsh suggestion which my pen, accustomed though it is to grappling with the plastic arts, has perhaps interpreted only too inadequately.

XIII Carriages

* * *

Monsieur G. retains a remarkable excellence which is all his own; he has deliberately fulfilled a function which other artists have scorned and which it needed above all a man of the world to fulfil. He has everywhere sought after the fugitive, fleeting beauty of present-day life, the distinguishing character of that quality which, with the reader's kind permission, we have called 'modernity'. Often weird, violent and

excessive, he has contrived to concentrate in his drawings the acrid or heady bouquet of the wine of life.

9 Walt Whitman (1819–1892) on the American Artist from Preface to *Leaves of Grass*

First published in 1855, Whitman's *Leaves of Grass* went on to become a foundation stone of American literature. It was revised, expanded, divided up into 'chants', and expanded again. In the 1860s Whitman began considering it the bible of a new religion, divided into 365 'psalms', to be read successively on each day of the year. The beginnings however were very different. A journalist and printer by trade, Whitman educated himself in literature. By the age of 36 he had accumulated enough verse for a slim volume of twelve poems (compared with 383 in the final edition). Whitman paid for the printing and binding, and even set some of the type himself. Few copies were sold, however. Whitman's fortune was that he sent a copy to Emerson, then the foremost American man of letters (see IIA5 and IID6). Emerson responded positively ('the most extraordinary piece of wit and wisdom that America has yet contributed . . . incomparable things said incomparably well'), and the publication of his letter thanking Whitman caused enough of a stir to get the book read. Whitman's revolutionary poetic style, coupled with his equally anti-academic ideas on the proper nature and role of the American artist, did the rest. *Leaves of Grass* remained commercially unsuccessful, as Whitman himself remained controversial. But his work derived a lasting impact from his articulation of a strong American identity at a time when the national consciousness demanded one. The present extracts from Whitman's preface to the first edition of 1855 are taken from the reprint of that edition, edited with an introduction by Malcolm Cowley, New York, 1959. Our selections are taken from the Penguin Classics edition, Harmondsworth, 1986, pp. 5–6, 12–13, 17–18. Ellipses not contained in square brackets are integral to Whitman's text.

[. . .] The Americans of all nations at any time upon the earth have probably the fullest poetical nature. The United States themselves are essentially the greatest poem. In the history of the earth hitherto the largest and most stirring appear tame and orderly to their ampler largeness and stir. Here at last is something in the doings of man that corresponds with the broadcast doings of the day and night. Here is not merely a nation but a teeming nation of nations. Here is action united from strings necessarily blind to particulars and details magnificently moving in vast masses. Here is the hospitality which forever indicates heroes. . . . Here are the roughs and beards and space and ruggedness and nonchalance that the soul loves. Here the performance disdaining the trivial unapproached in the tremendous audacity of its crowds and groupings and the push of its perspective spreads with crampless and flowing breadth and showers its prolific and splendid extravagance. One sees it must indeed own the riches of the summer and winter, and need never be bankrupt while corn grows from the ground or the orchards drop apples or the bays contain fish or men beget children upon women.

Other states indicate themselves in their deputies . . . but the genius of the United States is not best or most in its executives or legislatures, nor in its ambassadors or authors or colleges or churches or parlours, nor even in its newspapers or inven-

tors . . . but always most in the common people. Their manners speech dress friend-
ships – the freshness and candour of their physiognomy – the picturesque looseness of
their carriage . . . their deathless attachment to freedom – their aversion to anything
indecorous or soft or mean – the practical acknowledgement of the citizens of one
state by the citizens of all other states – the fierceness of their roused resentment –
their curiosity and welcome of novelty – their self-esteem and wonderful sympathy –
their susceptibility to a slight – the air they have of persons who never knew how it felt
to stand in the presence of superiors – the fluency of their speech – their delight in
music, the sure symptom of manly tenderness and native elegance of soul . . . their
good temper and openhandedness – the terrible significance of their elections – the
President's taking off his hat to them not they to him – these too are unrhymed
poetry. It awaits the gigantic and generous treatment worthy of it.

The largeness of nature of the nation were monstrous without a corresponding
largeness and generosity of the spirit of the citizen. Not nature nor swarming states
nor streets and steamships nor prosperous business nor farms nor capital nor learning
may suffice for the ideal of man . . . nor suffice the poet. No reminiscences may suffice
either. A live nation can always cut a deep mark and can have the best authority the
cheapest . . . namely from its own soul. This is the sum of the profitable uses of
individuals or states and of present action and grandeur and of the subjects of
poets. – As if it were necessary to trot back generation after generation to the eastern
records! As if the beauty and sacredness of the demonstrable must fall behind that of
the mythical! As if men do not make their mark out of any times! As if the opening of
the western continent by discovery and what has transpired since in North and South
America were less than the small theatre of the antique or the aimless sleepwalking of
the middle ages! The pride of the United States leaves the wealth and finesse of the
cities and all returns of commerce and agriculture and all the magnitude of geography
or shows of exterior victory to enjoy the breed of fullsized men or one fullsized man
unconquerable and simple.

The American poets are to enclose old and new for America is the race of races. Of
them a bard is to be commensurate with a people. To him the other continents arrive
as contributions.

* * *

The art of art, the glory of expression and the sunshine of the light of letters is
simplicity. Nothing is better than simplicity . . . nothing can make up for excess or for
the lack of definiteness. To carry on the heave of impulse and pierce intellectual
depths and give all subjects their articulations are powers neither common nor very
uncommon. But to speak in literature with the perfect rectitude and insouciance of
the movements of animals and the unimpeachableness of the sentiment of trees in the
woods and grass by the roadside is the flawless triumph of art. If you have looked on
him who has achieved it you have looked on one of the masters of the artists of all
nations and times. You shall not contemplate the flight of the graygull over the bay or
the mettlesome action of the blood horse or the tall leaning of sunflowers on their stalk
or the appearance of the sun journeying through heaven or the appearance of the
moon afterward with any more satisfaction than you shall contemplate him. The
greatest poet has less a marked style and is more the channel of thoughts and things
without increase or diminution, and is the free channel of himself. He swears to his

art, I will not be meddlesome, I will not have in my writing any elegance or effect or originality to hang in the way between me and the rest like curtains. I will have nothing hang in the way, not the richest curtains. What I tell I tell for precisely what it is. Let who may exalt or startle or fascinate or soothe I will have purposes as health or heat or snow has and be as regardless of observation. What I experience or portray shall go from my composition without a shred of my composition. You shall stand by my side and look in the mirror with me.

The old red blood and stainless gentility of great poets will be proved by their unconstraint. A heroic person walks at his ease through and out of that custom or precedent or authority that suits him not. Of the traits of the brotherhood of writers savans musicians inventors and artists nothing is finer than silent defiance advancing from new free forms. In the need of poems philosophy politics mechanism science behaviour, the craft of art, an appropriate native grand-opera, shipcraft, or any craft, he is greatest forever and forever who contributes the greatest original practical example. The cleanest expression is that which finds no sphere worthy of itself and makes one.

* * *

These American states strong and healthy and accomplished shall receive no pleasure from violations of natural models and must not permit them. In paintings or mouldings or carvings in mineral or wood, or in the illustrations of books or newspapers, or in any comic or tragic prints, or in the patterns of woven stuffs or any thing to beautify rooms or furniture or costumes, or to put upon cornices or monuments or on the prows or sterns of ships, or to put anywhere before the human eye indoors or out, that which distorts honest shapes or which creates unearthly beings or places or contingencies is a nuisance and revolt. Of the human form especially it is so great it must never be made ridiculous. Of ornaments to a work nothing outre can be allowed ... but those ornaments can be allowed that conform to the perfect facts of the open air and that flow out of the nature of the work and come irrepressibly from it and are necessary to the completion of the work. Most works are most beautiful without ornament ... Exaggerations will be revenged in human physiology. Clean and vigorous children are jetted and conceived only in those communities where the models of natural forms are public every day ... Great genius and the people of these states must never be demeaned to romances. As soon as histories are properly told there is no more need of romances. [...]

10 Various Artists, Women's Petition to the Royal Academy

Throughout the nineteenth century women were routinely discouraged from practising as artists and authors. There were individual exceptions, but any success was won in the face of repeated criticism that the female nature was unsuited to the demands of artistic creativity, particularly in the higher academic genres. A *Society of Female Artists* was founded in London in 1857 to promote the exhibition of work by women artists. Adequate training remained a problem, however. In the late 1850s a campaign was mounted to open the Royal Academy schools to women students. In April 1859 38 signatories sent a petition to all Academicians asking for their support in this project. The text of the petition was also printed in *The Athenaeum* of 30 April 1859. One woman artist gained entry the following

year (through the tactic of using her initials rather than her full name on her submission of work). Despite a handful of further entries, an Academy resolution of 1863 not to accept any more female students was passed unanimously, and although others did gain entry later in the decade, resistance long continued (see VB9). The present text of the Women's Petition to the Royal Academy is taken from Pamela Gerrish Nunn, *Victorian Women Artists*, London: The Women's Press, 1987, p. 46.

Sir – we appeal to you to use your influence, as an artist and a member of the Royal Academy, in favour of a proposal to open the Schools of that institution to women. We request your attentive consideration of the reasons which have originated this proposal. When the Academy was established in 1769, women artists were rare; no provision was therefore required for their Art-education. Since that time, however, the general advance of education and liberal opinions has produced a great change in this particular; no less than one hundred and twenty ladies have exhibited their works in the Royal Academy alone, during the last three years, and the profession must be considered as fairly open to women. It thus becomes of the greatest importance that they should have the best means of study placed within their reach; especially that they should be enabled to gain a thorough knowledge of *Drawing* in all its branches, for it is in this quality that their works are invariably found deficient. It is generally acknowledged that study from the Antique and from Nature, under the direction of qualified masters, forms the best education for the artist; this education is given in the Royal Academy to young men, and it is given gratuitously. The difficulty and expense of obtaining good instruction oblige many women artists to enter upon their profession without adequate preparatory study, and thus prevent their attaining the position for which their talents might qualify them. It is in order to remove this great disadvantage, that we ask the members of the Royal Academy to provide accommodation in their Schools for properly qualified Female Students, and we feel assured that the gentlemen composing that body will not grudge the expenditure required to afford to women artists the same opportunities as far as practicable by which they themselves so greatly profited.

11 Various Authors, on the Salon des Refusés

The Salon des Refusés was an important moment in the emergence of modern art, not least because of the exhibition there of three works by Edouard Manet, including his *Déjeuner sur l'herbe*, then known as *Le Bain* (The Bath). The question of artistic quality was of concern in 1863, due to mounting unease about the continuing relevance of Academic criteria in a rapidly changing world. This unease was given focus by the rising number of submissions for the Salon. Out of 5,000 works submitted, 3–4,000 were rejected. The resulting outcry caught the attention of Louis Napoleon himself, and the upshot was a decision to display the rejected works in a separate exhibition: ostensibly to let the public make up its own mind, actually to confirm the jury's judgement. Many artists quickly withdrew their work because of the stigma that would attach to a public admission of rejection. (As if to confirm their fears, when the show did open, Louis Leroy, the critic of *Charivari*, dubbed the exhibitors 'pariahs of the Salon'.) The result was that the Salon des Refusés tended to mix the hopeless with the radical, the work of those who could not meet

academic standards with the work of those who rejected them. When the exhibition opened on 15 May, the public largely failed to differentiate. The critical response varied from hostility to enthusiasm. We reproduce here the original announcement from the *Moniteur*, and extracts from the comments of eight reviewers. Extracts i-viii are taken from George Heard Hamilton, *Manet and his Critics*, New Haven and London: Yale University Press, 1954, pp. 41–50 of the 1986 edition; extract ix is from John Rewald, *The History of Impressionism*, London: Secker and Warburg, 1973, pp. 82–5. In the present instance, we have felt justified in reprinting the fragments as already published, without further amendment or amplification, partly because of the intrinsic importance of the event described and partly because of the authority of the texts through which they have entered into contemporary art history. Ellipses conform to the existing edits of Hamilton and Rewald.

(i) from the announcement of the exhibition, in the *Moniteur*, 24 April 1863

Numerous complaints have reached the Emperor on the subject of works of art which have been refused by the jury of the exhibition [the Salon]. His Majesty, wishing to let the public judge the legitimacy of these complaints, has decided that the rejected works of art are to be exhibited in another part of the Palace of Industry. This exhibition will be voluntary, and artists who may not wish to participate need only inform the administration, which will hasten to return their works to them. This exhibition will open on May 15th. Artists have until May 7th to withdraw their works. After this date their pictures will be considered not withdrawn and will be placed in the galleries.

(ii) from Maxime du Camp's review, in the *Revue des deux mondes*

This exhibition, at once sad and grotesque, is one of the oddest you could see. It offers abundant proof of what we knew already, that the jury always displays an unbelievable leniency. Save for one or two questionable exceptions there is not a painting which deserves the honour of the official galleries... There is even something cruel about this exhibition; people laugh as they do at a farce. As a matter of fact, it is a continual parody, a parody of drawing, of colour, of composition. These, then, are the unrecognized geniuses and their productions! These are the impatient painters, those who complain, who rail at men's injustice, at their hard lot, who appeal to posterity! No more brilliant sanction could have been given the decisions of the jury, and it can be thanked for having tried to spare us the sight of such lamentable things.

(iii) from Fernand Desnoyers' brochure, *La Peinture en 1863*

Manet's three pictures must have profoundly upset the dogmatic ideas of the jury. The public also has not failed to be astonished by this kind of painting which at the same time aggravates art lovers and makes art critics facetious. You can consider it evil but not mediocre. Manet certainly has not the least bias. He will keep on because he is sure of himself in the long run, whatever the art lovers claim they find in his manner

imitative of Goya or of Couture – small difference that makes. I believe that Manet is indeed his own master. That is the finest praise one can give him.

(iv) from Louis Etienne's brochure, *Le Jury et les exposants*

A commonplace woman of the demimonde, as naked as can be, shamelessly lolls between two dandies dressed to the teeth. These latter look like schoolboys on a holiday, perpetrating an outrage to play the man, and I search in vain for the meaning of this unbecoming rebus... This is a young man's practical joke, a shameful open sore not worth exhibiting this way... The landscape is well handled... but the figures are slipshod.

(v) from Edouard Lockroy's review, in the *Courrier artistique*

The exhibition of the rejected works, which we saw only for a moment, will certainly be a triumph for the jury. More than 1,500 artists have withdrawn, and of course some of the best. Nevertheless among the remaining canvases are some which would have held an honourable place with the work which was accepted... Manet has a gift for displeasing the jury. If he had only that, we should most certainly not be grateful to him, but he has others. Manet has not yet had the last word. His paintings, whose qualities the public cannot appreciate, are full of good intentions. Manet will triumph some day, we have no doubt, over all the obstacles he encounters, and we shall be the first to applaud his success.

(vi) from Zacharie Astruc's weekly paper, *Le Salon*

One must have the strength of two to stand up under the storm of fools who pour in here by the thousands to jeer to the limit, with stupid smiles on their lips... Manet, one of the greatest personalities of our time, is its lustre, inspiration, pungent savour, and surprise. The injustice committed in his case is so flagrant it confounds... In contrast to the great natural-born talents who compel us to study first the technical aspects of their art, he imposes and, so to speak, manifests his personal vitality... He pleases or displeases at once; he quickly charms, attracts, or repels. His individuality is so powerful that it eludes technical considerations. Technique is effaced in favour of the full metaphysical and tangible value of the work. Only long afterwards are we aware of the method by which it was accomplished, the elements of colour, relief, and modelling.

(vii) from Jules-Antoine Castagnary's review, in *L'Artiste*

There has been a lot of excitement about this young man. Let us be serious. The *Bath*, the *Majo*, the *Espada* are good sketches, I will grant you. There is a certain verve in the colours, a certain freedom of touch, which are in no way commonplace. But then what? Is this drawing? Is this painting? Manet thinks himself resolute and powerful. He is only hard. And the amazing thing is that he is as soft as he is hard. That's

because he is uncertain about some things and leaves them to chance. Not one detail has attained its exact and final form. I see garments without feeling the anatomical structure which supports them and explains their movements. I see boneless fingers and heads without skulls. I see side whiskers made of two strips of black cloth that could have been glued to the cheeks. What else do I see? The artist's lack of conviction and sincerity.

(viii) from Théophile Thoré's review, in *L'Indépendance Belge*

After due thought one sees that most of the rejected paintings share a certain similarity in primary conception and technique; in their eccentricities they resemble each other. An innocent stranger who might visit this Salon thinking he was in the official exhibition would undoubtedly suppose that the French school tends with apparent unity towards the reproduction of men and nature just as we see them, without preconceived ideals or stylistic dogmas, without tradition but also without individual inspiration. It looks as if these artists were taking art back to its origins without bothering about what civilization has been able to do before them ... People who begin anything have, even in their barbarism, something sincere and deeply felt, and at the same time ludicrous and incomplete, something both novel and unique. French art, as it is seen in the rejected work, seems to begin or to begin all over again. It is odd and crude yet sometimes exactly right, even profound. The subjects are no longer the same as those in the official galleries: very little mythology or history; contemporary life, especially among the common people; very little refinement and no taste. Things are as they are, beautiful or ugly, distinguished or ordinary, and in a technique entirely different from those sanctioned by the long domination of Italian art. Instead of looking for outlines which the Academy calls *drawing*, instead of slaving over details which those who admire classic art call *finish*, these painters try to create an effect in its striking unity, without bothering about correct lines or minute details ...

If the artistic unrest as it appears in the work of a great many young painters signifies, as it seems to, a return to nature and humanity, we must not take exception to it. The misfortune is that they have scarcely any imagination and that they despise charm. These pioneers of the possible transfiguration of an old exhausted art are for the most part until now only impotent or even absurd. Therefore they excite the uncontrolled laughter of gentlemen well educated on sane principles. But let there appear some painters of genius, loving beauty and distinction in the same subjects and techniques, and the revolution will be quick. The public would even be astonished at having admired the nonsense now triumphant in the official Salon ...

After Whistler, the artist who arouses the most discussion is Manet. He, too, is a true painter; several of his etchings, particularly the reproduction of the *Petits cavaliers* by Velasquez in the Louvre, exhibited among the rejected works, are lively, witty, and colourful. His three paintings look a bit like a provocation to the public which is dazzled by the too vivid colour. In the centre, a bathing scene; to the left a Spanish *Majo*; to the right a Parisian girl in the costume of an *Espada*, waving her purple cape in the bull ring. Manet loves Spain, and his favourite master seems to be Goya, whose vivid and contrasting hues, whose free and fiery touch, he imitates. There are some amazing materials in these two Spanish figures, the *Majo*'s black

costume and the heavy scarlet burnous of the young Parisienne disguised as an *Espada*. But underneath these brilliant costumes personality itself is somewhat lacking; the heads ought to have been painted differently from the drapery, with more accent and contrast.

The *Bath* is very daring ... The nude hasn't a good figure, unfortunately, and one can't think of anything uglier than the man stretched out next to her, who hasn't even thought of taking off, out of doors, his horrid padded cap. It is the contrast of a creature so inappropriate in a pastoral scene with this undraped bather that is shocking. I can't imagine what made an artist of intelligence and refinement select such an absurd composition, which elegant and charming characters might perhaps have justified. But there are qualities of colour and light in the landscape, and even very convincing bits of modelling in the woman's body.

(ix) from P. G. Hamerton's review, in the *Fine Arts Quarterly Review*

It is dangerous to allow the jury, or any members of the jury, to have any influence over the hanging of pictures rejected by the jury. Their first object is, of course, to set themselves right with the public, and, to achieve this, they have in this instance reversed the usual order of things by carefully putting the worst pictures in the most conspicuous places ... The Emperor's intention of allowing the rejected painters to appeal to the public has been in a great measure neutralized by the pride of the painters themselves. With a susceptibility much to be regretted, and even strongly condemned, the best of these have withdrawn their works, to the number of more than six hundred. We are consequently quite unable to determine, in any satisfactory manner, how far the jury has acted justly towards the refused artists as a body ...

On entering the present exhibition of refused pictures, every spectator is immediately compelled, whether he will or no, to abandon all hope of getting into that serious state of mind which is necessary to a fair comparison of works of art. That threshold once past, the gravest visitors burst into peals of laughter. This is exactly what the jurymen desire, but it is most injurious to many meritorious artists ... As for the public generally, it is perfectly delighted. Everybody goes to see the refused pictures ...

I ought not to omit a remarkable picture of the realist school, a translation of a thought of Giorgione into modern French. Giorgione had conceived the happy idea of a *fête champêtre* in which, although the gentlemen were dressed, the ladies were not, but the doubtful morality of the picture is pardoned for the sake of its fine colour ... Now some wretched Frenchman has translated this into modern French realism, on a much larger scale, and with the horrible modern French costume instead of the graceful Venetian one. Yes, there they are, under the trees, the principal lady, entirely undressed, ... another female in a chemise coming out of a little stream that runs hard by, and two Frenchmen in wide-awakes sitting on the very green grass with a stupid look of bliss. There are other pictures of the same class, which lead to the inference that the nude, when painted by vulgar men, is inevitably indecent.

12 Various Authors on Manet's *Olympia*

The controversy over artistic standards that was represented by the Salon des Refusés in 1863 continued in the Salon of 1865. Again, a work by Manet focused the issue: in effect a rupture in the consensus as to what art was, and what it could – or should – address in the wider culture. Eighty-seven reviews of the Salon of 1865 have been traced by historians, seventy-two of which make reference to Manet's *Olympia*. The majority of these are formulaic or abusive, or both. A minority do discuss Manet while making little of the *Olympia* itself. In the judgement of T. J. Clark only one review, that signed 'Jean Ravenel', seriously grasps the implications of the work, and even then its manner is troubled and staccato. The review appeared in a left-wing paper, *L'Epoque*. The name 'Jean Ravenel' was a *nom de plume* of Alfred Sensier, the socialist writer and correspondent of Millet. The verses quoted by Ravenel are from Baudelaire's *Fleurs du Mal*, from 'Le Chat' and 'Les Phares' respectively. In the exhibition catalogue, Manet had placed next to his title *Olympia* the following verse by Zacharie Astruc: 'Quand, lasse de songer, Olympia s'éveille,/Le printemps entre au bras du doux messager noir;/ C'est l'esclave, à la nuit amoureuse pareille,/ Qui vient fleurir le jour délicieux à voir:/L'auguste jeune fille en qui la flamme veille'. In Clark's translation this is rendered as: 'When, weary of dreaming, Olympia wakes, Spring enters in the arms of a gentle black messenger; it is the slave, like the amorous night, who comes to make the day bloom, delicious to see: the august young girl in whom the fire burns'. We reproduce here short extracts from twenty reviews. Numbers i-xv are taken from George Heard Hamilton, *Manet and his Critics*, New Haven and London: Yale University Press, 1954, pp. 70–8 of the 1986 edition; numbers xvi-xx are taken from T. J. Clark, *The Painting of Modern Life*, London and New York: Thames and Hudson, 1985, pp. 94, 96, 139–40. We reproduce the extracts as they have been previously excerpted from the original texts for the same reasons given at IIIᴅ11.

(i) A. J. Du Pays in *L'Illustration*

Separate mention must be made of the black painting of the *Saint Sebastian* by [Théodule] Ribot who, finding his inspiration in the crude manner of Ribera, wantonly cultivates ugliness but displays energetically pictorial qualities. A much more pronounced ugliness is still apparent in Manet's paintings, *Olympia* and *Christ Scourged*, whose pictorial values we confess we do not appreciate. They are offensive eccentricities and lively sensations of the Salon.

(ii) Charles Clément in *Le Journal des débats*

As to the two canvasses contributed by Manet, they are beyond words. It would have been very unfortunate to reject them. An example was required. The jury accepted them. It was well done.

(iii) Paul de Saint-Victor in *La Presse*

The mob, as at the Morgue, crowds around the spicy *Olympia* and the frightful *Ecce Homo* by Manet. Art sunk so low doesn't even deserve reproach. 'Do not speak of

them; observe and pass on', Virgil says to Dante while crossing one of the abysses of hell. But Manet's characters belong rather to Scarron's hell than to Dante's.

(iv) Félix Jahyer in *Etude sur les Beaux-Arts, Salon de 1865*

Such indecency! It seems to me that *Olympia* could have been hung at a height out of range of the eye where certain unassuming studies by conscientious workers have been lost... I cannot take this painter's intentions seriously. Up to now he has made himself the apostle of the ugly and repulsive. I should hope that the derision of serious people would disgust him with this manner so contrary to art.

(v) Ernest Filloneau in *Le Moniteur des arts*

An epidemic of crazy laughter prevails... in front of the canvasses by Manet... [It is] a subject of general surprise that the jury accepted these works... Olympia is a nude, recumbent woman to whom some sort of Negress offers a bouquet voluminously wrapped in paper. At the foot of the bed crouches a black cat, its hair on end, who probably doesn't like flowers since it cuts such a pathetic figure. Moreover, the heroine herself seems indifferent to the homage of the Negress. Is Olympia waiting for her bath or for the laundress?

(vi) Léon Lagrange in *Le Correspondant*

After Ribot, must we speak of Manet? No, if it is only to ascertain that this is a group of invalids trying to pass themselves off as incurable. A hospital flirtation! Do they think they can impose themselves on us? They will be cured, one after the other, and Manet himself in spite of his excesses will not die impenitent.

(vii) Ernest Chesneau in *Le Constitutionnel*

I must say that the grotesque aspect of his contributions has two causes: first, an almost childish ignorance of the fundamentals of drawing, and then, a prejudice in favour of inconceivable vulgarity... He succeeds in provoking almost scandalous laughter, which causes the Salon visitors to crowd around this ludicrous creature called *Olympia*... In this case, the comedy is caused by the loudly advertised intention of producing a noble work, a pretension thwarted by the absolute impotence of the execution.

(viii) Jules Clarétie in *L'Artiste*

I like audacity and I believe, like Danton, that a good deal is necessary, but yet not too much. Once upon a time there was a young man called Manet who, one fine day, bravely exhibited among the rejected paintings [ie. at the Salon des Refusés] a nude woman lunching with some young men dressed in sack suits and capped with Spanish sombreros. Many cried shame, some smiled, others applauded, all noted the name of

the audacious fellow who already had something and who promised much more. We find him again this year with two dreadful canvasses, challenges hurled at the public, mockeries or parodies, how can one tell? Yes, mockeries. What is this Odalisque with a yellow stomach, a base model picked up I know not where, who represents Olympia? Olympia? What Olympia? A courtesan no doubt. Manet cannot be accused of idealizing the foolish virgins, he who makes them vulgar virgins. I had promised myself not to speak of it any more.

(ix) Jules Clarétie in *Le Figaro*

During the last few days of the Salon several alterations took place in the arrangement of the paintings. You had seen Manet's *Venus with the Cat* flaunting her wan nudity on the stairs. Public censure chased her from that place of honour. One found the wretched woman again, when one did find her, at a height where even the worst daubs had never been hung, above the huge door of the last room, where you scarcely knew whether you were looking at a parcel of nude flesh or a bundle of laundry.

(x) Théophile Gautier *fils* in *Le Monde illustré*

In certain circles Manet's paintings have already been extensively discussed. This artist counted a bit on the jury refusing his works; this would have been a fine occasion to exclaim about injustice and prejudice. But nothing like that happened. The jury accepted his paintings and was kind enough to have them hung in one of the best places in the salon, so that everyone could judge the case with full knowledge. The jury ought indeed to have been good enough to ask Manet for a statement of his tendencies which should have been printed as a brochure. Perhaps that would have enlightened public opinion. As it is, the appearance alone of Manet's pictures doesn't sufficiently satisfy the eye and the mind; it doesn't explain the hue and cry that people have tried to stir up about this new school. Perhaps his aesthetic is excellent, but it is really impossible to have any idea of it in actual practice. The *Christ Mocked* beggars description. In *Olympia* Manet seems to have made some concession to public taste. In spite of his prejudices one sees pieces which demand no more than to be thought good.

(xi) Théophile Gautier in *Le Moniteur universel*

With some repugnance I come to the peculiar paintings by Manet. It is awkward to discuss them, but one cannot pass them in silence... In many persons' opinion it would be enough to pass by and laugh; that is a mistake. Manet is not of no account; he has a school, he has admirers and even enthusiasts; his influence extends further than you think. Manet has the distinction of being a danger. But the danger is now passed. *Olympia* can be understood from no point of view, even if you take it for what it is, a puny model stretched out on a sheet. The colour of the flesh is dirty, the modelling non-existent. The shadows are indicated by more or less large smears of blacking. What's to be said for the Negress who brings a bunch of flowers wrapped in a paper, or for the black cat which leaves its dirty footprints on the bed? We would still forgive the ugliness, were it only truthful, carefully studied, heightened by some

splendid effect of colour. The least beautiful woman has bones, muscles, skin, and some sort of colour. Here there is nothing, we are sorry to say, but the desire to attract attention at any price.

(xii) Marc de Montifaud in *L'Artiste*

We can recognize Manet's touch in the midst of the eccentricities he has been pleased to offer us ... and this touch denotes a vigour which, used by a healthier imagination, could produce a real work.

(xiii) Anon. in *L'Autographe au Salon de 1865*

He who laughs last laughs best. Manet has fired his shots today, and the wide-open ears of the public have heard his name. Let him just take time, from now on, to clean out and tidy up his pictures, and you will see the public marvelling over this same painting which has so thoroughly frightened it. For Manet has unusual qualities of originality and character as a draughtsman, of subtlety and pungency as a colourist. You can see this even in these little sketches which seem to have been done with the end of a pen, with the flawless casualness and picturesque spirit of Goya.

(xiv) Gonzague Privat in *Place aux jeunes! Causeries critiques sur le Salon de 1865*

Do not be displeased; Manet's *Olympia* is more than something good; solid and painterly qualities predominate in it. The young girl is done in a flat tone, her flesh is of an exquisite delicacy, a nicety, in a perfect relationship with the white draperies. The background is charming, the green curtains which enclose the bed are of a light and airy colour. But the public, the crude public that finds it easier to laugh than to look, understands nothing at all of this art which is too abstract for its intelligence ... [*Olympia*] has in it the great seed: life, because it has been conceived and painted by a sincere man.

(xv) Théophile Thoré in *L'Indépendance Belge*

Manet should not want to be taken for an old hack at copy-work. Nevertheless, having had the unfortunate idea of painting a Christ scourged, well enough. But this new work is almost a copy of the famous composition by Van Dyck! A year ago, painting a Spanish subject which he had never seen, he copied the Velasquez in the Pourtalès Collection ... Manet's *Olympia* has caused all Paris to run to see this curious woman with her magnificent bouquet, her Negress, and her black cat. Manet's friends defy the author of the Siamese Scarabs [Gérôme] to paint a bouquet so luminous or a cat so weird.

(xvi) Amédée Cantaloube in *Le Grand journal*

This Olympia, a sort of female gorilla, a grotesque in India rubber outlined in black, apes on a bed, in a state of complete nudity, the horizontal attitude of Titian's *Venus*: the right arm rests on the body in the same fashion, except for the hand, which is flexed in a sort of shameless contraction.

(xvii) 'Pierrot' in *les Tablettes de Pierrot – Histoire de la Semaine*

. . .a woman on a bed, or, rather, some form or other, blown up like a grotesque in India rubber; a sort of monkey making fun of the pose and the movement of the arm in Titian's *Venus*, with one hand shamelessly flexed.

(xviii) Victor de Jankovitz in *Etude sur le Salon de 1865*

The author represents for us under the name of Olympia a young girl lying on a bed, having as her only garment a knot of ribbon in her hair, and her hand for fig leaf. The expression of her face is that of being prematurely aged and vicious; her body, of a putrefying colour, recalls the horror of the morgue.

(xix) 'Ego' in *Le Monde Illustré*

The *auguste jeune fille* is a courtesan, with dirty hands and wrinkled feet; she is lying down, wearing one Turkish slipper and with a red cockade in her hair; her body has the livid tint of a cadaver displayed in the morgue; her outlines are drawn in charcoal and her greenish, bloodshot eyes appear to be provoking the public, protected all the while by a hideous Negress. No, never has anything so . . . strange been hung on the walls of an art exhibition.

(xx) 'Jean Ravenel' (Alfred Sensier) in *L'Epoque*

MONSIEUR MANET – *Olympia* – The scapegoat of the salon, the victim of Parisian Lynch law. Each passer-by takes a stone and throws it at her face. *Olympia* is a very crazy piece of Spanish madness, which is a thousand times better than the platitude and inertia of so many canvases on show in the exhibition.

Armed insurrection in the camp of the bourgeois: it is a glass of iced water which each visitor gets full in the face when he sees the BEAUTIFUL *courtisane* in full bloom.

Painting of the school of Baudelaire, freely executed by a pupil of Goya; the vicious strangeness of the little *faubourienne*, a woman of the night from Paul Niquet's, from the mysteries of Paris and the nightmares of Edgar Poe. Her look has the sourness of someone prematurely aged, her face the disturbing perfume of a *fleur du mal*; her body fatigued, corrupted, but painted under a single, transparent light, with the shadows light and fine, the bed and pillows put down in a velvet, modulated grey. Negress and flowers insufficient in execution, but with a real harmony to them, the shoulder and arm solidly established in a clean and pure light. – The cat arching its back makes the visitor laugh and relax; it is what saves M. Manet from a popular execution.

> De sa fourrure noire et brune
> Sort un parfum si doux, qu'un soir
> J'en fus embaumé pour l'avoir
> Caressé une fois . . . rien qu'une.

(From its fur black and brown/ Comes a perfume so soft, that one evening/ I was embalmed in it for having/ Caressed it once . . . only once.)

> C'est l'esprit familier du lieu;
> Il juge, il préside, il inspire
> Toutes choses dans son empire;
> Peut-être est-il fée, est-il dieu?

(It is the familiar spirit of the place;/ It judges, it presides, it inspires/ All things in its empire;/ Perhaps it is a sprite, is it a god?)

Monsieur Manet, instead of Monsieur Astruc's verses, would perhaps have done well to take as epigraph the quatrain devoted to Goya by the most *advanced* painter of our epoch:

> GOYA – Cauchemar plein de choses inconnues,
> De foetus qu'on fait cuire au milieu des sabbats,
> De vieilles au miroir et d'enfants toutes nues
> Pour tenter les démons ajustant bien leurs bas.

(Goya – Nightmare full of unknown things/ Of a foetus cooked in the middle of a sabbath/ Of old women at a mirror and naked girls/ Straightening their stockings to tempt demons)

Perhaps this *olla podrida de toutes les Castilles* is not flattering for Monsieur Manet, but all the same it is something. One does not make an *Olympia* simply by wanting to. – The *Christ* would call for a certain technical analysis which we do not have time to give. – To summarize, it is hideous, but all the same it is something. A painter is in evidence, and the strange group is bathed in light.

13 Edouard Manet (1832–1883) 'Reasons for Holding a Private Exhibition'

The Salon jury of 1866 rejected both Manet's *Fifer* and his *Tragic Actor*. The next year he was apparently ignored when a large exhibition of French art was being prepared for the Paris World's Fair. Following Courbet's precedent he took matters into his own hands and mounted a private exhibition of fifty of his works in a specially erected wooden building at the Pont de l'Alma, near the exhibition site. The following statement was printed as a foreword to the catalogue. Its message, like that of Courbet's statement of 1855, was that it was merely the artist's individuality that had aroused hostile reactions to his work, and that if the members of the public could only be allowed to judge for themselves they would be persuaded of his sincerity. In fact the venture attracted no significant attention from the public or the press. The statement was subsequently published in Jacques de Biez, *Edouard Manet*, Paris, 1884, and was reprinted in Pierre Cailler and Pierre Courthion (eds), *Manet raconté par lui-même et par ses amis*, Geneva, 1953. This translation by Michael Ross is taken from the English version of the latter publication, *Portrait of Manet by Himself and His Contemporaries*, London: Cassell, 1960, pp. 60–1. The ellipsis is in the original.

Monsieur Manet has been exhibiting or trying to exhibit his pictures since 1861.

This year he has decided to present to the public the whole of his work.

When he first showed in the Salon, Monsieur Manet received a good notice. But later, when he found that he was so often turned down by the jury, he realized that the first stage in an artist's career is a battle, which at least should be fought on equal terms, that is to say that the artist should be able to show the public what he has done.... Without this opportunity, the painter would become too easily imprisoned in a circle from which there is no escape. He would be forced to make a pile of his canvases or roll them up in an attic.

Official recognition, encouragements and rewards are in fact regarded as a hall-mark of talent; the public have been informed already what to admire and what to avoid, according to whether the works are accepted or rejected. On the other hand an artist is told that it is the public's spontaneous reaction to his pictures which makes them so unwelcome to the various selection committees. In these circumstances the artist has been advised to wait; but wait for what? Until there is no selection committee? He would be much better off if he could thrash the question out directly with the public. The artist today is not saying, Come and see some perfect pictures, but, Come and see some sincere ones.

It is sincerity which gives to works of art a character which makes them appear an act of protest, when in fact the painter has only thought of rendering his own impressions.

Monsieur Manet has never wished to protest. On the contrary, the protest, entirely unexpected on his part, has been directed against himself; this is because there is a traditional way of teaching form, methods and manner of looking at a picture, and because those who have been brought up to believe in these principles will admit no others. It makes them childishly intolerant. Any works which do not conform to these formulas they regard as worthless; they not only provoke criticism, but hostility and even *active* hostility. To be able to exhibit is the vital concern, the *sine qua non* for the artist, because it happens that after looking at something for some while, one becomes familiar with what seemed before to be surprising, or if you will, shocking. Little by little it becomes understood and accepted. Time itself imperceptibly refines and softens the original hardness of a picture.

By exhibiting, an artist finds friends and allies in his struggle for recognition. Monsieur Manet has always recognized talent where he has met it; he has had no pretensions to overthrow old methods of painting or to create new ones. He has simply tried to be himself and no one else.

Further, Monsieur Manet has met with valuable encouragement and recognizes how, day by day, the opinion of men of real discernment is becoming more favourable. It only remains now for the artist to regain the goodwill of a public who have been taught to regard him as an enemy.

14 Eugène Boudin (1824–1898) Letters to Martin

Boudin was a regular exhibitor in the Salon between 1863 and 1897, and in 1874 was included in the first exhibition of the Independent artists – subsequently the Impressionists (see IVA10–13). He concentrated increasingly on paintings of the harbours and beaches of Northern France. The works for which he became best known were relatively small in scale,

and apparently lightly sketched, yet combining highly specific effects of lighting and atmosphere with apparently dispassionate observation of the bourgeois holidaymakers – their dispositions, their fashions, the uncomfortable isolation of some and the suggestive groupings of others. He came from Le Havre, as did Claude Monet, who owed a great deal to the encouragement and informal instruction he received from the older painter in the mid-1850s. Martin was a member of the Commission for the Fine Arts in Le Havre and a long-term friend and supporter of Boudin. The first of the following letters was written on the artist's return from a period of travel. This had ended with a week in Brittany, where he had attended 'the most marvellous Pardon' (a form of religious ceremony particular to the area). The second letter contains suggestive echoes of Baudelaire's writing and particularly of his 'Salon of 1846' (IID13). Ribot and Bureau were painters and Boudin's contemporaries. On Millet see IIIB7. Charles-Emile Jacque and Jules Breton were painters specializing in peasant scenes. Isabey and Meissonier were known for paintings of historical subjects. The latter specialized in small and minutely detailed costume pieces and military scenes that were regularly singled out for disparagement by artists and critics of a modern inclination. The letters were first published in George Jean-Aubry (ed.), *Eugène Boudin d'après des documents inédits*, Paris: Les Editions Bernheim-Jeune, 1932. Our text is taken from the reprinted edition of 1968, pp. 65 and 70–1, translated for this volume by Christopher Miller.

28 August 1867

We completed our voyage with a trip to Plougastel where we spent a week. We attended the most marvellous Pardon imaginable.

Must I confess? Now I am back, this Trouville beach, which used to be my pride and joy, strikes me as a dreadful masquerade. It needs something like genius to make anything of this bunch of lazy 'poseurs'. When one has just spent a month amid the races of those doomed to hard labour in the fields, living on black bread and water, and comes back to this band of gilded parasites with their triumphant air, it's pitiful; it makes you feel a tinge of shame about painting lazy people who have nothing to do. Fortunately, dear friend, the Creator has everywhere spread his warming, radiant light and it is less this world we reproduce than the element in which it is enveloped. But how much more beautiful Bihama is than these satin ladies, with her white linen skirt, her black and white blouse and her long *coiffe* when she waves her winnowing basket by the sea's edge and the grain falls thick and pure on the sailcloth. And those who thresh enveloped in the gold of rye and barley, and those who pray, kneeling on the granite flagstones of the church with not a chair in sight . . .

3 September 1868

Your letter reached me just as I was showing Ribot, Bureau and another person my little studies of 'society' beaches. These gentlemen were congratulating me precisely because I had dared put the things and people of our time in pictures, and found a way to make the gentleman in his overcoat and the lady in her waterproof acceptable, thanks to the sauce and trimmings.

Yet there is nothing new about this attempt; the Italians and the Flemish did the same thing, painting the people of their time, either in interiors, or in their huge

architectural settings; the idea is beginning to make its way, and a number of young painters, at the head of whom I place Monet, think it's an element too often neglected till now. The peasants have their painters of predilection: Millet, Jacque, Breton. It's a good thing; they do serious work, they work hard at it, they have a part in the work of the Creator which they carry on by helping it become manifest in a way that bears fruit for mankind. It's a good thing, but between ourselves, these bourgeois who walk on the jetty towards the sunset, have they no right to be fixed on canvas, *to be brought into the light*? Between ourselves, they are often resting after unremitting labour, these people who come from their offices and their chambers. If there are some parasites among them, are there not others who have done their work? There you have a serious, an irrefutable argument.

I don't want to condemn myself to painting trash under any pretext, but is it not pitiful to see serious people like Isabey, Meissonier and so many others looking out cheap carnival finery, and, for the sake of the picturesque, dressing up models in it who mostly don't know how to pose in this borrowed rig-out?

Meissonier has made his fortune with an old felt hat with a feather in it and a pair of musketeer's boots, which he has painted and repainted under a thousand guises. I really wish one of these gentlemen would explain to me what possible interest these objects have for the future and whether the picturesque in these paintings will have any hold over our grand-nephews. You shouldn't overlook the fact that painting often earns its title and right to conservation by perfection of technique. Why do you find a Chardin jug in the museums? If your committee takes this view of things, then it should make haste to buy a Monet, a Ribot or a Courbet: but let it choose one way or another. Because, my God, on the matter of quality the choice is straightforward. I allow myself this little digression, my honest friend, because your kind friendship is leading you astray; you are worried about me, you think I should turn back and make concessions to the taste of a certain public. I have been long enough unhappy, and therefore worried enough, to have rummaged, probed, and pondered; I have looked into others enough to know what they've got in their bags and to weigh mine up against them. Well, my dear friend, I shall persist along my own modest way, narrow as it is, simply hoping to walk with a firmer, more solid step and widen it a bit if need be. One can find art in anything, if one is gifted. Any man who wields a brush or pencil necessarily believes he has a gift. It's up to the public to judge, and up to the artist to go ahead, to stick close to nature, whether he is painting cabbages, cheeses, or supernatural and divine beings...

So I don't accept your opinion about my bad choice of subjects; on the contrary, I am beginning to like them more and more, and hope to broaden this genre, which is still too confined.

Ribot wanted to buy one of these studies, and his friend Bureau has taken one too.

15 Ivan Nikolayevich Kramskoy (1837–1887) 'The Destiny of Russian Art'

The painter Ivan Kramskoy was a founder member both of the *Artel' khudozhnikov* (Artists' Co-operative), established in 1863, and the *Tovarishchestvo peredvizhnykh khudozhest-*

vennykh vystavok (Association of Travelling Art Exhibitions), established in 1870. The *Artel* came into being after fourteen students at the St Petersburg Imperial Academy of Arts refused to participate in the Gold Medal competition, protesting at the imposed choice of subject, 'The Festival of the Gods in Valhalla'. The students asserted their right to choose their own subject-matter, and by leaving the Academy and establishing the *Artel* they sought to achieve both professional and creative independence from official control. The 'Association of Travelling Art Exhibits', or the 'Wanderers' as its members have popularly become known, combined a desire to address social themes and subjects taken from everyday life with an attempt to expand the audience for art by taking exhibitions of their work to the provinces of Russia. Under the prompting of Vladimir Stasov (1824–1906), a writer and critic who sought to promote the idea of a native school of painting, Kramskoy wrote a lengthy article in 1877 for the nationalist *Novoye Vremya* (New Times). Kramskoy's principal concern, however, and one that remained consistent with his earlier struggles, was the liberation of artists from the influence of the state. Kramskoy's article was originally published as 'Sud'by russkogo iskusstva'. This extract has been edited and translated for the present volume by Natalie Vowles from *Ivan Nikolayevich Kramskoy. Pisma i Statyi* (Letters and Essays), 2 volumes, Moscow: Iskusstvo, 1965–6, volume II, pp. 339–43.

The principal thesis I should like to put forward, and of which one can never say enough, is as follows: art can only be national, it must be national and nothing else but national. The idea, thus expressed, is perhaps shared by many, but practice differs from theory to a great extent.

One need not concern oneself with being national in art, all one needs is to be allowed to create in complete freedom. With full artistic freedom, nationality, as a spontaneous force, will naturally (like water down a slope) impregnate everything created by artists of a given nation, even those artists who, due to their personal inclinations, distance themselves from the influence of traditional folklore.

Some will ask: should we allow complete creative freedom in these present times of almost universal intellectual anarchy? Yes! It is both necessary and imperative because only complete freedom in this sphere can cure ugly distortions.

What is creativity? A bright image of an idea or a certain human impulse, a sudden flash in the artist's soul. Once it has arisen in the artist's soul, such an image cannot be revolutionary because the artist (ideally) is there to serve truth in the form of beauty. This is his purpose in life and no artist – nor any prophet – has ever tried to avoid responding to this internal calling. When an artist, poet or prophet remains unappreciated by his contemporaries, it is usually an indication of some malaise in society; the artist's task is to put aright things that have gone wrong within the moral fabric of society.

Having said this, I anticipate the objection: all this might be right, but, first, these are the higher matters and, besides, it can only be true if every artist is a true artist, one who has a calling for it. But how is it possible to make sure that this is the true state of affairs? How is it possible to determine, and by what standards, who is a real artist and who is just profiting from the name? Well, there is no need to determine or bring about anything. This is a mysterious business, a matter of the human spirit which concerns the relation between the creator and his creation. The artist's instinct places him on his chosen path, at a time when no one is yet in a position to say whether this is the birth of a new talent. Here, in this mysterious laboratory of the human soul

an invisible process is under way – atoms are quietly and invisibly concentrating on a certain side until, by the law of gravity, the body begins to roll on by itself, leaving its inert state and revealing itself for everyone to see. This is how the great art schools were born. First, someone becomes an artist, perhaps not such a great one, but capable of learning. Then, a very young apprentice joins him and soon goes further and further until the whole school blossoms – and all this without academies and officialdom.

This theory seems trivial and obvious, but it is the truth, and it is dangerous to destroy the truth. After all, we do not wish to break the laws of physics, since we know that they are nature's laws. Why, then, do we want new ways, why are we setting up academies, allocating grants, issuing regulations, presenting awards – in short, making so much effort all round? In my opinion, we need not exert ourselves at all.

If only I could prove that the state will benefit only when it does not support the Academy but simply creates the right conditions for the arts to flourish by abolishing everything that the Academy represents. There should be no official encouragement, for the existing system serves only to draw ever-increasing numbers of people towards official art, thereby creating a whole class of people who will then have to be looked after by the state. Many such people who are protected by the state then complain about the lack of commissions or their inability to sell their art – in other words, that society does not need them. The artists who are in demand are supported by society. The rest have to be cared for by the state, like the needy. They are cared for by various charities, albeit in the guise of decorations, titles, stipends, etc. We need to establish a balance between supply and demand.

How is this to be done? The Academy must be removed of its privileges and its rights to all sorts of tempting attractions. A place where people are taught to draw and paint should not be in a position to issue exemptions from military service, medals, awards and other such encouragements. All these are things of the past. We have come a long way since the times of Catherine the Great, and now the foreign tree that has been planted on our soil must be allowed to grow by itself – the period of acclimatization is over. The time of the great art patrons of the Renaissance cannot be compared to the present patronage of the arts by the government. What was then a lively and keen involvement has now become nothing more than official activity. The art patrons of the past were as passionate about art as the artists themselves and they seem to have understood art better than the present ones.

With the abolition of the Academy people who appreciate art and are devoted to it but do not know its nature sufficiently well might seriously worry that, as a result, art will begin to decline and its aims be lost. If there is no Academy, who will then support the 'high' art decorating our monuments? Who will take care of 'serious art', and so forth. The questions which arise in the hearts of people who love art so much are serious indeed and they must not remain unanswered. They do seem important. But they seem important only for those who do not understand the nature of art.

What do we see now? For more than one hundred years the Academy has been in charge of cultivating high art, but everything created within its walls has gone no further than imitation and has not been able to elevate our nation in the opinion of

peoples who have a national art of their own. All that was really high in our national art came not from the Academy and not by those routes which it recommends, but rather in spite of its advice and its assistance – as is revealed by our contemporaries Ivanov and Vasnetsov. When a nation possesses God-given aspirations, the high ideals in art will appear naturally. It is necessary for them to arise naturally because no one can ever tell what kind of high ideals they might be. Dante's *Inferno* is the highest achievement in poetry, but Gogol's *Dead Souls* is not low either. Nobody can dispute that now. And when a nation has no aspirations of a higher kind, nothing can bring about or invoke such aims. The Dutch are an important example of this and they prove my point: in spite of the absence of high art in comparison with the Italians, Dutch artists will never be forgotten by other nations.

It is necessary to determine in what spheres of art government efforts and the appreciation of connoisseurs or the expertise of tutors can help, and what areas must be left to the age-old, natural order of things which always works without fault both at times of ignorance and at times of high civilization. Only a man with the heart of an artist can influence both development and decline. This is like religion: a mysterious and intimate experience. It can be a matter of a special debate, and the more the issue is discussed between students and teachers, the better; but it must be totally removed from our teaching programmes.

What can one teach another in art? Absolutely nothing. What can a youth learn from an artist who he would like to have as his teacher? All that his teacher knows and can do. Let us take drawing. Can one be taught to draw? One can learn about proportion, size, movement – to a certain degree. But one cannot teach how to feel the form, the very soul of drawing. The slightest changes in the arrangement of the planes and the degree to which they must bend, the way the eye sees their interaction and the way the light plays upon them – this can only be felt, and an artist must be born with this sense. When an artist possesses this sense all he needs is the right conditions: the model, the lighting and the peace to create – and he will find the way without a teacher. With a teacher who is good, he will proceed more quickly, and without him – slower, but in either case he will understand and do things correctly.

What knowledge can one acquire about painting, other than the technique of representing nature's colours? Very little, in fact. One can learn some techniques of secondary importance – such as brush strokes, or the way to layer paints. But neither the combination of colours, nor the proportions in which they should be mixed – in short, the feeling for colour – can ever be taught. This is a completely subjective quality, which, again, comes naturally, like a purely physical quality and like the feeling for the form, it is given in a sufficient degree that it is already well-developed in adult people.

Part IV
Temperaments and Techniques

IV
Introduction

By the mid century, those writers in England and France who were interested in the idea of a modern art were generally clear in their distaste for attenuated forms of classicism and in their lack of enthusiasm for the types of literary and mythological subjects on which academic painters were inclined to dwell. Early supporters of Realist art had tended first and foremost to applaud the distinctive character of its motifs. By the 1860s, however, Realism in painting was understood to mean not only that motifs should be derived from a present and discernible world, but also that the surface of the canvas should be used to make the spectator *feel* that presence. Supportive writers were now alert to those pictorial effects that could be explored and enjoyed without any concern for the pursuit of narratives or the translation of symbols. The effects in question were for the most part those by which painters established the plasticity of represented forms and conveyed the sense of pictorial depth and light.

Techniques for modelling form and for suggesting depth and light had for several centuries been central to the mimetic functions of painting, and they played an important part in characterizing the subjects of Realist painting. But as the entry from Corot's notebook suggests (IVA1), during the later nineteenth century there was a growing tendency to conceive of pictorial content as decided less by the nature of the scene pictured and more by a character established or revealed in the picturing itself. As we suggested at the close of our introduction to Part III, the priorities gradually shifted. The process occurred earlier in France and in Italy than elsewhere (IVA2 and 3), and in France more decisively even than in Italy (IVA6). If the traditional tendency had been for critical attention to be directed first to pictorial subjects and only then to the manner of their realization, the criticism that now seemed most successfully to keep pace with change in painting was one responsive to any distinctive use of the painted surface. Zola's essay on Manet reads like a virtual manifesto for this change in priorities (IVA7).

It is a noticeable feature of such criticism that it has an oppositional character. The rhetorical form is that of argument against a still dominant set of values. There are two ways in which this oppositional character may be explained. The first would start by looking to the shift in the balance of political and economic power between nations, but above all between classes, that took place throughout the West during the

nineteenth century, at different times and rates and with different forms of final distribution, but in each case to the general disadvantage of the old landed gentry and in favour of the largely capitalist middle class. Between the 1830s and the mid-century the novel form was powerfully employed by writers to represent the social consequences of these changes. Among works of particular relevance in England are Charles Dickens's *Oliver Twist* of 1838 and *A Christmas Carol* of 1843, and in France, Honoré de Balzac's *Père Goriot* of 1834 and his extensive 'Comédie Humaine', begun in 1842. The institution of the Salon des Refusés in 1863 offered further evidence that conflicting forms of valuation were at work within the wider culture of art in France and that taste was no longer a matter that one dominant section of society could define and control. In 1871 the long reign of Napoleon III ended following defeat in the disastrous Franco-Prussian War. After a short-lived Commune, France became once again a republic, its principal political alternatives represented by a clerical–militarist right and a socialist left. In England the shift in the balance of power was recognized in the Second Reform Bill of 1867, which extended the franchise to a wider section of the male population. The unifications of Italy and of Germany, in 1861 and 1871 respectively, established two of the major nation-states of modern Europe and prepared the way for substantial industrial development. Meanwhile, across the Atlantic, the end of the American Civil War in 1865 had seen the more industrialized and mercantile North established as the controlling force in government and in culture.

In France, wittingly or not, the avant-garde critics of the 1860s and 1870s, like the avant-garde artists, acted as the forward representatives of a new constituency whose members were to be found spread throughout the industrialized nations – a constituency impatient with the old scenes and stories and uncomfortable with the values these scenes and stories had traditionally been used to articulate. A part of the fascination of Manet's art of the 1860s – even, and perhaps especially, for those who sought to dismiss it – lay in the way in which it seemed to turn those very values back upon themselves. In the late 1860s and 1870s a complementary search for modern scenes and subjects finds articulation in the letters and notebooks of artists, and in the exhortations of sympathetic critics. Predictably, these searches were conducted at some distance from the traditional sites of high culture, whether in its Classical or its Romantic guise. They tended to concentrate on environments shaped by the effects of industrialization and by the swelling of the middle classes, in railway stations and bathing places, in cafés and in shops (IVA4, 8, 14 and 16). The figures that populate the urban scenes of Manet, Degas and occasionally Renoir are generally those for better or worse caught up in the unsettled aftermath of social and economic change, much like the characters in Zola's 'naturalist' novels of the 1870s and 1880s. In the perceptions of the avant-garde, the image of the age was established by two standard types in particular: the businessman and the prostitute. In one guise or another, in isolation or juxtaposed, these two complementary figures recur with remarkable frequency in the art of the period.

We do not mean to reduce the work of writers as different as Zola, Castagnary, Duranty and Mallarmé to mere spokesmanship for an emergent bourgeois ideology, however, nor do we mean to suggest that the painting of the Impressionists should be regarded simply as up-to-date decoration for bourgeois homes. As early as 1937 the art historian Meyer Shapiro noted that the 'urban idylls' of early Impressionism were

addressed not to the emergent class as a whole but to the 'enlightened bourgeois detached from the official beliefs of his class'. With Manet, modern painting had assumed a set of sceptical functions which it could not thereafter disarm without loss of critical power. These tended to be brought to bear as soon as *any* set of beliefs threatened to become regulative. The 'I' who is another, in Rimbaud's memorable phrase, is a consciousness detached from the self-images of the age (IVA9). It was to the 'newcomers of tomorrow', not of today, that Mallarmé saw Impressionist painting as addressed (IVA15). With such cautions in mind, however, it can be said that if we seek adequately to explain the shift in the priorities of art we now associate with modernism, due consideration will have to be given to the social and economic conditions under which the bourgeoisie acquired cultural power. When Zola argued against the academic canon and for a view of art as nature seen through an individual temperament, it was with the prevailing values of his own class that his argument was conducted.

But we mentioned that there were two possible means to explain the oppositional character of writing about art in the 1860s and 1870s. The second concerns those causes and implications of the shift in priorities that are not so much social as technical. As conceived in the academic practice of the time, the highest genres of art were those in which the human figure occupied a central position. As we have suggested, even the Realist painters of the mid century generally treated the figure as the principal vehicle for critical content. Traditionally, the means to render the physical presence of a figure was through modelling by light and shade; in other words, by isolating it plastically within the pictorial space and atmosphere. But we have already noted a growing tendency for attention to be devoted to distinctive use of the painted surface, and to such overall effects of light and atmosphere as this surface might be made to convey. The early date of John Ruskin's *Elements of Drawing* (IVB1) serves to remind us that the view of nature as a tissue of colour patches did not actually originate with the French Impressionists. Even in relatively mainstream accounts of studio practice, such as those of Manet's teacher Thomas Couture (IVB4) or the Royal Academician Edward Poynter (IVB10), we find an increased emphasis placed upon the expressive functions of colour and upon the autonomy of pictorial procedures and effects. To conceive of the character of a picture as decided *primarily* by its qualities of surface and atmosphere is not only to reduce the significance accorded to the figure; it is to establish the grounds of a possible conflict between different technical requirements. Vigorous modelling tends to demand strong tonal contrasts. But the best way to establish a vivid pictorial atmosphere is to increase the brilliance of colour and to avoid strong contrasts. It should not surprise us, then, to discover that much of the most technically adventurous painting of the 1860s and 1870s was based on landscape subjects, in which figures could be reduced to patches of brushstrokes, in so far as their presence was required at all, and in which the achievement of an overall pictorial atmosphere could be seen as a form of Realism. By 1874, when the Impressionists-to-be held their first group exhibition, it was in the sphere of landscape painting that technical innovation was generally expected. It was the relatively small proportion of landscapes shown in that exhibition, rather than the urban scenes, that provoked the strongest critical reactions.

The conservative response to these works is represented by Leroy's fictional academician (IVA13). To their defenders, however, the paintings ridiculed by 'M.

Vincent' offered a spontaneous and thus trustworthy account of the natural world seen under specific conditions of light and atmosphere (IVA12). The signs of this spontaneity were to be found in the strength and vividness of the painting's optical effects. In the early justifications of Impressionist painting there thus develops a new theoretical understanding of the specific aptitudes by which the artist is qualified and distinguished. In the academies the highest skills to be taught were generally those required in the pictorial stage-management of history paintings. But the status of the academic genres had been declining as power and credibility ebbed away from the social and cultural regimes they tended to serve best. Instead, value was now increasingly placed on an unpremeditated response to nature; in other words, on the capturing of an impression. It was as though the impression was where the subjective and the objective briefly coincided. What supposedly qualified the artist for this task was not the rigour of an academic training, but rather the possession of some innate sensitivity. 'He is an eye', is supposed to have been said by Ingres in disparagement of Courbet. It now seemed that to be an eye could be enough, if only that eye were sufficiently responsive. The modernist tendency of the 1870s was thus to assess painting in terms of the vividness with which naturalistic effects were transcribed. This tendency received both direction and support from the considerable growth in studies of colour and optics (IVB6, 8). During the later 1860s and the 1870s, the benefits of work pursued at the level of empirical scientific research were made widely available to artists, both through incorporation in teaching manuals (IVB5) and through accessible publications such as those of Helmholtz (IVB8) and Rood (IVB9).

What we have referred to as a shift in priorities was thus the consequence of a convergence of interests. Our two forms of explanation come together to frame the broader conditions of modernist avant-gardism in the later 1860s and 1870s. At a time when the advanced representatives of a newly established social constituency were eager to prove the relative modernism of their own tastes and interests, dissident artists were developing a form of painting that largely eschewed literary and historical allusions, and that based its appeal rather on the 'scientific' status of empirical experience. Positive attitudes towards science and technology were among the typical signs of artistic modernism in its early form. The need to bring empiricist methods into the understanding of art was voiced by the German aesthetician Robert Zimmermann, in a paper published in 1861 (IVB2), and was further argued in the later work of Gustav Fechner (IVB7). At the end of the 1870s the American painter Thomas Eakins spoke for the importance of first-hand anatomical study freed from the idealizing tendencies of classicism (IVB11).

So far as the mainstream history of art is concerned, however, the definitive moment of convergence of interests is located in the France of the late 1860s and early 1870s. Its specific occasion is the formation of the Society of Independent Artists in 1874, in which the various painters who were to be known as the Impressionists exhibited together for the first time. Local forms of avant-gardism developed throughout the Western world during the remainder of the century, but everywhere the term 'Impressionism' became synonymous with a dissident and ultimately victorious modernism. It is also significant that the Impressionist movement should have been associated with a major evolution in the means of exhibition and distribution of art. By the end of the 1870s the monopoly of the Salon had been broken in France.

From then until the end of the century, alternative exhibiting societies and dealers' galleries proliferated throughout the West, hindered but not in the end prevented by the worldwide economic depression that set in in 1873.

The development of photography gave both impetus and confirmation to the shift in priorities we identify with artistic modernism. As an efficient witness to the momentary, and as a device for the recording of likenesses, the camera served to automate several of painting's traditional functions. In so far as it served to undercut the skills involved, it threatened to render those functions redundant. The typical effects can be seen in the field of portraiture. If all that was required was a likeness, then the photographer could now produce one much faster and cheaper than the painter. If painters were to maintain some stake in portraiture as an art, it would have to be by offering something more than mere likeness. For example, it might be claimed that a painted portrait was particularly attractive as a form of decoration. In other words, competition from photography supported the tendency for painters to concentrate upon the vividness of painterly effects rather than the realism of figurative illusions (IVc1). There were other positive consequences to be noticed. As early as 1855, Antoine Wiertz welcomed photography as the medium that would liberate the painter from the task of achieving likenesses and encourage concentration upon what might be thought of as art's philosophical aspects (IVc2). In his Salon of 1859, Baudelaire offered the other face of the same coin. For those, like him, who wished to castigate the technical conservatism of the academic painter, photography's detailed copying of the world of appearances furnished a ready and damning comparison (IVc5).

On the other hand, the means of production of the photographic image availed later writers of a powerful model or metaphor for the objective response of the artist's eye. It seemed that there was no arguing with the image that exposure to light produced on a light-sensitive surface. If the human eye could be thought of as operating like the lens of a camera, and if the resulting retinal impression were developed with minimum interference from the traditions of artistic culture, then the 'objectivity' of the resulting image could be seen as similarly established. Such arguments could be used to support the avant-garde claim that the critique of artistic tradition was pursued in the interests of modern Realism.

During the course of the later nineteenth century, arguments in support of the medium of photography generally followed a matching evolution. At first, the concern was to establish that the camera was not entirely restricted to the slavish copying of appearances, and that its operator could produce artistic effects and organize composition and content in the manner expected of high pictorial art (IVc1 and 4). Increasingly, however, the claim for photography as a pictorial art was grounded in its responsiveness to the effects of light – or rather in its standing as the very medium of light (IVc8).

Taken together, the modernist shift in priorities and the development of photography may be associated with one further change deserving of note. In each case the consequence was to direct a certain emphasis towards the experience of the viewing subject – the subject identified, in this case, not with the responding artist or photographer, but rather with the viewer of the resulting work. A simple contrast will serve to distinguish different concepts of viewing experience. Traditionally, the

painter's colours had been conceived of as mixed on the palette and then applied to the painting so as to compose a harmonious illusion. The Impressionist painter, however, conceived of colours as acting upon each other through an 'optical' mixture, occurring in the eye of the viewer, in the same way that a certain mix of light and shade would generate an image upon the photo-sensitive surface. The result was neither an exact copy of the natural world, nor an entirely independent form of decoration, but rather in Cézanne's words, 'a harmony ... parallel with nature' (see VIB 17).

IVA
Effects and Impressions

1 Camille Corot (1796–1875) Notebook Entry

Like the previous excerpt from Corot's notebooks, this passage was transcribed by E. Moreau-Nélaton and was published in his *Histoire de Corot et de ses oeuvres*, Paris, 1905 (see IIc2). It may be dated to the period around 1855. As Moreau-Nélaton observed, it constitutes a resumé of the painter's theory. By the later 1840s his career was well established. He was receiving critical support from both Champfleury and Baudelaire and in 1849 was elected to the Salon jury. Around this time the distinction between plein-air atmosphere and studio light became less marked in his work, and his subjects tended often to take on more marked metaphorical and allegorical connotations. He achieved a distinctive success with the theme of the picturesque 'souvenir' – a type of composition in which landscapes based on naturalistic sources and effects and figure-studies were interpreted as though recalled in the light of remembered emotion. In the 1860s the example of his discrete craftsmanship was important to the painters of the Impressionist generation, and particularly to Camille Pissaro, who styled himself 'pupil of Corot' in his early submissions to the Salon. The text of this passage is taken from Moreau-Nélaton p. 172, and has been translated for this volume by Peter Collier.

Let your feelings be your only guide. Yet, since we are mere mortals, we do make mistakes; so listen to advice; but follow only that which you can understand and which complements your own feeling. – Be strong but flexible. – Follow your convictions. Better to be nothing at all than to be overshadowed by the paintings of the past. As the wise man says, he who follows is always one step behind. The beautiful in art is truth, filtered through the impressions we receive as we see nature. Any place I see affects me. However conscientiously I seek to imitate it, I never for a moment lose sight of its first emotional impact on me. Reality is a part of art, but it is feeling which makes it whole. When faced with nature, begin by looking for form; then values and tonal relations, colour and execution: and subordinate the whole to your original feelings. Our feelings are as real as anything else. Faced with any particular landscape or object, we are moved by a certain elegance or grace. We should never let go of that emotion, and even when seeking truth and precision, we should never forget to reclothe it in the form in which it first struck us. Any landscape, any object; we should yield to our first impression. If we have really been moved, the sincerity of our feeling will be communicated to others.

2 Telemaco Signorini (1835–1901) and Giuseppe Rigutini (1829–1903) Exchange over the First Exhibition of the Macchiaioli

On 10 October 1862 the artist Telemaco Signorini published an anonymous review of the Florentine 'Promotrice Exhibition' in the journal *La Nuova Europa* in which he drew attention to the work of a number of exhibitors who were seeking to introduce a more innovative dimension into their paintings. Signorini, together with the artists Silvestro Lega and Rafaello Serenesi, discussed in the review, was a key figure amongst a group of painters centred around the Café Michelangiolo in Florence. Members of the group were united both by their opposition to the narrow classicism of the Florentine Academy and by their support for the ideals of the *risorgimento*, the political movement led by Garibaldi which sought to unite the disparate Italian kingdoms into a modern nation-state. The name by which they were to become known, the 'Macchiaioli', first appeared in print in a critical response to Signorini's article, published in the *Gazzetta del Popolo* on 3 November, by the philologist and linguist Giuseppe Rigutini, under the pseudonym 'Luigi'. The term 'Macchiaioli' derives from the root word *macchia* and means, literally, 'mark' or 'spot' painters. However, what these artists strove for is perhaps more accurately captured by the term *effetto*, the overall effect or impression generated by the whole, with a corresponding devaluation of the significance of individual depicted details. Their attention to the element of 'effect' led them increasingly to attempt to capture the broad distribution of light and shade by working direct from nature in the form of rapid sketches or *bozzetti*. However, unlike the French Impressionists, whose ideas they anticipate in many respects, the Macchiaioli conceived of these sketches as preliminary to work in the studio. Signorini in turn responded to Rigutini's criticisms in an article published in *La Nuova Europa* on 19 November. Whilst his comments serve to clarify the aims and ambitions of the group, they also suggest that the concern with the *macchia* belonged to a period of enquiry and experimentation which had now come to an end. These extracts are taken from the translation of the three articles printed in the exhibition catalogue, *The Macchiaioli: The First Europeans in Tuscany*, edited by Emilio Cecchi and Mario Borgiotti, Florence, 1963, pp. 25–31.

Telemaco Signorini: A Few Remarks about the Art Exhibitions in the Rooms of the Society for the Promotion of the Arts

Once again we have had the painful experience of seeing the Exhibition of the Society for the Promotion of the Arts pass unnoticed. Admittedly, it does not contain masterpieces, and this is not to be wondered at, since art in Italy today is going through a so-called period of transition. We believe, nevertheless, that it is our duty to break the silence which, although it honours a city proverbially known as a cradle of the arts, is, at the same time, extremely unfair to the artists themselves, who, in the exercise of their noble profession ask not only for a scrap in order to keep body and soul together but beg even more eagerly for the moral satisfaction of publicity and a constant flow of visitors. It is equally distressing to note that while the public, following an old tradition, streams to see only two paintings in the popular Autumn Show at the Academy of Fine Arts it neglects the rooms of the Society although they are near at hand. The works of many young artists, who are striving to free art from the bonds of old methods and to give it new life after such a long period of

dreary neglect and decadence, hang completely unnoticed and abandoned in these rooms.

These notes are intended to make up for the first of the above mentioned defects, namely the lack of publicity; they have been jotted down without any bias towards any particular group or school and their only aim is to attempt to arrive at the truth by promoting discussion.

Complete liberty and reciprocal tolerance are essential if there is to be any real progress.

* * *

One of the most charming landscapes in the Exhibition is Baracco's *Twilight in the Marshes near Ostia*. Buonamici's painting *Barracks in Modena during the Campaign of 1859* is a work in which the extremely difficult effects of various kinds of illumination within an interior have been rendered with enormous skill; although the painter uses very few colours he has nevertheless succeeded in creating a varied and colourful whole. This painting would have been quite perfect if some of the charming figures had been more carefully finished. Cabianca, an artist with a ready imagination, has exhibited six pictures. We prefer his *Bridge on the Road to Poggio a Caiano* which, although it appears to be the easiest is, in fact, the most successful both as an ingenuous expression of that state of tranquil repose in which the artist most loved to contemplate and to represent nature and because he has discovered a source of emotion where the majority fail to see anything. Giuseppe di Napoli is an artist in whom the union of solid concepts and profoundly felt impressions are excellently and suitably expressed. The three interiors on exhibition are worthy of praise because the details all contribute to maintain the general tone of the picture. We must point out, however, that since his impressions are overwhelmingly sad they will not easily appeal to the majority. As to Signorini: although we must praise his intention which is to study Nature and observe in her those moments which express a character and inspire a particular emotion we cannot, at the same time, avoid criticizing a certain tendency he has to exaggerate this aim by adding something too subjective and individual to his pictures, especially if we consider how difficult it is to render these ideas only through the means at the disposal of art, and to arouse in the public an appreciative under-standing of what the artist was trying to achieve. Although we are aware of the difficulties he is facing we do not wish to express any doubts as to his capacities nor to try to dissuade him from the path he is following. Connoisseurs of art will remember that the first impulse towards emancipation came from Serafino da Tivoli. We regret that he has not followed more firmly along the path he pointed out to others. We also regret that the pictures he has shown this year are not up to his standard, except for a small *Landscape with Two Goats*. He should stand firmly by his convictions, because only a small step separates him from those artists who paint only for profit. We offer Silvestro Lega our heartiest congratulations. The modesty of his works, even if it does not strike the common observer, nevertheless assures him of the certain approval of an intelligent and well-informed public. He should have more faith in himself and should more frequently offer the public works that reach the same high level as his charming painting *The Toilette*. Raffaelle Serenesi's *Pasture in the Mountains* is a simple, pleasant little picture in which the delicate tones of the whole are suffused with the tranquil peace of the countryside. We cannot pass over Egisto

Ferroni's *Saltimbanco* in silence. How unfortunate that such a sincere intention of studying nature should lead to such a sad result! The red tones throughout the picture are so excessive that the eye cannot dwell upon it without repugnance and effort. The drawing appears quite competent, but some figures are disproportionate in comparison with others. We are grateful to him, however, for having had the courage to attempt one of the most difficult effects in nature. He should not be discouraged by our criticism, but should be spurred on to continue in the direction he has taken.

The crowd of other painters exhibiting form a contrast to the above-mentioned. Although they enjoy more success with the public on account of their conventional technique and choice of subjects, they cannot meet with the same approval among those who have a higher concept of art. [. . .]

Giuseppe Rigutini – Florentine Chat

Artists have been talking for some time about a new school of painting that has been formed, called the school of the Macchiaioli. The painting of this school has appeared frequently in the exhibitions of the Society for the Promotion of the Arts and this year, too, it is amply represented. But, the reader will ask if he is not a painter himself, what are the Macchiaioli? I propose to explain. They are young painters, some of them undeniably gifted, who have put it into their heads to reform art, starting from the principle that effect is everything. Have you ever met anyone who offers you his snuff-box and insists that in the grain and various patterns in the wood he can recognize a head, a little man or a tiny horse? And the head, the little man and the tiny horse are all there in the fortuitous lines in the wood! All one needs is the imagination to see them. This is true of the details in the Macchiaioli paintings. You gaze at the heads of their figures and look for the nose, mouth, eyes and other parts of a face. All you see are shapeless splashes: the nose, mouth and eyes are all there all right – you only have to imagine them! Enough is as good as a feast! There certainly has to be an effect – but it is going too far when the effect destroys the design and even the form. If the Macchiaioli continue at this rate they will end by painting with a brush on the end of a pole and will scribble all over their canvases from a respectable distance of five or six yards. They will then be sure to obtain nothing else but an effect.

A new European, Mr X, offered our Macchiaioli a consolation the other day. He informed us that although their school of painting is a failure in old Europe it will certainly be the rage in the Europe that is to come . . . if brains are re-fashioned to follow the sayings of the prophets! I really did not believe that the new Europeans of today had such a strange taste in art; but for the Macchiaioli there may be some hope in this idea and for the lack of anything better they may as well cling to this fantastic vision of the future. Let me make myself quite clear: if I criticize the Macchiaioli it is not because I like polished, smooth painting like miniatures on porcelain; however, the artist can easily choose a middle way between an oily smoothness and a rugged crust, between forms without any effect and effects without any form. Nay – it would be all to the advantage of art if that kind of haunted, obscure painting were to be

abandoned altogether in favour of a return to the Venetian and Bolognese schools. Camino, whom Mr X has forgotten, represents independent art in the present exhibition of the Society for the Promotion of the Arts, but without the Macchiaioli's exaggeration.

Tivoli who was among the first to follow in Camino's wake, later claimed to have freed himself from his guide; he now hesitates to throw himself whole-heartedly into the ranks of the Macchiaioli, and in his hesitation has given abortive birth to a *Primavera* – may Heaven forgive him! He has also produced some landscapes among which Mr X praises the ugliest because it is the most macchiaiolo. Buonamici, however, did not hesitate at all. His painting of a *Barracks in Modena during the Campaign of 1859* (and may we say in passing that we do not understand why this picture has not been purchased by the government, instead of others far less worthy) shows that he has really been able to emancipate himself without falling into the exaggerated errors of the Macchiaioli. Oddly enough, Mr X reproaches him quite rightly with not having finished some of his charming figures. Be logical, dear Sir, and tell us how we should reproach the real Macchiaioli, who never do anything else but merely sketch out their pictures? The paintings of Induno, unjustly placed among those of the mere producers of commercial pictures by X are, for those who look at them without bias, among the most beautiful in the whole exhibition.

The charming and skilfully treated subjects, the finished and spontaneous execution which shows no sense of strain, make of Induno's two pictures two little jewels. My attention has been called to the works of Lega by Mr X's congratulations to him. Alas! If the hideous creatures painted by Lega are to be found among spring roses and garden-flowers in the Europe to come, then the new Europeans will have to seek for love among the deepest ravines and in the most inhospitable forests. And what about the washerwomen? Mercy upon us! Everything I have said about the Macchiaioli in general must be applied to Cabianca and Signorini in particular, because they are the most exaggerated examples of their school. Any criticism I might make of their paintings would be a mere repetition of what I have already said. I shall add that in the case of Cabianca his figures on the eve of a feast-day do not walk, but fly.

This chat today is not intended to be a review of the Exhibition and therefore I do not feel obliged to mention all the exhibitors, whatever their merits may be. All I intended to do was to mention the controversy raging at the moment among the artists and reduce to their proper value the principles upon which the Macchiaioli base their theories. I shall conclude by telling them not to put it into their heads that they are suffering the persecution usually accorded to innovators and leaders of new schools; they are not innovators; the Venetian and Bolognese schools sought for effect long before they did, and more recently Bezzuoli and Morelli have also tried to do the same; but his brilliant colours could not protect Bezzuoli from the criticism levelled at his careless drawing. The Venetian and Bolognese schools, Bezzuoli and Morelli, obtained their effects without abandoning form, and a fine painting by Celentano in the Italian Exhibition proves that effects and light can be achieved without neglecting drawing and finish.

Telemaco Signorini: Art Controversy

Although we appealed to the Press in an earlier article on the exhibition sponsored by the Society for the Promotion of the Arts, in order to provoke some discussion upon certain principles which we consider fundamental to the development and future of modern art we see with regret that we have failed to achieve our aim. The article referring to the exhibition which appeared in Nr. 301 of the *Gazzetta del Popolo* in reply to ours cannot be regarded as a serious contribution to the matter under discussion. Being fully persuaded that only profound and conscientious research may lead to a discovery of the truth, we would be untrue to our own beliefs if we did not reply logically to those who seek to dismay us by using the blunt and vulgar weapon of ridicule.

* * *

Let us first of all examine the notion he has formed of those artists whom he so aptly calls *Macchiaioli*. Perhaps someone he once knew in 1855 and who is now among the progressives once talked to him about the *macchia* (spot or splash). Now you should know that the *macchia* was only an exaggerated form of chiaroscuro brought about by the need artists felt at the time to free art from the chief fault of the old school, which had sacrificed relief and body in their pictures in favour of an excessive transparency. Having recognized the fault they tried to correct it and perhaps exaggerated, which always happens with any force that races ahead before it finds its pivot and eventually its own equilibrium. When the blind obstinacy of various reactionaries attacked the attempts of the first artists who were trying to improve matters, the innovators, naturally, exaggerated the practical application of a principle which had been good in itself and for a time they fell into excesses and eccentricities which were caused more by the reaction they had encountered than by their own desires. In this way the *macchia*, useful as it was as a bold attempt and an incomplete but fruitful type of technique, became the first imprint left upon the new arena which was open to modern art. Nowadays, when you talk of the *macchia* you are obviously confusing the first with the last step, the instrument with the work itself and the means with the end.

Are we leading you into the empty fields of abstract discussion? You will reply with the usual commonplaces about the limits of art – as if art had any recognized limits and the progressive activity of the human mind in all fields had any boundaries! But, you will object, surely the ancients conceived and did everything of which the human mind is capable? Agreed, they did all they could in their own age. Refusing to imitate the centuries that preceded them, they were able to understand their own and represent it; they translated into the world of art the inspirations and sentiments they had received from their own age. Our generation, on the contrary, is weak and feeble. Being the slaves of innumerable prejudices, we fail to elevate our minds to the free regions of speculation; being unable to understand our own century we are incapable of representing it. We have been so busy admiring the glorious path our ancestors trod that we have turned our backs on the road we should follow into the future. We have forgotten that every age has its own civilizing task to perform – unless

the generations living in a given age are content to be numbered among those who, as Dante says: 'Lived without infamy and without praise'.

And nowadays? All that is left of such a glorious patrimony are our traditions; these must of necessity be upheld and continued, unless we want to see the blind cult of the past (which cannot and should not be repeated), leading us to a period of decadence equal to that which lies immediately behind us.

The past should not be praised as the apogee of art, but recommended as a study of progress in a period which, however great and glorious, nevertheless did not possess the material and intellectual resources which we have at our disposal nowadays. Let us admire the past but not adore it; since adoration stultifies discussion let us be disposed to acknowledge merit in all times and all places, but let us not reject the inestimable advantages of free examination and criticism, however authoritative the names and works before us may be. If adoration is a good thing in religion, in art it leads to servile imitation and therefore to decay, just as an exclusive admiration for celebrities produces intolerance; by preventing the free use of reason and imposing silence, it inhibits discussion by depriving thought of the principles and foundations wherein its strength lies. [. . .]

3 Vittorio Imbriani (1840–1886) Letters on the 5th 'Promotrice' Exhibition

Imbriani's thirteen 'letters' on the 5th 'Promotrice' exhibition in Naples were published in the journal *La Patria*, of which he was the editor. They are addressed to the noted engraver Saro Cucinotta, to whom he gives the elaborate nickname Ciarusarvangadarsana. Although written in a playful, ironic and at times mocking tone, these letters contain a carefully elaborated and persuasive account of the concept of the *macchia* (see previous text). Imbriani begins by recanting his own earlier ideas, insisting upon the specificity of the 'pictorial idea' in art, in contrast with the form of expression proper to both poetry and philosophy. The pictorial idea consists in the *macchia*, an accord of light and shade which constitutes the 'characteristic effect' of a painting. Like the theme of a musical score, the *macchia* underlies the painting as a whole and is that from which everything else develops and is 'organically derived'. However, far from identifying the *macchia* with some abstract notion or idea in the artist's mind, Imbriani suggests that it may be discovered in the residue of paint scraped onto a canvas or the stains left on the table after a meal. The first annual exhibition of the Neapolitan 'Società Promotrice de Belle Arti' was held in 1862 and was intended to replace those formerly held by the Accademia Reale, suppressed after Garibaldi's troops entered Naples in 1860. The president of the society was the innovative landscape and genre painter Filipo Palizzi. A committed patriot, Imbriani fought under Garibaldi in the campaign to liberate Venice in 1866, returning to Naples shortly after to take up a lectureship in aesthetics at the university. The letters were originally published in *La Patria*, Naples, 25 Dec. 1867–10 Feb. 1868, and were subsequently published in book form in 1868 as *La Quinta Promotrice, 1867–68*. The following extracts, from letters IV and V, have been translated for the present volume by Olivia Dawson and Jason Gaiger from Vittorio Imbriani, *Critica d'arte e prose narrative*, Gino Doria (ed.), Bari: Giuseppe Laterza, 1937, pp. 40–6, 48–51.

Fourth letter

Naples, 9 January 1868

* * *

When the philosophers accepted Art amongst the subjects of their disquisitions, they said – in that amenable language of theirs – that in every work of Art, whether a poem, a musical score, a statue, a building or a painting, there had to be the idea. That was very well said, but it was not clearly said; and unfortunately they were themselves misled by this polysemic word, and were in turn misunderstood both by artists and by the general public. I too erred, I confess and repent it. Father Ciarusarvangadarsana, I prostrate myself full of contrition before your holy knees for having written my *Letter to Bernardo Celentano*, and retract every word, from the first to the very last syllable. Absolve me for not having had sufficient good sense to at least suspect that the pictorial idea could and should be intrinsically different from the poetic idea. Pardon me for having sought to reduce paintings to learned books. Pardon this unpardonable stupidity if only because of the repentance I feel and the virtue I now show in thus humbling myself in public for the greater edification of those very few who take Art seriously.

Yes, gentlemen, every painting must contain an idea, but it must be a pictorial idea and not a poetic one; similarly every poem must contain an idea, but a poetic idea and not a philosophical one. All the doctrine infused in a poem by Giambattista Vico does not make it readable, just as all the poetry crammed into the frescoes by Kaulbach on the staircase of the New Museum in Berlin does not suffice to make them pleasing to the eye. Every plant, indeed, every animal contains an idea, not in the form of syllogisms and reasoning, but rather vegetation and life. The idea of beauty is defined by the artistic idea, and it differs in every art form in such a way that its character and appearance are completely transformed. Surely, you do not think that it is like the same water poured into jugs of different shapes and colours. Not at all! It is like carbon, which is transformed into both coal and diamonds. This phenomenon I would term ideal isomorphism. What in poetry is thought, in music is the theme, and in sculpture the type.

But what does the pictorial idea consist in? What is it that constitutes the painting, and which cannot be wanting if it is to be called a painting? What is, in short, the soul of the painting? Well, I believe it to be the *macchia*, the mark or stain, and I shall take the liberty of explaining at length what I mean by this word in order to avoid the same kind of misunderstandings to which the word 'idea' gave rise.

I remember that once in your study you showed me the catalogue which had been published for the Florence Exhibition of 1861. Seeing that I was unimpressed by the etchings and photographs, you took the book away from me saying that you wanted to show me the best thing of all. The best thing was a fly which had been squashed between two pages in such a way that nothing could be better. You exclaimed, 'Look how pretty this *macchia* is! There, really, is a painting!' These words made me reflect and I remembered how as a boy I used to sprinkle ink on a sheet of paper, fold it, and take pleasure from the accidental designs, from the *macchia* that resulted.

If in an ink spot, in a squashed fly, there can be a painting – in a rudimentary state, of course – this means that the essence, the constitutive element of a painting is not the expression of the figures, nor the perspective, nor the composition of the groups, nor any other of the incidental elements on which people habitually place too much importance.

On another occasion I was in Filippo Palizzi's studio, which you know well. With the addition of a couple of houri and a cupboard well stocked with food and drink, I would think myself in Paradise, were I weak enough to believe in it. And why? Because I cannot conceive of any pleasure or delight greater than that which I experience when contemplating the studies which line its walls. But let's return to our subject. Amongst the many paintings there was a small card no more than a few centimetres wide, beautifully framed, on which there was nothing more than four or five brushmarks. Well, in all honesty, Ciarusarvangadarsana, I say to you, who, undoubtedly, remember that small *macchia*, those five brushmarks did not represent anything definable, but they combined so harmoniously together that in my eyes no other painting equalled it, no matter how perfect its plastic form or how interesting its subject. That formless harmony of colours moved me to a state of excited delight. I could not take my eyes away from it, and the more I looked the more my imagination was filled with images. In short, it had excited my mind into a state of productivity, which is the very aim of art, since that transformation which art brings about on material things is only the means through which my imagination is to be aroused.

Forgive a third example. I fell in love, for a while, with a fragment of a column of wonderful African marble, which was for sale at a marble dealer's in Constantinopoli Street. No one can fully appreciate the beauty of marble if they have not seen that fragment of column. A beauty, I swear to you! An incomparable *macchia* which pulled the cords and set in motion the bells of the imagination. Like the burning-glass which ignites in objects flames which it does not have in itself, it brought a thousand lovely images to my mind which, though not expressed or defined in the veins of the marble, were certainly a response to the sentiment which it possessed. [...]

Every evening, Filippo Palizzi, before closing up his studio, cleans his brushes and wipes his palette, and spreads the colours which remain on his palette knife over the white canvases which are destined to receive his future thoughts. In this way he not only prepares the canvases with a layer of paint on which successive applications of colour will adhere more effectively, he also attains some strange and singular stains which will give him an idea for a painting to be executed later. This last example serves to demonstrate how a simple, undefined *macchia* may assume a more defined form not only in the mind of the spectator, but also under the hands of the painter, who is able to effectively realize the painting which our minds can only imagine. Michelangelo saw his statue in the rough shape of the mass of stone, and he did nothing more with his chisel than remove some inopportune chips of stone that partially hid the statue from his sight. Similarly Palizzi, on certain happy occasions, simply adds to the contingent *macchia* a little more precision of form.

And how many beautiful *macchie* are created by splashes of wine, sauce, or coffee which spill upon the tablecloth. And speaking of this ... what time is it? Five o'clock?

Farewell dear friend. You are a fine and good man, and all this talk is fine and good, but dinner is even finer and better. *Amicus Ciarusarvangadarsana, magis amica coquina.* Remember your hungry friend,
Quattr' Asterischi

Fifth letter

Naples, 12 January 1868

What, then, is the *macchia* ultimately? It is an accord of tones, that is of light and shadow, which is capable of arousing various sorts of emotion in the soul and of exciting the imagination into a state of productivity. The *macchia* is the *sine qua non* of painting, the one indispensable component which can, on occasion, allow us to forget other qualities when they are absent but which cannot itself be replaced by anything else. The *macchia* is the pictorial idea, just as the musical idea is the harmony of sounds which the maestro terms the *theme*. And just as beneath even the longest and most varied score a fundamental theme is required from which everything else develops and is organically derived, so underlying the most enormous painting, even one as vast as Michelangelo's *Last Judgement*, there needs to be a certain division of light and shadow from which it derives its character. And this division of light and shadow, this *macchia*, is what really moves the observer and not, as the common people delude themselves, the expression of the figures or the sterile materiality of the bare subject. Similarly, in the case of music, it is not the attached words, the libretto, but the character of the melody which produces emotions in the listener, which makes our tears flow or our steps quicken, and which fills us with passion, pulling us to dance or calming our agitations.

* * *

But now let us turn to an examination of the entire content of that *macchia* which we have defined as an accord of light and shadow. Effects of light and shadow cannot be achieved without colour; colour is, in fact, the effect itself, it is the light rendered visible by its proximity to shadow. Speaking in absolute terms, light and shadow are both difficult for the eye to perceive, for the eye cannot discern anything determinate in either. Colour results from the different ways in which they are combined together. It is the second element which we find in the *macchia*, immediately after the tone. But beneath colour there is something else again. Colour does not exist by itself alone, floating in ether. Just as the vine and the ivy do not grow up towards the sky by their own powers alone, but require some sort of support to hold them upright, so colour needs to rest upon forms and to be incorporated into objects. Only in the mind of the philosopher or the critic can colour be detached from the objects in which it exists, and without which it is unimaginable. Colour pleases us to the extent that it successfully characterizes the object. The fly squashed between the pages of your album, the small card with four brushmarks in Palizzi's studio, the flesh-coloured veins in my column of African marble, the canvases stained with the colours left on the palette after a day's work – all these contain the accord of colours required by a painting and which stimulate my imagination to conceive a possible painting without yet being that painting. The first measure of the

theme is certainly not the whole score, even though the entire score is nothing but the explication of that first measure. Colour becomes a full element of art only when it serves to determine those forms which only colour can make visible to the eye.

We are now in a position to explain more practically what the *macchia* is. It is the representation of the first distant impression of an object or, rather, of a scene, the first and characteristic effect which impresses itself on the eye of the artist, whether he actually sees the object or the scene, or whether he perceives them in his imagination or his memory. It is that which is salient and characteristic in the effect of light, produced by a special grouping of persons or of variously coloured things. And when I say *distant*, I do not mean physical distance but rather moral distance, which consists in not yet having gathered together all the details of the object perceived, a receptiveness which can only take place through sustained contemplation and loving attention.

To this indeterminate and distant impression which the painter affirms in the *macchia* there follows another, but this time more distinct, precise and detailed. The execution, the completion of a painting is nothing other than a coming ever closer to the object, an attempt to separate and fix down that which passes in a flash before the painter's eyes. But, I repeat, if that first harmonious accord which is fundamental to the execution is missing, the finished work, no matter how grandiose it might be, will never be able to move the observer or to arouse any emotion in him. Whereas one solitary and bare *macchia*, which does not describe any distinct object, is most eminently capable of giving rise to such emotion.

* * *

Now consider this phenomenon! As the painter comes closer, both in attention and execution, to that which first formed the *macchia* it happens all too often that it loses some of its vigour, and at times is lost altogether. How often are the preparatory sketches for a painting, artistically speaking, not far superior to the finished painting which is refined and perfected? It is always the case that the first sketch of a work of art, no matter of what kind, reveals the artist and his way of thinking more powerfully than the polished and completed work itself. The very incorrectness which causes the first manifestation of a powerful impression to exaggerate its characteristic quality lends effectiveness to the manifestation. Execution diminishes that first robust perception, and close attention often generates confusion. The *macchia* belongs entirely to the artist: it is his way of capturing the theme he has chosen. It is his idea, the subjective part of the painting, whilst the execution is the objective part, where the subject matter takes on value and imposes itself. The truly great artist is he who can boast of having produced a masterpiece through *antonomasia*, who succeeds in reproducing the details with such exactness that they create an illusion, without in the least diminishing or losing the expressive *macchia*. This sometimes happens – it is not impossible.

Thus our *macchia*, from being a pure accord of tones, has established itself as a harmony of colours; and colour has been defined through form. And there you have it, the painting is finished. [...]

Quattr' Asterischi

4 Claude Oscar Monet (1840–1926) Letters to Bazille

Monet met the painters Renoir, Sisley and Bazille in the atélier of Charles Gleyre in the early 1860s. He had work accepted in the Salons of 1865, 1866 and 1868, but his submissions were rejected in 1867, 1869 and 1870. He attempted two large and ambitious paintings on modern-life themes, *Déjeuner sur l'Herbe* and *Women in the Garden*, but was unable to complete the first for submission, while the second was among those rejected. In the period covered by these letters his relationship with Bazille was coloured by his own impoverished state and by his friend's agreement to purchase the *Women in the Garden*, and to make payments in monthly instalments. In the first of the following letters, from the small coastal town of Etretat, he writes relatively free from anxiety, working on manageable themes in the company of his mistress and child. The tone of the second letter, sent from Paris, is partly provoked by Bazille's advice that Monet should seek part-time employment, but it also betrays his continuing anxiety about the need to be represented in the Salon by a suitably distinctive work. The painting he envisages is one that would combine technically up-to-date *plein-air* effects with a number of thoroughly Baudelairean themes: a scene of modern leisure at the fashionable suburban bathing-place of La Grenouillère on the Seine. The picture Monet had in mind was never painted, but the 'bad studies' he refers to (the French term 'pochade' means the most preliminary of sketches) survive in the form of two scenes from La Grenouillère, one in the Metropolitan Museum of Art in New York and another in the National Gallery in London, which, together with comparable works by Renoir in Stockholm, Winterthur and Moscow, are now identified with a crucial stage in the development of Impressionist painting. The letters were first published in Gaston Poulain, *Bazille et ses amis*, Paris: La Renaissance du Livre, 1932. Our text is taken from the transcripts of Monet's correspondence in Daniel Wildenstein (ed.), *Claude Monet, biographie et catalogue raisonné*, Lausanne and Paris: Bibliothèque des Arts, 1974, volume I, pp. 425–7, translated for this volume by Kate Tunstall.

Etretat, December 1868

My dear friend,

As I told you in my scribbled note, I am very happy, quite delighted. I am as happy as a king, for I am surrounded by everything that I love. I spend all my time in the open air down on the beach when the weather is really rough, or when the fishing boats are putting out to sea, or else, go into the country, which is so beautiful around here, and which I think I find even more enjoyable in winter than in summer. And of course I am working all this time, and I think that this year I will do some serious work. And then, my dear friend, when evening comes, I return to my little house to find my warm fireside and my loving family. If only you could see how sweet your godson has become. My dear friend, it's such a pleasure to watch this young fellow grow up, and I must admit how happy I am to have him. I'm going to put him in a picture, with some other figures around him, just the sort of thing for the Salon. This year I am going to do two figure paintings, an interior with a baby and two women, and sailors in the open air, and I want to make them really striking. Thanks to the gentleman at Le Havre who is taking care of my needs, I am enjoying the most perfect peace and quiet, since I have no worries. I can think of nothing better than staying like this for ever, in my peaceful country home. I assure you that I do not envy you being in Paris, and I

hardly miss our meetings [at the Café Guerbois], although I wouldn't mind seeing some of the regulars, but frankly you can't do anything worthwhile in those kinds of surroundings; surely you would admit that you couldn't fail to do better on your own, in the midst of nature. I'm sure of it myself. At all events, this is what I have always thought, and what I have achieved in these conditions has always been my best work.

We are always too concerned by what we see and hear in Paris, however strong we are, and at least the work that I intend to do here has the merit of not looking like anyone else's, or at least I think it won't, because it will simply be the expression of my own personal feelings. As time goes by, I regret more and more how little I know, that's the main problem, I'm sure of it. As time goes by, I become more and more aware that we never dare express our feelings openly. Isn't it strange? That's why I am overjoyed at being here and I don't think now that I will be returning to Paris for a long time, certainly not for more than a month each year.

I hope that you are full of energy and that you will keep your nose to the grindstone. It's so silly to waste time on purpose. In such ideal circumstances, you should produce something marvellous. O happiest of men, tell me what you have had accepted by the Salon, and if you are satisfied.

Please look out for any of my canvases that you might still have. I have lost so many that I am very attached to those that remain. Besides, I have already relieved you of most of them, and if you want to be of service to me, look high and low for any [blank] canvases that I may still have left, and also for any half-finished ones, like your full-length portrait, and another canvas from 1860, with some bad flowers on it. Have a look and send me anything that I could use. Please hurry, my dear friend, it would be a great help, for I am working so hard that I have almost used up the few canvases that I had, and Carpentier has just decided not to give me any more credit, so I'm forced to pay cash and you have no idea how much that costs.

Don't forget to do this, and do write to me.

I shake your hand [. . . .]

Ever yours, Claude Monet

25 September 1869

This is to tell you that I have not followed your (unforgivable) advice to go to Le Havre on foot. I have been a little happier this month than before, but I am still in a state of desperation. I've sold one still life and I've been able to work a little. But once again I have ground to a halt for want of paint. Lucky you, you will be piling up the canvases! I myself will have achieved nothing this year. That makes me furious with everyone and everything, I am bitter and utterly jealous; if only I could work, everything would be all right. You tell me that 50 or 100 francs wouldn't help; you may be right, but in that case I may as well keep banging my head against a brick wall, as I have no hope of suddenly becoming rich, and if I'd had 50 or even 40 francs for every time that someone took your line, I wouldn't be in this situation, that's for sure. I am rereading your letter, my dear friend; it is really very funny, and, if I didn't know you, I'd think you were joking. You tell me in all seriousness, and you really seem to

think it, that if you were in my shoes you would go and get a job as a woodcutter. Only someone in your position could think that, and if you were in mine you might be even more upset than I am. It's harder than you think and I wager that you wouldn't make a very good woodcutter. So you see, advice is difficult to give and I don't think it is much use, no offence intended. Despite all this there is probably worse in store. Winter is round the corner, and it's always harder to bear when you're down on your luck. Then comes the Salon. Alas, I'll be left out once again, because I won't have produced anything. I do have a dream, a painting of bathing at la Grenouillère, which I've daubed a few bad studies for, but it is a dream. Renoir, who has just spent two months here, wants to do the same picture. On the subject of Renoir, that reminds me that when I was at his brother's, I drank some really good wine which he had just got from Montpellier. It also reminds me that it is absurd to have a friend from Montpellier but not to be able to get him to send me some wine. Look, Bazille, there can't be a shortage of wine in Montpellier at the moment. Couldn't you have someone send me a cask and deduct the cost from what you still owe me? At least we wouldn't have to drink so much water and it wouldn't cost us much. You can't imagine what a favour you would be doing us, because otherwise it would be very expensive, so I would be most obliged to you. Please reply by the first of the month.

5 Paul Cézanne (1839–1906) Letters 1866–76

The admixture of Cézanne's technical radicalism and his integrity had an unequalled influence on younger artists at the very end of the nineteenth century. Some of his followers tried to capture the effects of his conversation and render them more overtly theoretical in their own writings (cf. VIB15). His own words, however, are preserved almost exclusively in private letters. These three early letters are to his childhood friend the novelist Émile Zola, to his Impressionist colleague and mentor Camille Pissarro, and to his mother. They detail his commitment to painting in the open air, and hint at something of the ethical motivation behind his technical radicalism, as well as offering a description of some aspects of that technical radicalism itself. Our extracts are taken from the translation by Marguerite Kay in John Rewald (ed.) *Paul Cézanne: Letters*, Oxford: Bruno Cassirer, 1976, pp. 111–13, 141–2, 145–6. (Further extracts may be found at VIB17).

Aix, circa 19 October, 1866

My dear Emile,

For some days it has been raining in a determined way. Guillemet arrived on Saturday evening, he has spent some days with me and yesterday – Tuesday – he went to a small place, good enough, which costs him 50 francs a month, linen included. In spite of the driving rain the countryside is magnificent and we have done a bit of sketching. When the weather clears up he will start work seriously. For my part, idleness overwhelms me, for the last four or five days I have done nothing. I have just finished a little picture, which is, I believe, the best thing I have yet done; it represents my sister Rose reading to her doll. It is only one metre, if you like I will give it to you; it is the size of the frame of the Valabrègue. I shall send it to the Salon. [. . .]

But you know all pictures painted inside, in the studio, will never be as good as those done outside. When out-of-door scenes are represented, the contrasts between the figures and the ground is astounding and the landscape is magnificent. I see some superb things and I shall have to make up my mind only to do things out-of-doors.

I have already spoken to you about a picture I want to attempt; it will represent Marion and Valabrègue setting out to look for a motif (a landscape motif of course). The sketch, which Guillemet considers good and which I did after nature, makes everything else fall down and appear bad. I feel sure that all the paintings by the old masters representing subjects out-of-doors have only been done with skill [*chic*] because all that does not seem to me to have the true, and above all original, appearances provided by nature. Père Gibert of the museum invited me to visit the Musée Bourguignon. I went there with Baille, Marion, Valabrègue. I thought everything was bad. It is very consoling. I am fairly bored, work alone occupies me a little, I am less despondent when someone is there. I see no one but Valabrègue, Marion and now Guillemet. [...]

Paris, 26th September, 1874

My dear Mother,

I have first of all to thank you very much for thinking of me. For some days the weather has been beastly and very cold. – But I don't suffer in any way and I make a good fire. [...]

Pissarro has not been in Paris for about a month and a half; he is in Brittany, but I know that he has a good opinion of me, who has a very good opinion of myself. I am beginning to consider myself stronger than all those around me, and you know that the good opinion I have of myself has only been reached after serious consideration. I have to work all the time, not to reach that final perfection which earns the admiration of imbeciles. – And this thing which is commonly appreciated so much is merely the effect of craftsmanship and renders all work resulting from it inartistic and common. I must strive after perfection only for the satisfaction of becoming truer and wiser. And believe me, the hour always comes when one breaks through and has admirers far more fervent and convinced than those who are only attracted by an empty surface.

It is a very bad time for selling, all the bourgeois jib at letting go of their sous, but this will end. [...]

L'Estaque, 2 July, 1876

My dear Pissarro,

[...] If I dared I should say that your letter bears the marks of sadness. Pictorial business does not go well; I am much afraid that your morale is coloured slightly grey by this, but I am convinced that it is only a passing thing.

How much I should like not always to talk of impossibilities and yet I always make plans which are most unlikely to come true. I imagine that the country where I am would suit you marvellously. – There are some famous vexations but I think they are

purely accidental. This year it rains two days out of seven every week. That's unbelievable in the Midi. – It's unheard of.

I must tell you that your letter surprised me at Estaque on the sea shore. I am no longer at Aix, I left a month ago. I have started two little motifs with the sea, for Monsieur Chocquet, who had spoken to me about them. – It's like a playing-card. Red roofs over the blue sea. If the weather becomes favourable I may perhaps carry them through to the end. Up to now I have done nothing. – But there are motifs which would need three or four months' work, which would be possible, as the vegetation doesn't change here. The olive and pine trees always keep their leaves. The sun here is so tremendous that it seems to me as if the objects were silhouetted not only in black and white, but in blue, red, brown and violet. I may be mistaken, but this seems to me to be the opposite of modelling.

6 Émile Zola (1840–1902) 'Dedication to Cézanne' and 'The Moment in Art' from *Mon Salon*

Zola combined critical journalism with novel writing throughout his career, from a defence of the new art in the 1860s to his intervention in the Dreyfus affair thirty years later. The first of these forays consisted of a series of articles on the Salon of 1866 which Zola contributed to *L'Evénément*. The controversy they aroused resulted in his leaving the newspaper. In the first two articles, of 27 and 30 April, Zola condemned the Salon jury for their conservatism. It was in the face of criticism provoked by these two pieces that Zola, having condemned the status quo, now set out to present his own views in the third article. Titled 'Le Moment artistique' it appeared on 4 May. Zola argues against the idea of a single, unchanging canon of beauty, rooted in the antique, and possessed in the present by the Academy. Against this he sets not the work of a particular school, but a notion of artistic truth, which is to be achieved by reconciling two elements: a more objective standard given by truth to nature, and an infinitely variable, subjective standard given by truth to one's individual response. For Zola in 1866, three years after the Salon des Refusés and a year after the *Olympia* scandal, this ideal was most convincingly met by Manet. In his fourth article, of 7 May, he continued the exploration of Manet's work broached at the end of 'Le Moment artistique'. In the final article, of 11 May, Zola reiterated his notion of artistic truth, concluding with the famous definition of the work of art as 'a corner of the world seen through a temperament'. He reprinted the articles as a booklet later in 1866 under the generic title *Mon Salon*. For this he wrote a new preface, in which he dedicated the work to the then completely unregarded Paul Cézanne, in effect attributing the ideas of 'Le Moment artistique' and the other articles to the conversations the two friends had shared since adolescence. Zola's dedication to Cézanne is reprinted from the translation by Margaret H. Liebman in John Rewald, *Paul Cézanne: A Biography*, New York: Simon and Schuster, 1948, pp. 56–7. 'The Moment in Art' was translated for the present volume by Kate Tunstall from F. W. J. Hemmings and Robert J. Niess (eds), *Emile Zola. Salons*, Geneva: Libraire E. Droz and Paris: Libraire Minard, 1959, pp. 60–4.

To my Friend Paul Cézanne

I experience deep joy, my friend, in having a tête-à-tête with you. You cannot imagine how much I have suffered from this quarrel which I have just had with the herd, with

the unknown crowd; I felt so misunderstood, I felt such hatred around me, that discouragement often made me drop my pen. Today I can avail myself of the intimate pleasure of one of the good talks we have had together for the past ten years. It is for you alone that I write these few pages; I know you will read them with your heart, and that tomorrow you will love me more affectionately.

Imagine that we are alone together in some remote place, far from any struggle, and that we are talking like old friends who know each other's very soul and understand each other at a mere glance.

For ten years we have been speaking of art and literature. We have lived together – do you remember? – and often daybreak caught us still conversing, searching the past, questioning the present, trying to find the truth and to create for ourselves an infallible and complete religion. We shuffled stacks of terrible ideas, we examined and rejected all systems, and after such arduous labour we told ourselves that outside of powerful and individual life there only exist lies and stupidity.

Happy are they who have memories! I envisage your role in my life as that of the pale young man of whom Musset speaks. You are my whole youth; I find you mixed up with all my joys, with all my sufferings. Our minds, in brotherhood, have developed side by side. Today, at the beginning, we have faith in ourselves because we have penetrated our hearts and flesh.

We used to live in our shadow, isolated, unsociable, enjoying our thoughts. We felt lost in the midst of the complacent and superficial crowd. In all things we sought men, in every dawn, in every painting or poem we wanted to find an individual emphasis. We asserted that the masters, the geniuses, are creators, each of whom had made a world of his own, and we rejected the disciples, the impotent, those whose trade it is to steal here and there a few scraps of originality.

Did you know that we were revolutionaries without being aware of it? I have just been able to say aloud what we told each other for ten years. The noise of the quarrel reached you, did it not? And you have witnessed the fine welcome accorded our dear thoughts. Ah! the poor lads who lived healthily in the middle of Provence, in the sun, and who clung to such folly and such bad faith!

For – you probably did not know this – I am a man of bad faith. The public has already ordered several dozen straitjackets to take me to Charenton. I only praise my relatives and my friends, I am a fool and evil man, I am a scandalmonger.

This inspires pity, my friend, and it is very sad. Will it always be the same story? Will we always have to talk like the others or be still? Do you remember our long conversations? We said that the least new truth could not be revealed without provoking anger and protests. And now I, in turn, am being jeered at and insulted.

It is a good experience, my friend. For nothing in the world would I wish to destroy these pages; they are not much in themselves but they have been, so to speak, my touchstone of public opinion. We now know how unpopular our dear thoughts are.

Yet, I am pleased to present my ideas a second time. I believe in them, I know that in a few years everyone will agree with me. I am not afraid that they will be thrown in my face later on.

Emile Zola
Paris, May 20, 1866

The Moment in Art

Before passing the slightest judgement, I ought perhaps to have explained categori-
cally my views on art, and what my aesthetics are. The fragments of opinions that I
have been forced to give out of context have offended received opinion, and people are
resentful of such forthright views when they seem unfounded.

I have my pet theory like everyone else, and like everyone else, I think that my
theory is the only true one. At the risk of being boring, I am going to spell out that
theory. My likes and dislikes will be easy to infer.

For the public – and I don't wish to use the word in a derogatory sense – a work of
art, a painting, is a pleasant thing which touches the heart in a gentle or terrifying way;
it may be a massacre, where groaning victims, threatened by guns, breathe their last;
or it may be a delightful young girl, white as snow, dreaming in the moonlight, leaning
against a column. What I mean is that the crowd only sees in a painting what grabs it
by the throat or tugs at its heart-strings, and it asks nothing more of the artist than a
tear or a smile.

For me – and for many people, I would like to think – a work of art is on the
contrary the expression of a personality, of an individual.

What I ask of the artist is not that he give me sweet visions or terrible nightmares,
but that he give of himself, body and soul, that he clearly express the force and
singularity of his mind, the harshness and strength of his character, that he take
nature firmly in his grasp and set it down firmly in front of us just as he sees it. In a
word, I have nothing but contempt for petty skills, self-interested flattery, for things
learned in school and drilled into us repeatedly, for the historical theatricality of Mr X
and the sweet-smelling dreams of Mr Y.

But I have the greatest admiration for individual works, for those which flow
spontaneously from a unique and energetic hand.

Seen from this point of view, it's not about being pleasant or unpleasant, it's about
being yourself, laying bare your heart, creating yourself as a dynamic individual.

I support no particular school, because I support human truth which admits of no
cliques or systems. I dislike the word 'art'; it implies some idea of formal necessity or
an absolute ideal. When we produce art, are we not producing something which is
beyond man and nature? I want us to produce life, that's what I want; I want
something alive, I want a new creation, previously unknown, true to the artist's
own eyes and to his temperament. What I seek above all in a painting is the man
and not the painting.

There are, in my opinion, two elements in a work: the element of reality, which is
nature, and the personal element, which is man. The element of reality, nature, is
fixed, always the same; it is given equally to all men; I would suggest that it may act as
a common term for all works, if I were to admit that there could be any common term.

The personal element, man, is, on the other hand, infinitely variable; there are as
many possible works as there are different minds; if there were no such thing as
temperament, no painting could ever be more than a photograph.

So, a work of art is never anything more than a combination of man, the variable
element, with nature, the fixed element. The word 'realist' means nothing to me,

since I am determined to subordinate the real to temperament. Be true to life and I will applaud; but above all be personal and vivid, and I will applaud louder. If you refuse to accept this line of reasoning, you are forced to deny history and to redefine art every year.

For it is equally ridiculous to believe that in matters of artistic beauty, there is one absolute and eternal truth. The single and whole truth is no good for us, since we construct new truths each morning and have worn them out by the evening. Like all things, art is a product of man, a human secretion; our bodies exude the beauty of our works. Our bodies change in relation to different climates and customs, and our secretions change accordingly.

This means that the works of tomorrow cannot be the same as those of today; you cannot formulate any rules or devise any formulae; you have to give in willingly to your nature and avoid self-deception. Are you afraid of speaking your own language, you who spend hours transcribing dead ones!

My fervent desire is this: – I want no schoolboy's exercises copied from masters' lessons. Such works remind me of the lithographed pages of handwriting that I copied as a child. I want no appeals to the past, no supposed resurrections, no pictures painted according to an ideal thrown together from fragments of all the ideals of the past. I want nothing to do with anything other than life, temperament, reality!

And, now, I beg of you, take pity on me. Imagine the suffering inflicted yesterday on a temperament like mine, lost in the bleak and vacuous wastes of the Salon. Quite frankly, for a moment I was tempted to give up, for fear that I might be too harsh.

The problem is not whether I risk offending the tastes of the artists, but the fact that they have already offended my feelings even more rudely. If my readers understand my position, will they say: 'This poor devil is sick to his stomach, but he's holding it back in the interest of public decency'?

I have never seen such a mediocre collection. There are two thousand paintings, and not three real men among them. Of these two thousand canvases, five or six speak some known human language; others merely twitter sweetly and seductively. Is this too harsh? Yet I'm only saying out loud what everyone else is secretly thinking.

At least I do not deny our own time. I believe in it, I know that we are searching and working hard. We are living through a period of struggles and passions, we have our talents and our geniuses. But we must not fail to distinguish between the mediocre and the powerful. I believe that it is not right to give way to that indiscriminate indulgence which distributes words of praise to everyone and thereby praises no one.

Our age is this one. We are civilized, we have boudoirs and salons; the poor may put whitewash on the walls of their houses, but the rich need paintings on theirs. So this has led to the creation of a whole corporation of workmen who finish off the work started by the masons. This takes a lot of painters, as you can imagine, and we have to spoon-feed them by the dozen. In addition, we give them the best advice on how to please and how not to offend contemporary tastes.

On top of this, there's the state of mind of the modern artist. Faced with the encroachment of science and industry, artists have reacted by plunging into a dream-world of sequins, paper chains and tinsel heavens.

Go and look at the Renaissance masters and see if they cared about those sweet little details that make us swoon; they were strong characters who put their whole life into

their work. Whereas we are nervous and anxious; there is too much of the feminine in us, and we feel so weak and worn out that even the full bloom of health upsets us. It's all so sentimental and insipid!

Our artists are poets. Saying this sounds like a grave insult to people who are not even required to think, but I maintain that I am right. Look at the Salon: nothing but verses and madrigals. One turns out an ode to Poland, another an ode to Cleopatra; one sings in the style of Tibullus and another blows into the great trumpet of Lucretius. Not to mention the martial hymns, the elegies, the ribald songs, or the fables.

What a jumble!

I beg of you, since you are painters, paint, do not sing. I give you flesh, I give you light: make an Adam of your own creation. You should be makers of men, not makers of shadows. But I know that it is hardly proper to show a naked man in a boudoir. That is why you paint grotesque giant puppets which are no more indecent and no more alive than a little girl's pink doll.

Talent works in a different way, don't you think? Look at the handful of canvases in the Salon which really stand out. They burn a hole in the wall, they are almost unpleasant, they shout down the gentle murmurs of their neighbours. The painters who are guilty of these works have no place in the guild of elegant whitewashers that I have mentioned. There are very few of them, they are sufficient unto themselves, outside any school.

I've already argued that we cannot accuse the jury of being as mediocre as our painters. But since they think it is their job to judge severely, why haven't they saved us the sight of all this rubbish? If you are only accepting talent, you only need one room, three metres square.

Is it so revolutionary to express regret for the few strong characters who are not included in the Salon? We don't have such a wealth of individuality that we can reject the few we do have. And in any case, I am sure that a true temperament won't die of a single rebuff. I am taking their side because it seems to be a just cause; but deep down, I have no fears for the health of their talent. Our fathers laughed at Courbet; and now we wax lyrical over his work; we laugh at Manet, and our sons in their turn will praise him to the skies. I am not in the business of competing with Nostradamus, but I am very tempted to announce that this extraordinary event will happen sooner than we think.

7 Émile Zola (1840–1902) 'Edouard Manet'

Zola first defended Manet in his Salon of 1866 (see IVA6). He then extended his discussion into a three-part essay solely devoted to Manet's work. This was first published under the title 'A New Manner in Painting: Edouard Manet' in the *Revue du XX Siècle*, January 1867. Later in 1867 Zola republished it in the form of a separate pamphlet, which is how it appears in the portrait Manet painted of him that same year. Zola begins by reiterating his criticism of the Academy. He then goes on to offer an account of Manet's painting which relates the 'truth' of his art to its formal and technical characteristics. This is not quite 'art for art's sake' though. In part it is a device to rescue Manet from the bohemianism and scandal-seeking of which he then stood accused. More important is the nature of Zola's emphasis on 'truth': truth-to-art is at the forefront of his account, but it is never completely disconnected from another truth, the truth of 'the contemporary girl we meet everyday on

the pavements'. Zola dislikes Romanticism, just as he admires science, and for him Manet is an 'analyst'. For Zola, the truth of modernity consists in the analytic disposition, rather than in some narrative which may be woven about it. The present extracts are drawn from the translation of the French text by Michael Ross published in Pierre Courthion and Pierre Cailler (eds), *Portrait of Manet by Himself and his Contemporaries*, London: Cassell, 1960, pp. 113–39.

[. . .] Circumstances have made Edouard Manet, who is quite young, into a most unusual and instructive subject for study. The very odd place which the public – and even the critics and his artist colleagues – have accorded him in contemporary art, struck me as something which should be carefully studied and explained. And here it is not only the personality of Edouard Manet that I am trying to analyse, but the whole of our artistic movement itself and contemporary opinion on aesthetics.

A curious situation has arisen, and this situation can be summed up in two words. A young painter has obeyed, in a very straightforward manner, his own personal inclinations concerning vision and understanding; he has begun to paint in a way which is contrary to the sacred rules taught in schools. Thus, he has produced original works, strong and bitter in flavour, which have offended the eyes of people accustomed to other points of view. And now you find that these same people, without trying to understand why their eyes have been offended, abuse this painter, insult his integrity and talent; and have turned him into a sort of grotesque lay-figure who sticks out his tongue to amuse fools.

Isn't such a commotion an interesting subject for study? Isn't it a reason for an inquisitive, unbiased man like myself to halt on his way in the presence of the mocking, noisy crowds which surround the young painter and pursue him with their hoots of derision?

I picture myself in the middle of a road where I meet a gang of young ruffians who are throwing brick-bats at Edouard Manet. The art critics – pardon, I mean the police – are not doing their job well. They encourage the row instead of calming it down, and even – may God forgive me! – it looks as though the policemen themselves have enormous brick-bats in their hands Already, it seem to me, there is something decidedly unpleasant about this scene which saddens me – me, a disinterested passer-by, calm and unbiased.

I go up to the young ruffians and question them; I question the police, I even question Edouard Manet himself. And I become more and more convinced about something. The reason for the anger of the young ruffians and the weakness of the police is explained to me. I am given to understand what crime it is that this pariah whom they are stoning has committed. I go home and prepare, for the sake of truth, the official evidence which you are about to read.

Obviously, I have only one object in mind – to calm down the blind anger of the rowdies and to try to make them return to a more common-sense point of view, and, at all costs, to stop them making such a din in the street. I ask them not only to criticize Edouard Manet fairly but also *all* original artists who will make their appearance. I extend my plea further – my aim is not only to have one man accepted, but to have all art accepted.

Taking Edouard Manet's case as typical of the way really original personalities are received by the public, I protest against this reception, and from the individual I proceed to a question which touches all real artists.

This article, I repeat, for several reasons, will not be a definitive portrait. It is a simple summary of the existing state of affairs. It is an official account of the regrettable influence – as it seems to me – that centuries of tradition have had on the public as far as art is concerned.

I The Man and the Artist

Edouard Manet was born in Paris in 1833. I have only a few biographical details concerning him. In this orderly police state of ours, an artist's life is the same as that of any quiet bourgeois; he paints his pictures in his studio as others sell pepper over their counters. The long-haired types of 1830, thank heavens, have completely disappeared, and our painters have become what they ought to be – people living the same life as everyone else. [. . .]

[. . .] Contemporary fools, who earn their living by making the public laugh, have turned Manet into a sort of Bohemian character, a rogue, a ridiculous bogey, and the public has accepted the jokes and the caricatures as so much truth. The truth is far removed from these dummies, created in the imagination of penny-a-line humorists, and it is in order to present the real man that I write these lines.

The artist has confessed to me that he adores society and that he found secret pleasure in the perfumed and glittering refinement of *soirées*. He was drawn to them by his love of bold and vivid colour; but, in his heart of hearts he had an innate need for refinement and elegance which I try hard to find in his works.

Such, then, is his life. He works assiduously and the number of his canvases is already considerable. He paints without getting discouraged; without wearying; marching forward according to his own lights. Then he returns to his home and there tastes the quiet pleasures of the modern bourgeois. He goes out a great deal, following the same sort of life as most people, but perhaps with this difference, that he is more quiet and cultivated than the majority. [. . .]

I would not like to lay down the principle, as an argument in favour of Edouard Manet, that because he wasted his time at Thomas Couture's, a student's failure to follow the teaching of his master is a mark of genius. In the career of every artist, there is necessarily a period of groping and hesitation which lasts, more or less, for a long time; it is admitted that each artist must pass through this period in the studio of a professor, and I see no harm in that. The advice received here, even though it may, to begin with, prevent the expression of original talent, does not prevent this talent from eventually manifesting itself; the studio influence will sooner or later be quite forgotten so long as the artist has individuality and perseverance.

But in the present case, it pleases me to regard Edouard Manet's long and difficult apprenticeship as a symptom of originality. It would be a long list if I was to mention here all those artists who were discouraged by their masters and who later became men of the greatest merit. 'You will never succeed in doing anything,' says the teacher, which no doubt means, 'Without me there there is no hope, and you are not me.' Happy pupils who are not recognized by the masters as their children! They

are a race apart, each one adds his word to the great sentence which humanity writes and which will never be complete. They are destined themselves in their own turn to be masters, egoists set in their own opinions.

Edouard Manet tried to find his own way and see for himself. [. . .] He spoke in a language full of harshness and grace which thoroughly alarmed the public. I do not claim that it was an entirely new language and that it did not contain some Spanish turns of phrase (about which moreover I will have to make some explanation). But judging by the forcefulness and truth of certain pictures, it was clear that an artist had been born to us. He spoke a language which he had made his own, and which henceforth belonged entirely to him.

This is how I explain the birth of a true artist, Edouard Manet, for example. Feeling that he was making no progress by copying the masters, or by painting Nature as seen through the eyes of individuals who differed in character from himself, he came to understand, quite naturally, one fine day, that it only remained to him to see Nature as it really is, without looking at the works or studying the opinions of others. From the moment he conceived this idea, he took some object, person or thing, placed it at the end of his studio and began to reproduce it on his canvas in accordance with his own outlook and understanding. He made an effort to forget everything he had learned in museums; he tried to forget all the advice that he had been given and all the paintings that he had ever seen. All that remained was a singular gifted intelligence in the presence of Nature, translating it in its own manner.

Thus the artist produced an *oeuvre* which was his own flesh and blood. Certainly, this work was linked with the great family of works already created by mankind; it resembled, more or less, certain among them. But it had in a high degree its own beauty – I should say vitality and personal quality. The different components, taken perhaps from here and there, of which it was composed, combined to produce a completely new flavour and personal point of view; and this combination, created for the first time, was an aspect of things hitherto unknown to human genius. From then onwards Manet found his direction; or to put it better, he had found himself. He was seeing things with his own eyes, and in each of his canvases he was able to give us a translation of Nature in that original language which he had just found in himself. [. . .]

I am forced here, to my greatest regret, to set forth some general ideas. My aesthetic, or rather the science which I will call 'the modern aesthetic', differs too much from the dogma which has been taught up till now, to risk speaking without making myself perfectly clear.

Here is the popular opinion concerning art. There is an 'absolute' of beauty which is regarded as something outside the artist or, to express it better, there is a perfect ideal for which every artist reaches out, and which he attains more or less successfully. From this it is assumed that there is a common denominator of beauty. This common denominator is applied to every picture produced, and according to how far the work approaches or recedes from this common denominator, the work is declared good or less good. Circumstances have elected that the Classical Greek should be regarded as the standard of beauty, so that all works of art created by mankind have ever since been judged on their greater or lesser resemblance to Greek works of art.

[...] For two thousand years the world has been constantly changing, civilizations have flourished and crumbled, society has advanced or languished in the midst of ever-changing customs; on the other hand, artists are born here or there, on pale, cold mornings in Holland, or in the warm, voluptuous evenings of Italy and Spain – but what of that! The 'absolute' of beauty is there, unchangeable, dominating the centuries. All life, all passions, all that creative energy which has enjoyed itself and suffered for two thousand years is miserably crushed under this idea.

Here, then, is what I believe concerning art. I embrace all humanity that has ever lived and which at all times, in all climates, under all circumstances, has felt, in the presence of Nature, an imperious need to create and reproduce objects and people by means of the arts. Thus I have a vast panorama, each part of which interests and moves me profoundly. Every great artist who comes to the fore gives us a new and personal vision of Nature. Here 'reality' is the fixed element, and it is the differences in outlook of the artists which has given to works of art their individual characteristics. For me, it is the different outlooks, the constantly changing view-points, that give works of art their tremendous human interest. I would like all the pictures of all the painters in the world to be assembled in one vast hall where, picture by picture, we would be able to read the epic of human creation. The theme would always be this self-same 'nature', this self-same 'reality' and the variations on the theme would be achieved by the individual and original methods by which artists depict God's great creation. In order to pronounce fair judgment on works of art, the public should stand in the middle of the vast hall. Here beauty is no longer 'absolute' – a ridiculous common denominator. Beauty becomes human life itself; the human element, mixed with the fixed element of 'reality' giving birth to a creation which belongs to mankind. Beauty lies within us, and not without. What is the use of philosophic abstractions! Of what use is a perfection dreamed up by a little group of men! It is humanity that interests me. What moves me, what gives me exquisite pleasure is to find in each of the creations of man an artist, a brother, who shows me with all his strength and with all his tenderness the face of Nature under a different guise.

[...] The ridiculous common denominator does not exist any more; the critic studies a picture for what it is, and pronounces it a great work when he finds in it a vital and original interpretation of reality. He can then state that to the genesis of human creation another page has been added; that an artist has been born who has given Nature a new soul and new horizons. Our creation stretches from the past into an infinite future. Every society will produce its artists, who will bring with them their own points of view. No systems, no theories can hold back life in these unceasing productions.

Our task then, as judges of art, is limited to establishing the language and the characters; to study the languages and to say what new subtlety and energy they possess. The philosophers, if necessary, will take it on themselves to draw up formulas. I only want to analyse facts, and works of art are nothing but simple facts.

Thus I put the past on one side – I have no rules or standards – I stand in front of Edouard Manet's pictures as if I were standing in front of something quite new which I wish to explain and comment upon.

What first strikes me in these pictures, is how true is the delicate relationship of tone values. Let me explain. . . . Some fruit is placed on a table and stands out against a

grey background. Between the fruit, according to whether they are nearer or further away, there are gradations of colour producing a complete scale of tints. If you start with a 'note' which is lighter than the real note, you must paint the whole in a lighter key; and the contrary is true if you start with a note which is lower in tone. Here is what I believe is called 'the law of values'. I know of scarcely anyone of the modern school, with the exception of Corot, Courbet and Edouard Manet, who constantly obeys this law when painting people. Their works gain thereby a singular precision, great truth and an appearance of great charm.

Manet usually paints in a higher key than is actually the case in Nature. His paintings are light in tone, luminous and pale throughout. An abundance of pure light gently illuminates his subjects. There is not the slightest forced effect here; people and landscapes are bathed in a sort of gay transluscence which permeates the whole canvas.

What strikes me is due to the exact observation of the law of tone values. The artist, confronted with some subject or other, allows himself to be guided by his eyes which perceive this subject in terms of broad colours which control each other. A head posed against a wall becomes only a patch of something more, or less, grey; and the clothing, in juxtaposition to the head, becomes, for example, a patch of colour which is more, or less, white. Thus a great simplicity is achieved – hardly any details, a combination of accurate and delicate patches of colour, which, from a few paces away, give the picture an impressive sense of relief.

I stress this characteristic of Edouard Manet's works, because it is their dominating feature and makes them what they are. The whole of the artist's personality consists in the way his eye functions: he sees things in terms of light, colour and masses.

What strikes me in the third place is his elegance – a little dry but charming. Let us understand each other. I am not referring to the pink and white elegance of the heads of china dolls, I am referring to a penetrating and truly human elegance. Edouard Manet is a man of the world and in his pictures there are certain exquisite lines, certain pretty and graceful *attitudes* which testify to his love for the elegance of the salons. Therein the unconscious element, the true nature of the painter is revealed. And here I take the opportunity to deny the existence of any relationship (as has been claimed) between the paintings of Edouard Manet and the verses of Charles Baudelaire. I know that a lively sympathy has brought painter and poet together, but I believe that the former has never had the stupidity, like so many others, to put 'ideas' into his painting. The brief analysis of his talent which I have just made, proves with what lack of affectation he confronts Nature.

If he groups together several objects or several figures, he is only guided in his choice by a desire to obtain beautiful touches of colour and contrasts. It is ridiculous to try to turn an artist, obeying such instincts, into a mystical dreamer.

After analysis, synthesis; let us take no matter what picture by the artist, and let us not look for anything other than what is in it – some illuminated objects and living creatures. The general impression, as I have said, is of luminous clarity.

Faces in the diffused light are hewn out of simple bold patches of flesh colour; lips become simple lines; everything is simplified and stands out from the background in strong masses.

The exact interpretation of the tone values imbues the canvas with atmosphere and enhances the value of each object.

It has been said that Edouard Manet's canvases recall the 'penny-plain, twopence-coloured' pictures from Epinal. There is a lot of truth in this joke which is in fact a compliment. Here and there the manner of working is the same, the colours are applied in broad patches, but with this difference, that the workmen of Epinal employ primary colours without bothering about values, while Edouard Manet uses many more colours and relates them exactly. It would be much more interesting to compare this simplified style of painting with Japanese engravings, which resemble Manet's work in their strange elegance and magnificent bold patches of colour.

One's first impression of a picture by Edouard Manet is that it is a trifle 'hard'. One is not accustomed to seeing reproductions of reality so simplified and so sincere. But as I have said, they possess a certain stiff but surprising elegance. To begin with one's eye only notices broad patches of colour, but soon objects become more defined and appear in their correct place.

After a few moments, the whole composition is apparent as something vigorous; and one experiences a real delight in studying this clear and serious painting which, if I may put it this way, renders Nature in a manner both gentle *and* harsh.

On coming close to the picture, one notices that the technique is more delicate than bold; the artist uses only a brush and that with great caution; there is no heavy impasto, only an even coat of paint. This bold painter, who has been so hounded, works in a very calculated manner, and if his works are in any way odd, this is only due to the very personal way in which he sees and translates objects on to canvas.

In a word, if I were interrogated, if I were asked what new language Manet was speaking, I would answer, 'He speaks in a language which is composed of simplicity and truth.' The note which he strikes in his pictures is a luminous one which fills his canvas with light. The rendering which he gives us is truthful and simplified, obtained by composing his pictures in large masses.

I cannot repeat too often that, in order to understand and savour his talent, we must forget a thousand things. It is not a question, here, of seeking for an 'absolute' of beauty. The artist is neither painting history nor his soul. What is termed 'composition' does not exist for him, and he has not set himself the task of representing some abstract idea or some historical episode. And it is because of this that he should neither be judged as a moralist nor as a literary man. He should be judged simply as a painter. He treats figure subjects in just the same way as still-life subjects are treated in art schools; what I mean to say is that he groups figures more or less fortuitously, and after that he has no other thought than to put them down on canvas as he sees them, in strong contrast to each other. Don't expect anything of him except a truthful and literal interpretation. He neither sings nor philosophizes. He knows how to paint and that is all. He has his own personal gift, which is to appreciate the delicacy of the dominant tones and to model objects and people in simplified masses. He is a child of our age. I see him as an analyst painter. All problems have been re-examined; science requires solid foundations and this has been achieved by accurate observation of facts. This approach is not confined to the world of science alone. In all branches of knowledge and in all the works of mankind, man has tended to find basic and definitive principles in reality.

Compared with our historical and *genre* painters, our modern landscape artists have achieved much more, because they have studied our countryside, content to interpret the first corner of a forest they came upon. Manet uses this same method in each of his works; while others break their heads trying to compose a new picture of 'The Death of Caesar' or 'Socrates Drinking Hemlock', he quietly places some objects or poses some people in a corner of his studio and begins to paint. I repeat, he is merely an analyst. His work is much more interesting than the plagiarisms of his colleagues. Art as practised by him leads to ultimate truth. This artist is an interpreter of things as they are, and, for me, his works have the great merit of being accurate descriptions, rendered in an original and human language. [...]

II His Works

[...] My first impression on entering Edouard Manet's studio was one of unity and power. One is aware of both harshness and delicacy as one first glances at the walls. Before one's attention is arrested by one particular picture, one's eyes wander from top to bottom, from right to left. These clear tones and graceful shapes, blending together, possess a harmony and a boldness of style which is both simple and extremely powerful. [...]

'Le Déjeuner sur l'Herbe' is Edouard Manet's largest picture, in which he has realized the dream of all painters – to pose life-size figures in a landscape. One knows how skilfully he has overcome this problem. There is some foliage, a few tree trunks, and in the background a river in which a woman in a shift is bathing. In the foreground two young men are seated facing a second woman who has just emerged from the water and who is drying her naked body in the open air. This nude woman has shocked the public which has been unable to see anything but her in the picture. Good heavens! How indecent! What! A woman without a stitch of clothing seated between two fully clad men! Such a thing has never been seen before! But this belief is a gross error; in the Musée du Louvre there are more than fifty pictures in which clothed people mix with the naked. But no one goes to the Louvre to be shocked. Besides, the public has taken good care not to judge 'Le Déjeuner sur l'Herbe' as a true work of art. The only thing it has noticed is that some people are eating, seated on the grass after bathing. It was considered that the artist's choice of subject was obscene and showy, whereas all that the artist had sought to do was to obtain an effect of strong contrasts and bold masses. Artists, especially Manet, who is an analytical painter, do not have this preoccupation with subject matter which, more than anything else, worries the public. For example the nude woman in 'Le Déjeuner sur l'Herbe' is undoubtedly only there to give the artist an opportunity of painting flesh. What you have to look for in the picture is not just a picnic on the grass, but the whole landscape, with its bold and subtle passages, its broadly painted solid foreground, its light and delicate background and that firm flesh modelled in broad areas of light, those supple and strong materials, and, particularly that delicate splash of white among the green leaves in the background; in fact to look at the whole of this vast, airy composition, at this attention to Nature, rendered with such accurate

simplicity – at the whole of this admirable work, in which the artist has concentrated his unique and rare gifts. [. . .]

In 1865, Manet was still admitted to the Salon where he exhibited 'Jésus Insulté par les Soldats' and his masterpiece, 'Olympia'. I say 'masterpiece' and I don't retract the word. I maintain that this painting is the veritable flesh and blood of the painter. It contains everything the artist has in him and nothing but the artist. It will remain as the most characteristic example of his talent, his greatest achievement. In it I descried the personality of Edouard Manet, and when I made an analysis of the artist's character, it was precisely this picture, which incorporates all his characteristics, that I had in my mind's eye. Here we have one of those 'penny-plain, twopence-coloured' pictures as the professional humorists say. Olympia, lying on white linen sheets, appears as a large pale mass against a black background. In this black background is seen the head of a Negress carrying a bouquet of flowers, and that famous cat which so diverted the public. At first sight one is aware of only two tones in the picture – two violently contrasting tones. Moreover, all details have disappeared. Look at the head of the young girl: the lips are just two thin pink lines, the eyes are reduced to a few black strokes. Now look closely at the bouquet, I beg you. Simple masses of rose colour, blue and green. Everything is simplified, and if you want to reconstruct reality, move back a few paces. Then a strange thing happens – each object falls into correct relation, the head of Olympia stands out in astonishing relief from the background, the bouquet becomes a marvel of brilliance and freshness. Accuracy of vision and simplicity of handling has achieved this miracle. The artist has worked in the same manner as Nature, in large, lightly coloured masses, in large areas of light, and his work has the slightly crude and austere look of Nature itself. But the artist has his *partis pris*: for art can only exist by enthusiasm. These *partis pris* consist of precisely that elegant dryness and those violent contrasts which I have pointed out. Here is the personal touch, which gives his works their peculiar flavour. Nothing is more exquisitely delicate than the pale tones of the different white of the linen on which Olympia reclines: in the juxtaposition of these whites an immense difficulty has been overcome. The pale colouring of the child's body is charming. She is a young girl of sixteen, no doubt a model whom Edouard Manet calmly painted just as she was. And yet everybody cried out in protest: the nude body was found to be indecent – but naturally, because here was flesh – a naked girl whose charms are already a little faded, whom the artist had thrown on to canvas. When our artists give us a Venus, they 'correct' Nature, but Edouard Manet has asked himself, 'Why lie, why not tell the truth?' He has made us acquainted with Olympia, a contemporary girl, the sort of girl we meet every day on the pavements, with thin shoulders wrapped in a flimsy faded woollen shawl. The public as usual has taken good care not to understand the painter's intentions. Some people tried to find a philosophic meaning in the picture, others, more lighthearted, were not displeased to attach an obscene significance to it.

Ho there! proclaim out loud to them, *cher Maître*, that you are not at all what they imagine, and a picture for you is simply an excuse for an exercise in analysis. You needed a nude woman and you chose Olympia, the first-comer. You needed some clear and luminous patches of colour, so you added a bouquet of flowers; you found it necessary to have some dark patches so you placed in a corner a Negress and a cat. What does all this amount to – you scarcely know, no more do I. But I know that you

have succeeded admirably in doing a painter's job, the job of a great painter; I mean to say you have forcefully reproduced in your own particular idiom the truths of light and shade and the reality of objects and creatures. [. . .]

III The Public

It now remains to me to study and explain the attitude of the public towards the pictures of Edouard Manet. The man, the artist and his works are already known. There is another element – the public – which must be taken into account if we are to understand entirely the singular artistic state of things which we have seen come to pass. The drama will be complete, we will hold in our hands all the threads connecting the various actors; all the details of this strange adventure.

On the other hand, it would be a mistake to believe that the painter has never met with any sympathy. For the majority, he is a pariah, but for a group of people, which increases in number every day, he is a painter of talent. Latterly, especially, the movement in his favour has increased and become more noticeable. [. . .]

When the crowd laughs, it is nearly always over a trifle. [. . .] Put ten people of average intelligence in front of a new and original picture and these people, all ten, will behave in the most childish way. They will nudge each other and comment on the picture in the drollest way imaginable. Curious idlers, in their turn, will arrive on the scene to swell the group and soon it will turn into a real hubbub – an access of mad folly. I'm not making up anything. The artistic history of our times is there to tell how such purblind fools and scoffers gathered in front of the first paintings by Decamps, Delacroix and Courbet. [. . .]

[. . .] It is simply the more or less original appearance of the picture which has induced this idiotic mirth. The pose is excruciatingly funny! This colour makes you cry with laughter! This line has made more than a hundred people sick! All that the public has seen is a subject – a subject treated in a certain manner. They look at works of art in the same way as children look at picture books – to amuse themselves, to get some fun out of them. Ignorant people laugh with complete self-assurance; knowledgeable people – those who have studied art in moribund schools – are annoyed, on examining the new work, not to discover in it the qualities in which they believe and to which their eyes have become accustomed. No one thinks of looking at it objectively. The former understands nothing about it, the latter make comparisons. None of them can 'see', and hence they are roused to mirth or anger. I repeat, it is simply the superficial way the work presents itself to the eye that is the cause of all this. The public never tries to probe further. They have stuck, as it were, on the surface. What is shocking and irritating to them is not the inner meaning of the work, but the general superficial aspect of it. If it were possible, the public would willingly accept the same subject matter, presented differently.

Originality! That's what shocks. We are all more or less, without knowing it, creatures of habit who obstinately follow the same beaten path to which we are accustomed. Every new path alarms us, we shy at unknown precipices and refuse to go forward. We always want to have the same horizon before us; we laugh at, or are irritated by the things we don't understand. That is why we are quite happy to accept originality when it is watered down but reject violently anything that upsets our

preconceived ideas. As soon as someone with individuality appears on the scene, we become defiant and scared; we are like suspicious horses that rear at a fallen tree across the road because they can't comprehend either the nature or the cause of this obstacle and don't seek any further to explain it to themselves.

It is only a question of what you are used to. By dint of seeing the obstacle, fear and mistrust are diminished. After that there is always some kind passer-by who will make us ashamed of our anger and explain to us the reason for our fear. I want to play the modest role of the passer-by for the benefit of those who, mistrusting the pictures of Edouard Manet, remain cavorting and frightened on the road.

The artist is beginning to get tired of his role of scarecrow. In spite of all his courage, he is beginning to feel that he is losing his strength in the face of the public's exasperation. It is high time that the public drew nigh and recognized the reason for their ridiculous fear. [...]

But there is nobody to guide the public, and what do you expect the public to do today in the midst of all this hubbub? Art, in a manner of speaking, is split up. The great kingdom, split into pieces, has formed itself into a host of small republics. Each artist has attracted his public, flattering it, giving it what it likes, gilded and decorated toys with rosy favours – this art, with us, has become one vast sweet-shop where there are *bonbons* for all tastes. Painters have merely become pathetic decorators who ornament our terrible modern apartments. The best of them have become antiquaries stealing a bit of this or that from the dead masters, and apart from the landscape painters, these narrow-minded and bourgeois decorators have made the deuce of a noise: each one has his own feeble theory, each tries to please and conquer. The mob, fawned upon, goes from one to the other, enjoying today the whimsies of this painter, and tomorrow the bogus strength of that. And all this disgraceful business, flattery and admiration of trumpery, is carried on in the so-called sacred name of Art. Greece and Italy are staked against chocolate soldiers, beauty is spoken of in the way one speaks of a gentleman acquaintance with whom one is on very friendly terms.

Then come the critics to cast still more trouble into this tumult. Art critics are like musicians who all play their own tunes simultaneously, hearing only their own instruments in the appalling hubbub that they are producing. One wants colour, another drawing, a third intellectual quality. I could name one who polishes his phrases and is only happy when he is able to describe a picture in the most picturesque terms possible, and another, who apropos of a woman lying supine finds occasion to write a discourse on democracy; and yet another who frames his ridiculous opinions in the form of rhyming music-hall couplets. [...]

So the mob, seeing how little in accord are those who have pretensions of guiding them, allow themselves to admire or jeer as they please. There is no common point of view. A word pleases them, or displeases them – that's all. And note, what pleases them is always the most commonplace, something they have seen every year. Our artists do not spoil them; they have so accustomed them to insipidity, to pretty lies, that they reject the real truth with all their might. It is simply a question of education. When a Delacroix appears on the scene, he is hissed. [...]

And that is how, one day, a gang of urchins met Edouard Manet in the street and started the rumpus which brought me to a halt – me, a fastidious and unbiased passer-

by. I laid information against them as well as I could, asserting that the urchins were in the wrong, and sought to snatch the artist from their grasp and lead him to a safe place. There were some policemen – I beg your pardon, I mean art critics – present, who assured me that the man was being stoned because he had outrageously desecrated the Temple of Beauty. I answered them that Destiny had undoubtedly already chosen the future setting in the Louvre for 'Olympia' and 'Le Déjeuner sur l'Herbe'. No one listened, and I retired as the urchins were now beginning to cast sullen looks at me.

8 Edgar Degas (1834–1917) from Notebooks 22, 23 and 30

Besides drawings and sketches, the notebooks that Degas used throughout his career contain occasional admonitions to himself and written proposals for themes and for pictures. Two particular interests are revealed in the following extracts. The first concerns the expressive character of the human face and figure and the artistic means by which that character might be conveyed. In Notebook 23 he refers to various stages of development in the theory of physiognomic expression: the *tête d'expression* or 'expressive head' was a standard academic exercise based on the late-seventeenth century studies of Charles Lebrun; Lavater's influential works of a century later were intended to show how character was revealed through physiognomy and facial movement; and nearer Degas's own day the 'applied aesthetics' of Delsarte were concerned with the repertoire of human expression in the context of musical and rhetorical performance. Degas's second abiding interest lies in the details and atmospheric effects of modern urban and domestic life, and in the means by which a momentary awareness of these might be represented. Some of the artist's most remarkable works result from the successful combination of these two interests. Typically they show expressive figures in modern settings, but the manner of that showing is such as also to evoke the consciousness and disposition of an imagined viewer. These notes provide interesting glimpses into the materials and techniques from which such pictures were made. It is clear, for instance, that Degas was much preoccupied with the effect on the viewer of rotating a viewpoint in relation to a fixed image – a technique that was to be crucial in development of the art of animation. The 'Belle Feronnière' is an Italian painting in the Louvre formerly thought to be by Leonardo. The 'journal' referred to in Notebook 30 was a publication to be called *Le Jour et la nuit* ('Day and Night') which was planned by Degas in association with a group of other artists, including Cassatt, Braquemond and Pissarro, in 1879–80. Excerpts from the notebooks were first published in Jean Sutherland Boggs, 'Degas Notebooks at the Bibliothèque Nationale', I–III, *Burlington Magazine*, May, June, July 1958. Our text of the notes is principally based on the later transcriptions of Degas's manuscript in Theodore Reff (ed.), *The Notebooks of Edgar Degas: A Catalogue of the Thirty-eight Notebooks in the Bibliothèque Nationale and Other Collections*, Oxford: Clarendon Press, 1976, volume I, pp. 117–18 and 133–4. We have also referred to Boggs, however, and have occasionally adopted her reading in preference. The translation for this volume is by Charles Harrison. Punctuation has been added or modified where necessary to the sense. Words in square brackets have been inserted for clarity. We have followed Reff's conclusions on the dating of the respective notebooks.

From Notebook 22, 1867–74

One thing that's sure is that to establish a piece of nature and to really draw it are two entirely different things. [...] One does not like to hear people speaking as if to

children about rosy and glowing flesh, 'Ah, what life, what blood'. Human skin is as varied in aspect, among us most of all, as is the rest of nature, fields, trees, mountains, water, forests. It happens that one can encounter as much resemblance between a face and a pebble as between two pebbles, since everyone knows it's common enough for faces to appear virtually identical (I'm talking about the question of colour; form is another issue, since there's plenty of [formal] resemblance to be found between a pebble and a fish, a mountain and the head of a dog, clouds and horses, etc.) So it's only instinct that leads us to say that where coloration is concerned one should seek everywhere for the point of affinity between live forms and those which are dead or vegetating. For instance, it's easy for me to recall the colour of someone's hair because what comes to my mind is that it was hair like polished walnut, or flax, or horse-chestnut. It's the rendering of the form that will then transform this more or less exact tone of walnut, of flax or of horse-chestnut into real tresses with their suppleness and lightness or their stiffness and weight. And then, one paints in such different ways on different supports that the same tone will have one value here and another there. [...]

Ah Giotto, don't prevent me from seeing Paris, and you, Paris, let me see Giotto.

From Notebook 23, 1868–72

Do *têtes d'expression* (in the style of an academy piece), a study of modern feeling – it's like Lavater, but Lavater in a sense more relative to content, sometimes using symbolic accessories. Study Delsarte's observations on the impassioned movements of the eye.

Her beauty can be no more than a certain physiognomy.

Work hard on evening effects, lamp, candle, etc. Piquancy lies in not always showing the light source, but rather showing the effects of light. This aspect of art has immense potential at the moment – how could anyone not see that?

Plenty of drawing. Ah! The fine art of drawing! [...] Consider a treatise on ornament for women or by women, according to their ways of observing, of combining, of grooming themselves and everything else. – Far more than men they daily make comparison of a thousand visible things, one with another.

In getting up in the morning I can still save everything of my highly compromised life.

Do portraits of people in familiar and typical attitudes. Above all give to their faces the same choice of expression that one gives to their bodies. Thus if laughter is the hallmark of a person, make him laugh. Of course, there are feelings that one can't render, from considerations of propriety; portraits not being just for us, painters.

What fine nuances there are to establish. All this gets revived in this unfortunate *têtes d'expression*. (A prize endlessly contested.) The mystery of the *Belle Feronnière* is not the repose of the figure but her expression.

From Notebook 30, 1877–83

One evening I placed a hand on her shoulder – in an embarrassed manner. I didn't know what I was doing. I felt her cheek, which she had leant against her shoulder and which suddenly touched my hand.

There is a kind of shame in being known principally by people who don't understand you. Great reputation is a form of shame. [It is not very easy to understand where the true centre is. But][1] it is fine to orientate oneself towards the centre – but it is certainly [an honour][2] better than being in accord with the Institut. We will amuse ourselves as eruditely as possible.

After doing portraits seen from above, I will do some seen from below – seated very close to a woman and looking at her from low down, I will see her head in the chandelier, surrounded with crystals – etc.

Do simple operations like drawing a profile which does not move, [but] moving oneself, raising or lowering [the viewpoint], the same for an entire figure, a piece of furniture, a complete drawing-room.

Do a series of movements of arms in dancing, or of legs which don't move, turning one's position around them. Then study a figure or object – it doesn't matter what – from every viewpoint. One could use a mirror for this. One wouldn't actually move from one's position. But the position itself would be lowered or tilted. One would [seem to] move around.

Studio projects. Set up tiered benches all round the room to get in the habit of drawing things from below and from above. Only be allowed to paint things seen in a mirror so as to instil a hatred of *trompe l'oeil*. For a portrait have the figure pose on the ground floor and have to work on the first floor to get used to keeping a grasp of the forms and expressions, never drawing or painting *directly*.

For the journal: cut things a lot. For a dancer do either the arms or the legs, or the lower-back, do the shoes, the hands of a hairdresser, the padded coiffure, bare feet in the process of dancing etc, etc. Do all kinds of common objects, so arranged and contextualized that they have the *life* of men and women – corsets just taken off, for example, which retain the form of the body etc. etc.

Series on instruments and instrumentalists, their forms, the contortion of the violinist's hands and arms and neck, for example. Puffing and contracting of the cheeks of the bassoons, oboes etc.

Do a series on *mourning* in aquatint (different blacks, black veils of deep mourning floating over the face, black gloves, funeral carriages, undertakers' outfits, carriages like Venetian gondolas).

On smoke, smoke of chimneys, pipes, cigarettes, cigars, smoke of locomotives, of tall factory chimneys, of steam-ships, etc. scrunching of smoke under the bridges, steam.

On evening. Subjects with the sense of infinity. In cafés, different tones of the lighting-globes reflected in the mirrors.

On the bakery, *Bread*. Series on bakery-workers, seen in the cellar itself, or from the street through the ventilation shafts – Backs the colour of pink flour – beautiful curves of pastry. Still lives of different breads. Large loaves, ovals, flutes, rounds, etc. Colour-variations on the yellows, pinks, greys, whites of the loaves. Perspectives of bread laid out in rows, delightful displays of loaves. Cakes, corn, mills, flour, sacks, market porters.

No one has ever done monuments or houses seen from low down, from beneath, close to as one sees them in passing on the streets.

[1] Crossed out by Degas [2] Crossed out by Degas.

9 Arthur Rimbaud (1854–1891) Letter to Paul Demeney

The first text of Rimbaud's to be included in his Collected Works is a prose fragment written at the age of ten. By the time he was fifteen, sixty poems in Latin had been composed. All his major work, including the poems of *A Season in Hell*, were concentrated into the next four years. At the age of nineteen he abandoned literature permanently. On 13 and 15 May 1871 the sixteen-year-old Rimbaud wrote two letters, the first to George Izambard, the second, reproduced here, to Paul Demeney. Both were radical young teachers whom he had befriended at college in Charleville, a provincial town in the Ardennes, north-east of Paris. In the first, shorter letter to Izambard, Rimbaud identifies what he calls his 'objective poetry' with the revolutionary struggle then taking place in Paris. The letter to Demeney is longer and more directed towards art. Both letters contain almost identical formulations of the avant-garde credo: the need for the artist to become steeped in experience to the point of madness, in order to be able to express it; and the alienation felt by such an artist, not merely from society at large, but from one's own self. The present extracts are taken from the translations by Oliver Bernard in *Arthur Rimbaud: Collected Poems*, Harmondsworth: Penguin Classics, 1986, pp. 7–16.

Charleville, 15 May 1871

[. . .] Romanticism has never been properly judged. Who was there to judge it? The Critics!! The Romantics? who prove so clearly that the song is very seldom the work, that is to say, the idea sung and intended by the singer.

For *I* is someone else [Car JE est un autre]. If brass wakes up a trumpet, it is not its fault. To me this is obvious: I witness the unfolding of my own thought: I watch it, I listen to it: I make a stroke of the bow: the symphony begins to stir in the depths, or springs on to the stage.

If the old fools had not discovered only the *false* significance of the Ego, we should not now be having to sweep away those millions of skeletons which, since time immemorial, have been piling up the fruits of their one-eyed intellects, and claiming to be, themselves, the authors of them!

In Greece, I say, verses and lyres take their rhythm from Action. After that, music and rhymes are a game, a pastime. The curious are charmed with the study of this past: many of them delight in reviving these antiquities – that's their affair. Universal mind has always thrown out its ideas naturally; men would pick up a part of these fruits of the brain: they acted through them, they wrote books through them: and so things went on, since man did not work on himself, either not yet being awake, or not yet in the fullness of the great dream. Writers, civil servants: author, creator, poet, *that* man never existed!

The first study for a man who wants to be a poet is the knowledge of himself, complete. He looks for his soul, inspects it, puts it to the test, learns it. As soon as he knows it, he must cultivate it! It seems simple: in every brain a natural development takes place; so many *egoists* proclaim themselves authors; there are plenty of others who attribute their intellectual progress to themselves! – But the soul has to be made monstrous, that's the point: after the fashion of the *comprachicos*, if you like! Imagine a man planting and cultivating warts on his face.

I say that one must be a *seer*, make oneself a *seer*.

The poet makes himself a *seer* by a long, prodigious, and rational *disordering* of *all the senses*. Every form of love, of suffering, of madness; he searches himself, he consumes all the poisons in him, and keeps only their quintessences. This is an unspeakable torture during which he needs all his faith and superhuman strength, and during which he becomes the great patient, the great criminal, the great accursed – and the great learned one! – among men. – For he arrives at the *unknown*! Because he has cultivated his own soul – which was rich to begin with – more than any other man! He reaches the unknown; and even if, crazed, he ends up by losing the understanding of his visions, at least he has seen them! Let him die charging through those unutterable, unnameable things: other horrible workers will come; they will begin from the horizons where he has succumbed! [...]

So, then, the poet really is the thief of fire.

He is responsible for humanity, even for the *animals*; he must see to it that his inventions can be smelt, felt, heard. If what he brings back from *down there* has form, he brings forth form; if it is formless, he brings forth formlessness. A language has to be found – for that matter, every word being an idea, the time of the universal language will come! One has to be an academician – deader than a fossil – to finish a dictionary of any language. Weak-minded people, beginning by *thinking about* the first letter of the alphabet, would soon rush into madness!

This [new] language would be of the soul, for the soul, containing everything, smells, sounds, colours; thought latching on to thought and pulling. The poet would define the amount of the unknown awakening in the universal soul in his own time: he would produce more than the formulation of his thought or the measurement *of his march towards Progress*! An enormity who has become normal, absorbed by everyone, he would really be a *multiplier of progress*!

This future will, as you see, be materialistic. – Always filled with *Number* and *Harmony*, these poems will be made to endure. Essentially, it will be Greek poetry again, in a way.

Eternal art will have its function, since poets are citizens. Poetry will no longer take its rhythm from action; *it will be ahead of it*!

Poets like this will exist! When the unending servitude of women is broken, when she lives by and for herself, when man – hitherto abominable – has given her her freedom, she too will be a poet! Woman will discover part of the unknown! Will her world of ideas be different from ours? She will discover things strange and unfathomable, repulsive and delicious. We shall take them unto ourselves, we shall understand them.

Meanwhile let us ask the *poet* for the *new* – in ideas and in forms. All the bright boys will imagine they can soon satisfy this demand: – it is not so! [...]

10 Camille Pissarro (1831–1903) *et al.*, **Constitution of the Independent Artists**

Avant-garde art has been widely associated with rebelliousness and a contempt for material values. Yet the first such group set themselves up as a commercial enterprise, on the model of a joint-stock company. The idea of an independent exhibition arose twice in

the late 1860s among younger artists centred on the Café Guerbois. On both occasions it came to nothing: in 1867 for lack of money, and in 1869 due to the political crisis which eventually issued in the Franco-Prussian war. However, by 1873 the idea was revived. Reasons included the continued hostility of the Salon jury to innovation, further exacerbated by the post-war climate of a call-to-order in which art was expected to participate. A second factor was the mixed reception accorded that year to a second Salon des Refusés, in which the technically radical had mingled with the academically inept. The combination of these factors together with the economic crisis which forced the dealer Durand-Ruel to reduce his operation, finally caused radical artists to push ahead with their aim of a fully independent exhibiting group. After reports in the press in the summer of 1873, and considerable wrangles over both scope and aims, the artists concerned (including Monet, Renoir, Pissarro, Morisot, Sisley and Degas) finally constituted themselves as the 'Societé anonyme coopérative d'artistes-peintres, sculpteurs etc' on 27 December 1873. The constitution, drawn up by Pissarro, was modelled on that of a bakers' cooperative in Pontoise. It was published in several Parisian art periodicals in early 1874 and attracted considerable attention. The planned journal did not appear. The exhibition, however, opened on 15 April 1874, and 165 works were exhibited for one month. Although the Impressionists went on to hold seven more exhibitions over the next twelve years, this first venture was not a commercial success. On Renoir's initiative, the insolvent Societé anonyme was dissolved on 17 December 1874. The constitution has been translated for the present volume by Paul Wood, from the text as first published in *La Chronique des arts et de la curiosité*, a supplement to the *Gazette des beaux-arts*, on 17 January 1874, p. 19.

Co-operative Joint Stock Company of Artists in Painting, Sculpture etc., of Paris

A Joint Stock Company, formed by a group of artists, is being set up in Paris. They have conveyed their statutes to us; we publish them without delay, compliment the artists on their initiative, and wish them every success in their project:

A Co-operative Joint Stock Company, with variable personnel and capital, is being formed between artists in painting, sculpture, engraving and lithography, for a period of ten years, commencing the 27th December last, and having as its object: (1) the organization of free exhibitions, without a jury or honorary remuneration, where each member can exhibit his work; (2) the sale of the aforesaid works; (3) the publication, as soon as possible, of a journal, exclusively devoted to the arts.

The registered office is in Paris, provisionally at the treasurer, M. A. Ottin's address, no. 9, rue Vincent-Compoint.

The society's funds, which may be increased, whether through the addition of new members who must each subscribe at least one share of 60 francs payable in twelve instalments, or through any donations which may be made to the society, are set at 1,200 francs. Each member shall deposit, every month, the sum of 5 francs in the society's account. He will be issued with a share every time his deposits reach the sum of 60 francs. The share may only be transferred to another member with the authorization of the administrative council. Until the time of the first general assembly, the society is to be provisionally administered by the painters MM. Pissarro, Mettling, Rouart, Feyen-Perrin, Meyer, de Molins, Monet.

The provisional supervisory council is composed of MM. Beliard – painter; Ottin – sculptor; Renoir – painter.

In consequence of these nominations, and following the subscription of a dozen shares, the society is definitively constituted.

The society's proceeds consist of: (1) fees from entry to exhibitions; (2) deductions levied on sales; (3) any other takings whatsoever. These proceeds, after the deduction of expenses, will be divided up among members in proportion to their deposits.

11 Edgar Degas (1834–1917) Letter to Tissot

James Tissot (1836–1902) was a painter who specialized in scenes of fashionable social life during the period from the mid 1860s until the 1880s, and who made his career in London during the 1870s, possibly in order to escape reprisal for his association with the Commune. His style remained conservative in relation to Impressionism, but appeared modern and naturalistic by comparison with the work of such figures as Bouguereau, Cabanel and Gérôme. This letter was written in an attempt to recruit him to the Society of Independent Artists, who were to exhibit at 35 Boulevard des Capucines. The painter Alphonse Legros, mentioned at the close of the letter, had been living in London since 1863, and in 1876 was to succeed Poynter as Professor of Fine Art at the Slade School. Neither of the two was to join the independent artists. The letter was first published in Marcel Guérin (ed.), *Lettres de Degas*, Paris: Editions Bernard Grasset, 1931; the following text is taken from the English edition, translated by Marguerite Kay, *Edgar Germain Hilaire Degas: Letters*, Oxford: Bruno Cassirer, 1947, pp. 38–40.

Friday, 1874

Look here, my dear Tissot, no hesitations, no escape. You positively must exhibit at the Boulevard. It will do you good, you (for it is a means of showing yourself in Paris from which people said you were running away) and us too. Manet seems determined to keep aloof, he may well regret it. Yesterday I saw the arrangement of the premises, the hangings and the effect in daylight. It is as good as anywhere. And now Henner (elected to the second rank of the jury) wants to exhibit with us. I am getting really worked up and am running the thing with energy and, I think, a certain success. The newspapers are beginning to allow more than just the bare advertisement and though not yet daring to devote a whole column to it, seem anxious to be a little more expansive.

The realist movement no longer needs to fight with the others, it already *is*, it *exists*, it must show itself as *something distinct*, there must be a *salon of realists*.

Manet does not understand that, I definitely think he is more vain than intelligent.

So exhibit anything you like. The 6 or 7 is a date but unless I am very much mistaken you will be accepted after then.

So forget the money side for a moment. Exhibit. Be of your country and with your friends.

The affair, I promise you, is progressing better and has a bigger reception than I ever thought possible.

My eyes are very bad. The occulist wanted me to have a fortnight's complete rest. He has allowed me to work just a little until I send in my pictures. I do so with much difficulty and the greatest sadness.

Ever your,

Degas

I have not yet written to Legros. Try and see him and stir up his enthusiasm for the matter. We are counting firmly on him. He has only another 60 francs to deposit. The bulk of the money is all but collected.

The general feeling is that it is a good, fair thing, done simply, almost boldly.

It is quite possible that we wipe the floor with it as they say. But the beauty of it will be ours.

Hurry up and send.

12 Jules-Antoine Castagnary (1830–1888) 'The Exhibition on the Boulevard des Capucines'

The Independent exhibition has often been represented in modern art history as a founding manifestation of the avant-garde tradition. It should be borne in mind, however, that exhibitions independent of the Salon were not entirely unusual by 1874, and that though this particular one attracted a degree of hostility and ridicule from conservative figures like Leroy, it also received a measure of support from those already sympathetic to the search for modern forms of Naturalism. Castagnary was by now a senior figure in the latter category. He was also well enough versed in the critical issues at stake to pick out from among the thirty exhibitors the five painters by whose work the original character of the new movement was principally established and its early direction decided. The identification of these painters as 'Impressionists' was well prepared, given that an association between spontaneity of response and objectivity of representation had already been proposed in positivist theories of perception (see IIIB11), and had been fully accepted by Naturalists such as Castagnary. Yet even in Castagnary's case, when he asks himself whether what he is faced with is a new 'school' or a new 'manner', the apparent informality of the painting leads him to conclude that it is only the latter. For those who had once defended the work of the Realists against the 'subjectivism' of the Romantics, the work of Cézanne in particular presented an absolute sticking-point. The review was originally published as 'Exposition du boulevard des Capucines – Les Impressionistes', in *Le Siècle*, Paris, 29 April 1874. A translated version was published in John Rewald, *The History of Impressionism*, New York: Museum of Modern Art, 1946; our text is taken from the fourth edition of this work, London: Secker and Warburg, 1973, pp. 329–30. For other texts by Castagnary, see IIIB14 and 15.

[. . .] In order to bar the road to those four young men [Pissarro, Monet, Sisley, Renoir] and that young lady [Berthe Morisot], the jury has for four or five years accumulated stupidities, piled up abuses of power, and compromised itself so extensively that today there is not a single person in France daring to speak in its favour. Here is talent, and even much talent. These youths have a way of understanding nature which is neither boring nor banal. It is lively, sharp, light; it is delightful. What quick intelligence of the object and what amusing brushwork! True, it is summary, but how just the indications are!

...The common concept which unites them as a group and gives them a collective strength in the midst of our disaggregate epoch is the determination not to search for a smooth execution, but to be satisfied with a certain general aspect. Once the impression is captured, they declare their role terminated...If one wants to characterize them with a single word that explains their efforts, one would have to create the new term of *Impressionists*. They are impressionists in the sense that they render not a landscape but the sensation produced by a landscape.

What is the value of this novelty? Does it constitute a real revolution? No, because the principle and – to a large extent – the forms of art remain unchanged. Does it prepare the emergence of a [new] school? No, because a school lives on ideas and not on material means, distinguishes itself by its doctrines and not by a technique of execution. But if it does not constitute a revolution and does not contain the seed of any school, what then is it? It is a manner and nothing else [...] Within a few years the artists who today have grouped themselves on the boulevard des Capucines will be divided. The strongest among them...will have recognized that while there are subjects which lend themselves to a rapid 'impression', to the appearance of a sketch, there are others and in much greater numbers that demand a more precise impression [...] Those painters who, continuing their course, will have perfected their draftsmanship, will abandon *impressionism* as an art really too superficial for them. As to the others who – neglecting to ponder and to learn – pursue the impression to excess, the example of M. Cézanne can reveal to them as of now the lot which awaits them. Starting with idealization, they will arrive at that degree of unbridled romanticism where nature is merely a pretext for dreams and where the imagination becomes powerless to formulate anything but personal, subjective fantasies without any echo in general reason, because they are without control and without possible verification in reality.

13 Louis Leroy (1812–1885) 'The Exhibition of the Impressionists'

Louis Leroy was a painter of landscapes who had exhibited in the Salon between 1835 and 1861, and an occasional critic whose hostility to Manet had already been established. His review was first published in *Charivari* on 25 April 1874, ten days after the opening of the exhibition. Since the following translation was first included in John Rewald's pioneering study of Impressionism it has served vividly to represent an element of derision and hostility in response to the work of the Impressionists. It should be borne in mind, however, that *Charivari* was a satirical magazine and that its contributors were expected to amuse. Leroy's 'M. Joseph Vincent' makes an entertaining commentator, but this is partly because he is himself a caricature of the beribboned conservative. It is significant that Leroy, like Castagnary, devoted his principal attention to the more advanced painters and their works. Renoir's *Dancer* is now in the National Gallery of Art, Washington, Pissarro's 'Ploughed Field' refers to his *Hoar-frost: the Old Road to Ennery*, which is now in the Musée d'Orsay, as are Cézanne's *Maison du Pendu* and *Modern Olympia*. Monet's *Impression–Sunrise* is the painting now in the Musée Marmottan, Paris. It is not known which of his two paintings of the Boulevard du Capucines is the one shown in 1874. (They are now in the Nelson-Atkins Museum of Art, Kansas City, and the Pushkin Museum, Moscow, respectively.) This version of the review was originally published in Rewald, *The History of Impressionism*,

New York: Museum of Modern Art, 1946; our text is taken from the fourth edition of this work, London: Secker and Warburg, 1973, pp. 318–24. The ellipses are in the original.

Oh, it was indeed a strenuous day when I ventured into the first exhibition on the boulevard des Capucines in the company of M. Joseph Vincent, landscape painter, pupil of Bertin, recipient of medals and decorations under several governments! The rash man had come there without suspecting anything; he thought that he would see the kind of painting one sees everywhere, good and bad, rather bad than good, but not hostile to good artistic manners, to devotion to form, and respect for the masters. Oh, form! Oh, the masters! We don't want them any more, my poor fellow! We've changed all that.

Upon entering the first room, Joseph Vincent received an initial shock in front of the *Dancer* by M. Renoir.

"What a pity," he said to me, "that the painter, who has a certain understanding of colour, doesn't draw better; his dancer's legs are as cottony as the gauze of her skirts."

"I find you hard on him," I replied. "On the contrary, the drawing is very tight."

Bertin's pupil, believing that I was being ironical, contented himself with shrugging his shoulders, not taking the trouble to answer. Then, very quietly, with my most naive air, I led him before the *Ploughed Field* of M. Pissarro. At the sight of this astounding landscape, the good man thought that the lenses of his spectacles were dirty. He wiped them carefully and replaced them on his nose.

"By Michalon!" he cried. "What on earth is that?"

"You see . . . a hoar-frost on deeply ploughed furrows."

"Those furrows? That frost? But they are palette-scrapings placed uniformly on a dirty canvas. It has neither head nor tail, top nor bottom, front nor back."

"Perhaps . . . but the impression is there."

"Well, it's a funny impression! Oh . . . and this?"

"*An Orchard* by M. Sisley. I'd like to point out the small tree on the right; it's gay, but the impression . . . "

"Leave me alone, now, with your impression . . . it's neither here nor there. But here we have a *View of Melun* by M. Rouart, in which there's something to the water. The shadow in the foreground, for instance, is really peculiar."

"It's the vibration of tone which astonishes you."

"Call it the sloppiness of tone and I'd understand you better—Oh, Corot, Corot, what crimes are committed in your name! It was you who brought into fashion this messy composition, these thin washes, these mud-splashes against which the art lover has been rebelling for thirty years and which he has accepted only because constrained and forced to it by your tranquil stubbornness. Once again a drop of water has worn away the stone!"

The poor man rambled on this way quite peacefully, and nothing led me to anticipate the unfortunate accident which was to be the result of his visit to this hair-raising exhibition. He even sustained, without major injury, viewing the *Fishing Boats Leaving the Harbor* by M. Claude Monet, perhaps because I tore him away from dangerous contemplation of this work before the small, noxious figures in the foreground could produce their effect.

Unfortunately, I was imprudent enough to leave him too long in front of the *Boulevard des Capucines*, by the same painter.

"Ah-ha!" he sneered in Mephistophelian manner. "Is that brilliant enough, now! There's impression, or I don't know what it means. Only, be so good as to tell me what those innumerable black tongue-lickings in the lower part of the picture represent?"

"Why, those are people walking along," I replied.

"Then do I look like that when I'm walking along the boulevard des Capucines? Blood and thunder! So you're making fun of me at last?"

"I assure you, M. Vincent. . . ."

"But those spots were obtained by the same method as that used to imitate marble: a bit here, a bit there, slap-dash, any old way. It's unheard-of, appalling! I'll get a stroke from it, for sure."

I attempted to calm him by showing him the *St. Denis Canal* by M. Lépine and the *Butte Montmartre* by M. Ottin, both quite delicate in tone; but fate was strongest of all: the *Cabbages* of M. Pissarro stopped him as he was passing by and from red he became scarlet.

"Those are cabbages," I told him in a gently persuasive voice.

"Oh, the poor wreteches, aren't they caricatured! I swear not to eat any more as long as I live!"

"Yet it's not their fault if the painter"

"Be quiet, or I'll do something terrible."

Suddenly he gave a loud cry upon catching sight of the *Maison du pendu* by M. Paul Cézanne. The stupendous impasto of this little jewel accomplished the work begun by the *Boulevard des Capucines*: *père* Vincent became delirious.

At first his madness was fairly mild. Taking the point of view of the impressionists, he let himself go along their lines:

"Boudin has some talent," he remarked to me before a beach scene by that artist; "but why does he fiddle so with his marines?"

"Oh, you consider his painting too finished?"

"Unquestionably. Now take Mlle Morisot! That young lady is not interested in reproducing trifling details. When she has a hand to paint, she makes exactly as many brushstrokes lengthwise as there are fingers, and the business is done. Stupid people who are finicky about the drawing of a hand don't understand a thing about impressionism, and great Manet would chase them out of his republic."

"Then M. Renoir is following the proper path; there is nothing superfluous in his *Harvesters*. I might almost say that his figures. . . ."

". . . are even too finished."

"Oh, M. Vincent! But do look at those three strips of colour, which are supposed to represent a man in the midst of the wheat!"

"There are two too many; one would be enough."

I glanced at Bertin's pupil; his countenance was turning a deep red. A catastrophe seemed to me imminent, and it was reserved for M. Monet to contribute the last straw.

"Ah, there he is, there he is!" he cried, in front of No. 98. "I recognize him, *papa* Vincent's favourite! What does that canvas depict? Look at the catalogue."

"*Impression, Sunrise*."

"*Impression* – I was certain of it. I was just telling myself that, since I was impressed, there had to be some impression in it . . . and what freedom, what ease of workmanship! Wallpaper in its embryonic state is more finished than that seascape."

In vain I sought to revive his expiring reason . . . but the horrible fascinated him. *The Laundress*, so badly laundered, of M. Degas drove him to cries of admiration. Sisley himself appeared to him affected and precious. To indulge his insanity and out of fear of irritating him, I looked for what was tolerable among the impressionist pictures, and I acknowledged without too much difficulty that the bread, grapes and chair of *Breakfast*, by M. Monet, were good bits of painting. But he rejected these concessions.

"No, no!" he cried. "Monet is weakening there. He is sacrificing to the false gods of Meissonier. Too finished, too finished! Talk to me of the *Modern Olympia*! That's something well done."

Alas, go and look at it! A woman folded in two, from whom a Negro girl is removing the last veil in order to offer her in all her ugliness to the charmed gaze of a brown puppet. Do you remember the *Olympia* of M. Manet? Well, that was a masterpiece of drawing, accuracy, finish, compared with the one by M. Cézanne.

Finally the pitcher ran over. The classic skull of *père* Vincent, assailed from too many sides, went completely to pieces. He paused before the municipal guard who watches over all these treasures and, taking him to be a portrait, began for my benefit a very emphatic criticism:

"Is he ugly enough?" he remarked, shrugging his shoulders. "From the front, he has two eyes . . . and a nose . . . and a mouth! Impressionists wouldn't have thus sacrificed to detail. With what the painter has expended in the way of useless things, Monet would have done twenty municipal guards!"

"Keep moving, will you!" said the 'portrait'.

"You hear him – he even talks! The poor fool who daubed at him must have spent a lot of time at it!"

And in order to give the appropriate seriousness to his theory of aesthetics, *père* Vincent began to dance the scalp dance in front of the bewildered guard, crying in a strangled voice:

"Hi-ho! I am impression on the march, the avenging palette knife, the *Boulevard des Capucines* of Monet, the *Maison du pendu* and the *Modern Olympia* of Cézanne. Hi-ho! Hi-ho!"

14 Edmond Duranty (1833–1880) from *The New Painting*

At the first exhibition of the Independent artists, it had been the work in landscape that had drawn most attention, in part no doubt because the effects of light and colour in the *plein-air* scenes had indeed been distinctive, but also perhaps because it was in the genre of landscape that technical adventurism was looked for by experienced commentators. From these early responses to Impressionism, we get little sense of its complementary aspect: the engagement with an urban and Baudelairean sense of modernity that was particularly evident in the work of Degas, of Renoir and of Caillebotte. This aspect of the movement was to be more clearly pronounced in the third group exhibition in 1877 (see IVA16). It is

also this second aspect of Impressionism that forms the principal concern of Duranty's text. He was a member of the group that frequented the Café Guerbois and Café de la Nouvelle Athènes, but in 1856–7 he had edited the short-lived literary journal *Réalisme* and he was a close friend of Zola, sharing his commitment to the principle of 'social naturalism'. He was also interested in current theories of science and perception. His inclination was thus on the one hand to stress the connection of Impressionism to the legacy of Realism and Naturalism, and on the other to justify its novelty by reference to advances in social and scientific theory. Of all the Impressionists he was closest to Degas, whose portrait of him is now in Edinburgh. The article was originally published in the form of a separate pamphlet under the title *La Nouvelle peinture (à propos du groupe d'artistes qui expose dans les Galeries Durand-Ruel)*, Paris: E. Dentu, 1876. This version is taken from the translation by Charles S. Moffat, 'The New Painting: Concerning the Group of Artists Exhibiting at the Durand-Ruel Galleries', in *The New Painting: Impressionism 1874–1886*, exhibition catalogue, The Fine Arts Museums of San Francisco, 1986, pp. 37–46. The names of artists in square brackets are those Duranty marked in a copy of the pamphlet given to the writer Diego Martelli.

[. . .] Do the[se] artists of the Ecole really believe that they have created great art because they have rendered helmets, footstools, polychrome columns, boats, and bordered robes according to the latest archaeological decrees? Do they believe they succeed because in their figures they scrupulously respect the most recently accepted prototype of the Ionian, Dorian, or Phrygian race? Finally, do they think they are successful because they have hunted down, overwhelmed, and consigned to hell the monster 'Anachronism'? They forget that every thirty years this same archaeology sheds its skin, and that the latest word in erudite fashion – the Boeotian skullcap with its nose and cheekguards, for example – will end up on the scrap heap along with David's great helmet of Léonidas, in its day the ultimate expression of an erudite familiarity with antiquities.

They do not realize that it is by the flame of contemporary life that great artists and learned men illuminate these ancient things. [. . .]

[. . .] What is it, then, this world of the Ecole des Beaux-Arts, even taken at its best? One sees reflected in it the melancholy of those who sit without appetite at a table laden with wonderful things. Deprived of the capacity for pleasure themselves, they do not enjoy the banquet, but find fault with those who do.

Well! Gentlemen! As artists you have nothing to be proud of in receiving an education that only turns out a race of sheep . . .

Nevertheless, it would appear that you are disdainful of the endeavours of an art that tries to capture life and the modern spirit, an art that reacts viscerally to the spectacle of reality and of contemporary life. Instead, you cling to the knees of Prometheus and the wings of the Sphinx.

And do you know why you do it? Without suspecting it, what you really want is to ask the Sphinx for the secret of our time and Prometheus for the sacred fire of the present age. No, you are not as disdainful as you appear.

You are made uneasy by this artistic movement that already has lasted for a long time, which perseveres despite the obstacles and despite the little sympathy shown it.

But despite all that you know, ultimately you would like to be individuals. You begin to be disgusted by this mummification, this sickening embalming of the spirit.

You start to look over the wall into the little garden of these new painters, perhaps just to throw stones into it, or perhaps simply to see what is going on there.

Come now, tradition is in disarray; your efforts to build on it prove this only too well. You feel you must let in that light from the street that fails to satisfy your guide, that honourable and clever painter-author, so courteous, so ironic, and so cynical in his speech. You, too, would very much like to come out into the world.

Tradition is in disarray, but tradition is tradition, representing as it does the ancient and magnificent formulas of the preceding ages. Like feudal serfs you are bound to the land of official art by the legitimists, while these new painters are considered artistic revolutionaries. The battle is really between you and them. [. . .]

[. . .] Come and have a look into the little garden of the people here. You will see that they are trying to create from scratch a wholly modern art, an art imbued with our surroundings, our sentiments, and the things of our age. [. . .]

In literature we have succeeded – laboriously and thanks to brilliant examples – in putting this subject beyond dispute. Like literature, current serious art criticism is Realist, affecting the most varied forms and techniques. The present author of these lines has contributed to the establishment of this movement, for which he was one of the first to provide a clear aesthetic definition nearly twenty years ago.

Painting, too, must enter this movement. Artists of great talent have attempted to do so ever since Courbet. Like Balzac, they have blazed the trail enthusiastically. Painting must enter it because, however conventional one might wish it to be, painting is the least conventional of all the arts. It is the only art that successfully *recreates* figures and objects, which *fixes* figures, costumes, and backgrounds, leaving nothing to doubt or ambiguity, which *imitates*, *depicts*, and *sums up* life better than any other art, in spite of all artifice and technique. [. . .]

The battle really is between traditional art and the new art, between old painting and the new painting. The *idea* on exhibit in the Durand-Ruel galleries has its sole adversaries at the Ecole and the Institut. It is there that the movement can, and must, seek its converts. However, it is only there, at the Ecole and Institut, that it has been treated with any justice.

Ingres and his principal students admired Courbet. Flandrin greatly encouraged that other realistic painter [Alphonse Legros] now established in England, who had a passion for contemporary religious scenes in which he was able to express both naivete and grandeur, whether in his paintings or in his powerful etchings.

In effect the movement already has its roots. It was not born only yesterday, but at least the day before. It was little by little that it evolved and abandoned the old approach in order to reach the open air and real sunlight. Little by little it rediscovered originality and spontaneity. That is to say, it discovered real character in its subjects and in its composition. Little by little it developed a penetrating draftsmanship, consonant with the character of modern beings and things. With great sagacity and perception it revealed their mannerisms, professional behaviour, and the gestures and sentiments appropriate to their class and rank.

In order to speak of a movement, I have combined discrete artistic efforts and temperaments, but ones that are similar in their endeavours and aims.

The origins of these efforts and the first manifestations of these temperaments can be found in the atelier of Courbet in such works as *L'enterrement d'Ornans* and *Les*

demoiselles du village. They are in the work of the great Ingres and Millet, those pious and ingenuous spirits, those men of powerful instinct. Ingres sat on the ivory footstool with Homer and was among the crowd who watched Phidias work on the Parthenon, but he brought back from Greece only respect for nature. [...] He never hesitated or cheated when confronted with modern forms, and executed portraits of such simplicity and truth that they were rigorous, bold, and strange, and would not have been out of place in the Salon des Refusés. Millet, that Homer of the modern countryside, gazed at the sun until he was blinded by it. He depicted the labouring peasant as a simple animal among the oxen, swine, and sheep. He adored the *land*, which he depicted as infinitely simple, noble, and rustic, yet bathed in radiant light.

The roots of the new painting lie also in the work of the great Corot and his disciple Chintreuil, that man who was always *searching*, and whom Nature seems to have loved because she revealed so many of her secrets to him. They appear next among some of the students of a certain drawing master, whose name in particular is linked to the so-called method of *l'éducation de la mémoire pittoresque*, but whose principal merit lies in allowing the originality and individual inclinations of his students to develop, rather than leading them along the beaten path under the yoke of inviolable technique.

Simultaneously, the origins of the new painting are visible in the work of the Dutch painter of perfect tonalities who veiled his windmills, steeples, and ship masts in shimmering and delicate greys and violets [Johan Barthold Jongkind]. They also lie with another painter from Honfleur who carefully observed and analysed the ocean skies, rendering the essence of the seascape [Eugène Boudin]. Both contributed their share to this enthusiastic expedition that sees itself setting sail, searching out new passageways as it navigates Art's Cape of Good Hope.

These daring and determined explorers first appeared at the Salon des Refusés in 1863. Since then several of them have won medals or found fame and fortune in London or Paris.

I have already mentioned the painter of *L'ex-voto* [Alphonse Legros], the work that appeared in 1861. This painting was quite modern, yet had the ingenuousness and grandeur of fifteenth-century works. What, then, did it depict? Just some old, *ordinary* women, dressed in *ordinary* clothes. But that quality of rigidly mechanical dullness produced by the painful and narrow life of the humble springs from these lined and withered faces with a profound intensity. All that is striking in human beings, all that holds the attention, all that is significant, concentrated, and unexpected in life radiates from these old creatures.

Three years ago, in these same Durand-Ruel galleries, another painter, an American [James Abbott McNeill Whistler], exhibited remarkable portraits and paintings with colour variations of infinite delicacy – dusky, diffused, and vaporous tints that belong to neither night nor day. A third painter [Henri Fantin-Latour] created a highly personal palette, subtly rich and harmonious, and became the most marvellous flower painter of our time. He united contemporary artistic and literary figures in a curious series of group portraits, introducing himself as a remarkable painter of characters, which should become even more evident in the future. Finally, another painter [Edouard Manet] repeatedly produced the most daring innovations, and carried on an impassioned fight. He did not let in only a crack of light, but flung wide the windows and advanced into the open air and real sunlight. Time and time

again he placed himself at the forefront of the movement. With a candour and courage linking him to men of genius, he offered the public the most innovative works, works fraught with flaws yet full of fine qualities, works full of depth and originality standing apart from all others, works whose strength of expression inevitably clashes with the hesitancy of an almost entirely new feeling that does not yet have the means to express itself fully. [...]

These, then, are the artists who exhibit in the Durand-Ruel galleries, in association with those who preceded them and those who accompany them. They are isolated no longer. It would be a mistake to consider them as drawing alone upon their own resources.

I am less concerned with the present exhibition than its *cause* and *idea*.

What, then, do this cause and idea bring us? What does the movement contribute? And, consequently, what do these artists contribute, these artists who wrestle with tradition, admire it, and simultaneously want to destroy it, these artists who acknowledge that tradition is great and powerful and who attack it for that very reason?

Why, then, are people interested in them? Why are they forgiven for too often producing – and with a touch of laziness – nothing but sketches, abbreviated summaries of works?

The real reason is that, in an age like ours, when there seems nothing left to discover, when previous ages have been analysed so much, and when we suffocate under the weight of the creations of past centuries, it is a great surprise to see new ideas and original creations suddenly burst forth. A new branch emerges on the trunk of the old tree of art. Will it bear leaves, flowers, and fruit? Will it spread its shade over future generations? I hope so.

What, then, do these painters contribute?

A new method of colour, of drawing, and a gamut of original points of view.

Some of them limit themselves to transforming tradition, striving to translate the modern world without deviating too far from the superannuated and magnificent formulas that served earlier eras. Others cast aside the techniques of the past without another thought.

In the field of colour they made a genuine discovery for which no precedent can be found, not in the Dutch master, not in the clear, pale tones of fresco painting, nor in the soft tonalities of the eighteenth century.

They are not merely preoccupied by the refined and supple play of colour that emerges when they observe the way the most delicate ranges of tone either contrast or intermingle with each other. Rather, the real discovery of these painters lies in their realization that strong light mitigates colour, and that sunlight reflected by objects tends, by its very brightness, to restore that luminous unity that merges all seven prismatic rays into one single colourless beam – light itself.

Proceeding by intuition, they little by little succeeded in splitting sunlight into its rays, and then reestablishing its unity in the general harmony of the iridescent colour that they scatter over their canvases. With regard to visual subtleties and delicate blending of colours, the result is utterly extraordinary. Even the most learned physicist could find nothing to criticize in these painters' analysis of light.

In this connection, some speak of the Japanese, and maintain that these new painters do nothing more than imitate the colour of Japanese prints.

Indeed, I said earlier that they had set off to round Art's Cape of Good Hope. Was it not, then, in order to travel to the Far East? For if the same instincts of the Asian peoples, who live in the perpetual daze of the sun, impels these painters to render the sensation that continually strikes them – specifically, that of clear, matte tones, amazingly live and light, and of its luminous quality distributed almost equally everywhere – then why not investigate such an instinct, placed as it is for observation at the very sources of the sun's brilliance?

Was there not, in the proud, melancholy eye of the Hindus, in the great, languorous, contemplative eye of the Persians, and in the lively, narrowed eye of the Chinese and the Japanese a masterful ability to blend exquisite harmonies of delicate, soft, neutral tones with bold, bright colours?

Although the Venetians had glimpsed these facts about light, the Romantics knew absolutely nothing about them. As for the Ecole des Beaux-Arts, it never made it its concern, as there they only copy old paintings, everyone having rid himself of nature.

The Romantic artist, in his studies of light, knew nothing but the orange-tinted band of the setting sun over sombre hills, or the white impasto tinged with chrome yellow or rose lake, which he threw across the opaque bitumen of his woods. No light could exist without bitumen, without ivory black, or Prussian blue, without the contrasts that were said to make the tone appear warmer, to heighten it. He believed that light coloured and awakened tone, and was persuaded that it could not exist unless surrounded by shadow. A cellar pierced by a bright ray issuing from a narrow opening – such was the ideal that ruled the Romantic. Even today, landscape is everywhere treated as if it were the back wall of a chimney or the back room of a shop.

And yet everyone has crossed seventy-five miles of countryside in the middle of summer, and seen how the hillsides, meadows, and fields disappear, as it were, into a single luminous reflection that they share with the sky. For such is the law that engenders light in nature – in addition to the particular blue, green, or composite ray of light that each substance absorbs, it reflects both the spectrum of all light-rays and the tint of the vault that curves above the earth. Moreover, for the first time painters understand and reproduce these phenomena, or try to. In certain canvases you feel the vibration and palpitation of light and heat. You feel an intoxication of light, which is something of no merit or importance for those painters trained outside of nature and in opposition to it. It is something much too bright and distinct, much too crude and explicit.

Turning to drawing, it is well understood that among these new painters as elsewhere, the inevitable differences between colourists and draftsmen persist. Thus, when I speak of colour, you should only think of those who primarily are colourists. And, when I refer to drawing, you should only envision those who primarily are draftsmen.

In his *Essay on Painting* on the Salon of 1765, the great Diderot established the *ideal* of modern drawing – that is, drawing from nature, based on observation:

We say of a man passing in the street that he is a poor specimen. Measured in terms of our wretched little rules, yes. But in terms of nature, it is a different matter. We say of a statue that its proportions are beautiful. Yes, following our wretched little rules, but in terms of nature. . . . !

Were I initiated into the mysteries of art, perhaps I would know how much the artist ought to submit to the accepted rules of proportion, and I would tell you. But what I do know is that these rules cannot compete against the omnipotence of nature, and that the age and condition of the subject predicate compromise in a hundred different ways. [. . .]

This extraordinary man is at the threshold of everything that the art of the nineteenth century would like to accomplish.

And what drawing wants in terms of its current goals is just to know nature intensely and to embrace nature with such strength that it can render faultlessly the relations between forms, and reflect the inexhaustible diversity of character. Farewell to the human body treated like a vase, with an eye for the decorative curve. Farewell to the uniform monotony of bone structure, to the anatomical model beneath the nude. What we need are the special characteristics of the modern individual – in his clothing, in social situations, at home, or on the street. The fundamental idea gains sharpness of focus. This is the joining of torch to pencil, the study of states of mind reflected by physiognomy and clothing. It is the study of the relationship of a man to his home, or the particular influence of his profession on him, as reflected in the gestures he makes: the observation of all aspects of the environment in which he evolves and develops.

A back should reveal temperament, age, and social position, a pair of hands should reveal the magistrate or the merchant, and a gesture should reveal an entire range of feelings. Physiognomy will tell us with certainty that one man is dry, orderly, and meticulous, while another is the epitome of carelessness and disorder. Attitude will reveal to us whether a person is going to a business meeting, or is returning from a tryst. 'A man opens a door, he enters, and that is enough: we see that he has lost his daughter!' Hands kept in pockets can be eloquent. The artist's pencil will be infused with the essence of life. We will no longer simply see lines measured with a compass, but animated, expressive forms that develop logically from one another. . . .

But drawing is such an individual and indispensable means of expression that one cannot demand from it methods, techniques, or points of view. It fuses with its goal, and remains the inseparable companion of the idea.

Thus, the series of new ideas that led to the development of this artistic vision took shape in the mind of a certain draftsman [Edgar Degas], one of our own, one of the new painters exhibiting in these galleries, a man of uncommon talent and exceedingly rare spirit. Many artists will not admit that they have profited from his conceptions and artistic generosity. If he still cares to employ his talents unsparingly as a *philanthropist* of art, instead of as a businessman like so many other artists, he ought to receive justice. The source from which so many painters have drawn their inspiration ought to be revealed.

The very first idea was to eliminate the partition separating the artist's studio from everyday life, and to introduce the reality of the street. . . . It was necessary to make the painter come out of his sky-lighted cell, his cloister, where his sole communication was with the sky – and to bring him back among men, out into the real world.

. . . Our lives take place in rooms and in streets, and rooms and streets have their own special laws of light and visual language.

For the observer there is a complete logic to the colour and drawing associated with an image, which depends on the hour, the season, and the place in which it is seen. This image is not expressed and this logic is not determined by throwing Venetian

cloth together with Flemish background, or by making old sideboards and vases shine in the light of the atelier.

If one wants to be truthful, one must neither conflate time and place, nor confuse the time of day and the source of light. The velvety shadows and golden light of Dutch interiors resulted from the structure of their houses, the small, multi-paned, leaded windows, and the misty streets beside steaming canals. Here, in our homes, tonal values vary infinitely, depending on whether one is on the first floor or the fourth, whether a home is heavily furnished and carpeted, or whether it is sparsely furnished. An atmosphere is created in every interior, along with a certain personal character that is taken on by the objects that fill it. The number, spacing, and arrangement of mirrors decorating an apartment and the number of objects hung on the walls – these things bring something to our homes, whether it is an air of mystery or a kind of brightness, that can be achieved no longer with Flemish methods and harmonies, even by adding Venetian formulas, nor by using any imaginable combination of daylight and composition in the best-equipped studio.

Suppose, for example, that at a given moment we could take a coloured photograph of an interior. We would have a perfect match, a truthful and real representation, with every element sharing the same feeling. Suppose then that we waited, and when a cloud covered the sun, we immediately took another picture. We would have a result analogous to the first. It is up to observation to compensate for these instantaneous means of execution that we do not possess, and to preserve intact the memory of the images they would have rendered. But what if we were to take some details from the first photograph and combine them with some of the detail from the second, and to create a painting? Then homogeneity, harmony, and the truth of the impression will have disappeared and have been replaced by a false and inexpressive note. Every day, however, that is what painters do who do not look but instead rely on ready-made formulae provided by paintings already done.

And, as we are solidly embracing nature, we will no longer separate the figure from the background of an apartment or the street. In actuality, a person never appears against neutral or vague backgrounds. Instead, surrounding him and behind him are the furniture, fireplaces, curtains, and walls that indicate his financial position, class, and profession. The individual will be at a piano, examining a sample of cotton in an office, or waiting in the wings for the moment to go onstage, or ironing on a makeshift table. He will be having lunch with his family or sitting in his armchair near his worktable, absorbed in thought. He might be avoiding carriages as he crosses the street or glancing at his watch as he hurries across the square. When at rest, he will not be merely pausing or striking a meaningless pose before the photographer's lens. This moment will be a part of his life as are his actions.

The language of an empty apartment must be clear enough to enable us to deduce the character and habits of its occupant. The passers-by in a street should reveal the time of day and the moment of everyday life that is shown.

In real life views of things and people are manifested in a thousand unexpected ways. Our vantage point is not always located in the centre of a room whose two side walls converge toward the back wall; the lines of sight and angles of cornices do not always join with mathematical regularity and symmetry. Nor does our point of view always exclude the large expanse of ground or floor in the immediate foreground.

Sometimes our viewpoint is very high, sometimes very low; as a result we lose sight of the ceiling, and everything crowds into our immediate field of vision, and furniture is abruptly cropped. Our peripheral vision is restricted at a certain distance from us, as if limited by a frame, and we see objects to the side only as permitted by the edge of this frame.

From indoors we communicate with the outside world through windows. A window is yet another frame that is continually with us during the time we spend at home, and that time is considerable. Depending on whether we are near or far, seated or standing, the window frames the scene outside in the most unexpected and changeable ways, providing us with constantly changing impromptu views that are the great delights of life.

For example, if in turn one considers a figure, either in a room or on the street, it is not always in a straight line with two parallel objects or at an equal distance from them. It is confined on one side more than on the other by space. In a word, it is never in the centre of the canvas or the centre of the scene. It is not shown whole, but often appears cut off at the knee or mid-torso, or cropped lengthwise. At other times the eye takes it in from up close, at its full height, and relegates to perspectival diminution others in a street crowd, or a group gathered in a public place. It would be an endless task to detail every cut or to describe every scene – the railways, notion shops, construction scaffolds, lines of gaslights, benches on the boulevards and newspaper kiosks, omnibuses and teams of horses, cafés with their billiard-rooms, and restaurants with their tables set and ready.

The new painters have tried to render the walk, movement, and hustle and bustle of passers-by, just as they have tried to render the trembling of leaves, the shimmer of water, and the vibration of sun-drenched air – just as they have managed to capture the hazy atmosphere of a grey day along with the iridescent play of sunshine.

But there are so many things that the art of landscape has not yet dreamed of expressing. Almost all landscape artists lack a feel for the *structure* of the land itself. If the hills are of a certain shape, the trees are sure to be grouped in a certain way, the houses nestled together in a certain fashion among the fields, and the riverbanks given a certain shape. Thus the character of the countryside takes form. No one yet has discovered how to capture the essence of the French countryside. And as we have made so much of bold colour, now that we have had a little fling with intoxicating colour, it is time to call *form* to the banquet.

Twenty years ago I wrote the following about subjects in painting:

I have witnessed a whole society, a wide range of actions and events, professions, faces, and milieux. I have seen dramatic gestures and faces that were truly paintable. I have observed the comings and goings that are predicated upon the relations between people as they met at different times and places – church, dining room, drawing room, cemetery, parade-ground, workshop, Chamber of Deputies – everywhere. Differences in dress played a large role in these scenes and coincided with differences of physiognomy, manner, feeling, and action. Everything seemed to me arranged as if the world were created expressly for the delight of painters, for the delight of the eye.

I imagined painting attempting a vast series about society people, priests, soldiers, workers, and merchants. In such a series characters would differ in their individual roles, yet be linked by those scenes common to all, especially those scenes that happen

frequently and thus accurately express the everyday life of a country – marriages, baptisms, births, successions, celebrations, and family scenes.

I thought that a painter who had been seduced by this great spectacle might end by working with strength, calm, certainty, and broad-mindedness – perhaps of a like possessed by no contemporary man – and gaining great superiority of execution and feeling.

But where, you will ask, is all this?

All this has been achieved, some of it here and some of it abroad, while some lies just on the horizon. All this exists in works already painted, as well as in sketches, projects, dreams, and discussions. Art does not struggle in this fashion without some confusion.

Rather than acting as a group who share the same goal and who arrive successively at this crossroads where many paths diverge, these artists above all are people of independent temperaments. They come in search of freedom, not dogma.

Originality in this movement coexists with eccentricity and ingenuousness, visionaries exist with strict observers, and ignorant naïfs with scholars who want to rediscover the naivete of the ignorant. There are voluptuous delights in painting for those who know and love it, and there are unfortunate attempts that grate on the nerves. An idea ferments in one's brain while almost unconscious audacity spills from another's brush. All of this is interrelated.

The public is bound to misunderstand several of the leading artists. It only accepts and understands correctness in art, and, above all, it demands finish. The artist, enchanted by delicacy or brilliance of colour, or by the character of a gesture or a grouping, is much less concerned with the finish and the correctness, the *only* qualities valued by those who are not artists.

Laissez faire, laissez passer. Do you not see the impatience in these attempts? Do you not see the irresistible need to escape the conventional, the banal, the traditional, as well as the need to find oneself again and run far from this bureaucracy of the spirit with all its rules that weigh on us in this country? Do you not see the need to free your brow from this leaden skullcap of artistic routine and old refrains, to abandon at last this common pasture where we all graze like sheep?

They have been treated like madmen. They may be madmen, but the little finger of a fool is assuredly worth more than the entire head of a banal man. [. . .]

15 Stéphane Mallarmé (1842–1898) 'The Impressionists and Edouard Manet'

Mallarmé supported himself and his family by working as a schoolteacher. He taught English, and published a French translation of Edgar Allen Poe in the year before the present essay. In 1876 his own *L'Apres-midi d'un faune* appeared. Both texts were illustrated by Manet. In the 1880s Mallarmé went on to become a central figure in the Symbolist movement (see VIc *passim*). In addition to his own poetry, Mallarmé published a variety of critical essays, including studies of Verlaine and Wagner. He was commissioned to write the present essay for an English-speaking audience, and he supervised and corrected the English translation himself. No copy of the French original has survived. In his essay, Mallarmé establishes Manet as the head of the Impressionist movement, despite the fact that he had refused to participate in the Independent exhibitions. He also traces the roots of

this expanded sense of Impressionism to Courbet's Realism, and draws connections between the new school in painting and the work of both Baudelaire and Zola in literature. Mallarmé confers particular emphasis on the 'open air' aspect of Impressionism, connecting this technical feature to the modern 'truth' of the new approach. He concludes by insisting on a link between the new painting and the new, broadly democratic, social movement of the time. 'The Impressionists and Edouard Manet' was originally published in *The Art Monthly Review and Photographic Portfolio*, London, 30 September 1876, pp. 117–22. Our present source is the text as reprinted in Charles S. Moffat, *The New Painting: Impressionism* 1874–1886, San Francisco: Fine Art Museums of San Francisco, 1986, pp. 28–34.

[...] Rarely do our annual exhibitions abound with novelty, and some few years back such years of abundance were still more rare; but about 1860 a sudden and a lasting light shone forth when Courbet began to exhibit his works. These then in some degree coincided with that movement which had appeared in literature, and which obtained the name of Realism; that is to say, it sought to impress itself upon the mind by the lively depiction of things as they appeared to be, and vigorously excluded all meddlesome imagination. It was a great movement, equal in intensity to that of the Romantic school, just then expiring under the hands of the landscape painters. [...] But in the midst of this, there began to appear, sometimes perchance on the walls of the Salon, but far more frequently and certainly on those of the galleries of the rejected, curious and singular paintings – laughable to the many, it is true, from their very faults, but nevertheless very disquieting to the true and reflective critic, who could not refrain from asking himself what manner of man is this? and what the strange doctrine he preaches? For it was evident that the preacher had a meaning; he was persistent in his reiteration, unique in his persistency, and his works were signed by the then new and unknown name of Edouard Manet. There was also at that time, alas! that it should have to be written in the past tense, an enlightened amateur, one who loved all arts and lived for one of them. These strange pictures at once won his sympathy; an instinctive and poetic foresight made him love them; and this before their prompt succession and the sufficient exposition of the principles they inculcated had revealed their meaning to the thoughtful few of the public many. But this enlightened amateur died too soon to see these, and before his favourite painter had won a public name.

That amateur was our last great poet, Charles Baudelaire.

Following in appreciative turn came the then coming novelist Emile Zola. With that insight into the future which distinguishes his own works, he recognized the light that had arisen, albeit that he was yet too young to then define that which we to-day call Naturalism, to follow the quest, not merely of that reality which impresses itself in its abstract form on all, but of that absolute and important sentiment which Nature herself impresses on those who have voluntarily abandoned conventionalism.

In 1867 a special exhibition of the works of Manet and some few of his followers, gave to the then nameless school of recent painting which thus grew up, the semblance of a party, and party strife grew high. The struggle with this resolute intruder was preached as a crusade from the rostrum of each school. For several years a firm and implacable front was formed against its advance [...]

[...] Yet, and notwithstanding all this, and in spite of concurrent Salons, the public rushed with lively curiosity and eagerness to the Boulevard des Italiens and the galleries of Durand Ruel in 1874 and 1876, to see the works of those then styled

the Intransigeants, now the Impressionists. And what found they there? A collection of pictures of strange aspect, at first view giving the ordinary impression of the motive which made them, but over beyond this, a peculiar quality outside mere Realism. And here occurs one of those unexpected crises which appear in art. Let us study it in its present condition and its future prospects, and with some attempt to develop its idea.

Manet, when he casts away the cares of art and chats with a friend between the lights in his studio, expresses himself with brilliancy. [...] One of his habitual aphorisms then is that no one should paint a landscape and a figure by the same process, with the same knowledge, or in the same fashion; nor what is more, even two landscapes or two figures. Each work should be a new creation of the mind. The hand, it is true, will conserve some of its acquired secrets of manipulation, but the eye should forget all else it has seen, and learn anew from the lesson before it. It should abstract itself from memory, seeing only that which it looks upon, and that as for the first time; and the hand should become an impersonal abstraction guided only by the will, oblivious of all previous cunning. As for the artist himself, his personal feeling, his peculiar tastes, are for the time absorbed, ignored, or set aside for the enjoyment of his personal life. Such a result as this cannot be attained all at once. To reach it the master must pass through many phases ere this self-isolation can be acquired, and this new evolution of art be learnt; and I, who have occupied myself a good deal in its study, can count but two who have gained it.

Wearied by the technicalities of the school in which, under Couture, he studied, Manet, when he recognized the inanity of all he was taught, determined either not to paint at all or to paint entirely from without himself. Yet, in his self-sought insulation, two masters – masters of the past – appeared to him, and befriended him in his revolt. Velasquez, and the painters of the Flemish school, particularly impressed themselves upon him [...] Welcomed on his outset, as we have said, by Baudelaire, Manet fell under the influence of the moment, and, to illustrate him at this period, let us take one of his first works, 'Olympia'; that wan, wasted courtesan, showing to the public, for the first time, the non-traditional, unconventional nude. The bouquet, yet enclosed in its paper envelope, the gloomy cat, (apparently suggested by one of the prose poems of the author of the 'Fleurs du Mal,') and all the surrounding accessories, were truthful, but not immoral – that is, in the ordinary and foolish sense of the word – but they were undoubtedly intellectually perverse in their tendency. Rarely has any modern work been more applauded by some few, or more deeply damned by the many, than was that of this innovator. [...] It surprised us all as something long hidden, but suddenly revealed. Captivating and repulsive at the same time, eccentric, and new, such types as he gave us were needed in our ambient life. In them, strange though they were, there was nothing vague, general, conventional, or hackneyed. Often they attracted attention by something peculiar in the physiognomy of his subject, half hiding or sacrificing to those new laws of space and light he set himself to inculcate, some minor details which others would have seized upon.

Bye and bye, if he continues to paint long enough, and to educate the public eye – as yet veiled by conventionality – if that public will then consent to see the true beauties of the people, healthy and solid as they are, the graces which exist in the bourgeoisie will then be recognized and taken as worthy models in art, and then will come the time of peace. As yet it is but one of struggle – a struggle to render those

truths in nature which for her are eternal, but which are as yet for the multitude but new.

The reproach which superficial people formulate against Manet, that whereas once he painted ugliness now he paints vulgarity, falls harmlessly to the ground, when we recognize the fact that he paints the truth, and recollect those difficulties he encountered on his way to seek it, and how he conquered them. [...]

[...] I should like to comment somewhat on that truism of to-morrow, that paradox of to-day, which in studio slang is called 'the theory of open air' or at least on that which it becomes with the authoritative evidence of the later efforts of Manet. But here is first of all an objection to overcome. Why is it needful to represent the open air of gardens, shore or street, when it must be owned that the chief part of modern existence is passed within doors? There are many answers; among these I hold the first, that in the atmosphere of any interior, bare or furnished, the reflected lights are mixed and broken and too often discolour the flesh tints. For instance I would remind you of a painting in the salon of 1873 which our painter justly called a 'Rêverie.' There a young woman reclines on a divan exhaling all the lassitude of summer time; the jalousies of her room are almost closed, the dreamer's face is dim with shadow, but a vague, deadened daylight suffuses her figure and her muslin dress. This work is altogether exceptional and sympathetic.

Woman is by our civilization consecrated to night, unless she escape from it sometimes to those open air afternoons by the seaside or in an arbour, affectionated by moderns. Yet I think the artist would be in the wrong to represent her among the artificial glories of candlelight or gas, as at that time the only object of art would be the woman herself, set off by the immediate atmosphere, theatrical and active, even beautiful, but utterly inartistic. Those persons much accustomed, whether from the habit of their calling or purely from taste, to fix on a mental canvas the beautiful remembrance of woman, even when thus seen amid the glare of night in the world or at the theatre, must have remarked that some mysterious process despoils the noble phantom of the artificial prestige cast by candelabra or footlights, before she is admitted fresh and simple to the number of every day haunters of the imagination. [...] The complexion, the special beauty which springs from the very source of life, changes with artificial lights, and it is probably from the desire to preserve this grace in all its integrity, that painting – which concerns itself more about this flesh-pollen than any other human attraction – insists on the mental operation to which I have lately alluded, and demands daylight – that is space with the transparence of air alone. [...] Air reigns supreme and real, as if it held an enchanted life conferred by the witchery of art; a life neither personal nor sentient, but itself subjected to the phenomena thus called up by science and shown to our astonished eyes, with its perpetual metamorphosis and its invisible action rendered visible. And how? By this fusion or by this struggle ever continued between surface and space, between colour and air. Open air: – that is the beginning and end of the question we are now studying. Aesthetically it is answered by the simple fact that there in open air alone can the flesh tints of a model keep their true qualities, being nearly equally lighted on all sides. On the other hand if one paints in the real or artificial half-light in use in the schools, it is this feature or that feature on which the light strikes and forces into undue relief, affording an easy means for a painter to dispose a face to suit his own fancy and return to by-gone styles.

The search after truth, peculiar to modern artists, which enables them to see nature and reproduce her, such as she appears to just and pure eyes, must lead them to adopt air almost exclusively as their medium, or at all events to habituate themselves to work in it freely and without restraint: there should at least be in the revival of such a medium, if nothing more, an incentive to a new manner of painting. This is the result of our reasoning, and the end I wish to establish. As no artist has on his palette a transparent and neutral colour answering to open air, the desired effect can only be obtained by lightness or heaviness of touch, or by the regulation of tone. Now Manet and his school use simple colour, fresh, or lightly laid on, and their results appear to have been attained at the first stroke, that the ever-present light blends with and vivifies all things. As to the details of the picture, nothing should be absolutely fixed in order that we may feel that the bright gleam which lights the picture, or the diaphanous shadow which veils it, are only seen in passing, and just when the spectator beholds the represented subject, which being composed of a harmony of reflected and ever-changing lights, cannot be supposed always to look the same, but palpitates with movement, light, and life.

But will not this atmosphere – which an artifice of the painter extends over the whole of the object painted – vanish, when the completely finished work is as a repainted picture? If we could find no other way to indicate the presence of air than the partial or repeated application of colour as usually employed, doubtless the representation would be as fleeting as the effect represented, but from the first conception of the work, the space intended to contain the atmosphere has been indicated, so that when this is filled by the represented air, it is as unchangeable as the other parts of the picture. Then composition (to borrow once more the slang of the studio) must play a considerable part in the aesthetics of a master of the Impression-ists? No; certainly not; as a rule the grouping of modern persons does not suggest it, and for this reason our painter is pleased to dispense with it, and at the same time to avoid both affectation and style. Nevertheless he must find something on which to establish his picture, though it be but for a minute – for the one thing needful is the time required by the spectator to see and admire the representation with that promptitude which just suffices for the connection of its truth. If we turn to natural perspective (not that utterly and artificially classic science which makes our eyes the dupes of a civilized education, but rather that artistic perspective which we learn from the extreme East – Japan for example) – and look at these sea-pieces of Manet, where the water at the horizon rises to the height of the frame, which alone interrupts it, we feel a new delight at the recovery of a long obliterated truth.

The secret of this is found in an absolutely new science, and in the manner of cutting down the pictures, and which gives to the frame all the charm of a merely fanciful boundary, such as that which is embraced at one glance of a scene framed in by the hands, or at least all of it found worthy to preserve. This is the picture, and the function of the frame is to isolate it; though I am aware that this is running counter to prejudice. For instance, what need is there to represent this arm, this hat, or that river bank, if they belong to someone or something exterior to the picture; the one thing to be attained is that the spectator accustomed among a crowd or in nature to isolate one bit which pleases him, though at the same time incapable of entirely forgetting the abjured details which unite the part to the whole, shall not miss in the work of art one

of his habitual enjoyments, and whilst recognizing that he is before a painting half believes he sees the mirage of some natural scene. Some will probably object that all of these means have been more or less employed in the past, that dexterity – though not pushed so far – of cutting the canvas off so as to produce an illusion – perspective almost conforming to the exotic usage of barbarians – the light touch and fresh tones uniform and equal, or variously trembling with shifting lights – all these ruses and expedients in art have been found more than once in the English school, and else-where. But the assemblage for the first time of all these relative processes for an end, visible and suitable to the artistic expression of the needs of our times, this is no inconsiderable achievement in the cause of art, especially since a mighty will has pushed these means to their uttermost limits. [. . .] There is indeed no painter of consequence who during the last few years has not adopted or pondered over some one of the theories advanced by the Impressionists, and notably that of the open air, which influences all modern artistic thought. [. . .]

Claude Monet loves water, and it is his especial gift to portray its mobility and transparency, be it sea or river, grey and monotonous, or coloured by the sky. I have never seen a boat poised more lightly on the water than in his pictures or a veil more mobile and light than his moving atmosphere. It is in truth a marvel. Sisley seizes the passing moments of the day; watches a fugitive cloud and seems to paint it in its flight; on his canvas the live air moves and the leaves yet thrill and tremble. He loves best to paint them in spring, 'when the yonge leves on the lyte wode, waxen al with wille,' or when red and gold and russet-green the last few fall in autumn; for then space and light are one, and the breeze stirring the foliage prevents it from becoming an opaque mass, too heavy for such an impression of mobility and life. On the other hand, Pizzaro [sic], the eldest of the three, loves the thick shade of summer woods and the green earth, and does not fear the solidity which sometimes serves to render the atmosphere visible as a luminous haze saturated with sunlight. It is not rare for one of these three to steal a march on Manet, who suddenly perceiving their anticipated or explained tendency, sums up all their ideas in one powerful and masterly work. For them, rather are the subtle and delicate changes of nature, the many variations undergone in some long morning or afternoon by a thicket of trees on the water's side.

The most successful work of these three painters is distinguished by a sure yet wonderfully rapid execution. [. . .] As thorough Impressionists, these painters (excepting M. Claude Monet, who treats it superbly) do not usually attempt the natural size of their subjects, neither do they take them from scenes of private life, but are before everything landscape painters, and restrict their pictures to that size easiest to look at, and with shut eyes preserve the remembrance of.

With these, some other artists, whose originality has distanced them from other contemporary painters, frequently, and as a rule, exhibit their paintings, and share in most of the art theories I have reviewed here. These are Degas, Mademoiselle Berthe Morizot [sic], (now Madame Eugène Manet,) and Renoir, to whom I should like to join Whistler, who is so well appreciated in France, both by critics and the world of amateurs, had he not chosen England as a field of his success.

The muslin drapery that forms a luminous, ever-moving atmosphere round the semi-nakedness of the young ballet-dancers; the bold, yet profoundly complicated attitudes of these creatures, thus accomplishing one of the at once natural and yet

modern functions of women, have enchanted M. Degas, who can, nevertheless, be as delighted with the charms of those little washerwomen, who fresh and fair, though poverty-stricken, and clad but in camisole and petticoat, bend their slender bodies at the hour of work. No voluptuousness there, no sentimentality here; the wise and intuitive artist does not care to explore the trite and hackneyed view of his subject. A master of drawing, he has sought delicate lines and movements exquisite or grotesque, and of a strange new beauty, if I dare employ towards his works an abstract term, which he himself will never employ in his daily conversation.

More given to render, and very succinctly, the aspect of things, but with a new charm infused into it by femine vision, Mademoiselle Berthe Morizot [sic] seizes wonderfully the familiar presence of a woman of the world, or a child in the pure atmosphere of the sea-shore, or green lawn. Here a charming couple enjoy all the limpidity of hours where elegance has become artless; and there how pure an atmosphere veils this woman standing out of doors, or that one who reclines under the shade of an umbrella thrown among the grasses and frail flowers which a little girl in a clean dress is busy gathering. The airy foreground, even the furthermost outlines of sea and sky, have the perfection of an actual vision, and that couple yonder, the least details of whose pose is so well painted that one could recognize them by that alone, even if their faces, seen under the shady straw hats, did not prove them to be portrait sketches, give their own characteristics to the place they enliven by their visit. The air of preoccupation, of mundane care or secret sorrows, so generally characteristic of the modern artist's sketches from contemporary life, were never more notably absent than here [. . .]

The shifting shimmer of gleam and shadow which the changing reflected lights, themselves influenced by every neighbouring thing, cast upon each advancing or departing figure, and the fleeting combinations in which these dissimilar reflections form one harmony or many, such are the favourite effects of Renoir – nor can we wonder that this infinite complexity of execution induces him to seek more hazardous success in things widely opposed to nature. A box at a theatre, its gaily-dressed inmates, the women with their flesh tints heightened and displaced by rouge and rice powder, a complication of effects of light – the more so when this scene is fantastically illuminated by an incongruous day-light. Such are the subjects he delights in.

All these various attempts and efforts (sometimes pushed yet farther by the intrepid M. de Césane [sic]) are united in the common bond of Impressionism. Incontestably honour is due to these who have brought to the service of art an extraordinary and quasi-original newness of vision, undeterred by a confused and hesitating age. [. . .]

If we try to recall some of the heads of our argument and to draw from them possible conclusions, we must first affirm that Impressionism is the principal and real movement of contemporary painting. The only one? No; since other great talents have been devoted to illustrate some particular phrase or period of bygone art; among these we must class such artists as Moreau, Puvis de Chavannes, etc.

At a time when the romantic tradition of the first half of the century only lingers among a few surviving masters of that time, the transition from the old imaginative artist and dreamer to the energetic modern worker is found in Impressionism.

The participation of a hitherto ignored people in the political life of France is a social fact that will honour the whole of the close of the nineteenth century. A parallel

is found in artistic matters, the way being prepared by an evolution which the public with rare prescience dubbed, from its first appearance, Intransigeant, which in political language means radical and democratic.

The noble visionaries of other times, whose works are the semblance of worldly things seen by unworldly eyes (not the actual representations of real objects), appear as kings and gods in the far dream-ages of mankind; recluses to whom were given the genius of a dominion over an ignorant multitude. But to day the multitude demands to see with its own eyes; and if our latter-day art is less glorious, intense, and rich, it is not without the compensation of truth, simplicity and child-like charm.

At that critical hour for the human race when nature desires to work for herself, she requires certain lovers of hers – new and impersonal men placed directly in communion with the sentiment of their time – to loose the restraint of education, to let hand and eye do what they will, and thus through them, reveal herself.

For the mere pleasure of doing so? Certainly not, but to express herself, calm, naked, habitual, to those newcomers of to-morrow, of which each one will consent to be an unknown unit in the mighty numbers of an universal suffrage, and to place in their power a newer and more succinct means of observing her.

Such, to those who can see in this the representative art of a period which cannot isolate itself from the equally characteristic politics and industry, must seem the meaning of the manner of painting which we have discussed here, and which although marking a general phase of art has manifested itself particularly in France.

Now in conclusion I must hastily re-enter the domain of aesthetics, and I trust we shall thoroughly have considered our subject when I have shown the relation of the present crisis – the appearance of the Impressionists – to the actual principles of painting – a point of great importance.

In extremely civilized epochs the following necessity becomes a matter of course, the development of art and thought having nearly reached their far limits – art and thought are obliged to retrace their own footsteps, and to return to their ideal source, which never coincides with their real beginnings. English Preraphaelitism, if I do not mistake, returned to the primitive simplicity of mediaeval ages. The scope and aim (not proclaimed by authority of dogmas, yet not the less clear), of Manet and his followers is that painting shall be steeped again in its cause, and its relation to nature. But what, except to decorate the ceilings of saloons and palaces with a crowd of idealized types in magnificent foreshortening, what can be the aim of a painter before everyday nature? To imitate her? Then his best efforts can never equal the original with the inestimable advantages of life and space. – 'Ah no! this fair face, that green landscape, will grow old and wither, but I shall have them always, true as nature, fair as remembrance, and imperishably my own; or the better to satisfy my creative artistic instinct, that which I preserve through the power of Impressionism is not the material portion which already exists, superior to any mere representation of it, but the delight of having recreated nature touch by touch. I leave the massive and tangible solidity to its fitter exponent, sculpture. I content myself with reflecting on the clear and durable mirror of painting, that which perpetually lives yet dies every moment, which only exists by the will of Idea, yet constitutes in my domain the only authentic and certain merit of nature – the Aspect. It is through her that when rudely thrown at the close of an epoch of dreams in the front of reality, I have taken from it only that which properly belongs to my art, an

original and exact perception which distinguishes for itself the things it perceives with the steadfast gaze of a vision restored to its simplest perfection.'

16 Georges Rivière (1855–1943) 'The Exhibition of the Impressionists'

Rivière was a friend of Renoir and an admirer of his work. With the assistance of the painter's brother Edmond he wrote and published a weekly journal during the period of the third Impressionist exhibition in 1877. Four issues of *L'Impressioniste. Journal d'art* appeared between 6 and 28 April 1877. The enthusiastic contents could not have been thought of as offering objective appraisal. Rather they presented Impressionist paintings to the public in the terms that the artists themselves must have hoped would be persuasive. (Given that Edmond Renoir was a professional writer it is likely that he had a considerable hand in the authorship of the journal, and that Rivière's name was used in part to conceal the family connection.) Of all the Impressionist exhibitions this was the one that offered the strongest showing of the core group of painters – Monet, Renoir, Cézanne, Degas, Pissarro, Sisley, Caillebotte and Morisot. Monet included a group of paintings of the Gare St-Lazare, Renoir his *Ball at the Moulin de la Gallette* (now Musée d'Orsay), and Caillebotte two large paintings on urban modern-life themes (*Pont de l'Europe* and *Rainy Day, Paris Street*, now in the Musée du Petit Palais, Geneva, and the Art Institute of Chicago, respectively). Cézanne was represented by sixteen works, and he received more serious attention from Rivière on this occasion than he was to be given in print for another decade. The 'scene by the sea' referred to is the work now known as *Scene of Fantasy with Fishermen*. Our extracts are taken from issues 1 and 2 of *L'Impressioniste*, Paris, 6 and 14 April 1877, in the versions reprinted in Lionello Venturi (ed.), *Les Archives de l'Impressionisme*, Paris and New York: Durand-Ruel, 1939, pp. 308–20, translated for this volume by Carola Hicks.

No. 1, 6 April

What delights, what remarkable works, what masterpieces even, are brought together in the galleries of the rue Le Peletier! Nowhere else and never before has such an exhibition been presented to the public. From the moment you enter you are stunned and charmed, and the further you go the more the charm increases. In the first room, there are several very fine canvases by M. Renoir, and paintings by MM. Monet and Caillebotte. In the second room, M. Monet's large painting of turkeys, paintings by M. Renoir, and landscapes by MM. Monet, Pissarro, Sysley [*sic*], Guillaumin, Cordey and Lamy create an atmosphere of ineffable and almost musical gaiety.

As you pass into the middle room, your eyes are immediately drawn to M. Renoir's *Bal* and M. Pissarro's large-scale landscape; then you turn round in order to admire M. Cézanne's masterly canvases, and Mme. Berthe Morisot's charming, subtle and supremely feminine pictures.

In the main salon, immediately adjoining, you find MM. Monet, Pissarro, Sysley and Caillebotte all together.

And at the end, in a little gallery you come to some astonishing paintings by M. Degas, and some utterly ravishing watercolours by Mme. Berthe Morisot.

That, more or less, is the plan of the exhibition. The paintings have been arranged with perfect taste, each section of wall is pleasing to the eye, not one false note mars this potentially disparate collection of works.

The exhibition in the rue Le Peletier shows us only vivid scenes which never fail to cheer the eye and the mind; joyous, epic or luminous landscapes; never one of those gloomy chords which cloud the view.

Let us start with M. Renoir's works and with his most important painting, *Le Bal*. Sunshine floods a garden faintly dappled by the shade of one or two slender acacia trees whose flimsy foliage trembles in the slightest breeze, where charming girls in all the freshness of fifteen, proud of the fine fabric of their dresses, which cost so little to buy and nothing at all to make, and exuberant young men form a joyful crowd that drowns out the orchestra with its din. From time to time, the odd notes of a country dance can just be heard reminding the dancers of the beat. Noise, laughter, movement, sunshine, a sense of youth: this is M. Renoir's '*bal*'. It is a typically Parisian work. These really are the young girls that we bump into every day and whose chatter sometimes fills the streets of Paris. All they need to be pretty is a smile and a lacy cuff – Renoir has proved it. Look at the grace of that pretty girl leaning on a bench! She is chatting away, underlining her words with a subtle smile, while her inquisitive eyes try to read the expression of the man she is talking to. And that young philosopher sprawled on his chair puffing away at his pipe, what contempt he must have for those carefree dancers skipping away, rivalling the sun with the heat of their polka!

M. Renoir has every right to be proud of his '*bal*'. He has never been more inspired. This is a historical document, a priceless monument to Parisian life, scrupulously faithful. Nobody before had thought to set down such an everyday event on such a large-scale canvas; his boldness will be rewarded with well-deserved success. This painting has important implications for the future which I must point out. This is a historic picture. M. Renoir and his friends have realized that history painting isn't just the more or less comical illustration of stories from the past. They have shown the way forward, and others will have to follow. Let those who want to do history paintings show the history of their own times rather than scrabbling in the dust of past centuries. What do we care for comic-opera kings got up in blue or yellow robes with sceptre in hand and crown on head! When for the hundredth time we are shown St Louis dispensing justice under the oak tree, where does that take us? What sort of documentary evidence of the history of our times are the artists who go in for this kind of fantasy providing for future generations?

Any conscientious artist wants to make his work immortal. What hope do these pictures, which contribute nothing new in terms of colour or choice of subject, have of claiming such immortality?

What distinguishes the impressionists from other painters is that they treat a subject for its tonal values and not for the subject-matter itself. For there are Italians, Belgians and others who colour in their little figures dressed up like us, and who are also said to be contributing to the history of our own times. We do not deny that this is true, indeed, we might add that the photographers and dress designers who are published in fashion magazines contribute at least as much; so are they artists too? It is above all his searching for a new way to reveal the subject that makes M. Renoir so individual; instead of trying to discover the secrets of the great masters, such as Velasquez or Franz Hals, like the raw recruits of the Quai Malaquais, he has sought and found a contemporary note, and *Le Bal*, with its pleasing and

innovative colours, will certainly be the outstanding success of any exhibition this year.

* * *

M. Monet, whose works we shall now attempt to describe, seems to be the absolute antithesis of Renoir. The strength and vitality, in a word the life, that the painter of *Le Bal* invests in his characters, M. Monet invests in things; he has given them a soul. In his paintings the water laps, trains move, boat-sails billow in the wind, the fields, the houses, everything in this great artist's work has an intense life of its own which nobody before him had revealed or even suspected.

M. Monet is not satisfied with merely depicting the awe-inspiring and majestic side of nature, but he can also render its pleasant and charming side, as seen by any cheerful young man. No gloomy thought ever disturbs the viewer of this powerful painter's canvases. The only regret we ever feel, after the pleasures of admiring his work, is that of not being able to live for ever amid the luscious nature that flourishes in his paintings.

This year M. Monet offers us a number of canvases, showing locomotives either separately or coupled to a string of carriages in the Gare St Lazare. These paintings have amazing variety, despite their dull and monotonous subject-matter. Here, more than anywhere else, we see that science of composition and arrangement on the canvas, which is one of M. Monet's supreme skills.

In one of the largest paintings, there is a locomotive which has just arrived, and is ready to depart again. Like a fiery steed, stimulated rather than exhausted by the long trek that it has only just finished, it tosses its mane of smoke, which lashes the glass roof of the main hall. Men swarm onto the track around the beast, like pygmies at a giant's feet. Opposite, resting engines sleep. We can hear the shouting of the railway-men, the shrill whistling of the machines sounding their alarm calls in the distance, the constant clattering of iron and the mighty, urgent rhythms of the steam.

We see the vast and manic movements at the station where the ground shakes with every turn of the wheel. The platforms are sticky with soot, and the air is full of that bitter scent exuded by burning coal.

As we look at this magnificent picture, we are overcome by the same feelings as if we were really there, and these feelings are perhaps even more powerful, because in the picture the artist has conveyed his own feelings as well.

Beside this picture, there is another on the same scale showing the arrival of a train in bright sunshine. This is a joyful and lively canvas, people are hurrying down from the carriages, smoke pours away into the distance and rises higher, the sun, passing through the glass roof, gilds the engines and the sandy track. In some of his pictures, trains, swathed in wispy coils of smoke, hurtle swiftly and relentlessly towards the platforms. In other pictures, great motionless locomotives lie scattered around, waiting to depart. In all of the paintings, things themselves are filled with that life that only M. Monet has the power to convey.

M. Degas

How can we do justice to this quintessentially Parisian artist whose every work contains as much literary and philosophical flair as it does the arts of draughtsmanship and the scientific use of colour?

In one single line he says more about himself, and says it more fluently than we ever could, for his works are always witty, subtle and sincere. He doesn't try to make us believe in a naivety he doesn't have; on the contrary, his prodigious knowledge is everywhere evident; with his remarkably attractive powers of invention, he arranges his characters in the most unexpected and entertaining way, yet they always remain truthful and ordinary. Indeed, what he hates most of all is romantic flights of fancy, substituting dreams for real life, in a word, panache. He is an observer; he never tries to exaggerate. To achieve his effects he only ever relies on nature itself, unadorned. This is what enables him to provide us with the most valuable historical record of such scenes that we have.

You will never need to go to the opera again once you have seen his pastels of *les dames du ballet*. His studies of 'café-concerts' will have even more effect on you than going to the place itself, because this artist has more knowledge and skill than you will ever have. One of those 'café-concerts', with a woman in a red dress, is truly wonderful. What art there is in the women in the background, in their muslin dresses, hiding behind their fans, and in the eager spectators in the foreground, all raising their heads and straining their necks, revelling in the ribald song with its saucy gestures! You can tell, can't you, that the woman's voice is a gin-soaked contralto? This is the crowd's ideal! How carefully that gesture and that voice will be practised in the privacy of the boudoir, by some pretty countess hoping to win the applause of her lady friends when she sings: *Am I just a paper doll?*

The extraordinary gesture that the singer makes as she leans towards the crowd exemplifies her success. She does not suffer from what actors call 'stage fright', on the contrary, she addresses her public, asking them questions, knowing that they will offer up the answers that they both want to hear, an indulgent mistress flattering the vices of a corrupt despot.

Then here are some women sitting outside a café in the evening. The one shrugging her shoulders disdainfully, saying 'no luck tonight', is a whole story in herself. The other drops a limp, gloved hand onto the table. In the background the hubbub of the boulevard gradually fades away. This is another remarkable historical document.

* * *

No. 2, 14 April

The artist who has been most maligned and misjudged over the last fifteen years by press and public alike is M. Cézanne. There is no epithet so vile that it has not been used to describe him, and his works have been rewarded with the hysterical laughter that we still hear today [...]

M. Cézanne's works are those of a Greek of the classical period; his canvases have the tranquil and heroic serenity of antique painting and pottery, and the fools who laugh at *les Baigneurs*, for instance, make me think of barbarians criticizing the Parthenon.

M. Cézanne is a painter, and a great painter. Those who have never wielded a brush or a pencil have said that he can't draw, and they have identified 'flaws' in his work which are in fact deliberate refinements, the result of his enormous skill.

I know only too well that in spite of everything, M. Cézanne will not achieve the success of more fashionable painters. Between *les Baigneurs* and pictures of toy

soldiers, there is not a moment's hesitation, the public goes for the toy soldiers. The lady leaning on the arm of her tall, fair-haired young man will never gaze wide-eyed at these paintings, and say 'How sweet!' One critic will despair because he will not be able to use his bizarre jargon, words like 'mellow', 'magisterial' and 'effortless', etc. Another will feel that no thought has been put into choosing the subject, because it doesn't have a title like 'In my Garden', 'Together at Last', 'Broken Promises', or 'The Engagement', the titles of thousands of pictures which sell so well as photographs in the cheap stores of the rue St Denis and the boulevards, or as coloured prints encouraging us to eat more tapioca.

None the less M. Cézanne's painting has the indefinable attraction of biblical and Greek antiquity, the movement of his characters is as simple and as noble as that of classical sculpture, his landscapes impose a sense of majesty, and his beautiful still lives, whose tonal values are so accurate, have dignity as well as truth. In all his pictures the artist moves us, because he himself has already experienced violent emotions when confronted with nature, and used his skill to transfer them to canvas.

Hanging over a door in the second salon, there is a picture by M. Cézanne showing a scene by the sea. It is strikingly powerful and extraordinarily peaceful. It's like a scene emerging from the past as you flick through the pages of your memory.

A gentleman wearing a black frock coat and a pointed hat hobbles forward into the warm sunshine, leaning on his stout cane. He's the local storyteller, the one who asks all the questions, he's Ahasuerus who knows everything about everyone who lives within ten leagues, he's medicine man, wizard, rich man, poor man, who can tell?

Now he's going to thaw out his frozen body and look out at the deep blue sea, blinking his bloodshot eyes. In front of this old man, a woman summons the ferryman with a noble gesture, and in a little inlet a fishing boat with a tall white sail is moored. One sailor on the quay pulls his nets out of the water; another, an old sea dog in a red shirt directs the work. It's as profound and sublime as a beautiful memory; the scenery is magnificent with trees tossing in the sea breeze, the water is blue and transparent and the clouds are dazzling in the sunshine.

These are works which bear comparison with the greatest works of antiquity, these are the weapons of Cézanne's struggle against the bad faith of some and the ignorance of others, and they will ensure his victory.

One of my friends has written to me: 'It is a remarkable thing that the same society which can look straight-faced on the pretentious products of our puerile archaeology, and pay equal respect to the mutilated masterpieces from the Louvre on display in the Campana museum, and to the first faltering steps of an art in its infancy, a society that places a ridiculous premium on the trial pieces of some insignificant Renaissance potter, that this society actually laughs at a living artist without even bothering to wonder whether he is a man of genius. Just consider Michelangelo's *Night*, compare its proportions with those of Nature or Antiquity, and that masterpiece would seem to you monstrous, inhuman, ridiculous, and so to be strictly logical, you should laugh at that.'

The same friend, faced with *les Baigneurs*, added 'I can think of no qualities that could be added to that picture that would make it more moving, more impassioned, and I seek in vain the faults that people find in it. The man who painted *les Baigneurs* belongs to a race of Titans. As he confounds all comparison, it seems easier to ignore

him; yet we respect other artists like him, and if the present day cannot do him justice, the future will look at his peers and rank him among the demi-gods of art.'

Let us rank alongside M. Cézanne someone who has been accused of clumsiness, but who has been encouraged to think that he's a young man who might grow up to achieve something, I'm speaking of M. Pissarro. [. . .]

M. Pissarro was one of the first to start the fight. He has changed, his talents have evolved variously before attaining their present form, his painting has grown lighter, but he was lumped together with MM. Cézanne, Manet and Monet when they were shown the door of the Salon and saw their canvases hissed and booed by their colleagues, and when they struggled on regardless eventually to achieve the success they have today, despite the cat-calls of a few petty journalists who need to make loud noises to fill their empty heads.

Where could one find more grandeur, truth and poetry than in these calm and beautiful landscapes, so full of that peasant spirituality that tinges the green fields with its melancholy.

Some of the landscapes recall passages from *Les Misérables*. There is the same epic scope, the same mystery, the same strength, always simple even when solemn.

Those two women walking down a little hedge-lined path, with fields below on either side, and the great cloudy sky rising from the very depths of the valley, covered in a light mist rising towards the sun, doesn't all this make a fine chapter of *Les Misérables*? It's the same style, so why don't we admire in painting what we quite rightly praise to the skies in literature? This great mystery is difficult to solve, a prejudice that only time will dispel.

* * *

Now we find ourselves in the company of an artist whose praise no longer needs to be sung. For a number of years Mme. Berthe Morisot has thoroughly demonstrated her charming and feminine talents. Her watercolours, pastels and oil paintings all reveal those spontaneous qualities and that light unpretentious style which we admire in her. Mme. Morisot's eye has extraordinary sensitivity. Her (pastel) seascape is charming. The form and tones of the large blue boat whose heavy keel emerges from the water are very accurate. Doesn't that young woman in a pink peignoir reclining on a sofa make a pretty picture! And what ravishing creatures are that lady at her toilette, and the lady at her looking glass. Hung above these is a charming little landscape full of sunshine and greenery, with a lady in a blue dress. Mme. Berthe Morisot has learned how to mark her canvases with fleeting notes, and all this with the delicacy, intelligence and skill which entitle her to be represented equally with the other impressionists.

17 Edgar Degas (1834–1917) Letter to Pissarro

The market for artists' prints expanded rapidly during the later nineteenth century. For many of the painters of the Impressionist generation printmaking formed a significant aspect of their activities. Degas in particular was a prolific and highly inventive maker of lithographs, etchings, aquatints and monotypes, using the variety of graphic media in turn or in combination to develop images and effects as another artist might use the pages of a sketchbook. He was also interested in the graphic output of others, Mary Cassatt and the engraver Bracquemond among them. His exchange with Pissarro resulted in a series of

collaborative impressions. This letter can be linked to the period in 1879–80 when Degas was involved with these three artists among others in plans for a journal to be called *Le Jour et la nuit* (see IVA8). This was to be illustrated with original prints. Pissarro was living at the time in the village of Pontoise, without access to a press, and on his visits to Paris he relied on Degas among others for the proofing of his plates. (The rue de la Huchette was the address of the planisher Godard.) Pissarro had recently undertaken a soft-ground etching of a cabbage field. The letter was first published in Marcel Guérin (ed.), *Lettres de Degas*, Paris: Editions Bernard Grasset, 1931, pp. 33–6; the following text is taken from the English edition, translated by Marguerite Kay, *Edgar Germain Hilaire Degas: Letters*, Oxford: Bruno Cassirer, 1947, pp. 56–9.

My dear Pissarro,
I compliment you on your enthusiasm; I hurried to Mademoiselle Cassatt with your parcel. She congratulates you as I do in this matter.

Here are the proofs: The prevailing blackish or rather greyish shade comes from the zinc which is greasy in itself and retains the printer's black. The plate is not smooth enough. I feel sure that you have not the same facilities at Pontoise as at the rue de la Huchette. In spite of that you must have something a bit more polished.

In any case you can see what possibilities there are in the method. It is necessary for you to practise dusting the particles in order, for instance, to obtain a sky of a uniform grey, smooth and fine. That is very difficult, if one is to believe Maître Bracquemond. It is, perhaps, fairly easy if one wants only to do engravings after original art.

This is the method. Take a very smooth plate (it is essential, you understand). Degrease it thoroughly with whitening. Previously you will have prepared a solution of resin in very concentrated alcohol. This liquid, poured after the manner of photographers when they pour collodion onto their glass plates (take care, as they do, to drain the plate well by inclining it) this liquid then evaporates and leaves the plate covered with a coating, more or less thick, of small particles of resin. In allowing it to bite you obtain a network of lines, deeper or less deep, according as to whether you allowed it to bite more or less. To obtain equal hues this is necessary; to get less regular effects you can obtain them with a stump or with your finger or any other pressure on the paper which covers the soft ground.

Your soft ground seems to me to be a little too greasy. You have added a little too much grease or tallow.

What did you blacken your ground with to get that bistre tone behind the drawing? It is very pretty.

Try something a little larger with a better plate.

With regard to the colour I shall have your next lot printed with a coloured ink. I have also other ideas for coloured plates.

So do also try something a little more finished. It would be delightful to see the outlines of the cabbages very well defined. Remember that you must make your début with one or two very, very beautiful plates of your own work.

I am also going to get down to it in a day or two.

Caillebotte, so I am told, is doing the *refuges of the Boulevard Haussmann* seen from his window.

Could you find someone at Pontoise who could cut on very light copper some things traced by you? That kind of pattern could be applied on a line proof – touched

up a little for effect – of etchings or soft ground etchings and then the exposed parts printed with porous wood coated with water colours. That would enable one to try some attractive experiments with original prints and curious colours. Work a little on that if you can. – I shall soon send you some of my own attempts along these lines. – It would be economical and new. And would I think be suitable enough for a beginning.

No need to compliment you on the quality of the art of your vegetable gardens.

Only as soon as you feel a little more accustomed try on a larger scale with more finished things.

Be of good cheer,

Degas

18 Winslow Homer (1836–1910) Statement on *plein-air* Painting

Homer spent his childhood in New England. He paid his first visit to Paris in 1867, going to visit the Universal Exhibition and staying for nine months. In 1881 he was in England, where he spent time in the company of his compatriots Whistler and Sargent. After 1883, however, he lived a virtual hermit's life at Prout's Neck on the Maine Coast. His most representative paintings and watercolours were populated with human figures isolated or in groups, their moods or interactions defined not in narrative terms, but through the dramatic naturalistic effects of the sea and the coast. Consistency of light and atmosphere was an important condition of the success of these paintings. The following statement confirms that this consistency was achieved by a determined application of the principles of *plein-air* painting (it forms an interesting contrast with Signac's diary entry of 10 May 1899, VIB13). Homer left no written account of his art. His words on this occasion were transcribed by an interviewer from the New York edition of the *Art Journal*, who visited his studio in 1880. The resulting text was published in the *Art Journal*, new series, New York: D. Appleton, April 1880, 'Sketches and Studies', pp. 107–8. The writer commences his section on Homer by observing that 'No painter in this country, probably, has a profounder respect for ... outdoor work, a more lively apprehension of its value, or a sincerer and more serious aversion to manufactured and conventional studio-pictures'. Homer's words are then reported directly.

'I prefer every time a picture composed and painted outdoors. The thing is done without your knowing it. Very much of the work now done in studios should be done in the open air. This making studies and then taking them home to use them is only half right. You get the composition, but you lose freshness, you miss the subtle and, to the artist, the finer characteristics of the scene itself. I tell you it is impossible to paint an outdoor figure in a studio light with any degree of certainty. Outdoors you have the sky overhead giving one light; then the reflected light from whatever reflects; then the direct light of the sun: so that, in the blending and suffusing of these several luminations, there is no such thing as a line to be seen anywhere. I can tell in a second if an outdoor picture with figures has been painted in a studio. When there is any sunlight in it, the shadows are too positive. Yet you see these faults constantly in pictures in the exhibitions, and you know that they are bad. Nor can they be avoided when such work is done indoors. By the nature of the case the light in a studio must be emphasized at some point or part of the figure; the very fact that there are walls around the painter which shut out the sky shows this.

'I wouldn't go across the street to see a Bouguereau. His pictures look false; he does not get the truth of that which he wishes to represent; his light is not outdoor light; his works are waxy and artificial, they are extremely near being frauds.'

[The writer interjects] He believes, however, that the most complete pictures are not founded upon outdoor studies. 'The great compositions of the old masters,' he says, 'were almost all interiors. You can't control the thing outdoors'. Yet he admits that it is possible, sometimes, to find a picture – a complete one – outdoors; to meet with a combination of facts so happy that a sketch of it would deserve to be called a picture . . . 'I couldn't even copy in a studio a picture made outdoors; I shouldn't know where the colours came from, nor how to reproduce them. I couldn't possibly do it. Yet an attempted copy might be more satisfactory to the public, because more like a made picture.'

19 Pierre Auguste Renoir (1841–1919) Three Letters to Durand-Ruel

Renoir exhibited with the Impressionists from the first exhibition in 1874 until the third in 1877. In 1878 he submitted work to the official Salon. The following year he submitted again and scored a considerable success with his portrait of the wealthy Madame Charpentier and her children (now in the Metropolitan Museum of Art in New York). This commission led to others and from that point on he was reasonably well assured of an income from his work. He refused to identify himself with the Independent artists at their exhibitions of 1879 and 1880, continuing to exhibit in the annual Salons until 1883. In 1881–2 he travelled to North Africa and to Italy, changing to a more emphatic style of drawing and modelling on his return. There has been a tendency to represent Renoir's abandonment of the Impressionists as a form of betrayal. On a more charitable view, he was seeking an individual means to go on in face of a slackening in the Naturalist and Impressionist impulse. His consequent strategy involved simultaneous re-engagement with the legacies of classicism and Romanticism, the former through attention to the figure, the latter by following Delacroix's path to North Africa and by attention to the earlier painter's use of colour. The first of the following letters to the Impressionists' principal dealer Durand-Ruel was written during the artist's travels. Renoir offers a frank explanation of his reasons for preferring the Salon. Matters had changed by the time the second letter was written, however. In 1882 Durand-Ruel acted as organizer of the seventh Impressionist exhibition and proposed to include works by Renoir from his stock. The artist's response to this proposal is given in two letters written early in that year from l'Estaque, where he was staying in the company of Cézanne. Gauguin had first shown with the Impressionists in 1880, and had immediately aroused the suspicions of several of the more established artists through what they saw as his manipulative tendencies (see also VIc11). The letters were first published in Lionello Venturi (ed.), *Les Archives de l'Impressionisme*, Paris and New York: Durand-Ruel, 1939, volume I, pp. 115–21, from which source they have been translated for this volume by Carola Hicks.

Algiers, March 1881

My dear Monsieur Durand-Ruel,
I should explain to you why I am submitting to the Salon. In Paris there are scarcely fifteen art–lovers able to appreciate a painter outside the Salon. And there are 80,000 who wouldn't buy a picture of the nose on their face if it wasn't painted by a Salon painter. That is why I submit a couple of portraits every year, little though that is.

Moreover I don't want to fall into the trap of judging something to be good or bad according to its location. In a word, I don't want to waste my time nursing a grievance against the Salon. I don't even want to seem to be doing so. I believe you should just paint as well as you can. That's all. Now, if my critics were to accuse me of negligence in art, or of ridiculous ambition, causing me to sacrifice my ideas, then I would understand them. But since that is not true, they have absolutely no case to make. My one concern at the moment, as ever, is to produce good work. I want to paint splendid pictures that you can sell at the highest price. Success is not far away, I do believe. I've stayed out in the sunshine, away from all other painters, in order to think better. I think I've found what I've been looking for. I could be wrong, but I'd be very surprised if I am. Just continue to be patient, and very soon I hope to prove to you that it is possible to exhibit at the Salon and be a good painter.

So I urge you to put my case to my friends. My approach to the Salon is entirely commercial. At all events, like some medicine, even if it doesn't do any good, at least it does no harm.

I think that I am completely cured. I shall be able to work hard, and make up for lost time.

With that, I wish you the best of health. And lots of rich customers. But keep some for my return. I shall be away for another month. I don't want to leave Algiers without being able to bring back something of this marvellous country. My warmest wishes to you and all our friends.
Renoir.

L'Estaque, 24 February 1882

Dear Monsieur Durand-Ruel,
If you were holding an exhibition which you were in sole charge of − even if this exhibition were to be held at the Bastille or some even more insalubrious quarter, I would have no hesitation in saying to you: have all my paintings, even at the risk of a total flop.

But that's not the issue. I should like to think that you have not committed yourself personally to this weird enterprise that they are trying to drag you into and which I refuse to sign up for. It's no exaggeration to say that the exhibition planned by these gentlemen was conceived and arranged behind my back, that they only told me about it at the last moment, when the others had dropped out, and that I was never even invited to contribute to the previous Independent exhibitions, let alone beseeched!

At this very moment I am racking my brains in order to work out whatever their motivation was in thinking of me...

But I shouldn't go on like this... otherwise it might look as if I minded missing out on something that I don't mind missing out on at all. That would be awful, and I'm so delighted to have been left in peace in the past that I really can't insist that they continue to do so on this occasion.

I would agree to exhibit with Monet, Sisley, Mlle. Morisot, Pissarro, but only with them.

With just five or six of us, together with the elusive Degas, we could mount an exhibition that would be a significant artistic event.

But I'm willing to bet that Monet for one won't want to accept these gentlemen's terms.

So to sum things up, I formally refuse to join this enterprise, of which I had no prior knowledge.

However, if you personally need any of my canvases, let me reassure you, that I would make them available to you.

I remain convinced that one day you will come round to my point of view, which is that only the kindness of your heart persuaded you to make this approach, which you will later regret having taken so seriously.

I beg you to accept my most cordial regards.

Renoir

L'Estaque, 26 February 1882

My Dear Durand-Ruel,

... I have this morning sent you the following telegram: 'The pictures of mine which you have in your possession are your own property, I cannot prevent you from disposing of them as you choose, but it will not be me who exhibits them'.

These few words fully express my opinion.

Let it be clearly understood that I will have no dealings with the Pissarro–Gauguin enterprise and I do not agree for one moment to be included in the so-called Independents' group.

The main reason is that I exhibit at the Salon, which is hardly compatible with all this.

So I refuse, and I shall continue to refuse.

Now of course you don't need my permission to show those of my canvases that you own. They are your property, and I will not claim the right to stop you making use of them as you think fit, as long as it is done under your own name. Only let it be absolutely agreed and accepted that it is you, as owner of these canvases which bear my name, who is exhibiting them, and not me.

Under these conditions, the catalogue, the posters, the leaflets, and any other public notices will state that my canvases are the property of, and exhibited by, M. Durand-Ruel.

In this way, I shall not become an Independent against my will, given that I'm not able to avoid being one altogether.

Don't blame me for this decision, which won't really affect you personally since it is not you but M. Gauguin who is organizing the exhibition, and do believe me when I say that I am still one of your loyal and devoted artists. Nevertheless, I am defending our common interest, because I reckon that being exhibited there would reduce the price of my canvases by 50%.

Let me repeat again, you should not feel hurt by any aspect of my refusal, for none of it is aimed at you personally, but all of it at those gentlemen whose company I don't wish to share, for the sake of my well being, on grounds of good taste, and on account of your own interests.

Please accept my heartfelt good wishes for your health, and the assurance of my most friendly feelings.

Renoir

IVB
Science and Method

1 John Ruskin (1819–1900) from *The Elements of Drawing*

These extracts are taken from Ruskin's book *The Elements of Drawing; in Three Letters to Beginners*, first published in London in 1857. Ruskin is best known for his advocacy of the art of his English contemporaries, particularly Turner and the Pre-Raphaelites, and for his ceaseless campaign to improve standards of design in England (see IIB6 and 7, IIIA9, IIIc5 and 6). But he was also a very competent draughtsman and watercolourist, with a considerable gift for transmitting basic practical principles through writing and instruction. (The book was illustrated with the author's own drawings and studies.) In his account of the procedures of perception and transcription of coloured effects Ruskin was on common ground with the most advanced colour theory of his time, anticipating principles that the French Impressionist painters were to put into practice in the late 1860s and 1870s. The American colour-theorist Ogden Rood was among those who were to acknowledge the importance of the book (see IVB9). *The Elements of Drawing* was still in use as a manual of instruction in British and American art schools well into the twentieth century. Our text is taken from Letter I, 'On First Practice', Exercises I and VIII, in the edition of 1886, New York: John Wiley, pp. 22–4, 46–8 and 52–4.

Exercise I

Everything that you can see in the world around you, presents itself to your eyes only as an arrangement of patches of different colours variously shaded.[1]

Some of these patches of colour have an appearance of lines or texture within them, as a piece of cloth or silk has of threads, or an animal's skin shows texture of hairs: but whether this be the case or not, the first broad aspect of the thing is that of a patch of some definite colour; and the first thing to be learned is, how to produce extents of smooth colour, without texture.

This can only be done properly with a brush; but a brush, being soft at the point, causes so much uncertainty in the touch of an unpractised hand, that it is hardly possible to learn to draw first with it, and it is better to take, in early practice, some instrument with a hard and fine point, both that we may give some support to the hand, and that by working over the subject with so delicate a point, the attention may be properly directed to all the most minute parts of it. Even the best artists need occasionally to study subjects with a pointed instrument, in order thus to

discipline their attention: and a beginner must be content to do so for a considerable period. [. . .]

[1] The perception of solid Form is entirely a matter of experience. We *see* nothing but flat colours; and it is only by a series of experiments that we find out that a stain of black or grey indicates the dark side of a solid substance, or that a faint hue indicates that the object in which it appears is far away. The whole technical power of painting depends on our recovery of what may be called the *innocence of the eye*; that is to say, of a sort of childish perception of these flat stains of colour, merely as such, without consciousness of what they signify – as a blind man would see them if suddenly gifted with sight.

For instance: when grass is lighted strongly by the sun in certain directions, it is turned from green into a peculiar and somewhat dusty-looking yellow. If we had been born blind, and were suddenly endowed with sight on a piece of grass thus lighted in some parts by the sun, it would appear to us that part of the grass was green, and part a dusty yellow (very nearly of the colour of primroses); and, if there were primroses near, we should think that the sunlighted grass was another mass of plants of the same sulphur-yellow colour. We should try to gather some of them, and then find that the colour went away from the grass when we stood between it and the sun, but not from the primroses; and by a series of experiments we should find out that the sun was really the cause of the colour in the one – not in the other. We go through such processes of experiment unconsciously in childhood; and having once come to conclusions touching the signification of certain colours, we always suppose that we *see* what we only know, and have hardly any consciousness of the real aspect of the signs we have learned to interpret. Very few people have any idea that sunlighted grass is yellow.

Now, a highly accomplished artist has always reduced himself as nearly as possible to this condition of infantine sight. He sees the colours of nature exactly as they are, and therefore perceives at once in the sunlighted grass the precise relation between the two colours that form its shade and light. To him it does not seem shade and light, but bluish green barred with gold.

Strive, therefore, first of all, to convince yourself of this great fact about sight. This, in your hand, which you know by experience and touch to be a book, is to your eye nothing but a patch of white, variously gradated and spotted; this other thing near you, which by experience you know to be a table, is to your eye only a patch of brown, variously darkened and veined; and so on: and the whole art of Painting consists merely in perceiving the shape and depth of these patches of colour, and putting patches of the same size, depth, and shape on canvas. The only obstacle to the success of painting is, that many of the real colours are brighter and paler than it is possible to put on canvas: we must put darker ones to represent them.

Exercise VIII

Go out into your garden, or into the road, and pick up the first round or oval stone you can find, not very white, nor very dark; and the smoother it is the better, only it must not *shine*. Draw your table near the window, and put the stone . . . on a piece of not very white paper, on the table in front of you. Sit so that the light may come from your left, else the shadow of the pencil point interferes with your sight of your work. You must not let the *sun* fall on the stone, but only ordinary light: therefore choose a window which the sun does not come in at. If you can shut the shutters of the other windows in the room it will be all the better; but this is not of much consequence.

Now if you can draw that stone, you can draw anything; I mean, anything that is drawable. Many things (sea foam, for instance) cannot be drawn at all, only the idea of them more or less suggested; but if you can draw the stone *rightly*, everything within reach of art is also within yours.

For all drawing depends, primarily, on your power of representing *Roundness*. If you can once do that, all the rest is easy and straightforward; if you cannot do that, nothing else that you may be able to do will be of any use. For Nature is all made up of roundnesses; not the roundness of perfect globes, but of variously curved surfaces. Boughs are rounded, leaves are rounded, stones are rounded, clouds are rounded,

cheeks are rounded, and curls are rounded: there is no more flatness in the natural world than there is vacancy. The world itself is round, and so is all that is in it, more or less, except human work, which is often very flat indeed.

Therefore, set yourself steadily to conquer that round stone, and you have won the battle.

Look your stone antagonist boldly in the face. You will see that the side of it next to the window is lighter than most of the paper; that the side of it farthest from the window is darker than the paper; and that the light passes into the dark gradually, while a shadow is thrown to the right on the paper itself by the stone...

Now, remember always what was stated in the outset, that everything you can see in Nature is seen only so far as it is lighter or darker than the things about it, or of a different colour from them. It is either seen as a patch of one colour on a ground of another; or as a pale thing relieved from a dark thing, or a dark thing from a pale thing. And if you can put on patches of colour or shade of exactly the same size, shape, and gradations as those on the object and its ground, you will produce the appearance of the object and its ground. The best draughtsmen – Titian and Paul Veronese themselves – could do no more than this; and you will soon be able to get some power of doing it in an inferior way, if you once understand the exceeding simplicity of what is to be done. Suppose you have a brown book on a white sheet of paper, on a red tablecloth. You have nothing to do but to put on spaces of red, white, and brown, in the same shape, and gradated from dark to light in the same degrees, and your drawing is done. If you will not look at what you see, if you try to put on brighter or duller colours than are there, if you try to put them on with a dash or a blot, or to cover your paper with 'vigorous' lines, or to produce anything, in fact, but the plain, unaffected, and finished tranquillity of the thing before you, you need not hope to get on. Nature will show you nothing if you set yourself up for her master. But forget yourself, and try to obey her, and you will find obedience easier and happier than you think.

* * *

Generally, then, every solid illumined object – for instance, the stone you are drawing – has a light side turned towards the light, a dark side turned away from the light, and a shadow, which is cast on something else (as by the stone on the paper it is set upon). You may sometimes be placed so as to see only the light side and shadow, sometimes only the dark side and shadow, and sometimes both or either without the shadow; but in most positions solid objects will show all the three...

Hold up your hand with the edge of it towards you, as you sit now with your side to the window, so that the flat of your hand is turned to the window. You will see one side of your hand distinctly lighted, the other distinctly in shade. Here are light side and dark side, with no seen shadow; the shadow being detached, perhaps on the table, perhaps on the other side of the room; you need not look for it at present.

Take a sheet of note-paper, and holding it edgewise, as you hold your hand, wave it up and down past the side of your hand which is turned from the light, the paper being of course farther from the window. You will see, as it passes, a strong gleam of light strike on your hand, and light it considerably on its dark side. This light is *reflected* light. It is thrown back from the paper (on which it strikes first in coming

from the window) to the surface of your hand, just as a ball would be if somebody threw it through the window at the wall and you caught it at the rebound.

Next, instead of the note-paper, take a red book, or a piece of scarlet cloth. You will see that the gleam of light falling on your hand, as you wave the book, is now reddened. Take a blue book, and you will find the gleam is blue. Thus every object will cast some of its own colour back in the light that it reflects.

Now it is not only these books or papers that reflect light to your hand: every object in the room on that side of it reflects some, but more feebly, and the colours mixing all together form a neutral light, which lets the colour of your hand itself be more distinctly seen than that of any object which reflects light to it; but if there were no reflected light, that side of your hand would look as black as a coal.

Objects are seen therefore, in general, partly by direct light, and partly by light reflected from the objects around them, or from the atmosphere and clouds. The colour of their light sides depends much on that of the direct light, and that of the dark sides on the colours of the objects near them. It is therefore impossible to say beforehand what colour an object will have at any point of its surface, that colour depending partly on its own tint, and partly on infinite combinations of rays reflected from other things. The only certain fact about dark sides is, that their colour will be changeful, and that a picture which gives them merely darker shades of the colour of the light sides must assuredly be bad.

2 Robert Zimmermann (1824–1898) 'Towards the Reform of Aesthetics as an Exact Science'

Zimmermann's ideas were decisively shaped by the work of the philosopher and psychologist Johann Friedrich Herbart (1776–1841), whose introduction of a strict formalist approach to aesthetics exercised an enormous influence on the second half of the nineteenth century. Herbart sought to analyse aesthetic appreciation in terms of responses to such elementary components as line, colour, form, relation and tone, in complete abstraction from any moral, emotional or intellectual response that the object might arouse. He maintained that the content or 'meaning' of a work is wholly extraneous to its aesthetic properties. In the two volumes of his *Aesthetics*, published in 1858 and 1865, Zimmermann sought to expand Herbart's ideas into a rigorous and comprehensive 'science'. The first, 'historical–critical' volume, entitled 'History of Aesthetics as a Philosophical Science', provides a comprehensive overview of the subject from a formalist standpoint. The second 'systematic' volume, entitled 'Universal Aesthetics as the Science of Form', expounds the method and principles on which the new science is based. In 1861, whilst still working on the second volume, Zimmermann published an essay entitled 'Zur Reform der Aesthetik als exacter Wissenschaft' (Towards the reform of aesthetics as an exact science) in the Leipzig *Zeitschrift für exacte Philosophie*, a journal dedicated to the propagation of Herbart's ideas. As the title suggests, Zimmermann's essay is essentially a programmatic declaration of intent, advocating the introduction of empirical procedures and a concern with measurable data in order that aesthetics, too, may enter on the sure path of science. These extracts have been translated for the present volume by Nicholas Walker from *Zeitschrift für exacte Philosophie*, Leipzig, 1861, Band II, Heft I, pp. 309, 349–52, 354–5.

That philosophical trend which has turned its back on the false trails of metaphysical idealism and turned instead towards the characteristic methods of the exact sciences has already begun to exercise an influence upon the general scientific aspirations of our contemporaries. It is all the more to be expected, therefore, that the fruits of this inner transformation of philosophical approach should also increasingly reveal themselves within the individual disciplines of philosophy itself. In this respect we can see that metaphysics, psychology, the philosophy of nature and that of religion, on the one hand, and practical philosophy, pedagogics, political and legal philosophy on the other, have already renewed themselves, and actually revealed the possibility of a complete reformation of philosophy from a realist perspective. There is only one domain which has as yet apparently remained almost entirely untouched by this general change of attitude and in which indeed the necessity for some such transformation hardly seems to have been felt at all in many circles, and unfortunately it is a domain where precisely the opposite state of affairs is highly desirable, given its profound significance for practical life: namely the domain of – *Aesthetics*.

[. . .]

The experience of the beautiful rests upon *aesthetic judgements*, that of the merely pleasant upon *feelings*. In the former case, the object of consideration, the constitution of which produces an aesthetic feeling of pleasure or displeasure merely through being contemplated, can also always be regarded independently in its own right, whereas in the latter case, the feeling in question coalesces and coincides immediately as one with the object of feeling. And that is why it is possible in the first case to enumerate and find verbal expression for that which produces the feeling of pleasure or displeasure simply through contemplation of the same, whereas in the second case it is not. Consequently, it is never mere feelings, but only aesthetic judgements, that can ever constitute the basis for aesthetics as a science.

It is therefore perfectly correct to say that the beautiful cannot be demonstrated, but it is not correct to claim that the beautiful can only be felt. The aesthetic judgement as such possesses a certain evidence, that is, it requires nothing further beyond the mere contemplation of the given content in its connected and various relations in order to produce aesthetic delight or the opposite, as the case may be. The only further thing we can do in this connection is to represent this content to ourselves as thoroughly as we can, and to prevent any interference through alien ideas, feelings or intentions, in particular through everything which Kant described with classical concision as 'interest'. Everything else must be left to the content of our representations themselves. We cannot prescribe aesthetic judgements for any other individual; to this extent, the famous proposition that there is no disputing over taste is quite valid; but if and when the same content is properly conceived and allowed to develop in accordance with its own activity alone, the same aesthetic judgement will emerge spontaneously, because the same causes will necessarily and invariably produce the same effects in each case. Thus I can never demonstrate to anyone that the tonic and the fifth together inevitably sound harmonious, whereas the sixth and the seventh sound the opposite; but if I can arrange someone with a good ear to listen to precisely these notes alone, then I can be quite sure that this individual will perceive the first combination of sounds as pleasing, and the latter as unpleasing. It is easy to see how this can be so, because the *content* of the representations for one individual

must necessarily be the same for anyone else, and the feeling which is produced simply through perception of this representational content alone *and by nothing else*, must necessarily be the same in one individual as in another. To that extent, aesthetics bears a resemblance to logic, in so far as it is, like the latter, solely concerned with the content of representations; the only difference being that the logical subject can take any predicate whatsoever, whereas the subject in an aesthetic judgement can only ever have a certain specific predicate, namely a feeling of pleasure or displeasure, and must always grasp the relationship of several representational contents to one another. But these two types do correspond to the extent that in the logical judgement the actual, possible or necessary connection of the predicate with the subject is conditioned solely by the content of the latter, while in the aesthetic judgement the necessary connection of the feeling of pleasure or displeasure with the subject is conditioned solely by the perception of the content of the subject.

But the fact that the beautiful can be known, and not merely felt, derives from the circumstance that the component elements of the pleasing or displeasing relationship in question can be represented and retained in pure separation from the feeling itself. However difficult it may be to put in words what it is that makes the scent of a flower or the sensation of warm air seem pleasant to us, it is quite possible to identify the specific relations of sound or colour which produce a pleasing or a disturbing effect upon the ear or the eye. An 'evident' aesthetic judgement like this is the proper *source of all knowledge* for aesthetics as a science.

It is simply the notion that the whole of aesthetics can be derived from a *single* highest principle which must now be abandoned. The aesthetic judgement: harmony is pleasing, is not the only kind of aesthetic judgement. Evident and unconditioned as it is, every aesthetic judgement is simultaneously a principle in its own right, and none is capable of being deduced from or grounded on any other. Thus there are just as many objective principles of taste as there are aesthetic judgements. Just as realist metaphysics is based upon recognition of the original and indeterminate plurality of being in its own right, so a realist aesthetics is likewise based upon the recognition of the plurality of what originally pleases in its own right. The enumeration and presentation of the various elements of aesthetic taste is the proper task of aesthetics as a science.

It is precisely the method of this form of scientific aesthetics which justifies the analogy with the empirical natural sciences. Just as natural science seeks to reduce large and complex phenomena to their simplest elements, so too this kind of aesthetics seeks initially to reduce the most complex expressions of taste, as produced by the works of nature and of art, to those original factors which are incapable of further analysis. Once aesthetics has determined the simple elements of taste in this analytical fashion, it then tries to explain the more extensive manifestations of aesthetic pleasure and displeasure synthetically from the possible combinations of these first elements. It thus proceeds from the same perspective which guides all our exact investigations into nature: namely that the initial obscurity in which certain phenomena are shrouded is simply a consequence of the complex concatenation of other innumerable, more fundamental and intrinsically quite intelligible phenomena, and that therefore the only real task is to penetrate the nature of the latter in order to dispel the mysterious and obscure impression of the original phenomenon as a whole. Just like the telescope

which is capable of separating out a vague patch of light into so many distinct collections of stars, so too the scientific process of analysis must be capable of separating out the total aesthetic impression, which initially seems to scorn such an approach, into all those isolated effects of taste of which the original impression is essentially composed. To the extent that aesthetics succeeds in this task, no one will be able any longer to make the obscurity of our aesthetic judgements a principal cause for lament.

* * *

It should now be obvious that the conception of aesthetics as outlined here must inevitably lead to a complete reform of the discipline. In this way we shall not merely conquer the ancient prejudice that aesthetics can never be a proper science, but shall simultaneously base this discipline upon firm principles which will leave no room for artistic caprice and arbitrary subjectivity. Concrete aesthetic relationships, the observation of which will meet with ineluctable praise and the neglect of which with inevitable censure, can now replace all former appeals to an all-dominating 'aesthetic attitude', to the variegated but utterly indefinite notion of human nature, to the high-sounding but essentially hollow 'absolute', to some abstract logical and conceptual content which only acquires any aesthetic value by illegitimately smuggling in the latter either from our spontaneous aesthetic judgements or one knows not where. Instead of this, the discovery of concrete aesthetic relationships will open up for aesthetics an immense new field of research, and in the progressive elaboration of which aesthetics must naturally strive to become a science as exact as that of chemistry or physiology when they attempt to identify the entirety of simple fundamental physical substances or the simple physical basis of all vital phenomena respectively. Once aesthetics has engaged with an abundance of original examples of beauty, it will be able to drop the vacuous concept of beauty and effectively furnish those who turn to this discipline with a rich body of aesthetic material instead of a number of barren formulae. And it will also present us with a normative standard of eternal validity which no one can any longer afford to ignore with impunity.

3 Hippolyte Taine (1828–1893) from *Lectures on Art*

Taine was one of the leading exponents of French nineteenth-century Positivism (cf. IIA2). In essence this was an attempt to apply the methods of natural science to the study of society. Taine's particular contribution was to extend this to the study of culture, especially literature and art. For Taine the characteristics of works of art may be explained by objective factors lying behind their production. He emphasized three: 'race', 'milieu' and 'moment', that is, the author's cultural inheritance, geographical place or situation, and historical period. In 1864 Taine was appointed Professor of Aesthetics and the History of Art at the Ecole des Beaux Arts in Paris, where he continued to lecture for twenty years. We reprint below three extracts. The first two are from Sections IX and X of the second part of the series 'The Philosophy of Art', subtitled 'On the Production of the Work of Art' (the first part having been 'On the Nature of the Work of Art'). These lectures were delivered in late 1864 and were first published in 1865 as *La Philosophie de l'art*. Taine has just presented a variety of historical examples from the ancient world, the medieval period, and progres-

sing up through seventeenth- and eighteenth-century France to the Romantic period. He now proceeds to his general conclusion. Our third selection is from Section V of the series 'On the Ideal in Art' of 1867. Our extracts are taken from the English translation by John Durand of Hippolyte Taine, *Lectures on Art*, third edition, New York, 1896, part I, chapters IX and X, pp. 157–65 and part II, chapter V, pp. 248–51.

On the Production of the Work of Art

IX

The foregoing illustrations, gentlemen, seem to me sufficient to establish the law governing the character and creation of works of art. And not only do they establish it, but they accurately define it. In the beginning of this section I stated *that the work of art is determined by an aggregate which is the general state of the mind and surrounding manners*. We may now advance another step and note precisely in their order each link of the chain, connecting together cause and effect.

In the various illustrations we have considered, you have remarked first, a *general situation*, in other words, a certain universal condition of good or evil, one of servitude or of liberty, a state of wealth or of poverty, a particular form of society, a certain species of religious faith; in Greece, the free martial city, with its slaves; in the middle ages, feudal oppression, invasion and brigandage, and an exalted phase of Christianity; the court life of the seventeenth century; the industrial and studied democracy of the nineteenth, guided by the sciences; in short, a group of circumstances controlling man, and to which he is compelled to resign himself.

This situation develops in man corresponding needs, distinct *aptitudes* and *special sentiments* – physical activity, a tendency to reverie; here rudeness, and there refinement; at one time a martial instinct, at another conversational talent, at another a love of pleasure, and a thousand other complex and varied peculiarities. In Greece we see physical perfection and a balance of faculties which no manual or cerebral excess of life deranges; in the middle ages, the intemperance of over-excited imaginations and the delicacy of feminine sensibility; in the seventeenth century, the polish and good-breeding of society and the dignity of aristocratic *salons*; and in modern times, the grandeur of unchained ambitions and the morbidity of unsatisfied yearnings.

Now, this group of sentiments, aptitudes and needs, constitutes, when concentrated in one person and powerfully displayed by him, *the representative man*, that is to say, a model character to whom his contemporaries award all their admiration and all their sympathy; there is, for instance, in Greece, the naked youth, of a fine race and accomplished in all bodily exercise; in the middle ages, the ecstatic monk and the amorous knight; in the seventeenth century, the perfect courtier; and in our days, the melancholy insatiable Faust or Werther.

Moreover, as this personage is the most captivating, the most important and the most conspicuous of all, it is he whom artists present to the public, now concentrated in an ideal personage, when their art, like painting, sculpture, the drama, the romance or the epic, is imitative; now, dispersed in its elements, as in architecture and in music, where art excites emotions without incarnating them. All their labour, therefore, may be summed up as follows: they either represent this character, or address

themselves to it; the symphonies of Beethoven and the 'storied windows' of cathedrals are addressed to it; and it is represented in the Niobe group of antiquity and in the Agamemnon and Achilles of Racine. *All art, therefore, depends on it*, since the whole of art is applied only to conform to, or to express it.

A general situation; [this] provoking tendencies and special faculties; a representative man, embodying these predominant tendencies and faculties; sounds, forms, colours, or language giving this character sensuous form, or which comport with the tendencies and faculties comprising it, such are the four terms of the series; the first carries with it the second, the second the third, and the third the fourth, so that the slightest variation of either involves a corresponding variation in those that follow, and reveals a corresponding variation in those that precede it, permitting abstract reasoning in either direction in an ascending or descending scale of progression.* As far as I am capable of judging, this formula embraces everything. If, now, we insert between these diverse terms the accessory causes occurring to modify their effects; if, in order to explain the sentiments of an epoch, we add an examination of race to that of the social medium; if, in order to explain the works of art of any age, we consider, besides the prevailing tendencies of that age, the particular period of the art, and the particular sentiments of each artist, we shall then derive from the law not only the great revolutions and general forms of man's imagination, but, again, the differences between national schools, the incessant variations of various styles, and the original characteristics of the works of every great master. Thus followed out, such an explanation will be complete, since it furnishes at once the general traits of each school, and the distinctive traits which, in this school, characterize individuals. [. . .]

* This law may be applied to the study of all literatures and to every art. The student may begin with the fourth term, proceeding from this to the first, strictly adhering to the order of the series.

X

Before proceeding further, gentlemen, there is a practical and personal conclusion due to our researches, and which is applicable to the present order of things.

You have observed that each situation produces a certain state of mind followed by a corresponding class of works of art. This is why every new situation must produce a new state of mind, and consequently a new class of works; and therefore why the social medium of the present day, now in the course of formation, ought to produce its own works like the social mediums that have gone before it. This is not a simple supposition based on the current of desire and of hope; it is the result of a law resting on the authority of experience and on the testimony of history. From the moment a law is established it is good for all time; the connections of things in the present, accompany connections of things in the past and in the future. Accordingly, it need not be said in these days that art is exhausted. It is true that certain schools no longer exist and can no longer be revived; that certain arts languish, and that the future upon which we are entering does not promise to furnish the aliment that these require. But art itself, which is the faculty of perceiving and expressing the leading character of objects, is as enduring as the civilization of which it is the best and earliest fruit. What its forms will be, and which of the five great arts will provide the vehicle of expression

of future sentiment, we are not called upon to decide; we have the right to affirm that new forms will arise, and an appropriate mould be found in which to cast them. We have only to open our eyes to see a change going on in the condition of men, and consequently in their minds, so profound, so universal and so rapid that no other century has witnessed the like of it. The three causes that have formed the modern mind continue to operate with increasing efficacy. You are all aware that discoveries in the positive sciences are multiplying daily; that geology, organic chemistry, history, entire branches of physics and zoology, are contemporary productions; that the growth of experience is infinite, and the applications of discovery unlimited; that means of communication and transport, cultivation, trade, mechanical contrivances, all the elements of human power, are yearly spreading and concentrating beyond all expectation. None of you are ignorant that the political machine works smoother in the same sense; that communities, becoming more rational and humane, are watchful of internal order, protecting talent, aiding the feeble and the poor; in short, that everywhere, and in every way, man is cultivating his intellectual faculties and ameliorating his social condition. We cannot accordingly deny that men's habits, ideas and condition transform themselves, nor reject this consequence, that such renewal of minds and things brings along with it a renewal of art. The first period of this evolution gave rise to the glorious French school of 1830; it remains for us to witness the second – the field which is open to your ambition and your labour. On its very threshold, you have a right to augur well of your century and of yourselves; for the patient study we have just terminated shows you that to produce beautiful works, the sole condition necessary is that which the great Goethe indicated: 'Fill your mind and heart, however large, with the ideas and sentiments of your age and the work will follow.'

* * *

On the Ideal in Art

V

[. . .] Other things being equal, according as the character brought into light by a picture or a statue is more or less important, this picture and this statue are more or less beautiful. This is why you find in the lowest rank, those drawings, aquarelles, pastels, and statuettes, which in man do not depict the man, but his dress, and especially the dress of the day. Illustrated reviews are full of them; they might almost be called fashion-plates; every exaggeration of costume is therein displayed: wasp-like waists, monstrous skirts, overloaded and fantastic head-dresses; the artist is heedless of the deformity of the human body; that which gives him pleasure is the fashion of the moment, the gloss of stuffs, the close fitting of a glove, the perfection of the chignon. Alongside of the scribbler with the pen he is the scribbler with the pencil; he may have a good deal of talent and wit, but he appeals only to a transient taste; in twenty years his coats will be completely out of date. Countless sketches of this description which, in 1830, were in vogue, are, at the present hour, simply historic or grotesque. Numbers of portraits in our annual exhibitions are nothing but portraits of costumes, and, alongside of the painters of man, are the painters of moire-antique and of satin.

Other painters, although superior to these, still remain on the lower steps of art; or rather they have some talent besides their art; they are badly-placed observers, born to compose romances and studies on society, and who, instead of the pen, have taken up the brush. That which strikes them is the peculiarities of a calling, of a profession, of training, the impress of vice or of virtue, of passion or of habit; Hogarth, Wilkie, Mulready, and hosts of English painters possessed this gift so slightly picturesque and so literary. They see in the physical man only the moral man; with them colour, drawing, truthfulness, and the beauty of the living body, are subordinate. It suffices for them to represent by forms, attitudes and colours, at one time the frivolity of a fashionable woman, at another the honest sorrow of an old steward, at another the debasement of a gambler, and innumerable petty dramas or comedies of real life, all instructive or diverting, and almost all with a view to inspire good sentiments or to correct abuses. Properly speaking, they delineate nothing but spirits, minds, and emotions. They incline so strongly to this side as to outrage form and render it inflexible; frequently their pictures are caricatures, and always illustrations, the illustrations to a village idyl, or to a domestic romance which Burns, Fielding, or Dickens might better have written. The same prepossessions attend them when treating historical subjects; they treat them not as painters, but as historians, in order to display the moral sentiments of a personage or of an epoch, – the expression of a Lady Russell contemplating her condemned husband piously receiving the sacrament, the despair of Edith with the swan's neck on discovering Harold among the dead at Hastings. Composed of archaeological researches and of psychological documents, their work appeals only to archaeologists and to psychologists, or at least, to the curious and to philosophers. At most, it answers the purpose of a satire or of a drama; the spectator is made to laugh or to weep, as at the fifth act of a play on the stage. It is evident, nevertheless, that this order of art is eccentric; it is an encroachment of painting on literature, or rather an invasion of literature on the domain of painting. Our artists of the school of 1830, Delaroche among the first, fell, although less gravely, into the same mistake. The beauty of a plastic work is, above all, plastic, and an art always degenerates when, discarding its own peculiar means for exciting interest, it borrows those of another art. [. . .]

4 Thomas Couture (1815–1879) from *Conversations on Art Methods*

Today Thomas Couture is best known for two things: his large painting *Romans of the Decadence*, the sensation of the Salon of 1847 (now in the Musée d'Orsay), and the fact that Manet studied at his atelier between 1850 and 1856. In the mid-nineteenth century it was the former which was significant. Couture was a prominent figure at the Ecole des Beaux-Arts and his studio was well attended. However, divisions were caused among his students during the next decade by his identification with the eclecticism of the *juste milieu*: the attempt to compromise between Classicism and Romanticism in the name of continuing the academic ideal. In 1861 several left and urgently requested Courbet to take them on (see IIIB12). In 1863 Couture closed his studio in the face of the tensions building up in the French art world, as exemplified by the episode of the Salon des Refusés. He then turned to representing the precepts of his academic teaching in the form of a book. This was first

published in 1867 as *Méthode et Entretiens d'Atelier*. It contained 32 chapters proceeding from instruction in elementary drawing to detailed prescriptions on how to paint in the academic manner. Couture filled out his principles with examples drawn from the Old Masters, and also discussed more philosophical issues such as 'originality', 'the antique', and the question 'Is Art superior to Nature?' The book remains a comprehensive statement of the academic approach to art at the moment when it was beginning to disintegrate. The present extracts are drawn from the translation by S. E. Stewart, published as *Conversations on Art Methods*, New York, 1879, pp. 1, 6–8, 143–8, 209.

Elementary Drawing

I commence by saying that I know nothing more simple than what is called the art of imitation; I will explain elementary things, the material means which are all easy to understand. Later, when we touch true Art, you will see that the art of drawing surpasses everything else, and that the qualities of colour and light are only secondary to it.

I will proceed in order, and will for the time separate the art from the trade, and will ignore the antique (those beautiful things,) in my first lessons. It is a monstrosity to use them with beginners.

* * *

The First Principles of Painting

Trace your drawing on the canvas with charcoal, which is preferable to chalk; your points well determined, you mix strong boiled oil and spirits of turpentine, half and half, making what is called 'sauce'; put upon your palette the necessary colour for the first preparation, such as ivory black, bitumen, brown-red, and cobalt.

With a tint composed of black and brown-red, you will obtain bister; bitumen, cobalt, and brown-red will give you nearly the same result.

Return now to your drawing.

Brushes of sable, a little long, are necessary to trace the design; your charcoal dust would spoil the effect of the colour; therefore, with a maul stick strike the canvas as upon a drum; the charcoal falls, the drawings become lighter, but sufficient remains to guide you. Then you take the sable brush, dip it into your 'sauce,' then into the bister tint, and trace all your outline. These outlines being made, mass your shadows and you obtain a kind of sepia drawing in oil.

This first preparation must be allowed to dry; the execution will require a day's work. It will dry in the night, and the next day you work with the same preparation; wet your shadows and arrange your lights.

Clean your palette, and set it in the following manner:

Lead white, or silver white.
Naples yellow.
Yellow ochre.
Cobalt.
Vermilion.

Brown–red.
Lake (the madders are the best).
Burnt sienna.
Cobalt.
Bitumen.
Ivory black.

I leave you to your own inspiration in mixing your colours; experiment and make mistakes, but above all, acquire habits of accuracy.

* * *

On Painting

It is a great mistake to believe our colours are not as good as those employed by the ancients; they are not different in any respect, they are the same, the best are the most simple, and are used by house painters. If there is a difference, it is in the excessive care bestowed on some colours, which are expensive, complicated, and therefore bad. The Rubens red, the Van Dyck brown, the Veronese green, are made of different colours and give ready-made tones to the amateurs, who believe by using more expensive productions, that they will have what are called fine colours. But you ask me why are the old pictures so much better preserved than the modern? Does it come from a more careful preparation of colour? No.

It comes only from a better use of them.

Let me Explain

The ochres and the earths are the most solid. Those obtained by chemical processes are excellent, when they are used with boldness. The bitumen and lakes may be unchangeable.

This is how it is done

As much as possible, use your colours pure, without mixing; if it is absolutely necessary to employ several colours to obtain exactly what you need, never go beyond three; if you increase this number, you introduce into your picture a bad element. If you use four, five, six, then your picture has no longer any life, it becomes scrofulous, it vegetates and dies. Never forget simplicity in the composition of tone, and freedom in execution. Mix your three colours as you would twist three differently coloured threads, so that they could be distinguished. If as sometimes happens you need a fourth colour, wait until the three are dry; moisten your brush with linseed oil, and with lightness and rapidity put a thin glaze upon the surface only, with your fourth colour.

Ask your merchant for finely ground colours. One can get fine results by super-position; thus, for flesh, prepare with bitumen, the brown red, or vermilion – you may have a ground the colour of amber and a preparation suggesting the sepias of the

masters – let this dry, then moisten again all the shadows, and manage the lights with care; if these lights are sufficiently ambered in their preparation, you will obtain all the shadings of the skin by means of one flesh colour made simply, and by laying on the colours with more or less vigour.

Example

For a tone of the skin, in light, take flake white, Naples yellow, vermilion.

Paint the light parts thickly, what I have called the secondary lights more or less so, and by a singular phenomenon you obtain azure tones not possible to be obtained in any other way.

Another Guide, another Phenomenon

I have spoken to you of the necessity of great simplicity in the composition of tone, and of mixing your colours, always using them finely ground.

If you use more than three, you will feel it in a moment, having less body, less elasticity in your colour; the numbers five, six, decompose it, and even if you have employed only thick colours, your tone becomes flabby, viscous, and without consistency; it is death if you employ it, it will not adhere to your canvas, it will dry with difficulty (indeed sometimes it never dries), it blackens, and at last falls entirely from the canvas.

Now let us speak of Shadows

I have said it was necessary to moisten anew by a preparation like that already used; it is necessary to work the shadows with more freedom than even the lights; touch them and leave them; if you do not do it in this way your shadows become heavy and without transparency.

This is the way in which it should be done

You wait until your preparation is set (try it with your finger to see if it sticks sufficiently), then take yellow ochre and cobalt which you mix, for your light places, and put on the tint with a single stroke of your brush; this stroke will necessarily mix a little with the under preparation and lighten your greenish tone: then with a long supple brush, which you dip into a mixture of boiled oil and essence of turpentine, dilute the vermilion, which gives you a tint somewhat like that of a water colourist; with this you lightly glaze your shadows, and find you obtain a satisfactory result.

Thus, you see, bitumen and vermilion, two for preparation; yellow ochre and cobalt blue, two more, already four; then vermilion over them makes five colours; we have gone beyond three; but the way in which we have put the colours one over the other without mixing them, has made them unchangeable.

Pictures are judged by their preservation. The great masters understood not only the beauties of nature, but they rendered and developed them to make us understand

them; and they also understood the secrets of matter. Rubens, who is certainly one of the greatest, understood best the secrets of which I speak: his paintings are admirably preserved, not only preserved but improved. We have had an example of this lately, in the cleaning of the pictures in the gallery of the Medicis; all painted by Rubens, or by Van Dyck, his equal, have remained pure. These pictures are as hard as diamonds, but those painted by inferior men, or retouched by bad artists have disappeared.

Time, as you see, judges pictures. Rubens, Titian, Correggio, Veronese, Raphael, Velasquez, Murillo, Van Dyck, Watteau, Greuze, etc., all remain; bad pictures painted at the same time have passed away.

* * *

Originality

Do not listen to those who say to you, these rules are useless, and even hurtful to those who have originality.

There are not two ways of painting; there is but one, which has always been employed by those who understand the art.

Knowing how to paint and to use one's colours rightly has not any connection with originality.

This originality consists in properly expressing your own impressions.

5 Charles Blanc (1813–1882) on Colour

Blanc was a critic, art historian and aesthetician, who had acted as Director of the Ecole des Beaux-Arts in Paris during the revolution of 1848, and who was to serve in the same role again in 1872–4. He was a friend of Manet's and the founder of the *Gazette des beaux-arts*. The following excerpt is taken from his highly influential *Grammar of Painting and Engraving*. Though this work was widely adopted as a model for academic practice in France and elsewhere, it was informed by the most advanced colour theories and by a liberal understanding of developments in painting. Blanc played a particularly important part in explaining the colour effects of Delacroix's paintings and in connecting them to a coherent body of theory. By this means he made the lessons of that art fully available to the painters of a subsequent generation. His book was published in time to influence under-standing of the techniques of Impressionist painting, and it was to furnish much of the theoretical background to the Neo-Impressionist work of Seurat and Signac. Originally published as *Grammaire des arts du dessin*, Paris, 1867, our text is taken from the translation by Kate Newell Doggett, *The Grammar of Painting and Engraving*, New York: Hurd and Houghton; and Cambridge: The Riverside Press, 1874, chapter XIII, pp. 146–53, 154–8, 161–2 and 165–9.

XIII. Colour being that which especially distinguishes painting from the other arts, it is indispensable to the painter to know its laws, so far as these are essential and absolute.

Supposing the painter had only ideas to express, he would perhaps need only drawing and the monochrome of chiaro'scuro, for with them he can represent the only

figure that thinks – the human figure, which is the *chef d'oeuvre* of a designer rather than the work of a colourist. With drawing and chiaro'scuro he can also put in relief all that depends upon intelligent life, that is life in its relation to other lives, but there are features of organic, of interior and individual life that could not be manifested without colour. How for instance without colour give, in the expression of a young girl, that shade of trouble or sadness so well expressed by the pallor of the brow, or the emotion of modesty that makes her blush? Here we recognize the power of colour, and that its role is to tell us what agitates the heart, while drawing shows us what passes in the mind, a new proof of what we affirmed at the beginning of this work, that drawing is the masculine side of art, colour the feminine.

As sentiment is multiple, while reason is one, so colour is a mobile, vague, intangible element, while form, on the contrary, is precise, limited, palpable and constant. But in the material creation there are substances of which drawing can give no idea; there are bodies whose distinctive characteristic is in colour, like precious stones. If the pencil can put a rose under the eye, it is powerless to make us recognize a turquoise or a ruby, the colour of the sky or the tint of a cloud. Colour is *par excellence*, the means of expression, when we would paint the sensations given us by inorganic matter and the sentiments awakened in the mind thereby. We must, then, add to chiaro'scuro, which is only the external effect of white light, the effect of colour, which is, as it were, the interior of this light.

We hear it repeated every day, and we read in books that colour is a gift of heaven; that it is an impenetrable arcanum to him who has not received its *secret influence*; that one learns to be a draughtsman but one is born a colorist, – nothing is falser than these adages; for not only can colour, which is under fixed laws, be taught like music, but it is easier to learn than drawing, whose absolute principles cannot be taught. Thus we see that great designers are as rare, even rarer than great colorists. From time immemorial the Chinese have known and fixed the laws of colour, and the tradition of those laws, transmitted from generation to generation down to our own days, spread throughout Asia, and perpetuated itself so well that all oriental artists are infallible colorists, since we never find a false note in the web of their colours. But would this infallibility be possible if it were not engendered by certain and invariable principles?

What, then, is colour?

Before replying, let us take a look at creation. Beholding the infinite variety of human and animal forms, man conceives an ideal perfection of each form; he seeks to seize the primitive exemplar, or at least, to approach it nearer and nearer, but this conception is a sublime effort of his intelligence, and if, at times, the soul believes it has an obscure souvenir of original beauty, this fugitive memory passes like a dream, and the perfect form that issued from the hand of God is unknown to us; remains always veiled from our eyes. It is not so with colour, and it would seem as if the eternal colorist had been less jealous of his secret than the eternal designer, for he has shown us the ideal of colour in the rainbow, in which we see, in sympathetic gradation, but also in mysterious promiscuity, the mother-tints that engender the universal harmony of colours.

Whether we observe the iris, or look at the soap-bubbles with which children amuse themselves, or, renewing the experiment of Newton, use a triangular prism of crystal to analyse a ray of light, we see a luminous spectrum composed of six rays differently

coloured, violet, blue, green, yellow, orange, red. How do these colours strike the eye? As sounds do the ear. As each sound echoes in modulating itself upon itself and passes, by vibrations of equal length, from fullness to a murmur, and from a murmur to silence, so each colour seen in the solar spectrum has its maximum and minimum of intensity; it begins with its lightest shade and ends with its darkest.

Newton saw seven colours in the prism, doubtless to find a poetical analogy with the seven notes of music; he has arbitrarily introduced, under the name of *indigo*, a seventh colour which is only a shade of *blue*. It is a license that even the greatness of his genius cannot excuse. These seven colours he called *primitive*; but in reality there are only three primitive colours. We cannot put in the same rank *yellow*, *red*, and *blue*, which are simple colours, and *violet*, *green*, and *orange*, which are composite colours, because we can produce them by combining two by two the first three, the *orange*, by mixing yellow and red, the *green*, from yellow and blue, the *violet*, from blue and red.

Antiquity, which did not wait till Newton's day, to observe the coloured light of the iris, admitted only three as truly mother-colours, and the evidence of truth forces us to-day to return to the principle of the ancients, and to say, there are three primary colours, yellow, red, blue, and three composite or binary colours, – orange, green, violet. In the intervals that separate them, are placed the intermediate shades whose variety is infinite, and which are like the sharps of colour which precede, and the flats which follow them.

Separated, these colours and these shades enable us to distinguish and recognize all the objects of creation. Reunited they give us the idea of white. White light is the union of all colours, all are contained and latent in it.

This composition of white light once known, we can define colour. It is the property all bodies have of reflecting certain rays of light, and absorbing all others. The jonquil is yellow, because it reflects the yellow rays and absorbs the red and blue. The oriental poppy is scarlet, because it reflects only the red rays and absorbs the blue and yellow. If the lily is white, it is because, absorbing no ray, it reflects all, and a body is black because absorbing all rays, it reflects none. White and black, properly speaking, are not colours, but may be considered as the extreme terms of the chromatic scale.

White light containing the three elementary and generative colours, yellow, red, and blue, each of these colours serves as a *complement* to the other two to form the equivalent of white light. We call *complementary* each of the three primitive colours, with reference to the binary colour that corresponds to it. Thus blue is the complement of orange, because orange being composed of yellow and red, contains the necessary elements to constitute white light. For the same reason yellow is the complement of violet, and red of green, Reciprocally each of the mixed colours, produced by the union of two primitive colours, is the complement of the primitive colour not employed in the mixture; thus orange is the complement of blue, because blue does not enter into the mixture that produces it.

Law of complementary colours. If we combine two of the primary colours, yellow and blue, for instance, to compose a binary colour, *green*, this binary colour will reach its maximum of intensity if we place it near its complement – *red*. So, if we combine yellow and red to form *orange*, this binary colour will be heightened by the neighbourhood of *blue*. Finally, if we combine red and blue to form *violet*, this colour will be

heightened by the immediate neighbourhood of *yellow*. Reciprocally, the red placed beside the green will seem redder; the orange will heighten the blue, and the violet the yellow. It is the reciprocal heightening of complementary colours in juxtaposition that M. Chevreul called '*The law of simultaneous contrast of colours.*'

But these same colours that heighten each other by juxtaposition, destroy each other by mixture. If you place red and green in equal quantities and of equal intensity upon each other, there will remain only a colourless grey. The same effect will be produced if you mingle, in a state of equilibrium, blue and orange, or violet and yellow. This annihilation of colours is called *achromatism*.

Achromatism is also produced if we mingle in equal quantities, the three primitive colours, yellow, red, blue. If we pass a ray of light across three cells of glass filled with three liquids, yellow, red, blue, the ray that has traversed them will pass out perfectly achromatic, that is colourless. This second phenomenon does not differ from the first, for if the blue destroys the orange, it is because the orange contains the two other primary colours, yellow and red; and if the yellow annihilates the violet, it is because the violet contains the two other primary colours, red and blue. Thus we see how just is the expression, friendly and hostile colours, since the complementaries triumphantly sustain or utterly destroy each other.

* * *

But the complementary colours have other virtues not less marvellous than those of mutually heightening and destroying each other. 'To put a colour upon canvas,' says Chevreul, 'is not merely to tint with this colour all that the pencil has touched, it is also to colour with its complement the surrounding space; thus a red circle is surrounded by a light green aureole, less and less strongly marked according to its distance from the red; an orange circle is surrounded by a blue aureole, a yellow circle by a violet, and reciprocally.'

This had already been noticed by Goethe and by Eugène Delacroix. Eckermann relates ('Conversations de Goethe'), 'that walking in a garden with the philosopher, upon an April day, as they were looking at the yellow crocuses which were in full flower, they noticed that turning their eyes to the ground, they saw violet spots.' At the same epoch, Eugène Delacroix, occupied one day in painting yellow drapery, tried in vain to give it the desired brilliancy and said to himself: 'How did Rubens and Veronese find such brilliant and beautiful yellows?' He resolved to go to the Louvre, and ordered a carriage. It was in 1830, when there were in Paris many cabs painted canary colour; one of these was brought to him. About to step into it, Delacroix stopped short, observing to his great surprise that the yellow of the carriage produced violet in the shadows. He dismissed the coachman, entered his studio full of emotion, and applied at once the law he had just discovered, that is, that the shadow is always slightly tinged with the complement of the colour, a phenomenon that becomes apparent when the light of the sun is not too strong, and 'our eyes,' as Goethe says 'rest upon a fitting background to bring out the complementary colour.'

Is this colour produced by the eye? It is not for us to decide; but it is certain that in going out of a chamber hung with blue, for instance, for some moments we see objects tinted with orange. 'Let us suppose,' says Monge ('Géométrie Descriptive'), 'that we are in an apartment exposed to the sun, whose windows are covered with red curtains; if in the curtain there is a hole three or four lines in diameter, and a white paper be held

at a little distance to receive the rays of light that pass through this hole, these rays will make a *green* spot upon the paper; if the curtains were green the spot would be red.'

Monge does not give the reason of the phenomenon. I believe it is, that our eye being made for white light, needs to complete it when it receives only a part. To a man who perceives only *red* rays, what is necessary to complete the white light? Yellow and blue; but these are both contained in *green*. It is green then that will reestablish the equilibrium of the light in an eye wearied by red rays.

From having known these laws, studied them profoundly, after having intuitively divined them, Eugène Delacroix became one of the greatest colorists of modern times, one might even say the greatest, for he surpassed all others, not only in the aesthetic language of his colouring, but in the prodigious variety of his motives and the orchestration of his colours. Like a singer endowed with the whole register of the human voice, he has widened the limits of painting by adding new expressions to the language of art.

Again, if we mix two complementary colours in unequal proportions, they will partially destroy each other, and we shall have a broken tone that will be a shade of grey. Make, for instance, a mixture in which there shall be ten parts yellow and eight violet; there will be destruction of colour or achromatism for eight tenths, but the other two tenths will form a grey shaded with yellow, because there was excess of yellow in the mixture. Thus are formed all the innumerable varieties of colour that we call lowered tones, as if nature employed for her ternary colourations the destruction of colour, as she uses death to maintain life.

The law of complementary colours once known, with what certainty the painter will proceed whether he wishes to attain brilliancy of colour, to temper his harmony or to make it striking by abruptly bringing together tints that suit the expression of a warlike or tragic scene. Suppose it is necessary to lower a vivid vermilion, the artist learned in the laws of colour, instead of softening by soiling it at hazard, will lower it by the addition of blue, and thus will follow the path of nature.

But without even touching a colour, one can strengthen, sustain, lower, almost neutralize it, by working upon its neighbour. If we place in juxtaposition two similars in a pure state, but of difference degrees of energy, as dark red and light red, we shall obtain a contrast by the difference of intensity and a harmony by the similitude of tints. If we bring together two similars, one pure, the other broken, for instance, pure blue and grey blue, there will result another kind of contrast that will be moderated by resemblance. The moment colours are not to be employed in equal quantities, nor of equal intensity, the artist is free, but within the limits of infallible laws. He must try his *doses*, must distribute to his tints their places and roles, calculate the extent he will give them, and make, as it were, a secret rehearsal of the drama his colouring will form. He must employ the resources of white and black, foresee the optical mixture, know the vibration of the colours, and finally take care of the effect the diversely coloured light is to produce, according as it is of the morning or the evening, from the North or the South.

* * *

The Optical Mixture. One day in the library of the Luxembourg we were struck with the marvellously rich effect produced by Delacroix, the painter of the central cupola, where the artist had to combat the obscurity of the concave surface he had to paint,

and to create an artificial light by the play of his colours. Among the mythological or heroic figures that made up the decoration, and which were walking in a sort of enchanted garden, we distinguished a half-nude woman, seated in the shadows of this Elysium, whose flesh preserved the most delicate, the most transparent tints. As we were admiring the admirable freshness of this rose-tone, an artist friend of Delacroix, who had seen him at work, said smiling, 'You would be surprised if you knew what colours had produced the rosy flesh that charms you. They are tones that seen separately would seem as dull as the mud of the street.' How was this miracle wrought? By the boldness with which Delacroix had slashed the naked back of this figure with a decided green, which partly neutralized by its complement rose, forms with the rose in which it is absorbed a mixed and fresh tone apparent only at a distance, in a word a *resultant* colour which is what is called the optical mixture.

If at a distance of some steps, we look at a cashmere shawl, we generally perceive tones that are not in the fabric, but which compose themselves at the back of our eye by the effect of reciprocal reactions of one tone upon another. Two colours in juxtaposition or superposed in such or such proportions, that is to say according to the extent each shall occupy, will form a third colour that our eye will perceive at a distance, without having been written by weaver or painter. This third colour is a resultant that the artist foresaw and which is born of optical mixture.

* * *

Colour of the Light. In nature the light comes to us variously coloured, according to climate, the medium, the hour of the day. If the painter has chosen an effect of colourless light, of diffused and grey light, the laws of the heightening and enfeebling of the colours will not be contrary to those of chiaro'scuro, that is to say it will suffice to render vigorously the colours in the light and to soften them in the shadow (except for shining stuffs and polished bodies like satin, coats of mail, etc). But if the painter chooses a cold and blue light, or warm and orange, he cannot represent the phenomena produced if he has not the notions of colour.

Blue drapery, for example, under the cold light of the north will have its blue heightened in the light, attenuated in the shade. On the contrary if the light is orange like that of the sun, this same drapery will seem much bluer in the shade and less so in the light. Why? Because the mixture of the complementary colours will have substituted a tinted grey for the pure blue of the stuff in the lightest portions. Now replace the blue by orange drapery, pour upon it the light from the north, the blue of this light will partly neutralize the orange, but that will happen only in the light, for in the shadow the orange, finding itself sheltered from the rays that would have taken its colour, will preserve all the value the shadow can give it. Whence it results that the effect of coloured light upon colours can be obtained only by the absolute knowledge of the phenomena we have described.

Such are the laws that must guide the painter in the play of colours; such are the riches at his disposal. Happy if he adds to optical beauty the expression of the wished-for sentiment, if tuning his palette to the diapason of the fable or history, he knows how to draw from it the accents of poetry. In truth it is only in our days that the eloquence, the aesthetic value of colour has been discovered. Veronese and Rubens are always intent upon presenting a fête, playing a serenade, even when the drama

represented demands sombre, austere, or cold harmonies. Whether Jesus Christ is seated at the marriage at Cana, or marches to Calvary, or appears to the disciples at Emmaus, Veronese scarcely changes the moral character of his colours. He does not renounce the enchantment of the eye, with naive serenity he contradicts at need the severity of the theme by external magnificence. In his turn Rubens scarcely makes a difference in the colouring he uses to paint those superb women in the 'Garden of Love,' and that which will show us in a 'Last Judgement,' these same women, like a stream of fresh and rosy bodies, precipitated into hell. Even when he wishes to frighten he is determined to seduce.

More poetical, more penetrated by his subject, more moved by his emotion, Eugène Delacroix never fails to tune his lyre to the tone of his thought, so that the first aspect of his picture shall be the prelude to his melody, grave or gay, melancholy or triumphant, sweet or tragic. Afar off, before discerning anything, the spectator forebodes the shows that will strike his soul. What desolation in the crepuscular sky of the 'Christ at the Tomb.' What bitter sadness in the picture of 'Hamlet and the Grave-diggers.' What a sensation of physical well-being in the 'Jewish Wedding in Morocco,' whose harmony, composed of two dominant and complementary colours, red and green, gives the idea of coolness while allowing us to divine without an incandescent sun. What a flourish of trumpets in the colouring of the 'Justice of Trajan,' in which we see the Roman Emperor in his pomp and his purple issuing from a triumphal arch, accompanied by his generals, his trumpeters, and his eagles, while a woman bathed in tears, throws at his feet a dead child. Below, livid tones; above, the splendid, radiant gamut, an arch filled with azure, a sky that becomes dazzling by the contrast formed by the tones of an orange-coloured trophy.

Thus colorists can charm us by means that science has discovered. But the taste for colour, when it predominates absolutely, costs many sacrifices; often it turns the mind from its course, changes the sentiment, swallows up the thought. The impassioned colorist invents his form for his colour, everything is subordinated to the brilliancy of his tints. Not only the drawing bends to it, but the composition is dominated, restrained, forced by the colour. To introduce a tint that shall heighten another, a perhaps useless accessory is introduced. In the 'Massacre of Scio,' a sabre-tache has been put in the corner solely because in that place the painter needed a mass of orange. To reconcile contraries after having heightened them, to bring together similars after having lowered or broken them, he indulges in all sorts of license, seeks pretexts for colour, introduces brilliant objects; furniture, bits of stuff, fragments of mosaic, arms, carpets, vases, flights of steps, walls, animals with rich furs, birds of gaudy plumage; thus, little by little, the lower strata of nature take the first place instead of human beings which alone ought to occupy the pinnacle of art, because they alone represent the loftiest expression of life, which is thought.

In passionately pursuing the triumph of colour, the painter runs the risk of sacrificing the action to the spectacle. Our colorists go to the Orient, to Egypt, Morocco, Spain, to bring back a whole arsenal of brilliant objects; cushions, slippers, narghilehs, turbans, burnous, caftans, mats, parasols. They make heroes of lions and tigers, exaggerate the importance of the landscape, double the interest of the costume, and of inert substances, and thus painting becomes descriptive; high art sensibly declines and threatens to disappear.

Let colour play its true role, which is to bring to us the côrtege of external nature, and to associate the splendours of the material creation with the action or the presence of man. Above all let the colorist choose in the harmonies of colour those that seem to *conform to his thought*. The predominance of colour at the expense of drawing is a usurpation of the relative over the absolute, of fleeting appearance over permanent form, of physical impression over the empire of the soul. As literature tends to its decadence, when images are elevated above ideas, so art grows material and inevitably declines when the mind that draws is conquered by the sensation that colours, when, in a word, the orchestra, instead of accompanying the song, becomes the whole poem.

6 James Clerk Maxwell (1831–1879) 'On Colour Vision'

Maxwell was a Scottish scientist with a devotion to empirical experiment and testing. Among his numerous scientific papers there are several concerned with the perception of colour, commencing with studies on the phenomenon of colour-blindness. Drawing on the earlier work of Newton and Young and on the work of his contemporary Helmholtz (see IVв8), he proposed 'the existence of three elementary sensations, by the combination of which all the actual sensations of colour are produced' in normal vision (1853). The 'elementary qualities' which decided these sensations were the three primary colours, 'so that in mathematical language the quality of a colour may be expressed as a function of three independent variables' (1857). Given the various peculiarities of vision, he concluded that 'investigation into the theory of colour is truly a physiological inquiry' (1861). The following paper offers a summary of developments in the theory of perception of colour, combined with a review of the considerable experimental evidence that Maxwell was able to provide in support of that theory. One important point he makes, contrary to wide assumptions at the time, is that the effect of combining two coloured pigments on the painter's palette does not necessarily coincide with the effect produced by mixing two rays of light of the same colours. The paper was originally given as an illustrated lecture. It was first published in *The Proceedings of the Royal Institution of Great Britain*, volume VI, c. 1872; reprinted in *The Scientific Papers of James Clerk Maxwell*, ed. W. D. Wiven, Cambridge: Cambridge University Press, 1890, volume II, paper XLVII, pp. 267–76, from which this text is taken.

All vision is colour vision, for it is only by observing differences of colour that we distinguish the forms of objects. I include differences of brightness or shade among differences of colour.

It was in the Royal Institution, about the beginning of this century, that Thomas Young made the first distinct announcement of that doctrine of the vision of colours which I propose to illustrate. We may state it thus: – We are capable of feeling three different colour-sensations. Light of different kinds excites these sensations in different proportions, and it is by the different combinations of these three primary sensations that all the varieties of visible colour are produced. In this statement there is one word on which we must fix our attention. That word is, Sensation. It seems almost a truism to say that colour is a sensation; and yet Young, by honestly recognizing this elementary truth, established the first consistent theory of colour. So far as I know, Thomas Young was the first who, starting from the well-known fact

that there are three primary colours, sought for the explanation of this fact, not in the nature of light, but in the constitution of man. Even of those who have written on colour since the time of Young, some have supposed that they ought to study the properties of pigments, and others that they ought to analyse the rays of light. They have sought for a knowledge of colour by examining something in external nature – something out of themselves.

Now, if the sensation which we call colour has any laws, it must be something in our own nature which determines the form of these laws; and I need not tell you that the only evidence we can obtain respecting ourselves is derived from consciousness.

The science of colour must therefore be regarded as essentially a mental science. It differs from the greater part of what is called mental science in the large use which it makes of the physical sciences, and in particular of optics and anatomy. But it gives evidence that it is a mental science by the numerous illustrations which it furnishes of various operations of the mind.

In this place we always feel on firmer ground when we are dealing with physical science. I shall therefore begin by shewing how we apply the discoveries of Newton to the manipulation of light, so as to give you an opportunity of feeling for yourselves the different sensations of colour.

Before the time of Newton, white light was supposed to be of all known things the purest. When light appears coloured, it was supposed to have become contaminated by coming into contact with gross bodies. We may still think white light the emblem of purity, though Newton has taught us that its purity does not consist in simplicity.

We now form the prismatic spectrum on the screen [*exhibited*]. These are the simple colours of which white light is always made up. We can distinguish a great many hues in passing from the one end to the other; but it is when we employ powerful spectroscopes, or avail ourselves of the labours of those who have mapped out the spectrum, that we become aware of the immense multitude of different kinds of light, every one of which has been the object of special study. Every increase of the power of our instruments increases in the same proportion the number of lines visible in the spectrum.

All light, as Newton proved, is composed of these rays taken in different proportions. Objects which we call coloured when illuminated by white light, make a selection of these rays, and our eyes receive from them only a part of the light which falls on them. But if they receive only the pure rays of a single colour of the spectrum they can appear only of that colour. If I place this disk, containing alternate quadrants of red and green paper, in the red rays, it appears all red, but the red quadrants brightest. If I place it in the green rays both papers appear green, but the red paper is now the darkest. This, then, is the optical explanation of the colours of bodies when illuminated with white light. They separate the white light into its component parts, absorbing some and scattering others.

Here are two transparent solutions [*exhibited*]. One appears yellow, it contains bichromate of potash; the other appears blue, it contains sulphate of copper. If I transmit the light of the electric lamp through the two solutions at once, the spot on the screen appears green. By means of the spectrum we shall be able to explain this.

The yellow solution cuts off the blue end of the spectrum, leaving only the red, orange, yellow, and green. The blue solution cuts off the red end, leaving only the green, blue, and violet. The only light which can get through both is the green light, as you see. In the same way most blue and yellow paints, when mixed, appear green. The light which falls on the mixture is so beaten about between the yellow particles and the blue that the only light which survives is the green. But yellow and blue light when mixed do not make green, as you will see if we allow them to fall on the same part of the screen together.

It is a striking illustration of our mental processes that many persons have not only gone on believing, on the evidence of the mixture of pigments, that blue and yellow make green, but that they have even persuaded themselves that they could detect the separate sensations of blueness and of yellowness in the sensation of green.

We have availed ourselves hitherto of the analysis of light by coloured substances. We must now return, still under the guidance of Newton, to the prismatic spectrum. Newton not only

'Untwisted all the shining robe of day,'

but shewed how to put it together again. We have here a pure spectrum, but instead of catching it on a screen we allow it to pass through a lens large enough to receive all the coloured rays. These rays proceed, according to well-known principles in optics, to form an image of the prism on a screen placed at the proper distance. This image is formed by rays of all colours, and you see the result is white. But if I stop any of the coloured rays the image is no longer white, but coloured; and if I only let through rays of one colour, the image of the prism appears of that colour.

I have here an arrangement of slits by which I can select one, two, or three portions of the light of the spectrum, and allow them to form an image of the prism while all the rest are stopped. This gives me a perfect command of the colours of the spectrum, and I can produce on the screen every possible shade of colour by adjusting the breadth and the position of the slits through which the light passes. I can also, by interposing a lens in the passage of the light, shew you a magnified image of the slits, by which you will see the different kinds of light which compose the mixture.

The colours are at present red, green, and blue, and the mixture of the three colours is, as you see, nearly white. Let us try the effect of mixing two of these colours. Red and blue form a fine purple or crimson, green and blue form a sea-green or sky-blue, red and green form a yellow.

Here again we have a fact not universally known. No painter, wishing to produce a fine yellow, mixes his red with his green. The result would be a very dirty drab colour. He is furnished by nature with brilliant yellow pigments, and he takes advantage of these. When he mixes red and green paint, the red light scattered by the red paint is robbed of nearly all its brightness by getting among particles of green, and the green light fares no better, for it is sure to fall in with particles of red paint. But when the pencil with which we paint is composed of the rays of light, the effect of two coats of colour is very different. The red and the green form a yellow of great splendour, which may be shewn to be as intense as the purest yellow of the spectrum.

I have now arranged the slits to transmit the yellow of the spectrum. You see it is similar in colour to the yellow formed by mixing red and green. It differs from the mixture, however, in being strictly homogeneous in a physical point of view. The prism, as you see, does not divide it into two portions as it did the mixture. Let us now combine this yellow with the blue of the spectrum. The result is certainly not green; we may make it pink if our yellow is of a warm hue, but if we choose a greenish yellow we can produce a good white.

You have now seen the most remarkable of the combinations of colours – the others differ from them in degree, not in kind. I must now ask you to think no more of the physical arrangements by which you were enabled to see these colours, and to concentrate your attention upon the colours you saw, that is to say on certain sensations of which you were conscious. We are here surrounded by difficulties of a kind which we do not meet with in purely physical inquiries. We can all feel these sensations, but none of us can describe them. They are not only private property, but they are incommunicable. We have names for the external objects which excite our sensations, but not for the sensations themselves.

When we look at a broad field of uniform colour, whether it is really simple or compound, we find that the sensation of colour appears to our consciousness as one and indivisible. We cannot directly recognize the elementary sensations of which it is composed, as we can distinguish the component notes of a musical chord. A colour, therefore, must be regarded as a single thing, the quality of which is capable of variation.

To bring a quality within the grasp of exact science, we must conceive it as depending on the values of one or more variable quantities, and the first step in our scientific progress is to determine the number of these variables which are necessary and sufficient to determine the quality of a colour. We do not require any elaborate experiments to prove that the quality of colour can vary in three and only in three independent ways.

One way of expressing this is by saying, with the painters, that colour may vary in hue, tint, and shade.

The finest example of a series of colours, varying in hue, is the spectrum itself. A difference in hue may be illustrated by the difference between adjoining colours in the spectrum. The series of hues in the spectrum is not complete; for, in order to get purple hues, we must blend the red and the blue.

Tint may be defined as the degree of purity of a colour. Thus, bright yellow, buff, and cream-colour, form a series of colours of nearly the same hue, but varying in tint. The tints, corresponding to any given hue, form a series, beginning with the most pronounced colour, and ending with a perfectly neutral tint.

Shade may be defined as the greater or less defect of illumination. If we begin with any tint of any hue, we can form a gradation from that colour to black, and this gradation is a series of shades of that colour. Thus we may say that brown is a dark shade of orange.

The quality of a colour may vary in three different and independent ways. We cannot conceive of any others. In fact, if we adjust one colour to another, so as to agree in hue, in tint, and in shade, the two colours are absolutely indistinguishable. There are therefore three, and only three, ways in which a colour can vary.

I have purposely avoided introducing at this stage of our inquiry anything which may be called a scientific experiment, in order to shew that we may determine the number of quantities upon which the variation of colour depends by means of our ordinary experience alone.

Here is a point in this room: if I wish to specify its position, I may do so by giving the measurements of three distances – namely, the height above the floor, the distance from the wall behind me, and the distance from the wall at my left hand.

This is only one of many ways of stating the position of a point, but it is one of the most convenient. Now, colour also depends on three things. If we call these the intensities of the three primary colour sensations, and if we are able in any way to measure these three intensities, we may consider the colour as specified by these three measurements. Hence the specification of a colour agrees with the specification of a point in the room in depending on three measurements.

Let us go a step farther and suppose the colour sensations measured on some scale of intensity, and a point found for which the three distances, or co-ordinates, contain the same number of feet as the sensations contain degrees of intensity. Then we may say, by a useful geometrical convention, that the colour is represented, to our mathematical imagination, by the point so found in the room; and if there are several colours, represented by several points, the chromatic relations of the colours will be represented by the geometrical relations of the points. This method of expressing the relations of colours is a great help to the imagination. . . .

There is a still more convenient method of representing the relations of colours by means of Young's triangle of colours. It is impossible to represent on a plane piece of paper every conceivable colour, to do this requires space of three dimensions. If, however, we consider only colours of the same shade – that is, colours in which the sum of the intensities of the three sensations is the same, then the variations in tint and in hue of all such colours may be represented by points on a plane. For this purpose we must draw a plane cutting off equal lengths from the three lines representing the primary sensations. The part of this plane within the space in which we have been distributing our colours will be an equilateral triangle. The three primary colours will be at the three angles, white or grey will be in the middle, the tint or degree of purity of any colour will be expressed by its distance from the middle point, and its hue will depend on the angular position of the line which joins it with the middle point.

Thus the ideas of tint and hue can be expressed geometrically on Young's triangle. To understand what is meant by shade we have only to suppose the illumination of the whole triangle increased or diminished, so that by means of this adjustment of illumination Young's triangle may be made to exhibit every variety of colour. If we now take any two colours in the triangle and mix them in any proportions, we shall find the resultant colour in the line joining the component colours at the point corresponding to their centre of gravity.

I have said nothing about the nature of the three primary sensations, or what particular colours they most resemble. In order to lay down on paper the relations between actual colours, it is not necessary to know what the primary colours are. We may take any three colours, provisionally, as the angles of a triangle, and determine the position of any other observed colour with respect to these, so as to form a kind of chart of colours.

Of all colours which we see, those excited by the different rays of the prismatic spectrum have the greatest scientific importance. All light consists either of some one kind of these rays, or of some combination of them. The colours of all natural bodies are compounded of the colours of the spectrum. If therefore we can form a chromatic chart of the spectrum, expressing the relations between the colours of its different portions, then the colours of all natural bodies will be found within a certain boundary on the chart defined by the positions of the colours of the spectrum.

But the chart of the spectrum will also help us to the knowledge of the nature of the three primary sensations. Since every sensation is essentially a positive thing, every compound colour-sensation must be within the triangle of which the primary colours are the angles. In particular, the chart of the spectrum must be entirely within Young's triangle of colours, so that if any colour in the spectrum is identical with one of the colour-sensations, the chart of the spectrum must be in the form of a line having a sharp angle at the point corresponding to this colour.

I have already shewn you how we can make a mixture of any three of the colours of the spectrum, and vary the colour of the mixture by altering the intensity of any of the three components. If we place this compound colour side by side with any other colour, we can alter the compound colour till it appears exactly similar to the other. This can be done with the greatest exactness when the resultant colour is nearly white. I have therefore constructed an instrument which I may call a colour-box, for the purpose of making matches between two colours.

[. . .] The observer looks into the box through a small slit. He sees a round field of light consisting of two semicircles divided by a vertical diameter. The semicircle on the left consists of light which has been enfeebled by two reflexions at the surface of glass. That on the right is a mixture of colours of the spectrum, the positions and intensities of which are regulated by a system of slits.

The observer forms a judgment respecting the colours of the two semicircles. Suppose he finds the one on the right hand redder than the other, he says so, and the operator, by means of screws outside the box, alters the breadth of one of the slits, so as to make the mixture less red; and so on, till the right semicircle is made exactly of the same appearance as the left, and the line of separation becomes almost invisible.

When the operator and the observer have worked together for some time, they get to understand each other, and the colours are adjusted much more rapidly than at first.

When the match is pronounced perfect, the positions of the slits, as indicated by a scale, are registered, and the breadth of each slit is carefully measured by means of a gauge. The registered result of an observation is called a 'colour equation.' It asserts that a mixture of three colours is, in the opinion of the observer (whose name is given), identical with a neutral tint, which we shall call Standard White. Each colour is specified by the position of the slit on the scale, which indicates its position in the spectrum, and by the breadth of the slit, which is a measure of its intensity.

In order to make a survey of the spectrum we select three points for purposes of comparison, and we call these the three Standard Colours. The standard colours are selected on the same principles as those which guide the engineer in selecting

stations for a survey. They must be conspicuous and invariable and not in the same straight line.

In the chart of the spectrum you may see the relations of the various colours of the spectrum to the three standard colours, and to each other. It is manifest that the standard green which I have chosen cannot be one of the true primary colours, for the other colours do not all lie within the triangle formed by joining them. But the chart of the spectrum may be described as consisting of two straight lines meeting in a point. This point corresponds to a green about a fifth of the distance from b towards F. This green has a wave length of about 510 millionths of a millimetre by Ditscheiner's measurement. This green is either the true primary green, or at least it is the nearest approach to it which we can ever see. Proceeding from this green towards the red end of the spectrum, we find the different colours lying almost exactly in a straight line. This indicates that any colour is chromatically equivalent to a mixture of any two colours on opposite sides of it, and in the same straight line. The extreme red is considerably beyond the standard red, but it is in the same straight line, and therefore we might, if we had no other evidence, assume the extreme red as the true primary red. We shall see, however, that the true primary red is not exactly represented in colour by any part of the spectrum. It lies somewhat beyond the extreme red, but in the same straight line.

On the blue side of primary green the colour equations are seldom so accurate. The colours, however, lie in a line which is nearly straight. I have not been able to detect any measurable chromatic difference between the extreme indigo and the violet. The colours of this end of the spectrum are represented by a number of points very close to each other. We may suppose that the primary blue is a sensation differing little from that excited by the parts of the spectrum near G.

Now, the first thing which occurs to most people about this result is that the division of the spectrum is by no means a fair one. Between the red and the green we have a series of colours apparently very different from either, and having such marked characteristics that two of them, orange and yellow, have received separate names. The colours between the green and the blue, on the other hand, have an obvious resemblance to one or both of the extreme colours, and no distinct names for these colours have ever become popularly recognized.

I do not profess to reconcile this discrepancy between ordinary and scientific experience. It only shews that it is impossible by a mere act of introspection to make a true analysis of our sensations. Consciousness is our only authority; but consciousness must be methodically examined in order to obtain any trustworthy results.

I have here . . . a picture of the structure upon which the light falls at the back of the eye. There is a minute structure of bodies like rods and cones or pegs, and it is conceivable that the mode in which we become aware of the shapes of things is by a consciousness which differs according to the particular rods on the ends of which the light falls, just as the pattern on the web formed by a Jacquard loom depends on the mode in which the perforated cards act on the system of moveable rods in that machine. In the eye we have on the one hand light falling on this wonderful structure, and on the other hand we have the sensation of sight. We cannot compare these two things; they belong to opposite categories. The whole of Metaphysics lies like a great

gulf between them. It is possible that discoveries in physiology may be made by tracing the course of the nervous disturbance

'Up the fine fibres to the sentient brain;'

but this would make us no wiser than we are about those colour-sensations which we can only know by feeling them ourselves. Still, though it is impossible to become acquainted with a sensation by the anatomical study of the organ with which it is connected, we may make use of the sensation as a means of investigating the anatomical structure.

7 Gustav Theodor Fechner (1801–1887) 'Aesthetics from Above and from Below'

Fechner trained as a physician and a physicist and in 1834 was appointed professor of physics at Leipzig. Shortly thereafter, however, he succumbed to a protracted and debilitating illness in which he developed an extreme sensitivity to light and was temporarily obliged to give up all reading and writing, able to endure only a darkened room. He later developed an interest in the connection between psychological and physiological phenomena, and helped to formulate the Weber–Fechner law relating stimuli to sensations. His *Elemente der Psychophysik* (Elements of psychophysics), published in 1860, was influential on the theories of the Symbolists who saw it as providing scientific support for the notion of 'correspondences', taken up from the writings of Baudelaire (see IIID 4, above). In the 1870s Fechner turned his attention to the domain of aesthetics. His *Vorschule der Aesthetik* (Introduction to aesthetics), published in 1876, represents an important contribution to the new, experimental–empirical approach to the subject. The following extract reprints the famous opening chapter in which Fechner distinguishes between two different paths, the path 'from above' characteristic of the work of Kant, Hegel and Schelling, and the path 'from below' which seeks to derive general laws only on the basis of close examination of empirical evidence. Fechner finds a starting point for empirically verifiable study in the investigation of the causal relationship between the outer object and the pleasure to which it gives rise, narrowly defining aesthetics as the doctrine of what is pleasurable and displeasurable. This extract has been translated for the present volume by Jason Gaiger from chapter one of *Vorschule der Aesthetik*, in the edition published in Leipzig: Breitkopf & Härtel, 1925, pp. 1–6.

The two different ways in which we seek to ground and develop human knowledge are also applicable in the realm of aesthetics, that is, the doctrine of what is pleasurable and displeasurable, or what others term the doctrine of beauty. To use a convenient expression, human knowledge is either treated *from above*, in which case enquiry starts out from the most general ideas and concepts and descends to the particular, or it is treated *from below*, in which case enquiry starts out from the particular and ascends to the universal. In the first case, the domain of aesthetic experience is categorized and subsumed under an ideal framework which is constructed from the highest points of view; in the latter case, the whole aesthetic edifice is built up from below on the basis of aesthetic facts and laws. The former is concerned in the first and highest instance with the ideas or concepts of beauty, art and style, and their position in the system of

universal concepts, especially their relation to the true and the good. From here further ascent is gladly made to the absolute, the divine, the divine ideas and the divine act of creation. From the pure heights of such universality descent is then made down into the mundane empirical realm of the particular, into the temporal and spatial manifestation of the beautiful, such that everything particular is measured against the criterion of the universal. In contrast, the latter procedure starts out with the experience of what is pleasurable and displeasurable and employs this as the basis for all the concepts and laws which are to play a role in aesthetics. Whilst taking into account the universal laws governing what ought to be the case, under which the laws of pleasure must always be subordinated, it seeks increasingly to generalize these concepts and laws and thereby to arrive at a system with the greatest possible universality.

The two methods of procedure can be distinguished as *philosophical* and *empirical*. In themselves they do not stand in contradiction with each other. For, on the one hand, a correct and complete knowledge of the highest principles of existence, of divine and human things, must also include a correct understanding of actual aesthetic relations. And on the other, the correct universalization of the facts and laws of the aesthetic domain gained through experience must enter into this higher knowledge. Both cover the same domain, but from opposite directions, and the possibility of progress in one direction is everywhere increased by progress in the other. Both paths, however, possess their own particular advantages, and their own difficulties and dangers.

The first path places us, so to speak, from the outset at the goal, which on the second path we must strive to reach, and from there provides us with the most general perspective and the loftiest points of view. However, along this path it is difficult to gain a clear orientation concerning the grounds of pleasure and displeasure in the particular case – and this is something with which, none the less, we must also be concerned. We remain in the realm of more or less determinate floating concepts which in their universality cannot sharply distinguish the particular. Moreover, in order for this path to lead us in the right direction it must presuppose a correct starting point, something which can only be provided by a comprehensive philosophical or even theological system – neither of which do we possess. All we have are manifold attempts at constructing such a system, together with manifold attempts to establish the relation of aesthetics within it, all of which leave a great deal to be desired. None the less, such attempts must be seen to accommodate the need for the highest and most universal points of view, and even if they do not fully satisfy this need they at least serve to occupy it and keep it alive. Such advantages and disadvantages are more or less discernible in the great variety of different theories of aesthetics and the different ways of treating questions of aesthetics which, taking their orientation from Schelling, Hegel and even Kant, seek to pursue the direction from above.

In contrast, the other path, that from below, preserves or at least promises to preserve a clear orientation not only in the set of concepts under which the domain of pleasure and displeasure is to be subsumed, but also as concerns the grounds of pleasure and displeasure in the individual and immediate case. On this path, however, universal ideas and points of view are only reached with difficulty and one can easily remain trapped in particularities, one-sidedness and viewpoints which possess only

subsidiary value and compass. This can be seen in the case of those Englishmen (such as Hutcheson, Hogarth, Burke, Hay and others) who have preferred to pursue the path from below.

In light of the above remarks, it is clear that of the various attempts to treat of the subject of aesthetics which have so far been carried out, those pursued in accordance with the first approach are more likely to satisfy someone whose principal interest resides in the subsumption of things under the most universal concepts and ideas and who is content with striving for their correct arrangement, without raising stricter claims to clarity and objectivity. On the other hand, the attempt to deal with aesthetics along the second path is more likely to satisfy someone who is primarily concerned with gaining a simple and clear orientation in what lies directly before him and who does not raise claims to any elevation or universality greater than the point which has in fact been reached. In general, it can be said that higher demands or expectations are placed on an aesthetics from above, but that the lower expectations placed on an aesthetics from below are more easily satisfied.

Should an aesthetics from above be carried out which actually realizes what previous attempts have tended to promise rather than achieve, then, in my opinion, one of the highest and ultimate principles from which it must begin is to progress slowly and carefully not only through the domain of aesthetics but all the other individual domains of human knowledge whilst taking into account practical or moral demands. From here it should then be possible to descend once again into the individual branches of human knowledge, such that each of the spheres of human knowledge not only reveals its dependency on higher points of view, which otherwise could only have been reached by an upward path, but also allows its content to appear clarified and justified through its connection with other branches of human knowledge in a way which the path upwards could not have revealed. However, an aesthetic of this sort, determined by higher points of view, remains a thing of the future and all previous attempts to develop such an aesthetic are better suited to characterizing and keeping us aware of the legitimate task involved than actually to realizing it.

There can, then, be a philosophical aesthetics of a higher order in relation to empirical aesthetics, just as there can be a philosophy of nature which is higher than physics and physiology, even if such a philosophy does not yet exist. But just as a correct philosophy of nature would not replace, or dismiss these disciplines on *a priori* grounds, but rather requires them – without yet losing itself in their degree of specialization – as the foundation and presupposition of its own activity, so a philosophical aesthetics of a higher order would also require an empirical aesthetics. However, in the latter case what is still missing is just this empirical foundation; and for this reason all of our systems of philosophical aesthetics seem to me like mighty giants with feet of clay.

From this it can clearly be seen that I consider an aesthetics from below to be an essential precondition for carrying out an aesthetics from above. And since up to now these and other preconditions have not been adequately fulfilled, I cannot enter onto the path from above with any more clarity, security or confidence of success than others before me. For this reason I propose to hold strictly to the path from below and to make my own small contribution to fulfilling these essential preconditions,

whereby I lay claim to all the advantages of this path without being able to avoid its intrinsic disadvantages. However, I shall at least strive to avoid the dangers which it presents.

It may well be asked whether it is possible to combine the merits and advantages of both procedures by illuminating the path from below with ideas and guiding it with principles derived from above. This sounds fine, and, indeed, there have been many recent attempts to commence the path from below in this fashion, or to grasp the path from above in this way. The most universal formal principles of thought and enquiry which belong to aesthetics from above and below should remain the same as those in other domains of enquiry; and here the same applies to aesthetics as to physics which has been confused and led astray by the light with which the philosophy of nature has sought to clarify and lead its enquiries. Whoever is searching for light – and pursuing the path from below is such a search – cannot seek to illuminate this path with a light that is already given.

In my opinion the following are to be characterized amongst the essential tasks of a general aesthetics: first, the clear presentation of the concepts under which aesthetic facts and relations are to be ordered, and second, the establishment of the laws which these facts and relations obey. The most important employment of these laws pertains to the doctrine of art. However, the approach pursued by an aesthetics from above has tended only to recognize the first of these tasks, in so far as it has sought to substitute the explanation of aesthetic facts by reference to laws with the explanation of aesthetic facts by reference to concepts or ideas, rather than supplementing the former by means of the latter.

In fact, if one looks at the majority of the available text books and general treatises on aesthetics – most of which follow the path from above – it can be seen that the principal content of these accounts is made up of discussions and disputes concerning the correct determination of the concepts of beauty, sublimity, ugliness, the agreeable, the charming, the comic, the tragic, the absurd, humour, style, manner, art, artistic beauty, natural beauty, the subsumption of particular cases under these concepts and the division of the complete domain of aesthetics from the point of view of each concept. But the task of aesthetics is not thereby completed. For every time we encounter something which might be considered aesthetic the question we must ask is not only: under which concept can it be ordered?, or, what place does it occupy in the system of our concepts as a whole? These are, indeed, important questions, and are a necessary aspect of gaining clear orientation in our knowledge. However, the most important and interesting question remains: why does this object please or displease us and with what right does it give rise to pleasure or displeasure? This question can only be answered through reference to the laws of pleasure and displeasure, taking into account the law of what ought to be, just as the question concerning why it is that a body moves in such and such a way and in what way we should cause it to move is not to be answered through reference to the concept of movement and its various different types, but through reference to the law of movement and through consideration of the different ends to which this law can be applied. As long as the conceptual explanation of aesthetics is not completed with an explanation of the laws of aesthetics, it must remain an empty frame.

8 Hermann von Helmholtz (1821–1894) 'On the Relation of Optics to Painting'

The German physicist and physiologist Hermann von Helmholtz possessed one of the most versatile minds of the nineteenth century. At the age of 26 he formulated the principle of the conservation of energy, now recognized as the first law of thermodynamics, in a paper given to the Physical Society of Berlin. His work on seeing, especially the perception of colour, is regarded as fundamental to modern visual science. He was the first to carry out a thorough experimental study of the eye, inventing the opthalmoscope which made possible the observation of the retina. His *Handbook of Physiological Optics*, published in three volumes in 1856–7, remains the classical text on the eye. He also made an important contribution to physiological acoustics in his pioneering study, *On the Sensations of Tone as a Physiological Basis for the Theory of Music*, published in 1863. Helmholtz refers to this work at the start of the present text, in which he turns his attention from music towards the visual arts. Drawing on research into the physiological basis of our perception of colour, shade and form, Helmholtz seeks to uncover the underlying processes governing the diverse optical effects which painting achieves. He shows how great the difference is between our perception of natural phenomena and our perception of *depictions* of these phenomena, reaching the conclusion that 'the artist cannot transcribe Nature; he must translate her', that is, he must seek to achieve corresponding effects through techniques internal to the medium of painting. Originally published as 'Optisches über Malerei' in *Populäre Wissenschaftliche Vorträge*, volume III, Braunschweig, 1876, Helmholtz's essay was translated into French in 1878, and into English in 1881. The present extracts are taken from this first English translation, made by E. Atkinson and published in Helmholtz, *Popular Lectures on Scientific Subjects*, London: Longmans, Green & Co., 1881, pp. 73–5, 94–7, 98–101, 135–8.

I fear that the announcement of my intention to address you on the subject of plastic art may have created no little surprise among some of my hearers. For I cannot doubt that many of you have had more frequent opportunities of viewing works of art, and have more thoroughly studied its historical aspects, than I can lay claim to have done; or indeed have had personal experience in the actual practice of art, in which I am entirely wanting. I have arrived at my artistic studies by a path which is but little trod, that is, by the physiology of the senses; and in reference to those who have a long acquaintance with, and who are quite at home in the beautiful fields of art, I may compare myself to a traveller who has entered upon them by a steep and stony mountain path, but who, in doing so, has passed many a stage from which a good point of view is obtained. If therefore I relate to you what I consider I have observed, it is with the understanding that I wish to regard myself as open to instruction by those more experienced than myself.

The physiological study of the manner in which the perceptions of our senses originate, how impressions from without pass into our nerves, and how the condition of the latter is thereby altered, presents many points of contact with the theory of the fine arts. On a former occasion I endeavoured to establish such a relation between the physiology of the sense of hearing, and the theory of music. Those relations in that case are particularly clear and distinct, because the elementary forms of music depend more closely on the nature and on the peculiarities of our perceptions than is the case

in other arts, in which the nature of the material to be used and of the objects to be represented has a far greater influence. Yet even in those other branches of art, the especial mode of perception of that organ of sense by which the impression is taken up is not without importance; and a theoretical insight into its action, and into the principle of its methods, cannot be complete if this physiological element is not taken into account. Next to music this seems to predominate more particularly in painting, and this is the reason why I have chosen painting as the subject of my present lecture.

* * *

It might at first sight appear that of the requisite truth to nature of a picture, so much would remain that, seen from the proper point of view, it would at least produce the same distribution of light, colour, and shadow in its field of view, and would produce in the interior of the eye exactly the same image on the retina as the object represented would do if we had it actually before us, and looked at it from a definite, fixed point of view. It might seem to be an object of pictorial skill to aim at producing, under the given limitations, the *same* effect as is produced by the object itself.

If we proceed to examine whether, and how far, painting can satisfy such a condition, we come upon difficulties before which we should perhaps shrink, if we did not know that they had been already overcome.

Let us begin with the simplest case; with the quantitative relations between luminous intensities. If the artist is to imitate exactly the impression which the object produces on our eye, he ought to be able to dispose of brightness and darkness equal to that which nature offers. But of this there can be no idea. Let me give a case in point. Let there be, in a picture-gallery, a desert-scene, in which a procession of Bedouins, shrouded in white, and of dark negroes, marches under the burning sunshine; close to it a bluish moonlight scene, where the moon is reflected in the water, and groups of trees, and human forms, are seen to be faintly indicated in the darkness. You know from experience that both pictures, if they are well done, can produce with surprising vividness the representation of their objects; and yet, in both pictures, the brightest parts are produced with the same white-lead, which is but slightly altered by admixtures; while the darkest parts are produced with the same black. Both, being hung on the same wall, share the same light, and the brightest as well as the darkest parts of the two scarcely differ as concerns the degree of their brightness.

How is it, however, with the actual degrees of brightness represented? The relation between the brightness of the sun's light, and that of the moon, was measured by Wollaston, who compared their intensities with that of the light of candles of the same material. He thus found that the luminosity of the sun is 800,000 times that of the brightest light of a full moon.

An opaque body, which is lighted from any source whatever, can, even in the most favourable case, only emit as much light as falls upon it. Yet, from Lambert's observations, even the whitest bodies only reflect about two fifths of the incident light. The sun's rays, which proceed parallel from the sun, whose diameter is 85,000 miles, when they reach us, are distributed uniformly over a sphere 195 millions of miles in diameter. Its density and illuminating power is here only the one

forty-thousandth of that with which it left the sun's surface; and Lambert's number leads to the conclusion that even the brightest white surface on which the sun's rays fall vertically, has only the one hundred-thousandth part of the brightness of the sun's disk. The moon however is a grey body, whose mean brightness is only about one fifth of that of the purest white.

And when the moon irradiates a body of the purest white on the earth, its brightness is only the hundred-thousandth part of the brightness of the moon itself; hence the sun's disk is 80,000 million times brighter than a white which is irradiated by the full moon.

Now pictures which hang in a room are not lighted by the direct light of the sun, but by that which is reflected from the sky and clouds. I do not know of any direct measurements of the ordinary brightness of the light in a picture gallery, but estimates may be made from known data. With strong upper light and bright light from the clouds, the brightest white on a picture has probably 1-20th of the brightness of white directly lighted by the sun; it will generally be only 1-40th, or even less.

Hence the painter of the desert, even if he gives up the representation of the sun's disk, which is always very imperfect, will have to represent the glaringly lighted garments of his Bedouins with a white which, in the most favourable case, shows only the 1-20th part of the brightness which corresponds to actual fact. If he could bring it, with its lighting unchanged, into the desert near the white there, it would seem like a dark grey. I found in fact, by an experiment, that lamp-black, lighted by the sun, is not less than half as bright, as shaded white in the brighter part of a room.

On the picture of the moon, the same white which has been used for depicting the Bedouins' garments must be used for representing the moon's disk, and its reflection in the water; although the real moon has only one fifth of this brightness, and its reflection in water still less. Hence white garments in moonlight, or marble surfaces, even when the artist gives them a grey shade, will always be ten to twenty times as bright in his picture as they are in reality.

On the other hand, the darkest black which the artist could apply would be scarcely sufficient to represent the real illumination of a white object on which the moon shone. For even the deadest black coatings of lamp-black, black velvet, when powerfully lighted appear grey, as we often enough know to our cost, when we wish to shut off superfluous light. I investigated a coating of lamp-black, and found its brightness to be about $\frac{1}{100}$ that of white paper. The brightest colours of a painter are only about one hundred times as bright as his darkest shades.

The statements I have made may perhaps appear exaggerated. But they depend upon measurements, and you can control them by well-known observations. According to Wollaston, the light of the full moon is equal to that of a candle burning at a distance of 12 feet. You know that we cannot read by the light of the full moon, though we can read at a distance of three or four feet from a candle. Now assume that you suddenly passed from a room in daylight to a vault perfectly dark, with the exception of the light of a single candle. You would at first think you were in absolute darkness, and at most you would only recognize the candle itself. In any case, you would not recognize the slightest trace of any objects at a distance of 12 feet from the candle. These however are the objects whose illumination is the same as that which

the moonlight gives. You would only become accustomed to the darkness after some time, and you would then find your way about without difficulty.

If, now, you return to the daylight, which before was perfectly comfortable, it will appear so dazzling that you will perhaps have to close the eyes, and only be able to gaze round with a painful glare. You see thus that we are concerned here not with minute, but with colossal, differences. How now is it possible that, under such circumstances, we can imagine there is any similarity between the picture and reality?

Our discussion of what we did not see at first, but could afterwards see in the vault, points to the most important element in the solution; it is the varying extent to which our senses are deadened by light; a process to which we can attach the same name, fatigue, as that for the corresponding one in the muscle. Any activity of our nervous system diminishes its power for the time being. The muscle is tired by work, the brain is tired by thinking, and by mental operations; the eye is tired by light, and the more so the more powerful the light. Fatigue makes it dull and insensitive to new impressions, so that it appreciates strong ones only moderately, and weak ones not at all.

But now you see how different is the aim of the artist when these circumstances are taken into account. The eye of the traveller in the desert, who is looking at the caravan, has been dulled to the last degree by the dazzling sunshine; while that of the wanderer by moonlight has been raised to the extreme of sensitiveness. The condition of one who is looking at a picture differs from both the above cases by possessing a certain mean degree of sensitiveness. Accordingly, the painter must endeavour to produce by his colours, on the moderately sensitive eye of the spectator, the same impression as that which the desert, on the one hand, produces on the deadened, and the moonlight, on the other hand, creates on the untired eye of its observer. Hence, along with the actual luminous phenomena of the outer world, the different physiological conditions of the eye play a most important part in the work of the artist. What he has to give is not a mere transcript of the object, but a translation of his impression into another scale of sensitiveness, which belongs to a different degree of impressibility of the observing eye, in which the organ speaks a very different dialect in responding to the impressions of the outer world.

* * *

The artist cannot transcribe Nature; he must translate her; yet this translation may give us an impression in the highest degree distinct and forcible, not merely of the objects themselves, but even of the greatly altered intensities of light under which we view them. The altered scale is indeed in many cases advantageous, as it gets rid of everything which, in the actual objects, is too dazzling, and too fatiguing for the eye. Thus the imitation of Nature in the picture is at the same time an ennobling of the impression on the senses. In this respect we can often give ourselves up more calmly and continuously, to the consideration of a work of art, than to that of a real object. The work of art can produce those gradations of light, and those tints in which the modelling of the forms is most distinct and therefore most expressive. It can bring forward a fulness of vivid fervent colours, and by skilful contrast can retain the sensitiveness of the eye in advantageous equilibrium. It can fearlessly apply the entire energy of powerful sensuous impressions, and the feeling of delight associated therewith, to direct and enchain the attention; it can use their variety to heighten the direct

understanding of what is represented, and yet keep the eye in a condition of excitation most favourable and agreeable for delicate sensuous impressions.

If, in these considerations, my having continually laid much weight on the lightest, finest, and most accurate sensuous intelligibility of artistic representation, may seem to many of you as a very subordinate point – a point which, if mentioned at all by writers on aesthetics, is treated as quite accessory – I think this is unjustly so. The sensuous distinctness is by no means a low or subordinate element in the action of works of art; its importance has forced itself the more strongly upon me the more I have sought to discover the physiological elements in their action.

What effect is to be produced by a work of art, using this word in its highest sense? It should excite and enchain our attention, arouse in us, in easy play, a host of slumbering conceptions and their corresponding feelings, and direct them towards a common object, so as to give a vivid perception of all the features of an ideal type, whose separate fragments lie scattered in our imagination and overgrown by the wild chaos of accident. It seems as if we can only refer the frequent preponderance, in the mind, of art over reality, to the fact that the latter mixes something foreign, disturbing, and even injurious; while art can collect all the elements for the desired impression, and allow them to act without restraint. The power of this impression will no doubt be greater the deeper, the finer, and the truer to nature is the sensuous impression which is to arouse the series of images and the effects connected therewith. It must act certainly, rapidly, unequivocally, and with accuracy if it is to produce a vivid and powerful impression. These essentially are the points which I have sought to comprehend under the name of intelligibility of the work of art.

Then the peculiarities of the painters' technique [*Technik*], to which physiological optical investigation have led us, are often closely connected with the highest problems of art. We may perhaps think that even the last secret of artistic beauty – that is, the wondrous pleasure which we feel in its presence – is essentially based on the feeling of an easy, harmonic, vivid stream of our conceptions, which, in spite of manifold changes, flow towards a common object, bring to light laws hitherto concealed, and allow us to gaze in the deepest depths of sensation of our own minds.

9 Ogden Rood (1831–1902) 'On the Mixture of Colors'

Rood was an American physicist and theorist of colour who studied for four years in Berlin and Munich before being appointed to the Chair of Physics at Columbia University, a post he occupied from 1863 till the end of his life. He was also an amateur artist and member of the American Watercolor Society. In 1874 he delivered two lectures on 'Modern Optics in Painting' to the National Academy of Design in New York. His assertion in that context that 'colour is a sensation existing merely in ourselves' was consistent with the conclusions Maxwell had reached. The three constants into which he divided colour – purity, luminosity and hue – were equivalent to Maxwell's tint, shade and hue. His handbook on colour was first issued in 1879 as *Modern Chromatics, with Applications to Art and Industry* (New York: D. Appleton & Co, and London: C. Kegan Paul & Co.). German and French versions followed in quick succession: *Die moderne Farbenlehre*...1880 (Leipzig: F. A. Brockhaus) and *Théorie Scientifique des Couleurs*...1881 (Paris: Librairie Germer Baillière et Cie). Two years after its first publication, the English-language version was reissued with the

subtitle *Students' Textbook of Color*, which was precisely what the publication had rapidly and widely become. The key to the success of Rood's book lay in its combination of the virtues of its predecessors: like Blanc's *Grammar*, it was marked by attentiveness to the painter's practice, yet like Maxwell's work (which it often echoes) it carried the authority of rigorous scientific demonstration. One passage in particular played a suggestive part in the development of a 'Neo-Impressionist' technique by Seurat and his followers (see VIв9). This is where Rood refers to 'the custom of placing a quantity of small dots of two colours very near each other' as 'almost the only practical [method] at the disposal of the artist whereby he can actually mix, not pigments, but masses of coloured light'. In connection with the reference to Ruskin, with whom Rood corresponded, see IVв1. Our excerpt is taken from the original New York edition, 1879, chapter X, pp. 124–7 and 139–43.

Those who watch a painter at work are astonished at the vast number and variety of tints which can be made by mixing in varying proportions a very few pigments: from red and yellow there is produced a great series of orange tints; yellow and blue furnish a multitude of green hues; blue and red, a series of purples. The results seem almost magical, and we justly admire the skill and knowledge which enable him in a few seconds accurately to match any colour which is within the compass of his palette. As we continue our observations we soon find that the matter is more complicated than it appeared at first sight, each pigment having a particular set of properties which it carries into its mixtures, and these properties being by no means fully indicated by its mere colour. Thus, some blue pigments furnish fine sets of greens, while others, as beautiful and intense, yield only dull olive-greens; some reds give glowing purples, while from others not less bright it is possible to obtain only dull, slaty purples. Before touching on these complicated cases it will be well to study this subject under its simplest aspects, and to content ourselves for the present with making an examination of the effects which are produced by mixing *light* of different colours. This can not be brought about by mixing pigments, as was for a long time supposed. In some cases the mixture of pigments gives results more or less like those produced by the mixture of coloured light, but as a general thing they differ, and in some cases the difference is enormous. In the previous chapter, for instance, it was shown that while the mixture of yellow with blue pigments produced invariably a green hue of varying intensity, the mixture of blue with yellow light gave a more or less pure white, but under no circumstances anything approaching green. The mixture of two masses of coloured light can easily be effected in a simple manner so as to be exhibited readily to a large audience. Two magic lanterns are to be employed, ... the usual slides being replaced by plates of coloured glass. ... Each lantern then will furnish a large bright circle of coloured light, which can be projected on a white screen, the room in which the experiments are made being first darkened. In this way it will be found that violet-blue light when mixed with green light gives blue or greenish-blue light, according to the proportions of the two constituents; green with red gives various hues of orange or whitish yellow, instead of a set of dull, indescribable shades of greenish, reddish, or brownish grey, as is the case with pigments. These and many other beautiful experiments on the mixture of coloured light can easily be made; and even the effects produced by varying the intensity of either of the masses of coloured light can readily be studied by gradually diminishing the brightness of one of the coloured circles, the other remaining constant.

To all these experiments it may be objected that we are not using coloured light of sufficient purity; that our yellow glass transmits . . . not only yellow but red, orange, and green light; and that the other stained glasses are not much better off in this respect. Hence, to meet all such objections, physicists have been finally obliged to conduct their researches in this direction on the pure coloured rays of the spectrum. The difficulties encountered in the use of this method are much greater, but the results so obtained are far more precious. Very beautiful investigations of this character have been made by Helmholtz, Maxwell, and J. J. Müller. The general character of their results is something like this: By mixing two kinds of pure coloured light they obtained, as a general thing, light having a colour different from either of the original ingredients; for example, red and yellowish green gave an orange hue which looked in all respects like the pure orange of the spectrum; also, in this new orange it was impossible by the *eye* to detect the presence of either red or yellowish-green light. This was true of all mixtures; in no case could the original ingredients be detected by the eye. In this respect the eye differs from the ear; for by practice it is possible with the unaided ear to analyse up compound sounds into the elements which compose them, at least to some extent. It was also ascertained that the same colour could be produced in several different ways – that is, by combining together different pairs of spectral colours. Thus, violet with cyan-blue gave an ultramarine hue, but violet gave the same colour when mixed with bluish-green, or even with green; in the last case the tint was somewhat whitish. By mixing certain colours of the spectrum, it was found that one new colour or colour-sensation could be produced which originally was not furnished by the plain pure spectrum itself; we refer to purple, or rather to the whole class of purples, ranging from violet-purple to red-purple. These are produced by mixing the end colours of the spectrum, red and violet, in varying proportions. Furthermore, mixtures of certain colours of the spectrum gave rise to white; this was true, for example, of red and bluish-green, and of yellow and ultramarine-blue. The white in these two cases, though so different in origin, had exactly the same appearance to the eye. Again, by mixing three or more spectral colours no new hues were produced, but simply varieties of those which could be obtained from two colours.

* * *

Another method of mixing coloured light seems to have been first definitely contrived by Mile in 1839, though it had been in practical use by artists a long time previously. We refer to the custom of placing a quantity of small dots of two colours very near each other, and allowing them to be blended by the eye placed at the proper distance. Mile traced fine lines of colour parallel to each other, the tints being alternated. The results obtained in this way are true mixtures of coloured light, and correspond to those above given. For instance, lines of cobalt-blue and chrome-yellow give a white or yellowish-white, but no trace of green; emerald-green and vermilion furnish when treated in this way a dull yellow; ultramarine and vermilion, a rich red-purple, etc. This method is almost the only practical one at the disposal of the artist whereby he can actually mix, not pigments, but masses of coloured light. In this connection we are reminded of an interesting opinion of Ruskin which has some bearing on our subject. The author of 'Modern Painters,' in his most admirable 'Elements of Drawing,' says: 'Breaking one colour in small points through or over

another is the most important of all processes in good modern oil and water-colour painting....In distant effects of a rich subject, wood or rippled water or broken clouds, much may be done by touches or crumbling dashes of rather dry colour, with other colours afterward put cunningly into the interstices....And note, in filling up minute interstices of this kind, that, if you want the colour you fill them with to show brightly, it is better to put a rather positive point of it, with a little white left beside or round it, in the interstice, than to put a pale tint of the colour over the whole interstice. Yellow or orange will hardly show, if pale, in small spaces; but they show brightly in fine touches, however small, with white beside them.'

This last method of mixing coloured light is one which often occurs in nature; the tints of distant objects in a landscape are often blended in this way, and produce soft hues which were not originally present. Even near objects, if numerous and of small dimension, act in the same manner. Thus the colours of the scant herbage on a hillside often mingle themselves in this way with the greenish-grey tints of the mosses and the brown hues of the dried leaves; the reddish- or purplish-brown of the stems of small bushes unites at a little distance with their shaded green foliage; and in numberless other instances, such as the upper and lower portions of mosses, sunlit and shaded grass-stalks, and the variegated patches of colour on rocks and trunks of trees, the same principle can be traced.

There is another mode of mingling coloured light, which is not much used by physicists, though it is of constant occurrence in nature. We refer to the case where two masses of coloured light fall simultaneously on the same object. Sunsets furnish the grandest examples of these effects, the objects in a landscape being at the same time illuminated by the blue sky and the orange or red rays of the sinking sun. Minor cases happen constantly; among them the commonest is where a coloured object reflects light of its own tint on neighbouring objects, thus modifying their hues and being in turn modified by them. The white or grey walls of a room are often very wonderfully tinted by coloured light which is cast on them in nebulous patches by the carpet, window-curtains, or other coloured objects that happen to be present. In all cases where the surface receiving the manifold illumination is white or grey, or but slightly coloured, the laws for the mixture of coloured light which have been explained above hold good; when, however, this surface has a distinct colour of its own, the phenomena are modified in a manner which will presently be noticed.

We pass on now to compare the results which are obtained by mixing coloured *lights* with those which are given by the mixture of coloured *pigments*. It was for a long time supposed that these were identical, and that experiments on mixtures of coloured light could be made with the aid of the painter's palette. Lambert appears to have been the first to point out the fact that the results in the two cases are not always identical. Thus the celebrated experiment of combining blue with yellow light, and obtaining not green but white, was first made by him ... The same fact was afterward independently discovered by Plateau, and finally by Helmholtz, who, using it as a starting-point, made an examination of the whole subject. When we study this matter with some attention, we find that in mixing pigments two different effects are produced. Suppose we mix chrome-yellow and ultramarine-blue, both in dry powder. If we rub this mixture on paper, we shall produce a uniform and rather dull green. An examination even with a moderately powerful microscope will fail to reveal the

separate particles of the two pigments. Yet we know that there must be a superficial layer, made up of a mosaic work of blue and yellow particles placed side by side. These two sets of particles send light of their own colour to the eye, which there undergoes a true mixture, and gives as the resultant hue a yellowish-grey. Thus far the result entirely corresponds with that produced by mixing two masses of coloured light. The second and more important effect is brought about by light which penetrates two or more layers of particles. Here the light undergoes absorption . . . : the yellow particles absorb the blue and violet; the blue particles, the red, orange, and yellow rays. The green light is absorbed also by both sets of particles, but not nearly so much as the other rays. From all this it follows that chrome-yellow and ultramarine-blue jointly absorb all the colours which are present in white light, except green; hence green light, as the result, is reflected back from the surface, and reaches the eye of the observer. This green light is finally mingled with the yellowish-grey light before mentioned. When dry pigments are employed, both of the effects just described are always present. If the pigments are used as water-colours, the light from the surface is diminished, and with it the first of these effects; and a still further diminution of it takes place if the pigments are ground up in oil. From all this it is evident that by *mingling two pigments* we obtain the resultant effect of two acts of absorption due to the two pigments: white light is twice subjected to the process of subtraction, and what remains over is the coloured light which finally emerges from the painted surface. On the other hand, the process of *mixing coloured light* is essentially one of addition; and, this being so, we find it quite natural that the results given by these two methods should never be identical, and often should differ widely. From this it follows that painters can not in many cases directly apply knowledge acquired from the palette to the interpretation of chromatic effects produced by nature, for these latter often depend to a considerable extent on the mixing of masses of differently coloured *light*. This fact is now admitted in a general way by intelligent artists, but probably few who have not made experiments in this direction fully realize how wide are the discrepancies which exist between the results given by the two different modes of mixture. [. . .]

10 Sir Edward Poynter (1836–1919) 'On the Study of Nature'

Poynter studied at the Royal Academy Schools in London, spent some time in Rome where he met Alphonse Legros, and in the late 1850s attended the atélier of Charles Gleyre in Paris, where Monet, Bazille and Renoir were to meet shortly after. His first success came with the painting *Israel in Egypt* at the Academy in 1867. In 1871 he was appointed first Slade Professor of Fine Art at University College London, a post he held until succeeded by Legros on his own recommendation in 1876. He was Director of the National Gallery in London from 1894 to 1904 and was President of the Royal Academy from 1896 until shortly before his death. During his time at the Slade School he was responsible for introducing into English art education those aspects of French studio practice that were consistent with the academic tradition and with maintenance of a belief in painting as a form of high art. Over the same period he also gave a number of lectures at University College and elsewhere, and versions of ten of these were collected together for publication in 1879. 'On the Study of Nature' had its origins in an address delivered at the St Martin's

School of Art in London, *c.* 1875. Despite Poynter's apparent concern with work in design, the warnings regarding the colouring of the Pre-Raphaelites may actually have been intended for any students of painting who were tempted to follow the direction recently taken by French forms of Naturalism. As printed, the lecture offers testimony to the remarkable survival of a long-standing academic assumption: that the proper and 'unprejudiced' study of nature must lead inexorably to the emulation of classical ideals. Our text is taken from Edward J. Poynter, *Lectures on Art*, London: Chapman and Hall, third edition, 1885, Lecture VI, pp. 165–71.

In some interesting lectures on the Philosophy of the Italian Art of the Renaissance, M. Henri Taine calls attention to the immense advantage the old Italian artists enjoyed over the men of to-day, in the fact that their minds were not overburdened with ideas. Under modern conditions of life we think so much and so subtly, that our impressions of nature no longer come to us with simplicity and directness, while, according to M. Taine, a noble form of art is only possible when the images which nature stamps on our minds are not blurred or distorted by the intrusion of our ideas.

This remark is a valuable one, inasmuch as it points out one great difficulty which stands in the way of a free development of art, the difficulty, that is, of securing that the study of nature shall be carried on upon right principles. For this 'study of nature' is not as simple a matter as it appears at first sight, and it is quite possible that we may pursue it in such a way as to interpose ideas and prejudices of our own between ourselves and nature, which may prevent our receiving its impressions in the form most stimulating to the artistic powers. I will endeavour to make this clearer by a practical illustration derived from the study of artistic ornament.

In this branch of art a novel idea was started some little time ago, which had for its object a new application of the forms and colours of flowers to the ornamenting of wall papers, hangings, and other materials for surface decoration. This was, that the student should take a flower or a plant, and commence by drawing it in its natural form; next, that he should dissect the plant botanically, making separate geometrical drawings, plans, and sections, of the petals, corolla, stamen, pistil, branching of the leaves from the stem, &c., that he might understand how the flowers could be treated geometrically; thirdly, that from these drawings a geometrical pattern should be made, combining artistically the forms which had been discovered during the process. Now here was an idea, a thing that had never been thought of before; so that a step forward in a direction never before explored seemed inevitable. Yet I must express my opinion that quite the most unfortunate attempts at decorative patterns, both as regards form and colour, that I have ever seen, were some which were produced by this infallible process!

The reason is simply this, that the idea takes in the student's mind the place of the impression; he thinks the design must necessarily turn out well, for he has been taught that nature's forms are beautiful; and here are nature's forms reduced to their simplest expression, and, with due deference to the exigencies of a formal design, combined in the way in which nature combines them. Unfortunately, this process of reasoning does not necessarily lead to a work of art; but merely to an ingenious combination, which may be absolutely deficient in any qualities of beauty or prettiness. Nature is not necessarily beautiful in all her forms, in spite of all that we are taught as children,

– still less dissected nature. It is not every flower that is good in colour and graceful in form; and it is the business of the artist to select what is beautiful and reject what is ugly and unsuitable. Now the dissection of a flower, however ingenious the idea may seem, may indeed give the student an admirable understanding of its botanical properties, but does not necessarily lead to an appreciation of its artistic fitness for ornament. I would not have students neglect any means of advancing themselves in the knowledge of the construction of natural growths: to know the anatomy of a flower is as useful in drawing it as to know the anatomy of the body in drawing the human figure; but unless the mind has impressed upon it by instinct or observation a distinct image of the various graces of form, and harmonious combinations of colour, which flowers and plants possess in their natural state, no amount of ideas, acquired in the way just described, will be of the least use for the production of good artistic design. Ancient art produced ornamental designs without end, of the most perfect beauty, without the necessity of bringing in any such ideas. These decorative forms were produced by a pure natural instinct, which led the ancients to combine and modify in the most beautiful manner the most beautiful natural forms. There are also abundant examples of oriental decorative work of the most ordinary kind, which are perfect in proportion, form, and colour. In such cases we can see in the first place that the beauty of certain natural forms had been impressed in the most vivid manner upon the designer's mind, and in the second, that his hand was guided by a sort of unconscious instinct when he sought to apply those beautiful forms to a decorative purpose.

In pictorial art also the same difficulty is constantly occurring: our ideas are continually getting the better of our natural impressions. The remedy is, however, the same as in the other case, and is fortunately easier of application. The highest possible forms of pictorial art have as their object the representation of the human form and face in all their varied aspects of tragic and joyful expression. There the imitation of nature is the principal object, only it is an imitation which leaves out of sight all that is weak, ungainly, or ignoble, and delights only in beauty, strength, and life, as is the case in the noble works of the Greek and Italian schools. For the student of to-day there is accordingly but one thing to aim at, and that is so to study nature as to receive and retain the most complete and distinct impressions. Once let his mind be thoroughly imbued with a true knowledge of nature, and he may use it as he pleases; if he has studied thoroughly he is not likely to go far wrong. But to do this, he must get rid of extraneous ideas, and rely on the images which are formed in his mind, and which nature constantly presents to his eyes. And here as before a practical illustration may be of service.

What I am about to refer to is a very strong and very curious instance of the way in which ideas run away with us in art, to the prejudice of what we might naturally do if we relied on our impressions alone. It has reference to the origin twenty years ago of what was called the Pre-Raphaelite movement; and I trust that I may not be supposed in these remarks to be attempting to throw ridicule on the enthusiasm of young men, anxious to make a reform which was urgently needed, who have long ago grown out of the weaknesses which are incidental to enthusiasm, and to whom, as men of genius, we owe the utmost respect and gratitude. The instance is, however, a very apposite one. At the beginning of this movement, one of the predominant ideas was that purity is in all its forms essential to good art. Purity of subject, purity of sentiment, purity of

expression, being all necessary, were only to be secured by the utmost purity of form and colour. To attain to purity of colour was a most important point, and to this end nothing but the most refined and brilliant pigments were to be used. Ochres and umbers were earthy, and perhaps therefore earthly, so the newest chemical compounds were sought out for the sake of procuring the clearest and brightest tints of green, yellow, scarlet, violet, and blue, that could be employed for the palette. These, combined in prismatic hues on the purest white, were to take the place in flesh-tints of the sober colours which artists had been content to use up to that time. The idea was carried so far that the use of these colours was considered as a sort of test of the earnestness of a painter in his work, and they were even invested with a sort of religious halo. Here then is a case where the idea completely out-mastered the impression, for it is certain that no painter trusting to his eyes alone would paint the shade of even the purest maiden's cheek with violet madder and emerald green, and with cadmium or orange vermilion to complete the triad of prismatic colours.

The above is perhaps an extreme instance, but the influence of the same kind of feeling may be traced in various forms through the whole range of our modern art. Sometimes it is a religious, sometimes a sentimental, sometimes a scientific idea which obtains possession of the painter's mind with the effect of deadening his true artistic perceptions. The cause may be found in the want of training common to English artists, which leads them to reject through ignorance and prejudice what practice and experience have shown to be convenient, if not necessary, modes of procedure.

11 Thomas Eakins (1844–1916) on the Teaching of Art

For previous material on Eakins, see IIIʙ18. Eakins was appointed Assistant Professor of Painting and Pro-Sector in Anatomy at the Pennsylvania Academy of the Fine Arts in 1876, six years after his return from Paris. He rose to Professor of Painting and Drawing three years later. He gave lectures on perspective and on anatomy and he put particular stress upon the study of the model. He was made Director of the Academy in 1882, but four years later was forced to resign, having fallen foul of contemporary notions of propriety. At least in part this was due to his having treated work from the nude as an equal priority for male and female students, irrespective of the sex of the model. The following text is taken from a long article on 'The Art Schools of Philadelphia', written by a well-informed writer who visited the Pennsylvania Academy in 1879, at a time when Eakins was still an assistant professor, with Christian Schussele the senior figure. The original opening of the article gave a detailed description of the school and its extensive facilities. These included a hall of casts from the antique, a collection of photographs of works by the Old Masters, and a large life room. In accordance with the standard academic practice of the time, students were only admitted to the life room once they had shown sufficient ability in drawing from the casts. This was a protocol which Eakins sought to change. In the continuation of the article, the artist's reported views are interspersed with further description and comment by the writer. We have edited this material so as to extract whatever may be directly attributed to Eakins himself, but without entirely losing the flow of the original or concealing its character as a piece of journalism. Given the substance of the reported discussion, it is relevant to note that the operating theatre was the setting for two of Eakins's most

celebrated paintings – *The Gross Clinic* of 1875 and *The Agnew Clinic* of 1889. William C. Brownell, 'The Art Schools of Philadelphia,' was printed in *Scribner's Monthly*, volume XVIII, September 1879, pp. 737–50. Our version is taken from pp. 740–6 of this publication.

Professor Schussele, who is conservative, prefers a long apprenticeship in drawing with the point or stump. He insists on a long preliminary study of the antique. Mr Eakins, who is a radical, prefers that the pupil should paint at once, and he thinks a long study of the antique detrimental. There is no conflict; for the instruction is nothing if not elastic, it appeals to the pupil's reason with candour, and avoids anything like rigid direction. But, as is natural with ambitious students, most of these take Mr Eakins's advice. That advice is almost revolutionary of course. Mr Eakins's master, Gérôme, insists on preliminary drawing; and insistence on it is so universal that it was natural to ask an explanation.

'Don't you think a student should know how to draw before beginning to colour?'

'I think he should learn to draw with colour,' was Mr Eakins's reply. And then in answer to the stock objections he continued: 'The brush is a more powerful and rapid tool than the point or stump. Very often, practically, before the student has had time to get his broadest masses of light and shade with either of these, he has forgotten what he is after. Charcoal would do better, but it is clumsy and rubs too easily for students' work. Still the main thing that the brush secures is the instant grasp of the grand construction of the figure. There are no lines in nature, as was found out long before Fortuny exhibited his detestation of them; there are only form and colour. The most important, the most changeable, the most difficult thing to catch about a figure is the outline. The student drawing the outline of that model with a point is confused and lost if the model moves a hair's-breadth; already the whole outline has been changed, and you notice how often he has had to rub out and correct; meantime he will get discouraged and disgusted long before he has made any sort of portrait of the man. Moreover, the outline is not the man; the grand construction is. Once that is got, the details follow naturally. And as the tendency of the point or stump is, I think, to reverse this order, I prefer the brush. I don't at all share the old fear that the beauties of colour will intoxicate the pupil, and cause him to neglect the form. I have never known anything of that kind to happen unless a student fancied he had mastered drawing before he began to paint. Certainly it is not likely to happen here. The first things to attend to in painting the model are the movement and the general colour. The figure must balance, appear solid and of the right weight. The movement once understood, every detail of the action will be an integral part of the main continuous action; and every detail of colour auxiliary to the main system of light and shade. The student should learn to block up his figure rapidly, and then give to any part of it the highest finish without injuring its unity. To these ends, I haven't the slightest hesitation in calling the brush and an immediate use of it, the best possible means.'

'All this quite leaves the antique out of consideration, does it not?'

Mr Eakins did not say 'the antique be hanged', because though he is a radical he is also contained and dispassionate; but he managed to convey such an impression. 'I don't like a long study of casts,' he said, 'even of the sculptors of the best Greek period. At best, they are only imitations, and an imitation of imitations cannot have so much life as an imitation of nature itself. The Greeks did not study the antique: the

"Theseus" and "Ilyssus," and the draped figures in the Parthenon pediment were modelled from life, undoubtedly. And nature is just as varied and just as beautiful in our day as she was in the time of Phidias. You doubt if any such men as that Myron statue in the hall exist now, even if they ever existed? Well, they must have existed once or Myron would never have made that, you may be sure. And they do now. Did you ever notice, by the way, those circus tumblers and jumpers – I don't mean the Hercules? They are almost absolutely beautiful, many of them. And our business is distinctly to do something for ourselves, not to copy Phidias. Practically, copying Phidias endlessly dulls and deadens a student's impulse and observation. He gets to fancying that all nature is run in the Greek mould; that he must arrange his model in certain classic attitudes, and paint its individuality out of it; he becomes prejudiced, and his work rigid and formal. The beginner can at the very outset get more from the living model in a given time than from study of the antique in twice that period. That at least has been my own experience; and all my observation confirms it.'

Here then are two things which distinguish Philadelphia from the New York schools – immediate drawing with the brush and no prolonged study of the antique. Another is modelling, of which there is none at all done at either the Cooper Union or the National Academy, and which is not practised at the League in direct connection with painting. When Mr Eakins finds any of his pupils, men or women, painting flat, losing sight of the solidity, weight and roundness of the figure, he sends them across the hall to the modelling-room for a few weeks [...]

Nowhere is there any effort at anything but individual portraiture – no attempt to make a Phidian statue from a scullion model. I saw an excellent test case of this: the model was a heavy, finely developed woman; the trunk was admirable, but the extremeties were large and coarse – manifestly made so by hard physical labour. One would have said that the temptation to correct the distortions of nature by the aid of the idea furnished by the trunk would have been irresistible. But apparently no such notion had even occurred to any one. Evidently, the modellers were, for the time being, bent on learning how to work rather than on original creation.

'We change the model as often as possible,' explained Mr Eakins, 'because it is only by constant change that pupils learn that one model does not look at all like another. There is as much difference in bodies as in faces, and the character should be sought in its complete unity. On seeing a hand one should know instinctively what the foot must be.'

'Sometimes there seems to be small indication in one of the other,' I interposed innocently, glancing at the model on the turn-table.

'I only mean that nature builds harmoniously,' was the reply. 'I grant that you can't instinctively apprehend unnatural distortions, or argue from a man's hand that he has lost a toe.'

What chiefly distinguishes the Philadelphia school, however, is its dissections for advanced pupils. Every winter, something more than a fourth part of the students spend more or less time in the dissecting-room, under Mr Eakins's supervision, and twice a week all the pupils listen to the lectures of Dr Keen upon artistic anatomy. [...] Every winter or early spring, Mr Eakins takes a large class to a suburban bone-boiling establishment, where they dissect horses in the slaughter-house, and in summer they continue the work with studies of the living animal (modelling and

painting and studying his movements), which they make at Mr Fairman Rogers's farm [. . .] . . . In dissections presided over and directed by the professor of painting, the school of the Philadelphia Academy is, so far as I know, unique.

* * *

'Don't you find this sort of thing repulsive? At least do not some of the pupils dislike it at first?' Mr Eakins is asked.

'I don't know of anyone who doesn't dislike it,' is the reply. 'Every fall, for my own part, I feel great reluctance to begin it. It is dirty enough work at the best, as you can see. Yes, we had one student who abstained a year ago, but this year, finding his fellows were getting along faster than himself, he changed his mind and is now dissecting diligently.'

'But you find it interesting nevertheless?'

'Intensely,' says one of the students, with ardour.

'And don't you find your interest becoming scientific in its nature, that you are interested in dissection as an end in itself, that curiosity leads you beyond the point at which the aesthetic usefulness of the work ceases? I don't see how you can help it.'

'No,' replied Mr Eakins, smiling, 'we turn out no physicians and surgeons. About the philosophy of aesthetics, to be sure, we do not greatly concern ourselves, but we are considerably concerned about learning how to paint. For anatomy, as such, we care nothing whatever. To draw the human figure it is necessary to know as much as possible about it, about its structure and its movements, its bones and muscles, how they are made, and how they act. You don't suppose we pay much attention to the viscera, or study the functions of the spleen, I trust.'

'But the atmosphere of the place, the hideousness of the objects! I can't fancy anything more utterly – utterly – inartistic.'

'Well that's true enough. We should hardly defend it as a quickener of the aesthetic spirit, though there is a sense in which a study of the human organism is just that. If beauty resides in fitness to any extent, what can be more beautiful than this skeleton, or the perfection with which means and ends are reciprocally adapted to each other? But no one dissects to quicken his eye for, or his delight in, beauty. He dissects simply to increase his knowledge of how beautiful objects are put together to the end that he may be able to imitate them. Even to refine upon natural beauty – to idealize – one must understand what it is that he is idealizing; otherwise his idealization – I don't like the word, by the way, becomes distortion, and distortion is ugliness. This whole matter of dissection is not art at all, any more than grammar is poetry. It is work, and hard work, disagreeable work. No one, however, needs to be told that enthusiasm for one's end operates to lessen the disagreeableness of his patient working toward attainment of it. In itself I have no doubt the pupils consider it less pleasant than copying the frieze of the Parthenon. But they are learning the niceties of animal construction, providing against mistakes in drawing animals, and they are, I assure you, as enthusiastic over their "hideous" work as any decorator of china at South Kensington could be over hers. As for their artistic impulse, such work does not affect it in any way whatever. If they have any when they come here they do not lose it by learning how to exercise it; if not, of course, they will no more get it here than anywhere else.'

* * *

In the evening there is a lecture in the spacious lecture-room, upon the specific subject with which the students have been making themselves practically familiar during the few days just preceding. Upon the platform is Dr Keen, the professor of artistic anatomy, surrounded by the illustrations for his lecture. He describes the leg, bones, muscles and tendons, and their several functions. Then he illustrates its construction by the skeleton, the manikin and the 'subject' – it is worth noting that compared with the last, the two former are of small account in point of clearness and vividness of illustration. Then the model steps upon a chair and is put through various movements which show the action and aspects of what has just been described and explained. Every one pays strict attention; the lecturer is vivacious to enthusiasm and the perfect lucidity of his lecture is emphasized by constant iteration until the youngest and the dullest must understand it; in less than two hours every pupil probably knows as much about the leg as will be of any service to him in drawing and painting it.

'Do you imagine that the pupil will be able to draw a leg better for knowing all that?' I asked Mr Eakins.

'Knowing all that will enable him to observe more closely, and the closer his observation is the better his drawing will be,' he returned; and the whole point of such instruction is there. [. . .]

IVC
Photography as an Art

1 Sir William Newton (1785–1869) 'Upon Photography in an Artistic View, and its Relation to the Arts'

From the moment of its discovery, photography's relationship to painting and drawing was keenly debated. Whether the new technique for making images was by its nature inferior to the traditional fine arts, or whether it could itself qualify as a kind of art with its own characteristics and qualities, was a topic frequently discussed, both in the new literature which arose and in the many photographic societies which were formed. The Photographic Society of London was one such. The Society's first President was Sir Charles Eastlake, also President of the Royal Academy. Eastlake invited the Academic painter Sir William Newton, a specialist in portrait miniatures, to read a paper on the subject at the Society's first meeting. Newton's argument was that the very qualities of detail which distinguished photography, as well as the relative harshness of the tones of early photographs, militated against its being accorded the status of an art. However, the camera could *serve* the trained artist in the production of studies. To this end, paradoxical devices such as deliberately blurring the image, or chemically altering the negatives, could be employed in order to produce a more 'artistic' effect. Newton's paper was read to the Photographic Society in 1853 and published that same year in the first issue of the *Journal of the Photographic Society of London*, pp. 6–7.

The present advanced state of Photography, and its applicability to the Fine Arts, as well as to many branches of science, suggested the idea of forming a Photographic Society, and I am happy to state that it is now established under most favourable circumstances, and if carried out with zeal and energy, must produce results of the greatest importance to art and science.

It is not however my intention to dilate upon the science of Photography. I shall endeavour to direct attention principally to its *artistic* character, and to embrace what, after all appears to me to be almost of first importance, viz. the mode of proceeding which a Photographer ought to adopt, and how his labours and productions should bear upon it.

Let us consider what these productions are. The subjects vary with the taste of the operator; and the collection, which but lately decorated these walls, showed how numerous were the selections, in which solar action had been applied. Every variety of

subject, from the most solid and substantial to the most light and airy, were displayed with that exactitude of delineation which completely sets at nought the exertions of *manual* ingenuity; still the general tone of nature has yet to be accomplished by means of Photography.

Who has *not* studied nature so much as to observe how beautifully she throws her atmospheric veil, detaching each object, while producing that harmony and union of parts which the most splendid specimen of chemical Photography fails to realize! Consequently, *at present*, it is in vain to look for that true representation of light and shade in Photography, which is to be found in a fine work of art.

What course therefore ought a Photographer to pursue? – Let him in the laboratory devise and discover the means by which he can produce his pictures still more minute and perfect in detail, as that must always be a great stride in what is, strictly speaking, Photography and science; but, he must ever remember, that his subjects are principally natural objects, powerfully acted upon by atmospheric influence.

Therefore, in the illustrations which are sent forth to the world to be placed in similar positions as pictures and engravings, their appearance ought not to be so *chemically*, as *artistically* beautiful. The nearest approach in this respect, which I have yet seen, were the excellent Photographs exhibited by Mr Stewart.

It must always be borne in mind, that essentially speaking, the Camera is by no means calculated to *teach* the *principles* of art; but, to those who are already well informed in this respect, and have had practical experience, it may be made the means of considerable advancement. At the same time I do not conceive it to be necessary or *desirable* for an *artist* to represent or aim at the attainment of every minute detail, but to endeavour at producing a broad and general effect, by which means the *suggestions* which nature offers, as represented by the Camera, will assist his studies materially: and indeed, for this purpose, I do not consider it necessary that the whole of the subject should be what is called *in focus*; on the contrary, I have found in many instances that the object is better obtained by the whole subject being a little *out of focus*, thereby giving a greater breadth of effect, and consequently more *suggestive* of the true character of nature. I wish, however, to be understood as applying these observations to artists only, such productions being considered as private *studies* to assist him in his compositions; and for groups of figures, or any subject requiring to be obtained as quickly as possible, the Collodion process is, of course, the best we are yet acquainted with.

I will now take this opportunity of adverting to another mode which an *artist* may fairly adopt, with respect to his negatives, in order to render them more like works of art; and I am particularly desirous of directing attention to this subject, because it has been recently stated in this room, that a Photograph should always remain as represented in the Camera, without any attempt to improve it by art. In this, however, I by no means agree, and therefore I am desirous of removing such false and limited views as applying to the practice of artists, or indeed, to any person having the skill and judgment requisite for the above object.

Wonderful as the powers of the Camera are, we have not yet attained that degree of perfection so as to represent faithfully the effect of *colours*, and consequently of *light and shade*; for instance, a bright red or yellow which would act as a *light* in nature, is always represented as a *dark* in the Camera; and the same with green; blue, on the

contrary, is always lighter; hence the impossibility of representing the true effect of nature, or a picture, by means of Photography. Consequently, I conceive that when a tolerably faithful and picturesque effect can be obtained by a chemical or other process, applied to the negative, the operator is at full liberty to use his own discretion. [. . .]

In conclusion, I consider it to be a sort of duty, as an artist, to recommend the student in art *not* to take up the Camera as a means of advancement in his profession until he has made himself well acquainted with the true principles of his art, as well as acquired considerable power of hand, with a view to draw with ease and correctness the *outline* of any object he may wish to represent. If, however, any student should imagine that the Camera will help him to this desirable attainment without the requisite study on his part, he will find himself much mistaken when, perhaps, it may be too late to repair the injury. I am the more desirous of directing the attention of the student in Art to the foregoing observations, because I am well aware of the seductive nature of the practice of Photography, and how it is calculated to divert him from his principal object in the earlier part of his studies.

2 Antoine Joseph Wiertz (1806–1865) 'Photography'

Wiertz was a Belgian academic painter who specialized in portentous or even macabre allegories. Whereas many such academic painters considered photography a threat to art, Wiertz believed it to be a liberation. The daguerreotype could take over that function of painting and drawing which was dedicated to recording the everyday world. In essence it rendered artistic Naturalism obsolete. But by the same token it freed artists to pursue the imaginative aspects of their work. In the event it was just this freedom that modern painters exploited, most notably in the long and complex development of abstraction. What Wiertz himself had in mind however, is more likely to have been the ascendancy of his own type of nineteenth-century Symbolism. Most early discussions of photography and art held their relation to be unequal. Either photography simply was not art, or it could at best serve art by providing rapid studies. Wiertz looked further ahead to a future partnership. Subsequently, in the 1930s, Walter Benjamin referred to Wiertz's 'great article on photography' as having 'assigned to it the philosophical enlightenment of painting'. He also made the more controversial claim that Wiertz had provided a distant anticipation of montage through his speculations about art and photography working together as equals in the future. The article 'La Photographie' was published in Le National, Brussels, in June 1855 and was reprinted in his Oeuvres Littéraires, Paris, 1870, pp. 309–10. It has been translated by Kate Tunstall for the present volume.

Good news for the future of painting!

As one knows, art is divided into two parts – the material and the intellectual. Some painters concern themselves only with the material part and admirably render a satin dress. Others are attached to the intellectual part; they invent, compose, draw and seem to be unaware of the rendering.

The painter who renders well is the mason who constructs; the other, is the architect who invents and composes. The architect and the mason in painting are in the presence of a great event. This event will be a subject of joy for the architect and a subject of despair for the mason.

A few years ago, a machine was born which is the honour of our time and which, each day, astonishes our thoughts and shocks our eyes.

A century from now this machine will be the brush, palette, colours, skill, rules, patience, eye, style, brushwork, paste, glaze, tricks of the trade, modelling, finish, and rendering.

A century from now, there will no longer be a mason in painting: there will only be architects, painters in all senses of the word.

Let it not be thought that the daguerreotype kills art. No, it only kills the work of patience and pays homage to the work of thought.

When the daguerreotype, this great child will have attained the age of maturity; when all of its force and potential have been developed, then the genius of art will suddenly put its hand on its collar and cry: 'Mine! You are mine now! We will work together.'

What I have just said, I have been saying for ten years.

I recall that to this subject someone offered this reflection: Daguerreotypes will never attain the dimensions of nature. To this I responded that they would certainly arrive at this result.

What I predicted is already coming to pass. M. Plumier, our capable photographer, one of these men of the race of exploring spirits who sometimes honour their country by some discovery, has invented the means of producing photographic drawings which represent objects as large as they are in nature. Moreover, the new method is such that he can reproduce in as many sizes as possible...

Human knowledge, go forward! March on!

3 Lady Elizabeth Eastlake (1809–1893) 'Photography'

Elizabeth Eastlake, née Rigby, was an amateur artist and a close friend of J. M. W. Turner. She was a patron of the Society of Female Artists (cf. IIIᴅ10) and in 1880 wrote a memoir of its founder Harriet Grote. She was married to Sir Charles Eastlake, President of the Royal Academy and also first President of the Photographic Society. The present essay, which was originally published anonymously, began as an extensive review of a range of publications on photography, including Daguerre's history of his invention, and reports of a range of technical developments such as the Calotype, the Collodion process, and the stereoscope. Much more than just a review however, it amounted to a history of photography up to that time, as well as offering a considered analysis of the question of photography's relation to art. For the present anthology we have selected only that part of Lady Eastlake's essay which addresses this last question. Her basic argument is that however notable or exciting the qualities of a photograph may be, none the less these are not the qualities of art as such. The argument is saved from conservatism, however, by her view of photography as a new and legitimate form of communication in its own right. Thus photography liberates art to concentrate on the effects proper to its expressive, aesthetic dimension by freeing it from the burden of documentation. The essay was originally published in the *Quarterly Review*, London, April 1857, pp. 442–68.

Our chief object at present is to investigate the connexion of photography with art – to decide how far the sun may be considered an artist, and to what branch of imitation his powers are best adapted.

* * *

[...] This bring us to the artistic part of our subject, and to those questions which sometimes puzzle the spectator, as to how far photography is really a picturesque agent, what are the causes of its successes and its failures, and what in the sense of art are its successes and failures? And these questions may be fairly asked now when the scientific processes on which the practice depends are brought to such perfection that, short of the coveted attainment of colour, no great improvement can be further expected. If we look round a photographic exhibition we are met by results which are indeed honourable to the perseverance, knowledge, and in some cases to the taste of man. The small, broadly-treated, Rembrandt-like studies representing the sturdy physiognomies of Free Church Ministers and their adherents [e.g. the calotypes of Hill and Adamson], which first cast the glamour of photography upon us, are replaced by portraits of the most elaborate detail, and of every size not excepting that of life itself. The little bit of landscape effect, all blurred and uncertain in forms, and those lost in a confused and discoloured ground, which was nothing and might be anything, is superseded by large pictures with minute foregrounds, regular planes of distance, and perfectly clear skies. The small attempts at architecture have swelled into monumental representations of a magnitude, truth, and beauty which no art can surpass – animals, flowers, pictures, engravings, all come within the grasp of the photographer; and last, and finest, and most interesting of all, the sky with its shifting clouds, and the sea with its heaving waves, are overtaken in their course by a power more rapid than themselves.

But while ingenuity and industry – the efforts of hundreds working as one – have thus enlarged the scope of the new agent, and rendered it available for the most active, as well as for the merest still life, has it gained in an artistic sense in like proportion? Our answer is not in the affirmative, nor is it possible that it should be so. Far from holding up the mirror to nature, which is an assertion usually as triumphant as it is erroneous, it holds up that which, however beautiful, ingenious, and valuable in powers of reflection, is yet subject to certain distortions and deficiencies for which there is no remedy. The science therefore which has developed the resources of photography, has but more glaringly betrayed its defects. For the more perfect you render an imperfect machine the more must its imperfections come to light: it is superfluous therefore to ask whether Art has been benefited, where Nature, its only source and model, has been but more accurately falsified. If the photograph in its early and imperfect scientific state was more consonant to our feelings for art, it is because, as far as it went, it was more true to our experience of Nature. Mere broad light and shade, with the correctness of general forms and absence of all convention, which are the beautiful conditions of photography, will, when nothing further is attempted, give artistic pleasure of a very high kind; it is only when greater precision and detail are superadded that the eye misses the further truths which should accompany the further finish.

For these reasons it is almost needless to say that we sympathize cordially with Sir William Newton [cf. IVc1], who at one time created no little scandal in the Photographic Society by propounding the heresy that pictures taken slightly out of focus, that is, with slightly uncertain and undefined forms, 'though less *chemically*, would be found more *artistically* beautiful.' Much as photography is supposed to inspire its votaries with aesthetic instincts, this excellent artist could hardly have chosen an

audience less fitted to endure such a proposition. As soon as could an accountant admit the morality of a false balance, or a seamstress the neatness of a puckered seam, as your merely scientific photographer be made to comprehend the possible beauty of 'a slight *burr*.' His mind proud science never taught to doubt the closest connexion between cause and effect, and the suggestion that the worse photography could be the better art was not only strange to him, but discordant. It was hard too to disturb his faith in his newly acquired powers. Holding, as he believed, the keys of imitation in his camera, he had tasted for once something of the intoxicating dreams of the artist; gloating over the pictures as they developed beneath his gaze, he had said in his heart 'anch' io son pittore' [I, also, am a painter]. Indeed there is no lack of evidence in the Photographic Journal of his believing that art had hitherto been but a blundering groper after that truth which the cleanest and precisest photography in his hands was now destined to reveal. Sir William Newton, therefore, was fain to allay the storm by qualifying his meaning to the level of photographic toleration, knowing that, of all the delusions which possess the human breast, few are so intractable as those about art.

But let us examine a little more closely those advances which photography owes to science – we mean in an artistic sense. We turn to the portraits, our *premiers amours*, now taken under every appliance of facility both for sitter and operator. Far greater detail and precision accordingly appear. Every button is seen – piles of stratified flounces in most accurate drawing are there, – what was at first only suggestion is now all careful making out, – but the likeness to Rembrandt and Reynolds is gone! There is no mystery in this. The first principle in art is that the most important part of a picture should be best done. Here, on the contrary, while the dress has been rendered worthy of a fashion-book, the face has remained, if not so unfinished as before, yet more unfinished in proportion to the rest. Without referring to M. Claudet's well-known experiment of a falsely coloured female face, it may be averred that, of all the surfaces of a few inches square the sun looks upon, none offers more difficulty, artistically speaking, to the photographer, than a smooth, blooming, clean washed, and carefully combed human head. The high lights which gleam on this delicate epidermis so spread and magnify themselves, that all sharpness and nicety of modelling is obliterated – the fineness of skin peculiar to the under lip reflects so much light, that in spite of its deep colour it presents a light projection, instead of a dark one – the spectrum or intense point of light on the eye is magnified to a thing like a cataract. If the cheek be very brilliant in colour, it is as often as not represented by a dark stain. If the eye be blue, it turns out as colourless as water; if the hair be golden or red, it looks as if it had been dyed, if very glossy it is cut up into lines of light as big as ropes. This is what a fair young girl has to expect from the tender mercies of photography – the male and the older head, having less to lose, has less to fear. Strong light and shade will portray character, though they mar beauty. Rougher skin, less glossy hair, Crimean moustaches and beard overshadowing the white under lip, and deeper lines, are all so much in favour of a picturesque result. Great grandeur of feature too, or beauty of *pose* and sentiment, will tell as elevated elements of the picturesque in spite of photographic mismanagement. Here and there also a head of fierce and violent contrasts, though taken perhaps from the meekest of mortals, will remind us of the Neapolitan or Spanish school, but, generally speaking, the inspection of a set of faces, subject to the usual conditions of humanity and the camera, leaves us with the

impression that a photographic portrait, however valuable to relative or friend, has ceased to remind us of a work of art at all.

And, if further proof were wanted of the artistic inaptitude of this agent for the delineation of the human countenance, we should find it in those magnified portraits which ambitious operators occasionally exhibit to our ungrateful gaze. Rightly considered, a human head, the size of life, of average intelligence, and in perfect drawing, may be expected, however roughly finished, to recall an old Florentine fresco of four centuries ago. But, 'ex nihilo, nihil fit' [nothing comes from nothing], the best magnifying lenses can in this case only impoverish in proportion as they enlarge, till the flat and empty Magog which is born of this process is an insult, even in remotest comparison with the pencil of a Masaccio.

The falling off of artistic effect is even more strikingly seen if we consider the department of landscape. Here the success with which all accidental blurs and blotches have been overcome, and the sharp perfection of the object which stands out against the irreproachably speckless sky, is exactly as detrimental to art as it is complimentary to science. The first impression suggested by these buildings of rich tone and elaborate detail, upon a glaring white background without the slightest form or tint, is that of a Chinese landscape upon looking-glass. We shall be asked why the beautiful skies we see in the marine pieces cannot be also represented with landscapes; but here the conditions of photography again interpose. The impatience of light to meet light is, as we have stated, so great, that the moment required to trace the forms of the sky (it can never be traced in its cloudless gradation of tint) is too short for the landscape, and the moment more required for the landscape too long for the sky. If the sky be given, therefore, the landscape remains black and underdone; if the landscape be rendered, the impatient action of the light has burnt out all cloud-form in one blaze of white. But it is different with the sea, which, from the liquid nature of its surface, receives so much light as to admit of simultaneous representation with the sky above it. Thus the marine painter has both hemispheres at his command, but the landscape votary but one; and it is but natural that he should prefer Rydal Mount and Tintern Abbey to all the baseless fabric of tower and hill which the firmament occasionally spreads forth. But the old moral holds true even here. Having renounced heaven, earth makes him, of course, only an inadequate compensation. The colour green, both in grass and foliage, is now his great difficulty. The finest lawn turns out but a gloomy funeral-pall in his hands; his trees, if done with the slower paper process, are black, and from the movement, uncertain webs against the white sky, – if by collodion, they look as if worked in dark cambric, or stippled with innumerable black and white specks; in either case missing all the breadth and gradations of nature. For it must be remembered that every leaf reflects a light on its smooth edge or surface, which, with the tendency of all light to over-action, is seen of a size and prominence disproportioned to things around it; so that what with the dark spot produced by the green colour, and the white spot produced by the high light, all intermediate grades and shades are lost. This is especially the case with hollies, laurels, ivy, and other smooth-leaved evergreens, which form so conspicuous a feature in English landscape gardening – also with foreground weeds and herbage, which, under these conditions, instead of presenting a sunny effect, look rather as if strewn with shining bits of tin, or studded with patches of snow.

For these reasons, if there be a tree distinguished above the rest of the forest for the harshness and blueness of its foliage, we may expect to find it suffer less, or not at all, under this process. Accordingly, the characteristic exception will be found in the Scotch fir, which, however dark and sombre in mass, is rendered by the photograph with a delicacy of tone and gradation very grateful to the eye. With this exception it is seldom that we find any studies of trees, in the present improved state of photography, which inspire us with the sense of pictorial truth. Now and then a bank of tangled bushwood, with a deep, dark pool beneath, but with no distance and no sky, and therefore no condition of relation, will challenge admiration. Winter landscapes also are beautiful, and the leafless Burnham beeches a real boon to the artist; but otherwise such materials as Hobbema, Ruysdael, and Cuyp converted into pictures unsurpassable in picturesque effect are presented in vain to the improved science of the photographic artist. What strikes us most frequently is the general *emptiness* of the scene he gives. A house stands there, sharp and defined like a card-box, with black blots of trees on each side, all rooted in a substance far more like burnt stubble than juicy, delicate grass. Through this winds a white spectral path, while staring palings or linen hung out to dry (oh! how unlike the luminous spots on Ruysdael's bleaching-grounds!), like bits of the white sky dropped upon the earth, make up the poverty and patchiness of the scene. We are aware that there are many partial exceptions to this; indeed, we hardly ever saw a photograph in which there was not something or other of the most exquisite kind. But this brings us no nearer the standard we are seeking. Art cares not for the right finish unless it be in the right place. Her great aim is to produce a whole; the more photography advances in the execution of parts, the less does it give the idea of completeness.

There is nothing gained either by the selection of more ambitious scenery. The photograph seems embarrassed with the treatment of several gradations of distance. The finish of background and middle distance seems not to be commensurate with that of the foreground; the details of the simplest light and shadow are absent; all is misty and bare, and distant hills look like flat, grey moors washed in with one gloomy tint. This emptiness is connected with the rapidity of collodion, the action of which upon distance and middle ground does not keep pace with the hurry of the foreground. So much for the ambition of taking a picture. On the other hand, we have been struck with mere studies of Alpine masses done with the paper process, which allows the photograph to take its time, and where, from the absence of all foreground or intermediate objects, the camera has been able to concentrate its efforts upon one thing only – the result being records of simple truth and precision which must be invaluable to the landscape-painter.

There is no doubt that the forte of the camera lies in the imitation of one surface only, and that of a rough and broken kind. Minute light and shade, cognisant to the eye, but unattainable by hand, is its greatest and easiest triumph – the mere texture of stone, whether rough in the quarry or hewn on the wall, its especial delight. Thus a face of rugged rock, and the front of a carved and fretted building, are alike treated with a perfection which no human skill can approach; and if asked to say what photography has hitherto best succeeded in rendering, we should point to everything near and rough – from the texture of the sea-worn shell, of the rusted armour, and the fustian jacket, to those glorious architectural pictures of French, English, and Italian

subjects, which, whether in quality, tone, detail, or drawing, leave nothing to be desired.

Here, therefore, the debt of Science for additional clearness, precision, and size may be gratefully acknowledged. What photography can do is now, with her help, better done than before; what she can but partially achieve is best not brought too elaborately to light. Thus the whole question of success and failure resolves itself into an investigation of the capacities of the machine, and well may we be satisfied with the rich gifts it bestows, without straining it into a competition with art. For everything for which Art, so-called, has hitherto been the means but not the end, photography is the allotted agent – for all that requires mere manual correctness, and mere manual slavery, without any employment of the artistic feeling, she is the proper and therefore the perfect medium. She is made for the present age, in which the desire for art resides in a small minority, but the craving, or rather necessity for cheap, prompt, and correct facts in the public at large. Photography is the purveyor of such knowledge to the world. She is the sworn witness of everything presented to her view. What are her unerring records in the service of mechanics, engineering, geology, and natural history, but facts of the most sterling and stubborn kind? What are her studies of the various stages of insanity – pictures of life unsurpassable in pathetic truth – but facts as well as lessons of the deepest physiological interest? What are her representations of the bed of the ocean, and the surface of the moon – of the launch of the *Marlborough*, and of the contents of the Great Exhibition – of Charles Kean's now destroyed scenery of the 'Winter's Tale', and of Prince Albert's now slaughtered prize ox – but the facts which are neither the province of art nor of description, but of that new form of communication between man and man – neither letter, message, nor picture – which now happily fills up the space between them? What indeed are nine-tenths of those facial maps called photographic portraits, but accurate landmarks and measurements for loving eyes and memories to deck with beauty and animate with expression, in perfect certainty, that the ground-plan is founded upon fact?

In this sense no photographic picture that ever was taken, in heaven, or earth, or in the waters underneath the earth, of any thing, or scene, however defective when measured by an artistic scale, is destitute of a special, and what we may call an historic interest. Every form which is traced by light is the impress of one moment, or one hour, or one age in the great passage of time. Though the faces of our children may not be modelled and rounded with that truth and beauty which art attains, yet *minor* things – the very shoes of the one, the inseparable toy of the other – are given with a strength of identity which art does not even seek. Though the view of a city be deficient in those niceties of reflected lights and harmonious gradations which belong to the facts of which Art takes account, yet the facts of the age and of the hour are there, for we count the lines in that keen perspective of telegraphic wire, and read the characters on the playbill or manifesto, destined to be torn down on the morrow.

Here, therefore, the much-lauded and much-abused agent called Photography takes her legitimate stand. Her business is to give evidence of facts, as minutely and as impartially as, to our shame, only an unreasoning machine can give. In this vocation we can as little overwork her as tamper with her. The millions and millions of hieroglyphics mentioned by M. Arago may be multiplied by millions and millions more, – she will render all as easily and as accurately as one. When people, therefore,

talk of photography, as being intended to supersede art, they utter what, if true, is not so in the sense they mean. Photography *is* intended to supersede much that art has hitherto done, but only that which it was both a misappropriation and a deterioration of Art to do. The field of delineation, having two distinct spheres, requires two distinct labourers; but though hitherto the freewoman has done the work of the bondwoman, there is no fear that the position should be in the future reversed. Correctness of drawing, truth of detail, and absence of convention, the best artistic characteristics of photography, are qualities of no common kind, but the student who issues from the academy with these in his grasp stands, nevertheless, but on the threshold of art. The power of selection and rejection, the living application of that language which lies dead in his paint-box, the marriage of his own mind with the object before him, and the offspring, half stamped with his own features, half with those of Nature, which is born of the union – whatever appertains to the free-will of the intelligent being, as opposed to the obedience of the machine, – this, and much more than this, constitutes that mystery called Art, in the elucidation of which photography can give valuable help, simply by showing what it is not. There is, in truth, nothing in that power of literal, unreasoning imitation, which she claims as her own, in which, rightly viewed, she does not relieve the artist of a burden rather than supplant him in an office. We do not even except her most pictorial feats – those splendid architectural representations – from this rule. Exquisite as they are, and fitted to teach the young, and assist the experienced in art, yet the hand of the artist is but ignobly employed in closely imitating the texture of stone, or in servilely following the intricacies of the zigzag ornament. And it is not only in what she can do to relieve the sphere of art, but in what she can sweep away from it altogether, that we have reason to congratulate ourselves. Henceforth it may be hoped that we shall hear nothing further of that miserable contradiction in terms 'bad art' – and see nothing more of that still more miserable mistake in life 'a bad artist'. Photography at once does away with anomalies with which the good sense of society has always been more or less at variance. As what she does best is beneath the doing of a real artist at all, so even in what she does worst she is a better machine than the man who is nothing but a machine.

Let us, therefore, dismiss all mistaken ideas about the harm which photography does to art. As in all great and sudden improvements in the material comforts and pleasures of the public, numbers, it is true, have found their occupation gone, simply because it is done cheaper and better in another way. But such improvements always give more than they take. Where ten self-styled artists eked out a precarious living by painting inferior miniatures, ten times that number now earn their bread by supplying photographic portraits. Nor is even such manual skill as they possessed thrown out of the market. There is no photographic establishment of any note that does not employ artists at high salaries – we understand not less than £1 a day – in touching, and colouring, and finishing from nature those portraits for which the camera may be said to have laid the foundation. And it must be remembered that those who complain of the encroachments of photography in this department could not even supply the demand. Portraits, as is evident to any thinking mind, and as photography now proves, belong to that class of facts wanted by numbers who know and care nothing about their value as works of art. For this want, art, even of the most abject kind, was,

whether as regards correctness, promptitude, or price, utterly inadequate. These ends are not only now attained, but, even in an artistic sense, attained far better than before. The coloured portraits to which we have alluded are a most satisfactory coalition between the artist and the machine. Many an inferior miniature-painter who understood the mixing and applying of pleasing tints was wholly unskilled in the true drawing of the human head. With this deficiency supplied, their present productions, therefore, are far superior to anything they accomplished, single-handed, before. Photographs taken on ivory, or on substances invented in imitation of ivory, and coloured by hand from nature, such as are seen at the rooms of Messrs. Dickinson, Claudet, Mayall, Kilburn, &c., are all that can be needed to satisfy the mere portrait want, and in some instances may be called artistic productions of no common kind besides. If, as we understand, the higher professors of miniature-painting – and the art never attained greater excellence in England than now – have found their studios less thronged of late, we believe that the desertion can be but temporary. At all events, those who in future desire their exquisite productions will be more worthy of them. The broader the ground which the machine may occupy, the higher will that of the intelligent agent be found to stand. If, therefore, the time should ever come when art is sought, as it ought to be, mainly for its own sake, our artists and our patrons will be of a far more elevated order than now: and if anything can bring about so desirable a climax, it will be the introduction of Photography.

4 Francis Frith (1822–1898) 'The Art of Photography'

Frith is best known for his photographs of Egypt and Palestine. These were taken on expeditions he made there between 1856 and 1860. He set up a factory in Reigate for the bulk processing of the resulting pictures, thousands of which were sold internationally. In the present essay Frith is determined to treat photography as more than a scientific curiosity. For him it is a medium which has already established itself alongside the other pictorial arts, with its own virtues and defects. Thus the main concern of Frith's essay is no longer to defend the merits of photography as compared with art, but to draw out what its merits are *as* a pictorial art. Foremost among these is its truthfulness. Far from belittling this aspect as 'mere' documentation, Frith recognizes that it represents photography's essential power. Rather than the matter at issue being one of whether photography can rank as art, it is whether the key skills of taste, selection and aesthetic judgement can be taken over and used by the photographer to transcend the mechanical dimensions of the process and to maintain the quality of his own productions. The true significance of the art/ photography debate, that is to say, is not comparative but methodological. Frith's essay was originally published in *The Art Journal*, no. 5, London, 1859, pp. 71–2.

[. . .] It is not our intention in the present article, or in subsequent articles, upon photography, to adopt any theories of partizanship, or to be enslaved by any prejudices whatever. We shall endeavour to write purely in the interests of *Art*. The character of this Journal, as a friend of the easel and palette, is sufficiently known to screen us from the jealousy of painters; and, on the other hand, we profess so ample an acquaintance with the practice and results of photography in its various branches, that its lovers need not fear our doing it full and impartial justice. The history of the art,

the steps by which it progressed, and the formulae of these operations, are not so much our province as is its present state, and the comparative success of its various processes. Of these, we must be permitted to judge *with reference to pictorial and illustrative Art in general*. We think that we are now entitled to decline to take up a photograph, and pronounce upon it simply as 'a most curious and wonderful production, made in a few seconds, sir, – in a few seconds! *Everything* is there, you see!' We must allow to the art the credit of having established for itself a title to be regarded in comparison with its neighbours. Photographers do not now want to be patted on the back, and told that they are good little boys, and that their performances are very creditable, considering their age; but they boldly hire the Suffolk Street Gallery, and challenge the *abstract* admiration of the men who have been used there to exhibit their own beautiful works.

It is a critical and timid time of life, this, when the quondam schoolboy feels that he must renounce the privileges of his class, and be judged as a man by the stern world of men. *Such an ordeal, we do not hesitate to say, the art of photography is now passing through*; and this is *our* starting point. Almost up to the present time, it has been, very properly, in the hands of chemists and opticians, and the men who had a steady hand and a correct eye for the 'definition' in a brick-wall. Not that we would deny to exceptional productions of years ago, to daguerreotype portraits, and to a few 'talbotype' landscapes, a high degree of delicacy and artistic beauty; but we may safely say that anything approaching to a satisfactory uniformity of successful and pleasing result has only been established within a very recent period. Thus, to close the first or introductory branch of our subject, we remark, that although we are inclined to admit that photography has passed the bounds of mere scientific interest, and now takes rank amongst the great pictorial arts of the day, – with lithographic or steel-plate printing, and even, with certain broad distinctions, with painting itself, – we do not thus necessarily place it on a par with any of these arts; it is still, as compared with them, 'in its infancy;' and it has its own distinctive defects, which are, as yet, more obvious and objectionable than any which can ordinarily be charged upon the sister Arts. To counterbalance these, however, it has its own peculiar charms and beauties, and it possesses certain qualities, to be discussed hereafter, both in its practice and results, which are *altogether* its own. Whether some of these are to be regarded as advantages, or otherwise, will continue to be a matter of opinion, but they will afford us subject for interesting discussion and remark.

Having defined, to some extent, the position to which photography has attained, we now turn our attention to some of its chief peculiarities as a pictorial art.

Of these, the most obvious, and that which undoubtedly lies at the root of its popularity, is its *essential* truthfulness of outline, and, to a considerable extent, of perspective, and light and shade.

[. . .] We find it difficult to express how fully, and for how many different reasons, we appreciate this attribute of photography. We can scarcely avoid moralizing in connection with this subject; since truth is a divine quality, at the very foundation of everything that is lovely in earth and heaven; and it is, we argue, quite impossible that this quality can so obviously and largely pervade a popular art, *without exercising the happiest and most important influence, both upon the tastes and the morals of the people*. It is an attribute, to which, we believe, there is, in the whole range of Art, no parallel; to

whose uses and delights we can assign no limits, and shall, of course, not attempt to enumerate them. We will merely suggest to our readers an offer, by auction, of a collection of genuine photographic portraits of all the great and holy men of antiquity, and of our Newton, and Milton, and Shakespeare! The concourse of people! The bids! The reserved price! We protest there *is*, in this new spiritual quality of Art, a charm of wonderful freshness and power, which is quite independent of general or artistic effect, and which appeals instinctively to our readiest sympathies. Every stone, every little perfection, or dilapidation, the most minute detail, which, in an ordinary drawing, would merit no special attention, becomes, on a photograph, worthy of careful study. Very commonly, indeed, we have observed that these faithful pictures have conveyed to ourselves more copious and correct ideas of detail than the inspection of the subjects themselves had supplied; for there appears to be a greater aptitude in the mind for careful and minute study *from paper, and at intervals of leisure*, than when the mind is occupied with the general impressions suggested by a view of the objects themselves, accompanied, as these inspections usually are, by some degree of unsettlement, or of excitement, if the object be one of great or unwonted interest. [. . .]

We now come to the disadvantages of this attribute: for it happens, by a singular fatality, that upon it hangs the chief reproach to photographic productions as works of Art. The fact is, that it is *too truthful*. It insists upon giving us 'the truth, the whole truth, and nothing but the truth.' Now, we want, in Art, the first and last of these conditions, but we can dispense very well with the middle term. Doubtless, it is as truly the province of Art to improve upon nature, by control and arrangement, as it is to copy her closely in all that we *do* imitate; and, therefore, we say boldly, that by the non-possession of these privileges, photography pays a heavy compensation to Art, and must for ever remain under an immense disadvantage in this respect. We are sure that no one will be more ready to subscribe to the accuracy of this remark, than the accomplished photographer himself. No man knows so well as he, that very rarely indeed does a landscape arrange itself upon his focussing-glass, as well, as effectively, as he could arrange it, *if he could*. No man is so painfully conscious as he is, that nature's lights and shades are generally woefully patchy and ineffective, *compared with Turner's*; and, in short, that although his chemical knowledge be perfectly adequate, and his manipulation faultless, it is a marvel, an accident, a chance of a thousand, when a picture 'turns out' as *artistic*, in every respect, as his cultivated taste could wish.

Next to the truthfulness of photography, its most striking peculiarities are its somewhat mechanical character, and the rapidity with which its results are produced. These characteristics constitute the chief elements of the extent and popularity of the practice of photography, just as its truthfulness is the greatest charm of its results. It was perfectly natural and inevitable that when this art began to excite universal attention, the whole body of skilled draughtsmen looked upon it with jealousy and distrust. It is inevitable that many artists must continue to dislike or to despise it. We can even imagine that some who hailed it as a beautiful thing, and who even made a partial and timid use of it, have harboured it as they would a tame snake; giving it a good switching now and then, lest it should grow rampant, and bite. It is evident that some classes of artists had substantial cause to dread it. It has already almost entirely

superseded the craft of the miniature painter, and is upon the point of touching, with an irresistible hand, several other branches of skilled Art.

But, quite apart from 'interested motives,' there was, and there continues to be, a reasonable jealousy, not so much of the Art itself, or of its capabilities, as of its pretensions, and the *spirit of its practice*. We do not participate in these fears, because we are convinced of two things with reference to this subject. Firstly, that to practice the Art *with distinction*, which will very shortly be, if it be not now, the only kind of practice which will command notice, requires a much greater acquaintance with the principles of Art than would seem to be applicable to 'a merely mechanical science.' And, secondly, we are convinced that no extravagant 'pretensions' can long be maintained in the public mind. Photography does not even now profess to be either 'high Art,' or in any way a substitute for it. [. . .]

The class of persons, now a very large one, who practise photography, is undoubtedly a very different class from the old regime of 'artists.' It certainly includes a vast number who know nothing, and, if we judge by their *crimes*, care less for the principles, we will not say of Art, but of common sense and decency. But even these, its practice, how degrading soever to an 'artist,' may insensibly benefit. Whatever Art may, in the opinion of some, suffer from photography, that large class of the public, who are sunk so far *below Art*, will unquestionably reap from it a more than compensating advantage. We do not believe in its power to deter any youth, to whom nature has given an artist's eye and heart, from a proper cultivation of those tastes and talents from which he is gifted. Your most accomplished artist, if he will stoop to the task, will ever be your best photographer, and your skillful 'manipulator,' if he be possessed likewise of a grain of sense or perception, will never rest until he has acquainted himself with the rules which are applied to Art in its higher walks; and he will then make it his constant and most anxious study how he can apply these rules to his own pursuit. And this – although no easy matter, and a thing not to be perfected in a day – he will find to be a study which will admit of the most varied and satisfactory application.

The rapidity of production of which the merely mechanical process of photographic picture-making is capable, may easily become a source of great mischief. The student should bear in mind that what he is to aim at is not the production of a large number of 'good' pictures, but, if possible, of ONE which shall satisfy all the requirements of his judgement and taste. That one, when produced, will be, we need not say, of infinitely greater value to his feelings and reputation than a 'lane-full' of merely 'good' pictures. Think of the careful thought and labour which are expended over every successful piece of canvas, and the months of patient work which are requisite to perfect a first-class steel plate! And then turn to the gentleman who describes a machine which he has contrived for taking six dozen pictures a day! Every one of them – this is the distressing part of the business – every one of them capable of throwing off as many impressions as the steel plate! We shudder to think of the thousands of vile 'negatives' boxed up at this moment in holes and corners, any one of which may, on a sunny day, hatch a brood of hateful 'positives.'

We feel it to be a solemn duty to remind photographers of the responsibilities which they incur by harbouring these dangerous reproductive productions; and we beg of them – for their own sakes, and for that of society – to lose no time in washing

off, or otherwise destroying, by far the greater part of their 'negative' posses-
sions. [...]

5 Charles Baudelaire (1821–1867) 'The Modern Public and Photography'

The essay from which this extract is taken originally formed the second section of
Baudelaire's 'Salon of 1859' (see IIID6), where it was positioned between a critique of
those artists who over-valued technique and a celebration of the critical powers of the
imagination. One overall theme of his review was the question of whether art makes its own
public – thus receiving the level of response it deserves; or whether the public imposes
certain expectations upon the artist, which it is then the artist's duty to resist, so that the
public response may be educated and improved. His provisional conclusion was that 'if the
artist makes the public stupid, the public pays him back in kind'. The particular form of
'stupidity' he was concerned with was 'the progressive domination of matter' and 'the
miraculous everyday diffusion of the common run of skill', both of which he associated with
simple-minded Naturalism. At this point photography is introduced into his argument as the
naturalistic device *par excellence* and thus as both a symptom and a cause of the
impoverishment of art's imaginative functions. Baudelaire's 'Salon de 1859' was originally
published in the *Revue Française*, Paris, 10 June–20 July 1859. This version is taken from
the translation in Jonathan Mayne (ed.), *Art in Paris: 1845–62*, London: Phaidon, 1964,
pp. 151–5.

[...] For us the natural painter, like the natural poet, is almost a monster. The
exclusive taste for the True (so noble a thing when it is limited to its proper
applications) oppresses and stifles the taste of the Beautiful. Where one should see
nothing but Beauty (I mean in a beautiful painting, and you can easily guess what is in
my mind), our public looks only for Truth. The people are not artists, not naturally
artists; philosophers perhaps, moralists, engineers, connoisseurs of instructive anec-
dotes, whatever you like, but never spontaneously artists. They feel, or rather they
judge, in stages, analytically. Other more fortunate peoples feel immediately, all at
once, synthetically.

I was speaking just now of artists who seek to astonish the public. The desire to
astonish and to be astonished is very proper. 'It is a happiness to wonder'; but also 'it
is a happiness to dream'.[1] The whole question, then, if you insist that I confer upon
you the title of artist or of connoisseur of the fine arts, is to know by what processes
you wish to create or to feel wonder. Because the Beautiful is *always* wonderful, it
would be absurd to suppose that what is wonderful is *always* beautiful. Now our
public, which is singularly incapable of feeling the happiness of dreaming or of
marvelling (a sign of its meanness of soul), wishes to be made to wonder by means
which are alien to art, and its obedient artists bow to its taste; they try to strike, to
surprise, to stupefy it by means of unworthy tricks, because they know that it is
incapable of ecstasy in front of the natural devices of true art.

During this lamentable period, a new industry arose which contributed not a little
to confirm stupidity in its faith and to ruin whatever might remain of the divine in the
French mind. The idolatrous mob demanded an ideal worthy of itself and appropriate
to its nature – that is perfectly understood. In matters of painting and sculpture, the

present-day *Credo* of the sophisticated, above all in France (and I do not think that anyone at all would dare to state the contrary), is this: 'I believe in Nature, and I believe only in Nature (there are good reasons for that). I believe that Art is, and cannot be other than, the exact reproduction of Nature (a timid and dissident sect would wish to exclude the more repellent objects of nature, such as skeletons or chamber-pots). Thus an industry that could give us a result identical to Nature would be the absolute of art.' A revengeful God has given ear to the prayers of this multitude. Daguerre was his Messiah. And now the faithful says to himself: 'Since Photography gives us every guarantee of exactitude that we could desire (they really believe that, the mad fools!), then Photography and Art are the same thing.' From that moment our squalid society rushed, Narcissus to a man, to gaze at its trivial image on a scrap of metal. A madness, an extraordinary fanaticism took possession of all these new sun-worshippers. Strange abominations took form. By bringing together a group of male and female clowns, got up like butchers and laundry-maids at a carnival, and by begging these *heroes* to be so kind as to hold their chance grimaces for the time necessary for the performance, the operator flattered himself that he was reproducing tragic or elegant scenes from ancient history. Some democratic writer ought to have seen here a cheap method of disseminating a loathing for history and for painting among the people, thus committing a double sacrilege and insulting at one and the same time the divine art of painting and the noble art of the actor. A little later a thousand hungry eyes were bending over the peepholes of the stereoscope, as though they were the attic-windows of the infinite. The love of pornography, which is no less deep-rooted in the natural heart of man than the love of himself, was not to let slip so fine an opportunity of self-satisfaction. And do not imagine that it was only children on their way back from school who took pleasure in these follies; the world was infatuated with them. I was once present when some friends were discreetly concealing some such pictures from a beautiful woman, a woman of high society, not of mine – they were taking upon themselves some feeling of delicacy in her presence; but 'No,' she cried. 'Give them to me! Nothing is too much for me.' I swear that I heard that; but who will believe me? [. . .]

As the photographic industry was the refuge of every would-be painter, every painter too ill-endowed or too lazy to complete his studies, this universal infatuation bore not only the mark of a blindness, an imbecility, but had also the air of a vengeance. I do not believe, or at least I do not wish to believe, in the absolute success of such a brutish conspiracy, in which, as in all others, one finds both fools and knaves; but I am convinced that the ill-applied developments of photography, like all other purely material developments of progress, have contributed much to the impoverishment of the French artistic genius, which is already so scarce. In vain may our modern Fatuity roar, belch forth all the rumbling wind of its rotund stomach, spew out all the undigested sophisms with which recent philosophy has stuffed it from top to bottom; it is nonetheless obvious that this industry, by invading the territories of art, has become art's most mortal enemy, and that the confusion of their several functions prevents any of them from being properly fulfilled. Poetry and progress are like two ambitious men who hate one another with an instinctive hatred, and when they meet upon the same road, one of them has to give place. If photography is allowed to supplement art in some of its functions, it will soon have

supplanted or corrupted it altogether, thanks to the stupidity of the multitude which is its natural ally. It is time, then, for it to return to its true duty, which is to be the servant of the sciences and arts – but the very humble servant, like printing or shorthand, which have neither created nor supplemented literature. Let it hasten to enrich the tourist's album and restore to his eye the precision which his memory may lack; let it adorn the naturalist's library, and enlarge microscopic animals; let it even provide information to corroborate the astronomer's hypotheses; in short, let it be the secretary and clerk of whoever needs an absolute factual exactitude in his profession – up to that point nothing could be better. Let it rescue from oblivion those tumbling ruins, those books, prints and manuscripts which time is devouring, precious things whose form is dissolving and which demand a place in the archives of our memory – it will be thanked and applauded. But if it be allowed to encroach upon the domain of the impalpable and the imaginary, upon anything whose value depends solely upon the addition of something of a man's soul, then it will be so much the worse for us!

I know very well that some people will retort, 'The disease which you have just been diagnosing is a disease of imbeciles. What man worthy of the name of artist, and what true connoisseur, has ever confused art with industry?'. I know it; and yet I will ask them in my turn if they believe in the contagion of good and evil, in the action of the mass on individuals, and in the involuntary, forced obedience of the individual to the mass. It is an incontestable, an irresistible law that the artist should act upon the public, and that the public should react upon the artist; and besides, those terrible witnesses, the facts, are easy to study; the disaster is verifiable. Each day art further diminishes its self-respect by bowing down before external reality; each day the painter becomes more and more given to painting not what he dreams but what he sees. Nevertheless *it is a happiness to dream*, and it used to be a glory to express what one dreamt. But I ask you! does the painter still know this happiness?

Could you find an honest observer to declare that the invasion of photography and the great industrial madness of our times have no part at all in this deplorable result? Are we to suppose that a people whose eyes are growing used to considering the results of a material science as though they were the products of the beautiful, will not in the course of time have singularly diminished its faculties of judging and of feeling what are among the most ethereal and immaterial aspects of creation?

[1] Quoted from Poe, *Morella*.

6 Oliver Wendell Holmes (1809–1894) 'The Stereoscope and the Stereograph'

As well as being a poet and essayist, Holmes was an eminent physician. From 1847 he was Professor of anatomy and physiology at Harvard, and later Dean of the Medical School there. He was also a keen photographer. The United States was at the forefront of the early practice, if not the actual invention, of photography. The world's first photographic portrait studio opened in New York as early as March 1840. By 1850 that city had 77 photography galleries, and more daguerreotypes were produced in the US than anywhere else. For Holmes the daguerreotype was miraculous, 'the most audacious, improbable, incredible triumph of human ingenuity'. He was particularly fascinated by the possibilities of

stereoscopic viewing, to enhance the three-dimensional effect of the image. The first part of the present essay offered a brief history of photography. Our extracts are taken from the latter part, which concentrates on the effects of photographs. As with so many early commentators, Holmes is taken with the detail of photographic reproductions as compared with paintings. His essay conveys something of the wonder of first looking at photographs, traces of real things apparently made without the mediating hand of the artist. Holmes is concerned not so much with the question of photography's relation to fine art but with the power of the photograph to make images *real*. He even goes so far as to glimpse a time when the image will be more powerful and more pervasive than real things. In sum, Holmes correctly sees that the advent of photography reaches far beyond the question of its relation to art: the photographic image has opened 'a new epoch in the history of human progress'. Holmes's essay was originally published in *The Atlantic Monthly*, volume 3, Boston, June 1859, pp. 738–48.

[. . .] The first effect of looking at a good photograph through the stereoscope is a surprise such as no painting ever produced. The mind feels its way into the very depths of the picture. The scraggy branches of a tree in the foreground run out at us as if they would scratch our eyes out. The elbow of a figure stands forth so as to make us almost uncomfortable. Then there is such a frightful amount of detail, that we have the same sense of infinite complexity which Nature gives us. A painter shows us masses; the stereoscopic figure spares us nothing, – all must be there, every stick, straw, scratch, as faithfully as the dome of St Peter's, or the summit of Mont Blanc, or the ever-moving stillness of Niagara. The sun is no respecter of persons or of things.

This is one infinite charm of the photographic delineation. Theoretically, a perfect photograph is absolutely inexhaustible. In a picture you can find nothing the artist has not seen before you; but in a perfect photograph there will be as many beauties lurking, unobserved, as there are flowers that blush unseen in forests and meadows. It is a mistake to suppose one knows a stereoscopic picture when he has studied it a hundred times by the aid of the best of our common instruments. Do we know all that there is in a landscape by looking out at it from our parlour-windows? In one of the glass stereoscopic views of Table Rock, two figures, so minute as to be mere objects of comparison with the surrounding vastness, may be seen standing side by side. Look at the two faces with a strong magnifier, and you could identify their owners, if you met them in a court of law. [. . .]

This distinctness of the lesser details of a building or a landscape often gives us incidental truths which interest us more than the central object of the picture. Here is Alloway Kirk, in the churchyard of which you may read a real story by the side of the ruin that tells of more romantic fiction. There stands the stone 'Erected by James Russell, seedsman, Ayr, in memory of his children,' – three little boys, James, and Thomas, and John, all snatched away from him in the space of three successive summer-days, and lying under the matted grass in the shadow of the old witch-haunted walls. It was Burns's Alloway Kirk we paid for, and we find we have bought a share in the griefs of James Russell, seedsman; for is not the stone that tells this blinding sorrow of real life the true centre of the picture, and not the roofless pile which reminds us of an idle legend?

We have often found these incidental glimpses of life and death running away with us from the main object the picture was meant to delineate. The more evidently

accidental their introduction, the more trivial they are in themselves, the more they take hold of the imagination. It is common to find an object in one of the twin pictures which we miss in the other; the person or the vehicle having moved in the interval of taking the two photographs. There is before us a view of the Pool of David at Hebron, in which a shadowy figure appears at the water's edge, in the right-hand farther corner of the right-hand picture only. This muffled shape stealing silently into the solemn scene has already written a hundred biographies in our imagination. In the lovely glass stereograph of the Lake of Brienz, on the left-hand side, a vaguely hinted female figure stands by the margin of the fair water; on the other side of the picture she is not seen. This is life; we seem to see her come and go. All the longings, passions, experiences, possibilities of womanhood animate that gliding shadow which has flitted through our consciousness, nameless, dateless, featureless, yet more profoundly real than the sharpest of portraits traced by a human hand. Here is the Fountain of the Ogre, at Berne. In the right picture two women are chatting, with arms akimbo, over its basin; before the plate for the left picture is got ready, 'one shall be taken and the other left'; look! on the left side there is but one woman, and you may see the blur where the other is melting into thin air as she fades forever from your eyes.

Oh, infinite volumes of poems that I treasure in this small library of glass and pasteboard! I creep over the vast features of Rameses, on the face of his rockhewn Nubian temple; I scale the huge mountain-crystal that calls itself the Pyramid of Cheops. I pace the length of the three Titanic stones of the wall of Baalbec, – mightiest masses of quarried rock that man has lifted into the air; and then I dive into some mass of foliage with my microscope, and trace the veinings of a leaf so delicately wrought in the painting not made with hands, that I can almost see its down and the green aphis that sucks its juices. I look into the eyes of the caged tiger, and on the scaly train of the crocodile, stretched on the sands of the river that has mirrored a hundred dynasties. I stroll through Rhenish vineyards, I sit under Roman arches, I walk the streets of once buried cities, I look into the chasms of Alpine glaciers, and on the rush of wasteful cataracts. I pass, in a moment, from the banks of the Charles to the ford of the Jordan, and leave my outward frame in the arm-chair at my table, while in spirit I am looking down upon Jerusalem from the Mount of Olives.

'Give me the full tide of life at Charing Cross,' said Dr Johnson. Here is Charing Cross, but without the full tide of life. A perpetual stream of figures leaves no definite shapes upon the picture. But on one side of this stereoscopic doublet a little London 'gent' is leaning pensively against a post; on the other side he is seen sitting at the foot of the next post; – what is the matter with the little 'gent'?

The very things which an artist would leave out, or render imperfectly, the photograph takes infinite care with, and so makes its illusions perfect. What is the picture of a drum without the marks on its head where the beating of the sticks has darkened the parchment? In three pictures of the Ann Hathaway Cottage, before us, – the most perfect, perhaps, of all the paper stereographs we have seen, – the door at the farther end of the cottage is open, and we see the marks left by the rubbing of hands and shoulders as the good people came through the entry, or leaned against it, or felt for the latch. It is not impossible that scales from the epidermis of the trembling hand of Ann Hathaway's young suitor, Will Shakespeare, are still adherent about the old latch and door, and that they contribute to the stains we see in our picture.

Among the accidents of life, as delineated in the stereograph, there is one that rarely fails in any extended view which shows us the details of streets and buildings. There may be neither man nor beast nor vehicle to be seen. You may be looking down on a place in such a way that none of the ordinary marks of its being actually inhabited show themselves. But in the rawest Western settlement and the oldest Eastern city, in the midst of the shanties at Pike's Peak and stretching across the court-yards as you look into them from above the clay-plastered roofs of Damascus, wherever man lives with any of the decencies of civilization, you will find the *clothes-line*. It may be a fence, (in Ireland,) – it may be a tree, (if the Irish license is still allowed us,) – but clothes-drying, or a place to dry clothes on, the stereoscopic photograph insists on finding, wherever it gives us a group of houses. This is the city of Berne. How it brings the people who sleep under that roof before us to see their sheets drying on that fence! And how real it makes the men in that house to look at their shirts hanging, arms down, from yonder line! [. . .]

What is to come of the stereoscope and the photograph we are almost afraid to guess, lest we should seem extravagant. But, premising that we are to give a *coloured* stereoscopic mental view of their prospects, we will venture on a few glimpses at a conceivable, if not a possible future.

Form is henceforth divorced from matter. In fact, matter as a visible object is of no great use any longer, except as the mould on which form is shaped. Give us a few negatives of a thing worth seeing, taken from different points of view, and that is all we want of it. Pull it down or burn it up, if you please. We must, perhaps, sacrifice some luxury in the loss of colour; but form and light and shade are the great things, and even colour can be added, and perhaps by and by may be got direct from Nature.

There is only one Coliseum or Pantheon; but how many millions of potential negatives have they shed, – representatives of billions of pictures, – since they were erected! Matter in large masses must always be fixed and dear; form is cheap and transportable. We have got the fruit of creation now, and need not trouble ourselves with the core. Every conceivable object of Nature and Art will soon scale off its surface for us. Men will hunt all curious, beautiful, grand objects, as they hunt the cattle in South America, for their *skins*, and leave the carcasses as of little worth.

The consequence of this will soon be such an enormous collection of forms that they will have to be classified and arranged in vast libraries, as books are now. The time will come when a man who wishes to see any object, natural or artificial, will go to the Imperial, National, or City Stereographic Library and call for its skin or form, as he would for a book at any common library. We do now distinctly propose the creation of a comprehensive and systematic stereographic library, where all men can find the special forms they particularly desire to see as artists, or as scholars, or as mechanics, or in any other capacity. Already a workman has been travelling about the country with stereographic views of furniture, showing his employer's patterns in this way, and taking orders for them. This is a mere hint of what is coming before long.

Again, we must have special stereographic collections, just as we have professional and other special libraries. And as a means of facilitating the formation of public and

private stereographic collections, there must be arranged a comprehensive system of exchanges, so that there may grow up something like a universal currency of these bank-notes, or promises to pay in solid substance, which the sun has engraved for the great Bank of Nature.

To render comparison of similar objects, or of any that we may wish to see side by side, easy, there should be a stereographic *metre* or fixed standard of focal length for the camera lens, to furnish by its multiples or fractions, if necessary, the scale of distances, and the standard of power in the stereoscope-lens. In this way the eye can make the most rapid and exact comparisons. If the 'great elm' and the Cowthorpe oak, if the State-House and St Peter's, were taken on the same scale, and looked at with the same magnifying power, we should compare them without the possibility of being misled by those partialities which might tend to make us overrate the indigenous vegetable and the dome of our native Michel Angelo.

The next European war will send us stereographs of battles. It is asserted that a bursting shell can be photographed. The time is perhaps at hand when a flash of light, as sudden and brief as that of the lightning which shows a whirling wheel standing stock still, shall preserve the very instant of the shock of contact of the mighty armies that are even now gathering. The lightning from heaven does actually photograph natural objects on the bodies of those it has just blasted, – so we are told by many witnesses. The lightning of clashing sabres and bayonets may be forced to stereotype itself in a stillness as complete as that of the tumbling tide of Niagara as we see it self-pictured.

We should be led on too far, if we developed our belief as to the transformations to be wrought by this greatest of human triumphs over earthly conditions, the divorce of form and substance. Let our readers fill out a blank check on the future as they like, – we give our endorsement to their imaginations beforehand. We are looking into stereoscopes as pretty toys, and wondering over the photograph as a charming novelty; but before another generation has passed away, it will be recognized that a new epoch in the history of human progress dates from the time when He who

> – never but in uncreated light
> Dwelt from eternity –

took a pencil of fire from the hand of the 'angel standing in the sun,' and placed it in the hands of a mortal.

7 Albert Sands Southworth (1811–1894) 'The Early History of Photography in the United States'

Southworth and his partner Josiah Johnson Hawes were the foremost American practitioners of the daguerreotype. They both encountered the daguerreotype in 1840, only a few months after its introduction to the United States, and together opened a portrait studio in Boston in 1841. Their portrait work eschewed staged poses and painted backdrops and set new standards in informality and naturalism. Southworth's health began to

fail in the 1850s. He took less of an active part in the business and ended the partnership in 1861 (Hawes continued alone), and turned more to writing. In the present essay, as well as offering a history of American developments, Southworth discusses photography as a form of art. Somewhat like Frith (IVc4) Southworth argues that its artistic dimension transcends its mechanical side. Manipulating lenses or shutters is no more the sum of photography than dexterity with a chisel is a guarantee of value in sculpture. To this end, he begins to use the hyphenated term 'artist-photographer'. The point at issue is quality, and while for Southworth there is no question that quality *can* exist in photography, it is likely to be as scarce there as in any other artistic genre. Southworth's essay was originally published in *The British Journal of Photography*, no. 18, London, November 1871, pp. 530–2.

[. . .] But the artist, even in photography, must go beyond discovery and the knowledge of facts. He must create and invent truths, and produce new developments of facts. I would have him an artist in the highest and truest sense applicable to the production of views or pictures of any and every kind, or to statues and forms in nature universally. I would have him able to wield at pleasure the power of drawing Nature in all her forms, as represented to vision, with lights and shadows, and colours and forms, in all of nature's changes. I would have him as familiar with her as with his alphabet of letters. He should not only be familiar with Nature and her philosophy, but he should be informed as to the principles which govern or influence human actions, and the causes which affect and mark human character. History and poetry should be to him mere *pastime*; observation of nature, cause and effect, should be his employment. Familiar with all that has been done, with a genius to comprehend and estimate excellencies and defects, he will bend his energies to rival this one, while, at the same time, he discards the other. Thus he will save and have time for the application and use of the true principles of art, which otherwise would require to be devoted to laborious and often unsuccessful experiments. This truth is not believed, or, if admitted, is not realized; yet it is truth still that there is no high, easy, unobstructed road to knowledge, but the same long, steep and toilsome path which has ever led, and still is ever to lead, to the treasuries of learning and wisdom. [. . .]

We appreciate the perfection of the lenses with which we make the images of nature or art in our cameras; the perfection in the manufacture of our chemicals, glass, and paper; the variety and beauty in the style of our mountings and frames; but that which is necessary and requisite to fit one for the disposition of light and shade, the arrangement of the sitter, and accessories for the design and composition of the picture, is of a far higher order in the scale of qualifications, demands more observation and comprehensive knowledge, a greater acquaintance with mind in its connection with matter, a more ready and inventive genius, and greater capacity for concentrated thought and effort with prompt accompaniment in action. What is to be done is obliged to be done quickly. The whole character of the sitter is to be read at first sight; the whole likeness, as it shall appear when finished, is to be seen at first in each and all its details and in their unity and combinations. Natural and accidental defects are to be separated from natural and possible perfections – these latter to obliterate or hide the former. Nature is not all to be represented as it is, but as it ought

to be, and might possibly have been; and it is required of, and should be the aim of, the artist-photographer to produce in the likeness the best possible character and finest expression of which that particular face or figure could ever have been capable. But in the result there is to be no departure from truth in the delineation and representation of beauty, expression, and character.

But it may be asked whether the standard for the qualifications of the artist in photography is to be considered equal to that for painting and sculpture? If the aim and the purpose be the highest point of human perfection in either art, then I repeat that, as great as may be estimated the necessary qualifications and intellectual discipline and natural talents and genius for the painter and sculptor, precisely as much would I require for the artist in photography. The mere manipulations – the handling of brush or chisel – are as mechanical and in no respect beyond adjusting the camera or retouching correctly. The mind must express the value, and mark and impress resemblances and differences; it must be instructed and directed by impressions at the time emanating from the subject itself.

Photographs possessing all the desirable points are as scarce and valuable as the gems of India or Brazil, and the thousands of multiplied copies of the one are as common and worthless as the counterfeit glass imitations of the other. The demand for this class of photographs increases with the facilities for rapid execution and diminished value and cost. Whilst there exists this demand for a picture of a quality scarcely worthy of the name, we will not find fault with those who stand ready to supply that demand. The taste of the public is to be formed and educated before work of a higher and more meritorious character is required [. . .]

[. . .] Do not understand me as attempting to discourage any who may have entered upon the business of photographing, or of holding up before you any impracticable theory of unattainable perfection. I would impress upon you the necessity of the most constant and unremitting attention to Nature – her changes, her variations, her moods, and her principles and productions. I suppose the picture-maker to be endowed with genius for, and a mind devoted to, art; to such an one no scene can be vacant or uninteresting. He will see in every place something for observation and investigation, from the simplest to the most imposing and sublime. All the actions and the varied expressions of man under all influences – the characteristic forms, lines, and effects of health, age, and condition, of beauty and deformity – he will regard with scrutiny; all varieties of country, all species of animals under all circumstances of repose or excitement, all of the earth below, all of the heavens above. This is his discipline of mind and vision, with fatigue and trouble at first, to be rewarded afterwards with enlarged powers and higher views, until another sense seems to have been added to his faculties unfelt and unknown to the uninitiated. The artist is conscious of something beside the mere physical in every object in nature. He feels its expression, he sympathizes with its character, he is impressed with its language; his heart, mind, and soul are stirred in its contemplation. It is the life, the feeling, the mind, the soul of the subject itself. Nature is the creation of infinite knowledge and wisdom, and it is hardly permitted to humanity to even faintly express nature by a copy. [. . .]

8 Peter Henry Emerson (1856–1936) 'Photography, A Pictorial Art'

Emerson's work marked a new stage in the theorization of photography as an art. He originally trained as a doctor, and began taking photographs to document the lives of farmers and fishermen in East Anglia. This body of work constitutes a memorable record of English rural life in the nineteenth century, but part of its power is due to the aesthetic Emerson had begun to develop. Influenced by French artistic Naturalism, notably the work of Millet and others of the Barbizon group, he advocated a naturalistic approach to photography: going out of the studio, into the open air, and photographing real workers engaged in actual labour. Emerson was also technically influenced by Helmholtz's investigations of the nature of perception (see IVB8). Studies of the impact on the eye of masses of light and shade led Emerson to advise photographers to abandon the pursuit of all-over detail (seen as such a hallmark of early photography) and concentrate on the main subject set against vaguer, atmospheric distances. What was involved here was a view of photography as an expressive rather than solely a mimetic art. Emerson gave the present paper as a lecture to the Camera Club in London on 11 March 1886. It was followed by a book, *Naturalistic Photography*, in 1889. Subsequently, Emerson himself abandoned the advocacy of photography as an art form, but his ideas none the less remained influential on the development of art-photography in the twentieth century (see VIA19). His lecture was published in *The Amateur Photographer* no. 3, London, 19 March 1886, pp. 138–9.

[. . .] We must now leave this fascinating development of Art, and show how and why photography is a fine Art. Pictorial Art is man's expression by means of pictures of that which he considers beautiful in nature. Now any Art is a fine Art which can, by pictures, express these beauties, and that Art is best which best expresses them. Let us begin with painting, the master pictorial Art, for until we can reproduce the colours of nature, we can never equal painting; but all other branches of pictorial Art we are able to surpass. Painting alone is our master. Now let us see how far painting can reproduce nature. Professor Helmholtz has worked this question out for us, and to him I am indebted for the following notes. In reproducing nature, as he says, one of the principal things is the quantitative relation between luminous intensities. 'If the artist is to imitate exactly the impression which the object produces on our eye, he ought to be able to dispose of lightness and darkness equal to that which nature offers.' But of this there can be no idea. Let me give a case in point. Let there be, in a picture gallery; a desert scene, in which a procession of Bedouins shrouded in white, and of dark negroes, marches under the burning sunshine; close to it a bluish moonlight scene, where the moon is reflected in the water, and groups of trees, and human forms, are seen to be faintly indicated in the darkness. You know from experience that both pictures, if they are well done, can produce with surprising vividness the representation of their objects; and yet, in both pictures, the brightest parts are produced with the same white lead, which is but slightly altered by admixtures; while the darkest parts are produced with the same black, both being hung on the same wall, share the same light, and the brightest as well as the darkest parts of the two scarcely differ as concerns the degree of their brightness. How is it, however, with the actual degrees of brightness represented? Now, although the pictures scarcely differ as regards the degrees of their brightness, yet in nature the sun is 800,000 times

brighter than the moon; but as pictures are lighted by reflected light, the brightest white in a picture has about 1/20th the brightness of white directly lighted by the sun. Hence it will be seen that white surfaces in pictures in sunlight are much less bright than in reality, and the moonlight whites of pictures are much brighter than they are in reality. How, then, is it that there is any similarity between the picture and the reality? This is explained by the physiological process of fatigue. Any sense, as we know, is dulled by fatigue; to wit, the effect of loud noises and bright lights on hearing and seeing. The eye of the man in the desert is dulled by the dazzling sunlight, whilst the eye of the wanderer by moonlight has been raised to an extreme degree of sensitiveness. What, then, must the painter do? He must endeavour to produce by his colours in the moderately sensitive eye of the spectator in a picture gallery the same effect as seen in the sunlight or moonlight. To accomplish this, he gives a translation of his impression into another scale. We know, regarding all sensations, that any particular sense is so coarse that it cannot distinguish differences between certain wide limits. The finer distinctions of light cannot therefore be appreciated by the eye. The painter, therefore, must, as nearly as he can, give the same *ratio* of brightness to his colours as that which actually exists. Helmholtz says that 'perfect artistic painting is only reached when we have succeeded in imitating the action of light upon the eye, and not merely the pigments.'

Now let me give you an example of the fallacy of the pre-Raphaelites. They imitated the pigments, not the light. . . . We . . . see that much is impossible in Art, and that one of the greatest points is rendering correctly the relative values or ratio of luminous intensities. Now we know that the effect of binocular vision is to force a scene on our perceptions as a plane surface; hence the painter has in this point no pull over the photographic lens, but rather the reverse. Of the greatest importance to a picture also is aerial perspective, that is, the scattering of light by atmospheric turbidity, more generally moisture. This turbidity is most important, and the lack of it dwarfs distant objects; hence from the lack of it in the higher Alps, we get these caricatures which yearly adorn our galleries. These dwarfed maps of mountain peaks seem rather in fashion just now – heaven only knows why. No painter can do them justice, and no good one ever attempts them, and yet photographers, who are not so able to represent them, are constantly doing so, and, to show the prevalent ignorance, these photographs are often honoured with the highest awards because of their sharpness and clearness. Letters have been written suggesting that English and foreign views should not be classed together, and much other nonsense of this description, all simply showing ignorance.

A work of Art is, as we have said, an expression by means of pictures of what is beautiful, and the points to gauge in a picture are to notice what a man wishes to express, and how well he has expressed it. I know Switzerland, and love it well; but I would no more attempt to make a picture of a peak than I would of a donkey engine. A peak, shrouded and accentuated by aerial turbidity, and just peeping into an Alpine subject, might from its mystery and sentiment add to the artistic value of a foreground subject. But the usual photographs of peaks could be of interest only in a Baedeker. This turbidity can be well rendered in a photograph. Painters, as we do, use optical instruments, such as Claude glasses [curved mirrors used by landscape painters, to emulate effects found in the work of Claude Lorrain], prisms, and the

camera itself. The whole point, then, that the painter strives to do is to render, by any means in his power, as true an impression of any picture which he wishes to express as possible. A photographic artist strives for the same end, and in two points only does he fall short of the painter – in colour, and in ability to render so accurately the relative values, although this is, to a great extent, compensated for by the tone of the picture. I here use the word in its artistic sense, and not in its misused photographic sense. How, then, is photography superior to etching, wood-cutting, charcoal drawing? The drawing of the lens is not to be equalled by any man; the tones of a correctly and suitably printed picture far surpass those of any other black and white process. An etching, in fact, has no tones, except those supplied by the printer. As I have said before, if it falls short anywhere, it is in the rendering of the relative values, but the perfection of the tone corrects this in a great measure. There is ample room for selection, judgment, and posing, and, in a word, in capable hands, a finished photograph is a work of Art. Again, it is evident that the translation of pictures by photogravure, for the same reasons given above, will be superior to that of any engraving. But we must not forget that nine-tenths of photographs are no more works of Art than the chromos, lithos, and bad paintings which adorn the numerous shops and galleries.

Thus we see that Art has at last found a scientific basis, and can be rationally discussed, and that the modern school is the school which has adopted this rational view; and I think I am right in saying that I was the first to base the claims of photography as a fine Art on these grounds, and I venture to predict that the day will come when photographs will be admitted to hang on the walls of the Royal Academy.

Reference was made in the earlier part of this paper to Greek statues, and it is now easy to understand why they have endured so long, and are the beau ideals of the artists to-day, as they were of the artists of Ancient Greece. The secret all lies in the fact that they were done from nature, from actual living models – Phidias and Praxiteles tried their utmost to express in an artistic way, in living marble, the human being before them. They succeeded, and these statues to-day are of more value than the monstrosities of the middle ages, and are unequalled by the moderns. In closing I would say, the modern school of painting and photography are at one; their aims are similar, their principles are rational, and they link one into the other; and will in time, I feel confident, walk hand in hand, the two survivals of the fittest.

Part V
Aesthetics and Historical Awareness

V
Introduction

The last decades of the nineteenth century witnessed a renewed flourishing of that rich tradition of theoretical and philosophical reflection on art in the German-speaking world which reaches back through the Idealism of Schopenhauer (IA1) and Hegel (IA10) to the work of Immanuel Kant (1724–1804) and to the founding of the modern conception of the 'aesthetic' in the work of Alexander Baumgarten (1714–62). Whilst Paris undoubtedly remained at the forefront of artistic practice and innovation, German-speaking critics and theorists began to explore new methods and approaches for comprehending the specific character and status of the visual arts. The unification of Germany in 1871 was preceded by a period of rapid economic and industrial growth. This was accompanied not only by a boom in the founding of new companies and large enterprises in the period known as the *Gründerzeit* (founders' years) but by a proliferation of educational and cultural institutions, such as museums, theatres and art galleries. These, it was hoped, would provide a solid foundation for bourgeois social and political values. Within the universities, German achievements in the natural sciences were being met by an extension of the range and critical power of the social or human sciences, and this, in turn, provided a new context for the investigation of the domain of human culture.

In 1873, just two years after unification, the bubble of the *Gründerzeit* burst and Germany suffered a severe economic crash. The response of the government was to repudiate the free trade policies supported by the liberals and to establish a policy of protectionism. Worsening economic conditions in the 1870s were accompanied by a revival of antisemitism and the consolidation of conservative reaction. Calls for national unity and the retrenchment of national identity inevitably focused on the role of educational and cultural institutions, and the field of culture itself became a battle ground between competing tendencies. It was, in part, the high value placed upon 'culture' as a unifying social force which animated the intense debate surrounding the role and purpose of art in the closing decades of the 1800s, a debate which spread across much of Europe and the United States. In the middle of the century a positivist spirit had asserted itself in Germany, involving a naive faith in the laws of science and the inevitability of progress. This was now increasingly replaced by a form of cultural pessimism which emphasized the instability and uncertainty of modern existence. The notion of *Kulturkritik*, or 'cultural criticism', encompassed both extremes of reaction to this situation. On the one hand, artists and writers as diverse

as Julius Langbehn (VB14), Paul Signac (VB16) and Leo Tolstoy (VB20) accorded art a critical and socially regenerative function. At the other extreme, Max Nordau (VB17) sought to construct a psychopathology of the artist, claiming that modern art was essentially degenerate and dysfunctional. A third reaction, represented in section VC, was to declare the independence of art from its wider social context, a response which led to a pronounced and self-conscious aestheticism and to a renewal of the doctrine of 'art for art's sake'.

In Germany, the speculative and metaphysical systems which had exerted such an impact during the first third of the century had by now come to seem obsolete, undermined on the one hand by the development of the new experimental and empiricist aesthetics of Fechner (IVB7), Helmholtz (IVB8) and Zimmermann (IVB2) and, on the other, by the changing conditions of art and modern life itself. However, it is in large part as a reaction against the perceived inadequacies of positivist and 'scientistic' accounts of art and aesthetics that the renewal of theoretical interest in the arts in Germany is to be understood. Despite the diversity of their responses, the principal figures in this renewal were united in a common endeavour. Alike, they aimed to counter the extreme narrowness of the formalist approach initiated by Johann Friedrich Herbart and defended by his followers with such success. However, rather than appealing to the rich legacy of German Idealist and Romantic thought, which they also saw as inadmissible, thinkers such as Robert Vischer (VA2), Adolf Hildebrand (VA6) and Heinrich Wölfflin (VA7 and 8) sought to reintroduce the role of 'content' into aesthetics by investigating the psychological and physiological basis of tour apprehension of the visible world. Battle was thus conjoined not in the field of metaphysics, but in the domain of psychology itself.

The work of Friedrich Theodor Vischer is of central importance here, serving as a bridge between the beginning and the end of the century. Vischer was a student of Hegel, and his six volume *Aesthetics* (1846–57) was conceived as an attempt to bring to completion Hegel's 'science of the beautiful'. It became the standard reference work of the period. In his later writings, however, Vischer increasingly entered into dialogue with scientific developments of his time and came vigorously to question the presuppositions on which his system had been based. In *Critique of my Aesthetics* (VA1) he placed his finger on the weak point of his own system, questioning the assumption that beauty can be conceived in abstraction from the perceiving subject. His insistence that beauty is not an 'object' but an 'act', something which first arises through the active apprehension of the observer, is combined with a prophetic claim: namely, that the unconscious process whereby the subject projects his or her feelings into the inanimate object must be investigated on the level of our physical and psychological organization. These suggestions were first worked out in their modern form by his son Robert Vischer (VA2), who successfully established the centrality of the problem of 'empathy' to the modern understanding of art. The work of Heinrich Wölfflin was decisively affected by his account of the role of the body's physiology in conditioning our sensory and emotional experience and his identification of an unconscious symbolism operative at all levels of our aesthetic awareness (VA7 and 8).

A second, equally important feature of the last decades of the nineteenth century was a heightened sense of historical awareness. This reached its clearest expression in Wölfflin's attempt to replace the mere chronicle of dates and facts with a 'history of

style', that is, an account of the inner dynamic and changing 'world view' which underlies the various works of a period. It was also evident in Alois Riegl's attempt to provide a 'foundation for the history of ornament'. With the publication of *Stilfragen* (Problems of style) in 1893, Riegl set out to show that the development of ornament possesses its own independent history (VA10). Constantly repeated motifs such as the lotus and the acanthus follow their own internal patterns of development, a process which is largely independent of concerns with imitation. The methodological difficulty entailed in understanding the cultural products of different historical periods is given its fullest realization in the work of Wilhelm Dilthey, one of the founders of modern hermeneutics (VA9). With the recognition that cultural phenomena can only be adequately comprehended by considering their place within a process of historical development, many thinkers sought to avoid the relativism that seemed to follow. The problem of historicism thus acquired increasing urgency as the century progressed. In the essay reprinted here, Dilthey maintains that the study of works of art which are historically and culturally remote from ourselves can, in fact, help us to transcend our own historically limited taste, thereby allowing us to grasp the nature of art itself.

The conception of works of art growing organically out of the totality of a national spirit and developing in law-like stages has its origins in the work of Johann Gottfried Herder (1744–1803) and in the *Sturm und Drang*. This idea, however, takes on a new critical and polemical dimension in the period under discussion. This critical turn is effected through the recognition that by means of a 'psychology of style' it is possible to diagnose the condition of society as a whole. The attempt to draw a causal connection between the work of art and broader social processes has important antecedents in the writings of figures such as Pugin (IIA4) and Ruskin (cf. IIIA9). However, the tracing of such connections was brought to a new level of sophistication in the highly influential lectures and studies of the historian Jacob Burckhardt (VB1). And in the hands of William Morris it becomes a powerful critical and diagnostic tool (VB4 and 5). In his study of the 'lesser arts', Morris takes the dichotomous hierarchy of 'fine' over 'applied' art as the starting point for a critique of the underlying social and economic conditions which give rise to such divisions. Friedrich Nietzsche was for a short time Burckhardt's colleague at Basel, and his writing too is informed by reflection upon the broader role which art plays in society and its contribution to the maintenance of a specific value system (VB2 and 12). The subject of Nietzsche's first publication, *The Birth of Tragedy*, is the opposition between the 'tragic' and the 'Socratic' tendencies in ancient Athens. Underlying this opposition, however, is the contrast between the 'age of art' – represented by the world of early Greek drama – and the present 'age of science', which represents the ultimate victory of the rational disenchantment of the world initiated by Socrates' attempt to replace illusion with truth.

Nietzsche's insistence, contra Schopenhauer, that art should serve as a 'stimulus to life', together with his attempt to bring about what he termed a 'transvaluation of values', helped to awaken the demand for a new 'age of art'. In the work of Julius Langbehn this took the form of a call on the artist to provide the spiritual leadership for a thoroughgoing regeneration of society (VB14). Langbehn's *Rembrandt as Educator* was enormously successful. There was a widespread welcome for his hostility to the dominant values of materialism and intellectualism, for his critique of science,

commerce and technology and of the 'democratic, levelling tendencies of the century', and for the mood of heroic vitalism and the cult of simplicity and intuition which permeated his book. A belief in the possibility of art's regenerative function also informed the work of Tolstoy. His critique of the decadence of contemporary literature and art and of the dangers of specialization was underpinned by an ultimately Christian faith in the idea that art should foster unity between human beings (VB20). Perhaps the most extreme formulation of the anti-modern tendency is provided by Max Nordau's *Degeneration* (VB17). Here the wheel turns full circle so that modern art is seen as the symptom rather than the cure of social ills. The axis around which the wheel turns, however, remains a preoccupation with the issue of form. Although Nordau's ideas were widely shared, George Bernard Shaw's 'Reply' (VB18) demonstrates the ability of the modern movement to defend itself against such criticisms, employing humour and common sense against Nordau's reductive and pseudo-scientific arguments.

More specific forms of critique were directed at the class and gender bias in the academy and beyond; here the contrasts between the universal aspirations of art and the real restrictions still operative in practice were felt particularly acutely. The journal of Marie Bashkirtseff (VB7) bears powerful witness to the difficulties which women artists had to overcome. In particular it makes clear that choices for women artists still lay between conformity to stereotypes of femininity in the pursuit of a patronized 'success' (see VB10) and suppression of the actually feminine in the pursuit of recognition and independence. As the texts by Leader Scott (VB8), George Moore (VB10), Octave Uzanne (VB11) and the anonymous contributor to the *Magazine of Art* (VB9) testify, conservative critics continued to exclude women from serious consideration as artists. However, arguments based upon the supposedly 'natural' connection between women and the 'lesser arts' were challenged by the increasingly visible achievements of women artists and by the gradual opening of the academies to artists on the basis of talent and ability rather than gender. The extent to which access to and enjoyment of the arts was also determined by class and social status was made clear by writers such as Thorstein Veblen, whose *Theory of the Leisure Class* sought to uncover the material or 'pecuniary' interests governing various approaches to the arts (VB21).

If the common factor which bound together the diverse elements of 'cultural criticism' was a concern to explore the connection between art and society, the last decades of the nineteenth century also witnessed an opposing tendency which insisted on the ultimate independence of art from social life. In the English context this was in part a reaction against the climate of moralizing art-interpretation which had surrounded the Pre-Raphaelite movement. In the work of writers such as Walter Pater (VC1 and 2) and Oscar Wilde (VC9) it took the form of a principled 'aestheticism' which insisted on the purity and independence of art from all moral or utilitarian concerns, whilst celebrating an extreme subjectivism on the level of individual response. In Wilde's case, however, commitment to the doctrine of art for art's sake was qualified by his advocacy of the apparently antithetical values of socialism (VB15). Public declarations of the self-sufficiency of the aesthetic domain were frequently met by charges of decadence and moral irresponsibility. The most celebrated *cause célèbre* was the very public trial which followed upon Ruskin's charge that Whistler's

Nocturne in Black and Gold represented a 'pot of paint [flung] in the face of the public'. Libel proceedings allowed Whistler to defend his views concerning the self-sufficiency of art's formal and decorative qualities, whilst insisting upon its relative independence from the constraints of depiction (VC3). Similar issues were also taken up in France in the 1880s, marking the resurgence of an aestheticist discourse with roots in the earlier work of such figures as Gautier, Poe and Baudelaire (see IA18, IID8, IIID4). A general shift away from the concerns of Naturalism is apparent in Redon's 'Notes' of 1878/9 and in his critical comments on the fifth Impressionist exhibition of 1880 (VC5). Renoir's continuing absence from the group exhibitions further emphasizes a growing tendency to conceive of the practice of art in terms of individualistic interests on the one hand and a concern for decorative properties on the other (VC7 and 8). By 1890 Maurice Denis could famously declare that 'a picture – before being a battle horse, a nude woman, or some anecdote – is essentially a plane surface covered with colours assembled in a certain order' (VC10).

However, it is important to realize the extent to which recognition of the centrality of the problem of form represents a denominator common to both of these divergent tendencies. Claims concerning the irreducibility of art to anything beyond itself were largely based upon an emphasis on those very formal aspects which the 'psychology of style' took up as the starting point for its wider analyses. This is particularly apparent in the work of Konrad Fiedler, whose writings consistently emphasize the formal aspects of the work of art over any attempt to reduce artistic activity to a mimetic or merely imitative relation to the visual world (VA3 and 4). Prefiguring Klee's dictum that 'Art does not reproduce the visible, it makes visible', Fiedler insists that art does not passively reproduce the visible world but creates its own reality from out of itself. Art is viewed as a self-sufficient domain, subject to its own internal rules and laws, and possessed of its own intrinsic significance. Fiedler conceives of a 'third way' between the idealizing art of the academies and a naive Realism based on ever greater approximation to the 'given'. This provides a cogent theoretical framework for understanding the increasing concern with exploring art's own internal possibilities. At its most extreme this idea devolves upon the claim that the work of art does not need to be 'about' anything, but rather 'dramatizes its own becoming'. Fiedler's friendships with the painter Hans von Marées and the sculptor Adolf Hildebrand is reflected in his attempt to present an aesthetics of artistic productivity rather than receptivity, that is, a theory of art which is primarily concerned with the creative process itself. Encouraged by Fiedler, both Marées and Hildebrand gave written shape to their reflections upon their own work as artists (VA5 and 6). Outside of this circle, the impact of Fiedler's writings was not to be felt until the early years of the twentieth century, when his ideas were taken up by artists such as Klee and Kandinsky. However, his insistence on art as an independent and legitimate form of enquiry, distinct from cognitive knowledge, whose activity does not take place in the head or even in the eyes alone but directly on the canvas or stone itself, parallels that search for a new artistic vocabulary which characterized innovative developments in the arts through into the early years of the next century.

VA
Empathy and the Problem of Form

1 Friedrich Theodor Vischer (1807–1887) from *Critique of My Aesthetics*

Friedrich Theodor Vischer has often been dismissed as a mere epigone of Hegel, a view most forcefully expressed in Benedetto Croce's claim that Vischer's work represents 'the tombstone of Hegelian aesthetics'. However, a more sympathetic reading reveals Vischer's openness to new ideas and his extraordinary willingness to put into question the most deeply held presuppositions of the system he inherited from his Idealist predecessors. Vischer published his *Critique of My Aesthetics* in 1866, just a decade after completing his monumental *Aesthetics*. The opening section provides a fascinating insight into the *esprit de système*, with its overriding demand for internal order and completeness. Not without a certain pathos, Vischer identifies a fundamental flaw in the edifice he had so carefully built up, recognizing that beauty cannot be treated as an object in abstraction from the contribution of the perceiving subject. Underlying Vischer's attempt to make room for what he terms 'a strange, dark, unconscious, naturally necessary and yet free symbolization', is a critique of Hegel, for whom the symbolic represented not only the first and most primitive, but also a historically superseded form of art (see IA10, above). Vischer's account of 'free' symbolic activity as a process of 'emotional identification' anticipates the fully developed theory of 'empathy', subsequently developed by his son, Robert Vischer (see VA2, below). Vischer's *Kritik meiner Aesthetik* was originally published in his *Kritische Gänge, Neue Folge*, volume II, parts 5 and 6, Stuttgart, 1866. These extracts have been translated for the present volume by Jason Gaiger from *Kritische Gänge*, volume IV, second, expanded edition, Robert Vischer (ed.), Munich: Meyer und Jessen Verlag, 1922, pp. 222–4, 316–20. The numbered paragraphs in the following text refer to Vischer's own *Aesthetik; oder Wissenschaft des Schönen*, Reutlingen, 1846–57.

This critique must start out from the structure of the whole. My system seemed to me a well-made construction. The first part, the metaphysics of the beautiful, was concerned with the concept of beauty in itself, considered in abstraction from the question as to how and where it is realized. The second part, in two sections, encompassed the two first, one-sided forms in which beauty manifests itself, natural beauty and the imagination, the former being the objective and the latter the subjective form of existence of the beautiful. With these first two forms of its real existence, its physical existence as natural beauty and its psychical existence as beauty in the imagination, the unity of the fundamental concept of beauty, originally con-

ceived abstractly, passes over into a clear division which is then sublated in the third part. I believed that in the first part I had treated my subject in such a way that I could begin the second quite objectively with the fact of beauty's appearance, as if beauty simply resided in the natural and human world without any contribution from us, as something given. Protected by the category of appearance, thus firmly grasped, the first section could contain the doctrine of natural beauty, that is, of the realm of nature, as well as the universal and historical forms of mankind considered in terms of the type and degree of beauty which they contain. At the start of the second section this concept of appearance was dissolved and it was revealed that there is, in fact, no such thing as natural beauty, that there is no beauty without the perceiving, and through the act of perceiving, reshaping, subject: what we term natural beauty already presupposes the imagination. In this way the doctrine of the imagination was revealed as the content of the section as a whole. The third part, the doctrine of art, began by showing that the imagination, being merely the inner creation of the beautiful, is itself one-sided and in need of completion, and that natural beauty has the essential advantage of objectivity over merely subjective constructions, even if, as the transition from the doctrine of beauty to the doctrine of imagination had shown, this is only in the form of appearance. [...]

Nothing seemed rounder or more effective than this construction of the system: starting out with the clear division of a still unrealized unity into two one-sided forms, each of which, being insufficient, refutes the other, I then showed how this unity is sublated into a true, substantial unity and reality. At the same time this created room for an agreeable excursion through the domain of natural beauty. It was with pleasure that my readers accompanied me on this journey, and it was this first section of the second part that won my book its most friends. But all to no avail, for it must go: this section must be given up – though this does not mean that what is essential in the logical transition to the doctrine of art must thereby be sacrificed.

In its very first step, aesthetics must destroy the illusion that beauty can exist without the active contribution – as yet we still wish to use this indeterminate expression – of the perceiving subject. The subject cannot be left behind during the investigation of the universal essence of beauty in order, subsequently, to be used in the enquiry into the world itself, an enquiry which artificially suppresses the fact that it looks and judges through the eyes of the imagination and the various arts. Philosophical science is not like a novel which can hold back a secret in order to generate tension and entertain the reader. Beauty is, quite simply, not an object – it first comes into being through perception. Beauty is the contact between an object and an apprehending subject, and since what is truly active in this contact is the subject, it can be termed an act. In short, beauty is simply a particular form of perception. It is with this that the first part must begin, and in the very first sentence of the system the illusion must be given up that beauty is something we simply find before us, apprehended by our senses as by a passive mirror.

* * *

[...] In several places I have spoken of a particular form of symbolization through which alone it is possible to explain the fact that abstract forms which do not represent any individual living thing can yet affect us as aesthetic, that is, as something which possesses a content. Here we have to do with a strange, dark, unconscious, naturally

necessary and yet free symbolization. Aesthetics may not postpone discussion of this psychological phenomenon until we come to the doctrine of the imagination, although the form under discussion is to be taken up there once again. It cannot do so for the reason that the first part of the system, the doctrine of the beautiful, itself requires that this enquiry be carried out. If abstract, mathematically calculable forms could please us without any symbolic relation to a particular content, then [aesthetic] formalism would be right in its dismissal of the attempt to discover the fundamental determination of the beautiful in form which possesses content. [. . .]

What we now must show is that consciousness itself, which creates and vivifies symbolic images, can somehow avoid recognizing the purely symbolic aspect of its own activity. This it can do either completely, or – if the expression 'half' sounds too arithmetic – let us say for the time being, in an indeterminate way which rather evades open examination. This latter we will explain in more detail later. First we need to identify and discount the type of symbol which is produced by that form of consciousness which is totally hidden from itself. For here we have to do with historical forms of consciousness which do not belong to the pure and free imagination but to the imagination which is determined by religion. These historical forms of the symbol are: first, the symbol in the narrow sense as I addressed it in my work (§426), the straightforward confusion of an impersonal image with that which it is supposed to represent. Thus, for example, the *Apis* signifies elementary power through the strength of the bull; through this and the pallor on its brow it signifies the sun; it also signifies the Nile, but the sun and the Nile are themselves again symbols of the elementary power. The Egyptian, however, was quite unaware that he merely drew comparisons between these things, but confused the one with the other so completely that he revered the *Apis* as a divinity. The symbol in this sense is a search for a language in which thoughts concerning the mystery of the world can be articulated. The symbol is a necessary vessel for the word and consciousness remains trapped in images without being able to extract the thought – for which the image serves as an equivalent for the word – and establish it as something independent. The second, incomparably higher of these historical forms is the myth: here the image is personalized and the world forces are personified. However, consciousness still does not know that it is constructing personifications, but believes in the gods as if they were real beings. Here the symbol is, in the primary and strictest sense of the word, 'degraded', as Hegel strikingly phrases it in his critical discussion: it is given alongside as an attribute and its meaning is no longer merely a meaning but is inherent in the god as his own soul, as the most vivid property of a humanly manifold and variegated inner life. At the same time, it is animately articulated in the form of the god's body, movements and deeds. However, the belief that such beings exist is not free and lies outside of the pure aesthetic domain. Yet since free beauty none the less grew from this soil, this connection began to be dissolved and art – as I have shown elsewhere – was just as much the betrayer as the servant of religion.

For us, the gods, when we make reference to them, are free aesthetic images. The symbolic thereby takes on a new and different significance, for here, instead, there is a free process of aesthetic symbolization. Here there is no confusion, no religious belief in the persons represented. Rather, what is decisive is the purely aesthetic standpoint of illusion as such, of a kind of ideal play. *None the less, it is necessary to distinguish once*

again between a *dark, but inner*, and a *clearly conscious* process which takes place along the path of reflection. This is the crucial point. The flaw in my aesthetics to which I have already confessed consists in my having neglected to draw *this* distinction. I described the form of expression belonging to architecture as symbolic (§561) without having previously introduced and discussed the particular form of the symbolic which lies at its basis. In the doctrine of natural beauty I explained the aesthetic effect of all non-organic appearances, that is of light and colour, and also the first appearances of the organic, that is, of plants, in sum, the entire landscape as such, in terms of an intimating interjection, an unconscious ascription of one's deepest emotions, and this is nothing other than the form of symbolization with which we are concerned here. In the doctrine of music, where this comes out more clearly than anywhere else, the actual word lay on the tip of my tongue without ever being uttered. – With these forms of representation we are concerned with the domain of impersonal life; it is wholly analogous to the historical and religious form of the symbol which we discussed above, the symbol in the strictest sense of the word, in which an impersonal object is connected with its meaning by means of an obscure conflation. What is impersonal can only ever be made to express a humanly addressed content figuratively through an external point of comparison; by virtue of its animate life an animal indeed stands close to us, but only a human being can fully show forth the inner life of man. The connection of image and content through a mere point of comparison is only an external conjunction. The two do not fully cohere with each other; the image has many other characteristics other than the point of comparison, and the content could just as well be expressed through other images. However, the externality of this mere conjunction which we, who reflect, recognize as such, can well appear, in the darkly intimating life of the soul, about which we reflect – even if it is our own from an earlier hour – as an inner emotional identification of the unity of image and content. This emotional identification is, historically, that thoroughgoing conflation which gives rise to the symbol in the natural religions. However, it also appears in another, psychically necessary and permanent form which is universally grounded in the essence of the human imagination. How, then, is this latter form distinguished from the earlier and obscure conflation? Thereby that the freedom, the insight into the fact that what is involved is a mere comparison is here spontaneously withheld. I do not know of any other expression for this form of unconscious, instinctive and yet not religiously bound, purely aesthetic symbolism than that it is 'withheld'; whoever can make no sense of this should observe what goes on in the mind more closely. Consider first the beauty of landscape, which is so strangely analogous and related to the beauty of music. Here light and colour effect us through inorganic forms and yet they do so in such a way that the landscape as a whole appears to us a mirror image of our own emotional state. This act, whereby we believe that we encounter our own interior life in what is inanimate, rests quite simply on a comparison. What is physically bright is compared to what is spiritually or emotionally bright, the dark and gloomy to dark and gloomy moods, and so forth. One sees that language, too, employs the same words, which it derives pictorially from nature. The comparison is drawn so unconsciously and instinctively that we, far removed from thinking of it as a mere 'resemblance', attribute emotional states as predicates to inanimate objects. Thus we say, for example, that this place, these skies, the colour of the whole, *is* cheerful, *is*

melancholy, and so forth. We do not for a moment seriously believe that there is a living soul in these objects as, earlier, the worshippers of light religiously looked upon the divine spirit in the sidereal glow. We could clearly say to ourselves that we are simply carrying out an act of comparison with our imagination – but we do not say this, we tarry in a state of illusion, and it is this which I term withholding. The awareness that we are merely drawing a comparison remains undeveloped, unformulated – we give ourselves up to the illusion and allow the confusion to take place. This I term a profound, dark, certain, inner, yet free, emotional identification of the unity and interconnection of image and content. In contrast to the unfree, religious form of symbolism it could be termed 'chiaroscuro', if the term were not itself too pictorial. Here there resides a mystery which would have to be explained by means of psychology working together with physiology – if this point at which the soul and the nervous centre are *one* were not veiled in impenetrable darkness. [...]

2 Robert Vischer (1847–1933) 'The Aesthetic Act and Pure Form'

Friedrich Theodor Vischer's son, Robert Vischer, was the first to introduce the term 'empathy' into modern aesthetics, although antecedents are to be found in the writings of Novalis and the German Romantics. He uses the term to describe the way in which we are able to project our feelings into the objects we perceive, thereby establishing a subjective, animate relation to the phenomenal world. Vischer's arguments are largely directed against the narrow formalist approach initiated by J. F. Herbart, and in the present essay he seeks to defend his position against criticism from Herbart's follower, Robert Zimmermann (see IVB2, above). Vischer challenges the formalist abstraction from content by emphasizing the role that subjective feeling plays in our apprehension of the visible world. He maintains that our aesthetic response to form is at least partially conditioned by the inner psychological life of the percipient. Vischer first articulated his theory of empathy in an essay entitled 'Über das optische Formgefühl' (On the optical sense of form), published in 1873. The present essay provides a more discursive and less technical introduction to its principal ideas. It was originally published as 'Der ästhetische Akt und die reine Form' in *Die Literatur: Wochenschrift für das nationale Geistesleben der Gegenwart* in 1874. This translation was made for the present volume by Nicholas Walker from Robert Vischer, *Drei Schriften zur Ästhetischen Formproblem* (Three essays on the problem of aesthetic form), Halle: Max Niemyer Verlag, 1927, pp. 45–6, 47–8, 50–1, 52–3.

In its most recent phase modern philosophy has shown a distinct preference for a generally psychologistic approach to problems. And in aesthetics too everyone is rushing to do the same. And it is now increasingly apparent that the protracted debate between formalists and idealists cannot be brought to any fruitful conclusion unless we can reach some agreement concerning the nature and the genesis of that process which transpires in the case of aesthetic perception and artistic presentation.

 The formalists speak about forms which please us 'for their own sake'; the idealists about forms which please us 'for the sake of the content'; this is how Robert Zimmermann, the principal representative of aesthetic formalism, defines exactly the difference between these approaches. But we must ask ourselves: what do we

mean by 'content' here? What precisely is the site of aesthetic content? It would certainly spare us a great deal of trouble and confusion if we finally undertook to distinguish two quite different concepts of content: firstly, the objectively given content (a beautiful or characteristic human countenance, a merry round-dance, the raging of Ajax, or the crucified Christ) which is directly presented to us by the object of contemplation in its own right, that is, by the aesthetic object itself as a concrete phenomenon, and secondly, the subjective content, that is, our own psychological life which as percipients we bring into contact with any and every phenomenon capable of being grasped aesthetically. Now I wish to claim that this contact can be so intimate in character that even rigid, lifeless and inorganic forms, like the contours of a boulder, can be capable of arousing and directing our changes of mood and feeling. [. . .]

On my view of the matter, it is quite possible in the sphere of the imagination for purely formal phenomena to coalesce with other essential features of our humanity. This is the work or achievement of our representational or imaginative faculty, which can itself be distinguished as three different forms, types of behaviour, or, let us say, functions, two external ones and one central one.

1. I can place myself into a simple and essentially unilateral relation to the external appearance of some form of object in a purely sensitive-physiological fashion by fixing my gaze upon it. In this way I simply stand over against the object. I approach the latter, as it were, with my gaze; or, expressed the other way about, the object approaches me upon the intervening light waves and is thus absorbed, as it were, into me. I receive nothing but the external impression of the object into my eye, or into my personal subjectivity, and feel myself affected by it, pleasantly attracted or unpleasantly repelled as the case may be. But this internal conjunction produces a conflation of my immediate feeling with the present form of the phenomenon. I see in the latter a sort of duplicate of myself, the photographic image of my own mood. Thus I conflate the phenomenon itself with my feeling, and I speak for example of the angry glare of the tempest, of the oppressive or threatening glimmer of dusk, of the sober light of day, the melancholy twilight, the blissful blue of the ocean, and so on. It is particularly the play of light, or colour, as a simple oscillating movement which produces this kind of sensitively coloured direct emotional participation in things. The light waves emanating from the moon, for example, perpetuate themselves in the perceiving eye as neural vibrations all the way to the central nervous system, and it is thus in and out of the latter that the entire sensible and spiritual economy of the human being finds itself transposed into a state of excitation specifically determined and coloured by this bluish-white luminescence and by the global lunar form which is simultaneously perceived along with it.

2. But this formal relation to the external form of the phenomenon can also proceed in a strictly motor fashion. Then, by means of the appropriate muscular movements of the ophthalmic ligaments, I allow my gaze to roam over the external contours of the phenomenon, along the periphery of the lunar globe for example; at the same time my conscious second self, as it were, likewise roams along the periphery of the object and thereby also takes a pleasure of its own in the accomplished spontaneous movement of the eye itself. The very course of the line described by the eye seems to waver and to

run with a life of its own. I identify myself with the process. I too rise and plunge along those rocky contours, along the 'heaving mountains'. I follow the unpredictable twists and turns of the branch of a tree and internally repeat them for myself. That pleasurable feeling of movement which is otherwise communicated to me by objects actually in motion, by the stormy sea, the leaping hound, the flying bird, is generated within me as I successively perceive the forms, dimensions and lines of motionless objects. – Artistic representation succeeds in realizing this inner process of moving perception. Just as the viewer moves his gaze, so too the painter moves his brush and the sculptor moves his clay.

3. The third function is a kind of central transposition. I transpose myself as a sensible and intellectual subject into the inner being of the object and explore its formal character from within as it were. I am now on the moon, from where I can look down with a melancholy gaze and see myself below. I wrap myself up angrily into a cloud, I tower up proudly in a fir tree, I rear and plunge exultantly with the waves. I am at once the ocean breaker in all its protean forms which beats and strikes the rocky coast and the rocky coast itself which scorns the onslaught of the sea. As a gently waving flower I nod and lean towards the running spring which I also am in turn. A thorny plant lowers at me like some rough unshaven fellow. I have so thoroughly transposed and transformed myself into a cactus that this my new transposed person-ality looks back at me as a prickly stubborn cactus, even though I am still conscious of myself.

This kind of transposition can take a motor or a sensitive form, even when it is concerned with lifeless and motionless forms. I can imagine to myself that this pine tree is about to move, or has just now been moving; I can entertain the thought of shooting up into space with it like a rocket. [. . .]

In addition to the three functions involved in the aesthetic perception of form we must also go on to consider the process of mental association as a further secondary and subsequent act. Now I claim that this process, simply by virtue of a real causal chain of events, connects up with other images, thoughts, and vital feelings which are not strictly present as such and which initially have nothing whatsoever to do with the immediate effect of form itself. [. . .] The moon, for example, can effect me in a sentimental manner through the association of ideas, because it reminds me of certain loved ones who used to serenade it or languish before it, or because it is the heavenly body which represents a dreamy and passive aspect of our life. If the colour green strikes us as a symbol of hope, this is also through the association of ideas: it reminds us of the green flowering meadows of springtime, of the verdant blessings of the returning sun, and thus by a natural progression of all kinds of things hoped for or desired. The image of a gathering storm can be regarded, for purely instrumental reasons, as something genuinely threatening because it evokes the possible damage its violence can inflict. [. . .]

* * *

As far as pure forms are concerned, then, I would claim that they are pleasing to me because they favourably dispose the activation, the mobilization and the transposition of my imagination, and because they generate a generally harmonious process of feeling in me. Everything in the world is subject to mathematical regularities. But that certainly does not mean the intrinsic truth of things consists

in number. Even when we have mathematically analysed a rosette down to the very smallest atom, we still have not learned to understand the true nature of its beauty, and even if we examine the person who produced it and explain the entire statics and mechanics of that individual down to the very smallest molecule, we would still have failed to grasp the fundamental character and nature, the *energeia* or inner power of the person's imagination or subjective beauty. [...] The intrinsic being of the phenomenon in itself is and remains something ideal and incalculable, and thus the entire phenomenon does too. It is only when we abstract from the centre of the phenomenon in question and turn our attention to the individual aspects of what is peripheral, to the purely quantitative, that we require the assistance of mathematical analysis. Even with regard to the so-called pure forms, where such analysis is much more at home than it is with the concretely vital forms, mathematics can still only play a subordinate role in aesthetics precisely to the extent that we always perceive these forms, as we have said, with the participation of imagination, together with the movements of our own sensible and ideal inner life. There can be no question, therefore, of appealing to a special kind of quantifying judgement, to a barren calculation of relationships, but only of a certain feeling for measure, something which is indeed inconceivable without mathematical regularity but is essentially sustained and supported by the ideal character of life.

It always strikes me as quite remarkable that the followers of Herbart, who are never willing to concede any role to feeling, and who regard the forms as pleasing purely in their own right, are none the less ready to concede that aesthetic relations are unlike the mathematical relations in that the representation of the former never remains neutral or indifferent to the mind of the percipient, but rather necessarily produces an effect of pleasure or displeasure as far as the latter is concerned. 'The interconnected elements of the aesthetic relation are living forces, real psychological acts with content and intensity, which can indeed restrain and inhibit but never annihilate one another, which can never simply dissolve into a third term which would be equivalent as far as the perceiving subject is concerned' (Zimmermann, *Aesthetics*, p. 27).

It still remains the case, therefore, that the aesthetic act which is realized optically in perceiving form does not consist in an act of assessment produced solely by perception itself. The artist invariably and essentially has the phenomenal appearance before his eyes, and indeed the phenomenon as a whole, not merely the golden section which someone has inscribed within it. And the artist never perceives the phenomenon merely and solely with the organs of sight and perceptual judgement in general, but rather with his freely ideal and favourably disposed personality in its entirety.

Phenomenal appearance and ideal personality, reflected image and paradigmatic image, these are the concepts which can never be too highly regarded, can never be too faithfully preserved. In fact things only appear in their full significance, only become wholly and evidently manifest to us, when they approach us as reflections of our own inner life. The plastic and visual arts are concerned with neither content nor form, but rather with the possibilities of configuration and phenomenal appearance.

3 Konrad Fiedler (1841–1895) from *On Judging Works of Visual Art*

A substantial private income enabled Konrad Fiedler to abandon his work in the field of law in order to devote himself to the study of art and philosophy. It also provided him with the means to offer direct financial support to a number of artists whose work he encouraged. Fiedler's meeting with the painter Hans von Marées (see VA5, below) in Rome in the winter of 1866/7 was decisive for his future development, a debt he partially repaid in 1874 when he helped Marées, together with the sculptor Adolf Hildebrand (see VA6, below), to establish a workshop in the old cloister of San Francesco di Paolo in Florence. Whilst Fiedler's writings on art owe much to his direct involvement with these artists, his position is also shaped by his early enthusiasm for Schopenhauer's subjective Idealism (cf. IA1, above). The framework for Fiedler's understanding of artistic activity is provided by his epistemological conviction that reality is not something which we find fully formed in front of us, but is something that we must first bring into existence through our own active contribution. Fiedler rejects mimetically based theories of art, insisting that 'Artistic activity is neither slavish imitation, nor arbitrary feeling; rather it is free formative activity'. The creation of genuine works of art is based upon a heightened development of perceptual experience, parallel to, but distinct from, the scientific or 'conceptual' comprehension of the world. The activity of the artist is none the less genuinely creative in that it brings forth a world which cannot exist apart from this activity. Fiedler's essay was originally published as *Über die Beurteilung der Werken der bildenden Künste* in Leipzig in 1876. These extracts are taken from the translation by Henry Schaeffer-Simmern and Fulmer Mood, *On Judging Works of Visual Art*, University of California Press Berkeley and Los Angeles, 1957, pp. 27, 42–51, 54–6.

The understanding of art can be grasped in no other way than in terms of art. Only if we see the world before us in terms of the particular interest of the artist can we succeed in reaching an understanding of works of art that is founded solely on the innermost essence of artistic activity. In order to be able to grasp the artist's concern with the visible world it is well to remember that man's interest in appearances is divided into two principal types. They start from perceptual experience but soon come into opposition to each other. It is to the independent and free development of perceptual experience that we must look for the peculiar power of artistic talent.

* * *

It is the essential characteristic of the artist's nature to be born with an ability in perceptual comprehension and to free use of that ability. To the artist perceptual experience is from the beginning an impartial, free activity, which serves no purpose beyond itself and which ends in that purpose. Perceptual experiences alone can lead him to artistic shape formations. To him the world is but a thing of appearances. He approaches it as a whole and tries to re-create it as a visual whole. The essence of the world which he tries to appropriate mentally and to subjugate to himself consists in the visible and tangible shape-formation of its objects. Thus we understand that to the artist perceptual experience can be endless, can have no aim or end fixed beyond itself. At the same time, also, we understand that to the artist perceptual experience must have immediate meaning, independent of any other purpose than can be produced by it.

The artist's relationship to the world, which to us remains incomprehensible as long as we as nonartists stand in our own relationship to the world, becomes intelligible to us once we consider the artist's relationship as a primary and peculiar connection between his powers of visual comprehension and the objects visually comprehended. And this relationship is based on a need which in turn is an attribute of man's spiritual nature. The origin and existence of art is based upon an immediate mastering of the visible world by a peculiar power of the human mind. Its significance consists solely in a particular form of activity by which man not only tries to bring the visible world into his consciousness, but even is forced to the attempt by his very nature. Thus the position in which the artist finds himself while confronting the world has not been chosen arbitrarily, but is determined by his own nature. The relation between himself and the objects is not a derived but an immediate one. The mental activity with which he opposes the world is not fortuitous, but necessary, and the product of his mental activity will not be a subordinate and superfluous result, but a very high achievement, quite indispensable to the human mind if that mind does not want to cripple itself.

The artist's activity is often said to be a process of imitation. At the basis of this notion lie errors which beget new errors.

First, one can imitate an object only by making another which resembles it. But what agreement could exist between the copy and the object itself? The artist can take but very little from the quality of a model which makes it an object of nature. If he tries to imitate nature he will soon be compelled to combine in his copy some very different aspects of the natural object. He is on the way to encroaching upon nature's creative work – a childish, senseless enterprise, which often takes on the appearance of a certain ingenious boldness, usually based on absence of thought. Where efforts of this kind are concerned, the trivial objection is justified that art, so far as it is imitating nature, must remain far behind nature, and that imperfect imitation must appear as both useless and worthless since already we are amply supplied with originals.

Imitation which aims merely at copying outward appearances implies that one starts from the premise that there is in nature a substantial capital of minted and fixed forms at the disposal of the artist and that the copying of these forms is a purely mechanical activity. Hence arises the demand, on the one hand, that artistic imitation should serve higher purposes, that is, that it should be a means of expressing something independently existent, not in the realm of the visible but in the realm of the invisible; and on the other, that the artist in his imitations should represent nature purified, ennobled, perfected. Out of his own mastery he should make demands on the natural model; what nature offers should serve him as a basis for that which nature might be if he had been its creator. Arrogance justifies itself and capriciousness becomes intellectual power. Man's unfettered imagination, inflated to vainglory, is taken to be artistic creative power. The artist is called upon to create another world beside and above the real one, a world freed from earthly conditions, a world in keeping with his own discretion. This realm of art opposes the realm of nature. It arrogates to itself a higher authority because it owes its existence to the human mind.

Artistic activity is neither slavish imitation nor arbitrary feeling; rather, it is free formative activity. Anything that is copied must first of all have existed. But how should that nature which comes into being only through artistic representation have

an existence outside of this production and prior to it? Even at the simplest, man must create his world in its visual forms; for we can say that nothing exists until it has entered into our discerning consciousness.

Who would dare to call science an imitation of nature? Yet one could do so with as much right as to call art an imitation. In science, however, one sees much more easily that it is simultaneously an investigation and a formulation, that it has no other meaning than to bring the world into a comprehensible and comprehended existence by means of man's mental nature. Scientific thinking is the natural, the necessary activity of man, as soon as he wakes up from a dull, animal-like state to a higher, clearer consciousness. Art as well as science is a kind of investigation, and science as well as art is a kind of formative activity. Art as well as science necessarily appears at the moment when man is forced to create the world for his discerning consciousness.

The need of creating a scientifically comprehended world, and with it the possibility of producing such a world, arises only at a certain level of mental development. Likewise, art too becomes possible only at that moment when the perceived world appears before man as something which can and should be lifted up to a rich and formed existence. It is the power of artistic phantasy that brings about this transformation. The phantasy of the artist is at bottom nothing else than the imaginative power which to a certain degree all of us need in order to get any grasp at all upon the world as a world of visible appearances.

But this power of ours is weak, and this world of ours remains poor and imperfect. Only where a powerful imagination with its indefatigable and sharp activity calls forth from the inexhaustible soil of the world elements after elements does man find himself suddenly confronted with a task immensely complicated, where before he has found his way without difficulty. It is phantasy that, looking far out round itself, summons together and conjures up on the narrowest ground the abundance of life which from dull minds is withheld. Through intuition one enters into a higher sphere of mental existence, thus perceiving the visible existence of things which in their endless profusion and their vacillating confusion man had taken for granted as simple and clear. Artistic activity begins when man finds himself face to face with the visible world as with something immensely enigmatical; when, driven by an inner necessity and applying the powers of his mind, he grapples with the twisted mass of the visible which presses in upon him and gives it creative form. In the creation of a work of art, man engages in a struggle with nature not for his physical but for his mental existence, because the gratification of his mental necessities also will fall to him solely as a reward for his strivings and his toil.

Thus it is that art has nothing to do with forms that are found ready-made prior to its activity and independent of it. Rather, the beginning and the end of artistic activity reside in the creation of forms which only thereby attain existence. What art creates is no second world alongside the other world which has an existence without art; what art creates is the world, made by and for the artistic consciousness. And so it is that art does not deal with some materials which somehow have already become the mental possession of man; that which has already undergone some mental process is lost to art, because art itself is a process by which the mental possessions of man are immediately enriched. What excites artistic activity is that which is as yet untouched by the human mind. Art creates the form for that which does not yet in any way exist

for the human mind and for which it contrives to create forms on behalf of the human mind. Art does not start from abstract thought in order to arrive at forms; rather, it climbs up from the formless to the formed, and in this process is found its entire spiritual meaning.

In the artist's mind a peculiar consciousness of the world is in process of development.

To some degree, everyone acquires that consciousness which, when developed to a higher level, becomes the artistic consciousness of the world. Every man harbours in his mind a world of forms and figures. His early consciousness is filled with the perceiving of visible objects. Before the capacities of forming concepts and of submitting the consequences of natural processes to the law of cause and effect have been developed in him, he stores his mind with the multifarious images of existing objects. He acquires and creates for himself the many-sided world, and the early substance of his mind is the consciousness of a visible, tangible world. Every child finds himself thus situated. To him the world is that which is visually apparent, so far as the world attains an existence through his mind. The child acquires a consciousness of the world and, even before he knows anything about it, before he can denote what it is by the expression 'world,' possesses the world. When other mental forces have grown in man and become active, and provide him with another consciousness, he very easily fails to appreciate that earlier consciousness by which he had been first awakened on entering life. He now believes that his early stage of existence was an unconscious one, like that of animals, when compared to the new consciousness of the world which he has attained. In mastering the world as a concept he believes that only thus does he possess it and that his early consciousness is doomed to decay. While he struggles to bring the world of concepts within himself to richer and clearer consciousness, the world of appearances remains for him scanty and obscure. He does not pass from a lower, unconscious stage to a higher, conscious one, but rather sacrifices the one for the sake of building up the other. He loses his world by acquiring it.

Had man's nature not been endowed with the artistic gift, an immense, an unending aspect of the world would have been lost to him, and would have remained lost. In the artist, a powerful impulse makes itself felt to increase, enlarge, display, and to develop toward a constantly growing clarity, that narrow, obscure consciousness with which he grasped the world at the first awakening of his mind. It is not the artist who has need of nature; nature much more has need of the artist. It is not that nature offers him something – which it does not offer to anyone else; it is only that the artist knows how to use it differently. Moreover, through the activity of the artist, nature rather gains a richer and higher existence for him and for any other person who is able to follow him on his way. By comprehending and manifesting nature in a certain sense, the artist does not comprehend and manifest anything which could exist apart from his activity. His activity is much more an entirely creative one, and artistic production cannot in general be understood except as the creation of the world which takes place in the human consciousness and exclusively with respect to its visible appearance. An artistic consciousness comes into being in which solely the experience with appearances becomes important and leads to visual conception and in which everything steps back that is of other importance to man than the visual experience.

The mental life of the artist consists in constantly producing this artistic conscious-ness. This it is which is essentially artistic activity, the true artistic creation, of which the production of works of art is only an external result. [. . .]

* * *

Artistic consciousness in its totality does not go beyond the limits of the individual; and it never finds a complete outward expression. A work of art is not the sum of the creative activity of the individual, but a fragmentary expression of something that cannot be totally expressed. The inner activity which the artist generates from the driving forces of his nature only now and then rises to expression as an artistic feat, and this feat does not represent the creative process in its entire course, but only a certain state. It affords views into the world of artistic consciousness by bringing from out of that world one formed work in a visible, communicable expression. This accomplishment does not exhaust, does not conclude this world, for just as infinite artistic activity precedes this feat, so can an infinite activity follow. 'A good painter,' says Dürer, 'is inwardly full of figures, and if it were possible that he could live forever, he would have always something new from his inner stock of ideas, of which Plato writes, to pour forth through his works.'

Although the mental activity of the artist can never fully express itself in the form of a work of art, it continuously strives toward expression and in a work of art it reaches for the moment its highest pitch. A work of art is the expression of artistic consciousness raised to a relative height. Artistic form is the immediate and sole expression of this consciousness. Not by roundabout ways does the artist arrive at the employment of the artistic form; he need not search for it in order to represent herein a content which, born formless, is looking for a body in which it may find shelter. The artistic expression is much more immediate and necessary, and at the same time exclusive. A work of art is not an expression of something which can exist just as well without this expression. It is not an imitation of that figure as it lives within the artistic consciousness, since then the creation of a work of art would not be necessary for the artist; it is much more the artistic consciousness itself as it reaches its highest possible development in the single instance of one individual. [. . .]

4 Konrad Fiedler (1841–1895) from 'Modern Naturalism and Artistic Truth'

Fiedler identifies his own position as offering a 'third way' between the two apparent alternatives of official academic art and the movement of 'modern naturalism', represented paradigmatically by the work of Courbet and the writer Emile Zola (for further material on Naturalism and Realism see section IIIB above). Fiedler endorses the challenge raised by Naturalism against the idealizing presuppositions of academic painting, with its employ-ment of allegorical, mythical, religious and historical–patriotic subjects. However, whilst he praises Naturalism for having returned art to the soil of its own times and for stripping away the deceptions and distortions of official art, he accuses it of remaining entrapped in a philosophically and aesthetically naive form of realism. Not only does it fail to enquire into the connection between reality and truth, but it remains tied to a conception based on the exact *imitation* of the external world. In contrast, Fiedler introduces an account of artistic

activity which is based neither on idealization nor on imitation of the real. For Fiedler, the work of art is not a copy of reality but an independent and autonomous result of the *productivity* of the creative artist. Fiedler's essay was originally published as 'Moderner Naturalismus und künstlerische Wahrheit' in the *Wissenschaftlicher Beilage der Leipziger Zeitung* in January 1881. The following extracts have been translated for the present volume by Jason Gaiger from *Konrad Fiedlers Schriften zur Kunst*, volume I, Gottfried Boehm (ed.), Munich: Wilhelm Fink Verlag, 1971, pp. 137–8, 145–6, 157–61, 169–70, 179–80.

A levelling and inexorably positivistic wind is coursing through the world. In its own sphere art has taken a long time to reflect the general tendency of the age. For art, too, however, the age of Romanticism is past and with mighty strides artists are now seeking to catch up with the times which have hurried ahead of them. The modern naturalists are convinced that artists have never before apprehended nature in its full scope, in its full nakedness. They have never before had the courage boldly to represent nature as it is. The entire art of the past is an idealization and falsification of reality. Now, as humanity for the first time is beginning to free itself from the fetters of prejudice and superstition, the artist too is beginning to shake off the shackles in which he has been held by a thousand-year-old tradition and to strive towards the great goal which lies hidden in all human activity – the truth. The spokesmen of the [Naturalist] school explicitly evoke the achievements of scientific thought. They claim the same rights and the same freedom for art and declare war on everything which might hinder or restrict the task of representing life in its fullest range. They deride every rule to which artistic activity is supposed to submit. These radical principles do not designate a new phase in the development of artistic activity. Rather, where art had previously roamed aimlessly in the stage of childhood, it now begun to reflect upon the true seriousness of its task and, for the first time, is becoming art in the true sense, an art which is worthy of enlightened humanity.

* * *

[The Naturalists] want to stand upon their own feet and, at the same time, are resolved that their thought and deeds should belong to the age in which they live. Heedlessly, they destroy the entire world of inner, untrue creativity and treat these ideal themes, which a higher artistic need had sought to preserve over against a hostile reality, as a refuge for obsolete prejudices and errors long since overcome. They place the artist once again on the soil of the world which surrounds him and at the centre of his own times. They show him life as it is and demand of him nothing other than its faithful representation. They see life before them, and this fact is sufficient for them; they do not question or judge how it could or should be different or better; they immerse themselves in its study and observation and find there a great and inexhaustible material which is, at the same time, their only material. This material never ages and is the shared property of the most universal understanding. As soon as it is discovered, it presents itself as the most natural and self-evident material of all and as something which does not need to be sought out.

* * *

The stronger and more widespread the spirit of realism becomes in the sphere of science and of life itself, the more vigorously those who defend the so-called ideal

values seek to preserve these values from its influence. Art stands as the highest of these ideals. When the old way of thinking saw itself increasingly exiled from every position in life and knowledge, it sought refuge in art. With stubborn zeal it defended art against every attack which sought to displace it from the position it had previously occupied. And, in the midst of a vast convulsion of spiritual life in which creative work was set free, it did in fact succeed in holding a vast and complete domain under its spell. For it is still the case today that the realm of art is held up in opposition to the realm of reality as the domain in which man seeks to approximate an ideal, to attain an ideal which stands above reality. Questions concerning the actual nature of this presupposed ideal, the different sorts of demands which can be placed upon artistic activity, and the laws governing artistic activity which can be derived from reflection upon its task, in short, the entire apparatus of an ambitious but superficial aesthetic still remain the subject of ongoing dispute.

It is here that the genuine significance of the Naturalist movement is revealed. For it is through this movement that art is now emancipating itself from subordination to external authority. In so far as Naturalism audaciously breaks with the old idealistic notions, it makes all the old conflicts of aesthetics superfluous, all the earlier demands of aesthetics vacuous. Whilst the powers which previously governed the so-called aesthetic side of life accord Naturalism little respect, or reject it as alien to their world, Naturalism has already left this world behind, which is in the process of collapsing, and has made itself into a force in a world which rests upon completely new spiritual foundations. In the most radical tendency of Naturalism, artistic activity participates in the great spiritual movement which surely desires to separate the new world for ever from the old. It leaves the realm of imagination and dreams behind in the old world and demands its own place on the firm ground of reality. It no longer wishes to be a means to external ends, it wishes to be free of every compulsion. Its entire past seems to it to be fettered in bondage, hedged and confined by all sorts of barriers. Only now, for the first time, does it appear to itself as free. No longer blinded by prejudices, nor led astray by false ambitions, it believes that it looks for the first time upon the world, the real world, and it sees an infinite task lying before it.

Thus the Naturalist tendency in art would appear to be justified no matter what arguments are raised against it. The weapons deployed against it are spent. On its side are determination, strength and a striving towards the future. It is animated by the spirit of the new age in whose name it fights. And yet one question still remains. Even if it can no longer be denied that the modern Naturalists are right to reject the conditions and ideas which still govern the domain of art, still one should not neglect the investigation of the principle which they themselves have articulated and the way in which it has been realized in their artistic productions. This alone is the point which really matters. The question whether the Naturalist principle in art is justified and should be tolerated is only valid for those who still entertain hope in the retrogressive movement of spiritual life, for those who would like to save the last remnants of a wholly discredited view of the world by preserving it in the domain of art, safely preserving it there for all eternity, dreaming of some enchanted realm of beauty and the ideal beyond base reality, a realm of which art now and again may bring us word. For those, however, who adhere to the modern movement of the spirit and do not recoil from the necessary conclusion that it is necessary to challenge every aspect of

the life of the spirit, the question can only be whether the principle defended by the modern Naturalists gives proper expression to this recognition and whether they fulfil in their own work that which they demand. The question requiring resolution is not whether truth is the exclusive principle of art, but what truth means in the context of art. Only in this way is it possible to attain clarity about the value or lack of value of the endeavours of modern Naturalism. And if then it could be shown that the deeply rooted aversion towards the works of Naturalism and the conviction, unshakeable by any argument, that it lacks artistic value were, in fact, correct, this demonstration would rest upon grounds freely and necessarily conceded from the standpoint of the Naturalists themselves.

It is often emphasized that the artists who belong to the Naturalist movement do not seek to represent the truth, but only reality. The Naturalists themselves correctly reply that only reality is true, that outside of reality there can be no truth; only he who makes the unconstrained representation of reality into his exclusive goal is an ambassador of the freedom and natural rights of art. Here, however, we can see that it is easier to make oneself free than it is to be free. The dogma of the Naturalists sounds simple, clear and uncontradictory. But the spiritual force which fights so boldly when in opposition, quickly becomes reticent when it is a question of developing further the freedom which it has won. For the concept of reality with which these new artists content themselves is highly undeveloped; and in this undeveloped state it represents the new fetters which modern Naturalism has placed on itself after it had succeeded in freeing itself of its older ones.

* * *

It is nothing other than a wholly naive realism which is supposedly to be made the centre of artistic activity. Although the adherents of the new movement claim to have elevated art onto the same high ground as that which is occupied by the spirit of scientific enquiry, they none the less seek to ground art in a view of the world which science has long since had to overcome in order to make further progress in its knowledge of the world. This is the key point from which modern Naturalism is both to be explained and refuted. What is gained by their attempt to awaken art from the dogmatic slumbers into which it had fallen under the old aesthetic theories, if they themselves are only to fall immediately into a new dogmatic slumber?

The decisive turning point in our striving for knowledge takes place when, on deeper reflection, we realize that external reality, which appears to be the absolutely real, is in fact a deceptive illusion. Our faculty of knowledge is not confronted by an exterior world which is wholly independent of us, like an object in a mirror. Rather what we term the exterior world is in fact the eternally changing result of our own mental activity, continually recreated anew from out of itself. This insight was of momentous consequence for the development of human knowledge, but due to a curious failing it has as yet not been employed to investigate the essence of artistic activity.

* * *

[. . .] All true art – and this alone is what is essential – unifies an enormous wealth of experiences in a highly spiritualized form. If its images may be termed typical, this means nothing other than that they raise an infinite series of shapes and events taken from life into the light of understanding and clarity.

Only when grasped in this way is artistic activity genuinely free. Only thus understood is artistic activity freed on the one hand from the pressure exerted by the shortsighted assumption that its model is to be found in a reality standing over against it, and, on the other, from becoming the servant of foreign and arbitrarily imposed demands. Only in this way do we see that art follows no other law than that of its own innermost nature. By recognizing the free play of artistic powers, we can see that art is condemned neither to creep along at the level of the base reality which is common to all human beings, nor to obey the suspect call to ascend to the heights of an enchanted world which should deliver us from reality. Since time immemorial two great principles have contended as to which is the true expression of the essence of artistic activity, the one claiming that art is an imitation of reality, the other that art transforms reality. This dispute can only be resolved by establishing a third principle in place of the other two: the principle of the production of reality. For art is nothing less than one of the means through which man first produces reality.

Thus all further progress in our understanding of the essence of art depends upon developing the concept of artistic activity. We should stand on the side of the modern Naturalists in their struggle against those who would force artistic activity to subjugate itself to an arbitrary authority; but we must oppose them once we realize that they only understand the great word 'truth' in an undeveloped and erroneous manner.

5 Hans von Marées (1837–1887) Letters to Fiedler, 22 January 1882; 29 January 1882; 5 February 1882

These letters, written to Fiedler from Rome, reveal the close exchange of thoughts and ideas between the two men. Marées responds positively to Fiedler's essay 'Modern Naturalism and Artistic Truth' and seeks to put his own conceptions down on paper. Like Fiedler, he places the productive activity of the artist at the centre of his reflections. For Marées, however, the artist is someone who sees through to what is essential in appearances. In his own work he strove to distil typical forms through a concentrated process of observation. Marées had left Germany to work in Rome at the age of 27, remaining there until his death in 1887. Supported by an annual stipend from Fiedler, he stayed aloof from the commercial world of galleries and exhibitions, with the result that few of his paintings ever left his studio during his lifetime. His one public commission was for the frescoes in the Zoological Institute of Naples. However, a number of his paintings were brought together in a special room dedicated to his work in the Annual Munich Exhibition of 1891, where Heinrich Wölfflin praised the 'unique fascination' of his figures and sought to introduce to a wider public the particular achievement of his art. These letters have been translated for the present volume by Jason Gaiger from *Hans von Marées Briefe*, Julius Meier-Graefe (ed.), Munich: R. Piper & Co., 1920, pp. 208–11, 213–16.

Rome, 22nd January 1882

Dear Fiedler

Although I had not meant to, I became so involved in my work today that the sun went down while I was still working. For this reason, just a few lines.

On reading and re-reading your essay[1] it became increasingly clear to me that you have thoroughly grasped and comprehended the essence of art, and if in places I wanted to raise an objection, this was quickly resolved by what came next. The composition, too, seems more flowing and easier to understand than your earlier works and I cannot believe that it will not have an enormous influence. In my opinion, however, the majority of readers today are less concerned to grasp the matter itself, but rather are preoccupied with their own talent and abilities, and do not reflect upon the basis on which they pass judgement.

I draw this conclusion from hearing the opinions of many people in similar circumstances who are regarded as intelligent men. Only a few, I believe, perceive that it is not a matter of competition but rather of reciprocal understanding.

Since, of necessity, I am often compelled to reflect upon the characteristics that someone must possess to be a real artist, the first condition that occurs to me is that they must be born to it, that is, they must be completely consumed by the drive to bring something forth.

Properly understood, the artist's concern with truth is directed towards doing justice to his own instincts, unlike the philosopher who is concerned with truth for its own sake.

If it is not disagreeable to you, I will develop my thoughts on this subject further. You will, of course, not expect to receive a treatise from me, for you know that I am concerned only with placing my own ideas and actions in the clearest possible light. Today I am too tired.

My best regards to your wife.

Yours faithfully

H. v. M.

[1] 'Modern Naturalism and Artistic Truth', see VA4, above.

Rome, 29th January 1882

Dear Fiedler

Right at the start of today's letter I need to point out that I expressed myself quite wrongly in my previous letter and that this is something which might happen to me more often. I should have omitted to use the word truth; perhaps if I had used the even more immodest word *wisdom* instead, it would have been more correct. The latter is, in any case, at least something relatively attainable.

In order to understand the essence of art I hold it to be absolutely necessary, before everything else, to understand the artist, for without the artist there can be no art; once the universal essence of man is known, it will be that much easier to distinguish and evaluate the various different types.

A born artist I would term someone in whom nature has, from the outset, placed an ideal in their soul, an ideal which stands for truth, and in which he believes uncondi-tionally. It becomes the life's task of the artist to attain the purest awareness of this ideal so that he can bring it to the perception of others. The word ideal is another one of those which is open to all sorts of misunderstandings; in my opinion, for the visual artist, it consists in the fact that for him everything which his gaze lights upon reveals

itself in its complete fullness, in its *value*, as something inexhaustible. This determines early on his particular way of thinking and he will, accordingly, quickly develop the necessary characteristics such as attentiveness and the instinct for imitation, together with the requisite skills and abilities. I still remember quite clearly how the world appeared to me when I was five years old and how I immediately sought to capture these impressions in images. It was at this age, too, that the external world began to intervene. For scarcely does one arouse the attentions of others than their influence begins to impose itself and, even though well intended, in the majority of cases this forms a barrier between the individual and revelation. (Revelation: in any case only he is an artist to whom the *essential* in appearances reveals itself. All previous attempts to grasp this in words or to subsume it under rules have been in vain; it is only through the helpful intercession of nature that a new revelation can take place. In all the various works of art from Phidias to Velasquez which from the outside appear so very different from one another it is one and the same thing which moves and enlightens me. If one grasps this, then one realizes that time and historical change can only have a minimal effect upon the artist; just as a man with conservative and traditional views only succeeds in covering these over by wearing some fashionable suit of clothes.) (I would like to include another parenthesis within this parenthesis: that is, that art is not in fact old. She is just as old and just as new as the eternally unchanging passions of man. But art is not a passion, and it is for this reason that the ancients called it divine.) If, earlier, I spoke of my childhood, this is because I wanted to say that from the very beginning I felt that I possessed a standard or measure within myself by means of which I could form my own judgements. Properly understood, it has been my life's work to develop this capacity: for even the most gifted individual can achieve nothing without mature judgement. 'And he saw that it was good'. This is something which the artist must finally be able to say, even if, as a human being, he can do so only in a limited or conditioned way. That he is human, this is what makes it so difficult to be an artist; and yet it is only in virtue of being human that we can become artists at all. For this reason, the artist can never escape the task of becoming a complete, and where possible, a purified human being. I know of no other path by which one can attain that immediate and unconstrained relationship to nature which is revealed to us in childhood as the most beautiful gift, and which imposes on us the task of learning how to express it in a way which can be understood by everyone. (Easy accessibility remains as always one of the most beautiful properties of a work of art.) As soon as one begins to live attentively one realizes that this is something that can further the realm of art. Without recognizing one's own weaknesses, it is not possible to change oneself.

* * *

Rome, February 5th 1882

Dear Fiedler

The meaning of what I recently said is that whoever dedicates himself to the practice of art must be concerned to strive for and to sustain an unimpeded relationship to nature, and this is something which is only possible if he holds himself aloof from contingently existing social circumstances and from petty-bourgeois concerns. The external sign of such a condition would be an indestructible freshness of youth.

If people were to succeed in penetrating through to the essence which underlies appearances and in holding firm to what is important, they would find it relatively easy to grasp the essence of their art and to work as artists in a natural and appropriate way. Both things, the comprehension of nature and art, are necessary if one is to be able to judge what one can and ought to achieve. (To embolden and encourage us, we can remind ourselves what an extraordinarily beneficial effect Lessing's 'Laokoon' exercised on German literature; Lessing does not really discuss the visual arts in this essay; he uses them only as a contrast.) In connection with the above, the question which forces itself upon us is whether it is a matter of using talent and skilfulness to bring one's response to nature to expression. For myself, I would answer this question with a decisive 'No' and say that even a heightened and refined response to nature should be no more than a necessary means to create a powerful and determinate impression on the spectator. (The visual artist should not speak of himself but of that which resides outside of himself.)

To speak somewhat freely, I must say that I would find it far easier to develop my thoughts in conversation – not in conversation in a closed room but, for example, one which transpired between Monte Cavallo and the Capitol, or the Parthenon and some spot in the open, in short, moving back and forth between art and nature. This is something I do for myself when through incessant work I find myself in a state of constriction and dependency. In this way, I sometimes succeed in controlling the circumstances under which nature and art bind me and work upon me, and as a consequence I begin to grasp the reasons why they do so. Above all else, by such means I cannot distance myself from the ultimate goal of all visual art, that is, that it should possess life, and naturally the course of my thoughts must tend towards learning how this life is to be called forth, what it is advisable to do and what is best avoided. Thus it happens that even though I cannot work with it, sculpture is just as important to me as painting and I allow myself to believe that I have grasped some of the fundamental conditions that make it into a living art. (The great simplicity of means and the relatively limited character of its tasks make it much easier to speak of sculpture than of painting. It cannot do any harm to the artist today to be clear about sculpture; precisely because his art is a later fruit it needs even greater care to allow it to ripen once again.)

It is thanks to this way of proceeding, together with the way in which I conduct my life in general, that the concept of time no longer plays any role for me; it is true that now just as two thousand years ago human beings still run on two legs, just as at that time man could probably distinguish distance from proximity and shadow from light just as well as he can now. If, in connection with this, I were to say, for example, that it is no matter of secondary importance for a sculptor to ensure that his figures are always recognizably two-legged creatures, this would not be completely without any deeper meaning, and if he could recognize what is meant by this, it would protect him from many important errors in his artistic practice and goals.

High excellence cannot be achieved if the fundamental preconditions have not been fulfilled. The entire striving of the Greeks was directed towards excellence; to achieve this they had to possess a clear, natural basis. Breadth of knowledge, great talent and eminent skills ultimately serve for nothing if they are not guided by a sense of what is healthy, pure and natural. For this reason, I always have to emphasize again and again

that the artist must direct the greatest attention to his character as human being; and equally to his relationship with other human beings. You can see, dear Fiedler, that I am no longer exerting myself to write coherently connected sentences; this, as you know, is something which is impossible given the short amount of time I reserve for it [. . .]

It is uncommonly cold here and my fingers are becoming stiff, so I shall close for today and send my best regards to your wife.
Yours faithfully
Hans v. Marées

6 Adolf Hildebrand (1847–1921) from *The Problem of Form in the Visual Arts*

Since the date of its publication in 1893, Adolf Hildebrand's *The Problem of Form in the Visual Arts* has rapidly assumed the status of a classic text. From letters exchanged with Konrad Fiedler, we know that he first conceived the idea of writing an essay on this subject as early as 1876. The work underwent several drafts, and Fiedler provided critical comments and suggestions throughout the successive stages of its completion. Hildebrand develops his argument with great clarity, drawing both upon his own experience as a sculptor and on the groundbreaking research carried out by Helmholtz and others into the structure of our perception of the visible world (see IVв8, above). Hildebrand sets out to show that the idea of form is not something immediately given in perception, but must be actively grasped by the mind through comparing different appearances. In order to elicit a clear idea of form, or spatial presence, the artist cannot simply reproduce the givenness of our visual perceptions, but must order these into a unity. For Hildebrand, form is 'not a perception pure and simple but the articulation of many perceptions from one specific viewpoint'. Hildebrand's essay was originally published as *Das Problem der Form in der bildenden Kunst*, Strasbourg: Heitz & Mündel, 1893. These extracts are taken from the translation by H. F. Mallgrave and E. Ikonomou in *Empathy, Form and Space: Problems in German Aesthetics, 1873–1893*, Santa Monica, 1994, pp. 227–9, 233, 235–7.

The present work concerns the relation of form to appearance [*Erscheinung*] and its implications for artistic representation [*Darstellung*].

Since the appearance of one and the same object can be very different, the visual artist is faced with two questions: Are these different appearances of equal value, and how do we measure their value?

It may perhaps be said, without arguing the point in detail, that our relation to the external world, in so far as it exists for the eye, is based above all on our knowledge and idea [*Vorstellung*] of space and form. Orientation within the external world is absolutely impossible without them. We must therefore view the idea of space in general, and the idea of form or delimited space in particular, as the essential content or the essential reality of things. If we compare the object or our spatial idea of it with all the changing appearances that it may manifest, we see that all such appearances are images expressing our idea of space and that the value of each is measured by the intensity of the expression as a spatial idea.

The vivid colours of nature are to be regarded, then, as a brilliant raiment in which nature like a body clothes herself, and the value of these shifting hues must likewise be measured by the extent to which they clarify the spatial expression.

Thus we look upon nature as offering only all possible phenomenal variations on a theme without ever giving us the theme itself. For the idea of form is a sum total that we have extracted by comparing appearances: a comparison that has already separated the necessary from the accidental. It is therefore not a perception pure and simple but the assimilation of many perceptions from one specific viewpoint. By this I do not mean a subjective viewpoint but, on the contrary, the entirely general one of spatial orientation, which each of us must naturally fashion for ourselves in dealing with the spatial world.

Because we need, in our everyday life, to extract only a few clues in order to orient ourselves in space, we are not aware of how much our idea of form and space derives from the stimulus of the specific thing seen and how much we ourselves add to it. (We already know most of what we need to know and require just a few clues to orient ourselves immediately.) The artist's relation to the appearance, however, is very different. In order to elicit a clear idea of form, he must (or should) know what data the specific appearance actually presents and what it lacks. There are natural conditions of light, such as an abundance of reflected light, that dissolve any impression of form and thereby defeat any possibility of obtaining a clear spatial impression. In his representation the artist should therefore not concern himself with simply presenting the appearance as such; rather, he must learn, albeit indirectly, how the appearance expresses its formal content, which he does by learning to discern when it speaks clearly to us and when it does not. For his representation must not depend on the observer's prior knowledge but should actually supply the factors on which our imagination depends. Indeed, the artist deals with the substratum on which spatial ideas are unconsciously built: the level that we take for granted. Artistic representation without these elementary factors is mere dilettantism.

How the need for a clear expression of space and form in the appearance leads the artist to a specific idea of form, and how therefore in all artistic periods a basic kind of artistic appearance has to be extracted systematically from the mass of natural appearances – that is the subject of the following work as elaborated from the author's own artistic experience.

It is evident that the clarity that we, as artists, require in our work is, as with every active person, not a relationship mediated by words but a direct application of refined instinct. In a written formulation such as this – and especially in a time in which there is such immaturity in the understanding of the artistic problem and so much uncertainty about artistic instinct – we cannot avoid attempting to bring some cogent and logical order to visual intuitions [*Anschauungen*] that are by nature concurrent, interdependent, and without beginning or end. This work will therefore speak an unfamiliar language to those who are used to working with their vision, and it will speak of an unfamiliar visual process to those who are used to working with language. This is unfortunate but it cannot be helped.

In order to understand the relation between form and appearance, we must first of all get a clear understanding of a distinction in the mode of perception. For this purpose, let us take an object with its surroundings and background as given and with

the line of sight of an observer likewise given. Let us further assume that the observer can move but only toward or away from the object. If his vantage point is distant, the eyes no longer converge at an angle but view the object in parallel lines. Then the overall image is two-dimensional, for the third dimension (all closer and more distant parts within the object's appearance) or the modelled object can be perceived only by surface contrasts: that is, as surface features indicating distance or nearness. If the observer steps closer to the object, he will need a different visual accommodation to see the given object; he will cease taking in the overall appearance at *one* glance and can compose the image only by moving the eyes back and forth and making various accommodations. He will therefore divide the overall appearance into several visual impressions that are connected by the movements of his eyes. The closer the observer comes to the object, the more eye movements he will need, and the less coherent will be the visual impression. Finally the field of vision becomes so confined that he will be able to focus only on one point at a time, and he will experience the spatial relationships between different points by moving his eyes. Now seeing becomes scanning, and the resulting ideas are not visual [*Gesichtsvorstellungen*] but kinesthetic [*Bewegungsvorstellungen*]; they supply the material for an abstract vision and idea of form.

These two extremes of visual activity are actually two different modes of seeing. The image received by the viewing eye at rest expresses three-dimensionality only by surface signs, through which coexisting elements are simultaneously apprehended. At the other extreme, the eye's mobility enables it to scan a three-dimensional object directly from a close vantage point and to transform the perception into a temporal sequence of images.

* * *

By developing kinesthetic ideas and the outlines of objects associated with them, we are able to attribute to objects a form that is independent of changing appearance. We recognize this form as that factor of the appearance that depends solely on the object. We call this form, which is partly gained through movement directly and partly abstracted from the appearance, the *inherent form* [*Daseinsform*] of the object.

Yet the impression of form that we acquire from the appearance and that is contained in it as an expression of the inherent form is always a joint product of the object, on the one hand, and of its lighting, surroundings, and our changing vantage point, on the other. In contrast to the abstracted, unchanging inherent form, this may therefore be termed the *effective form* [*Wirkungsform*].

It is in the nature of effective form that each individual factor of the appearance has meaning only in relation and contrast to another factor and that all distinctions of size, light and shade, colour, and so on, can have only a relative value. Everything depends on reciprocity. Everything affects and determines the value of everything else.

When we therefore speak of an overall impression, we mean the combined effect produced by all the factors of the appearance. Since the distant image consists of the apprehension of a combined effect, it follows that the individual factors of that image acquire their meaning only through the specific relationship evoked by the overall impression. They lose this meaning when they are considered in isolation or taken out of context.

Accordingly, whenever we mentally construct an object's form out of its overall appearance and its effects, this is a product of the relationship between the individual factors.

It follows from this that if, in starting out from the idea of form, we seek to achieve an adequate overall impression of the image – an equation, so to speak, between the inherent form and appearance – we will not succeed if we try to grasp the kinesthetic or formal ideas individually and directly and then assemble them into an overall impression. For in any such piecemeal approach we interpret the details not in the way they condition and are conditioned by the whole but always as single, isolated factors.

We are therefore forced to translate our idea of form into such factors of appearance that they equate with the form in their overall effect through their collective effort. For what matters is not only that the ideas of depth are transformed into surface impressions and can be apprehended all together in a coherent visual act but also that the overall surface impression provides a correct expression of the idea of form.

* * *

Whenever we imagine a form, we involuntarily create a visual idea that is effective. However meagre, this visual idea is nevertheless capable of conveying the general concept of form that manifests itself in this effect. When children draw a face as a circle with two dots for eyes, a vertical line for a nose, and a horizontal line for a mouth, they present just this necessary effect, as a wholly adequate image of our natural idea of effective form.

Thus, if an artistic representation is to be strong and natural, it must extract from a superabundance of appearances those elementary effects that bring to life even the most generalized concept of form. That basic effect that the child captures with a few strokes must likewise be emphasized in a painted or chiselled face. The so called Greek facial type, or Grecian nose, of antique statuary, for example, arose from this requirement and not because the Greeks looked like that. Such a head makes a clear effect under all circumstances and presents the typical effective accents.

We see from all this that the inherent form – the measurable form of nature or its given spatial dimensions – can be scanned by the eye but not grasped as a whole. This whole exists for the eye only in the form of effects that translate all actual dimensions into relative values; only in this way do we possess it as a visual idea. Even ideas of abstract outlines and of their relative positions, which are added to the inherent form, always exist only as visual ideas, that is, as relative statements and thus as relative dimensions. The idea of form thus achieves a degree of abstraction by retaining the sensation of spatial values that can be realized in practice only in terms of specific, individual relations of size. We can correctly abstract the values of form only from the effect of the distant image, for only there do visual elements appear similarly and simultaneously. Artistic seeing therefore resides in a strong grasp of these sensations of form and not in the mere knowledge of the inherent form as a sum of isolated perceptions; the latter can have significance only for scientific analysis.

Imagination, as opposed to immediate perception or mere perceptual memory, captures such impressions. Art then consists of reinvesting these abstracted ideas, thereby creating an impression that entirely coincides with the observer's imagination. By contrast, the impression derived from nature is not identical with any mental image.

This effective value, being only a product of a composite appearance, which cannot be grasped or represented in and of itself, can, as noted, result in a work of art only when the appearance as a whole is such as to fulfil the necessary conditions. And since *in natura* it is entirely a matter of chance whether or not these conditions are present, the artistic representation cannot consist of a mechanical, positively similar, perceptual likeness of the chance appearance but of the representation of those conditions that positively produce this effective value for our imagination. In order to endow the inherent form with its effect we have to fashion the overall context according to our experience of the conditions governing the effect. We must so present the inherent form that it will reproduce the idea we have gradually acquired. In structuring the individual case for effect, we convey the idea that has been built up over a thousand cases. Thus the artistic representation of nature means a representation of the artist's world of forms, which his imagination has already processed and on which it has set its imprint in terms of effect. In the representation, this imprint must be tangible and forcefully expressed, for only in this way will the work of art become a true expression of our relationship with nature as it naturally takes place in our spatial imagination. This conception springs from the awareness that our relation to nature and its abstracted inherent form can be made manifest only by treating the object as an effective relation and product. This is the artistic conception.

The so-called positivistic conception, which supposes truth to lie in our perception of the object itself and not in the idea of the object that we create, defines the artistic problem only as the exact replication of what we immediately perceive. It considers any influence of the imagination to be a falsification of the so-called truth of nature, and it endeavours to adopt a purely mechanical, receptive attitude and to make the representation into the most exact record possible. It strives to detach the momentary impression from the ideas that naturally condition the process of seeing. Yet seeing is certainly no purely mechanical act; it is only through experience that the imagination turns the mechanical retinal image into a spatial image, allowing us to recognize what it represents. It does not matter whether this adherence to perception is related to kinesthetic ideas or to visual impressions. There is a positivism with respect to both the given inherent form and the effective form, in sculpture as well as in painting. The height of positivism would be to perceive appearances with the inexperience of a newborn child. Positivism seeks an artistic representation that accords with those obscure impressions of the first few hours of life when ideas are only beginning to form. This tendency has very much been supported by the invention of photography. Yet it overlooks the fact that we are incapable of altogether casting off our ideas, for it is through them that we see. They unconsciously resist any attempt to do so. Such a rendering, of course, results in a very meagre idea of space rather than one intensified and developed by the work of art. Such artistic representations are, so to speak, mute, for the ability to speak to our notions of form has been artificially divorced from the appearance.

Thus the work of art is a total, self-contained effect, a reality in its own right as opposed to nature.

The inherent form exists in the work of art only as an effective reality. By apprehending nature as a relationship between a kinesthetic idea and a visual impression, the work of art liberates nature from change and chance.

7 Heinrich Wölfflin (1864–1945) from *Prologomena to a Psychology of Architecture*

Heinrich Wölfflin was born in Winterthur, Switzerland, in 1864. He studied under both Jacob Burckhardt (see VB1, below) and Wilhelm Dilthey (see VA9, below), succeeding Burckhardt to the chair in history at Basle in 1893. It was said of Wölfflin when he died that he had 'found art criticism a subjective chaos and left it a science'. This judgement is in no small part due to the enormous influence of his *Kunstgeschichtliche Grundbegriffe*, published in 1915 and translated into English as *Principles of Art History* in 1932. Through this text, Wölfflin's name has come to be associated primarily with terms such as 'formalism', the 'historical development of style' and the theory of 'pure seeing'. However, it seems to have been his meeting with Hildebrand in 1899 that confirmed him in his concern with the analysis of form. Prior to this he had been influenced by contemporary theories of psychology, and above all by the theory of empathy put forward by thinkers such as Robert Vischer (see VA2, above), Hermann Lotze and Johannes Volkelt. This influence was clearly demonstrated in Wölfflin's doctoral dissertation, *Prolegomena to a Psychology of Architecture*, published in 1886. His commitment to an aesthetics of content as opposed to a formalist aesthetic is already apparent from his opening question: 'How is it possible that architectural forms are able to express an emotion or a mood?' Wölfflin seeks to show that our responses to art are at least partially conditioned by our own bodily organization, maintaining that the basic elements of architecture are 'defined by our experience of ourselves'. (It is interesting to compare here the writings of Humbert de Superville, who some forty years earlier also made enquiries into the expressive properties of architectural forms and their connection to our most primary and fundamental experiences. See IIc1, above.) Wölfflin's dissertation was originally published as *Prolegomena zu einer Psychologie der Architektur*, Munich: Dr. C. Wolf & Sohn, 1886. It was reprinted in Heinrich Wölfflin, *Kleine Schriften*, edited by Joseph Gantner, Basle: Benno Schwabe, 1946. These extracts are taken from the translation by H. F. Mallgrave and E. Ikonomou in *Empathy, Form and Space: Problems in German Aesthetics, 1873–1893*, The Getty Centre for the History of Art and the Humanities Santa Monica, 1994, pp. 149, 150–2, 154–5, 157–8, 182–5.

The observations that follow concern a question that seems to me an altogether remarkable one: How is it possible that architectural forms are able to express an emotion or a mood?

The fact is indisputable. Not only does the judgement of the layman most decidedly confirm that every building produces a specific impression within a whole range of moods, from the serious and the sombre to the cheerful and the friendly, but even the art historian does not hesitate to characterize periods and nations by their architecture. The capacity for expression is thus conceded. But how? On what principles does the historian make judgements?

* * *

The psychology of architecture has the task of describing and explaining the emotional effects that this art is able to evoke with the means proper to it.

We designate the effect that we receive the *impression*.

And we understand this impression to be the *expression* of the object.

Thus we may also formulate the question as follows:

How can tectonic forms be expression?

(By 'tectonic forms' we mean both the decorative and the applied arts, for they are subject to the same conditions of expression.)

One can try to answer this question from a subjective or an objective viewpoint. Both have been done.

I will first mention the widely held thesis that the emotional tone of a form is explained by the *kinesthetic response of the eye* when its focus follows the lines. We experience a wavy line and a zigzag line quite differently.

What is the difference?

In the former case, it is said, it is easier for the moving eye to trace the form: 'Owing to its physiological structure, when the eye moves freely, it follows a straight line in the vertical and horizontal directions, but it travels in an arc when moving in any oblique direction' (Wundt, *Vorlesungen*, 2: 80).

Therefore, we take pleasure in the wavy line and have an aversion to the zigzag. The beauty of a form is directly proportional to its suitability for our eye. We can say the same thing by asserting that the purpose of a column capital is to lead the eye gently from the vertical to the horizontal or that the outline of a mountain is beautiful because the eye is able to glide over it smoothly and without stumbling.

Reasonable enough when put this way, but the theory lacks the one essential requirement – confirmation by experience. We have only to ask ourselves: How much of the form's actual impression can be explained by the kinesthetic response? Is the greater or lesser ease with which the eye performs its movement to be regarded as the crucial factor in a multitude of effects? The most superficial psychological analysis will show how little such a theory squares with reality. Indeed, we cannot even grant this factor a secondary role. In pointing out the uniform pleasure to be derived from both a wavy line and a rectilinear meander, Lotze has quite correctly observed that we invariably disregard physical effort in forming our aesthetic judgements and that the sense of pleasure is therefore not based on the ease with which we obtain the perception (*Geschichte der Ästhetik in Deutschland*, 310–11).

The evident error in this theory, therefore, appears to be the belief that, because it is the *eye* that perceives physical forms, their visual properties are the determining factors. Yet the eye appears to respond with pleasure or displeasure only to the intensity of light; it is indifferent to forms or at least is unable to determine their expressive nature.

We must therefore look for another principle. The comparison with music will give us one, for in music we have the same relationship. The ear is the perceiving organ, but we could never grasp the emotional content of sounds by analysing the auditory process. To understand the theory of musical expression, it is necessary to observe *our own production of sounds*, the meaning and use of *our own voice*.

If we did not have the ability to express our own emotions in sounds, we could never understand the meaning of sounds produced by others. We understand only what we ourselves can do.

So here, too, we must say: *Physical forms possess a character only because we ourselves possess a body*. If we were purely visual beings, we would always be denied an aesthetic judgement of the physical world. But as human beings with a body that teaches us the nature of gravity, contraction, strength, and so on, we gather the experience that enables us to identify with the conditions of other forms. Why is no one surprised that

the stone falls toward the earth? Why does that seem so very natural to us? We cannot account for it rationally: the explanation lies in our personal experience alone. We have carried loads and experienced pressure and counterpressure, we have collapsed to the ground when we no longer had the strength to resist the downward pull of our own bodies, and that is why we can appreciate the noble serenity of a column and understand the tendency of all matter to spread out formlessly on the ground.

One might say that all this has nothing to do with apprehending *linear* and *planimetric* relationships; however, this objection merely reveals insufficient observation. On paying attention, we find that we read a mechanical significance into such relationships as well and that there is no oblique line that we do not see as rising and no irregular triangle that we do not perceive as unbalanced. It hardly needs to be added that we do not experience architectural creations in merely geometric terms but rather as *massive forms*. Yet an extreme school of formalist aesthetics time and again assumes the former.

Let us go further. Musical sounds would have no meaning if we did not consider them the expression of some sentient being. This relationship, which was a natural one in the original musical form, that of song, has been obscured by instrumental music but by no means effaced by it. We always attribute the sounds we hear to a subject whose expression they are.

The same is true in the physical world. Forms become meaningful to us only because we recognize in them the expression of a sentient soul. Instinctively we animate each object. This is a primeval instinct of man. It is the source of the mythological imagination; and even today, is not a long educational process necessary to rid ourselves of the impression that an unbalanced figure must itself feel uneasy? Indeed, will this instinct ever die out? I believe not. It would be the death of art.

We read our own image into all phenomena. We expect everything to possess what we know to be the conditions of our own well-being. Not that we expect to find the appearance of a human being in the forms of inorganic nature: we interpret the physical world through the categories (if I may use this term) that we share with it. We also define the expressive capability of these other forms accordingly. *They can communicate to us only what we ourselves use their qualities to express.*

At this point, some might become dubious and question what similarities or expressive feelings we could possibly share with an inanimate stone. Briefly, there are degrees of heaviness, balance, hardness, etc., all of which have expressive value for us. Since only the human form, of course, can express all that lies in humanity, architecture will be unable to express particular emotions that are manifested through specific faculties. Nor should it try to do so. Its subject remains the *great vital feelings*, the moods that presuppose a constant and stable body condition.

* * *

Lotze and Rob. Vischer, who first raised the importance of the bodily experience, were evidently only thinking of processes that take place in the imagination. In this sense Rob. Vischer writes, 'We have the wonderful ability to project and incorporate our own physical form into an objective form.' Similarly, Lotze says, 'No form is so unyielding that our imagination cannot project its life into it.'

If I understand him correctly, Volkelt here has gone further than his predecessors but without focusing any more sharply on the problem.

The justness of the question cannot be doubted, for the bodily emotions we experience in considering an architectural work cannot be denied. I can well imagine that someone might assert that the impression of a mood conveyed by architecture is based in our own involuntary effort to imitate other forms through our organization – in other words, that we judge the vital feeling of architectural forms according to the physical state that they induce in us. Powerful columns energetically stimulate us; our respiration harmonizes with the expansive or narrow nature of the space. In the former case we are stimulated as if we ourselves were the supporting columns; in the latter case we breathe as deeply and fully as if our chest were as wide as the hall. Asymmetry is often experienced as physical pain, as if a limb were missing or injured. Likewise, we know the disagreeable condition that is induced by looking at something unbalanced, and so on. Everyone will find something similar in one's own experience. And when Goethe once remarked that we ought to sense the effect of a beautiful room, even if we were led through it blindfolded, he was expressing the very same idea: that the architectural impression, far from being some kind of 'reckoning by the eye,' is essentially based on a direct bodily feeling.

Instead of an inexplicable 'self-projection,' we might perhaps imagine that the optic nerve impulse directly stimulates the motor nerves, which cause specific muscles to contract. As an illustrative analogy we could cite the fact that a musical tone will make all related tones resonate.

* * *

Nor can anyone challenge our right to liken the apprehension of human expression to the apprehension of architectural forms. Where are the limits, where does this vicarious response cease? It will occur wherever we find vital conditions similar to our own, that is, wherever we encounter *bodies*.

To pursue such an investigation further would lead us back into the mysterious history of psychological evolution. And even if we could eventually confirm a universally shared experience – even if we were able to prove that our body undergoes precisely the changes corresponding to the expression that the object communicates to us – what would be gained by that?

Who can say which takes priority? Is the bodily response a condition for the impression of a mood, or are the sensory feelings simply the result of a lively imagination? Or, finally, is there not a third possibility – that psychological and physical activities run parallel?

Since we have pressed the question to this point, it is time to break off the discussion; the problems that we now confront mark the limits of all science. [. . .]

The basis that has been established is this:

Our own bodily organization is the form through which we apprehend everything physical. I shall now show that the basic elements of architecture – material and form, gravity and force – are defined by our experiences of ourselves; that the laws of formal aesthetics are none other than the sole conditions under which our organic well-being appears possible; and, finally, that the expression intrinsic to horizontal and vertical articulation is presented according to human (organic) principles.

* * *

We have seen how the general human condition sets the standard for architecture. This principle may be extended still further: any architectural style reflects the

attitude and movement of people in the period concerned. How people like to move and carry themselves is expressed above all in their costume, and it is not difficult to show that architecture corresponds to the costume of its period. I would like to emphasize this principle of historical characterization all the more energetically because I am unable here to pursue the idea in any detail.

The Gothic style will serve as an example.

Lübke saw it as the expression of spiritualism. Semper called it lapidary scholasticism. According to what principles has it been judged? The *tertium comparationis* [third term of comparison] is not exactly clear, even though there may be a grain of truth in both descriptions. We will find firm ground only by referring these psychological observations to the human figure.

The mental fact in question is the tendency to be precise, sharp, and conscious of the will. Scholasticism clearly reveals this aversion to anything that is imprecise; its concepts are formulated with the greatest precision.

Physically, this aspiration presents itself in precise movements, pointed forms, no relaxation, nothing bloated, and a will that is everywhere most decisively expressed.

Scholasticism and spiritualism can be considered the expression of the Gothic period only if one keeps in mind this intermediate stage, during which a psychological feeling is directly transformed into bodily form. The sophisticated subtlety of the scholastic centuries and the spiritualism that tolerated no matter divested of will can have shaped architectural form only through their bodily expression.

Here we find the Gothic forms presented in principle: the bridge of the nose becomes narrower; the forehead assumes hard vertical folds; the whole body stiffens and pulls itself together; all restful expansiveness disappears. It is well known that many people (especially university lecturers) like the feeling of rolling a sharply angled pencil between their fingers in order to sharpen their thoughts. A round pencil would not serve the same purpose. What does roundness want? Nobody knows. And the same is true with the Romanesque rounded arch; no definite will can be recognized. It ascends, but this upward impulse finds a clear expression only in the pointed arch.

The human foot points forward but does that show in the blunt outline in which it terminates? No. The Gothic age was troubled by this lack of the precise expression of a will, and so it devised a shoe with a long pointed toe (the crakow appears in the twelfth century; see [Hermann] Weiss, *Kostümkunde*, 4: 8).

The width of the sole is a result of the body's weight. But the body has no rights; it is material, and no concessions are to be made to senseless matter. The will must penetrate every part.

This is why Gothic architecture dissolved the wall into vertical members, and the sole of the human foot becomes a shoe with three high heels, thereby eliminating the feeling of a broadly planted sole.

I shall not pursue how the principle of the gable can be seen in the pointed hats, how stiff, delicate, determined, and precise all of these movements are, or finally (as I have already noted) how the body itself appears to have been stretched out and made excessively slim; I am satisfied if I have made my point.

It is astonishing to travel through history and observe how architecture every where imitates the ideal of man in the form and movement of the body and how great *painters*

even created a suitable architecture for their figures. Do the architectural forms of Rubens not pulsate with the same life that animates his bodies?

I will conclude. It has not been my intention to give a complete psychology of architecture, but I hope to have made one idea manifest: an organic understanding of the history of forms will be possible only when we know with what threads our form imagination is bound to human nature.

The historian who has to evaluate a style has no organon for his definition of character but is directed only by an instinctive presentiment.

The ideal of 'working exactly' is also present in the historical disciplines. Art history adopts such an ideal above all to avoid any corrupting contact with aesthetics; and often the historian simply strives to describe what happened and when, without comment. Little as I am inclined to understimate the positive side of this tendency, I firmly believe that this cannot be the highest calling of scholarship. A history that seeks only to ascertain the chronology of what has taken place cannot be sustained; it would be particularly mistaken if it supposed itself thereby to have become 'exact.' One can work exactly only when it is possible to capture the stream of phenomena in fixed forms. Mechanics, for instance, supplies physics with such fixed forms. The humanities still lack any such foundation; it is only in psychology that it can even be sought. Psychology would also enable art history to trace individual events to general principles or laws. Psychology is certainly far from a state of perfection in which it could present itself as an organon for historical characteristics, but I do not believe this goal is unattainable.

Some may object to the idea of a psychology of art – one that infers from the impressions we receive the popular sentiments that generated these forms and proportions – by arguing that conclusions of this kind are without foundation, for proportions and lines do not always mean the same thing but change with the human sense of form [*Formgefühl*].

This objection cannot be refuted so long as we have no psychological basis; yet as soon as the organization of the human body is shown to be the constant denominator within all change, we are safe from this charge, for the continuity of this organization also insures the continuity of the sense of form.

It is too well known to require comment that styles are not created at will by individuals but grow out of popular sentiments and that individuals can create successfully only by immersing themselves in the universal and by representing perfectly the character of the nation and the time. But even if the sense of form remains qualitatively unchanged, one should not underestimate the fluctuations in its intensity. There have been few periods in which every form has been purely understood, that is, experienced. These are the only periods that have created styles of their own.

But since the large forms of architecture cannot respond to every minute change in popular sentiment, a gradual alienation sets in, and the style becomes a lifeless schema maintained only by tradition. The individual forms continue to be used but without understanding; they are falsely applied and thus completely deprived of life.

The pulse of the age then has to be felt elsewhere: in the minor or decorative arts, in the lines of ornament, of lettering, and so on.

Here the sense of form satisfies itself in the purest way, and here also the birthplace of a new style has to be sought.

This fact is of great importance for countering the materialist nonsense that finds it necessary to account for the history of architectural form through the mere compulsion of material, climate, and purpose. I am far from underestimating the significance of these factors, but I must insist that they can never divert a people's true vision of form into other paths. What a nation has to say, it always says; and if we observe its language of form where it speaks most freely and later rediscover the same forms, the same lines, and the same proportions in the high art of architecture, then we may rightly expect to hear no more of that mechanistic view.

And with that, the most dangerous adversary of a psychology of art will have quit the field.

8 Heinrich Wölfflin (1864–1945) from *Renaissance and Baroque*

Wölfflin's groundbreaking study *Renaissance and Baroque* was published in 1888 and still clearly bears the traces of his earlier interest in theories of empathy. The book is primarily concerned with stylistic changes in Roman architecture between 1520 and 1580. However, the discussion extends beyond the domain of architecture, resulting in a contribution to our understanding of the concept of style as such. In the first extract Wölfflin introduces the concept 'painterly' as one of four general concepts for the classification of the Baroque (the others being grandeur, massiveness and movement). He uses the term to describe architectural fiction or suggestiveness, and contends that it is best understood as a striving after effects which properly belong to the medium of painting. In the second extract, Wölfflin enquires into the sources of the Baroque itself and raises the question as to how it is that stylistic change takes place. The concept of stylistic change subsequently became an important influence on Modernist explanations of artistic development in the mid-twentieth century. In the present text, Wölfflin returns to the ideas developed in his doctoral dissertation, maintaining that such an enquiry must start out from the 'psychological fact' that we judge every object by analogy with our own bodies. The period which Wölfflin terms the Baroque is now generally identified as the Mannerist period. Originally published as *Renaissance und Barock*, Munich: Theodor Ackermann, 1888, these extracts are taken from the translation by Kathrin Simon, published in London: Fontana, 1964, pp. 29–34, 73–80.

The Painterly Style

It is generally agreed among historians of art that the essential characteristic of baroque architecture is its painterly quality. Instead of following its own nature, architecture strove after effects which really belong to a different art-form: it became 'painterly'.

The term *painterly* is both one of the most important and one of the most ambiguous and indefinite with which art history works. There is not only painterly architecture, but painterly sculpture. The history of painting has a painterly phase, and yet we speak of painterly light effects, painterly disorder, painterly profusion, and so on. Clearly it is impossible to use the word to definite purpose without first clarifying its meaning. What does 'painterly' mean? It would be simple enough to say that painterly is that which lends itself to being painted, that which without addition would serve as a motif for the painter. A strictly classical temple, if it is not in

ruins, is not a picturesque object. However impressive it may be as a piece of architecture, it would look monotonous in a picture. An artist painting it on a canvas today would have great difficulty in making it look interesting; in fact he could only succeed with the aid of light and atmospheric effects and a landscape setting, and in the process the architectural element would retreat completely into the background. But a rich baroque building is more animated, and would therefore be an easier subject for a painterly effect. The freedom of line and the interplay of light and shade are satisfying to the painterly taste in direct proportion to the degree to which they transgress the rules of architecture. If the beauty of a building is judged by the enticing effects of moving masses, the restless, jumping forms or violently swaying ones which seem constantly on the point of change, and not by balance and solidity of structure, then the strictly architectonic conception of architecture is depreciated. In short, the severe style of architecture makes its effect by what it *is*, that is, by its corporeal substance, while painterly architecture acts through what it *appears* to be, that is, an illusion of movement. Neither of these extremes, of course, exists in a pure state.

Painterliness is based on an illusion of movement. Why movement is painterly, and why it is communicated through painting rather than another art form can only be answered by examining the special character of the art of painting. Because it has no physical reality painting has to depend on effects of illusion. Its means of creating an illusion of movement are also greater than those of any other art form. This has not always been so; the painterly period . . . was only one phase in the history of painting, and the painterly style was only slowly evolved by discarding a predominantly linear style. In Italy this process reached completion in the High Renaissance, notably in the work of Raphael. [. . .]

The new expressive means that were to have such a decisive influence on architecture were various, and we may now try to list the main features of the painterly style. The most direct expression of an artist's intention is the sketch. It represents what appears most vital to him, and reveals him actually in the process of thinking. It may therefore be useful to start by comparing two sketches so that we may establish the clearest distinction between the two manners. To begin with, the medium changes with the style. Where the linear style employs the pen or the silver-point, the painterly uses charcoal, red chalk or the broad water-colour brush. The earlier style is entirely linear: every object has a sharp unbroken outline and the main expressive element is the contour. The later style works with broad, vague masses, the contours barely indicated; the lines are tentative and repetitive strokes, or do not exist at all. In this style, not only individual figures but the entire composition are made up of areas of light and dark; a single tone serves to hold together whole groups of objects and contrast them with other groups. While the old style was conceived in terms of *line* and its purpose was to express a beautiful and flowing linear harmony, the painterly style thinks only in masses, and its elements are light and shade.

Light and shade contain by nature a very strong element of movement. Unlike the contour, which gives the eye a definite and easily comprehensible direction to follow, a mass of light tends to a movement of dispersal, leading the eye to and fro; it has no bounds, no definite break in continuity, and on all sides it increases and decreases. This, basically, is how the painterly style evokes an illusion of constant change. The

contour is quite annihilated, and the continuous, static lines of the old style are replaced by an indistinct and gradually fading boundary area. Where figures had been sharply silhouetted against a light ground, it is now the ground that is usually dark; the edges of the figures merge into it, and only a few illuminated areas stand out.

Corresponding to this distinction between linear and massive is another, that between 'flat' and 'spatial' (substantial). The painterly style, with its chiaroscuro, gives an illusion of physical relief, and the different objects seem to project or recede in space. The expression 'backward and forward' in itself suggests the element of movement inherent in all three-dimensional substances as compared to flat planes. In the painterly style, therefore, all flat areas become rounded and plastic with a view to effects of light and shade. If the contrast between light and dark is extreme an object may appear to jump right out of the picture plane. [. . .]

The aim of the painterly style is to create an illusion of movement; its first element is composition in terms of areas of light and shade, its second is what I should call the *dissolution of the regular*, a free style or one of painterly disorder. What is regular is dead, without movement, unpainterly.

Unpainterly are the straight line and the flat surface. When these cannot be avoided, as in the representation of an architectural motif, they are either interrupted by some kind of accidental feature, or the building is depicted in a state of crumbling ruin; an 'accidental' drapery fold or something of the sort must be introduced to enliven it.

Unpainterly are the uniform series and the regular interval; a rhythmic succession is better, and better still is an apparently quite accidental grouping, depending entirely on the precise distribution of the masses of light.

To gain an even greater sense of movement, all or most of the composition is placed obliquely to the beholder. [. . .]

Unpainterly, finally, is the symmetrical composition. In the painterly style, there is only an equilibrium of the masses, with no neat correspondence of the individual forms to each other; sometimes the two sides of the picture are quite dissimilar, and the centre of the picture is undefined. The centre of gravity is transferred to one side, giving the composition a peculiar tension. A free painterly composition has no structural framework, no rule in accordance with which the figures are arranged; it is dictated only by an interplay of light and shade which defies all rule.

The third element in the painterly style may be called *elusiveness*, the lack of definition. It is characteristic of 'painterly disorder' that individual objects should be not fully and clearly represented, but partially hidden. The overlapping of one object by another is one of the most important devices for the achievement of painterliness, for it is recognized that the eye quickly tires of anything in a painting that can be fully grasped at first glance. But if some parts of the composition remain hidden and one object overlaps another, the beholder is stimulated to imagine what he cannot see. The objects that are partly hidden seem as if they might at any moment emerge; the picture becomes alive, and the hidden parts then actually do seem to reveal themselves. Even the severe style could not always avoid overlapping objects, but all the essential features stood out clearly and any restlessness was softened. In the painterly style the composition is purposely arranged in such a way that the effect is

an impression of transitoriness. A similar device is the partial concealment of the figures by the frame, so that all we see of them is half-figures looking into the picture.

It is, in fact, on the indefinable that the painterly style ultimately depends. If the dissolution of the regular is the opposite of the structural, then it is also the antithesis of the sculptural. Sculptural symmetry avoids the indefinite and un-finite, the qualities most essential to the painterly style. [...]

Ultimately the painterly style had to lead to a total annihilation of three-dimensional form. Its real aim was to represent all the vitality and variety of light, and for this purpose the simplest subject was as suitable as the richest and most painterly profusion.

* * *

The Causes of the Change in Style

Where are the sources of the baroque? In one's astonishment at this great phenomenon, appearing like a natural force, irresistibly carrying all before it, one is bound to seek an origin and a cause. Why did the Renaissance come to an end? Why was it followed, particularly, by baroque?

The change seems an inevitable one. It is inconceivable that this style originated at the will of one man seeking satisfaction through something that had never existed before. It was not a matter of experiments by individual architects, each of them exploring in a different direction, but rather of a *style* of which the most essential characteristic was the universality of its sense of form. We can see the new movement beginning at many different points: here and there the old style began to change and gradually more and more was gripped by change, until nothing could resist its force. With this the new style had come into being. Why did it happen in this way?

One possible answer is the theory of *blunted sensibility*, commonly offered in the past. It suggests that the forms of the Renaissance had ceased to exert their charm, so that the too-often-seen was no longer effective and that jaded sensibilities demanded a more powerful impact. Architecture changed in order to supply this demand and thus became baroque.

This theory is opposed by another, which sees the history of style as a reflection of changes in the pattern of human life. According to this hypothesis, style is an *expression* of its age, and changes with the changes in human sensibility. The Renaissance had to die because it no longer responded to the pulse of the age; it no longer expressed the ideas that governed the age or appeared most vital to it.

In the first theory, formal development is totally independent of its temporal context. The progress from hard to soft and from straight to curved is purely mechanical, so to speak; the sharp, angular forms soften under the artist's hands as if of their own accord. The style unravels, lives itself out, or what you will. The best analogy for this process is that of a plant blossoming and withering. Thus, the Renaissance could no more go on without changing than a flower can bloom without withering. It is no fault of the soil that the plant dies: the plant carries with it the laws of its own existence. And so it is with style; the necessity for change comes not from without but from within and formal sensibility develops according to its own laws. The basic assumption of this theory is correct. It is quite true that the organs of

perception are numbed by an effect which is too often repeated. Our emphatic response to this effect becomes less intensive, forms lose their power to impress because they no longer invoke this response; they are played out and lose their expressiveness. This diminished empathy could be called a 'jaded formal response'. It seems doubtful that this process is due entirely to a 'clearer memorized image', as Adolf Göller would have us believe, but it is feasible that this jaded response should necessitate more powerful effects.

This theory, however, does little to explain the baroque style. It is unconvincing for two reasons. The first is that it is one-sided; man is regarded purely as a form-experiencing creature, enjoying, tiring, demanding fresh stimuli, not as a real and vital being. Yet an action or experience not conditioned by our general responses to life, our personality and our whole being, is inconceivable. If, therefore, the baroque style sometimes had recourse to extravagantly powerful effects, the reason is rather a reaction to a general numbing of the nerves, and not to a jaded formal perceptiveness. It is not because Bramante's forms had ceased to excite the imagination that architecture had to resort to more forceful expressive means, but because of a universal loss of refined perceptiveness caused by a high degree of emotional indulgence, which rendered all less obtrusive stimuli ineffective. But can this phenomenon work in favour of the formation of a style? What kind of enhancement does it require? To increase the size, the slenderness or the degree of animation of a thing, or to invent ever more complicated combinations, does not in itself engender something basically new. Although Gothic art developed in the direction of ever slimmer and more pointed shapes, to a point of extreme exaggeration; although it is possible to invent the most complicated proportional system or the most artful combinations of forms, it remains doubtful how such developments can lead to a new style. The baroque style, however, is something completely new; it cannot be deduced from what went before. The separate devices used to counter this dulled sensibility – for instance, the less easily comprehended proportional system, do not constitute the *essence* of the new style. Why do the forms of art become heavy and massive; why not light and playful? There must be a different explanation; this one is insufficient.

The hypothesis put forward by Professor Göller seems hardly tenable. The 'jading of formal sensibility' to him is but 'the driving force to which we owe the progress in art since the primitive decorations of the earliest peoples'. Its cause is 'the sharpening of the memory image'. Since 'the mental effort needed to create the memory of a beautiful form' is supposed to consist in 'the unconscious spiritual pleasure generated by this form', this hypothesis indeed stipulates a state of constant change; for as soon as we have memorized the forms, they lose all their attraction for us. The task of the architect then, is constantly to produce something novel by varying the grouping of masses, the shape and combination of individual forms. But how, then, does a consistent formal approach, a style, come into being? Why, for instance, did not everyone at the end of the Renaissance experiment in a different direction? Is the answer that only one was acceptable, and if so, why?

The psychological approach has also been used to explain the new formal conception that comes with baroque. According to this point of view the formal style is the expression of its age; it is not a new approach, but one which has never been systematically founded. The technical side of the profession has always opposed it,

sometimes with reason, for the so-called 'kultur-historisch' introductions in textbooks contain a good deal that is ridiculous, summarizing long periods of time under concepts of a very general kind which in turn are made to account for the conditions of public and private, intellectual and spiritual life. They present us with a pale image of the whole, and leave us at a loss to find the threads which are supposed to join these general facts to the style in question. We are given no clue to the relationship between the artist's personal fantasies and the contemporary background. What has Gothic to do with the feudal system or with scholasticism? What bridge connects Jesuitism with the baroque? Can we be satisfied with comparisons with a vague movement towards an end that totally disregard the means? Is there aesthetic significance in the fact that the Jesuits forced their spiritual system on the individual and made him sacrifice his rights to the idea of the whole?

Before we indulge in comparisons of this kind, we must first ask what can be expressed by means of architecture at all, and what are the factors which influence artistic imagination. A few indications must suffice, no systematic investigation can be undertaken here. What, first of all, determines the artist's creative attitude to form? It has been said to be the character of the age he lives in; for the Gothic period, for instance, feudalism, scholasticism, the life of the spirit. But, we still have to find the path that leads from the cell of the scholar to the mason's yard. In fact little is gained by enumerating such general cultural forces, even if we may with delicate percept-iveness discover some tendencies similar to the current style in retrospect. What matter are not the individual products of an age, but the fundamental temper which produced them. This in turn, cannot be contained in a particular idea or system; if it were, it would not be what it is, a temper or a mood. Ideas can only be explicitly stated, but moods can also be conveyed with architectural forms; at any rate, every style imparts a more or less definite mood. We must only determine what kind of expressive means a style commands. To do this we must proceed from a psychological fact which is both familiar and easily checked. We judge every object by analogy with our own bodies. The object – even if completely dissimilar to ourselves – will not only transform itself immediately into a creature, with head and foot, back and front; and not only are we convinced that this creature must feel ill at ease if it does not stand upright and seems about to fall over, but we go so far as to experience, to a highly sensitive degree, the spiritual condition and contentment or discontent expressed by any configuration, however different from ourselves. We can comprehend the dumb, imprisoned existence of a bulky, memberless, amorphous conglomeration, heavy and immovable, as easily as the fine and clear disposition of something delicate and lightly articulated.

We always project a corporeal state conforming to our own; we interpret the whole outside world according to the expressive system with which we have become familiar from our own bodies. That which we have experienced in ourselves as the expression of severe strictness, taut self-discipline or uncontrolled heavy relaxation, we transfer to all other bodies.

Now it is very unlikely that architecture should not participate in this process of unconscious endowment of animation: indeed it does so in the greatest possible measure. Moreover, it is clear that architecture, an art of corporeal masses, can relate only to man as a corporeal being. It is an expression of its time in so far as it reflects the

corporeal essence of man and his particular habits of deportment and movement, it does not matter whether they are light and playful, or solemn and grave, or whether his attitude to life is agitated or calm; in a word, architecture expresses the 'Lebensgefühl' of an epoch. As an art, however, it will give an ideal enhancement of this 'Lebensgefühl'; in other words, it will express man's aspirations.

It is self-evident that a style can only be born when there is a strong receptivity for a certain kind of corporeal presence. This is a quality which is totally absent in our own age; but there is, on the other hand, a Gothic deportment, with its tense muscles and precise movements; everything is sharp and precisely pointed, there is no relaxation, no flabbiness, a will is expressed everywhere in the most explicit fashion. The Gothic nose is fine and thin. Every massive shape, everything broad and calm has disappeared. The body sublimates itself completely in energy. Figures are slim and extended, and appear as it were to be on tiptoe. The Renaissance, by contrast, evolves the expression of a present state of well-being in which the hard frozen forms become loosened and liberated and all is pervaded by vigour, both in its movement and its static calm.

The most immediate formal expression of a chosen form of deportment and movement is by means of costume. We have only to compare a gothic shoe with a Renaissance one to see that each conveys a completely different way of stepping; the one is narrow and elongated and ends in a long point; the other is broad and comfortable and treads the ground with quiet assurance.

I have of course no intention of denying that individual architectural forms may originate with technical causes. Forms have certainly always been influenced to a certain extent by the nature of the material, the methods of working it, and techniques of construction. But I shall maintain, particularly in face of certain recent theories, that technical factors cannot create a style; that the word art always implies primarily a particular conception of form. The forms which result from technical necessity must not be allowed to contradict this conception; they can only endure if they fit into a formal taste already previously established. Nor, in my opinion, is a style a uniformly accurate mirror of its time throughout its evolution. I am thinking not so much of the early periods of history, when style was still at odds with expression and only gradually becoming articulate, as of those periods when a fully developed formal language was transmitted from one race to another; when the style, having become hardened and exhausted by uncomprehending misuse, turns more and more into a lifeless scheme. When this happens the temper of a people must be gauged not in the heavy and ponderous forms of architecture, but in the less monumental decorative arts; it is in them that formal sensibility finds an immediate and unchecked outlet, and in them that the renewal takes place. A new style, in fact, is always born within the sphere of the decorative arts.

To *explain* a style then can mean nothing other than to place it in its general historical context and to verify that it speaks in harmony with the other organs of its age. The point of departure for our investigation of the origins of baroque will therefore be the most analogous comparison, that of the conception and representation of the human figure in the representational arts, rather than a general 'kulturhistorisch' sketch of the post-Renaissance; and the point of comparison will be the general type of appearance rather than the individual motifs. Whether a complete characterization of a style can be obtained in this way is another problem, with which I

shall not deal here. But the significance of reducing stylistic forms into terms of the *human body* is that it provides us with an immediate expression of the spiritual.

9 Wilhelm Dilthey (1833–1911) from 'The Three Epochs of Modern Aesthetics and its Present Task'

A student of the historian Leopold von Ranke, Dilthey occupied posts at Basle, Kiel and Breslau before, in 1882, taking up the chair in Berlin that had once belonged to Hegel. Dilthey's principal achievement resides in his attempt to clarify the relationship between the natural sciences and the social or human sciences, including the study of art and literature. Dilthey sought to show that those disciplines which have as their object human behaviour or institutions are required to recognize a crucial difference between the task of *explaining* processes and events through reference to laws, and the task of *understanding* human action and behaviour in terms of the conceptions and practices of the actors themselves. In the present essay Dilthey turns his attention to the relationship between aesthetics, art criticism and art itself, asking how it is that these may once again be brought into a productive relationship with each other. He criticizes both 'experimental' and 'rationalist' aesthetics, maintaining that abstract theories about 'unity' and 'order in multiplicity' should be replaced with ideas 'acquired from an analysis of the living historical nature of art'. On Dilthey's account, enquiry into the nature and means of artistic creation has been internal to recent developments in art and literature, with the consequence that artists have succeeded in creating their own artistic principles. Dilthey's essay was originally published as 'Die drei Epochen der modernen Aesthetik und ihre heutige Aufgabe', in *Die Deutsche Rundschau*, volume 18, 1892. These extracts are taken from the translation by Rudolf A. Mackreel and Frithjof Rodi in Dilthey, *Selected Works, Volume V: Poetry and Experience*, Princeton: Princeton University Press, 1985, pp. 175–6, 178–80, 205–8, 209–10, 219–22.

It is one of the most vital tasks of contemporary philosophy to reestablish, through the further development of aesthetics, the natural relationship among art, criticism, and an engaged public. This relationship has always been very difficult to maintain, but that is to be expected. We know how much attention and effort Goethe and Schiller devoted to this relationship, and how today it is particularly wanting. The creative artist has always been very sensitive about criticism that violates the lovingly formed organic unity of his work. But he is currently developing a special dislike of aesthetics for its abstract speculations about beauty which prevailed for so long at the universities.

In the days of Boileau, Lessing, or Wilhelm Schlegel, criticism found a fixed standard in the prevailing aesthetic theory. Today, however, in relation to his new tasks, the critic is too often forced to judge on the basis of his own *ad hoc* reflections. No consensus exists among the public which can sustain the artist striving to attain higher goals. A lively exchange between aesthetic reflection and aesthetic culture is thus lacking in the leading circles of our society.

If the artist, the aesthetician, the critic, and the public are to influence one another and to learn from one another, aesthetics must proceed from an unbiased understanding of the vast artistic movement within which we live today. And a few

displeasing works of art produced by this new movement should not make aesthetics blind or deaf to its legitimacy.

The beginnings of this artistic movement lie far back in the past. However, it seems to me that the generation directly influenced by the July Revolution of 1830 was the first to break away completely from classicism and romanticism. Then, as in 1848, one could still clearly hear the rumble of the oncoming legions determined to bring about the transformation of European society in accordance with the principles of a thoroughly secular and earth-centred spiritual life. The soil of the old Europe trembled. The view of life which had been developing since the fifteenth century and which had found its expression in art from Leonardo da Vinci and Shakespeare through Goethe was disintegrating. The broad outlines of a new view, still indistinct, began to emerge on the horizon. The recognition of this European situation became the source of a new literature and art, which in turn provided evidence for the power of the suddenly changed life-mood that was setting in.

* * *

We find ourselves today in the midst of this new movement. The strength of its stylistic principles is shown by the fact that even opposing tendencies are obliged to conform to them. Thus even such a classical author as Gottfried Keller, in his *Leute von Seldwyla* (The People of Seldwyla), has employed stark realism to make apparent the social soil from which his characters, their passions, and destinies grow. Our age is no longer acquainted with ideal characters such as Iphigenia, Wilhelm Meister, and Lothario, who transcend time and place. Painting has returned to colour as its fundamental means of expression. It is seeking to do away with all traditional schemata of perception and composition, and to look at the world as though with new eyes. Everywhere the natural tendency to elevate the ideally beautiful above common reality – that is, the traditional well-ordered delineation of form – is being sacrificed to the need for uncurtailed, untrammelled reality and truth. What our age finds most important is to see reality, or at least the desire to see it – the striving to subordinate all of our thought, production and action to it, and to submit our deepest wishes and ideals to its laws. Donatello, Verrocchio, Masaccio, the old Dutch and Southern German masters, and the creators of the old English theatre, most especially Marlowe, also wanted to see reality with new eyes. With this impulse, they created a major new style of European art, whose period of prominence has just now elapsed. Today we are experiencing a similar turning point; but for each new epoch of art the tasks become more difficult. An artist of the fifteenth and sixteenth centuries apprehended human reality in terms of the powers of individuals, the destiny implicit in their character, contrasts and relations among them, and their relation to a higher context. Today's artist would have us see in the artwork the actual relations in which men stand to one another and to nature, and the laws of reality to which we are subject. This is the driving force of the application of the biological law of heredity already to be found in George Sand, and in the preference given by Balzac and Musset to abnormal psychic states and complexes, but above all in the derivation of characters and passions from social conditions. A colossal task!

Certainly, success has also been achieved recently along the usual well-trodden paths, as has been shown by Peter Cornelius, Anselm Feuerbach, Gottfried Keller, Neo-Gothic architecture, and a number of important composers. Moreover, historical

consciousness and historical learning have facilitated the appreciation, utilization, and remembrance of the existing major forms of art. However, our sympathy is with those venturesome artists who are not only able to see into the soul of our society – a society whose outlook is undergoing a tremendous upheaval unknown since the last days of the Greco-Roman world – but who are also capable of articulating something of the liberating vision for which our society yearns. From them we hope for new modes of artistic expression appropriate to us. And we shall follow them all the more confidently, the better they command the traditional modes of expression, the more ready they are to make use of what is sound and is still valid for us in these forms, and the more they avoid the danger of allowing the basic expressive powers of their art to degrade into base sensuality and brutality, and the graphic reproduction of vulgar reality.

We do not need to build up aesthetics anew in order for it to enter into a healthy relationship to these vital artistic endeavours of the present. For the artists themselves have already found it necessary to enquire into the true nature and means of the particular arts; they have had to create aesthetic principles for themselves. The aesthetics of our century must be sought elsewhere than in compendia and thick textbooks. In their times, Leonardo da Vinci and Dürer thought and wrote about their art; Lessing, Schiller, and Goethe created a new technique of drama and epic poetry by combining theoretical reflection with artistic practice. In our day Semper, Schumann, Richard Wagner, and the modern poets have similarly coupled artistic speculation with artistic creation. In Germany, Otto Ludwig especially, and Hebbel as well, are perceptive guides to the new directions; in France, it is the whole new generation of poets from the Goncourts on. Moreover, contemporary anthropology and art history can teach us, through the comparison of forms and their development, to transcend every historically limited mode of taste and to return to the nature of art itself. They furnish the means for considering aesthetic questions in an unbiased, scientific way, free from traditional speculative aesthetics.

* * *

Experimental aesthetics is unable to explain how the work of art is more than a heap of impressions. By means of the analysis of aesthetic impressions, it arrives at only an aggregate of elements that arouse us. The unity of the artwork is for it merely one operative factor alongside others. Should this unity be lacking, then there is just one less pleasure-inducing element, which can, it is assumed, be replaced by adding others. Consequently the style of an artwork and of its particular effects cannot really be made comprehensible by this experimental aesthetics.

Rationalist aesthetics, for its part, perceives beauty only as an intelligible unity. This unity is distinguished from logical unity merely by its lower degree of distinctness. Therefore, according to the principles of this aesthetic theory, beauty must produce a weaker effect than truth. Aesthetic sense impressions are themselves regarded as reducible to relations among ideas. The theory of music put forth by Leibniz and Euler is the necessary consequence of this approach. Every attempt to reduce harmony, tonal affinities and colour effects to relations among ideas has failed. Yet if the attempt at such a reduction is abandoned, all that is left is a faint pleasure in an intelligible relation accompanying the elementary sense effects, but foreign and external to them; the unified and powerful effect of a great work of art remains

unintelligible, since the unity of the artwork, i.e., its style, pervades and enlivens the whole and inheres in each line, in each melody.

Consequently, both methods are insufficient. We must supplement the analysis of impressions by means of an analysis of creation. And we must replace abstract theorems about unity and order in multiplicity with ideas acquired from an analysis of the living historical nature of art.

For the expert even a few notes from a melody by Mozart suffice to distinguish it from all other music. A fragment of a marble statue from the classical Greek period can be dated by the archaeologist. Raphael's use of line cannot be mistaken by the expert for that of any other painter. Thus for any particular genius, the mental activity by which he combines sensuous elements has the same fundamental character in each recurring combination. Accordingly, there is in each artwork a mode of unified activity – an inner delineation, as it were – proceeding from the articulation of the basic shapes down to the smallest ornamentation. This we call the *style* of the artwork.

The style of an artwork produces an impression which is not adequately characterized as pleasure, satisfaction, or a delightful feeling. Rather, a definite form of activity is imparted to the psychic life of the perceiver, and in this activity the psyche is broadened, intensified, or expanded, as it were. Style exudes an energy which enhances the vitality of the perceiver and his feeling of life. The attempt to re-create the activity of a great soul, as embodied in a fresco of Michelangelo or in a fugue of Bach, calls up in me a corresponding energy and thus, in a very specific manner firmly established by the object, heightens my own vitality. Thus feeling here is only the reflex of the exertion of psychic energy and activity by which I appropriate the artwork. Through feeling I obtain a reflexive awareness of this inner activity. Consequently the processes involved in the *aesthetic apprehension* of reality, in artistic *creation*, and, finally, artistic *appreciation* are closely *akin* to one another. The appreciation of an artwork is also an activity of the psyche, though more relaxed and tranquil. Its phases take place imperceptibly, but that heightening of spontaneous vitality which is so characteristic of aesthetic pleasure results directly from the form of this activity. We can go further. The enhancement and expansion of one's existence in aesthetic creation or appreciation is akin to the delight that arises from the mode of volitional activity involved in bold and consistent thinking or in courageous actions. In both cases, the psyche, by its *delight in the inner form of its own activity*, assumes a superiority over the crude satisfaction of impulses. This delight alone, among all feelings of pleasure, is independent of what is external and can always give lasting fulfilment to the psyche. The history of our moral development consists of the progressive triumph of this highest vitality which manifests itself in our inner and outer struggles as well as in that mode of spiritual existence which constantly operates independently of external influences.

If I want to glimpse reality through the eyes of a great creator, if I want to comprehend a great spatial magnitude, or the dynamical, moral sublime, then an even greater exertion of energy is required. All of my sensory, emotional, and intellectual powers will be summoned up, enlivened, and intensified, without being overstrained, since I am only re-creating something. When I follow a dramatic action by Schiller, in which the noble spirit of a powerful will is at work, I must elevate and

raise myself into an analogous state of mind. But as I assimilate the work in this manner, the particular components of aesthetic delight, which were distinguished in the analysis of aesthetic impressions, also enter the process. These components . . . blend into the more encompassing process of reception just described. They not only enhance my delight through an addition of new pleasure elements; they do still more in that they satisfy all aspects of my psychic life equally and completely, and impart an awareness of a fullness which is unfathomable because it flows from many sources, like a mountain stream swelling up from countless rivulets.

The meaning of an artwork does not, therefore, lie in an aggregate of pleasurable feelings; on the contrary, the enjoyment of that work fulfils us completely because it increases the vitality of our mind and leaves no striving which has been awakened in us unfulfilled. It satisfies our senses and expands our psyche at one and the same time. An artwork which produces such persistent and total satisfaction in people of different nationalities and times is a *classic*. In this effect alone, and not in some abstract concept of beauty which the work should realize, lies the criterion for the authenticity and value of an artwork. For all too long, aestheticians and art critics have put this barren concept of beauty at the basis of the theory of art. Similarly, an isolated consideration of impressions of pleasure which are produced by the artwork is utterly incapable of making the meaning of the work comprehensible. The immense and sacred importance of art for humanity can only be understood if one starts with the natural power and scope of the artist's psyche and the way in which it encompasses reality significantly, thus impressing a public, which, despite the fact that it consists of people from all walks of life, can be carried away by greatness. In this way, it is possible to grasp the intensification of the powers of apprehension, the expansion of the psyche, its discharge, and its purification as it produces a great artwork. [. . .]

In light of all this, it is clear that there is within art no right or wrong path, no absolute beauty, and no final authority. Rather, a genius comes upon the scene and compels men to see through his eyes. Then other artists learn to perceive and to represent in the same way, and a movement or a school is formed. These are questions of influence and power, not of what is right or justified. For it is merely a question of whether the style of Marlowe and Shakespeare can dominate the stage and move their most distinguished contemporaries – above all the great queen – whether Michelangelo can build palaces and churches and fill them with human forms so that even competing contemporary and later artists will fall under the spell of his forms. All great battles of art criticism involve the evaluation of something already existing or established, and the claim of a pretender to mount the throne or to overthrow an artistic dynasty which has become stultified. These critical battles have been very useful and effective, and I will show that aesthetics has accumulated sufficient criteria for resolving such struggles, provided that the critic learns to understand art in relation to its time, the secret of which the artist is striving to articulate. For 'We, we live! The day is ours and the living are in the right.' [. . .]

* * *

We have seen how a mode of apprehension and a style are determined by the spirit of an artist. This spirit is, however, historically conditioned and shared by a large number of the artists of an epoch. The appreciative public of an age learns to favour

the same mode of apprehension, and this, in turn, has an influence on the artists.
That the *technique* of a poet is always just the *expression of a historically limited epoch*.
There are artistic laws for literature, but there is no universally valid literary tech-
nique. Attempts . . . to project a general technique of drama cannot succeed. Form and
technique are historically conditioned in their very substance. And it is the task of art
history to trace the successive types of technique.

The style and the technique of Raphael, Michelangelo, Shakespeare, Cervantes,
and Corneille are no longer ours. That style was the greatest since the days of the
Greeks. Just as it appropriated universally valid elements from the ancients and
turned them to good account, it will itself continue to have a further influence. But
it was also merely the expression of an age. It may appear audacious to single out its
main characteristics by means of those mimetic arts whose subject matter is man; yet
such an approach is enlightening precisely for our present age and its concerns. The
individual power of human beings, their autonomy, yet at the same time their
connection with a pure ideal system of order and other individuals participating in
it: this was the secret which all great artworks of that epoch articulated in a variety of
ways. As a result, this style shows a propensity for ideal relations between persons,
contrasts, parallels, gradations, and harmonious arrangements of groups. Its figures
are all constructed within an ideal space, as it were. [. . .]

Science has taught us to always seek lawful relations in reality. Today even man can
only be understood by the systems that condition him – the systems of natural laws, of
society, and of history. Every artistic work reflects this striving to understand. We
seek to articulate the lawful relations existing in any sphere of phenomena, even in an
individual formation. With an unlimited concern for truthfulness, the artist seeks to
express the character and value of the real system of natural laws in which man is
placed. The arts point to real relations everywhere: the relation of the worker to the
machine and the farmer to his soil, the bond of persons working together for a
common end, genealogical lines of descent and heredity, the confrontation of the
sexes, the relation of passion to its social and pathological basis and of the hero to
masses of unnamed people who make him possible. In the present upheaval surround-
ing the arts, we await men of genius who will create a new style for the particular
mimetic arts.

In every such time of crisis, naturalism appears. It destroys the worn-out language
of forms; it attaches itself to reality, seeking to obtain something new from it. This was
the case with Donatello, Verrocchio, Masaccio, and Marlowe. They prepared for the
style and technique of great creative geniuses.

Today, too, new means are being sought to produce new effects.

Who could turn a deaf ear to the power of this progressive movement? It will
continue to transform our literature and produce a new style in all the arts, for it
manifests the power of a new mode of thinking gained from science. From a sense of
affinity between literature and science, which has grown steadily since Voltaire,
Diderot, and Rousseau, this new school has provided a blend of both. Zola especially
advocates this blend. We have shown how an estimable feeling for truth here never-
theless leads literature astray. To be sure, the poet also makes real life – and, as such,
truth – his theme. However, for him everything that exists becomes understandable
through that point on which all actions and feelings ultimately turn, never through the

abstractions of the conceptual attitude. With all the resources of his vitality he appropriates life, encompassing and grasping it. A literary work claiming to be scientific goes even more radically astray than one that preaches morality. The poet must suspend the easy answers offered by an uncritical scientific attitude to the great question, What is life? He must learn from science and will not want to contradict any real truth. However, he should not allow himself to be misled by popular natural science journalism. When an artistic genius looks life in the face in his own way – patiently, seriously and persistently – he will, like Dante, Shakespeare, and Goethe, apprehend it more profoundly than he ever could from all the books on physiology and psychology. Then we will be able to move beyond the theory of the animality of human nature, the gloomy spectre that haunts our literature and makes it so dismal. On the one hand, it has led an idealist like Tolstoy, moved by a half barbaric, half French dread of human bestiality, to negate life. On the other hand, it has encouraged others to find a dismal delight in animalism.

It is a profound and honest trait of our new literature that it strives to portray current society as it is, with relentless truthfulness, and thereby subject it to criticism. But how much more fortunate were Cervantes, Erasmus, and Rabelais as they fought their battles against a feudal, priestly society. They did so in the name of a middle-class common sense. They were convinced of the ultimate triumph of their cause. Consequently a radiant sense of humour emanates from their works. But our middle class dramas have no heroes. Our sharply etched images of society as it is lack the feeling that even in social crises human nature has latent within it the power to triumph and that man can overcome all the dislocations from which he suffers today. Our writers are at times impressed by the Latin ideal of the destruction of family and property in the interest of political tyranny, at times by the backward Nordic cult of the rights of unbridled individuality, or then again by a barbaric Slavic wallowing in the bestial sphere of human life. The depth of the Germanic character must become our poetic source for a consciousness appropriate to our time of what life is and what society should be. Such a consciousness must do justice to the present and no more. For every generation of poets and thinkers attempts to make sense of the enigmatic, unfathomable face of life, with its laughing mouth and mournful eyes. This will remain an unending task.

10 Alois Riegl (1858–1905) from *Problems of Style*

A student of Robert Zimmermann (see IVB2, above), Alois Riegl worked for many years in the Museum of Art and Industry in Vienna where his duties included ordering and cataloguing the textile collection. His first major publication, *Stilfragen. Grundlegungen zu einer Geschichte der Ornamentik* (Problems of style: Foundations for a history of ornament) challenged the technical–materialist approach to the history of ornament derived from the work of Gottfried Semper (see IIIA5, above). Where Semper had sought to ground the study of ornament in an analysis of the materials and techniques employed by different societies at different historical stages, Riegl maintains that the history of ornamental forms must be seen as pursuing its own internal principles of development. He argues that form is transformed from within according to motives which are strictly artistic. His as yet

undeveloped notion of a *Kunstwollen*, or 'urge to form', makes its first appearance here. *Stilfragen* was first published in Berlin by G. Siemens in 1893. These extracts, all from the Introduction, are taken from the translation by Evelyn Kain, *Problems of Style*, Princeton: Princeton University Press, 1992, pp. 3–6, 6–8, 9–10, 12–13.

The subtitle of this book announces its theme: 'Foundations for a History of Ornament.' How many of you are now shrugging your shoulders in disbelief merely in response to the title? What, you ask, does ornament also have a history? Even in an era such as ours, marked by a passion for historical research, this question still awaits a positive, unqualified answer. Nor is this purely the reaction of radicals who consider all decoration original and the direct result of the specific material and purpose involved. Alongside these radical extremists, there are also those of a more moderate bent, who would accord to the decorative arts some degree of historical development from teacher to pupil, from generation to generation, and from culture to culture, at least in so far as they have to do with so-called high art, devoted to the representation of man, his achievements, and struggles.

Certainly, from the very inception of art historical research, there have always been some scholars in the field who also conceived of pure decoration in terms of a progressive development, i.e., according to the principles of historical methodology. But these were, of course, mainly learned academicians who adapted the rigorous training in philology and history acquired at gymnasia and universities to the study of ornamental phenomena as well. However, the drastic impact of this more extremist position upon the general attitude toward the decorative arts is revealed by the way in which historical methodology has been applied to the study of ornament up to now. For example, scholars have been extremely reticent to propose any sort of historical interrelationships, and even then, only in the case of limited time periods and closely neighbouring regions. Their courage seems to fail them completely the moment an ornament ceases to have any direct relationship with objective realities – to organic, living creatures or to works fashioned by the human hand. As soon as they deal with the so-called Geometric Style, which is characterized by the mathematical expression of symmetry and rhythm in abstract lines, all consideration of artistic, mimetic impulses or of variation in the creative abilities of various cultures immediately ceases. The degree to which the terrorism of extremists has successfully intimidated even the 'historians' involved in the study of ornament emerges clearly in the haste of scholars to assure us that they would never be so foolish and naive as to believe, for example, that one culture could have ever copied a 'simple' meander band from another, or by their repeated apologies whenever they do venture to assert even a loose connection between, shall we say, the stylized two-dimensional vegetal motifs current in two geographic areas.

What led to this situation, which has had such a decisive and, in many respects, paralysing effect upon all art historical research in the last twenty-five years? The blame can be placed squarely on the materialist interpretation of the origin of art that developed in the 1860s, and which succeeded in winning over, virtually overnight, everyone concerned with art, including artists, art lovers, and scholars. The theory of the technical, materialist origin of the earliest ornaments and art forms is usually attributed to Gottfried Semper. This association is, however, no more justified than

the one made between contemporary Darwinism and Darwin. I find the analogy between Darwinism and artistic materialism especially appropriate, since there is unquestionably a close and causal relationship between the two: the materialist interpretation of the origin of art is nothing other than Darwinism imposed upon an intellectual discipline. However, one must distinguish just as much and just as sharply between Semper and his followers as between Darwin and his adherents. Whereas Semper did suggest that material and technique play a role in the genesis of art forms, the Semperians jumped to the conclusion that all art forms were always the direct product of materials and techniques. 'Technique' quickly emerged as a popular buzzword; in common usage, it soon became interchangeable with 'art' itself and eventually began to replace it. Only the naive talked about 'art'; experts spoke in terms of 'technique.'

It may seem paradoxical that so many practising artists also joined the extreme faction of art materialism. They were, of course, not acting in the spirit of Gottfried Semper, who would never have agreed to exchanging free and creative artistic impulse [*Kunstwollen*] for an essentially mechanical and materialist drive to imitate. Nevertheless, their misinterpretation was taken to reflect the genuine thinking of the great artist and scholar. Furthermore, the natural authority that practising artists exert in matters of technique resulted in an environment where scholars, archaeologists, and art historians swallowed their pride and beat a hasty retreat whenever the question of technique arose. For they – mere scholars that they were – could have little or no competence in this regard. Only recently have scholars become bolder. The word 'technique' proved to be extremely flexible: first came the discovery that most ornamental motifs could be (and had actually been) rendered in a variety of techniques; then came the pleasant realization that techniques were an excellent source of controversy. In time, archaeological publications, as well as journals devoted to arts and crafts, joined in the wild chase for techniques, a pastime that will probably continue until all the technical possibilities for each and every humble motif have been exhausted, only to return – one may be sure – precisely to the point where it all began.

In the midst of such a spirited intellectual atmosphere, this book ventures to come forward with foundations for a history of ornament. The wisdom of beginning with foundations that pretend to be nothing more than that is obvious. In a situation where not only the field of action is hotly contested at every step along the way but even the groundwork itself is constantly in dispute, our first concern is to secure a few positions, a connected series of strongholds from which a comprehensive, systematic, and complete offensive can later be launched. The nature of the situation militates further that 'negative arguments' take up a far greater portion of this book than is customary in a positive, pragmatic description of history. Here our most immediate and urgent objective is to address the most fundamental and harmful of the misconceptions and preconceptions that still hinder research today. This is another reason why, for the present, the concepts of this study are presented in the form of 'foundations.'

Having said this, I still feel compelled to justify the existence of this book. However, anything one might say in this regard will sound unconvincing as long as the technical–materialist theory of the origin of the earliest primeval art forms and

ornamental motifs remains unchallenged, even though it has failed to define the precise moment when the spontaneous generation of art ends, and the historical development effected by laws of transmission and acquisition begins. The first chapter, therefore, is devoted to challenging the validity of the technical–materialist theory of the origin of art. As its title indicates, it deals with the nature and origin of the Geometric Style. Here, I hope to demonstrate that not only is there no cogent reason for assuming a priori that the oldest geometric decorations were executed in any particular technique, least of all weaving, but that the earliest, genuinely historical artistic monuments we possess in fact contradict this assumption. Similar conclusions will also emerge from deliberations of a more general nature. It will become evident, namely, that the human desire to adorn the body is far more elementary than the desire to cover it with woven garments, and that the decorative motifs that satisfy the simple desire for adornment, such as linear, geometric configurations, surely existed long before textiles were used for physical protection. As a result, this eliminates one principle that has ruled the entire field of art theory for the past quarter century: the absolute equation of textile patterns with surface decoration or ornament. The moment it becomes untenable to assume that the earliest surface decoration first appeared in textile material and technique, then the two can no longer be considered identical. Surface decoration becomes the larger unit within which woven ornament is but a subset, equivalent to any other category of surface decoration.

* * *

[. . .] In the case of the Geometric Style, it is especially necessary to dispel once and for all the misconceptions surrounding its purely technical, material origin and the allegedly ahistorical nature of its development. Yet one fact enormously complicates any historical approach to the Geometric Style: whereas organic nature and the handicrafts inspired by it allow the artist manifold alternatives, the mathematical laws of symmetry and rhythm that govern the simple motifs of the Geometric Style are more or less the same the world over. Spontaneous generation of the same geometric decorative motifs in different parts of the world is, therefore, not out of the question; but even so, one can take specific historical factors into account with complete objectivity. Certainly, some cultures were always leading the way for others, just as more talented individuals have always distinguished themselves from their peers. And surely it was just as true in the remote past as it is today that the vast majority of people find it easier to imitate than to invent.

Once plants are used as decorative motifs, the study of ornament finds itself on more solid ground. There are infinitely more species of plants that can be used as the basis for patterns than there are abstract, symmetrical shapes, limited as these are to the triangle, the rectangle, the rhombus, and only a few others. This is the point where classical archaeology begins to take an interest in vegetal ornament; in particular, the connection between Greek plant motifs and their ancient Near Eastern prototypes, which mark the beginning of art history proper, has already provided the subject of intense study and extensive debate. Nevertheless, German archaeology has not yet attempted a systematic description of the history of the vegetal ornament that was so crucial to antique art from ancient Egyptian to Roman times; this is a consequence of the enormous resistance to making 'mere ornament' the basic theme of a more ambitious historical study. However, an American has recently taken the

step that German-trained scholars timidly avoided. W. G. Goodyear, in his book, *The Grammar of the Lotus*, was the first to argue that all antique vegetal ornament, and a good deal more, was a continuation of ancient Egyptian lotus ornament. The driving force behind the ubiquitous diffusion of this ornament was, in his opinion, the sun cult. This American scholar is apparently no more concerned with the technical–materialist theory of the origin of art than he is with Europe's crumbling castles and basalt deposits – unless I am mistaken, Gottfried Semper's name is not mentioned once in the entire book.

Strictly speaking, Goodyear's main thesis is not completely new; what is indisputably unique, however, is his radical determination to accord his ideas a universal significance, as well as the motivation that he cites for the entire development.

As far as the latter is concerned, however, the idea that the sun cult had such an overwhelming influence on decoration is surely erroneous. It is not even certain whether sun-cult symbolism played such a preponderant role in ancient Egyptian ornament, much less outside of Egypt, where there is absolutely no proof and, moreover, no likelihood that it did. Symbolism was unquestionably one of the factors that contributed to the gradual creation of a wealth of traditional ornament. However, by proclaiming symbolism the sole and decisive factor, Goodyear makes the same mistake as the materialists who single out technique in this way. Moreover, both interpretations share an obvious desire to avoid at all costs the purely psychological, artistic motivation behind decoration. In cases where the artist is obviously responding to an immanent, artistic, creative drive, Goodyear sees symbolism at work, just as the artistic-materialists in the same instance utilize technique as their incidental, lifeless objective.

* * *

It is very easy to trace the historical development of traditional stylized vegetal motifs. The same is not true, however, the moment that man attempts to produce ornament related to the natural appearance of an actual vegetal prototype. For example, the projection of the palmette found in Egypt and Greece cannot have been invented independently in both places, since the motif bears no resemblance to the actual plant. One can only conclude, therefore, that it originated in one place and was subsequently transmitted to the other. It is quite another matter, however, in the case of two ornamental works of differing origin that depict a rose, for instance, as it appears in nature; since the natural appearance of the rose is generally the same even in the most diverse countries, it is conceivable that similar depictions could arise independently. It becomes readily apparent from the study of vegetal ornament as a whole, however, that realistic renderings of flowers for decorative purposes, as is nowadays the vogue, is a recent phenomenon. The naive approach to art characteristic of earlier cultures insisted adamantly on symmetry, even in the case of reproductions of nature. Representations of humans and animals soon departed from symmetry by way of the Heraldic Style and other similar arrangements. Yet plants – subordinate and seemingly lifeless as they are – remained symmetrical and stylized throughout the centuries even in the most sophisticated styles, particularly as long as they functioned as pure decoration and had no representational value. The transition from ancient stylization to modern realism, of course, did not come about in a day. Naturalism, the tendency to make ornamental forms resemble actual plants seen in perspective, crops

up repeatedly in the history of vegetal ornament. Indeed, there was even a period in antiquity when naturalism was quite advanced; however, it represents only a brief interlude in the otherwise constant use of traditional, stylized forms. Generally speaking, the naturalistic vegetal motifs of antiquity and of almost the entire medieval period were never copied directly from nature.

The acanthus motif provides us with the best, and probably most crucial, insight into how naturalized vegetal motifs were understood and executed in antiquity. Nevertheless, Vitruvius's story that decorative acanthus motifs were originally based directly upon the actual plant is still accepted without question today. No one seems disturbed by the improbable suggestion that a common ordinary weed could suddenly and miraculously be transformed into an artistic motif. Seen within the context of the history of ornament as a whole, the situation is unprecedented, without parallel, and downright absurd. Furthermore, it is the earliest acanthus motifs that least resemble the actual plant. Only in the course of time did the stylized motifs begin to acquire the characteristics of the acanthus plant itself; obviously, no one referred to them as acanthus motifs until much later in their development, when they actually began to resemble the plant. Chapter 3 will prove that the earliest acanthus ornaments are nothing more than palmettes that were either executed in sculpture or else conceived sculpturally. As a result, the acanthus motif, by far the most important vegetal ornament of all time, makes its debut in art history not as a *deus ex machina* but with a role that is fully integrated into the coherent course of development of antique ornament.

* * *

Even though the principal task of historical and art historical research is usually to make critical distinctions, this book tends decidedly in the opposite direction. Things once considered to have nothing in common will be connected and related from a unified perspective. In fact, the most pressing problem that confronts historians of the decorative arts today is to reintegrate the historical thread that has been severed into a thousand pieces.

Since this book threatens to undermine so many deeply-ingrained and fondly-cherished opinions, it is bound to create a storm of protest. I am acutely aware of this. However, I also know that there are many who already share my views, and still others who may be in tacit agreement but who are not yet ready to speak out. And as for those who remain unpersuaded by my arguments, I shall have accomplished something even if I succeed only in compelling them to realize that they must go back and reexamine their premises and seek better and stronger evidence to support their cherished theories. For even limited success is worth the effort, if it sheds some light on the fundamental issues that concern us in this book. Only through trial and error can one approach the truth.

VB
Cultural Criticism

1 Jacob Burckhardt (1818–1897) from *Reflections on World History*

The Swiss historian Jacob Burckhardt held the chair in history at Basle from 1858 to 1893 where he directly influenced both Heinrich Wölfflin (see VA7 and 8, above) and Friedrich Nietzsche (see VB2, 12 and 13, below). He is most widely known through his study *Die Kultur der Renaissance in Italien*, published in 1860 and translated into English as *The Civilisation of the Renaissance in Italy* in 1929. The present text derives from a lecture series which he delivered between 1868 and 1872 under the title 'On the Study of History', published posthumously in 1915 as *Weltgeschichtliche Betrachtungen* (Reflections on world history). Whilst Burckhardt expressed scepticism concerning the possibility of achieving a comprehensive grasp of the meaning of human history, he saw the present as confronted with the ongoing task of uncovering and interpreting the achievements of past human civilization. The following extracts, written in note form, and hence highly compressed, none the less contain some of his most fascinating insights into the domain of human culture. After distinguishing the state, religion and art as three separate and heterogeneous 'powers', he suggests that the domain of culture has gradually transformed itself into a 'self-reflecting facility'. The nineteenth century has become a 'world culture', able to comprehend the achievements of all previous epochs, but as a consequence, art and poetry no longer possess a secure place of their own. The following extracts have been translated for the present volume by Nicholas Walker from *Über das Studium der Geschichte: Der Text der 'Weltgeschichtlichen Betrachtungen' auf Grund der Vorarbeiten von Ernst Ziegle nach den Handschriften*, Peter Ganz (ed.), Munich: C. H. Beck, 1982, pp. 254, 276–82, 284.

Concerning the Three Powers

There is something arbitrary in the way in which we separate state, religion and art from one another merely in order to permit ourselves a picture of the same. Of course it is none the less true that every specialist consideration of history must proceed to separate the relevant domains in this fashion.

It is rather as if one were to extract a certain number of figures from a general picture, while leaving all the rest standing. (And of course every area of specialist research always considers its *own* field as the most essential one.)

The three powers in question are utterly heterogeneous amongst themselves and cannot be coordinated with one another; – and even if one were to treat the two stable factors, namely state and religion, as part of a single series, the factor of culture would substantially remain something else again.

State and religion both claim, at least for the affected people in question, and indeed for the world, a *universal validity*.

Culture here [signifies]: the sum total of everything which serves to promote material life, and everything which has arisen *spontaneously* as an expression of spiritual, dispositional and ethical life, all forms of sociality, of technology and skill, all forms of art, literature and science. [It represents] the world of free and dynamic elements which are not (necessarily) absolutely universal ones; of that which claims no ineluctable validity for itself.

* * *

Culture

Culture, that is, the total sum of all those spiritual developments which occur spontaneously and which claim no absolutely universal validity for themselves.

Culture works ceaselessly to modify and to break down both stable forms of social life; – except where the latter have taken culture entirely into their own service and set limits to it in accordance with their own purposes – otherwise culture represents a critique of both, the clock which strikes and betrays the hour when form and substance in the latter no longer correspond with one another – Furthermore:

Culture is that multiform process through which the naively immediate and ethnic [activity] is transformed into a self-reflecting facility, indeed, in its ultimate and highest stage, into scientific knowledge and especially into philosophy: into nothing but reflection.

The total external form of culture [however], over against state and [religion], is society itself in the broadest sense.

Every one of its elements sustains, just like state and religion, its development, its flourishing, [which is to say, its total realization], its dissolution, and its survival within the general tradition as such (in so far as such elements are capable and worthy of this): – Countless things also continue to survive in unconscious form, as an acquired possession which may well have passed over from some now forgotten people into the very life-blood of humanity.

Such growth and such dissolution obeys higher and inscrutable laws of life.

* * *

The sciences are in part the spiritual aspect of what is practically indispensable and the systematic aspect of everything that is knowledge-worthy in all its infinite variety, that is to say, the great gatherers and [organizers] of everything which is actually present in reality *even without their assistance*, – in part the sciences press forward and discover this presence, whether as an individual phenomenon or as a general law, – and finally philosophy seeks to ground the ultimate laws which underlie all beings, but also as something which subsists independently and prior to philosophy itself, namely eternally.

The arts are quite different again: they are *not* essentially concerned with that which also already exists independently of themselves, nor are they concerned with revealing any laws (they do not represent a kind of scientific knowledge), but only with presenting a higher form of life which would not exist without them.

The arts rest upon mysterious forms of resonance into which the soul finds itself transported. What is liberated through such resonances is then no longer something merely individual and temporal in character, but rather something imaginatively significant that is now imperishable.

From the world, from time and from nature art and poetry gather their universal valid and intelligible images as the only truly enduring earthly thing, as a second ideal creation which transcends the particular temporality of individual things, at once an earthly and immortal language available for all nations. A mighty representative of the age in question, just like philosophy. Externally regarded, the works of art and poetry are also subject to the same fate as all earthly things and everything that has been handed down over time, but enough of them still lives on to liberate, to inspire and to unite the most distant of coming millennia. [...]

Within the realm of culture the individual domains *suppress*, *replace* and *condition* one another; there is here a ceaseless fluctuation from one side to another.

Individual *peoples* and individual *epochs* reveal certain preeminent gifts and a certain preference for individual domains.

Powerful *individuals* emerge and show the way which entire ages and peoples then begin to pursue with total commitment.

On the other hand, it can often prove extremely difficult for us to decide how far a certain cultural element, which has now come to colour a whole epoch in our eyes, really did prevail over life at that time.

The influence of individual cultural elements and cultural stages of various different regions *upon one another* is principally promoted in the first instance through *trade and commerce*, which serves to disseminate the products of the more highly developed individuals with a special aptitude in certain fields amongst everyone else. Of course, it is not always the case that spiritual emulation follows as a result; the Etruscans and those who dwelt around the Hellespont rather preferred to buy [or order] beautiful Greek things for themselves.

Yet cultural history still continues to provide more than abundant evidence of elective and fateful *contacts*

between one people and another
between one field and another
between one spirit and another.

And then finally we shall make acquaintance with those great spiritual *centres of exchange* like Athens, Florence and so forth, where a powerful local presumption is formed that one must be able to achieve all things there, and that there the best society and the greatest, indeed the only possible stimulus [and appreciation is to be found].

Such places therefore also produce out of their own citizen population a dispro-portionately large number of significant individuals and thereby exercise a further effect upon the wider world.

This is not the same as our great modern urban centres [or even our smaller towns!] with all their 'opportunities for cultivation and education', for the latter merely produce ambitious mediocrities and a universal tendency to criticism; it is rather a question of rousing the highest of human forces and capacities through exceptional exemplarity. It is not a question of 'producing talents' but of genius appealing to genius.

A principal condition of all truly highly developed culture, even disregarding such centres of exchange of the first order, is *sociality* itself.

(As an opposite case: the cast system with its one-sided, albeit relatively high partial level of culture, which may have its proper place in the technical domain, in the perpetuation and perfecting of external skills, but in the spiritual domain merely generates stagnation, limitation and stultification in relation to the outer world (the principal example of this: the Egyptians)).

Sociality, on the other hand, brings *all* the elements of culture, from the very highest spiritual achievements to the slightest of technical [facilities], more or less into reciprocal contact, and this then forms a mightily involved and manifold concatena-tion of phenomena which is affected more or less at every individual point by a single electrical impulse. A *single* significant innovation in the realm of soul and spirit can also bring it about that otherwise apparently quite unconcerned individuals now grasp the sense of their accustomed and everyday activities in a different light.

Finally, what we call the *higher* sociality also constitutes an indispensable forum for the arts in particular. The arts should not simply depend upon the former in any essential sense, especially not upon its spurious symptoms, on the idle gossip of contemporary salons etc., but they should derive from such sociality *that* appropriate measure of what is intelligible without which they are in danger either of flying off into the blue or of falling victim to a select circle of admirers.

* * *

The culture of the nineteenth century as a world culture, one capable of possessing and appreciating the traditions of all times, peoples and cultures; literature is a world literature.

The greatest gain of all lies on the side of those who contemplate this; a magnan-imous, comprehensive and silent communion: something which brings an objective interest in everything and attempts to transform the whole of the past and present world into a spiritual possession.

State and church now no longer tend to inhibit this aspiration and are themselves gradually turning toward a varied wealth of perspectives. Partly it is the power to suppress this, but also partly the intent to do so, which is lacking; one is more prepared to entrust one's survival to living with an (apparently) limitlessly developed culture than in trying to repress it. . . .

Things are far more doubtful as far as any gain on the part of those directly involved in acquiring culture is concerned, for these represent the essentially for-ward-striving element who are driving with elementary intensity towards (1) a further accelerating development of trade and commerce, and towards (2) the eventual and total elimination of all existing barriers, i.e. towards a universal state. And the penalty:

an enormous degree of competition from the highest to the lowest and a ceaseless unrest. The cultured human being who wishes to acquire all this would dearly love to learn to understand and enjoy so many things as rapidly as possible, but is still painfully forced to relinquish the best part of this to others; it is others who must be cultured individuals for his sake, just as other people prayed and sang for the mighty Lord during the Middle Ages.

It is of course true that cultivated Americans constitute a great quantity, but they have largely repudiated the historical dimension, that is, the realm of spiritual continuity, and would simply like to enjoy art and poetry as nothing more than forms of luxury.

It is art and poetry as such which find themselves in the most lamentable state in our time, inwardly deprived as they are of a permanent place in this restless world, [in this hideous environment], while every form of artless production finds itself gravely threatened. That production [that is to say, genuine production, for the spurious sort only too easily survives] still continues to live can only be explained by recourse to the mightiest of impulses.

2 Friedrich Nietzsche (1844–1900) from *The Birth of Tragedy*

Nietzsche's early brilliance as a classical scholar was rewarded by his appointment to the Chair of Classical Philology in Basle at the extraordinarily young age of 24. However, after just ten years he was forced to resign his university position due to ill health. In the remaining years before suffering an irretrievable mental and physical breakdown in 1889 he moved between various resorts in France, Italy and Switzerland, producing his best-known works in the space of several highly productive years. *The Birth of Tragedy* was his first book and though highly unconventional it helped to bring about a re-evaluation of the way in which Greek culture was understood. Nietzsche's celebrated opposition between the Apollinian and the Dionysian has often been misunderstood as a straightforward attack on classicism. Far from seeking to advocate an anti-classical aesthetic grounded in Dionysian 'intoxication', however, Nietzsche's real concern is to demonstrate the internal connection and reciprocal necessity which holds between the two principles. This concern is made apparent in his discussion of the relation between the two halves of Raphael's *Transfiguration. The Birth of Tragedy* is dedicated to Richard Wagner, through whom Nietzsche developed his early enthusiasm for the work of Schopenhauer (see IA1, above). Nietzsche's account of an underlying 'primal unity', characterized by 'eternal suffering and contradiction', is still profoundly indebted to Schopenhauer's metaphysics of the will. The work was originally published as *Die Geburt der Tragödie, oder Griechentum und Pessimismus*, Leipzig: E. W. Fritzsch, 1872. These extracts are taken from sections 1, 2 and 4 in the translation by Walter Kaufmann, New York: Vintage, 1967, pp. 33–8, 44–7.

We shall have gained much for the science of aesthetics, once we perceive not merely by logical inference, but with the immediate certainty of vision, that the continuous development of art is bound up with the *Apollinian* and *Dionysian* duality – just as procreation depends on the duality of the sexes, involving perpetual strife with only periodically intervening reconciliations. The terms Dionysian and Apollinian we borrow from the Greeks, who disclose to the discerning mind the profound mysteries

of their view of art, not, to be sure, in concepts, but in the intensely clear figures of their gods. Through Apollo and Dionysus, the two art deities of the Greeks, we come to recognize that in the Greek world there existed a tremendous opposition, in origin and aims, between the Apollinian art of sculpture, and the nonimagistic, Dionysian art of music. These two different tendencies run parallel to each other, for the most part openly at variance; and they continually incite each other to new and more powerful births, which perpetuate an antagonism, only superficially reconciled by the common term 'art'; till eventually, by a metaphysical miracle of the Hellenic 'will,' they appear coupled with each other, and through this coupling ultimately generate an equally Dionysian and Apollinian form of art – Attic tragedy.

In order to grasp these two tendencies, let us first conceive of them as the separate art worlds of *dreams* and *intoxication*. These physiological phenomena present a contrast analogous to that existing between the Apollinian and the Dionysian. [. . .]

The beautiful illusion of the dream worlds, in the creation of which every man is truly an artist, is the prerequisite of all plastic art, and, as we shall see, of an important part of poetry also. In our dreams we delight in the immediate understanding of figures; all forms speak to us; there is nothing unimportant or superfluous. But even when this dream reality is most intense, we still have, glimmering through it, the sensation that it is *mere appearance:* at least this is my experience, and for its frequency – indeed, normality – I could adduce many proofs, including the sayings of the poets.

Philosophical men even have a presentiment that the reality in which we live and have our being is also mere appearance, and that another, quite different reality lies beneath it. Schopenhauer actually indicates as the criterion of philosophical ability the occasional ability to view men and things as mere phantoms or dream images. Thus the aesthetically sensitive man stands in the same relation to the reality of dreams as the philosopher does to the reality of existence; he is a close and willing observer, for these images afford him an interpretation of life, and by reflecting on these processes he trains himself for life.

It is not only the agreeable and friendly images that he experiences as something universally intelligible: the serious, the troubled, the sad, the gloomy, the sudden restraints, the tricks of accident, anxious expectations, in short, the whole divine comedy of life, including the inferno, also pass before him, not like mere shadows on a wall – for he lives and suffers with these scenes – and yet not without that fleeting sensation of illusion. And perhaps many will, like myself, recall how amid the dangers and terrors of dreams they have occasionally said to themselves in self-encourage-ment, and not without success: 'It is a dream! I will dream on!' [. . .]

This joyous necessity of the dream experience has been embodied by the Greeks in their Apollo: Apollo, the god of all plastic energies, is at the same time the soothsaying god. He, who (as the etymology of the name indicates) is the 'shining one,'[1] the deity of light, is also ruler over the beautiful illusion of the inner world of fantasy. The higher truth, the perfection of these states in contrast to the incompletely intelligible everyday world, this deep consciousness of nature, healing and helping in sleep and dreams, is at the same time the symbolical analogue of the soothsaying faculty and of the arts generally, which make life possible and worth living. But we must also include in our image of Apollo that delicate boundary which the dream image must not overstep lest it have a pathological effect (in which case mere appearance would

deceive us as if it were crude reality). We must keep in mind that measured restraint, that freedom from the wilder emotions, that calm of the sculptor god. His eye must be 'sunlike,' as befits his origin; even when it is angry and distempered it is still hallowed by beautiful illusion. And so, in one sense, we might apply to Apollo the words of Schopenhauer when he speaks of the man wrapped in the veil of *maya*.[2] 'Just as in a stormy sea that, unbounded in all directions, raises and drops mountainous waves, howling, a sailor sits in a boat and trusts in his frail bark: so in the midst of a world of torments the individual human being sits quietly, supported by and trusting in the *principium individuationis*' [principle of individuation]. In fact, we might say of Apollo that in him the unshaken faith in this *principium* and the calm repose of the man wrapped up in it receive their most sublime expression; and we might call Apollo himself the glorious divine image of the *principium individuationis*, through whose gestures and eyes all the joy and wisdom of 'illusion,' together with its beauty, speak to us.

In the same work Schopenhauer has depicted for us the tremendous *terror* which seizes man when he is suddenly dumbfounded by the cognitive form of phenomena because the principle of sufficient reason, in some one of its manifestations, seems to suffer an exception. If we add to this terror the blissful ecstasy that wells from the innermost depths of man, indeed of nature, at this collapse of the *principium individuationis*, we steal a glimpse into the nature of the *Dionysian*, which is brought home to us most intimately by the analogy of intoxication.

Either under the influence of the narcotic draught, of which the songs of all primitive men and peoples speak, or with the potent coming of spring that penetrates all nature with joy, these Dionysian emotions awake, and as they grow in intensity everything subjective vanishes into complete self-forgetfulness. In the German Middle Ages, too, singing and dancing crowds, ever increasing in number, whirled themselves from place to place under this same Dionysian impulse. In these dancers of St John and St Vitus, we rediscover the Bacchic choruses of the Greeks, with their prehistory in Asia Minor, as far back as Babylon and the orgiastic Sacaea. There are some who, from obtuseness or lack of experience, turn away from such phenomena as from 'folk-diseases,' with contempt or pity born of the consciousness of their own 'healthy-mindedness.' But of course such poor wretches have no idea how corpselike and ghostly their so-called 'healthy-mindedness' looks when the glowing life of the Dionysian revellers roars past them.

Under the charm of the Dionysian not only is the union between man and man reaffirmed, but nature which has become alienated, hostile, or subjugated, celebrates once more her reconciliation with her lost son, man. Freely, earth proffers her gifts, and peacefully the beasts of prey of the rocks and desert approach. The chariot of Dionysus is covered with flowers and garlands; panthers and tigers walk under its yoke. Transform Beethoven's 'Hymn to Joy' into a painting; let your imagination conceive the multitudes bowing to the dust, awestruck – then you will approach the Dionysian. Now the slave is a free man; now all the rigid, hostile barriers that necessity, caprice, or 'impudent convention'[3] have fixed between man and man are broken. Now, with the gospel of universal harmony, each one feels himself not only united, reconciled, and fused with his neighbour, but as one with him, as if the veil of *maya* had been torn aside and were now merely fluttering in tatters before the mysterious primordial unity.

In song and in dance man expresses himself as a member of a higher community; he has forgotten how to walk and speak and is on the way towards flying into the air, dancing. His very gestures express enchantment. Just as the animals now talk, and the earth yields milk and honey, supernatural sounds emanate from him, too: he feels himself a god, he himself now walks about enchanted, in ecstasy, like the gods he saw walking in his dreams. He is no longer an artist, he has become a work of art: in these paroxysms of intoxication the artistic power of all nature reveals itself to the highest gratification of the primordial unity. The noblest clay, the most costly marble, man, is here kneaded and cut, and to the sound of the chisel strokes of the Dionysian world-artist rings out the cry of the Eleusinian mysteries: 'Do you prostrate yourselves, millions? Do you sense your Maker, world?'

Thus far we have considered the Apollinian and its opposite, the Dionysian, as artistic energies which burst forth from nature herself, *without the mediation of the human artist* – energies in which nature's art impulses are satisfied in the most immediate and direct way – first in the image world of dreams, whose completeness is not dependent upon the intellectual attitude or the artistic culture of any single being; and then as intoxicated reality, which likewise does not heed the single unit, but even seeks to destroy the individual and redeem him by a mystic feeling of oneness. With reference to these immediate art-states of nature, every artist is an 'imitator,' that is to say, either an Apollinian artist in dreams, or a Dionysian artist in ecstasies, or finally – as for example in Greek tragedy – at once artist in both dreams and ecstasies; so we may perhaps picture him sinking down in his Dionysian intoxication and mystical self-abnegation, alone and apart from the singing revellers, and we may imagine how, through Apollinian dream-inspiration, his own state, i.e., his oneness with the inmost ground of the world, is revealed to him in a *symbolical dream image*.

* * *

Now the dream analogy may throw some light on the naive artist. Let us imagine the dreamer: in the midst of the illusion of the dream world and without disturbing it, he calls out to himself: 'It is a dream, I will dream on.' What must we infer? That he experiences a deep inner joy in dream contemplation; on the other hand, to be at all able to dream with this inner joy in contemplation, he must have completely lost sight of the waking reality and its ominous obtrusiveness. Guided by the dream-reading Apollo, we may interpret all these phenomena in roughly this way.

Though it is certain that of the two halves of our existence, the waking and the dreaming states, the former appeals to us as infinitely preferable, more important, excellent, and worthy of being lived, indeed, as that which alone is lived – yet in relation to that mysterious ground of our being of which we are the phenomena, I should, paradoxical as it may seem, maintain the very opposite estimate of the value of dreams. For the more clearly I perceive in nature those omnipotent art impulses, and in them an ardent longing for illusion, for redemption through illusion, the more I feel myself impelled to the metaphysical assumption that the truly existent primal unity, eternally suffering and contradictory, also needs the rapturous vision, the pleasurable illusion, for its continuous redemption. And we, completely wrapped up in this illusion and composed of it, are compelled to consider this illusion as the truly

nonexistent – i.e., as a perpetual becoming in time, space, and causality – in other words, as empirical reality. If, for the moment, we do not consider the question of our own 'reality,' if we conceive of our empirical existence, and of that of the world in general, as a continuously manifested representation of the primal unity, we shall then have to look upon the dream as a *mere appearance of mere appearance*, hence as a still higher appeasement of the primordial desire for mere appearance. And that is why the innermost heart of nature feels that ineffable joy in the naive artist and the naive work of art, which is likewise only 'mere appearance of mere appearance.'

In a symbolic painting, *Raphael*, himself one of these immortal 'naive' ones, has represented for us this demotion of appearance to the level of mere appearance, the primitive process of the naive artist and of Apollinian culture. In his *Transfiguration*, the lower half of the picture, with the possessed boy, the despairing bearers, the bewildered, terrified disciples, shows us the reflection of suffering, primal and eternal, the sole ground of the world: the 'mere appearance' here is the reflection of eternal contradiction, the father of things. From this mere appearance arises, like ambrosial vapour, a new visionary world of mere appearances, invisible to those wrapped in the first appearance – a radiant floating in purest bliss, a serene contemplation beaming from wide-open eyes. Here we have presented, in the most sublime artistic symbolism, that Apollinian world of beauty and its substratum, the terrible wisdom of Silenus; and intuitively we comprehend their necessary interdependence. Apollo, however, again appears to us as the apotheosis of the *principium individuationis*, in which alone is consummated the perpetually attained goal of the primal unity, its redemption through mere appearance. With his sublime gestures, he shows us how necessary is the entire world of suffering, that by means of it the individual may be impelled to realize the redeeming vision, and then, sunk in contemplation of it, sit quietly in his tossing bark, amid the waves.

If we conceive of it at all as imperative and mandatory, this apotheosis of individuation knows but one law – the individual, i.e., the delimiting of the boundaries of the individual, *measure* in the Hellenic sense. Apollo, as ethical deity, exacts measure of his disciples, and, to be able to maintain it, he requires self-knowledge. And so, side by side with the aesthetic necessity for beauty, there occur the demands 'know thyself' and 'nothing in excess'; consequently overweening pride and excess are regarded as the truly hostile demons of the non-Apollinian sphere, hence as characteristics of the pre-Apollinian age – that of the Titans; and of the extra-Apollinian world – that of the barbarians. Because of his titanic love for man, Prometheus must be torn to pieces by vultures; because of his excessive wisdom, which could solve the riddle of the Sphinx, Oedipus must be plunged into a bewildering vortex of crime. Thus did the Delphic god interpret the Greek past.

The effects wrought by the *Dionysian* also seemed 'titanic' and 'barbaric' to the Apollinian Greek; while at the same time he could not conceal from himself that he, too, was inwardly related to these overthrown Titans and heroes. Indeed, he had to recognize even more than this: despite all its beauty and moderation, his entire existence rested on a hidden substratum of suffering and of knowledge, revealed to him by the Dionysian. And behold: Apollo could not live without Dionysus! The 'titanic' and the 'barbaric' were in the last analysis as necessary as the Apollinian.

And now let us imagine how into this world, built on mere appearance and moderation and artificially dammed up, there penetrated, in tones ever more bewitching and alluring, the ecstatic sound of the Dionysian festival; how in these strains all of nature's *excess* in pleasure, grief, and knowledge became audible, even in piercing shrieks; and let us ask ourselves what the psalmodizing artist of Apollo, with his phantom harp-sound, could mean in the face of this demonic folk-song! The muses of the arts of 'illusion' paled before an art that, in its intoxication, spoke the truth. The wisdom of Silenus cried 'Woe! woe!' to the serene Olympians. The individual, with all his restraint and proportion, succumbed to the self-oblivion of the Dionysian states, forgetting the precepts of Apollo. *Excess* revealed itself as truth. Contradiction, the bliss born of pain, spoke out from the very heart of nature. And so, wherever the Dionysian prevailed, the Apollinian was checked and destroyed. But, on the other hand, it is equally certain that, wherever the first Dionysian onslaught was successfully withstood, the authority and majesty of the Delphic god exhibited itself as more rigid and menacing than ever. For to me the *Doric* state[4] and Doric art are explicable only as a permanent military encampment of the Apollinian. Only incessant resistance to the titanic–barbaric nature of the Dionysian could account for the long survival of an art so defiantly prim and so encompassed with bulwarks, a training so warlike and rigorous, and a political structure so cruel and relentless.

Up to this point we have simply enlarged upon the observation made at the beginning of this essay: that the Dionysian and the Apollinian, in new births ever following and mutually augmenting one another, controlled the Hellenic genius; that out of the age of 'bronze,' with its wars of the Titans and its rigorous folk philosophy, the Homeric world developed under the sway of the Apollinian impulse to beauty; that this 'naive' splendour was again overwhelmed by the influx of the Dionysian; and that against this new power the Apollinian rose to the austere majesty of Doric art and the Doric view of the world. If amid the strife of these two hostile principles, the older Hellenic history thus falls into four great periods of art, we are now impelled to enquire after the final goal of these developments and processes, lest perchance we should regard the last-attained period, the period of Doric art, as the climax and aim of these artistic impulses. And here the sublime and celebrated art of *Attic tragedy* and the dramatic dithyramb presents itself as the common goal of both these tendencies whose mysterious union, after many and long precursory struggles, found glorious consummation in this child – at once Antigone and Cassandra.

[1] *Der 'Scheinende.'* The German words for illusion and appearance are *Schein* and *Erscheinung*.
[2] A Sanskrit word usually translated as illusion.
[3] An allusion to Friedrich Schiller's hymn *An die Freude* (to joy), used by Beethoven in the final movement of his Ninth Symphony.
[4] Sparta.

3 Helena Petrovna Blavatsky (1831–1891) from *Isis Unveiled*

Born in Ekaterinoslav in the Ukraine, Madame Blavatsky travelled widely in Europe and Asia in pursuit of her interest in spiritualism and the occult. In 1875 she and others founded the Theosophical Society in New York. In brief, Theosophy represented an amalgam of Ancient

and Oriental philosophies directed against the twin opponents of Christianity and Science. Although she was subsequently dismissed as a fraud by the London Society for Psychical Research, Blavatsky's cult attracted a large following. It was particularly influential in the art world where, by the end of the nineteenth century, the long dominance of Positivism and Naturalism had given way to the widespread embrace of mysticism. In a climate where technology was helping to undermine traditional social relations and their ethical under-pinnings, and where even science itself seemed to threaten the conventional view of reality, Blavatsky's 'Secret Doctrine' (1888) provided fertile ground for those seeking a new spiritual orientation. Many of the pioneers of early twentieth-century abstraction were influenced by the pervasive spiritualism, and some, most notably Kandinsky and Mondrian, became members of the Theosophical Society. Blavatsky's first major work was *Isis Unveiled*, subtitled *A Master-Key to the Mysteries of Ancient and Modern Science and Theology*. It was published in New York and London in 1877. The present extracts are taken from 'Before the Veil', an introductory overview placed at the start of the first volume, pp. ix–xlv. Blavatsky's footnotes have been omitted.

It is nineteen centuries since, as we are told, the night of Heathenism and Paganism was first dispelled by the divine light of Christianity; and two-and-a-half centuries since the bright lamp of Modern Science began to shine on the darkness of the ignorance of the ages. Within these respective epochs, we are required to believe, the true moral and intellectual progress of the race has occurred. The ancient philoso-phers were well enough for their respective generations, but they were illiterate as compared with modern men of science. The ethics of Paganism perhaps met the wants of the uncultivated people of antiquity, but not until the advent of the luminous 'Star of Bethlehem,' was the true road to moral perfection and the way to salvation made plain. Of old, brutishness was the rule, virtue and spirituality the exception. Now, the dullest may read the will of God in His revealed word; men have every incentive to be good, and are constantly becoming better.

This is the assumption; what are the facts? On the one hand an unspiritual, dogmatic, too often debauched clergy; a host of sects, and three warring great religions; discord instead of union, dogmas without proofs, sensation-loving preach-ers, and wealth and pleasure-seeking parishioners' hypocrisy and bigotry, begotten by the tyrannical exigencies of respectability, the rule of the day, sincerity and real piety exceptional. On the other hand, scientific hypotheses built on sand; no accord upon a single question; rancorous quarrels and jealousy; a general drift into materialism. A death-grapple of Science with Theology for infallibility – 'a conflict of ages.' [. . .]

Between these two conflicting Titans – Science and Theology – is a bewildered public, fast losing all belief in man's personal immortality, in a deity of any kind, and rapidly descending to the level of a mere animal existence. Such is the picture of the hour, illumined by the bright noonday sun of this Christian and scientific era!

Would it be strict justice to condemn to critical lapidation the most humble and modest of authors for *entirely rejecting the authority of both these combatants?* Are we not bound rather to take as the true aphorism of this century, the declaration of Horace Greeley: 'I accept *unreservedly* the views of no man, living or dead'? Such, at all events, will be our motto, and we mean that principle to be our constant guide throughout this work.

Among the many phenomenal outgrowths of our century, the strange creed of the so-called Spiritualists has arisen amid the tottering ruins of self-styled revealed religions and materialistic philosophies; and yet it alone offers a possible last refuge of compromise between the two. That this unexpected ghost of pre-Christian days finds poor welcome from our sober and positive century, is not surprising. [. . .]

But what of that? When was ever truth accepted *a priori?* Because the champions of Spiritualism have in their fanaticism magnified its qualities, and remained blind to its imperfections, that gives no excuse to doubt its reality. A forgery is impossible when we have no model to forge after. The fanaticism of Spiritualists is itself a proof of the genuineness and possibility of their phenomena. They give us facts that we may investigate, not assertions that we must believe without proof. Millions of reasonable men and women do not so easily succumb to collective hallucination. And so, while the clergy, following their own interpretations of the *Bible*, and science its self-made *Codex* of possibilities in nature, refuse it a fair hearing, *real* science and *true* religion are silent, and gravely wait further developments.

The whole question of phenomena rests on the correct comprehension of old philosophies. Whither, then, should we turn, in our perplexity, but to the ancient sages, since, on the pretext of superstition, we are refused an explanation by the modern? Let us ask them what they know of genuine science and religion; not in the matter of mere details, but in all the broad conception of these twin truths – so strong in their unity, so weak when divided. Besides, we may find our profit in comparing this boasted modern science with ancient ignorance; this improved modern theology with the 'Secret doctrines' of the ancient universal religion. Perhaps we may thus discover a neutral ground whence we can reach and profit by both.

It is the Platonic philosophy, the most elaborate compend of the abstruse systems of old India, that can alone afford us this middle ground. Although twenty-two and a quarter centuries have elapsed since the death of Plato, the great minds of the world are still occupied with his writings. He was, in the fullest sense of the word, the world's interpreter. And the greatest philosopher of the pre-Christian era mirrored faithfully in his works the spiritualism of the Vedic philosophers who lived thousands of years before himself, and its metaphysical expression. Vyasa, Djeminy, Kapila, Vrihaspati, Sumati, and so many others, will be found to have transmitted their indelible imprint through the intervening centuries upon Plato and his school. Thus is warranted the inference that to Plato and the ancient Hindu sages was alike revealed the same wisdom. So surviving the shock of time, what can this wisdom be but divine and eternal?

[. . .] For the old Grecian sage there was a single object of attainment: REAL KNOWLEDGE. He considered those only to be genuine philosophers, or students of truth, who possess the knowledge of the really-existing, in opposition to the mere seeing; of the *always-existing*, in opposition to the transitory; and of that which exists *permanently*, in opposition to that which waxes, wanes, and is developed and destroyed alternately. [. . .]

Basing all his doctrines upon the presence of the Supreme Mind, Plato taught that the *nous*, spirit, or rational soul of man, being 'generated by the Divine Father,' possessed a nature kindred, or even homogeneous, with the Divinity, and was capable of beholding the eternal realities. This faculty of contemplating reality in a direct and

immediate manner belongs to God alone; the aspiration for this knowledge constitutes what is really meant by *philosophy* – the love of wisdom. The love of truth is inherently the love of good; and so predominating over every desire of the soul, purifying it and assimilating it to the divine, thus governing every act of the individual, it raises man to a participation and communion with Divinity, and restores him to the likeness of God. 'This flight,' says Plato in the *Theaetetus*, 'consists in becoming like God, and this assimilation is the becoming just and holy with wisdom.'

The basis of this assimilation is always asserted to be the pre-existence of the spirit or *nous*. In the allegory of the chariot and winged steeds, given in the *Phaedrus*, he represents the psychical nature as composite and two-fold; the *thumos*, or *epithumetic* part, formed from the substances of the world of phenomena; and the θυμοειδές, *thumoeides*, the essence of which is linked to the eternal world. The present earth-life is a fall and punishment. The soul dwells in 'the grave which we call *the body*,' and in its incorporate state, and previous to the discipline of education, the noetic or spiritual element is 'asleep.' Life is thus a dream, rather than a reality. Like the captives in the subterranean cave, described in *The Republic*, the back is turned to the light, we perceive only the shadows of objects, and think them the actual realities. Is not this the idea of *Maya*, or the illusion of the senses in physical life, which is so marked a feature in Buddhistical philosophy? But these shadows, if we have not given ourselves up absolutely to the sensuous nature, arouse in us the reminiscence of that higher world that we once inhabited.

* * *

It is recognized by modern science that all the higher laws of nature assume the form of quantitative statement. This is perhaps a fuller elaboration or more explicit affirmation of the Pythagorean doctrine. Numbers were regarded as the best representations of the laws of harmony which pervade the cosmos. We know too that in chemistry the doctrine of atoms and the laws of combination are actually and, as it were, arbitrarily defined by numbers. As Mr W. Archer Butler has expressed it: 'The world is, then, through all its departments, a living arithmetic in its development, a realized geometry in its repose.'

The key to the Pythagorean dogmas is the general formula of unity in multiplicity, the one evolving the many and pervading the many. This is the ancient doctrine of emanation in few words. Even the apostle Paul accepted it as true. 'ἐξ αὐτοῦ, καὶ δἰ αὐτοῦ, καὶ εἰς αὐτὸν τα πανια' – Out of him and through him and in him all things are. This, as we can see by the following quotation, is purely Hindu and Brahmanical:

'When the dissolution – Pralaya – had arrived at its term, the great Being – Para-Atma or Para-Purusha – the Lord existing through himself, out of whom and through whom all things were, and are and will be . . . resolved to emanate from his own substance the various creatures' (*Manava-Dharma-Sastra*, book i., slokas 6 and 7).

The mystic Decad $1 + 2 + 3 + 4 = 10$ is a way of expressing this idea. The One is God, the Two, matter; the Three, combining Monad and Duad, and partaking of the nature of both, is the phenomenal world; the Tetrad, or form of perfection, expresses the emptiness of all; and the Decad, or sum of all, involves the entire cosmos. The universe is the combination of a thousand elements, and yet the expression of a single spirit – a chaos to the sense, a cosmos to the reason.

The whole of this combination of the progression of numbers in the idea of creation is Hindu. The Being existing through himself, Swayambhu or Swayambhuva, as he is called by some, is one. He emanates from himself the *creative faculty*, Brahma or Purusha (the divine male), and the one becomes *Two*; out of this Duad, union of the purely intellectual principle with the principle of matter, evolves a third, which is Viradj, the phenomenal world. It is out of this invisible and incomprehensible trinity, the Brahmanic Trimurty, that evolves the second triad which represents the three faculties – the creative, the conservative, and the transforming. These are typified by Brahma, Vishnu, and Siva, but are again and ever blended into one. *Unity*, Brahma, or as the *Vedas* called him, Tridandi, is the god triply manifested, which gave rise to the symbolical *Aum* or the abbreviated Trimurty. It is but under this trinity, ever active and tangible to all our senses, that the invisible and unknown Monas can manifest itself to the world of mortals. When he becomes *Sarira*, or he who puts on a visible form, he typifies all the principles of matter, all the germs of life, he is Purusha, the god of the three visages, or triple power, the essence of the Vedic triad. [. . .]

He who has studied Pythagoras and his speculations on the Monad, which, after having emanated the Duad retires into silence and darkness, and thus creates the Triad, can realize whence came the philosophy of the great Samian Sage, and after him that of Socrates and Plato. [. . .]

A man's idea of God, is that image of blinding light that he sees reflected in the concave mirror of his own soul, and yet this is not, in very truth, God, but only His reflection. His glory is there, but, it is the light of his own Spirit that the man sees, and it is all he can bear to look upon. *The clearer the mirror, the brighter will be the divine image*. But the external world cannot be witnessed in it at the same moment. In the ecstatic Yogin, in the illuminated Seer, the spirit will shine like the noonday sun; in the debased victim of earthly attraction, the radiance has disappeared, for the mirror is obscured with the stains of matter. Such men deny their God, and would willingly deprive humanity of soul at one blow.

NO GOD, NO SOUL? Dreadful, annihilating thought! The maddening nightmare of a lunatic – Atheist; presenting before his fevered vision, a hideous, ceaseless procession of sparks of cosmic matter created by *no one*; self-appearing, self-existent, and self developing; this Self *no* Self, for it is *nothing* and *nobody*; floating onward from *nowhence*, it is propelled by no Cause, for there is none, and it rushes *nowhither*. And this in a circle of Eternity blind, inert, and – CAUSELESS.

* * *

The idea that 'numbers' possessing the greatest virtue, produce always what is good and never what is evil, refers to justice, equanimity of temper, and everything that is harmonious. When the author speaks of every star as an individual soul, he only means what the Hindu initiates and the Hermetists taught before and after him, viz.: that every star is an independent planet, which, like our earth, has a soul of its own, every atom of matter being impregnated with the divine influx of the soul of the world. It breathes and lives; it feels and suffers as well as enjoys life in its way. What naturalist is prepared to dispute it on good evidence? Therefore, we must consider the celestial bodies as the images of gods; as partaking of the divine powers in their substance; and though they are not immortal in their

soul-entity, their agency in the economy of the universe is entitled to divine honours, such as we pay to minor gods. The idea is plain, and one must be malevolent indeed to misrepresent it. [. . .]

It is these doctrines, which, studied analogically, and on the principle of correspondence, led the ancient, and may now lead the modern Philaletheian step by step towards the solution of the greatest mysteries. On the brink of the dark chasm separating the spiritual from the physical world stands modern science, with eyes closed and head averted, pronouncing the gulf impassable and bottomless, though she holds in her hand a torch which she need only lower into the depths to show her her mistake. But across this chasm, the patient student of Hermetic philosophy has constructed a bridge.

* * *

Deeply sensible of the Titanic struggle that is now in progress between materialism and the spiritual aspirations of mankind, our constant endeavour has been to gather into our several chapters, like weapons into armouries, every fact and argument that can be used to aid the latter in defeating the former. Sickly and deformed child as it now is, the materialism of To-Day is born of the brutal Yesterday. Unless its growth is arrested, it may become our master. It is the bastard progeny of the French Revolution and its reaction against ages of religious bigotry and repression. To prevent the crushing of these spiritual aspirations, the blighting of these hopes, and the deadening of that intuition which teaches us of a God and a hereafter, we must show our false theologies in their naked deformity, and distinguish between divine religion and human dogmas. Our voice is raised for spiritual freedom, and our plea made for enfranchisement from all tyranny, whether of SCIENCE or THEOLOGY.

4 William Morris (1834–1896) 'The Lesser Arts'

Morris combined the roles of craftsman, designer, printer, painter and poet with those of cultural critic and social reformer. At the heart of his analysis of social conditions lay his sense of himself as a craftsman, and his commitment to the principle that making was a worthy activity and that it should be pleasurable and rewarding – which principle he attempted to put into practice in the firm of Morris & Co. He shared Pugin's concern at what he saw as a general decline in standards of design (see IIA4), though he traced the causes more explicitly into the economic organization of modern society. He was thus on common ground with Proudhon (IIIB13) and with the young Marx (IIA9), in particular in his conviction that work in the arts was the ideal form of all human labour. He had also responded to Ruskin's concern at the separation of the 'great arts' of painting, sculpture and architecture from the 'lesser arts' of craft and design, and at the wedge thus driven between the intellectual and spiritual aspects of the arts and the manual and material forms of their production (see IIIc6). His particular conclusion was that the resulting division was related to the class divisions of modern society and to the economic tendencies of 'modern commerce'. It was this conclusion that made Morris a socialist. This paper was originally delivered in the form of an address to the Trades Guild of Learning in London, 4 December 1877, with the title 'The Decorative Arts: Their Relation to Modern Life and Progress', and was first published under that title as a pamphlet, London: Ellis and White, 1878. It was subsequently incorporated as 'The Lesser Arts' in William Morris, *Hopes and Fears for Art: Five Lectures Delivered in Birmingham, London and Nottingham, 1878–1881*, London:

Ellis and White, 1882. This version is taken from pp. 3–8, 10–11, 14–20, 22–4, 26, 28, 29–36 of the latter publication.

[. . .] I have not undertaken to talk to you of Architecture, Sculpture, and Painting, in the narrower sense of those words, since, most unhappily as I think, these masterarts, these arts more specially of the intellect, are at the present day divorced from decoration in its narrower sense. Our subject is that great body of art, by means of which men have at all times more or less striven to beautify the familiar matters of everyday life: a wide subject, a great industry; both a great part of the history of the world, and a most helpful instrument to the study of that history.

A very great industry indeed, comprising the crafts of house-building, painting, joinery and carpentry, smiths' work, pottery and glass-making, weaving, and many others: a body of art most important to the public in general, but still more so to us handicraftsmen; since there is scarce anything that they use, and that we fashion, but it has always been thought to be unfinished till it has had some touch or other of decoration about it. True it is that in many or most cases we have got so used to this ornament, that we look upon it as if it had grown of itself, and note it no more than the mosses on the dry sticks with which we light our fires. So much the worse! for there *is* the decoration, or some pretence of it, and it has, or ought to have, a use and a meaning. For, and this is at the root of the whole matter, everything made by man's hands has a form, which must be either beautiful or ugly; beautiful if it is in accord with Nature, and helps her; ugly if it is discordant with Nature, and thwarts her; it cannot be indifferent: we, for our parts, are busy or sluggish, eager or unhappy, and our eyes are apt to get dulled to this eventfulness of form in those things which we are always looking at. Now it is one of the chief uses of decoration, the chief part of its alliance with nature, that it has to sharpen our dulled senses in this matter: for this end are those wonders of intricate patterns interwoven, those strange forms invented, which men have so long delighted in: forms and intricacies that do not necessarily imitate nature, but in which the hand of the craftsman is guided to work in the way that she does; till the web, the cup, or the knife, look as natural, nay as lovely, as the green field, the river bank, or the mountain flint.

To give people pleasure in the things they must perforce *use*, that is one great office of decoration; to give people pleasure in the things they must perforce *make*, that is the other use of it.

Does not our subject look important enough now? I say that without these arts, our rest would be vacant and uninteresting, our labour mere endurance, mere wearing away of body and mind.

As for that last use of these arts, the giving us pleasure in our work, I scarcely know how to speak strongly enough of it. [. . .]

We all know what people have said about the curse of labour, and what heavy and grievous nonsense are the more part of their words thereupon; whereas indeed the real curses of craftsmen have been the curse of stupidity, and the curse of injustice from within and from without: no, I cannot suppose there is anybody here who would think it either a good life, or an amusing one, to sit with one's hands before one doing nothing – to live like a gentleman, as fools call it.

Nevertheless there *is* dull work to be done, and a weary business it is setting men about such work, and seeing them through it, and I would rather do the work twice over with my own hands than have such a job: but now only let the arts which we are talking of beautify our labour, and be widely spread, intelligent, well understood both by the maker and the user, let them grow in one word *popular*, and there will be pretty much an end of dull work and its wearing slavery; and no man will any longer have an excuse for talking about the curse of labour, no man will any longer have an excuse for evading the blessing of labour. I believe there is nothing that will aid the world's progress so much as the attainment of this; I protest there is nothing in the world that I desire so much as this, wrapped up, as I am sure it is, with changes political and social, that in one way or another we all desire.

Now if the objection be made, that these arts have been the handmaids of luxury, of tyranny, and of superstition, I must needs say that it is true in a sense; they have been so used, as many other excellent things have been. But it is also true that, among some nations, their most vigorous and freest times have been the very blossoming times of art: while at the same time, I must allow that these decorative arts have flourished among oppressed peoples, who have seemed to have no hope of freedom: yet I do not think that we shall be wrong in thinking that at such times, among such peoples, art, at least, was free; when it has not been, when it has really been gripped by superstition, or by luxury, it has straightway begun to sicken under that grip. [. . .]

Now as these arts call people's attention and interest to the matters of every-day life in the present, so also, and that I think is no little matter, they call our attention at every step to that history, of which . . . they are so great a part; for no nation, no state of society, however rude, has been wholly without them: nay, there are peoples not a few, of whom we know scarce anything, save that they thought such and such forms beautiful. So strong is the bond between history and decoration, that in the practice of the latter we cannot, if we would, wholly shake off the influence of past times over what we do at present. I do not think it is too much to say that no man, however original he may be, can sit down to-day and draw the ornament of a cloth, or the form of an ordinary vessel or piece of furniture, that will be other than a development or a degradation of forms used hundreds of years ago; and these, too, very often, forms that once had a serious meaning, though they are now become little more than a habit of the hand; forms that were once perhaps the mysterious symbols of worships and beliefs now little remembered or wholly forgotten.

* * *

Time was when the mystery and wonder of handicrafts were well acknowledged by the world, when imagination and fancy mingled with all things made by man; and in those days all handicraftsmen were *artists*, as we should now call them. But the thought of man became more intricate, more difficult to express; art grew a heavier thing to deal with, and its labour was more divided among great men, lesser men, and little men; till that art, which was once scarce more than a rest of body and soul, as the hand cast the shuttle or swung the hammer, became to some men so serious a labour, that their working lives have been one long tragedy of hope and fear, joy and trouble. This was the growth of art: like all growth, it was good and fruitful for a while; like all

fruitful growth, it grew into decay: like all decay of what was once fruitful, it will grow into something new.

Into decay; for as the arts sundered into the greater and the lesser, contempt on one side, carelessness on the other arose, both begotten of ignorance of that *philosophy* of the Decorative Arts, a hint of which I have tried to put before you. The artist came out from the handicraftsmen, and left them without hope of elevation, while he himself was left without the help of intelligent, industrious sympathy. Both have suffered; the artist no less than the workman. [. . .]

I must in plain words say of the Decorative Arts, of all the arts, that it is not so much that we are inferior in them to all who have gone before us, but rather that they are in a state of anarchy and disorganization, which makes a sweeping change necessary and certain.

* * *

To what side then shall those turn for help, who really understand the gain of a great art in the world, and the loss of peace and good life that must follow from the lack of it? I think that they must begin by acknowledging that the ancient art, the art of unconscious intelligence, as one should call it, which began without a date . . . is all but dead; that what little of it is left lingers among half-civilized nations, and is growing coarser, feebler, less intelligent year by year; nay, it is mostly at the mercy of some commercial accident, such as the arrival of a few shiploads of European dye-stuffs or a few dozen orders from European merchants: this they must recognize, and must hope to see in time its place filled by a new art of conscious intelligence, the birth of wiser, simpler, freer ways of life than the world leads now, than the world has ever led.

I said, *to see* this in time; I do not mean to say that our own eyes will look upon it: it may be so far off, as indeed it seems to some, that many would scarcely think it worth while thinking of: but there are some of us who cannot turn our faces to the wall, or sit deedless because our hope seems somewhat dim; and, indeed, I think that while the signs of the last decay of the old art with all the evils that must follow in its train are only too obvious about us, so on the other hand there are not wanting signs of the new dawn beyond that possible night of the arts, of which I have before spoken; this sign chiefly, that there are some few at least who are heartily discontented with things as they are, and crave for something better, or at least some promise of it – this best of signs: for I suppose that if some half-dozen men at any time earnestly set their hearts on something coming about which is not discordant with nature, it will come to pass one day or other; because it is not by accident that an idea comes into the heads of a few; rather they are pushed on, and forced to speak or act by something stirring in the heart of the world which would otherwise be left without expression.

By what means then shall those work who long for reform in the arts, and whom shall they seek to kindle into eager desire for possession of beauty, and better still, for the development of the faculty that creates beauty?

* * *

The only real help for the decorative arts must come from those who work in them; nor must they be led, they must lead.

You whose hands make those things that should be works of art, you must be all artists, and good artists too, before the public at large can take real interest in such

things; and when you have become so, I promise you that you shall lead the fashion; fashion shall follow your hands obediently enough.

That is the only way in which we can get a supply of intelligent popular art. [. . .] The handicraftsman, left behind by the artist when the arts sundered, must come up with him, must work side by side with him: apart from the difference between a great master and a scholar, apart from the differences of the natural bent of men's minds, which would make one man an imitative, and another an architectural or decorative artist, there should be no difference between those employed on strictly ornamental work; and the body of artists dealing with this should quicken with their art all makers of things into artists also, in proportion to the necessities and uses of the things they would make.

I know what stupendous difficulties social and economical, there are in the way of this; yet I think that they seem to be greater than they are: and of one thing I am sure, that no real living decorative art is possible if this is impossible.

* * *

For your teachers, they must be Nature and History: as for the first, that you must learn of it is so obvious that I need not dwell upon that now . . . As to the second, I do not think that any man but one of the highest genius, could do anything in these days without much study of ancient art, and even he would be much hindered if he lacked it . . . If we do not study the ancient work directly and learn to understand it, we shall find ourselves influenced by the feeble work all round us, and shall be copying the better work through the copyists and *without* understanding it, which will by no means bring about intelligent art. Let us therefore study it wisely, be taught by it, kindled by it; all the while determining not to imitate or repeat it; to have either no art at all, or an art which we have made our own.

* * *

Moreover you may sometimes have an opportunity of studying ancient art in a narrower but a more intimate, a more kindly form, the monuments of our own land . . . Out in the country we may still see the works of our fathers yet alive amidst the very nature they were wrought into, and of which they are so completely a part: for there indeed if anywhere, in the English country, in the days when people cared about such things, was there a full sympathy between the works of man, and the land they were made for: – the land is a little land; too much shut up within the narrow seas, as it seems, to have much space for swelling into hugeness: there are no great wastes overwhelming in their dreariness, no great solitudes of forests, no terrible untrodden mountain-walls: all is measured, mingled, varied, gliding easily one thing into another: little rivers, little plains, swelling, speedily-changing uplands, all beset with handsome orderly trees; little hills, little mountains, netted over with the walls of sheep-walks: all is little; yet not foolish and blank, but serious rather, and abundant of meaning for such as choose to seek it: it is neither prison, nor palace, but a decent home.

All which I neither praise nor blame, but say that so it is: some people praise this homeliness overmuch, as if the land were the very axle-tree of the world; so do not I, nor any unblinded by pride in themselves and all that belongs to them [. . .] as was the land, such was the art of it while folk yet troubled themselves about such things; it strove little to impress people either by pomp or ingenuity: not unseldom it fell into commonplace, rarely it rose into majesty; yet was it never oppressive, never a slave's

nightmare nor an insolent boast: and at its best it had an inventiveness, an individuality, that grander styles have never overpassed: its best too, and that was in its very heart, was given as freely to the yeoman's house, and the humble village church, as to the lord's palace or the mighty cathedral: never coarse, though often rude enough, sweet, natural and unaffected, an art of peasants rather than of merchant-princes or courtiers, it must be a hard heart, I think, that does not love it: whether a man has been born among it like ourselves, or has come wonderingly on its simplicity from all the grandeur over-seas. A peasant art, I say, and it clung fast to the life of the people, and still lived among the cottagers and yeomen in many parts of the country while the big houses were being built 'French and fine': still lived also in many a quaint pattern of loom and printing-block, and embroiderer's needle, while over-seas stupid pomp had extinguished all nature and freedom, and art was become, in France especially, the mere expression of that successful and exultant rascality, which in the flesh no long time afterwards went down into the pit for ever.

Such was the English art, whose history is in a sense at your doors, grown scarce indeed, and growing scarcer year by year, not only through greedy destruction, of which there is certainly less than there used to be, but also through the attacks of another foe, called now-a-days 'restoration'. [. . .]

You will see by all that I have said on this study of ancient art that I mean by education herein something much wider than the teaching of a definite art in schools of design, and that it must be something that we must do more or less for ourselves: I mean by it a systematic concentration of our thoughts on the matter, a studying of it in all ways, careful and laborious practice of it, and a determination to do nothing but what is known to be good in workmanship and design.

Of course, however, both as an instrument of that study we have been speaking of, as well as of the practice of the arts, all handicraftsmen should be taught to draw very carefully; as indeed all people should be taught drawing who are not physically incapable of learning it: but the art of drawing so taught would not be the art of designing, but only a means towards *this* end, *general capability in dealing with the arts*.

[. . .] If other circumstances, social and economical, do not stand in our way, that is to say, if the world is not too busy to allow us to have Decorative Arts at all, these two are the *direct* means by which we shall get them; that is, general cultivation of the powers of the mind, general cultivation of the powers of the eye and hand.

* * *

There is a great deal of sham work in the world, hurtful to the buyer, more hurtful to the seller, if he only knew it, most hurtful to the maker: how good a foundation it would be towards getting good Decorative Art, that is ornamental workmanship, if we craftsmen were to resolve to turn out nothing but excellent workmanship in all things, instead of having, as we too often have now, a very low average standard of work, which we often fall below.

I do not blame either one class or another in this matter, I blame all . . . I know that the public in general are set on having things cheap, being so ignorant that they do not know when they get them nasty also; so ignorant that they neither know nor care whether they give a man his due: I know that the manufacturers (so called) are so set on carrying out competition to its utmost, competition of cheapness, not of excellence, that they meet the bargain-hunters half way, and cheerfully furnish them with nasty

wares at the cheap rate they are asked for, by means of what can be called by no prettier name than fraud...

I say all classes are to blame in this matter, but also I say that the remedy lies with the handicraftsmen, who are not ignorant of these things like the public, and who have no call to be greedy and isolated like the manufacturers or middlemen; the duty and honour of educating the public lies with them, and they have in them the seeds of order and organization which make that duty the easier.

When will they see to this and help to make men of us all by insisting on this most weighty piece of manners; so that we may adorn life with the pleasure of cheerfully *buying* goods at their due price; with the pleasure of *selling* goods that we could be proud of both for fair price and fair workmanship: with the pleasure of working soundly and without haste at *making* goods that we could be proud of? – much the greatest pleasure of the three is that last, such a pleasure as, I think, the world has none like it.

You must not say that this piece of manners lies out of my subject: it is essentially a part of it and most important: for I am bidding you learn to be artists, if art is not to come to an end amongst us: and what is an artist but a workman who is determined that, whatever else happens, his work shall be excellent? or, to put it in another way: the decoration of workmanship, what is it but the expression of man's pleasure in successful labour? But what pleasure can there be in *bad* work, in *un*successful labour; why should we decorate *that*? and how can we bear to be always unsuccessful in our labour?

As greed of unfair gain, wanting to be paid for what we have not earned, cumbers our path with this tangle of bad work, of sham work, so the heaped-up money which this greed has brought us...has raised up against the arts a barrier of the love of luxury and show, which is of all obvious hindrances the worst to overpass: the highest and most cultivated classes are not free from the vulgarity of it, the lower are not free from its pretence. I beg you to remember both as a remedy against this, and as explaining exactly what I mean, that nothing can be a work of art which is not useful; that is to say, which does not minister to the body when well under command of the mind, or which does not amuse, soothe, or elevate the mind in a healthy state. What tons upon tons of unutterable rubbish pretending to be works of art in some degree would this maxim clear out of our London houses, if it were understood and acted upon! To my mind it is only here and there (out of the kitchen) that you can find in a well-to-do house things that are of any use at all: as a rule all the decoration (so called) that has got there is there, for the sake of show, not because anybody likes it. I repeat, this stupidity goes through all classes of society: the silk curtains in my Lord's drawing-room are no more a matter of art to him than the powder in his footman's hair; the kitchen in a country farmhouse is most commonly a pleasant and homelike place, the parlour dreary and useless.

Simplicity of life, begetting simplicity of taste, that is, a love for sweet and lofty things, is of all matters most necessary for the birth of the new and better art we crave for; simplicity everywhere, in the palace as well as in the cottage.

Still more is this necessary, cleanliness and decency everywhere, in the cottage as well as in the palace: the lack of that is a serious piece of *manners* for us to correct: that lack and all the inequalities of life, and the heaped-up thoughtlessness and disorder of

so many centuries that cause it: and as yet it is only a very few men who have begun to think about a remedy for it in its widest range: even in its narrower aspect, in the defacements of our big towns by all that commerce brings with it, who heeds it? who tries to control their squalor and hideousness? there is nothing but thoughtlessness and recklessness in the matter: the helplessness of people who don't live long enough to do a thing themselves, and have not manliness and foresight enough to begin the work, and pass it on to those that shall come after them.

Is money to be gathered? cut down the pleasant trees among the houses, pull down ancient and venerable buildings for the money that a few square yards of London dirt will fetch; blacken rivers, hide the sun and poison the air with smoke and worse, and it's nobody's business to see to it or mend it: that is all that modern commerce, the counting-house forgetful of the workshop, will do for us herein.

And Science – we have loved her well, and followed her diligently, what will she do? I fear she is so much in the pay of the counting-house, the counting-house and the drill-sergeant, that she is too busy, and will for the present do nothing. Yet there are matters which I should have thought easy for her; say for example teaching Manchester how to consume its own smoke, or Leeds how to get rid of its superfluous black dye without turning it into the river, which would be as much worth her attention as the production of the heaviest of heavy black silks, or the biggest of useless guns. Anyhow, however it be done, unless people care about carrying on their business without making the world hideous, how can they care about art? I know it will cost much both of time and money to better these things even a little; but I do not see how these can be better spent than in making life cheerful and honourable for others and for ourselves... I should begin to think matters hopeful if men turned their attention to such things, and I repeat, that unless they do so, we can scarcely even begin with any hope our endeavours for the bettering of the Arts.

Until something or other is done to give all men some pleasure for the eyes and rest for the mind in the aspect of their own and their neighbours' houses, until the contrast is less disgraceful between the fields where beasts live and the streets where men live, I suppose that the practice of the arts must be mainly kept in the hands of a few highly cultivated men, who can go often to beautiful places, whose education enables them, in the contemplation of the past glories of the world, to shut out from their view the everyday squalors that the most of men move in. Sirs, I believe that art has such sympathy with cheerful freedom, open-heartedness and reality, so much she sickens under selfishness and luxury, that she will not live thus isolated and exclusive. I will go further than this, and say that on such terms I do not wish her to live. I protest that it would be a shame to an honest artist to enjoy what he had huddled up to himself of such art, as it would be for a rich man to sit and eat dainty food amongst starving soldiers in a beleaguered fort.

I do not want art for a few, any more than education for a few, or freedom for a few.

No, rather than art should live this poor thin life among a few exceptional men, despising those beneath them for an ignorance for which they themselves are responsible, for a brutality that they will not struggle with, – rather than this, I would that the world should indeed sweep away all art for a while... Rather than the wheat should rot in the miser's granary, I would that the earth had it, that it might yet have a chance to quicken in the dark.

I have a sort of faith, though, that this clearing away of all art will not happen, that men will get wiser, as well as more learned; that many of the intricacies of life, on which we now pride ourselves more than enough, partly because they are new, partly because they have come with the gain of better things, will be cast aside as having played their part, and being useful no longer. I hope that we shall have leisure from war, – war commercial, as well as war of the bullet and the bayonet; leisure from the knowledge that darkens counsel; leisure above all from the greed of money, and the craving for that overwhelming distinction that money now brings: I believe that as we have even now partly achieved LIBERTY, so we shall one day achieve EQUALITY, which, and which only, means FRATERNITY, and so have leisure from poverty and all its griping, sordid cares.

Then, having leisure from all these things, amidst renewed simplicity of life we shall have leisure to think about our work, that faithful daily companion, which no man any longer will venture to call the Curse of labour: for surely then we shall be happy in it, each in his place, no man grudging at another; no one bidden to be any man's *servant*, everyone scorning to be any man's *master*: men will then assuredly be happy in their work, and that happiness will assuredly bring forth decorative, noble, *popular* art.

That art will make our streets as beautiful as the woods, as elevating as the mountain-sides: it will be a pleasure and a rest, and not a weight upon the spirits to come from the open country into a town; every man's house will be fair and decent, soothing to his mind and helpful to his work: all the works of man that we live amongst and handle will be in harmony with nature, will be reasonable and beautiful: yet all will be simple and inspiriting, not childish nor enervating; for as nothing of beauty and splendour that man's mind and hand may compass shall be wanted from our public buildings, so in no private dwelling will there be any signs of waste, pomp, or insolence, and every man will have his share of the *best*.

5 William Morris (1834–1896) from 'Art under Plutocracy'

Morris's aim in this paper is to consider 'what hindrances may lie in the way towards making art what it should be, a help and solace to the daily life of all men'. What he has in mind is not simply what are generally thought of as 'the arts'. His sense of art extends to take in 'the shapes and colours of all household goods... the arrangements of the fields for tillage and pasture, the management of towns and... highways... the aspect of all the externals of our life'. As in the previous text, he notes the tendency for the 'Intellectual' and the 'Decorative' forms of art to become separated, to the disadvantage of both. In considering the former, he offers a description of the alienated conditions of the modern fine artist that is now as commonplace as it was then unusual. His main concern, however, is to alert the members of his audience to the rapidly declining conditions of their own environment, and to the social and economic processes of which he believes that decline to be the inevitable result. By now Morris's account of the development of societies is clearly informed by Marx's analysis of social development. There can be no mistaking the conclusion to which his arguments lead: 'that it is not the accidents of the system of

competitive commerce which have to be abolished, but the system itself'; that neither joy in labour nor an extension of art into everyday life can now be achieved without social revolution. His hope is that this revolution will be accomplished peacefully, if only the middle classes can be educated to perceive that its consequence must be an improvement in the lives of all. Hence this paper, which was delivered as a lecture to the Russell Club, in University College Hall, Oxford, on 11 November 1883. Our excerpt is taken from the early section of the paper, as printed in Gary Zabel (ed.), *Art and Society: Lectures and Essays by William Morris*, Boston: George's Hill, 1993, pp. 20–7.

Perhaps I had best begin by stating what will scarcely be new to you, that art must be broadly divided into two kinds, of which we may call the first Intellectual, and the second Decorative Art, using the words as mere forms of convenience. The first kind addresses itself wholly to our mental needs; the things made by it serve no other purpose but to feed the mind, and, as far as material needs go, might be done without altogether. The second, though so much of it as is art does also appeal to the mind, is always but a part of things which are intended primarily for the service of the body. I must further say that there have been nations and periods which lacked the purely Intellectual art but positively none which lacked the Decorative (or at least some pretence of it); and furthermore, that in all times when the arts were in a healthy condition there was an intimate connexion between the two kinds of art; a connexion so close, that in the times when art flourished most, the higher and lower kinds were divided by no hard and fast lines. The highest intellectual art was meant to please the eye, as the phrase goes, as well as to excite the emotions and train the intellect. It appealed to all men, and to all the faculties of a man. On the other hand, the humblest of the ornamental art shared in the meaning and emotion of the intellectual; one melted into the other by scarce perceptible gradations; in short, the best artist was a workman still, the humblest workman was an artist. This is not the case now, nor has been for two or three centuries in civilized countries. Intellectual art is separated from Decorative by the sharpest lines of demarcation, not only as to the kind of work produced under those names, but even in the social position of the producers; those who follow the Intellectual arts being all professional men or gentlemen by virtue of their calling, while those who follow the Decorative are workmen earning weekly wages, non-gentlemen in short.

Now, as I have already said, many men of talent and some few of genius are engaged at present in producing works of Intellectual art, paintings and sculpture chiefly. It is nowise my business here or elsewhere to criticize their works; but my subject compels me to say that those who follow the Intellectual arts must be divided into two sections, the first composed of men who would in any age of the world have held a high place in their craft; the second of men who hold their position of gentleman-artist either by the accident of their birth, or by their possessing industry, business habits, or such-like qualities, out of all proportion to their artistic gifts. The work which these latter produce seems to me of little value to the world, though there is a thriving market for it, and their position is neither dignified nor wholesome; yet they are mostly not to be blamed for it personally, since often they have gifts for art, though not great ones, and would probably not have succeeded in any other career. They are, in fact, good decorative

workmen spoiled by a system which compels them to ambitious individualist effort, by cutting off from them any opportunity for co-operation with others of greater or less capacity for the production of popular art.

As to the first section of artists, who worthily fill their places and make the world wealthier by their work, it must be said of them that they are very few. These men have won their mastery over their craft by dint of incredible toil, pains, and anxiety, by qualities of mind and strength of will which are bound to produce something of value. Nevertheless they are injured also by the system which insists on individualism and forbids co-operation. For first, they are cut off from tradition, that wonderful, almost miraculous accumulation of the skill of ages, which men find themselves partakers in without effort on their part. The knowledge of the past and the sympathy with it which the artists of to-day have, they have acquired, on the contrary, by their own most strenuous individual effort; and as that tradition no longer exists to help them in their practice of the art, and they are heavily weighted in the race by having to learn everything from the beginning, each man for himself, so also, and that is worse, the lack of it deprives them of a sympathetic and appreciative audience. Apart from the artists themselves and a few persons who would be also artists but for want of opportunity and for insufficient gifts of hand and eye, there is in the public of to-day no real knowledge of art, and little love for it. Nothing, save at the best certain vague prepossessions, which are but the phantom of that tradition which once bound artist and public together. Therefore the artists are obliged to express themselves, as it were, in a language not understanded of the people. Nor is this their fault. If they were to try, as some think they should, to meet the public half-way and work in such a manner as to satisfy at any cost those vague prepossessions of men ignorant of art, they would be casting aside their special gifts, they would be traitors to the cause of art, which it is their duty and glory to serve. They have no choice save to do their own personal individual work unhelped by the present, stimulated by the past, but shamed by it, and even in a way hampered by it; they must stand apart as possessors of some sacred mystery which, whatever happens, they must at least do their best to guard. It is not to be doubted that both their own lives and their works are injured by this isolation. But the loss of the people; how are we to measure that? That they should have great men living and working amongst them, and be ignorant of the very existence of their work, and incapable of knowing what it means if they could see it!

In the times when art was abundant and healthy, all men were more or less artists; that is to say, the instinct for beauty which is inborn in every complete man had such force that the whole body of craftsmen habitually and without conscious effort made beautiful things, and the audience for the authors of intellectual art was nothing short of the whole people. And so they had each an assured hope of gaining that genuine praise and sympathy which all men who exercise their imagination in expression most certainly and naturally crave, and the lack of which does certainly injure them in some way; makes them shy, over-sensitive, and narrow, or else cynical and mocking, and in that case well nigh useless. But in these days, I have said and repeat, the whole people is careless and ignorant of art; the inborn instinct for beauty is checked and thwarted at every turn; and the result on the less intellectual or decorative art is that as a spontaneous and popular expression of the instinct for beauty it does not exist at all.

It is a matter of course that everything made by man's hand is now obviously ugly, unless it is made beautiful by conscious effort; nor does it mend the matter that men have not lost the habit deduced from the times of art, of professing to ornament household goods and the like; for this sham ornament, which has no least intention of giving anyone pleasure, is so base and foolish that the words upholstery and upholsterer have come to have a kind of secondary meaning indicative of the profound contempt which all sensible men have for such twaddle.

This, so far, is what decorative art has come to, and I must break off a while here and ask you to consider what it once was, lest you think over hastily that its degradation is a matter of little moment. Think, I beg you, to go no further back in history, of the stately and careful beauty of S. Sophia at Constantinople, of the golden twilight of S. Mark's at Venice; of the sculptured cliffs of the great French cathedrals, of the quaint and familiar beauty of our own minsters; nay, go through Oxford streets and ponder on what is left us there unscathed by the fury of the thriving shop and the progressive college; or wander some day through some of the out-of-the-way villages and little towns that lie scattered about the country-side within twenty miles of Oxford; and you will surely see that the loss of decorative art is a grievous loss to the world.

Thus then in considering the state of art among us I have been driven to the conclusion that in its co-operative form it is extinct, and only exists in the conscious efforts of men of genius and talent, who themselves are injured, and thwarted, and deprived of due sympathy by the lack of co-operative art.

But furthermore, the repression of the instinct for beauty which has destroyed the Decorative and injured the Intellectual arts has not stopped there in the injury it has done us. I can myself sympathize with a feeling which I suppose is still not rare, a craving to escape sometimes to mere Nature, not only from ugliness and squalor, not only from a condition of superabundance of art, but even from a condition of art severe and well ordered, even, say, from such surroundings as the lovely simplicity of Periclean Athens. I can deeply sympathize with a weary man finding his account in interest in mere life and communion with external nature, the face of the country, the wind and weather, and the course of the day, and the lives of animals, wild and domestic; and man's daily dealings with all this for his daily bread, and rest, and innocent beast-like pleasure. But the interest in the mere animal life of man has become impossible to be indulged in in its fulness by most civilized people. Yet civilization, it seems to me, owes us some compensation for the loss of this romance, which now only hangs like a dream about the country life of busy lands. To keep the air pure and the rivers clean, to take some pains to keep the meadows and tillage as pleasant as reasonable use will allow them to be; to allow peaceable citizens freedom to wander where they will, so they do no hurt to garden or cornfield; nay, even to leave here and there some piece of waste or mountain sacredly free from fence or tillage as a memory of man's ruder struggles with nature in his earlier days: is it too much to ask civilization to be so far thoughtful of man's pleasure and rest, and to help so far as this her children to whom she has most often set such heavy tasks of grinding labour? Surely not an unreasonable asking. But not a whit of it shall we get under the present system of society. That loss of the instinct for beauty which has involved us in the loss of popular art is also busy in depriving us of the only compensation possible for that

loss, by surely and not slowly destroying the beauty of the very face of the earth. Not only are London and our other great commercial cities mere masses of sordidness, filth, and squalor, embroidered with patches of pompous and vulgar hideousness, no less revolting to the eye and the mind when one knows what it means: not only have whole counties of England, and the heavens that hang over them, disappeared beneath a crust of unutterable grime, but the disease, which, to a visitor coming from the times of art, reason, and order, would seem to be a love of dirt and ugliness for its own sake, spreads all over the country, and every little market-town seizes the opportunity to imitate, as far as it can, the majesty of the hell of London and Manchester. [. . .]

Even if a tree is cut down or blown down, a worse one, if any, is planted in its stead, and, in short, our civilization is passing like a blight, daily growing heavier and more poisonous, over the whole face of the country, so that every change is sure to be a change for the worse in its outward aspect. So then it comes to this, that not only are the minds of great artists narrowed and their sympathies frozen by their isolation, not only has co-operative art come to a standstill, but the very food on which both the greater and the lesser art subsists is being destroyed; the well of art is poisoned at its spring.

Now I do not wonder that those who think that these evils are from henceforth for ever necessary to the progress of civilization should try to make the best of things, should shut their eyes to all they can, and praise the galvanized life of the art of the present day; but, for my part, I believe that they are not necessary to civilization, but only accompaniments to one phase of it, which will change and pass into something else, like all prior phases have done. I believe also that the essential characteristic of the present state of society is that which has so ruined art, or the pleasure of life; and that this having died out, the inborn love of man for beauty and the desire for expressing it will no longer be repressed, and art will be free. At the same time I not only admit, but declare, and think it most important to declare, that so long as the system of competition in the production and exchange of the means of life goes on, the degradation of the arts will go on; and if that system is to last for ever, then art is doomed, and will surely die; that is to say, civilization will die. I know it is at present the received opinion that the competitive or 'Devil take the hindmost' system is the last system of economy which the world will see; that it is perfection, and therefore finality has been reached in it; and it is doubtless a bold thing to fly in the face of this opinion, which I am told is held even by the most learned men. But though I am not learned, I have been taught that the patriarchal system died out into that of the citizen and chattel slave, which in its turn gave place to that of the feudal lord and the serf, which, passing through a modified form, in which the burgher, the gild-craftsman and his journeyman played their parts, was supplanted by the system of so-called free contract now existing. That all things since the beginning of the world have been tending to the development of this system I willingly admit, since it exists; that all the events of history have taken place for the purpose of making it eternal, the very evolution of those events forbids me to believe.

For I am 'one of the people called Socialists'; therefore I am certain that evolution in the economical conditions of life will go on, whatever shadowy barriers may be drawn across its path by men whose apparent self-interest binds them, consciously or unconsciously, to the present, and who are therefore hopeless for the future. I hold

that the condition of competition between man and man is bestial only, and that of association human; I think that the change from the undeveloped competition of the Middle Ages, trammelled as it was by the personal relations of feudality, and the attempts at association of the gild-craftsmen into the full-blown *laissez-faire* competition of the nineteenth century, is bringing to birth out of its own anarchy, and by the very means by which it seeks to perpetuate that anarchy, a spirit of association founded on that antagonism which has produced all former changes in the condition of men, and which will one day abolish all classes and take definite and practical form, and substitute association for competition in all that relates to the production and exchange of the means of life. I further believe that as that change will be beneficent in many ways, so especially will it give an opportunity for the new birth of art, which is now being crushed to death by the money-bags of competitive commerce.

My reason for this hope for art is founded on what I feel quite sure is a truth, and an important one, namely that all art, even the highest, is influenced by the conditions of labour of the mass of mankind, and that any pretensions which may be made for even the highest intellectual art to be independent of these general conditions are futile and vain; that is to say, that any art which professes to be founded on the special education or refinement of a limited body or class must of necessity be unreal and short-lived. ART IS MAN'S EXPRESSION OF HIS JOY IN LABOUR. [. . .]

6 Friedrich Engels (1820–1895) Letter to Margaret Harkness

Marx and Engels devoted no major work to the philosophy of art and culture. Yet the socialist tradition became militantly committed to a notion of Realism in art. This was conceived to be the equivalent of historical materialism in philosophy (see IIA11). As such it involved the rejection of all tendencies to idealism (which at various times has been identified with Symbolism, Abstraction, or Modernism in general). Engels' brief letter to the author Margaret Harkness has come to be regarded as a canonical statement of this doctrine. It advocates a striving for realism, which it identifies not so much with the particular detail as with a representation of the *type*. The letter also distinguished this realism from 'tendency' art. True realism is to emerge from the work, rather than from the artist's or author's explicit political convictions. Thus for Engels, the Royalist Balzac could produce a realist novel, just as later for Georg Lukács, communist avant-garde artists could fail to produce realism despite their best intentions. Margaret Harkness was a novelist of English working-class life who published under the male pseudonym John Law. She was a member of the Social Democratic Federation, and a friend of Marx's daughter Eleanor. Our text is from a draft of his letter which Engels wrote in English in 1888. It is taken from Lee Baxendall and Stefan Morawski (eds), *Marx and Engels on Literature and Art*, Documents on Marxist Aesthetics I, New York: International General, 1974, pp. 115–17.

Dear Miss H[arkness],
I thank you very much for sending me through Messrs. Vizetelly your *City Girl*. I have read it with the greatest pleasure and avidity. [. . .]

What strikes me most in your tale besides its realistic truth is that it exhibits the courage of the true artist. Not only in the way you treat the Salvation Army, in the

teeth of supercilious respectability, which respectability will perhaps learn from your tale, for the first time, *why* the Salvation Army has such a hold on the popular masses. But chiefly in the plain unvarnished manner in which you make the old, old story, the proletarian girl seduced by a middle class man, the pivot of the whole book. [. . .]

If I have anything to criticize, it would be that perhaps after all, the tale is not quite realistic enough. Realism, to my mind, implies, besides truth of detail, the truthful reproduction of typical characters under typical circumstances. Now your characters are typical enough, as far as they go; but the circumstances which surround them and make them act, are not perhaps equally so. In the 'City Girl' the working class figures as a passive mass, unable to help itself and not even making any attempt at striving to help itself. All attempts to drag it out of its torpid misery come from without, from above. Now if this was a correct description about 1800 or 1810, in the days of Saint Simon and Robert Owen, it cannot appear so in 1887 to a man who for nearly fifty years has had the honour of sharing in most of the fights of the militant proletariat. The rebellious reaction of the working class against the oppressive medium which surrounds them, their attempts – convulsive, half-conscious or conscious – at reco-vering their status as human beings, belong to history and must therefore lay claim to a place in the domain of realism.

I am far from finding fault with your not having written a point blank socialist novel, a 'Tendenzroman' as we Germans call it, to glorify the social and political views of the author. That is not at all what I mean. The more the opinions of the author remain hidden, the better for the work of art. The realism I allude to, may crop out even in spite of the author's opinions. Let me refer to an example. Balzac whom I consider a far greater master of realism than all the Zolas *passés, présents et à venir*, [past, present, and future] in *La Comédie humaine* gives us a most wonderfully realistic history of French 'Society,' describing, chronicle-fashion, almost year by year from 1816 to 1848, the progressive inroads of the rising bourgeoisie upon the society of nobles, that reconstituted itself after 1815 and that set up again, as far as it could, the standard of *la vieille politesse française* [the old French ways]. He describes how the last remnants of this, to him, model society gradually succumbed before the intrusion of the vulgar moneyed upstart, or were corrupted by him; how the grande dame whose conjugal infidelities were but a mode of asserting herself in perfect accordance with the way she had been disposed of in marriage, gave way to the bourgeoise, who corned her husband for cash or cashmere; and around this central picture he groups a complete history of French Society from which, even in economical details (for instance the rearrangement of real and personal property after the Revolution) I have learned more than from all the professed historians, economists and statisticians of the period together. Well, Balzac was politically a Legitimist; his great work is a constant elegy on the irretrievable decay of good society; his sympathies are all with the class doomed to extinction. But for all that his satyre is never keener, his irony never bitterer than when he sets in motion the very men and women with whom he sympathizes most deeply – the nobles. And the only men of whom he always speaks with undisguised admiration, are his bitterest political antagonists, the republican heroes of the Cloître Saint Merri [*Méry*], the men, who at that time (1830–36) were indeed the representatives of the popular masses. That Balzac thus was compelled to go against his own class sympathies and political prejudices, that he *saw* the necessity

of the downfall of his favourite nobles, and described them as people deserving no better fate; and that he *saw* the real men of the future where, for the time being, they alone were to be found – that I consider one of the greatest triumphs of Realism, and one of the grandest features in old Balzac [...]

7 Marie Bashkirtseff (1859–1884) Journal Entries 1877–82

Marie Bashkirtseff was born into a landowning aristocratic family in Pultowa in the Ukraine in 1859. At the age of twelve she moved with the family to Nice and then to Paris. In 1877, at the age of eighteen, she decided to train as a professional artist. Women were still excluded from the prestigious École des Beaux-Arts until 1897, and she enrolled in the Académie Julian where she could work from the nude model. Her work was exhibited at the annual Salon, but her career was cut short by her death from tuberculosis at the age of 25. In her journal she records both her ambitions as an artist and her frustration at the restrictions imposed on her by late-nineteenth century society. Under the pseudonym Pauline Orell, she also wrote reviews and articles for the socialist and feminist paper *La Citoyenne*. An early precedent for the contribution of women to left-wing debate on the arts is given by Marie-Camille de G. (see IIA3, above). Bashkirtseff's journal caused a sensation on its publication in 1887 and soon appeared in English in 1890. The present extracts are taken from the translation by Mathilde Blind, originally published in two volumes, London and New York: Cassell, 1890, reprinted in one volume, London: Virago Press, 1985, pp. 264, 274, 275, 276–7, 294, 331, 335, 340, 341, 347–8, 536.

August 7th 1877–[...] IT IS IMPOSSIBLE!! Oh! terrible, despairing, horrible, and frightful word!!! To die! My God, to die!!! To die!!!! Without leaving anything behind me? To die like a dog! just as a hundred thousand women have died, whose names are barely inscribed on their tombstones. To die like ...

Fool, fool, that I am, not to see what God wills! God wills that I should renounce everything, and give myself up entirely to art. In five years I shall still be quite young – perhaps beautiful, after my style of beauty.... But if I should become only an artistic mediocrity, as so many are!

As far as the world goes it would be all very well; but to give up one's life to it, and not succeed....

At Paris, as everywhere else, there is a Russian colony. It is not these paltry considerations that provoke me; but because, paltry as they are, they fill me with despair, and prevent me from thinking of my greatness.

What is life without congenial society? What can one do left entirely to oneself? This it is that makes me detest the whole world, my family – even to myself – and makes me utter blasphemies. To live, to live!.... Holy Mary, Mother of God, O Lord Jesus Christ, O my God, come and help me!

But to devote oneself to art, one should go to Italy. Yes, to Rome. Oh! this granite wall against which I am dashing my forehead every instant! ...

I will stay where I am.

October 2nd 1877 – To-day we move to 71, Avenue des Champs-Elysées. In spite of all the bustle, I have found time to go to Julian's studio – the only good one for women.

They work there every day from eight till twelve, and from one till five. A man was posing nude when M. Julian took me into the studio.

October 4th 1877 –

* * *

At last I am working with artists, real artists, who have exhibited at the Salon, and who sell their pictures and portraits – who even give lessons.

Julian is pleased with the way I have begun. 'By the end of the winter you will be able to paint some very good portraits,' he said to me.

He says that sometimes his female students are as clever as the young men. I should have worked with the latter, but they smoke – and, besides, there is no advantage. There was when the women had only the draped model; but since they make studies from the nude, it is just the same.

The maid at the studio *is* like those they describe in novels.

'I have always been with artists,' she says, 'and I am no longer *bourgeoise* – I am an artist.'

I am, oh! so happy!

October 8th 1877 – A new model for the heads – that is to say, in the morning (a sort of music-hall singer who sang during the rests) – and in the afternoon a young girl for the nude.

They say she is only seventeen; but I can assure you her figure has been rather spoilt. They say these creatures lead a dreadful life.

The pose being difficult I find it hard. What makes men ashamed of being naked is that they are afraid of their defects. If one felt sure of not having a spot on the skin, or a muscle ill made, or a deformed foot, one would go about without clothes, and one would not be ashamed. People don't realize the truth of this, but it is this and nothing else which makes people ashamed. Who can resist the temptation of showing something that is really beautiful, and of which one may be proud. Who, from King Candaules onwards, has ever kept for himself any treasure or any beauty without boasting of it? But as easily as one is satisfied with one's face, so fastidious is one instinctively for the body.

The sense of shame only disappears before perfection – beauty being all-powerful. And when you say anything else but 'How beautiful!' it is that the thing isn't really beautiful, and there is room for blame and for any kind of opinion. That wretch of a model had straight and pretty if somewhat fat fingers, and a rather shapeless though regular and not over-big foot.

I said just now that perfect beauty keeps all other ideas away, and it is the same with anything else which is perfect. The music which lets you notice the defects in the stage appointments is itself faulty. An act of heroism which at the time allows of any other feeling but admiration, is not as heroic as you could have imagined.

The thing you see or hear may be great enough in itself to fill your soul, and then alone is it all-powerful.

If, on seeing a woman naked, you feel that it is wrong, this woman is not the highest expression of beauty, since there is room in your mind for an idea other than that which should pass to your brain through your eyes. You forget the beautiful, to think of the

nude. The beauty, therefore, was not perfect enough to occupy all your thoughts. And then those who display themselves are ashamed, and the onlookers are shocked.

One is ashamed because one knows that others disapprove; but if they did not disapprove, it would be the right thing, and so one would not be ashamed. To sum up, perfection and absolute beauty annul blame – or, rather, prevent its occurrence – and suppress shame.

November 26th 1877 – At last I have taken my first lesson in anatomy – from four to half-past, just after my drawing.

M. Cuyer teaches me. He was sent by Mathias Duval, who has promised to show me the Ecole des Beaux-Arts. I began with the bones, of course, and one of the drawers of my writing-table is full of vertebrae... real ones. It is horrible, when you think that the other two contain scented paper and visiting-cards from Naples, &c.

On returning from the studio, I found M. Cuyer waiting in the twilight of the drawing-room, and on the sofa opposite I found mamma and Marcuard, most pompous of commanders, who had returned for ten days, and who kissed my hand covered with charcoal, and... which had been in contact with vertebrae, for I had stolen away from the drawing-room to take my lesson.

September 1st 1878 – And I see nothing for me.... nothing but painting. If I were to become a great painter, it would be a divine compensation; I should have the right, before my own conscience, of having feelings and opinions of my own. I should not despise myself for writing down all these trifles. I should be somebody.... I might have been nothing, and should be happy in being nothing but the beloved of a man who would be my glory.... But now I must be somebody by my own effort.

September 30th 1878 – I have done my first regular painting. I was to do still-life studies, so I painted, as you already know, a blue vase and two oranges, and afterwards a man's foot, and that is all.

I dispensed with the drawing from the antique; I shall perhaps be able to do without the work from still-life.

I have written to Colignon that I should like to be a man. I know that I could be somebody, but with petticoats what do you expect one to do? Marriage is the only career for women; men have thirty-six chances, women only one, as with the bank of the gaming table, but, nevertheless, the bank is always sure to win; they say it is the same with women, but it is not so, for there is winning and winning. But how can one ever be too particular in the choice of a husband? I have never before felt so indignant at the present condition of women. I am not mad enough to claim that stupid equality which is an utopian idea – besides, it is bad form – for there can be no equality between two creatures so different as man and woman. I do not demand anything, for woman already possesses all that she ought to have, but I grumble at being a woman because there is nothing of the woman about me but the envelope.

October 20th 1878 –

[...] We saw the Ecole des Beaux-Arts. It is enough to make one cry.

Why cannot I go and study there? Where can any one get such thorough teaching as there? I went to see the Exhibition of the Prix de Rome. The second prize was won by one of Julian's pupils. Julian is much pleased. If ever I am rich I will found a School of Art for women.

November 5th 1878 – One thing there is which I think truly beautiful, and worthy of the heroic age: that self-annihilation of a woman before the superiority of the man she loves must be the most exquisite gratification of her self-esteem that can be felt by a woman of noble mind.

January 2nd 1879 – What I long for is the freedom of going about alone, of coming and going, of sitting on the seats in the Tuileries, and especially in the Luxembourg, of stopping and looking at the artistic shops, of entering the churches and museums, of walking about the old streets at night; that's what I long for; and that's the freedom without which one can't become a real artist. Do you imagine I can get much good from what I see, chaperoned as I am, and when, in order to go to the Louvre, I must wait for my carriage, my lady companion, or my family?

Curse it all, it is this that makes me gnash my teeth to think I am a woman! – I'll get myself a *bourgeois* dress and a wig, and make myself so ugly that I shall be as free as a man. It is this sort of liberty that I need, and without it I can never hope to do anything of note.

The mind is cramped by these stupid and depressing obstacles; even if I succeeded in making myself ugly by means of some disguise I should still be only half free, for a woman who rambles about alone commits an imprudence. And when it comes to Italy and Rome? The idea of going to see ruins in a landau!

'Marie, where are you going?'

'To the Coliseum.'

'But you have already seen it! Let us go to the theatre or to the Promenade; we shall find plenty of people there.'

And that is quite enough to make my wings droop.

This is one of the principal reasons why there are no female artists. O profound ignorance! O cruel routine! But what is the use of talking?

Even if we talked most reasonably we should be subject to the old, well-worn scoffs with which the apostles of women are overwhelmed. After all, there may be some cause for laughter. Women will always remain women! But still . . . supposing they were brought up in the way men are trained, the inequality which I regret would disappear, and there would remain only that which is inherent in nature itself. Ah, well, no matter what I may say, we shall have to go on shrieking and making ourselves ridiculous (I will leave that to others) in order to gain this equality a hundred years hence. As for myself, I will try to set an example by showing Society a woman who shall have made her mark, in spite of all the disadvantages with which it hampered her.

June 20th 1882 – [. . .] Ah! how women are to be pitied; men are at least free. Absolute independence in every-day life, liberty to come and go, to go out, to dine at an inn or at home, to walk to the Bois or the café: this liberty is half the battle in acquiring talent, and three parts of every-day happiness.

But you will say, 'Why don't you, superior woman as you are, seize this liberty?'

It is impossible, for the woman who emancipates herself thus, if young and pretty, is almost tabooed; she becomes singular, conspicuous, and cranky; she is censured, and is, consequently, less free than when respecting those absurd customs.

So there is nothing to be done but deplore my sex, and come back to dreams of Italy and Spain. Granada! Gigantic vegetation! pure sky, brooks, oleanders, sun, shade, peace, calm, harmony, poetry!

8 Leader Scott (1837–1902) 'Women at Work: Their Functions in Art'

Leader Scott was an art historian, concerned primarily with the work of earlier periods. His most successful publication was a book on *The Renaissance of Art in Italy*, first issued in 1888. In the following essay a hierarchy of 'genius', 'talent' and 'dexterity' is employed explicitly to distinguish different levels of artistic production, and implicitly to underline assumptions regarding men's capacity for 'stronger genius' and women's 'true mission' as 'the presiding genius of the home'. Like the earlier and anonymous author of 'Women Artists' (IIᴅ5), Leader pays lip-service to the possibility that a woman might be endowed with the compulsion of the true artist. The familiar implication of his conclusion, however, is that a woman's *natural* concern is with the handicrafts, and with the exercise of (mere) talent and dexterity. The present essay is thus typical of prevalent and unchanging attitudes towards women's involvement in the arts. It also offers some unwitting validation of Morris's arguments concerning the political character of demarcations between the 'great' and 'lesser' arts – ironically enough given that Scott was later to publish a work on *The Cathedral Builders*. The essay was published in the annual edition of the *Magazine of Art*, volume VII, London: Cassel & Co. Ltd, 1884, pp. 98–9, from which this text has been taken. In considering the representativeness of Scott's views, it should be borne in mind that this was a relatively expensive and conservative publication.

A distinguishing mark of modern feminine education is the large part taken in it by art. Instead of being deemed an accomplishment for the few who possess special talent, it has become almost compulsory for the many. After the school drawing-master is left comes the local art centre, the attraction of which is often a question of medals and honorary distinctions rather than of the higher culture or even technical education. This indiscriminate emulation in art has its uses and its abuses. Knowledge is good; training in art is an admirable means of refining the national character. But if the process of refinement is to be successful it must, to begin with, be correct in type and perfect in application. To inundate our lives with commonplace pictures, and insist, with a total want of the artistic temperament, on the cultivation of mere technical dexterity, is worse than useless. We do not dream of making engineers of boys without a taste for mathematics, and we should equally shrink from making our girls musicians without ear, or artists without eyes and hands. That latent talent may not be ignored, it is as well that a certain amount of aesthetic training should be compulsory in the earlier stages of education. There are very few in whom the eye and hand cannot to some extent be educated; and there are thousands of women who, without being artists, have technical aptitude enough to be useful in less ambitious

ways. The question therefore is: what use are women to make of the knowledge which has almost superseded housewifery and skill with the needle? In other words, what are the functions of women in art?

To answer it we must consider the nature of art, which to be perfect should be triune; requiring for its highest development the best qualities of soul, mind, and body. The corporeal part of art is technicality, requiring only hand and eye; the intellectual is composition, requiring thought and reason; the spiritual, the inner and higher meaning which soul alone has the power of expressing. When this last gift is added to the other two, and the artist's power is threefold, we call it genius. The twofold ability of combining intellect and hand constitutes talent; simple dexterity of hand is mere aptitude. Before deciding on an artistic career, a woman should be sure of her capacities and of the nature of her position with regard to art – whether it be that of genius, talent, or aptitude, inasmuch as the functions of each are distinct. If when she leaves the art school she is irresistibly impelled to continue the pursuit, if she originates subjects which have a touch of soul in them, if she can throw the inner meaning of nature into a landscape or a pure sentiment into a face – then we may be sure that she has a touch of genius. She is one of the few to whom art in its highest forms will be revealed, and she may, and must, devote her life to its quest. She will idealize and beautify every-day life, and become a teacher and priestess of nature. The instinctive perceptions of woman are often more subtle and finer than those of man; and her heart will guide her to the interpretation of delicacies of sentiment which pass unrecognized by his stronger genius.

If a girl be only endowed with a correct eye and clever hand, if she can do no more than readily adapt forms to their uses and give a certain intellectual value to composition, she may be said to have talent, and may be a worker in a lower sphere. To her the many branches of decorative art are open. She may copy or paint tapestries and panels, design chintzes, and so forth. But she must not waste her time in painting second-rate pictures. For those who can only draw what they see before them, neither interpreting nor teaching, there is nothing but the pursuit of drawing as a handicraft. It would be better, unless they be content to become mere artisans, to abandon art and take up the needle. Genius will win fame; talent may attain wealth; but dexterity is only serviceable as a handmaid to other minds.

With a very large class of feminine artists the great object is not to become famous, but to earn a livelihood, for girls are beginning to tire of the drudgery of teaching at servants' wages, and marriage is a remote chance with a large proportion of women. With emancipation there have come the desire and the possibility of independence. New careers must be made for woman, and art opens a wide field to her. If she have genius, she will have no choice but to follow it. She may make it remunerative if she have talent, and may live by it even if she only possesses dexterity; but she must do this chiefly in its limits as decoration. It is by no means necessary for her to confine her efforts to mere water-colours and oils. She may etch, and draw on wood. She may design chintzes and wallpapers for the manufacturers; paint on china in a porcelain manufactory; paint tapestries for hangings, portières, and screens, and also paint on silk dresses. A softer and more natural effect may be obtained with the brush than in embroidery, which is only artistic if used in conventional subjects. I have seen in Miss Aumonier's studio a dress of pale blue-grey silk with a long double spray of Banksia

roses in water-colour flung across the skirt. The effect surpassed in delicacy that of any embroidery I ever saw.

Again, why should not woman take up the art of wall-decoration as a profession? If wall-papers suit the English climate better than fresco, why not produce them in original designs instead of depending for them on the manufacturers, and repeating in our own apartments the taste of hundreds of our neighbours? A painted frieze and dado would adorn a room much more eloquently than paper stamped by machinery, yard after yard alike. A frieze of children for the household drawing-room; of fairy stories for the nursery; of flowers and fruit for the dining-room, would touch the house with poetry. And the more delicate uses of wood-carving, as for frames, letter-cases, work-boxes, are in the same category. I have spoken hitherto of the practice of art as a livelihood. But there is happily a large class of women who have no need to earn their bread, and to whom art and the practice of art may yet be a solace and a delight. And here we come to what is after all woman's true mission – that of the presiding genius of the home. Here all her artistic proclivities may be brought into full play, as the beautifier and refiner of the household dwelling-place. Here again art is not confined to a mere use of the brush. Its forms and objects are infinite. In the mother it finds its outlet in the training of her little ones' taste, in surrounding them with beauty from their childhood, in touching their dress with the beauty of bright embroideries and graceful shapes, in aiding their amusement by drawing little pictures for them to paint; in illustrating their favourite stories. A fairy book with blank leaves bound into it, illustrated by the mother under her children's eye, will give them a thousand times more pleasure than the same book illustrated with mere engravings, especially if the children are allowed to suggest their own imaginings, and to see them expressed. In the wife a cultivated taste, even without manual dexterity, is a great beautifier. Such a woman will give artistic beauty to a spray of ivy or feathery tamarisk by wreathing it round a mirror, and glorify a handful of red poppies by placing them in a sunny room in an antique jar. It depends on her artistic taste whether her table looks like a mere feeding-board or a hymn to nature, the mother of food.

The daughter at home may find endless occupation for her artistic fingers. She has only to remember that all adornment should begin by being appropriate. She must not hang her walls with plates which nobody uses, or with water-colours not worthy of their frames. She will paint a pretty frieze round her room, and a dado underneath it, of foxgloves or tall lilies. If the room is panelled she will paint the panels, or even fling a handful of flowers in colour over shutters and doors. Instead of buying a machine-made table-cloth whose chief virtue is that it is the fashion, she will get hold of some Cinque-Cento arabesques and adapt them to a border, and let her cloth be *acu picta* (needle-painted); for the needle is as worthy an artistic implement as the brush, though it cannot be used in the same way. Conventional art suits the needle, natural art the brush. She will design you a wreath of embroidered flowers or arabesque for your curtains; she will paint your Christmas cards, your *menu* cards, your ball programmes. A very artistic programme – framed in ivy – was lately hung on the ball-room wall in Florence. It was a fishing-boat in the Mediterranean, with a lateen sail on whose wide expanse the dances were inscribed.

The home, in fact, has endless uses for art, if we would only be content to make it original and express our own ideas, instead of blindly following the fashion. It would

be well, too, if we recognized more distinctly the difference between genius and talent. Let genius alone stand as the teacher and apostle of art, and leave to talent and dexterity the handicrafts. Our picture exhibitions would then be temples of art, and our homes the idealization of utility.

9 Anonymous, 'Woman, and her Chance as an Artist'

The following text makes even Leader Scott appear as a liberal. It was originally published in a monthly round-up of news items in the conservative *Magazine of Art* in 1888. The anonymous writer notes that in that year ten out of twelve of the successful candidates for admission to the Royal Academy Schools were women (for contrast see IIID10). On the other hand he notes the general absence of considerable women artists. From these two observations he draws the conclusion that the criteria of selection must be at fault, favouring women's supposed capacity for patient imitation rather than the 'power and breadth' to be found in art made by men. The argument that the dearth of successful women artists might be due to other forms of restriction is dismissed out of hand on the simple grounds that 'Art will out'. The implication is that the Royal Academy is squandering opportunities and resources in encouraging women artists, and the conclusion that it should cease to do so. Our text is taken from the original publication in 'The Chronicle of Art: Art in April', *Magazine of Art*, London, April 1888, pp. xxv–xxvi.

The particulars of the last candidates' examination for admission to the Royal Academy schools shed some light on the capacity, or otherwise, of women to become artists of real eminence. Of the eighty-seven candidates who presented themselves, only a round dozen succeeded in forcing their way into the fold of the 'probationers,' while of these twelve, no fewer than ten were women, and women for the most part – in all gallantry be it said – no longer in the first hot flush of ambitious youth and inspiration. Thus, indeed, it must always be under the present Royal Academy rules, whereby is demanded in the probationary drawings a high degree of patient imitativeness – a simple and touching devotion to stipple and shadow – rather than true artistic power and breadth of any kind. In this sort of work, indeed – that of patient, dexterous manipulation – woman may always be depended on to assert her power of *execution*; but it is in *invention* and *originality*, or the realization of them, that the failure of the sex in art becomes apparent. Hence it is that the artists of first-class ability produced by the country are furnished by the small minority of male passed candidates; the women usually relapse into obscurity, after achieving a partial success – they win the minor scholarships, and then lose themselves into the Nirvana of artistic mediocrity. The generally accepted principle that imaginative creation is out of the range of feminine capacity is nowhere more apparent than in art, and the sooner the truth of this is recognized by the sex, the better it will be for those who, thirsting for fame and fortune, adopt the light and ladylike profession of art. History proves that, though the artistic perception is strong in woman, her successful power of realization is, in the vast majority of cases, non-existent; for not one female name can be found worthy to be placed on a level even with the masters of the second rank. Angelica Kauffmann, Mme. Lebrun, perhaps, and above all, Rosa Bonheur (the latter as masculine in her somewhat narrow range of execution and conception as she is in

face and method of dress), are the few distinguished exceptions that emphasize the rule. The explanation of 'repression' and 'lack of education,' always advanced by the champions of the sex in so-called vindication of its non-performance, can hardly hold in the present case; for it has been proved a thousand times that Art, like Truth, will out, despite every disadvantage, every discouragement, and lack of opportunity. It surely behoves the Academy, whose province it is to do its utmost to aid the advance of art by imparting proper instruction and not to act as the amiable *cicerone* of the china-painter and the amateur-professional, to so alter its rules as to remedy the present anomalous state of things.

10 George Moore (1852–1933) 'Sex in Art'

Moore was born in Ireland, but left at eighteen for Paris, where he intended to become a painter. He failed in this, however, and turned to writing, in which field he achieved fame by importing elements of French Naturalism into English-language fiction. Posterity has not valued this work as highly as did his contemporaries. In addition to his fiction, Moore also wrote about art, notably in his *Reminiscences of the Impressionist Painters*, published in 1906. In the present text Moore offers a positive assessment of the work of Berthe Morisot, who by the 1890s had come to be widely acknowledged as a central figure in the Impressionist movement. The terms of Moore's appraisal are so deranged by late nineteenth-century sexism, however, that it is as a symptom of those views, rather than for any particular merits as art criticism, that his essay is worthy of notice today. Our extracts are taken from Moore's *Modern Painting*, London: Walter Scott, 1893, pp. 220–3 and 228–31.

Woman's nature is more facile and fluent than man's. Women do things more easily than men, but they do not penetrate below the surface, and if they attempt to do so the attempt is but a clumsy masquerade in unbecoming costume. In their own costume they have succeeded as queens, courtesans, and actresses, but in the higher arts, in painting, in music, and literature, their achievements are slight indeed – best when confined to the arrangements of themes invented by men – amiable transpositions suitable to boudoirs and fans.

I have heard that some women hold that the mission of their sex extends beyond the boudoir and the nursery. It is certainly not within my province to discuss so important a question, but I think it is clear that all that is best in woman's art is done within the limits I have mentioned. This conclusion is well-nigh forced upon us when we consider what would mean the withdrawal of all that women have done in art. The world would certainly be the poorer by some half-dozen charming novels, by a few charming poems and sketches in oil and water-colour; but it cannot be maintained, at least not seriously, that if these charming triflings were withdrawn there would remain any gap in the world's art to be filled up. Women have created nothing, they have carried the art of men across their fans charmingly, with exquisite taste, delicacy, and subtlety of feeling, and they have hideously and most mournfully parodied the art of men. George Eliot is one in whom sex seems to have hesitated, and this unfortunate hesitation was afterwards intensified by unhappy circumstances. She was one of those women who so entirely mistook her vocation as to attempt to think, and really if she had assumed the dress and the duties of a policeman, her failure could hardly have been

more complete. Jane Austen, on the contrary, adventured in no such dismal masquerade; she was a nice maiden lady, gifted with a bright clear intelligence, diversified with the charms of light wit and fancy, and as she was content to be in art what she was in nature, her books live, while those of her ponderous rival are being very rapidly forgotten. 'Romola' and 'Daniel Deronda' are dead beyond hope of resurrection; 'The Mill on the Floss,' being more feminine, still lives, even though its destiny is to be forgotten when 'Pride and Prejudice' is remembered.

Sex is as important an element in a work of art as it is in life; all art that lives is full of sex. There is sex in 'Pride and Prejudice'; 'Jane Eyre' and 'Aurora Leigh' are full of sex; 'Romola,' 'Daniel Deronda,' and 'Adam Bede' are sexless, and therefore lifeless. There is very little sex in George Sand's works, and they, too, have gone the way of sexless things. When I say that all art that lives is full of sex, I do not mean that the artist must have led a profligate life; I mean, indeed, the very opposite. George Sand's life was notoriously profligate, and her books tell the tale. I mean by sex that concentrated essence of life which the great artist jealously reserves for his art, and through which it pulsates. Shelley deserted his wife, but his thoughts never wandered far from Mary. Dante, according to recent discoveries, led a profligate life, while adoring Beatrice through interminable cantos. So profligacy is clearly not the word I want. I think that gallantry expresses my meaning better.

The great artist and Don Juan are irreparably antagonistic; one cannot contain the other. Notwithstanding all the novels that have been written to prove the contrary, it is certain that woman occupies but a small place in the life of an artist. She is never more than a charm, a relaxation, in his life; and even when he strains her to his bosom, oceans are between them. Profligate, I am afraid, history proves the artist sometimes to have been, but his profligacy is only ephemeral and circumstantial; what is abiding in him is chastity of mind, though not always of body; his whole mind is given to his art, and all vague philanderings and sentimental musings are unknown to him; the women he knows and perceives are only food for it, and have no share in his mental life. And it is just because man can raise himself above the sentimental cravings of natural affection that his art is so infinitely higher than woman's art. 'Man's love is from man's life a thing apart' – you know the quotation from Byron, ''Tis woman's whole existence.' The natural affections fill a woman's whole life, and her art is only so much sighing and gossiping about them. Very delightful and charming gossiping it often is – full of a sweetness and tenderness which we could not well spare, but always without force or dignity.

In her art woman is always in evening dress: there are flowers in her hair, and her fan waves to and fro, and she wishes to sigh in the ear of him who sits beside her. Her mental nudeness is parallel with her low bodice, it is that and nothing more. She will make no sacrifice for her art; she will not tell the truth about herself as frankly as Jean Jacques, nor will she observe life from the outside with the grave impersonal vision of Flaubert. In music women have done nothing, and in painting their achievement has been almost as slight. It is only in the inferior art – the art of acting – that women approach men. In that art it is not certain that they do not stand even higher.

Whatever women have done in painting has been done in France. England produces countless thousands of lady artists; twenty Englishwomen paint for one French-woman, but we have not yet succeeded in producing two that compare with Madame

[Elizabeth Vigée] Lebrun and Madame Berthe Morisot. The only two English-women who have in painting come prominently before the public are Angelica Kauffman and Lady Butler. The first-named had the good fortune to live in the great age, and though her work is individually feeble, it is stamped with the charm of the tradition out of which it grew and was fashioned. Moreover, she was content to remain a woman in her art. She imitated Sir Joshua Reynolds to the best of her ability, and did all in her power to induce him to marry her. How she could have shown more wisdom it is difficult to see. Lady Butler was not so fortunate, either in the date of her birth, in her selection of a master, or her manner of imitating him. Angelica imitated as a woman should. She carried the art of Sir Joshua across her fan; she arranged and adorned it with ribbons and sighs, and was content with such modest achievement.

Lady Butler, however, thought she could do more than to sentimentalize with De Neuville's soldiers. She adopted his method, and from this same stand-point tried to do better; her attitude towards him was the same as Rosa Bonheur's towards Troyon; and the failure of Lady Butler was even greater than Rosa Bonheur's.

* * *

Nevertheless, among these well-intentioned ladies we find one artist of rare excellence – I mean Madame Lebrun. We all know her beautiful portrait of a woman walking forward, her hands in a muff. Seeing the engraving from a distance we might take it for a Romney; but when we approach, the quality of the painting visible through the engraving tells us that it belongs to the French school. In design the portrait is strangely like a Romney; it is full of all that brightness and grace, and that feminine refinement, which is a distinguishing characteristic of his genius, and which was especially impressed on my memory by the portrait of the lady in the white dress walking forward, her hands in front of her, the slight fingers pressed one against the other, exhibited this year in the exhibition of Old Masters in the Academy.

But if we deny that the portrait of the lady with the muff affords testimony as to the sex of the painter, we must admit that none but a woman could have conceived the portrait which Madame Lebrun painted of herself and her little daughter. The painting may be somewhat dry and hard, it certainly betrays none of the fluid nervous tendernesses and graces of the female temperament; but surely none but a woman and a mother could have designed that original and expressive composition; it was a mother who found instinctively that touching and expressive movement – the mother's arms circled about her little daughter's waist, the little girl leaning forward, her face resting on her mother's shoulder. Never before did artist epitomise in a gesture all the familiar affection and simple persuasive happiness of home; the very atmosphere of an embrace is in this picture. And in this picture the painter reveals herself to us in one of the intimate moments of her daily life, the tender, wistful moment when a mother receives her growing girl in her arms, the adolescent girl having run she knows not why to her mother. These two portraits, both in the Louvre, are, I regret to say, the only pictures of Madame Lebrun that I am acquainted with. But I doubt if my admiration would be increased by a wider knowledge of her work. She seems to have said everything she had to say in these two pictures.

Madame Lebrun painted well, but she invented nothing; she failed to make her own of any special manner of seeing and rendering things; she failed to create a style. Only one woman did this, and that woman is Madame Morisot, and her pictures are

the only pictures painted by a woman that could not be destroyed without creating a blank, a hiatus in the history of art. True that the hiatus would be slight – insignificant if you will – but the insignificant is sometimes dear to us; and though nightingales, thrushes, and skylarks were to sing in King's Bench Walk, I should miss the individual chirp of the pretty sparrow.

Madame Morisot's note is perhaps as insignificant as a sparrow's, but it is as unique and as individual a note. She has created a style, and has done so by investing her art with all her femininity; her art is no dull parody of ours: it is all womanhood – sweet and gracious, tender and wistful womanhood. Her first pictures were painted under the influence of Corot, and two of these early works were hung in the exhibition of her works held the other day at Goupil's, Boulevard Montmartre. The more important was, I remember, a view of Paris seen from a suburb – a green railing and two loitering nursemaids in the foreground, the middle of the picture filled with the city faintly seen and faintly glittering in the hour of the sun's decline, between four and six. It was no disagreeable or ridiculous parody of Corot; it was Corot feminized, Corot reflected in a woman's soul, a woman's love of man's genius, a lake-reflected moon. But Corot's influence did not endure. Through her sister's marriage Madame Morisot came in contact with Manet, and she was quick to recognize him as being the greatest artist that France had produced since Delacroix.

Henceforth she never faltered in her allegiance to the genius of her great brother-in-law. True, that she attempted no more than to carry his art across her fan; but how adorably she did this! She got from him that handling out of which the colour flows joyous and bright as well-water, the handling that was necessary for the realization of that dream of hers, a light world afloat in an irradiation – light trembling upon the shallows of artificial water, where swans and aquatic birds are plunging, and light skiffs are moored; light turning the summer trees to blue; light sleeping a soft and lucid sleep in the underwoods; light illumining the green summer of leaves where the diamond rain is still dripping; light transforming into jewellery the happy flight of bees and butterflies. Her swans are not diagrams drawn upon the water, their white-ness appears and disappears in the trembling of the light; and the underwood, how warm and quiet it is, and penetrated with the life of the summer; and the yellow-painted skiff, how happy and how real! Colours; tints of faint green and mauve passed lightly, a few branches indicated. Truly, the art of Manet *transporté en éventail*.

A brush that writes rather than paints, that writes exquisite notes in the sweet seduction of a perfect epistolary style, notes written in a boudoir, notes of invitation, sometimes confessions of love, the whole feminine heart trembling as a hurt bird trembles in a man's hand. And here are yachts and blue water, the water full of the blueness of the sky; and the confusion of masts and rigging is perfectly indicated without tiresome explanation! The colour is deep and rich, for the values have been truly observed; and the pink house on the left is an exquisite note. No deep solutions, an art afloat and adrift upon the canvas, as a woman's life floats on the surface of life. 'My sister-in-law would not have existed without me,' I remember Manet saying to me in one of the long days we spent together in the Rue d'Amsterdam. True, indeed, that she would not have existed without him; and yet she has something that he has not – the charm of an exquisite feminine fancy, the charm of her sex. Madame Morisot is the eighteenth century quick with the nineteenth. [. . .]

11 Octave Uzanne (1852–1931) 'Women Artists and Bluestockings'

Uzanne was a bibliophile and writer of occasional and anecdotal literature. Like Victor Fournel (IIID7) and Edmondo de Amicis (VIA2), he helped to cultivate the image of Paris as a city of modern and sophisticated pleasures, and of Parisiennes as the models of modern attractiveness and elegance. It is clear from the following excerpt, however, that the woman who aspired to the status of artist or of intellectual was as much at risk of being condemned as unattractive and unmarriageable in the Paris of the 1890s as she had been in the 1830s (see IID5) or as she was in contemporary London (see VB8 and 9). The difference from earlier periods, however, was that women artists were now more visible. For all its assumed urbanity, the tone of Uzanne's writing, like that of the anonymous author of VB9 above, suggests unwittingly that this visibility had come to constitute a form of threat. Given the frequency with which views such as Uzanne's were expressed over a considerable period of time, it was inevitable that women seeking a degree of emancipation should come to associate the concept of genius with masculine oppression. 'Women Artists and Bluestockings' was originally published in Octave Uzanne, *La Femme à Paris: notes successives sur les Parisiennes de ce temps dans leurs divers milieux, états et conditions*, Paris: Ancienne Maison Quartin, Libraries-Imprimeries, 1894. This was a large and luxurious book, with tooled binding and copious hand-coloured engravings by Pierre Vidal. The present chapter was illustrated with pictures of palpably amateur women artists and mannish bluestockings at work. Images such as these provided a background against which the less stereotypical images of Manet, Degas, Morisot and Cassatt established their difference in the eyes of spectators at the time. Our extract is taken from the original English translation, *The Modern Parisienne*, London: Heinemann, 1912, chapter XI, pp. 125–33, though we have referred to the French publication of 1894 in excluding material added subsequent to the first edition.

The intellectual faculties of women have never been so much discussed as they are to-day. After the studies made by Proudhon, Ernest Legouvé, Michelet, Belouino, J. de Marchef-Girard, we have had the works of Paul Rousselot, Mantegazza, Dr H. Thuhié, Mme. Romieu, and many others much more recent, all endeavouring to raise the moral standard and social condition of women.

The physiological and psychological condition of the feminine brain has been discussed at great length, and also its special aptitudes for letters and the arts. Proudhon declared that woman is only receptive, and that she only becomes productive by her influence on man in ideas and real life. Michelet, in his *Education*, said that woman is only a harmony, as man is essentially a worker and producer, and Legouvé was of opinion that woman is an artist by her temperament, impressionable as all artists are – an exact and precise instrument – and that she feels and exhibits the most imperceptible variations of atmosphere in the world of sentiment. All, however, are agreed that from the earliest times to the present, no great work has been signed by a woman's name. In the fine arts, no immortal picture or statue has been produced by a woman. In music, no woman has composed an opera or sonata which can be fitly called a masterpiece. In dramatic art, no authoress has written a tragedy or comedy beyond the mediocre, and in history there has never been a Tacitus or a Thucydides in petticoats.

One might mention Mary Somerville in the realm of physical science; Mme. de Staël, George Eliot, George Sand in literature; Rosa Bonheur and Mme. Lebrun in art. But do they draw us up to the heights as do Newton and Michelangelo?

What is the reason of this absolute lack of genius properly so called among women? Is it to be attributed to social conditions, or to the ignorance in which women are kept, or to the obstacles of all kinds that beset them? The question is a most difficult one. M. Cesare Lombroso, the celebrated Italian physiologist, whose studies are so audacious and whose conclusions are so strange, has lately, in *L'uomo di genio* [*The Man of Genius*], described the difference between genius and talent, and denies genius to women, for the following reasons:

'In all vertebrate animals,' he says, 'the female is inferior to the male in intellect. The aesthetic sentiment is apparent primarily in the males. In singing birds, the male alone sings. Darwin has noticed that in monkeys the feeling for music is more developed in the males. Among certain insects, such as ants and bees, the superiority of the female is only evidenced at the expense of sexuality, that is to say, that the bee is queen only in so far as she ceases to be female'. In this connection M. Lombroso has tried to demonstrate the insensibility of women, or at least their inferiority, in sensations of touch and of pain. Her inferiority in the arts and in intelligence he explains by this insensibility.

'Another cause,' he says, 'which forbids genius in women is that genius is demonstrated by invention. Now the essential characteristic of women is misoneism [hatred of novelty]. She does not care for new things: she preserves for long the customs and beliefs which men have outgrown. Spencer had already remarked that women rarely criticize existing things. In politics her influence is conservative. In short, her imitative sense is highly developed. Now the gift of imitation develops at the expense of originality, which is one of the characteristics of genius. It is the lot of woman to have less keen senses and less active brains, but nature gives her an ennobling compensation.

'The functions of maternity absorb her activity – they must of necessity do so. If we think of the enormous physical and moral importance of this function, of the psychical and organic sacrifice demanded from the mother in child-birth, it must be seen that maternity is of necessity the basis of her mental and physical composition, and that it even endows her with certain anatomical peculiarities. In the function of maternity, we must look for the explanation of the inferior sensibility of woman. Her organism in spending so much vital force on the perpetuation of the race has not sufficient strength left to attain to the muscular and nervous development to which man owes his organic and psychic superiority'.

For these reasons, genius is rarely found in women, and when found it is less intense than the genius of man.

The curious and paradoxical physiologist even goes so far as to say that there are no women of genius, and that if they manifest it, it is by some trick of nature, in the sense that they *are men*. Edmond de Goncourt had already expressed this view, but Cesare Lombroso develops it, and tries to prove that Mme. de Staël, George Eliot, and George Sand were men in physique, in voice, in gesture, and in all the manifestations of their activities. This extreme view, although crude, touches on a great truth. Genius in women is chiefly confined to the emotions, and rarely ascends to the higher regions of thought. Further (and I think this theory has not been broached before), one of the conditions of genius is solitude. Most great men have been solitary spirits. Women cannot live alone, they need support, moral contact, and above all they need

expansion, tenderness, friendship. No woman of talent has been quite able to bear solitude. St Theresa herself loved to receive visits from the outside world at the beginning of her secluded life, and she gave to St John of the Cross the names of son and disciple.

Women have a predisposition to react against extraneous ideas, and at the same time to be influenced by them. In the highest forms of art they express themselves with feeling, delicacy, subtlety, and ingenuity, but rarely with originality. They excel chiefly in miniatures, in flower-painting, in the novel, in letter-writing and conversation, in a word, where feeling, wit and delicacy predominate.

The twentieth century will witness the emancipation of women in art and letters. We are at the dawn of a new era, which will give facilities to women for the development as far as possible of their intellectual faculties. At no other epoch have their talents for painting, sculpture, and above all, literature, been as considerable as at the present day. Women painters, and musicians have multiplied during the last twenty years in bourgeois circles, and even in the *demi-monde*. In painting especially they do not meet with the violent opposition they endured in former times. One may even say that they are too much in favour, too much encouraged by the pride and ambition of their families, for they threaten to become a veritable plague, a fearful confusion, and a terrifying stream of mediocrity. A perfect army of women painters invades the studios and the Salons, and they have even opened an exhibition of 'women painters and sculptors' where their works monopolize whole galleries. The profession of a woman painter is now consecrated, enrolled, and amiably regarded; the girl of a bygone age, who made her own dresses and hats, who cooked jams, and attended to her devotions – the modest flower proposed to candidates for matrimony; this young girl without fortune, educated by her mother in excellent principles of order and economy, is now only to be found in distant provincial places where good traditions still flourish.

The contemporary little bourgeoise does not shine nowadays by her domestic virtues. To the proposer for her hand nothing is said about whether she can cook or whether she has any vague notions of needlework, or any inclinations towards housekeeping, but he is assured that she is a wonderful musician, reading the most difficult Wagner score at sight, that she draws in pastel like Rosalba, executes landscapes like Corot, paints miniatures like Isabey, and that her studies from the life are the admiration of her teachers MM. Jules Lefèvre, Carolus-Duran, or Gervex. They even imply that at a pinch she could, if she would, make money out of her work, and that in such uncertain times as the present it is an excellent thing for a woman to have an occupation, and be able if necessary to maintain herself by her art and her work.

Among these young prodigies, these wonderful little phenomena who challenge the glory of Rosa Bonheur, there are very few who get beyond feeble sketches, or who show any interesting personality. Most of them, in spite of long study, only produce, after great exertion, dreadful green studies from nature, flowers in the style of Madeleine Lemaire, or draw countless pastel portraits before which parents gaze open mouthed, overwhelmed with admiration for the child's genius.

Those who soar above the commonplace, and who do not get their heads turned by their families, the intellectual spirits who, like Marie Bashkirtseff, despise the

imperfections of mediocrity, sometimes realize their dreams and produce most inter-
esting work. There are at present in Paris about fifty young women painters of real
talent, whose pastels, water-colour portraits, miniatures, landscapes, and pretty
sentimental allegories, show sufficient vigour and delicate talent to make one forget
the dreadful daubs of their numerous fellow painters.

Let us come now to their education, and show how the young, energetic and
graceful artists are formed.

Mme. Romieu (Marie Sincère) has given us a little sketch of the girl artist. Let us
examine the different phases of her special education, scarcely known to the general
public.

'If the girl,' she says, 'is too poor to attend a studio, free schools and all kinds
of classes for her art are open to her. But the studio really forms the artist. For the sum
of twenty-five or thirty francs per month, the pupils can spend the whole day at the
studio. They arrive at eight or nine in the morning, and stay until four or six in the
afternoon. The master, generally a painter of merit, visits his pupils twice or three
times in the week. He examines the work of each in turn and makes his comments. He
has no sort of control over them, and does not even live in the house in which his
studio is situated. The pupils gain most of their experience from each other. A studio
is a kind of mutual school and, in spite of the lack of supervision, it is very orderly.
The pupils answer (as it were) for each other's conduct. As pupils are of all ages, there
are not the same drawbacks that might arise were they all young girls. There are
married women, young girls, and children. A child of ten or twelve years sits next to a
woman of thirty. As to the social position of the women, there are daughters of
artisans, of business men, of tradespeople; often daughters of retired military men,
and girls of a higher class whose parents have the good sense to send them where
they can study with professional artists. Young girls of position and fortune are more
or less numerous, according as the studios are more or less fashionable. The studios
are less noisy than one might suppose. Women of all ages are inclined to be on
their guard and reserved with each other. There is seldom the same camaraderie as is
found in men. Some friendships are formed, but not many. Those who come
early bring their lunch, which in winter they eat sitting near the stove. Here they
talk a little, and also in the occasional intervals for rest. They stroll about, looking
at each other's work. These intervals are pretty frequent, as with some the work is
not very assiduous, but the girls who really wish to be artists work with great
industry.'

There are two classes of studio for painting. In one, landscape is exclusively taught;
in the other, the figure. In the latter, models sit twice a week. In the former, which are
the most fashionable, the winters are spent in making sketches, studying detail and
flowers, and in the summer they adjourn to the country to sketch in the open air. The
studios for the figure are full of plaster casts, designs for decoration, busts, and
anatomical drawings. Landscape studios are plainer and emptier. Girls in society
generally devote themselves to landscapes and flowers.

Many of these pupils become, after many disappointments, copyists at the Louvre
and may be seen there any day, working at *Assumptions* or *Descents from the Cross* for
country churches. Others go to the print department at the Bibliothèque Nationale to
copy rare pieces or illuminated missals.

The livelihood of these copyists is precarious. How do they live? How much do they receive for the mediocre works executed with so much patience and courage? Who orders these pictures? For what use are they intended? All these are insoluble problems. The older copyists are mostly silent. Their aspect is forbidding, needy, depressing. They spend their lives in attempting to extract a spark from the inspiration they interpret, and they do not see the frightful abyss that separates their work from its model. They have the blindness of the feeble and mediocre; their very blindness is their strength and helps them to live, they believe themselves to be unrecognized, but they love their work. It is fair to say that some have real talent and a scrupulous care in rendering detail.

Many women distinguish themselves in flower painting, in *genre*, in still life, in miniatures. They never excel in landscape, why, one cannot say.

Women sculptors, who can count among their number the Princesse Marie d'Orléans, Mlle. Fauveau, Mme. Lefèvre-Deumier, Mme. Clovis Hugues, Sarah Bernhardt, and Mme. Besnard, have not so far shown any remarkable talent. The plastic art does not seem to suit them.

We will not enter into descriptions of those who have made their name, whose studios are open to Tout-Paris, who are treated by society like spoilt children. It would be outside the scope of this work to discuss personalities. One may remark, however, that the recognized artist is more agreeable, a better companion and less of a *poseuse* than the unrecognized painter struggling for notoriety.

The last named believes tremendously in herself. She is impossible to live with, and is a great cause of suffering to her husband or lovers. She is irritable, restless, egotistical, and art (which she calls 'her art'), of which she is always talking, has deprived her of all feminine grace, all playfulness and youth, all in fact which makes women charming. In the country there is no poetry left, she only searches for studies. If one speaks of any sentiment, she talks of *values*, *tones*, and *compositions*. In her studio she is worse; she thinks only of her canvases, her rough sketches, her future exhibits, the frames she has to get, the notices she must obtain. She is a terribly tedious person, for she forgets her sex and her natural qualities, and affects airs of superiority, which are justified neither by her natural talent nor her acquired dexterity.

12 Friedrich Nietzsche (1844–1900) from *The Will to Power*

The material collected under the title *The Will to Power* was first published in Leipzig in 1901, a year after Nietzsche's death, by his sister, Elisabeth Förster-Nietzsche. It consists of a selection of writings from his notebooks from the years 1883 to 1888. A second expanded edition appeared in 1904, and then a third in 1906, published in two volumes, which increased the number of notes included to 1,067. The present extract is of a draft for a preface to the new edition of *The Birth of Tragedy*, which appeared in 1886. Although fragmentary, it provides a fascinating insight into Nietzsche's understanding of his own earlier work and reveals the extent to which he has succeeded in transforming his Schopenhauerian commitments. Where Schopenhauer (see IA1, above) had conceived aesthetic experience in terms of the suspension of the will, and

thus as a temporary release from suffering, Nietzsche maintains that art must be seen as 'the great stimulant to life', recognizing art as 'the only superior counterforce to all will to denial of life'. The text is taken from the English translation of the third, expanded edition of *Der Wille zur Macht*, by Walter Kaufmann and R. J. Hollingdale, New York: Vintage, 1968, pp. 451–53.

(I)

The conception of the work that one encounters in the background of this book is singularly gloomy and unpleasant: no type of pessimism known hitherto seems to have attained to this degree of malevolence. The antithesis of a real and an apparent world is lacking here: there is only *one* world, and this is false, cruel, contradictory, seductive, without meaning – A world thus constituted is the real world. *We have need of lies* in order to conquer this reality, this 'truth,' that is, in order to *live* – That lies are necessary in order to live is itself part of the terrifying and questionable character of existence.

Metaphysics, morality, religion, science – in this book these things merit consideration only as various forms of lies: with their help one can have *faith* in life. 'Life *ought* to inspire confidence': the task thus imposed is tremendous. To solve it, man must be a liar by nature, he must be above all an *artist*. And he *is* one: metaphysics, religion, morality, science – all of them only products of his will to art, to lie, to flight from 'truth,' to *negation* of 'truth.' This ability itself, thanks to which he violates reality by means of lies, this artistic ability of man *par excellence* – he has it in common with everything that is. He himself is after all a piece of reality, truth, nature: how should he not also be a piece of *genius in lying*!

That the character of existence is to be misunderstood – profoundest and supreme secret motive behind all that is virtue, science, piety, artistry. Never to see many things, to see many things falsely, to imagine many things: oh how shrewd one still is in circumstances in which one is furthest from thinking oneself shrewd! Love, enthusiasm, 'God' – So many subtleties of ultimate self-deception, so many seductions to life, so much faith in life! In those moments in which man was deceived, in which he duped himself, in which he believes in life: oh how enraptured he feels! What delight! What a feeling of power! How much artists' triumph in the feeling of power! – Man has once again become master of '*material*' – master of truth! – And whenever man rejoices, he is always the same in his rejoicing: he rejoices as an artist, he enjoys himself as power, he enjoys the lie as his form of power. –

(II)

Art and nothing but art! It is the great means of making life possible, the great seduction to life, the great stimulant of life.

Art as the only superior counterforce to all will to denial of life, as that which is anti-Christian, anti-Buddhist, antinihilist *par excellence*.

Art as the *redemption of the man of knowledge* – of those who see the terrifying and questionable character of existence, who want to see it, the men of tragic knowledge.

Art as the *redemption of the man of action* – of those who not only see the terrifying and questionable character of existence but live it, want to live it, the tragic-warlike man, the hero.

Art as the *redemption of the sufferer* – as the way to states in which suffering is willed, transfigured, deified, where suffering is a form of great delight.

(III)
One will see that in this book pessimism, or to speak more clearly, nihilism, counts as 'truth.' But truth does not count as the supreme value, even less as the supreme power. The will to appearance, to illusion, to deception, to becoming and change (to objectified deception) here counts as more profound, primeval, 'metaphysical' than the will to truth, to reality, to mere appearance: – the last is itself merely a form of the will to illusion. In the same way, pleasure counts as being more primeval than pain: pain only as conditioned, as a consequence of the will to pleasure (of the will to become, grow, shape, i.e., *to create*: in creation, however, destruction is included). A highest state of affirmation of existence is conceived from which the highest degree of pain cannot be excluded: the *tragic-Dionysian* state.

(IV)
In this way, this book is even anti-pessimistic: that is, in the sense that it teaches something that is stronger than pessimism, 'more divine' than truth: *art*. Nobody, it seems, would more seriously propose a radical negation of life, a really *active* negation even more than merely *saying* No to life, than the author of this book. Except that he knows – he has experience of it, perhaps he has experience of nothing else! – that art is *worth more* than truth.

Already in the preface, in which Richard Wagner is invited as to a dialogue, this confession of faith, this artists' gospel, appears: 'art as the real task of life, art as life's *metaphysical* activity –'

13 Friedrich Nietzsche (1844–1900) from *Twilight of the Idols*

Nietzsche wrote *Twilight of the Idols* in 1888, the last year of his productive activity, but it did not appear in print until January 1889, by which time he had suffered a complete mental collapse. Bearing the subtitle, 'How one Philosophises with a Hammer', it provides a wide-ranging summary of his later thought in the form of a series of aphorisms, a mode of writing which Nietzsche brought to its highest pitch. The present extracts are taken from the section entitled 'Skirmishes of an Untimely Man'. Nietzsche returns once again to the conceptual opposition between the Apollinian and the Dionysian, but his account is enriched by his new, 'psychological' enquiry into the underlying purpose and function of art. Originally published as *Götzen-Dämmerung*, Leipzig: C. G. Naumann, 1889, these extracts are taken from the translation by Walter Kaufmann in *The Portable Nietzsche*, New York: Viking, 1980, pp. 518–21, 525–7, 529–30.

Toward a psychology of the artist. If there is to be art, if there is to be any aesthetic doing and seeing, one physiological condition is indispensable: frenzy. Frenzy must first have enhanced the excitability of the whole machine; else there is no art. All kinds of frenzy, however diversely conditioned, have the strength to accomplish this: above all, the frenzy of sexual excitement, this most ancient and original form of frenzy. Also the frenzy that follows all great cravings, all strong affects; the frenzy of feasts,

contests, feats of daring, victory, all extreme movement; the frenzy of cruelty; the frenzy in destruction; the frenzy under certain meteorological influences, as for example the frenzy of spring; or under the influence of narcotics; and finally the frenzy of will, the frenzy of an overcharged and swollen will. What is essential in such frenzy is the feeling of increased strength and fullness. Out of this feeling one lends to things, one *forces* them to accept from us, one violates them – this process is called *idealizing*. Let us get rid of a prejudice here: idealizing does not consist, as is commonly held, in subtracting or discounting the petty and inconsequential. What is decisive is rather a tremendous drive to bring out the main features so that the others disappear in the process.

In this state one enriches everything out of one's own fullness: whatever one sees, whatever one wills, is seen swelled, taut, strong, overloaded with strength. A man in this state transforms things until they mirror his power – until they are reflections of his perfection. This *having to* transform into perfection is – art. Even everything that he is not yet, becomes for him an occasion of joy in himself; in art man enjoys himself as perfection.

It would be permissible to imagine an opposite state, a specific anti-artistry by instinct – a mode of being which would impoverish all things, making them thin and consumptive. And, as a matter of fact, history is rich in such anti-artists, in such people who are starved by life and must of necessity grab things, eat them out, and make them more meagre. This is, for example, the case of the genuine Christian – of Pascal, for example: a Christian who would at the same time be an artist simply does not occur. One should not be childish and object by naming Raphael or some homeopathic Christian of the nineteenth century: Raphael said Yes, Raphael *did* Yes; consequently, Raphael was no Christian.

What is the meaning of the conceptual opposites which I have introduced into aesthetics, *Apollinian* and *Dionysian*, both conceived as kinds of frenzy? The Apollinian frenzy excites the eye above all, so that it gains the power of vision. The painter, the sculptor, the epic poet are visionaries par excellence. In the Dionysian state, on the other hand, the whole affective system is excited and enhanced: so that it discharges all its means of expression at once and drives forth simultaneously the power of representation, imitation, transfiguration, transformation, and every kind of mimicking and acting. The essential feature here remains the ease of metamorphosis, the inability *not* to react (similar to certain hysterical types who also, upon any suggestion, enter into *any* role). It is impossible for the Dionysian type not to understand any suggestion; he does not overlook any sign of an affect; he possesses the instinct of understanding and guessing in the highest degree, just as he commands the art of communication in the highest degree. He enters into any skin, into any affect: he constantly transforms himself.

Music, as we understand it today, is also a total excitement and a total discharge of the affects, but even so only the remnant of a much fuller world of expression of the affects, a mere residue of the Dionysian histrionicism. To make music possible as a separate art, a number of senses, especially the muscle sense, have been immobilized (at least relatively, for to a certain degree all rhythm still appeals to our muscles); so

that man no longer bodily imitates and represents everything he feels. Nevertheless, that is really the normal Dionysian state, at least the original state. Music is the specialization of this state attained slowly at the expense of those faculties which are most closely related to it.

The actor, the mime, the dancer, the musician, and the lyric poet are basically related in their instincts and, at bottom, one – but gradually they have become specialized and separated from each other, even to the point of mutual opposition. The lyric poet remained united with the musician for the longest time; the actor, with the dancer.

The *architect* represents neither a Dionysian nor an Apollinian state: here it is the great act of will, the will that moves mountains, the frenzy of the great will which aspires to art. The most powerful human beings have always inspired architects; the architect has always been under the spell of power. His buildings are supposed to render pride visible, and the victory over gravity, the will to power. Architecture is a kind of eloquence of power in forms – now persuading, even flattering, now only commanding. The highest feeling of power and sureness finds expression in a *grand style*. The power which no longer needs any proof, which spurns pleasing, which does not answer lightly, which feels no witness near, which lives oblivious of all opposition to it, which reposes within itself, fatalistically, a law among laws – that speaks of itself as a grand style.

Beautiful and ugly. Nothing is more conditional – or, let us say, narrower – than our feeling for beauty. Whoever would think of it apart from man's joy in man would immediately lose any foothold. 'Beautiful in itself' is a mere phrase, not even a concept. In the beautiful, man posits himself as the measure of perfection; in special cases he worships himself in it. A species cannot do otherwise but thus affirm itself alone. Its *lowest* instinct, that of self-preservation and self-expansion, still radiates in such sublimities. Man believes the world itself to be overloaded with beauty – and he forgets himself as the cause of this. He alone has presented the world with beauty – alas! only with a very human, all-too-human beauty. At bottom, man mirrors himself in things; he considers everything beautiful that reflects his own image: the judgement 'beautiful' is the *vanity of his species*. For a little suspicion may whisper this question into the sceptic's ear: Is the world really beautified by the fact that man thinks it beautiful? He has *humanized* it, that is all. But nothing, absolutely nothing, guarantees that man should be the model of beauty. Who knows what he looks like in the eyes of a higher judge of beauty? Daring perhaps? Perhaps even amusing? Perhaps a little arbitrary?

'O Dionysus, divine one, why do you pull me by my ears?' Ariadne once asked her philosophic lover during one of those famous dialogues on Naxos. 'I find a kind of humour in your ears, Ariadne: why are they not even longer?'

Nothing is beautiful, except man alone: all aesthetics rests upon this naïveté, which is its *first* truth. Let us immediately add the second: nothing is ugly except the degenerating man – and with this the realm of aesthetic judgement is circumscribed. Physiologically, everything ugly weakens and saddens man. It reminds him of decay,

danger, impotence; it actually deprives him of strength. One can measure the effect of the ugly with a dynamometer. Wherever man is depressed at all, he senses the proximity of something 'ugly.' His feeling of power, his will to power, his courage, his pride – all fall with the ugly and rise with the beautiful. In both cases we draw an inference: the premises for it are piled up in the greatest abundance in instinct. The ugly is understood as a sign and symptom of degeneration: whatever reminds us in the least of degeneration causes in us the judgement of 'ugly.' Every suggestion of exhaustion, of heaviness, of age, of weariness; every kind of lack of freedom, such as cramps, such as paralysis; and above all, the smell, the colour, the form of dissolution, of decomposition – even in the ultimate attenuation into a symbol – all evoke the same reaction, the value judgement, 'ugly.' A *hatred* is aroused – but whom does man hate then? There is no doubt: the *decline of his type*. Here he hates out of the deepest instinct of the species; in this hatred there is a shudder, caution, depth, farsightedness – it is the deepest hatred there is. It is because of this that art is deep.

L'art pour l'art. The fight against purpose in art is always a fight against the moralizing tendency in art, against its subordination to morality. *L'art pour l'art* means, 'The devil take morality!' But even this hostility still betrays the overpowering force of the prejudice. When the purpose of moral preaching and of improving man has been excluded from art, it still does not follow by any means that art is altogether purposeless, aimless, senseless – in short, *l'art pour l'art*, a worm chewing its own tail. 'Rather no purpose at all than a moral purpose!' – that is the talk of mere passion. A psychologist, on the other hand, asks: what does all art do? Does it not praise? glorify? choose? prefer? With all this it strengthens or weakens certain valuations. Is this merely a 'moreover'? an accident? something in which the artist's instinct had no share? Or is it not the very presupposition of the artist's ability? Does his basic instinct aim at art, or rather at the sense of art, at life? at a desirability of life? Art is the great stimulus to life: how could one understand it as purposeless, as aimless, as *l'art pour l'art*?

One question remains: art also makes apparent much that is ugly, hard, and questionable in life; does it not thereby spoil life for us? And indeed there have been philosophers who attributed this sense to it: 'liberation from the will' was what Schopenhauer taught as the over-all end of art; and with admiration he found the great utility of tragedy in its 'evoking resignation.' But this, as I have already suggested, is the pessimist's perspective and 'evil eye.' We must appeal to the artists themselves. What does the tragic artist communicate of himself? Is it not precisely the state *without* fear in the face of the fearful and questionable that he is showing? This state itself is a great desideratum; whoever knows it, honours it with the greatest honours. He communicates it – *must* communicate it, provided he is an artist, a genius of communication. Courage and freedom of feeling before a powerful enemy, before a sublime calamity, before a problem that arouses dread – this triumphant state is what the tragic artist chooses, what he glorifies. Before tragedy, what is warlike in our soul celebrates its Saturnalia; whoever is used to suffering, whoever seeks out suffering, the heroic man praises his own being through tragedy – to him alone the tragedian presents this drink of sweetest cruelty.

14 Julius Langbehn (1851–1907) from *Rembrandt as Educator*

Langbehn initially studied chemistry, and then art and architecture, at Munich, but after receiving his doctorate he abandoned any attempt to pursue an orthodox academic career. In the 1880s he lived an itinerant and impoverished existence, reading widely whilst developing his plan for a 'reform of the entire cultural life of Germany'. When *Rembrandt as Educator* was finally published in 1890 it was an astonishing success, running through 39 editions in the first two years. Langbehn had the work published anonymously as 'by a German', and he refused all royalties, declaring that 'Money is dirt'. Langbehn preached a return to old German values based on a form of populist primitivism that emphasized the role of the 'Volk'. A restoration of the virtues of simplicity, spontaneity and individuality was required in order to reverse the cultural decline of Germany brought about by the effects of science, commerce and materialism. The source of social regeneration, however, was to be found in the domain of art, and Langbehn employs the historical figure of Rembrandt, the 'very prototype of the German artist', as a model for the cultural ideal through which a 'lacerated' modern society was to be healed. Langbehn's critique of liberal urban culture influenced a generation of German artists and contributed towards the cult of artists' communities established in remote rural areas. It also stimulated the so-called 'hunger for wholeness'. This was a powerful influence on conservative cultural reactions in Germany against the alienation of modern life, finding its culmination in the rise of National Socialism. *Rembrandt als Erzieher* was first published in Leipzig in 1890. These extracts have been translated for the present volume by Nicholas Walker from the second edition Leipzig: G. L. Hirschfeld Verlag, pp. 1–3, 6, 8–9, 37–8, 75.

It has now really become an open secret that the cultural and spiritual life of the German people currently finds itself in a condition of slowly, though some would even claim rapidly, unfolding decline. The realm of science dissipates itself on every side into narrow specialism; individuals of epoch-making significance can no longer be found either in the realms of thought or of higher literature; the visual and plastic arts, although they can still boast certain significant masters, are quite lacking in monumentality, and thereby also in their most outstanding effect; genuine musical spirits are rare, while musicians abound. Architecture constitutes the axis of the plastic and visual arts, just as philosophy constitutes the axis of all systematic thought; but at the present time we cannot speak either of a German architecture or a German philosophy. The mighty Corephae are all dying out in the most varied domains; *les rois s'en vent* [the kings depart]. The contemporary art market, with its obsessive interest in every style, has already sampled every possible people and epoch, but despite this, or rather precisely because of it, has still failed to discover a style of its own. There is no doubt that all of this expresses the democratizing, levelling and atomizing spirit of our own century. What is more, the entire culture of the present age represents a historical and backward-looking, or 'Alexandrian', culture, one which directs its energies less towards the creation of new values than towards the cataloguing of ancient ones. And this is what essentially characterizes the enfeebled aspect of all our modern contemporary culture; it is scientifically systematic, and wishes to be scientifically systematic; but the more scientific it actually becomes, the less creative it turns out to be. 'You hold indeed the parts within your hand, but yet

the spiritual bond itself is gone'. Goethe, someone whom contemporary Germans honour theoretically rather than practically, could not endure the sight of people with spectacles; Germany is now full of people who wear real as well as spiritual spectacles; but when shall we return to Goethe's standpoint in this respect? It is certainly not fitting for the inhabitants of a newly emerged kingdom like Germany simply to shrug their shoulders and confess themselves epigones, renouncing further progress in the crucial issues and questions of cultural and spiritual life. There is no more fateful error than that of believing oneself to be in full and final possession of the essential features of culture, in thinking that one merely has to patch things up in the occasional spot: as long as a people is still alive, it cannot evade the necessity of opening itself to great spiritual and cultural transformations of perspective in the innermost core of its being. These days discoveries are being made in East Africa, but there are still far more important discoveries to be made within Germany itself; it is not enough that the Germans have discovered themselves as political citizens, for they must also discover themselves as human beings.

And in fact it is already possible to descry an incipient movement in this direction; the finer spirits amongst the educated classes in Germany are already spying out new objectives in the spiritual and cultural realm. Bismarck has expressed the thought that 'the people's view is difficult to recognize', and indeed the latter is often enough quite different from what is called 'public opinion'; but even a half-concealed tendency often betrays itself as a kind of obscure rumbling. And so too it is here. The interest in scientific knowledge in general, and particularly in the natural sciences which were once so popular, seems to be declining in many circles of the German world; and a perceptible reversal of the general mood is beginning to occur; those times in which a highly respected member of a scientific association in Kassel could seriously describe such an organization as 'the very brain of Germany' are now past and gone. No one really believes in that particular kind of gospel any longer. We are now quite sated with the processes of scientific induction, and what we thirst after is synthesis; the days of objectivity are gradually nearing their end once again, and it is subjectivity which we now hear knocking at the door. [. . .]

Given the decline of the prevailing scientific culture on the one hand, and the emergence of a dawning artistic culture on the other, we should perhaps investigate the best means to promote these two developments as much as possible, to guide and develop them as clearly as possible. In its present state of culture the German people is all too mature; but this maturity is at bottom merely a form of immaturity; for barbarism is always immature with respect to culture; and in Germany a certain systematic, scientific and cultivated barbarism has always been at home. 'You know what our Germany is like; it has not yet ceased to lack culture', as Reuchlin once wrote to Manutius, and any honest German could still say the same to another German even today. An excess of cultivation is actually cruder than a total lack of cultivation. This is where various new educational factors would have to come into play; and indeed they would have to try and counter the effects of our former and traditional forms of education: the people must be educated back to nature rather than away from her. But through whom? Through itself. And how? By reaching back into its own fundamental resources.

* * *

One thing is certain: Germany cannot renounce its ideals without thereby renouncing itself; but it must accommodate its ideals to the time and its times to its ideals. The historicizing and scientific tendencies of this our present age are not themselves fundamentally opposed to this; for it would constitute an extremely superficial judgement to assume that a world-view firmly based upon reality could or should dispense with some deeper ideal content. Culture itself never simply goes backwards; but rather, like a tree, it constantly gives rise to new rings and layers which include the earlier ones within themselves: this is precisely what we call 'growth'. Accordingly, the Germans of today, whose grandfathers possessed an ideal culture and whose fathers possessed a historical culture, must draw upon the cultural achievements of both preceding generations precisely by appropriating certain historical ideals for themselves. Such individuals will be the heroes of the spirit, forefathers of the people, exemplary representatives of those characteristic features of the people which are destined to appear upon the surface of history in the present and the imminently dawning age. According to the much under-appreciated Grabbe, 'There is only one great fortune, and that is: to reform oneself, to be intelligent enough to be utterly noble'. And such spirits can help the Germans to attain this good fortune. They are mirror-images of the fairest existence of the people itself; and in them the people can find the measure for its own achievements, its own powers and its own objectives; in them the people honours itself. They are a focus enabling the development of the people's spirit to crystallize at the relevant stage; they constitute a school in the highest sense, one in which the people can prepare itself for the events of its future destiny; in short, they are the educators of their people.

* * *

If the Germans constitute an eminent people, then in the artistic sphere only the most individual figure amongst their artists is capable of serving as a spiritual guide; for only such a one would most likely bring them back to themselves. But amongst all German artists the most individual is Rembrandt. [...] Rembrandt is the very prototype of the German artist; he and he alone therefore answers in an exemplary fashion to the needs and desires which hover before the German people of today in the cultural and spiritual realm – even if this is still partly unconscious. Under different conditions from those currently prevailing it is quite possible that some other great German might or must indeed assume this role. But today, when Germans see their culture withering away through the pursuit of specialism or standardization, it is only Rembrandt as the most thorough universalist and individualist who is in a position to help them. He can lead them back towards themselves. He constitutes the relevant historical ideal for the age that is dawning; he is the firm and solid basis from which new cultural forms with a promising future could take a start. But Rembrandt was a Dutchman by birth. It is a characteristic feature of the Germans, and one which externally confirms their eccentric nature, that their most national artist only belongs to them in an inner rather than a political sense; the national spirit of the Germans had displaced, as it were, the German body politic. That must change from now on; the spirit and the body, both in the people and in the individual, must be reunited; the rent which lacerates modern culture must once again be closed. And only a living human individual, cast like Curtius into the abyss, can close it; Rembrandt is such an individual. His personality, in all its utterly unforced spontaneity and exceptional

individuality, appears as a truly effective antidote to that German scholastic pedantry which has already wreaked such havoc; this man can be accommodated in no standard school; he scorns any attempt to force him upon any Procrustean bed of erudition. Academic programmes and scholastic formulae can not be coined in his image, as they can with Raphael and others; he is and remains who he is: simply Rembrandt.

* * *

It is impossible to imagine that Rembrandt's sensibility can have any influence upon the art of the German people without at the same time influencing the ethical and broader cultural and spiritual life of the same people. If the visual and plastic arts are indeed to stand at the very centre of the people's life in the future, then these arts will also exercise an influence far beyond their own immediate borders; and therefore Rembrandt too, quite apart from the aspect of his artistic mastery, will also be able to offer inspiration and guidance of various kinds to the German spirit and the German realm. A real human being is something inexhaustible, and this is equally true of one of the most authentic German spirits, the man Rembrandt. The individualization of art, in Rembrandt's sense, will of itself already promote a closer association of life and art; once art is mindful once again of the spirit of the people, so the spirit of the people will also become mindful once again of art; that the latter is not yet the case, that our contemporary German art simply addresses itself to the vague concept of the 'culti-vated individual', is all too obvious. Any truly effective influence upon the people on the part of art can only be developed from the perspective of a genuine art of the people. Here too Rembrandt can serve as a focus and guiding light for our efforts. What our contemporary German artists and our contemporary German connoisseurs lack most of all: namely, a profound inner seriousness of attitude and of life, a total disregard for all external considerations – the market, fashion, society, cultural trivia and the romantic cult of personality – this is nowhere better to be found than in Rembrandt! The surviving works of no other painter, indeed of no other artist, are so filled with such a profound seriousness quite regardless of the world as are those of Rembrandt. The figures he created peer at us from the very bottom of their souls; one almost wants to say that it is not merely the labour of the artist but the manifest presence of the work of art itself which we utterly forget in contemplation of its very soul. Such things can only be achieved by the greatest of masters. Rembrandt's art is permeated by character throughout; it recalls the sacred seriousness of Luther and stands out strikingly against the frivolity which so often prevails in the life and accomplishments of the artistic world of today. During the final years of his life the Dutch Master also stood alone and isolated amongst the passing artistic fashions of the day which were beginning to take root in his own country; none the less, he remained the individual he was. The profound, spontaneous and unshakeable faith in authentic truth never abandoned him; and the Germans of today, exposed as now they are to such a spurious and glittering display of character and culture, should try especially to learn this faith from him. For then they shall not merely honour the artist but also the man Rembrandt; and the blessings of his great and wholesome presence will stream down upon them.

* * *

It is obvious that German science and scholarship can not simply renounce the results which it has already attained; but it must strive, much more than it has before,

to bring the personal element to these results; it may no longer limp along at a distance, insisting on its so-called objectivity. For new and vital creations can only arise from the equal standing, from the inner penetration, from the spiritual union of subjectivity and objectivity. If art, according to Shakespeare, is indeed a mirror, then we can certainly compare science and scholarship with a pane of glass; the latter lets the light through, while the former captures it for us; but one must not forget that a pane of glass only becomes a mirror once we supply it with the appropriate dark background; so too, science and scholarship, when and to the extent that it tries to approach more closely to art itself, cannot dispense with a certain dark background either. [. . .]

15 Oscar Wilde (1854–1900) 'The Soul of Man under Socialism'

Wilde was born into an intensely literary, professional family in Dublin, his father a writer as well as an eminent surgeon, his mother a radical poet and Irish nationalist. After studying at Trinity College, Dublin, Wilde went to Oxford in 1874 where he fell under the twin influences of Ruskin and Pater (cf. IIIA9 and Vc1). For all their differences both these writers placed the experience of art at the centre of life. During the 1880s Wilde became identified as the leading figure of English Aestheticism and as an advocate of 'art for art's sake' (cf. Vc9). Art for art's sake is usually taken to bespeak elitism, or at least a carelessness for worldly affairs. However in Wilde's case it coincided with a commitment to socialism. Wilde is concerned above all with the self-realization of the human individual, a condition which he identifies with the experience of art. His point is that, because of the economic inequality which capitalism structurally produces, it is socialism which holds out the best prospect for the full realization of the individual. Seen in this light, the presumed antithesis of art for art's sake and socialism tends to dissolve. *Together* they represent the condition of human freedom. 'The Soul of Man under Socialism' was originally published in *The Fortnightly Review*, London, February 1890. Our extracts are from the text as printed in Vyvyan Holland (ed.), *Complete Works of Oscar Wilde* (1948), London and Glasgow: Harper Collins, 1992, pp. 1080–91).

[. . .] Socialism itself will be of value simply because it will lead to Individualism.

Socialism, Communism, or whatever one chooses to call it, by converting private property into public wealth, and substituting co-operation for competition, will restore society to its proper condition of a thoroughly healthy organism, and ensure the material well-being of each member of the community. It will, in fact, give Life its proper basis and its proper environment. But, for the full development of Life to its highest mode of perfection, something more is needed. What is needed is Individualism.

But it may be asked how Individualism, which is now more or less dependent on the existence of private property for its development, will benefit by the abolition of such private property. The answer is very simple. It is true that, under existing conditions, a few men who have had private means of their own, such as Byron, Shelley, Browning, Victor Hugo, Baudelaire, and others, have been able to realize their personality, more or less completely. Not one of these men ever did a single day's work for hire. They were relieved from poverty. They had an immense

advantage. The question is whether it would be for the good of Individualism that such an advantage should be taken away. Let us suppose that it is taken away. What happens then to Individualism? How will it benefit?

It will benefit in this way. Under the new conditions Individualism will be far freer, far finer, and far more intensified than it is now. I am not talking of the great imaginatively realized Individualism of such poets as I have mentioned, but of the great actual Individualism latent and potential in mankind generally. For the recognition of private property has really harmed Individualism, and obscured it, by confusing a man with what he possesses. It has led Individualism entirely astray. It has made gain, not growth, its aim. So that man thought that the important thing was to have, and did not know that the important thing is to be. The true perfection of man lies, not in what man has, but in what man is. Private property has crushed true Individualism, and set up an Individualism that is false. It has debarred one part of the community from being individual by starving them. It has debarred the other part of the community from being individual by putting them on the wrong road, and encumbering them. Indeed, so completely has man's personality been absorbed by his possessions that the English law has always treated offences against a man's property with far more severity than offences against his person, and property is still the test of complete citizenship. The industry necessary for the making of money is also very demoralizing. In a community like ours, where property confers immense distinction, social position, honour, respect, titles, and other pleasant things of the kind, man, being naturally ambitious, makes it his aim to accumulate this property, and goes on wearily and tediously accumulating it long after he has got far more than he wants, or can use, or enjoy, or perhaps even know of. Man will kill himself by overwork in order to secure property, and really, considering the enormous advantages that property brings, one is hardly surprised. One's regret is that society should be constructed on such a basis that man has been forced into a groove in which he cannot freely develop what is wonderful, and fascinating, and delightful in him – in which, in fact, he misses the true pleasure and joy of living. He is also, under existing conditions, very insecure. An enormously wealthy merchant may be – often is – at every moment of his life at the mercy of things that are not under his control. If the wind blows an extra point or so, or the weather suddenly changes, or some trivial thing happens, his ship may go down, his speculations may go wrong, and he finds himself a poor man, with his social position quite gone. Now, nothing should be able to harm a man except himself. Nothing should be able to rob a man at all. What a man really has, is what is in him. What is outside of him should be a matter of no importance.

With the abolition of private property, then, we shall have true, beautiful, healthy Individualism. Nobody will waste his life in accumulating things, and the symbols for things. One will live. To live is the rarest thing in the world. Most people exist, that is all. [. . .]

Up to the present, man has been, to a certain extent, the slave of machinery, and there is something tragic in the fact that as soon as man had invented a machine to do his work he began to starve. This, however, is, of course, the result of our property system and our system of competition. One man owns a machine which does the work of five hundred men. Five hundred men are, in consequence, thrown out of employ-

ment, and, having no work to do, become hungry and take to thieving. The one man secures the produce of the machine and keeps it, and has five hundred times as much as he should have, and probably, which is of much more importance, a great deal more than he really wants. Were that machine the property of all, everybody would benefit by it. It would be an immense advantage to the community. All unintellectual labour, all monotonous, dull labour, all labour that deals with dreadful things, and involves unpleasant conditions, must be done by machinery. Machinery must work for us in coal mines, and do all sanitary services, and be the stoker of steamers, and clean the streets, and run messages on wet days, and do anything that is tedious or distressing. At present machinery competes against man. Under proper conditions machinery will serve man. There is no doubt at all that this is the future of machinery; and just as trees grow while the country gentleman is asleep, so while Humanity will be amusing itself, or enjoying cultivated leisure – which, and not labour, is the aim of man – or making beautiful things, or reading beautiful things, or simply contemplating the world with admiration and delight, machinery will be doing all the necessary and unpleasant work. The fact is, that civilization requires slaves. The Greeks were quite right there. Unless there are slaves to do the ugly, horrible, uninteresting work, culture and contemplation become almost impossible. Human slavery is wrong, insecure, and demoralizing. On mechanical slavery, on the slavery of the machine, the future of the world depends. And when scientific men are no longer called upon to go down to a depressing East End and distribute bad cocoa and worse blankets to starving people, they will have delightful leisure in which to devise wonderful and marvellous things for their own joy and the joy of every one else. There will be great storages of force for every city, and for every house if required, and this force man will convert into heat, light, or motion, according to his needs. Is this Utopian? A map of the world that does not include Utopia is not worth even glancing at, for it leaves out the one country at which Humanity is always landing. And when Humanity lands there, it looks out, and, seeing a better country, sets sail. Progress is the realization of Utopias.

Now, I have said that the community by means of organization of machinery will supply the useful things, and that the beautiful things will be made by the individual. This is not merely necessary, but it is the only possible way by which we can get either the one or the other. An individual who has to make things for the use of others, and with reference to their wants and their wishes, does not work with interest, and consequently cannot put into his work what is best in him. Upon the other hand, whenever a community or a powerful section of a community, or a government of any kind, attempts to dictate to the artist what he is to do, Art either entirely vanishes, or becomes stereotyped, or degenerates into a low and ignoble form of craft. A work of art is the unique result of a unique temperament. Its beauty comes from the fact that the author is what he is. It has nothing to do with the fact that other people want what they want. Indeed, the moment that an artist takes notice of what other people want, and tries to supply the demand, he ceases to be an artist, and becomes a dull or an amusing craftsman, an honest or a dishonest tradesman. He has no further claim to be considered as an artist. Art is the most intense mood of Individualism that the world has known. I am inclined to say that it is the only real mode of Individualism that the world has known. Crime, which, under certain conditions, may seem to have created Individualism, must take cognisance of other people and interfere with them. It

belongs to the sphere of action. But alone, without any reference to his neighbours, without any interference the artist can fashion a beautiful thing; and if he does not do it solely for his own pleasure, he is not an artist at all.

And it is to be noted that it is the fact that Art is this intense form of Individualism that makes the public try to exercise over it an authority that is as immoral as it is ridiculous, and as corrupting as it is contemptible. It is not quite their fault. The public has always, and in every age, been badly brought up. They are continually asking Art to be popular, to please their want of taste, to flatter their absurd vanity, to tell them what they have been told before, to show them what they ought to be tired of seeing, to amuse them when they feel heavy after eating too much, and to distract their thoughts when they are wearied of their own stupidity. Now Art should never try to be popular. The public should try to make itself artistic. There is a very wide difference. If a man of science were told that the results of his experiments, and the conclusions that he arrived at, should be of such a character that they would not upset the received popular notions on the subject, or disturb popular prejudice, or hurt the sensibilities of people who knew nothing about science; if a philosopher were told that he had a perfect right to speculate in the highest spheres of thought, provided that he arrived at the same conclusions as were held by those who had never thought in any sphere at all – well, nowadays the man of science and the philosopher would be considerably amused. Yet it is really a very few years since both philosophy and science were subjected to brutal popular control, to authority in fact – the authority of either the general ignorance of the community, or the terror and greed for power of an ecclesiastical or governmental class. Of course, we have to a very great extent got rid of any attempt on the part of the community, or the Church, or the Government, to interfere with the individualism of speculative thought, but the attempt to interfere with the individualism of imaginative art still lingers. In fact, it does more than linger; it is aggressive, offensive, and brutalizing.

In England, the arts that have escaped best are the arts in which the public take no interest. Poetry is an instance of what I mean. We have been able to have fine poetry in England because the public do not read it, and consequently do not influence it. The public like to insult poets because they are individual, but once they have insulted them, they leave them alone. In the case of the novel and the drama, arts in which the public do take an interest, the result of the exercise of popular authority has been absolutely ridiculous. No country produces such badly written fiction, such tedious, common work in the novel form, such silly, vulgar plays as England. It must necessarily be so. The popular standard is of such a character that no artist can get to it. It is at once too easy and too difficult to be a popular novelist. It is too easy, because the requirements of the public as far as plot, style, psychology, treatment of life, and treatment of literature are concerned are within the reach of the very meanest capacity and the most uncultivated mind. It is too difficult, because to meet such requirements the artist would have to do violence to his temperament, would have to write not for the artistic joy of writing, but for the amusement of half-educated people, and so would have to suppress his individualism, forget his culture, annihilate his style, and surrender everything that is valuable in him. In the case of the drama, things are a little better: the theatre-going public like the obvious, it is true, but they

do not like the tedious; and burlesque and farcical comedy, the two most popular forms, are distinct forms of art. Delightful work may be produced under burlesque and farcical conditions, and in work of this kind the artist in England is allowed very great freedom. It is when one comes to the higher forms of the drama that the result of popular control is seen. The one thing that the public dislike is novelty. Any attempt to extend the subject-matter of art is extremely distasteful to the public; and yet the vitality and progress of art depend in a large measure on the continual extension of subject-matter. The public dislike novelty because they are afraid of it. It represents to them a mode of Individualism, an assertion on the part of the artist that he selects his own subject, and treats it as he chooses. The public are quite right in their attitude. Art is Individualism, and Individualism is a disturbing and disintegrating force. Therein lies its immense value.

16 Paul Signac (1863–1935) 'Impressionists and Revolutionaries'

Signac was a member of the group of painters that first gathered around Seurat in the mid 1880s, adopting and variously developing the systematic 'divisionist' or 'Neo-Impressionist' technique that he pioneered (see VIʙ6–10). For several members of this group the virtue of the technique lay in its capacity to realize not simply an untraditional but also an unhierarchical vision of the modern world – a vision consonant with the anarchist views they held at the time. After Seurat's death, Signac was to be the most consistent exponent of the technique and its most determined advocate in print (see VIʙ14). This article was originally published as a communication from an anonymous 'camarade impressioniste' in the communist–anarchist journal *La Révolte*, 13–19 June 1891. The editor noted that 'we strongly disagree with certain of his literary judgements'. Signac's authorship was convincingly identified and extracts reprinted by Robert L. Herbert and Eugenia W. Herbert in 'Artists and Anarchism: Unpublished Letters of Pissarro, Signac and others', part I, *Burlington Magazine*, CII, London, November 1960, pp. 473–82. Our version is taken from the original French source, translated for this volume by Christopher Miller. Forain was a painter who showed with the Impressionists, and whose pictures dwelt on the self-importance of the judiciary and the inelegance of the bourgeois male in his encounters with the *demi-monde*. *Germinal* is a novel by Zola about a miner's strike. It gained a particular topicality during an actual strike which the anarchists supported. Jean Valjean is a character in Hugo's novel *Les Misérables*. The Belgian sculptor Constantin Meunier was a Realist specializing in figures of labourers and peasants.

Some weeks ago, at the Exhibition of Independent Artists, faced with the pictures of the Independent and impressionist painters, there were those who exclaimed against them; a poor sort of fellow, whose inveterate vulgarity has been perfectly captured by the ironist Forain. On Sunday, by contrast, some proletarians were rather intrigued by what they saw.

The revolutionary tendency of the impressionist painters explains both the raucous malice of the former and the reserved sympathy of the latter. In the matter of technique, these painters are innovators; by a more logical and scientific arrangement of tones and colours they are replacing outdated procedures: the financial mixtures made on the palette, the scumbles so long in fashion, the heavy impasto expressive of

an ardour generally factitious. In moral terms, the example they set for our sensual generation is all too rare: faithful to their idea of art, convinced of the superiority of their methods, they remain poor at a time when they might, as so many others have done, at the cost of a few compromises enjoy the favour of the standard, influential critics, whose stale prose translates for the artist into gold, honours and decorations.

Were it only for these reasons, the impressionist artists, expelled from the community of art like revolutionaries from society, would deserve a sympathetic greeting from those who applaud the breakdown of all prejudice and all routine. But they have a more important claim on such sympathies. Their works, the products of a purely aesthetic emotion elicited by the picturesque aspect of things and beings, have that unconsciously social character that is the stamp of contemporary literature. Certain novels by Flaubert, the Goncourt brothers, Zola and their disciples, written from purely literary preoccupations on the basis of lived experience, have served the revolutionary cause far more powerfully than any novel in which political preoccupations took precedence over the literary.

Two examples: *Germinal*, whose influence on opinion has been undeniable and which has several times worked in favour of proletarian demands – remember the Basly election and the subscriptions to which people till then indifferent to social events contributed during the strikes which followed. And *L'Education sentimentale*, in which the sceptical and aristocratic Flaubert, in the grip of the truth, speaks of the June 1848 Insurrection, and gives eloquent witness of the ignominious, sanguinary cruelty of the victors.

From a purely revolutionary point of view, one can hardly deny that these works are superior to the *romans à thèse* of Georges Sand and Eugène Sue or that epic fraud that goes under the name *Les Misérables*, a novel read by the entire bourgeoisie and which can only have strengthened the principles of which Jean Valjean is the apostle:

1. Hasten to make your fortune;
2. Speculate on the work of others;
3. Found asylums, crêches and hospices when one has just *too* much money and is past sensual pleasure (this is the system of Boucicaut, Chauchard, Pruvot & co.).

In the same book, we witness the paltry escapade of foolish youths convinced the Revolution of 1789 was made merely to allow their daddies to buy national goods. When the insurrection comes, instead of joining the army of revolutionaries, they construct a useless barricade, to no purpose, just for the pleasure of it...

If we turn from the literary document to the witness of art, we find a similar state of affairs. Millet remained a peasant; completely absorbed by his art, he produced a corpus whose social tendency is much clearer than the intendedly philosophical paintings of Courbet, painter and thinker – to cite an artist of similar tendency in art.[1]

At this very time, at the *Exposition Nationale des Beaux-Arts*, one can see a little water-colour by Meissonnier, *The Barricade (1848)*, which is a terrible indictment of the social conditions established over the last hundred years by the Bourgeoisie. The riot has been quelled; in a desolate street, bodies lie mutilated amid pavés and splintered barrels, their features contracted by their death-agonies, the shirt of the

insurgent touching the soldier's red breeches. Before this scene – summarily outlined with a few strokes of the pen and a little colour – the heart bleeds. For one feels it is a thing seen and rendered in all its sincerity by an artist simply attracted by the strangeness of the scene and the colour effects to which it gave rise. – Note that Meissonnier was a bourgeois who took his hatred of socialists to the lengths of banning Courbet from the official *Salon* because he had taken part in the Insurrection of 18 March [i.e. the Commune].

It would therefore be an error – an error into which the best informed revolutionaries, such as Proudhon, have too often fallen – systematically to require a precise socialist tendency in works of art; this tendency will be found much stronger and more eloquent in pure aesthetes – revolutionaries by temperament, who, departing from the beaten track, paint what they see, as they feel it, and, often unconsciously, give a solid pick blow to the old social edifice, the which, worm-eaten, cracks and crumbles like some abandoned cathedral.

This can easily be seen in the works that the impressionist painters sent to the *Exposition des Indépendants*. By their new technique, which runs counter to the standard rules, they showed the futility of unchanging procedures. By their picturesque studies of working-class housing of Saint-Ouen and Montrouge, sordid and overwhelmingly real, by reproducing the broad and strangely vivid gestures of a navvy working by a pile of sand, of a blacksmith in the incandescent light of the forge – or better still by synthetically representing the pleasures of decadence, balls, riotous dances, and circuses, as did the painter Seurat, who had such a strong sense of the debasement of our epoch of transition – they have contributed their witness to the great social process which pits the workers against Capital.

Now, it can hardly be denied that the reproduction of such subjects elicits a more sincere sentiment of justice and more fertile thoughts than a melodramatic composition showing a 'Family Fallen on Hard Times' where the father has an Italian-style beard, the mother wears the head of the Virgin, and the children have cherubic hairstyles, all this painted on a background of rags and utensils straight from an *Opéra Comique* stage-set; or than those vast decorations intended for the Hôtel-de-Ville and town halls, such as we see at the Champ-de-Mars, in which artists have painted, besides episodes from the War and the Siege, the hard labour of the workshops and factories. But these scenes, painted on commission by people who care not a fig for the Republic or the people, have no power to move, for they lack both art and conviction. – Proof of this comes from a sculptor, who shall be nameless: after composing patriotic groups for the last ten years, he insisted on his right as a holder of the Prix de Rome not to go to the front.

For these reasons, only artists haunted by pure art and in particular the impressionist painters, whose technique is the negation of the old artistic routines, deserve the sympathy of all those who applaud the breakdown of ancient prejudices. – I make an exception of the symbolist-impressionists, who, by confining themselves to retrograde subjects, revive old errors and forget that art is much more a matter of seeking the future in all its breadth than of exhuming the legends of the past – golden though they be.

Sooner or later the veritable artists will be found at the side of the insurgents, united with them in one and the same notion of justice.

PS – The readers of *La Révolte* who have visited the *Exposition du Champ de Mars* may be surprised to find here no mention of Monsieur Meunier, that powerful sculptor of the proletariat.

The works he exhibits can only confirm the thesis argued here.

I hasten to state my sincere admiration for Monsieur Meunier, who is not merely a great artist but – as his works show – a lofty spirit.

[1] Thus [Millet's] *Man with Hoe* is a faithful representation of the peasant physically and mentally degraded by continuous labour.

17 Max Nordau (1859–1923) from *Degeneration*

The idea of 'degeneration' played a sinister role in twentieth-century art. In particular it was used by the Nazis as a weapon with which to attack the entire modern movement, most notably in the *Entartete Kunst* (Degenerate Art) exhibition of 1937. The concept attained its first substantial articulation in the work of Max Nordau, at the end of the nineteenth century, and he also used it to attack innovation in contemporary art. But Nordau, though conservative, was not a proto-Nazi, however stultifying and ultimately dangerous his arguments were. Born into a Jewish milieu in Budapest, he spent most of his career in Paris. He was a doctor there and one of the most influential writers and journalists of the day. In later life he was a committed Zionist. His central belief was a Darwinian conviction in human progress based on advances in natural science. 'Degeneration' represented a threat precisely because it stood to undermine the state of order and optimism on which continued progress depended. For Nordau, symptoms of such decline could be observed particularly in the arts. Pessimism and alienation, and their presumed correlates of formal disorder and garish colour, threatened a breakdown in human evolution. And with the same ghastly logic which was to be followed through to the full half a century later, the thinker of the wrong thought and the painter of the wrong image were no less guilty than the criminal who commits the wrong act. Punishment was in order for each. Nordau's *Entartung* was first published in 1892. An English translation of the second edition was published as *Degeneration* in London and New York in 1895. The present extracts are taken from the facsimile reprint of that edition, Lincoln, Nebraska, and London: University of Nebraska Press, 1993, pp. 1–6, 15–18, 27–32 and 322–6.

Fin-de-siècle is a name covering both what is characteristic of many modern phenomena, and also the underlying mood which in them finds expression. Experience has long shown that an idea usually derives its designation from the language of the nation which first formed it. This, indeed, is a law of constant application when historians of manners and customs inquire into language, for the purpose of obtaining some notion, through the origins of some verbal root, respecting the home of the earliest inventions and the line of evolution in different human races. *Fin-de-siècle* is French, for it was in France that the mental state so entitled was first consciously realized. The word has flown from one hemisphere to the other, and found its way into all civilized languages. A proof this that the need of it existed. The *fin-de-siècle* state of mind is to-day everywhere to be met with; nevertheless, it is in many cases a mere imitation of a foreign fashion gaining vogue, and not an organic evolution. It is in the land of its birth that it appears in its most genuine form, and Paris is the right place in which to observe its manifold expressions.

No proof is needed of the extreme silliness of the term. Only the brain of a child or of a savage could form the clumsy idea that the century is a kind of living being, born like a beast or a man, passing through all the stages of existence, gradually ageing and declining after blooming childhood, joyous youth, and vigorous maturity, to die with the expiration of the hundredth year, after being afflicted in its last decade with all the infirmities of mournful senility. [. . .]

But it is a habit of the human mind to project externally its own subjective states. And it is in accordance with this naively egoistic tendency that the French ascribe their own senility to the century, and speak of *fin-de-siècle* when they ought correctly to say *fin-de-race*.

But however silly a term *fin-de-siècle* may be, the mental constitution which it indicates is actually present in influential circles. The disposition of the times is curiously confused, a compound of feverish restlessness and blunted discouragement, of fearful presage and hang-dog renunciation. The prevalent feeling is that of imminent perdition and extinction. *Fin-de-siècle* is at once a confession and a complaint. The old Northern faith contained the fearsome doctrine of the Dusk of the Gods. In our days there have arisen in more highly-developed minds vague qualms of a Dusk of the Nations, in which all suns and all stars are gradually waning, and mankind with all its institutions and creations is perishing in the midst of a dying world. [. . .]

Such is the notion underlying the word *fin-de-siècle*. It means a practical emancipation from traditional discipline, which theoretically is still in force. To the voluptuary this means unbridled lewdness, the unchaining of the beast in man; to the withered heart of the egoist, disdain of all consideration for his fellow-men, the trampling under foot of all barriers which enclose brutal greed of lucre and lust of pleasure; to the contemner of the world it means the shameless ascendency of base impulses and motives, which were, if not virtuously suppressed, at least hypocritically hidden; to the believer it means the repudiation of dogma, the negation of a super-sensuous world, the descent into flat phenomenalism; to the sensitive nature yearning for aesthetic thrills, it means the vanishing of ideals in art, and no more power in its accepted forms to arouse emotion. And to all, it means the end of an established order, which for thousands of years has satisfied logic, fettered depravity, and in every art matured something of beauty.

One epoch of history is unmistakably in its decline, and another is announcing its approach. There is a sound of rending in every tradition, and it is as though the morrow would not link itself with to-day. Things as they are totter and plunge, and they are suffered to reel and fall, because man is weary, and there is no faith that it is worth an effort to uphold them. Views that have hitherto governed minds are dead or driven hence like disenthroned kings, and for their inheritance they that hold the titles and they that would usurp are locked in struggle. Meanwhile interregnum in all its terrors prevails; there is confusion among the powers that be; the million, robbed of its leaders, knows not where to turn; the strong work their will; false prophets arise, and dominion is divided amongst those whose rod is the heavier because their time is short. Men look with longing for whatever new things are at hand, without presage whence they will come or what they will be. They have hope that in the chaos of thought, art may yield revelations of the order that is to follow on this tangled web.

The poet, the musician, is to announce, or divine, or at least suggest in what forms civilization will further be evolved. What shall be considered good to-morrow – what shall be beautiful? What shall we know to-morrow – what believe in? What shall inspire us? How shall we enjoy? So rings the question from the thousand voices of the people, and where a market-vendor sets up his booth and claims to give an answer, where a fool or a knave suddenly begins to prophesy in verse or prose, in sound or colour, or professes to practise his art otherwise than his predecessors and competitors, there gathers a great concourse, crowding around him to seek in what he has wrought, as in oracles of the Pythia, some meaning to be divined and interpreted. And the more vague and insignificant they are, the more they seem to convey of the future to the poor gaping souls gasping for revelations, and the more greedily and passionately are they expounded.

Such is the spectacle presented by the doings of men in the reddened light of the Dusk of the Nations. Massed in the sky the clouds are aflame in the weirdly beautiful glow which was observed for the space of years after the eruption of Krakatoa. Over the earth the shadows creep with deepening gloom, wrapping all objects in a mysterious dimness, in which all certainty is destroyed and any guess seems plausible. Forms lose their outlines, and are dissolved in floating mist. The day is over, the night draws on. The old anxiously watch its approach, fearing they will not live to see the end. A few amongst the young and strong are conscious of the vigour of life in all their veins and nerves, and rejoice in the coming sunrise. Dreams, which fill up the hours of darkness till the breaking of the new day, bring to the former comfortless memories, to the latter high-souled hopes. And in the artistic products of the age we see the form in which these dreams become sensible.

Here is the place to forestall a possible misunderstanding. The great majority of the middle and lower classes is naturally not *fin-de-siècle*. It is true that the spirit of the times is stirring the nations down to their lowest depths, and awaking even in the most inchoate and rudimentary human being a wondrous feeling of stir and upheaval. But this more or less slight touch of moral sea-sickness does not excite in him the cravings of travailing women, nor express itself in new aesthetic needs. The Philistine or the Proletarian still finds undiluted satisfaction in the old and oldest forms of art and poetry, if he knows himself unwatched by the scornful eye of the votary of fashion, and is free to yield to his own inclinations. He prefers Ohnet's novels to all the symbolists, and Mascagni's *Cavalleria Rusticana* to all Wagnerians and to Wagner himself; he enjoys himself royally over slap-dash farces and music-hall melodies, and yawns or is angered at Ibsen; he contemplates gladly chromos of paintings depicting Munich beer-houses and rustic taverns, and passes the open-air painters without a glance. It is only a very small minority who honestly find pleasure in the new tendencies, and announce them with genuine conviction as that which alone is sound, a sure guide for the future, a pledge of pleasure and of moral benefit. But this minority has the gift of covering the whole visible surface of society, as a little oil extends over a large area of the surface of the sea. It consists chiefly of rich educated people, or of fanatics. The former give the *ton* to all the snobs, the fools, and the blockheads; the latter make an impression upon the weak and dependent, and intimidate the nervous. All snobs affect to have the same taste as the select and exclusive minority, who pass by everything that once was considered beautiful with an

air of the greatest contempt. And thus it appears as if the whole of civilized humanity were converted to the aesthetics of the Dusk of the Nations.

* * *

The manifestations described ... must be patent enough to everyone, be he never so narrow a Philistine. The Philistine, however, regards them as a passing fashion and nothing more; for him the current terms, caprice, eccentricity, affectation of novelty, imitation, instinct, afford a sufficient explanation. The purely literary mind, whose merely aesthetic culture does not enable him to understand the connections of things, and to seize their real meaning, deceives himself and others as to his ignorance by means of sounding phrases, and loftily talks of a 'restless quest of a new ideal by the modern spirit,' 'the richer vibrations of the refined nervous system of the present day,' 'the unknown sensations of an elect mind.' But the physician, especially if he have devoted himself to the special study of nervous and mental maladies, recognizes at a glance, in the *fin-de-siècle* disposition, in the tendencies of contemporary art and poetry, in the life and conduct of the men who write mystic, symbolic and 'decadent' works, and the attitude taken by their admirers in the tastes and aesthetic instincts of fashionable society, the confluence of two well-defined conditions of disease, with which he is quite familiar, viz. degeneration (degeneracy) and hysteria [...]

Degeneracy betrays itself among men in certain physical characteristics, which are denominated 'stigmata,' or brand-marks – an unfortunate term derived from a false idea, as if degeneracy were necessarily the consequence of a fault, and the indication of it a punishment. Such stigmata consist of deformities, multiple and stunted growths in the first line of asymmetry, the unequal development of the two halves of the face and cranium; then imperfection in the development of the external ear, which is conspicuous for its enormous size, or protrudes from the head, like a handle, and the lobe of which is either lacking or adhering to the head, and the helix of which is not involuted; further, squint-eyes, hare-lips, irregularities in the form and position of the teeth; pointed or flat palates, webbed or supernumerary fingers (syn- and poly-dactylia), etc. [...]

There might be a sure means of proving that the application of the term 'degenerates' to the originators of all the *fin-de-siècle* movements in art and literature is not arbitrary, that it is no baseless conceit, but a fact; and that would be a careful physical examination of the persons concerned, and an inquiry into their pedigree. In almost all cases, relatives would be met with who were undoubtedly degenerate, and one or more stigmata discovered which would indisputably establish the diagnosis of 'Degeneration.' Of course, from human consideration, the result of such an inquiry could often not be made public; and he alone would be convinced who should be able to undertake it himself.

Science, however, has found, together with these physical stigmata, others of a mental order, which betoken degeneracy quite as clearly as the former; and they allow of an easy demonstration from all the vital manifestations, and, in particular, from all the works of degenerates, so that it is not necessary to measure the cranium of an author, or to see the lobe of a painter's ear, in order to recognize the fact that he belongs to the class of degenerates.

Quite a number of different designations have been found for these persons. Maudsley and Ball call them 'Borderland dwellers' – that is to say, dwellers on the

borderland between reason and pronounced madness. Magnan gives to them the name of 'higher degenerates' (*dégénérés supérieurs*), and Lombroso speaks of 'mattoids' (from *matto*, the Italian for insane), and 'graphomaniacs,' under which he classifies those semi-insane persons who feel a strong impulse to write. In spite, however, of this variety of nomenclature, it is a question simply of one single species of individuals, who betray their fellowship by the similarity of their mental physiognomy.

In the mental development of degenerates, we meet with the same irregularity that we have observed in their physical growth. The asymmetry of face and cranium finds, as it were, its counterpart in their mental faculties. Some of the latter are completely stunted, others morbidly exaggerated. That which nearly all degenerates lack is the sense of morality and of right and wrong.

* * *

The curious style of certain recent painters – 'impressionists,' 'stipplers,' or 'mosaists,' 'papilloteurs' or 'quiverers,' 'roaring' colourists, dyers in grey and faded tints – becomes at once intelligible to us if we keep in view the researches of the Charcot school into the visual derangements in degeneration and hysteria. The painters who assure us that they are sincere, and reproduce nature as they see it, speak the truth. The degenerate artist who suffers from *nystagmus*, or trembling of the eyeball, will, in fact, perceive the phenomena of nature trembling, restless, devoid of firm outline, and, if he is a conscientious painter, will give us pictures reminding us of the mode practised by the draughtsmen of the *Fliegende Blätter* when they represent a wet dog shaking himself vigorously. If his pictures fail to produce a comic effect, it is only because the attentive beholder reads in them the desperate effort to reproduce fully an impression incapable of reproduction by the expedients of the painter's art as devised by men of normal vision.

There is hardly a hysterical subject whose retina is not partly insensitive. As a rule the insensitive parts are connected, and include the outer half of the retina. In these cases the field of vision is more or less contracted, and appears to him not as it does to the normal man – as a circle – but as a picture bordered by whimsically zigzag lines. Often, however, the insensitive parts are not connected, but are scattered in isolated spots over the entire retina. Then the sufferer will have all sorts of gaps in his field of vision, producing strange effects, and if he paints what he sees, he will be inclined to place in juxtaposition larger or smaller points or spots which are completely or partially dissociated. The insensitiveness need not be complete, and may exist only in the case of single colours, or of all. If the sensitiveness is completely lost ('achromatopsy') he then sees everything in a uniform grey, but perceives differences in the degree of lustre. Hence the picture of nature presents itself to him as a copper-plate or a pencil drawing, where the effect of the absent colours is replaced by differences in the intensity of light, by greater or less depth and power of the white and black portions. Painters who are insensitive to colour will naturally have a predilection for neutral-toned painting; and a public suffering from the same malady will find nothing objectionable in falsely-coloured pictures. But if, besides the whitewash of a Puvis de Chavannes, obliterating all colours equally, fanatics are found for the screaming yellow, blue, and red of a Besnard, this also has a cause, revealed to us by clinical science. 'Yellow and blue,' Gilles de la Tourette teaches us, 'are peripheral colours' (i.e., they are seen with the outermost parts of the retina); 'they are, therefore, the last

to be perceived' (if the sensitiveness for the remaining colours is destroyed). 'These are . . . the very two colours the sensations of which in hysterical amblyopia [dullness of vision] endure the longest. In many cases, however, it is the red, and not the blue, which vanishes last.'

Red has also another peculiarity explanatory of the predilection shown for it by the hysterical. The experiments of Binet have established that the impressions conveyed to the brain by the sensory nerves exercise an important influence on the species and strength of the excitation distributed by the brain to the motor nerves. Many sense-impressions operate enervatingly and inhibitively on the movements; others, on the contrary, make these more powerful, rapid and active; they are 'dynamogenous,' or 'force-producing.' As a feeling of pleasure is always connected with dynamogeny, or the production of force, every living thing, therefore, instinctively seeks for dynamogenous sense-impressions, and avoids enervating and inhibitive ones. [. . .]

Hence it is intelligible that hysterical painters revel in red, and that hysterical beholders take special pleasure in pictures operating dynamogenously, and producing feelings of pleasure.

If red is dynamogenous, violet is conversely enervating and inhibitive. It was not by accident that violet was chosen by many nations as the exclusive colour for mourning, and by us also for half-mourning. The sight of this colour has a depressing effect, and the unpleasant feeling awakened by it induces dejection in a sorrowfully-disposed mind. This suggests that painters suffering from hysteria and neurasthenia will be inclined to cover their pictures uniformly with the colour most in accordance with their condition of lassitude and exhaustion. Thus originate the violet pictures of Manet and his school, which spring from no actually observable aspect of nature, but from a subjective view due to the condition of the nerves. When the entire surface of walls in salons and art exhibitions of the day appears veiled in uniform half-mourning, this predilection for violet is simply an expression of the nervous debility of the painter.

There is yet another phenomenon highly characteristic in some cases of degeneracy, in others of hysteria. This is the formation of close groups or schools uncompromisingly exclusive to outsiders, observable to-day in literature and art. Healthy artists or authors, in possession of minds in a condition of well-regulated equilibrium, will never think of grouping themselves into an association, which may at pleasure be termed a sect or band; of devising a catechism, of binding themselves to definite aesthetic dogmas, and of entering the lists for these with the fanatical intolerance of Spanish inquisitors. If any human activity is individualistic, it is that of the artist. True talent is always personal. [. . .]

No one is able completely to withdraw himself from the influences of his time, and under the impression of events which affect all contemporaries alike, as well as of the scientific views prevailing at a given time, certain features develop themselves in all the works of an epoch, which stamp them as of the same date. But the same men who subsequently appear so naturally in each other's company, in historical works, that they seem to form a family, went when they lived their separate ways far asunder, little suspecting that at one time they would be united under one common designation. Quite otherwise it is when authors or artists consciously and intentionally meet together and found an aesthetic school, as a joint-stock bank is founded, with a title for

which, if possible, the protection of the law is claimed, with by-laws, joint capital, etc. This may be ordinary speculation, but as a rule it is disease. The predilection for forming societies met with among all the degenerate and hysterical may assume different forms. Criminals unite in bands, as Lombroso expressly establishes. Among pronounced lunatics it is the *folie à deux*, in which a deranged person completely forces his insane ideas on a companion; among the hysterical it assumes the form of close friendships, causing Charcot to repeat at every opportunity: 'Persons of highly-strung nerves attract each other;' and finally authors found schools.

The common organic basis of these different forms of one and the same phenomenon – of the *folie à deux*, the association of neuropaths, the founding of aesthetic schools, the banding of criminals – is, with the active part, viz., those who lead and inspire, the predominance of obsessions: with the associates, the disciples, the submissive part, weakness of will and morbid susceptibility to suggestion. [...]

Under the influence of an obsession, a degenerate mind promulgates some doctrine or other – realism, pornography, mysticism, symbolism, diabolism. He does this with vehement penetrating eloquence, with eagerness and fiery heedlessness. Other degenerate, hysterical, neurasthenical minds flock around him, receive from his lips the new doctrine, and live thenceforth only to propagate it.

In this case all the participants are sincere – the founder as well as the disciples. They act as, in consequence of the diseased constitution of their brain and nervous system, they are compelled to act. The picture, however, which from a clinical standpoint is perfectly clear, gets dimmed if the apostle of a craze and his followers succeed in attracting to themselves the attention of wider circles. He then receives a concourse of unbelievers, who are very well able to recognize the insanity of the new doctrine, but who nevertheless accept it, because they hope, as associates of the new sect, to acquire fame and money. In every civilized nation which has a developed art and literature there are numerous intellectual eunuchs, incapable of producing with their own powers a living mental work, but quite able to imitate the process of production. These cripples form, unfortunately, the majority of professional authors and artists, and their many noxious followers often enough stifle true and original talent. Now it is these who hasten to act as camp-followers for every new tendency which seems to come into fashion. They are naturally the most modern of moderns. ...

* * *

The 'bonzes' of art, who proclaim the doctrine of 'art for art's sake,' look down with contempt upon those who deny their dogma, affirming that the heretics who ascribe to works of art any aim whatsoever can be only pachydermatous Philistines, whose comprehension is limited to beans and bacon, or stock-jobbers with whom it is only a question of profit, or sanctimonious parsons making a professional pretence of virtue. They believe that they are supported in this by such men as Kant, Lessing, etc., who were likewise of the opinion that the work of art had but one task to perform – that of being beautiful. We need not be overawed by the great names of these guarantors. Their opinion cannot withstand the criticism to which it has been subjected during the last hundred years by a great number of philosophers (I name only Fichte, Hegel and Vischer), and its inadequacy follows from the fact, among others, that it allows absolutely no place for the ugly as an object of artistic representation.

Let us remind ourselves how works of art and art in general originated.

That plastic art originally sprang from the imitation of Nature is a commonplace, open justly to the reproach that it does not enter deeply enough into the question. [. . .]

Imitation is not the source of the arts, but one of the media of art; the real source of art is emotion. Artistic activity is not its own end, but it is of direct utility to the artist; it satisfies the need of his organism to transform its emotions into movement. He creates the work of art, not for its own sake, but to free his nervous system from a tension. The expression, which has become a commonplace, is psycho-physiologically accurate, viz., the artist writes, paints, sings, or dances the burden of some idea or feeling off his mind.

To this primary end of art – the subjective end of the self-deliverance of the artist – a second must be added, viz., the objective end of acting upon others. Like every other animal living in society and partly dependent upon it, man has, in consequence of his racial instinct, the aspiration to impart his own emotions to those of his own species, just as he himself participates in the emotions of those of his own species. This strong desire to know himself in emotional communion with the species is sympathy, that organic base of the social edifice. [. . .]

Once we have established, as a fact, that art is not practised for its own sake alone, but that it has a double aim, subjective and objective, viz., the satisfaction of an organic want of the artist, and the influencing of his fellow-creatures, then the principles by which every other human activity pursuing the same end is judged are applicable to it, i.e., the principles of law and morality.

We test every organic desire to see whether it be the outcome of a legitimate need or the consequence of an aberration; whether its satisfaction be beneficial or pernicious to the organism. We distinguish the healthy from the diseased impulse, and demand that the latter be combated. If the desire seeks its satisfaction in an activity acting upon others, then we examine to see if this activity is reconcilable with the existence and prosperity of society, or dangerous to it. The activity imperilling society offends against law and custom, which are nothing but an epitome of the temporary notions of society concerning what is beneficial and what is pernicious to it.

Notions healthy and diseased, moral and immoral, social or anti-social, are as valid for art as for every other human activity, and there is not a scintilla of reason for regarding a work of art in any other light than that in which we view every other manifestation of an individuality.

It is easily conceivable that the emotion expressed by the artist in his work may proceed from a morbid aberration, may be directed, in an unnatural, sensual, cruel manner, to what is ugly or loathsome. Ought we not in this case to condemn the work and, if possible, to suppress it? How can its right to exist be justified? By claiming that the artist was sincere when he created it, that he gave back what was really existing in him, and for that reason was subjectively justified in his artistic expansion? But there is a candour which is wholly inadmissible. The dipsomaniac and clastomaniac are sincere when they respectively drink or break everything within reach. We do not, however, acknowledge their right to satisfy their desire. We prevent them by force. We put them under guardianship, although their drunkenness and destructiveness may perhaps be injurious to no one but themselves. And still more decidedly does

society oppose itself to the satisfaction of those cravings which cannot be appeased without violently acting upon others. The new science of criminal anthropology admits without dispute that homicidal maniacs, certain incendiaries, many thieves and vagabonds, act under an impulsion; that through their crimes they satisfy an organic craving; that they outrage, kill, burn, idle, as others sit down to dinner, simply because they hunger to do so; but in spite of this and because of this, it demands that the appeasing of the sincere longings of these degenerate creatures be prevented by all means, and, if needs be, by their complete suppression. It never occurs to us to permit the criminal by organic disposition to 'expand' his individuality in crime, and just as little can it be expected of us to permit the degenerate artist to expand his individuality in immoral works of art. The artist who complacently represents what is reprehensible, vicious, criminal, approves of it, perhaps glorifies it, differs not in kind, but only in degree, from the criminal who actually commits it.

18 George Bernard Shaw (1856–1950) 'The Sanity of Art' (Reply to Nordau)

Shaw was born in Dublin, but left Ireland for London at the age of twenty. He spent much time reading and writing in the British Museum, although he enjoyed no success as an author and playwright until the 1890s. However, he was an important influence in the founding of the Fabian socialist society in 1884. In 1885 he got a job as a journalist and in the decade from then until the mid-1890s he established himself as a successful cultural commentator, reviewing a wide range of music, books and art exhibitions as well as theatrical productions. In 1895 Shaw was commissioned to write a response to Max Nordau's *Degeneration* (see VB17) for the left-wing American journal *Liberty*. He did so in the form of a lengthy open letter to the editor, Benjamin Tucker. Shaw has been described as 'the most trenchant pamphleteer since Swift' and his devastating riposte seems to have been instrumental in diminishing Nordau's impact, at least in English-speaking countries. In 1907 the essay was reprinted in pamphlet form by *The New Age*, a paper of the Arts Group of the Fabian Society, which is testimony to the fact that Shaw's attack on artistic conservatism outlasted the occasion which prompted it. The present extracts are taken from 'The Sanity of Art', subtitled 'An exposure of the current nonsense about artists being degenerate', as reprinted in George Bernard Shaw, *The Collected Works* volume XIX, *Major Critical Essays* (1932), London: Constable and Company, 1955, pp. 291–332.

My dear Tucker,

I have read Max Nordau's Degeneration at your request: two hundred and sixty thousand mortal words, saying the same thing over and over again. That is the proper way to drive a thing into the mind of the world, though Nordau considers it a symptom of insane 'obsession' on the part of writers who do not share his own opinions. His message to the world is that all our characteristically modern works of art are symptoms of disease in the artists, and that these diseased artists are themselves symptoms of the nervous exhaustion of the race by overwork.

 To me, who am a professional critic of art, and have for many successive London seasons had to watch the grand march past of books, of pictures, of concerts and

operas, and of stage plays, there is nothing new in Dr Nordau's outburst. I have heard it all before. At every new wave of energy in art the same alarm has been raised; and as these alarms always had their public, like prophecies of the end of the world, there is nothing surprising in the fact that a book which might have been produced by playing the resurrection man in the old newspaper rooms of our public libraries, and collecting all the exploded bogey-criticisms of the last half-century into a huge volume, should have a considerable success.

* * *

Imagine a huge volume, stuffed with the most slashing of the criticisms which were hurled at the Impressionists, the Tone Poets, and the philosophers and dramatists of the Schopenhauerian revival, before these movements had reached the point at which it began to require some real courage to attack them. Imagine a rehash not only of the newspaper criticisms of this period, but of all its little parasitic paragraphs of small-talk and scandal, from the long-forgotten jibes against Oscar Wilde's momentary attempt to bring knee-breeches into fashion years ago, to the latest scurrilities about 'the New Woman.' Imagine the general staleness and occasional putrescence of this mess disguised by a dressing of the terminology invented by Krafft-Ebing, Lombroso, and all the latest specialists in madness and crime, to describe the artistic faculties and propensities as they operate in the insane. Imagine all this done by a man who is a vigorous and capable journalist, shrewd enough to see that there is a good opening for a big reactionary book as a relief to the Wagner and Ibsen booms, bold enough to let himself go without respect to persons or reputations, lucky enough to be a stronger, clearer-headed man than ninety-nine out of a hundred of his critics, besides having a keener interest in science: a born theorist, reasoner, and busybody; therefore able, without insight, or even any very remarkable intensive industry (he is, like most Germans, *ex*tensively industrious to an appalling degree), to produce a book which has made a very considerable impression on the artistic ignorance of Europe and America. For he says a thing as if he meant it; he holds superficial ideas obstinately, and sees them clearly; and his mind works so impetuously that it is a pleasure to watch it – for a while. All the same, he is the dupe of a theory which would hardly impose even on the gamblers who have a system or martingale founded on a solid rock of algebra, by which they can infallibly break the bank at Monte Carlo. 'Psychiatry' takes the place of algebra in Nordau's martingale.

 This theory of his is, at bottom, nothing but the familiar delusion of the used-up man that the world is going to the dogs. But Nordau is too clever to be driven back on ready-made mistakes: he makes them for himself in his own way. He appeals to the prodigious extension of the quantity of business a single man can transact through the modern machinery of social intercourse: the railway, the telegraph and telephone, the post, and so forth. He gives appalling statistics of the increase of railway mileage and shipping, of the number of letters written per head of the population, of the newspapers which tell us things (mostly lies) of which we used to know nothing. 'In the last fifty years,' he says, 'the population of Europe has not doubled, whereas the sum of its labours has increased tenfold: in part, even fifty-fold. Every civilized man furnishes, at the present time, from five to twenty-five times as much work as was demanded of him half a century ago.' Then follow more statistics of 'the constant increase of crime, madness, and suicide,' of increases in the mortality from diseases of

the nerves and heart, of increased consumption of stimulants, of new nervous diseases like 'railway spine and railway brain,' with the general moral that we are all suffering from exhaustion, and that symptoms of degeneracy are visible in all directions, culminating at various points in Wagner's music, Ibsen's dramas, Manet's pictures, Tolstoy's novels, Whitman's poetry, Dr Jaeger's woollen clothing, vegetarianism, scepticism as to vivisection and vaccination, Anarchism and Humanitarianism, and, in short, everything that Dr Nordau does not happen to approve of.

You will at once see that such a case, if well got up and argued, is worth hearing, even though its advocate has no chance of a verdict, because it is sure to bring out a certain number of interesting and important facts. It is, I take it, quite true that with our railways and our postal services many of us are for the moment very like a pedestrian converted to bicycling, who, instead of using his machine to go twenty miles with less labour than he used to walk seven, proceeds to do a hundred miles instead, with the result that the 'labour-saving' contrivance acts as a means of working its user to exhaustion. It is also true that under our existing industrial system machinery in industrial processes is regarded solely as a means of extracting a larger product from the unremitted toil of the actual wage-worker. And I do not think any person who is in touch with the artistic professions will deny that they are recruited largely by persons who become actors, or painters, or journalists and authors because they are incapable of steady work and regular habits, or that the attraction which the patrons of the stage, music, and literature find in their favourite arts has often little or nothing to do with the need which nerves great artists to the heavy travail of creation. The claim of art to our respect must stand or fall with the validity of its pretension to cultivate and refine our senses and faculties until seeing, hearing, feeling, smelling, and tasting become highly conscious and critical acts with us, protesting vehemently against ugliness, noise, discordant speech, frowzy clothing, and re-breathed air, and taking keen interest and pleasure in beauty, in music, and in nature, besides making us insist, as necessary for comfort and decency, on clean, wholesome, handsome fabrics to wear, and utensils of fine material and elegant workmanship to handle. Further, art should refine our sense of character and conduct, of justice and sympathy, greatly heightening our self-knowledge, self-control, precision of action, and considerateness, and making us intolerant of baseness, cruelty, injustice, and intellectual superficiality or vulgarity. The worthy artist or craftsman is he who serves the physical and moral senses by feeding them with pictures, musical compositions, pleasant house and gardens, good clothes and fine implements, poems, fictions, essays, and dramas which call the heightened senses and ennobled faculties into pleasurable activity. The great artist is he who goes a step beyond the demand, and, by supplying works of a higher beauty and a higher interest than have yet been perceived, succeeds after a brief struggle with its strangeness, in adding this fresh extension of sense to the heritage of the race. This is why we value art: this is why we feel that the iconoclast and the Philistine are attacking something made holier, by solid usefulness, than their own theories of purity and practicality: this is why art has won the privileges of religion; so that London shopkeepers who would fiercely resent a compulsory church rate, who do not know Yankee Doodle from Luther's hymn, and who are more interested in photographs of the latest celebrities than in the Velasquez portraits in the National Gallery, tamely allow the London County

Council to spend their money on bands, on municipal art inspectors, and on plaster casts from the antique.

But the business of responding to the demand for the gratification of the senses has many grades. The confectioner who makes unwholesome sweets, the bull-fighter, the women whose advertisements in the American papers are so astounding to English people, are examples ready to hand to shew what the art and trade of pleasing may be, not at its lowest, but at the lowest that we can speak of without intolerable shame. We have dramatists who write their lines in such a way as to enable low comedians of a certain class to give them an indecorous turn; we have painters who aim no higher than Giulio Romano did when he decorated the Palazzo Te in Mantua; we have poets who have nothing to versify but the commonplaces of amorous infatuation; and, worse than all the rest put together, we have journalists who openly profess that it is their duty to 'reflect' what they believe to be the ignorance and prejudice of their readers, instead of leading and enlightening them to the best of their ability: an excuse for cowardice and time-serving which is also becoming well worn in political circles as 'the duty of a democratic statesman.' In short, the artist can be a prostitute, a pander, and a flatterer more easily, as far as external pressure goes, than a faithful servant of the community, much less the founder of a school or the father of a church. Even an artist who is doing the best he can may be doing a very low class of work: for instance, many performers at the rougher music-halls, who get their living by singing coarse songs in the rowdiest possible way, do so to the utmost of their ability in that direction in the most conscientious spirit of earning their money honestly and being a credit to their profession. And the exaltation of the greatest artists is not continuous: you cannot defend every line of Shakespear or every stroke of Titian. Since the artist is a man and his patron a man, all human moods and grades of development are reflected in art; consequently the iconoclast's or the Philistine's indictments of art have as many counts as the misanthrope's indictment of humanity. And this is the Achilles heel of art at which Nordau has struck. He has piled the iconoclast on the Philistine, the Philistine on the misanthrope, in order to make out his case.

* * *

When Nordau deals with painting and music, he is less irritating, because he errs through ignorance, and ignorance, too, of a sort that is now perfectly well recognized and understood. We all know what the old-fashioned critic of literature and science who cultivated his detective logic without ever dreaming of cultivating his eyes and ears, can be relied upon to say when painters and composers are under discussion. Nordau gives himself away with laughable punctuality. He celebrates 'the most glorious period of the Renaissance' and 'the rosy dawn of the new thought' with all the gravity of the older editions of Murray's Guides to Italy. He tells us that 'to copy Cimabue and Giotto is comparatively easy: to imitate Raphael it is necessary to be able to draw and paint to perfection.' He lumps Fra Angelico with Giotto and Cimabue, as if they represented the same stage in the development of technical execution, and Pollajuolo with Ghirlandaio. 'Here,' he says, speaking of the great Florentine painters, from Giotto to Masaccio, 'were paintings bad in drawing, faded or smoked, their colouring either originally feeble or impaired by the action of centuries, pictures *executed with the awkwardness of a learner* ... easy of imitation, since, in painting pictures in the style of the early masters, faulty drawing, deficient sense of colour,

and *general artistic incapacity*, are so many advantages.' To make any comment on these howlers would be to hit a man when he is down. Poor Nordau offers them as a demonstration that Ruskin, who gave this sort of ignorant nonsense its death-blow in England, was a delirious mystic. Also that Millais and Holman Hunt, in the days of the pre-Raphaelite brotherhood, strove to acquire the qualities of the early Florentine masters because the Florentine easel pictures were so much easier to imitate than those of the apprentices in Raphael's Roman fresco factory.

In music we find Nordau equally content with the theories as to how music is composed which were current among literary men fifty years ago. He tells us of 'the severe discipline and fixed rules of the theory of composition, which gave a grammar to the musical babbling of primeval times, and made of it a worthy medium for the expression of the emotions of civilized men,' and describes Wagner as breaking these fixed rules and rebelling against this severe discipline because he was 'an inattentive mystic, abandoned to amorphous dreams.' This notion that there are certain rules, derived from a science of counterpoint, by the application of which pieces of music can be constructed just as an equilateral triangle can be constructed on a given straight line by anyone who has mastered Euclid's first proposition, is highly characteristic of the generation of blind and deaf critics to which Nordau belongs. It is evident that if there were fixed rules by which Wagner or anyone else could have composed good music, there could have been no more severe discipline in the work of composition than in the work of arranging a list of names in alphabetical order. The severity of artistic discipline is produced by the fact that in creative art no ready-made rules can help you. There is nothing to guide you to the right expression for your thought except your own sense of beauty and fitness; and, as you advance upon those who went before you, that sense of beauty and fitness is necessarily often in conflict, not with fixed rules, because there are no rules, but with precedents, which are what Nordau means by fixed rules, as far as he knows what he is talking about enough to mean anything at all.

* * *

Wagner was discontented with the condition of musical art in Europe. In essay after essay he pointed out with the most laborious exactitude what it was he complained of, and how it might be remedied. He not only shewed, in the teeth of the most envenomed opposition from all the dunderheads, pedants, and vested interests in Europe, what the musical drama ought to be as a work of art, but how theatres for its proper performance should be managed – nay, how they should be built, down to the arrangement of the seats and the position of the instruments in the orchestra. And he not only shewed this on paper, but he successfully composed the music dramas, built a model theatre, gave the model performances, *did* the impossible; so that there is now nobody left, not even Hanslick, who cares to stultify himself by repeating the old anti-Wagner cry of craziness and Impossibilism – nobody, save only Max Nordau, who, like a true journalist, is fact-proof. William Morris objected to the abominable ugliness of early Victorian decoration and furniture, to the rhymed rhetoric which did duty for poetry from the Renaissance to the nineteenth century, to kamptulicon stained glass, and, later on, to the shiny commercial gentility of typography according to the American ideal, spread through England by Harper's Magazine and The Century. Well, did he sit down, as Nordau suggests, to rail helplessly at the men

who were at all events getting the work of the world done, however inartistically? Not a bit of it: he designed and manufactured the decorations he wanted, and furnished and decorated houses with them; he put into public halls and churches tapestries and picture-windows which cultivated people now travel to see as they travel to see first-rate fifteenth-century work in that kind; the books from his Kelmscott Press, printed with type designed by his own hand, are pounced on by collectors like the treasures of our national museums: all this work, remember, involving the successful conducting of a large business establishment and factory, and being relieved by the incidental production of a series of poems and prose romances which placed their author in the position of the greatest living English poet. Now let me repeat the terms in which Nordau describes this kind of activity. 'Ridiculously insignificant aims – beating the air – no earnest thought to improvement – astoundingly mad projects for making the world happy – persistent rage against everything and everyone, displayed in venomous phrases, savage threats, and destructive mania of wild beasts.' Is there not something deliciously ironical in the ease with which a splenetic pamphleteer, with nothing to shew for himself except a bookful of blunders tacked on to a mock scientific theory picked up at second hand from a few lunacy doctors with a literary turn, should be able to create a European scandal by declaring that the greatest creative artists of the century are barren and hysterical madmen? I do not know what the American critics have said about Nordau; but here the tone has been that there is much in what he says, and that he is evidently an authority on the subjects with which he deals. And yet I assure you, on my credit as a man who lives by art criticism, that from his preliminary description of a Morris design as one 'on which strange birds flit among crazily ramping branches, and blowzy flowers coquet with vain butterflies' (which is about as sensible as a description of the Norman chapel in the Tower of London as a characteristic specimen of Baroque architecture would be) to his coupling of Cimabue and Fra Angelico as primitive Florentine masters – from his unashamed bounce about 'the conscientious observance of the laws of counterpoint' by Beethoven and other masters celebrated for breaking them to his unlucky shot about 'a pedal bass with correct harmonization' (a pedal bass happening to be the particular instance in which even the professor-made rules of 'correct harmonization' are suspended), Nordau exposes his sciolism time after time as an authority upon the fine arts. But his critics, being for the most part ignorant literary men like himself, with sharpened wits and neglected eyes and ears, have swallowed Cimabue and Ghirlandaio and the pedal bass like so many gulls. Here an Ibsen admirer may maintain that Ibsen is an exception to the degenerate theory and should be classed with Goethe; there a Wagnerite may plead that Wagner is entitled to the honours of Beethoven; elsewhere one may find a champion of Rossetti venturing cautiously to suggest a suspicion of the glaringly obvious fact that Nordau has read only the two or three popular ballads like The Blessed Damozel, Eden Bower, Sister Helen, and so on, which every smatterer reads, and that his knowledge of the mass of pictorial, dramatic, and decorative work turned out by Rossetti, Burne-Jones, Ford Madox Brown, William Morris, and Holman Hunt, without a large knowledge and careful study of which no man can possibly speak with any critical authority of the pre-Raphaelite movement, is apparently limited to a glance at Holman Hunt's Shadow of the Cross, or possibly an engraving thereof. But in the main he is received as a serious authority on his subjects; and that is

why we two, without malice and solely as a matter of public duty, are compelled to take all this trouble to destroy him.

And now, my dear Tucker, I have told you as much about Nordau's book as it is worth. In a country where art was really known to the people, instead of being merely read about, it would not be necessary to spend three lines on such a work. But in England, where nothing but superstitious awe and self-mistrust prevents most men from thinking about art as Nordau boldly speaks about it; where to have a sense of art is to be one in a thousand, the other nine hundred and ninety-nine being either Philistine voluptuaries or Calvinistic anti-voluptuaries, it is useless to pretend that Nordau's errors will be self-evident. Already we have native writers, without half his cleverness or energy of expression, clumsily imitating his sham-scientific vivisection in their attacks on artists whose work they happen to dislike. Therefore, in riveting his book to the counter, I have used a nail long enough to go through a few pages by other people as well; and that must be my excuse for my disregard of the familiar editorial stigma of degeneracy which Nordau calls Agoraphobia, or Fear of Space.

19 Gustave LeBon (1841–1931) from *The Crowd: A Study of the Popular Mind*

LeBon's early career mixed anthropology, archaeology and natural science. He came late to social psychology, but it was in that field that he produced his most influential work. A conservative thinker, LeBon conceived society in terms of natural hierarchies, racial differences, and the 'national soul' of a people. Earlier in the nineteenth century, faced by the first evidence of the new social formation of modernity, it tended to be radical authors who were stimulated to reflect on the phenomenon of the urban crowd: men such as Engels, Baudelaire and Poe (cf. IID7, 11 and 13). But in later decades a fear of the urban mass grew among bourgeois intellectuals. The volatility and anonymity of the crowd seemed to threaten established values. In such circles, modernity became an object of fear rather than fascination. A discourse of decline and decay flourished across a spectrum of concerns from society to the arts. LeBon's social psychology carries echoes of Gobineau (IIIA6), as well as of his *fin de siècle* contemporary Nordau (VB17). The tradition would continue in the twentieth century with Spengler (see *Art in Theory 1900–1990*). LeBon's study was first published as *Psychologie des foules* in Paris in 1895. It was translated into English in 1897. The present extracts, drawn from LeBon's Introduction, 'The Era of Crowds', are taken from *The Crowd: A Study of the Popular Mind*, New York: Viking Press, 1960, pp. 13–18.

The great upheavals which precede changes of civilization, such as the fall of the Roman Empire and the foundation of the Arabian Empire, seem at first sight determined more especially by political transformations, foreign invasion, or the overthrow of dynasties. But a more attentive study of these events shows that behind their apparent causes the real cause is generally seen to be a profound modification in the ideas of the peoples. The true historical upheavals are not those which astonish us by their grandeur and violence. The only important changes whence the renewal of civilizations results, affect ideas, conceptions, and beliefs. The memorable events of history are the visible effects of the invisible changes of human thought. The reason

these great events are so rare is that there is nothing so stable in a race as the inherited groundwork of its thoughts.

The present epoch is one of these critical moments in which the thought of mankind is undergoing a process of transformation.

Two fundamental factors are at the base of this transformation. The first is the destruction of those religious, political, and social beliefs in which all the elements of our civilization are rooted. The second is the creation of entirely new conditions of existence and thought as the result of modern scientific and industrial discoveries.

The ideas of the past, although half destroyed, being still very powerful, and the ideas which are to replace them being still in process of formation, the modern age represents a period of transition and anarchy.

It is not easy to say as yet what will one day be evolved from this necessarily somewhat chaotic period. What will be the fundamental ideas on which the societies that are to succeed our own will be built up? We do not at present know. Still it is already clear that on whatever lines the societies of the future are organized, they will have to count with a new power, with the last surviving sovereign force of modern times, the power of crowds. On the ruins of so many ideas formerly considered beyond discussion, and to-day decayed or decaying, of so many sources of authority that successive revolutions have destroyed, this power, which alone has arisen in their stead, seems soon destined to absorb the others. While all our ancient beliefs are tottering and disappearing, while the old pillars of society are giving way one by one, the power of the crowd is the only force that nothing menaces, and of which the prestige is continually on the increase. The age we are about to enter will in truth be the ERA OF CROWDS.

Scarcely a century ago the traditional policy of European states and the rivalries of sovereigns were the principal factors that shaped events. The opinion of the masses scarcely counted, and most frequently indeed did not count at all. To-day it is the traditions which used to obtain in politics, and the individual tendencies and rivalries of rulers which do not count; while, on the contrary, the voice of the masses has become preponderant. It is this voice that dictates their conduct to kings, whose endeavour is to take note of its utterances. The destinies of nations are elaborated at present in the heart of the masses, and no longer in the councils of princes.

The entry of the popular classes into political life – that is to say, in reality, their progressive transformation into governing classes – is one of the most striking characteristics of our epoch of transition. [...]

To-day the claims of the masses are becoming more and more sharply defined, and amount to nothing less than a determination to destroy utterly society as it now exists, with a view to making it hark back to that primitive communism which was the normal condition of all human groups before the dawn of civilization. Limitations of the hours of labour, the nationalization of mines, railways, factories, and the soil, the equal distribution of all products, the elimination of all the upper classes for the benefit of the popular classes, etc., such are these claims.

Little adapted to reasoning, crowds, on the contrary, are quick to act. As the result of their present organization their strength has become immense. The dogmas whose birth we are witnessing will soon have the force of the old dogmas; that is to say, the

tyrannical and sovereign force of being above discussion. The divine right of the masses is about to replace the divine right of kings [...]

Universal symptoms, visible in all nations, show us the rapid growth of the power of crowds, and do not admit of our supposing that it is destined to cease growing at an early date. Whatever fate it may reserve for us, we shall have to submit to it. All reasoning against it is a mere vain war of words. Certainly it is possible that the advent to power of the masses marks one of the last stages of Western civilization, a complete return to those periods of confused anarchy which seem always destined to precede the birth of every new society. But may this result be prevented?

Up to now these thoroughgoing destructions of a worn-out civilization have constituted the most obvious task of the masses. It is not indeed to-day merely that this can be traced. History tells us, that from the moment when the moral forces on which a civilization rested have lost their strength, its final dissolution is brought about by those unconscious and brutal crowds known, justifiably enough, as barbarians. Civilizations as yet have only been created and directed by a small intellectual aristocracy, never by crowds. Crowds are only powerful for destruction. Their rule is always tantamount to a barbarian phase. A civilization involves fixed rules, discipline, a passing from the instinctive to the rational state, forethought for the future, an elevated degree of culture – all of them conditions that crowds, left to themselves, have invariably shown themselves incapable of realizing. In consequence of the purely destructive nature of their power, crowds act like those microbes which hasten the dissolution of enfeebled or dead bodies. When the structure of a civilization is rotten, it is always the masses that bring about its downfall. It is at such a juncture that their chief mission is plainly visible, and that for a while the philosophy of number seems the only philosophy of history.

Is the same fate in store for our civilization? There is ground to fear that this is the case, but we are not as yet in a position to be certain of it.

However this may be, we are bound to resign ourselves to the reign of the masses, since want of foresight has in succession overthrown all the barriers that might have kept the crowd in check.

20 Leo Tolstoy (1828–1910) from *What is Art?*

Tolstoy was born into a landed family of the Russian nobility. After showing little interest in formal studies at Kazan University and even less in managing his estate, Tolstoy joined the army in the Caucasus in 1851, and stayed for five years. He was already writing short stories and novels. After leaving the army he married and lived a settled family life on the estate. *War and Peace* was subsequently written in 1865–9, and *Anna Karenina* in 1875–7. Following a spiritual crisis in the late 1870s, Tolstoy embraced a form of Christian anarchism. He turned away from fiction and wrote on a variety of social and moral problems. Parts of *What is Art?* appeared in March 1898 in *Voprosy filosofii psikhologii*, having, according to Tolstoy, taken fifteen years to formulate. His argument is that art has the primary function of teaching values to as wide a social base as possible. For Tolstoy, art was primarily a form of communication. It does its work by the communication of feeling, which is achieved when the artist gets the form of the work right. There can be no art without this rightness of form, but the form is always dedicated to the communication of

value through feeling. Tolstoy called this process 'infection'. Because it operated at this fundamental level of the feelings rather than the intellect, art bore a grave moral responsibility to inculcate the best (which for Tolstoy ultimately means Christian) values in the widest number of people. The present extracts are from the English translation by Aylmer Maude, made in 1898 with Tolstoy's cooperation. We have used the World's Classics edition, London, 1930, as reprinted in 1969, pp. 120–3, 156–60, 170–2, 175–80. The 'amateur of art' to whose diary Tolstoy refers was his own eldest daughter, who was an art student at the time.

In order to define art correctly it is necessary first of all to cease to consider it as a means to pleasure, and to consider it as one of the conditions of human life. Viewing it in this way we cannot fail to observe that art is one of the means of intercourse between man and man.

Every work of art causes the receiver to enter into a certain kind of relationship both with him who produced or is producing the art, and with all those who, simultaneously, previously, or subsequently, receive the same artistic impression.

Speech transmitting the thoughts and experiences of men serves as a means of union among them, and art serves a similar purpose. The peculiarity of this latter means of intercourse, distinguishing it from intercourse by means of words, consists in this, that whereas by words a man transmits his thoughts to another, by art he transmits his feelings.

The activity of art is based on the fact that a man receiving through his sense of hearing or sight another man's expression of feeling, is capable of experiencing the emotion which moved the man who expressed it. To take the simplest example: one man laughs, and another who hears becomes merry, or a man weeps, and another who hears feels sorrow. A man is excited or irritated, and another man seeing him is brought to a similar state of mind. By his movements or by the sounds of his voice a man expresses courage and determination or sadness and calmness, and this state of mind passes on to others. A man suffers, manifesting his sufferings by groans and spasms, and this suffering transmits itself to other people; a man expresses his feelings of admiration, devotion, fear, respect, or love, to certain objects, persons, or phenomena, and others are infected by the same feelings of admiration, devotion, fear, respect, or love, to the same objects, persons, or phenomena.

And it is on this capacity of man to receive another man's expression of feeling and to experience those feelings himself, that the activity of art is based.

If a man infects another or others directly, immediately, by his appearance or by the sounds he gives vent to at the very time he experiences the feeling; if he causes another man to yawn when he himself cannot help yawning, or to laugh or cry when he himself is obliged to laugh or cry, or to suffer when he himself is suffering – that does not amount to art.

Art begins when one person with the object of joining another or others to himself in one and the same feeling, expresses that feeling by certain external indications. To take the simplest example: a boy having experienced, let us say, fear on encountering a wolf, relates that encounter, and in order to evoke in others the feeling he has experienced, describes himself, his condition before the encounter, the surroundings, the wood, his own lightheartedness, and then the wolf's appearance, its movements, the distance between himself and the wolf, and so forth. All this, if only the boy when

telling the story again experiences the feelings he had lived through, and infects the hearers and compels them to feel what he had experienced – is art. Even if the boy had not seen a wolf but had frequently been afraid of one, and if wishing to evoke in others the fear he had felt, he invented an encounter with a wolf and recounted it so as to make his hearers share the feelings he experienced when he feared the wolf, that also would be art. And just in the same way it is art if a man, having experienced either the fear of suffering or the attraction of enjoyment (whether in reality or in imagination), expresses these feelings on canvas or in marble so that others are infected by them. And it is also art if a man feels, or imagines to himself, feelings of delight, gladness, sorrow, despair, courage, or despondency, and the transition from one to another of these feelings, and expresses them by sounds so that the hearers are infected by them and experience them as they were experienced by the composer.

The feelings with which the artist infects others may be most various – very strong or very weak, very important or very insignificant, very bad or very good: feelings of love of one's country, self-devotion and submission to fate or to God expressed in a drama, raptures of lovers described in a novel, feelings of voluptuousness expressed in a picture, courage expressed in a triumphal march, merriment evoked by a dance, humour evoked by a funny story, the feeling of quietness transmitted by an evening landscape or by a lullaby, or the feeling of admiration evoked by a beautiful arabesque – it is all art.

If only the spectators or auditors are infected by the feelings which the author has felt, it is art.

To evoke in oneself a feeling one has once experienced and having evoked it in oneself then by means of movements, lines, colours, sounds, or forms expressed in words, so to transmit that feeling that others experience the same feeling – this is the activity of art.

Art is a human activity consisting in this, that one man consciously by means of certain external signs, hands on to others feelings he has lived through, and that others are infected by these feelings and also experience them.

Art is not, as the metaphysicians say, the manifestation of some mysterious Idea of beauty or God; it is not, as the aesthetic physiologists say, a game in which man lets off his excess of stored-up energy; it is not the expression of man's emotions by external signs; it is not the production of pleasing objects; and, above all, it is not pleasure; but it is a means of union among men joining them together in the same feelings, and indispensable for the life and progress towards well-being of individuals and of humanity.

* * *

When a universal artist (such as were some of the Greek artists or the Jewish prophets) composed his work he naturally strove to say what he had to say so that it should be intelligible to all men. But when an artist composed for a small circle of people placed in exceptional conditions, or even for a single individual and his courtiers – for popes, cardinals, kings, dukes, queens, or for a king's mistress – he naturally aimed only at influencing these people, who were well known to him and lived in exceptional conditions familiar to him. And this was an easier task, and the artist was involuntarily drawn to express himself by allusions comprehensible only to the initiated, and obscure to every one else. In the first place more could be said in that way; and secondly, there is (for the initiated) even a certain charm in the cloudiness of

such a manner of expression. This method, which showed itself both in euphuism and in mythological and historical allusions, came more and more into use until apparently it reached its utmost limits in the so-called art of the Decadents. It has come finally to this: that not only are haziness, mysteriousness, obscurity, and exclusiveness (shutting out the masses) elevated to the rank of a merit and a condition of poetic art, but even inaccuracy, indefiniteness, and lack of eloquence, are held in esteem.

Théophile Gautier in his preface to the celebrated *Fleurs du Mal* says that Baudelaire as far as possible banished from poetry eloquence, passion, and truth too strictly copied (*'l'éloquence, la passion, et la vérité calquée trop exactement'*).

And Baudelaire not only did this, but maintained this thesis in his verses, and yet more strikingly in the prose of his *Petits Poèmes en Prose*, the meanings of which have to be guessed like a rebus and remain for the most part undiscovered.

The poet Verlaine (who followed next after Baudelaire and was also esteemed great) even wrote an *Art poétique*, in which he advises this style of composition [. . .]

After these two comes Mallarmé, considered the most important of the young poets, and he plainly says that the charm of poetry lies in our having to guess its meaning – that in poetry there should always be a puzzle [. . .]

Thus is obscurity elevated into a dogma among the new poets. As the French critic Doumic (who has not yet accepted the dogma) quite correctly says: –

'Il serait temps aussi d'en finir avec cette fameuse "théorie de l'obscurité" que la nouvelle école a élevée, en effet à la hauteur d'un dogme.' (*Les Jeunes, études et portraits*, René Doumic).

But it is not only French writers who think thus. The poets of all other countries think and act in the same way: German, and Scandinavian, and Italian, and Russian, and English. So also do the artists of the new period in all branches of art: in painting, in sculpture, and in music. Relying on Nietzsche and Wagner, the artists of the new age conclude that it is unnecessary for them to be intelligible to the vulgar crowd; it is enough for them to evoke poetic emotion in 'the finest nurtured,' to borrow a phrase from an English aesthetician.

* * *

Painting not only does not lag behind poetry in this matter, but rather outstrips it. Here is an extract from the diary of an amateur of art, written when visiting the Paris exhibitions in 1894: –

'I was to-day at three exhibitions: the Symbolists', the Impressionists', and the Neo-Impressionists'. I looked at the pictures conscientiously and carefully, but again felt the same stupefaction and ultimate indignation. The first exhibition, that of Camille Pissarro, was comparatively the most comprehensible, though the pictures were out of drawing, had no content, and the colourings were most improbable. The drawing was so indefinite that you were sometimes unable to make out which way an arm or a head was turned. The subject was generally, "*effets*" – *Effet de brouillard*, *Effet du soir*, *Soleil couchant*. There were some pictures with figures but without subjects.

'In the colouring, bright blue and bright green predominated. And each picture had its special colour with which the whole picture was, as it were, splashed. For instance in "A Girl guarding Geese" the special colour is *vert de gris*, and dots of it were splashed about everywhere: on the face, the hair, the hands, and the clothes. In the same gallery – that of Durand-Ruel – were other pictures: by Puvis de Chavannes,

Manet, Monet, Renoir, Sisley, who are all Impressionists. One of them, whose name I could not make out – it was something like Redon – had painted a blue face in profile. On the whole face there is only this blue tone, with white-of-lead. Pissarro has a water-colour all done in dots. In the foreground is a cow entirely painted with various-coloured dots. The general colour cannot be distinguished, however much one stands back from, or draws near to, the picture. From there I went to see the Symbolists. I looked at them long without asking any one for an explanation, trying to guess the meaning; but it is beyond human comprehension. One of the first things to catch my eye was a wooden *haut-relief*, wretchedly executed, representing a woman (naked) who with both hands is squeezing from her two breasts streams of blood. The blood flows down, becoming lilac in colour. Her hair first descends and then rises again and turns into trees. The figure is all coloured yellow and the hair is brown.

'Next – a picture: a yellow sea on which something swims which is neither a ship nor a heart; on the horizon is a profile with a halo and yellow hair, which changes into the sea, in which it is lost. Some of the painters lay on their colours so thick that the effect is something between painting and sculpture. A third exhibit was even less comprehensible: a man's profile; before him a flame and black stripes – leeches, as I was afterwards told. At last I asked a gentleman who was there what it meant, and he explained to me that the *haut-relief* was a symbol, and represented "*La Terre.*" The heart swimming in a yellow sea was "*Illusion perdue,*" and the gentleman with the leeches was "*Le Mal.*" There were also some Impressionist pictures: elementary profiles, holding some sort of flowers in their hands; in monotone, out of drawing, and either quite blurred or else marked out with wide black outlines.'

This was in 1894; the same tendency is now even more strongly defined, and we have Böcklin, Stuck, Klinger, Sasha Schneider, and others. [. . .]

I can only conclude that art, becoming ever more and more exclusive, has become more and more incomprehensible to an ever-increasing number of people, and that in this, its progress towards greater and greater incomprehensibility (on one level of which I am standing with the art familiar to me), it has reached a point where it is understood by a very small number of the elect, and the number of these chosen people is becoming ever smaller and smaller.

As soon as ever the art of the upper classes separated itself from universal art a conviction arose that art may be art and yet be incomprehensible to the masses. And as soon as this position was admitted it had inevitably to be admitted also that art may be intelligible only to the very smallest number of the elect and eventually to two, or to one, of our nearest friends, or to oneself alone – which is practically what is being said by modern artists: – 'I create and understand myself, and if any one does not understand me so much the worse for him.'

The assertion that art may be good art and at the same time incomprehensible to a great number of people, is extremely unjust, and its consequences are ruinous to art itself; but at the same time it is so common and has so eaten into our conceptions, that it is impossible to make sufficiently clear its whole absurdity.

Nothing is more common than to hear it said of reputed works of art that they are very good but very difficult to understand. We are quite used to such assertions, and yet to say that a work of art is good but incomprehensible to the majority of men, is the same as saying of some kind of food that it is very good but most people can't eat it.

The majority of men may not like rotten cheese or putrefying grouse, dishes esteemed by people with perverted tastes; but bread and fruit are only good when they are such as please the majority of men. And it is the same with art. Perverted art may not please the majority of men, but good art always pleases every one.

It is said that the very best works of art are such that they cannot be understood by the masses, but are accessible only to the elect who are prepared to understand these great works. But if the majority of men do not understand, the knowledge necessary to enable them to understand should be taught and explained to them. But it turns out that there is no such knowledge, that the works cannot be explained, and that those who say the majority do not understand good works of art, still do not explain those works, but only tell us that in order to understand them one must read, and see, and hear, these same works over and over again. But this is not to explain, it is only to habituate! And people may habituate themselves to anything, even to the very worst things. As people may habituate themselves to bad food, to spirits, tobacco, and opium, just in the same way they may habituate themselves to bad art – and that is exactly what is being done.

Moreover it cannot be said that the majority of people lack the taste to esteem the highest works of art. The majority always have understood and still understand what we also recognize as being the very best art: the epic of Genesis, the Gospel parables, folk-legends, fairy-tales, and folk-songs, are understood by all. How can it be that the majority has suddenly lost its capacity to understand what is high in our art?

Of a speech it may be said that it is admirable but incomprehensible to those who do not know the language in which it is delivered. A speech delivered in Chinese may be excellent, and yet remain incomprehensible to me if I do not know Chinese; but what distinguishes a work of art from all other mental activity is just the fact that its language is understood by all, and that it infects all without distinction. The tears and laughter of a Chinaman infect me just as the laughter and tears of a Russian; and it is the same with painting and music, and also poetry when it is translated into a language I understand. The songs of a Kirghiz or of a Japanese touch me, though in a lesser degree than they touch a Kirghiz or a Japanese. I am also touched by Japanese painting, Indian architecture, and Arabian stories. If I am but little touched by a Japanese song and a Chinese novel, it is not that I do not understand these productions, but that I know and am accustomed to higher works of art. It is not because their art is above me. Great works of art are only great because they are accessible and comprehensible to every one. The story of Joseph translated into the Chinese language touches a Chinese. The story of Sakya Muni (Buddha) touches us. And there are, and must be, buildings, pictures, statues, and music, of similar power. So that if art fails to move men, it cannot be said that this is due to the spectators' or hearers' lack of understanding, but the conclusion to be drawn may be, and should be, that such art is either bad or is not art at all.

Art is differentiated from activity of the understanding, which demands preparation and a certain sequence of knowledge (so that one cannot learn trigonometry before knowing geometry), by the fact that it acts on people independently of their state of development and education, that the charm of a picture, of sounds, or of forms, infects any man whatever his plane of development.

The business of art lies just in this: to make that understood and felt which in the form of an argument might be incomprehensible and inaccessible. Usually it seems to the recipient of a truly artistic impression that he knew the thing before, but had been unable to express it.

And such has always been the nature of good, supreme art; the *Iliad*, the *Odyssey*; the stories of Isaac, Jacob, and Joseph; the Hebrew prophets, the psalms, the Gospel parables; the story of Sakya Muni and the hymns of the Vedas, all transmit very exalted feelings and are nevertheless quite comprehensible now to us, educated or uneducated, just as they were comprehensible to the men of those times, long ago, who were even less educated than our labourers. People talk about incomprehensibility; but if art is the transmission of feelings flowing from man's religious perception, how can a feeling be incomprehensible which is founded on religion, that is, on man's relation to God? Such art should be, and has actually always been, comprehensible to everybody, because every man's relation to God is one and the same. This is why the churches and the images in them were always comprehensible to every one. The hindrance to an understanding of the best and highest feelings (as is said in the Gospel) lies not at all in deficiency of development or learning, but on the contrary in false development and false learning. A good and lofty work of art may be incomprehensible, but not to simple, unperverted, peasant labourers (what is highest is understood by them) – it may be and often is unintelligible to erudite, perverted people destitute of religion. And this continually occurs in our society in which the highest feelings are simply not understood. For instance, I know people who consider themselves most refined, and who say that they do not understand the poetry of love of one's neighbour, of self-sacrifice, or of chastity.

So that good, great, universal, religious art may be incomprehensible to a small circle of spoilt people, but certainly not to any large number of plain men.

Art cannot be incomprehensible to the great masses only because it is very good – as artists of our day are fond of telling us. Rather we are bound to conclude that this art is unintelligible to the great masses only because it is very bad art, or even is not art at all. So that the favourite argument (naively accepted by the cultured crowd), that in order to feel art one has first to understand it (which really only means habituate oneself to it), is the truest indication that what we are asked to understand by such a method is either very bad, exclusive art, or is not art at all.

People say that works of art do not please the people because they are incapable of understanding them. But if the aim of works of art is to infect people with the emotion the artist has experienced, how can one talk about not understanding?

A man of the people reads a book, sees a picture, hears a play or a symphony, and is touched by no feeling. He is told that this is because he cannot understand. People promise to let a man see a certain show; he enters and sees nothing. He is told that this is because his sight is not prepared for this show. But the man knows for certain that he sees quite well, and if he does not see what people promised to show him he only concludes (as is quite just) that those who undertook to show him the spectacle have not fulfilled their engagement. And it is perfectly just for a man who does feel the influence of some works of art, to come to this conclusion concerning artists who do not by their works evoke feeling in him. To say that the reason a man is not touched by my art is because he is still too stupid, besides being

very self-conceited and also rude, is to reverse the roles, and for the sick to send the hale to bed.

Voltaire said that '*Tous les genres sont bons, hors le genre ennuyeux*';[1] but with even more right one may say of art that *Tous les genres sont bons, hors celui qu'on ne comprend pas*, or *qui ne produit pas son effet*,[2] for of what value is an article which fails to accomplish that for which it was intended?

Mark this above all: if only it be admitted that art may be unintelligible to any one of sound mind and yet be art, there is no reason why any circle of perverted people should not compose works tickling their own perverted feelings and comprehensible to no one but themselves, and call it 'art,' as is actually being done by the so-called Decadents.

The direction art has taken may be compared to placing on a large circle other circles, smaller and smaller, until a cone is formed, the apex of which is no longer a circle at all. That is what has happened to the art of our times.

[1] All styles are good except the wearisome style.

[2] All styles are good except that which is not understood, *or* which fails to produce its effect.

21 Thorstein Veblen (1857–1929) 'Pecuniary Canons of Taste'

Veblen was an American sociologist, who applied novel economic theories and ethnological hypotheses to the study of modern institutions. The result in the present case was an analysis which appears to inhabit a quite different world not only from the world of Fine Art in which prevailing aesthetic theories had been generated, but also from that other world of Design and the Lesser Arts in which those theories had been opposed for much of the nineteenth century. On the one hand his concept of a 'leisure class' was quite inconsistent with the self-images of those who were accustomed to seeing themselves as knowledge-able about art, though it did much to explain those self-images. No argument for the disinterestedness of aesthetic value would ever again sound entirely persuasive in the light of his thesis about the honorific value of 'conspicuous wastefulness', particularly where the object at stake was known to be rare and expensive. On the other hand his remarks about the 'ceremonial inferiority' attributed to machine-made goods did material damage to the alternative argument – so dear to Ruskin, Morris and their followers – that craftsmanship alone could serve to reconcile beauty with utility. No reader could retain quite the same reverence for these august figures having once conceived of them, at Veblen's suggestion, as engaged in 'exaltation of the defective'. Veblen himself stresses that he has no intention of impugning their 'aesthetic teaching'. What he does, however, is to point to the vulnerability of any modern theory which seeks to evaluate aesthetic productions in a world apart from other consumable goods – or to conceive of taste in terms irrelevant to the actual behaviour of modern consumers. 'Pecuniary Canons of Taste' forms chapter VI of Veblen's *The Theory of the Leisure Class: An Economic Study of Institutions*, New York: MacMillan, 1899; the text of our extracts is taken from the first English edition, London: George Allen & Unwin, 1925, pp 126–37, 149–53, 160–2 and 165–6.

[. . .] The requirements of pecuniary decency have, to a very appreciable extent, influenced the sense of beauty and of utility in articles of use or beauty. Articles are to

an extent preferred for use on account of their being conspicuously wasteful; they are felt to be serviceable somewhat in proportion as they are wasteful and ill adapted to their ostensible use.

The utility of articles valued for their beauty depends closely upon the expensiveness of the articles. A homely illustration will bring out this dependence. A hand-wrought silver spoon, of a commercial value of some ten to twenty dollars, is not ordinarily more serviceable – in the first sense of the word – than a machine made spoon of the same material. It may not even be more serviceable than a machine-made spoon of some 'base' metal, such as aluminium, the value of which may be no more than some ten to twenty cents. The former of the two utensils is, in fact, commonly a less effective contrivance for its ostensible purpose than the latter. The objection is of course ready to hand that, in taking this view of the matter, one of the chief uses, if not the chief use, of the costlier spoon is ignored; the hand-wrought spoon gratifies our taste, our sense of the beautiful, while that made by machinery out of the base metal has no useful office beyond a brute efficiency. The facts are no doubt as the objection states them, but it will be evident on reflection that the objection is after all more plausible than conclusive. It appears (1) that while the different materials of which the two spoons are made each possesses beauty and serviceability for the purpose for which it is used, the material of the handwrought spoon is some one hundred times more valuable than the baser metal, without very greatly excelling the latter in intrinsic beauty of grain or colour, and without being in any appreciable degree superior in point of mechanical serviceability; (2) if a close inspection should show that the supposed hand-wrought spoon were in reality only a very clever imitation of hand-wrought goods, but an imitation so cleverly wrought as to give the same impression of line and surface to any but a minute examination by a trained eye, the utility of the article, including the gratification which the user derives from its contemplation as an object of beauty, would immediately decline by some eighty or ninety per cent, or even more; (3) if the two spoons are, to a fairly close observer, so nearly identical in appearance that the lighter weight of the spurious article alone betrays it, this identity of form and colour will scarcely add to the value of the machine-made spoon, nor appreciably enhance the gratification of the user's 'sense of beauty' in contemplating it, so long as the cheaper spoon is not a novelty, and so long as it can be procured at a nominal cost.

The case of the spoons is typical. The superior gratification derived from the use and contemplation of costly and supposedly beautiful products is, commonly, in great measure a gratification of our sense of costliness masquerading under the name of beauty. Our higher appreciation of the superior article is an appreciation of its superior honorific character, much more frequently than it is an unsophisticated appreciation of its beauty. The requirement of conspicuous wastefulness is not commonly present, consciously, in our canons of taste, but it is none the less present as a constraining norm selectively shaping and sustaining our sense of what is beautiful, and guiding our discrimination with respect to what may legitimately be approved as beautiful and what may not.

It is at this point, where the beautiful and the honorific meet and blend, that a discrimination between serviceability and wastefulness is most difficult in any concrete case. It frequently happens that an article which serves the honorific purpose of

conspicuous waste is at the same time a beautiful object; and the same application of labour to which it owes its utility for the former purpose may, and often does, go to give beauty of form and colour to the article. The question is further complicated by the fact that many objects, as, for instance, the precious stones and metals and some other materials used for adornment and decoration, owe their utility as items of conspicuous waste to an antecedent utility as objects of beauty. Gold, for instance, has a high degree of sensuous beauty; very many if not most of the highly prized works of art are intrinsically beautiful, though often with material qualification; the like is true of some stuffs used for clothing, of some landscapes, and of many other things in less degree. Except for this intrinsic beauty which they possess, these objects would scarcely have been coveted as they are, or have become monopolized objects of pride to their possessors and users. But the utility of these things to the possessor is commonly due less to their intrinsic beauty than to the honour which their possession and consumption confers, or to the obloquy which it wards off. [. . .]

The generalization for which the discussion so far affords ground is that any valuable object in order to appeal to our sense of beauty must conform to the requirements of beauty and of expensiveness both. But this is not all. Beyond this the canon of expensiveness also affects our tastes in such a way as to inextricably blend the marks of expensiveness, in our appreciation, with the beautiful features of the object, and to subsume the resultant effect under the head of an appreciation of beauty simply. The marks of expensiveness come to be accepted as beautiful features of the expensive articles. They are pleasing as being marks of honorific costliness, and the pleasure which they afford on this score blends with that afforded by the beautiful form and colour of the object; so that we often declare that an article of apparel, for instance, is 'perfectly lovely,' when pretty much all that an analysis of the aesthetic value of the article would leave ground for is the declaration that it is pecuniarily honorific. [. . .]

By further habituation to an appreciative perception of the marks of expensiveness in goods, and by habitually identifying beauty with reputability, it comes about that a beautiful article which is not expensive is accounted not beautiful. In this way it has happened, for instance, that some beautiful flowers pass conventionally for offensive weeds; others that can be cultivated with relative ease are accepted and admired by the lower middle class, who can afford no more expensive luxuries of this kind; but these varieties are rejected as vulgar by those people who are better able to pay for expensive flowers and who are educated to a higher schedule of pecuniary beauty in the florist's products; while still other flowers, of no greater intrinsic beauty than these, are cultivated at great cost and call out much admiration from flower-lovers whose tastes have been matured under the critical guidance of a polite environment.

The same variation in matters of taste, from one class of society to another, is visible also as regards many other kinds of consumable goods, as, for example, is the case with furniture, houses, parks, and gardens. This diversity of views as to what is beautiful in these various classes of goods is not a diversity of the norm according to which the unsophisticated sense of the beautiful works. It is not a constitutional difference of endowments in the aesthetic respect, but rather a difference in the code of reputability which specifies what objects properly lie within the scope of honorific consumption for the class to which the critic belongs. It is a difference in the

traditions of propriety with respect to the kinds of things which may, without derogation to the consumer, be consumed under the head of objects of taste and art. With a certain allowance for variations to be accounted for on other grounds, these traditions are determined, more or less rigidly, by the pecuniary plane of life of the class.

* * *

To-day a divergence in ideals is beginning to be apparent. The portion of the leisure class that has been consistently exempt from work and from pecuniary cares for a generation or more is now large enough to form and sustain an opinion in matters of taste. Increased mobility of the members has also added to the facility with which a 'social confirmation' can be attained within the class. Within this select class the exemption from thrift is a matter so commonplace as to have lost much of its utility as a basis of pecuniary decency. Therefore the latter-day upper-class canons of taste do not so consistently insist on an unremitting demonstration of expensiveness and a strict exclusion of the appearance of thrift. [...]

* * *

The connection here indicated between the aesthetic value and the invidious pecuniary value of things is of course not present in the consciousness of the valuer. So far as a person, in forming a judgement of taste, takes thought and reflects that the object of beauty under consideration is wasteful and reputable, and therefore may legitimately be accounted beautiful; so far the judgement is not a *bona fide* judgement of taste and does not come up for consideration in this connection. The connection which is here insisted on between the reputability and the apprehended beauty of objects lies through the effect which the fact of reputability has upon the valuer's habits of thought. He is in the habit of forming judgements of value of various kinds – economic, moral, aesthetic, or reputable – concerning the objects with which he has to do, and his attitude of commendation towards a given object on any other ground will affect the degree of his appreciation of the object when he comes to value it for the aesthetic purpose. This is more particularly true as regards valuation on grounds so closely related to the aesthetic ground as that of reputability. The valuation for the aesthetic purpose and for the purpose of repute are not held apart as distinctly as might be. Confusion is especially apt to arise between these two kinds of valuation, because the value of objects for repute is not habitually distinguished in speech by the use of a special descriptive term. The result is that the terms in familiar use to designate categories or elements of beauty are applied to cover this unnamed element of pecuniary merit, and the corresponding confusion of ideas follows by easy consequence. The demands of reputability in this way coalesce in the popular apprehension with the demands of the sense of beauty, and beauty which is not accompanied by the accredited marks of good repute is not accepted. But the requirements of pecuniary reputability and those of beauty in the naive sense do not in any appreciable degree coincide. The elimination from our surroundings of the pecuniarily unfit, therefore, results in a more or less thorough elimination of that considerable range of elements of beauty which do not happen to conform to the pecuniary requirement.

The underlying norms of taste are of very ancient growth, probably far antedating the advent of the pecuniary institutions that are here under discussion. Consequently, by force of the past selective adaptation of men's habits of thought, it happens that the

requirements of beauty, simply, are for the most part best satisfied by inexpensive contrivances and structures which in a straightforward manner suggest both the office which they are to perform and the method of serving their end.

It may be in place to recall the modern psychological position. Beauty of form seems to be a question of facility of apperception. The proposition could perhaps safely be made broader than this. If abstraction is made from association, suggestion, and 'expression,' classed as elements of beauty, then beauty in any perceived object means that the mind readily unfolds its apperceptive activity in the directions which the object in question affords. But the directions in which activity readily unfolds or expresses itself are the directions to which long and close habituation has made the mind prone. So far as concerns the essential elements of beauty, this habituation is an habituation so close and long as to have induced not only a proclivity to the apperceptive form in question, but an adaptation of physiological structure and function as well. So far as the economic interest enters into the constitution of beauty, it enters as a suggestion or expression of adequacy to a purpose, a manifest and readily inferable subservience to the life process. This expression of economic facility or economic serviceability in any object – what may be called the economic beauty of the object – is best served by neat and unambiguous suggestion of its office and its efficiency for the material ends of life.

On this ground, among objects of use the simple and unadorned article is aesthetically the best. But since the pecuniary canon of reputability rejects the inexpensive in articles appropriated to individual consumption, the satisfaction of our craving for beautiful things must be sought by way of compromise. The canons of beauty must be circumvented by some contrivance which will give evidence of a reputably wasteful expenditure, at the same time that it meets the demands of our critical sense of the useful and the beautiful, or at least meets the demand of some habit which has come to do duty in place of that sense. Such an auxiliary sense of taste is the sense of novelty; and this latter is helped out in its surrogateship by the curiosity with which men view ingenious and puzzling contrivances. Hence it comes that most objects alleged to be beautiful, and doing duty as such, show considerable ingenuity of design and are calculated to puzzle the beholder – to bewilder him with irrelevant suggestions and hints of the improbable – at the same time that they give evidence of an expenditure of labour in excess of what would give them their fullest efficiency for their ostensible economic end. [. . .]

The canon of beauty requires expression of the generic. The 'novelty' due to the demands of conspicuous waste traverses this canon of beauty, in that it results in making the physiognomy of our objects of taste a congeries of idiosyncrasies; and the idiosyncrasies are, moreover, under the selective surveillance of the canon of expensiveness.

* * *

The appreciation of those evidences of honorific crudeness to which hand-wrought goods owe their superior worth and charm in the eyes of well bred people is a matter of nice discrimination. It requires training and the formation of right habits of thought with respect to what may be called the physiognomy of goods. Machine-made goods of daily use are often admired and preferred precisely on account of their excessive perfection by the vulgar and the underbred who have not given due thought

to the punctilios of elegant consumption. The ceremonial inferiority of machine products goes to show that the perfection of skill and workmanship embodied in any costly innovations in the finish of goods is not sufficient of itself to secure them acceptance and permanent favour. The innovation must have the support of the canon of conspicuous waste. Any feature in the physiognomy of goods, however pleasing in itself, and however well it may approve itself to the taste for effective work, will not be tolerated if it proves obnoxious to this norm of pecuniary reputability.

The ceremonial inferiority or uncleanness in consumable goods due to 'commonness,' or in other words to their slight cost of production, has been taken very seriously by many persons. The objection to machine products is often formulated as an objection to the commonness of such goods. What is common is within the (pecuniary) reach of many people. Its consumption is therefore not honorific, since it does not serve the purpose of a favourable invidious comparison with other consumers. Hence the consumption, or even the sight of such goods, is inseparable from an odious suggestion of the lower levels of human life, and one comes away from their contemplation with a pervading sense of meanness that is extremely distasteful and depressing to a person of sensibility. In persons whose tastes assert themselves imperiously, and who have not the gift, habit, or incentive to discriminate between the grounds of their various judgements of taste, the deliverances of the sense of the honorific coalesce with those of the sense of beauty and of the sense of serviceability – in the manner already spoken of; the resulting composite valuation serves as a judgement of the object's beauty or its serviceability, according as the valuer's bias or interest inclines him to apprehend the object in the one or the other of these aspects. It follows not infrequently that the marks of cheapness or commonness are accepted as definitive marks of artistic unfitness, and a code or schedule of aesthetic proprieties on the one hand, and of aesthetic abominations on the other, is constructed on this basis for guidance in questions of taste.

As has already been pointed out, the cheap, and therefore indecorous, articles of daily consumption in modern industrial communities are commonly machine products; and the generic feature of the physiognomy of machine-made goods as compared with the hand-wrought article is their greater perfection in workmanship and greater accuracy in the detailed execution of the design. Hence it comes about that the visible imperfections of the hand-wrought goods, being honorific, are accounted marks of superiority in point of beauty, or serviceability, or both. Hence has arisen that exaltation of the defective, of which John Ruskin and William Morris were such eager spokesmen in their time; and on this ground their propaganda of crudity and wasted effort has been taken up and carried forward since their time. And hence also the propaganda for a return to handicraft and household industry. So much of the work and speculations of this group of men as fairly comes under the characterization here given would have been impossible at a time when the visibly more perfect goods were not the cheaper.

It is of course only as to the economic value of this school of aesthetic teaching that anything is intended to be said or can be said here. What is said is not to be taken in the sense of depreciation, but chiefly as a characterization of the tendency of this teaching in its effect on consumption and on the production of consumable goods.

* * *

The position of machine products in the civilized scheme of consumption serves to point out the nature of the relation which subsists between the canon of conspicuous waste and the code of proprieties in consumption. Neither in matters of art and taste proper, nor as regards the current sense of the serviceability of goods, does this canon act as a principle of innovation or initiative. It does not go into the future as a creative principle which makes innovations and adds new items of consumption and new elements of cost. The principle in question is, in a certain sense, a negative rather than a positive law. It is a regulative rather than a creative principle. It very rarely initiates or originates any usage or custom directly. Its action is selective only. Conspicuous wastefulness does not directly afford ground for variation and growth, but conformity to its requirements is a condition to the survival of such innovations as may be made on other grounds. In whatever way usages and customs and methods of expenditure arise, they are all subject to the selective action of this norm of reputability; and the degree in which they conform to its requirements in a test of their fitness to survive in the competition with other similar usages and customs. Other things being equal, the more obviously wasteful usage or method stands the better chance of survival under this law. The law of conspicuous waste does not account for the origin of variations, but only for the persistence of such forms as are fit to survive under its dominance. It acts to conserve the fit, not to originate the acceptable. Its office is to prove all things and to hold fast that which is good for its purpose.

Vc
The Independence of Art

1 Walter Pater (1839–1894) 'Conclusion' to *The Renaissance*

Pater spent his entire career, first as a student and subsequently as a don, at Oxford University. He was originally a Classics scholar who began to write on the Renaissance. His *Studies in the History of the Renaissance* (later shortened to just *The Renaissance*) first appeared in 1873. It was however Pater's approach to his subject, rather than his subject as such, that made him a central figure of English Aestheticism. The key text of this position was printed in the first edition of *The Renaissance* as its 'Conclusion', but was dated 1868. The piece originally formed part of a review of the poetry of William Morris which had been published in the *Westminster Review* in October 1868. It represents a concentrated statement of the aesthetic attitude: that a love of art and beauty for its own sake is the highest wisdom. In the Victorian climate, this proved an obstacle to Pater's academic advancement. But by the same token, its keynote assertion that real success in life lies in the capacity 'to burn always with a hard gem-like flame', made it a credo for those among the young who sought an alternative to Ruskinian moralizing. Because of its controversial nature, Pater withdrew the 'Conclusion' from the second edition of *The Renaissance*, but reinstated it thereafter since the text's notoriety had given it a life of its own. The 'Conclusion' can be found in the 1971 Harper/Collins edition of *The Renaissance: Studies in Art and Poetry*, on pp. 220–4.

To regard all things and principles of things as inconstant modes or fashions has more and more become the tendency of modern thought. Let us begin with that which is without – our physical life. Fix upon it in one of its more exquisite intervals, the moment, for instance, of delicious recoil from the flood of water in summer heat. What is the whole physical life in that moment but a combination of natural elements to which science gives their names? But those elements, phosphorus and lime and delicate fibres, are present not in the human body alone: we detect them in places most remote from it. Our physical life is a perpetual motion of them – the passage of the blood, the waste and repairing of the lenses of the eye, the modification of the tissues of the brain under every ray of light and sound – processes which science reduces to simpler and more elementary forces. Like the elements of which we are composed, the action of these forces extends beyond us: it rusts iron and ripens corn. Far out on every

side of us those elements are broadcast, driven in many currents; and birth and gesture and death and the springing of violets from the grave are but a few out of ten thousand resultant combinations. That clear, perpetual outline of face and limb is but an image of ours, under which we group them – a design in a web, the actual threads of which pass out beyond it. This at least of flamelike our life has, that it is but the concurrence, renewed from moment to moment, of forces parting sooner or later on their ways.

Or if we begin with the inward world of thought and feeling, the whirlpool is still more rapid, the flame more eager and devouring. There it is no longer the gradual darkening of the eye, the gradual fading of colour from the wall – movements of the shore-side, where the water flows down indeed, though in apparent rest – but the race of the mid-stream, a drift of momentary acts of sight and passion and thought. At first sight experience seems to bury us under a flood of external objects, pressing upon us with a sharp and importunate reality, calling us out of ourselves in a thousand forms of action. But when reflexion begins to play upon those objects they are dissipated under its influence; the cohesive force seems suspended like some trick of magic; each object is loosed into a group of impressions – colour, odour, texture – in the mind of the observer. And if we continue to dwell in thought on this world, not of objects in the solidity with which language invests them, but of impressions, unstable, flickering, inconsistent, which burn and are extinguished with our consciousness of them, it contracts still further: the whole scope of observation is dwarfed into the narrow chamber of the individual mind. Experience, already reduced to a group of impressions, is ringed round for each one of us by that thick wall of personality through which no real voice has ever pierced on its way to us, or from us to that which we can only conjecture to be without. Every one of those impressions is the impression of the individual in his isolation, each mind keeping as a solitary prisoner its own dream of a world. Analysis goes a step farther still, and assures us that those impressions of the individual mind to which, for each one of us, experience dwindles down, are in perpetual flight; that each of them is limited by time, and that as time is infinitely divisible, each of them is infinitely divisible also; all that is actual in it being a single moment, gone while we try to apprehend it, of which it may ever be more truly said that it has ceased to be than that it is. To such a tremulous wisp constantly reforming itself on the stream, to a single sharp impression, with a sense in it, a relic more or less fleeting, of such moments gone by, what is real in our life fines itself down. It is with this movement, with the passage and dissolution of impressions, images, sensations, that analysis leaves off – that continual vanishing away, that strange, perpetual weaving and unweaving of ourselves.

Philosophiren, says Novalis, *ist dephlegmatisiren, vivificiren*. The service of philosophy, of speculative culture, towards the human spirit, is to rouse, to startle it to a life of constant and eager observation. Every moment some form grows perfect in hand or face; some tone on the hills or the sea is choicer than the rest; some mood of passion or insight or intellectual excitement is irresistibly real and attractive to us, – for that moment only. Not the fruit of experience, but experience itself, is the end. A counted number of pulses only is given to us of a variegated, dramatic life. How may we see in them all that is to be seen in them by the finest senses? How shall we pass most swiftly from point to point, and be present always at the focus where the greatest number of vital forces unite in their purest energy?

To burn always with this hard, gemlike flame, to maintain this ecstasy, is success in life. In a sense it might even be said that our failure is to form habits: for, after all, habit is relative to a stereotyped world, and meantime it is only the roughness of the eye that makes any two persons, things, situations, seem alike. While all melts under our feet, we may well grasp at any exquisite passion, or any contribution to knowledge that seems by a lifted horizon to set the spirit free for a moment, or any stirring of the senses, strange dyes, strange colours, and curious odours, or work of the artist's hands, or the face of one's friend. Not to discriminate every moment some passionate attitude in those about us, and in the very brilliancy of their gifts some tragic dividing of forces on their ways, is, on this short day of frost and sun, to sleep before evening. With this sense of the splendour of our experience and of its awful brevity, gathering all we are into one desperate effort to see and touch, we shall hardly have time to make theories about the things we see and touch. What we have to do is to be for ever curiously testing new opinions and courting new impressions, never acquiescing in a facile orthodoxy of Comte, or of Hegel, or of our own. Philosophical theories or ideas, as points of view, instruments of criticism, may help us to gather up what might otherwise pass unregarded by us. 'Philosophy is the microscope of thought.' The theory or idea or system which requires of us the sacrifice of any part of this experience, in consideration of some interest into which we cannot enter, or some abstract theory we have not identified with ourselves, or of what is only conventional, has no real claim upon us.

One of the most beautiful passages of Rousseau is that in the sixth book of the *Confessions* where he describes the awakening in him of the literary sense. An undefinable taint of death had clung always about him, and now in early manhood he believed himself smitten by mortal disease. He asked himself how he might make as much as possible of the interval that remained; and he was not biased by anything in his previous life when he decided that it must be by intellectual excitement, which he found just then in the clear, fresh writings of Voltaire. Well! we are all *condamnés*, as Victor Hugo says: we are all under sentence of death but with a sort of indefinite reprieve – *les hommes sont tous condamnés à mort avec des sursis indéfinis*: we have an interval, and then our place knows us no more. Some spend this interval in listlessness, some in high passions, the wisest, at least among 'the children of this world,' in art and song. For our one chance lies in expanding that interval, in getting as many pulsations as possible into the given time. Great passions may give us this quickened sense of life, ecstasy and sorrow of love, the various forms of enthusiastic activity, disinterested or otherwise, which come naturally to many of us. Only be sure it is passion – that it does yield you this fruit of a quickened, multiplied consciousness. Of such wisdom, the poetic passion, the desire of beauty, the love of art for its own sake, has most. For art comes to you proposing frankly to give nothing but the highest quality to your moments as they pass, and simply for those moments' sake.

2 Walter Pater (1839–1894) 'The School of Giorgione'

The third edition of Pater's book *The Renaissance* appeared in 1888. It contained two new essays, one of which, 'The School of Giorgione' had been published in the *Fortnightly*

Review in October 1877. Just as the 'Conclusion' (cf.Vc1) represents Pater's essential statement of the aesthetic attitude, so 'The School of Giorgione' contains the key formulation of his theory of art. In this essay Pater emphasizes the importance of the imagination in responding to art, and articulates a thoroughgoing subjectivism. Pater's exclusive emphasis on aesthetic response represented a radical departure from the norms of a Victorian approach to art which was saturated by moral concern (compare IIIc4). For Pater the arts are experienced through the senses, and if this aspect is denied, if art's independence from 'mere intelligence' is occluded, then its significance is diminished. The arts are not, however, isolated from one another because of the different senses through which each is apprehended. Pater feels that it is precisely through concentration within its own limitations that an art may, mysteriously, evoke the expressive power of other arts. Music stands in this as a kind of first among equals, the purest fusion of form and content. Hence Pater's dictum that 'all art aspires to the condition of music'. Our extracts are taken from the text as it appeared in *The Renaissance: Studies in Art and Poetry*, 1888, using the 1917 edition, London: MacMillan & Co., pp. 135–40 and 144–5.

It is the mistake of much popular criticism to regard poetry, music, and painting – all the various products of art – as but translations into different languages of one and the same fixed quantity of imaginative thought, supplemented by certain technical qualities of colour, in painting; of sound, in music; of rhythmical words, in poetry. In this way, the sensuous element in art, and with it almost everything in art that is essentially artistic, is made a matter of indifference; and a clear apprehension of the opposite principle – that the sensuous material of each art brings with it a special phase or quality of beauty, untranslatable into the forms of any other, an order of impressions distinct in kind – is the beginning of all true aesthetic criticism. For, as art addresses not pure sense, still less the pure intellect, but the 'imaginative reason' through the senses, there are differences of kind in aesthetic beauty, corresponding to the differences in kind of the gifts of sense themselves. Each art, therefore, having its own peculiar and untranslatable sensuous charm, has its own special mode of reaching the imagination, its own special responsibilities to its material. One of the functions of aesthetic criticism is to define these limitations; to estimate the degree in which a given work of art fulfils its responsibilities to its special material; to note in a picture that true pictorial charm, which is neither a mere poetical thought or sentiment, on the one hand, nor a mere result of communicable technical skill in colour or design, on the other; to define in a poem that true poetical quality, which is neither descriptive nor meditative merely, but comes of an inventive handling of rhythmical language, the element of song in the singing; to note in music the musical charm, that essential music, which presents no words, no matter of sentiment or thought, separable from the special form in which it is conveyed to us.

To such a philosophy of the variations of the beautiful, Lessing's analysis of the spheres of sculpture and poetry, in the *Laocoon*, was an important contribution. But a true appreciation of these things is possible only in the light of a whole system of such art-casuistries. Now painting is the art in the criticism of which this truth most needs enforcing, for it is in popular judgements on pictures that the false generalization of all art into forms of poetry is most prevalent. To suppose that all is mere technical acquirement in delineation or touch, working through and addressing itself to the intelligence, on the one side, or a merely poetical, or what may be called literary

interest, addressed also to the pure intelligence, on the other: – this is the way of most spectators, and of many critics, who have never caught sight all the time of that true pictorial quality which lies between, unique pledge, as it is, of the possession of the pictorial gift, that inventive or creative handling of pure line and colour, which, as almost always in Dutch painting, as often also in the works of Titian or Veronese, is quite independent of anything definitely poetical in the subject it accompanies. It is the *drawing* – the design projected from the peculiar pictorial temperament or constitution, in which, while it may possibly be ignorant of true anatomical proportions, all things whatever, all poetry, all ideas however abstract or obscure, float up as visible scene or image: it is the *colouring* – that weaving of light, as of just perceptible gold threads, through the dress, the flesh, the atmosphere, in Titian's *Lace-girl*, that staining of the whole fabric of the thing with a new, delightful physical quality. This *drawing*, then – the arabesque traced in the air by Tintoret's flying figures, by Titian's forest branches; this colouring – the magic conditions of light and hue in the atmosphere of Titian's *Lace-girl*, or Rubens's *Descent from the Cross*: – these essential pictorial qualities must first of all delight the sense, delight it as directly and sensuously as a fragment of Venetian glass; and through this delight alone become the vehicle of whatever poetry or science may lie beyond them in the intention of the composer. In its primary aspect, a great picture has no more definite message for us than an accidental play of sunlight and shadow for a few moments on the wall or floor: is itself, in truth, a space of such fallen light, caught as the colours are in an Eastern carpet, but refined upon, and dealt with more subtly and exquisitely than by nature itself. And this primary and essential condition fulfilled, we may trace the coming of poetry into painting, by fine gradations upwards; from Japanese fan-painting, for instance, where we get, first, only abstract colour; then, just a little interfused sense of the poetry of flowers; then, sometimes, perfect flower-painting; and so, onwards, until in Titian we have, as his poetry in the *Ariadne*, so actually a touch of true childlike humour in the diminutive, quaint figure with its silk gown, which ascends the temple stairs, in his picture of the *Presentation of the Virgin*, at Venice.

But although each art has thus its own specific order of impressions, and an untranslatable charm, while a just apprehension of the ultimate differences of the arts is the beginning of aesthetic criticism; yet it is noticeable that, in its special mode of handling its given material, each art may be observed to pass into the condition of some other art, by what German critics term an *Anders-streben* [striving to be other] – a partial alienation from its own limitations, through which the arts are able, not indeed to supply the place of each other, but reciprocally to lend each other new forces.

Thus some of the most delightful music seems to be always approaching to figure, to pictorial definition. Architecture, again, though it has its own laws – laws esoteric enough, as the true architect knows only too well – yet sometimes aims at fulfilling the conditions of a picture, as in the *Arena* chapel; or of sculpture, as in the flawless unity of Giotto's tower at Florence; and often finds a true poetry, as in those strangely twisted staircases of the *châteaux* of the country of the Loire, as if it were intended that among their odd turnings the actors in a theatrical mode of life might pass each other unseen; there being a poetry also of memory and of the mere effect of time, by which architecture often profits greatly. Thus, again, sculpture aspires out of the hard limitation of pure form towards colour, or its equivalent; poetry also, in many ways,

finding guidance from the other arts, the analogy between a Greek tragedy and a work of Greek sculpture, between a sonnet and a relief, of French poetry generally with the art of engraving, being more than mere figures of speech; and all the arts in common aspiring towards the principle of music; music being the typical, or ideally consummate art, the object of the great *Anders-streben* of all art, of all that is artistic, or partakes of artistic qualities.

All art constantly aspires towards the condition of music. For while in all other kinds of art it is possible to distinguish the matter from the form, and the understanding can always make this distinction, yet it is the constant effort of art to obliterate it. That the mere matter of a poem, for instance, its subject, namely, its given incidents or situation – that the mere matter of a picture, the actual circumstances of an event, the actual topography of a landscape – should be nothing without the form, the spirit, of the handling, that this form, this mode of handling, should become an end in itself, should penetrate every part of the matter: this is what all art constantly strives after, and achieves in different degrees.

* * *

Art, then, is thus always striving to be independent of the mere intelligence, to become a matter of pure perception, to get rid of its responsibilities to its subject or material; the ideal examples of poetry and painting being those in which the constituent elements of the composition are so welded together, that the material or subject no longer strikes the intellect only; nor the form, the eye or the ear only; but form and matter, in their union or identity, present one single effect to the 'imaginative reason,' that complex faculty for which every thought and feeling is twin-born with its sensible analogue or symbol.

It is the art of music which most completely realizes this artistic ideal, this perfect identification of matter and form. In its consummate moments, the end is not distinct from the means, the form from the matter, the subject from the expression; they inhere in and completely saturate each other; and to it, therefore, to the condition of its perfect moments, all the arts may be supposed constantly to tend and aspire. In music, then, rather than in poetry, is to be found the true type or measure of perfected art. Therefore, although each art has its incommunicable element, its untranslatable order of impressions, its unique mode of reaching the 'imaginative reason,' yet the arts may be represented as continually struggling after the law or principle of music, to a condition which music alone completely realizes; and one of the chief functions of aesthetic criticism, dealing with the products of art, new or old, is to estimate the degree in which each of those products approaches, in this sense, to musical law. [...]

3 James McNeill Whistler (1834–1903) Cross-examination in the Trial of Ruskin for Libel

An American by birth, Whistler was in Paris in the later 1850s and 1860s. He was a member of a circle of artists that included Manet, Legros and Fantin-Latour, and his *Symphony in White No. 1,* was among the paintings shown in the Salon des Refusés in 1863. But from 1859 till 1892 he made London his principal base, becoming a leading figure in the English aesthetic movement. In 1877 John Ruskin responded to the exhibition

of his *Nocturne in Black and Gold* at the Grosvenor Galleries with a condemnation which Whistler considered damaging to his livelihood. The ensuing libel case attracted considerable publicity. It has been seen with hindsight as a *cause célèbre* in the battle between competing standards and principles of judgement: on the one hand the conviction that art should be grounded in the natural world and that it should be edifying; on the other the view that the value of art lies in the autonomy of its formal and decorative effects. Ruskin did not take the stand, being reported too ill to attend the court. Whistler won the case but was awarded token damages of one farthing. The payment of his costs ruined him financially, at least for the time being. He published his own account of the trial in his book *The Gentle Art of Making Enemies* in 1893. The following report was originally published in the *Daily News*, London, 26 November 1878. The *Nocturne in Black and Gold* is now in the collection of the Detroit Institute of Arts.

Yesterday morning the trial of an action for libel in which Mr James Abbott McNeill Whistler, an artist, seeks to recover damages against Mr John Ruskin, the well-known author and art critic, was commenced in the Exchequer Chamber, before Baron Huddleston and a special jury. The case excited great interest, and the court was crowded throughout the entire day; even the passages to the court being filled.

Mr Serjeant Parry, in stating the case to the jury, said the plaintiff had followed the profession of an artist for many years both in this and other countries. Mr Ruskin, the defendant, was a gentleman well known to all of them, and he held perhaps the highest position in Europe or in America as an art critic. Some of his works, he thought he was not wrong in saying, were destined to immortality, and it was the more surprising, therefore, that a gentleman holding such a position could traduce another in a way which would lead that other to come into a court of law to ask for damages. He thought the jury, after hearing the case, would come to the conclusion that a great injustice had been done. [. . .]

Mr Ruskin edited a publication called *Fors Clavigera*, which had a large circulation amongst artists and art patrons. In the July number of 1877 there appeared a criticism of many matters besides art, but on the subject of art he first criticized in general terms what he called the modern school, speaking in complimentary terms of Sir Coutts Lindsay, and referring to Mr Burne-Jones as an artist, after which came the paragraph which was the defamatory matter complained of, and which ran as follows: – 'Lastly, the mannerisms and errors of these pictures (meaning some pictures by Mr Burne-Jones), whatever may be their extent, are never affected or indolent. The work is natural to the painter, however strange to us; and it is wrought with utmost conscience of care, however far, to his own or our desire, the result may seem to be incomplete. Scarcely so much can be said for any other pictures of the modern schools; their eccentricities are almost always in some degree forced; and their imperfections gratuitously, if not impertinently, indulged. For Mr Whistler's own sake, no less than for the protection of the purchaser, Sir Coutts Lindsay ought not to have admitted works into the gallery in which the ill-educated conceit of the artist so nearly approached the aspect of wilful imposture. I have seen and heard much of cockney impudence before now, but never expected to hear a coxcomb ask 200 guineas for flinging a pot of paint in the public's face.' Mr Ruskin pleaded that the alleged libel was privileged as being a fair and bona fide criticism upon a painting which the plaintiff had exposed to public view. He submitted that the terms in which

Mr Ruskin had spoken of the plaintiff were unfair and ungentlemanly, and that they were calculated to, and had done him considerable injury, and it would be for the jury to say what damages the plaintiff was entitled to.

Mr Whistler was then called, and he said – I am an artist and was born in St Petersburg. My father was the engineer of the St Petersburg and Moscow Railway. After leaving Russia I went to America, and was educated at West Point. I came back to England in 1865, or 1866. I resided in Paris for two or three years, and studied with M. Glare [Gleyre]. After leaving Paris I came to London, and settled here. While I have been in London I have continually exhibited at the Academy. The last picture I sent to the Academy was a portrait of my mother. The first picture that I exhibited in England, called 'At the Piano,' I sold to Mr Phillips, R. A. Since then I have exhibited 'La Mère Gerard,' 'Wapping,' 'Alone with the Tide,' 'Taking down Scaffolding at Old Westminster Bridge,' 'Ships in the Ice on the Thames,' 'The Little White Girl,' and many others. I have also exhibited in Paris. These pictures were painted by me, as an artist, for sale. Subsequently to this I exhibited pictures in the Dudley Gallery. I have been in the habit of etching. A number of my etchings were exhibited at the Hague, and I received a gold medal for them, which was the first intimation I had that they were there. There is a collection of my etchings in the British Museum. It is not complete. There is also a collection at Windsor Castle, in her Majesty's library. I exhibited eight pictures in the summer of 1877 at the Grosvenor Gallery. No pictures are exhibited there but on invitation. I was invited by Sir Coutts Lindsay to exhibit. The first was a 'Nocturne in Black and Gold,' the second a 'Nocturne in Blue and Silver,' the third a 'Nocturne in Blue and Gold,' the fourth a 'Nocturne in Blue and Silver,' the fifth 'An Arrangement in Black' (Irving, as Philip the Second), the sixth 'A Harmony in Amber and Black,' the seventh 'An Arrangement in Brown.' And, in addition to these, there was a portrait of Mr Carlyle. That portrait was painted from sittings which Mr Carlyle gave me. It has since been engraved, and the artist's proofs, or the mass of them, were all subscribed for. All the Nocturnes but one were sold before they went to the Grosvenor Gallery. One of them was sold to the Hon. Percy Wyndham for 200 guineas, the one in blue and gold. One I sent to Mr Graham in lieu of a former commission, the amount of which was 150 guineas. A third one, blue and silver, I presented to Mrs Leyland. The one that was for sale was in black and gold. I know the publication called *Fors Clavigera*. I believe it has an extensive sale.

Since the publication of this criticism have you sold a nocturne? – Not by any means at the same price as before. [...]

What is your definition of a Nocturne? – I have, perhaps, meant rather to indicate an artistic interest alone in the work, divesting the picture from any outside sort of interest which might have been otherwise attached to it. It is an arrangement of line, form, and colour first; and I make use of any incident of it which shall bring about a symmetrical result. Among my works are some night pieces; and I have chosen the word Nocturne because it generalizes and simplifies the whole set of them.

Cross-examined by the Attorney-General – I have sent pictures to the Academy which have not been received. I believe that is the experience of all artists. I did not send any of those which were exhibited in the Grosvenor Gallery. The nocturne in black and gold is a night piece, and represents the fireworks at Cremorne.

Not a view of Cremorne? – If it were called a view of Cremorne, it would certainly bring about nothing but disappointment on the part of the beholders. (Laughter) It is an artistic arrangement. It was marked 200 guineas. [. . .]

I suppose you are willing to admit that your pictures exhibit some eccentricities; you have been told that over and over again? – Yes; very often. (Laughter.)

You send them to the Gallery to invite the admiration of the public? – That would be such vast absurdity on my part that I don't think I could. (Laughter.)

Did it take you much time to paint the 'Nocturne in Black and Gold,' how soon did you knock it off? (Laughter.) – I knocked it off possibly in a couple of days – one day to do the work, and another to finish it.

And that was the labour for which you asked 200 guineas? – No; it was for the knowledge gained through a lifetime. (Applause.)

Mr Baron Huddleston said that if this manifestation of feeling were repeated, he would have to clear the court.

Cross-examination resumed – You don't approve of criticism? – I should not disapprove in any way of technical criticism by a man whose life is passed in the practice of the science which he criticizes; but for the opinion of a man whose life is not so passed I would have as little opinion as you would have if he expressed an opinion on law.

You expect to be criticized? – Yes, certainly; and I do not expect to be affected by it until it comes to be a case of this kind. [. . .]

The picture called the 'Nocturne in Blue and Silver' was then produced in court.

Cross-examination resumed – That is Mr Graham's picture, and is the 'Nocturne in Blue and Silver.' It represents Battersea Bridge by moonlight.

Baron Huddleston – Is this part of the picture at the top old Battersea Bridge? (Laughter.)

Witness – Your lordship is too close at present to the picture to perceive the effect which I intended to produce at a distance. The spectator is supposed to be looking down the river towards London.

The prevailing colour is blue? – Yes.

Are those figures on the top of the bridge intended for people? – They are just what you like.

That is a barge beneath? – Yes. I am very much flattered at your seeing that. The thing is intended simply as a representation of moonlight. My whole scheme was only to bring about a certain harmony of colour.

How long did it take you to paint that picture? – I completed the work of that in one day after having arranged the idea in my mind. . . .

Re-examined by Mr Serjeant Parry – I have also painted the portrait of Mr Carlyle, and a picture of a young lady, which have not been exhibited in the Grosvenor Gallery. [. . .] There is another picture which was at the Grosvenor called 'A Variation in Flesh Colour and Green.' There is another representing the sea-side and sand, called 'Harmony in Blue and Yellow.' The 'Nocturne in Black and Gold' was the one to which Mr Ruskin alluded. This subject of the arrangement of colours had been a life study to my mind. The pictures are painted off generally from my own thought and mind. Sketching on paper is very rare with me.

Do you conscientiously form your idea, and then conscientiously work it out? – Certainly.

And these pictures are published by you for the purpose of a livelihood? – Yes.

Your manual labour is rapid? – Certainly.

At this stage of the proceedings the court adjourned for luncheon, and for the purpose of enabling the jury to see the pictures in the Westminster Palace Hotel.

The jury having returned into court, the 'Nocturne in Black and Gold' was produced.

By the Attorney-General – This is Cremorne?

(Laughter.) – It is a 'Nocturne in Black and Gold.'

How long did it take you to paint that? – One whole day and part of another. That is a finished picture. The black monogram in the frame was placed in its position so as not to put the balance of colour out.

You have made the study of art your study of a lifetime. What is the peculiar beauty of that picture? – It would be impossible for me to explain to you, I am afraid, although I dare say I could to a sympathetic ear.

Do you not think that anybody looking at that picture might fairly come to the conclusion that it had no peculiar beauty? – I have strong evidence that Mr Ruskin did come to that conclusion.

Do you think it fair that Mr Ruskin should come to that conclusion? – What might be fair to Mr Ruskin I can't answer. No artist of culture would come to that conclusion.

You offer that picture to the public as one of particular beauty as a work of art, and which is fairly worth 200 guineas? – I offer it as a work which I have conscientiously executed, and which I think worth the money. I would hold my reputation upon this as I would upon any of my other works.

Re-examined by Mr Serjeant Parry – That picture was painted not as offering the portrait of a particular place, but as an artistic impression which had been carried away.

* * *

Mr Albert Moore, called and examined by Mr Petheran, stated – I am an artist. I have seen most of the picture galleries in Europe. I have studied in Rome, and have followed my profession in London for 15 years. I have had my pictures in the Academy and in the Grosvenor Gallery. I have known Mr Whistler for 14 years. I have seen the pictures which have been produced here to-day. The two pictures produced, in common with all Mr Whistler's works, have a large aim not often followed. People abroad charge us with finishing our pictures too much. In the qualities aimed at I say he has succeeded, and no living painter, I believe, could succeed in the same way in the same qualities. I consider them to be beautiful works of art. There is one extraordinary thing about them, and that is, that he has painted the air, especially in the 'Battersea Bridge' scene. The picture in black and gold I look upon as simply marvellous.

Would you call it a work of art? – Certainly, most consummate art.

Is 200 guineas a reasonable price? – I should say that as prices go it is not an unreasonable price. If I were rich I would buy them myself. The picture of Mr Carlyle is good as a portrait and excellent as a picture.

Is the picture with the fireworks an exquisite work of art? – There is a decided beauty in the painting of it.

Is there any eccentricity in these pictures? – I should call it originality.

4 James McNeill Whistler (1834–1903) 'The Ten O'Clock Lecture'

Whistler's lecture takes its name from the time in the evening at which it was first delivered in St James' Hall, Piccadilly, London, on 20 February 1885. He gave the same lecture twice more, in Cambridge on 24 March and in Oxford on 30 April. It was recognized at the time as a forceful statement of avant-garde views – as it was no doubt Whistler's intention it should be. Nevertheless its arguments were derived from what was by then a long tradition of belief in the independence and self-sufficiency of aesthetic values and judgements. Variations on that belief had been articulated at intervals throughout the century, though they had rarely gone unopposed for long (see, for instance, IA18). For the majority of his English audience, one of Whistler's provocative assertions is likely to have been seen as particularly outrageous: his claim that the production of art was unaffected by the moral conduct of individuals or societies. The association of aestheticism with independence from moral judgement was widely taken as a sign of decadence in the aesthetic movement as a whole. For many younger artists in England, however, Whistler's example was crucial in re-establishing the priority of technical effects over moral concerns. The lecture was first published as *Mr Whistler's 'Ten O'Clock'*, London: Chatto and Windus, 1885. It was translated into French by the poet Stéphane Mallarmé in 1888. This complete text of the lecture is taken from the second English edition of 1888, pp. 7–29.

Ladies and Gentlemen,

It is with great hesitation and much misgiving that I appear before you, in the character of The Preacher.

If timidity be at all allied to the virtue modesty, and can find favour in your eyes, I pray you, for the sake of that virtue, accord me your utmost indulgence.

I would plead for my want of habit, did it not seem preposterous, judging from precedent, that aught save the most efficient effrontery could be ever expected in connection with my subject – for I will not conceal from you that I mean to talk about Art. Yes, Art – that has of late become, as far as much discussion and writing can make it, a sort of common topic for the tea-table.

Art is upon the Town! – to be chucked under the chin by the passing gallant – to be enticed within the gates of the householder – to be coaxed into company, as a proof of culture and refinement.

If familiarity can breed contempt, certainly Art – or what is currently taken for it – has been brought to its lowest stage of intimacy.

The people have been harassed with Art in every guise, and vexed with many methods as to its endurance. They have been told how they shall love Art, and live with it. Their homes have been invaded, their walls covered with paper, their very dress taken to task – until, roused at last, bewildered and filled with the doubts and discomforts of senseless suggestion, they resent such intrusion, and cast forth the false prophets, who have brought the very name of the beautiful into disrepute, and derision upon themselves.

Alas! ladies and gentlemen, Art has been maligned. She has naught in common with such practices. She is a goddess of dainty thought – reticent of habit, abjuring all obtrusiveness, purposing in no way to better others.

She is, withal, selfishly occupied with her own perfection only – having no desire to teach – seeking and finding the beautiful in all conditions and in all times, as did her high priest Rembrandt, when he saw picturesque grandeur and noble dignity in the Jews' quarter of Amsterdam, and lamented not that its inhabitants were not Greeks.

As did Tintoret and Paul Veronese, among the Venetians, while not halting to change the brocaded silks for the classic draperies of Athens.

As did, at the Court of Philip, Velasquez, whose Infantas, clad in inaesthetic hoops, are, as works of Art, of the same quality as the Elgin marbles.

No reformers were these great men – no improvers of the ways of others! Their productions alone were their occupation, and, filled with the poetry of their science, they required not to alter their surroundings – for, as the laws of their Art were revealed to them, they saw, in the development of their work, that real beauty which, to them, was as much a matter of certainty and triumph as is to the astronomer the verification of the result, foreseen with the light given to him alone. In all this, their world was completely severed from that of their fellow-creatures with whom sentiment is mistaken for poetry; and for whom there is no perfect work that shall not be explained by the benefit conferred upon themselves.

Humanity takes the place of Art, and God's creations are excused by their usefulness. Beauty is confounded with virtue, and, before a work of Art, it is asked: 'What good shall it do?'

Hence it is that nobility of action, in this life, is hopelessly linked with the merit of the work that portrays it, and thus the people have acquired the habit of looking, as who should say, not *at* a picture, but *through* it, at some human fact, that shall, or shall not, from a social point of view, better their mental or moral state. So we have come to hear of the painting that elevates, and of the duty of the painter – of the picture that is full of thought, and of the panel that merely decorates.

A favourite faith, dear to those who teach, is that certain periods were especially artistic, and that nations, readily named, were notably lovers of Art.

So we are told that the Greeks were, as a people, worshippers of the beautiful, and that in the fifteenth century Art was engrained in the multitude.

That the great masters lived in common understanding with their patrons – that the early Italians were artists – all – and that the demand for the lovely thing produced it.

That we, of to-day, in gross contrast to this Arcadian purity, call for the ungainly, and obtain the ugly.

That, could we but change our habits and climate – were we willing to wander in groves – could we be roasted out of broadcloth – were we to do without haste, and journey without speed, we should again *require* the spoon of Queen Anne, and pick at our peas with the fork of two prongs.

And so, for the flock, little hamlets grow near Hammersmith, and the steam horse is scorned.

Useless! quite hopeless and false is the effort! – built upon fable, and all because 'a wise man has uttered a vain thing and filled his belly with the East wind.'

Listen! There never was an artistic period.

There never was an Art-loving nation.

In the beginning, man went forth each day – some to do battle, some to the chase; others, again, to dig and to delve in the field – all that they might gain and live, or lose and die. Until there was found among them one, differing from the rest, whose pursuits attracted him not, and so he stayed by the tents with the women, and traced strange devices with a burnt stick upon a gourd.

This man, who took no joy in the ways of his brethren – who cared not for conquest, and fretted in the field – this designer of quaint patterns – this deviser of the beautiful – who perceived in Nature about him curious curvings, as faces are seen in the fire – this dreamer apart, was the first artist.

And when, from the field and from afar, there came back the people, they took the gourd – and drank from out of it.

And presently there came to this man another – and, in time, others – of like nature, chosen by the Gods – and so they worked together; and soon they fashioned, from the moistened earth, forms resembling the gourd. And with the power of creation, the heirloom of the artist, presently they went beyond the slovenly suggestion of Nature, and the first vase was born, in beautiful proportion.

And the toilers tilled, and were athirst; and the heroes returned from fresh victories, to rejoice and to feast; and all drank alike from the artists' goblets, fashioned cunningly, taking no note the while of the craftsman's pride, and understanding not his glory in his work; drinking at the cup, not from choice, not from a consciousness that it was beautiful, but because, forsooth, there was none other!

And time, with more state, brought more capacity for luxury, and it became well that men should dwell in large houses, and rest upon couches, and eat at tables; whereupon the artist, with his artificers, built palaces, and filled them with furniture, beautiful in proportion and lovely to look upon.

And the people lived in marvels of art – and ate and drank out of masterpieces – for there was nothing else to eat and to drink out of, and no bad building to live in; no article of daily life, of luxury, or of necessity, that had not been handed down from the design of the master, and made by his workmen.

And the people questioned not, *and had nothing to say in the matter*.

So Greece was in its splendour, and Art reigned supreme – by force of fact, not by election – and there was no meddling from the outsider. The mighty warrior would no more have ventured to offer a design for the temple of Pallas Athene than would the sacred poet have proffered a plan for constructing the catapult.

And the Amateur was unknown – and the Dilettante undreamed of!

And history wrote on, and conquest accompanied civilization, and Art spread, or rather its products were carried by the victors among the vanquished from one country to another. And the customs of cultivation covered the face of the earth, so that all peoples continued to use what *the artist alone produced*.

And centuries passed in this using, and the world was flooded with all that was beautiful, until there arose a new class, who discovered the cheap, and foresaw fortune in the facture of the sham.

Then sprang into existence the tawdry, the common, the gew-gaw.

The taste of the tradesman supplanted the science of the artist, and what was born of the million went back to them, and charmed them, for it was after their own heart; and the great and the small, the statesman and the slave, took to themselves the abomination that was tendered, and preferred it – and have lived with it ever since!

And the artist's occupation was gone, and the manufacturer and the huckster took his place.

And now the heroes filled from the jugs and drank from the bowls – with understanding – noting the glare of their new bravery, and taking pride in its worth.

And the people – this time – had much to say in the matter – and all were satisfied. And Birmingham and Manchester arose in their might – and Art was relegated to the curiosity shop.

Nature contains the elements, in colour and form, of all pictures, as the keyboard contains the notes of all music.

But the artist is born to pick, and choose, and group with science, these elements, that the result may be beautiful – as the musician gathers his notes, and forms his chords, until he bring forth from chaos glorious harmony.

To say to the painter, that Nature is to be taken as she is, is to say to the player, that he may sit on the piano.

That Nature is always right, is an assertion, artistically, as untrue, as it is one whose truth is universally taken for granted. Nature is very rarely right, to such an extent even, that it might almost be said that Nature is usually wrong; that is to say, the condition of things that shall bring about the perfection of harmony worthy a picture is rare, and not common at all.

This would seem, to even the most intelligent, a doctrine almost blasphemous. So incorporated with our education has the supposed aphorism become, that its belief is held to be part of our moral being, and the words themselves have, in our ear, the ring of religion. Still, seldom does Nature succeed in producing a picture.

The sun blares, the wind blows from the east, the sky is bereft of cloud, and without, all is of iron. The windows of the Crystal Palace are seen from all points of London. The holiday-maker rejoices in the glorious day, and the painter turns aside to shut his eyes.

How little this is understood, and how dutifully the casual in Nature is accepted as sublime, may be gathered from the unlimited admiration daily produced by a very foolish sunset.

The dignity of the snow-capped mountain is lost in distinctness, but the joy of the tourist is to recognize the traveller on the top. The desire to see, for the sake of seeing, is, with the mass, alone the one to be gratified, hence the delight in detail.

And when the evening mist clothes the riverside with poetry, as with a veil, and the poor buildings lose themselves in the dim sky, and the tall chimneys become campanili, and the warehouses are palaces in the night, and the whole city hangs in the heavens, and fairy-land is before us – then the wayfarer hastens home; the working man and the cultured one, the wise man and the one of pleasure, cease to understand, as they have ceased to see, and Nature, who, for once, has sung in tune, sings her exquisite song to the artist alone, her son and her master – her son in that he loves her, her master in that he knows her.

To him her secrets are unfolded, to him her lessons have become gradually clear. He looks at her flower, not with the enlarging lens, that he may gather facts for the botanist, but with the light of the one who sees in her choice selection of brilliant tones and delicate tints, suggestions of future harmonies.

He does not confine himself to purposeless copying, without thought, each blade of grass, as commended by the inconsequent, but, in the long curve of the narrow leaf, corrected by the straight tall stem, he learns how grace is wedded to dignity, how strength enhances sweetness, that elegance shall be the result.

In the citron wing of the pale butterfly, with its dainty spots of orange, he sees before him the stately halls of fair gold, with their slender saffron pillars, and is taught how the delicate drawing high upon the walls shall be traced in tender tones of orpiment, and repeated by the base in notes of graver hue.

In all that is dainty and lovable he finds hints for his own combinations, and *thus* is Nature ever his resource and always at his service, and to him is naught refused.

Through his brain, as through the last alembic, is distilled the refined essence of that thought which began with the Gods, and which they left him to carry out.

Set apart by them to complete their works, he produces that wondrous thing called the masterpiece, which surpasses in perfection all that they have contrived in what is called Nature; and the Gods stand by and marvel, and perceive how far away more beautiful is the Venus of Melos than was their own Eve.

For some time past, the unattached writer has become the middleman in this matter of Art, and his influence, while it has widened the gulf between the people and the painter, has brought about the most complete misunderstanding as to the aim of the picture.

For him a picture is more or less a hieroglyph or symbol of story. Apart from a few technical terms, for the display of which he finds an occasion, the work is considered absolutely from a literary point of view; indeed, from what other can he consider it? And in his essays he deals with it as with a novel – a history – or an anecdote. He fails entirely and most naturally to see its excellencies, or demerits – artistic – and so degrades Art, by supposing it a method of bringing about a literary climax.

It thus, in his hands, becomes merely a means of perpetrating something further, and its mission is made a secondary one, even as a means is second to an end.

The thoughts emphasized, noble or other, are inevitably attached to the incident, and become more or less noble, according to the eloquence or mental quality of the writer, who looks, the while, with disdain, upon what he holds as 'mere execution,' a matter belonging, he believes, to the training of the schools, and the reward of assiduity. So that, as he goes on with his translation from canvas to paper, the work becomes his own. He finds poetry where he would feel it were he himself transcribing the event, invention in the intricacy of the *mise en scene*, and noble philosophy in some detail of philanthropy, courage, modesty, or virtue, suggested to him by the occurrence.

All this might be brought before him, and his imagination be appealed to, by a very poor picture – indeed, I might safely say that it generally is.

Meanwhile, the *painter's* poetry is quite lost to him – the amazing invention, that shall have put form and colour into such perfect harmony, that exquisiteness is the

result, he is without understanding – the nobility of thought, that shall have given the artist's dignity to the whole, says to him absolutely nothing.

So that his praises are published, for virtues we would blush to possess – while the great qualities, that distinguish the one work from the thousand, that make of the masterpiece the thing of beauty that it is – have never been seen at all.

That this is so, we can make sure of, by looking back at old reviews upon past exhibitions, and reading the flatteries lavished upon men who have since been forgotten altogether – but, upon whose works, the language has been exhausted, in rhapsodies, that left nothing for the National Gallery.

A curious matter, in its effect upon the judgement of these gentlemen, is the accepted vocabulary, of poetic symbolism, that helps them, by habit, in dealing with Nature: a mountain, to them, is synonymous with height – a lake, with depth – the ocean, with vastness – the sun, with glory.

So that a picture with a mountain, a lake, and an ocean – however poor in paint – is inevitably 'lofty,' 'vast,' 'infinite,' and 'glorious' – on paper.

There are those also, sombre of mien, and wise with the wisdom of books, who frequent museums and burrow in crypts; collecting – comparing – compiling – classifying – contradicting.

Experts these – for whom a date is an accomplishment – a hall mark, success!

Careful in scrutiny are they, and conscientious of judgement – establishing, with due weight, unimportant reputations – discovering the picture, by the stain on the back – testing the torso, by the leg that is missing, filling folios with doubts on the way of that limb – disputatious and dictatorial, concerning the birthplace of inferior persons – speculating, in much writing, upon the great worth of bad work.

True clerks of the collection, they mix memoranda with ambition, and, reducing Art to statistics, they 'file' the fifteenth century, and 'pigeon-hole' the antique!

Then the Preacher – 'appointed'!

He stands in high places – harangues and holds forth.

Sage of the Universities – learned in many matters, and of much experience in all, save his subject.

Exhorting – denouncing – directing.

Filled with wrath and earnestness.

Bringing powers of persuasion, and polish of language, to prove – nothing.

Torn with much teaching – having naught to impart.

Impressive – important – shallow.

Defiant – distressed – desperate.

Crying out, and cutting himself – while the Gods hear not.

Gentle priest of the Philistine withal, again he ambles pleasantly from all point, and through many volumes, escaping scientific assertion, 'babbles of green fields.'

So Art has become foolishly confounded with education – that all should be equally qualified.

Whereas, while polish, refinement, culture, and breeding, are in no way arguments for artistic result, it is also no reproach to the most finished scholar or greatest gentleman in the land that he be absolutely without eye for painting or ear for music – that in his heart he prefer the popular print to the scratch of Rembrandt's needle, or the songs of the hall to Beethoven's 'C minor Symphony.'

Let him have but the wit to say so, and not feel the admission a proof of inferiority.

Art happens – no hovel is safe from it, no Prince may depend upon it, the vastest intelligence cannot bring it about, and puny efforts to make it universal end in quaint comedy, and coarse farce.

This is as it should be, and all attempts to make it otherwise, are due to the eloquence of the ignorant, the zeal of the conceited.

The boundary line is clear. Far from me to propose to bridge it over – that the pestered people be pushed across. No! I would save them from further fatigue. I would come to their relief, and would lift from their shoulders this incubus of Art.

Why, after centuries of freedom from it, and indifference to it, should it now be thrust upon them by the blind – until, wearied and puzzled, they know no longer how they shall eat or drink – how they shall sit or stand – or wherewithal they shall clothe themselves – without afflicting Art?

But, lo! there is much talk without!

Triumphantly they cry, 'Beware! This matter does indeed concern us. We also have our part in all true Art! – for, remember the "one touch of Nature" that "makes the whole world kin."'

True, indeed. But let not the unwary jauntily suppose that Shakespeare herewith hands him his passport to Paradise, and thus permits him speech among the chosen. Rather, learn that, in this very sentence, he is condemned to remain without – to continue with the common.

This one chord that vibrates with all – this 'one touch of Nature' that calls aloud to the response of each – that explains the popularity of the 'Bull' of Paul Potter – that excuses the price of Murillo's 'Conception' – this one unspoken sympathy that pervades humanity, is – Vulgarity!

Vulgarity – under whose fascinating influence 'the many' have elbowed 'the few,' and the gentle circle of Art swarms with the intoxicated mob of mediocrity, whose leaders prate and counsel, and call aloud, where the Gods once spoke in whisper!

And now from their midst the Dilettante stalks abroad. The amateur is loosed. The voice of the aesthete is heard in the land, and catastrophe is upon us.

The meddler beckons the vengeance of the Gods, and ridicule threatens the fair daughters of the land.

And there are curious converts to a weird *culte*, in which all instinct for attractiveness – all freshness and sparkle – all woman's winsomeness – is to give way to a strange vocation for the unlovely – and this desecration in the name of the Graces!

Shall this gaunt, ill-at-ease, distressed, abashed mixture of *mauvaise honte* and desperate assertion, call itself artistic, and claim cousinship with the artist – who delights in the dainty – the sharp, bright gaiety of beauty?

No! – a thousand times no! Here are no connections of ours.

We will have nothing to do with them.

Forced to seriousness, that emptiness may be hidden, they dare not smile –

While the artist, in fullness of heart and head, is glad, and laughs aloud, and is happy in his strength, and is merry at the pompous pretension – the solemn silliness that surrounds him.

For Art and Joy go together, with bold openness, and high head, and ready hand – fearing naught, and dreading no exposure.

Know, then, all beautiful women, that we are with you. Pay no heed, we pray you, to this outcry of the unbecoming – this last plea for the plain.

It concerns you not.

Your own instinct is near the truth – your own wit far surer guide than the untaught ventures of thick-heeled Apollos.

What! will you up and follow the first piper that leads you down Petticoat Lane, there, on a Sabbath, to gather, for the week, from the dull rags of ages, wherewith to bedeck yourselves? that, beneath your travestied awkwardness, we have trouble to find your own dainty selves? Oh, fie! Is the world, then, exhausted? and must we go back because the thumb of the mountebank jerks the other way?

Costume is not dress.

And the wearers of wardrobes may not be doctors of taste!

For by what authority shall these be pretty masters? Look well, and nothing have they invented – nothing put together for comeliness' sake.

Haphazard from their shoulders hang the garments of the hawker – combining in their person the motley of many manners with the medley of the mummers' closet.

Set up as a warning, and a finger-post of danger, they point to the disastrous effect of Art upon the middle classes.

Why this lifting of the brow in deprecation of the present – this pathos in reference to the past?

If Art be rare to-day, it was seldom heretofore.

It is false, this teaching of decay.

The master stands in no relation to the moment at which he occurs – a monument of isolation – hinting at sadness – having no part in the progress of his fellow men.

He is also no more the product of civilization than is the scientific truth asserted, dependent upon the wisdom of a period. The assertion itself requires the *man* to make it. The truth was from the beginning.

So Art is limited to the infinite, and beginning there cannot progress.

A silent indication of its wayward independence from all extraneous advance, is in the absolutely unchanged condition and form of implement since the beginning of things.

The painter has but the same pencil – the sculptor the chisel of centuries.

Colours are not more since the heavy hangings of night were first drawn aside, and the loveliness of light revealed.

Neither chemist nor engineer can offer new elements of the masterpiece.

False again, the fabled link between the grandeur of Art and the glories and virtues of the State, for Art feeds not upon nations, and peoples may be wiped from the face of the earth, but Art *is*.

It is indeed high time that we cast aside the weary weight of responsibility and co-partnership, and know that, in no way, do our virtues minister to its worth, in no way do our vices impede its triumph!

How irksome! how hopeless! how superhuman the self-imposed task of the nation! How sublimely vain the belief that it shall live nobly or art perish!

Let us reassure ourselves, at our own option is our virtue. Art we in no way affect.

A whimsical goddess, and a capricious, her strong sense of joy tolerates no dullness, and, live we never so spotlessly, still may she turn her back upon us.

As, from time immemorial, has she done upon the Swiss in their mountains.

What more worthy people! Whose every Alpine gap yawns with tradition, and is stocked with noble story; yet, the perverse and scornful one will none of it, and the sons of patriots are left with the clock that turns the mill, and the sudden cuckoo, with difficulty restrained in its box!

For this was Tell a hero! For this did Gessler die!

Art, the cruel jade, cares not, and hardens her heart, and hies her off to the East, to find, among the opium-eaters of Nankin, a favourite with whom she lingers fondly – caressing his blue porcelain, and painting his coy maidens, and marking his plates with her six marks of choice – indifferent, in her companionship with him, to all save the virtue of his refinement!

He it is who calls her – he who holds her!

And again to the West, that her next lover may bring together the Gallery at Madrid, and show to the world how the Master towers above all; and in their intimacy they revel, he and she, in this knowledge; and he knows the happiness untasted by other mortal.

She is proud of her comrade, and promises that, in after years, others shall pass that way, and understand.

So in all time does this superb one cast about for the man worthy her love – and Art seeks the Artist alone.

Where he is, there she appears, and remains with him – loving and fruitful – turning never aside in moments of hope deferred – of insult – and of ribald mis-understanding; and when he dies she sadly takes her flight, though loitering yet in the land, from fond association, but refusing to be consoled.

With the man, then, and not with the multitude, are her intimacies; and in the book of her life the names inscribed are few – scant, indeed, the list of those who have helped to write her story of love and beauty.

From the sunny morning, when, with her glorious Greek relenting, she yielded up the secret of repeated line, as, with his hand in hers, together they marked, in marble, the measured rhyme of lovely limb and draperies flowing in unison, to the day when she dipped the Spaniard's brush in light and air, and made his people live within their frames, and *stand upon their legs*, that all nobility and sweetness, and tenderness, and magnificence should be theirs by right, ages had gone by, and few had been her choice.

Countless, indeed, the horde of pretenders! But she knew them not.

A teeming, seething, busy mass, whose virtue was industry, and whose industry was vice!

Their names go to fill the catalogue of the collection at home, of the gallery abroad, for the delectation of the bagman and the critic.

Therefore have we cause to be merry! – and to cast away all care – resolved that all is well – as it ever was – and that it is not meet that we should be cried at, and urged to take measures!

Enough have we endured of dullness! Surely are we weary of weeping, and our tears have been cozened from us falsely for they have called out woe! when there was no grief – and, alas! where all is fair!

We have then but to wait – until, with the mark of the gods upon him – there come among us again the chosen – who shall continue what has gone before. Satisfied that, even were he never to appear, the story of the beautiful is already complete – hewn in the marbles of the Parthenon – and broidered, with the birds, upon the fan of Hokusai – at the foot of Fusi-Yama.

5 Odilon Redon (1840–1916) Notes, and 'Reflections on an Impressionist Exhibition'

As a student in the 1860s, Redon saw himself, on his own retrospective account, as 'sensitive, and irrevocably of my time'. He was never to lose his conviction of the oppressiveness of the classical tradition, which conviction he formed during a brief attendance in the studio of Gérôme. His animosity to that tradition shows in his criticism of Ingres. His enthusiasm for Millet, on the other hand, is consistent with the direction of his own work, and with his idiosyncratic identification of Realism with the sensation of mystery. As his comparison of Rubens with Rembrandt makes clear, he conceived of this element of mystery not in literary but in pictorial terms – as something necessarily untranslatable into words. He had begun making highly individual charcoal drawings in the early 1870s, and his first album of lithographs was published in 1879. His criticism of the fifth Impressionist exhibition bears witness to a shift taking place within the avant-garde of the time, away from the commitment to modern forms of Naturalism and towards the subjectivism which was to be a marked feature of the Symbolist movement of the later 1880s. It should be borne in mind that Renoir, Monet and Sisley were all absent from the 1880 exhibition, and that several other writers besides Redon concluded that Impressionism was now a spent force. In fact, following his own rejection from the Salon, Redon was to exhibit with the Impressionists in the eighth and last group exhibition in 1886. By then Degas, Morisot and Pissarro were the only exhibitors remaining from the original core group of painters, while Seurat and Signac were among the other new recruits. 'Ingres', 'Millet', the note on Rubens and Rembrandt, and 'Refléxions sur une des Expositions des Impressionistes' were first printed in Redon, *A soi-même: journal (1867–1915): notes sur la vie, l'art et les artistes*, Paris, 1922. This posthumous publication was composed by friends and relatives from disparate notes, journal entries and reviews written over a long period. The dated extracts here presented have been rearranged in the order of their composition. Our text is taken from the edition of 1961, Paris: Libraire José Corti, pp. 146–8, 144–6, 79–83 and 162–3, translated for this volume by Kate Tunstall.

Ingres

Ingres was not a man of his times: he had a barren mind. When we look at his works, not only is our moral being not uplifted, but it is able to resume the placidity of bourgeois life, without being affected or modified in any way. His products do not constitute that real work of art whose value lies in its ability to enhance our moral being or in its greater power to influence others.

Such is the modern work of art: the roughest sketch by Delacroix, Rembrandt or Albrecht Dürer inspires us to take up our brush and start working in spite of everything: it is as if they conveyed and infused life itself to us; that is their decisive achievement, their supreme *import*. Whoever has this effect on others is a genius, whatever their field of activity, be it speech, writing or even their mere presence.

Ingres is an honest disciple and servant of the masters of a previous age. Since he lacks all reality and any warmth of life properly speaking, he will only be remembered in the temperate zones of this world of banality and ennui which admires a traditional ideal of beauty based on received opinion and fear of change. Like Poussin, David and others of their sort, he will always be the incarnation of that haughty and disdainful patronage that is official art. He will never leave the art school: every time some orator pronounces a professorial discourse on the principles and traditions of pagan art, his name will be heard.

Some would count him as an artist who still lives on, that is debatable: if he is not one of those who bring others to life, he cannot be alive; he is death itself.

Anyway, when certain people in high places dogmatically declare that works live on, what do they mean? What is this immortality?

Immortality is nothing other than the opening of that rare flower whose seeds lie at the heart of all beauty; immortality grows out of praise, admiration and the divine germination latent in the smallest piece of matter. Over a period of time, the flower grows more beautiful or less beautiful, depending on the public's nurture, for they only need to be left the right works of art to look at, love, consult and anxiously peruse in their moments of passion and curiosity. This is the higher power which attracts and elevates the public, who in their turn develop it, draw new life from it, and implant it in new works.

At the same time there exists a conservative school which longs to establish the principles that might arrest such growth; worse, it is a dark and sinister institution devoted to crushing all signs of that precious germination. It ceaselessly preserves and hands down its formula for death to the students that it trains and supports for its cause. In these false temples great false gods are placed on pedestals, Ingres always among them, his disciples at his feet. Graven here in letters of gold are sentencious maxims, laboriously hollowed out of marble, but as shallow as *Drawing is the source of probity in art*, words full of rhetoric, aimed at those hackneyed personnages who enter these pious institutions with their pompous airs. Does honesty have any place here?

Were they perhaps referring to the dogma of so-called classical drawing that is taught in such places? You are forbidden to study Michelangelo, Rembrandt or

Albrecht Dürer. They didn't produce honest art, and it is dishonest to be creative and to have genius, let alone be a prophet.

It has been said that these schools and the sterile fruit that they bear are useful. But then the question is, what has utility got to do with it? Is the beautiful useful? No. Is the useful beautiful? No. A shoe is not beautiful, nor is a loaf of bread.

Millet

Millet's great originality consists in his success in developing two apparently contradictory faculties rarely united in the same man: he was a painter and a thinker. I mean a painter in the true sense of the word, like the Spanish, the Dutch and some contemporary French artists; in short, like all those who are directly in touch with nature, and who make it tangible to others through their palette and its tones. This exquisite sensuality is a rare gift which produces infinite delight for the observer of external phenomena, but which also runs the risk of leading him into pure contemplation and absorbing or totally annihilating any thinking being who would abandon himself totally to it. This faculty predominates in the painter. Velasquez, for example, is the supreme example of this. He is the one who with great skill, I might even say with virtuosity, subjected himself most completely to the immediate reproduction of the object itself; he seems to have turned the artist into a passive and irresponsible being who leaves it to nature to do the talking. It's the same with the Dutch in whom the desire to make simple reproductions has produced some incomparable craftsmen, whose works are models of that genre. It is the same with some contemporary painters who, following Courbet's example call themselves Intransigents or Impressionists, and who in seeking to paint outdoors and in obstinately creating relief only through combining contradictory values, have found in colour new and unsuspected subtleties.

But the finest works of these artisans will never equal in quality the roughest sketch by Albrecht Dürer, in which he has handed down to us his very thoughts, the life of his soul, everything which is not part of the aforementioned sensuality, but which is none the less very human, full of life.

Like Dürer, Michelangelo is not a sensual painter; neither is da Vinci. Yet are these names not among the greatest in art! Rembrandt also had an admirable gift for bringing his dreams to life through chiaroscuro. And Millet takes after this master.

Since the poet in him was never subsumed by the painter, he had a vision. In his *plein air* painting he sought and found an entirely new world. He gave the clouds a soul. Man brings to life the trees, the countryside, all that is inanimate in nature. There is a drawing by Millet which gives full expression to his ideal: two children sitting at the bottom of a hill, one knitting and the other watching something or other, perhaps the flight of a bird, high in the bright sky. There is a genuinely new poetry in this page.

If we now note that throughout his life this master has represented the French peasant, that is to say the Frenchman in the humble labours of his agricultural life, we cannot call him a highly conscious thinker who spent his whole life making considered judgements. The study of his work invites us to reflect profoundly.

(23 April 1878)

On Rubens and Rembrandt

Antwerp, 5 August 1879

Dare I admit that Rubens speaks in a tongue I don't understand? Certainly, the *Crucifixion* reveals the full extent of the power of his mind; I don't believe I have ever seen such a profusion of actions and such convincing gestures, attitudes and varied expressions as are contained in this vast topic; never has a composition of such rich invention appeared so inextricably bound together by a deeply moving and beautiful thought; the crowd, the executioners, the thieves, one of whom radiates a brutish energy, the children appear just as graceful and charming as the children of the good Flemish people; the women unaware of their true native beauty, like that unfinished Mary Magdalene at the base of the cross supporting the feet of the divine body on her young shoulders, and whose deep suffering leads me to say that here Rubens has painted Goodness; all in all I feel overwhelmed yet inspired, I feel that I am in the presence of a truly superior creative force, and yet I resist that genius: something within it that I find totally alien prevents me from understanding it or liking it.

We have to admit that Rubens is a decadent master – we wouldn't say that of Rembrandt – he belongs to the dying days of classical art, for he has achieved nothing new or different. His turbulent, fiery genius, full of ideas, overflowed throughout his life, on the walls of churches, in palaces, among kings and princes, whose friend and favourite he was; but he was never – as far as we can tell – wracked by that long and painful agony of giving birth to a new ideal. He is not a colourist – which may seem paradoxical – but I wouldn't have thought that his reds, his blues, the illuminated contours of every object and fabric, were his main claim to fame. One of his simplest grisailles is as rich as the definitive work. This is because he immediately grasps the sense of the scene that he is going to paint, he shows it all at once just as it came to him, fully fledged, majestic in its truth and its forms; he has understood the crowd, he has seen it; he has painted Suffering, Goodness, Grace, the forlorn Beauty of women and children; he has, I believe, touched the most sensitive nerves of the human heart; he surely has his fingertips on the finest strings of the eternal lyre which great men have played to tell us of our agonizing fate; he has all this, and not a shadow, not a hint of plastic representation – he has neither line nor plane, none of the simplicity that makes for a proper, clear and simple presentation of things. In which he is akin to the English school; he has no overall linear design, as if the very idea had never occurred to him – I mean that straight line, that active and decisive abstraction without which neither form nor painting has organic unity. His drawing vigorously constructs each object, each person, it demonstrates admirable knowledge of the workings of the muscles of the human body. In this he is modern, he prefigures those painters of the North, who, like Delacroix in particular, express the life of things much more through the reflection of external nature in their memory than by the immediate observation and analysis of the original.

He has all this greatness, all these gifts and riches, but he has never suffered; – that is perhaps the only reason for my refusal to rank him among the greatest.

In the temple of love that we erect in our minds to great men, there are two tiers, two different places that it is important to keep separate: only one houses the

greatest masters, alone and suffering, weighed down by the burden of their great misfortune.

What limits the expression of the literary idea in painting?

Let us be clear. The literary idea comes into being wherever there is no plastic invention.

This argument does not preclude invention. It allows the formulation of any idea that words could express, but this idea is subordinated to the impression produced by purely pictorial patches of colour, and appears only incidental, and in some ways superfluous. A picture conceived in this fashion will leave a lasting impression which words cannot reproduce, except in artistic form, as in poetry.

The literary work leaves no impression, its impact comes from the ideas that it engenders in the mind, and which are dependent on memory. In this case we do not have a real work of art; a simple narrative, with its unashamed storytelling, would be more effective.

For example there is something other than the purely plastic in Rembrandt's *Angel Gabriel* – are not the different ages of man, and our intuitive sense of the miraculous, personifed with infinite subtlety in that old man who tumbles into the abyss of divinity; in that adolescent who admires but also analyses, looks and questions; in that woman who clasps her hands to pray; in that other older woman, who swoons; and, lower down, in that dog whose barking, with its fearful terror, seems to represent bestiality?

Such subtleties certainly belong to the domains of literature and philosophy, but we have a clear sense that all this is only incidental, and that the artist who consciously or unconsciously had these thoughts, did not intend his painting to depend on them alone. We find proof of this in the fact that none of the artist's striving, however moving, naive and deeply sincere it may be, is immediately apparent without a long process of analysis, and that most of the spectators who have been struck by this marvellous work, were affected by something different: the single feature that makes this a sublime composition is the supernatural light which illuminates and gilds the divine messenger. Here, in the purity and simplicity of tone, and in the subtleties of chiaroscuro lies the secret of the whole work. Its invention is entirely pictorial, ideas become incarnate, as if they were embodied in flesh and blood. This is as far from storytelling as we can get.

Nearly all the masterpieces of the Renaissance express a literary idea, which in the case of French painters, may also be a philosophical idea. Purely pictorial art is considered inferior, and, it is not surprising to find that neither the Dutch nor the Spanish have the reputation or the prestige of Italian art.

Reflections on an Impressionist Exhibition

It is to be feared that Berthe Morisot may already have given us the whole range of her talent; she is like a flower whose perfume is spent and which, alas, like all the most exquisite and fleeting blossoms, must soon fade. She is perhaps the only woman who had genuine talent as a painter. She contributed some charming and supremely distinguished notes to this concert of Intransigent artists who now only recognize themselves as the Independents. None the less Mme. Berthe Morisot betrays the

influence of her earlier artistic education which marks her out clearly along with M. Degas from that clique of artists whose programmes and precepts have never been clearly formulated. You only have to look at her watercolours to see that their lively execution, their extremely subtle and feminine patches of colour, are underpinned by hints of a linear structure, which give her charming works a genuinely refined accent, more subtly expressed than in other painters.

None of this detracts from the legitimacy of those craftsmen who always insist on displaying over the doorway of their temple (if indeed they have one): art exhibition. We can allow them this rather pretentious borrowed rhetoric, especially if we compare their works to all those even more worthless examples which fill our officially constituted galleries with their ridiculous and pathetic productions. What is their goal, what is their objective?

Their only concern is to rescue colour or light from their last lingering associations with classical painting. They are themselves classics in so far as they answer to an external ideal of the material nature of painting, they hope to judge painting as such in terms of tone, and tone alone. The seeds of this way of understanding art may be found in the latest works of Corot and Millet. Without distinguishing between surfaces, without organizing planes, they manage to create tonal vibration, through juxtaposition with a grey that fades into the distance, and whose result is only apparent when you step back from the frame. This mode of painting is perfectly legitimate when its object is primarily to represent the external world out in the open air. I don't believe that any of the mental processes that run through the mind of man as he reflects and meditates, that is, I do not believe that thought as such, has much to gain from this determination to take into consideration things that happen outside us. The only way that life can be expressed is through chiaroscuro. Those who think enjoy walking in the shadows, their minds feel at ease there, as if they were in their *element*. All things considered, these painters, however estimable they are, will find that their seeds do not fall on the more fertile fields of the rich domain of art. 'Man is a thinking being.' Man will always be subject to time and history, and for all its power, light cannot free him from them. On the contrary, the future belongs to the world of the subjective.

M. Degas, surely the greatest artist of this group, is a Daumier with a palette. He demonstrates the same profound and true observation of Parisian life.
(10 April 1880)

6 Hans Thoma (1839–1924) Letter to Emil Lugo

Thoma was born in Bernau in the Black Forest and many of his most successful paintings are of the people and landscape of his native region. He studied at the art schools of Karlsruhe, Düsseldorf and Munich, but the decisive influence on his development as a painter was his encounter with the work of Courbet on a visit to Paris in 1868. He became one of the major exponents of the Realist movement in German painting, together with figures such as Wilhelm Leibl (1844–1900), with whom he came into contact in the 1870s. His later work shows a tendency towards mythological and allegorical subjects, largely under the influence of his compatriot, Arnold Böcklin (1827–1901). The following letter

was written in June 1880 from Frankfurt to the painter Emil Lugo (1840–1902). Thoma uses the occasion to discuss his conception of art and the role of the artist at the present time. He distances himself from his earlier commitment to Realism, emphasizing the distinction between art and nature. He insists that the task of the artist is 'nothing but the revelation of the human soul', which must be allowed to express itself through art in accordance with its own laws. This letter has been translated for the present volume by Nicholas Walker from Else Cassirer (ed.), *Kunstlerbriefe aus dem neunzehnten Jahrhundert*, Berlin: Bruno Cassirer, 1919, pp. 366–9.

Dear Friend,

I initially responded to your letter once again with a 'quick letter' of my own, in which I give vent to a great deal of wise words concerning 'matters personal and second hand'. But unfortunately I read it through again before dispatching it, and so it has simply ended up in the waste paper basket, for I thought to myself: that is just the problem, that the sort of observations which readily spring from principles and prejudgements play such a major role in art at the present time, even though these same observations and high-sounding phrases can never be brought into harmony with our actual deeds. As for these critics and aestheticians, p., p. and p. (for I have noticed that the names of all those critics who are particularly hostile to me begin with p) can go on regaling us with their pronouncements as much as they like – warming up ancient sayings and concealing confused ideas behind quite legitimate sayings – I have no time for any of them; and if I do need to hear something sensible said about art, then I go to someone whom I can understand when they use the word art, someone whose works provide the evidence that he has not simply been spouting hot air; these are simpler, more straightforward and more intelligible words than those which are required by modern eccentricity, for they succeed in explaining to me everything that can be explained in words in matters of art. The words spoken by Dürer, Leonardo and Alberti, for example.

One indication of how the simplest concepts have gone astray is the proposition: 'Art can either give much more than nature or it can give much less'. This is just hot air! How can anyone try and compare art, this work of human beings, with the infinity of nature? – Since art is something quite different from nature, namely nothing other than the expression of human life and feeling over against the entirely monstrous chaos of nature, one could perhaps look upon art more directly as a kind of order imposed upon the confused variety of impressions which our souls receive from the external world. Art is good if it is the expression of a human soul, but it can also simply represent a work of superficial skill, and then it is not art in the authentic sense at all, however 'artfully' crafted it may be.

What particularly strikes me at a modern exhibition is the element of arbitrariness which prevails in the majority of pictures, the lack of any shaping spirit or intention – for good pictures always look as though they had emerged organically, as if nature had produced them, or as if they had been properly built – but most of the pictures in these exhibitions are prepared and arranged, as if they had been produced by pastry cooks or carpet makers, and many historical paintings look as though they had been turned out by theatrical directors. In contrast with such art of arrangement, one which

usually prides itself so highly on its good taste, the naturalism which seriously and lovingly attempts to imitate something of nature itself has done more to encourage the path towards genuine creation. But taste is of no significance in art in any case, and any milliner can have it; art must create according to its own true and essential nature, not according to some law or purpose which lies beyond itself, but rather according to those laws which lie within the essence of the human soul; and in this sense art does indeed emerge directly from nature because the essential character of human beings is itself entirely rooted in nature. Fundamentally speaking, the truth of art is nothing but the revelation of the nature of the soul. Art testifies to the perceiving soul, that soul which gives shape and form according to its own laws. This is the same in the visual and plastic arts as it is in the arts of music and poetry.

There will always be artists who possess the capacity to understand the nature of their own souls, and they will always discover the appropriate means of expression in art, will find the proper form and become the law givers. One who thereby creates according to the indwelling idea within him, the genuine idealist that is, will not be disturbed if either the naturalists or the artistic arrangers refuse to grant him recognition. For he will indeed be laughed out of court!

In art, too, a natural and childlike attitude is required in order to be genuinely truthful. Children are genuine and honest, and only unconditional honesty is capable of creating great and lasting achievements for humanity, as in everything else, so in art as well.

One who attempts to investigate the law of art from actual works of art as a kind of 'canon' is certainly right in demanding a serious commitment, for such a law is always fairly deeply concealed and only finds expression in a great variety of forms which can scarcely be surveyed. – Anyway, it is by no means clear that anything much is achieved by reconstructions of this kind – for the human soul must always rediscover its own artistic expression anew. And it also appears to me that we ourselves, the wild outgrowth of an inartistic culture, cannot possibly attach our tentative tendrils to the work of men who exist on such an elevated level of artistic achievement, like Rubens, van Dyk and others.

We beginners must have the courage to let ourselves be laughed at when we attempt to look upon nature with our own eyes, something which does indeed appear more laughable than seeing a dwarf proudly prancing around in a giant's armour.

But where have I got to now? At the beginning of this letter I am busy attacking the phrases and hollow words which are freely bandied around concerning art, and now you must be laughing at me too for falling into just the same absurdities myself. – I can even see this clearly enough for myself, and instead of indulging in such observations as this, an artist would surely do better investigating the structure and organization of some tiny little flower, if he cannot think of anything better to do, or simply lying in the grass and staring at the clouds, contemplating the spectacle produced by passing shadows upon a long familiar landscape and letting the self-same breeze which moves the grass in waves play about his face, all the while thinking of nothing whatsoever. This can certainly create a sense of well-being in the soul, and it is surely quite possible that extremely fine images can take shape in such a state of well-being; and under certain conditions such spontaneous images without principle can even harbour the fundamental principle of all artistic creation within themselves.

How much I should love to enjoy your company once again in the 'rocky valley of a thousand joys' as you described it, for us both to gaze upon all the beauties of nature together, since it often seems to be too much for a single pair of eyes to appreciate.

If you could come and visit us again, I could take you to the Taunus region where I have also discovered the most beautiful clouds and flower-filled meadows, although I have told no one else but you. My wife constantly returns home with her arms full of flowers from the meadows and sends her greetings on to you, as I do myself in the name of a long-lasting friendship. Do write soon to your
Hans Thoma.

7 Pierre Auguste Renoir (1841–1919) 'The Society of Irregularists'

Renoir enclosed a copy of this proposal in a letter to Durand-Ruel, dated May 1884, declaring his intention to come to Paris so that he could organize a first gathering of the society, and asking the dealer's views. There is no evidence that any such gathering ever took place, nor indeed that the proposal was actually meant as anything other than an ironic *jeu d'esprit*. Renoir's target was presumably the tendency to geometrical formalization then beginning to gather strength within the modern movement in architecture and design. More generally the text is illustrative of his commitment to intuition and to flexibility in the practice of art, and of his dislike for the systematic in any form. The text remained unpublished during the artist's lifetime. It was first printed, from a manuscript in the archive of the Louvre, in Lionello Venturi (ed.), *Les Archives de l'Impressionisme*, Paris and New York: Durand-Ruel, 1939, volume I, pp. 127–9, from which source it has been translated for this volume by Carola Hicks.

Among all the controversy that artistic questions provoke every day, the vital point to which we want to draw attention is one that is usually overlooked. I am talking of irregularity.

Nature abhors a vacuum, so physicists say; they could expand this axiom by adding that it finds regularity equally abhorrent.

Indeed, observant people acknowledge that, despite the apparent simplicity of the laws which govern their creation, the works of nature are infinitely varied, from the greatest to the least, regardless of the species or family that they belong to. No two eyes, even in the most beautiful face, will ever be exactly similar, no nose will ever be set above the exact centre of the mouth; the segments of an orange, the leaves of a tree, the petals of a flower, will never be exactly identical; indeed, it seems that beauty of any kind derives its charm from this diversity.

If we examine the most renowned artistic or architectural works from this point of view, we soon realize that the great artists who created them, concerned to follow the procedures of nature, whose faithful pupils they always remained, took great pains not to transgress its fundamental law, that of irregularity. We note that even those works – such as St Mark's, or François I's little house in Cours la Reine . . . just like all the churches we describe as Gothic – which are based on geometrical principles, never have a single exactly straight line, and that none of the round, square or oval shapes that we find there, which could easily have been perfectly formed, actually are. We may thus maintain, without fear of error, that all genuinely artistic works have been

conceived and executed according to the principle of irregularity, in a word, to use the neologism which best expresses our idea, that they are always the product of an Irregularist.

At a time when French art, which until the beginning of our century was still so full of pervasive charm and exquisite fantasy, is being killed by regularity, aridity and that mania for false perfection which leads us today to take the engineer's blueprint as our ideal, we deem it necessary to react urgently against the fatal doctrines which threaten to annihilate it, and consider it the duty of all men of taste and sensitivity to come together without delay, however little appetite they have for protest and struggle.

So an Association must be formed.

Without wishing at this moment to lay its definitive foundations, we would like to bring to your attention the following brief proposal:

The association will take as its title 'The Society of Irregularists', which expresses its founders' general principle.

Its aim will be to proceed as soon as possible to mount exhibitions open to all artists, whether painters, decorators, architects, goldsmiths, embroiderers, etc., whose aesthetics are based on irregularity.

Among other conditions of membership, the rules will stipulate explicitly, for architecture: that all ornament must be taken from nature, without allowing any motif, whether flower, leaf or figure, to be exactly repeatable; that the most trivial outline must be drawn by hand without precision tools; that, for the plastic arts, for goldsmiths, etc., they must exhibit with their finished work the drawings or paintings from nature which they based their composition on.

That no work copying another work or details from it will be accepted.

A complete grammar of art, discussing the Society's aesthetic principles, setting out its intentions and proving its utility, will be published under the auspices of the founding committee in collaboration with members who offer to contribute.

Photographs of famous monuments or works of decorative art suitable to provide evidence for the principle of irregularity will be purchased by the society and displayed in a special room open to the public.

8 Pierre Auguste Renoir (1841–1919) from his Notebook

The following notes were first published under the heading 'From Auguste Renoir's notebook' in Jean Renoir's *Renoir mon père*, Paris, 1958. Jean Renoir was an entertaining rather than a scrupulous raconteur where his father was concerned. While there is no reason to doubt the authenticity of these notes, there is little precise evidence on which they may be dated, nor any secure indication of how long a period the notebook covers (if the entries were indeed taken from a single book). The mention of reliance on tools in sculpture suggests a date – for that portion of the notes at least – sometime after 1907, when the artist started working in that medium. On the other hand his concluding reference to the idea for a 'Society of Irregulars' suggests a date before his actual written proposal for the 'Society of Irregularists' in May 1884 (see the previous text). On this evidence we would tentatively suggest that the notes should be assigned to the period *c.* 1880–1910. Renoir's views on art seem to have changed little over the course of

his career, however. Our text is taken from the edition translated by Randolph and Dorothy Weaver, *Renoir my Father*, London: Collins; and Boston, Mass.: Little, Brown & Co., 1962, pp. 215–19.

Everything that I call grammar or primary notions of Art can be summed up in one word: Irregularity.

The earth is not round. An orange is not round. Not one section of it has the same form or weight as another. If you divide it into quarters, you will not find in a single quarter the same number of pips as in any of the other three; nor will any of the pips be exactly alike.

Take the leaf of a tree: take a hundred thousand other leaves of the same kind of tree: not one will exactly resemble another.

Take a column. If I make it symmetrical with a compass, it loses its vital principle.

Explain the irregularity in regularity. The value of regularity is in the eye only ... the non-value of the regularity of the compass.

It is customary to prostrate oneself in front of the (obvious) beauty of Greek art. The rest has no value. What a farce! It is as if you told me that a blonde is more beautiful than a brunette; and vice versa.

Do not restore; only remake the damaged parts.

Do not think it is possible to repeat another period.

The artist who uses the least of what is called imagination will be the greatest.

To be an artist you must learn to know the laws of Nature.

The only reward one should offer an artist is to buy his work.

An artist must eat sparingly and give up a normal way of life.

Delacroix never won a prize.

How is it that in the so-called barbarian ages art was understood, whereas in our age of Progress exactly the opposite is true?

When art becomes a useless thing, it is the beginning of the end. . . . A people never loses half, or even just a part, of its value. Everything comes to an end at the same time.

If art is superfluous, why caricature or make a pretence of it? ... I only wish to be comfortable. Therefore I have furniture made of rough wood for myself, and a house without ornament or decoration. . . . I only want what is strictly necessary. . . . If I could obtain that result, I should be a man of taste. But the ideal of simplicity is almost impossible to achieve.

The reason for this decadence is that the eye has lost the habit of seeing.

Artists do exist. But one doesn't know where to find them. An artist can do nothing if the person who asks him to produce work is blind. It is the eye of the sensualist that I wish to open.

Not everyone is a sensualist just because he wishes to be.

There are some who can never become sensualists no matter how hard they try.

Someone gave a picture by one of the great masters to one of my friends, who was delighted to have an object of undisputed value in his drawing-room. He showed it off to everyone who came to see him. One day he came rushing in to see me. He was overcome with joy. He told me naively that he had never understood until that morning why the picture was beautiful. Until then, he had always followed the

crowd in being impressed only by the signature. My friend had just become a sensualist.

It is impossible to repeat in one period what was done in another. The point of view is not the same, any more than are the tools, the ideas, the needs or the painters' techniques.

A gentleman who has become newly rich decides that he wants a château. He makes inquiries as to the style most in fashion at the time. It turns out to be Louis XIII; and off he goes. And of course, he finds an architect who builds him an imitation Louis XIII. Who is to blame?

To own a beautiful palace, you should be worthy of it.

The art-lover is the one who should be taught. He is the one to whom the medals should be given – and not to the artist, who doesn't care a hang about them.

Painters on porcelain only copy the work of others. Not one of them would think of looking at the canary he has in a cage to see how its feet are made.

They ought to have cheaply-priced inns in luxuriant surroundings for those in the decorative arts. I say inns; but, if you wish, schools minus teachers. I don't want my pupils to be polished up any more than I want my garden to be tidied up.

Young people should learn to see things for themselves, and not ask for advice

Look at the way the Japanese painted birds and fish. Their system is quite simple. They sat down in the countryside and watched birds flying. By watching them carefully, they finally came to understand movement; and they did the same as regards fish.

Don't be afraid to look at the great masters of the best periods. They created irregularity within regularity. Saint Mark's Cathedral in Venice: symmetrical, as a whole, but not one detail is like another!

An artist, under pain of oblivion, must have confidence in himself, and listen only to his real master: Nature.

The more you rely on good tools, the more boring your sculpture will be.

The Japanese still have a simplicity of life which gives them time to go about and to contemplate. They still look, fascinated, at a blade of grass, or the flight of birds, or the wonderful movements of fish, and they go home, their minds filled with beautiful ideas, which they have no trouble in putting on the objects they decorate.

To get a good idea of what decadence is, you have only to go and sip a beer in some café on one of the boulevards, and watch the passing crowd. Nothing could be more comical. And magistrates with side-whiskers! Could anybody look at a gentleman 'tattooed' that way, and not die laughing?

Catholics who, like all the others, have fallen for the tinselled rubbish and the plaster statuettes sold in the Rue Bonaparte, will tell you there is no salvation outside the Catholic religion. Don't believe a word of it. Religion is everywhere. It is in the mind, in the heart, in the love you put into what you do.

Don't try to make a fortune, whatever you do. Because, as soon as you've made your fortune, you'll die of boredom.

I believe that I am nearer to God by being humble before this splendour (Nature); by accepting the role I have been given to play in life; by honouring this majesty without self-interest, and, above all, without asking for anything, being confident that He who has created everything has forgotten nothing.

I believe, therefore, without seeking to understand. I don't wish to give any name, and especially I do not wish to give the name of God, to statues or to paintings. For He is above everything that is known. Everything that is made for this purpose is, in my humble opinion, *a fraud*.

The sick and the infirm ought to be fed, without having to beg, in a country like France.

Go and see what others have produced, but never copy anything except Nature. You would be trying to enter into a temperament that is not yours and nothing that you would do would have any character.

The greatest enemy of the worker and the industrial artist is certainly the machine.

The modern architect is, generally speaking, art's greatest enemy.

We are proud of the renown of our old masters, and the countless works of art this marvellous country has produced. But we must not behave like those nobles who owe their titles to their ancestors and spend their last sou to hear themselves addressed as 'Monsieur le Baron' by the waiters in cafés – which costs them twenty francs each time.

Since you love the Republic so much, why are there no statues of the Republic as beautiful as the Athenas of the Greeks? Do you love the Republic less than the Greeks did their gods?

There are people who imagine that one can re-do the Middle Ages and the Renaissance with impunity. One can only copy: that is the watchword. And after such folly has continued long enough, go back to the sources. You will see how far away we have got from them.

God, the King of artists, was clumsy.

Not only do I not wish to see one capital of a column exactly resemble another, I do not wish it to resemble itself; or to be uniform any more than are the heads, feet and hands which God created. I do not wish a column to be perfectly round, any more than a tree is.

I say to young people, therefore: throw away your compasses, otherwise there is no Art.

Consider the great masters of the past. They were aware that there are two regularities: that of the eye and that of the compass. The great masters rejected the latter.

I propose to found a society. It is to be called 'The Society of Irregulars'. The members would have to know that a circle should never be round.

9 Oscar Wilde (1854–1900) on Art for Art's Sake

The two extracts from Wilde reprinted in the present section are statements of his 'art for art's sake' position unencumbered by the commitment to socialism he enunciated elsewhere (see VB15). *The Decay of Lying* takes the form of a dialogue between 'Vivian' and 'Cyril' about the relation between art on the one hand and nature and society on the other. It was first published in *The Nineteenth Century*, London, January 1889, and was reprinted in Wilde's book of essays, *Intentions*, in 1891. Wilde's only novel, *The Picture of Dorian Gray*, was originally published in *Lippincott's Magazine* in 1890. It was then republished in book form, expanded by six additional chapters, in 1891. For this edition, Wilde also added a

short preface in which he offered a concise exposition of his belief in the independence of art, its absolute non-utility, and its consecration around the aesthetic. Our selections are taken from Vyvyan Holland (ed.), *The Complete Works of Oscar Wilde* (1948), London and Glasgow: Harper Collins, 1992 edition. *The Decay of Lying* is printed on pp. 970–92; our extracts are from pp. 987–8 and 991–2. The Preface to *The Picture of Dorian Gray* can be found on p. 17.

from *The Decay of Lying*

CYRIL: [. . .] surely you would acknowledge that Art expresses the temper of its age, the spirit of its time, the moral and social conditions that surround it, and under whose influence it is produced.

VIVIAN: Certainly not! Art never expresses anything but itself. This is the principle of my new aesthetics; and it is this, more than that vital connection between form and substance, on which Mr Pater dwells, that makes basic the type of all the arts. Of course, nations and individuals, with that healthy natural vanity which is the secret of existence, are always under the impression that it is of them that the Muses are talking, always trying to find in the calm dignity of imaginative art some mirror of their own turbid passions, always forgetting that the singer of life is not Apollo but Marsyas. Remote from reality and with her eyes turned away from the shadows of the cave, Art reveals her own perfection, and the wondering crowd that watches the opening of the marvellous many-petalled rose fancies that it is its own history that is being told to it, its own spirit that is finding expression in a new form. But it is not so. The highest art rejects the burden of the human spirit, and gains more from a new medium or a fresh material than she does from any enthusiasm for art, or from any lofty passion, or from any great awakening of the human consciousness. She develops purely on her own lines. She is not symbolic of any age. It is the ages that are her symbols.

Even those who hold that Art is representative of time and place and people cannot help admitting that the more imitative an art is the less it represents to us the spirit of its age. The evil faces of the Roman emperors look out at us from the foul porphyry and spotted jasper in which the realistic artists of the day delighted to work and we fancy that in those cruel lips and heavy sensual jaws we can find the secret of the ruin of the Empire. But it was not so. The vices of Tiberius could not destroy that supreme civilization, any more than the virtues of the Antonines could save it. It fell for other, for less interesting reasons. The sibyls and prophets of the Sistine may indeed serve to interpret for some that new birth of the emancipated spirit that we call the Renaissance; but what do the drunken boors and bawling peasants of Dutch art tell us about the great soul of Holland? The more abstract, the more ideal an art is the more it reveals to us the temper of its age. If we wish to understand a nation by means of its art, let us look at its architecture or its music. [. . .]

[. . .] Art never expresses anything but itself. It has an independent life, just as Thought has, and develops purely on its own lines. It is not necessarily realistic in an age of realism, nor spiritual in an age of faith. So far from being the creation of its time, it is usually in direct opposition to it, and the only history that it preserves for us is the history of its own progress. Sometimes it returns upon its footsteps, and revives some antique form, as happened in the archaistic movement of late Greek Art, and in

the pre-Raphaelite movement of our own day. At other times it entirely anticipates its age, and produces in one century work that it takes another century to understand, to appreciate, and to enjoy. In no case does it reproduce its age. To pass from the art of a time to the time itself is the great mistake that all historians commit.

The second doctrine is this. All bad art comes from returning to Life and Nature, and elevating them into ideals. Life and Nature may sometimes be used as part of Art's rough material, but before they are of any real service to Art they must be translated into artistic conventions. The moment Art surrenders its imaginative medium it surrenders everything. As a method Realism is a complete failure, and the two things that every artist should avoid are modernity of form and modernity of subject-matter. To us, who live in the nineteenth century, any century is a suitable subject for art except our own. The only beautiful things are the things that do not concern us. It is, to have the pleasure of quoting myself, exactly because Hecuba is nothing to us that her sorrows are so suitable a motive for a tragedy. Besides, it is only the modern that ever becomes old-fashioned. M. Zola sits down to give us a picture of the Second Empire. Who cares for the Second Empire now? It is out of date. Life goes faster than Realism, but Romanticism is always in front of Life.

The third doctrine is that Life imitates Art far more than Art imitates Life. This results not merely from Life's imitative instinct, but from the fact that the self-conscious aim of Life is to find expression, and that Art offers it certain beautiful forms through which it may realize that energy. It is a theory that has never been put forward before, but it is extremely fruitful, and throws an entirely new light upon the history of Art.

It follows, as a corollary from this, that external Nature also imitates Art. The only effects that she can show us are effects that we have already seen through poetry, or in paintings. This is the secret of Nature's charm, as well as the explanation of Nature's weakness.

The final revelation is that Lying, the telling of beautiful untrue things, is the proper aim of Art.

Preface to *The Picture of Dorian Gray*

The artist is the creator of beautiful things.
To reveal art and conceal the artist is art's aim.
The critic is he who can translate into another manner or a new material his impression of beautiful things.
The highest, as the lowest, form of criticism is a mode of autobiography.
Those who find ugly meanings in beautiful things are corrupt without being charming. This is a fault.
Those who find beautiful meanings in beautiful things are the cultivated. For these there is hope.
They are the elect to whom beautiful things mean only Beauty.
There is no such thing as a moral or an immoral book.
Books are well written, or badly written. That is all.
The nineteenth century dislike of Realism is the rage of Caliban seeing his own face in a glass.

The nineteenth century dislike of Romanticism is the rage of Caliban not seeing his own face in a glass.

The moral life of man forms part of the subject-matter of the artist, but the morality of art consists in the perfect use of an imperfect medium. No artist desires to prove anything. Even things that are true can be proved.

No artist has ethical sympathies. An ethical sympathy in an artist is an unpardonable mannerism of style.

No artist is ever morbid. The artist can express everything.

Thought and language are to the artist instruments of an art.

Vice and virtue are to the artist materials for an art.

From the point of view of form, the type of all the arts is the art of the musician. From the point of view of feeling, the actor's craft is the type.

All art is at once surface and symbol.

Those who go beneath the surface do so at their peril.

Those who read the symbol do so at their peril.

It is the spectator, and not life, that art really mirrors.

Diversity of opinion about a work of art shows that the work is new, complex, and vital.

When critics disagree the artist is in accord with himself.

We can forgive a man for making a useful thing as long as he does not admire it. The only excuse for making a useless thing is that one admires it intensely.

All art is quite useless.

10 Maurice Denis (1870–1943) 'Definition of Neo-Traditionism'

When this text was written, Denis had been a student at the Beaux-Arts for two years and was only twenty years old. He was also enrolled at the Académie Julian, however, in company with Paul Sérusier, Pierre Bonnard, Edouard Vuillard and Paul Ranson, and he had learned from Sérusier of the work done by Gauguin and Bernard at Pont-Aven in the summer of 1888 (see VIc8). The painters who met at the Académie Julian during this period formed the nucleus of a group calling themselves the Nabis and composing a distinct faction within the broad tendency of Symbolism. Other members included H. G. Ibels, Ker-Xavier Roussel, and, later, Jan Verkade, Felix Valotton and Aristide Maillol. The opening statement of Denis's article has been much cited as establishing a link between the Symbolist theories of the late nineteenth century and the abstract art of the early twentieth. It does indeed provide a clear statement of priority for painting's formal and decorative principles over the functions of narration and description. It should be borne in mind, however, that this opening statement is one with which Denis's academic teachers would have found little reason to quarrel, and that it is entirely consistent with the brand of neo-classicism which he was soon to advocate. The modernism of the article as a whole lies principally in its determined disparagement of Naturalist principles and techniques and in its assertion of the transforming power of 'aesthetic imagination' in general. Denis's own typical paintings of this period were modernized versions of traditional Catholic motifs. He scored a particular success in 1889 with his *Catholic Mystery*, which was based on the theme of the annunciation. The article was first published as 'Définition du Néo-traditionnisme' in *Art et Critique*, Paris, 23 and 30 August 1890, signed with the pseudonym Pierre-

Louis. It was reprinted in Denis, *Théories 1890–1910: Du Symbolisme et de Gauguin vers un nouvel ordre classique*, Paris: Bibliothèque de l'Occident, 1912. Our text is taken from the third edition of 1913, pp. 1–12, translated for this volume by Peter Collier.

I

We should remember that a picture – before being a war horse, a nude woman, or telling some other story – is essentially a flat surface covered with colours arranged in a particular pattern.

II

My aim is to find how to define *painting* of 'nature', that simple term which labels and summarizes the most widely accepted theory of art at the end of this century.

Probably as the product of all optical experience? But even without speaking of the natural distortions of the modern eye, who isn't aware of the force exerted by intellectual habit on vision? I have known young people who have indulged in exhausting acrobatics with the optical nerve in order to perceive the trompe-l'oeil in *The Poor Fisherman*: and I know that they managed to do it. M. Signac can produce impeccable scientific arguments to prove that his chromatic insights are entirely necessary. And M. Bouguereau, while not disguising amendments made in the studio, is profoundly convinced that he is copying 'nature'.

III

Let us go to the Museum, and consider each canvas on its own, detaching it from all the others: each one will give you if not a complete illusion of nature then at least some allegedly real aspect of nature. You will see in each picture what you would expect.

Now, if it is possible, through an effort of the will, to see 'nature' in these pictures, it is equally possible not to. There is an inevitable tendency among painters to relate aspects of perceived reality to aspects of paintings that they have already seen.

It is impossible to determine all the factors that may modify our modern vision, but there is no doubt that the whirlwind of intellectual activity through which most young artists pass, causes them to create genuine optical anomalies. After searching for ages to decide whether certain greys are violet or not, we now see them quite clearly as violet.

That irrational admiration for old pictures which makes us seek out their faithful renderings of 'nature', since we feel obliged to admire them, has certainly distorted the eyes of the teachers of art.

Admiring modern pictures, if we study them with the same degree of dedication, generates other disturbances. Have we noticed how that elusive 'nature' is always changing, that it is not the same in the 1890 Salon as in the Salons of thirty years ago, and that there is always one kind of 'nature' in fashion – a whim that changes like frocks and hats?

IV

Thus the modern artist, through choice and synthesis, adopts the at once eclectic and exclusive habit of interpreting optical sensation, and this becomes the criterion of naturalism, the painter's sense of self, which the literati were later to call 'temperament'. It is a kind of hallucination which has nothing to do with Aesthetics, since our reason has to take it on trust but cannot control it.

V

Supposing that we remain within the bounds of aesthetic judgement, when someone says that Nature is beautiful, more beautiful than any painting, what he means is that his impressions of nature itself are better than those of others, which is fair enough. But if we were to compare the hypothetical, imaginary impact of the original, and the imprint of this impact on someone's mind, then we are faced with the key issue of temperament: 'Art is nature seen through a temperament'.

This is a very fair definition because it is so vague and leaves the main criterion, the measure for judging temperament, imprecise. M. Bouguereau's painting is nature seen through a temperament. M. Raffaëlli is a remarkable observer – but who would dare argue that he is sensitive to the beauty of form and colour? Where does 'temperament' in painting begin, where does it end?

We should remember that there is a science that deals with these matters, Aesthetics, which is developing a structure and becoming established, thanks to the practical investigations of people like Charles Henry, and to the psychology of others like Spencer and Bain.

Before externalizing pure sensations, we should determine their value in terms of beauty.

VI

I don't know why painters have failed to understand the term 'naturalist' applied in a purely philosophical sense to the Renaissance.

I have to admit that Fra Angelico's *Predellas* in the Louvre, Ghirlandaio's *Man in Red* and a number of other works by the Primitives, recall 'nature' to me more exactly than Giorgione, Raphael or da Vinci. It is just a different way of seeing – a different kind of imagination.

VII

Moreover, everything to do with our sensations, whether as subject or as object, is constantly changing. You would have to be an exceptionally diligent pupil to recreate the same composition on your table for two successive days. Here are life, intensity of colour, light, movement, atmosphere – a dozen things which you can't render. Here I am dealing with familiar themes, which are none the less true and obvious!

VIII

In short, I acknowledge that it is quite likely that in this, as in other insoluble problems, received opinion is of some value – that photography informs us of the degree of reality of a form, and that a plaster cast from nature is also 'as natural as possible'.

I therefore admit that this kind of work, and others which try to resemble them, are 'natural'. I would call 'natural' the vulgar trompe-l'oeil which we find in that ancient painter's grapes which were pecked by birds, or in M. Détaille's panoramas, which make us wonder – Oh what an aesthetic experience – whether that crate in the foreground is real or on canvas.

IX

'Be sincere: you need only be sincere in order to paint well. Be naive. Paint quite simply what you see.'

What infallible, rigorously precise machines we have tried to produce in the academies!

X

This is the only teaching provided for those who have been through Bouguereau's studio, exemplified when the master pronounced one day: 'The secret of drawing lies in the articulation of the joints'.

His poor mind was fixated upon a single notion, that he found overwhelmingly attractive, the anatomical complexity of the joints! Drawing is the articulation of the joints! And there are people who find in these works a resemblance to Ingres! I wouldn't be surprised if they secretly thought that Bouguereau has progressed further than Ingres. In naturalism, he certainly has! As a photographer!

That's where they've got to, all those petty painters who are today's masters. From Romantic exuberance, visits to Italian museums, and the compulsory adulation of Old Masters, they have retained vague and never fully assimilated memories of some of the motifs of the Masters, which serve to distort their aesthetic. Delacroix said that he would be perfectly happy to spend his time restoring bargain-basement stations of the cross (since they are, alas, so numerous in our churches!). Monsieur X and Monsieur Y, of the Institute, are busy messing up the canvases of the Renaissance. And enough of the splendour that they undermine remains to encourage its indiscriminate admiration by the masses, who are drawn instinctively to its beauty.

* * *

XIII

One of the young Neo-Traditionists, while at the Ecole des Beaux-Arts, having painted a woman, whose very white body shimmered with iridescent light – and it was the colour which interested him, he had taken a week to get it right – heard a

modern master say: 'She's not natural, you would never go to bed with a woman like that!'

How much there would be to say, if we adopted that viewpoint, about the morality of a work of art! We could compare the symbols of the Phoenicians and the Hindus, pornographic photographs, Chavannes's or Michelangelo's nudes, Rodin's amorous compositions – but with what? with analytic works, with their trompe-l'oeil, their licence pleasing both to callow youths and aged libertines: all those Roman baths, all those Temptations, all those Andromedas, all those Models, all those Studies by our young Academicians of the last fifteen Salons!

XIV

But have you noticed the beginnings of a return to beautiful things among the Impressionists? Manet is the main route. This is well known. Their imitators have all ended up seeking out especially colourful natural scenes: the effects of sunshine, lamps in the night, Orientalism, the Aurora Borealis.

And they spoil the fresh taste of their original sensation, a unique creation of some particular colour, by their disdain of composition, and their concern to be natural! And above all that exasperating mania, rooted in all of us, for modelling.

XV

'Art is the form turning' ['L'art, c'est quand ça tourne'], is another definition, by a madman.

Wasn't it Paul Gauguin who gave us the following ingenious and novel history of modelling?

In the beginning there was the pure arabesque, as far from trompe-l'oeil as possible; you take a bare wall, fill it with shapes symmetrical in form and harmonious in colour (stained-glass windows, Egyptian paintings, Byzantine mosaics, Japanese kakemonos).

Then came the painted bas-reliefs (metopes on Greek temples, churches in the Middle Ages).

Then the attempts made by artists in Antiquity at ornamental trompe-l'oeil were resumed in the fifteenth century, replacing the painted bas-relief by a painting imitating the modelling of a bas-relief, which moreover preserves the first principle of decoration (the Primitives, remember the circumstances under which a sculptor, Michelangelo, came to paint the ceiling of the Sistine chapel).

This modelling finds its perfection in full relief; which runs from the early academies of the Carracci to our own time of decadence. Art is the form turning.

XVI

We know that the earliest French sculpture (such as the portal at Vézelay) is derived from Byzantine manuscript illumination and not from relief carving, which helps us to understand the use of folds of togas and ample robes as simple arabesques to fill in the gaps – folds inspired by imagination and taste, and graven in stone with no

concern for the possibility of draping real cloth into such forms. Paul Sérusier explained how this tendency runs through archaic Athenes, Tanagra figurines, the wingless Victories of the temple of Nike Apteros, all Greek statues, all of the Middle Ages, all of the Renaissance. He added that the same concern to fill in gaps which were inoffensive to the average eye, had introduced unrealistic folds in garments, in flesh, and in painting, and had created relief. He cited a Raphael infant: 'Alternating curves, composing an empty space of considerable size – with a gentle relief filling it out and sustaining its forms'.

What a multitude of great empty skies above an insignificant grey sea! And the line of the horizon in whose imperceptible details literary critics have seen so many things, and which can be resumed as 'parallel lines on a neutral ground'! Just think of those Renaissance forms, gilded white on blue (Veronese's clouds, Fra Angelico's seraphim). Just think of their precious cobalt or emerald backgrounds!

* * *

XVIII

Our times are literary through and through: refining even minutiae, eager for complexity. Do you really believe that Botticelli had planned all the unhealthy sensitivity and sentimental preciosity that we now perceive in his *Primavera*? This is the kind of formulae that you are bound to come up with, if you work to such a clever hidden agenda!

In all periods of decadence, the plastic arts dwindle into literary affectation or naturalistic negation.

XIX

It would be too much to ask of us to settle our spirits. The Renaissance artists just let their infinitely profound and aesthetic work pour forth from the very fullness of their nature. A Michelangelo did not have to struggle to appear great, unlike a Bernini or an Annibale Carracci. His sensations, channelled through his perfect understanding of art, automatically turned into art. It is trying too hard which has ruined the Romantics.

XX

It is from the soul of the artist that true Sentiment arises, more or less unconsciously: 'He who would paint the things of Christ should live with Christ', said Fra Angelico. This is a truism.

* * *

It is through the canvas itself, a flat surface bathed in colour, that our emotions, whether bitter or soothing, are provoked. These emotions are 'literary', as painters say, and have no need to impose the memory of other past feelings (such as a familiar motif drawn from nature).

A Byzantine Christ is a symbol; the Jesus of our modern painters is merely literary, even if the *kiffyed* on his head is absolutely authentic. In the first it is

form which is expressive, in the second, expression is attempted through the imitation of nature.

And just as I was saying that any representation may appear natural, so any beautiful work of art can provoke the higher, absolute emotions, the 'Ecstasy' of the Alexandrian philosophers.

Even purely linear invention, as in d'Anquetin's *Femme en rouge*, exhibited at the Champ de Mars, has some emotional value.

And even the Parthenon frieze! Even, perhaps above all, one of Beethoven's great sonatas!

* * *

XXII

And such is the only true form of Art. When we have eliminated unjustifiable bias and illogical prejudice, the field remains open to painters of imagination and to aesthetic thinkers who appreciate the beauty of appearances.

Neo-Traditionism must not become trapped in extravagantly learned psychological theories, or in literary sentimentality, dressed up as legend, all things which do not belong to its emotional realm.

Neo-Traditionism has reached the moment of definitive synthesis. All is contained within the beauty of the work of art.

XXIII

What fools those artists were who wore themselves out racking their servile brains for something original, new subjects or new visions, rejecting the true feelings that they experienced, because they had been trained to deny beauty, because they had allowed their concern for trompe l'oeil to come between their emotions and the work of art!

How do we distinguish between different modern painters? Often through their vision (as I have already explained), often through their technique, and even more often through their subject matter.

But what identical imaginations! They all follow the same fashion. And if one should take it into his head to risk some new flight of fancy – instead of ever so slightly and politely adapting someone else's effects of light or relief – oh what a scandal!...

XXIV

Art is the sanctification of nature, that mundane nature which is content merely to be alive. What is great art – the art we call decorative – the art of the Indians, the Assyrians, the Egyptians and the Greeks, the art of the Middle Ages and the Renaissance, and the decidedly superior works of Modern Art, but the disguising of vulgar feelings – of natural objects – as sacred, hermetic and impressive icons?

What lies behind the hieratic simplicity of figures of the Buddha? Mere monks, transformed by the aesthetic sense of a pious people. Again, compare the natural lion with the lions of Khorsabad: which forces us to kneel? The Doryphorus, the Diadu-

menus, the Achilles, the Venus de Milo, the Winged Victory, these are, in truth, a redemption of the human form. Should we mention the Saints of the Middle Ages, both men and women? Should we add Michelangelo's Prophets and Leonardo da Vinci's Women?

I have seen the work by the Italian artist, Pignatelli, which inspired Rodin's John the Baptist, and instead of some banal model, I saw a venerable bronze, the embodiment of the Word in motion. And what kind of man was it that Puvis de Chavannes selected to be his *Poor Fisherman*, expressing eternal sorrow?

Everywhere those with aesthetic imagination triumph over those who attempt crude imitation, the emotions of Beauty triumph over the lies of Naturalism.

11 Rémy de Gourmont (1858–1915) 'Free Art and the Individual Aesthetic'

The author was an associate of Villiers de l'Isle Adam, of Huysmans and of Mallarmé and a contributor to several Symbolist literary journals. In 1890 he joined with Aurier, Jules Renard and others in founding the *Mercure de France*, and four years later he co-founded *L'Ymagier* with Alfred Jarry. During the spring of 1892 he published a series of articles in various reviews, each of them concerned with the philosophical underpinning of the Symbolist movement in the work of Kant, Hegel and Schopenhauer. These were gathered together in 1893 and issued in the form of a small book under the title *L'Idéalisme*. In a preface written in March 1893 de Gourmont suggested that while the battle against the Naturalists had been won, it was necessary to put the wounded out of their misery lest they revive and return to the fray. The present chapter was originally published as 'L'Art libre et l'esthétique individuelle'. Its argument is that while there may be an unknowable reality underlying all personal experience, it is through the idiosyncratic forms of personal expression that art is to be recognized, and not through its submission to some pre-existing set of aesthetic principles. *L'Idéalisme* was itself collected with other short works into de Gourmont's larger volume *Chemin de Velours*, Paris: Mercure de France, 1902. Our text is taken from pp. 226–31 of that edition, translated for this volume by Peter Collier. The notes are in the original version.

From time immemorial, models have preceded precepts. This dictum of M. de Laharpe looks like a commonplace, but only because of its outmoded form and the narrowness of its founding principles. Using a more philosophical, general and direct language, he might have said: 'Art precedes aesthetics', which no longer seems such a commonplace, but rather an eternal truth.

Eternal truths – no dialectical joust can be truly enjoyed if it is not mounted on the back of eternal truths. They are patient, will endure clumsy blows and insults, as well as caresses, and since their eternally ironic eyes are always directed towards the heavens, the combatants need never blush or flinch before their potentially Medusan gaze.

Eternal truths – they come in all shapes and sizes. There are blondes with creamy complexions who lure us with the nubile charms of a maiden offering herself to us, there are some who have the four legs of an animal, but whose bony skulls contain within their geometrical forms all human anxiety; there are some whose wings are wider than those of the condor, and whose feathers shelter a whole brood of ideas ...

The truth that I am talking of is one of the more modest Eons, she haunts the Earth, and prefers to make her syllogistic nest in some scholar's study rather than in Jupiter's beard.

Supposition: Art is anterior to aesthetics.

Premise: Aesthetics must be an explanation of, and not a theory of, art.

Since a number of people have disputed, not the aphorism itself, which is indisputable, but its premise, which is less so, perhaps some new arguments might be welcomed by readers of good will.

The essence of art is freedom. Art cannot accept any code of law, nor even submit to the necessary expression of the Beautiful.[1] Not only does Art cast off the yoke of any fleeting formula, but it rejects domination by the human absolute – which itself is no more than an average of the tastes, judgements and pleasures of average human kind. Art can violate this absolute, it can disfigure Beauty, and say 'Your Absolute is not Mine', and 'I like to disfigure Beauty'.

Art enjoys the full freedom of the conscious mind; it is its own judge and establishes its own aesthetics; it is personal and individual, like the soul, like the mind; and, since the soul is free of any obligation other than moral, and the mind is free of any obligation other than intellectual, Art must be free of any obligation other than the aesthetic. In vain would Art seek the True, which only our intelligence may know, or the Moral, which only our conscience recognizes; it is not equipped for these functions, it understands and assimilates only what is appropriate for its single sense: the aesthetic sense.

And it is precisely in this that art is free. It develops from the outside inwards, without having to worry about sharing its space with authoritarian entities. It develops, turns in upon itself, revels in complexity, breeds an abundance of inner shoots, leaves and flowers: it develops and grows in the darkness of the self, and when the day comes for its vitality to explode, for its urgent new growth to burst into bloom, we will be astonished by such an apparently abnormal, illogical and incomprehensible result.

The individual is abnormal: we can only classify him within the limits set by external appearances, but internally he is abnormal, he is a being different even from those beings who most resemble him. Art (which I regard here as one of the *Faculties* of the individual soul) is therefore, just like the individual himself, abnormal, illogical and incomprehensible.

Now, if the difference between all human individuals endowed with souls is evident (or can at least be established with the aid of a microscope) – this difference becomes even more evident (and indisputably obvious) between the small number of human beings endowed with a superior soul. As we go higher up the ladder of life, the members of each group become increasingly diverse, the more perfectly they have been created: the almost mechanically oscillating atoms of plasma which compose primitive animal colonies are indistinguishable; their form is often crystalline, they are rhomboid forms with feelers, or hairy polyhedra.[2]

Higher up, there comes a point where we can distinguish between kin – and finally, when we reach humanity, identical individuals are extremely rare, and an insignificant exception to the rule. Since they are endowed with a superior soul, individuals stand out from their formal group, each living as if he constituted a single, unique world; the only laws that they obey are the very general laws of vital gravity whose centre and

motive force is God. At this level of moral intensity, a predominance of Love creates great saints, a predominance of Mind creates great philosophers, and a predominance of Art, great artists – and different varieties of genius according to whether these tendencies are pure or mixed.

Therefore, if superior beings differ radically and essentially one from another, each one's aesthetic production will differ no less radically or essentially from the aesthetic production of another. Consequently, there is no common measure for any two works of art, no possible comparative judgement, no critical theory which can catch them in its net, no aesthetics, which, if relevant to the first work, remains relevant to the second – no rule made up in advance to which either the first or the second of these works of art, nor indeed any other, might submit.[3]

However, Art being 'abnormal, illogical, and incomprehensible', we may allow certain people who are very intelligent and capable of achieving objectivity to illuminate some of its obscurities – however few – and reveal the secrets of their magic lantern to their restive audience. This is retrospective aesthetics, explanatory criticism, commentary – and we must recast its principles for each new artist exhibited to the unenlightened masses, who will not allow anyone to diverge from the mediocre standards taught by the State.

Since Art is free, within the limits of its own organism, there must also be a free aesthetic, an individual and personal aesthetic, the right to judge according to individual and personal rules, despising all patterns, patrons and paragons.

Eternal Truths, with their eternally ironic eyes directed towards the heavens . . .

[1] 'Beauty, when created in art, is more elevated than that created in nature', and 'beauty in nature only appears as a reflection of the beauty of the mind'. Hegel, *Aesthetics*, Introduction.

[2] Cf. Perier, *Colonies animales*.

[3] 'The principle of judgement of taste which we call aesthetic can only be subjective.' Kant, *Critique of Judgement*, quoted by L. F. Schon, *Système de Kant*, Paris, 1831.

12 Hugo von Hofmannstahl (1874–1929) on the Inadequacy of Aestheticism

Hofmannstahl was born in Vienna and spent his working life in that city. His first success as a poet came at the early age of sixteen. He went on to become one of the leading figures in the circle around Stefan George, an approximate literary equivalent of the Secession movement in the visual arts. In 1894 the twenty-year-old Hofmannstahl wrote a review of the work of the English Aestheticist Walter Pater (see Vc1 and 2). The closing passages of Hofmannstahl's review concern Pater's historical romance *Marius the Epicurean*, published in 1885. He takes Pater's work to be symptomatic of the limitations of the Aesthetic viewpoint as a whole. While aesthetic considerations are valid enough when considering a work of art, they cannot alone afford criteria for a way of life. Hofmannstahl believes such a flawed aestheticism to be in certain respects characteristic of the whole *fin de siècle* condition: more concerned to juggle past achievements than to create its own, dilettante, cultivated and clever, rather than genuinely original. Hofmannstahl's review 'Walter Pater' was originally published in *Die Welt*, VII, 17 November 1894, pp. 6–7. It was reprinted in his *Gesammelte Werke*, volume 1, Frankfurt am Main, 1950, pp. 235–40. This extract is taken

from the English translation in R. M. Seiler (ed.), *Walter Pater: The Critical Heritage*, London: Routledge and Kegan Paul, 1980, pp. 289–92.

[. . .] In one way or another we are all in love with a past that has been perceived and stylized through the medium of the arts. It is, so to speak, our way of falling in love with an ideal, or at least an idealized life. This is Aestheticism, a great and famous word in England and generally an over-nourished and over-grown element of our culture, and perilous like opium. [. . .] *Marius the Epicurean* shows the inadequacy of the aesthetic world view, when one attempts to build a whole way of life upon it. The book is extremely clever, but its effect is sterile, without greatness and without true humanity. [. . .] It is the story of a young Roman of Hadrian's time, who has established his life on the basis of a very fine and complicated Epicureanism. But then life is much more colossal, much greater and more inexpressible, and this book makes a meagre impression, at the same remove from reality as marginalia to a dead text. Thus it is that the inadequacy of aestheticism (here Epicureanism) is demonstrated by that which in minor matters represents its magic; namely in the choice of epoch. At a certain semi-mature age full of longing and refinement everyone's fantasy has at some time become firmly and voluptuously attached to Rome at its decline, attached to that gracious epoch where the great strong words of early Latin become magnificent and sonorous titles, where the naked figures of earlier poetry rise up dreamlike from the blue sea, with naive hands and childlike brows before their later-born countrymen, and where a people with peculiar sphinx-eyes and narrow quivering fingers wander about, rummaging in the treasures they have inherited, in the carved stones, the pots of chrysoprase, the wax death-masks, the brilliantly sculptured old verse and the individual gems of the half-forgotten language. To us they appeared so like ourselves, living their lives away, not completely true, and yet very witty and very beautiful, with a morbid, Narcissus-like beauty, fond of everything allegorical and subject to a somewhat affected scepticism; womanlike and boylike and senile and vibrating with deep traces of beauty, with every kind of beauty, the beauty of gently swelling vases and the beauty of jagged rocks, the beauty of Antinous, the beauty of dying, of lying dead, of flowers, of the goddess Isis, the beauty of the great courtesans, the beauty of the sinking sun, of the Christian martyrs, the beauty of Psyche, that weeping, wandering, naively-perverse and small Psyche from the 'Golden Ass', every kind of beauty apart from the one, great and inexpressible beauty of existence; this is not revealed to weak generations.

Part VI
The Idea of a Modern Art

VI
Introduction

For the first time in the later nineteenth century it became possible to speak mean-ingfully of a world economy. The United States had expanded and was now begin-ning to compete for markets with the European countries. Despite the crash of 1873, a unified Germany came to replace France as the leading power on the Continent and was beginning to challenge and even in some areas to overtake Britain. Also newly unified, Italy industrialized late, at the very end of the century, but then made up some lost ground through development in modern fields such as the motor industry. Even in Russia, capitalism matured rapidly in the 1880s and 1890s, with considerable investment from abroad. Although the mass of the country remained backward by Western European standards, machines as modern as anywhere in the world were to be found in the isolated centres of industry in Moscow, St Petersburg and elsewhere, and they were manned by a new industrial proletariat.

The period was also marked by forms of imperialism, both economic and cultural. Each of the leading powers developed empires in Africa and the East. The British empire was dominant, controlling the whole of India and huge swathes of Africa, with a presence in China. Belgium possessed the mineral-rich Congo, while Germany was beginning to establish itself in East Africa. France advanced her interests along the southern rim of the Mediterranean, first in Algeria, then in Tunis and Morocco, acquiring a share in Egypt with Britain. She also extended her empire in the Far East, in Southeast Asia and in China. A further development of particular significance for the future was the forced opening-up of trade with Japan, effected by the United States in 1854.

The condition of the world economy was not one of uniform expansion, however. The economic boom of the 1850s and 1860s had given way in the early 1870s to a widespread depression that lasted almost till the end of the century. During the last quarter of the nineteenth century there were many areas where economic stagnation was the norm. In France, agriculture suffered and the movement of population into the towns increased accordingly, with consequent social tensions. In England, in Hobsbawm's words, the economy 'did not crash into ruins quite so dramatically as in the USA and central Europe, [but] among the debris of bankrupt financiers and cooling blast furnaces, it drifted inexorably downwards'. As the economies revived, the militancy of labour increased. The 1880s saw the emergence of New Unionism in Britain, with the unskilled becoming organized for the first time. In France, a

Workers Party was founded in 1880. In the late 1880s and 1890s there was an upsurge in anarchist activity, while right-wing agitation took an increasingly antisemitic turn, most visibly in the Dreyfus affair during the second half of the latter decade.

Developments in the theory and practice of art are not always easily correlated with the politico-economic conditions of the time. It does not follow, however, that those developments were unaffected, nor that there are no connections to be made. In France, for example, the Impressionist painters were adversely affected when Durand-Ruel ran into economic difficulties as a result of the slump. It was partly in response to the difficulty of finding buyers at home that he worked to expand his market in America, where Impressionist painting was to become strongly represented, and where the idea of a modern Naturalism was to retain its hold well into the 1890s (VIA18). Anarchism was a major influence on the Neo-Impressionists in the late 1880s and 1890s, and also on some of the Symbolists. The politics of anarchism largely determined the themes of Pissarro's album *Turpitudes Sociales*, while it was the apparent compatibility of anarchist beliefs with contemporary colour theory that sustained the late-Impressionist ideal of an ideologically unregulated and objective vision (IVA16; VIB8, 11 and 14).

Regarding the growth of imperialism there are also clear connections to be made. As the societies of the rest of the world were opened up to Western power and exploitation, there were reciprocal effects on Western cultures through the importation of exotic artefacts and images, through their sale in such outlets as Farmer and Roger's Oriental Warehouse in London and Siegfried Bing's Oriental crafts shop in Paris, and through displays in ethnographic museums and international exhibitions. The response of Western artists to Japanese woodblock prints during the 1860s and after is only the most conspicuous among a number of consequences of this expansion. In fact, unless due account is taken of the cultural impact of colonial expansion we shall altogether fail to understand the nature of the sea-change that affected the European avant-garde in the last two decades of the nineteenth century: the shift of emphasis from Naturalism to Symbolism, from a modernity predicated upon urban experience to a modernism endlessly renewed by contact with the primitive and the 'authentic', and from a manner determined by receptiveness to the specific *im*pression, to one driven by a primal need for *ex*pression. Given the mounting contradictions of the present, what could be more seductive than the idea of art as a mode of signification resonating in a world of images and symbols outside society and beyond history?

From mid-century the avant-garde had been primarily an urban phenomenon, in terms both of its own social locale and of its characteristic subjects. In the last decade and a half of the century, however, this circumstance was turned inside out. Though the avant-garde as a whole remained significantly metropolitan in its markets as well as its intellectual constituency, there was a tendency for component factions to seek a kind of legitimacy-by-association in the geographical peripheries of bourgeois society, and there to try out more robust or 'primitive' techniques. The connection of Gauguin and his coterie with Pont-Aven is one of the most exemplary cases (VIc9). A sense of voluntary exile from polite middle-class society led some artists and theorists to claim spiritual identification with other victims, such as those on the receiving end of imperialism in the colonies. As Meyer Schapiro noted, not long

before this John Ruskin had been viewing Europe as the sole seat of Art and the rest of the world as the home of barbarism. Now the erstwhile barbarians seemed to offer a form of hope for the future. Primitivism thus became a crucial component of modernism. Through its identification with the art of the supposedly primitive the avant-garde assured itself of a certain critical distance, both from the perceived materialism and artificiality of Western bourgeois society, and from its own earlier investments in positivism, in democracy and in modernity itself. In the process it restored a form of Romantic individualism, reworking it into an image of the artist as primitive hero. In the early 1890s, Cézanne was cast in this role by many who sought to explain the strange passion and integrity that seemed to emanate from his paintings (VIB 15 and 16); Gauguin's own adoption of the part persuaded many who had not been personally subject to his machinations (VIc 12); but it was van Gogh who in the end seemed to fit the role best (VIB 4).

It was in Paris first and foremost that the world's cultures seemed to be gathered, there to be refashioned into modern forms of art. In the later years of the century it was from Paris that this transformed modernism was in turn spread to the other industrialized nations. While Paris was to remain the fountain-head of avant-garde culture well into the twentieth century, the ideas and preoccupations and styles by which modern art had come to be defined were worked together with more local materials – in Munich, Vienna, Barcelona, St Petersburg, Moscow, New York, London – and made over into the stuff of new, self-sustaining avant-gardes. The subcultures that developed were thus not straightforward transplants of Naturalism or Impressionism. As we have noted, after the mid-1880s the French avant-garde itself entered a new phase. Elsewhere, Naturalism remained effective as an antidote to classical norms so long as academic forms of authority persisted, but it tended to be mixed into hybrid forms with elements of Neo-Impressionist technique or with types of Symbolist formalization or with both. The expansion of avant-garde activity thus did nothing to diminish the standing of Paris as point of origin. Rather, Paris came to be seen as the capital of a new and different form of empire. The nature of this empire is sketched out in Victor Hugo's panegyric to Paris as the capital of the future (VIA 1). This imaginary city was built out of myriad experiences of the kinds described by the Italian Edmondo de Amicis (VIA 2) and rendered into more perplexing and uncomfortable form by Manet and by Degas (VIA 3–5). We can see its image reflected back at the very end of the century by the German Paula Modersohn-Becker (VIA 7).

The Worpswede community, of which Paula Modersohn-Becker was a member, was a typical form of modernist hybrid: on the one hand sustained by commitment to a modern Naturalism, on the other partaking of the idealization of the primitive and the authentic that emerged among the avant-garde in the 1880s. Wherever this form of idealization took root it drew sustenance from indigenous sources: at Worpswede from the Netherlandish-German 'primitivism' associated with Rembrandt and Dürer; in Russia from the vernacular decorative forms of the peasantry and the 'flat' and ornamental quality of Byzantine art (VIA 14); in Bavaria from traditional glass-painting; in England from the craft practices of cottage industries, and so on. In Vienna and Munich avant-garde groupings identified themselves through secessions from the Fine Art academies, drawing their ethos largely from the Symbolist movement and finding moral support and practical employment in local forms of the

decorative arts (VIA9–12). Symbolism and Art Nouveau, or Jugendstil, are to be distinguished, but they share much that in turn marks them out clearly from Naturalism and Impressionism. In brief, a new and widespread constellation emerges in the 1890s, leavened at points with Naturalism, but marked by the key features of both primitivism and Symbolism. It is now this new combination that serves to maintain the crucial distinction between avant-garde art and bourgeois culture at large. As Hermann Bahr makes clear (VIA8), one of the main points at issue for the expanded avant-garde of the end of the century was whether what was in prospect was a form of terminus or a new beginning; the decadence and death of art, or the birth of avant-garde culture proper, as a vital component within the wider bourgeois society, though critically distinguished from it.

Meanwhile Impressionism still served as a name to rally round well after the Naturalist impulse had ceased to sustain any significant new developments in France (VIB1). Among the new recruits to the group exhibitions in Paris in the 1880s were Paul Gauguin and Georges Seurat, the one a central figure in the development of Symbolism as an artistic movement, the other the initiator of the divisionist painting technique that came to be known as Neo-Impressionism. Impressionism had been an art increasingly consecrated to the production of a unified effect, which is tantamount to saying (as Matisse was later to do) that the significance of the painting was carried by its expressive surface. Painting's capacity for expression was increasingly identified with enhancement of the effects of colour, which became the dominant focus of technical concern in the French painting of the 1880s and 1890s. For artists as diverse as van Gogh, Pissarro, Cézanne and Gauguin, colour rather than drawing or line came to seem the main vehicle of expressive purpose, if only it could somehow be set free from habit and from preconception (VIB3, 10, 17 and 18).

As to how such a liberation was to be achieved, theory polarized dramatically in the wake of Impressionism. The issues came to a head in 1886, the year that saw both the final group exhibition of the Impressionists (VIB6 and 7) and the publication of the first explicit Symbolist manifestos (VIC4 and 5). For the Neo-Impressionists grouped around Seurat, if colour was to be deployed to truly modern ends, then what was required was a combination of clarity of perception with an objective system of representation. In other words, painting had to become scientific, basing itself upon the findings of empirical research into colour and expression (VIB5, 8 and 9). A considerable number of artists in France and elsewhere were drawn to the idea that painting could be both scientifically rigorous in its procedures and modern in its effects, the veteran Impressionist Pissarro for a while among them (VIB10). Between the later 1880s and the early 1900s, Neo-Impressionism or Divisionism became a widespread international tendency, practised with varying degrees of rigour by artists in France, Belgium, Holland, Italy, Germany, Spain, England and America.

For the Symbolists, on the other hand, concepts of science and objectivity were thoroughly compromised through association with the materialism and spurious rationalism of bourgeois society. Symbolism was a literary movement in its origins, but even before its explicit programmes were published, its adherents had singled out what they saw as compatible subjective and idealist tendencies in art (VIC1 and 2). In his manifesto of 1886, Moréas traced the roots of the movement through Mallarmé and Baudelaire, especially the latter's notion of 'correspondence' (IIID4), and through

them back to Romanticism. The philosophical base was to be found not in Comte or Taine, or St Simon or Proudhon, but in the rediscovered Schopenhauer (IA 1), in Wagner (IIID 2 and VIc 2), and above all in Nietzsche (VB 2, 12 and 13). In 1890–1, the implications for the arts were to be clearly spelled out by Aurier (VIB 4 and VIc 10), as requiring an Idealist philosophy and a synthesizing method. But as we have suggested, interest in the idea of an independent art grounded in the expressive effects of colour was already a part of the legacy of Impressionism, albeit one which entailed reaction against Impressionism's Naturalist aspect. Those who now embraced the idea of a Symbolist art were encouraged to conceive of the liberation of colour and expression in terms of a militant pursuit of the mysterious and the subjective. From this perspective what was required was not clarity of perception but spontaneity of response, not adherence to a system but submission to feeling and intuition. By 1890 the idea of Symbolism in painting was serving to unite a series of overlapping groupings within the Parisian avant-garde, composed of Nabis (Vc 10), Cloisonnists (VIc 7) and Synthetists (VIc 8), with Gauguin firmly established at their centre (VIc 9 and 10), and with considerable support provided in the literary organs of the movement. Among the foreign artists drawn into the orbit of Symbolism at an early stage was the Norwegian Edvard Munch, who was in Paris in the late 1880s (VIc 14).

For all the wide impact of Neo-Impressionism, and for all the devotion with which Paul Signac carried the torch of theory and practice after Seurat's early death (VIB 13 and 14), it was the Symbolist tendency that was to become predominant within the modern movement as a whole. On the one hand the Neo-Impressionists' supposedly objective approach to colour and expression turned out to be prone to its own forms of subjectivism and mysticism, particularly in those areas where it had already been penetrated by Wagnerian theories (VIc 2). In fact, by the later 1880s the 'science' investing Seurat's more ambitious compositions was virtually indistinguishable from the Idealist approaches of the Symbolists. On the other hand, the strict application of divisionist principles exacted a high price in terms of the suppression of spontaneity and individuality. There were few artists who maintained so profound a distaste for subjectivist and Idealist theories as Camille Pissarro, but even he in the end found this price too high to pay (VIB 11).

The overwhelming importance that became attached to the art of Cézanne was due in part to his apparent reconciliation of the different demands upon painting in the 1880s and 1890s (VIB 11, 15 and 16). As we have suggested, he could be seen as the type of the intractable and solitary genius, as a sincerely creative author, yet his work remained independent of the literary apparatus that clung to Gauguin's work and to a lesser extent to van Gogh's. And his art could be seen as rooted in an Impressionist commitment to the objectivity of sensation in the presence of nature (VIB 17), yet the achieved and vibrant harmony of his compositions seemed to demonstrate precisely that independence and self-sufficiency of colour that had been canvassed among the Symbolists. If there is any single figure who may be said to have transmitted the complex values of nineteenth-century avant-gardism to the artists of the twentieth, then that figure is Cézanne.

But of course those values were not actually such as to be transmitted through a single body of work. The early avant-garde had been animated by a broad ensemble of commitments: to the idea of modern life, to Realism, to truth-telling, to positivism, to

rationality, to social progress. The late 1880s and 1890s saw a resurgent philosophical Idealism, a shifting of emphasis towards individual sensibility and intuition, and a tendency to value art not in terms of its relevance or its truth, but for its depth and its intensity. Rather than walking in step with wider forms of social emancipation, at however distant a remove, the Symbolist avant-garde was inclined to let the social world drown in its own mediocrity, nor was it much concerned to separate that world into its middle-class and working-class aspects. Emancipation was interpreted not as a possible outcome of material struggle or of conflict between classes, but rather as a matter for the spirit.

The broader Symbolist movement represented an amalgam of positions, with many of its roots in one world view but subject to the mutating impact of another. There was much that was of original critical significance in its stress on the values of intuition, imagination and creativity. Yet there was also a paradoxical aspect to its success as a *modern* artistic movement. For much of the nineteenth century the Ideal had been the banner under which the Academy mustered its increasingly conservative forces. In opposition to these forces, Naturalism and its positivist ideological cognates had animated a progressive avant-garde during the mid-century and after. By the end of the 1880s, however, Naturalism had itself become academicized. As the classical finally slipped below the horizon of lived experience, there had developed a mildly modernized style of picture, through which the bourgeoisie saw history and the world in forms it could comprehend. This was the dull staple of that ground on which what was left of the Academy met the conservative end of the modern. And now, a transformed Idealism sustained the avant-garde at its cutting edge. A vital expression supervened over an exhausted depiction; the primitive and the 'authentic' over the bourgeois and the urban; the independent, aesthetic effect, aimed at the adequately sensitive and sympathetic spectator, over the commonly recognizable representation of a shared and accessible experience of modernity.

There were important consequences for the position of the avant-garde as a whole. The great social movements of the coming century were to be mass movements. At its inception, whether in the theories of a St Simon or in the practice of a Courbet, avant-gardism had aspired to play its part in the wider social transformation. Yet the route it had taken through the latter part of the century had involved an increasing emphasis upon the individual, the subjective and even the spiritual, and it had rarely led to engagement with any more direct forms of social emancipation. Was it a cause of its direction or a consequence that the avant-garde now found itself lodged economically and socially in those upper sections of the bourgeoisie against which the wider social, and indeed socialist, movement was pitted? However we answer that question, it is clear that by the end of the century the avant-garde in art had become a significantly different kind of force from the vanguard in politics, and that highly contradictory relations obtained between the two. In prevailing forms of conceptualization, modern art was no longer a component part of a wider and more practically dedicated radical front. It was invested with its own independent power, a power which was not without strong ethical and even social implications, but which was in the first instance aesthetic. Thus was installed that form of polarization so familiar to the art history and art theory of the twentieth century: on the one – and generally subordinate – hand, various forms of committed 'Realism'; on the other, a dominant, autonomous 'mod-

ernism', within which an accompanying Modernist criticism was for better or worse to find virtually all that was alive in modern and avant-garde art.

And yet, as the twentieth century itself finally passes in review, it might be said that this polarization was always more readily accessible in theory than it was determining upon the most enduring forms of practice. One of the lessons to be learned from the art of the nineteenth century is that there has never been a substantial form of Realism that was not in some critical respect self-sufficient and self-sustaining, while there has been no interesting type of formal autonomy that was not grounded in art's critical relationship to the objects of a surrounding world.

Modernist Themes: Paris and Beyond

1 Victor Hugo (1802–1885) Epigraph to Zola's *Paris*

Paris itself was more than a city. It became a symbol of the whole modern movement, the 'city of light'. Walter Benjamin famously called it 'the capital of the nineteenth century'. Much of this was myth, but then modernity itself was a kind of myth. The underlying social tensions which repeatedly burst into revolution – in 1789, 1830, 1848 and 1871 – were still present at the end of the century. These tensions were the focus of Zola's novel *Paris*, published in 1898 as the culminating part of a 'cities' trilogy (the first two being Lourdes and Rome). Zola himself referred to the conflict he depicted between socialism and Catholicism as 'a door open upon the twentieth century'. When *Paris* was translated into English, later in 1898, its author was in temporary exile in England, due to the hostility aroused by his intervention in the Dreyfus affair. The English edition was provided with an epigraph by Victor Hugo extolling the mythical Paris. Hugo himself had been dead for a decade, but his writings spanned the century, and he was widely regarded as France's most eminent literary figure. Eminence notwithstanding, Hugo himself had also been an exile – during the years of the Empire, from 1851–70. It was not until the restoration of the republic in 1871 that he returned to France, and later in his own *Paris*, resumed his literary preoccupation with the city. For Hugo, Paris is the legitimate successor to Jerusalem, Athens and Rome. More than the capital of a single modern nation-state, Paris becomes, in his rhetorical prose, the allegorical capital of the future. It was from Hugo's *Paris* that Zola's English translator, Ernest Alfred Vizetelly, selected the material for his epigraph. (Vizetelly's father, Henry Vizetelly, had been financially ruined by the scandal surrounding his publication of Zola's *La Terre* [Soil] in 1887. The Vizetellys assisted Zola during his English exile.) The full text of Victor Hugo's *Paris* appears in *Oeuvres complètes de Victor Hugo, Actes et Paroles IV, Depuis l'Exil 1876–1885*, Paris: J. Hetzel et Cie. The selected passages can be found on pp. 19, 295, 296, 321 and 331–5. They were printed in the form in which they are reproduced here, as the epigraph to the English edition of Emile Zola's *Paris*, London: Chatto and Windus, 1898. Ellipses are given as they appeared in that edition.

In the Twentieth Century there will be an extraordinary nation. This nation will be great, but its greatness will not prevent it from being free. It will be illustrious, wealthy, thoughtful, pacific, cordial to the rest of mankind. ... The capital of this nation will be Paris, but its country will not be known as France. In the Twentieth Century its country will be called Europe, and in after centuries, as it still and ever develops, it will be called Mankind. ... Before possessing its nation, Europe possesses its city. The nation does not yet exist, but its capital is already here. This may seem a

prodigy, yet it is a law. Embryonic development, whether nation or creature be in question, always begins with the head.... Throughout historical times the world has ever had a city which has been The City. The brain is a necessity. Nothing can be accomplished without the organ whence come both initiative and will. Acephalous civilization is beyond conception. It is from three cities, Jerusalem, Athens, Rome, that the modern world has been evolved. They did their work. Of Jerusalem there now remains but a gibbet, Calvary; of Athens, a ruin, the Parthenon; of Rome, a phantom, its empire. Are these cities dead, then? No. A broken eggshell does not necessarily imply that the egg has been destroyed; it rather signifies that the bird has come forth from it, and lives. From out of those shells lying yonder – Rome, Athens, and Jerusalem – the human ideal has sprung and soared. From Rome has come power; from Athens, Art; from Jerusalem, freedom: the great, the beautiful, the true.... And they live anew in Paris, which in one way has resuscitated Rome, in another Athens, and in another Jerusalem; for from the cry of Golgotha came the principle of the Rights of Man. And Paris also has its crucified; one that has been crucified for eighteen hundred years – the People.... But the function of Paris is to spread ideas. Its never-ending duty is to scatter truths over the world, a duty it incessantly discharges. Paris is a sower, sowing the darkness with sparks of light. It is Paris which, without a pause, stirs up the fire of progress. It casts superstition and fanaticism, and hatred and folly and prejudice on to this fire, and from all such darkness comes a blaze of light.... Moreover, Paris is like the centre of our nervous system; each of its quivers is felt throughout the world.... And, further, it is like a ship sailing on through storms and whirlpools to unknown Atlantides, and ever towing the fleet of mankind in its wake. There can be no greater ecstasy than that which comes from perception of the universal advance, when one hears the echoes of the receding tempests, the creaking of the rigging and the panting of the toiling crew, when one feels the straining of the timbers, and realizes the speed with which, in spite of all, one happily travels onward. Search the whole world through; it is ever upon the deck of Paris that one may best hear the flapping and quivering of the full-spread, invisible sails of human Progress.

2 Edmondo de Amicis (1846–1908) 'The First Day in Paris'

Many guide books and commentaries on the sights and other pleasures of Paris were written in the late nineteenth century. Part-cultural criticism, part-tourist guide, part-prurient disapproval, part-advertising copy, they fuelled a widespread desire among an international middle-class audience for information about the freest city in Europe (cf. IIID7 and VB11). Edmondo de Amicis was an Italian writer of children's books, and short stories, often about the military life. He also wrote popular travel books, one of which was about Paris, which served in part as a guide and advertisement for the 1878 World's Fair. De Amicis does not set out to be critical, to look below the surface. Quite the contrary: the effect he presents is of bedazzlement by the surface. Parisian modernity is represented as an exotic spectacle. De Amicis's book becomes an analogue of the shop window, stuffed with commodities, into which his reader–customers gawp, as if they themselves were strolling the boulevards. The point being, that it would encourage them to do just that, to join the spectacle. Resistance is not only useless; it would be dull. *Studies of Paris* was

originally published in Italy in 1878. The present extracts are taken from 'The First Day in Paris', dated 28 June 1878, chapter one of the English translation by W. W. Cady, London and New York: G. P. Putnam's Sons, 1879, pp. 10–36.

[. . .] At last, we enter the Boulevard Mont-Martre, which is followed by those of the Italiens, Capucins and Madeleine. Ah! Here is the burning heart of Paris, the high road to mundane triumphs, the great theatre of the ambitions and of the famous dissolutenesses, which draws to itself the gold, vice and folly of the four quarters of the globe.

Here is splendour at its height; this is the metropolis of metropolises, the open and lasting palace of Paris, to which all aspire and everything tends. Here the street becomes a square, the sidewalk a street, the shop a museum, the café a theatre, beauty elegance, splendour dazzling magnificence, and life a fever. The horses pass in troops, and the crowd in torrents. Windows, signs, advertisements, doors, façades, all rise, widen and become silvered, gilded and illumined. It is a rivalry of magnificence and stateliness which borders on madness. There is the cleanliness of Holland and the gaiety of colour belonging to an oriental bazaar. It seems like one immeasurable hall of an enormous museum, where the gold, gems, laces, flowers, crystals, bronzes, pictures, all the masterpieces of industry, all the seductions of art, all the finery of riches, and all the caprices of fashion are crowded together and displayed in a profusion which startles, and a grace which enamours. The gigantic panes of glass, the innumerable mirrors, the bright trimmings of wood which extend half way up the edifices, reflect everything. Great inscriptions in gold run along the façades like the verses from the Koran along the walls of the mosques. The eye finds no space upon which to rest. On every side gleam names illustrious in the kingdom of fashion and pleasure, the titles of the restaurants of princes and Croesuses; and the shops, whose doors one opens with a trembling hand – everywhere an aristocratic luxury, provoking and bold, which says, Spend – Pour out – and Enjoy, and at the same time excites and chafes the desires. Here there is no substantial beauty; it is a species of theatrical and effeminate magnificence, a grandeur of ornamentation, excessive and full of coquetry and pride, which dazzles and confuses like blinding scintillations, and expresses to perfection the nature of a great, opulent and sensual city, living only for pleasure and glory. [. . .]

There is not one moment's repose, either for the ear, for the eye, or the brain. You hope, perhaps, to be able to drink your beer in peace before an almost empty café. Vain illusion! The *Réclame* pursues you. The first passer by puts into your hand a lyric which commences with an invective against the 'International Exhibition,' and ends by inviting you to purchase an overcoat at Monsieur Armangans, *Coupeur Émérité*. A moment after, you find yourself in possession of a sonnet which promises you a ticket to the Exhibition if you will go and order a pair of shoes in Rue Rougemont. In order to free yourself from this you raise your eyes. Oh, Heavens! A gilded advertising carriage is passing with servants in livery, which offers you high hats at a reduction. Look at the end of the street. What! Half a mile away there is an advertisement in titanic characters of the *Petit Journal* – 'Six thousand copies daily – three million readers!' which affects you like a shriek in your ear. You raise your eyes to Heaven, but, unfortunately, there is no freedom even in Heaven. Above the highest roof of the quarter, is traced in delicate characters against the blue of the sky the name

of a cloudland artist who wishes to take your photograph – so of course there is nothing left to do, but fasten your eyes upon the table! No – not even that! The table is divided into so many coloured and painted squares, which offer you dyes and pomades – you turn your face angrily around – oh, unfortunate man. The back of the chair recommends to you a glovemaker.

So there is no other refuge from these persecutions except to look at your feet, but alas, there is no refuge here even, for you see stamped upon the asphalt by a stencil plate an advertisement which begs you to dine on home-cooking in Rue Chaussée d'Antin. In walking for half an hour you read, without wishing to do so, half a volume. The whole city, in fact, is an inexhaustible, graphic, variegated and enormous decoration, aided by grotesque pictures of devils and puppets high as houses, which assail and oppress you, making you curse the alphabet. That *Petit Journal*, for example, covers half of Paris. You must either kill it or buy it. Everything that is put into your hand, from the boat-ticket to the coupon for the chair, upon which you rest your weary bones in the public gardens, conceal the snare of advertisement. Even the walls of the small temples, which you only enter by force, talk of, offer and recommend something. In every corner there are a thousand mouths which call you, and a thousand hands which beckon. It is a net that encircles Paris. You can spend your last centime, believing all the time that you are very economical. Yet how many varieties of objects and sights! In the space of fifteen steps you see a crown of diamonds, an enormous bunch of camellias, a pile of live turtles, an oil painting, a couple of automatic young women, who are swimming in a lake of tin, a complete suit of clothes to content a man, 'most scrupulously elegant,' for eight francs and fifty centimes, a number of the *Journal des Abrutis*, with an important article on the exhibitions of cows, a cabinet for experiments of the phonograph, and a shopkeeper who is flying feathered butterflies to attract the children who are passing by. At every step you see all the illustrious faces of France. There is no city which equals Paris in this kind of exposition. Hugo, Augier, Mlle. Judic, Littré, Coquelin, Dufaure and Daudet are in all the nooks. No impression, not even the places, is really new. One never sees Paris for the first time, but always sees it again. [...]

So we returned to the Boulevards. It was the dinner hour. At that time the commotion is simply indescribable. Carriages pass six in a row, fifty in a line, in great groups, or thick masses, which scatter here and there in the direction of the side streets, and it seems as if they issued from each other, like rays of light, making a dull, monotonous sound, resembling that of an enormous, unending railway train which is passing by. Then all the gay life of Paris pours itself out there from all the neighbour-ing streets, the galleries and the squares. The hundred omnibuses of the Trocadero arrive and unload, the carriages and the crowd on foot which is coming from the steps of the Seine, masses of people who cross the streets at the risk of their lives, step on to the sidewalk, assail the chiosks, from which myriads of newspapers are hanging, dispute the seats before the cafés and bubble up at the opening of the streets. The first lamps are being lighted, and the great banquet begins. From every side come the sound and glisten of the glasses and knives and forks on the white table-cloths spread in the sight of all. Delicious odours steal from the grand restaurants, the windows of whose upper storey are being lighted, showing fragments of gleaming rooms and the

shadows of women gliding backward and forward behind the lace curtains. A warm, soft air, like that of a theatre filled with the perfume of Havana cigars, and the penetrating odour of absinthe, which gives a greenish hue to ten thousand glasses, with the fragrance coming from the flower stalls, with musk, perfumed clothes and feminine coiffures; an odour belonging entirely to the Boulevards of Paris, its boudoirs and hotels, which always affects the head. The carriages stop; the *cocottes*, with their long trains descend from them, and disappear with the rapidity of arrows through the doors of the restaurants. Among the crowd at the cafés resounds the silvery and forced laughter of those seated in little circles. The 'couples' break audaciously through the crowd. The people begin to form themselves into double lines at the doors of the theatres, and circulation is interrupted at every moment. You are obliged to walk zigzag, taking short steps and gently forcing your way with your elbows through the forest of high hats, opera hats, black overcoats, dress suits, open waistcoats and embroidered shirt bosoms, taking care to avoid treading on little feet and trains, in the midst of a low, confused and hurried murmur, upon which is echoed the sound of flying corks, and in a fine cloud of dust arising from that terrible asphalt. It is no longer a mere coming and going of people, but a sort of whirlpool, or surging mass, as if an immense furnace were burning under the street. It is an idleness which seems a labour, a wearisome fête, as if people were fearful that they should be too late to take their places at the great banquet. The vast space is no longer sufficient for the black, nervous, elegant, sensual and perfumed multitude so full of gold and all kinds of appetites, which seeks pleasures for all the senses. From moment to moment the spectacle becomes more exciting. The rushing of the carriages resembles the disordered flight of a retreating army; the cafés sound like work-shops; under the shadow of the trees sweet colloquies are being held, and every thing moves and trembles in that half darkness, not yet conquered by the nocturnal illumination. An indescribable voluptuousness permeates the air, while the night of Paris, laden with follies and sins, prepares its enticing snares. This is the moment in which the great city takes possession of and conquers you, even if you be the most austere man on earth. [. . .]

It is an invisible hand which caresses you, a sweet voice whispering in your ear, a spark that runs through your veins, and an impetuous desire to dive into that vortex and be drowned, which having passed away, you can go somewhere and dine delightfully for two francs and fifty centimes.

The dinner, too, is a spectacle, for which you find yourself involuntarily (like us) in an immense restaurant, brilliant as a theatre, which consists of one large hall, encircled by a broad gallery, where five hundred persons, making the noise of a good-natured assembly, can be fed at once, – after which comes the last scene of the marvellous representation commenced at eight o'clock in the morning in the Square of the Bastile, namely – the night of Paris.

Let us return to the heart of the city. Here it seems as if day were beginning again. It is not an illumination, but a fire. The Boulevards are blazing. Half closing the eyes it seems if one saw on the right and left two rows of flaming furnaces. The shops cast floods of brilliant light half across the street, and encircle the crowd in a golden dust. Diffused rays and beams, which make the gilded letters and brilliant trimmings of the façades shine as if of phosphorus, pour down on every side. The chiosks, which extend in two interminable rows, lighted from within, with their many coloured

panes, resembling enormous Chinese lanterns placed on the ground, or the little transparent theatres of the Marionettes, give to the street the fantastic and childlike aspect of an Oriental fête. The numberless reflections of the glasses, the thousand luminous points shining through the branches of the trees, the inscriptions in gas gleaming on the theatre fronts, the rapid motion of the innumerable carriage lights, that seem like myriads of fireflies set in motion by the wind, the purple lamps of the omnibuses, the great flaming halls opening into the street, the shops which resemble caves of incandescent gold and silver, the hundred thousand illuminated windows, the trees that seem to be lighted, all these theatrical splendours, half-concealed by the verdure, which now and then allows one to see the distant illuminations, and presents the spectacle in successive scenes, – all this broken light, refracted, variegated, and mobile, falling in showers, gathered in torrents, and scattered in stars and diamonds, produces the first time an impression of which no idea can possibly be given. It seems like an immense display of fireworks, which suddenly being extinguished, will leave the city buried in smoke. There is not a shadow on the sidewalks, where one could find a pin. Every face is illuminated. You discover your own image reflected on every side. You can see everything, the interior of the cafés, even to the last mirrors, glistening with the diamonds of the fair sinners. The fair sex, which during the day seemed to be dispersed and hidden, abounds in the crowd. Before every café there is the parquette of a theatre, of which the Boulevard is the stage. Every face is turned toward the street, and it is a curious fact that aside from the rumbling of the carriages, no loud noise is to be heard. You look a great deal, but you say little, and that in a low voice, as if out of respect for the place, or because the great light imposes a certain reserve. You walk on, always in the midst of a fire, amid an immovable and seated crowd, so that it seems as if you were passing from saloon to saloon in an immense open palace, or through a suite of enormous Spanish *Patios*, amid the splendours of a ball, among a million guests, without knowing when you will arrive at the exit, if there be one.

So, step by step, you reach the Place de l'Opera.

It is here that Paris makes one of its grandest impressions. You have before you the façade of the *Theatre*, enormous and bold, resplendent with colossal lamps between the elegant columns, before which open Rue Auber and Rue Halévy; to the right, the great furnace of the Boulevard des Italiens; to the left, the flaming Boulevard des Capucines, which stretches out between the two burning walls of the Boulevard Madeleine, and turning around, you see three great diverging streets which dazzle you like so many luminous abysses: Rue de la Paix, all gleaming with gold and jewels, at the end of which the black *Colonne Vendôme* rises against the starry sky; the Avenue de l'Opera inundated with electric light; Rue Quatre Septembre shining with its thousand gas jets; and seven continuous lines of carriages issuing from the two Boulevards and five streets, crossing each other rapidly on the square, and a crowd coming and going under a shower of rosy and whitest light diffused from the great ground-glass globes, which produce the effect of wreaths and garlands of full moons, colouring the trees, high buildings and the multitude with the weird and mysterious reflections of the final scene of a fancy ballet. Here one experiences for the moment the sensations produced by Hasheesh. That mass of gleaming streets which lead to the *Theatre Français*, to the *Tuileries*, to the Concorde and Champs Elysées, each one of

which brings you a voice of the great Paris festival, calling and attracting you on seven sides, like the stately entrances of seven enchanted palaces, and kindling in your brain and veins the madness of pleasure. [...]

Yet this is not the greatest spectacle of the night. You go on as far as the *Madeleine*, turn into Rue Royale, emerge on the Place de la Concorde, and there give vent to the loudest and most joyous exclamation of surprise which Paris can draw from the lips of a stranger. There certainly is no other square in any European city where beauty, light, art and nature aid each other so marvellously by forming a spectacle which entrances the imagination. At the first glance you are unable to grasp anything, either the boundaries of the square, the distance, where you are or what you see. It is an immense open-air theatre, in the midst of an enormous flaming garden, which reminds one of the illuminated encampment of an army of three hundred thousand men; but when you have reached the centre of the square, are standing at the foot of the obelisk of Sesostris, between the two monumental fountains, and see, on the right, between two great Gabriel columned buildings, the superb Rue Royale, shut in at the end by the magnificent façade of the *Madeleine*; on the left, the Pont de la Concorde, opening opposite the palace of the Corps Législatif, whitened by a flood of electric light; on the other side, the great dark spot, the Imperial gardens, enwreathed in light, at the end of which are the ruins of the *Tuileries*, and in the opposite direction, the majestic avenue of the Champs Elysées, terminated by the high *Arc de l'Etoile*, dotted with fire from the lanterns of ten thousand carriages and cabs, and lined with two groves scattered with gleaming cafés and theatres; where you embrace with one glance the illuminated banks of the Seine, the gardens, monuments, and the immense and scattered crowd coming from the bridges, boulevards, groves, quays, theatres, and swarming confusedly from every side of the square; in that strange light, among the jets and cascades of silvery water, amid the statues, gigantic candelabra, pillars and verdure, in the limpid and fragrant air of a beautiful summer night, then you feel all the beauty of that spot, unrivalled in all the world, and you cannot refrain from crying, Oh, Paris! Cursed and dear Paris! Bold syren, is it indeed true that one must flee thee like a fury, or adore thee like a Goddess? From thence we went as far as the garden of the Champs Elysées, to wander among the open-air theatres, chiosks, alcazars, circuses and concert halls, through interminable and crowded avenues, from which we could hear the noisy sounds of the orchestras, applause and laughter of those immense tippling parquettes, and the falsetto voices of the canzonette singers, whose luxurious nudity and gypsy dresses we could see through the foliage, in the midst of the splendour of those stages framed by plants. We wished to go to the very end, but the farther we advanced, the more that nocturnal bacchanal lengthened out and enlarged; from behind every group of trees sprang a new theatre and luminary, at every turn of the avenue we found ourselves in face of a new revelry. [...]

So we returned to the Place de la Concorde, stopped a moment to contemplate that marvellous Rue de Rivoli, lighted for the length of ten miles like a ball room, and entered at midnight the Boulevards, still resplendent, crowded, noisy and gay as at the beginning of the evening, just as if the busy day of Paris were commencing then; as if the great city had banished sleep forever, and were condemned by God to the torture of an everlasting festival. [...]

3 Gustave Geffroy (1855–1926) 'Manet the Initiator'

Geffroy was a critic of literature and of art and a political journalist who wrote for Clemenceau's paper *La Justice* during the 1880s, and for *Le Journal* after 1893. He was close to Zola and the Goncourts, to Rodin and to Monet, whose biography he was to write. Against the grain of critical fashion during the 1880s, he continued to regard developments in art from the standpoint of a committed Naturalist. The following text was written as an obituary notice and was first published in *La Justice*, Paris, 3 May 1883. In the great majority of cases, contemporary writers on Manet's work tended either to celebrate the modernism of his technique or to stress the modernity of his themes. Geffroy's text is remarkable in demonstrating that it is the complementarity of these two aspects that gives the painter's work its distinctive critical character, and that ensures its status as a standard for future work in a modern vein. This translation by Michael Ross is taken from Pierre Courthion and Pierre Cailler (eds), *Portrait of Manet by Himself and his Contemporaries*, London: Cassell, 1960, pp. 157–9. For Geffroy's essay on Cézanne, see VIB16.

It is the evening of the opening of the Salon. The crowd has scarcely departed, the doors are hardly closed, when it is learnt that Edouard Manet is dead. The artist had been suffering for many months and the news was not unexpected, but that made no difference; all who had known the man, all who had loved his work, were heart-broken on learning of his sad end.

A shadow was cast over the first day of the Salon – that festival of art and spring which all Parisians love to celebrate – by the strange coincidence of death, all unconsciously, striking down Manet on the anniversary of his battles, in the fullness of his time and talent, when success had at last come to him and a long line of works from his hand was still awaited.

The artist had brought about, quite naturally, an evolution in art, as do all original artists. For a long time he had refused to look at Nature through the eyes of art school teachers or in terms of the pictures of the Old Masters. He had learnt to draw – not the sort of drawing which is merely related to lines surrounding objects, but drawing which indicates subtleties of movement, which reproduces form, recession, action, the vibration of air: drawing which indicates a pose or an expression in a few summary lines. He composed for himself a luminous palette, made up of bold tones and light transparent half-tones. With these means to hand he confronted things and painted them as he saw them. To begin with it was stupefying: so accustomed had one become to see pictures painted in a light other than that of out-of-doors.

Convention was an accepted thing: an indoor light shed on a landscape, trees with green-black foliage, dark figures, portraits painted in a cellar with a ray of electric light illuminating the face only – these things did not shock eyes accustomed to the compromises which for many people constitute art. Nobody wished to acknowledge that the pictures that are so admired in museums are covered with a golden patina put there by time, and that their colours are growing darker every day.

Astonishment was therefore intense on seeing pictures by this artist who did not paint trees and rivers under a studio light, but under the harsh light of afternoon. That is Manet's contribution and which will make his work endure.

Must we consider then that a new era was born with his appearance and regard his predecessors cheaply? Neither he, nor any of his defenders have ever entertained such an idea. Who would quibble, from the point of view of painting, over the mathematical way, so to speak, in which Delacroix applies the law of tone values? Who would deny the revolution made in landscape painting by Corot, that admirable painter of grey? But, also, what an injustice it would be to refuse Manet his place in the undefined evolution of art. With Corot, Jongkind, Degas and Claude Monet, he has added his own important contribution to truth. He has forced everyone who has not been too taken up with convention to think; he has shown the way to those who will come after him.

Just as so many great, sensitive artists of the past have done for the centuries in which they lived, he too wished to introduce into his art the society by which he was surrounded and to realize an intimate union between his work and the world into which he was born. From this moment he dismissed 'Christs', 'Espadas', history and mythology. He painted the reality that was under his eyes, the woman of his times, the manifestations of our pleasures, our occupations and dreams.

People who would never dream of protesting because Velazquez painted 'The Weavers' and 'The Drinkers', or because Rembrandt painted a butcher's shop and 'The Night Watch', protest vehemently when confronted by the pictures in which Manet has represented aspects of modern life – as though the France of the nineteenth century was unworthy of being perpetuated for future generations. Manet, together with Courbet, must be honoured as one of the best artisans of this artistic movement, parallel with the literary movement started by Balzac and continued by Flaubert, the Goncourts and by Zola, who has at last given artistic expression to our times, customs and morals.

This is the role of Edouard Manet. This is the essential task which he has accomplished and for which he must always be honoured. Has he not imposed on us a new way of looking at things – this accurate observance of the luminous film of light which envelops everything, which triumphs today in private exhibitions and in the Salons, and which obtrudes itself even in the official studies and art schools patronized by the Academy and the State? A whole galaxy of able painters, recognized by everyone, employs these methods; are they not striding forward into that field opened up by this painter who was so ridiculed, who will be buried tomorrow? The others who will come after him and who will do better than he – would they have existed without him?

That Manet has had failures, that the modelling of the flesh of his portraits is weak, that he sometimes starts in too high a key in establishing his tone values, that he has not carried some of his pictures far enough, and that some of his drawing is faulty – this I admit. This is not the moment to discuss his very considerable output, picture by picture, to point out his errors and the qualities of his technique. His friends owe it to him to organize a complete exhibition of his works which will allow the wordy warfare to die down and truth to be established. Personally, I await that day with complete confidence.

What can be discussed today is not the importance of Manet's pictures in themselves – as museum or gallery pieces – but the importance of Manet's role as an 'initiator' from the point of view of the history of Art; the importance of the con-

sequences of the revolution which he has affected, the influence that he has exercised, and which he *will* continue to exercise, until another original artist appears on the scene to exasperate the public who will castigate him in the name of Manet, whose 'Olympia' and 'Déjeuner sur l'Herbe' will be, by that time, already in the Louvre.

4 Joris-Karl Huysmans (1848–1907) on Degas's *Young Dancer* and Gauguin's *Nude Study*

Huysmans was a French writer of Dutch origin, best known for his novel *A Rebours* published in 1884 (see VIc1). This work established him at the centre of the Symbolist movement, and as the exponent of a form of extreme and highly coloured aestheticism. He published two volumes of art criticism, *L'Art moderne* in 1883 and *Certains* in 1889. The essays in these volumes take the form of reviews of the Salon and of the exhibitions of the Independents, some but not all previously published in journals. The present extracts are taken from Huysmans's essay on the sixth Impressionist group exhibition in 1881, much of which was devoted to the two most controversial works included. Degas's sculpture of the *Young Dancer* had been announced for the previous exhibition, but not shown. Huysmans responded forcefully to its experimental quality. Gauguin's painting prompted him to speculate on the nude as a quintessentially modern theme, and in the process to raise echoes from the writings of Baudelaire (see IID13 and IIID8) and of the Goncourts (see IIIB17). The wax original of Degas's sculpture is preserved in the Musée d'Orsay, Paris. Gauguin's *Nude Study* is in the Ny Carlsberg Glyptotek, Copenhagen. The review of 1881 seems not to have been published before its inclusion under the title 'L'Exposition des Indépendents en 1881', in Huysmans, *L'Art moderne*, Paris: G. Charpentier, 1883. Our extracts are taken from pp. 226–7 and 237–42 of that edition, translated for this volume by Kate Tunstall.

In his most negligent sketches just as in his finished works, M. Degas's personality explodes; in his rapid energetic drawing, as striking as that of any Japanese master, in movement captured in action or in a gesture surprised, he is unequalled; but the main attraction of his exhibition this year lies not in his drawings or paintings, which do not improve on those he exhibited in 1880 and which I have already described; it lies entirely in a wax statue, entitled *Jeune danseuse de quatorze ans* which has alienated a stunned and embarrassed public.

The terrifying reality of this statuette must obviously disturb its public; all their ideas on sculpture with its cool, inanimate whiteness, all the traditional formulae handed down from age to age, are overthrown. The fact is that, at a stroke, M. Degas has upset all the traditions of sculpture in the same way that, already some time ago, he had rocked the very foundations of painting.

Although drawing on the techniques of the Spanish Old Masters, M. Degas has immediately made them his own, made them modern through his original talent.

Just like those painted madonnas in real dresses and Christ himself in Burgos Cathedral with real hair and crown of real thorns, his loins covered in real cloth, M. Degas's dancer is wearing real skirts and ribbons, and a real corsage and she has real hair.

With her painted head tilted back, her chin upturned, her mouth half-open, her complexion sallow, sickly, prematurely drawn and aged, her hands clapsed behind her

back, her flat chest bound by a tight white corsage whose material is moulded in wax, her legs shaped by exercise and poised for action, those superb, supple, muscular legs, emerging from muslin skirts, her tense neck circled with a narrow choker, real hair tumbling down over her shoulders from a chignon tied with a ribbon matching the one round her neck, this dancer seems to come to life beneath our gaze and seems about to spring down from her pedestal.

This statuette, both refined and barbaric in its meticulous clothing and its coloured, almost breathing, flesh, informed by the play of the muscles, is the only genuinely modern experiment in sculpture that I have yet encountered.

* * *

Last year, M. Gauguin held his first exhibition. It was a series of landscapes, even more imprecise than the works of Pissarro; this year M. Gauguin is represented by a highly personal work, a canvas revealing his undoubted temperament as a modern painter.

It bears this title: *Etude de nu*; in the foreground there is a woman, in profile, seated on a sofa, darning her shirt; the parquet floor covered in a mottled carpet recedes into the background behind a bead curtain.

I am not afraid to say that of all the contemporary artists who have worked on the nude, none has yet struck such a vigorously realistic note; and I am not excluding Courbet, whose *Femme au perroquet*, is as far from reality in its composition and texture as Lefèvre's *Femme couchée* and Cabanel's peaches-and-cream *Vénus*. The Courbet is painted roughly with a palette knife dating from the times of Louis Philippe, whereas the flesh of the more modern nudes wobbles like half-eaten blancmange; this is moreover the only difference to be observed between any of these painters. Had Courbet not placed a modern crinoline at the foot of the bed, his woman could perfectly well have taken the title of Naïad or Nymph; it is through this simple trick that this woman comes to be considered as a modern woman.

In Gauguin's case there is nothing like this; she is a modern girl and not a girl posing for an exhibition, she is neither lascivious nor simpering, she is quite simply darning her clothes.

In addition she is blatantly fleshly; we no longer have the flat, smooth skin that painters prefer, that skin with no marks, spots or pores, that uniform skin dipped in rose water and pressed with a smoothing iron; we have instead an epidermis pulsing with blood and throbbing with nerves; in fact there is such truth in every part of her body, in that stomach sagging slightly over her thighs, in the folds of flesh beneath pendulous breasts, with their muddy contours, in the plump wrist resting on her chemise.

I am delighted to be able to celebrate a painter who has felt, as strongly as I have, an overwhelming repugnance for puppets with neat little pink breasts and slim hard stomachs, drawn up according to what passes for good taste and designed according to formulae learned from plaster casts.

O the nude! Who has ever painted her in her real splendour, without calculation, without readjustment, without falsifying her features or flesh? Who has ever shown the nation and the period to which an unclothed woman belongs, her social condition, her age, the pure or sullied state of her body? Who has ever captured her on canvas, so vital and convincing that we wonder what sort of a life she leads, that we can almost

trace the painful marks of childbirth, re-live her pains and pleasures, become incarnate in her for a moment or two.

In spite of his mythological titles and the eccentric costumes with which he adorns his models, Rembrandt is the only painter so far who has been able to paint the nude.

In this, he is the opposite of Courbet; if we remove the ceremonial regalia that linger on in his painting and restore to his characters the modern status that they had in his day, we see that Rembrandt's Venuses can only have been real Dutch women, matrons with folds of dimpled flesh overflowing their ample bones, their feet being scrubbed and their hair combed, all lit by haloes of golden light.

In the absence of a man of genius like this admirable painter, we would do well to hope that a talented artist like M. Gauguin might do for his age what Rembrandt did for his; that is, in those moments in which a nude becomes possible, in bed, in the studio, in the theatre or in the bath, that he captures French women whose bodies are not pieced together from various sources, their arms posed by one model, their heads or stomachs by another, and not, in addition to all this piecing together, painted according to the fraudulent procedures of the Old Masters.

But alas! these wishes will long remain unfulfilled, since we persist in imprisoning pupils in classrooms to feed them with the same old banal statements on art, in making them copy from antiquity, and we do not tell them that beauty is not single and invariable, that it does change according to climate and period, that the Venus de Milo, to take one example, is now no more interesting or beautiful than antique statues from the New World, with their gaudy tattoos and feather headdresses; that both are different examples of the same idea of beauty explored by divergent races; that nowadays we should not be attempting to achieve beauty by observing the Greek, Venetian, Dutch or Flemish rites, but by struggling to discover it in contemporary life, in the world we find all around us. For beauty does exist, and it is here in the streets, where those wretches who have slaved away in the Louvre cannot see it, outside, in girls passing, displaying the delicious charms of their langorous youth as if rendered divine by the rarefied air of the city; there is the nude lurking beneath the skimpy armour that hugs their arms and legs, moulds their hips and shapes their breasts, a nude which is different from that of past centuries, a tired, delicate, refined, vibrant nude, a civilized nude, whose artificial grace drives us to despair!

Oh how I laugh at the Winckelmanns and the Saint-Victors who wept with admiration at the sight of Greek nudes and who had the audacity to declare that beauty had once and for all time taken refuge in those piles of marble.

So I insist, M. Gauguin is the first artist for years to have attempted to represent modern woman and despite those heavy shadows that weigh on the face and the breasts of his model, he has fully succeeded in creating a boldly authentic canvas.

5 Joris-Karl Huysmans (1848–1907) on Degas's pastels

In the eighth and last Impressionist group exhibition Degas showed a series of pastels of nude women bathing, washing, drying themselves and dressing. These attracted a considerable body of comment. The reactions were highly varied. Some commentators

interpreted the pictures as savage and realistic accounts of the depravity of prostitution, coupling a reading of the women as brutal and brutalized to assumptions about the artist's misogyny. A small minority noticed the apparent absence of any defined position for the spectator and read the pictures as representations of ordinary women in moments of privacy and unselfconsciousness. In his response to the exhibition, Huysmans combines aspects of each of these readings. He attributes to Degas a misogyny for which he appears himself to be the source, and views the pastels not as pictures of prostitutes but as harshly realistic accounts of 'woman' in general, and thus as corrective of the idealized nude. Educated by subsequent developments in film and photography we are now better able to appreciate the naturalism of Degas's compositions and poses, and to understand their artful informality. It is thus easier to see the minority reading as appropriate. In the power and vividness of Huysmans's writing, however, we can still sense the troubling effect these works exercised over their viewers in 1886. For other contemporary responses to Degas's pastels and to the last Impressionist exhibition, see VIB6 and 7. The following excerpt is taken from the essay 'Degas', first published in Huysmans, *Certains*, Paris, 1889: Tresse & Stock, pp. 22–7, translated for this volume by Peter Collier.

This painter who is the most individual and incisive of all those who live in this wretched, ungrateful country, has chosen to exile himself from private exhibitions and public places. At a time when all painters have their snouts deep in the trough of public life, he has withdrawn into a world of silence to create his inimitable works.

Some of these were exhibited in an establishment in the rue Lafitte, in 1886, as an ironic farewell.

It was a collection of pastels described in the catalogue as: 'Series of female nudes, bathing, washing, wiping and drying themselves, or having their hair combed'.

M. Degas, who in some admirable paintings of ballet dancers, had already so mercilessly represented the degradation of those mercenary creatures, dehumanized by their mechanical twirls and predictable leaps, showed us on that occasion in his studies of the nude, his painstaking cruelty and unshakeable hatred.

It was as if, exasperated by the baseness of the world around him, he had decided to take his revenge and hurl the vilest insult at his century, by overturning its most consistently respected idol, woman, sullying her by representing her in the middle of her bath tub, in the humiliating positions of her most private ablutions.

And in order better to underline the force of his rejection, he makes her plump, pot-bellied and short, thus drowning the grace of her outlines beneath the rolls of fat, making her lose any artistic dignity of line, so that, regardless of which social class she belongs to, she becomes a fishwife or a butcher, in a word, a creature whose vulgar forms and shapeless features solicit continence and inspire disgust!

First we have a roly-poly dumpling of a redhead, bent double, her sacrum emerging from the taut flesh of her rounded buttocks; she strains to bring her arm over her shoulder and sponge herself, sending water cascading down her spine and over her backside; then there's a short, stocky blonde, standing upright, once more with her back to us; this one has finished scrubbing herself down, and arches her back, placing her hands behind her in a rather masculine gesture, like a man lifting the tails of his jacket to warm his behind in front of the fire; then another dumpy little creature,

squatting in her zinc bath tub, leaning right over sideways, lifting one leg up and reaching underneath to wash herself; and finally, one last woman, seen this time from the front, is wiping her stomach.

These are, briefly summarized, the cruel poses that this iconoclast assigns to a being who is accustomed to being worshipped in tones of inane gallantry, whereas in Degas's pastels we find mangled stumps, flabby breasts, legless torsos wriggling, and a whole series of postures, common to all women, whether lying or standing, young and pretty or froglike and apelike – like the one we see here bending down to limit the damage and disguise her decay.

But in addition to this individual note of contempt and hatred, what we should look for in these works is the unforgettable truth of their characters, captured in broad, confident lines, with lucid, controlled enthusiasm, with tempered fever; it's the ardent but muted colour, the mysterious and opulent atmosphere of these scenes, it's the supreme beauty of flesh washed blue or pink by water, flesh made visible in darkened bedrooms, where, in the light filtering through closed windows and muslin curtains from dim courtyards, we can make out cretonne Jouy wall-hangings, washbasins and bowls, bottles and combs, boxwood brushes, and coppery pink hot-water bottles!

This is no longer the soft, smooth, timelessly naked flesh of goddesses, that flesh whose archetypal formula is to be found in a painting by Régnault in the Lacaze museum, the painting where one of the three Graces flaunts her shiny pink cotton backside, glowing as if illuminated by inner candlelight, but real, living flesh just out of its clothes, flesh subjected to ablutions, flesh whose rough, cold skin has yet to be smoothed.

Among the people who visited that exhibition, there were those who, on finding themselves face to face with the squatting woman, whose stomach dispenses with the usual deceits, cried out against such shameless effrontery, but were none the less struck by the life radiating from these pastels. And all they were able to do was make a few remarks, showing their embarrassment or disgust, and leave the room uttering the immortal words: 'It's obscene'!

But were ever paintings less obscene! If ever a work were more wholly and decisively chaste, despite its lack of tentative precautions or crafty devices, this is it! – It celebrates even a disdain for the flesh, in a way that no artist since the Middle Ages had dared!

And we could go even further, for this is not a passing masculine disdain, but rather a profound, confident loathing by certain women for the sham pleasures of their sex, a loathing which fills them with a terrifying urge to sully themselves by openly exposing the clammy horrors of the body that no lotion can cleanse!

M. Degas is a powerful but isolated artist, with no known predecessors, and no significant heirs, who always in each of his paintings make us feel the presence of something strange and impalpable, but something so precise and definite that we are surprised, annoyed even, at being impressed; his works have a kind of realism that a brute like Courbet could not understand, but one which resembles that conceived by some of the Primitives, that is, an art which expresses the way that the soul may flood or burst into the human body when it is in perfect harmony with its environment.

6 Vincent van Gogh (1853–1890) Letters to his brother Theo

Van Gogh's artistic career was short. He began to draw and paint in 1880, and took his own life in the summer of 1890. His early work was done in Holland, mostly in Drenthe, in the north, in Nuenen in Brabant, and in The Hague. Impelled by the same Christian socialism that had earlier led him to the ministry, he followed models of social realism taken from the Dutch tradition and from the more recent example of French realists such as Millet and Daumier. Zola's Naturalistic novel of coalminers, *Germinal*, made an impression on him at this time. In the first of the present extracts van Gogh describes to his brother Theo *The Potato Eaters*, the major work of his early career. He discusses the painting's colour effects (cf. VIB3), but these selections are less concerned with technical aspects of his work than with its ethical character. He emphasizes *The Potato Eaters* as 'real and honest', qualities he also identifies with the way of life depicted. In the second letter he criticizes academic painting, and contrasts its studio *fini* with the outdoor painting of rural life subjects. Academic work, both in subject and technique, lacks what van Gogh calls 'the essential modern note'. He sharply distinguishes both his own work and that of kindred French Realists from Parisian Salon art. Within a year, however, he had himself left Holland for Paris. Our extracts have been translated from the Dutch for the present volume by Hester Ysseling, from Hans van Crimpen and Monique Berends-Albert (eds), *De brieven van Vincent van Gogh*, four volumes, The Hague: SDU Uitgeverij, 1990, volume III, pp. 1,304–7 and 1,344–9. We have retained van Gogh's own underlinings.

[Nuenen] *c*.30 April 1885

Dear Theo

On your birthday I heartily wish you good health and serenity. I would have liked to send you the painting of the *Potato Eaters* on this day, but although it has made good progress, it is not quite finished yet.

I will have painted the picture itself in a relatively short time and largely from memory, but it has taken an entire winter of painting studies of heads and hands. And as regards the few days in which I have now painted it – it has been a formidable struggle, but of a kind for which I have much enthusiasm. I feared repeatedly that it would not get on the canvas. But painting is also an 'agir-créer' [acting-creating].

When the weavers produce those fabrics which I believe are called cheviots, or also the peculiar Scottish multi-coloured plaid fabrics, then as you know, they seek to achieve peculiarly broken colours and greys in the cheviots – or, in the multi-coloured plaid things, to achieve a balance in the combination of the most vivid colours, in order that instead of the fabric becoming a jumble, the effet produit [produced effect] of the pattern, when seen from a distance, is harmonious. A grey that is woven from red, blue, yellow, and dirty white and black threads together – a blue that is broken by a green and an orange, or a red or yellow thread – these are very different from plain colours, because they swarm more, and complete colours become hard, cool and lifeless in comparison.

For the weaver, however, or rather for the designer of the pattern or the colour-combination, it is not always easy to determine precisely the calculation of the number of threads and their direction – nor is it easy to weave brush-strokes together into a

harmonious whole. If you could see alongside each other the first painted studies I made on coming here to Nuenen and the present canvas, I believe you would see that as regards colour, things have come to life.

I believe that the question of breaking colours up with respect to the colours will come to preoccupy you too some day. Because, as a connoisseur and a judge of art, one must, I believe, be certain of one's matter and have certain convictions. [. . .]

As to the *Potato Eaters* – it is a painting that looks good in gold – of that I am certain. But it would also look good on a wall, covered with paper with the deep tone of ripe corn. Without such a surround, however, it would simply not be visible. Against a dark background it does not appear to its full advantage and especially not against a dull background. And this is because it is a view into a very grey interior. In reality too it is set in a gilt-frame, as it were, because the hearth would be close to the spectator, and the glow of the fire on the white walls – these are now outside the painting, but in nature they throw the whole thing backwards.

Once more, it must be surrounded by placing something with a deep gold or brass colour around it. If you yourself want to see it as it should be seen, then please think of this. This relation to a gold tone also gives brightness to places where you would not expect it and takes away the marbled aspect that it gets when unfortunately placed against a dull or black background. The shadows are painted with blue and the colour of gold works on this.

Yesterday I brought it to an acquaintance of mine in Eindhoven, who is also painting. In a day or three I will go and glaze it with the white of an egg and finish a few more details at his place. This man who himself does his best to learn to paint and seeks to achieve good coloration was very much taken with it. He had already seen the study after which I made the lithograph and said he had not thought it possible that I could heighten the colour and the drawing so much more. Since he too paints from the model, he knows well enough what is in a peasant's head or fist, and of the hands he said that he himself had now got a whole new conception of how to represent them.

The fact is that I have been completely preoccupied with the desire to work on it, that one gets the idea that these folk, eating their potatoes under their lamp, with these hands they put in the dish, have been digging up the earth, and thus it speaks of manual labour and of – that they have earned their food so honestly. I have intended it to remind one of an entirely different way of life than that of us civilized people. For this reason I would not at all desire that everyone simply finds it beautiful or good.

All winter long I have had the threads of this fabric in my hands, searching for the definitive pattern – and if it is still a fabric now with a rough and coarse aspect, the threads have nevertheless been chosen with care and in accordance with certain rules. And it might prove to be a real peasant's painting. I know that it is one. But he who would rather see the peasant as mealy-mouthed, may do as he pleases. I for one am deeply convinced that it gives better results in the long run to paint them in their roughness than to put a conventional sweetness into it.

A peasant girl is more beautiful than a lady – in my opinion – in her dusty patched up blue skirt & bodice, which get the finest nuances through weather, wind and sun. But should she put on a lady's dress, then the real is gone. A peasant in his bombazine clothes in the field is more beautiful than when he goes to church on Sunday in a dress coat of sorts.

And also, in my opinion it would be wrong to give a certain ˈconventional smoothness to a painting of a peasant. If a painting of a peasant smells of bacon, smoke, potato steam, all right – that is not unhealthy – if a stable smells of dung – good, that is what it is a stable for – if the field has the odour of ripe corn or potatoes or of guano & manure – that is healthy, especially for city people. In such paintings they have something useful. But a painting of a peasant should not be perfumed. [. . .]

Painting peasant life is a serious thing, and I for one would reproach myself if I did not try to make paintings in such a way that they could rouse serious thoughts in those who think seriously of art and of life. Millet, De Groux, and so many others have given examples of character and of not minding the reproaches of 'sale, grossier, boueux, puant' [dirty, crude, muddy, stinking] &c., &c., so that it would be a shame to falter. No, one must paint peasants as if one of them, feeling and thinking as they do. As not being able to be other than one is. I think so often that the peasants are a world in themselves, in many respects so much better than the civilized world. Not in all respects, because what do they know about art and other such things?

I do have some smaller studies – but as you can imagine I have been so preoccupied with the larger one that I have not been able to do much besides. As soon as is it completely finished and dry, I shall send it to you in a box, and then I will add a few smaller ones. [. . .]

I believe the *Potato Eaters* will get finished – the last days are always dangerous for a painting, as you know, because as long as it is not quite dry one cannot touch it with a large brush without great risk of spoiling it. And the changes must be done very quietly and calmly with a small brush. Therefore I have simply taken it away and said to my friend that he should take care that I should not spoil it in this way and that I would come and do those little things at his place.

You will see that it has originality. Goodbye, I regret that it was not ready by today – once more I wish you health and serenity, believe me, with a handshake,
t. à. t. [tout à toi],
Vincent

[Nuenen] July 1885

Dear Theo
* * *
It will not be very long before what we can show will be more important.

You can see for yourself – and it is a phenomenon which gives me immense pleasure – that more and more exhibitions are being arranged of one person or of just a few who belong together. This is a phenomenon in the art world which I dare to believe has more avenir [future] than any other undertaking. It is good that they begin to understand that a Bouguereau cannot do well beside a Jacque – that a figure by Beyle or Lhermitte does not do well beside a Schelfhout or Koekkoek. Disperse the drawings of Raffaëlli and judge for yourself whether it would be possible to form a good understanding of that peculiar artist. He – Raffaëlli – is different than Regamey, but I think he is as much of a personality.

If my work remained with me, I believe I would continue to repaint it all the time. By sending it to you and to Portier just as it comes from the open air or from the cottages, occasionally one will pass through that is no good – but things that would not get any better by frequent repainting, will be saved.

Now when you have those four canvases and a few smaller studies of cottages, if somebody saw nothing by me but those, they would necessarily think that I did nothing but paint cottages. And the same goes for that series of heads. But peasant life brings with it so many different things that when Millet speaks of '*travailler comme plusieurs nègres*' [working like several negroes], this is what is truly needed if one wants to complete the whole.

One may laugh at what Courbet says: 'peindre des anges! qui est-ce qui a vu des anges?' [to paint angels! who has seen angels?] But I would like to add, for example 'des justices au harem, qui est-ce qui a vu des justices au harem?' [justice in the harem, who has seen justice in the harem?] Benjamin Constant's painting *Des combats de taureaux*, 'qui est-ce qui en a vu?' [who has seen bullfights?] And so many other Moorish, Spanish things, cardinals, and all those historical paintings, always metres high and metres wide! What is it all good for and what do they want with it? Most of it gets musty and boring when a few years have passed and it bores me more & more. But anyway, perhaps they are nicely painted – could be.

Nowadays, when experts stand before a painting like the one by Benj. Constant, or a reception at some cardinal's by I do not know what Spaniard – it is customary to say with an air of profundity something like 'clever technique'. But if those same experts were to stand before a picture of peasant life or, for instance, before a drawing by Raffaëlli, with that same air – à la C.M. – they would criticize the technique.

You may think I am wrong to make critical remarks about this, but I am so occupied by the fact that all those outlandish pictures are painted in the studio. Just go outside and paint on the spot itself! Then all sorts of things will happen as follows. I have had to wipe off at least a hundred and more flies from the four canvases you are going to receive, not counting dust and sand &c. – not counting that when one carries them across the heath and through the hedges for several hours, a branch or something will scratch them &c. Not counting that when one arrives on the heath, after a walk of several hours in this weather, one is tired and hot. Not counting that the figures do not stand still like the professional models do, and that the effects one wants to catch change with the progressing day.

I do not know how it is with you – but as for myself, the more I work on it, the more I get absorbed in peasant life. And the less I care for either the Cabanel-like things, among which I would also number Jacquet, also the present Benj. Constant – or the so highly praised but so unspeakable and desperately dry technique of the Italians and Spaniards. '*Imagiers!*' that word of Jacques', I think of it often.

And yet I have a parti pris, I respond to Raffaëlli who paints things quite other than peasants – I respond to Alfred Stevens, to Tissot, to mention something quite different from peasants – I respond to a beautiful portrait. Although in my opinion he often makes colossal mistakes in his judgement of paintings, Zola says a beautiful thing about art in general in *Mes haines*: 'Dans le tableau (l'oeuvre d'art), je cherche, j'aime l'homme – l'artiste' [in the painting (the work of art) I seek, I love the man – the artist]. This is something I find perfectly true – and I ask you: what kind of a man,

what kind of a seer, or <u>thinker</u>, observer, what kind of human character is behind certain canvases of which the technique is praised – in fact, often <u>nothing</u>. But a Raffaëlli is somebody, a Lhermitte is <u>somebody</u>, and in many paintings by people who are almost unknown one feels that they are made with a <u>will</u>, a <u>feeling</u>, a <u>passion</u>, a <u>love</u>.

The *technique* of painting from peasant life or – like Raffaëlli – from the heart of the city workmen – brings still other difficulties with it than those of the smooth painting and posturing of a Jacquet or a Benjamin Constant. Because to live in those cottages day in and day out, to sit in the fields like the peasants – in the summer to withstand the heat of the sun, in the winter, snow and frost, not indoors but outside, and not during a walk, but day in and day out like the peasants themselves.

And I ask you, if one considers these things, am I then so wrong about the experts, who these days more than ever make great play with the <u>often</u> so meaningless word 'technique' (they give it a more and more conventional meaning), to criticize their own criticism? If one considers the extent to which one has to walk and toil to paint the morning peasant and his cottage, I venture to maintain that this is a longer and more tiring journey than that undertaken by many painters of exotic subjects for their most exquisite and eccentric subjects, be it 'la justice au harem' or 'the reception at a cardinal's' – because Arabic or Spanish or Moorish models can simply be ordered and paid for in Paris. But he who paints the ragpickers of Paris <u>in their own quarter</u>, like Raffaëlli, encounters greater difficulties and his work is more serious.

<u>Nothing, seemingly, is simpler than painting peasants or ragpickers and other labourers, however – no subjects in painting are so difficult as these everyday figures!</u> As far as I know, there is not a single academy where one learns to draw and paint a digger, a sower, a woman hanging the pot over the fire or a seamstress. But in every city of some significance there is an academy with a choice of models for historical subjects, Arabic, Louis XV, and, in a word, <u>all sorts of figures, provided they do not exist in reality</u>.

When I send you & Serret a few studies of diggers or peasant women weeding, gleaning ears &c. <u>as the beginning</u> of a whole series on all kinds of field-labour, it may be that either Serret or yourself will discover faults in them, which it would be useful for me to know about and which I shall, of course, admit. But I want to point out something that may be worthy of attention. All academic figures are put together in the same manner and let us say '*on ne peut mieux*' [one cannot do better] – irreproach-able – <u>faultless</u>. You will already see what I am driving at – <u>also without giving us anything new</u> to discover.

This is not the case with the figures of a Millet, a Lhermitte, a Regamey, a Lhermitte [*sic*], a Daumier. They are also well put together – but <u>different from what the academy teaches</u> *après tout*. I believe that however correctly academic a figure may be, it is superfluous in these times, even if it is by Ingres himself (excepting, however, his *Source*, for that was, is and will remain something new), when it lacks that essentially modern note, the intimate character, the actual <u>doing of something</u>. You will perhaps ask me, when will the figure <u>not</u> be superfluous, even if there are faults, even great faults in it in my opinion? When the digger digs, when the peasant is a peasant and the peasant woman a peasant woman, is this something new? Yes, even the little figures by Ostade, or Terborch do not work as those of today.

I would like to say much more about this and I would like to say how much I myself want to do even better that which I have begun to do – and how much higher I value the work of some others than my own. I ask you – do you know one single digger, one single sower in the old Dutch school? Have they ever sought to make a 'labourer'? Has Velazquez sought it in his water carrier or his types from the people? No. <u>Working</u>, that is not what the figures in the old paintings do.

These days I am plodding at a woman who I saw last winter plucking out carrots in the snow. There – Millet has done it, Lhermitte and in general the peasant painters of <u>this</u> century – an Israëls, they find that more beautiful than anything else. But even in this century, how relatively few among the innumerable painters who want <u>the figure</u> – yes, above all for the figure's sake, that is for the sake of form and modelling, but <u>cannot think it otherwise than working</u>, and have the need – which the old ones avoided and also the old Dutch masters, who clung to many conventional actions – the need <u>to paint the action for the action's sake</u>. So that the painting or the drawing be a <u>figure</u>-drawing for the sake of the figure and the inexpressibly harmonious form of the human body – but also a <u>plucking out carrots in the snow</u>. Do I express myself clearly? I hope so, and do relate this to Serret.

I can say it in fewer words – a nude by Cabanel, a lady by Jacquet and a peasant woman, <u>not by Bastien Lepage himself</u>, but a peasant woman by a <u>Parisian</u> who has learned to draw at the academy, will make the limbs and the structure of the body always feel the same way – sometimes charming, and correct in proportion and anatomy. But when for instance Israëls, or when Daumier or Lhermitte, draws a figure, one will <u>feel</u> the <u>form</u> of the body <u>much more</u>, and yet – and that's why I include Daumier – the proportions will almost be <u>arbitrary</u> at times, the anatomy and structure often not at all right <u>in the eyes of the academician</u>. But it will *live*. And especially Delacroix too.

I still have not expressed it well. Tell Serret <u>that I should be desperate if my figures were right</u>, tell him I do not want them to be academically correct, tell him that I mean that when one <u>photographs</u> a digger, he would <u>certainly not be digging</u>. Tell him that I adore the figures of Michelangelo, even though the legs are rather too long – the hips and buttocks too wide. Tell him that that is why in my eyes Millet and Lhermitte are the true painters, because they paint things not as they are, traced in a dry analytical way, but as <u>they</u>, Millet, Lhermitte, Michelangelo, feel them. Tell him that I have a great longing to make such incorrectness, such deviations, remodellings, changes in reality, so that they may become, well – lies, if you want – but truer than the literal truth.

And now I must soon finish – but I wanted to say once more that those who paint the life of the peasants or the people, even if they do not belong to the '*hommes du monde*' [men of the world] might perhaps still wear better in the long run than the makers of exotic harems and cardinals' receptions, painted in Paris. [. . .]

You recently wrote to me that Serret had spoken to you 'with conviction' about certain faults in the structure of the figures of the *Potato Eaters*. But you will have seen from my answer that my own criticism also disapproves of them, seen in that perspective, but I have pointed out how this was an impression I had, after I had seen the cottage in the dim lamplight for many evenings, after having painted 40 heads, from which it follows that I started from a different point of view.

But now that we begin to speak about the figure, I have much to say. In Raffaëlli's words I discover his opinion about 'character': what he says about this is good and to the point, and is clarified by the drawings themselves. But people who move in artistic and literary circles, like Raffaëlli in Paris, think in an altogether different way than, for instance, I do, out on the land. I mean, they look for one word that comprises all their ideas – for the figures of the future he suggests the word 'character'. I agree with this, with the intention, I think – but I believe as little in the correctness of the word as in the correctness of other words – as little as in the correctness or effectiveness of my own expressions.

Rather than say: 'there must be character in a digger', I describe it by saying: that peasant must be a peasant, the digger must dig, and then there is something in them which is essentially modern. But about these words I also feel that one can draw conclusions from them which I do not intend – even if I should say much more. Instead of lessening the expenses for models – already quite a burden for me – I think I should prefer, very much prefer, spending a little more on them. For what I aim at is something quite different from just being able to do a little figure drawing. To render a peasant's figure in his action, that is what a figure is – I repeat – essentially modern, the very heart of modern art, that which neither the Greeks, nor the Renaissance, nor the old Dutch school have done.

For me this is a matter I think about every day. But the difference between the great as well as the minor masters of today (the great, for instance, Millet, Lhermitte, Breton, Herkomer; the lesser ones, for instance, Raffaëlli and Regamey) and the old schools – I have not often found it truly and openly expressed in the articles about art. But think over whether you would not think it true. The figure of the peasant and of the labourer was started as a 'genre' – but nowadays with Millet leading as the eternal master, it is the very heart of modern art and will remain so.

Chaps like Daumier – one should respect them highly, because they are among the pioneers. The simple nude but modern figure ranks high – as Henner and Lefèvre have renewed it, Baudry and particularly the sculptors like a Mercier, Dalou, that is also of the most solid nature. But peasants and workers are not nude, after all, and there is no need to imagine them in the nude. The more people would begin to paint figures of workers and peasants, the better I should like it. And as for myself, I don't know of anything else I enjoy so much.

This is a long letter and I still don't know whether I have said clearly enough, what I mean. Perhaps I will send a brief word to Serret, and if I do, I will send the letter to you to read, for I should like to make clear how much importance I attach to this question of the figure.

7 Paula Modersohn-Becker (1876–1907) from Letters and Journals

Paula Becker was born in Dresden in 1876. Her family moved to Bremen in north Germany when she was twelve, and it was here, after beginning to study painting and drawing in the early 1890s, that she first encountered the works of the Worpswede community of artists in 1895. Subsequently, in the later 1890s, she continued her studies in Berlin, but spent several periods in Worpswede. Her correspondence and journal of the time reflect two

main influences. The first of these was a commitment to Naturalism, indebted to the Worpswede artists and through them to the German–Netherlandish tradition exemplified by Dürer and Rembrandt (she had read Langbehn's influential *Rembrandt as Educator* (see VB14)). The second reflects her encounter with a range of cosmopolitan influences: Marie Bashkirtseff's Journal (see VB7), Ibsen's plays, Nietzsche's *Zarathustra*, and in art, the works of the French avant-garde which she had seen at exhibitions in Berlin and Vienna. Thus a commitment to the local and particular in her own experience co-exists with the gravitational pull of Paris: the productive tension out of which her mature art was made. The present extracts are taken from *Paula Modersohn-Becker: The Letters and Journals*, edited by Gunter Busch and Liselotte von Reinken, English edition edited and translated by Arthur S. Wensinger and Carole Clew Hoey, Evanston, Illinois: Northwestern U.P., 1990. The 'Sunken Bell' refers to a play of the same name by Gerhart Hauptmann; for Modersohn-Becker it connotes a fairy-tale mood associated with artistic creativity.

[Journal]

Worpswede, July 24, 1897

Worpswede, Worpswede, Worpswede! My Sunken Bell mood! Birches, birches, pine trees, and old willows. Beautiful brown moors – exquisite brown! The canals with their black reflections, black as asphalt. The [River] Hamme, with its dark sails – a wonderland, a land of the gods. I pity this beautiful part of the earth – the people who live here don't seem to know how beautiful it is. One tells them how one feels about it but they don't seem to understand. And yet one doesn't need to have pity. No, I really don't have any. No, Paula Becker, better take a little pity on yourself for not living here. Oh, not even that; you are alive, you are happy, your life is intense, and it all means that you are painting. Oh, if it weren't for the painting! And why take pity on this land at all? It has men, painters, who have sworn fidelity to it, who are devoted to it with the enduring and solid love of men. First there is Mackensen. He's the one with the golden medals from the art exhibitions. He does character portraits of the land and its people; the more characteristic the head, the more interesting. He understands the peasants completely. He knows their good aspects, all of them, and he knows their weaknesses. I think he could not understand the peasant so well if he had not grown up in humble circumstances himself. [. . .]

The second in this circle is little Vogeler, a charming fellow born under a lucky star. He is my real favourite. He's not nearly the realistic man that Mackensen is; he lives in his own world. [. . .]

His pictures move me very much. His models are the old German masters. In form and style he is very strict, almost stiff, . . . his image of spring: birches, delicate young birches with a girl in their midst – she is dreaming of spring. The girl is very stiff, almost ugly. And yet I am so touched to see how this young man can translate his urgent dreams of spring into such balanced form. The severe profile of the girl is seen contemplating a little bird; it is almost a masculine contemplation – at least it would be that if it weren't so reserved and dreamlike. That is little Vogeler. Isn't he a delight?

And then there is Modersohn. I've seen him only once and then just for a short time – and I did not get a real sense of him. All I remember is something tall, in a

brown suit, and with a reddish beard. There is something soft and sympathetic in his eyes. His landscapes, the ones I saw exhibited there, have a deep, deep mood about them – a hot, brooding autumn sun – or a mysterious, sweet evening light. [. . .]

Worpswede, September 7, 1898

My dear Aunt Cora,

My first evening in Worpswede. There is happiness and peace in my heart. All around about me the precious quiet of evening and the pungent smell of hay in the air. Above me the clear starry sky. Such sweet inner peace fills me and gently takes possession of every fibre of my whole being and existence. And one surrenders to her, great Mother Nature, fully and completely and without reservation. And says with open arms, 'Take me.' And she takes us and warms us through with her full measure of love, so that such a little human creature completely forgets it is made of ashes and dust and shall return to ashes and dust – This morning I walked out here with Kurt through the misty landscape, the green meadows, and the radiant fields of mustard. And the landscape grew more and more 'Worpswedeish'; then came the shining canals which reflected the blue sky, with the black peat barges slowly and silently gliding past. And finally came the brown heath, with happy, sparkling birches here and there, a strange mixture of melancholy and frivolity. We had a merry picnic under the open sky, and then in the afternoon a dreamlike hour with the painter Vogeler, who paints fairy tales, and lives fairy tales, and who offered us dream chairs in his fairy-tale hall. And there Kurt and I peacefully and happily entered a new existence. And then we returned deep into the moor, along shining canals, past laughing birch trees. It was the loveliest, purest atmosphere, straight out of Böcklin.

– And now a word about the practical side of this world. Would you be a friend and send me fifty marks and write me how much money I still have? I am savouring my life with every breath I draw, and in the distance Paris gleams and shimmers. [. . .]

[Journal]

November 15, 1898

The journal of Marie Bashkirtsev. Her thoughts enter my bloodstream and make me very sad. I say as she does: if only I could accomplish something! My existence seems humiliating to me. We don't have the right to strut around, not until we've made something of ourselves. I am exhausted. I want to accomplish everything and am doing nothing. Today Mackensen was confused and dissatisfied during his critique. If the little woman from Bergedorf hadn't been there, I would have cried afterward. And so I simply tormented myself for two long hours – and did the same thing again this afternoon. The result: less than nothing. And now I am placing all my hope in my little nude model this evening.

The world is grey all around me and the sky looks gloomy. The water murmurs, gently, dreamily. It makes my soul restless. I wandered beneath the birch trees. There

they stood, chaste and naked. Their bare branches stretched out to the sky, praying devoutly, begging for happiness. But the sky looked down in gloom, and they stand still now and mourn, gently, gently, with their little hands folded in piety. Living – breathing – feeling – dreaming – living.

I am wrapped in the riddle of the universe. And I sit down and say nothing. The water rushes along, the sound making my soul ill at ease. I tremble. Brilliant drops of water hang in the pine tree. Are they tears?

[Journal]

[Undated 1898]

I am not satisfied with my sketching now. I'm out of breath. I want to go further and further. I can hardly wait until I am a real artist.

And then I long so for life. I've only begun to get a little taste of it. I didn't have the real mind for it earlier. And here there is no life; it is a dream here.

I'm reading Nietzsche now, *Zarathustra*. Among so much that is confused and obscure, such pearls! His rearrangement and re-creation of values! His sermons against false brotherly love and self-sacrifice.

False brotherly love, that certainly gets in the way of great goals. Many great minds would not have been chopped into little pieces by everyday concerns if they had been armed with his way of thinking. The next generation should have this concept born into it.

[Journal]

December 15, 1898

[. . .] I am drawing Frau Meyer *aus dem Rusch*. She was in jail for four weeks because she and her man mistreated their illegitimate child so badly. A voluptuous blonde, a marvellous specimen of nature, with a throat gleaming like the Venus de Milo. She is very sensual. But isn't it true that sensuality, inborn and natural sensuality, always goes hand in hand with this kind of ripe and robust energy? For this sexuality contains something of a great Earth Mother with full breasts. And sensuality, sexuality, to the very fingertips, when it is united with chastity, that is the single, true, and proper concern of the artist.

[Journal]

December 16, 1898

My blonde was here again today. This time with her little boy at her breast. I had to draw her as a mother, had to. That is her single true purpose. Marvellous, these gleaming white breasts in her fiery red blouse. The whole thing is so grand in its shape and colour. [. . .]

I think I'm getting into the real mood and atmosphere of Worpswede now. What I used to call my Sunken Bell mood, the spell I was under when I first got here, was

sweet, very sweet – but it was really only a dream, and one that couldn't last long in any sort of active life. Then came the reaction to it, and after that something truer – serious work and serious living for my art, a battle I must fight with all my strength.

I am filled with the sun, every part of me, and with the breezy air, intoxicated with the moonlight on the bright snow. It lay heavy on all the twigs and branches, and a deep silence surrounded me. And into this silence the snow fell from the trees with a gentle and crisp sound, and then there was peace again. An indescribably sweet web of moonlight and soft snow air enveloped me. Nature was speaking with me and I listened to her, happy and vibrant. Life.

[Journal]

January 19, 1899

While I was bathing today, the sentence occurred to me: Here in solitude the human being is reduced to oneself. It's a peculiar feeling, the way all the confused, super-imposed, theatrical qualities that were in me fall away and a vibrant simplicity takes their place. I'm working on myself. I'm reworking myself, half consciously, half unawares. I'm changing – becoming better? At least I know I'm progressing, becoming more conscious of my goal, more independent. This is a good time for me now and I'm aware of a fine young energy that makes me rejoice and exult. I'm working very hard. I don't get tired, and even after work, in the evening, my head is still clear and can absorb and learn. I'm proud now and yet more modest about my accomplishments than ever, not particularly vain – probably because I haven't much of an audience here. Life seems to me like a crisp apple which I enjoy biting into – young teeth conscious of their strength, happy. Mackensen says strength is the finest thing of all. In the beginning was strength. I think about that, and I recognize that it is so. And yet I know at the same time that strength will not be the keynote in my own art. The feeling I have inside me is like a gentle weaving, a vibrating, a beating of wings, quivering in repose, holding of breath. When I am really able to paint, I shall paint that.

Outside, nature is putting on the grand fine dance. The wind is roaring. The rain is beating, hail is showering down – ancient and primeval might. One feels tiny in the face of it all – and then laughs, ready to measure one's strength against that nameless spirit of nature whose smallest atom makes up this little defiant creature, irrational in its struggle.

It's too bad to have to go to bed at night. My feeling of strength wants to fight on as it grows more and more conscious of itself; it wants to stay awake, not rest. Oh, don't leave me! My life will be like the flight of a young eagle. I delight in my wings, I exult in my motion, I rejoice in the blue air of heaven. I am alive.

Worpswede, Thursday, June 1899

My dear Brother,

It's evening again, another one of my beautiful evenings again. When they come, I feel as if the whole world were standing open before me. I sit down in my comfortable

chair, the one you know; I don't think very much, and not too little either, but this little thought I think intensely, feel intensely, and am very quietly happy about being Paula Becker.

After I've indulged myself enough in these happy thoughts, it's time to choose how I'm going to bring my day to its conclusion. Should I read? Right now I'm in my Ibsen period. Since I place such great demands on my feelings when I'm working, Ibsen, who in great part must be absorbed through the intellect, is just the right prescription to conclude the day with. He interests me very much. So far I've read *Hedda Gabler*, *Lady Inger of Östrat*, and *The Wild Duck* ..., you know, the play about being robbed of the illusions that seem necessary for life. I believe that I learn a great deal from reading, especially the way to observe people, and that eventually this has its effect on my art. I have a rather good knowledge of human nature, but also a tendency to idealize probably through Mother's influence. The close union I have with nature has convinced me, however, that naturalism is the only true approach, if only because naturalism assumes and demands a much greater diversity of individual types, something that is impossible in idealism. Idealism generalizes. I used to do that, too. I think the most important bit of progress this winter is the fact that I don't do it anymore, or at least that I have the will not to do it anymore. A great deal more clarity has come into my work. [...]

Worpswede, September 10, 1899

You dear People,

Here I sit in my beloved little nest again, working hard and thinking of the past and of things to come, of all the future holds. I think it did me good to see things from the outside for once, and not always from the inside. I mean, from inside our little village with all its goings-on.

I'm now confronting both the bright and the dark sides of my present life with a good deal more awareness, both what happens inside me and outside. And that is progress.

When I returned, I found that a great deal had changed. The lighthearted crowd seems to have moved in. A good number of lady painters have arrived on our hill-top, while the regular inhabitants all seem to be off on trips – Mackensen, Modersohn, Vogeler. But I really see nothing of other people. I'm trying to dig my way back again into my work. One absolutely has to dedicate oneself, every bit of oneself, to the *one* inescapable thing. That's the only way to get somewhere and to become something. I've made use of the beautiful weather to sketch and paint outside. I had been staying away from colour for such a long time that it had become something quite foreign to me. Working in colour was always a great joy to me. And now it *is* a great joy again. Still, I have to battle with it, wrestle with it, with all my strength. And sometimes that's not so easy, a battle one has to fight all by oneself. And one must be victorious. But if it weren't for the fight, all the beauty of it wouldn't exist at all, would it?

I'm writing this mostly for Mother who, I believe, thinks my whole life is one constant act of egotistic ecstasy.

But devotion to art also involves something unselfish. Some people give their lives to others, and some give their lives to an idea. Does that mean that the former are to be praised and the latter blamed? People must do what nature demands of them. [...]

Bremen, Wachtstrasse 43, December 30, 1899

Dear Mr Modersohn,

I am returning your Pauli lecture to you with many thanks. Reading it in Lilienthal during the half hour I had to wait for the omnibus shortened the time most agreeably. New Year's Eve, at half-past one, I begin the great journey. That will be a lovely little moment when I shake the dust of Bremen from my feet. Hurrah! Right now my poor head is in chaos: packing, saying adieu, talking about Fitger!!!, my plans in Paris, and Mozart arias which my sister is singing in this very room. And so for now, very happy New Year's greetings to you and your dear wife. And in the new century when I am in Paris, the great pit of sin, I shall often think of your sweet and peaceful little house, [...] So, once more, looking very much forward to seeing you again.
Your Paula Becker

The Weser is thawing. One can see again the living water and no longer the dead ice.

8　Hermann Bahr (1863–1934) 'The Modern'

Born in Linz, Austria, Hermann Bahr was a leading figure in 'Das Junge Wien', the movement which revitalized the cultural life of the city in the last years of the Habsburg empire. He was active as a dramatist, novelist and critic, and was later briefly director of the Burgtheatre. The present essay was written for the first edition of the newly founded Viennese journal *Moderne Dichtung*, and was published on 1 January 1890. It expresses in highly concentrated form the powerful *Endzeitgefühl* – the belief that an entire epoch was coming to an end – which dominated Vienna in the closing years of the nineteenth century. In religiously inflected language, Bahr articulates the full ambivalence which lay behind the concept of the 'modern'. A fateful sense of decline is combined with the promise of a new beginning, a promise subsequently taken up in the public declarations of the Vienna Secession (see VIA11 and 12, below). Bahr's essay has been translated for the present volume by Jason Gaiger from Gotthart Weinberg (ed.), *Das Junge Wien – Österreichische Literatur- und Kunstkritik, 1887–1902*, Tübingen: Max Niemeyer Verlag, 1976, volume 1, pp. 30–3.

[...] A terrible agony rends our times and the pain is no longer bearable. A call for the Saviour is heard on all sides, and the crucified are to be found everywhere. Is this the great death which is coming over the world?

It may be that we are witnessing the end, the death of exhausted humanity, and that these are the last convulsions. It may be that we are witnessing the beginning, the birth of a new humanity, and that these are the avalanches of spring. We are either

ascending to the divine or we are falling, falling into night and nothingness – but we cannot remain as we are.

That salvation will emerge from suffering and grace out of despair, that a new day will break after this terrible darkness and that art will return once again amongst men – this resurrection, blessed and glorious, is the belief of the modern.

Yes, it is but a faith, a humble, uncertain faith, devoid of surety.

One can say: it is the end. Tomorrow the world will break in two. Let us enjoy ourselves in intoxication and lasciviousness before the Flood!

Yes, we are defenceless in our simple longing when confronted by the mockery of the knowing.

We have no proof and no tidings other than the promise of God in our hearts. Whoever He has chosen is with us. Our enemies we can only compassionately put to death.

We have no knowledge other than that there is no life outside of our faith. We hearken to our faith in defiance of murder. We make this simple test: if we are not able to pull the trigger or empty the phial, then, despite everything, the truth must lie in our faith.

For us, the modern is something for which we can only wish, and yet it is out there everywhere, outside of ourselves. It is not in our spirit. It is the torment and the sickness of our century, feverish and enraged, that the life has flown from it. Life has been transformed down to its very foundations, and every day it is continually changing into something new, restless and unsatisfied. But the spirit remained old and stiff and did not stir or raise itself; and now it suffers helplessly, for it is isolated and abandoned by life.

Thus we have lost our unity and have fallen into deceit. The past still grows up within us just as the future grows out around us. There can be no peace, but only hate and discord, full of anger and violent deeds.

For hundreds of years the body had feuded with the spirit, the body of the new society. It created drives and desires, previously unknown and still not understood today, for the spirit remained narrow, hunched and deformed. It is not the new body which causes us pain, but the fact that we do not yet possess its spirit.

We want to become true. We want to obey the external laws and our inner longing. We want to become what the world around us has become. We want to shake off the decayed past, whose bloom has long since faded and which now suffocates our soul under its pale canopy of leaves. We want to be of the present.

The past was great and often delightful. We want to hold a festive funeral oration for it. But when the King is buried, long live the new King!

We want to open wide the windows and let in the sun, the blossoming sun of early May. We want to expose every sense and every nerve, greedily to hearken and hearken. And with jubilation and reverence we want to greet the light as it enters in to take up possession of the emptied halls.

It is not true that what is required is great deeds and mighty Messiah. All that is needed is a plain and simple love of truth. Only arrogant pride will be weeded out, which seeks to resist the senses with the understanding.

Redemption is out there in what, today, has begun to emerge. The curse is within, in the inheritance from the past. We want to make the pilgrimage out of the narrow, gloomy cloisters to the bright, expansive heights where the birds sing, those pilgrims of the senses.

Yes, we want to trust only our senses, what they proclaim to us and what they command. They are the tidings from without, where in truth happiness resides. It is they that we wish to serve.

We want to register every wish as it gently awakens within us. We want to learn every answer which they give to every event in the world. We want to preserve every sound.

Until the new spirit arises through which the old is destroyed and only reality remains. Until this foreign body, this monstrous body which cracks and groans, forms its soul in us, as monstrous and immeasurable, on the same gigantic scale as itself. Until the lie in us, the lie that we are different, different from steam and electricity, is strangled.

We have but to make the outer into the inner, so that we are no longer strangers, and can inherit what belongs to us. But first we must purify ourselves for what is to come, purify ourselves of tyrants. We can retain none of the old opinions, no deceit of the school, no rumour that is not a feeling. The wood must be cleared so that the morning wind of freedom can blow through it bearing the seed. The axe must fall murderously on the undergrowth.

This is our great concern – it is necessary to remove the rubble of our inheritance from our souls and we must tirelessly stir up the spirit with furious blows until every trace of the past is erased. We must become empty, empty of all doctrines, all faith, all the knowledge of our fathers, completely empty. Then we can fill ourselves.

But the blessing that will fill us will come from without, as a gift of life. We need only to open ourselves. If we give ourselves in loving devotion, then the fruit will germinate within us.

We should not wrestle and suffer for the impossible. Humble, we should be content to have the truth near us. It resides there, outside; we want to bring it into our soul – the entry of foreign life into the inner spirit, that is the new art.

But threefold is the truth, threefold the life, and threefold, therefore, the call of the new art. One truth is the body, one truth is the feelings, one truth is the mind. We want to look upon the body, of the individual and of the whole, in which mankind lives, we want to enquire into what laws it obeys, what fate it experiences, from which births to which deaths it travels, we want to depict it as it is. We want to search for feelings, in our breast or in the breasts of others, wherever they sigh, dream or rage, we want to put them in glass phials, heat them in steam and then cool them, combine them with others and mix them together, and evaporate them away in their own vapours – we want to record them as they are. And if, then, signs and symbols enter into the brain, where they meet and embrace each other, grouping together to dance in rows, if the truth which has entered into our souls changes into something spiritual, takes on the language of the soul and creates clear symbols, if finally everything external becomes internal, and the new man becomes wholly identical with new nature, once again an image of the divine after such a long period of distortion, then we want to bear witness to what this new spirit knows and what it commands.

We have no great words, and miracles are denied to us. We cannot promise any kingdom of heaven. We wish only for the lying to cease, the everyday lies, in schools, from the pulpit, on the throne, the terrifying, unseemly mendacity.

We have no other law than the truth as each person feels it. It is this which we serve. We cannot help it if this truth is raw and violent, and often scornful and cruel. We simply obey what it commands. Sometimes we ourselves are astonished by it and are even alarmed, but we can do no other.

This will be the new art, which we will create in this way. And it will be the new religion. For art, science and religion are the same. It is always only the spirit of the age, moulded into a different shape.

Perhaps we deceive ourselves. Perhaps it is only an illusion that the age has renewed itself. Perhaps it is only the last convulsion, whose groans are heard everywhere, the final convulsion before we ossify into nothingness.

But at least it would be a pious deception which would make death easier to accept.

Or is it gluttony which we should choose, and sexual abandon, so that we can render ourselves utterly insensible?

9 Various authors, Memorandum of the Munich Secession

The secession of a group of artists from the Munich Artists' Association (*Münchener Künstlergenossenschaft*) was the first such separation movement to take place in a German-speaking country. Subsequent secessions took place in Vienna in 1897 and in Berlin in 1898. The Munich secession was motivated by financial as well as artistic concerns, and the artists who formed the break-away group were partly responding to economic difficulties created by the sheer volume of artists participating in the Association's annual exhibition. An important element of the dispute, however, was the secessionists' claim that the vitality of Munich's indigenous art depended upon its keeping pace with the 'modern spirit', and their insistence that the annual exhibition maintain its international character. In March 1892 an announcement was circulated amongst the artistic community of Munich announcing the foundation of the 'Verein Bildender Künstler', signed by the 'provisional committee' of Josef Block, Bernhard Buttersack, Ludwig Dill, Hugo Freiherr von Habermann, [Otto] Hierl-Deronco, Ludwig Herterich, Paul Hoecker, Gustav Leopold von Kalckkreuth, Gotthard Kuehl, [Paul Wilhelm] Keller-Reutlingen, Hugo König, Albert Langhammer, Guido von Maffei, Bruno Piglhein, Robert Poetzelberger, Franz Stuck, Fritz von Uhde, Fritz Voellmy, Victor Weishaupt and Heinrich Zügel. On 21 June 1892 the following statement explaining the issues behind the founding of the Secession was published in the *Münchener Neueste Nachrichten*. Excerpts were also published in other newspapers and art journals, and the text was distributed in the form of a circular. This translation is taken from Maria Makela, *The Munich Secession: Art and Artists in Turn of the Century Munich*, Princeton: Princeton University Press, 1990, pp. 145–8.

Exceptional changes have occurred in the last decade in the art world. Ceaseless production has replaced comfortable creation, and exhibitions, sporadic in bygone days, occur now in unbroken succession.

Munich has been the headquarters of German art since the time of Ludwig I. That annual exhibitions must continue to be held here thus seems only a fulfilment of the

noble mission to which Ludwig I and his illustrious successors felt themselves called, and it is a fact whose accuracy has hitherto been doubted by no one. Yet the international character of these exhibitions has been challenged – indeed, passionately attacked from many quarters – either in principle or on the basis of the form that they have assumed in the last three years.

The criticism most often heard of the international character of the exhibitions is that it diminishes the earnings of the Munich art community. To put this question in perspective, some words about the expansion and contraction of the Munich art market are in order.

Early in the seventies the demand for Munich pictures increased in a way that was never anticipated. Both the talented and the less gifted had their hands full and were hardly able to keep pace with the great demand of the art dealers. These 'golden days' lasted into the eighties, and the Munich art community lived by and large on American and English money. But meanwhile a powerful stimulus enlivened foreign art, and many artists of different nationalities suddenly surprised the world with exceptional originality and productivity. The Dutch, Belgians, Danish, Italians, even the Americans – all of whom had previously produced very little and almost never left the borders of their own countries – increasingly submitted pictures to the Paris Salon. In this way they entered the art market as powerful competitors. This competition was to become especially dangerous for us Munich artists. For while the majority of us – under the spell of the art market – remained artistically on the level of the sixties, these countries had joined the great modern currents that were then flooding all of Europe. It was not long before Munich art was deemed provincial in foreign countries. Simultaneously, the world art market was undergoing what was for us a painful but beneficial transformation. Namely, the Americans soon became weary of the old Munich pictures and turned to the rejuvenated art, cultivated mostly outside of Germany, that breathed light and air. This change of taste had long since occurred by the beginning of the first annual exhibition in 1889, and the accusation that these exhibitions damaged the Munich art market is thus completely untenable. The demise of the Munich art market in its prior state is a fact. If satisfactory results were nevertheless attained at the three annual exhibitions, any thinking person must realize that while an equally large portion of the sales fell to the foreigners, this is far more advantageous than if no sales were made in Munich at all. In any case, the belief that Munich artists would earn all the profits if the foreigners were excluded is unrealistic.

Just as untenable as the accusation that the foreigners cause considerable material damage is another contention heard frequently, that the modern spirit that has penetrated Munich art has destroyed and discredited it in foreign countries. To the contrary, if Munich art had awakened sooner from its slumber, if it had recognized our neighbours' progress earlier and had tried to keep pace with it, it would certainly have been spared some unfortunate experiences.

Only through progress does living art exist. If Munich assumed Düsseldorf's heritage in the art market at the end of the sixties, it was only because it was the first city in Germany to possess the technical achievements of the French and the Belgians. Similarly, it is possible to win back this importance in the competition with our foreign neighbours only if [Munich] recovers that much more quickly what it lost

in the eighties. For what the opposition party so frequently labels 'imitation of the French' is in fact only a free and healthy manifestation of the new spirit of the age. National differences have always existed only in so far as they originate in the temperamental differences of the individual peoples. Technical advances, like all newly discovered truths, belong to the entire world, and every isolationist programme can lead only to a torpid art of dated formulas.

Like all new enterprises, the first annual exhibition of 1889 was the source of repeated complaints. After the close of the second it was generally agreed that the enterprise needed reform and that abuses had crept in whose elimination was desired by everyone. These reforms were postponed only because it was feared that untimely measures might play into the hands of threatening and competitive enterprises. It was unanimously decided to treat as exceptional the conditions in which the third annual exhibition of 1891 was formed. The jury of this show thus discharged admirably the duty it was assigned in regard to [the exhibition's] large size, but naturally the abuses also increased exponentially in this exceptional year.

The main problem that has begun to plague the annual exhibitions is their excessive expansion resulting from the acceptance of too many mediocrities. For the viewer it is tiring and antipathetic to work through a labyrinth of very disparate art products. If, as is willingly admitted, the number of foreigners should be reduced through the rejection of their inferior works, the same must apply equally, if not more so, to German and especially to Munich art. No doubt it is obvious to everyone that the more selective the admission of foreigners is, the more choosy we must be in reviewing our own ranks.

Although the jury of the last annual exhibition worked toward reform and insisted on the elimination of those abuses, one group of artists crassly twisted and exploited the exceptional conditions of 1891 that had been instigated, desired, and approved by the Genossenschaft. They won the support of many offended and discontented [artists], and because they, with the cooperation of the majority of the Genossenschaft, lost all objectivity – indeed, because they endangered the exceptional achievements of our exhibitions through overly hasty reforms – they made us realize that we could no longer remain part of the Genossenschaft.

The motto of the victorious majority was: 'We Munich artists want to organize the exhibition. The foreigners should be "admitted," but "Munich" art should be seen in Munich.'

We are certainly the last to doubt the capabilities of the Munich art community. But we believe that it is overvaluing our talents to feel confident that *each year* a brilliant exhibition worthy of international interest can be mounted without the significant participation of the foreigners. For even if the Munich artists constitute a very respectable contingent in this annual parade of art, we still urgently need the foreigners for both material and idealistic reasons. And if Munich art is to prove itself equal to foreign art at the Munich exhibitions, if it is to win back the reputation that it once had but has now in part lost, then it must present itself completely differently than it has in the [recent] past. It is in the interest of the artists – precisely because it is in the interest of art – that the principle of accepting only the absolutely artistic must be implemented with total commitment and ruthlessness. We acknowledge this as the only means of fully harnessing the considerable power that is unquestionably inherent

in the art production of Munich, and of securing for this power the recognition and respect of our contemporaries.

* * *

The purpose of our new association is to form an energetic, right-thinking group of artists of all orientations who will mount annual international exhibitions and who, disregarding all personal benefit, will unreservedly embrace the principle that the representative Munich exhibitions must be elite exhibitions! The best interests of what is purely artistic may not be confused with or thwarted by any other interests. We can neither promise nor grant 'equal rights for all,' in the sense of the above-mentioned group of artists within the Genossenschaft. *Art* should be seen at our exhibitions, and every talent whose work can bring honour to Munich, whether of old or new orientation, should be able to prosper. We are prepared to make considerable sacrifices; everyone will do his best and submit himself to a jury, whose duties will be discharged by the executive committee serving at the time.

In order to maintain lively artistic activity and avoid the primary mistake that has damaged the Genossenschaft, any member who has not exhibited in three consecutive years will lose his vote, which can be regained only when the artist is again represented at our exhibitions. The affairs of our association will be managed in such a way that their artistic, legal, and commercial aspects will be kept fully and professionally separate.

It would be completely wrong to assume that we – the initiators of the proposed exhibitions, the representatives and advocates of the ideas expounded [here] – consider ourselves the only worthy representatives of Munich art, going our own way so that our own light might shine. No! If at first we must aspire to the new goal in small numbers, we are nevertheless certain of the support of all our spiritually and artistically like-minded colleagues who have Munich's art at heart, regardless of their orientation.

We must forgo the understanding of the large majority of the Künstlergenossenschaft, and refrain from responding to the defamations and insinuations with which we shall be overwhelmed. That we renounce our part of the Genossenschaft property, that we are laying ourselves open to malicious attacks, that we are assuming the burden of organizing the exhibitions: all this may serve as proof that for us the only means to save our ideals were those that we have chosen – in cognizance of our artistic rights as well as of our artistic duties.

10 Hermann Bahr (1863–1934) 'Our Secession'

On 22 May 1897 Gustav Klimt (1862–1918) led a group of artists out of the established Artists' Association, an action which led to the founding of the Vienna Secession. Hermann Bahr (see VIA8, above) followed the group's activities closely, publishing an enthusiastic review of their first exhibition which was held the following year in the Gartenbaugebäude in the Parkring in Vienna. Here he reports on the events which led to the secession and seeks to distinguish the motives behind it from those which had informed similar events elsewhere. Bahr insists that the source of the rupture in Vienna was not a conflict between two contrasting aesthetics but rather a dispute over the value and status of art itself. Bahr's

article was originally published as 'Unsere Secession' in *Die Zeit*, volume 11, no. 139, 29 May 1897, a journal which he had helped to found in 1894. This translation has been made for the present volume by Jason Gaiger from Gotthart Weinberg (ed.), *Das Junge Wien – Österreichische Literatur- und Kunstkritik, 1887–1902*, Tübingen: Max Niemeyer Verlag, 1976, volume 1, pp. 718–19.

The last meeting of Viennese artists ended in an ugly scene. There was a great deal of shouting and screaming and it would not have taken much more for those present to have come to blows. Finally, the 'youths', offended by the rude manner of Herr Felix,[1] withdrew in protest. It is said that they have now decided to leave. Already, some months ago, they founded the *Vereinigung bildender Künstler Österreichs* (The Union of Austrian Artists). But this was originally conceived only as a new club within the old Association. They had not remotely intended to separate from it – rather, a few individuals, who felt bound together by their modernity and, even more so, by their artistic seriousness, wanted to form a special sub-division within the Association, or what might be termed their own small *comité*. [. . .]

If, now, they leave, their Union will become something different from what was originally planned. It will no longer be a club within the old Association, but will itself be a new Association alongside the old one, the Association of the young. The cry has gone up that at last we too shall have our own secession! Naturally, it is answered, we must imitate everything that happens – and, as always, of course, too late, once the others have long since started to see things differently. This is how people are talking, for they believe that our secession is the same as that which took place in Paris or Munich. It is important, however, to show them that this is not the case. Our secession shares in common with those of Paris and Munich only the external course of events, the withdrawal by a few of the 'young' from the society of those who are 'old'. But their motives are quite different, indeed the purpose of the whole undertaking is different. We need to be clear about this if we are going to protect ourselves from injustices, and indeed from disappointments.

In Paris and Munich the purpose of the secession was to enable a new form of art to claim those rights which the 'young' insisted were being denied to it by those who are 'old'. It was, then, a conflict within the domain of art concerning the best form of art. According to one's aesthetic one could say that it was a struggle of modernity against tradition; or, more modestly, a struggle concerning a new technique; or even, if one does not value such innovations, an attempt to play off contemporary fashion against eternal laws. But one thing remains constant: it was a conflict within the domain of art. Both opponents desired the same thing – to serve beauty. It was only the means that they could not agree upon. Both called upon art, only each did so in different words. Artists stood ranked against artists. It was a struggle over schools, doctrines, temperaments – or whatever one wishes to term it. But in Vienna this is not the issue at all. The dispute here is not about being for or against tradition, for we have no tradition. The dispute is not between old and new forms of art, it does not concern bringing about a transformation of art. Rather the dispute is about art itself. The 'Union' does not accuse the 'Association' by saying: 'You are for the "old"!', nor does it demand of it: 'Be "modern"!'. No, it simply says: 'You are manufacturers, we want to be artists!' This is the entire substance of the dispute. Business or art is the question

behind our secession. Should Viennese artists remain businessmen, or are they allowed to become artists? Whoever is of the opinion that paintings are items of merchandise like trousers or cigars should remain in the 'Association'. But whoever seeks to reveal through painting or drawing configurations of their innermost being will go to the 'Union'. The dispute is not over the right aesthetic, but rather between two different ways of thinking – the economic way of thinking and the artistic way of thinking. On the one side there stand all artists, whether 'old' or 'new', and, on the other, every Herr Felix.

¹ Eugen Felix, since November 1896 president of the *Genossenschaft bildender Künstler Wiens*.

11 Max Burckhard (1854–1912) 'Ver Sacrum'

In January 1898 the artists of the Vienna Secession brought out the first edition of their own journal under the title *Ver Sacrum*. Handsomely illustrated with original drawings and illustrations by members of the group, it also provided a forum for literary contributions from writers such as Hermann Bahr, Hugo von Hofmannsthal and Rainer Maria Rilke. On the first page of the journal stood the following piece by Max Burckhard, since 1890 director of the Hofburgtheatre in Vienna. Burckhard provides a pointed account of the Roman origins of the term 'secession' and connects this with the title of the journal, *Ver Sacrum* (sacred spring). With this name, based on a Roman ritual of consecration of youth in times of national danger, the group succeeded in marking its separation from the old Artists' Association whilst simultaneously proclaiming its ambitions for a regeneration of Austrian culture. Burckhard's article has been translated for the present volume by Jason Gaiger from *Ver Sacrum – Organ der Vereinigung bildender Künstler Österreichs*, volume 1, January 1898, Vienna: Verlag Gerlach & Schenk, pp. 1–3.

In ancient Rome, when the tension generated by economic conflicts reached a certain pitch, it happened on more than one occasion that a section of the people withdrew to the *mons sacer*, to the Aventin or the Janiculum, with the threat that if their wishes were not met they would found a second Rome there before the very eyes of the old mother state and the honourable city fathers. This was termed *secessio plebis*. The honourable city fathers were sensible men and sent a respected mediator to the secessionists. They promised much and delivered little – and then the *secessio plebis* was at an end.

When, however, the fatherland was threatened by a great danger, the entire populace dedicated to the gods everything living which the next spring would bring as a sacred gift of spring – VER SACRUM; and when those who were born in this sacred spring were grown up, this band of youths, themselves a sacred spring, withdrew from the old dwelling places into foreign parts in order to found a new polity with their own strength and their own purpose.

The band of artists which has voluntarily cut itself loose from the old ties in order to found a new independent union of artists in Vienna did not separate from the old association in order to achieve any sort of economic advantage, nor with the purpose of raising the threat of competition so as to win concessions or to allow themselves subsequently to be talked round by some modern Menenius Agrippa. For this reason

they did not choose the NAME 'Secession' in order to recall the origins, purposes and the results of the ancient *secessiones plebis*.

Since it was not their own personal interests which they held to be in danger but rather the sacred matter of art itself and since, in consecrated enthusiasm, they were and are prepared to take any sacrifice upon themselves and wish nothing other than by their own strength to attain their own goals, they chose to gather under the sign of VER SACRUM. The spirit of youth which courses through the spring brought them together and the spirit of youth, through which the present always becomes 'modern', and which is the driving force of artistic creativity, should also give these pages their name by means of the symbol of the VER SACRUM.

VER SACRUM

consecrated sacred spring; this is a positive emblem under which the new union of artists comes into being: for eternal Rome, the city of the arts and of art, was likewise born out of a VER SACRUM.

12 *Ver Sacrum* Editorial, 'Why are we publishing a journal?'

The publication of the journal *Ver Sacrum* in January 1898 preceded both the inauguration of the first Secession Exhibition in March and the construction of the Secession building by the architect Josef Olbrich (1867–1908), begun in April and completed by the end of that same year. The following editorial, which was published anonymously in the first volume, remains true to the statutes laid down at the group's inception. The purpose of the Vienna Secession was declared to be 'the furtherance of artistic interest and, above all, the elevation of artistic consciousness in Austria', but this was to be achieved through 'contact with prominent foreign artists' and 'the introduction of the most important art trends of foreign lands'. The Secessionists' outlook was thus both national and cosmopolitan, based on a belief in the vitality of art as an expression of its own time. The editorial, printed here in full, has been translated for the present volume by Jason Gaiger from *Ver Sacrum – Organ der Vereinigung bildender Künstler Österreichs*, volume 1, January 1898, Vienna: Verlag Gerlach & Schenk, pp. 5–7.

The merry war has been raging for years along the whole front, from London to Munich, from Paris to St Petersburg. It is only in Vienna – enveloped in quiet contemplation and a 'noble' silence – that not a single breath of its spirit has been felt. The thundering spring tempest has everywhere torn a liberating path through the domain of art. Like a deep release of breath it has convulsed the spiritual atmosphere with the first fertile rains of the storm, with illuminating flashes of lightning and the loud tidings of thunder, bringing everywhere life, movement, hope, and the thirst for action and exuberance. Only to Vienna it did not come, and here everything remained calm.

And yet it was not the calm of the grave. Here, too, there was a deep yearning and an intimation of coming events. Artists and writers who ventured to look beyond the bounds of the city brought tidings of something different, something new and timely, which here and there awoke a response, passing like a whisper from person to person:

perhaps there is something on the other side of the Kahlenberg – perhaps, finally, even such a thing as modern art!

This is not the place to repeat the story of what then took place, of how the stifling pressure weighing upon artists finally led them to take a decisive step within the Association. But the publication of a journal requires a justification – and we want to try to provide it, so far as the explanation of an artistic undertaking can be given by means of words.

The shameful fact that Austria does not possess a single illustrated journal that meets its particular needs and which is intended for the broadest possible circulation has made it impossible until now for artists to make their work known to wider circles. This journal is intended to remedy this situation. It will, for the first time, allow Austria to appear as an artistic factor independent of countries abroad, in contrast to the neglect which it has previously suffered almost everywhere in this regard. As the organ of the *Vereinigung bildender Künstler Österreichs* [Union of Austrian Artists], this journal is a summons to the artistic sensibility of the people to encourage, promote and propagate artistic life and artistic independence.

We wish to declare war on deedless idleness and rigid Byzantinism and on all lack of taste and we count upon the energetic support of all those who understand that art is a high cultural mission and who recognize it as one of the great educative tasks of a civilized nation.

We do not want to compose any long-winded program music, and this also holds true for this introductory essay. The treatment of particulars will be discussed at the appropriate place. There has been enough discussion and making of resolutions. Now is the time for deeds.

First, we need the necessary strength for destruction and annihilation. One cannot build upon a rotten foundation, and new wine cannot be kept in old skins. Then, however, once the ground has been prepared, cleared, and tilled we require the power of the beneficent sun and of constructive labour, the powers of creation and preservation. Like all work of building, this requires as its presupposition the removal of what stands in the way. But it is nonsensical to claim that contemporary art pursues destructive tendencies, that it dissolves form and colour, has no respect for the past and preaches the radical transformation of everything already standing. Art does not seek to preach at all. It seeks to create. All art is, in its innermost essence, constructive, not destructive. For this reason, every genuine artist honours and respects the great masters of the past, loves them with childlike reverence, and bows down before them in respectful admiration.

Whoever rails against the Old Masters is a buffoon. Since time immemorial buffoons have accompanied every world movement. They also accompany the present one, just as the fool follows behind the King's procession or dances in front of it. When the heroes ride into a tournament, the shield carriers rattle their lances. However, as soon as the knights enter the arena, the noise ceases and the real work begins, and then one sees nothing more of the squires and the shield carriers.

BUT EVERY TIME POSSESSES ITS OWN SENSIBILITY. Our goal is to awaken, encourage and propagate the artistic sensibility of OUR TIME, and this is the fundamental reason why we are publishing a journal. To all those who strive

towards the same goal, even if they travel along different paths, we gladly stretch out the hand of solidarity.

We want an art without subservience to foreigners but also without fear or hatred of them either. Art of other countries should stimulate us and lead us to reflect upon ourselves; we want to acknowledge it and admire it when it deserves admiration; only we do not want to imitate it. We want to bring art from abroad to Vienna, not for the sake of artists, intellectuals and collectors alone, but to educate the great mass of the people who are receptive to art, thereby awakening that dormant yearning for beauty and freedom in thought and feeling which already lies in every human breast.

And for this we turn to all of you, without distinction of status or wealth. We do not recognize any distinction between 'higher art' and 'low art', between art for the rich and art for the poor. Art is the property of everyone.

We wish to break at last with the old habit of Austrian artists, of lamenting the public's lack of interest in art without trying to effect a change. With burning tongues we will tell you again and again that art is more than an external, piquant charm, more than a mere dispensable perfume of your existence, that it is, rather, the necessary outward realization of the life of an intelligent people, as self-evident and indispensable as its language and customs. We ask that you give us the crumbs of time which fall from the table of your life, often so resplendent and yet so impoverished; and if just once you give these crumbs, if you extend to us only your smallest finger, then we shall seek to fill these brief minutes with such delight and splendour that you will realize the miserable emptiness of your life hitherto – and we will seek to gain the whole of your hand, your heart, yourselves!

And if one of you says, 'But what need do I have of artists? I do not like paintings', we shall answer, 'If you do not like paintings, we will decorate your walls with splendid carpets; you will take pleasure, perhaps, in drinking your wine from an artistically shaped glass; come to us, we know the right shape for the vessel which is worthy of a noble draught. Or you wish for an exquisite piece of jewellery, or some special material to adorn your wife or your beloved? Then speak, try it just once, and we will show that you have learnt a new world, that you too may contemplate and possess things whose beauty you have never experienced!'

The artist's sphere of influence is not the misty haze of the intoxicated enthusiast, rather he must stand in the midst of life; he must be familiar with everything exalted and splendid and with everything ugly which it hides; he must search deep in the storming turmoil. We wish to teach you to join fast with us, like a tower of iron, to join those who recognize, know and understand, who are adepts and masters of the spirit. This is our mission.

It lies in the hands of each of you to exercise influence in your own sphere and to win supporters, not for the personal advantage of the individual, but for the great, magnificent goal that is longed for, not only by ourselves, but by thousands of others as well. There are amongst you many more than know themselves, who in their hearts are for us. All of you, who in the dense struggle of this life belong to the vast army of the toiling and oppressed – amongst the rich and envied of this world just as much as amongst the poor – you all thirst to drink from the fountain of youth which gives eternal beauty and truth. You are all our natural allies in the great struggle that we are waging. On us it falls to march ahead of you. You may rely upon our loyalty to the

flag, for we have dedicated all our energy and hopes for the future, and everything that we are, to the 'SACRED SPRING'.

13 Santiago Rusiñol (1861–1931) Speech on the Occasion of the Third Festa Modernista

Together with Ramon Casas (1866–1932), Santiago Rusiñol was one of the key artists of the *modernista* movement in Barcelona. The two artists had spent time in Paris, and they sought to introduce the more progressive elements of French painting into their work. Initially they were influenced by French Naturalism, both in their choice of subject matter and, to a lesser extent, in their technique, but their work also reveals an increasing responsiveness to Symbolist themes. Developments in the visual arts formed part of a wider cultural renaissance in the city, encompassing architecture and the decorative arts as well as a renewed interest in the language and customs of the Catalan region. The first 'Festa Modernista' was held in 1892 in the seaside village of Sitges, just south of Barcelona. The festivals included art exhibitions, opera, theatre, dance and literature and were represented as a celebration of Catalan culture. The third festival, held in 1894, marked the official dedication of the 'Cau Ferrat' (the 'den of iron'), a ruined house over-looking the sea which Rusiñol had converted into a studio and exhibiting space. Rusiñol's opening speech to the third festival is taken from the translation by Marilyn McCully in *Els Quatre Gats and Modernista Painting in Catalonia in the 1890s*, unpublished Ph.D. dissertation, Yale University, 1975, Appendix X, pp. 323–4.

It is the third time that the Cau Ferrat meets next to the sea; the third time that, fleeing from the noise of the city, we come to dream at the foot of that beautiful beach, to feel the compass sway from the waves, to take poetic waters, sick as we are of the bad prose which abounds today in our land . . .

While we wait, my friends, for our Cau, for that intimate corner, for that modest and secure nest, we do not wish to demand more than one grace: that it continue always, our Cau, a place of illusions and hopes which remains a refuge to warm those who feel coldness in their hearts; a *pedris* where the spirit which arrives ill from the muddied road of the world can rest; a hermitage near the sea, a hospital for victims of indifference, and an inn for pilgrims of the Saint Poetry who come to see space, to breathe clouds and sea and storms and calm, to cure oneself from the evil of noise, to fill one's heart with peace in order to turn to fly with more wind towards the forests and brambles and to continue the Saintly Struggle.

That we would wish; and we would wish at the same time that all of you, those who carry ideas in your heads and feel your heart beating, stop dreaming low! Raise your voice which until now has been a monologue or smothered by the snoring multitudes and speak out, crying loudly to our people that the reign of egotism must fall! One does not live solely feeding the poor body – the religion of art is needed by poor and rich – people who do not love their poets must live without songs or colours, blind in spirit and sight. He who passes by the earth without adoring beauty is not worthy, nor does he have a right to receive the light of the sun, to feel the kisses of spring, to enjoy the sleeplessness of love, to dirty with drivel of ignoble beast the splendid beauties of great Nature.

That we would wish, oh poets.. and to achieve it, here before our eyes, we have two great examples to follow: the waves on one side striking the hard rocks, and on the other, the constancy of man doubling and dominating virgin iron. Flexible like amorous water you would be able to beat the hearts made of rock, valiant like the medieval blacksmith, you could bend the will of matter. We work under the pounding of kisses and hammers – all here together, all of our own kind, without fear of foreign ears, to art and to poetry we will be able to alleviate ourselves shouting what we do not often try to say surrounded by the great flock – that we wish to be poets and that we look down upon and pity those who do not feel poetry; that we love a Leonardo da Vinci or a Dante more than a province or a town; that we prefer to be symbolists and unstable, and even crazy and decadent to fallen and meek; that common sense oppresses us; that prudence is in excess in our land; that it does not matter to be a Don Quixote there where there are so many Sancho Panzas who nibble away; it does not matter to read books of chivalry there where nothing of any kind is read.

14 Mikhail Vrubel (1856–1910) Letters to his sister and to V. E. Savinsky

Mikhail Vrubel began his formal training at the Imperial Academy of Art in St Petersburg in 1880. He thus belongs to a later generation than the students who had left to establish the *Artel* some seventeen years earlier (see IIID5, above). As the first of these two letters reveals, by 1883 Vrubel had already taken up a critical position towards Realism and its overriding concern with social themes. Ilya Repin's painting *Religious Procession in the Kursk Province* was exhibited at the Wanderers' exhibition of that year (on Repin see VIA15; on the Wanderers see IIID5). At the basis of Vrubel's criticism is a new concern with the formal aspects of painting. This concern was given further impetus by the restoration work he carried out later that year on the twelfth-century church of St Cyril in Kiev. Vrubel's study of Byzantine art informed his search for a new pictorial vocabulary, and his interest in what he termed the effects of 'flatness' and 'the ornamental arrangement of form' can be seen in his own work of this period. The second letter reprinted here was written to the composer V. E. Savinsky in 1885 from Venice, where Vrubel had travelled to broaden his knowledge of Byzantine art. It was in this year that he began his series of 'Demon' paintings, inspired by the poem of that name by Mikhail Lermontov (1814–41), and it is likely that the reference to 'wings' refers to the underlying symbolism of these works. The letter to his sister is taken from *M. A. Vrubel: Pisma k sestre, vospominaniya o khudozhnike, otryvki iz pisem otsa ichdudozhnika* (M. A. Vrubel: letters to his sister, reminiscences about the artist and excerpts from letters by the artist's father), A. Ivanov and A. A. Vrubel (eds), Leningrad, 1929, pp. 80–2. The letter to V. E. Savinsky is taken from *Vrubel: Perepiska. Vospominaniya o Khudozhnike* (Vrubel: letters and reminiscences about the artist), Leningrad, 1963, p. 99. Both letters have been edited and translated for the present volume by Natalie Vowles.

Letter to his sister, St Petersburg, April 1883

[. . .] This is how it happened. An exhibition was put on by the Wanderers. Repin, of course, was interested in our reaction to his *Religious Procession in the Kursk Province*, the most fundamental and gifted work at the exhibition.

I went there with a large group of friends. And you know, we who are so busy studying the model as an art form in the life-class all day long, hungrily seeking to explore and absorb its endless lines and curves, we, who sometimes sit helplessly in front of the canvas, looking at fragments but seeing the whole world stretching beyond with its endless, wonderful details falling together in perfect harmony, we who treasure these minutes as if united in a worship of pure form – having arrived at the exhibition, we could not empty our hearts of all these things.

Row upon row of canvases were arrayed in front of us and they mocked our passions, our suffering and our work. Their form, that most important component of the plastic arts, is hackneyed, and there are only a few talented brush strokes. Moreover, the artist has no loving dialogue with the life he is painting, he simply does his best to ensure that his statement produces the profoundest possible impact on the viewer.

The public does not understand fine nuances, but it has a right to expect impressions from the artist. All these nuances are like a gourmet dish set before a hungry beggar. Therefore, let's give him gruel: it might be a rough dish, but it is the most appropriate to its time. This may be what the Wanderers are thinking. They are infinitely right to think that the artist must win recognition from the public, otherwise he has no right to exist. But being recognized does not make him a slave: he is engaged in his own, special work in which he is the best judge of himself – work which he must respect and not debase to the level of a public statement.

To do this would be to fool the public. It would play on public ignorance and steal from it that special pleasure which distinguishes the spiritual state of a person looking at a work of art from what they experience when they look at a page of printed paper. After all, these attitudes might lead to a complete atrophy of even the need for such pleasures. This would mean stealing one of the best things from man's life! And this is what Repin's picture brings to mind. [...]

Letter to V. E. Savinsky, Venice, April 1885

Thank you, my dear Vasiliy Yevmenyevich, for your letters. I have not done much grumbling, although I have lived through a lot, thought and observed masses of things and, in my impudence, drawn conclusions which could not have been more sweeping. Here they are, unabridged and unprompted:

What I mean by wings – to me, they mean my native soil and life itself. One can only learn from life, but we create either to delight the universal idleness and fill the void or for the sake of endless self-punishment for one's dropped or raised hand – and only in this case does it become fruitful. If they relegate you there, after you have seen enough life to chew on for a long time, then the problem eventually becomes that of comfort and seclusion. We, the young ones, at any rate, do not belong to this category. Just as 'technique' is the ability to see, 'creativity' is the ability to feel deeply. Feeling like that does not mean descending into sweet melancholy or soaring on the wings of pathos – although such things are easily embraced by the outer selves of some highly

impressionable observers, such as we are. This means forgetting that you are an artist, just being glad you are a human being, first of all. I am sorry if I am being too elaborate and not very clear. I was thinking so long and hard how best to express myself.

And where can one feel all these things better than among one's familiar surroundings? Not, of course, here, alone with this lovely, vague and burnt-out dilettante, which is how I see Italy and my life here at present. Ah, my dear Vasiliy Yevmenyevich, how much beauty we have in Russia! You are very close to me at this moment. And you know what is the essence of this beauty? The form, which is created by nature to last forever, with no reference to the canons of international aesthetics, but infinitely precious because it opens up its soul to you alone and then tells you everything about your own. Do you understand this? [...]

15 Ilya Repin (1844–1930) 'An Artist's Notes' and Letter to Diaghilev

Repin trained as an icon painter before entering the St Petersburg Academy of Art in 1864. On completing his studies he was awarded the Academy's Gold Medal, which enabled him to travel to Rome in 1873 and to spend the next three years in Paris. Although he did not become a member of the society of the 'Wanderers' until 1878, he is one of the most important of the Russian Realist painters. In the first extract reprinted here, taken from the magazine *Nedelya* (The Week), and written from Munich in November 1893, Repin addresses the question of a national school of art in relation to more progressive influences from abroad. The second extract is a letter written in the late 1890s to Sergei Diaghilev (see VIA16, below), the key figure behind the anti-Realist 'World of Art' movement. Repin initially sustained friendly relations with this new movement and the entire tenth issue of the *World of Art* journal was devoted to his work. In the present letter Repin endorses the emphasis which the 'decadents' sought to place on creative individuality, but he defends the role of the Academy, where he had been a professor of painting since 1893, and the importance of a thorough grounding in technique. 'An Artist's Notes' are taken from *I. E. Repin: Vospominaniya. Statyi i Pisma iz Zagranitsy* (I. E. Repin: Reminiscences. Articles and letters from abroad), N. B. Serova (ed.), St Petersburg, 1901, p. 109. The letter to Diaghilev is taken from *I. Repin. Izbrannyye Pisma v Dvukh Tomakh, 1867–1930* (I. Repin: Selected letters in two volumes, 1867–1930), I. Brodskiy (ed.), Moscow, 1969, volume 2. p. 160. Both texts have been edited and translated for the present volume by Natalie Vowles.

An Artist's Notes

Munich, 5 November 1893

'There is no art without nationality', as Turgenev said somewhere.

True, that art is good and is well understood which draws on its national roots and which springs from the very heart of the nation. No artificial encouragement can

create healthy art, no academies, no artistic genius is capable of creating it – or a teacher of nourishing the artist's talent – in the right way.

Fate determines that the art of every nation must pass through all the stages of its development. No measures of any kind can make it overleap a particular stage or period. It might seem as if the influence of a more progressive country could result in a step forward. But since this would involve departing from the particular stage of artistic progress at which one's own nation finds itself, it will be seen as something alien. And although such artists might initially stir up great excitement among specialists, they will eventually be forgotten and will not affect the general progress of the [national] school.

All incitement, all theories and all the great contrivances will be useless, as soon as the nation begins to live up to its own art. Then, every young talent will boldly and freely reflect the spirit and the tastes of his own times, and no encouragement or privileges will hold him back or force him to remain within the old, stale environment, among the already obsolete masters.

Letter to Diaghilev

Esteemed Sergei Pavlovich,
Yes, I agree that the best works of the decadent movement, as sincere expressions of individuality, will be crowned with glory when this individuality appears in the form of art. Dilettante imitations, however, will be met only with shrugs and nods of the head – this is common and inevitable in the critical evaluation of developments in the art world. Only narrow-minded people can keep on repeating the same thing over and over again, since they look at everything from the same viewpoint.

But there are a great many viewpoints.

There is a big difference between the Academy of one hundred years ago and our present Academy. Back in the old days it suppressed individuality, now it encourages it. But it was always supreme in its understanding of the form of art because that was what it always studied – it was a conservatory for the study of the form.

For the public, the dilettante or the dealer, for example, perfection of form will always remain an insoluble puzzle. Here, the most gifted dilettante will be at a great disadvantage before the least gifted Academy student who struggles for seven or eight years in the study of form. This is the Achilles heel of a dilettante, because knowledge does not simply come on a whim. Form is an object of knowledge. A student who is half taught cannot draw. A dilettante cannot pass judgement on a work of high art – for this, one needs a special training.

It may be easy to talk about things long ago which have been explored by the critics over the centuries, but even here a dilettante can make foolish assumptions. In his naiveté he puts such great artists as Velazquez and Rembrandt next to Fra Beato Angelico, that simple and illiterate icon painter who, painted everything with those silly pink and light-blue hues, edged with gold. Though certainly practised in his craft, he could not reach the level of fine art since he neither belonged to an artistic school nor was ever schooled in art.

Real art only begins when it has been touched by the genius of learning. [. . .]

16 Sergei Diaghilev (1872–1929) 'Complex Questions: Our Supposed Decadence'

The 'World of Art' group arose out of the activities of artists and writers in St Petersburg in the 1890s and came to represent the artistic avant-garde in Russia through to the first years of the twentieth century. Its leading members included the painters Alexander Benois (1870–1960), Leon Bakst (1866–1924) and Konstantin Somov (1869–1939), but both as an exhibiting society and as a journal it remained open to a wide range of artistic tendencies. The driving force behind the group was the impresario Sergei Diaghilev, later to become the founder of the *Ballet Russe*. The 'World of Art' has normally been associated with Art Nouveau and with the 'Art for Art's Sake' movement, but the key principle underlying its various activities is a commitment to the idea of the creative human personality. This is clearly expressed in Diaghilev's claim that 'The highest manifestation of individuality, regardless of the form it takes, is beauty in the sphere of human creativity'. The first issue of the journal *World of Art* (Mir Iskusstva) was published in St Petersburg in November 1899. The 'programme' of the group was outlined in a series of four articles, spread over the first two issues, under the title 'Complex Questions'. These articles were signed by Diaghilev alone, but Benois later affirmed that they served to express the ideas of the group as a whole. The following extracts are taken from the first article, entitled 'Our Supposed Decadence', in which the notion of artistic individualism is defended from charges of 'decadence', and the group's aesthetic is distinguished both from the Realism of the 'Wanderers' and from Romanticism and Classicism. Diaghilev's article was originally published as 'Slozhnye voprosy. Nash mnimyi upadok'. It has been edited and translated for the present volume by Natalie Vowles from *Mir Iskusstva*, no. 1, St Petersburg, November 1899, pp. 1–5, 10–11.

My task is not easy. I shall have to express the nature of my artistic beliefs and enter a sphere which, for many years, was nothing but a series of unresolved dilemmas and complex questions. Denouncing is not difficult, for we became perfect at it along with our scepticism, which we have elevated to the status of an art.

But what we are to proclaim, looking at the chaotic pile of heritage left to us by our fathers, when the whole life of our generation will not be enough even to evaluate or, shall I say, reappraise the vast treasure that we have inherited? Can we take for granted the controversies of our ancestors and the convictions of our fathers, we, who are only in search of our own personal, inner selves?

This is what distinguishes us, and whoever wishes to know us better must first relinquish the thought that, like Narcissus, we are in love with no one but ourselves. We love everything more generously and passionately than anyone at any time in the past, but we perceive everything through ourselves and it only in this sense that we love ourselves. If any of us ever casually dropped a light-hearted phrase to the effect that we love ourselves as much as we love God, it was only to express our eternal wish for total self-realization and the sincere belief that we alone have the divine power to solve all the complex puzzles.

The apparent artistic anarchy of the new generation, which has been accused of trampling on lovingly cultivated artistic authorities and of building ephemeral castles of sand, is a false view of a generation not yet properly understood. However, all of

this is nothing but the result of the same old judgement on the values of previous generations, an ever-repeated and legitimate quest which, nevertheless, never fails to annoy large numbers of people. The whole history of thought, since time immemorial, has principally been about overthrowing the old gods and replacing them with new ones, the process forever repeating itself with comic predictability. In spite of all this, we are forced to fight passionately every step of the way, through the barrage of foolish and wild accusations.

And so, we too have entered the scene, with our new demands, only to confirm the general rule of historical progress. True, we differ in some ways from those forms which are already known and well-developed. We have made a few timid and innocent steps away from the broad and well-beaten track. But, my God, how wrongly were we understood and what strange names were we called! The Classicists and Romantics and the noisy Realists who came in their wake – all the ever-changing splinter movements of the past century – were urging us in our efflorescence to become just another art form, complete with its own label.

But the main surprise – and a symptom of our degradation – was that we refused to paint with any of the colours which had already been mixed and laid out before us, nor had we any wish to do so. We remained sceptical observers, either rejecting or accepting all the previous attempts which had already been made.

And how was this pale and idle generation, vulgarized by the label 'fin de siècle', allowed to rise to a height from which it could calmly absorb and synthesize within itself all these 'minor developments', each of which held itself the sole interpreter of the truth and the future of art? This was too much for our judges. They could not accept that this malformed generation of the decadent age is not merely sharp-eyed, but is perfectly capable of seeing through the long list of previous mistakes, that it dares to question all and openly laugh at the peremptory manner in which things were previously adored, while, at the same time, openly worshipping its own chosen idols, free of subjective values and of pre-given conditions and demands. We were called the children of decline, and with meekness and resignation we suffer the meaningless and insulting name of the 'decadents'. We are supposed to represent the decline after rebirth, a weakness following strength and a disillusionment after faith – this is supposed to be the essence of our miserable existence. We are supposed to represent yet another pitiful era when art, having reached an apogee of maturity, is 'like a setting sun, casting its parting rays on an ageing civilization'. There is an eternal law of evolution which makes flowers blossom and then, inevitably, die, shedding their lifeless and fragile petals. It happened to the Greek tragedy of Euripides and to the Bologna school, which had only a superficial understanding of the Renaissance. It happened to the French drama of Voltaire, and the same is happening now to us, the involuntary witnesses and contemporaries of the new decadence.

But I should like to know when that flourishing age took place, that apogee of our art from which we are now falling deep into the abyss of decadence? Let us turn back a few pages and examine what was left to us by all those so eager to proclaim our decadence.

What they left us was a never-ending conflict of personal interests and obsolete ideas. They left us a century that has embodied a whole mosaic of controversial and ambiguous trends, in which different artistic schools and generations fought each

other and in which the impact and importance of an artistic development was measured in years, not ages. It was they who created the notion of 'sons and fathers', the never-ending conflict between one generation and the next. They helplessly fell out with one another, breaking up into factions and ferociously fighting their little wars, each defending his own importance and unique personality. When did these great epochs flourish? When were those periods of tranquillity in which great works of art were created, and all believed fully in the rights of the other, united by shared ideals and goals? When was that renaissance, the decline of which we are now supposed to represent?

* * *

And now, we enter the frame with our new expectations. And believe me, even as decadents we would happily be forgiven by our predecessors who would gladly welcome us to their fatherly bosoms, were we, by nature, a little bit more like them. But this is precisely what they cannot forgive us: that we do not take after them, that they themselves turned out to be the decadent products of their own little renaissances. They are bemoaning their own decline, while struggling to erect an edifice on the ruins of long-dead and decaying ideas. Who are they, our enemies and our teachers? In accordance with the last three art movements, they fall into three categories.

The first group are those who, in a kind of torpid bliss, still kow-tow, like Chinese dolls, before the splendour of pseudo-classical monuments, already licked all over. Looking through their lorgnettes, they delight at the glossy parquet craftsmanship of all these Alma-Tademas and Bakaloviches. They are the decadents of Classicism and our most decrepit, and thus most incorrigible, enemies.

The second group are the sickly sentimentalists, swooning to the sounds of Mendelssohn Lieder, who believe that Dumas and Eugene Sue are serious literature and whose ideas of painting do not stretch beyond the endless Madonnas produced in such profusion in German factories. They are the decadents of Romanticism and terrible enemies, for their name is legion.

And finally, the third group – a group that only recently imagined that it had amazed the world when it discovered how to drag onto the canvas bast-shoes and rags, when all this had been done incomparably better and with more freshness fifty years ago by the great Balzac and Millet.

This vociferous group only succeeds in recapturing the last stages of a period which had said it all long before them, and said it much better. They are the decadents of Realism, our tedious enemies, still straining to flex their enfeebled muscles and still believing in the urgency of their obsolete truths.

All these people are supposed to represent a threat to us. But what incredible derangement of mind is it that makes them talk about our decadence! There is no decadence and there cannot be because THERE IS NOTHING TO BE DECADENT ABOUT, and before daring to accuse us of decadence, they must first erect that great edifice from which we are then supposed to be falling down, crashing over its ruins. What temple of human genius are we destroying? Show it to us, lead us to this temple! We, too, are painfully searching for it, so as to ascend to its pinnacle and, in our turn, to fall from it without fear and with full recognition of our own passing glory.

17 Mary Cassatt (1844–1926) and Bertha Palmer (1849–1918) Correspondence

Cassatt was born in the USA and received her early training in art at the Philadelphia Academy (cf. IVb11). Her subsequent career was spent almost entirely in Europe. She studied in Paris in the 1860s, first with Gérôme and then with Couture (see IVb4). She moved definitively to Europe in 1871, and from 1874 she settled in Paris, where she became a member of the Impressionist group. In the spring of 1892, Cassatt received an invitation to design mural decorations for the Women's Building at the forthcoming World's Fair, to be held in Chicago in 1893. It was one of two such commissions for the tympana at either end of the long exhibition hall. The north end, by Mary MacMonnies, another French-trained American artist, was to depict *Primitive Woman*. Cassatt's painting at the south end of the building was to represent *Modern Woman*. Her mural was in three parts, separated by a decorative border, the whole measuring 12 feet high by 58 feet wide. Bertha Palmer, a prominent figure in Chicago society and wife of a wealthy businessman, was President of the Board of Lady Managers for the Women's Building. She was in overall charge of the mural project. Cassatt's mural was painted in France, and the panels were shipped to America early in 1893. The reference in Cassatt's letter to 'Woman glorified by Worth' is a reference to Charles Frederick Worth, a successful couturier in Paris. As well as herself wearing Worth's designs, it is possible that Cassatt had her models pose in them for the *Modern Woman* mural. The present extracts are from Nancy Mowll Mathews (ed.), *Cassatt and her Circle: Selected Letters*, New York: Abbeville Press, 1984, pp. 237–8 and 242.

Bachivillers

October 11 [1892]

My dear Mrs Palmer,

Your letter of Sept. 27th only arrived this morning, so unfortunately this will not reach you by the 18th as you desired. Notwithstanding that my letter will be too late for the ladies of the committee, I should like very much to give you some account of the manner I have tried to carry out my idea of the decoration.

Mr Avery sent me an article from one of the New York papers this summer, in which the writer, referring to the order given to me, said my subject was to be 'The Modern Woman as glorified by Worth'! That would hardly describe my idea, of course I have tried to express the modern woman in the fashions of our day and have tried to represent those fashions as accurately & as much in detail as possible. I took for the subject of the central & largest composition Young women plucking the fruits of knowledge or science & – that enabled me to place my figures out of doors & allowed of brilliancy of colour. I have tried to make the general effect as bright, as gay, as amusing as possible. The occasion is one of rejoicing, a great national fête. I reserved all the seriousness for the execution, for the drawing & painting. My ideal would have been one of those admirable old tapestries brilliant yet soft. My figures are rather under life size although they seem as large as life. I could not imagine women in modern dress eight or nine feet high. An American friend asked me in rather a huffy tone the other day 'Then this is woman apart from her relations to man?' I told him it was. Men I

have no doubt, are painted in all their vigour on the walls of the other buildings; to us the sweetness of childhood, the charm of womanhood, if I have not conveyed some sense of that charm, in one word if I have not been absolutely feminine, then I have failed. My central canvas I hope to finish in a few days, I shall have some photographs taken & sent to you. I will still have place on the side panels for two compositions, one, which I shall begin immediately is, young girls pursuing fame. This seems to me very modern & besides will give me an opportunity for some figures in clinging draperies. The other panel will represent the Arts, Music (nothing of St Cecilia) Dancing & all treated in the most modern way. The whole is surrounded by a border, wide below, narrower above, bands of colour, the lower cut with circles containing naked babies tossing fruit, &&c. I think, my dear Mrs Palmer, that if you were here & I could take you out to my studio & show you what I have done that you would be pleased indeed without too much vanity I may say I am almost sure you would.

When the work reaches Chicago, when it is dragged up 48 feet & you will have to stretch your neck to get sight of it all, whether you will like it then, is another question. Stillman, in a recent article, declares his belief that in the evolution of the race painting is no longer needed, the architects evidently are of that opinion. Painting was never intended to be put out of sight. This idea however has not troubled me too much, for I have passed a most enjoyable summer of hard work. If painting is no longer needed, it seems a pity that some of us are born into the world with such a passion for line and colour.

Chicago

December 15, 1892

My dear Miss Cassatt,
I have received your letter written after the arrival of my telegram of congratulation, and I need not tell you how pleased I am to have a further description of the charming decoration.

I consider your panel by far the most beautiful thing that has been done for the Exposition, and predict for it the most delightful success. It is simple, strong, and sincere, so modern and yet so primitive, so purely decorative in quality, and with still the possibility of having an allegory extracted if one wants to look for that sort of thing. It does seem a pity to torture such a lovely piece of decoration with any attempt at forcing a stilted meaning into it. I am enthusiastic over your success, and am making myself odious by my boasting to all the men who are doing decorations, for I feel sure that your colour is to be just as charming as your strong modelling and lovely composition. I must congratulate you most sincerely on having accomplished so successfully the heavy task which you had to perform in a very limited time. [. . .]

May I not conclude, my dear Miss Cassatt, by asking a very special favour, that is, that you accept the position of juror on the New York Art Jury which has been or will be tendered you. I know your hatred of art jury service, and that your inclinations will be against this, and also that you will probably be in Paris at the time this jury acts. It nevertheless is a great point gained by women to have their names prominently mentioned on art juries, and this effort has been successful only after a long struggle.

If it stands, therefore, even though you perform no service at all, it will help your sex who are generally entirely unrecognized in art matters. Pray do not refuse.

Of course you will come over to place your panel. When may we expect you?

With kindest regards, believe me

Most cordially yours
[Mrs Potter Palmer]

18 Hamlin Garland (1860–1940) from *Crumbling Idols*

Garland, born in Wisconsin, spent his formative years in the western United States before embarking on a literary career in the east. Several novels and short stories were followed in 1894 by a collection of essays and lectures under the title *Crumbling Idols*. Chapter XI, 'Impressionism', notes the impact of the French avant-garde on younger artists across the Atlantic. Written in response to art exhibited at the Chicago World's Fair of 1893, it concentrates on questions of technique and the ethos of Naturalism. In chapter XII, 'A Recapitulatory Afterword', Garland connects naturalistic looking, and the concomitant refusal of accepted canons of beauty and taste, with the democratic spirit, stressing the prospects of the new art in the New World. The present extracts are drawn from *Crumbling Idols: Twelve Essays on Art Dealing Chiefly With Literature, Painting and the Drama*, edited by Jane Johnson, Cambridge, Mass., 1960, pp. 97–107 and 140–1.

Impressionism

Every competent observer who passed through the art palace at the Exposition was probably made aware of the immense growth of impressionistic or open-air painting. If the Exposition had been held five years ago, scarcely a trace of the blue-shadow idea would have been seen outside the work of Claude Monet, Pissarro, and a few others of the French and Spanish groups.

To-day, as seen in this wonderful collection, impressionism as a principle has affected the younger men of Russia, Norway, Sweden, Denmark, and America [. . .]

This growth of an idea in painting must not be confounded with a mere vogue. It is evolutionary, if not destructive, in the eyes of the old-school painters, at least. To the younger men it assumes almost as much importance as the law of gravity. With them it is the true law of light and shade.

It may be worth while to consider, quite apart from technical terms, the principles upon which this startling departure from the conventional manner is based.

The fundamental idea of the impressionists, as I understand it, is that a picture should be a unified impression. It should not be a mosaic, but a complete and of course momentary concept of the sense of sight. It should not deal with the concepts of other senses (as touch), nor with judgements; it should be the stayed and reproduced effect of a single section of the world of colour upon the eye. It should not be a number of pictures enclosed in one frame, but a single idea impossible of subdivision without loss. [. . .]

The second principle, and the one most likely to be perceived by the casual observer, is the use of 'raw' colours. The impressionist does not believe nature

needs toning or harmonizing. Her colours, he finds, are primary, and are laid on in juxtaposition. Therefore the impressionist does not mix his paints upon his palette. He paints with nature's colours, – red, blue, and yellow; and he places them fearlessly on the canvas side by side, leaving the eye to mix them, as in nature. [. . .]

To most eyes the sign-manual of the impressionist is the blue shadow. And it must be admitted that too many impressionists have painted as if the blue shadow were the only distinguishing sign of the difference between the new and the old. The gallery-trotter, with eyes filled with dead and buried symbolisms of nature, comes upon Bunker's meadows, or Sinding's mountain-tops, or Larson's sunsets, and exclaims, 'Oh, see those dreadful pictures! Where did they get such colours.'

To see these colours is a development. In my own case, I may confess, I got my first idea of coloured shadows from reading one of Herbert Spencer's essays ten years ago. I then came to see blue and grape-colour in the shadows on the snow. By turning my head top-side down, I came to see that shadows falling upon yellow sand were violet, and the shadows of vivid sunlight falling on the white of a macadamized street were blue, like the shadows on snows.

Being so instructed, I came to catch through the corners of my eyes sudden glimpses of a radiant world which vanished as magically as it came. On my horse I caught glimpses of this marvellous land of colour as I galloped across some bridge. In this world stone-walls were no longer cold grey, they were warm purple, deepening as the sun westered. And so the landscape grew radiant year by year, until at last no painter's impression surpassed my world in beauty.

As I write this, I have just come in from a bee-hunt over Wisconsin hills, amid splendours which would make Monet seem low-keyed. Only Enneking and some few others of the American artists, and some of the Norwegians have touched the degree of brilliancy and sparkle of colour which was in the world to-day. Amid bright orange foliage, the trunks of beeches glowed with steel-blue shadows on their eastern side. Sumach flamed with marvellous brilliancy among deep cool green grasses and low plants untouched by frost. Everywhere amid the red and orange and crimson were lilac and steel-blue shadows, giving depth and vigour and buoyancy which Corot never saw (or never painted), – a world which Inness does not represent. Enneking comes nearer, but even he tones unconsciously the sparkle of these colours.

Going from this world of frank colour to the timid apologies and harmonies of the old-school painters is depressing. Never again can I find them more than mere third-hand removes of nature. The Norwegians come nearer to seeing nature as I see it than any other nationality. Their climate must be somewhat similar to that in which my life has been spent, but they evidently have more orange in their sunlight.

The point to be made here is this, the atmosphere and colouring of Russia is not the atmosphere of Holland. The atmosphere of Norway is much clearer and the colours more vivid than in England. One school therefore cannot copy or be based upon the other without loss. Each painter should paint his own surroundings, with nature for his teacher, rather than some Dutch master, painting the never-ending mists and rains of the sea-level.

This brings me to my settled conviction that art, to be vital, must be local in its subject; its universal appeal must be in its working out, – in the way it is done. Dependence upon the English or French groups is alike fatal to fresh, individual art.

The impressionist is not only a local painter, in choice of subject he deals with the present. The impressionist is not an historical painter, he takes little interest in the monks and brigands of the Middle Ages. He does not feel that America is without subjects to paint because she has no castles and donjon keeps. He loves nature, not history. [. . .]

The impressionist does not paint Cherubs and Loves and floating iron chains. He has no conventional pictures, full of impossible juxtapositions. He takes fresh, vital themes, mainly out-of-door scenes. He aims always at freshness and vigour. [. . .]

It is blind fetichism, timid provincialism, or commercial greed which puts the works of 'the masters' above the living, breathing artist. Such is the power of authority that people who feel no answering thrill from some smooth, dim old paintings are afraid to say they do not care for them for fear some one will charge them with stupidity or ignorance.

The time is coming when the tyranny of such criticism will be overthrown. There is no exclusive patent on painting. There are just as faithful artists to-day as ever lived, and much more truthful than any past age could have been. Day by day the old sinks an inch. [. . .]

A Recapitulatory Afterword

The natural thing for our society to-day is to demand of its artists fresh and vivid interpretations of nature and society. The feudalistic forms of life are drawing off. The certainly democratic is coming on. It is natural for Americans to say: Sophocles, Shakespeare, Molière, Schiller do not satisfy us. They represent other outlooks upon life. They do not touch us directly. [. . .]

The quality most needed in literary discussion to-day is not learning, it is candour. Literary discussion is full of lies. Men profess to admire things which do not touch them. They uphold forms of art which they know to be dead. [. . .]

But an era of reorganization is upon us. The common man is again moving in intellectual unrest, as in the time of Burns and Shelley. The young men are to speak their minds. The reassertion of artistic independence is to be made. The literary fetich is to fail of power, and original genius once more push the standards of art forward.

As a matter of fact, old idols are crumbling in literature and painting as in religion. [. . .]

19 Alfred Stieglitz (1864–1946) 'Pictorial Photography'

Although born in the USA, Stieglitz was educated in Europe before returning across the Atlantic in 1890. It was in Berlin that he first encountered the modern movement. He went on to become a leading figure, not only in the promotion of photography as an art, but in the general advance of artistic modernism in America. In the first decade of the twentieth century, that is, before the celebrated Armory Show of 1913, Stieglitz had already exhibited work by Cézanne, Rodin, Matisse and Picasso at his '291' gallery in New York. Prior to that, in 1902, he founded the Photo-Secession, a name derived from the various

movements in the German-speaking countries which broke from their Academies in the 1890s (cf. VIA9–12). During that decade, Stieglitz pioneered various technical innovations in photography, working outdoors, often in extreme weather conditions, or at night, frequently using a hand-held camera. These technical advances were closely bound up with Stieglitz's belief in photography as an expressive art; an independent plastic art, on a par with modern painting and sculpture. The present essay first appeared in *Scribner's Magazine*, New York, November 1899. It was illustrated by Stieglitz's own photographs.

About ten years ago the movement toward pictorial photography evolved itself out of the confusion in which photography had been born, and took a definite shape in which it could be pursued as such by those who loved art and sought some medium other than brush and pencil through which to give expression to their ideas. Before that time pictorial photography, as the term was then understood, was looked upon as the bastard of science and art, hampered and held back by the one, denied and ridiculed by the other. It must not be thought from this statement that no really artistic photographic work had been done, for that would be a misconception; but the point is that though some excellent pictures had been produced previously, there was no organized movement recognized as such. [...]

[...] In the photographic world to–day there are recognized but three classes of photographers – the ignorant, the purely technical, and the artistic. To the pursuit, the first bring nothing but what is not desirable; the second, a purely technical education obtained after years of study; and the third bring the feeling and inspiration of the artist, to which is added afterward the purely technical knowledge. This class devote the best part of their lives to the work, and it is only after an intimate acquaintance with them and their productions that the casual observer comes to realize the fact that the ability to make a truly artistic photograph is not acquired off-hand, but is the result of an artistic instinct coupled with years of labour. It will help to a better understanding of this point to quote the language of a great authority on pictorial photography, one to whom it owes more than to any other man, Dr P. H. Emerson. In his work, 'Naturalistic Photography,' he says: 'Photography has been called an irresponsive medium. This is much the same as calling it a mechanical process. A great paradox which has been combated is the assumption that because photography is not "hand-work," as the public say – though we find there is very much "hand-work" *and* head-work in it – therefore it is not an art language. This is a fallacy born of thoughtlessness. The painter learns his technique in order to speak, and he considers painting a mental process. So with photography, speaking artistically of it, it is a very severe mental process, and taxes all the artist's energies even after he has mastered technique. The point is, *what you have to say and how to say it*. The originality of a work of art refers to the originality of the thing expressed and the way it is expressed, whether it be in poetry, photography, or painting. That one technique is more difficult than another to learn no one will deny; but the greatest thoughts have been expressed by means of the simplest technique, writing.'

In the infancy of photography, as applied to the making of pictures, it was generally supposed that after the selection of the subjects, the posing, lighting, exposure, and development, every succeeding step was purely mechanical, requiring little or no thought. The result of this was the inevitable one of stamping on every picture thus

produced the brand of mechanism, the crude stiffness and vulgarity of chromos, and other like productions.

Within the last few years, or since the more serious of the photographic workers began to realize the great possibilities of the medium in which they worked on the one hand, and its demands on the other, and brought to their labours a knowledge of art and its great principles, there has been a marked change in all this. Lens, camera, plate, developing-baths, printing process, and the like are used by them simply as tools for the elaboration of their ideas, and not as tyrants to enslave and dwarf them, as had been the case.

The statement that the photographic apparatus, lens, camera, plate, etc., are pliant tools and not mechanical tyrants, will even to-day come as a shock to many who have tacitly accepted the popular verdict to the contrary. It must be admitted that this verdict was based upon a great mass of the evidence – mechanical professional work. This evidence, however, was not of the best kind to support such a verdict. It unquestionably established that nine-tenths of the photographic work put before the public was purely mechanical; but to argue therefrom that all photographic work *must* therefore be mechanical was to argue from the premise to an inconsequent conclusion, a fact that a brief examination of some of the photographic processes will demonstrate beyond contradiction. Consider, for example, the question of the development of a plate. The accepted idea is that it is simply immersed in a developing solution, allowed to develop to a certain point, and fixed; and that, beyond a care that it be not overdeveloped or fogged, nothing further is required. This, however, is far from the truth. The photographer has his developing solutions, his restrainers, his forcing baths, and the like, and in order to turn out a plate whose tonal values will be relatively true he must resort to local development. This, of course, requires a knowledge of and feeling for the comprehensive and beautiful tonality of nature. As it has never been possible to establish a scientifically correct scale of values between the high lights and the deep shadows, the photographer, like the painter, has to depend upon his observation of and feeling for nature in the production of a picture. Therefore he develops one part of his negative, restrains another, forces a third, and so on; keeping all the while a proper relation between the different parts, in order that the whole may be harmonious in tone. This will illustrate the plastic nature of plate development. It will also show that the photographer must be familiar not only with the positive, but also with the negative value of tones. The turning out of prints likewise is a plastic and not a mechanical process. It is true that it can be made mechanical by the craftsman, just as the brush becomes a mechanical agent in the hands of the mere copyist who turns out hundreds of paint-covered canvases without being entitled to be ranked as an artist; but in proper hands print-making is essentially plastic in its nature. [...]

With the appreciation of the plastic nature of the photographic processes came the improvement in the methods above described and the introduction of many others. With them the art-movement, as such, took a more definite shape, and, though yet in its infancy, gives promise of a robust maturity. The men who were responsible for all this were masters and at the same time innovators, and while they realized that, like the painter and the engraver their art had its limitations, they also appreciated what up to their time was not generally supposed to be the fact, that the accessories necessary

for the production of a photograph admitted of the giving expression to individual and original ideas in an original and distinct manner, and that photographs could be realistic and impressionistic just as their maker was moved by one or the other influence.

A cursory review of the magazines and papers the world over that devote their energies and columns to art and its progress will convince the reader that to-day pictorial photography is established on a firm and artistic basis. In nearly every art-centre exhibitions of photographs are shown that have been judged by juries composed of artists and those familiar with the technique of photography, and passed upon as to their purely artistic merit; while in Munich, the art-centre of Germany, the 'Secessionists,' a body of artists comprising the most advanced and gifted men of their times, who (as the name indicates they have broken away from the narrow rules of custom and tradition) have admitted the claims of the pictorial photograph to be judged on its merits as a work of art independently, and without considering the fact that it has been produced through the medium of the camera. [. . .]

The field open to pictorial photography is to-day practically unlimited. To the general public that acquires its knowledge of the scope and limitations of modern photography from professional show windows and photo-supply cases, the statement that the photographer of to-day enters practically nearly every field that the painter treads, barring that of colour, will come as something of a revelation. Yet such is the case: portrait work, genre-studies, landscapes, and marine, these and a thousand other subjects occupy his attention. Every phase of light and atmosphere is studied from its artistic point of view, and as a result we have the beautiful night pictures, actually taken at the time depicted, storm scenes, approaching storms, marvellous sunset-skies, all of which are already familiar to magazine readers. And it is not sufficient that these pictures be true in their rendering of tonal-values of the place and hour they portray, but they must also be so as to the correctness of their composition. In order to produce them their maker must be quite as familiar with the laws of composition as is the landscape or portrait painter; a fact not generally understood. [. . .]

For years the photographer has moved onward first by steps, and finally by strides and leaps, and, though the world knew but little of his work, advanced and improved till he has brought his art to its present state of perfection. This is the real photography, the photography of to-day; and that which the world is accustomed to regard as pictorial photography is not the real photography, but an ignorant imposition.

VIB
Painting: Expression and Colour

1 Jules Laforgue (1860–1887) 'Impressionism'

Laforgue is best known as a poet and literary critic, but his essay on Impressionism is the work of a writer with a strong and sympathetic interest in modern painting, and with a distinctive understanding of the role played by colour in distinguishing the modern from the traditional. In identifying the colour effects of the Impressionists with a form of progressive evolution of the sensibilities he anticipates claims that were to be made by Pissarro and the Neo-Impressionists in the following decade (cf. VIB11 and 14). For the relevant theories of Fechner and Helmholtz see IVB7 and 8. Between 1881 and 1886 Laforgue was retained as Reader of French at the Prussian court, and the essay was planned early in 1883 for translation and publication in a German journal. It was intended that it should coincide with the exhibition of a small collection of Impressionist paintings at the Gurlitt Gallery in Berlin. The exhibition took place in October of that year, but in fact no German publication of the essay has been traced. It seems likely that it was not finished in time. It was first published as 'L'Impressionisme' in Laforgue, *Mélanges posthumes, Oeuvres complètes*, fourth edition, volume III, Paris, 1902–3, pp. 133–45. This translation by William Jay Smith was originally published in *Art News*, LV, May 1956, pp. 43–5.

Physiological Origin of Impressionism: The Prejudice of Traditional Line. It is clear that if pictorial work springs from the brain, the soul, it does so only by means of the eye, the eye being basically similar to the ear in music; the Impressionist is therefore a modernist painter endowed with an uncommon sensibility of the eye. He is one who, forgetting the pictures amassed through centuries in museums, forgetting his optical art school training – line, perspective, colour – by dint of living and seeing frankly and primitively in the bright open air, that is, outside his poorly lighted studio, whether the city street, the country, or the interiors of houses, has succeeded in remaking for himself a natural eye, and in seeing naturally and painting as simply as he sees. Let me explain.

Leaving aside the two artistic illusions, the two criteria on which *aestheticians* have foolishly insisted – *Absolute Beauty* and *Absolute Human Taste* – one can point to three supreme illusions by which technicians of painting have always lived: *line, perspective, studio lighting*. To these three things, which have become second nature to the painter, correspond the three steps of the Impressionist formula: form obtained not by line but solely by vibration and contrast of colour; theoretic perspective replaced by the

natural perspective of colour vibration and contrast; studio lighting – that is, a painting, whether representing a city street, the country, or a lighted drawing room, painted in the even light of the painter's studio, and worked on at any hour – this replaced by *plein-air*, open air – that is, by the painting done in front of its subject, however impractical, and in the shortest possible time, considering how quickly the light changes. Let us look in detail at these three points, these three dead language procedures, and see them replaced by Life itself.

Line is an old deep-rooted prejudice whose origin must be sought in the first experiments of human sensation. The primitive eye, knowing only white light with its indecomposable shadows, and so unaided by distinguishing coloration, availed itself of tactile experiment. Then, through continual association and interdependence, and the transference of acquired characteristics between the tactile and visual faculties, the sense of form moved from the fingers to the eye. Fixed form does not originate with the eye: the eye, in its progressive refinement, has drawn from it the useful sense of sharp contours, which is the basis of the childish illusion of the translation of living non-dimensional reality by line and perspective.

Essentially the eye should know only luminous vibration, just as the acoustic nerve knows only sonorous vibration. The eye, after having begun by appropriating, refining, and systematizing the tactile faculties, has lived, developed, and maintained itself in this state of illusion by centuries of line drawings; and hence its evolution as the organ of luminous vibration has been extremely retarded in relation to that of the ear, and in respect to colour, it is still a rudimentary intelligence. And so while the ear in general easily analyses harmonics like an auditory prism, the eye sees light only roughly and synthetically and has only vague powers of decomposing it in the presence of nature, despite the three fibrils described by Young, which constitute the facets of the prisms.[1] Then a natural eye – or a refined eye, for this organ, before moving ahead, must first become primitive again by ridding itself of tactile illusions – a natural eye forgets tactile illusions and their convenient dead language of line, and acts only in its faculty of prismatic sensibility. It reaches a point where it can see reality in the living atmosphere of forms, decomposed, refracted, reflected by beings and things, in incessant variation. Such is this first characteristic of the Impressionist eye.

The Academic Eye and the Impressionist Eye: Polyphony of Colour. In a landscape flooded with light, in which beings are outlined as if in coloured grisaille, where the academic painter sees nothing but a broad expanse of whiteness, the Impressionist sees light as bathing everything not with a dead whiteness but rather with a thousand vibrant struggling colours of rich prismatic decomposition. Where the one sees only the external outline of objects, the other sees the real living lines built not in geometric forms but in a thousand irregular strokes, which, at a distance, establish life. Where one sees things placed in their regular respective planes according to a skeleton reducible to pure theoretic design, the other sees perspective established by a thousand trivial touches of tone and brush, by the varieties of atmospheric states induced by moving planes.

The Impressionist eye is, in short, the most advanced eye in human evolution, the one which until now has grasped and rendered the most complicated combinations of nuances known.

The Impressionist sees and renders nature as it is – that is, wholly in the vibration of colour. No line, light, relief, perspective, or chiaroscuro, none of those childish classifications: all these are in reality converted into the vibration of colour and must be obtained on canvas solely by the vibration of colour.

In the little exhibition at the Gurlitt Gallery, the formula is visible especially in the work of Monet and Pissarro where everything is obtained by a thousand little dancing strokes in every direction like straws of colour – all in vital competition for the whole impression. No longer an isolated melody, the whole thing is a symphony which is living and changing like the 'forest voices' of Wagner, all struggling to become the great voice of the forest – like the Unconscious, the law of the world, which is the great melodic voice resulting from the symphony of the consciousness of races and individuals. Such is the principle of the *plein-air* Impressionist school. And the eye of the master will be the one capable of distinguishing and recording the most sensitive gradations and decompositions on a simple flat canvas. This principle has been applied not systematically but with genius by certain of our poets and novelists.

False Training of the Eyes. Now everyone knows that we do not see the colours of the palette in themselves but rather according to the illusions which the paintings of the past have developed in us, and above all we see them in the light which the palette itself gives off. (Compare the intensity of Turner's most dazzling sun with the flame of the weakest candle.) What one might call an innate harmonic agreement operates automatically between the visual effect of the landscape and the paint on the palette. This is the proportional language of painting, which grows richer in proportion to the development of the painter's optical sensibility. The same goes for size and perspective. In this sense, one might even go so far as to say that the painter's palette is to real light and to the tricks of colour it plays on reflecting and refracting realities what perspective on a flat canvas is to the real planes of spatial reality. On these two things, the painter builds.

Mobility of Landscape and Mobility of the Painter's Impressions. You critics who codify the beautiful and guide the development of art, I would have you look at this painter who sets down his easel before a rather evenly lighted landscape – an afternoon scene, for example. Let us suppose that instead of painting his landscape in several sittings, he has the good sense to record its tonal values in *fifteen minutes* – that is, let us suppose that he is an Impressionist. He arrives on the scene with his own individual optic sensibility. Depending on the state of fatigue or preparation the painter has just been through, his sensibility is at the same time either bedazzled or receptive; and it is not the sensibility of a single organ, but rather the three competitive sensibilities of Young's fibrils. In the course of these fifteen minutes, the lighting of the landscape – the vibrant sky, the fields, the trees, everything within the insubstantial network of the rich atmosphere with the constantly undulating life of its invisible reflecting or refracting corpuscles – has undergone infinite changes, has, in a word, lived.

In the course of these fifteen minutes, the optical sensibility of the painter has changed time and time again, has been upset in its appreciation of the constancy and relative values of the landscape tones. Imponderable fusions of tone, opposing perceptions, imperceptible distractions, subordinations and dominations, variations

in the force of reaction of the three optical fibrils one upon the other and on the external world, infinite and infinitesimal struggles.

One of a myriad examples: I see a certain shade of violet; I lower my eyes towards my palette to mix it and my eye is involuntarily drawn by the white of my shirt sleeve; my eye has changed, my violet suffers.

So, in short, even if one remains only fifteen minutes before a landscape, one's work will never be the real equivalent of the fugitive reality, but rather the record of the response of a certain unique sensibility to a moment which can never be reproduced exactly for the individual, under the excitement of a landscape at a certain moment of its luminous life which can never be duplicated.

There are roughly three states of mind in the presence of a landscape: first, the growing keenness of the optical sensibility under the excitement of this new scene; second, the peak of keenness; third, a period of gradual nervous exhaustion.

To these should be added the constantly changing atmosphere of the best galleries where the canvas will be shown, the minute daily life of the landscape tones absorbed in perpetual struggle. And, moreover with the spectators the same variation of sensibility, and with each an infinite number of unique moments of sensibility.

Subject and object are then irretrievably in motion, inapprehensible and unapprehending. In the flashes of identity between subject and object lies the nature of genius. And any attempt to codify such flashes is but an academic pastime.

Double Illusion of Absolute Beauty and Absolute Man! Innumerable Human Keyboards. Aestheticians have always talked a great deal of nonsense about one or the other of two illusions: the objectivity of Absolute Beauty, and the subjectivity of Absolute Man – that is, Taste.

Today we have a more exact feeling for the life within us and outside us.

Each man is, according to his moment in time, his racial milieu and social situation, his moment of individual evolution, a kind of keyboard on which the exterior world plays in a certain way. My own keyboard is perpetually changing, and there is no other like it. All keyboards are legitimate.

The exterior world likewise is a perpetually changing symphony (as is illustrated by Fechner's law,[2] which says that the perception in differences declines in inverse proportion to their intensities).

The optical arts spring from the eye and solely from the eye.

There do not exist anywhere in the world two eyes identical as organs or faculties.

All our organs are engaged in a vital struggle: with the painter, it is the eye that is dominant; with the musician, the ear; with the philosopher, the powers of the mind, etc.

The eye most deserving of our admiration is the one which has evolved to the greatest extent; and consequently the most admirable painting will be not that which displays the academic fancies of 'Hellenic beauty,' 'Venetian colour,' 'Cornelius' thought,' etc., but rather that which reveals this eye in the refinement of its nuances or the complication of its lines.

The atmosphere most favourable to the freedom of this evolution lies in the suppression of schools, juries, medals, and other such childish paraphernalia, the patronage of the state, the parasitism of blind art critics; and in the encouragement of a nihilistic dilettantism and open-minded anarchy like that which reigns amid French

artists today: *Laissez faire, laissez passer*. Law, beyond human concerns, must follow its automatic pattern, and the wind of the Unconscious must be free to blow where it will.

Definition of Plein-Air Painting. Open air, the formula applicable first and foremost to the landscape painters of the Barbizon School (the name is taken from the village near the forest of Fontainebleau) does not mean exactly what it says. This open air concept governs the entire work of Impressionist painters, and means the painting of beings and things in their appropriate atmosphere: out-of-door scenes, simple interiors, or ornate drawing rooms seen by candlelight, streets, gas-lit corridors, factories, market places, hospitals, etc.

Explanation of Apparent Impressionist Exaggerations. The ordinary eye of the public and of the non-artistic critic, trained to see reality in the harmonies fixed and established for it by its host of mediocre painters – this eye, as eye, cannot stand up to the keen eye of the artist. The latter, being more sensitive to luminous variation, naturally records on canvas the relationship between rare, unexpected, and unknown subtleties of luminous variation. The blind, of course, will cry out against wilful eccentricity. But even if one were to make allowance for an eye bewildered and exasperated by the haste of these impressionistic notes taken in the heat of sensory intoxication, the language of the palette with respect to reality would still be a conventional tongue susceptible to new seasoning. And is not this new seasoning more artistic, more alive, and hence more fecund for the future than the same old sad academic recipes?

Programme for Future Painters. Some of the liveliest, most daring painters one has ever known, and also the most sincere, living as they do in the midst of mockery and indifference – that is, almost in poverty, with attention only from a small section of the press – are today demanding that the State have nothing to do with art, that the School of Rome (the Villa Medici) be sold, that the Institute be closed, that there be no more medals or rewards, and that artists be allowed to live in that anarchy which is life, which means everyone left to his own resources, and not hampered or destroyed by academic training which feeds on the past. No more official beauty; the public, unaided, will learn to see for itself and will be attracted naturally to those painters whom they find modern and vital. No more official salons and medals than there are for writers. Like writers working in solitude and seeking to have their productions displayed in their publishers' windows, painters will work in their own way and seek to have their paintings hung in galleries. Galleries will be their salons.

Framing. In their exhibitions the Independents have substituted intelligent, refined, imaginative frames for the old gilt frames which are the stock in trade of academic convention. A green sunlit landscape, a white winter page, an interior with dazzling lights and colourful clothes require different sorts of frames which the respective painters alone can provide, just as a woman knows best what material she should wear, what shade of powder is most suited to her complexion, and what colour of wallpaper she should choose for her boudoir. Some of the new frames are in solid colours: natural wood, white, pink, green, jonquil yellow; and others are lavish combinations of colours and styles. While this new style of frame has had repercussions in official salons, there it has produced nothing but ornate bourgeois imitations.

1 According to the Young–Helmholtz theory of colour vision, there are three elementary retinal and post-retinal processes, which produce sensations of red, yellow–green (chlor), and blue; all other colours, including white, are blendings of these.
2 'In order that the intensity of a sensation may increase in arithmetical progression, the stimulus must increase in geometric progression.'

2 Berthe Morisot (1841–1895) Letter to her Sister Edma

Berthe Morisot exhibited in all but one of the eight Impressionist exhibitions between 1874 and 1886. She was born into a wealthy *haute-bourgeois* family who were opposed to her career in art. None the less, she was determined, and studied under Corot in the 1860s, first exhibiting at the Salon in 1864. She met Manet in about 1868, and thereafter was committed to the avant-garde. Her correspondence reveals a woman who was respected and liked by her male Impressionist colleagues, and who in turn liked and trusted them, particularly Degas. The correspondence, however, while rich in the circumstantial detail of the art world, contains nothing in the way of an explicit theoretical statement about the principles of Impressionist painting. One passage, though, is obliquely revealing. In the summer of 1884 Morisot's sister, Edma, sent to her the diary of her eldest daughter. Morisot's reply about the adolescent girl's writing indicates her commitment to spontaneity and the value she placed on the personal expression of feeling, rather than 'correctness': qualities which she strove to bring to her own painting. Our extract is taken from the translation by Betty W. Hubbard in Denis Rouart (ed.), *The Correspondence of Berthe Morisot* (1957), with a new introduction and notes by Kathleen Adler and Tamar Garb, London, 1986, p. 139. (Marie Pau (1845–70) wrote a history of Joan of Arc, and her diary was posthumously published in 1874.)

It is very sweet of you to have sent me Jeannot's diary, which I find very nice and which touches me deeply. [. . .] To record her thoughts every day is an excellent idea; nothing forms one's style more effectively. And by this I mean not the habit of turning out fine phrases but of putting one's thoughts into words. It even seems to me that we ought to be very lenient, to condone lack of correctness, provided that the feeling is real, and that the ideas are personal.

Correctness will be the natural result of practice and constant effort, especially when one devotes oneself to this study from early youth. I could never write four consecutive lines that made sense, owing to my laziness as a young girl, to the great difficulties I experienced – if I had made an effort it might have degenerated into originality. All this perturbs me because I have just been glancing through the diary of Marie Pau. Do you know it? I read the most laudatory articles about it, and I am deeply disappointed. What shocks me is to see this girl of fourteen write as grammatically as if she were twenty-five; all this in a monotonous correct prose which savours neither of life nor of youth, and which drags on listlessly from the beginning to the end of the volume. In truth, I think that the 'not bad' is further removed from the good than is the bad. Don't you think so?

In short, let Jeannot develop freely; if I were you I would be particular in the choice of reading – no drivel, nothing sentimental, nothing affected, as many good old French authors as possible. We are all born monkeys before we are ourselves; therein lies the danger of bad examples. [. . .]

3 Vincent van Gogh (1853–1890) Letters to his brother Theo and his sister Wilhelmina

A mixture of contingency and artistic ambition took van Gogh from Holland to Paris in 1886. There he encountered the Impressionist avant-garde. Their commitment to modern subjects co-existed with an equal commitment to the animation of the painted surface and the production of independent visual effects. These concerns had by no means been absent from van Gogh's early, emphatically realist, work (cf. VIA6), as the present extracts from letters of 1882 demonstrate. From the beginning of his career, van Gogh clearly had a feeling for the power of colour. Even early on he found conventional ways of representing nature inadequate to the sensations it produced in him. And these sensations were largely carried by colour. His own transcriptions (he calls them his 'shorthand') took the form of colour marks made sometimes with a brush, sometimes straight from the tube. By the end of the decade, colour effects had come to dominate van Gogh's thinking. He now conceived the possibility of expressing the register of human passions through colour, understood as an independent pictorial element. For van Gogh, colour could express character in a way that mimesis, even photographic resemblance, could not. Furthermore, for van Gogh as for Cézanne, this modern treatment of colour could bring the modern back into touch with the ancient. Somehow, modern colour seemed able to give new life in the present not so much to the forms as to the *spirit* of the antique achievement. Our extracts have been translated for the present volume by Hester Ysseling. Those of 1882, from the Dutch, are taken from Hans van Crimpen and Monique Berends-Albert (eds), *De brieven van Vincent van Gogh*, four volumes, The Hague: SDU Uitgeverij, 1990, volume II, pp. 640–1 and 664–7. Those of 1888 and 1890, from the French, have been taken from the *Corréspondance complète de Vincent van Gogh*, three volumes, Paris, 1960, volume III, pp. 190–1 and 467–9.

[The Hague] *c*. 1 August 1882

Dear Theo

I send you a word of welcome just before you arrive. Also to let you know that I received your letter and the enclosed, for which I send you my warmest thanks. It was most welcome to me, for I am hard at work & need a few more things.

As far as I understand, of course once more we agree completely on the matter of black in nature. Absolute black does not really occur. But like white, it is present in almost all colours & forms the endless variety of greys – distinguished in tone & intensity – so that in nature one really does not see anything but tones and intensities. There are only 3 basic colours – red, yellow, blue, 'composites' orange, green and purple. By adding black & some white one gets the endless variations of greys, red-grey, yellow-grey, blue-grey, green-grey, orange-grey, violet-grey. It is impossible to say, for instance, how many different green-greys there are, it varies endlessly. But the whole chemistry of colours is no more complicated than these few simple basics. And a good understanding of this is worth more than 70 different colours of paint, since one can make more than 70 tones & intensities with the 3 principal colours & white and black. He is a colourist, who, seeing a colour in nature, knows very well how to analyse it & to say, for instance, that green-grey is yellow with black & almost no blue, &c.; in short, he who knows how to make the greys of nature on the palette.

However, in order to make notes outside or to make a little sketch, a strong sense of contour is an absolute prerequisite, also for heightening the drawing later. I believe one does not acquire this without effort, but first by observation, and then particularly by strenuous work & research, and then the study of anatomy & perspective is definitely needed.

Hanging beside me is a landscape study by Roelofs, a pen-and-ink sketch, though I cannot describe to you how expressive that simple contour is. Everything is there. Another even more telling example is the large woodcut Bergère by Millet which you showed me last year & which has stuck in my memory ever since. And then also, for instance, the pen-and-ink sketches by Ostade and Peasant Breughel. When I see such results, I feel most clearly the great importance of the contour. And you know from *Sorrow*, for instance, that I trouble myself greatly to make progress in that respect.

But when you come to the studio you will see that apart from seeking the contour, I have, just like anybody else, a feeling for the <u>intensities</u>. And that I do not object to making water-colours, but that these are rooted first of all in the drawing, and then, alongside the water-colour, many other branches come forth from the drawing that in time will develop in me as in anyone who works with love.

I have attacked that old giant of a pollard willow and I believe that it has become one of my best water-colours. A gloomy landscape, that dead tree near a stagnant pool covered with duckweed, in the distance a car shed of the Rhine Railway Company, where tracks cross each other, black smoke-stained buildings, then green meadows, a cinder path and a sky with chasing clouds, grey with a single glittering white edge and a depth of blue, where the clouds tear just a bit. In short, I have wanted to make it, like I think a signal man with his smock & little red flag must see & feel it when he thinks: <u>how gloomy it is</u> today. [...]

[The Hague] 3 September 1882

Dear Theo

I have just received your most welcome letter and, since I am taking some rest today anyway, I will answer you straight away. I thank you for it and for the enclosed and for the things you tell me. And for the description of that scene with the workers in Montmartre, which I found very interesting, since you mention the colours, so that I can see it, thank you for that. I am glad you are reading the book on Gavarni, I found it very interesting and have come to love G. twice as much because of it.

Paris & its surroundings may be beautiful, but we have nothing to complain of here either. This week I painted something which I believe would give you more or less the impression of Scheveningen as we saw it when we walked there together. A large study of sand, sea, sky – a big sky of fine grey & warm white, with a single small spot of soft blue gleaming through – the sand & the sea, light, so that the whole becomes blond, but animated by the brash and strangely coloured figures and fishing smacks, which are full of tone. The subject of the sketch I made of it is a fishing smack with its anchor being weighed. The horses are ready to be hitched to the boat and then to draw it into the water. Enclosed is a little sketch of it. It has given me much trouble, I wish I

had painted it on panel or on canvas. I have tried to bring more colour into it, that is, depth, firmness of colour.

How curious it is that you & I often seem to have the same thoughts. Last night, for instance, I came back from the woods with a study and just this week, especially at that time, I had been deeply absorbed in that question of the depth of colour. And I would have liked to talk it over with you some time, especially with reference to the study I had just made – and there, in this morning's letter you just happen to speak of having been struck in Montmartre by the strongly pronounced colours which nevertheless remained harmonious. I do not know whether it was exactly the same thing that struck us both, but I do know that you would certainly have felt what struck me so particularly, and that you would probably have seen it in the same way.

I begin by sending you a little sketch of the subject and I will tell you what it was about. The wood is becoming quite autumnal, there are effects of colour which I see only rarely in Dutch paintings. Last night I was working on a gently rising patch of woodland ground, covered with mouldered and dry beech leaves. The ground was lighter and darker reddish-brown, more so because of the shadows cast by the trees which threw lines over it, in weaker and stronger intensities, half obscured. The problem, and I found it very difficult, was to get the depth of colour, the enormous intensity & firmness of that ground and yet it was only while painting that I noticed how much light there still was in that darkness. To keep the light and yet to save the glow, the depth of that rich colour. Because there is no carpet imaginable that is so splendid as that deep brown-red in the glow of an autumnal evening sun tempered by the wood.

From the ground young beeches were sprouting, catching the light on one side, where they are a brilliant green, and the shadow-side of those stems a warm, strong black-green. Behind those saplings, behind the brown-red ground there is a sky, very delicate blue-grey warm, almost not blue, scintillating. And against it there is a hazy edge of greenishness and a network of little stems and yellowy leaves. A few figures of wood gatherers are wandering around like dark masses of mysterious shadows. A white cap of a woman bending to reach a dry branch suddenly speaks against the deep reddish brown of the ground. A skirt catches light, a cast shadow falls, a dark silhouette of a fellow appears above the underbrush. A white bonnet, cap, shoulder, bust of a woman shapes itself against the sky. These figures are large and full of poetry, in the twilight of the deep shadowy tone they appear as enormous terracottas being modelled in a studio.

I describe nature to you – how far I rendered it in my sketch, I do not know myself, but I do know that I was struck by the harmony of green, red, black, yellow, blue, brown, grey. It was very De Groux-like, an effect like, for instance, that sketch of *Le départ du conscrit*, formerly in the Palais Ducal.

To paint it was a tough job. There are one and a half large tubes of white in the ground – yet that ground is very dark – further red, yellow, brown, ochre, black, sienna, bistre, and the result is a red-brown, but one that varies from bistre to deep wine-red and to pale, blond, ruddy. And then there is moss and a border of fresh grass which catches light and sparkles brightly and is very difficult to get. There you have at last a sketch which I maintain has some significance, something to say, no matter what may be said about it.

While painting it I said to myself: let me not leave before something autumnal is in it, something mysterious, something with seriousness in it. But since the effect does not last, I had to paint quickly, the figures were put in at once with a few strong strokes of a firm brush. It struck me how firmly the stems were rooted in the ground – I started on them with a brush, but because the ground was already so heavily covered, each brush stroke sank away as if it were nothing. Then I squeezed roots and stems in from the tube, and modelled them a little with the brush. Yes, now they stand there, sprouting out of it, strongly rooted in it. In a sense I am glad I have never <u>learned</u> painting. Surely I would have <u>learned</u> to bypass such effects as this – now I say: no, it is just what I want. If it is not possible, it is not possible, I want to try it, though I do not know how it ought to be done. <u>I do not know myself</u> how I paint it, I sit down with a white plank before the spot which strikes me, I look at what is in front of me, I say to myself: that white plank must become something – I return, dissatisfied, I put it away and when I have rested a little, I go and look at it with a kind of fear. Then I am still dissatisfied, because I still have that splendid nature in my mind, too much for me to be able to be satisfied with it. But still, in my work I see an echo of what struck me, I see that nature has told me something, has spoken to me and that I have written it down in shorthand. In my shorthand there may be words which cannot be deciphered, mistakes or gaps, and yet something does remain of what the wood or beach or figure has said, and it is not a tame or conventional language that springs not from nature itself, but from a studied way of doing things or a system.

Enclosed is another small sketch from the dunes. There were these small bushes standing there, the leaves of which are white on one side and dark green on the other & which constantly move & glitter. Behind it, dark wood.

You see I am absorbed in painting with all my strength, I am absorbed in colour, until now I have held myself back from that & I do not regret it. If I had not drawn so much, I would not feel & grasp a figure which appears as an unfinished terracotta. But now I feel myself on the open sea, the painting must go forward with all the force we can lend to it.

When I paint on panel or canvas, the expenses will increase again, it is all so expensive, paint is also expensive and is so soon gone, well, those are the difficulties of all painters, we must see what can be done. I know for certain that I have a sense of colour and that it will come to me more & more, that painting is in the very marrow of my bones. Doubly & twice doubly I appreciate your helping me so faithfully and forcefully. I think of you so often, and I should want so dearly that my work would become firm, serious, manly and that you would also get satisfaction from it as soon as possible. [...]

[Arles]

8 September 1888

My dear Theo

A thousand thanks for your kind letter and the enclosed 300 francs. After a few weeks full of worries I have just had a somewhat better one. And just as worries do not come

singly, neither do the joys. For just when I was persistently burdened by financial problems with the landlord, I had resigned myself to it light-heartedly. I swore at the said landlord, who all things considered is not a bad man, and told him that to revenge myself for all the money I had paid him I would paint that whole rotten joint of his so as to reimburse myself. In short, to the great joy of the landlord, the postman, whom I have already painted, the visitors – night owls – and myself, I stayed up for three nights to paint, sleeping during the day. Often it seems to me that the night is even more living and richly coloured than the day. Now as for the idea of getting back the money I paid the landlord by means of my work, I'd better not dwell on that, for the painting is one of the ugliest I have made. It is comparable to the *Potato Eaters* and yet it is different.

With red and green I have tried to render the terrible passions of humanity.

The room is blood red and mat yellow, a green billiard table in the middle, four lemon-yellow lamps with an orange and green glow. Everywhere it is a clash and contrast of the most disparate greens and reds; in the figures of the little sleeping roughs, in the empty and high room, violet and blue. For instance, the blood-red and the yellow-green of the billiard table contrast with the tiny bit of soft Louis XV green of the counter, on which there is a pink bouquet.

The white clothes of the landlord who is watching from a corner of this green-house, turning lemon-yellow, pale green and luminous.

I am making a drawing of it in water-colours and will send it to you tomorrow to give you an idea of it.

* * *

I am very pleased that Pissarro saw something in the girl. Has Pissarro said anything about the *Sower*? Later, when I have carried these experiments further, the *Sower* will always remain the first attempt in that genre.

The *Night Café* is a continuation of the *Sower* just like the head of the old peasant and the head of the poet, if I succeed in making this last painting.

So it is a colour which from the realist point of view of the trompe-l'oeil is not true to nature, but one which suggests the emotion of a passionate temperament.

When, at the exhibition we saw at the Champs-Elysées, Paul Mantz saw the powerful and emotional sketch by Delacroix, *La Barque du Christ*, he left, afterwards to exclaim in his article: 'I did not know you could do such terrible things with blue and green.'

Hokusai provokes the same cry from him, but then because of his <u>lines</u>, his <u>drawing</u>, whereas you say in your letter: those waves are <u>claws</u>, they have the ship in their control, you feel it.

Well, if you'd make the colour true to nature or the drawing quite correct, then you would not be rendering the emotions.

Anyway, soon – tomorrow or the day after – I will write to you about this some more and answer your letter by sending you the sketch of the *Night Café*. [. . .]

t. à. t.
Vincent

[Auvers-sur-Oise]

5 June 1890

Dear Sister

I should long ago have answered your two letters which I received when I was still in St Rémy, but the journey, the work and lots of new emotions caused me to postpone it from day to day. [. . .]

* * *

For me the journey and the rest have gone well, and coming back north is a great distraction to me. And then, I have found a true friend in Dr Gachet and something of a new brother, so much do we resemble each other physically and also in our views. He is a very nervous man himself and very peculiar, and he has extended a great deal of friendship and rendered many services to the artists of the new school, as much as was in his power. I painted his portrait the other day and I am also going to paint the portrait of his daughter, who is nineteen years old. A few years ago he lost his wife, and this has contributed greatly to leaving him a broken man. I believe I may say that we have become friends straight away and every week I go to him for one or two days to work in his garden, of which I have already painted two studies, one with plants from the south: aloes, cypresses, marigolds, the other with white roses, vines and a figure, and further a bunch of buttercups. As well as these I have made an even larger painting of the village church – an effect in which the building stands purplish against a sky of deep and simple blue, of pure cobalt; the stained-glass windows are like ultramarine patches, the roof is violet and partly orange. In the foreground some greenery with flowers and sand made pink in the sun. Once again it is almost the same as the studies I made in Nuenen of the old tower and the cemetery, except that the colour is now probably more expressive, more sumptuous. But during the last weeks in St Rémy I was still working like a man possessed, especially on bouquets of flowers, roses and violet irises. For Theo's and Jo's little one I brought a rather large painting – which they have hung over the piano – of white almond blossoms – large branches against a background of sky-blue, and they also have a new *Portrait of an Arlésienne* in their apartment.

My friend Gachet is <u>decidedly enthusiastic</u> about this *Portrait of an Arlésienne*, which I made a copy of for myself, and also about a self-portrait, and that has pleased me greatly, because he will urge me to paint figures and will, I hope, be able to find some interesting models for me. What fascinates me most in my profession, much much more than everything else, is the portrait, the modern portrait.

I look to achieve it with colour, and surely I am not the only one who looks for things in that direction. I <u>should like</u> – you see, I am not at all saying that I can do it, but anyway, I try to – I <u>should like</u> to make portraits which would appear to people living a century from now like apparitions. Therefore, I do not seek to achieve this through photographic resemblance but by our passionate expressions, by using our knowledge and our modern taste for colours as a means of expressing and intensifying the character. Thus the *Portrait of Dr Gachet* shows you a face the colour of an overheated brick and tanned by the sun, with red hair, a white cap against a landscape with a background of blue hills; his clothes are ultramarine – this brings out the face

better and makes it paler, despite the fact that it is the colour of brick. The hands, hands of an obstetrician, are paler than the face.

Before him, on the red garden table, are yellow novels and a foxglove flower of sombre purple. My self-portrait is nearly the same, but the blue is a fine blue of the South and the clothes are bright lilac. The *Portrait of an Arlésienne* is of a colourless and matt flesh tone, the eyes calm and very simple, the clothes black, the background pink, and with her elbow she leans on a green table with green books.

But in the copy which Theo has the clothes are pink, the background yellow-white and the muslin at the front of the open bodice is of a white colour tending towards green.

Among all these bright colours, the hair, the lashes and the eyes alone form black spots.

[. . .] There is a superb painting by Puvis de Chavannes at the exhibition. The figures are dressed in bright colours and you cannot tell whether they are costumes of today or clothes of antiquity.

On one side, two women, in long, simple dresses, chat, on the other, some men, artists, in the middle a woman with a child on her arm picking a flower off an apple tree in bloom. One figure in forget-me-not blue, another in bright lemon-yellow, another soft pink, another white, another violet. The ground is a meadow dotted with small white and yellow flowers. A blue distance with a white town and a river. All humanity, all nature simplified, but as it might be if it is not so already.

This description does not tell you anything – but when you see the painting and look at it for a long time, you get the feeling of being present at a rebirth, total but benevolent, of all the things you have believed in, all you have longed for, a strange and happy meeting of distant antiquity with crude modernity. [. . .]

t. à. t.
Vincent

4 G.-Albert Aurier (1865–1892) 'The Isolated: Vincent van Gogh'

Aurier was one of the loose community of intellectuals and writers that occupied the Left Bank of Paris in the later 1880s and early 1890s. Like other members of the Symbolist circle, he was drawn to subjectivist and Idealist philosophical positions. He became interested in the development of modern art following a meeting with Bernard in 1887, which led in turn to contacts with van Gogh, Gauguin, Guillaumin and the Nabis. His journal *Moderniste illustré* had a brief life between April and September 1889, but his major contribution to art criticism was made in the years 1890–2 when he wrote for *La Revue indépendante* and for *Mercure de France*. The present essay was the first critical notice to be written on the work of van Gogh. Combining as it did a highly charged and vivid style of description with the sense of privileged insight into the artist's motivation, it did much to establish the terms in which the Dutch artist's work and personality were subsequently conceived. It was originally published as 'Vincent van Gogh' in the series 'Les isolées' in *Mercure de France*, Paris, January 1890, volume I, pp. 24–9. The translation from the original text has been made for this volume by Peter Collier.

Suddenly, just as I find myself staggering back into the muddy hubbub, the filth and the ugliness of real life and its dirty streets, some random snatches of verse rise unbidden from the depths of my memory:

> Intoxicating monochrome
> of metal, marble, watery foam . . .
> And every surface, even black,
> Seems garnished bright in rainbow lacquer,
> its glory liquidly entrapped
> In crystal rays. . . . thick cataract
> Whose glassy curtain falls
> In sunbursts on the metal walls.

Beneath skies, now carved from dazzling sapphire or turquoise, now encrusted with some unknown, infernal, hot, noxious and blinding sulphur; or beneath skies dripping like a liquid fusion of metal and crystal, where torrid solar discs sometimes spread radiantly; beneath a constant, terrifying stream of every imaginable kind of light, in a heavy, flaming, baking atmosphere which seems to bellow forth from fantastic furnaces, where gold, diamonds and the rarest gems become vapour – there is an anguishing, disturbing display of the strangest nature, both truly real and almost supranatural, of a nature so excessive that everything animate and inanimate, light and shade, form and colour, whirls upward in a furious desire to roar its unique and essential song in extraordinarily intense and savagely shrill tones; there are trees gnarled like embattled giants, gesticulating with their sinewy, threatening arms and the fearful whiplash of their green manes, proclaiming their indomitable power, their pride in their muscular might, their bloodshot sap, their eternal challenge to the tempest and its thunder, to the malediction of nature; there are cypresses raising their silhouettes like nightmarish, black flames; mountains arching their backs like mammoths or rhinoceri; orchards all white, all pink, all blonde, like ideal virgins' dreams, houses crouching and twisting in passion, like creatures in spasms of ecstasy, suffering or thinking, there are stones, fields, scrublands, lawns, gardens and rivers which seem sculpted from unknown minerals, from a polished, shiny, irridescent fairyland; there are landscapes on fire, which evoke the boiling of multicoloured enamel in some hellish alchemist's crucible, fronds seemingly cast in antique bronze, shining copper or spun glass; beds of flowers which are less flowers than sumptuous jewellery made of ruby, agate, onyx, emerald, corundum, chrysoberil, amethyst, or chalcedony; there is universal, blinding, mindless coruscation of matter; and this matter is the whole of nature strangled in a frantic paroxysm, exacerbated beyond belief; where form itself becomes nightmare, nightmare turns into flames, lava and precious stones, light becomes fire, and life becomes burning fear.

Such is, without exaggeration, whatever you may think, the impression left on the retina by a first glance at the extraordinary and intense works of Vincent van Gogh, that worthy compatriot and heir of the Dutch Old Masters.

O how far we have come – you must agree – since that great, ancient, healthy, reflective art of the Low Countries. How far from a Gerard Dou, an Albert Cuyp, a

Terbruggen, a Metzu, a de Hooch, a Vermeer, a van der Heyden, and their paintings full of a slightly bourgeois charm, so carefully refined, so coolly varnished, so minutely detailed! How far from those beautiful landscapes, always covered in such a sober, careful, gentle, grey and hazy mist, painted by van der Heyden, Berghem, van Ostade, Potter, van Goyen, Ruysdael, or Hobbema! How far from the slightly cold elegance of Wouwermans, of Schalken's eternally burning candle, of the worthy Slingerlandt's cautiously myopic and microscopic vision, and his fine-haired brushes! How far from the delicate but always slightly cloudy or misty colours of the North, from the tireless industry of these healthy artists from another place and another time, who painted 'at home by the fireside', with quiet minds, warm feet and bellies filled with beer, and how far from the art – so very honest, very conscientious, very scrupulous, very protestant, very republican, banal to the point of genius – that was painted by those incomparable Old Masters whose only fault – if indeed they saw it as one – was to be family men and burgermeisters!

And yet make no mistake, Vincent van Gogh is not such a stranger to his race. He has been subject to that inevitable atavistic law. He is well and truly Dutch, of the sublime lineage of Franz Hals.

And first and foremost like all his illustrious compatriots, he is a realist in the full meaning of the term. *Ars est homo, additus naturae* [Art is man, added to nature], as Bacon said, and M. Emile Zola has defined naturalism as 'nature seen through a temperament'. Yet this 'homo additus', this 'through a temperament', this casting of something objective and unified in the mould of man's subjectivity which is never constant, merely compounds the issue by suppressing the possibility of there being any definitive criterion for judging an artist's degree of sincerity. The critic therefore in attempting to determine this is bound to be reduced, to a more or less hypothetical but always refutable process of induction. Nevertheless, I consider that in the case of Vincent van Gogh, despite the sometimes disturbing strangeness of his works, it is difficult for anyone impartial and able to use his eyes to deny or disprove the naive truth of his art and the ingenuity of his vision. In fact, independently of that impalpable air of good faith and of the truly observed which is given off by all his paintings, the choice of subject, the constant harmony between even the most extravagant tones, the conscientious study of character, the continuing search for the essential meaning of each object, a thousand significant details affirm beyond all dispute his profound and almost childlike sincerity, his great love for nature and the truth, that is, his own truth.

With this in mind, we may then legitimately, starting only from the works themselves, arrive at Vincent van Gogh's temperament as a man, or rather as an artist – a hypothesis which it would be possible, if one wished, to corroborate by reference to his biography. What is singular in his entire work is its excess, an excess of energy, of sensitivity, of expressive violence. In his categorical affirmation of the nature of things, in his often rash simplification of form, in the insolent glare with which he fixes the sun, in the vehement energy of his line and his colour, in every last detail of his technique, he reveals himself as a powerful, virile, bold, often brutal yet sometimes naively sensitive man. And moreover we can guess from the almost orgiastic extravagance of everything that he has painted, that he is an inspired enemy of all bourgeois sobriety and scruple, a kind of drunken giant more suited to

moving mountains than rearranging ornaments, a man whose mind is constantly erupting, pouring its lava down through every channel of art, an irresistible, terrifying, crazed genius, often sublime, sometimes grotesque, always on the brink of the pathological. Finally and above all, he displays clear symptoms of hyperaesthesia, perceiving with abnormal, even painful intensity, the imperceptible hidden secrets of line and form, but even more those of colour and light, seeing nuances invisible to the healthy eye, and the magical iridescence of shadow. And that is why his realism, sincerity and truth, born of neurosis, are so different from the realism, sincerity and truth of those great but essentially petty-bourgeois Dutchmen, so healthy and balanced in mind and body, who were his ancestors and his masters.

Moreover this respect and love of material reality are not in themselves sufficient to explain and characterize the profoundly complex and extremely individual art of Vincent van Gogh. Of course, like all the painters of his race, he is highly conscious of the importance and beauty of matter, but in addition, he most often considers matter, however enchanting, as merely a sort of fantastic language designed for the translation of the Idea. He is, almost always, a symbolist. Not at all, I hasten to add, a symbolist in the manner of the Italian Primitives, those mystics who hardly felt the need to recast their dreams in material form, but a symbolist feeling the constant need to clothe his ideas in precise, measurable, tangible forms, envelop them in the intensity of flesh and matter. In nearly all of his canvases, within this formal envelope, within this flesh made flesh, within this most material matter, there lies, for the mind able to perceive it, a thought, an Idea, and this Idea, the essential core of the work, is at one and the same time its efficient and final cause. As for the dramatically brilliant symphonies of line and colour, however important they may be for the painter, they are in his work no more than the *medium* of expression, no more than mere *techniques* of symbolization. Indeed if we refuse to admit that behind this naturalist art lie idealist tendencies, a considerable part of the work would remain impenetrable to our understanding. How for instance could we explain *Le Semeur*, that noble but disturbing sower, that labourer whose brow bears a distant and flickering resemblance to the brutal genius of the artist himself, and whose outlines, gestures and labours have always obsessed Vincent van Gogh, and whom he painted time and again, now against ruby-red sunsets, now in the golden haze of the blazing midday sun, unless we are prepared to admit that his mind was haunted by an 'idée fixe', that is, the urgent need for there to come a man, a Messiah, a sower of truth, in order to regenerate our decrepit art and, perhaps, our mindless, industrialized society? And also his obsessive passion for the disc of the sun, whose glow he lovingly renders amid the blaze of his skies, and his equal passion for that other sun, of that floral star, the sumptuous sunflower, that he tirelessly returns to like a monomaniac, how can we explain all this, if we refuse to acknowledge his persistent preoccupation with some vague but splendid heliocentric allegory or myth?

In truth, Vincent van Gogh is not only a great painter driven by his art, by colour and by nature, but also a dreamer, a fervent believer, devouring utopias, feeding off the beauty of ideas and dreams.
 For years now, he has indulged his vision of a renovated art, made possible through a shift in civilization, a tropical art, imperiously demanded by the people,

corresponding to new kinds of habitat, produced by the artist's confrontation with a luminous and overpowering nature, hitherto unknown, finally admitting the impotence of all the old devices taught in the schools, and setting out naively to find the pure translation of all these new sensations! . . . Would he not in fact, given his intense and fantastical colours ground from gold and precious stones, have been a more worthy painter of those countries resplendent with dazzling sunlight and blinding colour than all your Guillaumets, your bland Fromentins and your murky Gérômes?

Then, later, as a result of his conviction that art had to be reborn, he conceived and consistently nurtured the notion of creating a new, very simple, almost childlike painting, destined to move the most humble unsophisticated people and to be understood by the most naive and innocent minds. [. . .]

Can any of Vincent van Gogh's theories or expectations be put into practice or are they merely beautiful but empty fantasies? Who can tell? At all events, I do not wish to debate the point here. It remains for me, in order to conclude, to define, as nearly as I can, this ingenious spirit who has strayed so far from all our well-worn paths, and to say a few words about his technique.

The material and outward thrust of his painting correlates perfectly with his artistic temperament. All of his works are executed vigorously, feverishly, brutally and intensely. His powerful, angry line, often awkward and sometimes rough, accentuates character, it simplifies and confidently, triumphantly omits details, achieving on occasion, but not always, a magisterial synthesis and grandeur of style.

We have all experienced his colours. They are unrealistically dazzling. He is to my knowledge the only painter able to perceive the chromatic nature of things with such intensity, rendering it with such a metallic, gemlike quality. His research into the colouring of shadow and into the reciprocal influence of tone on tone, into the full effects of sunlight are most ingenious. He is however not always able to avoid a certain disagreeable crudeness, a certain discord, a certain dissonance. As for his craftsmanship properly speaking and his precise techniques for illuminating the canvas, they are as fiery, powerful and energetic as everything he is and does. He proceeds in vast swathes of very pure tone, in curving trails, broken by straight brushstrokes; he builds up gleaming layers of rough-hewn paint, and all of this combines to give his paintings an appearance of solidity, of dazzling walls made of sun and crystal.

Will this robust and truthful artist – a thoroughbred, with the hands of a brutish giant, the nervous disposition of a hysterical woman and the soul of a mystic, so original and so estranged amid our pitiful modern art – ever experience one day the delights of being vindicated and flattered by some newly repentant fashion (nothing is impossible)? Perhaps. But whatever may happen, even if it became modish to pay the same price for his canvases as for M. Meissonier's miserable daubs – however unlikely that may be – I do not think that there would ever be anything very sincere in such a tardy admiration by the general public. Vincent van Gogh is at once too simple and too subtle for the contemporary bourgeois mind. He will only ever be completely understood by his brothers, the truly artistic artists – and by some lucky members of the lower orders, the humblest of all, who may, perchance, have escaped the pedagogical benefits of our lay education!

5 Charles Henry (1859–1926) 'Introduction to a Scientific Aesthetic'

Henry was a mathematician and psychologist who set out to remove aesthetics from the sphere of metaphysics, and to place it on a scientific footing (although his sense of science extended to an interest in mystical mathematics; as well as embracing contemporary beliefs now not thought scientific, such as the theory of ether). His work was largely synthetic, drawing on a variety of existing researches. These included Humbert de Superville's theories of linear direction (cf. IIc1); the work of Chevreul, Helmholtz and Rood on perception and colour (cf. IIc5 and IVB8 and 9); and perhaps most fundamentally, the mathematicians Hoene-Wronski and Gauss for ideas on angles and their harmonious relations. The result was a wide-ranging theory as to precisely which combinations of line and colour would produce effects of pleasure or melancholy in the viewer. Henry's mathematically and physiologically based aesthetics were directly influential on the work of Seurat and others in his circle in the late 1880s. More generally, Henry's work encouraged a tendency among the French avant-garde to view painting as the organization of independent forms and colours rather than the imitation of things in the world; that is to say, the shift from a mimetic to an expressive theory of art. Henry's paper was published in *La Revue contemporaine*, Paris, August 1885, pp. 441–69. Our extracts have been translated by Jonathan Murphy for the present volume.

I

There are two ways of looking at the world. The first is to study things in themselves, and examine their causes, the laws that govern them, the transformations they undergo, and look at them in an objective manner: such is the goal of Natural Philosophy. The second way is to present them in relation to ourselves, and depict them as happy or sad, agreeable or unpleasant, beautiful or ugly, in other words in a subjective manner, and such is the goal of Art. As we call Nature the objective consideration of things, let us term the subjective consideration of the world *the physiognomy of things*, and say that if Art seeks to express the physiognomy of things, aesthetics studies the conditions they must have met for a spectator to be able to identify them as happy or sad, agreeable or unpleasant, beautiful or ugly. There is as yet no aesthetic of taste or smell, nor art which corresponds to them; so for the purposes of this enquiry, aesthetic objects will be reduced to an assortment of shapes, colours and sounds.

Custom demands that I acknowledge the fact that the aesthetic problem, in common with all the other great problems, has haunted the best minds down the ages. Yet if one looks closely at all the solutions proposed to the problem it soon becomes apparent that these differences are merely superficial. It does not take a great effort of reasoning in order to prove that formulations of the idea of beauty such as 'the infinite in the finite', 'unity in variety', 'order', etc. are fundamentally all saying the same thing. And indeed how could it be otherwise, as analogous methods will inevitably lead to analogous results. Until extremely recently, right up until the last few decades in fact, and with very few exceptions, the only approach ever taken to the problem was a metaphysical one. Inevitably, with minor variations, the results have always been the same.

It would be childish to inveigh against such approaches: they were necessary, and they met that most human of all our impatient desires, that of knowing the maximum amount by the least demanding means. And of course, one must recognize that often the solutions offered have been acknowledged to be perfectly accurate, sometimes long after their initial formulation. But metaphysical truth and scientific truth are two different things. The former is founded on *a priori* principles and a sterile, superficial view of the world, while the latter is founded on an observation of phenomena, and its practical applications in the modifying of nature are almost limitless. Science is our ultimate freedom.

However advanced our knowledge, however perfect we imagine a science of aesthetics to be, aesthetics alone will never manage to create beauty. That particular problem is more the domain of absolute knowledge. Yet to demonstrate that no form of relative science is capable of solving it is in a sense to provide a solution as accurate as any mathematical proof, by showing that the question is badly formulated. What science can and must do by contrast is to make all that is agreeable within us and in the world around us as widespread as possible, and from this point of view its social function is immense, above all in these oppressive times, when conflict is all too widespread. It can save the artist endless hesitation and useless effort, by putting him on the track of the most effective means of achieving his goal, and it can provide the critic with the means to pin down the reasons for which he might be overcome with an ineffable but unmistakable sense of dissatisfaction.

* * *

II

1 The central problem of aesthetics, which constantly recurs, can be summed very briefly in one question: which lines provide a maximum of satisfaction? On reflection, it becomes apparent that a line is an abstraction, and is in fact the synthesis of the two opposing directions in which it can be traced. Reality is precisely that direction. I do not see circles; rather, I see circles drawn in one direction or another, which is to say that I see *cycles*. Once this has been established, the question can be slightly modified, and we ask ourselves instead which directions are the most agreeable. To put it in its simplest form, which directions do we associate with pleasure, and which with pain?

* * *

3 [. . .] Certain attitudes immediately spring to mind. In pain we are cast down, prostrate, or doubled up, and in states of pleasure we are exultant, radiant, and have a spring in our step. These metaphors are a clear indicator that a sense of weight accompanies the feeling of sadness, and that happiness is a lightness with upward motion. [. . .] Physiognomy serves to confirm our suppositions about gesture. It is quite clear that so far as pain is concerned, the aim of the movements is to place the body in a position which requires a minimal expenditure of effort, while the opposite is true for the condition of pleasure, where the requirement is a maximal expenditure of energy. [. . .] One can sum this up by noting that pleasure corresponds to an upward movement, and that it is the position achieved by this movement that determines the amount of energy we have at our disposal, as the high position

corresponds in thermo-dynamic terms to potential energy. Pain, by contrast, corresponds to a downward movement. The position achieved by the downward movement is the entropic one of energy that has lost all its use.

4 Two other directions also have their part to play. I refer of course to movement from left to right, and from right to left. Their expressivity is not of such general import as the above, but the first is often the more agreeable of the two. For this reason the place of honour is always the right-hand side. The medical observations of M. Delaunay seem to demonstrate that the choice of one of these directions is an indicator of the stage of evolution achieved by the subject: in general, when dancing, higher races and entities have a tendency to turn to the right, whereas inferior races and idiots have a tendency to turn to the left. We can conclude that the characteristics of the agreeable, for left to right, and unpleasant, for right to left are thus a remarkable confirmation of all that I have attempted to demonstrate above, and will in fact serve to refine this notion. When man watches the course of the sun as it turns from left to right, it is in fact travelling in the opposite direction to the rotation of the earth, which turns from right to left. Surely this direction is thus a greater effort than a direction conforming to the direction of the earth's rotation. [. . .] The earth's inverse direction thus provokes a greater resistance in the ether than would be the case if it turned contrariwise. If it did turn contrariwise, resistance would only be proportional to speed, but as it does not, resistance is compounded by the correspondingly increased resistance of the ether. We can conclude from all this that when he moves to the right, or rises upwards, man moves towards the sun. One cannot deny the logic of finding the origin of these expressive capacities we attribute to different directions in the sun itself, for the sun, after all, is the root of all life.

* * *

7 Moving on from the geometrical point of view, we shall now turn our attention to a more material point of view, and look instead at units of mass. If we ask ourselves what general law might cover the movement of a system of material points which are linked together by any means, as a result of any modification in the conditions that surround them, we soon see that the relevant principle is Gauss's minimum movement principle, which states that 'all movement is accomplished during each infinitesimal unit of time by the least possible effort'. [. . .]

8 Until now we have only considered direction itself, but we shall now move on and examine changes in direction. Any change of direction can be expressed as an angle, and any angle can be measured by the arc of the circle intersected by the sides, the centre of the circle being at the vertext of the angle. We must then ask ourselves which of the divisions of the circumference are the most agreeable, and construct the resulting different regular polygons accordingly. Now (and I would beg all non-mathematicians also to pay attention to this) we can construct geometrical regular polygons according to several formulae, e.g. of 4, 8, 16, 32, etc. sides; 2^n with 3, 6, 12, 24, etc.; 3.2^n with 5, 10, 20, 40, etc.; 5.2^n with 15, 30, 60, 120, etc.; $3.5.2^n$ with 17, 34, 51, 68, 85, etc.; or $3.5.17.2^n$ sides, etc. – i.e. any regular polygon, for which the number of sides is 2 or a power of 2, or a prime number of the form $2^n + 1$, or the product of a power of 2 multiplied by one or several numbers of that form; but we cannot construct any others geometrically. Any change of direction therefore, which

would imply that the circumference had a number of sections which did not correspond to any of the above series is therefore irregular and illogical. I hope to prove by all this that Gauss's magnificent theory is also the science of rhythm and indirectly that of measure.

9 [. . .] Rhythm can thus be defined as follows: *Rhythm is any determining change of direction on a circumference whose centre is at the centre of the change, which can be expressed as a possible geometrical division, i.e. a division into a number of M parts, which is contained by the series 2.2^n, or a prime number in the series $2^n + 1$, or the product of one or several numbers of this form to the power of 2.* For example, the only rhythmic numbers in the first 100 are the following values of M: 2, 3, 4, 5, 6, 8, 10, 12, 15, 16, 17, 20, 24, 30, 32, 34, 40, 48, 51, 60, 64, 68, 80, 85, 96.

Among the low numbers then, 7 is excluded from rhythm; in any figure therefore, one should never trace an angle determining a seventh of the circumference, in other words an arc subtending the side of a necessarily false regular heptagon. It almost goes without saying that prime numbers of the form $2^n + 1$ correspond to a minimum effort of perception.

10 The simplest expression of measure is a ratio, or relation between two terms. [. . .] In general (and indeed this is easily verified by experimentation) the most agreeable ratios are those where the numerator and the denominator are different from the whole unity, or from the smallest rhythmic numbers. The term rhythmic is appropriate as it is clear that even where there is no change of direction, these numbers are more agreeable than others precisely because they form the order in which changes of direction are effected.

* * *

12 One sort of relation which is even more agreeable than a ratio is the equivalence of a number of ratios, i.e. a simple or continuous proportion. One needs four terms for a proportion: $(a/b = c/d)$, but when the eye, which invariably proceeds by addition or subtraction, succeeds in reducing these terms to three or two, the proportions become even more agreeable: in the first instance, there is the scheme the Greeks termed *harmonic proportion*, $(a/c = a-b/b-c)$, e.g. $(6/2 = 6-3/3-2)$, and in the second we have Pacioli's *divine proportion* $(a/b = b/a+b)$ which the Germans term 'the golden section', but which in the final analysis is no more than a philosophical definition of harmony. The perfect correspondence between these two proportions and several important mathematical theories promises some extremely varied applications to the science of aesthetics, and quite evidently they are a new application of the minimum movement principle as applied to perception which we saw above, so that we may now consider ourselves authorized to consider this as the abiding general law of aesthetic perception.

* * *

III

14 Although more widely studied than the aesthetics of line, the aesthetics of colour none the less remains at present no more than a series of empirical recipes. Current charts and diagrams are based on ideas which are in fact totally arbitrary [. . .].

15 It is widely accepted that colours have precise expressive values, and people have even gone so far as to associate extremely complex ideas with them, so that hope is the colour green, faith the colour blue, etc. Clearly what is most important is to fix their simplest expressive values. Red, orange and yellow clearly are the colours of happiness, while green, blue and violet are the colours of discontent; with one set we associate light, with the other, darkness. [...] There is also a straightforward correlation, when talking of the expressive possibilities of colour, between that which we can deduce from psychological reasoning, and the observation of nervous phenomena. *A priori*, green being a mixture of yellow and blue, colours of contradictory expression, we would expect it to be a tiring one for the eye, and this is precisely what experience teaches. 'The enormous difficulty of using clear green or blue-green is well known to all painters, and many, so far as such a thing is possible, attempt to do without them altogether. The presence in a picture of any serious amount of a colour approaching blue or emerald green provokes a strong sense of antipathy towards it in the majority of spectators, and causes the picture to appear cold and hard. A painting which may be excellent from many other points of view may be completely spoiled by the presence of these colours alone.' Such are the findings of Professor Rood, who goes on to note that after-images and accidental colours are considerably more vivid with green than with any other colour: proof perhaps that the energy residing in the eye is more quickly used up by this colour. Rood also considers the hypothesis that green produces rapid alternations of excitement and repose, analogous to the sort of beats on which Helmholtz has founded his theory of musical discordances. This is indeed a possibility, but it requires further investigation before a decisive conclusion can be reached. *A priori*, the most tiring colour after green should be violet; and indeed, it is a mixture of blue, a sad colour, and red, a colour which astonishes, and so often fatigues; so much is also often confirmed by experience. After this, in a natural progression, come blue, then red, then orange and yellow, and here theory and experience still go hand in hand.

16 As we have seen, there are happy and sad directions, and there are happy and sad colours, and as one cannot suppose a colour to have no direction, each colour has a single fitting direction, i.e. of identical expression; but whenever direction increases in expressivity, the corresponding colour must also increase in expression or intensity, i.e. in purity and brightness. In consequence, on the colour wheel, as the colour red and movement in an upwards direction are both extremely agreeable, we place a red which increases in intensity as it rises on a radius perpendicular to the horizontal diameter of the circle. As yellow, and horizontal movement from left to right are both agreeable, we place yellow at a right angle to the red. Movement from high to low and right to left being sad, we place blue on the other two radiuses also at 90 degrees. Orange naturally comes between red and yellow, green between yellow and blue, and violet between blue and red. Between these different fixed points various gradations will naturally fall into place, and all shades and nuances (separated by white) will thus be present around the circumference. Darker shades can be determined on other circles which will contain fixed quantities of black instead.

A few remarks should be made. For pairs of complementary colours, the last radius of one will be precisely at 90 degrees to the other, but whereas the angles of red and

green, and orange and blue are to be calculated from left to right in a descending manner, the angle between yellow and violet is to be calculated from right to left in an ascending manner. For triads of complementary colours, the first radius of each is again 90 degrees distant from the first radius of the following one, so that there is a distance of 180 degrees between the first and the third. One should also note the preponderance of blue, which occupies three eighths of the circle, and which becomes black through the extension of the orange.

17 Once these preliminary principles have been established, it becomes apparent how the theory of contrasting directions illuminates the contrast of colours. The two orders are parallel, and one example might be as follows:

Directions	Colours
A radius which goes from low to high to 7/8 of the half-circumference will appear larger.	Blue green, contrasted with red, will appear more intense.

The general formula for the rhythms of colour is given by the same method, and with the same restrictions imposed by the conditions of direction and measure. We know why orange and green make for a good combination – the combination is from left to right, and why violet gives only one reasonable combination – because the combination is from right to left. It is the rigorous translation of the expression of a cycle. In both cases the rhythm is identical, i.e. equal to a quarter of the circumference. Red and yellow also give a good combination, as the rhythm is the quarter of a circumference. It improves still further when the red shades off into purple, and the yellow tends to green, because the rhythm becomes tertiary, i.e. becomes a more complex rhythmic number, as it is the first number in the sequence 2^n+1. These examples should suffice. Generally speaking, *providing other conditions have been satisfied, agreeable colour contrasts are those which can be expressed as being distant from each other on the chromatic circle by a section of the circumference expressed by a form such as 2^n, or 2^n+1 for primaries, or a product thereof.*

* * *

19 In the preceding sections, we have only been concerned with colour-substances, the only ones which painters actually use: i.e. colours which effectively suppress certain types of light in the transmission of white light through transparent media, while light colours by contrast effectively add themselves to the reflections off certain surfaces. Unfortunately, time and space dictate that this is not the place to show how the theory of expressiveness of direction can aid a theory of coloured light, and also go some way towards explaining our own impressions of colour, nor how colour theory in general can also serve to illuminate the general theory of direction. I feel confident that I have now sufficiently explained the efficacity of my method. [...]

6 Paul Adam (1862–1920) 'Impressionist Painters'

Like Seurat, Fénéon, Huysmans and Kahn, the critic and novelist Paul Adam frequented gatherings at the house of Robert Caze in the autumn of 1885. This involvement in Symbolist circles moderated his earlier tendency to Naturalism, but never entirely sup-

pressed it. When he came to review the final Impressionist exhibition he was therefore well placed to represent the work of Seurat and Signac as a form of continuation of the Impressionist project, which was how it had appeared to Pissarro. Few other reviewers of the exhibition even mentioned Seurat's *Sunday Afternoon on the Island of the Grand Jatte* (now in the Art Institute of Chicago) despite its size and manifest ambition, preferring rather to expatiate on Degas's pastels. Adam acknowledges the distinctiveness of Degas's work, and shows himself adept at the description of late-Impressionist painting, but it is the serious and sympathetic analysis that he gives to Seurat's painting that really serves to distinguish his review. The article was first published as 'Peintres Impressionistes' in *La Révue contemporaine*, Paris, May 1886. Our extracts are taken from the original source, pp. 541–2, 544–5 and 548–51, translated for this volume by Akane Kawakami.

[. . .] In 1874, a canvas by Claude Monet, exhibited by Durand-Ruel, was entitled *Impression*. Absolutely new, this painting disconcerted the critics and nearly succeeded in troubling the syrupy brewing of their wild imaginings: 'Were we going to have to learn something? assimilate an unknown sensibility? What does this annoying character want? What right has he to stand out from the conventional crowd?' They quibbled as to who would manhandle the intruder; they gave out this sentence: Claude Monet was only capable of giving an Impression, so he and his followers were Impressionists and *nothing else*.

The name was retained. By chance it was the correct one. For, different from other schools whose art adds to sensations perceived the ever-uncertain features of experience, this school aims to reproduce pure phenomena, the subjective appearance of things. It is a school of abstraction. It escapes the error imposed on our minds by twenty centuries of dualist education, which created, outside of our senses, a completely imaginary existence, that of an objective world. Modern philosophy was converted to the idea of a unique substance, the phenomenon–idea. The Impressionists work to translate the most characteristic manifestations thereof: to convey the very first aspect of a visual sensation, without allowing the understanding to lead it astray with the male science of the eye, or to complicate it with hypothetical traits; to learn to see, but to see exclusively the initial appearance of things; to conserve such a vision and to fix it; such is the goal of these analytical painters.

A rude labour of the mind. It is no longer enough to reproduce the concept with the trimmings furnished by the superficial memory of analogous sensations, it is necessary to abstract from it the teachings transmitted by atavism, and to pursue the subjectivity of apperception unto its most abstract formulation.

The frivolous public could not undertake the work needed to seize the value of the proffered canvases. So it despised them. And there was a lack of initiators. As well as moral prejudices, the masses possess sensory prejudices.

This artistic thesis seems to combine with the analytical movement of the new literary trends. The painstaking research into the motives which control human life, the struggle of ideas discovered by psychologists and substituted for the vain and crude plot of the old novel, the meticulous sensationism which dissects the feelings of the characters down to their simplest constituents; all this is in keeping with the pictorial preoccupation of conveying pure phenomena.

The colouring of the most advanced Impressionists becomes totally scientific. Despising the hotch–potch of colours, the trick of mixing and blending, they obtain

their colours by a simple juxtaposition of tones which, seen at a certain distance, composes the desired value, their resultant.

It is no less than an entire revolution.

Everywhere, the poverty and the insignificance of the classical tradition has been eschewed; we have rejected the methods it produced, we consider ourselves to have wearied of its narrow rules and of its inane pomp, of this art conceived for the narrow and rudimentary mind of the court. Today, these sources tend to be more consulted. The varied and melodious form of the Primitives is suited to the new generation. Extraordinary analogies impose themselves between the drawings of ancient frescoes and those of certain Impressionists.

Also revealed is the same concern to prune, for the benefit of the general synthesis, the accessories which distract the eye and cause the viewer to dissipate his attention. Their landscapes are pushed further back, their fields live in a lighter, more vibrant atmosphere. As against the ridiculous traditional convention, objects of the size that they seem to be when located at a distance of a few dozen metres present us no longer with details which would only be perceptible on objects closer to us. The dominant nuance of the air, sown with minuscule dabs on the masses and on the ground, unites the picture in an overall sensation. No one has known better than these painters how to make the water of a river lap, to inscribe in it the swaying and fragmented reflection of the sky, or to set free the transparency of the foliage, or to make a grassy stretch yellow with light. Then, clothes on bodies are given a twisted or stretched look using glimmers of light, gradations of nuanced light which give substance to the cloth. [. . .]

M. Guillaumin's skies make his landscapes. I am not aware of any other painter who has so correctly noted the corresponding values of the lights of the firmament and of the ground. Their unification in colour appears to be perfect. The hill which lies under that purplish cloud at twilight could not be nuanced otherwise; but nevertheless the specific nature of the earth and its fundamental colour come through just sufficiently to allow us to conceive of its particular reality. The admirable thing about these paintings is the complex melody of the transitory tones which, underneath a single shadow, are differentiated and refined. And the synthesis never suffers as a result:

Meadow in Damiette. Green and mauve sky. In full sunlight, a background visible in between the spine of hilly ground. Rugged silhouettes of trees lie about, green-black, standing out on the yellow-green of the sun-warmed grass. In the distance, pink scratches of collapsed humus. Shreds of foliage, sometimes reddening.

Sunset. Behind the foliage, pushed into the background as if by a vigorous relaxation of the trunks, the bleeding reds of the setting sun are spread out. From it a red path descends, where the sturdy builds of peasant women move about; and the darkness of their clothes attracts wine-red reflections.

This artist's portraits would no doubt be criticized for their stiffness, if his remarkable concern to be truthful did not implicate the naivety of his models in this shortcoming. Women are reading in front of apoplectic dahlias; another one is sewing near a window, illustrated by the thatch of rustic rooftops and a patch of sky which is just about to rain. A marvellous glow trickles in from the road and would invade the apartment; but to the viewer it appears so low and so dark. A lady is posing

against a percaline hanging patterned with bunches of roses; she has brown eyes, deep and intelligent, her skin is a little bit rough; her mouth is about to blossom into a smile.

If M. Guillaumin still retains a certain fondness for mixing on the palette, his colouring is no less intensely vibrant for that. M. Degas's colours, by contrast, monotonously express bituminous tones. One senses a determination in him to darken the painting in order to position a few happy oppositions, blades of light, which will then more easily create an impression. But his drawing is extremely fine. The naked women who wash, sponging themselves, in batrachian postures; thighs, backs, contorted hips, swollen with crouching; highly accurate foreshortenings. And the line of Ingres, whose pupil M. Degas was, appears pure, sure and rare under the pencil which inscribed that plump bourgeoise preparing for bed; her hands flat against the small of her back, she is contemplating herself, no doubt, in some invisible mirror.

* * *

As much for their uncompromising application of the scientific mode of colouring as for their strange qualities, characteristic of innovators, Camille Pissarro, Signac and Seurat attest most manifestly today to the definitive tendency of Impressionist art.

M. Camille Pissarro was, besides, one of its first practitioners. To dedicate himself to it, he renounced Corot, whose methods had attracted him. A magisterial manner of drawing where the peasant women's heavy postures sag, due to the use of a heavy, pliant line, where the trams, the platforms of stations, the modern houses retain their geometrical aspects and glow in the rain (etchings; Rouen); all this without using any procedures of opposition, without exaggeration of light or shadow; these achievements destined him from the first to become a master. *Apple picking* is a painting in his early style. 'The grey silhouette of the stunted apple trees stretches towards the furrows of brown earth which rise up to the frame. Women, in the shadow of this silhouette, can be made out through the branches. Red-faced, fat, their flesh floats in their loose blouses; the supreme stupidity of countryfolk unfolds itself in their smiles, the supreme mindlessness of manual labourers in repose.'

These qualities persist in the most recent paintings, with much more effect and amplitude. The artist adopts in them the method discovered by M. Seurat, the minuscule stroke repeated infinitely, varied infinitely, and which constitutes extraordinary diversities of nuance in a hand, a limb, a piece of cloth. Here it serves most specifically to capture the multiple effects of the grass, the vibrations of tints which indicate the swaying of cloth, a person's stride. With this procedure, superior because, better than any other, it succeeds in capturing the movement and division of colours, M. Pissarro has evoked flat, yellow fields which, in the limpidity of the air, run away towards skies which are not at all wide and whose narrowness broadens the plain further. In this grandiose simplicity where only fields divided into rectangular pieces, transparent hedges and the elongated spines of hills are to be found, where big white clouds flock and roam, the apperception of the fields seems to be rendered perfectly, with its clear and wide heavens, its distant horizons, the sky united with the earth.

The environs of Paris, their skies striped by factory chimneys, the trees in rows, the flutterings of river water, peeling river banks, at times visions of blue sea: these are what M. Signac likes to paint. From amongst other paintings, his works clamour for

our attention with their intense colouring, of a richness which is reserved for him. Still very young, M. Signac possesses an admirable tone: the sense of Parisianism, but a Parisianism which escapes caricature and ugliness. Some of his landscapes, if M. Raffaëlli had dealt with them, would have proffered desolate tones, thinning vegetation, a sooty black spreading everywhere. *The Bank of Asnières* is depicted completely differently, with a pale gold sky, which, reflected in the water, sows infinite sparks into it, of a skilful and ample variation. The red rooftops are new and gay, the smoke undulates gracefully and the sky almost shows through it. The water, above all, is impressive. The pilotis are reflected in them with real tremblings; they stretch, they flow, they come to moisten the bottom of the frame with their multiple reflections where extraordinary scales of colours play and complete themselves, at times dulled, at other times rendered metallic by the liquid. *Milliners*. – 'One figure has an angular, very strange face, concentrating on the work with which her slim fingers busy themselves, the other, crouched, is picking up a pair of scissors.' The outline is confident and the limbs are in the right place, in spite of the not very balanced pose of the latter. The colourist has allowed himself the joy of executing a symphony in blue; it is everywhere, on the wall hangings, in the dresses, in the reflections in the black hair, in the shadows of the papers. The excesses of a temperament.

The seascapes of M. Seurat were not put into question even by the journalists. Their immense calm imposes itself at very first sight, with their eroded, chipped cliffs in rows, their waves being reborn in the distance, and the enormous quantity of air moving between the sky and this water. M. Seurat succeeds in giving, as skilfully as M. Pissarro, the feeling of visual void in the stretches of air. The fate of the large painting *Sunday at the Grande Jatte* was completely different. No one understood the beauty of this hieratic drawing, the correctness of the yellow tints used where the crowd of people gradually grows smaller towards the background. The trees are thrust straight in; neither copse nor branch mark the successive distances or the points of reference, in the way required, wrongly, by convention. There is nothing fake in this depth obtained without even a gradation of the tones; the values of the colours are maintained throughout, to the last of the leaves. Everything appears clear, precise, without any mists where the difficult points could have been hidden. An extraordinary scale of tones. Silk roses on the dress of a baby, next to the woollen roses on the dress of the mother; a world of differences masterfully noted. And even the stiffness of the people, the sharp forms contribute to creating the sound, the ring of the modern, a reminder of our tight suits, moulded to our bodies, the reserve of our gestures, the British cant imitated by all of us. We take on the same attitudes as those of characters in Memling. M. Seurat has seen this perfectly, has understood, conceived and translated it with the pure drawing of the Primitives.

To summarize, this exhibition initiates us into a new art, eminently remarkable for the scientific basis of its methods, the return to primitive forms and the philosophical concern to arrive at pure apperception. It introduces us to two defining temperaments; the masters of the landscape, Guillaumin and Pissarro, a very gifted colourist M. Signac, and an artistic revolutionary, M. Seurat, who without doubt will soon manage to win the attention and the curiosity of the public.

7 Félix Fénéon (1861–1944) 'The Impressionists in 1886'

Fénéon was principally active as a writer during the period 1883–92, while he was employed in the War Ministry – which employment he was forced to resign after being tried for anarchism in 1894. In 1884 he co-founded the *Revue indépendante* and he was also involved with the *Revue Wagnérienne*, with *Le Symboliste*, and with *L'Art moderne*, published in Brussels. He was drawn to Seurat's work after seeing his *Bathers at Asnières* in the Salon des Indépendants in 1884, and subsequently became both a supporter of the Neo-Impressionist movement and a retailer of its theories. In the text that follows, his account of Degas's nudes offers an interesting contrast to Huysmans's review (VIA5). Though Fénéon shares the latter's assumptions concerning the cruelty of the artist's regard, his descriptions of the pictures are far more attentive to their actual formalities, and he makes the all-important practical point that Degas's Realism could not be the product of direct observation, but must be the result of an accumulation of studies. It is in his writing on the Neo-Impressionists that Fénéon comes into his own, however, displaying his acquaintance both with the colour theories underlying the practice of the painters and with the evolution of their work. The essay was first published as a review, 'Les Impressionistes en 1886', in *La Vogue*, Paris, 13–20 June 1886; later in the same year it was reissued as a separate pamphlet. The present text is taken from Fénéon, *Oeuvres plus que complètes*, edited by Joan U. Halperin, Geneva: Libraire Droz, 1970, pp. 29–31 and 33–7, translated for this volume by Peter Collier.

During the heroic period of 'Impressionism', the crowd always saw Edouard Manet in the forefront, provoking anger, bursting into the annual Salon, enthusiastic, versatile and dramatic; but to tell the truth the final metamorphosis that turned the tar-brush painter of the *Bon Bock* into the luminist of *Linge* and *Père Lathuile*, was achieved under the influence of Camille Pissarro, Degas, Renoir and above all Claude Monet: they were the leaders of the revolution of which he was the herald.

MM. Renoir and Monet are not at the rue Laffitte exhibition, nor are MM. Raffaëlli, Cézanne, Sisley or Caillebotte. Despite these omissions, the new exhibition makes the situation very clear: M. Degas presents some typical works; Mme Morisot and MM. Gauguin and Guillaumin represent the sort of Impressionism that we have come to expect from previous exhibitions; while MM. Pissarro, Seurat and Signac have something new to offer.

Concerning M. Degas. Women squatting in their bathtubs fill them to the brim with their proliferating curves: one, whose chins reach her bosom, is scouring her neck; another, twisted in a spiral, has her arm bent behind her back as she scrubs her coccyx with a foaming sponge. Here, another's bony spine bends, as forearms, exposing pendulous breasts, plunge down between thighs to moisten a flannel in the bathwater round her feet. Masses of hair cascade over shoulders, bosoms over hips, stomachs over thighs, limbs over joints; and then that hag, seen from above, standing by her bed and clasping her buttocks, looks like a series of slightly swollen cylinders, fitting into each other. Seen from the front, a girl is wiping herself, kneeling down with her legs apart and her head bent over her flaccid torso. And it is in cramped spaces in dark, furnished hotel rooms, that these bodies, bruised by a rich patina of copulation, childbirth and illness, stretch their limbs or scrape their skin.

But now for the open air. A woman who has been bathing in the river, stands amid the greenery to get dressed, her chemise billowing around her uplifted arms. Three peasant women, ample and bovine, enter the water, their bent backs exaggerating the swell of their enormous rumps beneath the blazing sun, and their half-stretched, ape-like arms flail the air as they wade laboriously into deeper water, a wolf-like dog snaps at their calves.

In M. Degas's work as in no other, human flesh lives an expressive life of its own. This cruel and knowing observer uses line to elucidate the mechanics of every movement, even when complicated by incredibly foreshortened ellipses; his lines record not only the essential movements of a creature in motion, but also the most insignificant and secondary muscular repercussions, hence the definitive unity of his drawing. This is an art of realism, yet one which does not derive from direct observation – when a person knows that they are being observed, their movements lose their innocent spontaneity; M. Degas does not copy from nature: he builds up a collection of sketches of the same subject, from which his work will draw its undeniable veracity; never have paintings less betrayed the laboured image of the 'posing model'.

His use of colour shows his individual and innovative expertise; he has expressed it through the gaudy silks worn by his jockeys, through his ballerinas' lips and ribbons; today he displays it in muted, almost latent effects, taking as their pretext the russet of a mane of hair, the purplish folds of damp linen, the pink of a cast-off cloak, the rainbow play of water swirling acrobatically round a basin.

* * *

M. Gauguin's tones are extremely close to one another, giving a muted harmony to his painting. Massive trees spring from rich, luxuriant and humid ground, invading the frame and blocking out the sky. The air is heavy. We catch a glimpse of bricks suggesting a nearby house; garments lie abandoned, bushes are parted by muzzles – cows. The painter constantly contrasts these russet tones of roof and beast with his greens, and echoes them in the water flowing between tree trunks and through the long grass. There are also his Norman beaches and his cliffs, a still life and finally a wood carving dating from 1882.

* * *

Mme. Berthe Morisot is sheer elegance: her workmanship is strong, bright and lively; charmingly feminine but never insipid; and despite an air of improvisation, her tonal values are accurately calculated. Her paintings of young girls in the grass, or just out of bed, or brushing their hair are exquisite pieces of work; and her confident drawings and swift watercolours are a delight.

* * *

From the very beginning the Impressionist painters, with their concern for truth which led them to limit themselves to the interpretation of modern life directly observed and of landscape directly painted, saw objects as intimately related to one another, with no chromatic independence, each sharing its neighbours' luminous codes of conduct; traditional painting considered objects as ideally separate, and lit them with a poor and artificial light.

These reactions between colours, these sudden perceptions of complementaries, this Japanese vision, could not be expressed through the murky sauces stirred on the

palette: these painters therefore used separate notes, leaving the colours to respond and vibrate as they suddenly came into contact, and recompose themselves at a distance; they surrounded their subjects with light and air, modelling them in luminous tones, sometimes daring to abandon all relief; sunshine itself became embedded in their canvases.

Thus they proceeded to decompose their colours; but this decomposition operated in an arbitrary way. A streak of pure paint flung across the canvas might give a sense of red; its glow would be cross-hatched with green – MM. Georges Seurat, Camille and Lucien Pissarro, Dubois-Pillet and Paul Signac all divide tones in a deliberate and scientific manner. This development dates from 1884, 1885 and 1886.

If, for example, in M. Seurat's *La Grande-Jatte*, we examine any ten-centimetre-square section sharing a uniform tone, we will find on each single square centimetre of its surface, forming a swirling cluster of tiny marks, all the elements which constitute that tone. In that shady lawn the majority of strokes yield the local colour of the grass; others, orange-tinted and more widely spaced, express imperceptible effects of sunlight; others, purple, act to introduce the complementary of green; a cyanide blue, elicited by the proximity of a patch of sunlit grass, concentrates its grapeshot towards the line of demarcation but scatters it more thinly nearer to hand. In the construction of the patch itself only two elements intervene, green and solar orange, deadening all reaction with the furious bombardment of their light. Black being absence of light, that black dog will be coloured by reactions within the grass; its dominant note will therefore be dark purple; but it will also be invaded by a dark blue elicited by adjacent areas of light. That monkey on its leash will be punctuated with yellow, its individual characteristic, and pockmarked with purple and ultramarine. All this – admittedly excessive when translated into the crude notation of writing – deploys within the frame of the painting a complex and subtle calculation.

These colours, isolated on the canvas, are recomposed on the retina: this gives not a mixture of colours as material (pigments), but a mixture of colours as light. Do we need to recall that, for the same colours, mixing pigments and mixing light do not necessarily produce the same results? We also know that the luminosity of optical mixing is always far superior to that of material mixing, as has been demonstrated by the many equations of luminosity established by M. Rood. For violet carmine and Prussian blue, giving blue grey:

$$\frac{50\,C + 50\,B}{\text{mixing of pigments}} = \frac{47\,C + 49\,B + 4\,\text{black}}{\text{mixing of light}}$$

for carmine and green:

$$50\,C + 50\,V = 50\,C + 24\,V + 26\,\text{black}$$

It is easy to understand why the Impressionists, and even Delacroix, in his time, when striving to express extremes of luminosity, might wish to substitute optical mixing for mixing on the palette.

M. Georges Seurat was the first to propose a complete and systematic paradigm of this new painting. His vast painting, *La Grande-Jatte*, displays as far as the eye can see

its monotonous and painstakingly spotted tapestry. In this case, quite clearly, talent is irrelevant and deception impossible, there is no place for virtuoso passages – however lazy the hand, the eye must be alert, perceptive and learned; the movements of the brush remain the same, whether faced with an ostrich, a haystack, a wave or a rock. And while it is possible to advocate the merits of cut and dried, 'honest craftsmanship' in rendering, say, long grass, still branches, or thick fur, on the other hand, 'fine-brush' painting is necessary at least for the execution of smooth surfaces, and especially for the nude, to which it has not yet been applied. The subject is the island itself – under a blazing sun, at four in the afternoon, boats gliding sideways, teeming with its haphazard Sunday population delighted to take the air and walk among the trees; and nearly forty people, informed by imperious, hieratic drawing – strictly defined, whether seen from in front or behind, seated at right angles, stretched out on their backs, or standing to attention – as if by a more modern Puvis de Chavannes.

The atmosphere is singularly transparent and vibrant; the surface seems to tremble. Perhaps this sensation, which we also experience when faced with other paintings in the same room, could be explained by Dove's theory: the retina, aware that different beams of light are acting upon it, perceives, in a series of very rapid oscillations, both the dissociated coloured elements and their resultant combination.

M. Paul Signac is attracted to the urban landscape. Those of his canvases which date from this year are painted by dividing the tones; they attain a frenetic intensity of light: *Les Gazomètres à Clichy* (March–April 1886) and *Le Passage du Puits-Bertin à Clichy* (March–April 1886), with their fences where workmen's trousers and smocks are hung up to dry, their desolate, raw walls, burnt grass and roofs ablaze in an almost tangible atmosphere, rise darkly, and then hollow out into an abyss of blinding blueness; in *L'Embranchement de Bois-Colombes* (April–May 1886) the trees are burnt and withered. Seas seethe beneath blazing skies. He also knows how to translate the melancholy of grey weather, how to show water trapped between quaysides: as in his *Boulevard de Clichy par la neige* and his *Berge à Asnières* (November 1885).

At the previous exhibitions, M. Camille Pissarro triumphed with his vegetable gardens, his *Plaine au chou*, his *Sente aux chou*, his *Clos du chou*, superb landscapes. Transforming his material, he brings to Neo-Impressionism a mathematical and analytical rigour and the authority of his name: henceforth he decomposes tones, systematically. Sunlit landscapes, white houses amid orchards in blossom, vanishing perspectives, cornfields punctuated by spindly trees, limitless space, and high above, an azure sky filters through light, fleecy clouds. There are also some very fine, very linear pastels, where country women stretch, dress, rest, eat or work. Some gouaches. Some etchings reproducing the streets and the port of Rouen.

8 Félix Fénéon (1861–1944) 'Neo-Impressionism'

Coined by Fénéon himself, the term 'Neo-Impressionism' served to acknowledge the connection of divisionist work to a specific modern tradition, while conveying the sense that it represented an advance. The purpose of the following essay was both to explain the connection and to make clear the nature of the advance. It was originally published as 'Néo-Impressionisme' in *L'Art moderne*, Brussels, 1 May 1887, where it answered to the interest

created by divisionist work at the exhibition of Les Vingt in 1886. At the outset, Fénéon makes an important distinction between the 'luminist' tendency of early Impressionism and the concentration on modern-life themes shown by Cassatt, Degas, Forain and Raffaëlli, further distinguishing those painters whose comparative public success was achieved through a watered-down combination of the two (de Nittis...Bastien-Lepage). In the second and third sections of the essay he offers a clear account of the rational basis of the technique and of its function in synthesizing the fleeting sensation into perpetual form. The essay was reprinted in Fénéon, *Oeuvres plus que complètes*, edited by Joan U. Halperin, Geneva: Libraire Droz, 1970, volume 1. The text of our extract is taken from pp. 71–4 of that edition, translated for this volume by Carola Hicks.

I

Impressionism, merely latent in Turner and Delacroix (the Chapel of the Holy Angels at Saint-Sulpice), tried to turn itself into a system under Edouard Manet, MM. Camille Pissarro, Renoir, Claude Monet, Sisley, Cézanne and Ludovic Piette. These painters are distinguished by their extraordinary sensitivity to their own reactions to colour, by a tendency to decompose tones, and by their attempts to imbue their canvases with intense light. In their choice of subjects, they proscribe history, anecdote and dream, and, as their working method, they promote rapid and direct execution from nature.

If we want the word 'Impressionism' to have any reasonably precise meaning, we have to reserve this term for the 'luminists' alone. This immediately eliminates Miss Mary Cassatt, MM. Degas, Forain and Raffaëlli, whom a mistaken public included under the same heading as MM. Camille Pissarro and Claude Monet: although it is true that all of them sought the sincere expression of modern life, scorned the traditions of the schools, and exhibited together.

Let us recall the first Impressionist exhibitions. Given the innate stupidity of the public, the idea of choosing between well-finished paintings and wild daubings left them dumbfounded. They found it crazy that a colour should produce its complementary, ultramarine giving yellow, red giving blue-green, since all the most learned physicists would have affirmed in scholarly tones that the definitive effect of darkening all the colours of the spectrum is virtually to add to it greater and greater quantities of violet light – they would always have infinitely preferred to bow down to the murky violets of a painted landscape. Accustomed to the pitch-black sauces cooked up by the cabin crew of the schools and academies, their stomachs churn at the sight of bright painting. We have to admit however that from time to time the public felt revolutionary pangs and they queued up to take their pleasure with de Nittis, Roll, Carrier-Belleuse, Dagnan-Bouveret, Goenette, Gilbert, Béraud, Duex, Gervex, Bastien-Lepage – and this was their great orgy of modernity.

As for technique, at first there was nothing very specific: the Impressionist works gave themselves airs of being improvised: they were rapid, rough and ready.

II

Impressionism only developed its rigorous techniques from 1884–5. The instigator was M. Georges Seurat.

The basis of M. Seurat's innovations, which were already implicitly contained in certain works by Camille Pissarro, was the scientific division of tones. Thus, instead of stirring his mixture on the palette to achieve the more or less finished hues required to represent the surface, the painter will place directly on the canvas brushstrokes depicting the local colour, that is the colour that the surface of the object would take on in bright light (essentially the colour of the object seen from close up). This colour which he has not made achromatic on his palette, he has made achromatic indirectly on the canvas, by virtue of the laws of simultaneous contrast and through the intervention of another series of brushstrokes, corresponding to:

(1) the proportion of coloured light reflected unadulterated on the surface (this will normally be an orangey sunlight);
(2) the smaller proportion which penetrates beneath the surface and which is reflected after having been modified by partial absorption:
(3) light reflected by adjacent bodies;
(4) surrounding complementary colours.

Stroked executed not through wild slashes of the brush, but through the application of tiny dots of colour.

Here are some prerequisites for this way of working:

I. These strokes are composed on the retina, in an optical mixing. Now, the luminous intensity of the optical mixing is much greater than the mixing of pigments. This is what modern physics tells us when it says that any mixing on the palette will eventually lead to black;

II. Since the numerical proportions of the drops of colour may vary infinitely within a very small space, the subtlest shifts in relief and the finest gradations of hue can be exactly translated;

III. This splattering of the canvas requires no special manual dexterity, only vision – but what experienced and artistic vision!

III

The first Impressionists sought to show how our view of sky, water and natural greenery varied from moment to moment. Their aim was to record on canvas one of these fleeting apparitions. This resulted in the need to capture a landscape in a single session, and the tendency to exaggerate the features of nature in order to prove that it was a unique moment which would never be seen again.

What the Neo-Impressionists are trying to do, is to synthesize landscape into a definitive aspect which will perpetuate that sensation. (In addition to which, their procedures are incompatible with haste, and require work in the studio.)

In their figure scenes, there is the same distancing from the accidental or the transitory. And so those critics who yearn for the anecdotal will grumble: they are showing us puppets not people. They still have not tired of that Bulgarian's portraits, which seem to ask: Guess what I'm thinking! They feel no shame in seeing on their wall a gentleman whose sarcasm is rendered

immortal in the malicious wink of his eye or a flash of light that has been waiting around for years.

The same perspicacious critics compare Neo-Impressionist pictures to tapestries or mosaics, and find them wanting. Even if correct, this argument would be worth very little; but it is fallacious: just take two steps back – and all these drops of reversed colour blend into waves of luminous matter; it's as if the craftsmanship vanished: the eye is now solicited only by the very essence of painting.

Need we add that this almost abstract uniformity of execution does not diminish the originality of the artist, and even enhances it. Indeed, not to distinguish Camille Pissarro, Dubois-Pillet, Signac and Seurat one from another would be ridiculous. Each of them proudly flaunts his individuality – if only through his own distinctive interpretation of the emotional significance of colour, and the degree of sensitivity of his optic nerves to varying stimuli – but never through the sole use of some facile device.

Alone among the crowd of mechanical copiers of the outside world, these four or five artists achieve the sensation of life itself: this is because objective reality is for them only a pretext for the creation of a higher, sublimated reality, which becomes infused with their personalities.

9 Georges Seurat (1859–1891) Letter to Maurice Beaubourg

By 1890, when this text was written, the divisionist technique had been adopted by a number of artists in France, Belgium and Italy, and Seurat was concerned to establish his status as its inventor. Maurice Beaubourg was a journalist to whom he aimed to explain the principles underlying his work. In the resulting statement, colour-theories derived from the works of Chevreul, Maxwell and Rood (IIc5, IVB6 and 9) are combined with Charles Henry's theories of expression (VIB5) and with Wagnerian ideas about the power of music. These last were common currency in the Symbolist circles to which Seurat's contacts were largely restricted after 1886 (see VIc2). The most substantial practical expression of the principles outlined is to be found in his major subject paintings *Parade* (1887–8), *Le Chahut* (1889–90) and *Le Cirque* (begun in 1890 and left unfinished at his death), though similar principles are also at work in the smaller landscapes of the same period. The letter is dated 28 August 1890 but seems never to have been sent. There are four extant drafts. The present version was first published by Fénéon in his article 'De Seurat', *Bulletin 9*, Paris, 17 June 1914. It was reprinted in *Seurat*, catalogue of an exhibition at the Grand Palais, Paris: Réunion des musées nationaux, 1991, Appendix E, pp. 430–1, from which this translation has been made by Akane Kawakami. Words crossed out by Seurat are printed within square brackets.

Aesthetics:

Art is Harmony

Harmony is the analogy of Opposites, the analogy of things similar in tone *in* tint *in* line *considered by the dominant and under the influence of a combined lighting*

gay	*calm*	*or sad*

The opposites are:
For a lighter/ more luminous tone, a darker tone. For the tint, complementary colours, that is to say a certain red opposed to its complement, etc.

Red – Green
Orange – Blue
Yellow – Violet

For the line, those which are at right angles to it.

Gaiety of tone *is the luminous dominant*
of tint, *the warm dominant*
of line, *the lines above the horizon.*

Calmness of tone is the equality of darkness and light, of tint, of warmth and of coolness and the Horizontal line

Sadness of tone is the dark dominant, of tint, the cool dominant, and of line, the downward directions

Technique

Given the phenomena of the duration of light impressions on the retina [they are the same]

[the method of expression will be synthetic]

The synthesis imposes itself as the resultant

The method of expression is the optical Mixture of tones, tints [of places and of clarifying colour, sun, petrol lamp, gas, etc.] that is to say of lights and their reactions (shadows) following the laws of contrast, of gradation, of irradiation.

The frame [is not as it was at the beginning] is [opposed to] in the harmony opposite [to] that of the tones, the tints and lines of [the motif] the picture.

10 Camille Pissarro (1831–1903) Letter to Durand-Ruel

Pissarro was introduced to Signac in October 1885 and by him to Seurat. He was immediately impressed by the divisionist technique, which he saw as a positive development of the Impressionist tradition, and he rapidly adopted it in his own work. He encouraged the contributions of both younger painters to the final Impressionist group exhibition early in 1886, showing together with them and with his son Lucien in a separate divisionist section dominated by Seurat's *Sunday Afternoon on the Island of the Grande Jatte*. In the same year Pissarro also showed divisionist works at the exhibition of Les Vingt in Brussels. The present letter was written from Eragny on 6 November 1886. It answered a request from the dealer Durand-Ruel, who was working hard to promote Impressionist painting during a period of severe recession, and who presumably foresaw occasions when the new work would have to be justified to potential clients. For the pamphlet by Fénéon referred to, see VIB7. For texts by Chevreul, Maxwell and Rood see IIc5, IVB6 and

IVв9. The letter was first published in Lionello Venturi (ed), *Les Archives de l'Impressionisme*, Paris and New York: Durand-Ruel, 1939, pp. 24–5. The present translation from this source has been made by Carola Hicks.

My dear M. Durand-Ruel,

Please find enclosed the note which you asked me to write about my new artistic doctrine.

You could add to it by consulting the pamphlet recently published by M. Félix Fénéon under the title of 'The Impressionists in 1886', on sale at Soiret's in Montmartre and at all the main booksellers.

If your son does publish something on this subject, I would wish him to make it quite clear that it was M. Seurat, that artist of great talent, who first had the idea, and who was the first to employ scientific theories after having studied them in depth. I only followed Seurat's example, as did my colleagues, Signac and Dubois-Pillet. I hope that your son will not mind doing me this favour, for which I shall be truly grateful.

Theory

To find a modern synthesis through scientifically established methods, to be based on the Theory of Colours discovered by M. Chevreul, in the light of Maxwell's experiments and N. O. Rood's measurements.

To substitute optical mixing for the mixing of pigments. In other words: to decompose tones into their constituent elements. Because optical mixing generates a much greater luminous intensity than that produced by the mixing of pigments.

As for skill of execution, we consider it pointless, it is anyway of minor significance: art having nothing to do with it, in our opinion: originality lies only in the nature of the drawing and the individual vision of each artist.

11 Camille Pissarro (1831–1903) on Technique and Sensation, from Letters to Lucien

During the 1880s and 1890s Pissarro maintained a regular correspondence with his son Lucien, who was also a painter and printmaker and who made his home in England. The surviving letters offer a vivid account of the older painter's thoughts about painting in general and about his own development, interspersed with quotidian details and matters of business. The following excerpts have been selected to represent Pissarro's deliberations about his medium during the period from immediately after his adoption of the divisionist technique in 1886 until after his final abandonment of it in 1894. The dilemma he faced during this period was not his alone. It was a part of the legacy of the wider Impressionist project. On the one hand there was a need for some solid theoretical basis upon which the modern practice of painting could be continued and defended. On the other, what seemed most clearly to distinguish the moderns from their academic contemporaries was their valuation of immediate sensations and spontaneous responses.

While Pissarro was drawn to Seurat and to his divisionist theories, he remained an unqualified admirer of Cézanne's work, over a period when there was no adequate theory available to explain its virtues. The 'passage' referred to in the third of the following extracts seems to have been intended as a means of rendering the divisionist technique more fluid and variable in practice. As Signac was later to observe, any such device must in fact breach the basic means of operation of the technique itself, depending as this does upon the precise contrast between unmodulated tints. The correspondence was collected and published with the assistance of Lucien Pissarro in John Rewald (ed.), *Camille Pissarro, lettres à son fils Lucien*, 1943, translated by Lionel Abel as *Camille Pissarro: Letters to his Son Lucien*, New York: Pantheon, 1944; reprinted Santa Barbara and Salt Lake City, 1981. Our extracts are taken from the latter edition, pp. 108, 151, 154–7, 163, 180–1, 221–2, 338 and 349–52.

Eragny, February 23, 1887

[. . .] This morning I received a letter from de Bellio. He writes that he does not believe scientific research into the nature of colour and light can help the artist, neither can anatomy nor the laws of optics. He wants to discuss these questions with me and find out my views.

Now everything depends on how this knowledge is to be used. But surely it is clear that we could not pursue our studies of light with much assurance if we did not have as a guide the discoveries of Chevreul and other scientists. I would not have distinguished between local colour and light if science had not given us the hint; the same holds true for complementary colours, contrasting colours, etc . . .

Paris, September 6, 1888

[. . .] I think continually of some way of painting without the dot. I hope to achieve this but I have not been able to solve the problem of dividing the pure tone without harshness. . . . How can one combine the purity and simplicity of the dot with the fullness, suppleness, liberty, spontaneity and freshness of sensation postulated by our impressionist art? This is the question which preoccupies me, for the dot is meagre, lacking in body, diaphanous, more monotonous than simple, even in the Seurats, particularly in the Seurats. . . . I'm constantly pondering this question, I shall go to the Louvre to look at certain painters who are interesting from this point of view. Isn't it senseless that there are no Turners [here].

Paris, February 20, 1889

[. . .] I don't know what to write Fénéon about the theory of 'passages'. I will write him what seems to me to be the truth of the matter, that I am at this moment looking for some substitute for the dot; so far I have not found what I want, the actual execution does not seem to me to be rapid enough and does not follow sensation with enough inevitability; but it would be best not to speak of this. The fact is I would be hard put to express my meaning clearly, although I am completely aware of what I lack.

Paris, September 9, 1889

I went to the exhibition on the rue de Grenelle [the *Indépendants*]. [...]
The hall is beautiful. Entering it, I found the light not too bad, on each side of the
main room are little connected rooms in which the light is horribly raw: the dots of
colour stand out in the most frightful way; but in the main room they impress
me favourably. Certainly at first sight the neo-impressionists seem meagre, lustre-
less and white, – particularly Seurat and Signac. But once you become accustomed
to them they appear much less so, while, however, having a kind of stiffness which
is disagreeable. A new Seurat in the big room seemed to me very beautiful, very clear,
a Signac in the same room, done the same year, is also very beautiful and firm but is
too dependent on Seurat. A landscape by Hayet painted in oil, very beautiful, well
drawn, good in its colour values, I found rather admirable, a little lustreless but that
comes from the uniformity and stiffness of the dot [...]

Eragny, November 17, 1890

Each one of us has several facets. The surface often appears more important than what
is inside, hence the errors of those who judge carelessly. How many times has that not
happened to me! The surface is often complete in some people from the very
beginning, but not the possession of their own sensations. From this come errors.
Some natures achieve the surface very slowly; this is the least danger an artist runs. So
one should not think of the surface or the appearance, but concentrate on what is
inner! [...]

Eragny, February 10, 1891

[...] I finished the painting for Kahn. I think (you know the doubts that assail one
when one has just finished something), I think it is good; it was done very freely. I
divided the tones without waiting for the paint to dry and nevertheless it is quite
luminous. It has much more suppleness than my previous paintings and has as much
purity and light. So I feel that I am about to make rapid progress with this
approach [...]

Eragny, June 10, 1891

As soon as I got back here I went to work. I began three canvases of about 36 x 28, 31 x
25 and 28 x 23 inches; they are progressing rapidly. One is even almost finished. It
is not executed in 'dots,' which I have completely abandoned in order to
accomplish the division of pure tones without having to wait for the paint to
dry; this last had the disadvantage of weakening the sensation. I am eminently
satisfied, and I assure you the tones are quite as delicate, express my
sensations more freely and are more personal; I believe my approach will vindicate
itself [...]

Eragny, July 26, 1893

[...] One can make such beautiful things with so little. The motifs that are too beautiful sometimes appear even theatrical – just look at Switzerland. Old Corot, didn't he make beautiful little paintings in Gisors, two willows, a little stream, a bridge ... Happy are those who see beauty in the modest spots where others see nothing. Everything is beautiful, the whole secret lies in knowing how to interpret.

Paris, April 8, 1895

[...] Tomorrow I shall see at the exhibition of the *Indépendants* the large painting by Signac, 4 x 5 metres, a *decorative picture* ... if I am to judge by the picture by Cross that I saw – and Cross follows Signac – it is still not my ideal. It is, however, pleasing enough and the colours are attractive, but the drawing has something of the disorder of official art, there is a lack of values and of personal conception, and there are exaggerations of complementaries around the figures which irritate me. – And then it has the look of a tendency that has become decadent! Yes, yes, it is pretty, as are all unmixed colours, it is a near relation to the chromo! I am so sick of this sort of thing that all my pictures done in my period of systematic divisionism, and even those I painted while making every effort to free myself from the method, disgust me. I feel the effects of that as late as 1894!

Paris, November 21, 1895

[...] How rarely do you come across true painters, who know how to balance two tones. I was thinking of Hayet, who looks for noon at midnight, of Gauguin, who, however, has a good eye, of Signac, who also has something, all of them more or less paralysed by theories. I also thought of Cézanne's show in which there were exquisite things, still lifes of irreproachable perfection, others *much worked on* and yet unfinished, of even greater beauty, landscapes, nudes and heads that are unfinished but yet grandiose, and so *painted*, so supple. ... Why? Sensation is there!

On the way to Durand-Ruel's, I saw two paintings of Puvis de Chavannes. No, no! That sort of thing is cold and tiresome! A representation of natives of Picardy, and very well composed. But all the same, at bottom the whole thing is an anomaly, it can't be seen as a painting, no, a thousand times no! On a great stone wall it is admirable ... but it is not painting. I am simply noting my immediate impressions.

Curiously enough, while I was admiring this strange, disconcerting aspect of Cézanne, familiar to me for many years, Renoir arrived. But my enthusiasm was nothing compared to Renoir's. Degas himself is seduced by the charm of this refined savage, Monet, all of us. ... Are we mistaken? I don't think so. The only ones who are not subject to the charm of Cézanne are precisely those artists or collectors who have shown by their errors that their sensibilities are defective. They properly point out the faults we all see, which leap to the eye, but the charm – that they do not see. As Renoir said so well, these paintings have I do not know what quality like the things of Pompeii, so crude and so admirable! ... Nothing of the *Académie Julian!* Degas and

Monet have bought some marvellous Cézannes, I exchanged a poor sketch of Louveciennes for an admirable small canvas of bathers and one of his self-portraits.

12 Camille Pissarro (1831–1903) Advice to le Bail

The following notes were written down by the painter Louis le Bail, to record the advice he received from Pissarro during the years 1896–7. Their content is consistent with the tendency revealed in the letters to Lucien. By this date Pissarro had altogether abandoned his advocacy of the divisionist technique. In 1896 he wrote to the Belgian painter Henri Van de Velde that he no longer considered himself one of the Neo-Impressionists, 'having found that it was impossible to be true to my sensations and consequently to render life and movement'. In the procedure he now suggests there are echoes of the admonitions and reflections of Corot, by whom he was himself instructed some forty years previously (see IIc2 and IVA1). Le Bail's account was transcribed from his notebooks by the art historian John Rewald and was published in the present translated form in *The History of Impressionism*, New York: Museum of Modern Art, 1946. Our text is taken from the English edition, London: Secker and Warburg, 1973, pp. 456–8.

Look for the kind of nature that suits your temperament. The motif should be observed more for shape and colour than for drawing. There is no need to tighten the form which can be obtained without that. Precise drawing is dry and hampers the impression of the whole, it destroys all sensations. Do not define too closely the outlines of things; it is the brush stroke of the right value and colour which should produce the drawing. In a mass, the greatest difficulty is not to give the contour in detail, but to paint what is within. Paint the essential character of things, try to convey it by any means whatsoever, without bothering about technique. When painting, make a choice of subject, see what is lying at the right and at the left, then work on everything simultaneously. Don't work bit by bit, but paint everything at once by placing tones everywhere, with brush strokes of the right colour and value, while noticing what is alongside. Use small brush strokes and try to put down your perceptions immediately. The eye should not be fixed on one point, but should take in everything, while observing the reflections which the colours produce on their surroundings. Work at the same time upon sky, water, branches, ground, keeping everything going on an equal basis and unceasingly rework until you have got it. Cover the canvas at the first go, then work at it until you can see nothing more to add. Observe the aerial perspective well, from the foreground to the horizon, the reflections of sky, of foliage. Don't be afraid of putting on colour, refine the work little by little. Don't proceed according to rules and principles, but paint what you observe and feel. Paint generously and unhesitatingly, for it is best not to lose the first impression. Don't be timid in front of nature: one must be bold, at the risk of being deceived and making mistakes. One must have only one master – nature; she is the one always to be consulted.

13 Paul Signac (1863–1935) Diary Entries

For previous material on Signac see VB16. The journals Signac kept from 1894 to 1899 were left with his daughter, and were subsequently edited by John Rewald and published in

the *Gazette des Beaux-Arts*, Paris, July–September 1949, April 1952 and July–August 1953. The first of the following excerpts is concerned with a large exhibition held at Durand-Ruel's gallery during the spring of 1899. This provided a virtual summary of the modern movement in French painting and sculpture. An entire room was devoted to each of the 'senior' painters Corot, Manet, Renoir, Monet, Pissarro and Sisley. Redon was accorded a prominent role, and there were separate sections for the various avant-garde groupings of the 1880s and 1890s: the Nabis, the Neo-Impressionists and the Salon de la Rose + Croix. Signac's low estimation of Pissarro's more recent work reflects his bitterness at the older painter's defection from the Neo-Impressionist project. The second excerpt is interesting for the priority that Signac gives to composition on the basis of colour-effects, with observation from nature accorded a distinctly secondary role. Nature is regarded as a source of 'motifs', which the artist then transforms into independent pictorial elements. The following passages are taken from John Rewald (ed.), 'Extraits du journal inédit de Paul Signac', *Gazette des Beaux-Arts*, July–August 1953, pp. 52–4 and 55–6, translated for this volume by Sabine Jaccaud.

22 April 1899

Revisited the exhibition at Durand-Ruel's. This is truly the apotheosis of Impressionism: a room of Renoirs, a room of Monets, a room of Sisleys and a room of Pissarros

For Renoir, this is the definitive triumph. The scope of his research, the diversity of his compositions, all of a unified genius. In this room, one can only think of Veronese. And one is surprised by what could have been shocking about his paintings, in the past. I have the impression of being in a room of the Louvre. His period I prefer, personally, is the one between 1878 and 1882. Of the *Boaters* and of *Bougival* one could say that he painted them with flowers.

Monet. As a consequence of the use of poor colours and a succession of coats of varnish, the bloom of the oldest canvases has disappeared. Some paintings, like the seascapes of Varengeville, are dead. The depth has changed and the horizons have moved to the foreground, and vice-versa. And since many of his canvases do not have any composition, what remains is not exactly brilliant. The beautiful tenor of times gone by is voiceless, the virtuoso is paralysed. For him as well, the good years were those between 1878 to 1882: the series of paintings of the *Gare St Lazare*, the *Thaw*, *Vétheuil* and *Pourville*.

Two canvases of the *Poplars* are still gloriously alive and are masterpieces, thanks to their beautiful arabesques and the purity of tints that are not yet soiled by varnish.

A small room of Sisleys. A triumph as well. The group is maybe more sumptuous than Monet's. Here, there are little landscapes from around Paris, from the years [around] 1874. They are marvels of colour. From this retrospective exhibition, it is obvious that he is the one who, before the others and more so than them, divided his touch. In this respect, the paintings in this style have maintained a stronger hold than Monet's.

As for Pissarro, he is the unfortunate fourth. From year to year we can observe his collapse and in his last paintings, he truly sinks into the mud. He paints the first motif available, from his window, without seeking any composition. He also uses the first mixture of colours at hand, with chance guiding his brush and with no research into

light or colours. This has produced flatter skies and uglier tints than those in the worst works by Damoye. For him as well, the good period is 1882 to 1883: Osny and Pontoise, blues, greens, reds, oranges juxtaposed by cross-hatching, probably soiled at each other's contact but thus creating shades of a beautiful optical grey that benefits a tender and harmonious whole and a pearlescent unity. But the *Boulevards*, the *Avenue de l'Opéra*, the last paintings of *Rouen* are truly worthless. They are the feeble contradiction of a lifetime of research.

It is odd that all of them, Monet – the *Cathedrals* – Pissarro, Renoir and Sisley as well, have, in the last five or six years, renounced the brilliant colouring and the research into luminosity for which they fought so courageously throughout their lives. Is it necessary to seek other reasons than age and weariness?

At the same time, a small exhibition of works by Corot. The lesson that ensues is that the Impressionists were wrong to renounce research into composition. Corot made paintings; except for Renoir, they have only produced studies.

10 May 1899

Went to the Vélodrome to take notes and make sketches for a small painting. Beforehand, I did a rough outline and the setting I created from memory and from earlier sessions is much closer to the subject than the one I bring back as a water-colour done on the spot. In reality, the sky occupies the largest part of the composition; it is a landscape with small trees, too much sky and the Vélodrome has too little importance. In the draft done from memory, the trees drew a large arabesque in the sky. It filled the composition. The multicoloured effects that triggered the idea of this painting took on more importance than they have in reality. The track, drawn from life, was too small and the parts that were of no use to the subject took too much space. Observation from nature was therefore interfering with what I wanted to do. But nevertheless, these sessions provided a few small details that will add a pictorial vividness to my painting: the pink blots of programmes, details of the slopes of fortifications, differences in greenery – the things I could never have imagined. The same lesson recurs: take compositional elements from nature, but shape them by following your will. One who has enough memory to hold all his impressions would not need to do this work directly from nature. Is it that paradoxical to wonder why a painter has to work from life any more than a writer or a musician? They all seek motifs rather than reality, in nature; emotional motifs, sensations they endeavour to interpret and communicate. But, one might add, a painter represents natural forms. And these forms, do they not become rhythms and measures as much for him as for the poet or the musician?

In my opinion, with the exception of a rapid piece of information that memory or a Kodak could provide just as well, an artist's work must be a creation. And can a painter not create something at his table or easel, just as well as under a bridge or on a road? All drawings by masters are information rapidly taken down; the superb sketch of legs for *Jacob Fighting with the Angel*, by Delacroix, was done in two minutes. Besides these documents, they draw or use water-colours, but do so creatively: *The Education of Achilles* or the water-colours *The Rivers of France* by Turner are compositions. Almost everything I have seen by Turner was done in his studio. I only know a

few immediate sketches by him, as well as notes and souvenirs that were done from life. And both his paintings and water-colours give as good a feeling of nature as the most impressionistic canvases of Monet. – And of Millet, and Corot

14 Paul Signac (1863–1935) from *From Eugène Delacroix to Neo-Impressionism*

Signac's book was written to establish the Neo-Impressionist tendency as the rightful and logical outcome of the modern tradition in painting. Building on the work of Seurat and of the chemist and colour-theorist Charles Henry (VIB5), he defined this tendency first and foremost in terms of developments in the vividness and expressiveness of optical effects. Accordingly, he singled out Delacroix and Turner as the major figures to whose precedence and authority it was necessary to appeal, combing the former's journals and correspondence for evidence of his thought on effects of colour and light. The outcome was a work which served both to focus attention on Delacroix's achievements as a colourist and to stimulate thought about the possible independence of colour as an expressive property in painting. In the first decade of the twentieth century a younger generation of painters was to go further than the Neo-Impressionists themselves in freeing the colours of their paintings from the local colours of particular surfaces and objects. Signac's work thus made a distinctive contribution to the growing body of theory which represented the modern development as a form of self-critical *progress*, directed towards an ideal end in which purity and expressiveness would be maximally combined. It was of particular importance to the Fauve painters. The book was originally published as *D'Eugène Delacroix au Néo-Impressionisme*, Paris, 1899. It was translated into German in 1903, but it was not until 1992 that a full English translation was published. The following extracts are taken from the reprinted edition edited by Françoise Cachin, Paris: Herman, 1964, sections I, V and VI, pp. 37–45, 51 and 106–8, translated for this volume by Sabine Jaccaud. We have renumbered the notes, in which Signac's original references are supplemented by the later editor. Further extracts from the book will be found translated in *Art in Theory 1900–1990*, IA2.

I Documents

1. To think that the Neo-Impressionists are painters who cover canvases with little multicoloured spots is a rather widespread mistake. We will prove this later on, but for now affirm it. This mediocre dot method has nothing to do with the aesthetic of the painters we are defending here, nor with the technique of *Divisionism* they use.

The Neo-Impressionist does not *stipple*, he *divides*. And *dividing* involves:

Guaranteeing all benefits of light, colouration and harmony by:

i. *An optical mixture of pigments which are pure (all the tints of the prism and all their tones);**

ii. *The separation of different elements (locally applied colour, lighting colours, their reactions, etc.);*

* The words *tone* and *tint* are usually used indiscriminately. By *tint* we specifically understand the quality of a colour, and by *tone* the degree of saturation or luminosity of a tint. The gradation of one colour into another will produce a series of intermediary *tints* and the gradation of one of these *tints* towards light or dark will move through a succession of *tones*. [*Author's note*.]

iii. *The balance of these elements and their proportion (following laws of contrast, deterioration, and irradiation)*;

iv. *Choosing a touch that is proportionate to the size of the painting.*

The method expressed in these four paragraphs will govern colour for the Neo-Impressionists. Most of them will also apply the more mysterious laws which discipline lines and direction and guarantee harmony and beauty of order.

Informed in this way about line and colour, the painter will definitely determine the linear and chromatic composition of his painting. Its dominant directions, tone and tint will fit the subject he is attempting to handle.

2. Before going any further, let us invoke the authority of the genius of Eugène Delacroix: the laws on colour, line and composition that we have just listed summarize *Divisionism* and were promulgated by the great artist.

We will go through all aspects of the aesthetic of the Neo-Impressionists one by one. We will then compare them to the lines written by Eugène Delacroix on the same issues, in his letters, articles and three volumes of his *Journal*.[1] We will show that these painters are only following the teaching of this master and pursuing his research.

3. The Neo-Impressionist's technique aims, as we have seen, at obtaining a maximum of colour and light. Is this aim not clearly outlined by the beautiful cry of Eugène Delacroix:

'*The enemy of all painting is grey!*'[2]

To obtain this colourful and luminous vividness, the Neo-Impressionists only make use of pure colours which are close to the colours of the prism, or as close as substance can be to light. Is this not another way of following the advice of one who writes:

'*Ban all earthy colours*'[3]

Of these pure colours, they will always respect the purity. They will avoid soiling them by mixing them on their palette (except of course with white and with neighbouring colours, for all the tints of the prism and all their tones). They will juxtapose them in clear and small brush strokes and through optical mixture, will obtain the desired result, with the advantage that while most blends of pigment tend not only to darken but also to lose their colour, all optical mixture tends towards clarity and brilliance. Delacroix was aware of the prerogatives of this method:

'*Colours of green and purple, roughly placed, here and there, in bright areas, without mixing*'[4]
'*Green and purple: it is indispensable to apply these tints one after the other and not mix them on the palette*'[5]

And indeed, this green, this purple are colours that are almost complementary. Mixed together as pigments, they would have produced a dull and soiled tint, one of these greys that are *the enemy of all painting*. On the other hand, when juxtaposed, they reconstitute a fine and pearlescent grey.

The treatment that Delacroix prescribed for green and purple, the Neo-Impressionists merely generalized, following a logical pattern, and applied it to the other colours. Warned by the master's research, informed by the works of Chevreul, they established this unique and safe method of obtaining light and colour at the same time: by replacing any pigmentary blend of enemy tints with optical mixture.

4. As all flat tints seem listless and faint, they strive to make the smallest part of their canvases shimmer through the optical mixture of strokes of juxtaposed and graded colours.

However, Delacroix spelt out clearly the principle and the advantages of this method:

'*It is better if strokes are not materially blended; they melt into one another naturally at a given distance through the sympathetic law by which they are associated. Colour thus receives more energy and freshness.*'[6]

And further on:

'*Constable said that the superiority of the green in his open spaces lies in the fact that it is composed of a multitude of different greens. The lack of life and intensity in the greenery of the common landscape painters is caused by the fact they usually paint it in a uniform tint. What he establishes here about the green of open spaces can also be said about all other tones.*'[7]

This last sentence clearly proves the great artist's presentiment of the decomposition of tints into graded strokes, this most important part of *Divisionism*. His passion for colour would bring him to acknowledge, inevitably, the benefits of optical mixture. However, to ensure optical mixture, the Neo-Impressionists were forced to use brushwork of a small scale so that, when standing back sufficiently, different elements could reconstitute the desired tint and not be perceived in isolation.

Delacroix had thought of using these small brush strokes and suspected the resources this technique could open up, since he wrote these two notes:

'*Yesterday, while working on the child that is near the woman on the left in* Orpheus, *I remembered these multiple little brush strokes on Raphael's* Virgin *which resemble the work on a miniature. I saw it in rue Grange-Batelière.*'[8]

'*Try to see the large gouaches of Correggio in the Museum. I think they are done with very small brush strokes.*'[9]

5. For the Neo-Impressionist, the different elements that reconstitute a tint by their optical mixture will be distinct from each other: light and localized colour will be clearly separated, and the painter will sometimes have one dominate, then the other, as he pleases.

Is this principle of the separation of elements not present in these lines by Delacroix:

'*Simplicity of setting and broad scope of light.*'[10]

'One has to reconcile "colour" colour and "light" light.'[11]

The balance and proportion of these separate elements are clearly outlined:

'To have light and large surfaces dominate to excess will lead to the absence of half-tones and as a consequence to decolouration. The opposite mistake is mostly damaging to large compositions that are meant to be seen from a distance. Veronese wins over Rubens by the simplicity of localities and the broad scope of light.'[12]

'So as not to seem discoloured by such a large light, Veronese's localized tint must be highly amplified.'[13]

6. Is the contrast in tone and tint that only contemporary artists – the Neo–Impressionists – observe not defined and established by the master:

'My palette, brilliant with the contrast of colours.'[14]

'General rule: more opposition, more brilliance.'[15]

'The satisfaction that the beauty, proportion, contrast, and harmony of colours provide in the spectacle of things.'[16]

'Even though this runs against the law that dictates cold sheen, laying them down as yellow on purple flesh tones, the contrast works to provide the desired effect.'[17]

'When, on the edge of a surface that you have solidly established, you end up with lighter tones than in the centre, you will emphasize all the more its flat surface or its protrusion ... Adding black as one might, one will not obtain a relief.'[18]

This comment in one of his notebooks from his trip to Morocco reveals the importance Delacroix granted to the laws of contrast and complementary colours. He knew these were an inexhaustible source of harmony and strength:

'Of the three primary colours, the three binary ones are formed. If you add to one of these the primary tone that is its opposite, it cancels it out. This means that you produce the required half-tone. Therefore, adding black is not adding a half-tone, it is soiling the tone whose true half-tone resides in this opposite we have just described. Hence the green shadows found in red. The heads of the two little peasants. The yellow one had purple shadows; the redder and more sanguine one had green ones.'[19]

7. According to the Neo-Impressionist technique, the light, whether it be yellow, orange or red, depending on the hour and the desired effect, adds itself to a localized colour, warming or gilding it in its brightest parts. Shadow, faithful complement to its regulator, light, is purple, blue or blue-green and these elements modify and cool down the darker parts of localized colour. These cold shadows and warm lights constitute outline and relief through their interplay with each other and with localized colour. Blended or contrasted, they spread across the whole surface of the painting, lighting it here, dulling it there, in places and proportions determined by chiaroscuro.
* * *

9. This technique, the optical mixture of small strokes of colour methodically laid down one next to the other, does not leave much room for virtuosity and skill. The

painter's hand has little importance; only his eye and brain take on a role. Without being tempted by the charm of brushwork, and by choosing a less shiny albeit conscientious and precise execution, the Neo-Impressionists took into account the following admonition by Delacroix:

'*The biggest challenge is to avoid the infernal convenience of the paint brush.*'[20]
'*Young people are only infatuated by the skill of the hand. There is probably no greater obstacle to any form of real progress than this universal obsession to which we have sacrificed everything.*'[21]

* * *

14. [. . .] The Neo-Impressionists relinquished the golden frame. Its gaudy glitter modifies or destroys the harmony of a painting. They generally use white frames which constitute an excellent blend between the painting and its setting and intensify the saturation of colours without disrupting their balance.

We can entertain ourselves by commenting that a painting that is bordered by one of these white, discreet and logical frames the only one, other than a contrasted one, that cannot do any harm to a luminous and colourful painting is immediately and without examination excluded from the official or pseudo-official Salons, for this simple reason.

* * *

V Divided Brushwork

Divisionism is a complex system of harmony, an aesthetic rather than a technique. The *dot* is only a method.

To divide is to seek the strength and harmony of colour by representing coloured light by its pure elements and by employing the optical mix of these separated pure elements, measured out according to the essential laws of contrast and gradation.

The separation of elements and an optical mixture guarantee purity, meaning the luminosity and intensity of the tints; gradation enhances lustre; contrast, by regulating the concordance of similars and the analogy of opposites, subordinates these powerful albeit balanced elements to the laws of harmony. The basis of *Divisionism* is contrast: is contrast not art itself?

The *pointillist* chooses a means of expression by which he applies colour on a canvas in small dots rather than spreading it flat. This involves covering a surface with little multicoloured and close-set strokes of either pure or dull tints and attempting to imitate through the optical mixture of these multiplied elements, the varied tones of nature. This is done without any desire for balance, with no concern for contrast. The *dot* is nothing more than a brush stroke, a technique. And like all techniques, it does not matter much.

The *dot* has only been used, as a word or as a texture, by those who were unable to appreciate the importance and the charm of a contrast and a balance between elements. They have only seen the means of *Divisionism* and not its spirit.

Some painters tried to verify the advantages of *Divisionism* and did not succeed. In their works, the paintings in which they tried out this method are inferior, in their

harmony more than in their luminosity, to ones preceding or succeeding their period of research. This is because only the method was used, and the *divina proportione* was absent. They must not blame *Divisionism* for this failure: they are *Pointillists* and not *Divisionists*...

We have never heard Seurat, Cross, Luce, Van de Velde or indeed Van Rysselberghe or Angrand speak of *dots*. We have never seen them be preoccupied by *Pointillism*. Read these lines, dictated by Seurat to Jules Christophe, his biographer:

'*Art is harmony; harmony is the analogy between opposites and between similar elements of tone, tint and line. By tone I mean light and dark; tint is red and its complementary: green, orange and its complementary: blue, yellow and its complementary: purple... The method of expression relies on the optical mixture of tones, tints and their reactions (shadows that follow very strict rules).*'[22]

Within these principles on art, the ones of *Divisionism*, is there any question of *dots*, any trace of a petty concern with *Pointillistic* methods?

One can also *divide* without being *Pointillistic*.

For instance, a small sketch by Seurat, drawn from life on a panel like the bottom of a thumb-sized box in a few brush strokes. This sketch is not *pointillistic*, but is an example of *Divisionism*. Indeed, despite the hasty aspect of the work, the style is pure, the elements are balanced and the contrast is maintained. And it is these qualities alone, and not a meticulous pickiness, that constitute *Divisionism*.

The role of a *pointillistic* method is more modest: it simply renders the surface of a painting more vibrant. However, it does not guarantee luminosity, or the intensity of colours, or harmony. This is due to the fact that complementary colours are favourable to and intensify each other when they are set *in opposition* and are enemies and destroy each other when they are blended, even optically. A red surface and a green surface, when adjacent, stimulate one another. Red dots blended into green dots produce a grey and colourless whole. *Divisionism* does not require strokes in the shape of *dots*. It can use this technique for small-sized canvases, but totally repudiates it for larger formats. Threatened by decolouration, the size of the *divisionist stroke* must be proportionate to the dimensions of the work. The *divisionist stroke* is changing, alive and like light. It is therefore not a *dot*, uniform, dead, 'matter'.

* * *

VI Summary of the Three Approaches

So many words. But it was necessary to produce all the evidence to be convincing about the legitimacy of Neo-Impressionism, by outlining its origin and its contributions. Could all these sentences not be condensed into a synoptic table?

	AIM
DELACROIX	
IMPRESSIONISM	*To maximize the brilliance of colour.*
NEO-IMPRESSIONISM	

	MEANS
DELACROIX	1. *Palette made up of pure colours and darkened colours;*
	2. *Mixing on the palette and optical mixture;*
	3. *Cross-hatching;*
	4. *Methodical and scientific technique.*
IMPRESSIONISM	1. *Palette only made up of pure colours which are close to the ones of the solar spectrum;*
	2. *Mixing on the palette and optical mixture;*
	3. *Brush stroke in the form of a comma or of a sweep;*
	4. *Technique relying on instinct and inspiration.*
NEO-IMPRESSIONISM	1. *Same palette as Impressionism;*
	2. *Optical mixture;*
	3. *Divided brush strokes;*
	4. *Methodical and scientific technique.*

	RESULTS
DELACROIX	*By repudiating all flat tints and through the technique of gradation, contrast and optical mixture, he succeeded in extracting a maximal brilliance from the partially darkened elements at his disposal. The harmony of this brilliance is guaranteed by the systematic application of the laws that regulate colour.*
IMPRESSIONISM	*By composing his palette solely with pure colours, [the Impressionist] obtains an effect that is more luminous and colourful than Delacroix's. However, he diminishes its brilliance through pigmentary and soiled mixing and also restricts its harmony by only applying irregularly and intermittently the laws that regulate colour.*
NEO-IMPRESSIONISM	*Through the suppression of all soiled mixture, by the exclusive use of optical mixing and pure colours, by methodical division and by observing the scientific theory of colours, [the Neo-Impressionist] guarantees maximal luminosity, colour and harmony to an unprecedented degree.*

1 All references to *Delacroix's Diaries* are from the Paul Flat and René Piot edition, Paris, Plon, 1893–95, 3 vols, in-8. Signac used this edition. For today's reader, we will complete these with references to the latest edition by André Joubin, Paris, Plon, 1961, 3 vols, in-8.

2 *Journal*, II, p. 136; no date, 1852 [Joubin, I, p. 500].

3 *Journal*, III, p. 209; 13 January 1857. [Joubin, III, p. 16].

4 *Journal*, II, p. 59; 5 May 1851. [Joubin, III, *Supplements*].

[5] *Ibid.*, p. 143; 15 January 1853. [Joubin, II, p. 5].

[6] Cited by Charles Baudelaire, *L'art Romantique*, Paris, 1885, p. 12.

[7] *Journal*, I, p. 234; 23 September 1846. [Joubin, III, *Supplements*].

[8] *Ibid*, p. 281, 5 March 1847. [Joubin, I, p. 199].

[9] *Ibid*. [Joubin, I, p. 200].

[10] *Ibid*. – From the sentence: 'In this last picture, Veronese wins over Rubens by the simplicity of setting and the broad scope of light.'

[11] *Journal*, II, p. 40; 29 September 1850. [Joubin, I, p. 418].

[12] *Ibid*. [Joubin, *ibid*.].

[13] *Ibid*. [Joubin, *ibid*.].

[14] *Journal*, II, p. 14; 27 July 1850. [Joubin, I, p. 392].

[15] *Ibid*., p. 42; 3 November 1850. [Joubin, I, p. 420].

[16] *Ibid*. [Joubin, *ibid*.].

[17] *Journal*, III, p. 426; 1 January 1861. [Joubin, III, p. 318].

[18] *Journal*, I, p. 198; no date, 1843. [Joubin, III, *Supplements*, p. 427].

[19] The notebook where this sentence appears was only published, in facsimile, in 1913 by J. Guiffrey. Signac therefore must have consulted it at the Condé Museum, in Chantilly. This Moroccan travel document was bought at the Delacroix sale by the painter Dauzats for the Duc of Aumale. The latter bequeathed his collection to the Institut de France in 1886.

[20] *Journal*, I, p. 137; 20 July 1824. [Joubin, I, p. 118].

[21] *Eugène Delacroix's Letters*, published by Ph. Burty, Paris, 1881, vol. II, p. 211.

[22] J. Christophe, *Seurat*, in *Les Hommes d'aujourd'hui*, no. 368, March–April 1890.

15 Emile Bernard (1868–1941) 'Paul Cézanne'

During the 1880s and 1890s Cézanne worked in relative isolation in Provence and made little attempt to exhibit his work in Paris. Assisted by persistent stories about his past intransigence and by the admiration in which his work was held by a handful of other painters, this virtual absence created a certain mystique around his name. Bernard saw some paintings by Cézanne in 1886–7 at the only place in Paris where they were then to be regularly encountered, the shop of the colour-merchant Tanguy (Signac had purchased one of Cézanne's landscapes from Tanguy in 1884). Thereafter Bernard took what opportunities he could to view the older painter's work in the collections of a few patrons and friends. In the spring of 1888 he showed his own 'Cloisonnist' works in the Salon des Indépendants, and that summer he was at Pont-Aven in company with Gauguin. Thus by the time he came to write the present text Bernard was clearly identified with one of the distinct tendencies of which the wider Symbolist movement was composed. It was consistent with his own interests at the time that he should dwell on the supposedly 'primitive' aspects of Cézanne's work. The *Temptation of Saint Anthony* is now in the Musée d'Orsay in Paris. The essay was first published in *Les Hommes d'aujourd'hui*, VIII, no. 387, Paris, 1891, pp. 1–3. The cover of this issue bore an etched portrait of Cézanne by Pissarro. The following translation from the original text has been made for this volume by Sabine Jaccaud.

Provence. A succession of events: a romantic boyhood filled with verse; declamatory walks with Zola, his friend from school; Hugo and Musset scattered through the foliage on the banks of the Arc; an enthusiastic arrival in Paris; night–time conversations under the stars set before the big city one dreams of conquering. Afterwards, a little spell of distress generated by a dull albeit wealthy family; a wedding; failure in

the eyes of the public and of impotent artists; the theoretical paroxysm (his most inspired period) and finally, his withdrawal into the Absolute.

But how many imaginary triumphs, how much astonishing art to create, how much fruitless hope!!

His friends: Pissarro, Guillaumin, Monet, Zola, Bail. They travelled their roads, had their share of glory, knew the joy of justice rendered. Unknown, or rather unrecognized, he loved art to the point of renouncing any notoriety through friends and allegiance to groups. He kept his efforts to himself through integrity rather than out of contempt. In this respect, what a surprise to us were his presentations at the Brussels Exhibition of Les XX: he was not understood any better than twenty years ago and not even honoured with a discussion. He was cited, and nothing else.

However, what presentations these were: naked women in a strange and blurred landscape, more suggestive than any others with their elegance of sixteenth-century Dianas; meridional landscapes endowed with an innovative solidity.

Style and tone: he is a painter first and foremost but a thinker as well. He is also solemn. He has opened to art this most surprising gate through which painting exists for its own sake.

At Tanguy's, number 14, rue Clauzel, in a narrow and dark shop, childish landscapes can be found: red houses in a tangle of slender branches and primitive hedges, still-lifes: apples rounded as if by compasses, triangular pears, lopsided fruit dishes, napkins folded in a rage; portraits. And all of this: bottle-green, brick-red, ochre and a launderer's blue.

Harsh, unpolished, acid, these canvases are staggering. They seem to defy all criticism, having been made to arouse battles . . . Some of them, however, have a child-like quality that awakens the precise idea of a brilliant shepherd-child like Giotto who dabbles in colours.

At Schuffenecker's: a white bowl on a blue-green background streaked by the flowers of a wall-paper; nearby, an urn-like glass, a spread-out cloth, apples holding up a lemon. Two landscapes: pines along a high road lined by villas and tall grass, red houses seen among groups of trees.

At Doctor Gachet's, in Auvers: landscapes like a solid Corot; severe still-lifes, powerful sketches. Then, at Choquet, Pissarro, Zola, Rouart, and Murer's, nude women, fragments of tables covered with fruit and stern portraits. I remember one work (his wife) that is worthy of Holbein: from a blue-green background on which hangs an item of clothing, the fine head with vague eyes and sensual mouth detaches itself, resting on a crimson red arm-chair. She is wearing a green and black striped vest. Pensive, the model poses; but in this pose, life's latent presence is visible.

Hieratic in its essence, and with a linear purity that is known only to the purest primitive masters, this canvas seems to me to be one of the major attempts Modern Art has made to reach classical beauty.

Three approaches stand out:
The arrival in Paris;
The bright period;
The sombre period.

The last approach is nothing other than a return to the first one. But it is a return that proceeds through budding theories on colour and very personal and unexpected remarks on style. The early works are in no way inferior or less interesting than the most recent. They are gripping in their precocious strength. They are gripping despite frequent echoes of Delacroix, Manet, Courbet, Corot and Daumier.

The bright period was his most unhappy. It was one of constraints from elsewhere. He had met Monet who only dreamt of sunshine and light and in turn he too succumbed to the charm of vast clarity. Progressively, he reaffirmed his hold on calm and balance and returned to his starting point, more knowledgeable and whole.

Of a solid texture and worked on in strokes slowly drawn from right to left, the works of the last period confirm a quest for a new art, a strange and unknown one. Well-balanced lights slide mysteriously into a *transparently solid* shadow; an architectural gravity presides over the order of lines. Sometimes, textures are prompting to sculptures.

The Temptation of Saint Antony (belonging to M. Murer) seems to me to be a true type of the painter's style, as well as its most complete example.

Romantic in its design, the canvas no bigger than 20/15 shows the legendary saint sunk to the ground. A red devil has climbed onto his head and is frantically pointing to a naked girl escorted by tiny cupids. The land is covered by pale roses on which this apparition walks. A blue sky flies its banner behind a tree that is leaning over the scene.

Here, no positive shadow. An equalized clarity prevails, rendering all things iridescent. One is reminded of a very old bas relief, rendered paler by the years and beautiful by the mysterious indecision that time impresses on art.

This is one of colour's most powerful masterpieces. It goes without saying that the picture is as naive as can be. Only a popular ancestral figure could convey a comparable idea of it.

Solely pictorial, this canvas could easily be taken for what is vulgarly called a 'coarse daub'. It indeed comes across as a pasty mess: this at least is how it would appear to the untrained eye (the exoteric one). But if we linger over it and seek to assess its qualities, its tone and its grace, as well as this *indefinable element* that puts more ideas into an artist's head than any fantastical representation sketched or described in an ordinary way, we have to admit that here lies the power of originality and technique always sought after and so seldom encountered in the works shown by the generation of artists currently known. And this makes me think of the opinion Paul Gauguin expressed one day to me about Cézanne: nothing looks more like a daub than a masterpiece. An opinion that I find cruelly true, in this present case.

Paul Cézanne was born in Aix en Provence. He is 50 years old.

16 Gustave Geffroy (1855–1926) 'Paul Cézanne'

Geffroy published his first article on Cézanne in *Le Journal* in 1894. The painter wrote expressing his appreciation and Geffroy was encouraged to compose this more substantial essay for his publication *La Vie artistique*, where it was accompanied by similar accounts of the other members of the original Impressionist generation. (The extent of Cézanne's withdrawal from the Impressionist exhibitions is overstated, since he was well represented

in the third exhibition in 1877.) Like Bernard, Geffroy responded to the mythology that had become attached to the painter's name and to his work, and like him he noted a certain 'primitive' quality. But he was also attentive to the decorative unity of the recent paintings he examined. Writer and painter met later in 1894 at Monet's house in Giverny, and following this meeting Cézanne embarked on a portrait of Geffroy, which he left uncompleted after some three months. In 1895 Ambroise Vollard organized the first one-man show of Cézanne's work, and viewers of a modernist persuasion were able to confirm the claims for its significance made by Bernard and Geffroy. The painter subsequently became disenchanted with Geffroy, whom he blamed for a form of public attention that compromised his privacy. The present essay was first published in *La Vie artistique*, third series, Paris, 1894: E. Dentu, pp. 249–60. Our text is taken from the original edition, translated for this volume by Akane Kawakami. (On Geffroy see also VIA3.)

Paul Cézanne will have had, for a long time, a singular artistic destiny. One could define him as a character both unknown and famous, having but rare contact with the public and held to be an influential figure amongst the restless seekers of art, known only to a few, living in a fierce isolation, reappearing and disappearing abruptly from the eyes of his closest friends. As a result of the poorly known facts of his biography, his quasi-secret production, the rarity of his paintings which did not seem to be subject to any of the conventional rules of publicity, he came to possess a sort of bizarre renown; and, already a distant figure, a mystery enveloped his person and his work. The novelty-seekers, those who like to discover things which have not yet been seen by the public, used to speak of Cézanne's paintings with an air of secret understanding, giving each other clues as if they were passwords. Those who approached, with curiosity and enthusiasm, the realms, new to them, of modern art, cultivated fields where one can see the shoots being born and growing taller, all the shoots, both the wheat and the ryegrass; these individuals would question their elders about this ghostly Cézanne, who thus lived on the margins of life, without a care for its main or walk-on parts. What did his paintings look like? Where could one see them? The answer would be that there was a portrait at Emile Zola's house, two trees at Théodore Duret's, four apples at Paul Alexis's, or perhaps that a painting had been seen the week before at Père Tanguy's, the art-supplier of rue Clauzel, but that you had to hurry to find it there, because there were always, for a Cézanne, amateur collectors who were quick to fall on the prey, specimens of which were few and far between. Extensive collections were also talked about, a variety of paintings in considerable numbers: it was necessary to get invited to M. Choquet's in Paris, or M. Murer's in Rouen, or Dr Gachet's in Auvers, near Pontoise, to see them.

In fact, encounters with Cézanne's paintings were rare in the everyday world, because the artist gave up promoting himself very early on, taking part only in the first exhibition of the Impressionists of 1874. Thus one would only glimpse, here and there, a landscape or a still life, a painting most often left unfinished, but with solid and beautiful parts, and one's opinion of it would remain in abeyance.

Ever since, in the artistic milieu, the reputation of Cézanne has asserted itself more, has grown visibly. Cézanne has become a sort of precursor figure claimed by the Symbolists, and it is certainly the case, to keep to the facts, that there exists a clearly established continuity between the painting of Cézanne and that of Gauguin, Emile Bernard and so on. The same goes for the art of Vincent van Gogh. If only from this

point of view, Paul Cézanne deserves to have his name put back to its rightful place. It is certain that, within the independent or Impressionist group, he maintained alongside his colleagues a special talent, an original character, and that there was a bifurcation in his work, a branching out started by him and continued by others. Whether this new path will carry on, and lead to magnificent spaces, or go and lose itself in potholes and marshes, is not what is in question today. That is the future's secret. Whatever happens, Cézanne will have been there as an indicator, and this is the point to retain. Art history is made up of a tracery of main routes and ramifications, and at the very least Cézanne has been at the head of one of the latter.

Another thing is that there is an absolutely unmistakable intellectual link between Cézanne and his successors, and that Cézanne had the same theoretical and synthetic preoccupations as the Symbolist artists. Today, if one so wishes, it is easy to obtain an idea of the sequence of efforts, and of the whole of the work, of Cézanne. Within the space of a few days I was given the opportunity to see twenty-odd of his characteristic paintings, an examination of which will give us as precise a summary of the artist's character as we can hope to attain. Now, the realization which was impressed upon me with a growing strength, and which remains dominant even now, is that Cézanne does not approach nature with an aesthetic programme, with the despotic intention of subjugating nature to a law which he has invented, to subject it to the formula of an ideal which is to be found in him. That is not to say that he has no programme, no law, no ideal; but these do not come to him from art, they come from his enthusiasm and his curiosity, from his desire to possess the things that he sees and admires.

He is a man who looks around himself, about himself, who feels intoxicated by the spectacle which unfolds, and who would transmit the sensation of this intoxication onto the restricted space of a canvas. He puts himself to work, and he seeks out the way to achieve this transposition as truthfully as possible.

This desire for truth, visible in all the paintings of Cézanne, is attested to by all those who were his contemporaries, his friends.

Firstly, by Emile Zola, in the dedication to *My Salon*, a pamphlet of 1866. Let us look at the terms of this dedication, which reveal the most tender intimacy of minds: 'To my friend Paul Cézanne. I experience a deep joy, my friend, in having a téte-à-téte with you…' The writer continues, reminisces over ten years of affection, chats, and when he comes to addressing the question of ideas debated, of systems examined, his conclusion is that Cézanne, like him, has rejected them all, and believes only in life, powerful and individual. This is a first-hand and trustworthy account. Zola and Cézanne, both born in Aix-en-Provence, running around the countryside together, going to school together, both coming to Paris with the same ambition, had shared their thoughts and their dreams, and the writer expresses, with his ideas, the ideas of the painter.

Then we have the testimonies, equally unambiguous, of those who were his companions, Cézanne's painter friends, those who were in the fields with him; Renoir, Monet, Pissarro, witnesses to his labours, who saw him, like themselves, throw himself into the search for the real and its realization through art.

Ceaselessly, as in the days of his adolescence, his youth, when he would go off for weeks to paint in the crevices of the hills and the clearings of the forests, ceaselessly

Cézanne set off to conquer the beautiful things he saw: the ground richly decked out with greenery, the gently curving roads, the strong and living trees, the stones covered with moss, the houses intimately united with the earth, the luminous and profound sky. He loved that, and he loved only that, to the point of forgetting all that was not that, to the point of staying before the same spectacle for hours and hours, days and days, working furiously to penetrate it, to understand it, to express it, – obstinate, searching, diligent, in the manner of shepherds who have found, in the solitude of the fields, the beginnings of art, astronomy and poetry.

It is not with hurried work, with a superficial creation, that he covered these canvases greeted at the exhibitions and the sales with facile mockery. Where many a visitor, many a badly inspired amateur insisted on seeing random daubs, the work of chance, there was on the contrary sustained application, the desire to approach, as close as possible, the truth. Any painting by Cézanne, simple and calm to look at, is the result of ferocious struggles, of feverish work and six months of patience. It was an unforgettable sight, Renoir told me, that of Cézanne installed at his easel, painting, looking at the countryside: he was truly on his own in the world, concentrated, attentive, respectful. He came back the next day, and every day accumulated his efforts, and at times also he went away desperate, returning without his canvas which he had abandoned, on a stone or in the grass, prey to the wind, the rain, the sun, absorbed by the earth, the painted landscape taken back by the surrounding nature.

Even if we did not know this, Cézanne's works would announce it, would affirm this tension towards the real, this patience, this length of time, this nature of an artist of integrity, this conscience so difficult to satisfy. There is all the evidence that the painter is often imperfect, that he was not able to overcome the difficulty, that the obstacle to the realization affirms itself to all viewers. It is a little like the touching search of the Primitives and that not intentionally. There are absences of the atmosphere, of the fluidity necessary for the surfaces to space themselves out and for the faraway objects to be seen at the right distance. The forms at times are awkward, the objects are confused, the proportions are not always established with a sufficient rigour.

But these points are not relevant when we are faced with Cézanne's individual works. He has traced and brought into being some infinitely expressive pages. There he unfurls fair, animated skies, white and blue, he stands his beloved hill of Sainte-Victoire in a limpid ether, the straight trees which surround his country residence in Jas de Bouffan, hillocks of colourful and golden foliage in the environs of Aix, the weighty entrance of the sea into a rocky bay where the landscape is crushed under an atmosphere of extreme heat.

We notice no more the arbitrary distribution of light and shadow which may have been surprising elsewhere. We are in the presence of the painting of a collection of things which appears to be of one piece and whose execution has taken a long time, layer upon thin layer, which has resulted finally in becoming compact, dense, and velvety. The earth is solid, the carpet of grass is thick, of that green nuanced with a bluish tinge which is so much the hallmark of Cézanne, which he distributes in precise dabs in the mass of foliage, spreads in vast

grassy stretches on the ground, and mingles with the mossy softness of tree trunks and rocks. Then his painting takes on the muted beauty of a tapestry, dons a strong, harmonious weft. Alternatively, as in the *Bathers*, coagulated and luminous, it assumes the brilliant and bluish-white look of a lavishly decorated piece of earthenware.

I know of another work by Cézanne, a portrait of a *Gardener* which is to be found at Paul Alexis's, a painting which is too big, the clothing appearing empty, but with a solid head, leaning firmly on his hand, with ardent eyes which really *look*. And finally, we have the famous apples that the painter loved to paint and painted so well. The backgrounds sometimes seem to creep forward somewhat, but the tablecloths, the napkins are so supple, of such nuanced whites, and the fruit are such naive, beautiful objects. Green, red, yellow, in little tuppenny piles, placed on plates, or poured into baskets to the brim, the apples have the roundness, the firmness, and the bright harmonious colours of nature. They are healthy, speak of rusticity, and evoke the good smell of fruit.

Whatever the subject, Cézanne's work has a real sincerity, the mark, at times charming, at times painful, of a will which has satisfied itself or has failed to do so. Often, also, an ingenuous greatness, as in the *Gardener* and the *Bathers*, where the inaccurate figures pose with such pride: that swimmer, for instance, who rests a foot on a mound, and who takes on, with his sad face, his long and muscled limbs, a kind of Michelangelesque appearance, not consciously, of course.

It is true that Cézanne did not, with the full force that he wished for, realize the dream which invaded him when faced with the splendour of nature; that much is certain, and that is his life and the life of many another. But it is also true that his ideas are revealed by them, and that the bringing together of his paintings would attest to a profound sensibility, a rare unity of existence. This man has undoubtedly lived and lives a beautiful internal novel, and the demon of art resides in him.

17 Paul Cézanne (1839–1906) Letters to Joachim and Henri Gasquet

Our earlier extracts from Cézanne's letters, from the 1860s and 1870s (see IVA5), indicated his technical radicalism, and some of the thinking behind it: his sense of the truth that lay beyond the illusory perfection of mere craftsmanship. In the present extracts from letters of 1897 and 1899, Cézanne represents art not as a copy of nature but an independent element in harmony with it. He goes on to speak of the lifelong impulse he felt to express the sensations which the experience of nature caused in him, particularly the experience of his native Provencal landscape. Cézanne wrote at somewhat greater length on his philosophy of art in the correspondence he subsequently conducted with the painter Emile Bernard, after 1900 (see *Art in Theory 1900–1990*). Henri and Joachim Gasquet were father and son: the former a school friend of Cézanne, the latter a young poet. The reference in the second letter here is to an article by Joachim on the town of Aix, where Cézanne himself was born and died. Our extracts are taken from John Rewald (ed.), *Paul Cézanne: Letters*, Oxford: Bruno Cassirer, 1941; fourth revised and enlarged edition, 1976, pp. 261 and 270–1.

Tholonet, 26 September, 1897

My dear Gasquet,

To my great regret I cannot avail myself of your excellent invitation. But as I left Aix this morning at 5 o'clock, I could not return before the end of the day. I have had supper with my mother and the state of lassitude in which I find myself at the end of the day does not allow me to present myself in suitable shape before other people. Therefore, please excuse me.

Art is a harmony which runs parallel with nature – what is one to think of those imbeciles who say that the artist is always inferior to nature? [...]

Paris, 3 June, 1899

My dear Henri,

Last month I received a number of the '*Memorial d'Aix*' which published at the head of its columns a splendid article of Joachim's about the age-old titles to fame of our country. I was touched by his thoughtfulness and I ask you to interpret to him the sentiments which he has re-awakened in me, your old school-fellow at the Pensionat St Joseph; for within us they have not gone to sleep for ever, the vibrating sensations reflected by this good soil of Provence, the old memories of our youth, of these horizons, of these landscapes, of these unbelievable lines which leave in us so many deep impressions.

As soon as I get down to Aix, I shall come and embrace you. For the time being I continue to seek the expression of the confused sensations which we bring with us when we are born. When I die everything will be finished, but never mind. [...]

18 Paul Gauguin (1848–1903) Notes on Colour

Gauguin had begun to conceive of colour as an expressive feature of painting in its own right in the late 1880s. He was influenced in this by Symbolist ideas on the musical qualities of painting, and indeed of poetry, which ultimately harked back to Schopenhauer (cf. IA1). We have included those writings of Gauguin's which are overtly Symbolist in tone in the next section, even though the question of colour remains a preoccupation in them (see VIc9, 12 and 13). The present text betrays less of the Symbolist metaphysic. Instead, Gauguin situates his thoughts on colour in terms of a plainer discussion of nineteenth-century painting. He refers to debates on the relation of form and colour, and contrasts the Impressionists with a looser group of 'modern masters' including Ingres, Delacroix and Puvis de Chavannes (as well as, interestingly, Degas). Gauguin believes the Impressionists will triumph, that they will be 'the official painters of tomorrow', but that their success will be undermined by their continuing debt to Naturalism. For his part, Gauguin claims to pay no heed to nature. He undertakes his art in search of 'pure colour': 'colour alone as the language of the listening eye'. Thus he aims to set the imagination free rather than to echo nature. The notes were written between 1896 and January 1898 in Tahiti. They are reprinted here from Daniel Guérin (ed.), *Oviri. Ecrits d'un sauvage*, Paris: Gallimard,

1974; translated by Eleanor Levieux as *Paul Gauguin: The Writings of a Savage*, New York: Paragon House, 1990, pp. 138–47. Ellipses are retained from that edition.

... The characteristic feature of nineteenth-century painting is the great struggle for form, for colour. For a long time two sides fought to gain the upper hand; today there is a third faction, more bourgeois and therefore less impassioned, which settles combats of this sort by a compromise, as would a judge. Oh King Solomon, how they have travestied your wisdom.

First of all, let's look at both sides, let's see what reasons they have, good or bad.

Form, or draftsmanship, which is infinitely rich in vocables, can express everything and do so nobly, either by line alone or by using tones which shape the drawing and thereby simulate colour. In another age Rembrandt's genius made people believe they saw colour, while Holbein, the German, and Clouet, the Frenchman, made outstanding use of line, and line only.

In the nineteenth century, Ingres still stands out. All of them fully earned their victory.

But why not add to this fine linear work another element, colour, which would complete and enrich it, making a masterpiece still more of a masterpiece? I have nothing against this, but I would like to point out that in that sense it is not another element; it is the same element; this would be coloured sculpture, so to speak. Regardless of whether Michelangelo's *Moses* has one tone or several tones, the outline is always the same. Velázquez, Delacroix, Manet did beautiful colour work, but, once again, the only direct feelings their masterpieces give come from the drawing. They drew with colours. And Delacroix thought he was fighting ... in favour of colour, whereas, on the contrary, he was helping drawing to dominate. His poetic fervour, inspired by Shakespeare, and his impassioned soul could find expression only in drawing. His lithographs and the photographs of his paintings reveal his entire vocabulary. And when I look at his paintings I experience the same feelings as after reading something; on the other hand, if I go to a concert to hear a Beethoven quartet, I leave the hall with coloured images that vibrate in the depths of my being. What happens with Delacroix is also the case with Puvis de Chavannes, and with Degas, to give examples of modern masters.

Then came the Impressionists! They studied colour, and colour alone, as a decorative effect, but they did so without freedom, remaining bound by the shackles of verisimilitude. For them there is no such thing as a landscape that has been dreamed, created from nothing. They looked, and they saw, harmoniously, but without any goal: they did not build their edifice on any sturdy foundation of reasoning as to why feelings are perceived through colour.

They focused their efforts around the eye, not in the mysterious centre of thought, and from there they slipped into scientific reasons. There are physics and metaphysics. In all events, their work was not without value, and some of them, such as Claude Monet, achieved real masterpieces of harmony. Intellect and sweet mystery were neither the pretext nor the conclusions; what they painted was the nightingale's song. They were right in beginning by studying nature in colour (just as his mother's milk readies the child for the day when he will eat more solid food), the necessary evolution which took place in those days, but which should also have been a gradual matter,

culminating in an ultimate development. And that they did not do; I could almost swear that they had no idea that such gradual progress was possible. Dazzled by their first triumph, their vanity made them believe it was the be-all and the end-all. It is they who will be the official painters of tomorrow, far more dangerous than yesterday's.

The latter have a glorious past behind them; they are placed in an edifice built on sturdy foundations; when one of them, no matter how weak he may be, says 'we,' we must bow before him. In their ranks were men like Ingres and Delacroix; today they have men such as Puvis de Chavannes, not to mention others. Then too, the art they talk about (most of them, without understanding it) stands on its own two feet, it is logical, and also it is age-old, which is a source of strength. Moreover, that art has gone all the way; it has produced and will still produce masterpieces.

But the official painters of tomorrow are in a wobbly boat, because it is a jerry-built, unfinished boat. When they say 'we,' who are they? How many of them are there? When they talk about their art, what exactly are they talking about? An entirely superficial art, nothing but affectation and materialism; the intellect has no place in it.

The century is coming to an end and the masses press anxiously about the scientist's door; they whisper, they frown, faces brighten. 'Is it all over?' 'Yes.' A few minutes later: 'No, not yet.' 'What is happening?' 'Is a virgin giving birth?' 'Is a pope becoming truly Christian?' 'Is a hanged man being resuscitated?' Not at all; quite simply it's the question of colour photography, the absorbing problem whose solution is going to make so many unsavoury characters fall down with their behinds right in their . . . At last we will know who is right, Cabanel, Claude Monet, Seurat, Chevreul, Rood, Charles Henry; the painters, the chemists.

Rood and Charles Henry broke colour down, decomposed it, or composed it, if you like. Delacroix naively left aside his worries as poet–painter to run after ladies' purple-shaded yellow hats.

Zola himself, who had so little of the painter in him, and had such a pronounced taste for an asphalt-coloured world [of streetwalkers] (to put it in polite terms), is busy, in Mouret's store, the Bonheur des Dames, fashioning white bouquets combining an infinite number of shades. As you can see, everybody is concerned with colour. I was about to forget Brunetière, such an educated man. At the Puvis de Chavannes banquet, we all listened, somewhat dazed, as he congratulated that great painter . . . on having made such beautiful paintings with pale tones. In your splendid garden only wisteria blooms; no deep-red roses, no scarlet geraniums, no deep-purple pansies, above all no sunflowers, no poppies; cornflowers perhaps! Like the Impressionist gardens. Then too, everyone has a preference for some specific colour. Paul does not like blue, Henri hates green (spinach!), Eugène is afraid of red, Jacques feels sick when he sees yellow. Confronted with these four critics a painter does not know how to account for himself; timidly he tries to say a few words about observation of colours in nature, calling upon Chevreul, Rood, Charles Henry in support of his views, but in vain; the critics howl and then are silent.

And as easily as you let out a fart in order to get rid of someone who's a pain in the neck, Cézanne says, with his accent from the Midi: 'A kilo of green is greener than half a kilo.' Everyone laughs: he's crazy! The craziest person is not the one you think.

His words have a meaning other than their literal meaning, and why should he explain their rational meaning to people who laugh? That would be casting pearls before swine.

The photography of colours will tell us the truth. What truth? the real colour of a sky, of a tree, of all of materialized nature. What then is the real colour of a centaur, or a minotaur, or a chimera, of Venus or Jupiter?

But you have a technique, people will say to me. No, I do not. Or rather, yes, I do have one, but it is very vagabond, very elastic, it depends on the mood in which I wake up in the morning; it's a technique I apply as I like in order to express my thinking, without paying any heed to nature's truth, which is only externally apparent. It is assumed at this time that either through the work of earlier painters – their observations as formulated in their works, then transcribed by literate translators – or through the latest chemical, physical, scientific research by scholars more enamoured of truth than of imaginary things; it is assumed (all of this being gathered in one great sheaf) that the last word has been said concerning painting techniques.

Well, personally, I do not think [so], and I am judging by the many observations I have made and put into practice. Yet if I believe I have found a great deal, then logically I must conclude that there still remains a great deal to be found by other painters; and they will find it.

It would be beside the point, in this slim volume, to set out all those observations; their application would be dangerous for anyone who did not understand more than half of them; you have to make a choice among them according to the mood you are in when you wake up in the morning; each subject to be handled needs a special technique, in harmony with the thinking which guides it. Nevertheless, I am going to discuss it a little for the sole purpose of showing, of sketching merely, the falsehood of truth and the truth of falsehood. I hope that the reader, who is not just anybody and who, above all, is well-meaning, will succeed, despite the sketchiness of this outline, in discovering the true, rational, and nonsupernatural meaning of the shocking things that will be stated for his benefit.

Truth is in front of our eyes, nature vouches for it. Would nature be deceiving you, by any chance? Is truth really naked, or disguised? Though your eyes cannot reason, have they the necessary perfection to discover truth?

Let's look and see, as the sceptical worker would say. The sky is blue, the sea is blue, the trees are green, their trunks are grey, the ground on which they grow is slightly indefinable. All of this, as everybody knows, is called local colour, but the light comes and changes the look of every colour at will. And the sea that we know to be blue, which is the pure truth, becomes yellow and somehow seems to take on a fabulous hue that you can find only at the clothes-dyers'. The shadows on the ground become purple or other colours that are complementary to the tones closest to them. And everyone peers through his opera glasses at the right colour and dexterously applies to the canvas, in squares prepared in advance, the true colour, the genuine colour which for a few seconds is there before his eyes.

All of this toned down a little – it is better to err on the side of less than more, exaggeration is a crime (as everybody knows). But who can guarantee that his colours are true at this very hour, this minute which no one has witnessed, not even the painter who has forgotten the previous minute? Men apply their tones delicately, with

utmost care, for fear of being called coarse; the women apply theirs with vigorous, bold strokes, so as to be considered masculine and jaunty, and hot-blooded (without any other adjective; in studio terms the word 'hot-blooded' is enough). But where is this source of luminous strength? Indeed I see shadows that indicate that the sun must have distorted the local colour, indeed I have heard the servant usher in the king, but I do not see the sun, the king.

This whole heap of accurate colours is lifeless, frozen; stupidly, with effrontery, it tells lies. Where is the sun that provides warmth, what has become of that huge Oriental rug?

When we see that little canvas, with its pretentious claim to imitate nature, we are tempted to say: 'Oh man, how small you are.' And also that a kilogram of green is greener than half a kilo.

I have observed that the play of shadows and zones of light did not in any way form a coloured equivalent of any light. A lamp, or the moon, or the sun can produce as much, that is, an effect; but what makes all these types of light distinct from one another? Colour. The pictorial rendering of these zones of light with the contrasting shadows becomes negative, and the values they embody become negative; it would be merely a literary translation (a signpost to indicate that here is where light, a form of light, resides). And also, since all these zones of light are indicated in the landscape in uniform fashion, mathematically, monotonously, governed by the law of radiance, and since they take over all the colours and they in turn are overtaken by that law, it follows that the wealth of harmonies and effects disappears and is imprisoned in a uniform mould. What then would be the equivalent? Pure colour! and everything must be sacrificed to it. A local-colour, bluish-grey tree trunk becomes pure blue, and so on for all colours. The intensity of colour will indicate the nature of each colour: for example, the blue sea will be of a blue more intense than the grey tree trunk which has become a pure blue, but less intense. And since a kilo of green is greener than half a kilo, then in order to achieve the equivalent (your canvas being smaller than nature) you have to use a green that is greener than the one nature uses. That is the truthfulness of falsehood. In this way your painting, illuminated by a subterfuge, a falsehood, will be true because it will give you the impression of something true (light, power, and grandeur), with harmonies as varied as you could wish. Cabaner, the musician, used to say that in order to give the impression of silence in music, he would use a brass instrument sounding one single high-pitched note rapidly and very loudly. This then would be a musical equivalent, rendering a truth by a lie. Let's not carry the subject any further; as I told you, this is merely a sketch. It can be important only to people concerned with physics. So now I'll leave that aside and talk about colour solely from the standpoint of art. About colour alone as the language of the listening eye, about its suggestive quality (says A. Delaroche) suited to help our imaginations soar, decorating our dream, opening a new door onto mystery and the infinite. Cimabue would have shown posterity the way into this Eden, but posterity answered, Watch out! What the Orientals, Persians, and others did, first of all, was to print a complete dictionary, so to speak, of this language of the listening eye; they made their rugs marvellously eloquent. Ah you painters who demand a technique for colour! study those rugs; in them you will find all that science can teach you, but who knows,

perhaps the book is sealed and you cannot read it. And the recollection of bad traditions obstructs your understanding. For you, the result of seeing colour thus determined by its own charm, yet indeterminate when it comes to designating objects perceived in nature, is a disturbing 'What on earth is that all about?' which defeats your powers of analysis. So what!

Photograph a colour, or several colours; that is, transpose them into black and white, and all you have left is an absurdity, the charm has disappeared. That is why a photograph of a Delacroix, a Puvis de Chavannes, etc., gives us a very rough idea of those paintings; and this proves that their qualities do not lie in their colour. Delacroix, it has been said over and over again, was a great colourist but a poor draftsman. Yet you can see that the opposite is true because the charm that pervades his works has not disappeared in the photographs of them.

As best we could, we have just pointed out and then explained colour as living matter; like the body of a living being. Now we must talk about its soul, that elusive fluid which by means of intelligence and the heart has created so much and stirred so much – about colour that helps our imagination to soar, opening a new door onto mystery and the infinite. We cannot explain it, but perhaps indirectly, by using a comparison, we can suggest its language.

Colour being enigmatic in itself, as to the sensations it gives us, then to be logical we cannot use it any other way than enigmatically every time we use it, not to draw with but rather to give the musical sensations that flow from it, from its own nature, from its internal, mysterious, enigmatic power. By means of skilful harmonies we create symbols. Colour which, like music, is a matter of vibrations, reaches what is most general and therefore most undefinable in nature: its inner power

Outlined so briefly, suggested so enigmatically, this problem of colour remains to be solved, you will say. But who has claimed that it could be solved by a mathematical equation or explained by literary means? It can be solved only by a pictorial work – even if that pictorial work is of an inferior quality. It is enough that the being be created, that it have an embryonic soul; whereupon the progression up to its perfected state ensures the triumph of doctrine.

The battle for painting through colour, thus explained, must be joined without delay. It is all the more appealing for being difficult, for offering a limitless and virgin terrain.

Of all the arts, painting is the one which will smooth the way by resolving the paradox between the world of feeling and the world of intellect. Has this movement of painting through colour been glimpsed, put into practice by someone? I will not draw any conclusions, nor name anyone. That is up to posterity.

And if such a man does exist, are others following him and likewise creating? . . . I would say no. There are indeed some young painters today who are very talented, who are intelligent (possibly too intelligent), but who are not instinctive or sensitive enough. They dare not cast off their shackles (after all, one must earn a living); they illustrate a new literature with the same means as were used formerly to illustrate the old literature – without the musical powers of colour. Then too, the task is cruelly difficult, easily ridiculed. They have not discovered anything by themselves and were never taught anything of what has just been said about colour. No master, that is their slogan: they won't be anyone's disciples, not they! Paintings which announce the

doctrine are right there before their eyes but as the prophet says: 'They cannot read, the book is sealed,' as Jesus says. It is offered to them only in the form of parables, so that seeing, they do not see, and hearing, they do not understand.

I have forgotten to mention the tendencies and aspirations towards this art of colour shown by the English painter Turner, in his second period. Although they are cloudy, the literary descriptions in his paintings actually prevent us from knowing whether, in his case, this art of colour stemmed from instinct or from a very deliberate and definite intellectual determination. It is only fair to mention it, whatever the source may be. Because of his talent, the talent of genius, he was considered mad, and later men like Delacroix were thoroughly shaken by it. But the time had not yet come . . .

VIc
Symbolism

1 Joris-Karl Huysmans (1848–1907) on Gustave Moreau

Huysmans's extensive art critical writings (including VIA4 and 5 in the present anthology) were complemented by a series of fictional works, for which he remains best known. Originally a Naturalist in the group around Zola, by the 1880s he had abandoned Naturalism in favour of a concentration on the subjective and aesthetic dimensions. His most lasting novel, *A Rebours*, which was published in 1884, charts the moods and experiences of a decadent aristocrat. Mingled with its fictional narrative, however, are powerful descriptions of contemporary art. These include evocations of works by Odilon Redon (cf. Vc5 and VIc19), as well as the passage reproduced here on Gustave Moreau. Moreau, born in 1826, was considerably older than Huysmans's generation, but his enigmatic and often erotic paintings struck a chord in the Symbolist milieu. In the present extract, the novel's protagonist Des Esseintes, who is undergoing a spiritual crisis, is absorbed in the solitary contemplation of Moreau's paintings of Salome. The text explores the psychological and sexual impact of Moreau's exotic images. But part of Huysmans's point is that the critical condition in which Des Esseintes finds himself (and in which, by implication, the wider culture is immersed) is beyond the reach of Naturalist art. Des Esseintes turns to Moreau because of 'the longing to see no more pictures of the human form toiling in Paris between four walls or roaming the streets in search of money'. Our extracts are taken from the translation by Robert Baldrick, *Against Nature*, Harmondsworth: Penguin, 1959, pp. 63–73.

Together with the desire to escape from a hateful period of sordid degradation, the longing to see no more pictures of the human form toiling in Paris between four walls or roaming the streets in search of money had taken an increasing hold on him.

Once he had cut himself off from contemporary life, he had resolved to allow nothing to enter his hermitage which might breed repugnance or regret; and so he had set his heart on finding a few pictures of subtle, exquisite refinement, steeped in an atmosphere of ancient fantasy, wrapped in an aura of antique corruption, divorced from modern times and modern society.

For the delectation of his mind and the delight of his eyes, he had decided to seek out evocative works which would transport him to some unfamiliar world, point the way to new possibilities, and shake up his nervous system by means of erudite fancies, complicated nightmares, suave and sinister visions.

Among all the artists he considered, there was one who sent him into raptures of delight, and that was Gustave Moreau. He had bought Moreau's two masterpieces, and night after night he would stand dreaming in front of one of them, the picture of Salome.

This painting showed a throne like the high altar of a cathedral standing beneath a vaulted ceiling – a ceiling crossed by countless arches springing from thick-set, almost Romanesque columns, encased in polychromic brickwork, encrusted with mosaics, set with lapis lazuli and sardonyx – in a palace which resembled a basilica built in both the Moslem and the Byzantine styles.

In the centre of the tabernacle set on the altar, which was approached by a flight of recessed steps in the shape of a semi-circle, the Tetrarch Herod was seated, with a tiara on his head, his legs close together and his hands on his knees.

His face was yellow and parchment-like, furrowed with wrinkles, lined with years; his long beard floated like a white cloud over the jewelled stars that studded the gold-laced robe moulding his breast.

Round about this immobile, statuesque figure, frozen like some Hindu god in a hieratic pose, incense was burning, sending up clouds of vapour through which the fiery gems set in the sides of the throne gleamed like the phosphorescent eyes of wild animals. The clouds rose higher and higher, swirling under the arches of the roof, where the blue smoke mingled with the gold dust of the great beams of sunlight slanting down from the domes.

Amid the heady odour of these perfumes, in the overheated atmosphere of the basilica, Salome slowly glides forward on the points of her toes, her left arm stretched out in a commanding gesture, her right bent back and holding a great lotus-blossom beside her face, while a woman squatting on the floor strums the strings of a guitar.

With a withdrawn, solemn, almost august expression on her face, she begins the lascivious dance which is to rouse the aged Herod's dormant senses; her breasts rise and fall, the nipples hardening at the touch of her whirling necklaces; the strings of diamonds glitter against her moist flesh; her bracelets, her belts, her rings all spit out fiery sparks; and across her triumphal robe, sewn with pearls, patterned with silver, spangled with gold, the jewelled cuirass, of which every chain is a precious stone, seems to be ablaze with little snakes of fire, swarming over the mat flesh, over the tea-rose skin, like gorgeous insects with dazzling shards, mottled with carmine, spotted with pale yellow, speckled with steel blue, striped with peacock green.

Her eyes fixed in the concentrated gaze of a sleepwalker, she sees neither the Tetrarch, who sits there quivering, nor her mother, the ferocious Herodias, who watches her every movement, nor the hermaphrodite or eunuch who stands sabre in hand at the foot of the throne, a terrifying creature, veiled as far as the eyes and with its sexless dugs hanging like gourds under its orange-striped tunic.

The character of Salome, a figure with a haunting fascination for artists and poets, had been an obsession with him for years. [. . .]

But neither St Matthew, nor St Mark, nor St Luke, nor any of the other sacred writers had enlarged on the maddening charm and potent depravity of the dancer. She had always remained a dim and distant figure, lost in a mysterious ecstasy far off in the mists of time, beyond the reach of punctilious, pedestrian minds, and accessible only to brains shaken and sharpened and rendered almost clairvoyant by neurosis; she had

always repelled the artistic advances of fleshly painters, such as Rubens who travestied her as a Flemish butcher's wife; she had always passed the comprehension of the writing fraternity, who never succeeded in rendering the disquieting delirium of the dancer, the subtle grandeur of the murderess.

In Gustave Moreau's work, which in conception went far beyond the data supplied by the New Testament, Des Esseintes saw realized at long last the weird and super-human Salome of his dreams. Here she was no longer just the dancing-girl who extorts a cry of lust and lechery from an old man by the lascivious movements of her loins; who saps the morale and breaks the will of a king with the heaving of her breasts, the twitching of her belly, the quivering of her thighs. She had become, as it were, the symbolic incarnation of undying Lust, the Goddess of immortal Hysteria, the accursed Beauty exalted above all other beauties by the catalepsy that hardens her flesh and steels her muscles, the monstrous Beast, indifferent, irresponsible, insensible, poisoning, like the Helen of ancient myth, everything that approaches her, everything that sees her, everything that she touches.

Viewed in this light, she belonged to the theogonies of the Far East; she no longer had her origin in Biblical tradition; she could not even be likened to the living image of Babylon, the royal harlot of Revelations, bedecked like herself with precious stones and purple robes, with paint and perfume, for the whore of Babylon was not thrust by a fateful power, by an irresistible force, into the alluring iniquities of debauch.

Moreover, the painter seemed to have wished to assert his intention of remaining outside the bounds of time, of giving no precise indication of race or country or period, setting as he did his Salome inside this extraordinary palace with its grandiose, heterogeneous architecture, clothing her in sumptuous, fanciful robes, crowning her with a nondescript diadem like Salammbo's, in the shape of a Phoenician tower, and finally putting in her hand the sceptre of Isis, the sacred flower of both Egypt and India, the great lotus-blossom.

Des Esseintes puzzled his brains to find the meaning of this emblem. Had it the phallic significance which the primordial religions of India attributed to it? Did it suggest to the old Tetrarch a sacrifice of virginity, an exchange of blood, an impure embrace asked for and offered on the express condition of a murder? Or did it represent the allegory of fertility, the Hindu myth of life, an existence held between the fingers of woman and clumsily snatched away by the fumbling hands of man, who is maddened by desire, crazed by a fever of the flesh?

Perhaps, too, in arming his enigmatic goddess with the revered lotus-blossom, the painter had been thinking of the dancer, the mortal woman, the soiled vessel, ultimate cause of every sin and every crime; perhaps he had remembered the sepulchral rites of ancient Egypt, the solemn ceremonies of embalmment, when practitioners and priests lay out the dead woman's body on a slab of jasper, then with curved needles extract her brains through the nostrils, her entrails through an opening made in the left side, and finally, before gilding her nails and her teeth, before anointing the corpse with oils and spices, insert into her sexual parts, to purify them, the chaste petals of the divine flower.

Be that as it may, there was some irresistible fascination exerted by this painting; but the water-colour entitled *The Apparition* created perhaps an even more disturbing impression.

In this picture, Herod's palace rose up like some Alhambra on slender columns iridescent with Moresque tiles, which appeared to be bedded in silver mortar and gold cement; arabesques started from lozenges of lapis lazuli to wind their way right across the cupolas, whose mother-of-pearl marquetry gleamed with rainbow lights and flashed with prismatic fires.

The murder had been done; now the executioner stood impassive, his hands resting on the pommel of his long, blood-stained sword.

The Saint's decapitated head had left the charger where it lay on the flagstones and risen into the air, the eyes staring out from the livid face, the colourless lips parted, the crimson neck dripping tears of blood. A mosaic encircled the face, and also a halo of light whose rays darted out under the porticoes, emphasized the awful elevation of the head, and kindled a fire in the glassy eyeballs, which were fixed in what happened to be agonized concentration on the dancer.

With a gesture of horror, Salome tries to thrust away the terrifying vision which holds her nailed to the spot, balanced on the tips of her toes, her eyes dilated, her right hand clawing convulsively at her throat.

She is almost naked; in the heat of the dance her veils have fallen away and her brocade robes slipped to the floor, so that now she is clad only in wrought metals and translucent gems. A gorgerin grips her waist like a corselet, and like an outsize clasp a wondrous jewel sparkles and flashes in the cleft between her breasts; lower down, a girdle encircles her hips, hiding the upper part of her thighs, against which dangles a gigantic pendant glistening with rubies and emeralds; finally, where the body shows bare between gorgerin and girdle, the belly bulges out, dimpled by a navel which resembles a graven seal of onyx with its milky hues and its rosy finger-nail tints.

Under the brilliant rays emanating from the Precursor's head, every facet of every jewel catches fire; the stones burn brightly, outlining the woman's figure in flaming colours, indicating neck, legs, and arms with points of light, red as burning coals, violet as jets of gas, blue as flaming alcohol, white as moonbeams.

The dreadful head glows eerily, bleeding all the while, so that clots of dark red form at the ends of hair and beard. Visible to Salome alone, it embraces in its sinister gaze neither Herodias, musing over the ultimate satisfaction of her hatred, nor the Tetrarch, who, bending forward a little with his hands on his knees, is still panting with emotion, maddened by the sight and smell of the woman's naked body, steeped in musky scents, anointed with aromatic balms, impregnated with incense and myrrh.

Like the old King, Des Esseintes invariably felt overwhelmed, subjugated, stunned when he looked at this dancing-girl, who was less majestic, less haughty, but more seductive than the Salome of the oil-painting.

In the unfeeling and unpitying statue, in the innocent and deadly idol, the lusts and fears of common humanity had been awakened; the great lotus-blossom had disappeared, the goddess vanished; a hideous nightmare now held in its choking grip an entertainer, intoxicated by the whirling movement of the dance, a courtesan, petrified and hypnotized by terror.

Here she was a true harlot, obedient to her passionate and cruel female temperament; here she came to life, more refined yet more savage, more hateful yet more exquisite than before; here she roused the sleeping senses of the male more

powerfully, subjugated his will more surely with her charms – the charms of a great venereal flower, grown in a bed of sacrilege, reared in a hot-house of impiety.

It was Des Esseintes' opinion that never before, in any period, had the art of water-colour produced such brilliant hues; never before had an aquarellist's wretched chemical pigments been able to make paper sparkle so brightly with precious stones, shine so colourfully with sunlight filtered through stained-glass windows, glitter so splendidly with sumptuous garments, glow so warmly with exquisite flesh-tints.

Deep in contemplation, he would try to puzzle out the antecedents of this great artist, this mystical pagan, this illuminee who could shut out the modern world so completely as to behold, in the heart of present-day Paris, the awful visions and magical apotheoses of other ages.

Des Esseintes found it hard to say who had served as his models; here and there, he could detect vague recollections of Mantegna and Jacopo de Barbari; here and there, confused memories of Da Vinci and feverish colouring reminiscent of Delacroix. But on the whole the influence of these masters on his work was imperceptible, the truth being that Gustave Moreau was nobody's pupil. With no real ancestors and no possible descendants, he remained a unique figure in contemporary art. Going back to the beginning of racial tradition, to the sources of mythologies whose bloody enigmas he compared and unravelled; joining and fusing in one those legends which had originated in the Middle East only to be metamorphosed by the beliefs of other peoples, he could cite these researches to justify his architectonic mixtures, his sumptuous and unexpected combinations of dress materials, and his hieratic allegories whose sinister quality was heightened by the morbid perspicuity of an entirely modern sensibility. He himself remained downcast and sorrowful, haunted by the symbols of superhuman passions and superhuman perversities, of divine debauches perpetrated without enthusiasm and without hope.

His sad and scholarly works breathed a strange magic, an incantatory charm which stirred you to the depths of your being like the sorcery of certain of Baudelaire's poems, so that you were left amazed and pensive, disconcerted by this art which crossed the frontiers of painting to borrow from the writer's art its most subtly evocative suggestions, from the enameller's art its most wonderfully brilliant effects, from the lapidary's and etcher's art its most exquisitely delicate touches. These two pictures of Salome, for which Des Esseintes' admiration knew no bounds, lived constantly before his eyes, hung as they were on the walls of his study, on panels reserved for them between the bookcases.

2 Téodor de Wyzewa (1862–1914) 'Wagnerian Art: Painting'

Téodor de Wyzewa was the adopted name of Theodore Etienne Wyzewski, Polish by birth but resident in France from his early childhood. He is known for the considerable part he played in the spread of Wagnerian ideas in France during the early years of the Symbolist movement, but his familiarity with a number of languages gave him a wider role as an intermediary between intellectual movements in France and those elsewhere. He was close to Laforgue, to Mallarmé and to Fénéon and was co-founder of the *Revue Wagnérienne* with Edouard Dujardin. He also wrote for *La Revue contemporaine*, for *La Vogue*, for *La Revue*

indépendante and for Durand-Ruel's *L'Art dans les deux mondes*. Even among his fellow Idealists in the Symbolist movement he was remarkable for the strength of his belief that it was by human feeling and imagination that 'reality' was properly defined. He was unsympathetic to the claims of science and of rational systems in general, and he was no admirer of Neo-Impressionism. Among contemporary artists he was closest to Renoir. The following text originated as an article in the *Revue Wagnérienne* of May 1886, written, as Wyzewa later recorded, during a time spent 'in the cafés of the Latin Quarter, when I lost my youth in wishing to resolve the insoluble problems of art and of life'. Among the themes deserving of note in this essay are the role accorded to language in fixing concepts, the priority accorded to vision in establishing sensation, the tendency observed in painting to abandon simple forms of realistic correspondence in favour of artifice and sophistication, and the independence allowed to colour and form in producing 'a new kind of music'. In 1895 Wyzewa combined the article with others on the theme of Wagnerian art, making some revisions in the process, so that it formed the second separate section of a longer text under the title 'L'Art Wagnérien: ebauche d'un esthétique idéaliste (1885–1886)' (Wagnerian art: sketch of an idealist aesthetic). This composite text was then included in a book of collected essays, *Nos Maîtres: études & portraits littéraires*, Paris: Perrin et Cie, 1895. Our version is taken from this edition, pp. 11–26, translated for the present volume by Nicholas Walker.

I have long believed that authentic Wagnerianism consisted in more than simply admiring the works of Richard Wagner; that these works must touch us above all as expressions of an artistic theory, and that this theory – elucidated repeatedly by the Master in his written works – calls for the fusion of all forms of art under a common idea. On all admirers of his genius Wagner has imposed the duty of working towards the renewal of art. And he has also shown them the proper means by which, and the ultimate ends for which, art, in all of its forms, must be renewed.

Thus it is that all true Wagnerians cannot limit their attentions solely to music – to a music which, alas! after Wagner is dead; for they must still concern themselves with advancing the Wagnerian spirit in the work of writers, poets and painters as well.

Unfortunately, however, it is not in the painters' Salons that they can properly seek out this Wagnerian art, nor indeed art of any kind: this is, it is true, a misfortune but it by no means merits all the usual expressions of indignation. Under the necessities of the struggle for existence which grows more bitter with every passing day, painters have had to renounce all genuine concern with art. Like every other individual, they too have learnt to obey the economic law of supply and demand; and in this annual market, under the constant pressure of competition and their own needs, they cannot possibly offer authentic artistic creations, since art is precisely not what a democratic society demands of them. Is it not unjustifiably harsh to reproach those who exhibit in 'The Palace of Industry' for not painting genuine works of art, although they make use of techniques (like design and coloration) which can certainly contribute to works of art?; and is it not merely to display total ignorance of the only possible function that a Salon de peinture can be expected to fulfil in future?

For all my considerable respect for them, I have never really understood those critics who vent their rage in the name of art when passing judgement upon these admirable commodities. The most appropriate way of appreciating a Salon, the present Salon for example, would be simply to treat it as a kind of shop, and the

painters who exhibit there as so many industrial workers; one would then proceed to establish, in accordance with the best expertise available, the precise advantages which these different images are capable of delivering to their putative buyers, to establish who these buyers would be, and the cost of supplying the relevant goods to the latter. And if I were not here engaged in speaking only of art proper, in Wagner's memory, I would outline just such a reasonable and unprejudiced critique of the Salon.

I would take full account of the high commercial profile of certain names, of the price which they can command today and that which they will command in the near future. And I would simply omit to mention – for entirely selfish reasons, calculated to lower their market value – certain particularly attractive paintings, conspiring thereby to enrich, at the cheapest possible price, my own little museum where I successfully collect the most entertaining of contemporary entertainments.

But I shall not reveal this useful and intelligent expertise here: for one might just come across works by real artists stranded amongst such wares after all. And before discussing this I must first present the artistic theory of Wagnerian painting, condemned by their presence to forget the products which lie around them, and the fascinating boutique where they are displayed.

I

Painting, as one particular form of art in general, must itself relate to the overall purpose and character of art.

And art, so Wagner tells us, should create life. Why so? Because it must freely pursue the natural function common to all activities of the spirit. This is why the world where we live, and which we call the real world, is a pure creation of the soul. The spirit cannot ever escape from itself; and the things which it believes to be exterior to itself are actually only its own ideas. To see, to hear, this is to create certain appearances within oneself, accordingly to create life. But the funereal character of these same creations has caused us to forget the blissful consciousness of our own creative powers. We have taken these dreams, which we give birth to, for real, and we have taken this personal *I*, limited as it is by things, to be subservient to those things we ourselves have conceived.

As a result we have become enslaved to the world, and our vision of the world, where we have pursued our interests, has ceased to be a source of enjoyment to us. And the Life which we have created, and created precisely in order to experience creative joy for ourselves, has lost this original character. That is why it must be recreated; it is necessary for us to construct, beneath and before this world of familiar appearances, a further sacred world of higher and better life: higher and better because it is one we can freely create for ourselves, and know that it is we who create it. This is the very task of art.

But where is the artist to discover the elements of this higher life? He certainly cannot derive them from anywhere except our own familiar life, from what we generally call 'reality'. Hence the artist, and those to whom he would communicate the higher life he has created, cannot, by virtue of the mental habits they have acquired, erect a living work within their souls unless the latter presents itself to them under the very conditions in which they have always perceived all life before.

This is what explains the necessity of realism in art; not that merely descriptive realism which replicates, without any further purpose, those insubstantial appearances which we take for reality; but rather that artistic realism which detaches these appearances from the false reality of immediate interests where we first perceive them, and transports them into the higher reality of a disinterested life. All around us we behold trees, animals and human beings, all of which we take to be living things; but, perceived in this way, they are merely so many empty images and shadows, lining the moving scenery of our vision: and they will only live when the artist, in whose privileged soul they possess a more intense reality, breathes superior life into them, and *recreates* them before us.

Art must therefore recreate, with total awareness of what it is doing, and by means of *signs* at its disposal, the entire life of the universe, that is, the life of the soul where the multifarious drama we call the universe is played out. But the life of our soul is composed of complex elements; and the differences in their complexity are what produce all the special modes of life which can be reduced, through the abitrariness of classification, to the three distinct and successive forms of sensation, conception and emotion.

In reality they are all constituted by one simple common element, namely sensation.

In the beginning our soul first of all experiences certain *sensations*, phenomena of pleasure and pain: the various colours, resistances, odours, or sonorities, all those things which we believe to be external qualities, but which are actually only interior states of the spirit. Then our sensations begin to collect and combine with one another and, by dint of repetition, acquire limitation and definition: certain groups of sensations come to organize themselves, in abstraction from the original totality of sentience: they are now fixed in *words*. It is thus that *sensations* become *conceptions*; the soul begins to *think* only after it has first *sensed*. Finally, amongst these conceptions a further more refined mode arises: the sensations now entwine themselves into extremely concentrated clusters; the soul now becomes an impression of one vast surge whose waves mingle confusedly with one another. The sensations and conceptions become attenuated, multiply themselves to the point where they eventually become indistinct moments caught up within the total swell. And now they become *emotions*, the urgent intensity of fear, the feverish expression of joy, these rare and ultimate states of the spirit; but even then they remain a confused turbulence of colours, of sounds, of thoughts: and finally a dizzying sense of vertigo.

These three modes of sensation, conception and emotion constitute the entire life of the human soul. And art too, this voluntary and disinterested recreation of life, has – throughout its history – always attempted an aesthetic reconstitution of these three modes of life.

Sensation is the very first mode: the earliest arts took sensation as their immediate object. But sensations are intrinsically diverse, the variety of scents, sounds, flavours, resistances of one kind or another. Was it originally necessary to allot a particular art form to each of these different groups? No, the plastic art of sculpture alone proved sufficient to encompass them all. For, long before the birth of art itself, the various sensations had already become associated with one another; our different senses had acquired the capacity for evoking each other, and one sense above all, that of sight, had developed this suggestive function in the most astonishing manner.

Under the gradual impact of habit our visual sensations have become capable, simply by their very presence, of evoking in us the entire cluster of other sensations. It had now become enough for an individual merely to see colours and thereby also perceive, without further assistance, the texture and resistance of objects, their warmth and smell and sound.

Thus the very first artists felt no need to recreate these different sensations by artificial means. For this purpose it was quite sufficient merely to remake their *visual sensations*.

That is why the art of sensations was, from the very first, the plastic art derived from *vision*.

I cannot begin to trace the history of this plastic art here, to demonstrate how it was always realist in character, and to reveal the various forms it took under the influence of different ways of seeing and perceiving.

First of all came the polychromatic art of the Egyptians, then the monochrome, or rather explicitly colourless, art of the Greeks, no less mindful of fidelity and vitality in their divine creations.

Then came the birth of medieval sculpture, that incomparable statuary which belonged to the great Romanesque and Gothic edifices and translated the spiritual vision of credulous and pious souls into external form with painstaking precision. But finally, despite all those agreeable works by the Florentine and French masters, and despite the Renaissance itself, which for a moment almost succeeded in giving new life to the intellectual outlook of the ancients, sculpture came to an end as a great art. Why was this? Partly because *vision* itself was increasingly becoming the special sense with regard to art, and because the varied play of light was now its essential instrument; but also, and above all, because, as the human spirit becomes increasingly sophisticated, art constantly demands to take advantage of all those procedures which differ from the manner in which reality suggests life itself. Thus a polychrome statue, for example, resembles the models which it has reproduced all too closely by virtue of its own material. Henceforth it proves impossible to reproduce living reality as such: we feel instinctively that if some aspect of the statue does resemble a real individual, then the work is thereby marked by a certain inadequacy, by a defect that can never be eliminated.

Thus again, a drama when read will appear more lively to a refined spirit than the same drama does when it is played in the theatre with living actors. We experience the ever more pressing need, if the artistic sentiment is to be preserved, for the impressions of life to be communicated to us through the life of art by means essentially different from those of real life.

It is this need to which *painting* responds. The means which painting employs to suggest sensations to us in an artistic manner differ completely from the means employed in everyday reality. For the colours and lines of a picture are not simply the reproduction of the colours and lines of reality, which are actually quite different; they are merely conventional signs which have become adequate to what they represent as a result of associating various images; but, in the last analysis, they are as different from real colours and lines as a word is different from a concept, or a musical sound is different from the emotion which it suggests.

And painting, since its glorious appearance in the Middle Ages, will remain a totally realist art, just as sculpture has always been.

The outstanding primitive masters were concerned solely to recreate the sensations which they experienced. Their ignorance of genuine anatomy was a constant factor, although they evinced extreme concern for real expression, and they always painted nature and the human body as they perceived them within the concentrated perspective of their own souls.

Then there came a powerful resurgence of realism with the work of Mantegna, Dürer and Raphael. The human body, hitherto a subject of ignorance, had now made its appearance; and these painters translated the amazing vision which had thereby been vouchsafed to them. The Flemish painters, ever since Jan van Eyck and all the Bruges masters which people enthusiastically like to treat as mystics today, were also marvellous realists, right up to that extraordinary master of the sensible world Franz Hals, the most perfect example of the realist painter.

And the great Velasquez, for his part, was also a most scrupulous realist, who simply possessed a very different soul, and different eyes, from which he then produced different images. Later came David, who recreated the art of the living human face; and finally there arrived painters like Constable, Rousseau, Daubigny and Chintreuil, who resurrected the life of the fields and trees.

After then the vision of reality became more refined still. Certain particular masters, with eyes gifted with an almost morbidly developed sensibility, now taught artists how to perceive things within the very air which bathes them. The vocabulary of painting was changed henceforth as a result. New signs were introduced which served in turn to create new sensations in tune with them.

And in the meantime the art of *conceptions* had constituted itself: namely, literature. And then finally there was the art of *emotions*, music. And after Beethoven, it was Wagner who pursued this art with the greatest power of genius.

But he understood that henceforth music, just like all the other arts, could no longer successfully survive entirely on its own; and he now reunited the three separated forms of art with one another in order to produce the sense of life as a whole.

II

Painting, literature and music each suggest only one mode of life. Now life actually exists as the intimate union of these three modes. Painters, just like writers, could not help perceiving their art to be inadequate to create the entirety of the life which they themselves imagined. Thus it was that they too had long desired to extend the range of their respective arts, to employ them to reconstitute different forms of life. Creative writers, for example, perceived that their words, over and above their precise conceptual signification, had acquired a particular sonority as far as the ear is concerned, and that the syllables of the same, along with the rhythms of phrasing, had become musical sonorities. Thus they now attempted to develop a new art, that of *poetry*. They no longer employed their words simply for their conceptual value, but as sonorous parts of speech, evoking emotion in the soul by means of harmonious verbal concordances.

The same need to translate the life of emotion, and to do so by means of specific artistic procedures, soon forced painters to transcend the limits of an entirely realist reproduction of their sensations.

They thus attempted to create a new kind of painting which permitted a fortunate combination of natural circumstances. This was due to the fact that colours and lines, under the influence of habit, had also, just like words, acquired for the perceiving soul an emotional value quite independent of the objects themselves which were being represented. We have always previously encountered this facial expression, this colour or that profile in association with those objects which inspired in us, for other reasons, this or that particular emotion: hence these colours, these profiles, and these expressions now come to be connected with these emotions within the soul; thus it transpires that such forms become signs not merely of visual sensations but of our emotions as well. Thus these forms have become, through this fortuitous combination, *emotional signs*, just like the syllables of poetry and the notes of music.

Certain painters, therefore, have been able to relinquish the original purpose of painting, which was simply to suggest the precise sensations occasioned by what we saw. They have begun to employ their lines and colours in a purely symphonic form of organization, without regard for the direct depiction of a visual object. And today these lines and colours which have originated in the course of painting can serve the ends of two very different kinds of art: the one purely sensory and descriptive in character, striving to recreate the objects exactly as seen, the other emotional and musical in character, neglecting all concern with the objects represented by their lines and colours and treating the latter simply as signs for our emotions, combining them together in such a way as to produce in us, through free play of their own, a total impression comparable to that of a symphony.

But what is the value and purpose of this new kind of music? And is the music of sounds itself insufficient to translate every possible emotion? It will never be sufficient to do so. The poets and the symphonic painters certainly create emotions, as do musicians, but they create quite different emotions, although it is impossible to define this difference since emotion is, by its very nature, quite indefinable. One only has to recall, for example, a picture by that symphonist called Rembrandt, or one by those masters described as 'colourists'. The objects which they most frequently depict are irrelevant to us; in this regard these painters reveal nothing to us, or what they do reveal is quite deprived of life and reality, powerless to suggest the real life of what we see. Yet their pictures move us above all through the way in which the play of light is composed, through the manner in which their lines are bathed in this light. Every element of the picture here expresses the value of harmonious concordance: and these painters, although they do not really represent what is seen, are none the less powerfully realist in so far as they recreate a total, real and living emotion for us. Yet can one not see how special this emotion is, how different from the emotion suggested to us by a musical work?

This *emotional painting* also has a perfectly legitimate right to exist, alongside of *descriptive painting*, and must be regarded as equally valuable artistically. It is simply the most recent form of painting, as an art characterized by more refined and sophisticated emotions; and it has produced works of no less beauty than other kinds of painting. Its first proper master (after the divine Padre Giovanni di Fiesole

and then Perugino, both of them so different from the realists of their time) was the poet Leonardo da Vinci. He brought forth for us the emotion of an almost lascivious terror in mysterious forms of strange and supernatural expression. And later Peter-Paul Rubens, an artist of no less genius, created the most intense symphonies of colour. There was anxiety and lightness in his touch, he understood the charm of subtle melancholy and the noble bearing of triumphant elation. It is to him that we owe the very greatest masterpiece of emotional painting, the supposed biography of Maria de Medici which has transformed one of the galleries of our Louvre into an enchanted palace: it displays a wonderful disregard for the subject under depiction. These are paradisiac pleasures of dazzling intensity, impulsive and turbulent excitements of the soul, like those induced by the allegro finales of Beethoven, or by that glorious and triumphant music in the last scene of 'Die Meistersinger'. With Rembrandt, on the other hand, we encounter a supernatural play of light and shade, producing at once a more disturbing and withdrawn emotion. Then there was Watteau, who translated the most refined sadness into art and consecrated delicate and sensitive poetry with the wonderful grace of his compositions, in a fashion which recalls certain slow movements in the quartets of Mozart. And finally there is Delacroix, the lyricist of violent passions which are perhaps a little crude in their romanticism.

All these masters have shown that painting can, with equal success, either describe our real sensations or suggest our real emotions. They have simply felt that these two tendencies demanded two different kinds of art, and that they had to choose between them in accordance with their own nature. Today the necessity of such a choice imposes itself even more urgently upon us. And yet our painters, today more than ever before, are still struggling to conflate these two kinds of painting. They wish to be descriptive and emotional painters at the same time, to depict the things which they see, while simultaneously embellishing them any way they like, that is by adding what they call 'a little poetry' to their depictions. As a result they merely create works without any life, deforming what they see in the vain hope of rendering it more poetic and conflating, in a childish and depressing imitation, the rather extravagant procedures of Hals with the emotional procedures of Leonardo da Vinci.

III

Picture-makers, conscientious and forced labourers, and amongst them, a handful of artists abandoned to a wretched compromise, this, in a few words, is how I would describe the 1886 'Salon of Painting', a worthy successor to that of last year, and a worthy antecedent of that of next year. Despite their high commercial value, these exhibitions would give a truly deplorable impression of the present state and probable future of contemporary painting if we were not fortunate enough to know that those master artists who do survive will continue their noble work of artistic creation, far away from the crowd and the Salons, in the solitude which will henceforth protect them.

With a remarkable truthfulness and the advantage of an incomparably subtle eye, Monet, perfecting the work of two authentic and powerful masters, Manet and Cézanne, now analyses the flickering play of light in all its nuances. And Cazin reproduces, with equal truthfulness, quite different kinds of vision: his is the simple

and rather monumental poetry of a naive and sentimental soul. And we have seen how another great contemporary master, Degas, has been able to capture the most elusive secrets of life and movement, just as Hals, and our own great artist Daumier, did before him. Yet emotional painting complicates and modifies its symphonic procedures through the copious admission of much more complex emotions. Gustave Moreau, who one would scarcely have imagined a modern da Vinci in the realm of art, delights in the harmonious arrangement of his iridescent gem-stones. While Odilon Redon attempts to recreate expressions of desperate fear amidst enigmatic landscapes, the cruel images of Felicien Rops give bitter utterance to the vicious passions of a perverse age. And then, as remote from these painters as from any others, there is the most *inspired*, the only truly inspired one amongst them all, Renoir, who spontaneously expresses the soft and artless dreams of an almost child-like soul in displays of colour as ravishing as songs or caresses: he is the only one who can inspire us today, the only one who can speak from the depths of his heart with a voice so strong that no noisy hubbub from outside can possibly drown it out.

Thus it is that even while the utter banality of standard formulas permeates the Salons we none the less witness a splendid flourishing of artistic work in masters such as these. It seems as if before the imminent end of these blessed aberrations that these rare and different souls of the time have somehow refined their differences even further to attempt to surmount their final challenges. When the fatal wave of the oncoming deluge of the new century mounts before us, then the men of true stature will resist being swept away and will seek refuge in the highest of mountains. But sooner or later the invading waters of democracy will penetrate to their lairs. And the sons of these artists, drowned in the equality of needs, will then renounce the vain desire for an art that will no longer find any clients. The day is advancing when, at last, the democratic and egalitarian art of universal suffrage will finally prevail.

3 Gustave Kahn (1859–1939) 'The Aesthetic of Polychrome Glass'

Like Wyzewa, Kahn was a friend of both Laforgue and Mallarmé and a contributor to several of the small journals which served as the literary organs of the Symbolist movement. He was also an exponent of an early form of 'free verse'. His 'Réponse des Symbolistes' was published in September 1886 (see VIc5). In the present *jeu d'esprit*, however, Kahn's inventive literary style is used to give novel treatment to a familiar theme: the dullness of the typical bourgeois environment and the association of colour with modernity. For all the difference in position and in tone, his article offers an interesting point of comparison with William Morris's nearly contemporary 'Art under Plutocracy' (VB5). It was first published as 'De L'esthétique du verre polychrome' in *La Vogue*, Paris, May 1886. Our extracts are taken from the original source, pp. 54–7, 60 and 64–7, translated for this volume by Sabine Jaccaud.

These lines are intended to clarify the role of the glass-making artist in a renaissance of the decorative and plastic arts. To the eye of an attentive observer, this renaissance appears sincere, subjective and has polychromatic tendencies.

It would be pointless to ask ourselves if we should tend towards a polychromatic art. Nothing about us is colourless or monochrome to the eye, especially to the

modern eye that is increasingly perceptive of diversity within a whole. Experiments in a Bunsen burner proved that when the light from bicarbonate of soda erased all colours into blacks and whites, panic ensued. A drawing that only circumscribes empty spaces is impressive in as much as it evokes the colours that have been omitted. Engraving suggests colour by graduated shading and contrasts. Observations in pathology show that individuals place colours naturally in festoons of different directions. Colours, like any form of stimulation, trigger a varying force of response in a subject. Charles Henry establishes through his work that 'variations in the release of available force are represented exactly by changes in the direction of this force'. The maximum strength available is represented by directions of the force upwards and to the right, the minimum by directions downwards and towards the left. Different colours being unequally stimulating, they therefore need to represent themselves to the brain by a difference in direction. The possibility of a rational polychromy exists for an individual. The indecisiveness of these attempted experiments must be catalogued and interpreted in a rational perspective, the one of a normal state of mind.

In our modern cities, was this much-sought-after triumph of white, following the erroneous theories of scale, actually reached? No. Walls are rapidly charged by warm or grey tones. Window hangings are visible, curtains are not always uniformly white. Golds appear on iron fittings, the lower parts of houses are distempered. Trees have been planted and the seasons practise their scales of colour on them. And one must not omit light and crowds! This is no longer a monochromatic set, but a polychromatic one, even if it is restricted in scope. One could only find this uniformity of tones in the rich areas, but what sadness emanates from there as well! This is apparent in the pitiful aspect of plaster-cast groups, of marbles or bronzes piled indigestibly in the courtyard of the Palais de l'Industrie, in salons, in certain deplorable alignments of roughly cut stone, in public gardens.

From where does an eagerness, on summer days, to escape to more open skies, free-running water, greenery, villages springing up from behind trees, capricious reliefs, the light and dark variations in the countryside, ensue? From the common person's attraction towards a diversity of colours.

Does this mean that nature models the polychrome art we ask for? No more than the shiver of trees, the lapping of water and the sounds of speech are music. In the same way that, in this era of ephemeral fashions, essential things encourage increasingly complex colourings. The inclination to use black, considered in the best of taste for a long time, was a habit supported by the bourgeois motto 'nothing dresses better than black' which translates as 'we do not know how to wear colours'. If we smear a few churches with yellow ochre, this too is a sentiment that is close to an admiration for ruins. But what is a ruin if not the revenge of independent colours madly invading things that were once white with ivy, wild flowers, and the dark tint of age. Then, the howls of crowds confronted with colourist painters quietened down into surprise and then a surrender of judgement. The reign of knick-knacks followed, meaning a quest for form and varied shades in furniture. The Orient was extracted from carpets, Japan from vases and plates, India from coppers. One became Algerian, Turkish and paid for coloured pottery and Venetian glass. Without challenging the evocative function in relation to time and distant places that these ornaments carry within them, one

must also see in their fashionable status an attraction towards the joy of colours. We decorate ourselves with these exoticisms, at times bizarre, because of a lack of other things with a similar allure. Walk along the boulevards, consider the shop windows, the ostentatious or bureaucratic furniture, bronzes of a viscous conception, good horses, fond dogs, little women with stiff breasts, bathers, sentimental or pedagogical with their beautiful shop-front smiles; the soft engravings, the tallowish paintings, the purse-snatching display of inconsiderate babblers and audiences. In this distress, cafés made a fortune out of no longer being white and gold. A multiplication of exhibitions of painted cloth attracted people. Theatres with loud sets and confused ballets were pleasing despite the stickiness of their aesthetic. One hoisted fabrics with changeable reflections, and painted dresses were not seen as scandalous. Polychromes were then admitted into the annual Salon.

In Germany, a theoretician named Doctor Treu, author of the treatise 'Sollen wir unsere Statuen bemalen' [Should we paint our statues] organizes conferences preceding exhibitions of painted statues. These proceed either from remains of the Greek technique, or from the old German art that raised so many gaudy Christs on roadsides. But, despite promoting coloured statuettes and busts within a home, Doctor Treu forbids their presence on the square and street. He believes that colours would disintegrate under our climate and that they would look dreadful in our grey décor. He accepts the hegemony of bronze and white marble and encounters with great men perched on improbable pedestals, engaging or sombre in their expression, even if they encourage preposterous thoughts in passers-by. It would be impossible for us to follow this opinion and accept this way of honouring the dead and decorating public places. We think that imaginary groups, realistic or symbolic but always polychromatic, would beneficially alter the dullness of such squares. The paint on these groups would provide a coat of wax that would cover them and seal the pores of the marble. Without maintaining the radiance that animates them in the summer, these marble groups would however be resistant to the atmospheric influences and sulfurous vapors of big cities that chemically transform marble into plaster.

* * *

An aesthete's imagination could contrive a whole piece of furniture, a wall ornament, built to the glory of glass. From a back of enamelled plates that would correspond to each other rather than be alike, arabesques recur and columns seemingly stemming from the bottom would be graded from top to toe with their colours. Between them, resting on vitrified monsters or animals reproduced in volume and colouring, a large shelf from where ornate colonnettes would spring, disappearing into the deepest opacity towards a dark ceiling and emerging, brighter, on a lighter ceiling. The aim would either be to unfold on the surface all colourations, by using molten glass, or to recall the material in use and find the fresh and transparent tones of pale smiles, of frost, of distant tenderness. If, in the room, glass is only partly present, in friezes, medallions or plastic forms, it must use its frigidity to give a sharp accent to the colours expressed by drapes, woods and marbles. In any case, this is the field of the specific inspiration of the decorator.

* * *

There exists no unexplainable paradox in the difference between light and coloured material. All differences stem from a primordial physical fact: the absorption by

coloured substance of a certain amount of light. From this, certain necessary coordinations with subjective consequences ensue, as well as the tendency towards black in painting and its impossibility to achieve at a given time the extreme luminosity that exists in nature. It is this tendency towards darkness which eventually has a depressive effect and is the weakness of all former painting.

Leonardo da Vinci's paintings only allow us to make out a mystery unravelling itself from darkness; Rousseau's landscapes tend towards solidification. However powerful the art of the Impressionist masters, do they manage to portray live reality? After the ferocious struggle of the painter with light and the triumphant moment of the last brush stroke, the tribulations of the canvas begin. From then on it will be time's task to transform the real thing into a fantasy that exists neither in dreams nor in reality. Even at first, during the gallery days, shadows of another hour come and diminish the work. Painting on glass would have, at certain times of the day, a topicality. One who was curious about exact suggestions could, through a simple system of rails, orchestrate a succession of landscapes on a glass-house, as well as set noon-time on fire with outside light and soften sunsets, conjure up the hour and setting of legends through the presence of objects. Following a whim, one could also tint arabesques with different colours. Would this not be the magic dreamt by Charles Baudelaire, the double room, multiple, evocative, happy, the escape from the cages of today?

All analogies encourage belief in the imminent bloom of this new art, all of light and strength, the bloom of works that will have flown far away from academic and conventional ideas.

4 Jean Moréas (1856–1910) 'Symbolism – a Manifesto'

Greek by birth, Moréas emigrated to Paris as a young man. He quickly became established there in the post-Baudelairean 'Decadent' literary circles out of which Symbolism was then emerging. In painting meanwhile, the break-up of the Impressionist group was in train, with the appearance of the 'divisionist' group around Seurat (cf. VIB7). This is not to say that these painters *were* Symbolists in the full sense of the word. Symbolism was in origin a literary movement, as Moréas's manifesto shows. It was not until the end of the decade that a confident sense of Symbolism emerged in the visual arts (cf. VIB8, 9 and 10). Nevertheless, enough shared principles were in evidence to indicate the rise of a new wave in the mid-1880s. These included an antipathy to Naturalism, an attraction to the ideas of Wagner and Schopenhauer, and in politics a widespread embracing of anarchism. In August 1885 an article attacking the 'decadents' gained wide circulation. Moréas issued a quick response, avowing the term 'Symbolism' instead, and went on to compose a positive statement of Symbolist principles the following year. He began by claiming that all arts, including literature, evolve cyclically, with new schools following on the inevitable decline of their predecessors. Thus Romanticism had given way to Naturalism; now Naturalism in its turn was finished. 'Symbolism – a Manifesto' was originally published in the *Supplement littéraire du Figaro*, on 18 September 1886. It was reprinted as 'Le Symbolisme. Manifeste de Jean Moréas' in *Les Premières armes du Symbolisme*, Paris: Léon Vanier, 1889. The present translation was made by Akane Kawakami for this volume.

[...] A new manifestation of art was ... expected, necessary, inevitable. This manifestation, which has long been in gestation, has just been born. And all the anodyne jokes of the pranksters of the press, all the worries of the grave critics, all the ill-temperedness of the public surprised in their sheep-like nonchalance, all this only affirms, more evidently every day, the vitality of the current evolution taking place in French literature, this evolution that hasty judges have classified, by an inexplicable antinomy, as decadence. Note, notwithstanding, that decadent literatures reveal themselves to be essentially hard-headed, long-winded, timorous and slavish: all Voltaire's tragedies, for example, are stamped by these marks of decadence. And what can we blame the new school for, what is it being blamed for? An abuse of pomp, a strangeness of metaphor, a new vocabulary where the harmonies combine with colours and lines: all the characteristics of a renaissance.

We have already proposed the appellation of *Symbolism* as being the only one capable of reasonably designating the current tendency of the creative spirit in art. This appellation may be retained. [...]

The enemy of teaching, of declamation, of false sensibility, of objective description, Symbolist poetry seeks to clothe the Idea with a sensible form which, nevertheless, would not be a goal in itself, but which, at the same time as expressing the Idea, would remain subject to it. The Idea, in its turn, must not be seen to be deprived of the sumptuous trappings of exterior analogies; for the essential character of Symbolist art consists in never going as far as the conception of the Idea itself. Thus, in this art, the scenes of nature, the actions of human beings, all concrete phenomena cannot manifest themselves as such: they are sensible appearances destined to represent their esoteric affinities with primordial Ideas. [...]

In order to achieve a precise translation of its synthesis, Symbolism requires a complex and archetypal style: unpolluted terms, phrases which rear up alternating with phrases with undulating weaknesses, significant pleonasms, mysterious ellipses, anacoluthons in suspense, all the bold and multiform tropes: in short the wholesome language – established and modernized – the good and luxuriant and high-spirited French language of an age prior to the Vaugelas and the Boileau-Despréaux, the language of François Rabelais and of Phillippe de Commines, of Villon, of Ruteboeuf and of many other writers, free and shooting the sharp terms of language as did the poisonous archers of Thrace with their sinuous arrows.

RHYTHM: Traditional metrics enlivened; a skilfully ordered disorder; a rhyme luminous and punctuated like a shield of gold and steel, juxtaposed with rhymes of abstruse fluidity; alexandrines with multiple and mobile pauses; the use of certain uneven lines.

* * *

Prose – novels, short stories, tales, fantasies – is evolving in a direction analogous to that of poetry. Elements which appear heterogeneous participate in this: Stendhal brings to it his translucid psychology, Balzac his exorbitant vision, Flaubert his cadences of amply unfurling sentences, M. Edmond de Goncourt his modern suggestive impressionism.

The concept of the Symbolist novel is polymorphous: at times a single character struggles in an environment deformed by his own hallucinations and his temperament: in this deformation lies the sole *reality*. Beings with mechanical gestures and

silhouettes in shadow bustle around the single character: they are but pretexts for his sensations and conjectures. He himself is a tragic or comic mask of a humanity which is nevertheless perfect, although rational. – At times crowds, affected superficially by the totality of the surrounding representations, are carried through alternatives of clashes and stagnant situations towards acts which remain unachieved. Occasionally, individual *wills* manifest themselves; they attract one another, become amalgamated and generalized towards the achievement of a goal which, whether it is reached or missed, scatters them back into their original elements. – At times mythical phantasms are evoked, from the ancient Demogorgon to Belial, from the 'Kabires' to the Necromancers, appearing luxuriously attired on Caliban's rock or in Titania's forest accompanied by melodies in mixolydian mode on octachords or barbitons.

Thus, disdainful of the puerile method of Naturalism – M. Zola was saved by his marvellous writer's instinct – the Symbolist novel will edify its work of *subjective deformation*, confident in this axiom: that in objectivity, art can only find a simple and extremely limited point of departure.

5 Gustave Kahn (1859–1939) 'Response of the Symbolists'

The Symbolist manifesto published by Moréas in *Figaro* immediately generated a conservative backlash. In response to this, Gustave Kahn issued an amplification of the Symbolist position ten days later in another daily paper, *L'Evénément*. Along with Jules Laforgue, Kahn was then pioneering the development of free verse. Four months earlier he had written in the journal *La Vogue* about the importance of colour in the plastic arts: colour conceived as a stimulus to the imagination rather than a way of accurately copying the appearance of objects (see VIc3). Here he stresses the importance of vocabulary and rhythm in poetry for the same reason. Kahn explicitly cites Zola's Naturalist credo of art as 'nature seen through a temperament' (see IVA6) and sets it against the Symbolist dedication to externalizing the subjective idea. The whole shift turns on the difference between 'subjectifying the objective' and 'objectifying the subjective'. Kahn's text was originally published in *L'Evénément*, 28 September 1886. The present extract is from the translation in John Rewald, *Post Impressionism from Van Gogh to Gauguin* (1956), New York and London: Secker and Warburg, 1978 edition, pp. 134–5.

[. . .] What unifies this tendency is the negation of the old monochord technique of verse, the desire to divide rhythm, to give in the graphic quality of a stanza the scheme of a sensation. With the evolution of minds, sensations become more complicated, they need more appropriate words that are not worn out by twenty years of hackneyed usage. Moreover there is the normal expansion of a language through inevitable neologisms and through the re-establishment of an ancient vocabulary necessitated by a return of the imagination to the epic and the marvellous.

The main way in which we distinguish ourselves from all similar endeavours is that we establish the fundamental principle of perpetual inflection of the verse, or better the stanza, which is considered the basic unit. Banal prose is the tool of conversation. We claim for the novel the right to make the sentence rhythmic, to accentuate its oratorical quality; the tendency is towards a poem in prose, very mobile and with a

rhythmic pattern that varies according to the turn, the swing, the twisting, and the simplicity of the Idea.

As to subject matter, we are tired of the quotidian, the near-at-hand, and the compulsorily contemporaneous; we wish to be able to place the development of the symbol in any period whatsoever, and even in outright dreams (*the dream being indistinguishable from life*). We want to substitute the struggle of sensations and ideas for the struggle of individualities, and for the centre of action, instead of the well-exploited décor of squares and streets, we want the totality of part of a brain. The essential aim of our art is to objectify the subjective (the externalization of the Idea) instead of subjectifying the objective (nature seen through the eyes of a temperament).

Analogous reflections have created the multitonal tone of Wagner and the recent technique of the impressionists. This is an adhesion of literature to scientific theories established by induction and controlled by the experimentation of M. Charles Henry, as stated in an introduction to the principles of a mathematical and experimental aesthetic. These theories are founded on the purely idealistic philosophical principle which prompts us to spurn all reality of matter and which admits the existence of the world only as representation.

Thus we carry the analysis of the *Self* to the extreme, we let the multiplicity and intertwining of rhythms harmonize with the measure of the Idea, we create literary enchantment by annulling the pattern of a forced and spiritual modernism, we compose a personal vocabulary based on the entire gamut of our work, and we endeavour to escape the banality of transmitted moulds.

6 Jean Moréas (1856–1910) 'Chronicle'

The years 1884–6 saw the appearance of a large number of Symbolist publications, some ephemeral, some longer lasting. In addition to the *Révue Indépendante* and *Révue Wagnérienne*, these included *La Révue contemporaine*, *La Vogue* and *Le Symboliste*. The editorial group of *Le Symboliste*, which ran for only four issues, included Gustave Kahn and Paul Adam, as well as Moréas. Moréas's short piece entitled 'Chronique' appeared on the front page of the first issue. The text inhabits a shadowland between obsessive description and flight of fancy, the line beyond which Naturalism tips over into something else; which is precisely Moréas's point. The real *is* fantastic, and an art which is to grasp the phantasmagoric aspect of modernity must escape the shackle of Naturalism. 'Chronique' was first published in *Le Symboliste*, no. 1, 7–14 October 1886. The original text was translated for the present volume by Akane Kawakami.

Under the weight of the flattened skies, in the vehement light of the street lamps, the monstrous and shifty-eyed houses line the street. The carriage wheels bustle about to the limping rhythm of the geldings and the piebald mares; here, the musettes keep time with the leaps of the jesters, lit up in the lamplight, there, the untrustworthy mouths of bald good-for-nothings proclaim the virtue of trinkets. Wearing full-length coats with rolled-up collars, chins covered with hair an ell long, or chancred, or covered with ulcers, are the gentlemen. With abortive smiles and conquered hair-dos, are the women, obsessed with their bodies; on divans and in *Agenouillée* poses in shadowy gardens, their glottis paralysed, women obsessed with their bodies, in veiled

capes. And lecherous secular monks in ecstacy over curvaceous orbs, card-players belonging to expert cliques, scribblers of disturbed anti-talent, traffickers of political Bulls, dishonest speculators at their weighing scales, crafty clerks, swimming lords, Swiss pseudo-philosophers from the canton of Vaud, donkey shearers, instantaneous ague curers, skinners of eels from the tail end, – under the vehement light of the street lamps, amongst the shifty-eyed and monstrous constructions, – the superfluous bites of the whimsical goddesses of fate who fly about...

– But where, asked Vondervotteimittiss, what fairytale land are you talking about?

– About the boulevard des Italiens, quite simply, answered Fortunato.

– But your painting is *false*, in every way.

– Mr Vondervotteimittiss, said Fortunato, *objective reality is but pure semblance, a vain appearance which I am free to vary, transform or annihilate as I wish.*

7 Edouard Dujardin (1861–1949) 'Cloisonnism'

Dujardin founded the *Révue Wagnérienne* in 1885, following the appearance of the *Révue Indépendante* under Fénéon's editorship in 1884. In 1886 the two joined forces to produce an improved version of the *Révue Indépendante* which included for the first time reproductions of visual art. They also began to hold exhibitions at the journal's premises. There seems little doubt that the search was on for something new that could count as a properly Symbolist form of visual art. Existing candidates included the fantasies of Moreau and Redon, and the Divisionists centred on Seurat. The former, however, were relatively conventional in their pictorial space and modelling, if not in their subjects. And the latter obviously descended from Impressionism, with its roots in the now despised painting of modern life. In 1887–8, the painters Louis Anquetin and Emile Bernard began to experiment with a radical simplification of form and colour derived from the examples of popular Epinal prints, Japanese prints, and stained glass. Dujardin, a school friend of Anquetin, wrote the following review of paintings exhibited by him in the offices of the *Révue Indépendante*, and subsequently in March 1888 at the Salon des Indépendantes. He dubbed them 'cloisonniste' after the metal compartments (*cloisons*) used to separate coloured enamels. Bernard objected that the priority was in fact his. Indeed, it seems to have been the sight of his painting which in 1888 stimulated Gauguin to produce *Vision After the Sermon* (exhibited in 1889), perhaps the defining 'cloisonnist' work. 'Le Cloisonnisme' was originally published in the *Révue Indépendante*, March 1888. We reprint the extracts translated in Henri Dorra (ed.), *Symbolist Art Theories*, Berkeley and London: University of California Press, 1994, pp. 179–81. (Internal ellipses without brackets are Dujardin's own).

[...] Anquetin had never exhibited until last month. His first acknowledged works were hung at the exhibition of Les XX in Brussels. They will be shown at the Indépendants exhibition in Paris at the end of March. His selection includes a series of paintings and a group of drawings. [...]

At first sight, these works look like decorative paintings: solid outlines and violent colour in distinct patches that inevitably remind one of folk imagery and japanism. Then, under the generally hieratic character of drawing and colour, one perceives a truth of sensation emerging from the romanticism of frenzied execution; and, above all, something deliberate, reasoned out, intellectually and systematically constructed, that requires analysis.

The point of departure is a symbolic conception of art. In painting, as in literature, nature is a chimera; the ideal representation of nature (whether or not seen through a temperament) is the trompe l'oeil. And why is it that in a trompe l'oeil painting the figures do not move? . . . Why do we not hear them? . . . The concern with the representation of nature logically turns theatre into the supreme art. The purpose of painting, of literature, in contrast, is to provide, by means specific to each, the *feeling* of things. Not the image but the *character* should be expressed. Once this principle is accepted, what is the point of reproducing the thousand details the eye perceives? One must seize the essential trait, reproduce it, or, even better, produce it; a silhouette suffices to express a physiognomy; the painter, ignoring all that is photographic, with or without retouching, only seeks to put down, in a few lines and in characteristic colours, the intimate reality, the essence of the object he sets out to paint.

Primitive art and naive art – which is the continuation of popular art in the contemporary era – are symbolic in this way. The imagery of Epinal relies on the drawing of outlines. At the height of their craft, ancient painters had adopted this technique. Such also is Japanese art . . .

What practical application can we draw from these observations?

In the first place, one must stress a definite distinction between drawing and coloration. To confuse line and colour – one must not bring up the futile claim that lines do not exist in nature – is to misunderstand the special means of expression of each: line expresses what is permanent, colour what is momentary; line, an almost abstract sign, gives the character of the object; the unity of colour determines the atmosphere, fixes the sensation. Whence the circumscription of colour by line as conceived in popular imagery and Japanese art; the Epinal and Japanese artists first draw lines and within them, with the help of templates, add colour; in the same way the painter draws continuous lines forming closed loops, applying inside them the various hues whose juxtaposition must give the sensation of the desired overall coloration, the drawing strengthening the colour and the colour the drawing. The work of the painter resembles painting *by compartments*, analogous to the cloisonné manner, and such a technique consists in a sort of cloisonnism.

That Louis Anquetin should have reached the stage of perfectly implementing this theory, I am still far from claiming; but it is evident that, thanks to remarkable gifts as an artist and a painter, a true knowledge of his craft, and an assiduously rigorous logic in pursuing his idea, he has been able, in the few canvases he has produced, to give a notable example of what he wants to accomplish. His *Mower*, a mower in a wheatfield, a path in the foreground, houses in the rear: the path, edged with grass; the grass, a few shorn clumps; the wheatfield; some ears of wheat that suggest a general movement. Above, bushes with flamelike tips. The houses, silhouettes that strengthen the character of the setting.

As for colour, the light is that of an August noon seen head-on (the landscape being between the sun and the spectator); incandescent light, orangy sensation; the hues of the different areas of the picture are coordinated within the general gamut; there are no complementaries, which would destroy unity. The need for antitheses to heighten the effect is denied here, as in some literature.

It is evident that a different coloration would yield a different sensation. It is as if he saw the landscape through a coloured glass.

8 Paul Sérusier (1863–1927) Letter to Maurice Denis

After an initial interest in philosophy, Sérusier studied art at the Academie Julian in Paris, from 1886. Here, in 1888, the *Nabi* group was formed. The present letter is usually taken to be a statement of their artistic principles. The term 'Nabi' is Hebrew for 'prophet', and the doctrine in question was, in substance, Gauguin's version of Symbolism. Sérusier made Gauguin's acquaintance painting in the artistic colony at Pont Aven in Brittany in the summer of 1888. It was here that he painted *The Talisman* under Gauguin's close instruction: a small landscape of trees reflected in water, painted in heightened, non-naturalistic red, yellow, blue and green (now in the Musée d'Orsay). The following year he went back to Brittany to paint with Gauguin again. It was then that Sérusier painted on the wall of the Pension Gloanec, where the group lodged, the *credo* from Wagner reproduced here. He also wrote to the young artist and critic Maurice Denis about the ideas that were circulating in the group around Gauguin. Principal among these were a desire to differentiate art from craft; and a concern to centre the notion of art on internal harmonies of colour and form rather than on the imitation of external things. These ideas had a substantial influence on the longer theoretical statement then being composed by Denis (see Vc10). Sérusier's letter of 1889 was published, with the quotation from Wagner, in Mme. P. Sérusier and Mlle. H. Boutarie (eds.), *Paul Sérusier: ABC de la peinture, suivi d'une correspondance inédite*, Paris: Librairie Fleury, 1950, pp. 42–5. The translation has been made by Akane Kawakami for the present volume.

I believe in a Last Judgement in which all those who in this world will have dared to peddle sublime and chaste art will be condemned to terrible punishments, all those who will have soiled and degraded it by the baseness of their feelings, by their vile covetousness for material pleasures.

I believe that on the other hand the faithful disciples of great art will be glorified and, enveloped in a celestial fabric of rays, perfumes and melodious chords, they will return to lose themselves forever at the heart of the divine origin of all harmony.
(R. Wagner)

Pouldu

Brother Nabi,
To a philosophical letter, a 'ditto' reply. I know some who would be annoyed by this, but you are not one of them.

First and foremost, I apologise for the incoherence of my last letter, started in a moment of bitterness and disgust and finished off during a period of unreasoned relief. I repent of what I said to you about Gauguin, he has nothing in him of a charlatan, at least not towards those he knows have the power to understand him. For the past fortnight, I have been living in the most profound intimacy with him, sharing the same room. We have talked about what displeased me in his work, they are the consequence of a few contradictory whims, and the habits of modern painting.

Let's come back to our philosophy.
I'm not trying to establish a formula for art. To subdivide and analyse:

PAINTING

I. – ART	II. – CRAFT
a) immutable principles b) personality	a$'$) knowledge b$'$) skill

a) There are immutable principles in art. There is a science, called aesthetics, which teaches them. Today this science is defunct. In the happy age of the Primitives, it existed as a tradition, if not in writing (in Japan as well). To be sure of this it is enough to see the impeccable harmony of line and colour that one encounters in them. These principles, forgotten little by little, have been rediscovered wholly or partly by several extraordinary geniuses such as Rembrandt, Velazquez, etc., Delacroix, Corot, Manet. These principles can be deduced from innate principles in ourselves, from ideas of harmony common to all men who have not been spoiled. They can be discovered through induction by observing, in the work of very different masters from all ages and countries, points they have in common; they are the laws of Harmony in line and colour.

b) I respect personality: it is an abstract thing. Given a certain quantity of lines and colours forming a harmony, there is an infinite number of ways of arranging them. The literary side, in painting, is a secondary part of personality; it can exist, it must exist even, but only as a pretext; if it becomes dominant, we descend into illustration. As you can see, I do not want to lay down rules about personality. Harmony is the variety that we bring to unity. In cases where individual personality is lacking, it is possible to make beautiful things with the character of a people or of a country, for example: Gothic cathedrals, Egyptian art.

a$'$) Knowledge, if it is not absolutely necessary, is never a bad thing. Through it much fumbling can be avoided, but above all it is necessary to avoid confusing it with b$'$), skill. The former can be taught. The latter must not be; it must even be suppressed. In order to express the work of art, one needs a system of signs, a writing; but calligraphy is unnecessary for the man of letters. What happens in the case of writing will also happen, of necessity, for manual skill: if one neglects to take special care of it, it will become all the more personal because it is awkward.

To sum up, a) and a$'$) must be learnt, it is necessary to constitute formulae of them; b) remains absolutely free, and b$'$) should be left alone. The more precisely a) and a$'$) are established, the more freedom of action b) will have.

I don't know if I am being clear: I would need to write a fat book to express my ideas, with supporting examples; we will talk about it again. In painting today, a) and a$'$) don't exist. b) is enslaved and b$'$) is resplendent in all its glory: it is art turned upside down; we will talk about all this this winter.

In a few days time I go to Villerville to join my family; then I have my twenty-eight days. So I will not do much painting before my return to Paris, where I will start working on the documents I have gathered here.

Good bye, brother; it is good to talk to you from time to time.

9 Paul Gauguin (1848–1903) Notes on Painting

After an adventurous early life, Gauguin had begun to take an interest in painting in the mid-1870s, while working as a stockbroker. He had a landscape accepted for the Salon of 1876. Over the next five years he built up a collection of Impressionist paintings, and became acquainted with the artists. From 1879 he showed his work at the Impressionist exhibitions. When the stockmarket crashed in 1883, Gauguin lost his job, and thereafter turned full-time to art. For the next few years he remained a somewhat muted Impressionist, but by the middle of the decade, with the emergence of Seurat and divisionism, he came to see Naturalism as 'an abominable error'. Under the growing influence of Symbolist ideas, Gauguin began to see art as an independent, expressive medium, more like a kind of instantaneous music than a picture of the natural world. Colour took on an unprecedented importance, as it did also for others of his generation such as van Gogh and Cézanne (see VIв3, 17 and 18). It was in search of such an independent art that Gauguin was led to abandon the urban modernity which had succoured Impressionism, in favour of more 'primitive', and hence authentic, locations. By the time of the present notes, Gauguin had developed his 'Synthetism', or 'Cloisonnism' (cf. VIc7). Paintings in this style, such as the *Vision after the Sermon* confirmed the rupture with his erstwhile Impressionist colleagues, most notably Pissarro (see VIc11). They were first publicly seen in 1889 at Volpini's 'Grand Café des Beaux-Arts' in an exhibition held by the Synthetist artists to coincide with that year's World's Fair. The 'Café Volpini' exhibition has subsequently been taken to mark the emergence of the new avant-garde phase. The present notes were written in one of Gauguin's Brittany sketchbooks in *c.* 1889–90. They remained incomplete. Our present text is taken from John Rewald, *Gauguin*, New York and Paris: Hyperion Press, 1938, pp. 161–3.

Painting is the most beautiful of all arts. In it, all sensations are condensed, at its aspect everyone may create romance at the will of his imagination, and at a glance have his soul invaded by the most profound memories, no efforts of memory, everything summed up in one moment. Complete art which sums up all the others and completes them. Like music, it acts on the soul through the intermediary of the senses, the harmonious tones corresponding to the harmonies of sounds, but in painting, a unity is obtained which is not possible in music, where the accords follow one another, and the judgement experiences a continuous fatigue if it wants to reunite the end and the beginning. In the main, the ear is an inferior sense to the eye. The hearing can only grasp a single sound at one time, whereas the sight takes in everything and at the same time simplifies at its will.

Like literature, the art of painting tells whatever it wants, with the advantage of letting the reader immediately know the prelude, the direction, and the dénouement. Literature and music ask for an effort of memory to appreciate the whole. This last art is the most incomplete and the least powerful.

You may dream freely when you listen to music as well as when you look at painting. When you read a book you are the slave of the author's mind.

Sight alone produces an instantaneous impulse.

But then, the men of letters alone are art critics, they alone defend themselves against the public. Their preface is always defence of their work, as if a really good work would not defend itself by itself.

These gentlemen flutter about the world like bats which flap their wings in the twilight, so that their dark mass appears to you in every direction; animals disquieted by their fate, and their too heavy bodies which prevent them from rising. Throw them a handkerchief full of sand and they will stupidly make a rush at it.

One must listen to them judging all human works. God has made man after his own image which, obviously, is flattering for man. 'This work pleases me and is done exactly the way I should have conceived it.' All art criticism is like that. To be in keeping with the public, to seek a work after its image. Yes, gentlemen of letters, you are not capable of criticizing a work of art, even a book. You are already corrupt judges, you had beforehand a ready-made idea, that of the man of letters, and you believe too much in someone else's mind. You do not like blue, since you condemn all blue paintings. If you are a sensitive and melancholy poet, you want all compositions to be in a minor key. Such a one likes graciousness, and he must have everything that way. Another one likes gaiety, and he does not understand a sonata. Intelligence and knowledge are necessary to judge a book. To judge painting and music special sensations in nature are necessary besides intelligence and artistic science. In short, one has to be a born artist, and few are chosen among all those who are called. Any idea may be formulated, but not so the sensations of the heart. What efforts are needed to master fear, or a moment of enthusiasm! Is not love often instantaneous and nearly always blind? And to say that thinking is called spirit, whereas the instincts, the nerves, and the heart are part of matter. The irony of it!

The vaguest, the most undefinable, the most varied, that is matter. Thinking is a slave of sensations.

Nature is above man.

Literature is human thinking described by words.

With whatever talent you may tell me how Othello comes, with his heart devoured by jealousy, to kill Desdemona, my soul will never be as much impressed as when I have seen Othello with my own eyes entering the room, his forehead presaging the storm. Therefore you need the theatre to complement your work.

You may describe a storm with talent, but you will never succeed in conveying to me the sensation of it.

Instrumental music as well as numbers are based on a unit. The entire musical system derives from this principle, and the ear has got used to all the divisions, but you may choose another base and the tones, half-tones, and quarter-tones, follow each other. Out of these you will have varying tones. The eye is less used to these variations than the ear, but then, the divisions are more manifold, and for further complication there are several units.

On an instrument you start from one tone. In painting you start from several. Thus, you begin with black and divide up to white – first unit, the easiest and also the most in use, consequently the best understood. But take as many units as there are colours in the rainbow, add those made up by composite colours, and you will have a rather respectable number of units, truly a Chinese puzzle, so that it is not astounding that the colorist's science has been so little investigated by the painters, and so little understood by the public. On the other hand, what richness of means to attain to an intimate relationship with nature.

They reprove our colours which we put unmixed side by side. In that domain we are perforce victorious, since we are powerfully helped by nature, which does not proceed otherwise.

A green next to a red does not result in a reddish brown like the mixture, but in two vibrating tones. If you put chrome yellow next to this red, you have three tones complementing each other and augmenting the intensity of the first tone: the green.

If, instead of the yellow, you apply blue, you will find three different tones, but vibrating through one another.

If instead of the blue, you apply a violet, the result will again be a single tone, but a composite one, belonging to the reds.

The combinations are unlimited. The mixture of colours results in a dirty tone. One colour alone is a crudity and does not exist in nature. They only exist in an apparent rainbow, but how well rich nature took care to show them to you side by side in an arbitrary and unalterable order, as if each colour was born out of another!

Now, you have fewer means than nature, and you condemn yourselves of all those which it puts at your disposal. Will you ever have as much light as nature, as much heat as the sun? And you speak of exaggeration, but how can you be exaggerating, since you remain below nature?

Ah! If you mean by exaggerated, any badly balanced work, then you are right in that respect. But I must draw your attention to the fact that, even if your work be timid and pale, it will be considered exaggerated, if there is a mistake of harmony in it.

Is there then a science of harmony? Yes.

And in that respect, the feeling of the colorist is exactly the natural harmony. Like singers, painters sometimes sing out of tune, and their eyes have no harmony.

Later there will be, through studies, an entire method of harmony, unless people omit to study it in the academies and in the majority of the studios. In fact, the study of painting has been divided into two categories. One learns to draw and then to paint, meaning that one colours inside of a ready-made contour, very much as a statue might be painted afterwards.

I admit that, so far I have understood only one thing about this practice, and that is that the colour is nothing but an accessory. 'Sir, you must draw properly before painting' – this said in a professorial manner; the greatest stupidities are always said that way.

Do you put on your shoes like your gloves? Can you really make me believe that drawing does not derive from colour and vice versa? And to prove it, I commit myself to reduce or enlarge one and the same drawing, according to the colour which I use to fill it up. Try to draw a head of Rembrandt in exactly the same proportions, and then put on it the colours of Rubens, and you will see what a misshappen thing you will have, and at the same time, the colour will have become unharmonious.

For centuries, important amounts of money have been spent on the propagation of drawing, and the number of painters is increasing without progressing in the least. Who are the painters we admire at the present moment? All those who reproved the schools, all those who drew their science from personal observation of nature. Not one . . .

10 G.-Albert Aurier (1865–1892) from 'Symbolism in Painting: Paul Gauguin'

For material on Aurier see also VIB4. Among Symbolist writers Aurier was one of the most determined in asserting the priority of the Idea and in disparaging what he saw as the materialistic preoccupations of Realism. In the present essay he argues that the alternative to Realism is not Idealism, by which he means Classicism, but Symbolism, which he represents as the pursuit of the pure idea. The quotation he cites from the painter Boulanger refers to the choice between heroic figures in antique costume (the classical 'helmet') and lowly figures in modern dress (the realist 'cap'). Aurier's implication is that such choices merely concern the forms of art's reference to the world of objects, and that they are therefore in the end irrelevant to the 'essential life' of art. Though Aurier quotes Baudelaire's poem *Correspondences* (IIID4), and though his dissociation of art from imitation is thoroughly Baudelairean, it is clear that the form of modernism he now proposes is one in which the earlier writer's call for a painting of modern life – and of modern *dress* – is no longer heard to any critical effect (cf. IID13 and IIID8). The tendency that Aurier represents is one in which response to modernity as a social and historical condition seems no longer to be a condition of the achievement of modernism in art. Though Gauguin's work is its ostensible subject, the essay is in effect a form of Symbolist manifesto for which Gauguin's work of the time appeared to furnish appropriate illustration. The characteristics by which it was qualified were a deliberately anti-naturalist use of colour, a marked formalization of the kind associated with primitive forms of art, and a repertoire of motifs from which the accustomed emblems of modern life had been carefully purged. This was a very different Gauguin from the one whose *Nude Study* Huysmans had praised ten years previously for its Realism and its modernity (see VIA4). Aurier's essay was originally published as 'Le Symbolisme en peinture: Paul Gauguin' in *Mercure de France*, Paris, II, 1891, pp. 159–64, and was reprinted in G.-Albert Aurier, *Oeuvres posthumes*, Paris: Mercure de France, 1893, pp. 211–18. This translation by H. R. Rookmaaker and H. B. Chipp is taken from H. B. Chipp (ed.), *Theories of Modern Art*, Berkeley and Los Angeles: University of California Press, 1968, pp. 89–93.

It is evident – it is almost trite to state it – that there exist in the history of art two great contradictory tendencies, of which, unquestionably, the one depends on blindness and the other on the clairvoyance of that inner eye of man on which Swedenborg speaks. They are the realist trend and the ideistic trend. (I do not say idealistic; we'll see why.)

Without a doubt, realistic art – that is, art of which the one and only aim is the representation of material externals, the sensory appearances – constitutes an interesting aesthetic manifestation. It shows the worker's soul in a certain way, as in a reflection, as it shows us the deformations that the object has undergone in going through it. Indeed, no one challenges the fact that realism, even if it has been a pretext for numerous abominations, as impersonal and banal as photographs, has often produced incontestable masterpieces, resplendent in the museum of our memories. But yet, it is not less unchallengeable for anyone willing to reflect truthfully, that ideistic art appears to be more pure and more elevated – more pure and more elevated through the complete purity and the complete elevatedness that separates matter from idea. We can even affirm that the supreme art cannot but be ideistic, art by definition

(as we know intuitively) being the representative materialization of what is the highest and the most truly divine in the world, of what is, in the last analysis, the only thing existent – the Idea. Therefore, those who do not know about the Idea, nor are able to see it, nor believe in it, merit our compassion, just as those poor stupid prisoners of the allegorical cavern of Plato did for free men.

And yet, if we except most of the Primitives and some of the great masters of the Renaissance, the general tendency of painting has been up until now, as everyone knows, almost exclusively realist. Many even confess to be unable to understand that painting, that art which is *representational* par excellence, and capable of imitating all the visible attributes of matter to the point of illusionism, could be anything else but a faithful and exact reproduction of objectivity, an ingenious facsimile of the so-called real world. Even the idealists themselves (who, I repeat, one should be careful not to confuse with those artists whom I wish to call ideist), were almost always, whatever they themselves pretended to be, nothing but realists; the goal of their art was nothing but the direct representation of material forms; they were content *to arrange* objectivity, following certain conventional and prejudiced notions of quality; they prided themselves upon presenting us *beautiful* objects – that means *beautiful as objects* – the interest in their works always residing in qualities of form, that is to say, of reality. What they have called ideal was never anything but the cunning dressing up of ugly tangible things. In one word, they have painted a conventional objectivity, which is yet objectivity, and, to paraphrase the famous saying of one of them, Gustave Boulanger, there is after all little difference between the idealists and the realists of today but a choice 'between the helmet and the cap.'

They are also poor stupid prisoners of the allegorical cavern. Let us leave them to fool themselves in contemplating the shadows that they take for reality, and let us go back to those men who, their chains broken and far from the cruel native dungeon, ecstatically contemplate the radiant heavens of Ideas. The normal and final end of painting, as well as of the other arts, can never be the direct representation of objects. Its aim is to express Ideas, by translating them into a special language.

Indeed, in the eyes of the artist – that is, the one who must be the *Expresser of Absolute Beings* – objects are only relative beings, which are nothing but a translation proportionate to the relativity of our intellects, of Ideas, of absolute and essential beings. Objects cannot have value more than objects as such. They can appear to him only as *signs*. They are the letters of an enormous alphabet which only the man of genius knows how to spell.

To write his thought, his poem, with these signs, realizing that the sign, even if it is indispensable, is nothing in itself and that the idea alone is everything, seems to be the task of the artist whose eye is able to distinguish essences from tangible objects. The first consequences of this principle, too evident to justify pause, is a necessary *simplification in the vocabulary of the sign*. If this were not true, would not the painter then in fact resemble the naive writer who believed he was adding something to his work by refining and ornamenting his handwriting with useless curls?

But, if it is true that, in this world, the only real beings cannot but be Ideas, and if it is true that objects are nothing but the revealers of the appearances of these ideas and, by consequence, have importance only as signs of Ideas, it is not less true that to our human eyes, our eyes of proud *shadows of pure beings*, shadows living unconscious of

their illusory state and the animated deceit of the spectacle of fallacious tangible things, I say, it is not less true that to our near-sighted eyes objects most often appear to be nothing but objects, nothing else but objects, independent of their symbolic meaning – to the point that often we are not able even by sincere efforts to imagine them to be signs.

This fatal inclination to consider in practical life the object as nothing but an object is evident and, one can say, almost general. Only the superior man, illuminated by that supreme quality that the Alexandrians rightly called ecstasy, is able to persuade himself that he himself is nothing but a sign thrown, by a mysterious preordination, in the midst of an uncountable crowd of signs; only he, the conqueror of the monster illusion, can walk as master in the fantastic temple

> whose living pillars
> sometimes give forth indistinct words

while the imbecile human flock, duped by the appearances that lead them to the denial of essential ideas, will pass forever blind

> through forests of symbols
> which watch him with familiar glances.

The work of art should never lend itself to such a deception, not even for the eyes of the popular herd. The art-lover, in fact (who is not an artist at all and consequently in no way has insight into the symbolic correspondences), would find himself before the work of art in a situation analogous to the crowd before the objects of nature. He would perceive the objects represented only as objects – that which must be avoided. It is necessary, therefore, that the ideistic work does not produce this confusion; it is necessary, therefore, that we should attain such a position that we cannot doubt that the objects in the painting have no meaning at all as objects, but are only signs, words, having in themselves no other importance whatsoever.

In consequence certain appropriate laws will have to rule pictorial imitation. The artist will have, necessarily, the task to avoid carefully this antimony of all art: concrete truth, illusionism, *trompe l'oeil*, in order not to give in any way by his painting that deceitful impression of nature that acts on the onlooker as nature itself, that is, without possible suggestion, that is (if I may be pardoned for the barbarous neologism), not ideistically.

It is logical to imagine the artist fleeing from the analysis of the object in order to guard himself against these perils of concrete truth. Every detail is, in fact, really nothing but a partial symbol, most often unnecessary for the total significance of the object. The strict duty for the ideistic painter is, therefore, to realize a rational selection among the multiple elements combined in objectivity, and to use in his work only the lines, forms, the general and distinctive colours serving to describe precisely the ideistic meaning of the object, adding to it those partial symbols which corroborate the general symbol.

Yet, it is easy to deduce, the artist always has the right to exaggerate those directly significant qualities (forms, lines, colours, etc.) or to attenuate them, to deform them,

not only according to his individual vision, not according to the configuration of his own personal subjectivity (as happens even in realistic art), but more to exaggerate them, to attenuate them, to deform them according to the needs of the Idea to be expressed.

Thus, to summarize and to come to conclusions, the work of art, as I have logically evoked it, will be:

1. *Ideist*, for its unique ideal will be the expression of the Idea.
2. *Symbolist*, for it will express this Idea by means of forms.
3. *Synthetist*, for it will present these forms, these signs, according to a method which is generally understandable.
4. *Subjective*, for the object will never be considered as an object but as the sign of an idea perceived by the subject.
5. (It is consequently) *Decorative* – for decorative painting in its proper sense, as the Egyptians and, very probably, the Greeks and the Primitives understood it, is nothing other than a manifestation of art at once subjective, synthetic, symbolic and ideist.

Now, we must reflect well upon this: decorative painting is, strictly speaking, the true art of painting. Painting can be created only *to decorate* with thoughts, dreams and ideas the banal walls of human edifices. The easel-picture is nothing but an illogical refinement invented to satisfy the fantasy or the commercial spirit in decadent civilizations. In primitive societies, the first pictorial efforts could be only decorative.

This art, that we have tried to legitimatize and to characterize by all the deductions above, this art that possibly seemed complicated and that some journalists like to treat as overrefined, has thus, in the last analysis, returned to the formula of art that is simple, spontaneous and primordial. This is the criterium of the rightness of the aesthetic reasoning employed. Ideistic art, that we had to justify by abstract and complicated arguments, as it seems so paradoxical to our decadent civilizations that have forgotten all primeval revelations, is thus, without any doubt, the true and absolute art. As it is legitimate from a theoretical point of view, it finds itself, moreover, fundamentally identical with primitive art, to art as it was divined by the instinctive geniuses of the first ages of humanity. But is this all? Is there not still some element missing that makes art, understood in this way, true art?

Is it in the man who, thanks to his innate talents, thanks also to the good qualities he has acquired, finds himself confronted with nature knowing how to read in every object its abstract significance, the primordial idea that goes beyond it, the man who, by his intelligence and his approach, knows how to use objects as a sublime alphabet to express the Ideas in which he has the insight? Is he truly, because of this, a complete artist? Would he be the Artist?

Is not this man rather an ingenious scholar, a supreme formulator who knows how to write down Ideas like a mathematician? Is not he in some ways an algebraicist of Ideas, and is not his work a miraculous equation, or rather a page of ideographic writing reminding us of the hieroglyphic texts of the obelisks of ancient Egypt?

Yes, without a doubt; the artist, even if he has no other psychic gifts, will not be only that, as he will then be only a *comprehensive expresser*, and if comprehension completed by the power to express is enough to constitute the scholar, it is not enough to constitute the artist.

He needs, to be really worthy of this fine title of nobility – so stained in our industrialized world of today –, to add another gift even more sublime to this ability of comprehension. I mean the gift of *emotivity*. This is certainly not the emotivity that every man has in relation to illusory sentimental combinations of beings and objects, nor is it the sentimentality of the popular café singers or the makers of popular prints – but it is the transcendental emotivity, so grand and precious, that makes the soul tremble before the pulsing drama of the abstractions. Oh, how rare are those who move body and soul to the sublime spectacle of Being and pure Ideas! But this is the gift that means the *sine qua non*, this is the sparkle that Pygmalion wanted for his Galatea, this is the illumination, the golden key, the Daimon, the Muse....

Thanks to this gift, symbols – that is, Ideas – arise from the darkness, become animated, begin to live with a life that is no longer our life of contingencies and relativities, but a splendid life which is the essential life, the life of Art, the being of Being.

Thanks to this gift, art which is complete, perfect, absolute, exists at last.

11 Camille Pissarro (1831–1903) on Anarchy, Symbolism and Primitivism, from Letters to Lucien

The following letters have been selected and edited from Pissarro's correspondence with his son in order to trace his responses to the growing prominence of the Symbolist movement. He deplored the Idealist philosophy by which Symbolism was underpinned, and in response reaffirmed the philosophical materialism on which he based his own commitment to anarchist socialism. In the first letter, Pissarro writes in answer to Lucien's report of an argument about contemporary novels he had had with an English friend. In the letter of 20 April the article by Aurier referred to is the one above, while the painting by Gauguin of the 'two struggling fighters' is his *Vision after the Sermon* (now in the National Gallery of Scotland, Edinburgh). The exhibition of Monet's work referred to in the letter of 5 May was one in which he showed a series of recent paintings of haystacks viewed at different seasons and times of day, with several sunset scenes among them. Gauguin's show of November 1893 was also held at Durand-Ruel's, and was dominated by work done in Tahiti, from whence he had returned that August. Like Renoir, Pissarro had come to view Gauguin with considerable suspicion. The text of the letters is taken from John Rewald (ed.), *Camille Pissarro: Letters to his Son Lucien*, translated by Lionel Abel, Santa Barbara and Salt Lake City: Peregrine Smith, 1981, pp. 42–3, 201–4, 207, 215–16, 224, 226–7, 257, 280 and 446. (For full bibliographical reference see VIB11.)

Osny, December 28, 1883

My dear Lucien,
I am sending you *Les Fleurs du Mal* and the book of Verlaine. I do not believe these works can be appreciated by anyone who comes to them with the prejudices

of English, or what is more, bourgeois traditions. Not that I am completely in favour of the contents of these books; I am no more for them than for Zola, whom I find a bit too photographic, but I recognize their superiority as works of art, and from the standpoint of certain ideas of modern criticism, they have value to me. Besides it is clear that from now on the novel must be critical, sentiment, or rather sentimentality, cannot be tolerated without danger in a rotten society ready to fall apart.

The discussion you had about naturalism is going on everywhere. Both sides exaggerate. It is clear that it is necessary to generalize and not lean on trivial details. – But as I see it, the most corrupt art is the sentimental, the art of orange blossoms which makes pale women swoon. [. . .]

There is no more time for amusements, you are right, education is what is necessary. See, then, how stupid the bourgeoisie, the real bourgeoisie have become, step by step they go lower and lower, in a word they are losing all notion of beauty, they are mistaken about everything. Where there is something to admire they shout it down, they disapprove! Where there are stupid sentimentalities from which you want to turn with disgust, they jump with joy or swoon. – Everything they have *admired for the last fifty years* is now forgotten, old-fashioned, ridiculous. For years they had to be forcibly prodded from behind, shouted at: This is Delacroix! That's Berlioz! Here is Ingres! etc., etc. And the same thing has held true in literature, in architecture, in science, in medicine, in every branch of human knowledge. They are Zulus with straw-yellow gloves, top hat and tails. They are like the falling, rolling rock which we must ceaselessly roll back in order to escape being crushed. Hence the sarcasms of Daumier, Gavarni, etc., etc. You are indeed young to want to convince a bourgeois! – English or other! [. . .]

Paris, April 13, 1891

. . . My work is not understood, particularly since the death of Théo van Gogh. Such is the influence of a man who believes! That is the sort of man it is necessary to find. But such men are not ready-to-order. Perhaps I am out of date, or my art may conflict and not be conciliable with the general trend which seems to have gone mystical. It must be that only another generation, free from all religious, mystical, unclear conceptions, a generation which would again turn in the direction of the most modern ideas, could have the qualities necessary to admire this approach. I firmly believe that something of our ideas, born as they are of the anarchist philosophy, passes into our works which are thus antipathetic to the current trend. Certainly I feel that there is sympathy for us among certain free spirits, but the one I can't understand is Degas, for he loves Gauguin and flatters me so. Friendliness and no more? . . . How understand him . . . such an anarchist! in art, of course, and without realizing it!

Paris, April 20, 1891

I am sending you the review *L'Art dans les Deux Mondes* and a review which contains an article on Gauguin by Aurier. You will observe how tenuous is the logic of this

littérateur. According to him what in the last instance can be dispensed with in a work of art is drawing or painting; only ideas are essential, and these can be indicated by a few symbols. – Now I will grant that art is as he says, except that 'the few symbols' have to be drawn, after all; moreover it is also necessary to express ideas in terms of colour, hence you have to have sensations in order to have ideas. . . . This gentleman seems to think we are imbeciles!

The Japanese practised this art as did the Chinese, and their symbols are wonderfully natural, but then they were not Catholics, and Gauguin is a Catholic. – I do not criticize Gauguin for having painted a rose background nor do I object to the two struggling fighters and the Breton peasants in the foreground, what I dislike is that he copied these elements from the Japanese, the Byzantine painters and others. I criticize him for not applying his synthesis to our modern philosophy which is absolutely social, anti-authoritarian and anti-mystical. – There is where the problem becomes serious. This is a step backwards; Gauguin is not a seer, he is a schemer who has sensed that the bourgeoisie are moving to the right, recoiling before the great idea of solidarity which sprouts among the people – an instinctive idea, but fecund, the only idea that is permissible! – The symbolists also take this line! What do you think? They must be fought like the pest!

Paris, May 5, 1891

[. . .] Yesterday Monet's show opened at Durand-Ruel's. I saw everybody there. I went with one eye bandaged and had only the other with which to take in Monet's marvellous *Sunsets*. They seemed to me to be very luminous and very masterful, that was evident, but as for our own development we ought to see deeper, I asked myself: what do they lack? Something very difficult to delimit clearly. Certainly in rightness and harmony they leave nothing to be desired; it would rather be in the unity of execution that I would find something to be improved, or rather I should prefer a calmer, less fleeting mode of vision in certain parts. The colours are pretty rather than strong, the drawing is good but wavering – particularly in the backgrounds – just the same, this is the work of a very great artist.

Need I add that the show is a great success? This is not surprising, considering how attractive the works are. These canvases breathe contentment. –

Mirbeau spoke to me of your woodcuts which he finds admirable, as does Monet. I saw not a few friends who enquired about you.

Luce wants to know whether you would collaborate with me in outlining the anarchist conception of the role artists could play and the manner in which they could organize in an anarchist society, indicating how artists could work with absolute freedom once rid of the terrible constraints of Messrs. capitalist collector-speculators and dealers. How the idea of art would be further developed, the love of beauty and purity of sensation, etc., etc. It won't be necessary to elaborate, Georges Lecomte will do the actual writing, it is a question only of ideas. It is to appear in a review which Pouget hopes to launch. I am afraid I will be unable to set down on paper the ideas that came to us so often – it is so difficult to formulate an idea.

Paris, May 13, 1891

[. . .] We are fighting against terribly ambitious 'men of genius,' who are concerned only to crush whoever stands in their path. It is sickening. If you knew how shamelessly Gauguin behaved in order to get himself elected (that is the word) man of genius, and how skilfully he went about it. We were left no choice except to smooth the way for him. Anyone else would have been ashamed! [. . .]

De Bellio, who had been obstinately cold to Gauguin, confessed to me that he had changed his view of Gauguin's work, that he now considered him to have great talent, although not in sculpture. Why? . . . It is a sign of the times, my dear. The bourgeoisie frightened, astonished by the immense clamour of the disinherited masses, by the insistent demands of the people, feels that it is necessary to restore to the people their superstitious beliefs. Hence the bustling of religious symbolists, religious socialists, idealist art, occultism, Buddhism, etc., etc. Gauguin has sensed the tendency. For some time now I have been expecting the approach of this furious foe of the poor, of the workers – may this movement be only a death rattle, the last. The impressionists have the true position, they stand for a robust art based on sensation, and that is an honest stand.

[. . .] I will send you *L'Echo de Paris* with an article by Mirbeau and an interview with Charles Henry, who gives his views on literature. Charles Henry has a most curious notion. He thinks that the future will be dominated by mysticism. It is strange that not one of the young men understands that it represents not the future but backwardness . . . for the future that will bring the abolition of capital and property will be so different that it is impossible to imagine what the ideal of that time will be, at least we cannot plumb its depths with our myopic vision. [. . .]

Eragny, July 8, 1891

I received your letter this morning. – Yes, my dear Lucien, I recognized at once the sentimental and *Christian* tendency in your crowned figure [*Sister of the Woods*], it was not the drawing, but the attitude, the character, the expression, the general physiognomy. I know that your first plan was conventional as compared with your last. But the figure itself is conventional in relation to your art. – There is not only this jarring note, but also, I insist, a sentimental element characteristically English and quite Christian, an element found in many of the Pre-Raphaelites . . . and elsewhere. As for the idea, my son, there are hundreds of ideas in your other engravings, which belong to you, anarchist and lover of nature, to the Lucien who reserves the great ideal for a better time when man, having achieved another mode of life, will understand the beautiful differently. In short, sentimentalism is a tendency for Gauguin, not as a style, but as an idea. Scorn compliments!

Proudhon says in *La Justice* that love of earth is linked with revolution, and consequently with the artistic ideal . . . Contradiction! Yes, one's work is cut out for one in that milieu, but one has to find one's style elsewhere and impose it and make the reasons for it clearly understood. For this, a certain authority is necessary – but haven't we Degas and all the impressionists? We have taken the right path, the

logically necessary path, and it will lead us to the ideal, *at least that is how it appears to me*.

I am at this moment reading J. P. Proudhon. He is in complete agreement with our ideas. His book *La Justice dans la Révolution* must be read from beginning to end. If you had an opportunity to study it you would understand that those who follow the new tendency are influenced by bourgeois reaction. Look how the bourgeois woo the workers! Isn't everybody socialist, hasn't even the Pope fallen into line? Reaction! The purpose behind all this, my dear boy, is to check the movement, which is beginning to define itself; so we must be suspicious of those who under the pretext of working for socialism, idealist art, pure art, etc., etc., actually support a false tendency, a tendency a thousand times false, even though, perhaps, it answers the need of certain types of people, but not our needs; we have to form a totally different ideal! Paul Adam, Aurier and all the young writers are in this counter-revolutionary movement, unconsciously, I am almost sure, or perhaps out of weakness . . . and for all that they believe they are doing something new! Fortunately the revolution that raised the problem has seen many other things. [. . .]

Les Damps by Pont-De-L'arche, September 9, 1892 [From Mirbeau's]

[. . .] Work, seek and don't give way too much to other concerns, and it will come. But persistence, will and *free* sensations are necessary, one must be undetermined by anything but one's own sensation.

I have begun four landscapes which seem to me superb in motifs and effects, with hills in the background. I don't know how they will develop. [. . .]

Paris, November 23, 1893

[. . .] Gauguin's present show is the admiration of all the men of letters. They are, it appears, completely enthusiastic. The collectors are baffled and perplexed. Various painters, I am told, all find this exotic art too reminiscent of the Kanakians. Only Degas admires, Monet and Renoir find all this simply bad. I saw Gauguin; he told me his theories about art and assured me that the young would find salvation by replenishing themselves at remote and savage sources. I told him that this art did not belong to him, that he was a civilized man and hence it was his function to show us harmonious things. We parted, each unconvinced. Gauguin is certainly not without talent, but how difficult it is for him to find his own way! He is always poaching on someone's ground; now he is pillaging the savages of Oceania.

Paris, April 26, 1900

Decidedly, we no longer understand each other. What you tell me about the modern movement, commercialism, etc., has no relation to our conception of art, here at least. You know perfectly well that just as William Morris had some influence on commercial art in England, so here the real artists who seek have had and will have some

effect on it. That we cannot prevent stupid vulgarization, even such things as the making of chromos for grocers from figures of Corot...is absolutely true. Yes, I know perfectly well that the Greek and the primitive are reactions against commercialism. But right there lies the error. Commercialism can vulgarize these as easily as any other style, hence it's useless. Wouldn't it be better to soak yourself in nature? I don't hold the view that we have been fooling ourselves and ought rightly to worship the steam engine with the great majority. No, a thousand times no! We are here to show the way! According to you salvation lies with the primitives, the Italians. According to me this is incorrect. Salvation lies in nature, now more than ever.

Let us pursue what we believe is good, soon it will be evident who is right. In short, money is an empty thing; let us earn some since we have to, but without departing from our roles!

12 August Strindberg (1849–1912) and Paul Gauguin (1848–1903) Exchange of Letters

Gauguin's quest for a more authentic art than could be provided by the legacy of Impressionism had initially been fulfilled in Brittany in 1888–9 (cf. VIc 9). However, his personal restlessness and a growing dislike for the circumstances of metropolitan culture, combined with what he had seen on a trip to Martinique in 1897, all conspired to draw him farther afield. Between 1891 and 1893 he made his first journey to Tahiti. He returned to France virtually penniless, but confirmed as the leading Symbolist painter. During the next year he began to plan a second trip to the South Pacific. As with the first expedition, he planned a sale of his work as a way of raising funds. Gauguin had met the Swedish playwright August Strindberg in the Symbolist circles both frequented in Paris. Strindberg's combination of fame and notoriety made him a perfect candidate for the essay accompanying Gauguin's catalogue. Gauguin accordingly asked, but Strindberg declined in a letter of 1 February 1895. His refusal however was so eloquent, combining a thumbnail sketch of the decline of Naturalism with a flattering portrait of Gauguin himself as the mysterious but creative savage, that Gauguin decided to use the letter anyway. In his reply of 5 February, Gauguin played up the contrast between decayed civilization and regenerative barbarism, and rooted it for good measure in competing visions of the primal woman, Eve. Both letters were first published in the catalogue *Vente de tableaux et dessins par Paul Gauguin, artiste peintre, Hôtel des ventes, Salle 7, le lundi 18 février 1895*. Our source for Strindberg is the translation by Van Wyck Brooks in *The Intimate Journals of Paul Gauguin*, New York: William Heinemann Ltd., 1923, pp. 17–19. Gauguin's reply was printed in Maurice Malingue (ed.) *Letters de Gauguin a sa femme et a ses amis*, Paris, 1946; translated by Henry J. Stenning as *Paul Gauguin: Letters to his Wife and Friends*, London: The Saturn Press, 1946, pp. 197–8.

Letter from Strindberg

You have set your heart on having the preface to your catalogue written by me, in memory of the winter of 1894–95 when we lived here behind the Institute, not far from the Pantheon and quite close to the cemetery of Montparnasse.

I should gladly have given you this souvenir to take away with you to that island in Oceania, where you are going to seek for space and a scenery in harmony with your powerful stature, but from the very beginning I feel myself in an equivocal position and I am replying at once to your request with an 'I cannot,' or, more brutally still, with an 'I do not wish to.'

At the same time I owe you an explanation of my refusal, which does not spring from a lack of friendly feeling, or from a lazy pen, although it would have been easy for me to place the blame on the trouble in my hands which, as a matter of fact, has not given the skin time to grow in the palms.

Here it is: I cannot understand your art and I cannot like it. I have no grasp of your art, which is now exclusively Tahitian. But I know that this confession will neither astonish nor wound you, for you always seem to me fortified especially by the hatred of others: your personality delights in the antipathy it arouses, anxious as it is to keep its own integrity. And perhaps this is a good thing, for the moment you were approved and admired and had supporters, they would classify you, put you in your place and give your art a name which, five years later, the younger generation would be using as a tag for designating a superannuated art, an art they would do everything to render still more out of date.

I myself have made many serious attempts to classify you, to introduce you like a link into the chain, so that I might understand the history of your development, but in vain.

I remember my first stay in Paris, in 1876. The city was a sad one, for the nation was mourning over the events that had occurred and was anxious about the future; something was fermenting.

In the circle of Swedish artists we had not yet heard the name of Zola, for L'Assommoir was still to be published. I was present at a performance at the Théâtre Français of Rome Vaincue, in which Mme. Sarah Bernhardt, the new star, was crowned as a second Rachel, and my young artists had dragged me over to Durand-Ruel's to see something quite new in painting. A young painter who was then unknown was my guide and we saw some marvellous canvases, most of them signed Monet and Manet. But as I had other things to do in Paris than to look at pictures (as the secretary of the Library of Stockholm it was my task to hunt up an old Swedish missal in the library of Sainte-Geneviève), I looked at this new painting with calm indifference. But the next day I returned, I did not know just why, and I discovered that there was 'something' in these bizarre manifestations. I saw the swarming of a crowd over a pier, but I did not see the crowd itself; I saw the rapid passage of a train across a Normandy landscape, the movement of wheels in the street, frightful portraits of excessively ugly persons who had not known how to pose calmly. Very much struck by these canvases, I sent to a paper in my own country a letter in which I tried to explain the sensation I thought the Impressionists had tried to render, and my article had a certain success as a piece of incomprehensibility.

When, in 1883, I returned to Paris a second time, Manet was dead, but his spirit lived in a whole school that struggled for hegemony with Bastien-Lepage. During my third stay in Paris, in 1885, I saw the Manet exhibition. This movement had now forced itself to the front; it had produced its effect and it was now classified. At the

triennial exposition, which occurred that very year, there was an utter anarchy – all styles, all colours, all subjects, historical, mythological, and naturalistic. People no longer wished to hear of schools or tendencies. Liberty was now the rallying-cry. Taine had said that the beautiful was not the pretty, and Zola that art was a fragment of nature seen through a temperament.

Nevertheless, in the midst of the last spasms of naturalism, one name was pronounced by all with admiration, that of Puvis de Chavannes. He stood quite alone, like a contradiction, painting with a believing soul, even while he took a passing notice of the taste of his contemporaries for allusion. (We do not yet possess the term symbolism, a very unfortunate name for so old a thing as allegory.)

It was towards Puvis de Chavannes that my thoughts turned yesterday evening when, to the tropical sounds of the mandolin and the guitar, I saw on the walls of your studio that confused mass of pictures, flooded with sunshine, which pursued me last night in my dreams. I saw trees such as no botanist could ever discover, animals the existence of which had never been suspected by Cuvier, and men whom you alone could have created, a sea that might have flowed out of a volcano, a sky which no God could inhabit.

'Monsieur,' I said in my dream, 'you have created a new heaven and a new earth, but I do not enjoy myself in the midst of your creation. It is too sun-drenched for me, who enjoy the play of light and shade. And in your paradise there dwells an Eve who is not my ideal – for I, myself, really have an ideal of a woman or two!' This morning I went to the Luxembourg to have a look at Chavannes, who kept coming to my mind. I contemplated with profound sympathy the poor fisherman, so attentively occupied with watching for the catch that will bring him the faithful love of his wife, who is gathering flowers, and his idle child. That is beautiful! But now I am striking against the crown of thorns, Monsieur, which I hate, as you must know! I will have none of this pitiful God who accepts blows. My God is rather that Vitsliputski who in the sun devours the hearts of men.

No, Gauguin is not formed from the side of Chavannes, any more than from Manet's or Bastien-Lepage's!

What is he then? He is Gauguin, the savage, who hates a whimpering civilization, a sort of Titan who, jealous of the Creator, makes in his leisure hours his own little creation, the child who takes his toys to pieces so as to make others from them, who abjures and defies, preferring to see the heavens red rather than blue with the crowd.

Really, it seems to me that since I have warmed up as I write I am beginning to have a certain understanding of the art of Gauguin.

A modern author has been reproached for not depicting real beings, but for quite simply creating his personages himself. Quite simply!

Bon voyage, Master; but come back to us and come and see me. By then, perhaps, I shall have learned to understand your art better, which will enable me to write a real preface for a new catalogue in the Hôtel Drouot. For I, too, am beginning to feel an immense need to become a savage and create a new world.

August Strindberg

Letter from Gauguin

I received your letter today; your letter which is a preface for my catalogue. The idea of asking you to write this preface occurred to me when I saw you the other day in my studio playing the guitar and singing; your Northern blue eyes studying the pictures hung on the walls. I felt your revulsion: a clash between your civilization and my barbarism...A civilization from which you are suffering: a barbarism which spells rejuvenation for me.

Studying the Eve of my choice, whom I have painted in forms and harmonies of a different world, she whom you elect to enthrone, evokes perhaps melancholy reflections. The Eve of your civilized imagination makes nearly all of us misogynists: the Eve of primitive times who, in my studio, startles you now, may one day smile on you less bitterly. This world I am discovering, which may perhaps never find a Cuvier nor a naturalist, is a Paradise the outlines of which I shall have merely sketched out. And between the sketch and the realization of the vision there is a long way to go. What matters! If we have a glimpse of happiness, what is it but a foretaste of *Nirvana*?

The Eve I have painted – and she alone – can remain naturally naked before us. Yours, in this simple state, could not move without a feeling of shame, and too beautiful, perhaps, would provoke misfortune and suffering.

To make clearer my ideas to you, I will not compare the two women themselves, but rather the languages they speak – the Maorie or Touranian language spoken by my Eve and the language spoken by your chosen woman, language with inflexions, European language.

Everything is bare and primordial in the languages of Oceania, which contain the essential elements, preserved in their rugged forms, whether isolated or united, without regard for politeness.

Whereas in the inflected languages, the roots, from which – as in all languages – they spring, disappear in daily use which wears away their angles and their contours. They are like a perfected mosaic where one forgets the more or less skilful joining of the stones in admiration for the fine lapidary painting. Only an expert eye can detect the process of construction.

Excuse this long philological digression, which I deem necessary to explain the barbarian drawing which I had to employ to represent a Touranian country and people.

It remains for me, dear Strindberg, to thank you.

When shall we see each other again?

To-day, as yesterday, with all my heart,

Paul Gauguin.

13 Paul Gauguin (1848–1903) Fable from 'Notes Eparses'

Gauguin embarked on his second journey to the Pacific in 1895. By then his position as the leading Symbolist painter was unassailable. In the present text he uses the device of an exotic fable to elaborate his view of painting as an art based around the orchestration of internal colour harmonies. It is not clear whether Gauguin wrote the entire story himself, or

whether he incorporated his own colour theories into an otherwise unknown text. Certainly, the studied exoticism, combined with hints of alchemy, are in keeping with Gauguin's self-presentation as an artist–visionary. Towards the end of the fable, the contrast between the mystic art of colour harmonies and both academic art and Naturalism is drawn in such a fashion as to implicitly identify the two latter. The fable is from Gauguin's 'Notes Eparses' (Scattered Notes), which were included in his manuscript *Diverses choses* of 1896–7. These were subsequently published in Jean de Rotonchamp, *Paul Gauguin*, Weimar, 1906. The present translation is by Van Wyck Brooks, from *The Intimate Journals of Paul Gauguin*, New York: William Heinemann Ltd, 1923, pp. 31–3.

It was in the days of Tamerlane, I think in the year X, before or after Christ. What does it matter? Precision often destroys a dream, takes all the life out of a fable. Over there, in the direction of the rising sun, for which reason that country is called the Levant, some young men with swarthy skins, but whose hair was long, contrary to the custom of the soldier-like crowd, and thus indicated their future profession, found themselves gathered together in a fragrant grove.

They were listening, whether respectfully or not I do not know, to Vehbi-Zunbul Zadi, the painter and giver of precepts. If you are curious to know what this artist could have said in these barbarous times, Listen.

Said he: 'Always use colours of the same origin. Indigo makes the best base; it turns yellow when it is treated with spirit of nitre and red in vinegar. The druggists always have it. Keep to these three colours; with patience you will then know how to compose all the shades. Let the background of your paper lighten your colours and supply the white, but never leave it absolutely bare. Linen and flesh can only be painted by one who knows the secret of the art. Who tells you that flesh is light vermilion and that linen has grey shadows? Place a white cloth by the side of a cabbage or a bunch of roses and see if it will be tinged with grey.

'Discard black and that mixture of white and black they call grey. Nothing is black and nothing is grey. What seems grey is a composite of pale tints which an experienced eye perceives. The painter has not before him the same task as the mason, that of building a house, compass and rule in hand, according to the plan furnished by the architect. It is well for young men to have a model, but let them draw the curtain over it while they are painting. It is better to paint from memory, for thus your work will be your own; your sensation, your intelligence, and your soul will triumph over the eye of the amateur. When you want to count the hairs on a donkey, discover how many he has on each ear, and determine the place of each, you go to the stable.

'Who tells you that you ought to seek contrast in colours?

'What is sweeter to an artist than to make perceptible in a bunch of roses the tint of each one? Although two flowers resemble each other, can they ever be leaf by leaf the same?

'Seek for harmony and not contrast, for what accords, not for what clashes. It is the eye of ignorance that assigns a fixed and unchangeable colour to every object; as I have said to you, beware of this stumbling-block. Practise painting an object in conjunction with, or shadowed by – that is to say, close to or half behind – other objects of similar or different colours. In this way you will please by your variety and your truthfulness – your own. Go from dark to light, from light to dark. The eye seeks to refresh itself through your work; give it food for enjoyment, not dejection. It is only the sign-

painter who should copy the work of others. If you reproduce what another has done you are nothing but a maker of patchwork; you blunt your sensibility and immobilize your colouring. Let everything about you breathe the calm and peace of the soul. Also avoid motion in a pose. Each of your figures ought to be in a static position. When Oumra represented the death of Ocraï, he did not raise the sabre of the executioner, or give the Khakhan a threatening gesture, or twist the culprit's mother in convulsions. The sultan, seated on his throne, wrinkles his brow in a frown of anger; the executioner, standing, looks at Ocraï as on a victim who inspires him with pity; the mother, leaning against a pillar, reveals her hopeless grief in this giving way of her strength and her body. One can therefore without weariness spend an hour before this scene, so much more tragic in its calm than if, after the first moment had passed, attitudes impossible to maintain had made us smile with an amused scorn.

'Study the silhouette of every object; distinctness of outline is the attribute of the hand that is not enfeebled by any hesitation of the will.

'Why embellish things gratuitously and of set purpose? By this means the true flavour of each person, flower, man or tree disappears; everything is effaced in the same note of prettiness that nauseates the connoisseur. This does not mean that you must banish the graceful subject, but that it is preferable to render it just as you see it rather than to pour your colour and your design into the mould of a theory prepared in advance in your brain.'

Some murmurs were heard in the grove; if the wind had not carried them off, one might perhaps have heard such evil-sounding words as Naturalist, Academician, and the like. But the wind made off with them while Mani knit his brows, called his pupils anarchists, and then continued:

'Do not finish your work too much. An impression is not sufficiently durable for its first freshness to survive a belated search for infinite detail; in this way you let the lava grow cool and turn boiling blood into a stone. Though it were a ruby, fling it far from you.

'I shall not tell you what brush you ought to prefer, what paper you should use, or in what position you should place yourself. This is the sort of thing that is asked by young girls with long hair and short wits who place our art on a level with that of embroidering slippers and making toothsome cakes.'

Gravely Mani moved away.

Gaily the young men rushed away.

In the year X all this took place.

14 Edvard Munch (1863–1944) Notebook and Diary Entries

By the 1880s, the force of Naturalism was beginning to dissipate in the French avant-garde. Elsewhere, however, it still stood for a progressive critique of the Academy. Munch began his career as a Naturalist painter in the avant-garde of Christiania (present-day Oslo) in Norway. In the late 1880s, however, Munch was already beginning to question Naturalism under the impact of contemporary literary ideas, as well as his own reflections and experiences. This direction was confirmed when he went to Paris in 1889. Here he saw the work of Gauguin and his circle at the Café Volpini exhibition, and encountered the wider

milieu of French Symbolism. Munch wrote copiously but fragmentarily, in sketchbooks and diaries, about the ideas which informed his changing art. We have tried to preserve the disconnected, somewhat staccato quality of this writing, some of which was later incorporated into more considered, retrospective statements. We reprint here five extracts from the period when his mature style was forming. Munch's most frequently reproduced statement is the so-called 'St Cloud Manifesto' written in Paris in 1889. Various translations of different lengths are in circulation in English. All centre on the incident in the ballroom on New Year's Eve 1889, and Munch's perception that this was what he had to capture in his painting. For a retrospective of his work held in Oslo in 1918, Munch himself added a contextualizing description of his entry into, and departure from, the ballroom. We have felt it best to include these later remarks to render the central text more fully intelligible. In our second extract, on the subjectivity of vision, Munch articulates the view that was beginning to dominate the avant-garde in France: that Naturalism, painting everything 'exactly as you see it', could not cope with the subjective dimension of our understanding of the world – a dimension that seemed to increase in importance as avant-garde artists came to feel increasingly ill at ease with the objectively describable bourgeois world around them. The other three extracts were all written in a notebook since referred to as the 'Violet Diary'. The first extract demonstrates Munch's deepening emphasis on subjectivity, with which he now associated the future direction of art. The second reveals his misgivings about the limitations of materialism and Naturalism. For him, it is the mysterious aspect of life, the great questions of birth and death, rather than the quantifiable minutiae of existence, which should concern the artist. In the final selection, Munch gives vent to the anguish which these questions provoked in him: an anguish which was given plastic expression in his most renowned single work, *The Scream*. All of the extracts have been translated for the present volume by Ingeborg Owesen, who also assisted in the selection and editing process. The translations were made from documents held in the Edvard Munch museum, Oslo.

Impressions from a ballroom, New Year's Eve in St Cloud, 1889

Danseuse espagnole – 1 fr. – Let me enter. –

It was a long hall with balconies on both sides – under the balconies people were sitting and drinking at round tables – In the middle they stood top hat by top hat – amongst them the ladies' hats!

At the far end above the top hats a small woman in a purple tricot was walking a tightrope – in the middle of the blue–grey tobacco-filled air. –

I strolled through those who were standing.

I searched for a beautiful girl's face – no – yes – there was one who was not too bad. –

When she discovered I was looking at her her face became stiff and mask-like and stared emptily into the air.

I found a chair – and let myself fall into it tired and slack.

There was clapping – the purple–coloured dancer bowed smiling and disappeared.–

The Romanian singers performed. – It was love and hate, yearning and reconciliation – and beautiful dreams – and the gentle music melted into the colours. All these colours – the scenery with green palms and blue–grey water – the strong colours of the Romanian costumes – in the blue–grey haze.

The music and the colours captured my thoughts. They followed the soft clouds and were carried by the gentle tunes into a world of light joyful dreams. –

I should do something – I felt it would be so easy – it should be formed under my hands as if it were magic. –

Then they should see. –

A strong naked arm – a sunburned muscular neck – a young woman places her head against the arched breast. –

She closes her eyes and listens with an open quivering mouth to the words he whispers into her long hair hanging loose.

I must give form to this as I saw it just now, but in the blue haze. –

These two in the moment when they are not themselves but only a part of the chain of the thousand generations that connect generations to generations. –

People must understand the sacredness and power of this moment and remove their hats as if they were in church.

I must produce a number of such pictures. Interiors should no longer be painted, people who read and women who knit.

There must be living people who breath and feel, suffer and love.

I felt I must do this – it should be so easy. The flesh would take on form and the colours come to life.

There was an interval – the music stopped.

I felt a sadness.

I recalled on how many previous occasions I had felt something similar – and when I had finished the painting – people shook their heads and smiled.

Once again I was out on the Boulevard des Italiens – with the white electric lamps and the yellow gas jets – with the thousands of strange faces that looked so ghostly in the electric light.

Notebook entry on subjective vision, 1889

The thing is that at different times you see with different eyes. You see differently in the morning than in the evening.

The way in which you see is also dependent on your state of mind.

It is this which makes it possible for a motif to be seen in so many different ways, and it is this which lends interest to art.

If in the morning you come out of a dark bedroom into the living room, you will, for example, see everything in a bluish light. Even the deepest shadows are overlain by a volume of air.

After a while you will become accustomed to the light and the shadows will deepen and everything will become sharper. If you were now to try to paint this atmosphere, if this atmosphere of the blue morning light has touched you, it would not be enough simply to sit and stare at each individual thing and to paint it 'exactly as you see it'. Rather, you must paint it 'such as it must be', as it looked when the motif touched you. And if you do not seek to paint after memory, but use models, you will inevitably get it wrong.

The detail painters call such painting dishonest – to paint honestly is to paint with photographic accuracy – the artist is to paint this or that chair, this or that table, as he sees it at a particular moment.

They call the attempt to depict an atmosphere dishonest.

When you drink heavily you see differently – often the picture flows – everything seems more like chaos. As is known one can, notoriously, then see everything incorrectly.

If you see double, then, for example, you must paint two noses.

And if you see a glass slanting, then you have to make the glass slant.

Or, if you want to present something experienced in an erotic moment when you are flushed and amorous – here you have found a motif which you cannot present exactly as you see it on another occasion when you are cold.

And it is this, precisely this, exclusively this, which gives art a deeper meaning. It is humanity, life, which must be represented. Not dead nature.

A chair may certainly possess as great an interest as a human being. But the chair must be seen by a human being. In one way or another it must have touched him, and you must make the audience be touched in the same way.

It is not the chair which is to be painted but what the human being has felt in relation to it.

The parody of this [ridiculous – crossed out] craftsmanlike understanding of art is also articulated by one of the leaders of the detail painters, Wentzel.[1]

A chair is a chair – it cannot be painted in more than one way.

For this reason supporters of this [Naturalist] tendency, hold the painters of atmosphere in such contempt.

They cannot understand that a chair can be seen in a thousand different ways.

A chair possesses this and that colour, ergo it must be painted like this.

You can admire their skilfulness – you can say that it is impossible to paint any better – but they might just as well stop painting – for they cannot become any better.

But you stand there cold – Your blood runs faster. You are never touched in your innermost part. – It has not given you something which remains with you and which, later, emerges again and again.

You forget the painting the moment you move away from it.

[1] Gustav Wentzel (1859–1927), Norwegian painter who helped shape Norwegian Naturalism in the 1880s, specializing in scenes of petit bourgeois domestic life.

From the Violet Diary, Nice, 2 January 1891

It would be great fun to preach a bit to all those people who for so many years have looked at our paintings – and have either laughed or shaken their heads in suspicion. They do not understand how it is that these impressions can make very little sense at all – these impressions of a particular moment – that a tree can be red or blue – that a face can be blue or green – they know that this is wrong. Ever since childhood they have known that leaves and grass are green and that the colour of skin is a delicate pink. – They cannot understand that it is meant seriously – it must be a hoax or the result of carelessness – or mental derangement – preferably the latter.

They cannot get it into their heads that these paintings are made in all earnestness – in pain – and that they are the product of sleepless nights – that they have cost blood – and nerves.

And these painters carry on and get worse and worse – Everything turns more and more in what, for them, is the same insane direction.

Yes – because – it is the road to the painting of the future – to the promised land of art.

Because in these images the painter gives what is most valuable to him – he gives his soul – his sorrow – his joy – he gives his own heart's blood.

He presents the human being – not the object. These images will – must – move the spectator all the more powerfully – first a few – then many more, then everyone. Just as when many violins are in a room – one strikes the note to which they are all attuned, they all sound.

I shall try to give an example of this incomprehension about colour –

A billiard table – Go into a billiard hall – After you have stared for some time at the intense green cloth, look up. How strangely red is everything around you. Those gentlemen who a moment ago were dressed in black, now wear costumes of crimson red – and the hall is reddish, its walls and ceiling –

After a while the costumes are black once again –

If you want to paint such an atmosphere – with a billiard table – then I suppose you must paint these things crimson red –

If one is going to paint the immediate impression of a moment, the atmosphere, that which is human – then this is what one must do.

From the Violet Diary, Nice, 8 January 1892

It is foolish to deny the existence of the soul. After all, you cannot deny the existence of life.

One must believe in immortality – in so far as the nucleus of life must after all exist after the death of the body.

This faculty – of keeping the body together – of bringing the matters to develop – the life spirit where is it –

Nothing perishes – there is no example of that in nature –

The body that dies – does not disappear – its parts separate from one another – are recombined –

But the life spirit, where is it –

Where, nobody can tell – to claim its non-existence after the death of the body is just as foolish as wanting firmly to point out where this spirit will exist.

The fanatical belief in one single religion – such as Christianity – brought about its opposite – brought a fanatical belief in a non-god –

One became resigned to this belief in a non-god – which after all was also a belief – to claim that something comes after death seems foolish.

All of this is connected with the great wave that spread over the earth – realism.

Things did not exist unless they could be demonstrated, explained schematically or physically – painting and literature turned towards what could be seen with the eye or heard with the ear – as if it was peeled off nature –

People were satisfied with the great discoveries which were made – and did not reflect that the greater the discoveries, the greater and more numerous were the mysteries to be solved – bacteria had been found – but what are they? again –

The mystical will always exist – the more that is discovered, the more there will be things that are unexplained –

The new movement – the progress of which can be seen everywhere – will provide expression for all this, which has now been suppressed for an entire generation – That which human beings always desire in abundance – mysticism –

It will express all that which is so delicate that it only exists in anticipation, in experiments of thought – there are many inexplicable things – and many new-born thoughts which have yet to take on form

The ancients were right when they said that love is a flame – for it departs like a flame, and leaves a pile of ashes –

From the 'Violet Diary', Nice, 22 January 1892

I was walking along the road with two friends – the sun went down – I felt a gust of melancholy – suddenly the sky turned a bloody red.

I stopped, leaned against the railing, tired to death – as the flaming skies hung like blood and sword over the blue-black fjord and the city – My friends went on – I stood there trembling with anxiety – and I felt a vast, infinite scream [tear] through nature.

15 Stanislaw Przybyszewski (1868–1927) 'Psychic Naturalism (The Work of Edvard Munch)'

The Polish novelist, dramatist and critic Stanislaw Przybyszewski was one of the first to appreciate the work of Edvard Munch (see VIc14, above), discovering in his painting a visual parallel to his own literary work. Przybyszewski met Munch in Berlin late in 1892, when the latter came to oversee an exhibition of his work held by the *Verein Berliner Künstler* in November of that year. The exhibition aroused a storm of critical protest and responses to Munch's work were so hostile that the *Verein* voted (by 120 to 105) for the exhibition to be closed. Munch's paintings were subsequently hung privately in the Equitable Palast. Przybyszewski responded by writing an appreciation of Munch's work, published under the title 'Psychischer Naturalismus'. Przybyszewski incorporated a discussion of the meaning and value of Munch's paintings into an account of his own philosophical and aesthetic views. This was Przybyszewski's first contribution to art criticism, but it sustained the dominant themes of his earlier work, *Zur Psychologie des Individuums* (On the psychology of the individual), a study of Chopin and Nietzsche, and *Totenmesse* (Requiem mass), a prose rhapsody dedicated to his young bride, Dagny Juel. 'Psychic Naturalism' was published in *Die Freie Bühne* in January 1894. That same year, Przybyszewski assembled three other well-known writers, including the art historian Julius Meier-Graefe, to contribute essays alongside his own, publishing the whole as *Das Werk Edvard Munch, Vier Beiträge* (The work of Edvard Munch, Four Essays), Berlin: S. Fischer Verlag, 1894. The following extracts have been translated for the present volume by Nicholas Walker from *Das Werk Edvard Munch*, pp. 11–14, 16–28.

I once had a dream which literally came to pass. But when the events anticipated by the dream actually transpired I was seized by a most singular and remarkable feeling, strangely compounded out of anxiety, dread and horror, a feeling of intense disquiet;

my brain was suddenly disoriented with a start, as I realized that the law according to which our psychic energy unfolds in terms of the smallest expenditure of force had suffered a violent contradiction.

And thus it was that I began to piece together the full story. It could only be explained by admitting that my brain had actually seen and heard things which 'I' myself have never seen or heard, things which nevertheless constituted a causal nexus that eventually produced the events in question. These acoustical and visual impressions already lay concealed somewhere in the depths of a quite different type of consciousness, where they preserved various related impressions, then organized and combined themselves into logical series, until the latter suddenly erupted into my personal consciousness.

This manifestation of individuality which sees and hears what my conscious personality cannot see or hear, this revelation of something deep within me which leads a life of its own, different from that I am conscious of, which possesses more sensitive organs of perception than those at my conscious disposal, this alien dimension within myself was what had filled me with such disquiet.

And I experienced exactly the same thing when I stood before the pictures of Edvard Munch; once again I found myself confronted with the naked revelation of an individuality, with the creative products of a somnambular and transcendental consciousness, what is commonly called 'the unconscious'. One can call it whatever one will, but I call it 'individuality'; it does not as such constitute some generic universal concept, as if it were simply the lowest, 'barely perceptible' threshold of consciousness, but rather represents an individual concept, one conceived in opposition and contrast to one's personal consciousness. For me this individuality is what is immortal and inalienable. It is the fundamental stock or trunk, upon which new properties and characteristics are continually engrafted through the process of heredity, indeed it is what sustains this process; this is an individuality which eternally perpetuates itself and has been living on continuously ever since the primal beginning, since the incipient dawning of life in its most rudimentary organic form, right up to the most highly developed form of life, man himself. It is like a great wave which grows everlastingly, a germ which perpetuates itself to infinity in constantly changing metamorphoses, and thus in every individual human being this individuality constitutes the collective focus of all those features which have characterized all the various branches of its own previous evolutionary development: it is a pangenesis in the sense understood by Darwin: every original generating cell carries the whole of human kind and all its characteristics within itself.

Individuality lends intensity and quality to these impressions, harbours the central point of connection where all these impressions flow together in one, where the most heterogeneous of things are experienced as if they were of equivalent value to one another, because this individuality reacts to all of them with the same affective impulse; here colour becomes line, and scent becomes sound: 'Les parfums, les couleurs et les sons se répondent.'

This individuality is the immortal dimension of man, and precisely because it is so infinitely more ancient than the relatively recent human brain itself, precisely because it is so infinitely more receptive than the brain, and precisely because it possesses such infinitely more sensitive organs of feeling and perception than the brain, such

individuality constitutes the primal ground and source of psychical life, saturates the impressions, lends life to these impressions, pours itself out into them in a mighty blood-stream of affects, feelings and passions. This individuality therefore is a power of shattering impact, a surging source of strength which is capable of piling Pelion upon Ossa, a powerful force of conviction in its own right, an eddying surge of vital warmth, of pulsing life.

Two different human beings contemplate a single landscape. The one sees it merely with the impoverished resources of the brain: impressions of light, colours, forms, lines, an attractively composed conglomeration of elements which nevertheless remain blank, uninvolving, commonplace, tedious. This same landscape appears quite differently before the consciousness which belongs to the individuality we have been describing. The colours are now perceived as glowing, burning and intense; lines which a child might have scratched out on a slate now acquire a mighty pulsing life of their own, enter into relation with the most intimate stirrings of our psychic life, and fuse themselves with the moving forms of the soul itself. We become one with the landscape, we find ourselves living in and through the latter.

This is the mysterious source of that most intimate of all feelings: our love for our native soil, for our fatherland – and this is also the mysterious source of that specific kind of feeling which animates the great and truly powerful artist.

* * *

Edvard Munch is the first one who has ever undertaken to represent the most subtle and inconspicuous of psychological processes just as they appear spontaneously in the pure consciousness of individuality, and quite independently of any mental activity on our part. His pictures are like so many painterly 'distillations' of the soul at the very moment when all our rational motivations fall silent, when all conscious activity of the imagination has ceased to function: distillations of the animal and irrational soul, as it twists and coils within, now seething upwards in raging tempests, now subsiding once again into the crepuscular gloom, as it shrieks in wild convulsive agony and howls abroad in hunger.

From the pictures which Munch exhibited in December of last year I would merely like to focus upon the cycle entitled 'Love' precisely because this series of paintings presents us with a truly comprehensive example of his characteristic style. There are six pictures in all: 'Sentiment of Spring', 'Kiss', 'Vampire', 'Jealousy', 'Despair' and 'Madonna'.

In the first of these paintings we are presented in the foreground with a young woman who is actually half invisible, shrouded in a kind of mystical twilight; between the intensely green trees we can make out the sea in a sort of fusion with the skyline, a moon which is reflected in the water like a chemist's test-tube, and right in the background a ship which seems to be sailing in the skies.

It is clear that what is objectively depicted here is almost entirely beyond the point, but it exerts a profound effect in terms of mood and atmosphere. This is the yearning of puberty. It is something which is suddenly brought to birth, begins to grow and swell, then fades away in formlessness, surges this way and then that, gathers itself up again and presses forward to find form and shape. And in such a situation as this heaven and earth certainly can flow into one another, the trees can certainly turn into green telegraph poles, everything can begin to whirl about us like a maelstrom, the

blood can seethe and pour from our very eyes. That is the yearning for growth and transformation, the deeply painful longing for physical maturity, the awful dread of trembling expectation: that intense hearkening to one's inner life, half in fear and half in pleasure, before the intoxicating abyss of sexual excitement. That is Venus Anadyomene, magnificently symbolized for us as she has been by Richard Dehmel.

The second picture represents the kiss. We see two human figures whose faces have indistinguishably melted into one another. There is no instantly identifiable defining feature; all we see is the moment of melting fusion like a gigantic ear which has become deaf to all else through the welling ecstasy of blood, like a pool of liquid flesh: there is something repulsive about the image. This kind of symbolization is admittedly rather extraordinary. The entire ardour of such a kiss, the terrifying power of painfully craving sexual desire, the annihilation of individual consciousness, the melting fusion of two naked individualities, the feeling of all of this is so honestly registered here that one overlooks the repulsive and extraordinary character of the image.

The third picture presents a Madonna. We see a woman in a dress with a characteristic gesture of unreserved devotion, whose every perception and sensation is finding itself transformed into an erethism of the most intense pleasure. A clothed Madonna with glowing halo on rumpled linen, awaiting the imminent martyrdom of painful labour, a Madonna captured in the moment of that secret mystery when the eternal ecstasy of conception radiates beauty across the woman's face, the moment when the deepest regions of life actually make themselves felt, when civilized man with all his metaphysical urge towards the eternal also encounters the animal with all of its exultant and destructive rage.

In the next picture Munch offers us a representation of love and pain: a broken man with a vampire-face biting into his neck. The background is provided by a remarkably chaotic combination of blue, purple, green and yellow dashes of colour, interfused with one another, now fading into one another, now jagged and harshly juxtaposed with one another, like so many crystal formations. But there is something terrifyingly calm and passionless about this picture, pervaded by an immeasurable fatedness and sense of resignation. The man in it is slipping away, powerless and unresisting, into unimaginable depths, and he is happy to fall away as unresistingly as a stone. But he cannot be rid of the vampire, and likewise he will never be rid of the pain either, for the woman will always be crouching there, biting at him for all eternity with a thousand vipers' tongues, with a thousand venomous fangs.

This is possibly his most individually conceived and realized picture. In a peripheral sense it may well be true that love is a fortunate gift: as far as the conscious personality is concerned love procures a certain satisfaction, it miraculously promotes and increases our mental and spiritual powers, it marvellously dominates our sensuous impressions, and it so fantastically captures the brain that it sends it spinning back and forth between the wretched boundary-stakes of experienced happiness like a game of roulette. But that immemorial soul woven by the rays of the ancient sun, that soul which has endured all, I say all, the storms of evolution, all the painful convulsions of natural selection, this soul experiences love in quite a different way. For in the nethermost depths of this soul love becomes a piercing pain, a biting vampire, a horrible and agonizing struggle which can never end, a struggle to rid oneself of this woman, to satisfy the ravenous demons of the flesh. And the simmering lava of this

ancient volcano will always burst in upon our happiest moments; and then comes the moment when we realize that all our happiness is really a wretched kind of bliss bred in the slime by the heat of the sun.

Another picture from the same series, entitled 'Jealousy', presents us with a landscape of coarsest outline in an obtusely inexpressive glimmering light. In the foreground we can see peering out of the frame, just as in Chinese paintings, a man's head with an eye resembling a triangle: a symbol of eternity, a symbol of the most commonplace and agonizing of feelings. The picture communicates the motionless and brutish brooding of a passion that has turned into a crazed and solitary despair. The picture almost paints the physiological process of light and colour as experienced by a desperate doting lover, almost a painted philosophy of the suffering sensations of adoration. This is how the landscape is reflected in the mind of some youth whose carefully chosen young bride to be has been wrested from him by another: the wild primeval struggle for the girl has become the melancholic, the crass and cowardly, brooding resignation of the civilized man.

Finally, to the last picture: 'Despair'. Upon a bridge, or something resembling a bridge – and it is completely irrelevant what precisely it represents – there stands a mythological creature with widespread wings. The hero of romance certainly no longer exists: the race of such has long since abandoned the human body and is now exploring the whole of nature herself in search of some new manifestation in which it can once again undergo the same agony, the same struggle as before. This picture is a sort of monstrous macrocosm, the final tableau of a terrifying struggle between the sexual life and the conscious mind, one in which the former has emerged triumphant. There is only one other painter who has depicted this same struggle on the same grandiose scale, albeit with quite different means, and that is the Frenchman Delville. We see a man with an enormous chest desperately struggling for his life; every single muscle represents an inferno of agonizing desire for salvation, every tendon and sinew a spinal cord connecting him with a world of burning pain, with the desire to be free of this torture. But his hips are clasped by a demonic female whose lower body terminates in some monstrous and wholly individualized organ. The entire woman is essentially nothing but a gigantic sexual organ. Both figures are caught up in a nest of thorns and veins; an entire network of uterine veins has entwined itself about them and the personified female organ laughs full-throatedly in the face of the magnificent attempted ascension of the male brain. Munch shows us the unfolding of this struggle. The brain is redeemed through its very destruction and sexual life, the eternally primordial element, stalks on in search of new victims.

The treatment of landscape in this picture is of great particular interest. It is of course an affectively toned landscape, as always in Munch's pictures. Landscapes like this are merely correlates of sensory feeling, just as the crude and unmusical music to be heard in the interjections of primitive man is merely the absolute correlate of his immediate affective state. This helps to produce a remarkable mystical sensation like that communicated by Baudelaire's description of an autumn landscape in *Confiteor de l'artiste*: 'toutes ces choses pensent par moi ou je pense par elles, car dans la grandeur de la rêverie, le moi se perd vite; elles pensent, dis-je, mais musicalement, et pittoresquement, sans arguties, sans syllogismes, sans déductions'. ['All these things think in and through me or I think in and through them, for in the

magnificence of dreams the self is lost almost at once; these things think, so I say, but do so musically and pictorially, without arguments, without syllogisms, without deductions.']

It was in such a mood as this that Gautier once dreamed up a landscape of metallic and marmoreal character, one where everything appeared hard and polished. But this sensuous carver of words presents us with nothing but the pure product of a refined and sophisticated brain, merely enacts a constructive fantasy of his own, whereas Munch presents us with the pure and naked feeling of individuality. His landscape is the absolute correlate of such naked feeling; every single vibration of nerves which have been directly exposed to the utmost ecstasy of pain is instantly converted into an appropriate sensation of colour. Every thrill of pain is a blood-red dash; every drawn-out howl of pain is a rod of blue, green and yellow dashes; they remain unharmonized, brutally confronting one another, like the seething elements of emerging worlds in the wild throes of formation.

In spite of the hosts of critics over the years who have either supported or attacked Munch, there is hardly a single critic who has properly grasped the central and fundamental feature of his art. He has been constantly judged by the criterion of the artist in the traditional sense, namely an artist trained and prepared in terms of an enormous preceding tradition with an infinite variety of forms, lines and colours already at his disposal; then the attempt was made to stuff him in the same pot with the Symbolists; until finally no one knew how to deal with him at all. One should not be too hard on the critics in this regard: it is indeed somewhat difficult to take up an appropriate position with respect to Munch. All previous painters were in effect painters of the external world, and they clothed every feeling they wished to express in the garb of some external process, allowed all mood and atmosphere to emerge indirectly from the external setting and environment. To depict psychological phenomena in terms of external events, to express 'états d'âmes' [states of the soul] in terms of 'états de choses' [states of things], has always constituted until now the unbreakable law of tradition which no artist has ever dared to violate. Munch has broken utterly with this tradition. He attempts to present psychological phenomena immediately through colour. He paints in the way that only naked 'individuality' can perceive once its eyes have turned away from the world of external appearances and peered instead within. His landscapes are all envisaged within the soul, as images of some Platonic anamnesis perhaps; his shapes and forms have been experienced musically, rhythmically; his rocks and boulders present the diabolical grimaces of a raging fever, and his clouds resemble some spectrographic collusion of colours; the borders of the horizon are nowhere to be seen, and his ships seem to be sailing in the skies: his images are precisely absolute correlates of certain groups of sensations and perceptions. Thus it is that Munch has entered upon an entirely new field of art for the first time. And he must indeed be regarded as the first in this respect; he really has no predecessors and no tradition, and even if he feels he does, it is to be hoped that he will soon cast it overboard anyway.

To put the matter briefly: Munch is aiming to reproduce a naked psychical phenomenon not mythologically, that is, not through sensuous metaphors, but rather immediately through its colouristic equivalent. From this perspective we can say that Munch is the 'Naturalist' *par excellence* of psychological phenomena, precisely in the

same sense in which Liebermann represents the most relentless Naturalist of the external world.

Munch paints the delirium and the dread of existence, paints the feverish chaos of sickness, the fearful premonitions in the depths of the mind: he paints a theory which is incapable of logical elucidation, one which can only be experienced obscurely and inarticulately in the cold sweat of direst horror, the way in which we may sense death although we properly cannot imagine it to ourselves.

And in this domain of experience there are no forms already prepared for us by artistic choice or traditional precedent; standard aesthetic principles, having been developed solely with reference to the external world, no longer possess any validity for us here; there is simply an urgent impulse to embody newly emerging ideas through the abrupt conjunction of rude and primitive symbols, through the obscurely shifting play of anthropomorphic images. [. . .]

And that is why Munch for me is essentially the one painter who struggles to give psychological form to our affective impulses, the painter of that psychical ecstasy in which a feeling announces itself with the utmost intensity, and this accounts for the crude, the exaggerated, the distorted character of Munch's style of painting. As my friend Peter Hille sharply observed: Munch possesses a courageous daring for distortion.

His works are the products of a mind in the most volatile state of conscious-ness imaginable, in which conscious and unconscious elements coalesce with one another; they are creations of a consciousness which has already seen everything before and earlier and possesses another tradition, quite different from that belonging to the recent brain of the conscious personality which hardly extends to the lifetime of a single generation; we are talking rather of phenomena which, psychologically considered, manifest themselves on the level of pure and individual life, of the phenomena of spiritual vision, of clairvoyance, of dreams and suchlike things.

16 Max Klinger (1857–1920) from *Drawing and Painting*

The most notable public works of the Leipzig-born painter, sculptor and engraver Max Klinger were a series of monumental polychrome sculptures of celebrated figures, which combined large scale with the use of materials such as ivory, mother of pearl and semi-precious stones. In honour of Klinger's work, the Vienna Secession organized their four-teenth exhibition (April–June, 1902) around his sculpture, *Beethoven*. This formed the focus for a transformation of the Secession building into a 'sanctuary', adorned by Klimt's *Beethoven-frieze*, which was originally intended for destruction once the exhibition was over. Klinger's other main achievement, however, was on a smaller scale, residing in his mastery of the graphic arts and the technically innovative works he produced on paper. In his only theoretical work, *Drawing and Painting*, privately published in 1891, he insists that monochrome arts such as engraving and drawing possess their own aesthetic which stands in 'emphatic contradiction' to the demands of painting, with its dependence on colour. Whilst the use of colour necessarily brings us back to the real world, the graphic arts liberate the imagination and free the artist from the constraints of 'everyday modes of perception'. Klinger was strongly influenced by Schopenhauer's theory of the Will (see IA1,

above), and his employment of the graphic arts to explore the reality behind appearances strikingly anticipates the later innovations of the Surrealists. Klinger's essay was originally published as *Malerei und Zeichnung*, Leipzig, 1891. These extracts have been translated for the present volume by Nicholas Walker from the reprint by Insel Verlag, pp. 3, 9–12, 21–4, 26–7.

Every developed language gathers together all those forms of representation which make colouristic use of oil, fresco, gouache, watercolour, pastels, etc. under the precise term 'painting'. For works of art which restrict themselves to the simple monochrome reproduction of light, shade and form, on the other hand, there is no precise and inclusive term.

Anyone who begins to consider the plastic and visual arts more closely will soon recognize that the manual forms of drawing, but especially the independent forms of engraving, etching, carving and lithography, frequently find themselves emphatically contradicting the demands of the painterly aesthetic, although they certainly do not thereby forfeit the character of perfected art-forms in their own right.

This contradiction is either declared an exception or is explained away in terms of the legitimate personal peculiarity of the artist. Both these assumptions are false. What we encounter here in the case of such works is rather a particular type of art with aesthetic interests of its own, and one which properly demands its own aesthetic. The fact that daily encounter with such works is almost unavoidable renders the lack of a proper term for them remarkable, all the more so since this lack results from an inadequate understanding of the differences which obtain between these particular arts and the art of painting.

To elucidate the unique status of drawing as an art and its relationship to the other arts, and to painting in particular, is the aim and purpose of this essay.

* * *

An engraving by Dürer does not provoke in us the thought of a transferred image, nor does it seem simply to translate coloured impressions for the sake of it, nor does it leave us merely with a sense of something fragmentary. No, it is complete and perfect in itself! It gives precisely what it was intended to give, with the exception of that eternally unattainable intention which commands every artist.

It is not as if Dürer had engraved the work in metal without any conception of its coloured character! For no human being is capable of ignoring the unified impression which nature makes upon us, and the colour aspect of things belongs indissolubly to that impression. It is rather that Dürer was led by his experience into a world which was quite possibly more colourful than the real world about us. But the colours of his world were so flickering, so incorporeal, so changing and various according to the play of imagination, that all external means were inadequate to capture them, even though the artist himself could perceive them with his inner eye. It was only the form, the event, the atmosphere, which he was capable of grasping. For the colours he had at his disposal would only lead his active imagination back into this real world. But this is precisely what he had transcended. And it is drawing alone which is capable of retaining and capturing such impressions in a manner untouched by our everyday modes of perception.

This engraving by Dürer represents drawing as an art in its own right, and one which requires a real artist if it is to be mastered. Such an artist requires nothing more than light and shade as his appropriate means of presentation. He will often remind us of colour, but he will not attempt to translate the latter. He is fully aware that real colour would only destroy that spiritual world which drawing alone shares with art and poetry.

* * *

The preceding claims are grounded in the fact that every material, by virtue of its phenomenal character and its inherent capacity for artistic treatment, harbours a spirit and poetry of its own which encourages a certain representational character when artistically approached and which can never be replaced by anything else. This is so, for example, when the character of a particular piece of music wholly depends upon a certain tonal scale and is quite destroyed if it is translated into a different one. Whenever this spirit of the material is not properly respected or addressed in the conception and execution of the work of art – whether because of defective technique or arbitrary whim, whether by accident or by external compulsion – or wherever the attempt is made to stamp one material with the character of another, the artistic unity of the overall impression is fatally compromised from the start. For in this case our thoughts, which are all too ready to stray from the matter at hand anyway, will turn away from the representation itself and occupy themselves instead with the means employed and the complexity of the effects obtained. An all too artistic technician and a real bungler will then produce the same result: in both cases we lose sight of the end because of the material.

The general thrust of these observations can now be encapsulated in the proposition: it is quite possible that a certain motif, thoroughly capable of artistic expression in drawing, will be incapable of representation for aesthetic reasons in painting as long as we regard the latter as the presentation of an image.

Thus I would define the nature of painting as follows: its task is to express the coloured material world in a harmonious fashion, and even the expression of passion and violent emotion must be subordinated to this harmonious effect. Its principal task is to preserve the unified character of the impression which it is capable of exercising upon the viewer, and the means at its disposal for this purpose allow painting to attain an extraordinary perfection in terms of the forms, colours, expression and general atmosphere out of which the picture is built up. We do not need to repeat here what Lessing has already pointed out in his 'Laokoon' essay, nor do we need to comment upon those passages in it where the writer and thinker draw false conclusions due to his lack of knowledge concerning artistic and technical practice itself. I can presuppose all his fundamental principles here as something well known.

* * *

If we now consider painting as a means, then the art appears to us as the most perfect expression of our joy in the world. Painting loves the beautiful for its own sake, and strives to attain it; and even where painting touches us through the depiction of the most distressing events of everyday life and the moments of highest tragedy, it moves us through the appeal of its colours and forms, harmoniously composed even in cases of extreme contrast. Painting is the glorification, the triumph of the world. And this is what it has to be.

Alongside this astonished adoration of the mighty moving world in all its splendour we also encounter the expressions of resignation, the wretched consolations and endless laments of the complaining creature in its risible insignificance, caught in an everlasting struggle between ambition and achievement.

The life of the artist consists in sensing and experiencing what he sees, consists in giving what he senses and experiences. Are then the mighty impressions with which the darker side of life inflict him, and from which he seeks deliverance, are these to remain unvoiced, restricted to the expression of the beautiful in form and colour? The monstrous contrasts between the beauty which is seen, sensed and sought on the one hand and all the terrible realities of life which so often cry out to us on the other inevitably produce images from out of the living sensibility of the poet and the composer. If such images as these are not to be lost, then there must also be another art which can supplement those of painting and sculpture, an art in which the aspect of figural repose does hinder communication between the image and the viewer to the same extent as it does in those arts. This art is the art of drawing.

* * *

As we have claimed, drawing stands in a freer relationship to the representable world:

It allows considerable leeway to the imagination in supplying the missing element of colour to the representation;

It can treat those forms which do not immediately belong to the principal subject, and indeed this subject itself, with such freedom that the imagination must also participate to supply the missing elements;

It can single out the object of representation in such a way that the imagination must create the relevant spatial dimension;

And it can apply these means either individually or in combination without the accomplished drawing having to forfeit anything whatsoever in aesthetic value or perfection.

The idea of the drawing serves as a substitute for the corporeality which has been relinquished. We are concerned here with an image which springs from the contrast effect obtaining between the real world and our own capacity for representation. It is essential for the expression of such an idea that the connection with the world at large be maintained. To accomplish this feat requires other means than those available to the art of painting. Painting represents every body simply as such, as a positive individual entity, as a complete and rounded totality which exists in its own right without relation to anything external. Everywhere it is the material aspects of things which occupy the art of painting: the lightness and brilliance of air, the moisture and glitter of the sea, the silky softness of flesh. For drawing, on the other hand, all these things can take on characteristics which may strike the synthesis of poetic perception more strongly than they do the eye itself. We tend to associate the idea of freedom with the air, that of violent might with the sea, and the human being strikes us here less as a person defined by individual shape and contour than as a being which stands in relation to and dependency upon all those other external forces; the human being here is above all the representative of the species. The possibility of treating the visible and corporeal world in such a poetically liberated manner is provided precisely by

those free features already mentioned, which allow any such representation to exercise a greater effect as phenomenal appearance than as corporeal form.

* * *

From everything that has been said so far we can now identify the most outstanding and characteristic feature of drawing: the intense subjectivity of the artist. He depicts his world and his way of looking at things, his own personal observations concerning the processes transpiring within him and about him, and the only thing he needs to concern himself with is to find an appropriate artistic response to the nature of his impressions and to his own capacities. Painting and sculpture always apply the strict and ineluctable parameters set by the conditions of nature, conditions which, universally binding as they are and vividly presented to everyone as they must be in the work of art, can never be violated. Only the one who draws is capable of shaping these conditions in accordance with his own capacity for expression without thereby betraying his artistic conscience in the slightest. The comparison with piano music and poetry strongly suggests itself here. In both cases the artist is released from the strict demands of scenery and orchestra, is capable of giving free artistic rein to his ownmost joys and pains, to his most fleeting and profoundly felt emotions in a spontaneous sequence and structure dictated solely by the force and power of the former.

The preceding observations all led to the conclusion that certain images produced by the imagination are not capable of adequate aesthetic representation in painting, or are capable of such only under certain limiting conditions; that such images on the other hand are accessible to representation in drawing without any loss of artistic value. It transpired that representations such as these spring from a certain way of looking at the world or, I would even say, a certain feeling for the world, in the same way that the representations of painting spring from a certain feeling for form.

17 Joséphin 'Sâr' Péladan (1858–1918) Manifesto and Rules of the *Salon de la Rose + Croix*

Péladan was a novelist and critic on the religious wing of the heterogeneous Symbolist movement. During the 1880s, in reviews of the annual Salon, he had joined the growing chorus against Naturalism, and came to embrace Wagnerian ideas about art. In the early 1890s a religious revival gained ground in France. Péladan seized the moment to launch his own Symbolist sect, the Catholic–Rosicrucian *Salon de la Rose + Croix*. At the first such Salon, in March 1892, 75 artists exhibited, and the crowd at the opening was so great that the street had to be closed and traffic diverted. In the six years of its existence, to 1897, the *Salon de la Rose + Croix* showed the work of 200 artists from a variety of countries. Many major figures, however, refused to become involved. Despite claims in the manifesto these included Puvis de Chavannes and Redon, as well as the English artist Burne-Jones. Also opposed were Moreau and Denis, whose own Catholicism was offended at Péladan's admixture of religion and the occult. Péladan's 'Rules' announced the intention to 'ruin realism' and 'create a school of idealist art'. None the less, the type of work found at the Salons of the *Rose + Croix* was not the Symbolism of Gauguin, Sérusier, Aurier, et al. Characteristic works were technically more orthodox, more conventionally modelled than that. Péladan admired the art of quattrocento Italy, and hence, not surprisingly, the work of

the German Nazarenes and the English Pre-Raphaelites. Also admired were the sexually charged enigmas of the Belgian Khnopff and the Swiss Hodler. Those with anarchist sympathies like Signac and Pissarro found the whole thing reactionary on political as well as artistic grounds. Fénéon felt that the literariness and occultism simply undermined the art: in his review of their first Salon he wrote that, in their hands, 'the entire Wagnerian Valhalla is as uninteresting as the Chamber of Deputies'. Péladan's 'Manifesto' was first published in *Le Figaro* on 2 September 1891. The 'Rules' were published as *Salon de la Rose + Croix. Règle et Monitoire*, Paris: Dentu, 1891. Both are reprinted here from the translation in Robert Pincus-Witten, *Occult Symbolism in France: Joséphin Péladan and the Salons de la Rose + Croix*, New York: Garland, 1976, pp. 205–10, 211–16.

Manifesto

How could an insertion in the *Petites Affiches* so arouse the press? Why does the announcement of a third Salon excite such streams of malevolence? By what obscure foreboding did the press, more clamouring than the Cassanire of Berlioz, denounce to the public as inauspicious a work of peace worthy of Pallas?

The *Rose+Croix du Temple*. For a week these simple words have been counter-pointed and fugued by the *kapelmeisters* of journalism. Such a fuse bears witness that our *Will*, blessed by *Providence*, will polarize *Necessity* with *Destiny*.

The Salon de la Rose+Croix will be the first realization of an intellectual order which originates, by theocratic principle, with Hugh of the Pagans; with Rosenkreutz by the idea of individualistic perfection.

The infidel today, he who profanes the Holy Sepulchre, is not the Turk, but the sceptic; and the militant monk with his motto 'ut leo feriatur' can no longer find a place for his effort.

On the black and white standard, sign of theocracy, we inscribe the Rose+Croix, Symbol of Beauty manifesting Charity.

For ten years we have awaited a comrade in arms who burned with the same artistic piety and at last we have met such a one impatient to undertake the same crusade: Antoine de La Rochefoucauld.

In only citing after the Grand Prior the Commanders Elémir Bourges, that admirable spirit, Count de Larmandie, that valiant knight, Gary de Lacroze, that subtle aesthete, and the three others still pseudonymous, one can predict that, transposed to its intellectual meaning, the proud thought of Saint Bernard will be justified.

The Politicians and clergy who have accepted the constitution can be reassured: until next Spring the entire order will be exclusively aesthetic.

The artist and the public need not ponder on what the Temple meditates, what the Rose+Croix prepares: simply the victorious manifestation of the Norms of Beauty which for twelve years we have offered.

The Salon de la Rose+Croix will be a temple dedicated to Art-God, with master-pieces for dogma and for saints, geniuses.

In all periods, the arts reflect letters. Delacroix, the greatest French master, incarnates Romanticism. Now for twenty years the arts have reflected the hackwork of Médan. Through his ignorance and base instinct, the author of *La Terre* has cast a spell on Manet; and Seurat, near death cried: 'Huysmans led me

astray!' Imagine making a picture after *Un Coeur simple* by Flaubert! one would fall into the inanity of Bastien Lepage and under the terrible judgement of Blaise Pascal: 'What vanity that painting would have us admire the representation of what one disdains in reality.'

The sentiment of Pascal is that of the Rose+Croix. We said in our last Salon: 'I believe that the aim of all arts is the beautiful. . . . I will defend the cause of Art against the palette workers and the sculpture practitioners.

'The Jury of the *Champ-de-Mars* is as hostile to abstract, religious, or simply artistic ideas, as that of the *Champs-Elysées*.

'Whosoever is practitioner, whosoever is mystical has nothing to hope for, neither from Carolus Duran nor from Bouguereau. Officially, the Ideal is vanquished! Oh well! *sed victo Catoni*, next Spring will witness a manifestation of Art against the arts, of the beautiful against the ugly, of the Dream against the real, of the Past against the infamous present, of Tradition against the hoax!'

Above all schools, without technical preference, admitting optical mixture as well as the Italian method of Desboutin, the Rose+Croix only insists upon the *ideality* of its works.

Among the eighty artists already elected and practically all adherents at this hour, it suffices to name the following: the great Puvis de Chavannes, Dagnan-Bouveret, Merson, Henri Martin, Aman-Jean, Odilon Redon, Khnopff, Point, Séon, Filiger, de Egusquiza, Anquetin, the sculptors Dampt, Marquest de Vasselot, Pezieux, Astruc and the composer Erik Satie.

We will go to London to invite Burne-Jones, Watts and the five other Pre-Raphaelites; we will invite the Germans Lehnbach and Boecklin.

The Order grows through invitation and the invited only have to observe the rule of ideality.

It banishes all contemporary, rustic or military representation; flowers, animals, genre treated like history-painting, and portraiture like landscape.

It accepts all allegory, legend, mysticism and myth and even the expressive head if it is noble or the nude study if it is beautiful.

You have to create BEAUTY to get into the Salon de la Rose+Croix.

One may wonder, in view of the small number of confirmed idealists as Lagarde, de Egusquiza, Antoine de La Rochefoucauld, how we will recruit our exhibitors.

In selecting ideal work, frequent in the production of the realists themselves, like the triptych of *Saint Cuthbert* of a Duez or the *Meneuse de Cygnes* and the *Charmeuse d'Etoiles* by Besnard.

As to landscape, it must be in the manner of Poussin, composed and subordinated to the figures; as to portraiture, excellence of execution will not suffice – the Order must also desire to honour the sitter. The 10th of March 1892, Paris will be able to contemplate, at the Durand-Ruel Gallery, the masters of which it is unaware; it will not find one vulgarity.

The Rose+Croix does not limit its solicitude to painting and sculpture; the *Soirées de la Rose+Croix*, held in the same place as the Salon, will be devoted to the fugues of Bach and Porpora, the quartets of Beethoven, to recitations of *Parsifal*. An evening will be set aside to the glorification of César Franck, the greatest French musician since Berlioz.

Among the idealist composers that the Rose-Croix will shed light on, it is proper to mention Erik Satie again, of whose work one will hear the harmonic suites for *le Fils des Etoiles* and the preludes to the *Prince de Byzance*.

Certain radical Leftist newspapers, beliving in obligatory calumny against Christian artists, have denounced the Salon de la Rose+Croix as a speculative venture.

Should there be profits they will be used for re-edition – so necessary to artists – of the Treatise on Painting by Leonardo da Vince, the divine Leonardo.

It has been proposed to the Council that the Order buy works to make gifts of them to provincial museums; but this point, like several others, must remain in abeyance until October when the *Règle esthétique des Rose+Croix* will appear.

Opinion forestalls our preparations and forces us to more immediate declarations which were unforeseen. Contrary to what one reads in the Papers, no work by a woman will be accepted because in our renovation of aesthetic laws we faithfully observe magical laws.

In 1886 we wrote: 'Merodack, Nebo, Alta, Tammuz, these Orphic figures, I have raised them in my work to foretell of the solemn day when the Rose+Croix, cleansed of Masonic contamination, purified of all heresy and blessed by the Pope, will be welded to the key of Peter, *urbi et orbi*.'

This solemn day will be the 10th of March, 1892: The day will begin with festivals of the mind as noble as those celebrated at Bayreuth; this day the Ideal will have its temple and knights and we, the Maccabeans of Beauty, will bring to Our-Lady, at the feet of our Suzerain Jesus, the homage of the Temple and the genuflection of the Rose+Croix.

We believe neither in progress nor salvation. For the latin race which is about to die, we prepare a last splendour, in order to dazzle and soften the barbarians who are coming.

We desire to add some statues and frescoes to the latin cathedral before it crumbles. Last enthusiasts, we arrive, amidst the braying of the *Marseillaise* and the cabarets, to intone a supreme hymn to Beauty, which is God, and thus one day earn the right to contemplate the mystical Rose through the achievements of Our-Lord's passion.

Ad Rosem per Crucem. Ad crucem per Rosam. In ea, in eis, gemmatus resurgam.

Rules

I The Order of the *Rose+Croix du Temple* is now enlarged to encompass the *Rose+Croix esthétique* in order to restore the cult of the IDEAL in all its splendour, with TRADITION as its base and BEAUTY as its means.

II The Salon de la Rose+Croix wants to *ruin realism*, reform Latin taste and create a school of idealist art.

III There is neither jury nor entry fee. The Order, which grows by invitation only, is too respectful of the artist to judge him on his method and imposes no other program than that of *beauty*, *nobility*, lyricism.

IV For greater clarity, here are the rejected subjects, no matter how well executed, even if perfectly:

1 History painting, prosaic and from a textbook, like Delaroche;
2 Patriotic and military painting, such as by Meissonnier, Neuville, Detaille;
3 All representations of contemporary, private or public life;
4 The portrait except if it is not dateable by costume and achieves style;
5 All rustic scenes;
6 All landscape, except those composed in the manner of Poussin;
7 Seascape; sailors;
8 All humorous things;
9 Merely picturesque orientalism;
10 All domestic animals and those relating to sport;
11 Flowers, still life, fruits, accessories and other exercises that painters ordinarily have the effrontery to exhibit.

V The Order favours first the Catholic Ideal and Mysticism. After Legend, Myth, Allegory, the Dream, the Paraphrase of great poetry and finally all Lyricism, the Order prefers work which has a Mural-like character, as being of superior essence.

VI For greater clarification, here are the subjects which will be welcome, even if *the execution* is imperfect:

1 Catholic Dogma from Margharitone to Andréa Sacchi;
2 The interpretations of oriental theogonies except those of the yellow races;
3 Allegory, be it expressive like 'Modesty and Vanity,' be it decorative like a work by Puvis de Chavannes;
4 The nude made *sublime*, the nude in the style of Primaticcio, Correggio, or the expressive head in the manner of Leonardo and of Michelangelo.

VII The same rule applies to sculpture. Ionic harmony, Gothic subtlety, and the intensity of the Renaissance is equally acceptable.

Rejected: Historical, patriotic, contemporary and picturesque sculpture, that is sculpture which only depicts the body in movement without expressing the soul. No bust will be accepted except by special permission.

VIII The Salon de la Rose+Croix admits all forms of drawing from simple lead-pencil studies to cartoons for fresco and stained glass.

IX Architecture: since this art was killed in 1789, only restorations or projects for fairy-tale palaces are acceptable.

X The theocratical nature of the Order of the R+C in no way entails the artists; their individuality remains outside the character of the Order.

They are only the Invited, and consequently are in no way in solidarity with the Order from a doctrinal point of view.

XI The artist who produces a work conforming to the programme of the R+C will be accepted even though his earlier work was of a different or realist nature, as the Order bases its judgements on what it is presented with and not with the development of a talent.

XII The artist who lives abroad and who wishes to exhibit with the R+C must send a photograph, on the basis of which his work will be accepted or rejected.

Kindly indicate dimensions of the work.

XIII As the Order, despite its solicitude, may be ignorant of the existence of idealist artists, it is permissible to whosoever believes that he has created a work conforming to the programme of the R+C, to present it on the first of March to the Archonte of Fine Arts at the Gallery Durand-Ruel, 11, rue Le Peletier. He will be informed of an admission or a refusal on the seventh, in which case the sender will see to it to remove his work before the ninth.

XIV Artists who might be prevented from framing their pictures may send their canvases on stretchers.

XV For the Order of the Rose+Croix the word 'foreign' has no meaning.

This Salon assumes an international character in the highest degree.

XVI It will officially open the 10th of March, 1892, and will terminate the 10th of April.

XVII From the 25th of February to the third of March, the artists invited to exhibit who live in Paris will receive the visit of the Sâr and the Archonte to whom they will remit a signed notice stating name, first name, subject of work, dimensions and selling price.

XVIII The invited artists who live in the provinces or abroad must send their works between the first and fifth of March (at the very latest), carriage paid, to the Archonte of the Salon de la Rose+Croix, Gallery Durand-Ruel, 11, rue Le Peletier.

XIX The work must bear a label on which is clearly written the name of the artist and subject of work.

XX In the case of loss or damage the Order declines all financial responsibility.

The R+C warns that the works of the Salon are not insured.

XXI Works must be picked up in the three days following the closing of the exhibition.

XXII From the 8th of March, 1892, beginning at 11 o'clock, the critics will be admitted on presentation of special cards which will already have been given them.

On the same day, at 8 p.m., a reception will be held for the Ambassadors and for the Minister of Public Instruction and the Fine Arts.

XXIII The 9th of March, exhibition by named invitation.

The 10th, Opening Day. (Entry fee: 20 francs.)

XXIV The following days the entry fee will be 2 francs from 10 a.m. till noon, 1 franc until 6 p.m. – except Sunday which is 50 centimes.

Fridays will be 5 francs, as well as closing day (open between 10 a.m. and 6 p.m.).

XXV Paris school children, accompanied by their teacher will be admitted with no charge on Thursday afternoons.

XXVI There will be five kinds of cards:

the white card of the critic
the red card of exhibition (by name)
the permanent green card (exhibitors)
the blue card, good for only one visit
the yellow card, good for the whole month and permitting one to escort a lady (price: 5 louis).

XXVII A Solemn Mass of the Holy Ghost will be celebrated on the 10th of March at
10 o'clock in the morning at the church of Saint Germain l'Auxerrois.

The Prelude, the Last Supper of the Grail, the Good Friday Spell and the Finale of
the Redemption from *Parsifal* by the superhuman Wagner will be played.

The Mass will be preceded by the three fanfares of the Order composed by Erik
Satie for harp and trumpet.

All participants will hold reserved seats.

Following Magical law, no work by a woman will ever be exhibited or executed by the
Order.

18 Ferdinand Hodler (1853–1918) 'Characteristic Expression through Form' and 'Parallelism, or the Doctrine of Equivalences'

Three years before his death in 1918, Hodler declared that 'My work stands or falls with
the correctness or incorrectness of my [theory of] Parallelism. Either Parallelism as I have
understood it, described it and applied it is a global law of universal validity, in which case
my work is of universal significance; or, I have erred, in which case all that I have achieved
is mere self-deception and error.' In the early 1890s Hodler was influenced by French
Symbolist ideas and Art Nouveau and began to develop his characteristic flat, linear style in
a series of paintings addressing fundamental themes of human existence. After his painting
Night was prevented from being shown in the Geneva municipal exhibition of 1891, it was
exhibited that same year in the Salon du Champ-de-Mars in Paris, where it was highly
praised by the salon's director, Puvis de Chavannes (1824–98). Hodler subsequently
exhibited in the first two salons of the *Rose+Cross* (see VIc17, above) and became a
member of both the Berlin and the Munich Secessions. In 1904 his work was given a large
retrospective by the Vienna Secession. Hodler left behind a large number of short state-
ments and written fragments, parts of which were incorporated into C. A. Loosli's four-
volume *Ferdinand Hodler: Leben, Werke und Nachlass* (Ferdinand Hodler: life, work and
literary remains), Bern: R. Suter Verlag, 1921–4. Whilst there is little reason to doubt the
authenticity of these fragments, Loosli does not enable us to date them with any certainty.
In content, however, they are compatible with the French Divisionist and Symbolist pre-
occupations of the 1890s, and Hodler had arrived at his theory of parallelism by the start
of that decade. The following extracts have been translated for the present volume by
Jason Gaiger from volume I, pp. 63–4, 72–3, 76–7, 78–9.

Characteristic Expression through Form

Whichever goal the artist strives towards, he will only reach it along the path which
leads through form. Form is the expression of everything corporeal; everything which
is visible and which exists in space possesses form.

For the artist, form is the fundamental, elemental and unavoidable presupposition.

Colour is inconceivable if it is not expressed in such a way that it can be perceived
through form.

Different sorts of bodies and living creatures, man, physiognomic expression
and all the infinite varieties of a type first become perceptible through form.
Unusual physiognomies, cheerfulness, laughter, sadness, the most intimate

conditions of the soul are made externally perceptible by bodily posture, by the play of physiognomic features – that is to say, it is possible to convey them by means of form.

The elements of form are: extension, relation, distance and space.

The elements of harmony consist of symmetry and number.

The primary or original figures of form I term the point, the straight line, the flat surface and the right angle.

Form, therefore, carries within itself all the distinguishing features which are necessary to determine the essence of the appearance (of a human being).

* * *

Nothing is visible without form. Form can be said to express by itself alone four fifths of resemblance. It shapes every body, every bodily characteristic, both space and the body within space, and it makes the body's external and surface expression perceptible to our senses. Form brings every human physiognomy to expression and reveals man's inner condition to himself.

Proof: all those forms of art which use black and white, photography, drawing, engraving.

Form is not only the predominant but also the most expressive element and, like colour, it is attractive to us: it possesses seductive powers.

We are also more able to reproduce it than colour. Form leads to fewer disappointments than colour.

A single line is sufficient to express an infinity of forms, for by means of the line I am able to express all possible forms, etc.

* * *

Form is common to all the arts which strive to capture reality in the round: to sculpture and architecture just as to painting. It is the element which possesses the greatest capacity for expression; like colour, it possesses an enticing charm. The straight line, the rectangle, the circle are highly expressive figures.

In terms of its use, form is also easier to grasp and manipulate than colour.

We are able to reproduce form better than colour, for our technical capacities correspond more closely to the element which we have to represent. Also, in painting form is far less subject to deception than colour, for it is the external expression of a body, the expression of its surfaces and lines.

For this reason, the task of the draughtsman resides in articulating the external shape of things. The means which stand at his disposal are the formal means of the line and the flat surface. By itself alone the line expresses the infinite.

The form of every object as we perceive it is composed of its outline and its inner form. This is the result of our way of seeing, for in reality every surface of a body is external. However, the outline has not only to give the extension, and the elevations and depressions of a body, it must also possess a decorative, architectonic character in so far as it clearly and unambiguously distinguishes the body from what surrounds it.

It is precisely because they emphasized the decorative property of the outline particularly clearly that we justly admire many masters of art.

The double task, on the one hand to express the consistency of movement, and on the other to make the beauty of the outline perceptible, is what makes the work of the artist often so difficult and requires that he struggle long and in vain with the form.

The contribution of the outline to the beauty of a work is now recognized and it has thereby become genuinely ornamental; it can be said that the decorative arts are increasingly taking on an Ornamental character.

Common to all great artists is the striving to separate form clearly and unambiguously from its surrounding; by opposing the short line to the long, and enquiring into the proportions of the human body so as to discover its rhythm, they have sought to discover the beauty and force of the line in the outline.

But how, then, do we see the body?

As oppositions of bright and dark, light and shadow, as various colours. And, finally, also in so far as bodies are linearly separated from another.

All bodies with a smooth outer surface have a very clear outline. If, under the pretext of making it more beautiful, someone takes away from the outline its character, weakening and blurring it, this falsifies the facts, especially when, on top of everything else, the lighting conditions demand exactness. Where it is not actually forbidden this form of softening and weakening results in something extremely tedious. Generally it serves to hide a lack of draughtsmanship, imprecision, something hackneyed and kitsch. Such people imagine that to soften means to make more beautiful, whereas in reality it means only to lie.

Parallelism, or the Doctrine of Equivalences

By parallelism I understand every form of repetition. Every time that I am stimulated in the most vivid manner by things in nature, I am effected by their unity.

If my path leads me through a pine forest, where tree on top of tree strives upwards towards the heavens, before, beside and behind me I see trunks rising up like innumerable pillars.

A straight line which repeats itself many times surrounds me.

Whether the bright trunks separate themselves off from an ever brightening background, or whether they strive heavenwards; it is always the same, oft-repeated line which combines into a beautiful unity.

The cause which brings about this unity is parallelism.

The innumerable, vertical lines create the effect of a single, enormous vertical or of a great surface.

If we allow our eye to roam across a meadow in which a single sort of flower blooms in abundance, as for example, dandelions in spring, where the vivid yellow is set off against the soft green of the grass, we experience a sensation of a great unity which delights us to the point of sheer jubilation.

And here we need to observe that the impression is all the stronger if only one sort of flower adorns the meadow, and that it would be weakened were the meadow strewn with flowers of different colours and forms.

Another example:

There stands a row of blossoming oleander, or we follow a path alongside a blossoming hedge, and immediately we are aware that the delight we take in these things is caused by the repetition.

Or, one may think of an area of open land densely strewn with boulders, the remnants of a landslide, such as at the foot of the Salève; immediately one has the

same impression, but of a melancholy sort, conditioned by the repetition of similar forms and colours.

A similar but much stronger example imposes itself on us when we stand on top of a mountain in the middle of the Alps. The innumerable peaks with which we are surrounded awaken in us that admiration and delight which arises from repetition of the same.

In autumn, when the leaves fall from the trees, a single type of leaf, such as that of the acacia, can delight us by the way in which it lies scattered on the ground, covering the earth in its hundreds.

When I gaze up at the cloudless sky, this enormous undivided expanse, this mighty unity, commands admiration from me.

Although here the individual elements which condition the parallelism are not clearly separated from one another, as in the above examples, they are none the less present. Every molecule of air acts just like every other, in parallel, and the sum of their individual effects conditions the great, undisturbed, overwhelming unity.

In every case in which parallelism reveals itself to be the immediate cause of our delight we can confirm a certain immutable order in nature.

Thus, for example, many flowers contain petals which are of the same form, colour and size, ordered around a common centre.

A tree always bears leaves and fruits of the same form and colour.

When Tolstoy writes in his book *What is Art?* that it is impossible to find two identical leaves on the same tree, it can, with more justice, be replied that nothing in the world looks so much like the leaf of a plane tree as precisely the leaf of a plane tree.

All these observations lead us to understand the significance and guiding role which parallelism or the repetition of uniformity plays in nature, and, indeed, precisely in those phenomena which gives us the most pleasure, flowers.

* * *

When a number of people with the same intention sit around a table, just as petals around a flower, they can be regarded as so many parallels which taken as a totality form a unity.

When we are in a cheerful or excited mood we hate every interruption, every disturbance of the resulting feeling of well-being because it disturbs or takes away the unity of our mood and our feelings.

The saying goes that 'Like is attracted to like'.

Quite rightly, for from all that has been said the parallelism of form of which I have been speaking can easily be derived and proven.

Now it is possible to understand my paintings, *The Weary of Life*, *The Disappointed Souls*, *Eurhythmie*, *Day* and *Truth*. One can grasp that in these paintings I combine emotional states with objects in which the unity of our sensations is most clearly and unambiguously revealed.

If the appearance of something is pleasing to us, its repetition will serve to strengthen the delight we take in it; if it is expressive of sorrow and pain, this suffering too will be increased by repetition. On the other hand, if something is ridiculous or vulgar repetition will make it unbearable.

Repetition, then, results in an increase in intensity; it gives the object the greatest possible added emphasis.

All the same: even when one completely frees oneself from the world of objects, the repetition of a form or a colour suffices to awaken a pleasant sensation in us.

Since the age of the primitives this principle of harmony and order has been forgotten and no one has thought upon it any more.

Delight is sought in diversity, but unity is thereby destroyed.

If I, for my part, succeeded in recognizing the value and the force of this element, this was because I observed nature, as I have shown in the examples given above, which could be multiplied indefinitely.

But, of course, it must not be forgotten that diversity too is also a world in itself.

19 Odilon Redon (1840–1916) 'Suggestive Art'

For a previous text by Redon see Vc5. Though Redon was claimed by the Symbolists, he maintained his distance from them, as he did from all other groupings from the later 1880s until the end of his life. In fact the principles and commitments of his art remained highly consistent. As the following text demonstrates, he retained his early enthusiasm for the thoroughly figurative work of Leonardo and Dürer. And while the decorative properties of his art appeared similar to those of other painters who identified themselves as Symbolists – particularly in the 1890s when he worked with bright colours in oil and pastel – he never entirely abandoned Naturalism for the world of pure ideas. He remained insistent that these compositions were derived from forms and details that were observable, if often unnoticed or unrecognized. Their apparent unreality was a consequence not of idealism but of the unusual combination of naturalistic elements or the imaginative extrapolation of organic principles. The passage on 'Suggestive Art' is taken from *A soi-même; journal (1867–1915)*, Paris, 1922; reprinted Paris: Libraire José Corti, 1961, pp. 25–8, translated for this volume by Akane Kawakami.

The fact remains that in my early attempts I always tended towards perfection, and, believe it or not, towards a perfection of form. But let me tell you now that no plastic form, by which I mean one perceived objectively, as itself, under the laws of light and shadow and by the conventional means of 'modelling', is to be found in my works. At the very most I often attempted, at the beginning, and for the reason that one must try as far as possible to be acquainted with everything, to reproduce in this way objects visible according to the artistic mode of the traditional optic. I did it only as an exercise. But I tell you today, in all consciousness of my maturity, and I insist thereupon, that all my art is limited to the resources of chiaroscuro and it also owes much to the effects of the abstract line, that primordial agent, directly affecting the mind. Suggestive art cannot furnish anything without having its sole recourse to the mysterious play of shadows and of the rhythm of mentally conceived lines. Ah! never were they more successfully used than in the work of Leonardo da Vinci! His work owes to them its mystery and the fecundity of the fascinations it exerts on our minds. They are the roots of the words of its language. And it is also through perfection, excellence, reason and a docile submission to the laws of the natural that this admirable and sovereign genius dominates the whole of the art of forms; he dominates it even unto their essence! 'Nature is full of infinite reasons which never existed in

experience', he wrote. Nature was for him, as was undoubtedly the case for all the masters, the obvious necessity and the axiom. Who is the painter who would think otherwise?

It is also nature who commands us to obey the gifts which she has given us. My own induced me to dream; I suffered the torments of the imagination and the surprises that it afforded me under my pencil; but I conducted them and led them, these surprises, in accordance with the laws of the artistic organism that I know, that I feel, for the sole purpose of obtaining in the viewer, by a sudden attraction, all its evocation, all the attraction of the uncertain, on the confines of thought itself.

Nor have I said much which was not largely foreshadowed by Albert Dürer in his engraving *Melancholy*. One would think it an incoherent work. No, it is *written*, it is written in sole accordance with the power of the line, its mighty powers. A grave and profound spirit rocks us in this work, as if to the hurried and sturdy accents of a stern fugue. After him we find ourselves singing only shortened motifs of but a few measures.

Suggestive art is like an irradiation of things which encourage dreaming accompanied also by thought. Decadent or not, that is how it is. Rather, we can call it a growing, an evolution of art towards the supreme flowering of our own lives, its expansion, its highest point of dependence or of moral support through a necessary exaltation.

This suggestive art is to be found in its entirety in the exhilarating art of music, more freely, more radiantly than in painting; but it is also present in my kind of art through a combination of diverse elements brought together, of transposed or transformed forms, bearing no relation to contingencies, but nevertheless following a logic. All the errors made by critics with regard to me, with regard to my first works, came of the fact that they failed to see that it was necessary *not* to define anything, understand anything, limit anything or point at anything specific, because all that is sincerely and gently new – like, for instance, beauty – bears its meaning in itself.

[. . .] Imagine some arabesques or some varied meanders, unwinding themselves, not on a flat surface, but in space, possessing everything that the profound and indeterminate margins of the sky would furnish the mind with; imagine the play of their lines projected and combined with the most diverse elements, including those of a human face; if this face has the particularities of that which we see every day on the street, with its fortuitous, immediate and completely real truth, you have there the customary make-up of many of my drawings.

They are, therefore, and there is no more precise explanation for them, the repercussion of a human expression, placed, by a permissible fantasy, within a play of arabesques, where, I truly believe, the action which it will derive from its position within the mind of the viewer will incite this latter to imagine fictions whose significations will be great or small, according to his sensibility and according to the aptitude of his imagination to aggrandize, or to diminish, everything.

And again, everything derives from the life of the universe; a painter who does not draw a wall vertically, draws badly, because he would thereby deflect the mind from the idea of stability. He who would not render water horizontal would do the same (to cite but the simplest phenomena). But there exist in natural vegetation, for example,

secret and normal tendencies of life which a sensitive landscape painter would not mistake; a tree trunk, with its characteristic of force, shoots forth its branches in accordance with the laws of expansion and according to the rush of its sap, which a true artist must feel and represent.

It is the same thing with animal or human life. We cannot move a hand without the whole of our being changing position, in obedience to the laws of gravity. A draughtsman knows this. I believe that I have obeyed these intuitive indications of my instinct in my creation of certain monsters. They do not originate, as Huysmans has insinuated, from the aid of the microscope faced with the alarming world of the infinitely small. No. I had, in creating them, the more important task of organizing their structures.

There is a mode of drawing which has been freed by the imagination from the annoying concern of real particularities, in order to be employed, freely, for the representation of things imagined. I have created several fantasies with a flower stem, or the human face, or even with elements derived from bone structure, which I believe are drawn, constructed and built as they should be. They are thus because they have an organism. Every time that a human figure does not give the illusion that it is, so to speak, about to come out of the picture frame to walk, act or think, the drawing is not a truly modern one. I cannot be refused the merit of giving an illusion of life to my most unreal creations. All my originality consists therefore in making unreal creatures live humanly, by putting, as much as possible, the logic of the visible at the service of the invisible. [. . .]

Bibliography

This bibliography combines the following types of reference in one alphabetical listing, with cross-references where appropriate.
1 Sources for all those texts which are printed and excerpted in the anthology, with dates of original publication given in brackets, where these are different. Texts are listed by author. The editorial prefaces to the individual anthologized texts should be consulted for more detailed references to original occasions of publication.
2 Collections of theoretical and critical materials in which these and related texts may be found, by artist/author, or by editor for compilations from more than one artist/author.
3 Sources for relevant authors and texts not themselves included in the anthology, but referred to or quoted within either editorial matter or anthologized texts.
4 Some further sources for nineteenth-century material of relevance to concerns addressed in the anthology.
5 Twentieth-century studies of the art, art theory and criticism of the period which the editors have found of particular value in the selection and tracing of texts.

Adam, P., 'Impressionist Painters', *La Révue contemporaine*, Paris, May 1886 (VIв6)
Adam, P., *Symbolistes et décadents*, ed. M. Pakenham, Exeter, 1989
Allston, W., 'Art' (*c.* 1835), in Allston, 1850 (IA17)
Allston, W., *Lectures on Art and Poems*, ed. R. H. Dana, Jr, New York, 1850
Anon., Response to Ruskin, *The Times*, 1851 (IIIc5)
Anon., Review of the Works of the Pre-Raphaelites, *The Times*, 1851 (IIIc5)
Anon., 'Woman, and her Chance as an Artist', *Magazine of Art*, London, April 1888 (Vв9)
Anon., 'Women Artists', in *L'Artiste*, Vol. 10, Paris, 1836 (IID5)
Arnold, M., *Culture and Anarchy* (1869), London, 1949 (IIIc11)
Aurier, G.-A., 'The Isolated: Vincent van Gogh', *Mercure de France*, Paris, January 1890 (Vв4)
Aurier, G.-A., 'Symbolism in Painting: Paul Gauguin' (1891), in Chipp, 1968 (VIc10)
Aurier, G.-A., *Oeuvres posthumes*, Paris, 1893
Bahr, H., 'The Modern' (1890), in G. Weinberg, 1976 (VIA8)
Bahr, H., 'Our Secession' (1897), in G. Weinberg, 1976 (VIA10)
Bahr, H., *Renaissance: neue Studien zur Kritik der Moderne*, Berlin, 1897
Balzac, H. de., *The Unknown Masterpiece* (1845), London, 1899 (IA16)
Barocchi, P., *Testimonianze e polemiche figurative in Italia*, Messina and Florence, 1972
Bashkirtseff, M., *The Journal of Marie Bashkirtseff* (1887), trans. M. Blind (1890), London, 1985 (Vв7)
Batissier, L., 'Biographie de Géricault', *Révue de XIX siècle*, Paris, 1842
Baudelaire, C., *Curiosités esthétiques*, Paris, 1868

Baudelaire, C., *Oeuvres complètes*, ed. Y. G. le Dantec, rev. C. Pichois, Paris, 1961

Baudelaire, C., *Art in Paris: 1845–1862: Salons and other Exhibitions, Reviewed by Charles Baudelaire*, ed. J. Mayne, London, 1964a

Baudelaire, C., 'The Painter of Modern Life' (1859–63), in Baudelaire, 1964b (IIID8)

Baudelaire, C., *The Painter of Modern Life and Other Essays*, ed. J. Mayne, London, 1964b

Baudelaire, C., *Salon of 1846* (1846), in Baudelaire, 1964a (IIc9; IID11)

Baudelaire, C., 'Exposition Universelle' (1855), in Baudelaire, 1964a (IIID5)

Baudelaire, C., 'Salon of 1859' (1859), in Baudelaire, 1964a (IIID6; IVc5)

Baudelaire, C., 'Correspondance'/'Correspondences' (1857), in Baudelaire, 1982 (IIID4)

Baudelaire, C., *Les Fleurs du Mal: The Complete Text of the Flowers of Evil*, trans. R. Howard, London, 1982

Beckett, R. B., *John Constable's Discourses*, Ipswich, 1970

Belinsky, V. G., 'A View of Russian Literature in 1847', in Belinsky 1948 (IIIB1)

Belinsky, V. G., *Selected Philosophical Works*, Moscow, 1948

Bender, H., see Greenough, H.

Benjamin, W., *Charles Baudelaire: A Lyric Poet in the Era of High Capitalism*, London, 1983

Bentham, J., *The Rationale of Reward*, London, 1825 (IIA1)

Bernard, E., *Souvenirs sur Paul Cézanne*, Paris, 1912

Bernard, E., *Letters to Emile Bernard*, Brussels, 1942

Bernard, E., 'Paul Cézanne', *Les Hommes d'aujourd'hui*, VIII, no. 387, Paris, 1981 (VIB15)

Bernard, E., et al., *Conversations avec Cézanne*, ed. P. Doran, Paris, 1987

Beyrodt, W., Bischoff, U., Busch, W. and Hammer-Schenk, H., *Kunsttheorie und Kunstgeschichte des 19. Jahrhunderts in Deutschland*, 3 Vols., Stuttgart, 1982–5

Bianchini, A., *Del purismo nelle arti*, Rome, 1843 (IIB8)

Biez, J. de, *Edouard Manet*, Paris, 1884

Blanc, C., *L'Oeuvre complet de Rembrandt*, Paris, 1859–61

Blanc, C., *Histoire des peintres de toutes les écoles*, Paris, 1865–77

Blanc, C., *Grammar of Painting and Engraving* (1867), New York and Cambridge, 1874 (IVB5)

Blavatsky, H. P., *Isis Unveiled*, New York and London 1877 (VB3)

Blavatsky, H. P., *The Secret Doctrine*, London, 1888

Boggs, J. S., 'Degas Notebooks at the Bibliotèque Nationale', I–III, *Burlington Magazine*, London, May–July 1958 (IVA8)

Boudin, E., Letters to Martin (1867–9), in Boudin, 1932 (IIID14)

Boudin, E., *Eugène Boudin d'après des documents inédits*, ed. G. Jean-Aubry, Paris, 1932

Brown, F. M., Notes on *Work* (1865), in F. M. Hueffer, *Ford Madox Brown: A Record of His Life and Work*, London, 1896 (IIIc10)

Brown, F. M., *The Diary of Ford Madox Brown*, New Haven, 1981

Brownell, W. C., 'The Art Schools of Philadelphia', in *Scribner's Monthly*, Vol. XVIII, New York, September 1879

Buchon, M., 'Annonce' (1850), in Courbet, 1977 (IIIB3)

Burckhard, M., 'Ver Sacrum', in *Ver Sacrum – Organ der Vereinigung bildender Künstler Österreichs*, Vienna, January 1898 (VIA11)

Burckhardt, J., *The Civilization of the Renaissance in Italy* (1860), London, 1878

Burckhardt, J., *Über das Studium der Geschichte: Der Text der 'Weltgeschichtlichen Betrachtungen' auf Grund der Vorarbeiten von Ernst Ziegle nach den Handschriften*, ed. Peter Ganz, Munich, 1982 (VB1)

Bürger, W., see also Thoré, T.

Bürger, W., 'New Tendencies in Art' (1857), in Thoré, 1868 (IIIB8)

Bürger, W., 'Salon of 1861' (1861), in Bürger, 1870 (IIIc9)

Bürger, W., *Salons de W. Bürger, 1861 à 1868*, Paris, 1870

Carlyle, T., 'Signs of the Times', *The Edinburgh Review*, Vol. XLIX, June 1829 (IID1)

Carlyle, T., *The Correspondence of Thomas Carlyle and Ralph Waldo Emerson 1834–1872* (1883), New York, 1964

Carlyle, T., *Sartor Resartus* (1833–4/1836), Oxford, 1987 (IA13)

Cartwright, J., *Jean-Francois Millet: His Life and Letters*, London and New York, 1896

Carus, C. G., *Neun Briefe über Landschaftsmalerei* (1831), Dresden, 1955 (IB1)

Cassatt, M., *Cassatt and her Circle: Selected Letters*, New York, 1984 (VIA17)

Cassirer, E., *Kunstlerbriefe aus dem neunzehnten Jahrhundert*, Berlin, 1919

Castagnary, J.-A., *Les Libres propos* (1864), Paris, 1989

Castagnary, J.-A., 'The Three Contemporary Schools' (1863), in Castagnary, 1892 (IIIB14)

Castagnary, J.-A., 'Naturalism' (1867), in Castagnary, 1892 (IIIB15)

Castagnary, J.-A., *Salons: 1857–1870*, Paris, 1892

Castagnary, J.-A., 'The Exhibition on the Boulevard des Capucines' (1874), in Rewald, 1973 (IVA12)

Catlin, G., 'Letter from the Mouth of the Yellowstone River' (1832), in Catlin, New York, 1841 (IB9)

Catlin, G., *Letters and Notes on the Manner, Customs and Conditions of the North American Indians*, New York and London, 1841

Catlin, G., *Notes of Eight Years' Travels and Residence in England with his North American Indian Collection*, New York, 1848

Cecchi, E., *The Macchiaioli: The First Europeans in Tuscany*, Florence, 1963

Cézanne, P., *Correspondance*, ed. J. Rewald, Paris, 1937

Cézanne, P., *Letters*, ed. J. Rewald (1941), Oxford, 1976 (IVA5 and VIB17)

Champfleury, *Le Réalisme*, Paris, 1857

Champfleury, *Histoire de l'imagerie populaire*, Paris, 1886

Champfleury, '*The Burial at Ornans*' (1851), in Courbet, 1977 (IIIB4)

Chernyshevsky, N. G., ' "The Aesthetic Relation of Art to Reality", reviewed by the Author' (1855) in N. G. Chernyshevsky, 1953 (IIIB9)

Chernyshevsky, N. G., *Selected Philosophical Essays*, Moscow, 1953

Chernyshevsky, N. G., *What is to be Done?*, Ann Arbor, 1986

Chevreul, E., *The Laws of Contrast of Colour: and their Application to the Arts* (1839), London and New York, 1859 (IIc5)

Chipp, H. B., *Theories of Modern Art*, Berkeley and Los Angeles, 1968

Chu, P. Ten-Doesschate, see Ten-Doesschate Chu, P.

Clark, T. J., *Image of the People: Gustave Courbet and the 1848 Revolution* (1973), London and New York, 1982

Clark, T. J., *The Absolute Bourgeois* (1973), New York and London, 1982

Clark, T. J., *The Painting of Modern Life: Paris in the Art of Manet and his Followers*, New York and London, 1985

Clayre, A., *Nature and Industrialisation*, Oxford, 1977

Clément, C., *Géricault, étude biographique et critique*, Paris, 1868 (IA2)

Cole, T., Letter to Luman Reed (1833), in Cole, 1853

Cole, T., *The Course of Empire, Voyage of Life, and other Pictures of Thomas Cole, N. A. with Selections from his Letters and Miscellaneous Writings*, ed. L. L. Noble, New York, 1853

Cole, T., 'Essay on American Scenery' (1836), in Cole, 1980 (IB10)

Cole, T., *The Collected Essays and Prose Sketches*, ed. M. Tymn, St Paul, 1980

Comte, A., *The Positive Philosophy of Auguste Comte*, trans. H. Marineau, London, 1853 (IIA2)

Constable, J., Letters to Fisher (1821–4), in Leslie, 1845 (IB4)

Constable, J., Introduction to *English Landscape* (1833), in Beckett, 1970 (IB7)

Constable, J., 'Discourses', in Leslie, 1845 (IB8)

Constable, J., *Correspondence*, ed. R. B. Beckett, 6 vols, London, 1962–8

Constable, J., *Further Documents and Correspondence*, eds. L. Parris, C. Shields and I. Fleming-Williams, London, 1975

Constitution of the Independent Artists, *La Chronique des arts et de la curiosité*, Paris, 17 January 1874 (IVA10)

Corot, C., see Moreau-Nélaton

Courbet, G., *Courbet in Perspective*, ed. P. Ten-Doesschate Chu, Englewood Cliffs, 1977

Courbet, G., Letter to Champfleury (1854), in Courbet, 1978 (IIIB5)

Courbet, G., *Gustave Courbet: 1819–1877*, exhibition catalogue, London, 1978

Courbet, G., Statement on Realism (1855), in Courbet, 1978 (IIIB6)

Courbet, G., Letter to Young Artists (1861), in Courbet, 1950 (IIIB12)

Courbet, G., *Courbet raconté par lui-même et par ses amis*, ed. P. Courthion, Geneva, 1950

Courbet, G., *Letters of Gustave Courbet*, ed. and trans. P. Ten-Doesschate Chu, Chicago, 1992

Courthion, P. and Cailler, P., *Portrait of Manet by Himself and his Contemporaries*, London, 1960

Cousin, V., *Lectures on the True, the Beautiful and the Good* (1836), Edinburgh and New York, 1853 (IIB4)

Cousin, V., *Oeuvres philosophiques* (1843), Geneva, 1969

Couture, T., *Conversations on Art Methods*, (1867), New York, 1879 (IVB4)

Darwin, C., *The Descent of Man and Selection in Relation to Sex* (1871), New York and London, 1874 (IIIA11)

De Amicis, E., 'The First Day in Paris' (1878), in *Studies of Paris*, London and New York, 1879 (VIA2)

Degas, E., *The Notebooks of Edgar Degas; A Catalogue of the Thirty-eight Notebooks in the Bibliothèque Nationale and Other Collections*, ed. T. Reff, Oxford, 1976 (IVA8)

Degas, E., Letter to Tissot (1874), in Degas, 1947 (IVA11)

Degas, E., *Edgar Germain Hilaire Degas: Letters*, ed. M. Guérin (1931), trans. M. Kay, Oxford, 1947

Degas, E., Letter to Pissarro (1880), in Degas, 1947 (IVA17)

Delaborde, H., *Ingres. Sa vie, ses travaux, sa doctrine*, Paris, 1870

Delacroix, E., *The Journal of Eugène Delacroix*, London 1938 (IA3, 15; IIIA4; IIIB2)

Delacroix, E., *Selected Letters*, London, 1971 (IA15)

Denis, M., 'Definition of Neo-Traditionism' (1890), in Denis, 1913 (VC10)

Denis, M., *Théories 1890–1910: Du Symbolisme et de Gauguin vers un nouvel ordre classique* (1912), Paris, 1913

Diaghilev, S., 'Complex Questions: Our Supposed Decadence', in *Mir Iskusstva*, No. 1, St Petersburg November 1899 (VIA16)

Dickens, C., 'Old Lamps for New Ones', in *Household Words*, Vol. I, No. 12, London, 1850 (IIIC3)

Dilthey, W., 'The Three Epochs of Modern Aesthetics and its Present Task' (1892), trans. R. A. Mackreel and F. Rodi, in W. Dilthey, 1985 (VA9)

Dilthey, W., *Selected Works. Vol. V: Poetry and Experience*, eds R. A. Mackreel and F. Rodi, Princeton, 1985

Dobrolyubov, N. A., 'When Will the Day Come?', in *Selected Philosophical Essays*, Moscow, 1956 (IIIB10)

Dorra, H., *Symbolist Art Theories*, Berkeley and London, 1994

Dujardin, E., 'Cloissonism' (1888), in Dorra (VIC7)

Dunlap, W., *Address to the Students of the National Academy of Design*, New York, 1831 (IID2)

Dunlap, W., *History of the Rise and Progress of the Arts of Design in the United States*, New York, 1835

Dunlap, W., *Diary of William Dunlap* (1930), New York, 1969

Duranty, E., *The New Painting* (1876), in Fine Arts Museums of San Francisco, 1986 (IVA14)

Dürer, A., *Writings*, trans. and ed. W. M. Conway, New York, 1951

Dürer, A., *A Book of the Art of Drawing...*, (1652), London, 1972

Eakins, T., Letter to Benjamin Eakins (1868), in Foster, K. A. and Leibold, C., 1989 (IIIB18)

Eakins, T., On the Teaching of Art, in Brownell, 1879 (IVB11)

Eastlake, E., 'Photography', *Quarterly Review*, London, April 1857; reprinted in Newhall (IVC3)

Eitner, L., *Neo-Classicism and Romanticism 1750–1850*, 2 Vols, Englewood Cliffs, 1970

Emerson, P. H., 'Photography, A Pictorial Art', *The Amateur Photographer*, No. 3, London, 19 March 1886; reprinted in Newhall (IVC8)

Emerson, P. H., *Naturalistic Photography for the Student of the Art* (1890), New York, 1972

Emerson, P. H., *The Death of Naturalistic Photography* (1890), New York, 1973

Emerson, R. W., 'Beauty' (1836), in R. W. Emerson, 1969 (IID6)

Emerson, R. W., *Nature: Origin, Growth, Meaning*, eds Merton M. Sealts, Jr and Alfred R. Ferguson, Carbondale and Edwardsville, 1969

Emerson, R. W., 'The American Scholar' (1837), in *The Works of Ralph Waldo Emerson*, London, 1889 (IIA5)

Engels, F., *The Condition of the Working Class in England in 1844* (1845), London, 1952 (IID11)

Engels, F., Letter to Margaret Harkness (1888), in *Marx and Engels on Literature and Art*, eds L. Baxendall and S. Morawski, New York, 1974 (VB6)

Fechner, G. T., *Vorschule der Aesthetik*, Leipzig (1860), 1925 (IVB7)

Fénéon, F., 'Neo-Impressionism' (1887), in Fénéon, 1970 (IVB8)

Fénéon, F., 'The Impressionists in 1886' (1886), in Fénéon, 1970 (VIB7)

Fénéon, F., *Oeuvres plus que complètes*, ed. J. U. Halperin, Geneva, 1970

Fénéon, F., *Au-delà de l'impressionisme*, cd. F. Cachin, Paris, 1966

Feuerbach, L. A., *The Essence of Christianity* (1841/3), trans. G. Elliot (1854), New York, 1957 (IIA8)

Fieder, K., *Konrad Fiedlers Schriften zur Kunst*, ed. Gottfried Boehm, Munich, 1971

Fiedler, K., 'Modern Naturalism and Artistic Truth' (1881), in K. Fiedler, 1971 (VA4)

Fiedler, K., *On Judging Works of Visual Art* (1876), trans. H. Schaeffer-Simmern and F. Mood, Berkeley and Los Angeles, 1957 (VA3)

Field, G., *Chromatics*, London, 1817

Field, G., *Chromatography: or a Treatise on Colour and Pigments and of their Powers in Painting* (1835), London, 1841 (IIC4)

Fine Arts Museums of San Francisco, *The New Painting: Impressionism 1874–1886*, exhibition catalogue, 1986

Fleury-Husson, J., see Champfleury

Foster, K. A. and Leibold, C., *Writing about Eakins: The Manuscripts in Charles Bregler's Thomas Eakins Collection*, Philadelphia, 1989

Fournel, V., *Ce qu'on voit dans les rues de Paris*, Paris, 1858 (IIID7)

Fox Talbot, W. H., 'Some Account of the Art of Photogenic Drawing', *The London and Edinburgh Philosophical Magazine and Journal of Science*, Vol. XIV, March 1839 (IIC6)

Friedrich, C. D., 'Observations on Viewing a Collection of Paintings Largely by Living or Recently Deceased Artists' (c. 1830), in C. D. Friedrich, 1968 (IA8)

Friedrich, C. D., *Caspar David Friedrich in Briefen und Bekenntnissen*, ed. Sigrid Hinz, Berlin, 1968

Frith, F., 'The Art of Photography', *The Art Journal*, London, 1859; reprinted in Newhall (IVC4)

G., Marie-Camille de, 'Fine Arts: Salon of 1834', in *Tribune des femmes*, Vol. II, Paris, April 1834 (IIA3)

Gage, J., *Colour in Turner*, London, 1969 (IB2)

Galeotti, M., Critique of the Purists (1852), in Barocchi, 1972 (IIIc7)

Galeotti, M., *Sull' arte pittorica e sulle attuali dottrine della medessima*, Palermo, 1852

Garland, H., *Crumbling Idols: Twelve Essays on Art* (1894), Cambridge, Mass., 1960 (VIa18)

Gasquet, J., *Cézanne*, Paris, 1921

Gasquet, J., *Cézanne: A Memoir with Conversations*, intro. R. Schiff, pref. J. Rewald, trans. T. Pemberton, London, 1991

Gauguin, P., 'Fable' (1896–7), in Gauguin, 1923 (VIc13)

Gauguin, P., *The Intimate Journals of Paul Gauguin*, New York, 1923

Gauguin, P., Letter to Strindberg (1895) in Gauguin, 1946 (VIc12)

Gauguin, P., *Letters to his Wife and Friends*, London, 1946

Gauguin, P., Notes on Colour (1896–8), in *Paul Gauguin: The Writings of a Savage*, New York, 1990 (VIb18)

Gauguin, P., Notes on Painting (1889–90), in Rewald, 1938 (VIc9)

Gauguin, P., *Intimate Journals (Avant et après)*, trans. F. Van Wyck Brooks, New York, 1921

Gautier, T., 'Art in 1848', *L'Artiste*, Series V, Vol. 1, Paris, 1848 (IIIa1)

Gautier, T., Preface to *Mademoiselle de Maupin* (1835), Paris, 1930 (Ia18)

Gautier, T., *Critique d'art: extraits du Salon 1833–1872*, Paris, 1944

Gay-Lussac, J.-L., Report on the Daguerrotype (1839), in L.-J.-M. Daguerre, *A Practical Description of that Process called the Daguerrotype*, London, 1839 (IIc7)

Geffroy, G., 'Manet the Initiator' (1883), in Manet, 1960 (VIa3)

Geffroy, G., 'Paul Cézanne', *La Vie Artistique*, 3rd series, Paris, 1894 (VIb16)

Gobineau, J.-A., *Essai sur l'Inégalité des Races Humaines* (1853–5), Paris, 1884 (IIIa6)

Goethe, J. F., 'Maxims and Reflections' (*c.* 1815–32), in *Goethes Werke*, Vol. XII, Hamburg, 1953 (Ia12)

Goncourt, E. de, *Hokusai*, Paris, 1896

Goncourt, E. de, and Goncourt, J. de, Journal Extracts, in *Paris and the Arts, 1851–1896: From the Goncourt Journal*, eds George G. Becker and Edith Philips, Ithaca & London, 1971 (IIIb16)

Goncourt, E. de, and Goncourt, J. de, Preface to *Germinie Lacerteux* (1864), London, 1887 (IIIb17)

Goncourt, E. de, and Goncourt, J. de, *French Eighteenth-century Painters* (1880–2), New York, 1948

Gourmont, R. de, *L'Idéalisme* (1893), in de Gourmont, 1902 (Vc11)

Gourmont, R. de, *Chemin de Velours*, Paris, 1902

Greenough, H., 'Remarks on American Art' (1843), in Greenough, 1852 (IId9)

Greenough, H., *Travels, Observations and Experiences of a Yankee Stonecutter*, New York, 1852

Hamilton, G. H., *Manet and his Critics*, New Haven and London, 1954

Hanslick, E., *On the Beautiful in Music* (1854), trans. Gustav Cohen (1891), Indianapolis and New York, 1957 (IIId3)

Harrison, C. and Wood, P., *Art in Theory 1900–1990*, Oxford, 1992

Haydon, B. R., *Lectures on Painting and Design*, London, 1844 (IIc3)

Hazlitt, W., 'On the Picturesque and the Ideal' (1821–2), in Hazlitt, 1908 (Ib3)

Hazlitt, W., *Table Talk* (1821–2), London, 1908

Hazlitt, W., *The Complete Works of William Hazlitt*, London and Toronto, 1934

Hazlitt, W., 'Originality', *The Atlas*, London, January 1830, in Hazlitt, 1934 (Ia9)

Hegel, G. W. F., *Vorlesungen über die Ästhetik*, Berlin, 1835–8

Hegel, G. W. F., *Introductory Lectures on Aesthetics*, trans. Bernard Bosanquet, London, 1886 (Ia10)

Heine, H., Salon of 1831, *Morgenblatt*, Augsburg Sept.–Oct. 1831, in Heine, 1893 (Ia14)

Heine, H., Salon of 1843, in Heine, 1893 (IIa7)

Heine, H., *The Works of Heinrich Heine, Vol. 4, The Salon, or Letters on Art, Music, Popular Life and Politics*, London, 1893

Helmholtz, H., 'On the Relation of Optics to Painting' (1876), in Helmholtz, 1881 (IVB8)

Helmholtz, H., *Popular Lectures on Scientific Subjects*, London, 1881

Henry, C., 'Introduction à une esthetique scientifique', *La Revue contemporaine*, Paris, August 1885 (VIB5)

Henry, C., *Cercle chromatique: presentant tous les compléments et toutes les harmonies de couleurs avec une introduction sur la théorie générale du contraste, du rhythm et de la mésure* (1888), Paris, 1987

Herbert, E. W., see Herbert, R. L.

Herbert, R. L. and Herbert, E. W. 'Artists and Anarchism: Unpublished Letters of Pissarro, Signac and Others', *Burlington Magazine*, CII, London, 1960

Herbert, R. L., *Impressionism: Art, Leisure and Parisian Society*, New Haven, 1988

Hildebrand, A., *The Problem of Form in the Visual Arts* (1893), trans. H. F. Mallgrave and E. Ikonomou, in H. F. Mallgrave, 1994 (VA6)

Hodler, F., 'Characteristic Expression through Form' (*c.* 1895–1900), in C. A. Lossli, 1921–4 (VIc18)

Hodler, F., 'Parallelism, or the Doctrine of Equivalances' (*c.* 1895–1900), in C. A. Lossli, 1921–4 (VIc18)

Hofmannstahl, H. von, on Aestheticism, from 'Walter Pater' (1894), in *Walter Pater: The Critical Heritage*, London, 1980 (Vc12)

Holmes, O. W., 'The Stereoscope and the Stereograph', *The Atlantic Monthly*, Vol. 3, Boston, June 1859; reprinted in Newhall (IVc6)

Holt, E., *The Triumph of Art for the Public 1785–1848*, Princeton, 1970

Holt, E., *The Art of All Nations 1850–73: The Emerging Role of Exhibitions and Critics* (1981), Princeton, 1982

Holt, E., *From the Classicists to the Impressionists: A Documentary History of Art Vol. 3*, New Haven and London, 1966/1986

Holt, E., *The Expanding World of Art 1874–1902*, New Haven and London, 1988

Homer, W., Statement on *plein-air* Painting, in 'Sketches and Studies', *Art Journal*, New York, April 1880 (IVA18)

Honour, H., *Romanticism*, Harmondsworth, 1979

Hugo, V., Preface to *Cromwell*, Paris, 1827, in Hugo, 1882 (IA7)

Hugo, V., *Oeuvres complètes*, Paris, 1882

Hugo, V., Epigraph to Zola's *Paris*, London, 1898 (VIA1)

Humbert de Superville, D. P. G., *Essai sur les signes inconditionnels dans l'art*, Leiden, 1827–32 (IIc1)

Huysmans, J.-K., *Against Nature (A Rebours)* (1884), Harmondsworth, 1959 (VIc1)

Huysmans, J.-K., 'L'Exposition des indépendants en 1881', in Huysmans, 1883 (VIA4)

Huysmans, J.-K., *L'Art moderne*, Paris, 1883

Huysmans, J.-K., 'Degas', in Huysmans, 1889 (VA5)

Huysmans, J.-K., *Certains*, Paris, 1889

Imbriani, V., 'Letters on the 5th "Promotrice" Exhibition' (1867/8) in *Critica d'arte e prose narrative*, ed. G. Doria, Bari, 1937 (IVA3)

Ingres, J. A. D., Notebook Entries (*c.* 1820–48), see Delaborde, 1870; Pach, 1939 (IIB1)

Ingres, J. A. D., 'Opinions on the Salon', in *La Chronique des arts*, Paris, March 1908 (IIID1)

Ingres, J. A. D., *Ingres d'après une correspondance inédite*, ed. Boyer d'Agen, Paris, 1909

Jameson, A., *Diary of an Ennuyé*, London, 1826 (IA6)

Jameson, A., *Handbook to the Public Galleries of Art in and near London*, 1842

Jameson, A., *Companion to the Most Celebrated Private Galleries in London*, London, 1844

Jameson, A., *Memoirs of the Early Italian Painters; and of the progress of painting in Italy from Cimabue to Bassano*, London, 1845

Jameson, A., *A Handbook to the Courts of Modern Sculpture*, London, 1854

Jameson, A., *The Poetry of Sacred and Legendary Art* (1848), London, 1883 (IIIc1)

Joubra, A., *Journal de Eugène Delacroix*, Paris, 1932

Kahn, G., 'The Aesthetic of Polychrome Glass', *La Vogue*, Paris, May 1886 (VIc5)

Kahn, G., 'Response of the Symbolists', *L'Evénément*, Paris, 28 September 1886, in Rewald, 1956/1978 (VIc5)

Kahn, G., *Symbolistes et décadents. Gustave Kahn* (1902), Geneva, 1977

Kierkegaard, S., 'The Individual' (1847), in Kierkegaard, 1938 (IID14)

Kierkegaard, S., Journal Entry (1835), in Kierkegaard, 1938 (IID4)

Kierkegaard, S., *The Journals of Kierkegaard*, trans. and ed. A. Dru, London and New York, Toronto, 1938

Kierkegaard, S., *Either/Or: A Fragment of Life* (1843), trans. H. V. Hong and E. H. Hong, Princeton, 1987 (IID10)

Klinger, M., *Malerei und Zeichnung*, Leipzig, 1891 (VIc16)

Kramskoy, I., 'The Destiny of Russian Art' (1877), in Kramskoy, 1965–6 (IIID15)

Kramskoy, I., *Pisma i Statyi*, Moscow, 1965–6

Laforgue, J., 'Impressionism' (1883), in Laforgue, 1902–3 (VB1)

Laforgue, J., *Mélanges posthumes. Oeuvres complètes*, Vol. III, Paris, 1902–3

Laforgue, J., *Jules Laforgue; textes de critique d'art*, ed. M. Dottin, Lille, 1988

Langbehn, J., *Rembrandt als Erzieher*, Leipzig, 1890 (VB14)

LeBon, G., *The Crowd* (1895), New York, 1960 (VB19)

Leibold, C., see Foster, K. A.

Leonardo da Vinci, *Trattato della pittura*, Rome, 1817

Leonardo da Vinci, *The Literary work of Leonardo da Vinci*, ed. J. P. Richter (1883), New York and London, 1970

Leroy, L., 'The Exhibition of the Impressionists' (1874), in Rewald, 1973 (IVA13)

Leslie, C. R., *Memoirs of the Life of John Constable* (1843), London, 1845

Littré, E., 'On Some Issues in Psycho-physiology' (1860), in Littré, 1876 (IIIB11)

Littré, E., *La Science au point de vue philosophique*, Paris, 1876

Loosli, C. A., *Ferdinand Hodler: Leben, Werke und Nachlass*, Berne, 1921–4

McCoubrey, J., *American Art 1700–1960*, Englewood Cliffs, 1972

McCully, M., *Els Quatre Gats and Modernista Painting in Catalonia in the 1890s*, unpublished Ph.D. dissertation, Yale University, 1975

Makela, M., *The Munich Secession: Art and Artists in Turn of the Century Munich*, Princeton, 1990 (VIA9)

Mallarmé, S., 'The Impressionists and Edouard Manet' in *The Art Monthly Review and Photographic Portfolio*, London, 30 September 1876; reprinted in Charles S. Moffat, *The New Painting: Impressionism 1874–1886*, San Francisco, 1986 (IVA15)

Mallgrave, H. F. and Ikonomou, E., *Empathy, Form and Space: Problems in German Aesthetics, 1873–1893*, Santa Monica, 1994

Manet, E., *Manet raconté par lui-même*, ed. E. Moreau-Nélaton, 2 vols, Paris, 1926

Manet, E., 'Reasons for Holding a Private Exhibition' (1867), in Manet, 1960

Manet, E., *Portrait of Manet by Himself and his Contemporaries* (1953), eds. P. Cailler and P. Courthion, London, 1960

Marées, H., Three Letters to Fiedler (1882), in H. Marées, 1920 (VA5)

Marées, H., *Hans von Marées Briefe*, ed. J. Meier-Graefe, Munich, 1920

Marx, K., *Early Writings*, Harmondsworth, 1975

Marx, K., 'Economic and Philosophical Manuscripts' (1844) in Marx, 1975 (IIA9)

Marx, K., 'The Fetishism of Commodities', from *Capital* (1867), London, 1974 (IIIA10)

Marx, K., *Grundrisse: Foundations of the Critique of Political Economy (Rough Draft)* (1857–8), Harmondsworth, 1973 (IIIA7)

Marx, K., Preface to *A Contribution to the Critique of Political Economy* (1859) in Marx, 1975 (IIIA8)

Marx, K., and Engels, F., *The Communist Manifesto* (1848), London, 1967 (IIA11)

Marx, K. and Engels, F., *The German Ideology* (1845–46), London, 1974 (IIA10)

Matisse, H., 'Notes of a Painter' (1908), in Harrison and Wood, 1992

Matlaw, R., *Belinsky, Chernyshevsky and Dobrolubov: Selected Criticism*, Bloomington, 1976

Maxwell, J. C., 'On Colour Vision' (*c.* 1872), in Maxwell, 1890 (IVB6)

Maxwell, J. C., *The Scientific Papers of James Clerk Maxwell*, ed. W. D. Wiven, Cambridge, 1890

Mill, J. S., 'What is Poetry?' (1833), in J. S. Mill, 1981 (IIB2)

Mill, J. S., *Autobiography and Literary Essays*, eds. J. M. Robson and J. Stillinger, Toronto and Buffalo, 1981

Millais, J. E., Letter to Mrs Coombe (1851), in J. G. Millais, 1899 (IIIc4)

Millais, J. G., *The Life and Letters of Sir John Everett Millais*, London, 1899

Millet, J.-F., Letters and Notebook Entries on Truth in Painting, in Cartwright, and Moreau-Nélaton, 1921 (IIIB7)

Modersohn-Becker, P., *The Letters and Journals*, Evanston, 1990 (VIA7)

Monet, C., Letters to Bazille (1868–9), in Wildenstein, 1974 (IVA4)

Moore, G., *Impressions and Opinions*, London and New York, 1891

Moore, G., 'Sex in Art' (1893), in *Modern Painting*, London, 1893 (VB10)

Moore, G., *Confessions of a Young Man* (1886), Montreal, 1972

Moréas, J., 'Chronique', *Le Symboliste*, No. 1, Paris, 7–14 October 1886 (VIc6)

Moréas, J., 'Symbolism – a Manifesto' (1886), *Les Premières armes du Symbolisme*, Paris, 1889 (VIc4)

Moreau-Nélaton, E., *Histoire de Corot et de ses oeuvres*, Paris, 1905 (IIc2; IVA1)

Moreau-Nélaton, E., *Millet raconté par lui-même*, 3 vols, Paris, 1921

Morisot, B., Letter to Her Sister, in *The Correspondence of Berthe Morisot*, London, 1986 (VIB2)

Morris, W., 'The Decorative Arts: Their Relation to Modern Life and Progress' (1878), see Morris, 'The Lesser Arts'

Morris, W., *The Art of the People*, London, 1879

Morris, W., 'The Lesser Arts' (1878), in Morris, 1882 (VB4)

Morris, W., *Hopes and Fears for Art: Five Lectures Delivered in Birmingham, London and Nottingham, 1878–1881*, London, 1882

Morris, W., ed., *Arts and Crafts Essays, by Members of the Arts and Crafts Exhibition Society*, preface by W. Morris, New York, 1893

Morris, W., 'Art under Plutocracy' (1883), in Morris, 1993 (VB5)

Morris, W., *Art and Society: Lecture and Essays by William Morris*, ed. G. Zabel, Boston, 1993

Morse, S. F. B., 'Examination of Colonel Trumbull's Address' (1833), in Dunlap, 1835 (IID3)

Munch, E., Notebook and Diary Entries, Munch Archive, Munch Museum, Oslo (VIc14)

Newhall, B., *Photography: Essays and Images*, New York and London, 1980/81

Newton, W., 'Upon Photography in an Artistic View, and its Relation to the Arts' (1853), in *Journal of the Photographic Society of London*, 1853; reprinted in Newhall, 1980/81 (IVc1)

Nietzsche, F., *The Birth of Tragedy* (1872), trans. Walter Kaufmann, New York, 1967 (VB2)

Nietzsche, F., *Twilight of the Idols* (1889), trans. Walter Kaufmann, in *The Portable Nietzsche*, New York, 1980 (VB13)

Nietzsche, F., *The Will to Power* (1901/6), trans. Walter Kaufmann and R. J. Hollingdale, New York, 1968 (VB12)

Noble, L. L., see Cole, 1853

Nochlin, L., *Realism and Tradition in Art 1848–1900*, Englewood Cliffs, 1966a

Nochlin, L., *Impressionism and Post-Impressionism 1874–1904*, Englewood Cliffs, 1966b

Nochlin, L., *Realism*, Harmondsworth, 1971

Nordau, M., *Degeneration* (1892), Lincoln and London, 1993 (VB17)

Nunn, P. G., *Victorian Women Artists*, London, 1987

Pach, W., *The Journal of Eugène Delacroix*, London, 1938 (IA3)

Pach, W., *Ingres*, New York and London, 1939

Paillot de Montabert, J. N., *Théorie de la geste dans l'art de la peinture*, Paris, 1813

Paillot de Montabert, J. N. *Traité complet de la peinture*, Paris, 1828–9

Paillot de Montabert, J. N., *L'Artistaire. Livre des principales initiations aux beaux-arts*, Paris, 1855 (IIB9)

Palmer, S., Letter to John Linnell (1828), in *The Letters of Samuel Palmer*, Oxford, 1974 (IB6)

Pater, W., Conclusion (1868) in Pater, 1971 (VC1)

Pater, W., *The Renaissance* (1873/1888), London, 1971

Pater, W., 'The School of Giorgione', *The Fortnightly Review*, London, October 1877; included in Pater, 1971 (VC2)

Pater, W., *Essays on Literature and Art*, ed. J. Uglow, London and Totowa, NJ, 1973

Peirce, C. S., 'On the Nature of Signs' (1873), in Peirce, 1991

Peirce, C. S., *Peirce on Signs: Writings on Semiotics by Charles Sanders Peirce*, ed. J. Hoopes, Chapel Hill, 1991

Péladan, J., 'Manifesto' of the Rose+Croix, *Le Figaro*, Paris, 2 September 1891, in Pincus-Witten, 1976 (VIC17)

Péladan, J., 'Rules' of the Rose+Croix, Paris, 1891, in Pincus-Witten, 1976 (VIC17)

Pincus-Witten, R., *Occult Symbolism in France* (1968), New York, 1976

Pissarro, C., Letter to Durand-Ruel (1886), in Venturi, 1939 (VIB10)

Pissarro, C., *Camille Pissarro: Letters to his Son Lucien* (1944), ed. J. Rewald, Salt Lake City, 1981 (VIB11; VIC11)

Pissarro, C., Advice to le Bail (1896–7), in Rewald, 1973 (VIB12)

Podro, Michael, *The Critical Historians of Art*, New Haven and London, 1982

Poe, E. A., 'The Colloquy of Monos and Una' (1841), in *The Complete Poetry and Selected Criticism of Edgar Allan Poe*, ed. A. Tate, New York, 1968 (IID8)

Poe, E. A., 'The Man of the Crowd' (1840), in Poe, 1993 (IID7)

Poe, E. A., *Tales of Mystery and Imagination* (1908), London, 1993

Poulain, G., *Bazille et ses amis*, Paris, 1932

Poynter, Sir E., *Lectures on Art*, London, 1885 (IVB10)

Prendergast, C., *Paris and the Nineteenth Century*, Oxford, 1992

Proudhon, P.-J., *Système des contradictions économiques*, Paris, 1846

Proudhon, P.-J., *Du Principe de l'art et sa destination sociale*, Paris, 1865 (IIIB13)

Proudhon, P.-J., *What is Property?* (1840), Cambridge, 1993

Przybyszewski, S., 'Psychic Naturalism' (1894), in *Das Werk Edvard Munch, Vier Beiträge*, ed. S. Przybyszewski, Berlin, 1894

Pugin, A. W., *Contrasts*, London, 1836 (IIA4)

Quatremère de Quincy, A., *An Essay on the Nature, the End and the Means of Imitation in the Fine Arts* (1823), London, 1837 (IB5)

Quatremère de Quincey, A. C., *Essai sur l'idèal*, Paris, 1837

Ratliff, F., *Paul Signac and Colour in Neo-Impressionism; including the first English translation of 'From Eugène Delacroix to Neo-Impressionism' by Paul Signac*, trans. W. Silverman, New York, 1992

Redon, O., *A soi-même: Journal (1867–1915): notes sur la vie, l'art et les artistes*, Paris, 1922 (Vc5; VIc19)

Redon, O., *Critiques d'art: Salon de 1868, Rodolphe Bresdin, Paul Gauguin; précédées de confidences d'artiste*, ed. R. Coustet, Bordeaux, 1987

Renan, E., *De L'origine du langage*, Paris, 1864

Renan, E., *The Future of Science, Ideas of 1848* (1888), London, 1891 (IIIA2)

Renoir, P. A., Three Letters to Durand-Ruel (1881–2), in Venturi, 1939 (IVA19)

Renoir, P. A., 'The Society of Irregularists' (1884), in Venturi, 1939 (Vc7)

Renoir, P. A., Notes (*c.* 1880–1910), in Renoir, J. 1962 (Vc8)

Renoir, J., *Renoir My Father* (1958), London, 1962

Repin, I., 'An Artist's Notes' (1897), in Repin, 1901 (VIA15)

Repin, I., Letter to Diaghilev (late 1890s), in Repin, 1969 (VIA15)

Repin, I., *Vospominaniya. Statyi i Pisma iz Zagranitsy*, ed. N. B. Serova, St Petersburg, 1901

Repin, I., *Izbrannyye Pisma v Dvukh Tomakh, 1867–1930*, ed. I. Brodskiy, Moscow, 1969

Rewald, J., *Gauguin*, New York and Paris, 1938

Rewald, J. (ed.), 'Extraits du Journal Inédit de Paul Signac', *Gazette des beaux-arts*, Paris, July–August 1953

Rewald, J., *The History of Impressionism* (1946), London, 1973

Rewald, J. *Post Impressionism from Van Gogh to Gauguin*, London, 1956/78

Riegl, A., *Problems of Style* (1893), trans. E. Kain, Princeton, 1992 (VA10)

Rigutini, G., 'Florentine Chat', *Gazetta del Popolo*, 3 November 1862 (IVA2)

Rimbaud, A., Letter to Paul Demeney (1871), *Collected Poems*, Harmondsworth, 1986 (IVA9)

Rivière, G., 'The Exhibition of the Impressionists' (1877), in Venturi, 1939 (IVA16)

Rood, O., *Modern Chromatics, with Applications to Art and Industry*, New York, 1879 (IVB9)

Rosetti, D. G., 'Hand and Soul', *The Germ*, No. 1, London, January 1850 (IIIc2)

Rosetti, W. M., *The Germ: Thoughts towards Nature in Poetry, Literature and Art* (1899), New York, 1965

Rusiñol, S., Speech on the occasion of the Third Festa Modernista, trans. M. McCully, in M. McCully, 1975 (VIA13)

Ruskin, J., *The Seven Lamps of Architecture*, London, 1849

Ruskin, J., 'The Nature of Gothic' (1853), in Ruskin, *The Stones of Venice*, 2 vols, London, 1851 and 1853 (IIIc6)

Ruskin, J., Letters to *The Times* (1851) (IIIc5)

Ruskin, J., *Elements of Drawing; in Three Letters to Beginners* (1857), New York, 1886 (IVB1)

Ruskin, J., *The Political Economy of Art*, London 1857

Ruskin, J., *Modern Painters* (1843), London, 1900 (IIB6)

Ruskin, J., 'Modern Manufacture and Design' (1859), in Ruskin, *The Two Paths* (1859), London, 1912 (IIIA9)

St Simon, C.-H. de, 'The Artist, the Savant and the Industrialist' (1825) in St Simon, 1825 (IA5)

St Simon, C.-H. de, *Opinions Littéraires, Philosophiques et Industrielles*, Paris, 1825

Schapiro, M., 'The Nature of Abstract Art' (1936), in Schapiro, 1978

Schapiro, M., *Modern Art 19th and 20th Centuries*, New York, 1978

Schleiermacher, F., 'On the Concept of Art' (1831/2), in Schleiermacher, 1984 (IA11)

Schleiermacher, F., *Ästhetik/ Über den Begriff der Kunst*, ed. Thomas Lehnerer, Hamburg, 1984

Schopenhauer, A., *The World as Will and Representation* (1818/44), trans. E. F. J. Payne, London and New York, 1969 (IA1)

Scott, L., 'Women at Work: Their Functions in Art', in *Magazine of Art*, Vol. VII, London, 1884 (VB8)

Scott, L., *The Renaissance in Italy*, London, 1888

Scott, L., *The Cathedral Builders: The Story of a Great Masonic Guild*, London and New York, 1899

Scott, L., *The Renaissance of Art in Italy* (1883), New York, 1973

Selvatico, P., *Sull'educazione del pittore storico odierno italiano*, Padova, 1842

Selvatico, P., *Scritte d'arte*, Florence, 1859

Selvatico, P., On Landscape (1842), in Barocchi, 1972 (IB11)

Selvatico, P., Merits of the Purists (1859) in Barocchi, 1972 (IIIc8)

Semper, G., *Science, Industry and Art* (1852), in Semper, 1966 (IIIA5)

Semper, G., *Wissenschaft, Industrie und Kunst und andere Schriften über Architektur, Kunsthandwerk und Kunstunterricht*, ed. H. M. Wingler, Frankfurt, 1966

Sérusier, P., *ABC de la peinture, suivi d'une correspondance inédite*, Paris, 1950

Sérusier, P., Letter to Maurice Denis (1889), in Sérusier 1950 (VIc8)

Seurat, G., Letter to Maurice Beaubourg (1890), in Seurat, 1991 (VIB9)

Seurat, G., *Seurat*, exhibition catalogue, Paris, 1991

Seurat, P., *Notes sur Delacroix*, Caen, 1987

Shaw, G. B., 'The Sanity of Art' (1895), in Shaw, *The Collected Works* Vol. XIX (1932), London, 1955 (VB18)

Shiff, R., *Cézanne and the End of Impressionism*, Chicago, 1984

Signac, P., 'Impressionists and Revolutionaries', *La Révolte*, Paris, 13–19 June 1891 (VB16)

Signac, P., Diary Entries (1899), in Rewald, 1953 (VIB13)

Signac, P., *From Eugène Delacroix to Neo-Impressionism* (1899), ed. F. Cachin, Paris, 1964 (VIB14)

Signorini, T., 'A Few Remarks about the Art Exhibitions in the Rooms of the Society for the Promotion of the Arts', *La Nuova Europa*, 10 October 1862 (IVA2)

Signorini, T., 'Art Controversy', *La Nuova Europa*, 19 November 1862 (IVA2)

Southworth, A. S., 'The Early History of Photography in the United States', *The British Journal of Photography*, No. 18, London, November 1871; reprinted in Newhall, 1980/81 (IVc7)

Stendhal, (M.-H. Beyle), *Racine and Shakespeare* (1823), New York, 1962

Stendhal, (M.-H. Beyle) *Histoire de la peinture en Italie* (1817), Paris, 1969

Stendhal, (M.-H. Beyle), *Oeuvres complètes*, Geneva, 1972

Stendhal (M.-H. Beyle), Salon of 1824 (1824) in Stendhal, 1972 (IA4)

Stieglitz, A., 'Pictorial Photography', *Scribner's Magazine*, New York, November 1899; reprinted in Newhall, 1980/81 (VIA19)

Stieglitz, A., *Photographs and Writings*, Washington, 1983

Stirner, M., *The Ego and its Own* (1844), trans. S. Byington (1907), London, 1982 (IID12)

Strindberg, A., Letter to Gauguin (1895), in Gauguin, 1923 (VIc12)

Superville, see Humbert de Superville, D. P. G.

Taine, H., *On Intelligence*, London, 1871

Taine, H., 'On the Production of the Work of Art', and 'On the Ideal in Art' (1865–7) in *Lectures on Art*, New York, 1896 (IVB3)

Taylor, J. C., *Nineteenth Century Theories of Art*, Berkeley and Los Angeles, 1987

Ten-Doesschate Chu, P., see Courbet, G.

Thoma, H., Letter to Emil Lugo (1880), in Cassirer, 1919 (Vc6)

Thoré, T., see also Bürger, W.

Thoré, T., *Le Salon de 1844 précéde d'une lettre à Théodore Rousseau* (1844), in Thoré, 1868 (IIB11)

Thoré, T., 'Salon of 1848' (1848), in Thoré, 1868 (IA12)

Thoré, T., *Salons de T. Thoré*, Paris, 1868

Tolstoy, L., *What is Art?* (1898), London, 1930 (VB20)

Turner, J. M. W., Lecture Note on Colour, Appendix II in J. Gage, *Colour in Turner*, London, 1969 (IB2)

Turner, J. M. W., Letter on Printmaking (1841), in *The Collected Correspondence of J. M. W. Turner*, Oxford, 1980 (IIc8)

Turner, J. M. W., *The Collected Correspondence of J. M. W. Turner: With an Early Diary and a Memoir by George Jones*, ed. J. Gage, Oxford, 1979

Uzanne, O., *The Modern Parisienne* (1894), London, 1912 (VB11)

Van Gogh, V., *Corréspondance complète de Vincent van Gogh*, 3 vols, Paris, 1960 (VIB3)

Van Gogh, V., *De brieven van Vincent van Gogh*, 4 vols, The Hague, 1990 (VIA6, VIB3)

Various artists, Women's Petition to the Royal Academy (1859), in Nunn, 1987 (IIID10)

Various authors, On the *Salon des Refusés* (1863), in Hamilton and Rewald, 1973 (IIID11)

Various authors, On Manet's *Olympia* (1865), in Hamilton, 1954 (IIID12)

Vaughan, R., *The Age of Great Cities*, London, 1843 (IIA6)

Veblen, T., *The Theory of the Leisure Class: An Economic Study of Institutions*, New York, 1899 (VB21)

Venturi, L., *Les Archives de l'Impressionisme*, Paris and New York, 1939

Vischer, F. T., *Aesthetik; oder Wissenschaft des Schönen*, Reutlingen, 1846–57

Vischer, F. T., 'Overbeck's *Triumph of Religion*' (1841) in F. T. Vischer, 1922 (IIB5)

Vischer, F. T., *Critique of My Aesthetics* (1866), in F. T. Vischer, 1922 (VA1)

Vischer, F. T., *Kritische Gänge*, ed. R. Vischer, Munich, 1922

Vischer, R., *Über das optische Formgefühl*, Leipzig, 1873

Vischer, R., 'The Aesthetic Act and Pure Form' (1874), in R. Vischer, 1927 (VB2)

Vischer, R., *Drei Schriften zur Ästhetischen Formproblem*, Halle, 1927

Vrubel, M., Letter to his Sister (1883), in Vrubel, 1929 (VIA14)

Vrubel, M., Letter to Savinsky (1885), in Vrubel, 1963 (VIA14)

Vrubel, M., *Pisma k sestre, vospominaniya o khudozhnike, otryvki iz pisem otsa*, eds A. Ivanov and A. A. Vrubel, Leningrad, 1929

Vrubel, M., *Perepiska. Vospominaniya o Khudozhnike*, Leningrad, 1963

Wagner, R., 'The Art-Work of the Future' (1849/50), in Wagner, 1892 (IIID2)

Wagner, R., *Richard Wagner's Prose Works*, trans. W. Ashton Ellis, London, 1892

Wagner, R., 'The Revolution' (1849), in *Wagner: A Documentary Study*, ed. H. Barth, D. Mach and E. Voss, Vienna and London, 1975 (IIIA3)

Weinberg G., *Das Junge Wien – Österreichische Literatur– und Kunstkritik, 1887–1902*, Tübingen, 1976

Whistler, J. McN., Cross-examination in the Trial of Ruskin for Libel, *The Daily News*, London, 26 November 1878 (VC3)

Whistler, J. McN., *Mr Whistler's "Ten O'Clock"*, London, 1885 (VC4)

Whistler, J. McN., *The Gentle Art of Making Enemies*, London, 1893

Whistler, J. McN., *Eden versus Whistler, the Baronet and the Butterfly*, Paris and New York, 1899

Whistler, J. McN., *Whistler on Art: Selected Letters and Writings of James McNeill Whistler*, ed. N. Thorp, Manchester and Washington, DC, 1994

Whitman, W., Preface to *Leaves of Grass* (1855), New York, 1959; Harmondsworth, 1986 (IIID9)

Wiertz, A. J., 'Photography', *Le National*, Brussels, June 1855; reprinted in Wiertz, *Oeuvres littéraires*, Paris, 1870 (IVC2)

Wilde, O., *The Complete Works of Oscar Wilde* (1948), London and Glasgow, 1992

Wilde, O., *The Decay of Lying*, *The Nineteenth Century*, London, January 1889, in Wilde 1948/1992 (VC9)

Wilde, O., Preface to *The Picture of Dorian Gray* (1890), in Wilde 1948/1992 (VC9)

Wilde, O., 'The Soul of Man Under Socialism' (1890), in Wilde 1948/1992 (VB15)

Wildenstein, D., *Claude Monet, biographie et catalogue raisonné*, Lausanne and Paris, 1974

Wölfflin, H., *Prolegomena to a Psychology of Architecture* (1886), trans. H. F. Mallgrave and E. Ikonomou, in Mallgrave, 1994 (VA7)

Wölfflin, H., *Renaissance and Baroque* (1888), trans. Kathrin Simon, London, 1964 (VA8)

Wölfflin, H., *Classic Art*, London and New York (1899), 1959

Wölfflin, H., *Principles of Art History* (1915), New York, 1950

Wordsworth, W., Letters on the Kendal and Windermere Railway (1844), in Wordsworth, 1974 (IIB10)

Wordsworth, W., *The Prose Works of William Wordsworth*, ed. W. J. B. Owen and J. Worthington-Smyser, Oxford, 1974

Wyzewa, T. de, 'Wagnerian Art: Painting' (1886), in Wyzewa, 1895a (VIc2)

Wyzewa, T. de, 'L'Art Wagnérien: ébauche d'un esthétique idéaliste (1885–1886)' (1895a), in Wyzewa, 1895b

Wyzewa, T. de, *Nos Maîtres: études & portraits littéraires*, Paris, 1895b

Zimmermann, R., 'Towards the Reform of Aesthetics as an Exact Science', in *Zeitschrift für exacte Philosophie*, Band II, Heft I, Leipzig 1861 (IVB2)

Zola, E., 'Dedication to Cézanne' (1866), in J. Rewald, *Paul Cézanne: A Biography*, New York, 1948 (IVA6)

Zola, E., 'The Moment in Art' (1866), in *Emile Zola. Salons*, Geneva, 1959 (IVA6)

Zola, E., 'Edouard Manet' (1867), in Courthion and Cailler, 1960 (IVA7)

Copyright acknowledgements

Index